The Complete Reprint of John Willie's

Bizarre

I

Cover / Umschlag / Couverture:

Original cover image from *Bizarre* Vol. 10, 1952

Ill. p. 4 / Abb. S. 4:

John Willie, "Pretty Polly", from *Bizarre* 20, p. 45, 1956

John Willie's *Bizarre* was published from 1948 to 1959 at irregular intervals. Volume 1 originally appeared in 1954, but in our reprint it has been placed in front of the subsequent volumes.

This book was printed on 100% chlorine-free bleached paper in accordance with the TCF standard.

© 1995 Benedikt Taschen Verlag GmbH, Hohenzollernring 53, D–50672 Köln
© 1995 Text: Eric Kroll
Edited by Eric Kroll
German translation by Gabriele-Sabine Gugetzer, Hamburg
French translation by Philippe Safavi, Paris

Printed in the Czech Republic
ISBN 3–8228–9269–6

The Complete
Reprint of
John Willie's

BiZARRE

Edited by Eric Kroll

TASCHEN

KÖLN LISBOA LONDON NEW YORK OSAKA PARIS

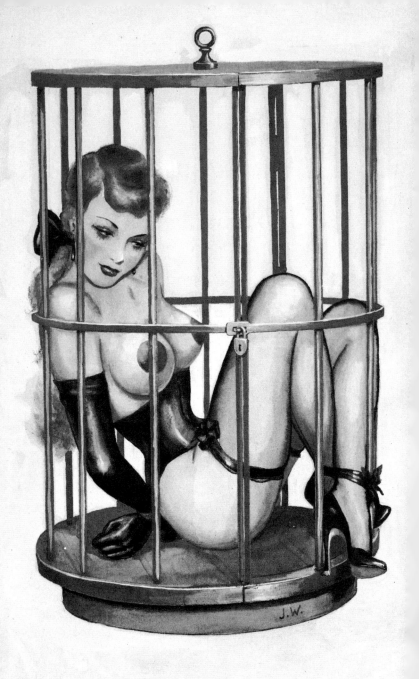

" PRETTY POLLY "

Contents
Inhalt
Sommaire

John Willie
is Bizarre

by Eric Kroll

It's midnight at the Club Trocadero, on a nondescript
Wednesday, south of Market Street in San Francisco,
California. I'm alone standing on a bench watching
blonde Alisse, her head perfectly still, be disciplined by
Master James. A sea of 20-year-olds, both male and
female, watch transfixed as Master James whips her
and binds her. Her fleshy rear is framed by a black
garter belt and she is topless, though I can't see her
breasts since she faces away from me. I sense black-
haired Jasmine is directly in front of her but Alisse
blocks my view and that is fine. I can imagine what he
is doing to the pair. Her legs appear extra long in the
five inch heels she is wearing. My attention is drawn to
where the top of her hose meets the garter belt. He's
just left a whip mark. This is Bondage A-Go-Go. This is
the end of the Twentieth Century and we are watching
the seeds that John Willie planted over 50 years ago.

I am writing the introduction to the long-awaited
reprinting of *Bizarre* magazine. But it's really about
John Alexander Scott Coutts, aka John Willie. Artist,
photographer, writer, publisher and banjo player John
Willie. I bow down to you. You are the Leonardo da
Vinci of Fetish and maybe this publication will give you
the recognition you merit.

In his life he came full circle. Born December 9,
1902, into a wealthy British merchant banking family,
he was banished to Australia. He married Holly and
they moved to New York City in the 1940s. He took
wonderful bondage photos of the dark-haired beauty
but the marriage bond disintegrated and they were
divorced. He started *Bizarre* magazine in 1946 and
published the first 20 issues before moving to Holly-

wood, California, in 1957, a bitter man. In 1961 he became ill (brain tumor) and was forced to discontinue his mail order business. He destroyed his archives and returned to England. He died on August 5, 1962. Brilliant. A great artist. A visionary. He died penniless. So what else is new?

Let me finish my first paragraph. As I was leaving the club I passed next to the bound body of Sweet Gwendoline, I mean Alisse. Her arms were tied behind her back, each elbow roped to an adjoining wrist.

Jasmine was in the same exquisite predicament. Their leather neck collars were joined together by a simple chain forcing them to lean slightly forward. I said "good night", but neither answered. Each had a large green apple stuck between her teeth!

This is (part of) the story as I could piece it together. Like the great bondage and pin-up model Bettty Page, there is more conjecture than there is fact about John Willie. I've spoken to three people who actually met him and one that saw him from a distance, but most of what I know is from the years of doing fetish fashion photography. Watching women undress, helping them to lace into corsets, squeeze into girdles, slide back into black rubber. They prance around in extremely high heels and sometimes I bind them up for my camera (and my pleasure) and sometimes I drop to my knees and worship them with my camera. I've read everything that has ever been printed on Mr. John Willie.

John Willie was the MASTER. I don't think he was into extreme cruelty. He believed in consensual bondage. He seems to have been cocky. This makes sense. He knew of a world that no one else could even imagine. His vision left him alone in the world. He had a drinking problem. I can understand that. He was rejected by his family. He was constantly broke and from the way he wrote he had a nagging wife.

One of the bars he drank in was Chumley's. I've been to this notorious art bar in West Greenwich Village. It has no name out front. One either knows it or not. In the late 1970s I stood at the urinal in the men's room and had a stimulating conversation with writer James Baldwin, having recently returned from Paris.

Rumor had it Willie's friend bought the drinks. Sir James, owner of the Chateau in North Hollywood, a private b&d/s&m establishment, told me how Willie found his models. There was another bar in the Village that shared an entranceway with a drugstore. As one entered there was a magazine rack. Willie put a stack of his recently printed *Bizarre* magazines in the rack. From the bar he could watch as the women came in from the street. Those females that took an interest in his publication he'd approach. I've heard that the secretaries at *Bizarre* were also his models.

He liked leggy, dark-haired, small-breasted women. To Willie a model's range of expression was very important. Could she show emotion? His art and his photographs were successful because they looked real. Willie took photographs and drew from the photographs. Sir James attended several of John Willie's photo sessions in studios in Greenwich Village and Manhattan's Westside. He claimed that Willie would do nude bondage photographs for his own private collection to draw from. Once he had drawn the body contours correctly he'd paint on the clothes. He recalled Willie photographing Betty Page. He hog-tied her, did semi-suspension bondage and even total nude bondage. Unfortunately, the armed services lost Sir James' two steamer trunks filled with bondage photos and drawings by Willie and others.

It is difficult to pinpoint exact events or connections. I know Sam Menning, prolific girlie photographer and cat lover, had a studio on the Westside. I know he knew Betty Page. Perhaps Willie was connected with Page at

Menning's studio. Or maybe John Willie knew Weegee, the great crime scene photographer who I know photographed Betty Page and who lived on West 47th street. More than likely Willie met Page at Irving Klaw's studio on East 14th street. I asked Eric Stanton, the great fetish artist, if he ever met Willie. He said he saw him once come into Klaw's office – 20 feet away. He began to go over to speak to him and Irving turned to Stanton, pointed a finger and said: "Stay away!" Irving didn't want his artists to fraternize.

I read with fascination the Correspondence section in almost all the issues of Bizarre. People could realize they weren't alone in their "peculiar" interests. I was amazed at how many couples practised consensual bondage, "Hydrophilia" (the art of getting wet while fully clothed) and the predominance of "slaverettes" (women as masters). It wasn't until volume 21 that I read a letter by someone I knew: Fakir Musafar, the body modifier and publisher of Body Play (Menlo Park, California). He detailed his ibitoe training with metal corset belt. In volume 23 (pp. 35-39) there was a second letter referring to "The Little Lass" who convinced Fakir to dress in drag. "I allowed her two full weeks of freedom. Since she is seldom without muzzle ..." I searched volume 22 for a letter I must have missed establishing the dominance of "The Little Lass". Finally, I phoned him and asked him to explain in more detail who this woman was. No problem. Fakir explained it was his alter ego!

So what is truth? How much of what I read is of the imagination and does it matter if it exists or is someone's fantasy? Both are extensions of the person and both trigger ideas and emotions – which is what John Willie's Bizarre magazines do. While reading the approximately 1,600 pages of Bizarre I found myself constantly jumping up to xerox a drawing or a photo, amazed at the thoughts these images provoked.

Fakir Musafar wrote Willie and received back letters from a Miss Maggie whom he believed could have been Willie's alter ego. Eric Stanton said he heard rumors Willie enjoyed wearing silk stockings. For comfort, or was this his female side? I think Willie was a pure dominant. In a letter to Jim reprinted in Belier Press' *Sweet Gwendoline* he stated: "I've tried a corset on myself and it was nothing else but damned uncomfortable. It gives a woman a beautiful shape which I like but I shall get double pleasure out of using it as an 'instrument of correction'." In the same letter to Jim he claimed: "I don't like extreme cruelty... I simply apply as much as is needed to correct disobedience. Discomfort in bondage helps increase the realization of helplessness." (His quest for realism.)

In volume 2 No. 1 of Fakir's *Body Play* he speaks about meeting Willie at a bar in Minneapolis, Minnesota. "We talked about ultra high heels and we both agreed that in themselves they possessed no unique charm. However what was exciting about them was the thought that someone had to endure hours of painful training to learn to wear them."

Sophisticated and interesting. I know that I videotape my models as they attempt to walk in extreme high heels for the first time. It is like watching a newborn doe walk for the first time. There is something beautiful in the awkward movement. And something triumphant in the ability to walk in, as my wife calls them, "cruel shoes". I remember my neighbor in New York City, performance artist, ex-porno star Annie Sprinkle, wearing extreme heels for hours at a time. No one in the room said anything but everyone was impressed.

I don't think *Bizarre*'s circulation was very big. It appeared erratically. I've never heard a logical explanation for why volume 2 came out first in 1946 and volume 1 appeared in 1954 just after volume 13. Was it

a practical joke of Willie's? Just like choosing "Willie" as his pseudonym, which meant "prick" in English slang.

I know that many readers first became aware of Willie through his serialization of *Sweet Gwendoline* in *Wink* magazine in the August and October 1949 issues. Others found copies of *Bizarre* by accident. "The Manhattanite" told me he was in Boston attending Harvard University when he went to the Howard Burlesque House and stopped at the neighboring cigar store. On the rack was *Bizarre* volumes 2 and 3. He "flipped" and began writing directly to Willie. They corresponded and he visited Willie in Los Angeles in the late 1950s. Willie hired one of his favorite models, Pat, and the Manhattanite photographed her with Willie in attendance in Willie's apartment. She wore high-waisted white underwear which are a favorite fetish for the Manhattanite and me. We also both love to play golf. I don't think there is a correlation. He said Willie picked him up at the airport. He was on a business trip.

He said Willie seemed troubled and thought he was bothered by censorship and mail problems. As Bunny Yeager cloaked her fine nude photography in "How To" technical photo books, Willie in *Bizarre* magazine felt it necessary to camouflage his interest in bondage photography by using his images to advise: "'Don't let this happen to you.' Learn jiu-jitsu, the art of self-defense."

In volume 17 Willie speaks out strongly against the police state: "It seems useless to point out to these people that freedom means 'freedom', with no qualification..." Right on John Willie. His ideal community may have been women in bondage wearing fetish attire, but it was consensual bondage, and even though he stated that the Suffragettes brought on the downfall of man, the master", it is obvious he welcomed and

championed freedom of expression, especially sexual expression. He wasn't too fond of the Church either, but that's another story.

Willie seemed to enjoy intricate correspondence with his readership and would give detailed rope bondage advice including step by step sketches. His handwriting was very fine and difficult to read. He recommended the sea scouts manual for learning knots. He had been a merchant marine while living in Australia. He guarded his mailing list tightly and destroyed it when he became ill and had to close his business in 1961. He never lacked integrity in his business, art or photography.

When he moved to L.A. he implied he sold or gave *Bizarre* to his secretary and her boyfriend but wasn't pleased with what they did with it. Fakir Musafar believes he sold it to Mahlon Blaine, the artist whose work appeared frequently after volume 20. Jeff Rund, in his biography of Willie in *Sweet Gwendoline*, says he sold the magazine to R.E.B. who continued to publish it until 1959.

Volume 2 was printed in Montreal, Canada, while all the others were printed in New York City. Coutts used Montreal as a mailing address. Shrewd. He wouldn't do that today. Canada frowns on bondage images. He was a poor businessman and complained constantly about high costs. Supposedly, his office in New York was ransacked and art stolen. He resented the deal he had with Irving Klaw as to *Sweet Gwendoline*. Klaw published *Sweet Gwendoline* in "The Escape Artist" and "The Missing Princess" and had Eric Stanton reluctantly paint clothes over the whip marks directly on the original art work.

John Willie and the entire sexual underground of that period (I exist pleasantly in that underbelly today) read like a Raymond Chandler detective novel filled with intrigue. Supposedly he kept several residential apart-

ments in New York City to shoot in and produce his magazine. People used initials or pseudonyms. "The Manhattanite" for example. Or "John Willie". In the 1950s Senator Keufaver held hearings on the supposed problem of morals and comics. It involved Irving Klaw and caused him great problems. There was a death in Miami, Florida, that government officials attempted to link to Klaw's bondage publications. It was unsuccessful, but the excitement contributed to his poor health and led to him destroying some negatives of severe bondage.

Conversely, it is rumored that Willie was greatly disturbed by the death of one of his models, Judy Ann Dull. She was the third victim of Harvey Glatman, the Los Angeles "Bondage Murderer". It was reported that Dull had agreed to pose for pin-up photographs for two hours for $40. She left her apartment with Glatman and never came back. After photographing the nude women bound and gagged he'd strangle them with the same sash cord. Another Willie model, Lorraine Virgil, was to be his fourth victim but instead was able to wrestle the gun from him and hold him at gunpoint until a California highway patrolman arrived. (Chandler novel.) After "owl-eyed" television repairman Glatman confessed to the murders he brought police investigators to his old address – 5924 Melrose Avenue – where another pin-up photographer was now living. The madman stated: "It seemed like I always had a piece of rope in my hands when I was a kid. I guess I was just kind of fascinated by rope." (*Los Angeles Times*, November 1, 1958).

Not the best press for a professional bondage photographer. It is said that Willie was very troubled that his photographs and art might have contributed in some way to this hedious crime. Ira Levine, current editor of O magazine, heard rumors that Willie had had an "old man's folly" for Dull, but unfortunately, in personality,

she was much like her name. Another victim was Angela Rojas, a local stripper, who put ads in newspapers offering to pose for amateur and professional photographers. "He picked her up and drove her into the desert, took many pictures and reluctantly strangled her." (*Los Angeles Times*, November 1, 1958).

If Willie was acutely upset that his photographs and art contributed to a murder, it didn't stop him from placing an ad several years later in *Adam* magazine offering to sell a BIG, 64 page MAGAZINE CARTOON of *Sweet Gwendoline* using a close-up of Gwen's gagged face and the following promotion: "In fact, no Stately Home with anything like a decent Dungeon is complete without a copy."

When I was 16 years old my parents allowed me to go to Paris for part of the summer. Most high school students went to the Louvre. I went directly to Pigalle. I remember a rainy night and my friend and I were trying to get out of the rain. Suddenly we found ourselves ushered into a cabaret. We sat in the cheaper seats in the back. Across the nightclub floor was a raised stage with curtains. The curtains opened and a muscular Black African came forth. He had no shirt and his hair was tied in a bun and hung as one solid piece down his back. There was a near-naked woman secured to a seat in the middle of the stage. He walked slowly over to her and swung his massive hair in an arch and slammed it down on her exposed shoulders. Her head snapped back and he repeated his motion. He was whipping this beautiful bound woman with his hair. This scene is etched upon my memory.

"The Rope Trick of the Rhine" in Bizarre volume 1, pp. 25-37, made me think of that night. Another cabaret bondage scene, but this one I got to enjoy at my leisure.

An old friend of mine is Veronica Vera, sex writer, performance artist and nude fetish model for Robert

Mapplethorpe. She is also the founder of "Miss Vera's Finishing School For Boys Who Want To Be Girls" in New York City. I had the privilege late one afternoon to watch a bevy of men transformed into beautiful women, one of whom was dressed as a French maid with ruffles. As I watched "her" serve everyone tea and sandwiches – curtsying between servings – I recalled many of the letters in Bizarre from irate wives. In volume 9, pp. 56-60, "Babs" caught her young husband being unfaithful. She demanded he must be punished and he accepted. Her 'unique' sentence was: "He must dress as a cute little French Maid and wait upon me hand and foot and I DON'T MEAN MAYBE!!!... High heels, lacy cap and lacy apron, long black silkhose, little short black silk maid's dress, AND a beautiful black hair wig!" Ah... the exquisite shame he must have enjoyed.

Years later I attended a "Dressing For Pleasure Ball" put on by Constance Enterprises in New Jersey. There was a fetish fashion show but I remember only a blonde with a severe ponytail stomping down the runway in a leather armless leotard made by Slimwear of America. I was instantly turned on by this woman. And I know what it was. It wasn't her physical beauty. It was her fashion BONDAGE. Her comfortable helplessness. In Bizarre volume 24, pp. 59, 62, there is a letter about corset training and how "a daughter of a wealthy widow is so completely addicted, that she comes in every day to have her hair fixed and makeup applied, often appearing in such constricting attire that she cannot walk nor stand without the help of her maids. She has preferred the 'Venus Style' of corset training and insists on going about, night and day, without use of her arms. She wears expensive, custom made clothes, designed without sleeves and of the many other customers that have seen her here, not one would suspect that she has arms tightly pinned to her

body beneath those clothes. She has often stated she gets the utmost thrill out of not being able to use her arms and the reaction of those about her."

Well now here follow the 26 issues of John Willie's *Bizarre* magazine. *Bizarre* magazine was an open forum for just that – bizarre ideas, concepts and costumes. I personally found plenty to think about and I'm certain everyone will. Simply open up your imagination and memory bank, float down the erotic stream of human consciousness and find the "bizarre" that is pleasantly within us. Willie believed it is bad to "bottle up" the bizarre which, left unexplored, can cause problems.

Please don't tell my publisher Benedikt Taschen, but today (the absolute deadline for this manuscript) at approximately six o'clock in the evening the bell rang. It was Wendy, who comes once a week to do office work, to pose in the nude or dress in fetish wear. I told her to choose something to wear. She lowered her head and in a halting whisper said: "You can beat me." I felt like Zorba in *Zorba the Greek*. I was obligated. I sent everyone else away and told her to find a pair of leather wrist restraints, a ball gag, eye binder and rope. I watched from my computer desk as she entered my work area and sat down on the adjoining couch. All this time I am thinking about Willie and what camera angle he would choose.

She slipped into six inch platform heels, placed the black rubber gag in her own mouth, snapped the eye binders in place and (blindfolded) handcuffed her left arm to the metal frame. She waited patiently for me to finish the sentence I was working on before latching her remaining wrist to the couch. I lifted her velvet skater skirt and stared down at her garter framed ass. The stockings were wrong but I reminded myself I was under great time pressure. The printing presses in Germany have already printed the hundreds of *Bizarre* magazines and are waiting for my introduction.

But so is Wendy waiting. After a short while I am back at the typewriter, the roll of tri-x film in my Leica is finished and Wendy is putting on her street clothes to catch the bus to go to college the next day. Is Wendy my alter ego? I think not. She is part of the rebirth of John Willie.

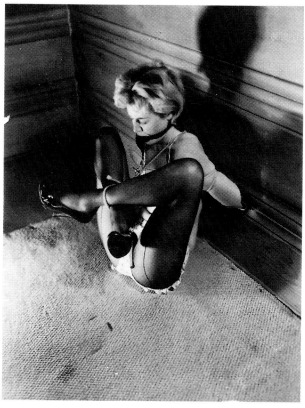

This photograph is assumed to have been taken by John Willie while he lived in Los Angeles, California, during the mid-50s.

John Willie
ist »Bizarre«

von Eric Kroll

Nach Mitternacht im »Trocadero«, an einem nicht
weiter besonderen Mittwoch, südlich der Market Street
in San Francisco, Kalifornien. Ich stehe ganz allein auf
einer Bank und beobachte Alisse. Alisse ist blond, ihr
Kopf ist völlig regungslos, sie wird von Master James
gezüchtigt. Ein Haufen Zwanzigjähriger beiderlei Ge-
schlechts sieht wie angewurzelt zu, als Master James
sie peitscht und fesselt. Ein Strumpfgürtel umrahmt
ihr schwarzes Hinterteil. Der Oberkörper ist entblößt,
aber ich kann ihre Brüste nicht sehen, da sie mir den
Rücken zudreht. Die dunkelhaarige Jasmine muß
wohl direkt vor ihr stehen, aber Alisse versperrt mir
den Blick und das ist in Ordnung. Ich kann mir auch
so vorstellen, was Master James mit den beiden treibt.
In den Stilettos wirken ihre Beine besonders lang.
Meine Aufmerksamkeit konzentriert sich auf den
Punkt an ihrem Körper, an dem Strumpf auf Strumpf-
band trifft. Gerade hat seine Peitsche einen Striemen
hinterlassen. Das ist *Bondage A-Go-Go*. Wir schreiben
das Ende des zwanzigsten Jahrhunderts und sehen die
Saat aufgehen, die John Willie vor über fünfzig Jahren
gesät hat.

Ich schreibe die Einleitung zu der langerwarteten
Wiederauflage des *Bizarre*-Magazins. Doch eigentlich
schreibe ich über John Alexander Scott Coutts alias
John Willie. Künstler, Fotograf, Schriftsteller und
Verleger John Willie, ich verneige mich vor Dir. Du bist
der Leonardo da Vinci der Fetischfotografie, und
vielleicht erhältst Du durch diese Veröffentlichung
endlich die Anerkennung, die Du verdienst.

In seinem Lebenslauf schloß sich ein Kreis. Am
9. Dezember 1902 wurde er in eine wohlhabende

englische Bankiersfamilie geboren. Später dann nach Australien verbannt. Er heiratete Holly und zog mit ihr in den vierziger Jahren nach New York. Er machte wundervolle Bondage-Fotos von dieser brünetten Beauty, doch das Band der Ehe hielt nicht, und er wurde geschieden. 1946 kam *Bizarre* auf den Markt. Er veröffentlichte zwanzig Ausgaben, bevor er 1957 nach Hollywood, Kalifornien zog, ein verbitterter Mann. 1961 erkrankte er an einem Gehirntumor und mußte seinen Mailorder-Versand aufgeben. Er vernichtete sein Fotoarchiv und kehrte nach England zurück, wo er am 5. August 1962 starb. Ein großer Künstler. Ein Visionär. Bettelarm, als er starb. Noch irgendwelche Fragen?

Doch zurück zum Anfang. Als ich den Club verließ, kam ich an dem gefesselten Körper von Sweet Gwendoline, ich meine Alisse, vorbei. Ihre Arme waren hinter dem Rücken zusammengebunden, die Ellenbogen an den Handgelenken. In der gleichen, gar köstlichen Lage befand sich Jasmine. Beide trugen ein ledernes Halsband, beide Halsbänder waren durch eine einfache Kette, die zu einer leicht vorgebeugten Haltung zwang, miteinander verbunden. Ich warf den beiden ein »Gute Nacht« zu, aber sie antworteten nicht. Lag das an den großen grünen Äpfeln, die zwischen ihren Zähnen steckten?

Das ist ein Teil von John Willies Biographie, wie ich sie zusammenstückeln kann. Ähnlich wie bei Betty Page, dem umwerfenden Bondage- und Pin-Up-Modell, gibt es mehr Mutmaßungen als Fakten über die Person John Willie. Ich habe mit drei Leuten gesprochen, die ihn tatsächlich kennengelernt haben, und mit einem, der ihn aus der Ferne gesehen hat. Das meiste ergab sich aus meiner jahrelangen eigenen Erfahrung im Bereich der Fetisch- und Modefotografie – den Frauen beim Auskleiden zusehen, ihnen die Korsetts zuschnüren helfen, sie in Hüfthalter zwängen

und ihnen den Einstieg in schwarzes Gummi erleichtern. Auf extrem hohen Stilettoabsätzen hüpfen sie herum, und manchmal fessele ich sie für die Kamera (und zu meinem Vergnügen), und manchmal falle ich auf die Knie und bete sie mit meiner Kamera an. Und ich habe alles gelesen, was je über Herrn John Willie geschrieben worden ist.

John Willie war der MEISTER. Daß er die extrem grausame Richtung bevorzugte, glaube ich nicht. Er war Verfechter des »consensual bondage« – Du fesselst mich, und ich habe nichts dagegen. Er scheint anmaßend gewesen zu sein und das ist verständlich, denn er wußte von einer Welt, die sich niemand sonst auch nur vorstellen konnte. Er hatte Alkoholprobleme. Das kann ich nachvollziehen. Seine Familie hatte sich von ihm abgewandt. Er war ständig pleite und nach dem zu urteilen, was er über seine Frau schrieb, hatte er einen nörgelnden Besen zu Hause.

Zu seinen Stammkneipen gehörte das »Chumley's«. Ich habe mir diese berüchtigte Künstlerkneipe im westlichen Greenwich Village einmal angeguckt. An der Tür steht kein Name. Entweder kennt man den Laden oder nicht. Ende der siebziger Jahre stand ich dort mit dem schwarzen Schriftsteller James Baldwin, der gerade aus Paris zurückgekehrt war, am Urinal und betrieb stimulierende Konversation.

Gerüchten zufolge wurde Willie von seinen Freunden freigehalten. Sir James, dem in North Hollywood das »Chateau« gehörte, ein Privatclub für Liebhaber von Fesseleien und Sado-Maso-Spielen, erzählte mir einmal, wie Willie seine Modelle fand. In Greenwich Village gab es damals eine Bar, die sich den Eingang mit einem Drugstore teilte, wo man neben Arzneimitteln auch Kaugummis, Zigaretten und Zeitschriften bekam. Gleich am Eingang stand ein Ständer für Zeitschriften, und dort deponierte Willie die neuesten Ausgaben von *Bizarre*. Dann setzte er sich in der Bar an

die Theke und beobachtete die Frauen, die den Drug-store betraten. Hatte er das Gefühl, sie interessierten sich für *Bizarre*, dann sprach er sie an. Auch die Sekre-tärinnen von *Bizarre*, so habe ich gehört, standen ihm Modell.

Er mochte Brünette mit kleinen Brüsten und langen Beinen. Wichtig war für ihn die Ausdruckskraft eines Modells. Konnte es Emotionen darstellen? Seine Kunst und seine Fotos waren deshalb so erfolgreich, weil sie immer echt wirkten. Willie machte Fotos, und seine eigenen Fotos inspirierten ihn dann bei seinen wei-teren Arbeiten. Sir James nahm an mehreren solcher Fotosessions von John Willie in Greenwich Village und der Manhattan Westside teil. Er behauptete, Willie hätte nackte Bondage-Fotos für seine Privatsammlung gemacht, um dann mit ihnen zu arbeiten. Erst wurden die Körperkonturen nachgezeichnet, und danach malte er den Körpern Kleidung an. Sir James erinnerte sich auch, wie Willie einmal Betty Page fotografierte. Betty wurde in allen denkbaren Stellungen abgelichtet, sogar nackt und an allen Vieren gefesselt. Leider verschlampte die Armee zwei Überseekoffer Sir James' mit Bondage-Fotos und Zeichnungen von Willie und anderen.

Es ist schwierig, tatsächliche Begebenheiten oder Verbindungen genau festzumachen. Ich weiß, daß Sam Menning, der ideenreiche und produktive Girlie-Fotograf und Katzenfan ein Studio an der Westside hatte. Vielleicht gab es in seinem Studio mal ein Zu-sammentreffen zwischen Willie und Page. Vielleicht kannte Willie ja auch den großartigen Weegee, der mit seinen Fotos von Verbrechern und deren Tatorten berühmt wurde und in der 47. Straße in Manhattan wohnte. Wahrscheinlicher ist, daß Willie Betty Page wohl im Fotostudio von Irving Klaw in der 14. Straße in der Manhattan Eastside kennenlernt hat. Ob er Willie denn je begegnet sei, fragte ich den genialen Fetisch-

künstler Eric Stanton. Ja, er habe ihn mal aus sechs Metern Entfernung in Klaws Studio kommen sehen. Er sei auf ihn zugegangen, um sich bekanntzumachen, aber Irving habe sich direkt umgedreht, mit dem Finger gedroht und gesagt: »Bleib, wo Du bist«. Klaw schätzte es nicht, wenn sich seine Künstler untereinander zu gut verstanden.

Faszinierend fand ich die Leserbrief-Rubrik in fast allen Ausgaben von *Bizarre*. Sie gab den Leuten das Gefühl, mit ihren »speziellen« Interessen nicht alleine dazustehen. Ich war überrascht, daß so viele Paare einvernehmliche Fesselpraktiken oder »Hydrophilie« (die Kunst, naß zu werden, während man vollständig bekleidet ist) betrieben. Auch die Vorherrschaft von »Slaverettes« (wenn die Damen zu Herren werden) überraschte mich. Erst in Heft 21 stieß ich dann auf einen Brief von jemandem, den ich auch kannte. Es war Fakir Musafar, der Herausgeber von *Body Play* (Menlo Park, Kalifornien). Er hatte seinen Körperbau mit Hilfe eines aus Neuguinea stammenden Eingeborenenrituals verändert und beschrieb sein »Ibitoe«-Gürteltraining mittels eiserner Korsettgürtel. In Heft 23 (auf den Seiten 35 bis 39) erwähnte er dann auch in einem zweiten Brief »The Little Lass«, sein kleines Mädel, das ihn davon überzeugte, Frauenkleider zu tragen. »Ich gestattete ihr zwei volle Wochen der Freiheit. Sonst trägt sie nämlich meistens einen Maulkorb...« In Heft 22 forschte ich dann nach einem Brief, der seine Dominanz über »das kleine Mädel« darstellen würde und den ich überlesen haben mußte. Schließlich rief ich ihn an und bat ihn um mehr Informationen zu der jungen Dame. Kein Problem. Fakir erklärte mir, sie sei sein Alter Ego!

Was ist dann also wirklich die Wahrheit? Soviel meiner Lektüre entspringt der Phantasie. Ist es denn so wichtig, ob etwas wirklich existiert oder ob es einfach der Phantasie eines anderen entspringt? Beide gehören

als legitime Weiterentwicklungen zu einer Person, und beide gebären Ideen und Gefühle. Genau das tun auch die *Bizarre*-Ausgaben von John Willie. Während ich die ungefähr eintausendsechshundert Seiten von *Bizarre* las, fand ich mich ständig am Fotokopierer wieder und kopierte Zeichnungen und Fotografien, überrascht von den Gedankengängen, die diese Bilder bei mir auslösten.

Fakir Musafar schrieb an Willie und erhielt Briefe zurück von einer Miss Maggie, die, so glaubt er, Willies Alter Ego gewesen sein könnte. Eric Stanton hatte Gerüchte gehört, denen zufolge Willie gerne Seidenstrümpfe trug. Als Trost oder um seiner weiblichen Seite Ausdruck zu verleihen? Ich halte Willie ganz eindeutig für einen dominanten Charakter. In einem Brief an Jim, der in *Sweet Gwendoline* (von Belier Press) neu abgedruckt wurde, erklärt er: »Ich habe selbst ein Korsett ausprobiert und fand es einfach nur extrem unbequem. Einer Frau verleiht es eine wunderbare Silhouette, die ich sehr schätze, aber noch mehr Vergnügen wird es mir bereiten, es als ›Züchtigungsinstrument‹ einzusetzen. Ich wende immer nur soviel Züchtigung an, wie vonnöten ist, um Ungehorsam zu zähmen. Das Gefühl des Unbehagens beim Bondage-Akt verstärkt das Gefühl der Hilflosigkeit.« Sein Streben nach Realismus.

In Ausgabe Nummer 2 seines *Body Play* spricht Fakir über sein Zusammentreffen mit Willie an einer Bar in Minneapolis, Minnesota. »Es ging um ultrahohe Stilettoabsätze, die für uns beide an sich keinen besonderen Reiz darstellten. Reizvoll war an ihnen nur der Gedanke, daß jemand lange, schmerzvolle Stunden der Übung hinter sich hatte, um auf ihnen laufen zu lernen.«

Raffiniert und faszinierend. Ich jedenfalls nehme immer den ersten Versuch meiner Modelle, auf extrem hochhackigen Schuhen zu laufen, auf Video auf. Es ist,

als sähe man einem neugeborenen Rehkitz bei seinen ersten Schritten zu. In den ungelenken Bewegungen liegt eine besondere Schönheit. Und ein Gefühl des Triumphes, in solcherlei Schuhwerk – das meine Frau als »grausame Schuhe« bezeichnet – überhaupt gehen zu können. Ich kann mich noch an meine New Yorker Nachbarin, den Ex-Pornostar und die jetzige Performance-Künstlerin Annie Sprinkle erinnern, die sie stundenlang trug. Niemand verlor darüber je ein Wort, doch alle waren davon beeindruckt.

Daß *Bizarre* je eine hohe Auflage erreichte, kann ich mir nicht vorstellen. Es kam unregelmäßig auf den Markt. Ich habe auch nie eine logische Erklärung dafür erhalten, warum Heft 2 1946 erschien und Heft 1 im Jahre 1954 – gleich nach Heft 13. War das ein typischer Willie-Witz? So, wie »Willie« als Pseudonym zu wählen? Denn das ist ein Slangwort für »Schwanz«.

Viele Leser wurden durch seine Fortsetzungsgeschichte von *Sweet Gwendoline* in den August- und Oktoberausgaben von *Wink* im Jahre 1949 erstmals auf Willie aufmerksam. Andere stießen durch Zufall auf seine Magazine. Der »Manhattanite« erzählte mir, er sei während eines Aufenthalts in Boston an der Harvard-Universität mal im Howard Burlesque House gewesen und hätte in einem Zigarettenladen in der Nähe Heft 2 und 3 von *Bizarre* im Zeitschriftenregal entdeckt. Er sei regelrecht »ausgeflippt« und habe sofort einen Briefwechsel mit Willie begonnen. In den späten fünfziger Jahren habe er ihn dann in Los Angeles besucht. Willie orderte Pat, eines seiner Lieblingsmodelle, und der »Manhattanite« fotografierte sie in Willies Apartment – mit ihm im Schlepptau. Pat trug weiße hochtaillierte Unterwäsche – ein Fetischfavorit sowohl von mir als auch vom »Manhattanite«. Auch auf anderem Gebiet haben wir den gleichen Geschmack: Wir spielen beide gerne Golf. Doch ich glaube nicht, daß da ein ursächlicher

Zusammenhang besteht. Willie habe ihn damals am Flughafen abgeholt, erinnert sich der »Manhattanite«. Er sei auf Geschäftsreise gewesen.

Willie habe den Eindruck erweckt, in Schwierigkeiten zu stecken, und er schien Probleme mit der Zensur und der Postzustellung zu haben. So wie Bunny Yeager ihre sehr ordentliche Aktfotografie in Büchern der Art von »Wie fotografiere ich richtig« versteckte, fühlte sich Willie bei seinem Magazin *Bizarre* dazu genötigt, sein Interesse an Bondage-Fotografie zu verschleiern und seinen Bildern einen abschreckenden Ton zu verleihen: »DAS sollte Ihnen nicht passieren. Lernen Sie Jiu-Jitsu, die Kunst der Selbstverteidigung.«

In Heft 17 spricht Willie sich vehement gegen den Polizeistaat aus: »Es scheint nutzlos zu sein, diesen Leuten klar zu machen, daß Freiheit einfach ›Freiheit‹ bedeutet, ohne Einschränkung.« Bravo, John Willie! Seine Vorstellung einer perfekten Gesellschaft war wohl die von gefesselten Frauen in Fetischkleidung, doch es sollte einvernehmliches Bondage sein. Zwar waren seiner Meinung nach die ersten Frauenrechtlerinnen, die Suffragetten, verantwortlich für »das Ende des Mannes als Herren und Meister«, doch begrüßte und verfocht er gleichzeitig Meinungsfreiheit, besonders im sexuellen Bereich. Auch von der Kirche hielt er nicht viel, aber das ist eine andere Geschichte.

Willie schien Freude an komplexer Korrespondenz mit seiner Leserschaft zu haben und gab detailliert Auskunft zum Thema Bondage nebst Zeichnungen, die die einzelnen Schritte erläuterten. Seine Handschrift war vornehm und schwer zu lesen. Er empfahl die Handbücher der Marine, um das richtige Knoten von Fesseln zu lernen. Während seines Aufenthalts in Australien hatte er bei der Handelsmarine gearbeitet. Seinen Postverteiler hütete er wie seinen Augapfel und vernichtete ihn, als er sich 1961 aus Krankheitsgründen

aus dem Berufsleben zurückzog. Es mangelte ihm niemals an Integrität, weder auf geschäftlicher Ebene, noch in der Kunst oder Fotografie.

Offenbar hatte er *Bizarre* nach seinem Umzug nach Los Angeles an seine Sekretärin und deren Freund verkauft oder ihnen überschrieben, doch schien er nicht glücklich über die Entwicklung des Blattes unter deren Ägide zu sein. Fakir Musafar ist der Meinung, er habe *Bizarre* an den Künstler Mahlon Blaine verkauft, dessen Arbeiten nach Heft 20 häufig erschienen. In seiner Biographie von Willie in *Sweet Gwendoline* behauptet Jeff Rund, er habe sein Magazin an R.E.B. verkauft, der es noch bis 1959 verlegte.

Mit Ausnahme von Heft 2, das in Montreal, Kanada, gedruckt wurde, wurden alle Ausgaben in New York gedruckt. Coutts gab Montreal als Postadresse an. Das könnte er heutzutage nicht mehr machen. In Kanada schätzt man Fesseleien nicht besonders.

Zum Geschäftsmann taugte er nicht und beklagte auch ständig die hohen Unkosten. Scheinbar wurde sein New Yorker Büro durchwühlt und während der Plünderung kamen Kunstgegenstände abhanden. Über den Vertrag, den er mit Irving Klaw für *Sweet Gwendoline* eingegangen war, war er selbst ärgerlich. Klaw veröffentlichte sie in *The Escape Artist* und *The Missing Princess* und ließ einen zögerlichen Eric Stanton die auf dem Original sichtbaren Peitschenstriemen durch aufgemalte Kleidungsstücke abdecken.

John Willie und überhaupt der ganze »Sex-Underground« (in dessen Bauch ich es mir heute eingerichtet habe) der damaligen Zeit lesen sich wie ein Raymond Chandler-Krimi voller Heimlichkeiten und Machenschaften. Er hatte wohl mehrere Apartments in New York, die als Wohnraum angemietet worden waren, von ihm jedoch als Fotostudio und zur Produktion der Hefte genutzt wurden. Man verwendete Pseudonyme – »The Manhattanite«, beispielsweise, oder eben »John

Willie«. In den fünfziger Jahren wurden auf Betreiben von Senator Keufaver öffentliche Anhörungen zum angeblichen Problem von Moral und Comics abgehalten. Dabei ging es auch um Irving Klaw, der durch diese Anhörungen große Schwierigkeiten bekam. Die Behörden versuchten, einen Todesfall in Miami, Florida, mit Klaws Publikationen in Verbindung zu bringen. Ihr Versuch blieb erfolglos, doch die ganze Aufregung verschlechterte Klaws Gesundheitszustand und ließ ihn auch einige harte Bondage-Fotos vernichten.

Umgekehrt schien Willie, Gerüchten zufolge, der Tod eines seiner Modelle, Judy Ann Dull, sehr mitgenommen zu haben. Sie war das dritte Opfer von Harvey Glatman, dem »Bondage-Mörder« von Los Angeles. Berichten zufolge hatte Dull zugesagt, für ein Honorar von 40 Dollar zwei Stunden Modell zu stehen, ihr Apartment zusammen mit Glatman verlassen und war danach nie wieder gesehen worden. Nachdem Glatman die nackten Frauen gefesselt und geknebelt fotografiert hatte, erdrosselte er sie mit der gleichen Schnur. Lorraine Virgil, die Willie ebenfalls Modell stand, sollte sein viertes Opfer werden, doch es gelang ihr, ihm die Pistole zu entreißen und ihn damit in Schach zu halten, bis ein Verkehrspolizist eintraf. Wie aus einem Chandler-Krimi.

Nachdem »Eulengesicht« und Fernsehmonteur Glatman die ihm zur Last gelegten Morde gestanden hatte, führte er die Polizeibeamten zu seiner früheren Wohnung – 5924 Melrose Avenue –, die wieder von einem Pin-Up-Fotografen bewohnt wurde. Die Erklärung des Verrückten: »Schon als Kind hatte ich immer ein Stück Seil in der Hand. Das muß mich irgendwie schon immer fasziniert haben.« (aus: *Los Angeles Times*, 1. November 1958).

So etwas liefert einem Fesselfotografen nicht gerade die beste Presse. Willie, so sagt man, war damals sehr

besorgt, daß seine Fotos und seine Kunst in irgend-
einer Weise zu diesem abscheulichen Verbrechen bei-
getragen haben könnten. Ira Levine, jetziger Heraus-
geber von O, kannte Gerüchte, denen zufolge Willie bei
Dull seinen zweiten oder dritten Frühling erlebte, doch
leider war die Dame wie ihr Name, »dull« (langweilig).
Ein anderes Opfer war Angela Rojas, eine Stripperin,
die in der Gegend ansässig war und in Zeitungen als
Modell für Amateur- und Profifotografen inserierte.
»Er holte sie ab, fuhr mit ihr in die Wüste, machte viele
Fotos und erdrosselte sie dann widerwillig.« (aus: *Los
Angeles Times*, 1. November 1958).

Falls Willie tatsächlich erschüttert darüber war,
daß seine Fotos und seine Kunst auf irgendeine Weise
zu diesem Mord geführt hatten, hielt ihn das jedoch
nicht davon ab, einige Jahre später im Magazin *Adam*
den Verkauf eines großen, 64seitigen Magazincar-
toons von *Sweet Gwendoline* mit einer Nahaufnahme
einer geknebelten Gwen zu inserieren. Sein Verkaufs-
text dazu lautete: »Kein Anwesen, das über eine halb-
wegs ansehnliche strenge Kammer verfügt, ist ohne
diesen Cartoon wirklich komplett ausgestattet.«

Als ich 16 war, erlaubten mir meine Eltern, einen Teil
der Sommerferien in Paris zu verbringen. Die meisten
der Schüler, mit denen ich dort war, marschierten in
den Louvre, ich dagegen schnurstracks nach Pigalle.
Ich kann mich an eine verregnete Nacht erinnern und
wie ein Freund und ich versuchten, ins Trockene zu
gelangen. Plötzlich wurden wir in ein Cabaret geführt
und saßen hinten auf den billigen Plätzen. Die er-
höhte, mit Vorhängen abgehängte Bühne verlief über
die ganze Breite des Nachtclubs. Nun öffneten sich die
Vorhänge und ein muskulöser Schwarzafrikaner trat
nach vorne. Er trug kein Hemd. Sein pechschwarzes
Haar war zu einem dicken Zopf, der an seinem Rücken
hinunterhing, zusammengebunden. Eine fast unbe-
kleidete Frau saß fest verankert auf einem Stuhl in der

Mitte der Bühne. Langsam schritt er auf sie zu und warf sein Haar auf ihre entblößten Schultern herab. Ihr Kopf schnellte zurück, und er wiederholte seine Bewegung. Er schlug diese wunderschöne Frau mit seinem Haar. Diese Szene ist auf ewig in meine Erinnerung gebrannt.

Als ich in Heft 1 auf den Seiten 25 bis 37 den »Rheinischen Seiltrick« las, erinnerte ich mich an diese Nacht. Es ist ebenfalls eine Fesselsequenz aus einem Nachtclub, die ich allerdings nach meinem Gusto genießen durfte.

Zu meinen langjährigen Freunden gehört Veronica Vera, Sex-Autorin, Performance-Künstlerin und Fetisch-Aktmodell von Robert Mapplethorpe. Sie war auch die Begründerin von »Miss Vera's Finishing School For Boys Who Want To Be Girls«, also einem Pensionat für Jungen, die lieber Mädchen wären, das in New York beheimatet war. An einem Spätnachmittag war mir dort das Privileg vergönnt, der Umwandlung einer ganzen Schar von Männern zu wunderschönen Frauen beizuwohnen. Einer oder besser: eine von ihnen hatte sich als französische Kammerzofe verkleidet, Rüschen inklusive. Während ich »ihr« so zuschaute – sie offerierte Tee und Sandwiches und knickste dabei artig –, erinnerte ich mich an die vielen Leserbriefe aufgebrachter Ehefrauen an *Bizarre*. In Heft 9 hatte »Babs« auf den Seiten 56 bis 58 ihren jungen Ehemann beim Fremdgehen erwischt. Sie bestand auf einer Strafe, und er akzeptierte. Ihre »außergewöhnliche« Strafe lautete folgendermaßen: »Er muß sich niedlich anziehen wie eine französische Kammerzofe, mich von hinten und vorne bedienen und ICH SCHERZE NICHT! ... Hohe Absätze, Spitzenhäubchen, Spitzenschürze, schwarze Seidenstrümpfe, kurzes schwarzes seidenes Kleidchen UND eine schöne schwarze Perücke.« Ach.... wie wird er diese Strafe genossen haben.

Viele Jahre später war ich bei einem »Dressing For Pleasure Ball«, den Constance Enterprises in New Jersey veranstalteten. Es gab eine Fetisch-Modenschau, doch ich erinnere mich nur noch an eine Blondine mit einem strengen Pferdeschwanz, die in einem ärmellosen ledernen Trikotoberteil von Slimwear of America den Laufsteg hinunterdonnerte. Diese Frau machte mich sofort an. Und ich wußte auch, warum. Es war nicht ihr Aussehen. Es war diese Mischung aus Mode und Bondage. Bequem, dennoch Hilflosigkeit suggerierend. In der Ausgabe 24 von Bizarre erschien auf Seite 59 ein Bericht über Korsetterziehung und über »die Tochter einer vermögenden Witwe, die so süchtig danach ist, daß sie jeden Tag kommt, sich frisieren und schminken läßt, und das in oft solch beengender Kleidung, daß sie ohne die Hilfe ihrer Zofen weder gehen noch stehen kann. Sie bevorzugt den ›Venusstil‹ der Korsetterziehung und besteht darauf, sich Tag und Nacht ohne den Einsatz ihrer Arme zu bewegen. Sie trägt teure, spezialgefertigte Kleider ohne Ärmel. Keiner der vielen Kunden, die sie hier gesehen haben, käme darauf, daß ihre Arme unter den Kleidern fest an den Körper gebunden sind. Für sie, so hat sie oft gesagt, ist es der größte Kick, ihre Arme nicht gebrauchen zu können und die Reaktion ihrer Umwelt darauf zu spüren.«

Also, Vorhang auf für 26 Ausgaben von John Willies Bizarre. Das Magazin war ein offenes Forum für genau das – bizarre Ideen, Konzepte, Kleidung. Ich jedenfalls habe viele Denkanstöße erhalten und glaube, das wird jedem so gehen. Man muß nur seiner Phantasie freien Lauf lassen und das »Bizarre« entdecken, das sich gemütlich in jedem von uns eingerichtet hat. Willie glaubte, daß es schlecht sei, das Bizarre im Menschen zu ignorieren. So könne es Schaden anrichten.

Mein Verleger Benedikt Taschen darf auf keinen Fall erfahren, daß es heute abend gegen 18 Uhr (dieses

Manuskript hätte schon längst fertig sein sollen) an der Tür klingelte. Es war Wendy, die sich einmal in der Woche um Bürokram kümmert, mein Nacktmodell ist oder in Fetischklamotten steigt. Ich bat sie, sich ein Kleidungsstück auszusuchen. Sie neigte ihren Kopf nach unten und sagte in einem stockenden Flüsterton, »Du darfst mich schlagen.« Ich fühlte mich plötzlich wie Anthony Quinn in dem Film *Alexis Sorbas*. Ich fühlte mich verpflichtet. Den Rest meiner Mannschaft schickte ich nach Hause und Wendy auf die Suche nach ledernen Armbändern, einem Knebel, einer Augenbinde und einem Seil. Ich saß an meinem Computertisch, als sie meinen Arbeitsbereich betrat und auf der angrenzenden Couch Platz nahm. Und denke ständig an Willie und welche Ausschnitte und Winkel er wohl für seine Kamera gewählt hätte.

Sie schlüpfte in Schuhe mit einem 18-cm-Absatz, beförderte den schwarzen Gummiknebel in ihren Mund, zog die Augenbinde zurecht und kettete ihren linken Arm (mit verbundenen Augen) an den Metallrahmen. Geduldig wartete sie, bis ich meinen Satz zu Ende getippt hatte, und kettete dann das noch freie Handgelenk an der Couch an. Ich hob ihr kurzes Samtröckchen, das aussah wie das Kostüm einer Eiskunstläuferin, und starrte auf ihr von Strumpfbändern umrahmtes Hinterteil. Die Strümpfe paßten nicht ganz, aber ich stand unter enormem Zeitdruck. Die Druckpressen Deutschlands hatten bereits Hunderte von *Bizarre*-Seiten gedruckt und warteten auf meinen Einleitungstext.

Doch Wendy wartete auch. Kurze Zeit später sitze ich bereits wieder am Computer, habe den Tri-X-Film in meiner Leica verknipst, Wendy zieht ihre normalen Klamotten an, um mit dem Bus nach Hause zu fahren und am nächsten Morgen wieder an der Uni einzulaufen. Ist Wendy mein Alter Ego? Ich glaube nicht. Sie ist Teil der Wiedergeburt von John Willie.

John Willie
est bizarre

par Eric Kroll

Il est minuit passé, un mercredi comme les autres, au Club Trocadéro, au sud de Market Street à San Francisco. Assis seul sur un banc, j'observe Alisse la blonde, sa tête parfaitement immobile, en train d'être corrigée par Maître James. Une foule de jeunes gens, garçons et filles, tous âgés d'une vingtaine d'années, regardent fascinés Maître James la ligoter et la fouetter. Les fesses charnues d'Alisse sont encadrées par un porte-jarretelles noir. Elle est torse nu, mais je ne vois pas ses seins car elle me tourne le dos. Je devine Jasmine la brune accroupie devant elle mais Alisse me bouche la vue, ce qui est aussi bien. Je peux imaginer ce qu'il leur fait à toutes les deux. Avec ses talons de plus de 10 cm, les jambes de Jasmine paraissent encore plus longues. Je remarque que la racine de son nez arrive à la hauteur du porte-jarretelles de sa partenaire, juste là où Maître James vient de laisser une marque de fouet. C'est la soirée «Bondage à gogo». Nous sommes à la fin du XXème siècle, en train de contempler le fruit de la graine semée par John Willie plus de cinquante ans plus tôt.

Je suis en train de rédiger la préface de la réédition tant attendue de la revue *Bizarre*. Mais il s'agit surtout de John Alexander Scott Coutts, alias John Willie, artiste, photographe, écrivain, éditeur et joueur de banjo. J.W., je m'incline devant toi. Tu es le Léonard de Vinci du fétichisme et j'espère que cette publication t'apportera enfin la reconnaissance que tu mérites.

Sa vie a décrit une boucle complète. Né le 9 décembre 1902 dans une famille de riches banquiers d'affaires anglais, il fut forcé de s'expatrier en Australie. Là, il épousa Holly, avec laquelle il s'installa à New York dans

les années 40. Il réalisa de merveilleuses photos SM (sadomasochistes) de cette beauté brune, mais les liens sacrés du mariage se dénouèrent bientôt et se soldèrent par un divorce. En 1946, il lança la revue *Bizarre*. Il en était au 20ème numéro lorsqu'il emménagea à Hollywood en 1957, un homme amer. En 1961, il tomba malade (une tumeur au cerveau) et dut interrompre son affaire de vente par correspondance. Il détruisit ses archives et retourna en Angleterre, où il mourut le 5 août 1962. C'était un homme brillant. Un grand artiste. Un visionnaire. Il est mort sans-le-sou. Toujours la même histoire!

J'en reviens à mon premier paragraphe. En sortant du Club, je suis passé près du corps ligoté de Sweet Gwendoline, pardon, je voulais dire Alisse. Elle avait les bras attachés derrière le dos, chaque poignet noué par une corde au coude de l'autre bras. Jasmine se trouvait dans la même situation délicieusement précaire. Elles étaient reliées l'une à l'autre par une simple chaînette fixée à leurs colliers de cuir, les forçant à se tenir légèrement penchées en avant. Je leur ai lancé un «bonsoir!» mais elles n'ont pas répondu: elles avaient chacune une grosse pomme verte coincée entre les dents!

Voici l'histoire de John Willie (ou une partie), telle que j'ai pu la reconstituer. Comme dans le cas de Betty Page, célèbre pin up et égérie SM, il circule davantage d'hypothèses que d'informations fiables au sujet de John Willie. J'ai parlé à trois personnes qui l'ont rencontré et à une quatrième qui l'a aperçu de loin. En fait, tout ce que je sais de lui, je le tiens surtout de mes années d'expérience comme photographe de mode fétichiste, à force de regarder des femmes se déshabiller, de les aider à lacer leur corset, à resserrer leurs gaines, à se glisser dans des combinaisons en latex noir. Elles arpentent mon studio perchées sur des talons vertigineux et il m'arrive de les ligoter pour des

prises de vue (et mon plaisir). Parfois, je tombe à genoux à leurs pieds et je les idolâtre à travers mon appareil. J'ai également lu tout ce qui a été publié sur M. John Willie.

John Willie était le MAITRE. Je ne pense pas qu'il se soit adonné à la cruauté extrême. Il croyait aux jeux sexuels avec consentement mutuel. Il paraît qu'il était arrogant. Cela n'a rien d'étonnant. Il connaissait un univers que personne d'autre ne pouvait imaginer. Sa vision le condamnait à la solitude. Il buvait. Je peux le comprendre. Il était rejeté par sa famille. Il était constamment fauché et, à en juger par ses écrits, sa femme était une mégère.

Chumley était l'un de ses bars de prédilection. Je connais ce rendez-vous d'artiste notoire dans l'ouest de Greenwich Village. Aucune enseigne ne permet de le distinguer de la rue, seuls les initiés savent le trouver. Dans ses toilettes, vers la fin des années 70, alors que je me tenais devant un urinoir, j'ai eu une conversation fort intéressante avec l'écrivain noir James Baldwin, qui venait de rentrer de Paris.

D'aucuns disent que c'étaient les amis de Willie qui lui payaient à boire. Sir James, propriétaire du Château à North Hollywood, un établissement «Bondage»-SM, m'a raconté comment il dénichait ses modèles. Il y avait un autre bar dans Greenwich Village qui avait une entrée commune avec un drugstore. Willie plaçait plusieurs copies de la dernière édition de *Bizarre* dans un présentoir à l'entrée puis allait s'asseoir dans le bar, afin de pouvoir observer les femmes qui entraient dans le magasin. Lorsque l'une d'entre elles semblait s'intéresser à sa revue, il l'abordait. J'ai aussi entendu dire que ses secrétaires lui servaient également de modèles.

Il aimait les brunes aux longues jambes et aux petits seins. Il attachait une grande importance à l'expressivité de ses modèles. Elles devaient pouvoir exprimer

des émotions. Ses dessins et ses photos étaient réussis parce qu'ils paraissaient réels. Willie prenait des photos, puis s'en servait comme base pour ses dessins. Sir James a assisté à plusieurs séances de pose dans des studios à Greenwich Village et dans le Westside de Manhattan. Selon lui, Willie faisait des photos de nu SM pour sa propre collection et les dessinait ensuite. Après avoir calqué le contour des corps avec application, il leur peignait des habits. Il se souvenait d'une série de prises de vue avec Betty Page. Willie l'a photographiée les poignets attachés aux chevilles, à demie suspendue et même ligotée entièrement nue. Malheureusement, les forces armées ont perdu les deux malles de Sir James, remplies de photos et de dessins de Willie et d'autres.

Il est difficile de déterminer avec exactitude comment et quand les choses se sont passées. Je sais que Sam Menning, prolifique photographe de charme et grand amateur de chats, avait un studio dans le Westside à New York. Je sais aussi qu'il connaissait Betty Page. Willie a donc pu rencontrer Betty chez Menning. A moins que J.W. n'ait connu Weegee. Ce célèbre photographe spécialisé dans la reconstitution de scènes de meurtre a photographié Betty Page et habitait sur West 47th Street. Mais il est plus probable que Willie ait rencontré Betty dans le studio d'Irving Klaw sur East 14th Street. J'ai demandé à Eric Stanton, le grand artiste fétichiste, s'il avait eu l'occasion de rencontrer Willie. Il m'a dit l'avoir aperçu une fois entrant dans le bureau de Klaw, à une cinquantaine de mètres de distance. Il a voulu s'approcher pour lui parler, mais Klaw s'est tourné vers lui, a pointé un doigt dans sa direction et lui a lancé: «Va-t'en». Klaw n'aimait pas que ses artistes fraternisent.

J'ai lu avec fascination le «Courrier des lecteurs» de pratiquement tous les numéros de *Bizarre*. Tout un tas de gens découvraient qu'ils n'étaient pas seuls à

partager ce goût «singulier». J'ai constaté avec stupéfaction combien de couples pratiquaient le SM consensuel et l'hydrophilie (l'art de se mouiller tout habillé), ainsi que la prédominance des «négrières» (des maîtresses). Dans le numéro 21, je suis enfin tombé sur la lettre de quelqu'un que je connaissais: Fakir Musafar, «modificateur de corps» et éditeur de *Body Play*. Menlo Park, Californie. Il y racontait en détail son apprentissage du corset métallique, une méthode utilisée en Nouvelle-Guinée (Ibitoe). Dans le numéro 23 (p. 35-39), il y avait une autre lettre faisant allusion à la «Petite Demoiselle» qui avait convaincu Fakir de s'habiller en femme. «Je lui ai octroyé deux semaines entières de liberté. Il faut dire qu'elle quitte rarement sa muselière...» J'ai parcouru le numéro 22 à la recherche d'une lettre qui m'aurait échappé et expliquant comment s'était établie la domination de la «Petite Demoiselle». Finalement, j'ai appelé Fakir au téléphone et lui ai demandé qui était cette femme. Pas de problème. Il m'a répondu que c'était son alter ego!

Mais qu'est-ce que la vérité? Quelle est la part de l'imaginaire dans ce que je lis? Quelle importance si les faits sont réels ou relèvent du fantasme? Dans les deux cas, il s'agit d'extensions de la personne et tous deux suscitent idées et émotions. C'est précisément ce que font les revues de John Willie. Pendant que je lisais les quelque 1600 pages de *Bizarre*, je n'arrêtais pas de courir à la photocopieuse pour copier tantôt un dessin tantôt une photo, stupéfait par les pensées que ces images éveillaient en moi.

Fakir Musafar écrivait à Willie et recevait en retour des lettres d'une certaine Miss Maggie qui, selon lui, était l'alter ego de Willie. Eric Stanton m'a fait part de rumeurs selon lesquelles Willie aimait porter des bas de soie. Pour le confort ou était-ce son côté féminin? A mon sens, Willie était un dominateur pur et dur. Dans une lettre à Jim rééditée dans le *Sweet Gwendoline* de

Belier Press, il déclare: «J'ai essayé un corset et n'ai éprouvé rien d'autre qu'un inconfort extrême. Il donne à la femme une belle silhouette et, dorénavant, j'aurai doublement plaisir à l'utiliser comme un ‹instrument de correction›». Un peu plus loin dans cette même lettre, il ajoute: «Je n'aime pas la cruauté extrême, je n'y ai recours qu'à petites doses et uniquement pour corriger la désobéissance. Dans les rapports de maître à esclave, l'inconfort aide à accroître la conscience de sa vulnérabilité.» (Sa quête du réalisme).

Dans le premier chapitre du volume 2 du *Body Play* de Fakir Musafar, Fakir raconte avoir rencontré Willie dans un bar de Minneapolis, dans le Minnesota. «Nous avons parlé de talons ultra hauts et nous sommes convenus qu'ils n'avaient aucun charme en eux-mêmes. En revanche, rien n'est plus excitant que d'imaginer les heures de torture que l'on doit subir pour apprendre à marcher avec eux».

Voilà qui est subtil et intéressant. C'est vrai que je filme mes modèles au caméscope quand elles tentent de marcher avec de très hauts talons pour la première fois. C'est comme de regarder un jeune faon faire ses premiers pas. Il y a quelque chose de beau dans la maladresse du mouvement. Et quelque chose de triomphal à marcher dans ce que ma femme appelle des «chaussures cruelles». Je me souviens d'une voisine à New York, Annie Sprinkle, ex-star du porno et célèbre artiste-performer. Elle portait des talons incroyablement hauts pendant des heures d'affilée. Personne autour d'elle ne pipait mot, mais tous étaient impressionnés.

Je ne crois pas que *Bizarre* ait jamais eu un grand tirage. La revue sortait de manière fantaisiste. Je n'ai jamais obtenu d'explication rationnelle quant au fait que le numéro 2 soit paru en 1946 et le numéro 1 en 1954, juste après le numéro 13. Etait-ce une farce de Willie? Tout comme d'avoir choisi «Willie»

comme pseudonyme (qui signifie «bite» en argot britannique).

Beaucoup de lecteurs ont découvert Willie grâce à la parution de *Sweet Gwendoline* sous forme de feuilleton dans les numéros d'août et d'octobre 1949 de la revue *Wink*. D'autres sont tombés sur ses publications par hasard. Le «Manhattanite» m'a raconté qu'un jour, il était alors étudiant à Harvard à Boston, il s'est rendu au Howard Burlesque House. En chemin, il s'est arrêté chez un marchand de cigares situé à deux pas. Les numéros 2 et 3 de *Bizarre* étaient sur le présentoir. Il a «flashé» et a aussitôt écrit à Willie. Tous deux ont entamé une correspondance. Vers la fin des années 50, le Manhattanite a rendu visite à Willie à Los Angeles. Willie a engagé Pat, un de ses modèles favoris, et le Manhattanite l'a photographiée dans l'appartement de Willie en présence de ce dernier. Elle portait une culotte montante blanche, l'un des fétiches préférés du Manhattanite et de moi-même. Nous partageons également une passion pour le golf. Je ne pense pas qu'il y ait un lien entre les deux. Il m'a raconté que Willie était venu le chercher à l'aéroport. Il était en voyage d'affaires.

Il m'a également dit que Willie avait l'air préoccupé et que, selon lui, il avait des ennuis avec la censure et les services postaux. Tout comme Bunny Yeager, qui publiait ses belles photos de nu dans des manuels du genre «La photographie en dix leçons», dans *Bizarre*, Willie se sentait obligé de camoufler son intérêt pour la photo SM sous des légendes telles que «Faites en sorte que cela ne vous arrive pas: apprenez le Jiu Jitsu, l'art de l'autodéfense».

Dans le numéro 17, Willie s'élève violemment contre l'Etat policier: «Il semble inutile d'expliquer à ces gens que le mot liberté signifie précisément cela: la liberté, sans restriction...» Bien dit, John Willie! Certes, sa vision d'une communauté idéale englobait des femmes

ligotées et portant des tenues fétichistes, mais il s'agissait de jeux où les deux parties étaient consentantes et bien qu'il prétendît que les Suffragettes avaient entraîné la «chute de l'homme, le maître», il était évident qu'il défendait la liberté d'expression, notamment d'expression sexuelle. Il n'était pas trop porté sur l'Eglise, mais c'est une autre histoire.

Willie semble avoir développé une intense correspondance avec ses lecteurs et leur fournissait des conseils détaillés sur les mille manières d'attacher les liens, fournissant même des graphiques étapes par étapes. Son écriture était très fine et difficile à lire. Pour apprendre à faire les nœuds, il recommandait le manuel des scouts marins. (Il avait travaillé dans la marine marchande en Australie). Il veillait jalousement sur la liste de ses abonnés et la détruisit quand il tomba malade et dut fermer boutique en 1961. En affaires, en art et en photographie, il se montra toujours d'une grande intégrité.

Lorsqu'il emménagea à Los Angeles, il laissa entendre qu'il avait vendu ou donné Bizarre à sa secrétaire et son petit ami mais qu'il n'était pas content de ce qu'ils en avaient fait. Fakir Musafar pense qu'il l'a vendue à Mahlon Blaine, l'artiste dont les œuvres apparaissent fréquemment à partir du numéro 20. Dans sa biographie de Willie dans Sweet Gwendoline, Jeff Rund affirme qu'il a vendu la revue à R.E.B., qui a continué à la publier jusqu'en 1959.

Le numéro 2 fut publié à Montréal, et les numéros suivants à New York. Coutts utilisait Montréal comme adresse postale. Foutu! Aujourd'hui, il ne pourrait plus en faire autant. Le Canada ne regarde pas d'un très bon œil les images SM.

Il n'était pas très doué pour les affaires et se plaignait sans cesse des hauts coûts de fabrication. Il semblerait que son bureau de New York ait été ‹visité› et qu'on lui ait volé des œuvres d'art. Il regrettait amèrement

l'accord qu'il avait conclu avec Irving Klaw quant à Sweet Gwendoline. Klaw publia *Sweet Gwendoline* dans «The Escape Artist» et dans «The Missing Princess». Il demanda à Eric Stanton de cacher les marques de fouet en peignant des vêtements directement sur les œuvres originales. Stanton s'exécuta à contrecœur.

Lorsqu'on se penche sur John Willie et l'ensemble de l'underground sexuel de l'époque (je suis heureux d'appartenir à ces bas-fonds aujourd'hui), on se croirait dans un de ces polars remplis d'intrigues de Raymond Chandler. Willie avait apparemment plusieurs appartements à New York qu'il utilisait pour ses prises de vue et concevoir sa revue. Les gens utilisaient des initiales ou des pseudonymes, comme le «Manhattanite» ou «John Willie». Dans les années 50, le sénateur Keufaver lança une campagne contre l'immoralité dans les bandes dessinées. Irving Klaw fut impliqué et eut de gros ennuis. Il y eut un mort à Miami en Floride, et les représentants du gouvernement tentèrent de le lier aux publications SM de Klaw. Ils ne purent rien prouver mais cela acheva de miner la santé déjà fragile de Klaw et l'incita à détruire quelques négatifs de SM poussé.

De même, Willie aurait été profondément choqué par la mort d'un de ses modèles, Judy Ann Dull. Elle fut la troisième victime de Harvey Glatman, le «Tueur SM de Los Angeles». Apparemment, Dull avait accepté de poser pour des photos de charme pour deux heures à 40$ de l'heure. On la vit quitter son appartement en compagnie du meurtrier pour ne jamais revenir. Glatman photographiait des femmes nues ligotées et bâillonnées, puis les étranglait en utilisant toujours le même cordon de fenêtre à guillotine. Un autre des modèles de Willie, Lorraine Virgil, faillit être sa quatrième victime. Elle parvint à lui arracher son revolver et le tint en joue jusqu'à l'arrivée d'un motard de la police californienne (encore un roman à la Chandler).

Après avoir avoué ses crimes, Glatman, un réparateur de télévision aux yeux «de hibou», conduisit la police à son ancienne adresse – 5924 Melrose Avenue – où habitait désormais un autre photographe de charme. Le tueur fou déclara: «Je crois bien que depuis ma plus tendre enfance, j'ai toujours eu un morceau de corde entre les mains. Je suppose que j'ai toujours été fasciné par les cordes» (*Los Angeles Times*. 1er nov. 1958).

Pour un photographe professionnel de SM, ce n'était pas la meilleure des publicités. Il semblerait que Willie ait été très perturbé par l'idée que ses œuvres puissent avoir contribué d'une manière ou d'une autre à ces crimes odieux. Ira Levine, éditeur de la revue *O*, a entendu dire que Willie s'était entiché de Dull, mais que malheureusement la jeune femme était aussi ennuyeuse que son nom le laissait entendre («dull» signifiant «terne» en anglais). Parmi ses victimes, Glatman comptait également Angela Rojas, une strip-teaseuse locale qui avait placé des annonces dans des journaux en s'offrant comme modèle pour photo-graphes amateurs et professionnels. «Il est passé la prendre chez elle et l'a conduite dans le désert. Là, il a pris de nombreux clichés puis, il l'a étranglée malgré lui» (*Los Angeles Times*. 1er nov. 1958).

Willie fut peut-être bouleversé par le fait que ses photos et ses dessins aient contribué à un meurtre, mais cela ne l'empêcha pas de placer une publicité dans le magazine *Adam* quelques années plus tard en proposant une GRANDE BANDE DESSINEE de 64 pages de *Sweet Gwendoline*, accompagnée d'un gros plan du visage bâillonné de l'héroïne et de la légende suivante: «Toute maison de maître équipée d'un cachot digne de ce nom se doit d'en posséder un exemplaire».

A seize ans, mes parents m'ont laissé partir à Paris pour une partie de l'été. La plupart des autres lycéens allaient au Louvre, moi, je filai à Pigalle. Je me souviens

d'une nuit pluvieuse. Mon ami et moi-même cherchions un abri. Soudain, nous nous sommes retrouvés dans un cabaret. Nous étions assis aux places les moins chères au fond. De l'autre côté se trouvait une scène surélevée cachée par des rideaux. Ces derniers s'ouvrirent et nous vîmes s'avancer un noir africain très musclé. Il était torse nu et ses cheveux noir de jais étaient noués dans son dos en une natte compacte. Une femme à moitié nue était assise ligotée sur une chaise au milieu de la scène. Il s'est approché d'elle lentement, a décrit un arc de cercle avec sa tête et lui a cinglé le dos avec sa natte. Elle a renversé brutalement sa tête en arrière et il a répété son geste. Il fouettait cette belle femme attachée avec ses cheveux. Cette scène est restée gravée dans ma mémoire.

La nouvelle «The Rope Trick of the Rhine», *Bizarre* numéro 1, p. 25–37) m'a rappelé cette fameuse nuit. Il s'agit d'une autre scène SM de cabaret, mais celle-ci, j'ai pu la savourer à loisir.

Je compte parmi mes vieilles amies Veronica Vera, auteur d'écrits érotiques, artiste-performer et modèle de nus fétichistes de Robert Mapplethorpe. Elle est également la fondatrice de la «Vera's Finishing School For Boys Who Want To Be Girls», à New York. Un après-midi, j'ai eu le privilège de voir tout un groupe de messieurs transformés en jolies femmes, dont un habillé en soubrette avec des manchettes. Tandis que je l'observais servir le thé et offrir des sandwiches à la ronde, il m'est revenu en mémoire une des nombreuses lettres de *Bizarre* adressées par des épouses en colère. Dans le numéro 9, p. 56–58, «Babs» raconte qu'elle a surpris son jeune mari en flagrant délit d'adultère. Elle a exigé qu'il soit puni et il a accepté. Elle n'a demandé qu'un seul châtiment: «Il doit s'habiller en jolie soubrette à la française et être aux petits soins pour moi ET JE NE PLAISANTE PAS!!! Talons aiguilles, tablier et coiffe en dentelle, longs

collants de soie noirs, petite robe en soie noire ET une belle perruque noire!» Ah... quelle exquise humiliation il a dû savourer.

Des années plus tard, j'ai assisté à une soirée à thème organisée par les entreprises Constance dans le New Jersey: «Dressing for Pleasure Ball». Il y avait un défilé de mode fétichiste mais je ne me souviens que d'une blonde dans un justaucorps en cuir sans manches de Slimwear of America. Je fus immédiatement excité par cette femme. Et je savais pourquoi. Ce n'était pas sa beauté, c'était sa tenue qui l'obligeait à garder les bras collés le long du corps, sa confortable vulnérabilité. Dans *Bizarre*, (numéro 24, p. 59), une lettre parle de l'apprentissage du corset et raconte le cas de la fille d'une riche veuve: «Elle est tellement mordue qu'elle vient tous les jours se faire coiffer et maquiller, apparaissant souvent tellement engoncée dans sa tenue qu'elle ne peut ni marcher ni tenir debout sans l'aide de ses domestiques. Elle a opté pour le style d'apprentissage du corset ‹Vénus de Milo› et tient à vivre, nuit et jour, sans l'usage de ses bras. Elle porte des vêtements coûteux, faits sur mesure, conçus sans manches. Les nombreux autres clients qui l'ont vue ici ne se doutent pas un instant qu'elle a des bras, écrasés contre son corps sous ces vêtements. Elle a souvent déclaré qu'elle puisait une jouissance extrême dans le fait de ne pouvoir se servir de ses bras et dans les réactions que cela suscite chez les autres.»

Voici donc les 26 numéros de la revue *Bizarre* de John Willie. Comme son nom l'indique, *Bizarre* était un forum ouvert sur les idées, les concepts et les costumes bizarres. Personnellement, j'y ai trouvé matière à réfléchir et je suis certain qu'il en ira de même pour tous ses lecteurs. Ouvrez grand votre imagination et votre mémoire, laissez-vous bercer par le flot érotique de la conscience humaine et découvrez avec plaisir le «bizarre» qui est en vous. Willie croyait qu'il était

mauvais de réprimer le bizarre qui, s'il n'était pas exploré, se retournait contre soi.

N'en dites rien à mon éditeur, Benedikt Taschen, mais aujourd'hui (la dernière limite pour la remise de ce manuscrit), vers six heures du soir, la sonnette a retenti. C'était Wendy qui vient une fois par semaine faire du secrétariat, poser nue ou revêtir des tenues fétichistes. Je lui ai dit de se choisir un vêtement. Elle a baissé la tête et, dans un murmure hésitant, elle a dit: «Tu as le droit de me battre.» Je me suis senti comme Zorba le Grec. Je ne pouvais pas lui refuser ça. J'ai renvoyé tout le monde et je lui ai dit d'aller chercher des lanières de cuir pour nouer les poignets, une balle en caoutchouc en guise de bâillon, des œillères et une corde. Je l'ai observée tandis qu'elle s'asseyait sur le sofa. Pendant tout ce temps, j'ai pensé à Willie, à l'angle de prise de vue qu'il choisirait.

Elle a enfilé des chaussures à semelles compensées de quinze centimètres d'épaisseur, a placé la balle de caoutchouc noir dans sa bouche, s'est masqué les yeux sous les œillères et, (à l'aveuglette), elle s'est noué un poignet aux montants métalliques du bureau. Puis elle a attendu patiemment que je finisse de taper ma phrase avant d'attacher son autre poignet au sofa. J'ai retroussé sa jupe en velours de patineuse et j'ai contemplé son cul encadré par un porte-jarretelles. Elle ne portait pas les bons bas mais le temps pressait. En Allemagne, les presses ont déjà imprimé les centaines de pages de *Bizarre* et attendent toujours mon introduction.

Mais Wendy attend, elle aussi. Quelque temps plus tard, je suis de retour devant mon clavier, le rouleau de pellicule tri-x dans mon Leica est terminé et Wendy renfile ses vêtements de ville. Elle doit attraper son bus pour aller à l'université demain matin. Wendy serait-elle mon alter ego? Je ne crois pas. Elle fait partie de la renaissance de John Willie.

"SWEET"

GWENDOLINE

& Sir Dystic d'Arcy

50 ¢

"THE RACE FOR THE GOLD CUP"

A Spine Chilling Melodrama With No Deed Too Dirty.

Bizarre Highlights

Selected by Eric Kroll

Bizarre Vol. 1 (1954)

The cover shows a magnificent black and white, perfectly composed
photo of a woman examining the heels of her black-laced boots.
Note the extra heels in casual disarray.

Inside front cover photo: (Willie's wife?) Holly holding shoes with
12" heels that frame her dark lips. The power of the image is in
her attitude.

PAGE 4: John Willie's sketches of women mimicking men's wear.

PAGE 9: Holly in black kid boots showing plenty of leg in public.

PAGES 10–15: Meandering Tale of the History of Footwear.
Sketches of extreme heels, many of them open-toed (p. 14).

PAGES 17–23: History of the corset.

PAGE 19: *The Gibson Girl Corset* drawing by John Willie.

PAGE 21: John Willie illustration of 1890s mistress being laced into
boned corset by high-heeled French maid.

PAGES 26–27: Centerfold of Holly on her back smoking, black kid
gloves, boots, exposed garters and an extra pair of heels near her
head. Dark eyebrows and lips. The confidence in her eyes is
compelling.

PAGES 25–37: *The Rope Trick of the Rhine* – a tale of cabaret bondage –
"wriggling like a naughty schoolgirl who expects, and hopes, to
be punished by her favorite mistress". Cleo's body was arched
back, but suddenly, as if she could resist no longer, she groaned
and seemed to bend back quickly like a bow, her face for once
showing considerable pain." A series of rope tricks.

PAGE 31: Photo of beauty in smart red rubber cape and very high
heels.

PAGE 33: John Willie's illustration of riding mistress with bull
whip, spurs on heels & skin-tight dark pants and white top.

PAGE 35: John Willie watercolor of two beautiful high fashion
female amputees in pencil – thin high heels and skin-tight
gowns.

PAGE 39: Drawing of a knight coming upon damsels bound to every
tree.

PAGES 38–45: Merrie England-testing for witches with pinpricks
& drownings.

PAGES 40–41: Double-page spread of photos of metal chastity belt,
legs & panties.

PAGES 48–50: *Discipline. Discipline.* Who beat who for what in the
good old days.

PAGE 49: John Willie watercolor of the lady in *Hobble Skirt*, wide
brim hat and heels.

PAGE 51: Close-up photo of typist in black leather kid gloves.

Bizarre Vol. 2 (1946)

Cover shows Willie's humor and fantasy. Ring master with whip in black leather corset, gloves & laced boots with red high heels controls toy tiger.

Inside cover: Photo of woman in shadow dressed in sheer black negligee and chains – "the spirit of fashion".

Editorial page champions freedom of speech and the freedom to wear the bizarre.

PAGES 4–6: History and championing of the corset. Fine watercolor of maid lacing her mistress into corset using her knee (p.5).

PAGES 7–12: *High Heels* by Achilles, a detailed analysis of heels: "The higher the heel the smaller in appearance will be the foot."

PAGES 8–9: Holly against seamless paper wearing a short, black, very tight skirt and knee-length black kid button boots.

PAGE 10: By raising the heel the length of the leg is also increased, and this gives more attractive proportions to the figure.

PAGE 12: A series of photos of Holly on steps in high heels & wide brim hat.

PAGE 13: Figure Training – forms of discipline and body molding: "a forced exaggeration of posture, for long periods".

PAGE 15: *John Willie's Exerciser & Home Aid to Beauty*. Pen & ink of damsel on training bike with an attached whipping wheel for errant young misses. John Willie continually harks back to the good old days of back-boards & shoulder braces.

PAGES 20–22: The instruments of punishment of bygone days.

PAGE 21: A drawing of a wrought-iron scold's bridle fastened with padlock.

PAGE 23: John Willie illustration of a naughty blonde pig-tailed damsel in the village stocks.

PAGES 24–26: Photos of model climbing a fence in hobble skirt & laced kid boots.

PAGE 27: *The History of the Ducking Stool* by G. Falstaff.

PAGE 33: A beauty in riding jodhpurs, riding boots with extreme heels and crop. Her back is to the camera and the riding crop just below her arse. Her toothy inviting smile is wonderful. Her features are like a Willie watercolor.

PAGE 36: Five drawn portraits of the principle characters of the cartoon serial *Sweet Gwendoline*. Sir d'Arcy d'Arcy mirrors John Willie and the Mysterious Countess looks a lot like Holly.

PAGES 38–46: Correspondence. Corporal punishment at 22 years old (p. 39). *A plea for perfume* (p. 43). Dominant woman with whip. *Not A Weakling She* (p. 46).

Bizarre Vol. 3 (1946)

Cover is whimsical with John Willie as designer devil. Are those fig leaves on the floor?

PAGE 5: Text the shape of a corset – two powerful women gesture to pathetic editor "Come out-worm." Women in scanty attire stand on the 'hips' of text pulling in.

PAGE 6: Historical photo of a Mlle. Polaire and her 13" waist.

PAGE 7: *The Confessions of a Tight Lacer*. The true life hardships of a young woman put through severe corset training.

PAGES 9–10: John Willie watercolors of two beauties heavily corsetted. One is smoking!

PAGES 11–17: *The Indian Rope Trick*. Sailors witness half-caste beauty in extreme rope bondage miraculously change from one stake to another.

PAGES 16, 18, 19, 20, 21, 29, 30: Willie's full-figure watercolors of bizarre costuming. My personal favorites are *The Rabbit* with enlarged ears and bunny tail (p. 18) and *The Pony* (p. 19) and *1972 Complete – the Mummy* (mummified female) (p. 30).

PAGE 23: Five variations of iron scolds to control "nags" (wives).

PAGES 25–26: A photo centerfold of Holly in mid-thigh black leather laced boots.

PAGE 27: Photo of Holly in pencil thin heel boots laced up to her mid-thigh.

PAGE 28: *The Hobble Skirt*. A dissertation on the hampering garment.

PAGE 32: Photo of a smartly dressed "slave of fashion" in 24" heels by Achilles.

PAGE 33: Sir d'Arcy d'Arcy – Episode 1. The stage is set. Foreclosure. Capture. Bound and gagged is poor Sweet Gwendoline!

PAGES 35–47: Correspondence. Letter from a woman seeking to be submissive to a man. "Do not bring flowers, bring cords instead with which to bind us" (p. 37). Letter extolling the pleasures of corduroy velvet (p. 37). Letter from a reader reminiscing about a pretty school mistress who punished students by making them stand in the corner with a dunce cap, hands tied behind with a piece of ribbon (p. 39). Illustration of school house discipline: extreme heels and tight waists (p. 40). Watercolor of damsel with raised skirt showing her frilly white bloomers (p. 41). *Goldilocks* (vol. 2, p. 23). This time in extreme boned corset dress (p. 42). "Patricia" retells her training: "My feet were both encased in a single specially shaped bootie." Letter from man claiming the right of man to also wear frilly things (p. 44). Illustration of raised skirt female with crop and mid-thigh laced boots with spurs (p. 44). Letter from man warning to be aware of the masculine woman, the "slaverettes", who emasculate men (p. 45).

Bizarre

VOL. 2

JANUARY 194

BIZARRE

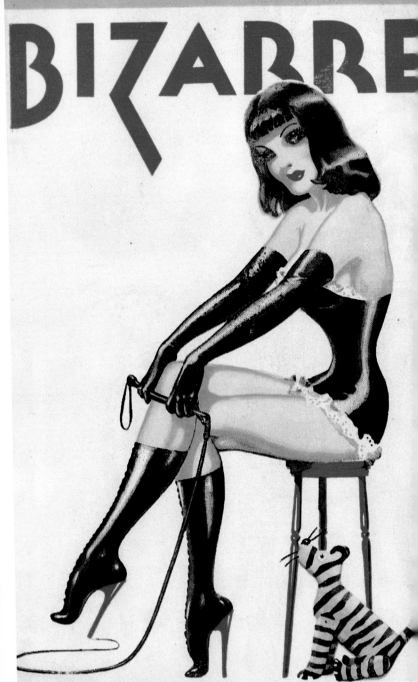

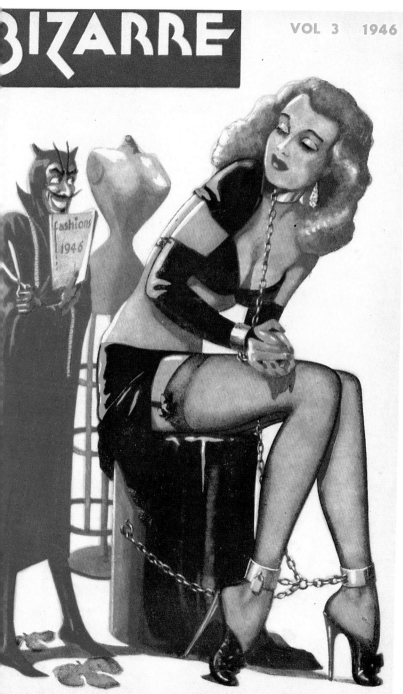

BIZARRE VOL 3 1946

Bizarre Vol. 4 (1946)

Cover illustration of close-up of heels bound with ribbon made into a bow.

Inside cover ad for shoes by Achilles of Holly in chains and heels.

PAGE 6: John Willie illustration of a "back-board" to improve a woman's posture.

PAGES 7–16, 48, 50: The Wasp Waist (fabulous illustration of corsetted beauty tightening the waist of a lady in leather hobble dress & stiff collar) "forcing an exaggeration of the ideal" (...) & "inventing ingenious methods of preventing their clients from removing their training devices".

PAGE 11: John Willie's illustration of the "single glove" to prevent slouching & stooping.

PAGE 17: John Willie's 6 panel illustration, Waist Space, of a woman that purchases a waist reducing machine and enjoys using it so much her waist becomes smaller and smaller until she pops in half!

PAGES 19–20: Footwear Fantasia – a dissertation on training to walk in high heels.

PAGES 23, 28–33: The Magic Island No 1. Sailor washed up on South Pacific island beach wakes up to blonde pony girls (p. 29). "Standing shoulder to shoulder... attached by harness... They had nothing on either except the harness and bridles and sandals... They smiled at me as much as their bits would allow."

PAGE 25: Fancy Dress. John Willie's original illustrations of reader's costume suggestions were available to the one who supplied the suggestions free of charge!

PAGE 27: John Willie illustration of the Bell Hop. Brilliant. Provocative.

PAGES 34–35: Episode No. 2 of Sweet Gwendoline. Gwen is left securely bound in the cellar of an abandoned barn by the wicked Countess and the evil d'Arcy. Fortunately, exquisite secret agent "U 69" finds the damsel in distress and offers to assist her (to be continued).

PAGES 36–46: Correspondence. Letter from a "Lover of Satin". All his wife's garments are made of satin as she teases and torments him into being her complete slave (p. 40). Letter from a lassoed wife (p. 42). Letter from perfume worshipper "to plunge your face into a well-drenched heaven of delicious perfume and have her command..." (p. 42). Letter from "Ursula", a dominant wife who transformed her husband into a ladies' maid (p. 43). Photo and letter about a woman with hair five feet long (p. 46).

Page 49: Photo of young miss in embroidered silk pantaloons and bare legs.

THIRTY-FIVE CENTS

Bizarre Vol. 5 (1946)

The correspondence issue.

PAGES 4–5: Episode No. 3 of *Sweet Gwendoline*, which Willie has entitled *Sir d'Arcy d'Arcy*. As Secret Agent "U 69" frees Gwen, the dastardly d'Arcy and the Countess return. "U 69" hides and Gwen is bound even tighter but not before blackening the eye of d'Arcy. The two villains wait outside the barn to see if Gwen escapes and she does with the help of the buxom secret agent.

PAGE 6: Rubber enthusiasts. He & she wear rubber bathing caps around the house.

PAGE 8: Figure training from corset lover.

PAGE 9: John Willie watercolor of kneeling wench in extreme corset & matching gloves.

PAGES 10–11: A call for dainty dress for men.

PAGE 12: An imaginary slave to a "silk stocking tyrant".

PAGE 14: Extreme heels for him and her.

PAGE 15: Photo of a blonde showing the entire length of her opera-length hose.

PAGE 17: A bevy of photos of black kid high-laced boots.

PAGE 18: Woman, whose lover adores extreme make-up, seeks face enamel.

PAGE 20: A discussion of modern day make-up and extreme fashion by "Raymond".

PAGE 21: A menage of four photos of very high heels.

PAGES 22–23: A family's uncontrollable passion for jam tarts and how each succeeding generation used punishment and restraint to overcome it.

PAGES 26–29: The use of corsets and high heels by the male. "I get a wonderful uplift, a surging exhilaration when so dressed... No living person can challenge my right to the claim of being a man's man..."

PAGE 30: John Willie illustration of young woman figure training with stiff posture collar & a belt over a boned corset with elbows tied together in back.

PAGE 31: A push for women with mannish haircuts.

PAGES 32–33: *Sir d'Arcy d'Arcy*, episode No. 4. Gwen arrives in time to enter her horse in the Cup. Evil d'Arcy instructs his rough henchman (with ultra feminine French maid on his lap rubbing his chin) to capture sweet Gwen and her comely companion. The ladies are left bound in the back of a moving van. Gracious! What will happen to these buxom innocents?

VOL 1 No. 5

1946

BIZARRE

Correspondence Digest

Bizarre Vol. 6 (1951)

After five years Bizarre re-appears!

PAGES 7–11, 13: Early movie stills of women in frilly pantaloons.

PAGE 14: A fabulous menage of very high heels and stockinged feet.

PAGE 16: Small illustration of a cigar-smoking serpent tempting a naked apple-eating, hand-on-hip Eve with a pair of frilly panties as matador's cape.

PAGE 17: Holly in silky black panty, bra, hat, matching dark lipstick & attitude.

PAGE 19: *Footwear Fantasia* by 'Achilles'. A treatise on high heels.

PAGES 22–32, 62: *The Magic Island No. 2*. Stranded sailor learns about island marriage custom: "bride-to-be" taken to the woods and bound & gagged to a tree. Groom has till noon to find her (p. 31). If found, a feast till sunset then bride is harnessed to bridal carriage and carries the groom home (p. 32). On the wedding night the husband ties the wife up in bed & falls asleep. If the bride gets loose then she will have final decision in future arguments but if she can't the husband "rules the roost" (p. 62).

PAGES 34–35: Fancy dress for special evenings-watercolors of costumed creatures.

PAGES 36–37: 4 illustrations of masculine men in frilly & unisex outfits.

PAGES 38–62: Correspondence reprints of letters from the 1850's to early 1900's on corsets (pp. 38–40). Letter in praise of rain and women in the rubber mackintosh (p. 40). Miniature female figures drawn in the margin of a letter from the editor (p. 41). Letter promoting the benefits and enjoyment of a mask (p.42). Fabulous spooky photos of fetish masks (pp. 43–44). Letter from woman who enjoys being blindfolded & more (pp. 43–45). Letter of 3 ladies comparing their very high heels. 6" won out (pp. 45–46). Wonderful drawing of Chinese home-style punishment & discipline apparatus-iron rods bent into a "U" with rings for the arms & iron collar (p. 49). Young girls learning to smoke, wear heels, put on make-up, etc. (pp. 50, 52). Photo of woman bound & gagged to post (p. 51) "My mother practiced 'Petticoat Punishment' on me ..." (p. 52). Letter about the thrill-value of long painted nails (p. 54). Smart woman in long tight skirt & high boots (p. 55). John Willie illustration of posture training using book-on-head method (p. 56).

PAGES 63–66: *Sir d'Arcy & The Wasp Women* kidnapping poor orphan Sally.

PAGE 67: 2 illustrations of Gwen in training & in servitude. John Willie offers weekly cartoon.

BiZARRE

N°6

Bizarre Vol. 7 (1952)

PAGE 6: Letter from Paris on the new trend by women for long hair.

PAGES 6–9: Movie publicity photos of long hair.

PAGES 11–13: Action illustrations of fit females in all variety of skirts. The frustration this beauty feels when choosing between a long, short, tight or loose skirt leads to her walking away nude except for heels & hose.

PAGES 10–17: The genesis of the "upside-down skirt" as fashion trend.

PAGE 17: Drawing of pencil silhouetted beauty in "upside-down skirt" perfectly balanced in extreme heels and diamond-studded collar.

PAGES 19–21: Fancy dress ideas from readers that John Willie illustrated. *The Dunce* (p. 21).

PAGE 22: Unusually intense photo – "ball masque" – of person in full face bondage, leather cape, gloves and leather chastity belt with silver studs.

PAGES 23–30: *The Magic Island No. 3*. A lengthy discourse on the genesis of the pony girls. Description of the "punishment harness" & "training harness". An explanation for the towering heels all the women wear – "to strengthen our arches for speed we walk and stand on tip-toe".

PAGE 26: Photo of Holly in heels clinging to a fence of vertical metal stakes.

PAGE 27: Sketch of blonde lion tamer with wasp waist corset, boots, gloves & whip.

PAGES 31–36: *Footwear Fantasia* – a championing of boots for women. "Then as the laces are tightened the soft touch of the kid as it molds itself firmly to every line of her arched in-step". Centerfold of Holly caressing a high heel to her cheek wearing 30 lace kid leather boots. *Footwear by Achilles* (pp. 34–35).

PAGES 37–39: Figure Training 1890. Illustration: Training corset & shoulder brace.

PAGES 40–62: Correspondence. A fancy dress party – 2 young women decided to go as the bound school girl dunces from issue No. 3. The hostess fastened their hands with wide adhesive & ribbon. Guests arrived to find them at opposite corners of the living-room, faces to the wall. "He had to feed me like a baby, of course, & after I got used to it I enjoyed the thrill almost as much as he did." (pp. 40–43). After World War I in several Paris cafes women punished men with their extreme heels and sharpened toenails. Often they tasted the women's toes (p. 44). A man's fond childhood remembrance of boot worship (p.46). Corporal punishment. "Cecile had to bend over and touch her toes…" (p. 59).

PAGES 63–66: *Sir d'Arcy & The Wasp Women*: bondage, smoking & high heels.

BIZARRE

N° 7

The cover is brilliant. Of course a woman in corset is a figure "8".
Inside cover: Woman in laced leather corset dress & shoulder brace.
PAGES 4–13: *The Magic Island No. 4.* Jim selects his female 'pony'
team at the pony market. 50 young women in their 'birthday
suits' except for tasseled g-string stand on tippy toes, their
necks attached to a ring above their heads which is attached to
a long pole; wrists crossed and tied behind their backs.
PAGES 14–15: *Fancy Dress.* John Willie illustrations: the "Cracker" –
woman as fire-cracker!
PAGE 16: *The Portable Prison.* An upside-down iron T with rings on all
three ends.
PAGES 17–62: Correspondence. Seeking beautiful girl without
arms (p. 17). Fiancée enslaves her mate through the mail
(p. 18). Sir d'Arcy's games re-enacted upon helpless Gwen look-
alike by husband & wicked sister-in-law for home movie (p. 20).
Woman happily married to 'Majorie', a transvestite (p. 23). A
man who enjoys wearing sheer nylons & opera pumps with high
heels More about buying heels (p. 23). John Willie illustration,
The Bloomer Girls – a breeze uplifts the skirts revealing the front &
back of two young frolicking beauties (p. 27). Woman enjoys
having her hands fettered at home – "My husband leads me
along by a leash fastened to a dog collar buckled around my
neck". Photo: *Shackled Susan* (p. 31). Lengthy dissertation on
corseting experiment – young girl with 22" waist belted down to
12"! The "subject enjoyed the sensations caused by the
constriction". At fifteen inches there was an "involuntary
motion of the hips and a lack of control of the abdominal
muscles" (p. 33). In favor of allowing adolescent kids to smoke.
"Many thousands of boys & girls of the finest character are
cigarette addicts today... The cigarette adds so much to the
attractiveness of a young girl... A pretty girl smoking a pipe or a
cigar is an extremely piquant & intriguing sight to masculine
eyes" (p. 38). The "Discipline Helmet" to silence bad girls. Fits
like a glove over the face, making her 'deaf, dumb & blind'.
(p. 44). The public application of lipstick. Shaving of a
woman's eyebrows, then penciling eyebrows on (p. 48). A
skin-tight leather mask for her boyfriend so that she can master
him (p. 50). Photos of platform heels (pp. 52–53). Young man
corseted to 17" waist by demanding aunt (p. 56). Photo of
woman gagging a bound woman (p. 60). Uxorial discipline
(p.61). *Sir d'Arcy & The Wasp Women.* The evil d'Arcy deceives the
helpless damsel.

BiZARRE

Bizarre Vol. 9 (1952)

A profile of a full-breasted orange butterfly in heels for the cover.

Inside cover: John Willie watercolor of ethereal, severely-corsetted blonde.

PAGE 4: 'Arty' photo of woman in extreme heels getting into streamlined auto.

PAGES 6–7: A devil that looks a lot like John Willie playing a corsetted blonde marionette.

PAGES 8–10: Photos & story on Hanka Kelter, woman with the longest hair in the world. For drying she sat under a long clothes-line in her apartment-dozens of separate strands of hair were spread out to dry in a huge fan-like arrangement, the ends pinned to the line with clothes-pegs.

PAGE 12–17: A fashionable wizard (1670s) was a full face mask held in place by a wooden button fastened to the inside & held between the wearer's teeth. Father punishes his wayward with full face leather helmet with painted smiling lips.

PAGE 14: Photo of smiling leggy can-can girls.

PAGE 21: *Fancy Dress* – the Slug costume, armless with hood over the eyes.

PAGES 22–23: *The Drum Majorettes* – John Willie illustration has woman wearing laced high heel boots that come just parallel to her pubis. All four with whips.

PAGE 28: The re-enactment of Sir d'Arcy (from No. 8, p. 20) "When the villain [her husband] was through I was bound, cord for cord, exactly as in your picture. Three hours of tight tree bondage. Fifteen friends came by to 'help' with our film; then there was a party where Gwen look-alike was 'Dumb-Belle of the Ball'".

PAGES 32–66: Correspondence. Mother & daughter pierce their ears after being strapped into chair (p. 40). Six days a week husband is a he, one day a week he is a she & his wife punishes him with his skirts pinned up (p.42). Six snapshots of shoes made of black kid with 5" platform & 10" heels (p. 43). Girl in skater skirt, 4" high heeled court shoes, black silk stockings & smoking a cigarette (p. 45). Photos of chained housewife in leather helmet, black panties, bra & leather bondage mittens! "I am completely helpless... my husband frequently spins me around until all sense of direction is lost" (p. 46). Young man falls in love with older woman dressed in vintage silk bloomers, stockings & boned corset (p. 52). 2 photos of woman bound & gagged to 2 x 4 post in black ruffled girdle (p. 55). Errant husband transformed into obedient French maid (p. 57). Photos – women in rain gear (pp. 58–59). Husband uses chastity belt on wife (p. 62). Wife married to shiny rubber boot devotee (p. 62). Full painted mask (p. 65).

Bizarre Vol. 10 (1952)

Cover: Photo – Holly smoking with tight low cut dress – great body language.

PAGE 4: Man Ray-like photo of man's wrist trapped by woman's heel!

PAGES 5–16: Fantasy dribble about various WILD gags and its eventual popularity.

PAGE 8: 6 John Willie illustrations of gagged beauties, each hairstyle unique as the gag.

PAGE 9: Photo: Sweater girl with taped mouth & illustration of a golfer with gagged friend.

PAGE 11: Illustration "Ultra" zippered mouth leather helmet.

PAGE 13: John Willie's *Scolds Bridle*.

PAGES 17–21: *Footwear Fantasia* – reader's description & photos of her towering high heels, patent leather corset & black kid gloves.

PAGES 23–26: *Fancy Dress*. The concept & John Willie illustrations: that man wear frilly outfits designed specifically for man's typical physical attributes.

PAGES 27–33: *The Magic Island No. 5*. The bidding on the female ponies began and multi-colored haired Suhanee high-stepped like the flight of an impala. After the sale Jim realized "she was all mine-now-to be kept helpless or not as my fancy dictated. Joanne, the golden-haired young tyrant (groom) claimed "When we're training, I beat her (Suhanee) really hard..." (p. 33).

PAGE 31: Photo of lady adjusting her stocking, exposing her high-laced boots.

PAGES 34–35: Photo centerfold of near-naked model binding up gagged photographer.

PAGES 36–37: Photo & article on Lana Turner in wasp-waist corsets. She's a 21"er.

PAGES 39–66: Correspondence. In favor of higher heels proportionate to shoe size (p. 41). Man found disciplining his bride on a leash in Prospect Park, Brooklyn (p. 42). Husband's duty to dress his wife, particularly putting on her stockings followed by "leg parade" (p. 44). Man wears bloomers under his street clothes and skirts at home (p. 45). Reminiscence of girl school punishment when all 23 students had to show their bloomers. Culprit wanted the caning across her stolen silk bloomers (p. 47). Husband made into French maid – "If he don't dance attendance as my maid then he dances to the tune of my switch." (p. 56) "Petticoat punishment" by older stepsister (p. 56). Club in England promotes the wearing of ultra high heels (p. 58). Rubber clothing & where to buy it (p. 63). Wife's face covered by black stockings with mouth taped & ears plugged with beeswax by husband (p.66).

BiZARRE

J.W.

N° 10

The cover of John Willie pen & ink drawings encompass all the topics from earlier issues-bondage, corsetry, dominance, etc.

Inside cover: John Willie watercolor of buxom Miss Wasp-Waist, 1953.

PAGE 4: Photo of completely gift-wrapped person entitled Merry Christmas.

PAGE 8: Photos & watercolors of woman in extreme heels adjusting her hose pushing her Bentley and laboring under the car in heels.

PAGES 9–11: Story from 1850s about wife of minister kidnapped by Chinese pirates and kept naked in bamboo pen with just her head outside the bars.

PAGE 13: Figure Training – for correct posture make the elbows meet in the back and strap them together. Also accomplished with yoke.

PAGE 14–16: 4 magnificent John Willie watercolors of damsels in severe figure training.

PAGES 17–19: Chinese foot binding. A woman with bound feet is like a rope dancer.

PAGES 21–23: Fancy Dress. John Willie illustration of Wooden Soldier, P.B.I with backpack to conceal her arms, & a Nelson with double eye patches & arms bound.

PAGE 24–32: From Girl To Pony – a wife-to-be's transformation into a pony girl. Photo – wavy haired brunette on her back with legs straight in the air (p. 27).

PAGES 34 Miss Bizarre. Willie's concept of the ideal woman – she must be both dominant & submissive. In the illustration one hand has a whip and the other is bound behind her. One high heel with spur & both heels chained together, one thigh with 6 garters, one with bloomer; a large nose ring & "drenched in perfume", covered in jewelry with one bracelet and a pair of handcuffs. Nice! (p. 35).

PAGES 38–67: Correspondence. "When I was twelve… auntie put us through disciplinarian exercises – we had to prance around the room making sure to raise our knees chest-high." A mis-cued 'Spanish Step' resulted in Auntie's switch (p. 40). Woman learns jiu-jitsu and binds her rival to get her husband. Bondage lingerie photos (pp. 42–43). Patent leather chastity belt bought in Montmatre (photos pp. 44–45). Woman with size 4 shoe finds 4" "skyscraper" heels (p. 47). Husband becomes a "sister" to help manage corset shop (p. 51). Figure training for boys through the wearing of girl's clothes (p. 53). Comprehensive survey of Victorian corporal punishment techniques (pp. 54–58). Woman wears tight laced corsets. "It was torture, but exquisite torture" (p. 60). Wife handcuffs then tattoos wayward husband (p.62).

BIZARRE

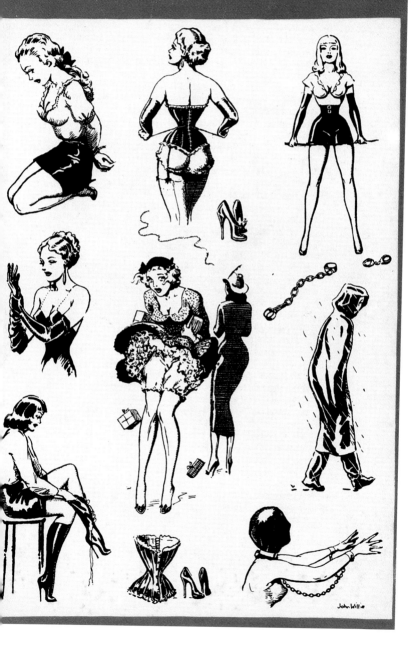

John Willie

Bizarre Vol. 12 (1953)

The cover of a giantess whipping her eleven female charges into
 shape. All are corseted, all wear black stockings, opera-length
 gloves & black bows except for one green bow. All are leggy. The
 rooftop damsel smokes, another hides behind the enormous
 heel of the shoehouse.
PAGES 6–12: For the love of mackintosh & high-laced boots (photos
 also).
PAGES 13–17: *From Girl To Pony* (to be continued). Bill succeeds in
 transforming future wife into "high action" pony girl. John
 Willie watercolor of woman with harness which pulls her
 forehead back & chest forward with the toe of the raised foot
 level with the knee of the other foot.
PAGES 18–21: *Fancy Dress & the Peacock Parade* – masculine men in
 frilly wear.
PAGE 23: John Willie watercolor of *The Silent Piper*, a metal arm &
 neck restraint.
PAGES 25–67: Correspondence: Corset training to 21" (p. 26).
 Photo: bound man in rubber straight jacket (?), his masked head
 under her high heel (p. 32). Mother uses petticoat punishment
 on her 18 year old son (p. 32). A man lamenting the disappear-
 ance of bloomers (p. 36). Man trains a woman like a dog, "no"
 to "slaverettes" (mannish women that master) (p. 37). Letter
 claims that face & finger grinding contests with women occur in
 American gambling establishments (p. 38). Beauty in white
 bra, white garter belt & white panties with dark stockings and
 heels with bows photographed outdoors (p. 41). Woman went
 from 36"-24"-37" to 36"-17"-37" with lacing corset (p. 39).
 "If 2 piece bathing suits are okay in public then why not bra &
 panties?" "Often I slip into the tub with my panties & bra on..."
 (pp. 40–43). Woman achieves hand span wasp-waist of 14"!
 (p .50) The anatomy of a 6" heel (p. 51). Four form Rubber
 Club (p. 52). Boy forced into girl's frilly clothes (p. 54). Mother
 dressed her three teenage daughters in revealing fetish garments
 & disciplined them in front of company (p. 56). Young mistress,
 older manacled slave at Manhattan restaurant (p. 59). Woman
 gets office job because of her willingness to wear gleaming
 rubber boots to work (p. 60). Man has healthy addiction to
 wearing lingerie since childhood (p. 62). Mlle. Polaire's
 vaudeville act had two strong men corset her down to 12" (p. 62).
 Wife, husband & husband's sister live a Bizarre life together
 with the women wearing John Willie-inspired upside-down
 skirts (p. 66).
Back cover: John Willie watercolor of Jane Russell (?)-inspired
 damsel in wasp corset.

BIZARRE

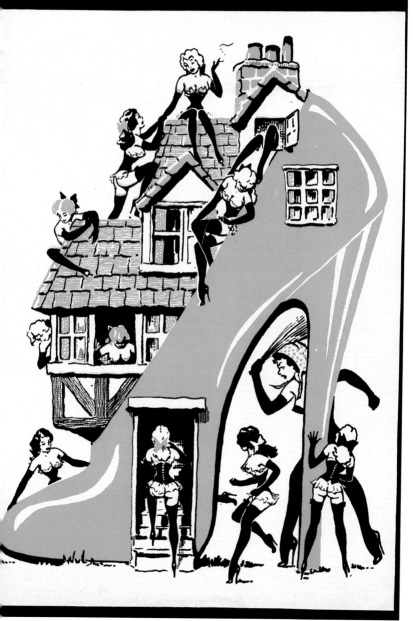

Comical cover of giant women in extreme heels clubbing subservient
tiny men. One man under heel, another begging at her thigh.
Two women lie at the bottom in rope bondage. Note the
repeated corset motif.

PAGE 4: Steel lattice corset with 4" diameter. Metal "tongue" covers
her privates.

PAGE 5: Illustration – editor with whip threatens 3 corsetted topless
workers.

PAGES 5–10: John Willie, archaeologist, digs up evidence of
giantesses who wore 12" heels & a leather corset laced to 14",
and who were enslaved by shorter, smarter men.

PAGES 11–15: Nose-Rings. Not a sign of submission but of
ornamentation. Photos.

PAGES 15–23: *Footwear Fantasia*. S. Soulier – a friend's collection of
fetish boots.

PAGES 25–66: Correspondence. Husband punishes wife for writ-
ing to *Bizarre*. First she dresses in Cincher Corset & Sheath Dress
which "fits like paper on a wall". Then he handcuffs her & lifts
the hem of the dress up over her shoulders into an upside-down
skirt! (p. 30) Photo of sophisticated woman outdoors in
rubber mackintosh (p. 32). Karen, a member of a group of
rubber enthusiasts, would allow herself to be clothed in rubber
garments, corsetted, made to parade around for hours & then
bound with leather straps, blindfolded with 3" wide strips of
rubber. Later a rubber mask was made from a mold of her
face which she wore as blindfold, gag, ear plug & hair net
(pp. 31–37). Centerfold photo of damsel washed up on shore
showing nylon clad leg (p. 34). Niece goes to ball without
undergarments & aunt's stolen jeweled garter belt. She is
discovered and caned. Afterwards the niece is made to return
garter belt by extracting it from her aunt's waist with her teeth,
since her arms are bound behind at wrist & elbow (p. 43). Out-
of-work Phil is transformed into Phyl to work as waitress (p. 49).
Photos of a woman cooking in bra & panties then swimming in
same (pp. 50–51). Photo of woman in leather straight jacket
with leather cloth across the eyes (p. 54). Husband creates
a Venus – bends her arm at the elbow with hand flat on the
shoulder then straps the wrist & upper arm tightly together
(p. 56). "Tightly laced people are more ready for love...a
delightful sensation of fullness in special areas". The most
complete instruction on figure training to create small waist, full
bust & hips (pp. 58–62). Chicago dance event – boys extracted
the heels of their dates' shoes, handcuffed their hands together
& danced with them (p. 65).

BiZARRE #13

Cover: Close-up photo of Betty Page with 3-button black leather gloves.

Inside cover photo: Black 5" platforms with 10" heels (double strap).

PAGES 6–11: Sylvia Soulier performs gymnastics in 7" heels and kid leather panties.

PAGE 10: Posture exercise photo of Sylvia with book on head in heels & gloves.

PAGES 13–22: John Willie, archeologist, returns to Grand Canyon in search of the origin of the corset & discovers Adam & Eve (in her wasp-waist corset & 6" heels of snake skin). Eve claimed the snake introduced her to corsetry, not fig leaves!

PAGE 19: Photo of female beauty in patterned lingerie & transparent opera gloves!

PAGES 24–25: Photos of fashion "Smog veils", an outgrowth of ornamental gags.

PAGES 28–37: Nini Ninette Ninon – a dream-like suburban community with wives wearing skin-tight fetish clothes and extreme heels while in severe bondage. Ninon is made to wear a Beanie – a leather mouth gag. Mrs. Betty Anderson wears a frilly apron, high-heeled sandals and a little waist-cinching corset with a pair of manacled wrists and metal collar as she hangs out the laundry. She is being punished for denting the new car. But her figure is becoming more & more hour-glass because her husband uses a metal belt over her corset which is tightened with a screw gadget at the back. Illustration of gagged Ninon (p. 28). Illustration of mummified wife observing her husband going to work (p. 29). Illustration of Mrs. Anderson in frilly apron (p. 34). Photos of blonde in leather straitjacket with leather eye mask (p. 35).

PAGES 38–62: Correspondence: A fancy dance party with elaborate descriptions of costumes including pretty Molly in leather skirt with amputated right leg (p. 39). Rubber photos (p. 41). Husband & wife with rubber bathing caps at home (p. 42). Man believes in frilly, pretty undies for men & desires photos of bloomerette panty-clad girls (p. 43). Husband & wife punishment by the palm of the hand to whipping with cane or hairbrush (p. 44). Continued letter from woman doing figure training. Bound to lacing bar by husband, she is put into rigid black satin corset from armpits to thighs with a high-boned lack satin collar (p. 48). Every year in Capio, Italy, there is a bondage carnival & everyone participates (p. 51). Infantilism & bondage done by "Madame" (p. 54). In praise of the "absolutely merciless" elderly tyrant (p. 57). Photos of 5" to 40" heels (p. 58). Fat redhead finds extreme corseting brings pleasure (p. 60).

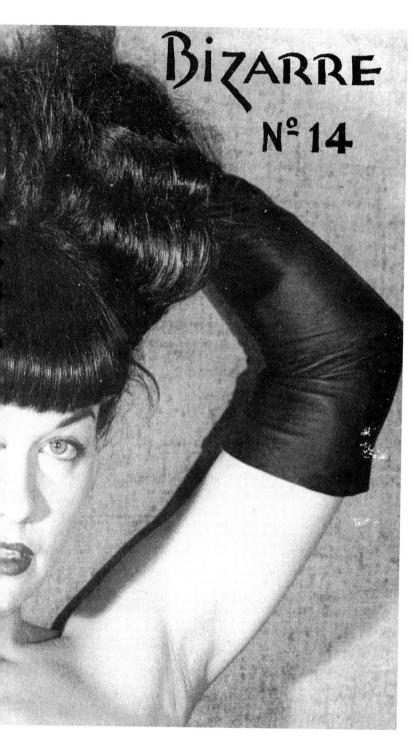

Bizarre Vol. 15/16 (1955)

Correspondence issue

BiZARRE

Nº 15/16

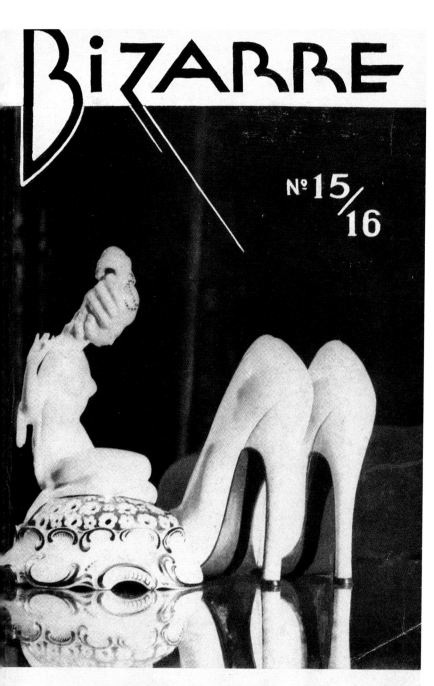

CORRESPONDENCE ISSUE

Cover photo of busty woman in satin dress and open-toed heels with black scarf over her face.

PAGE 2: Photo of woman with umbrella outdoors in long skirt & even longer white lacy petticoats.

PAGE 4: Photo of shiny black rubber boots.

PAGE 5: Strong editorial by John Willie on the oppressive State and censorship.

PAGES 8–11: *Footwear Fantasia* by Sylvia Soulier. Her friend Jennie's lacing techniques. She's described as 5'10'' tall & a waist of 21" with "electric black hair". Photos of high-laced kid boots with seamed black fishnet hose (pp. 9–11).

PAGES 13–16: The history of silk stockings (photos). Photo of bejeweled $2,500 stockings.

PAGES 17–23: *The Bridge of Sighs* (to be continued). The ideal community of fetish fashion bondage. Wives learn to play (imposed) "silent" bridge (p. 18). Fabulous illustration of leather helmeted gagged woman in chains.

PAGES 26–62: Correspondence. Wife, to please husband, dresses as amputee (p. 26). Reader suggests party games like "who can remain perfectly obedient the longest" (p. 27). The art & pleasure of tattooing with photos (pp. 28–31). Photo of five dancing women with raised skirts & petticoats (pp. 32–33). Photos & letter from couple who enjoyed camping & bondage in Maine woods (p. 35). College buddy invited to party where all women are gagged & bound. He meets his future wife (pp. 37–39). Rubber mackintosh enthusiast & photos (p. 41). Mother spanked daughter bare-bottomed & made Yvette keep her heels and stockings on when she was being punished (p. 44). Steel-reinforced ballet toe slippers with drawings (pp. 45–48). Photo of patent leather platform heels & seamed stockings. Photos of *au courant* shoes from London & Paris (pp. 50–51). Grandmother, mother & daughter were slaves to tight corset lacing. Mother had 15" waist. Grandmother believed that it was a woman's part to suffer, to be helpless, and to dress the part. Lengthy description of two maids getting 175 lb. grandmother into wasp-waist corset (pp. 53–58). Photo of one woman tossing another woman onto the ground (jiu-jitsu) (p. 55). Photo of single glove armbinder (p. 56). Photos of smiling blindfolded woman in armless clown outfit (p. 59). Detailed description of method for piercing ears (pp. 58–62).

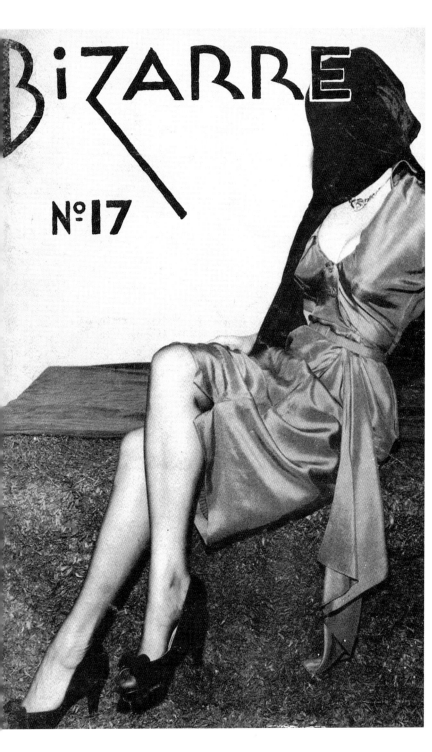

Bizarre Vol. 18 (1956)

Cover: Retouched photo of thighs, black leather gloves & full body in black leotard.

PAGE 7: Photo of blonde in shoulderless tightfitting black velvet evening gown.

PAGES 11–14: Description of pony girls in the South. "To remove the pony's (= the woman's) back teeth so that a studded bit rested on the tender gums."

PAGE 13: *Entre Acte* – John Willie illustration of vamp with whip and droopy earrings.

PAGE 14: Illustration: Close-up of beauty wearing "training harness".

PAGE 15: Illustration: high-stepping ring master whipping two prancing female ponies.

PAGES 16–21: *The Cult of the Corset*. French actress Polaire with 13" waist (p. 16). Portrait in white corset & laced boots. "Most women exerted an outward pressure of about eight pounds to the square inch against their corsets". Photo of an elegant woman in her evening gown (p. 18). He (Harry James ?) next to woman in the corset she is wearing under the gown. In Paris bordellos patrons are paid to lace girls into corsets.

PAGES 22–62: Correspondence. Doctor's wife looses her arms and is transformed into a modern Venus de Milo (pp. 22–24). Illustration of 5 corsetted beauties attacking the editor (p. 26). Illustration of filmy bra & panty-clad blondes attacking the editor (p. 28). Photo of tight high-laced leather boots & corset (p. 29). NYC Rubber Club with many couples who have a rubber room at home. Detailed description of the care of rubber (p. 30). 5 career girls live together wearing bizarre costuming (p. 31). Centerfold photo of Vera Ellen in black leather corset & transparent jeweled gloves & diamond neck choker (pp. 32–33). Long kid gloves (p. 36). Two women wrestle (p. 37). "The sight of the water running down over her hair, down her dress and onto her shoes, is a thrill." (p. 40). Photo of beauty in transparent skirt exiting a car (p. 41). In favor of tight skirts (p. 42). A woman in more than one fur (p. 42). Heel enthusiast travels to Europe (pp. 43–45). Illustration: Training corset with safety belt (p. 46). Anklets & thong sandals for him & her (pp. 47–48). Photos of mermaid & man bound by net in water & to log (pp. 50–51). With her toes in a shiny pair of chromium cups (p. 52). John Willie illustration of a corseted blonde in heels & gloves and a "straps only" hobble skirt (p. 53). Club "Modern Slaves" with men in bizarre fancy dress (p. 54). Photo of Batwoman completely encased in tight-fitting satin (p. 57). Six nude girls in the woods enjoying the sting of the switch (p. 62).

BiZARRE

N° 18

Bizarre Vol. 19 (1956)

Cover: Illustration of wasp-waist topless blonde in top hat & match-
ing bull whip.
Inside photo of woman's rubber boots atop the chest of helpless
man.
PAGE 4: Photo: Close-up of feet in open sandals (painted toes)
bound to bamboo.
PAGES 5–8: Report on Arabian slave auctions in 1856 & 1930s with
"the nipples dyed".
PAGES 9–13: Description & photos of a woman's extensive kid boot
collection.
PAGES 14–18: Paula Sanchez' memoirs (to be continued).
Grandmother's figure training for her two maids & herself
resulted in no-one able to sit or stand unless corsetted. Three
times a week – figure discipline – each loosely corsetted, then
forced to eat, then floor exercises, then more food & finally
tightly laced.
PAGES 19–62: Correspondence. Arm & leg war amputee
reintroduced to heels & corsets by task mistress. "I began to
enjoy the sense of restriction and helplessness" (pp. 20–24).
Photos of single 8" high-heel shoe & beauty in leather shorts,
heels & seamed hose (pp. 22–23). "Super garter belt" restraint
& illustration (p. 24). Illustration of corsetted beauty on her
knees (p. 25). Illustration of blonde amputee in 5" heels
& rubber tipped peg leg (p. 26). Woman challenges bondage
expert & looses (p. 27). She makes him "adorably helpless in
his petticoat imprisonment" (p. 28). Photos of man & woman
completely encased in tight-fitting black satin (pp. 32–33). She
desires to be in peg-leg bondage (pp. 31–34). "Woman... has
all of the softness and desirable beauty that are the levers
to control" (pp. 34–35). Rings dangling from the nipples
(pp. 38–41). Photo: Legs in hose with seam down the front
(p. 43). She dons a canvas vest with ring at the back which
is secured to a hook on the wall. She hangs suspended (in
bondage) in mid-air (pp. 44–45). A description of making a
"nice piece of horse-flesh" do her bidding (pp. 48–49). "For
obedience, pierce a nose, insert a ring in it and suspend her
from the ceiling by a chain." – Woman claims personal ex-
perience (p. 49). A cruel chain "saddle" worn beneath her
bloomers (pp. 51–52). Georgie is commanded to give her a
pedicure. If he does a good job he is permitted to kiss each toe
(pp. 54–55). Though adult, he is dressed & kept by auntie & her
friends as a little boy who is cuddled & spanked (p. 55). She
would always insist upon her arms tightly bound behind her
neck before being courted by dates (p. 55). Auntie raises boy
as pretty girl. He marries & serves wife & aunt as French maid
(p. 60). Rubberwear play (p. 62).

Bizarre Vol. 20 (1956)

Cover: Face & upper torso encased in black leather with leather
collar.
Back cover: Leather boots & hobble skirts.
PAGES 5–9: Photos of raised skirts in high heels & boots on a farm.
PAGES 10– 62: Correspondence. 16 years his junior she makes him
submit to her ping-pong paddle discipline (pp. 10 –11). Young
girl's hair is cut like a boy's & she is dressed like a boy as
punishment (pp. 11–12). Husband made into horse & whipped
and corsetted for hard labor (pp. 14–15). Illustration of topless
vixen with whip & heels (p. 15). Severe corsetting techniques,
long gloves as second skin & public handcuff bondage (pp.
16–23). Photo of Paris corset shop window (p. 17). Photo of
pretty Vera Ellen in corset & frills (p. 19). Photos of multi-toned
leather laced boots (pp. 24–25). Futuristic photo of black
rubber cloak (p. 30). Photo of shiny patent leather heels with
long tongue & spurs (p. 31). Caning of school girls in Ohio
(pp. 34–36). The ritual of spanking: made to go to the spanking
room, fetching the strap, assuming the position & baring the
spanking area (pp. 36–38). Photo of a woman in the shower
wearing her dress with the water streaming down her body
(p. 37). "He used to lie on the floor and I dug my heels into
him while we discussed the day's business." (p. 39). Photo of
elegant high shoes without heels (p. 42). Photo of woman in toe
shoes with steel support (p. 43). Costuming skirts to emphasize
a woman's derrière (pp. 44–47). Woman who had both legs
bound, ankle to thigh, "walked" around on her knees (p. 47).
Photo of woman in rubber bathing cap, garter, stockings & slip
standing in water (p. 49). "One night I pushed him onto his
back and began to dance upon his bare chest and face. I put my
toes into his mouth..." (pp. 48–50). He accidentally opens his
secretary's mail & finds Bizarre, then comes love & restriction
(pp. 50–51). Photo of two lovely ladies wrestling (p. 53). A
slave to ultra-high heels (p. 55). Game called "obedience": men
put in $10, women $5. First woman who refuses to obey loses
and other woman gets the money (p. 57). Husband "forced"
into complete rubber outfit (pp. 59–60). Photo of ornate corset
worn over the dress (p. 60). Photo of bound woman in
unbuttoned dress, adhesive tape over her mouth, her legs each
tied to a chair leg with her head forced back (p. 61). Man surveys
corset shops to buy outfits he will wear (p. 62). Man wears
Playtex panty girdle wife refuses to wear (p. 62). Photo of laced
masked beauty (p. 63).

BiZARRE

N° 20

Bizarre Vol. 21 (1957)

Inside cover: John Willie watercolor of Sweet Gwen bound and on a leash.

PAGES 9–18: *Diary of a Lady of Fashion* (c. 1840). Stern one-legged French governess arrives in leather skirt & corset (p. 9). Correctional exercises in 6" heels for daughters (p. 10). Selecting a rod for discipline (pp. 10–11). Thin bloomers no protection against correction exercises (p. 11). Daughters made into pony girls (p. 12). Deportment drill – girls in 7" heels, their arms in a punishment glove with heavy posture collars. They are made to walk blindfolded (p. 13). Photos of extreme heels sold through the magazine (pp. 14–15). Daughters bare to the waist learn about make-up (pp. 16–17). For secretly having loosened her corset laces Dorothy is beaten with a switch & then her blonde plaits are cut off (p.18).

PAGES 22–26: A dissertation on the ibitoe – the body modification & ritual a young itaburi of tight waist band that is worn for life. Nose & ear piercings. Western male writer decides to become ibitoe & uses old-fashioned leather ladies belt. The itaburi edges "feel like two hot wires, one around your pouting chest, the other around your hips." He cinches it to 16" (photos of man wearing itaburi).

PAGES 30–62: Correspondence. A list of Hollywood movies with bondage scenes (pp. 31–34). Man does housework dressed as woman and ventures out at night (p. 37). Photos of transvestites (pp. 35, 37, 38). Female office workers spanked by superior. Mrs. R. (the boss) suggests making her 22-year-old husband into a servant (pp. 38–46). Photos of contest winners of the leg competition (pp. 39–42). Photo of woman about to be spanked on her transparent panties (p. 44). Reminiscence of the family spanking ritual (p. 47). Wife blindfolded with tight leather mask, bound to "lacing bar" severely corsetted (pp. 48–51). Husband & wife both wear girdles or corsets when going out (pp. 53–54). Fully-dressed women are dunked in water & photos of wife in wet clothes & upside-down skirt (pp. 57–58). A club with barefoot slaves & bosses with high heels (pp. 59–61). Her husband has been trained as a perfect maid. He is made to sleep on the floor at her feet (pp. 61–62). More *Sweet Gwendoline* adventures.

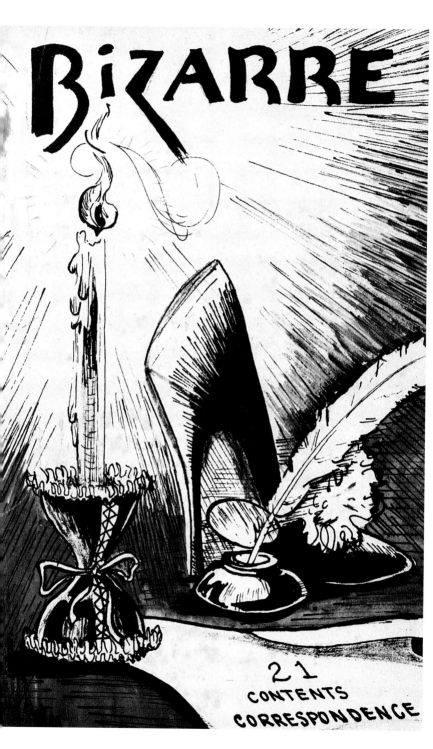

BiZARRE

21

CONTENTS

CORRESPONDENCE

Bizarre Vol. 22 (1957)

Cover of lower half of a woman with wrists & ankles bound with ribbon.
Back cover: Photo of front cover model.
Inside photo of pretty blonde in fancy full bra & panties with fencing sword.
PAGES 4–10: Photos & description of binding and gagging a woman.
PAGES 11–62: Correspondence. Husband & wife agree to use severe spanking as punishment (pp. 11–12). John Willie illustration: *The Ladies of Castile* – dark-haired beauty with high laced boots, severe corset & large dangling earrings (p. 14). A wide-brim hat & whip in thigh-high laced boots & bare midriff (p. 15). Husband attends to bound wife who shaves head & wears leather face helmet. She learns to do housework in darkness. She has a 36"-14 1/2"-36" shape (pp. 17–20). Man pierces his own septum twice to insert chain & later pierces his nipples (pp. 20–22). Photo of legs in heels & nylons bound at the ankle (p. 23). Husband & wife in woods find cabin filled with bound women. They are captured & bound. Later they relive their bondage at home (pp. 25–30).
PAGES 26–27: *"Do it youself" Department*: Description & diagram of converting standard high heels into 6" spikes.
Correspondence (continued): Young woman seeks woman to dominate her and dress her in bizarre apparel (pp. 30–31). As a young boy he enjoyed being spanked by aunt Flora & watching his friend being spanked by prettty nanny (pp. 31, 34). A collage of leg & heel photos (pp. 32–33). Blonde room-mate spanks her to the rhythm of music (pp. 34–35). Pretty 18-year-old Jacqueline is made to wear little girl clothes, then spanked (pp. 35–36). 21-year-old male dresses as woman at home, ties ankles together & puts four pairs of nylon hose over his head (p. 37). The birch used for punishment in New Hampshire pp. 39, 43). 2 pages of 4 photos of heels (pp. 40–41). Young man in sheer woman's panties is punished by girdle-clad aunt in her basement
(pp. 43–44). Transvestism guide to feminity (pp. 46– 47). Her punishment is discussed before their friends. She is made to feel absurd & ashamed (pp. 49–50). WAC major turns younger husband into "house girl" (pp. 51–53). Wife objects to poker game & ends up bound in closet (pp. 56–57). Rich young woman married to 20-year-old frilly "chorus boy" slave (pp. 57–58). Photo of nipple-pierced leggy beauty in heels (p. 59). Secretary becomes bosses' boss when she puts on rubber boots (pp. 61–62).

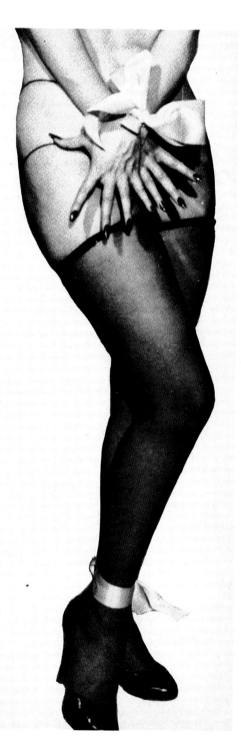

BiZARRE

TWENTY
TWO

Bizarre Vol. 23 (1958)

Cover drawing of high-heel, high-hat, high-booted lion tamer with whip.

Inside cover: Photo of smiling Marilyn Monroe in corset.

Back cover: Nude profile of Lilly Christine, the "Queen of Cabarets", sitting on white fur.

PAGE 4: Photo of masked leather dominatrix in high-laced boots & cane.

PAGES 9, 12–13: Drawings by Mahlon Blaine of a dominatrix riding an old man in boxers & one of a strange creature binding a nude woman.

PAGES 16–17: Three reader photos of bound wife in nylons, heels, bra & panties.

PAGES 18–19: Photos of Brigitte Bardot as fetish doll in corset and open-toe heels. A comparison of the arc of B.B.'s back and a figure training drawing by John Willie.

PAGES 20–21: An article & a fine drawing of ladies in extreme corsets from 1888.

PAGES 22–23: Photos of Jayne Mansfield and other beauties in short skirts.

PAGES 24–62: Correspondence: "She grew to want to be bound." Couple & female room-mate enjoy restriction that leads to love-making (pp. 24–25). An Oriental Slaverette who walks on his face & chest in heels (pp. 26–27). A letter about "hydrophilia" – the art of getting wet while fully clothed. Dress must be feminine & of a clingy material. Rayon jersey & cotton are good. She must be wearing shoes. No girdles because they interfere with the clinging of the wet clothing. Photos (pp. 27–32). Rubber enthusiast since childhood, when forced to wear rubber panties & to sleep on rubber sheets. Collected 20 rubber capes in college (pp. 32–34). Agrees to wear rubber panty & bra, etc. for photos & goes into training to wear specially-made high heels (pp. 35–39). The "Mujerados Club" of Buenos Aires for male & female impersonators (pp. 41–43). Photo of dominatrix in laced boots (p. 45). Photos of woman being surprised & bound while vacuuming, her dress made into a U.D. skirt (upside-down dress) (pp. 47–49). Photo of smiling woman with raised skirts & exposed garters & stockings (p. 50). Mahlon Blaine illustration of large woman in corset & whip stepping on the heads of men standing in a row (p. 51). In Paris department store a woman buys a leather dog collar for her handcuffed male companion (p. 54). A riding mistress from the horse's perspective (pp. 57–59). A news' reprint of Rochelle Lofting with a 42"-20"-36" belted figure (p. 58). A male wears corsets from early childhood (p. 60). Photo of Gina Lollobrigida in jeweled corset (p. 63).

BIZARRE

Nº 23

Bizarre Vol. 24 (1958)

Cover art by Mahlon Blaine of corseted faceless female smoking a
 cigarette seated on a stool with laced boots, nylons & gloves.
Back cover: Jeweled hands.
PAGE 11: Photos of lounging brunette & in bondage lighting a
 cigarette.
PAGES 13–31: *More Memoirs of Paula Sanchez.* Grandmother as a
 young house servant in Paris. The master insisted on strict
 corset training (p. 16). To achieve the desired figure she had to
 gain weight above and below the corset (p. 17). The bosom was
 thrust up almost level with her chin and her abdomen thrust out
 like a small shelf (p. 18). One eats to keep the passages open &
 functioning (p. 20). A "chest improver" was used to pull back
 her shoulders & widen her chest (p. 20). "You can cause them
 [= her feet] to adjust sooner if you keep them in the high-heel
 position even in bed." (p. 25). "There were dimples in the
 peaches-and-cream elbows just as there were in her cheeks."
 (p. 25). The waist appeared to be smaller than the neck (p. 26).
 Each breath causes "her breasts to appear to spill out over its
 [= the corset's] edge and then to sink back in" (p. 27). She
 learned to keep her balance on one leg with a book on her
 head (p. 30).
PAGES 34–62: Correspondence. 12-year-old boy accidentally comes
 upon young nude mother who lays him across her naked thighs,
 pulls down his pants & spanks him (p. 34). Errant husband
 made to haul cotton in women's drawers and beaten by fine
 Amazon woman if he doesn't perform (pp. 35–36). She was
 dressed in a black rubber siren skirt, high-heel rubber boots,
 rubber gloves & rubber hood (p. 37). A man & his female wigs,
 kid shoes & gloves (pp. 38–41). Husband wants her helpless.
 Armless, missing one leg, one eyed and barely able to speak
 from an accident. He makes her a restraint corset & builds up
 her measurement to 42"-16"-34". Also gagged by full face mask
 after he has shaved her head & plucked her eye lashes. Gets her a
 custom 6" heel (pp. 42–43). Accident forces man to be tightly
 corsetted for life (pp. 43–46). Photos of "Do-it-yourself"
 leather restraints (pp. 50–51). Likes piercings & feminine
 apparel (p. 53). A discourse and illustrations on the scold's
 bridle & branks (pp. 54–55). The feeling of compression &
 absolute dependence on others is what she dearly loves. "Venus"
 corset training – going about day & night without use of her
 arms (pp. 56–57). A career woman enjoys spanking female
 room-mate, errant office boy & tardy grocery delivery boy
 (pp. 59–62).

Bizarre Vol. 25 (1958)

Cover illustration by Mahlon Blaine of corset frilly panties, garters
& stockings.
Inside cover: Mahlon Blaine illustration: Woman as hour-glass in
gloves & stockings.
PAGES 7–9: History of wasp waists. Minoan fashion of metal belts
for men & women.
PAGES 10–13: Photos & text on history of earrings.
PAGES 16–19: Four 15th-century French wood engravings of bound
naked women.
PAGES 20–37: Correspondence. Young man grows up being
spanked by pretty step-mother (pp. 20–22). Photo of bikini-clad
Betty Page on a couch (p. 25). Tattoo enthusiasts (pp. 26–28).
"I can still remember the feeling of utter helplessness as I lay
pinioned across those broad thighs." (p. 29). Photos –
advertisement of women in girdles & hose (pp. 32–33). Article
on rubber clothing & photos (pp. 34–35). Tall blonde wore
short black skirt. Later she was found to wear a little girl outfit
while bound at the leg. (pp. 36–37).
PAGES 38–40: "Do it yourself" Department: The making of hoofs to be
worn with arms bound behind the back, a bit between the teeth
while wife whips him.
PAGES 41–61: Correspondence (continued): Wife wears a bra with
her sheer panties & fancy garter belt & stockings. They enjoy
getting her wet while wearing clothes. They spank each other
for discipline & pleasure. Mother-in-law joins them (pp. 41–45).
"I wear a mask of soft rubber which covers my eyes and ears"
while doing housework (p. 45). 4 photos of leather corsets
(pp. 46–47). How to develop will power & master pain. "I began
with sticking a pin into my skin." He finds a willing partner
[= his wife]. "We have acquired a long leather whip which we
use on each other." (pp. 55–57). Wife writes: "I am heavily
manacled, my wrists being encased in tight handcuffs which are
locked to the end of a short iron bar, the other end of which is
bolted to a heavy iron collar locked around my neck. My ankles
are shackled and connected by heavy chains to a steel band
locked around my waist." (p. 57). Husband enforces his will by
piercing his wife's nose, nipples & ears. He attaches her to
various spots in the house. She is strapped to unusual saddles.
The worst is the "electric saddle" which gives out small electric
shocks. He spanks her while she is wearing panties lined with
emery paper, the rough side next to her skin. She loves him
(pp. 58–61).

Cover by Mahlon Blaine of a woman with extremely long finger nails in a diamond-studded catsuit & heels sitting on the head of a smiling devil.

PAGE 4: John Willie drawing of naked Gwen, her wrists bound, calling out to Willie.

PAGES 6–7: Men first wore the heels, hose & corsets, when women took over. Illustration.

PAGE 8: John Willie sketch of discipline in higher education.

PAGES 12–15: London corseting. "Encased" they aim for 13" – their devotion is spiritual. Details of several women's corset training.

PAGE 13: Photo from the back of a tightly metal-bound woman.

PAGE 15: A painting of a tiny waisted woman with big hips in a body stocking.

PAGE 17: Reprinted article from *London Life* on ear piercing.

PAGES 19–63: Correspondence: The panty girdle as male chastity girdle (p. 20). Street fashion in London (p. 20). When punished she wears a long satin skirt and a rubber diaper. The victim blindly chooses the instrument of punishment (p. 21–23). Admires strong Amazon-type woman (p. 23). "The Rubber Club" – 15 members meet once a month & play dress up. Each wears a pad locked rubber hood to prevent identification (pp. 24–26). Young man goes to party & meets beauty with long legs who suggests he spank her. Afterwards she kisses him & disappears (pp. 27–29). Woman in high heels asks police officer to handcuff her hands behind her (pp. 29–30). Photos of woman in rubber suit & full face mask (pp. 32–33). A discourse on corsets – "stays", the "lacing bar", the "elbow board", the "evil screw belt" (pp. 34–40). John Willie illustration of maid tightening the laces of a beauty bound to a "lacing bar" (p. 35). Male admirer writes young married woman in high heels love letter. She arrives at his house with her daughter & spanks him soundly (pp. 42–43). A description of male corset fitting. After locking him back in his corset, Madame mails the key to his wife (pp. 43–46). "Spanking Tom" in Victorian England would seize corsetted women and spank them (pp. 46–48). To break husband's bizarre behavior she helps him to dress up then binds him severely (p. 48–50). Often they are both "blind". She smokes using her toes (pp. 50–51). Leather corset encased from head to ankles. Neck corsetting – a head harness used as rope (with weighted end) & pulley to stretch neck (pp. 51–53). She married Johannes & he became her sister Johanna (pp. 58–62). Photo of laced & bound woman in a corset dress (p. 63).

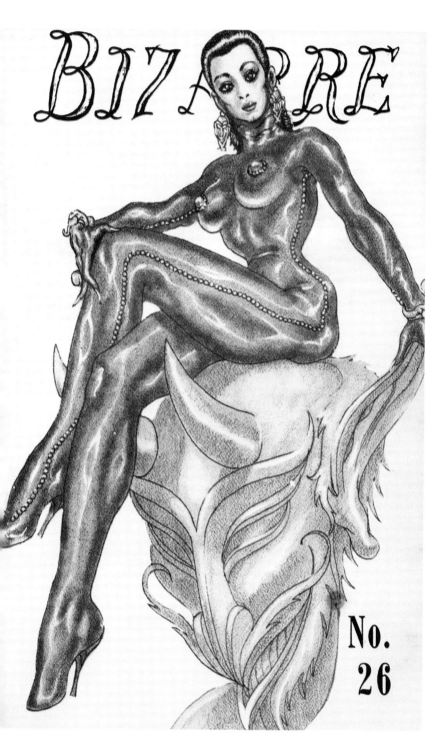

BIZARRE

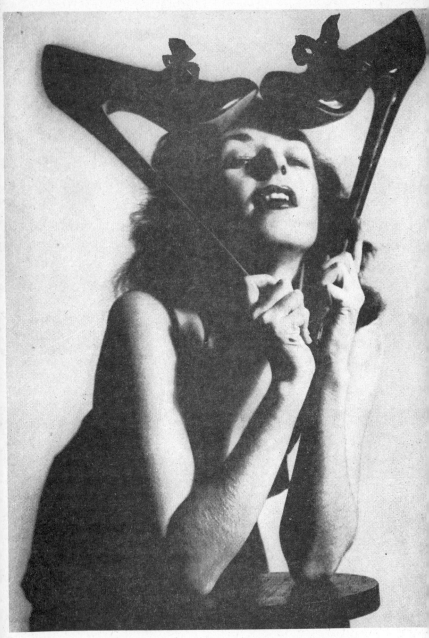

ACHILLES — for heels of any height

BIZARRE No. 1

Copyright 1954 by John Coutts

Contents

Future issues may be ordered direct from—
BIZAARE, P.O. BOX 511, MONTREAL 3, CANADA

LADIES !!- PLEASE !

You've taken our jobs !

Our beer and tobacco !

Our clothes ! yes- our hats · our ties-

our games !

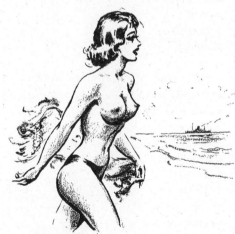

Even our trousers !

Please! Why not take our SWIM SUITS ?

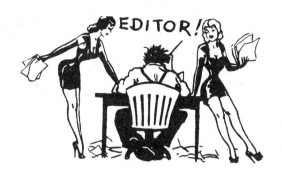

In a certain town in a certain country there is a small club whose members all belong to the tailoring trade. On each day of each year each member is pledged to eat an apple — not because they have an affinity for doctors' wives — but simply because their motto dates back to the dawn of time.

"IF IT WERE NOT FOR THE APPLE WHERE WOULD THE TAILORING BUSINESS BE?"

They could of course include dressmakers, and shoe makers, and so on, but they don't — which perhaps is rather unfair, and it definitely seems unfair not to include the rest of mankind, for we owe a debt of gratitude to the apple, or the snake, or whatever it was that put the idea of fig leaves and so on into the heads of simple, unadorned, Adam and Eve.

After much deliberation, and much research conducted from the front row stalls in a dozen different theatres, and convenient tables at some suitable cabarets, the entire staff have come to the unanimous conclusion that our education has been sadly misdirected, and that it was a fairy godmother wrapped up in that serpent's skin and not Old Nick in person

As we were thoroughly delighted with what we saw we think it an idle waste of time to question, argue the toss, or debate as to whether or not the ladies and gentlemen appeared as they did for our benefit, and by this simple process shelve, once and for all, the question "Do women dress to please men or merely for their own amusement?"

THE LOWDOWN ON THE UPLIFT

To our way of thinking there is too much hustle and bustle these days, particularly in the world of fashion.

Men's fashions change only very slightly over a long period of years, why must women keep popping in and out of new creations every few months? Is a change so vitally necessary? — We think not, and that is why we have decided to publish Bizarre. It will we hope act as a forum in which, by writing letters for publication, all readers can express their opinions on this matter.

Having reached this momentous decision it seems reasonable to devote some space in this first issue to a brief history of clothing in general. However, even a most cursory study of the subject immediately uncovered a glorious tangle with climate, customs, religions, and sex all hopelessly joined, rolled up, and tangled up, in, and around each other.

On top of all this, and sticking out like a sore thumb, was the disappointing discovery that everything did not start with the fig leaf — and it was such a delightfully droll story too — Pity!

Finding ourselves fouled up with Adam and Eve as a starter, we went back to the dawn of time when man, like all other animals, ran around naked, living by the simple law of the jungle — "kill or be killed."

There are no ugly wild beasts because the old and the weak are killed off by the young and the strong. Primeval man, a drab looking individual, lived under the same simple code, but as his brain developed he saw that he could improve on his own shortcomings in regard to colour by decorating himself. He daubed his body with bright clay. He tatooed himself. He wore ornaments, and the feathers from gaudy plumaged birds. In fact he made himself quite a gorgeous old boy!

From this very simple beginning came the custom in every country of the world to wear what we now call "Clothes," with the quantity of the clothing being

6

determined by climate. However a lot of things happened before the leopard skin developed into a "gents' natty 3 piece suit."

In the beginning of time (so to speak) the aged and the weak made the great discovery that brain could outsmart brawn so that they, as well as the muscled bully boys, could survive. And not only survive, but, in addition get someone else to do all the hard work of providing for their needs. To achieve this purpose the obvious stunt was to study "conjuring," "magic," and by "wizardry" terrify the ignorant, and claim without dispute to know all about life and death, and to be able to produce either by a few mysterious words.

"Magic" scared the daylights out of the mighty chieftains alright, but on the other hand, the wizards, who knew that it was hocus-pocus, still went in fear of the club well swung by a beefy knight's arm. In fact, it wasn't until someone hit upon the bright idea of "The Divine Right of Kings," which made each dependent on the other, that a peaceful existence could be assured for the witch doctors (from whom are descended our modern clergy).

Unfortunately, when it came to wooing, the aged and the "misfits of nature" found themselves well and truly out in the cold, for the female of the species had little time for their creaky and oddly shaped carcasses, and much preferred the young and dumb but powerful hunters. So the first frustration complexes were born, and instead of a healthy stock the breed suffered as the frail, the mentally twisted, and the deformed began to reproduce their odd progeny whenever they could.

Those were the days when — as Dryden put it — "man on many multiplied his kind, ere one to one was cursedly confined."

The result became somewhat confused.

Naturally at times, as in every mixed breed, there would be a throw-back to the true stock, but otherwise sadist produced sadist, masochist produced masochist, while homosexual, of course, produced nothing at all — all of which had no effect on clothing until religious leaders began to monkey about with nature by

7

denying themselves the natural outlet for their emotions.

With the strong willed ascetism is one thing, but few are strong willed. The weak in frustration at their failure to curb their normal desires became frantic, fanatical, or if you prefer it "plain nuts," and like every weak person blamed everyone but themselves for their sad condition, particularly members of the opposite sex.

However, it occurred to them that if the body is completely covered up you can't tell whether it is beautiful or not, and so in your suppressed state of ascetism you won't go getting naughty ideas — or will you? Therefore, following the technique of their witch doctor ancestors, they decreed that nakedness was taboo — in fact it was terribly sinful — a dogma that met with the complete approval of all the old and odd shaped characters in the community.

There would be nothing unusual about this. It has always been the custom in guiding primitive people to play on "superstition." Nothing else works. The leaders create a religion complete with gods and wield that like a club.

At the beginning of our recorded civilization no one but the Christians appears to have worried much about nakedness. The Greeks, the Romans, and the Egyptians certainly didn't — they wore clothes for decoration and warmth but regarded sex and the human body in a perfectly wholesome and unfrustrated manner. They thought nothing of shedding their garments when the mood took them; with the result that "fashion" as we know it today was pretty well non-existant.

However, when the later followers of the Christian church took up the whole Eden business, apple serpent and all, added the fig leaf, and started plugging it to the limit, it paid off, so far as the garment industry is concerned, by becoming one of the shrewdest promotion stunts of all time. — And that is really all that concerns us.

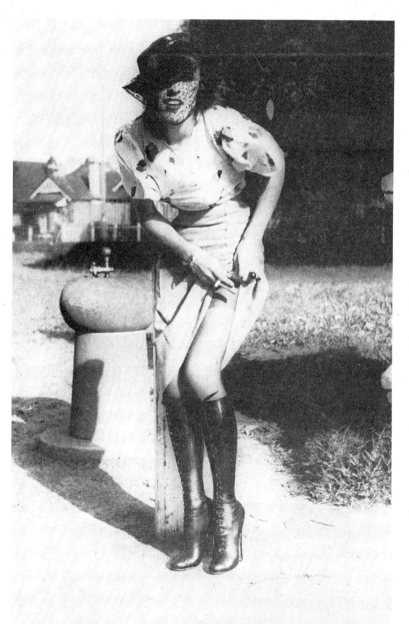

Black Kid Knee Boots are smart

FOOTWEAR FANTASIA

A sage once remarked that "a shoe is like a woman: it can be a torment and a delight" — so far as the wearer is concerned. This of course all depends upon the skill of the shoemaker, and the vanity of the wearer.

The human foot, if never shod, spreads, or to put it bluntly, though perhaps still beautiful in shape it becomes pretty enormous. For reasons best known to herself nature impregnated woman with an urge to be dainty, and man to desire that quality in woman. Women therefore are prone to

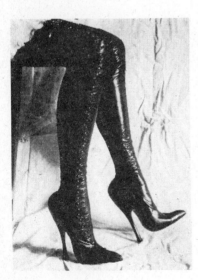

wear a shoe which is too small for them. It pinches their feet and gives an optical illusion to the wearer, but no one else, that their foot looks smaller. The sole result is corns, bunions, and sore feet generally.

The first original purpose of a shoe was nothing more than something which would serve as a protection against thorns, rocks, cold or the burning sands of the desert. For this all that was actually needed was a stout sole made of leather, cork, wood or some other suitable material, but the sole had to be held on somehow and so either thongs were used, or in colder countries a laced moccasin. In any case the spread of the foot was controlled and when this was done with a child, the foot when she reached adult age was narrower and more graceful.

Until quite recently — when modern knowhow and mass production have made shoes available to the smallest purse — a shoe of any sort was extremely expensive and only the wealthy could afford them. The peasants went barefoot. The aristocracy

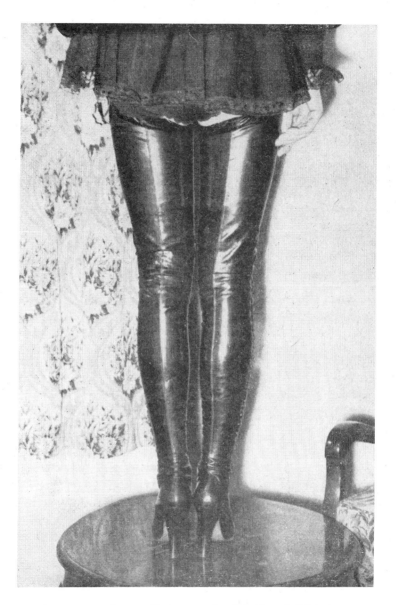

An excellent example of buttoned thigh boots

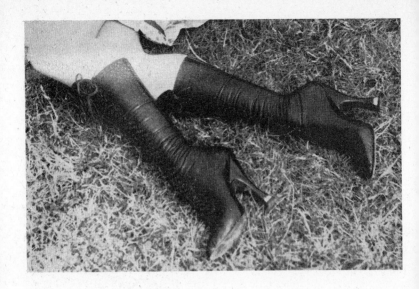

did not, and so, as the aristocracy's feet grew more graceful, a slender foot was a sure sign of "a lady by birth."

The Chinese carried this idea to the extreme by binding and crippling the childish foot right from the cradle before the bones had a chance to harden — a barbarous practice whichever way you look at it, even though it resulted in a "foot" (?) so small that the average Chinese lady's shoe measured only from three to four inches in length.

Other civilizations on the other hand just let events take their natural course. The tab-tebs — plaited papyrus strips or hides secured by thongs — which the early Egyptians wore soon became more elaborate and decorative.

Queen Hat-shep-set (1600 B.C.) wore sandals studded with precious stones and with turned-up toes. In fact cut and decorations of footwear became so much the rage that shoemaking was classified as an "art" — not a trade — and a shoemaker was a most important person.

The Ethiopians at that time wore magnificent boots of red, yellow, blue, and purple. In the Eastern Mediterranean Lydia did a very steady business in delicate perfumed footwear for the lady of fashion, and the poetess Sappho, we are told, "used to encase her slender feet in embroidered shoes of various delightful colours" and sang of "The Golden Sandals of Dawn."

So it has been over the ages.

**Anna Held's
20 strap
boot**

Women of taste are foot con-
scious, always in search of some-
thing new, something different,
as an adornment. The scope of
design, however, is not unlimited
and though in 1902 the "Twenty
strap sandals" which were worn
by Anna Held (and which cost
the actress $50.00) were claimed
to be "unlike anything ever worn
before in the history of the world,
it is pretty safe to say that some-
thing very similar adorned some
lady's legs about 300, 500 or 1000
years earlier. Incidentally, if you
are interested, the particulars of
Anna Held's shoes — or to be more
exact "thigh length boots" — were
— black kid — size 3½D, ankle
8½ inches, calf 14½ inches, knee
13½ inches, top 23 inches, height
26 inches from the heel, which
was raised 4½ inches off the
ground.

Perhaps one of the most in-
teresting incidents connected with

the development of the shoe for
the feminine foot is this custom,
dating right from the very earli-
est times, of raising the heel and
thereby increasing the height and
length of the leg of the wearer
to more graceful proportions and
at the same time decreasing the
lengh of the foot in appearance.

The "Wedgees" which are now
in fashion are by no means new.
They were worn away back in
the time of the Pharoahs. In fact
the only change that has taken

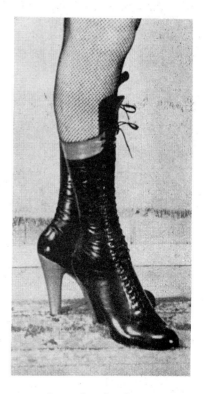

Boots for Gentlemen

13

place in modern times is the introduction of the steel shank, which enables a shoe to be built lightly, but yet with the necessary strength to support the full weight of the body, and the arch of the foot, when the heel is permanently raised from the ground by a high heel.

The heel itself presents a problem. If it is made thick the foot still appears clumsy — in fact probably more so. To create a heel which while being as thin as a pencil still has the needed strength to support the thudding jar of a 100 pounds is an art in itself. It is an art which so far machinery has not been able to copy, though with lighter metals coming onto the market the day of the molded metal or plastic heel is not far distant. At present, however, the would-be wearer of extreme heels must have the purse necessary to pay for the time of the craftsman, as he whittles away on his sanding wheel, turning out the delicate, tapering, five- and six-inch pencil-thin stilts which alone can make the dainty foot appear smaller and daintier still.

So great is the effect of a small foot and a dainty shoe on both the wearer and the spectator alike that it is safe to say that once the machine has mastered the skill of the artisan in regard to ultra high heels the ordinary everyday lady's slipper will no longer carry the 2½ or 3-inch stump that it does today. We can confidently look forward to an era of more beautiful feet with the 4-inch heel on a size 4 shoe as a standard — with the heel rising in height as the shoe increases in size. From there it will be only a step to the ultra-smart 5 and 6-inch stilt.

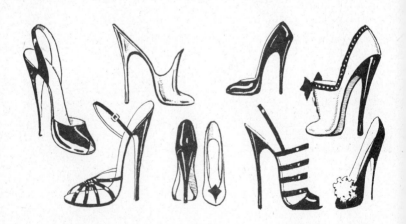

Lost Something?

The simple elegance of black & white

A HISTORY OF THE CORSET

The origin of the word corset is said to come from the French word "corps" meaning the body, and the verb "serrer," meaning to tightly enclose or encase. An early instance of the use of the term "corset" may be found as a portion of an entry in the household register of Eleanor, Countess of Leicester, which bears the date May 24, 1265.

Corsets in those early days were worn by gentlemen as well as ladies. Everything was tightly laced. A great number of ancient writings descriptive of female beauty go clearly to prove that both slenderness and length of waist were held in high esteem and considered indispensible elements of elegance.

In the 14th century the first real corset appeared. It was a coat-shaped fabric garment without any boning, held tightly over the hips by a band. It was stiff and unnatural and in many instances it was worn over the dress, being attached to the skirt. This garment was called a "surcoat." Later in the 14th century, during the reign of Isabelle of Bavaria, the first fitted corset was made. It introduced the first lacing, at front or back. The corsets were very stiff and could be laced with extreme tightness.

About 1559, fashion held such despotic sway throughout the continent of Europe that the Emperor Joseph of Austria passed a law rigorously forbidding the use of the corset in all nunneries and places where young females were educated. And no less a threat than that of excommunication hung over the heads of those damsels who persisted in the practice of confining their waists with such evil instruments as stays. This royal command startled the College of Physicians into activity and learned dissertations on the crying sin of the tight-laced ladies of the time. It is interesting to note that all this furor was met with open defiance.

Catherine de Medici, Queen of France, introduced the steel corset, covered with velvet, silk or other rich materials, which was worn throughout Europe. At this time a 13" waist measurement was considered the standard of fashionable elegance. The steel

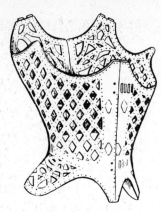

The Steel Corset

corset cover was constructed of very thin steel plate fashioned in an open-work pattern. It was made in two pieces and opened longitudinally on hinges being secured when closed by a sort of hasp and pin arrangement much like an ordinary box closing.

Superseding the corset covers of steel, we find a most powerful and unyielding form of the corset constructed of very stout material and closely ribbed with whalebone. These first corsets using whalebone were made during the reign of Elizabeth of England. The material used was often of coarse linen, sometimes with a busk of wood. (The word "busk" means a strip of metal or wood, usually inserted at the center-front of a corset.)

Toward the end of the 18th century, we find stay-busks to be at the height of their popularity.

They were made of whalebone or wood and were carved and engraved. Many a gentleman, returning from a trip would bring back as a gift, a stay-busk engraved with some sentiment. A typical example of this practice is a stay-busk with this inscription, "The gift is small but Love is All — Marey Oran — 1788." (The zip-fastener has done away with what must have required gymnastic exercise by our grandmothers and great-grandmothers. But how unromantic! Who will ever trouble to engrave love symbols on a set of fasteners.)

During the reign of Louis XV, there appeared the first corset in two pieces — the first real "pair of corsets." It had shoulder straps and a busk of wood. Also in the 18th century during the reign of Louis XVI, there was the quilted corset of strong linen with busk of boxwood, whalebone or steel.

After the French Revolution, the tight corset disappeared. The Directoire era began with its high-waisted gown loose to the figure. A band was worn, extending slightly upward in the center front. Later this belt was replaced by a boneless corset.

About 1810, we find stays no longer composed of whalebone or hardened leather but of bars of iron and steel from three to four inches broad and many of them

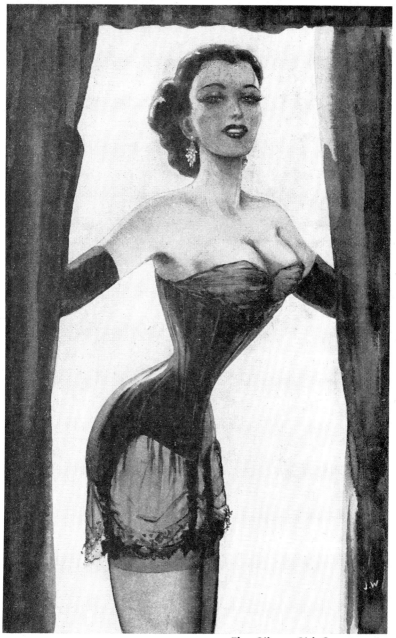

The Gibson Girl Corset

not less than eighteen inches in length. At the same period, the appearance of "LaNinon" created a furor. It was of one piece laced up the back—the original "wasp-waist."

In the decade 1820 to 1830, there occurred in France what can rightly be termed the birth of the corset industry. At this

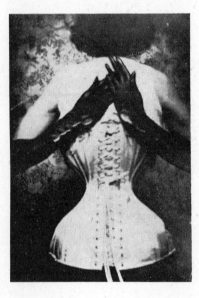

time, both men and children wore corsets. Lads intended for the army were tighthly laced. Corsetiers were very much in vogue. There is mention of a corsetiering establishment where were made corsets, Evening corsets and even Maternity corsets. During this period, corsets gradually grew higher in front and back, but left

the hips unencased. Gussets enclosed the bust. In 1842, the "Pariseuse" (lazy one) was popular. It was not very different from the corsets of the time but was more comfortable—its waist was not as confining. Steel Clasps appeared for front closing with lacings at the back.

About 1875, the ordinary stock corset was heavily boned and stiffly lined: the principal object to be gained seeming to be durability, with little regard to style, and still less regard for comfort. This was the corset made in one model and length that was supposed to fill the requirements of all classes of trade; about the only differences in styles being in the quality of materials used; and it was this corset which was popularly supposed to fit all figures whether tall or short, full figure or scant, the strong and healthy housewife as well as the young and undeveloped Miss. Whether robust or weakly, one and all were forced to wear the same style of corset or pay the extremely high prices demanded by the custom maker. It is not to be wondered at that many women today can trace present ill health to the wearing of corsets that were not in any way adapted to their forms or constitutions. Improvements, even in this old style of corset, were made, it is true, from time to time, but

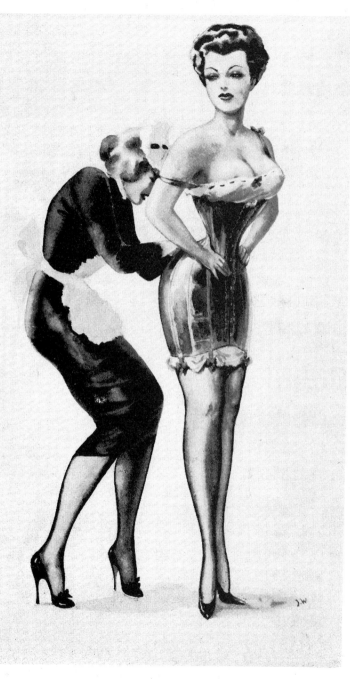

Dressing for the Ball (1899)

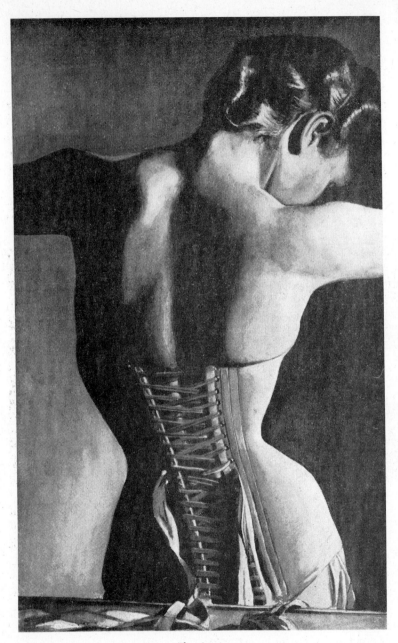

The Laces

it was not until the adoption of the single-strip corsets that the possibilities for making garments that would be hygienic as well as comfortable, while affording all necessary support, began to be realized.

A popular model of the time was the front clasp corset called the "Spoon Clasp" because of the shape of the clasp at the lower front. This garment extended high on the bust but did little to control the hips which were full in the accepted fashion of the time.

With the adoption of the strip corset, came the idea of different lengths, and models of different dimensions of bust and hips. For the tall slim waist figure, there was the long and extra long corset; and for the short and stout body, the medium and short corset. As the demand increased, new models were designed, and today it is hard to find a figure that cannot be perfectly fitted in a modern corset department from goods carried regularly in stock.

Many changes have come about, not only in the styles of corsets worn, but in the methods of manufacture as well. Materials have been satin, sateen, coutil and batiste; silk brocades came in with real lace or good imitation. New and greatly improved machinery, adapted especially for corset making, has been invented and perfected, greatly facilitating the process of manufacture, and enabling the manufacturers to keep up with every changing fashion.

The modern figure illustrates the trend to the natural idealized figure of youth. The bust is high uplift, the diaphragm is flat, the hip-line smooth and long. Today we think we have perfected comfortable corsetry. Corsets are scientifically designed for all types

of figures. A customer's normal measurements are a great consideration, but it is possible through correct corsetry to reduce measurements by two or three inches without any harm or physical discomfort.

☆　☆　☆

The Black Kid Corset

The Rope Trick of the Rhine.
by "the Traveller."

"Write!" said my friend, having hailed me like a long-lost brother.

"Write!" said he, paying again for the drinks.

"We are putting out a bizarre magazine—I am that magnificent person, the Editor—You've been around — You must have seen strange customs and strange magic in strange lands — Write about them! We'll be pleased to pay—ahem—a reasonable fee."

Now it so happens that though I have travelled a bit, and have done all sorts of things in odd places to earn a living, my life has really been most uneventful. I have never seen anything unusual anywhere and so far as magic is concerned I've never progressed beyond observing the "parlor trick entertainer" — except on one occasion.

No, it wasn't in Shanghai where the "heathen Chinee" plants a seed in a pot, waters it, and in a matter of minutes produces a beautiful plant in full bloom . . . it wasn't in the Congo where the witch doctor selects a young and beautiful virgin, trusses her up very carefully with rawhide thongs and then with magic words, much smoke and much ceremony, turns her into a hyena . . . and it wasn't in India where the fakirs do the world-famed Indian rope trick . . . It was in Germany early in the Spring of 1924, and it was a rope trick all right, but, unlike the Indian one, which no one actually ever seems to have seen, this one I spied with my own little eye.

I was in Cologne on a trip playing Rugby Football for the Army against the Rhine Army of Occupation, and late in the evening after the game, as might be expected, a couple of us wandered into a cabaret.

It was an intimate sort of place —you know what I mean—dim lights, secluded tables, and an orchestra tucked away in a balcony somewhere making pleasant sounds. In the centre was a diminutive dance floor on which about twenty couples were packed like sardines bobbing shoulders in time to the music.

We apparently had timed our
(*Continued on page* 28)

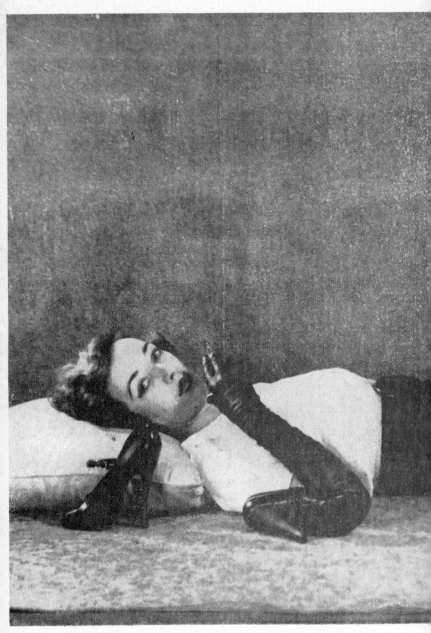

Boots by Achilles

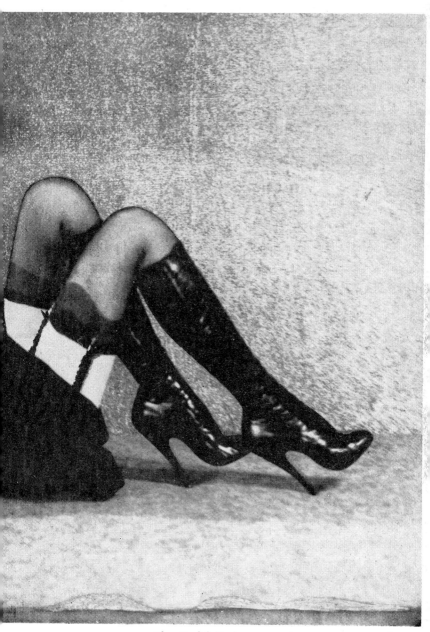

The Model Rests

entrance just right, for after a couple of encores the music stopped and the cabaret show began.

There were some excellent turns, singing and dancing, and then

some very cutely dressed usherettes who had been dishing out the drinks and cigarettes brought onto the floor a series of screens about seven feet high, which they stood up to enclose an area about twelve feet by twelve feet square.

The screens were magnificent oriental-looking affairs, red lacquer with golden Chinese dragons clambering about the place, and having satisfied themselves that everything was in order the girls folded them up again at the four corners and stood smartly at attention by them.

Suddenly all the lights went out, to be followed almost instantaneously by a spotlight which focused on one of the most seductively gorgeous creatures I've ever seen,

gliding down the passageway between the tables. She didn't seem to walk — she floated, her head bent slightly forward, her eyes sparkling, and glancing mischievously from side to side in greeting to the audience, of whom a bunch of students in their funny little pillbox hats seemed to know her well.

All I could see otherwise was a pair of graceful shoulders and a large expanse of bosom, which disappeared into what I took to be a daringly low-cut shining black satin evening gown. But as she stepped out onto the floor, it resolved itself into a one-piece bathing dress sort of affair of black kid, from the bottom of which emerged two of the loveliest legs I've ever seen covered in the sheerest of black silk stockings. Impossible legs, disastrous legs, the kind of legs which, when they cross the road, pile up traffic in a heap and stop fire engines — and the way she moved on them wouldn't help put out the fire either. How she managed to walk at all I don't know, for the heels of her little black kid slippers were pencil-thin and fantastically high.

The applause was terrific—the students keeping up a steady chant of "Cleo-Cleo — hurrah for lovely Cleo" while she turned this way and that, clasping and unclasping her hands behind and in front of

her and wriggling like a naughty schoolgirl who expects, and hopes, to be punished by her favourite mistress. Her naturally fair hair, wavy and glistening and reaching well below her shoulders, was tied back at the nape of her neck by a big black bow which added to the schoolgirl illusion. Perhaps schoolgirls don't also wear crease-less black kid gloves which reach to the shoulders as she did — and they certainly don't wear a costume that shows every curve and line of the body — but that is beside the point.

To be quite candid, the thing fitted so like a second skin that it wasn't until later that I could be certain that it wasn't just a coat of paint.

As the applause died down, two usherettes in very cute "riding costumes," stepped onto the floor carrying a solid old-fashioned many-runged high-backed kitchen chair, on which was a great pile of stout cord.

They put their burden down, and suddenly I noticed that their boots were not only laced to the knee, but also had fantastically high heels. This made me look at the screen holders. I hadn't had much chance of observing their feet before, as they were too close when they brought the drinks or cigarettes, in fact, even now I had to lean forward to see. As I sus-

pected, the heels were all terrific and as thin as a pencil. Whether one was higher than the others, or whether all were the same height I don't know — but I do know that every leg had a line and every arched instep a shape which was quite new to me and quite intriguing — quite definitely. I thought

in derogatory comparison of my noble sister Jane in her "sensible" shoes and wondered why women at home had to look so dull about the feet. Something like the shoes worn by these sprightly damsels would be much more interesting to see around the place.

I was enjoying myself hugely.

The stage now being set, so to speak, Cleo produced some chalk and proceeded to draw and number nine circles on the floor — eight of them in white and one in the centre in red. This done, she returned to the chair and slowly unravelled a longish length of cord from the heap, drawing it caressingly through her gloved fingers. Then, undulating in that disastrous walk of hers and looking as steamy as all get-out through eyes that glanced at you and held for a second with invitation before they turned down and away, she said in a low, husky voice, "I want to be tied up."

At this there were more cheers from the students.

She put her finger to her lips and when the hubbub died down explained that anyone could tie her up in any way they liked, as tightly as they liked, without worrying about hurting her. She was to be placed bound, on the red circle, the screens closed around her so that she could not be seen, and she would then try to move to one of the white circles in exactly one minute.

To add a bit of excitement the audience could make bets among themselves, or with the usherettes on behalf of the management, as to which circle she would be found on when the screens were removed.

To show what she meant, the girls in the bizarre riding costumes would tie her first and no bets would be placed.

Turning she beckoned to them and began to slide the chair forward, but one said, "No, we'll do without the chair," and taking Cleo's wrists began to tie them behind her back.

She was then helped down so that she sat on the floor and, while one girl tied her ankles, crisscrossing the cord around her feet and tying them too for good measure, the other with cords over her shoulders lashed Cleo's knees up to her chest. Those two girls worked with the smoothness of a team and the precision of experts.

Having finished her task, the one who had attended to the ankles now stood, gleaming boots astride Cleo's legs holding her shoulders to prevent her from falling, while the other passed coil after coil of cord around, pinning the girl's elbows to her sides and her thighs close to her body as if they were all one piece. This done, they unceremoniously rolled her onto her

30

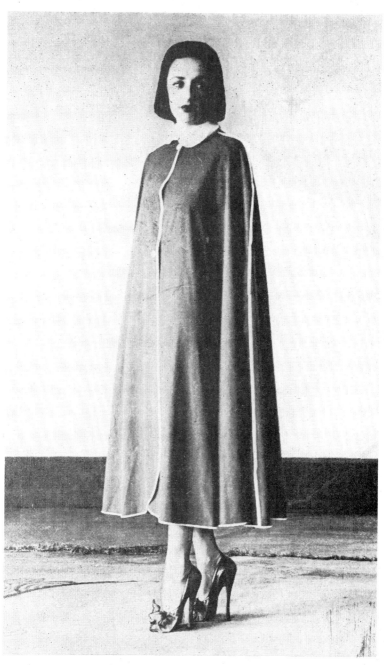

A smart red rubber cape

side, passed a cord from her wrists around the lashings on her ankles, tightened it, and without pausing as they doubled her legs back, rolled her upright again — or to be more exact onto her knees.

As if Cleo were nothing but a sack of potatoes they dragged her onto the red circle and turning, suggested that the audience test the knots, examine the screens, look around to make sure there were no hidden trapdoors and so on — "Nothing up my sleeve" in fact, and all that.

There was a general move forward on everyone's part, in which I joined. It was a most odd sensation to be standing so close to such a lovely and such a completely and utterly helpless girl. Once she half clenched and unclenched the fingers of one hand, once she stretched the fingers of the other, and once she turned her head sideways and looked for a moment at the feet of the audience standing around her — but otherwise she never moved a muscle — not a twitch, not a quiver.

One very pretty woman in an extremely low-cut green evening gown knelt down on the floor too, looked up into Cleo's face, then down at her feet, and with an exploring finger tested the cord around those dark, mist-covered ankles. "Ooh, it *is* tight," she said, looking up at me and then around when she found it was yours truly instead of her partner. However, she apparently decided she must talk to someone for she looked up at me again and said once more, "See!"

I obligingly got down on all fours too, and had an excellent close up view of those dainty little shoes, the kid so soft and so close-fitting that it showed every line of her toes. Oh, those slender tapering heels! I reached out a tentative hand, thinking absent-mindedly that I might be able to turn one this way and that for a better look, but so tightly were her feet tied together and so completely were they one with the rest of her that each heel was as firm and rigid as if she were standing on it.

"Hm!" I grunted, turning to the damsel in green, and to be sort of conversational, added, "Yes, very tight."

I thought we made a very intimate little group all huddled so close together on the floor, me, Cleo trussed like a turkey, and this charming damsel on my left in the very daring gown, one shoulder of which had slipped down her arm. She made no move to adjust the mishap, and I couldn't help but notice that she really was extremely easy on the eye all over the place. In fact, I was surrounded by attractions, so to speak.

Again she gently touched the

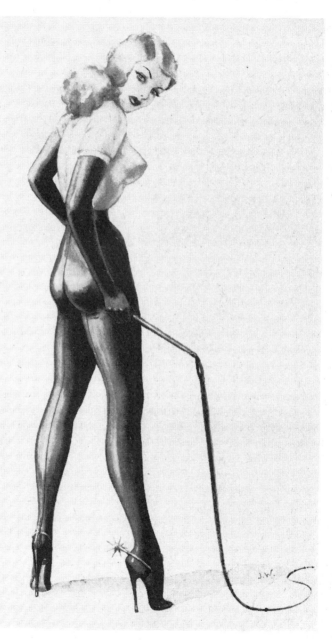

The Riding Mistress

cords biting so deeply into Cleo's soft skin. "Poor thing," she said, and then, after a pause, sighed "— how nice," gave me an odd look, and started to get to her feet. I helped her up. She said "Thank you" very prettily, and while slowly rearranging the errant shoulder strap gave me that sort of smile for which a girl should be spanked, and went off in search of partner.

I thought I'd better make some sort of show of looking at the screens and things — but how the hell could I take any interest in anything else with that lovely little captive bundle huddled in the centre of the floor?

For quite a while the customers continued to handle and prod Cleo. "She ought to have her mouth tied up too," I heard one woman exclaim. "She might use her teeth to undo the knots — Hi! Carl! Carl!" The manager obligingly came across to her.

"Carl," she said, grabbing his arm. "I insist she ought to have her mouth tied up too. Look, can I do it? — I can use this scarf" and she flipped a long black gossamer thing which hung halfway down her back, and almost to the ground on each side in front. "Why not?" said Carl. "Go ahead."

The woman needed no second bidding. She whipped off the scarf — grabbed a large silk handkerchief from her escort's breast pocket, ordered Cleo to open her mouth, stuffed the hanky into it, and then began to wind the scarf tightly around and between her teeth. There was so much of it that eventually it covered the lower half of her face completely.

But this sort of thing couldn't go on forever. Cleo had been tied up on her knees for a hell of a time and now, to add to her discomfort, she was very thoroughly gagged as well. With gentle persuasion on the part of Carl everyone at last drifted back to their tables, leaving the silent figure alone in the centre of the floor.

Carl waved to the band, which began to play weird music.

The usherettes placed the screens in position, and then the bandleader began to count through a megaphone — 60, 50, and so on at ten-second intervals, stepping it up to every second during the last five.

On the shout of "zero," the usherettes whipped the screens aside and there was Cleo, as securely tied up as before, but now instead of being in the centre of the red circle she was over in one corner on a white one.

There was a loud gasp of amazement from everyone — and then the applause was deafening. Two or three people sitting near Cleo hurried onto the floor for a quick

34

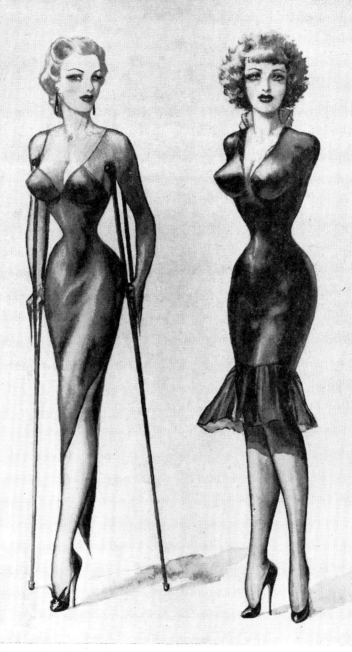

If you are handicapped —
 you can still make the best of what you've got

examination of the knots — and seeing that not one had been loosened, and not a cord had slipped out of place, shook their heads in amazement.

The usherettes, of course, hurried over and began the by no means easy task of untying the parcel.

It was now anyone's chance to try his hand and the audience wasn't slow in coming forward. Cleo was tied every which way — some of the women being extremely mean in the way they did it, as if they not only wanted to make her helpless but, in addition, to cause her as much discomfort as possible in the process.

Some used the chair, some did not, but all took good care to see that every twist and turn of the cord and every knot was as tight as blazes.

It never made any difference. The screens would be placed around Cleo, the band would play while the leader counted the seconds, and when the screens were moved, there she would be on some other circle.

At last one woman, a gorgeous but vicious-looking creature in a long sheathlike black satin gown — split away up on one side — suggested a variation. She offered Cleo 100 marks (which meant Renten marks or about $5.00) if she could move to a certain specified circle; when Cleo agreed she directed the rest of her party to take bets from all comers about it whilst she tied the girl.

This looked like easy money to me. There was obviously a trick somewhere, and that Cleo had nothing to do with its operation was also obvious—she was always too tightly tied to move an inch.

Anyway, how the stunt was done I didn't know, but I felt pretty certain that if I bet 100 marks on Cleo I'd win. How I'd pay the bill if I lost was just one of those things.

There was a crowd of bettors around that lady's table, and as I waited to get my money down I watched her at work on her victim. Cleo was once more sitting on the floor, her wrists crossed behind her back and her arms drawn so far back, with a multiple lacing of cord from her wrists to up around her shoulders that her elbows almost touched, and by the look of them her shoulders were nearly pulled out of joint.

She had her back to me and appeared to be sitting cross-legged like a Buddha—and judging from the antics of the woman in black her feet were being tied in that position. My assumption proved correct when, with the help of two usherettes, she was unceremoniously rolled over onto her tummy. Her ankles were indeed crossed

36

and, in addition, each foot was twisted flat against the calf of the opposite leg, and tied and retied with multiple knots so that to all intents and purposes her legs now formed a triangle with two sides formed by her widely stretched thighs and the third by her calves and feet.

Next, a cord was tied from wrists to ankles, and, with the red spike heel of her satin slipper in Cleo's back, the woman in black tugged. Slowly, very slowly as if it were a trial of strength, Cleo's body was arched back, but suddenly, as if she could resist no longer, she groaned and seemed to bend back quickly like a bow, her face for once showing considerable pain. In a flash, knots were tied, holding her in this position, and she was once more rolled over onto her back — her body still arched in a fantastic manner.

She looked as if she were going to cry, but there was no sign of sympathy on that woman's face as she pushed her captive over to a white circle at the end of the floor opposite to the one she had selected as a finishing point.

The screens were placed around, but as usual it was the same old story when they were removed. There she was, where she was supposed to be. Everyone cheered like blazes, while the woman in black just sat at her table shaking her head.

"Let's all put our money on the circle Cleo came from," one of the students yelled, "and let her have it all if she can get back there."

Everybody thought this a grand idea, but nobody worried to ask Cleo what she thought about it.

Carl, the perfect showman, piped up, announcing that everyone would now have a drink on the house and, striding onto the floor, added a bottle of champagne to the centre of the heap of money. He then proclaimed that as this would be an extremely difficult feat for Cleo, she must be allowed a full five minutes in which to do it.

"Oh no, please, Carl—" I heard Cleo moan, "only a minute, oh please—," but he took no notice and the screens were placed around, hiding her from view.

The minutes dragged by 4½-4-3½-3- and so on to zero, with the usual result when the screens were removed — and that finished the show for the evening.

Now how it was done was, and still is, a complete mystery to me — and you, my dear Editor, wanted a mystery — I hope you are satisfied.

☆ ☆ ☆

Merrie England

When civilization moved northward from the warm shores of the Mediterranean, with the Roman conquest of Gaul and Britain, the invaders soon found that ordinary clothes were no protection against the cold winters.

The Britons, a hardy race, were happy enough going about in the summer with nothing on but a coating of blue dye called "wode" — but the early Christian saints arriving from Italy with their "nakedness complex" soon put a stop to that, which was just the fillip needed to get things going. The Roman-Empire fell, but nobody in the garment industry cared — business was booming.

Clothing became more elaborate and most colourful. Rich silks from the Orient were on the market, and the art of tanning became well established.

As time went on, even iron was brought into use by the clothiers to make armour for the knights — and, appropriately enough, tough underwear in the form of chastity belts for their ladies.

Snapping the lock around the waist of his ever-loving wife, and pocketing the key, my lord The Baron would go off to do battle in the Crusades — confident that everything would still be in order when — if ever — he got back home again. (Simple soul.)

Of course it may be sheer coincidence, but it was just at this time that the locksmith became one of the most important people in the social whirl.

Merrie England had arrived with a fanfare of trumpets, and

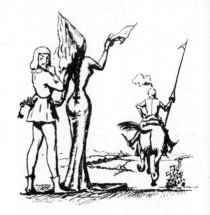

from all accounts it wasn't a bad time in which to be alive.

It was the era of Chivalry; the era of stout-hearted men and gracious women. The era of beautiful country untouched by the factory chimneys, the slums, and billboard skirted highways of civilization.

It was the era of moated castles and silent woodland glades through which the knight errant, when the Lady Guinever's singing began to pall, could ride in search of adventure with the certain knowledge that somewhere along the way he'd find a dragon or two to kill, or maybe come across a sadistic and revoltingly ugly ogre who would be holding some beautiful princess captive in a dungeon. If in the process of attending to the matter he didn't have the misfortune to be turned into a frog or something equally unpleasant, he always got the Princess' hand and half her old man's kingdom. A nice piece of business.

Travel was really adventure in those days. All you needed was a good steed and a stout lance, and as you went along — no doubt singing a ballad — almost everywhere you looked there would be a lovely damsel tied to a tree simply yearning to be rescued — but not too quickly.

Unfortunately, this state of af-

fairs was too good to last, and it stopped when gunpowder was introduced from China with an appropriate "bang!"

The lance and the longbow gave place to the musket and the cannon, killing became more scientific, and armour, being not much use against a bullet, went almost completely into the discard. It was still worn in the form of a light breastplate and helmet, as a protection in close combat, but having no further need to wrap

(Continued on Page 42)

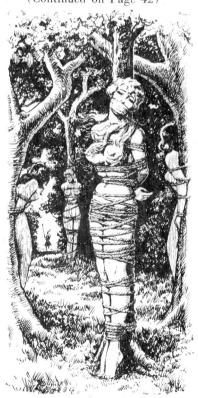

Les Pantalons

themselves up like one of the 57 varieties of Mr. Heinz, men began to let their heads go in the matter of dress with a riot of colour and costly silks, and women followed suit.

Clothes went on getting more and more beautiful, leading up to the magnificent plumage of the Stuart period.

In Good King Charles' glorious reign the Cavaliers in Britain and the aristocrats in France were gayer than any peacocks.

They simply reeked of costly perfume. They increased their height by wearing high heels, and women copied them and went higher. They wore silk stockings and fancy garters. They nipped in their waists with corsets and women went one better — and they finished things off with bows and ruffles and lace and magnificent plumed hats, and a very sharp rapier in case anyone was rash enough to argue.

Life for the "gentlemen" was gay and reckless and their clothing matched the mood, while the women, far from being chaste, were chased alright, in every direction. The bal masque became extremely popular because, though the men were fully dressed the fair ones as they were wearing masks, saw no reason to wear anything else but shoes and stockings — held up by snappy garters.

Unfortunately the religious experts, like the Boy Scouts, were even in those days always out to do good and they of course alone knew all the answers. To save you from a terrible fate in hell — a place which the sadists had great fun in conjuring up — the churchmen of the time would give you a taste of hell on earth by most unpleasant torture, which would be guaranteed to make you repent, and thus be certain of reaching heaven.

The cheerfully carefree and wild

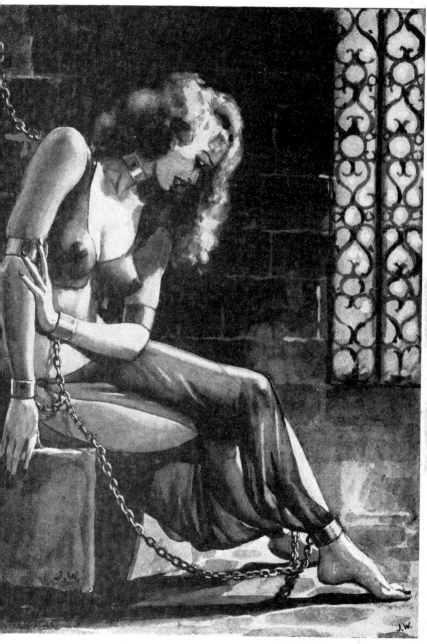

The Harem Slave

behaviour of the aristocracy didn't suit these "do-gooders" one little bit, for by now the garment industry had got past the witch doctor stage and, because no one taught the beautiful phrase and metaphor of Oriental legend, there were people who not only really believed in Adam and Eve, but who also considered that any bodily decoration was a sin. Give the superstitious time and any fable will become fact.

Thundering in their righteousness the Puritans, led by Oliver Cromwell, kicked all the Cavaliers' finery down their throats. Everyone began wearing subdued clothing, shut himself up on Sunday, and cultivated a gloomy facial expression. Fear, of the hereafter took all the fun out of the present, and those who did not conform had a most unpleasant time — while, as for witches, the countrysides were full of them.

This "witchcraft" business, which swept the country like a scourge, was so fantastic that we must digress for the moment to elaborate on it.

The leaders of the church of course knew what to do about this fascinating divergence. You could always find out whether some lovely girl, who attracted more than her fair share of men, was a witch, by torture, such as the simple process of tying her naked to a bench or a table and then sticking pins into her. The inventors of this particular stunt ensured that their fun would not be of short duration by decreeing that you hadn't found the "witch's spot" until your writhing victim did not scream or twitch when you prodded her with the pin. It would therefore take hours, days maybe, depending on how slowly you went about it, for her to be so covered with pinpricks, so exhausted and so numbed with pain that she could no longer feel that single little prick. Then you had her! She was a witch alright! You knew darn well she would be.

There was also the test by drowning. Witches, as everyone knows, can't drown, they float — that the human body also cannot sink if the lungs are filled with

air is just one of those things — so the victim's right wrist was tied to her left ankle and her left wrist to her right ankle, so that her arms made the sign of a cross. Then she was lowered head down into the water by a rope around her middle.

Unless she had the good sense to blow the air out of her lungs and let them fill with water so that she could sink — in which case she would drown — she was a cooked goose — quite literally, because witches were usually burnt at the stake. Those were gentle times — with the whipping post,

the stocks, the pillory and the scolds' bridle for minor social errors. To say nothing of the rack, breaking on the wheel, or being "hung-drawn-and-quartered" if you did something really bad.

Meanwhile Dame Nature with tongue in cheek was tagging along, and to their dismay the elders of the church found that, in spite of their own somewhat odd views on sex, the general public refused to be daunted. Certainly everyone appeared and outwardly behaved in a sombre manner from fear of torture, but inwardly and privately they carried on in the ripe old robust manner that nature always intended — and to make matters worse for the devout, the very severity of the garments worn gave an added feminine piquancy to the fair sex.

It was most forcibly brought home to the ordinary citizen that nudity, when all is said and done, is quite bare of interest, but that what you cannot see is quite exciting. It has possibilities.

A leg is a leg but the thing that is attached to the toe of that little slipper is a limb, and possibly the most delightful stem that you ever did see — particularly if the face is attractive. There just ain't no justice.

☆　☆　☆

ACCESSORIES

Regardless of your taste in dress you must consider the "accessories".

One of the most important is of course "perfume." The right perfume can turn the dullest moment into sheer delight, and fortunately these days there is a wide variety to choose from. The wise woman chooses with care.

The next question is jewelry. Fortunately these days manufacturers have the skill to reproduce all the beauty of the natural stone and there is also a wide range of "costume" jewelry — "decorative what nots" — if you prefer that term — which give that little touch of chic — particularly in regard to earrings. For earrings the ears must of course be pierced. The screw type never can have the same dainty appearance and can never feel the same from the wearers point of view. The actual piercing is simple, almost painless, rather like a slight bee sting to be exact — and, provided ordinary hygenic measures are employed, can be done by anyone.

And while on the subject of decoration we must include tatooing. There are tatooists and tatooists — some crude — others brilliant craftsmen. The unfortunate part about it is that once tatooed you stay tatooed so it is advisable to make sure that you only visit the best artist if you want the job done. So much for fair weather accessories — now for the rain.

For rainy days nothing can compare with rubber, and rainy or not no other material has quite the same attractive appearance. The very nature of rubber makes it hang with such a graceful drape. On page 31 you have an example of the simplicity and charm of a red rubber cape trimmed with white, which also affords complete protection in the heaviest downpour.

Rubber boots are also made in attractive styles and colours so that no longer need anyone worry about looking like nothing but a drowned rat on rainy days. Thanks to rubber we can still be smart.

But regardless of what you wear, or what you put on you must have a body. To keep this body in good shape is of the utmost importance. Certainly by the lavish use of cosmetics — lipstick, eye shadow, nail lacquer or polish — you can create a picture of beauty but no beauty can ever equal that of a healthy skin which comes primarily from a healthy body.

Exercise is of paramount importance — tennis and swimming

are excellent but if there are no facilities for these sports you can still get all the exercise you want in a gymnasium — or your own room. Physical "jerks" have been scientifically worked out to build up here and reduce you there. Of course if you want to be a bit more strenuous you can study the art of self-defense in the form of boxing, judo, and wrestling.

While on the subject of wrestling an interesting style is that favoured by a race of South American Indian women. At the start each contestant has a length of cord tied around her waist. When a "hold" is obtained this cord is used to tie the hands. The winner then uses the loser's cord to further immobilize her. The loser then has about ten minutes in which to attempt to free herself — if she succeeds they call it a "tie" — and start all over again.

However wrestling and boxing, though useful, are inclined to make women less feminine to our way of thinking — and we do like our women to be feminine. Perhaps you prefer a dominant type — why not? We are all entitled to our opinion.

THE AMERICAN INDIAN WRESTLERS

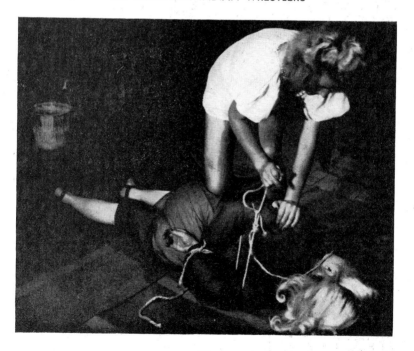

Discipline

Discipline

The late 19th Century was the age of stern parents. Discipline in the old homestead was strict. Somewhere in every house was a locked cupboard in which a cane was kept. In almost every hall, hung a hunting crop. The way of the independent rebel was hard.

Daughters were turned out into the snow; sons were cut off with a shilling or packed off to foreign lands (Australia for preference) and wives were horsewhipped or tied to bedposts to keep them in order.

Meanwhile, women, to ensure an austere appearance, indulged in self-inflicted torture by developing the corset to fantastic proportions. Waists became thinner and slimmer and no lady of culture ever thought of taking any athletic exercise. Her place was in a home as a gracious wasp waisted hostess.

Children were seen — not allowed to be heard — and had one heck of a time. Well-bred little boys had long curly hair and went around in velveteen. To make sure that they did not engage in rowdy games they wore extremely tight white kid gloves, and if a speck of dirt showed on so much as one finger at the end of the day they were punished — by whipping.

Little girls were squeezed in by tight training corsets of which the laces were knotted and cut. If this wasn't enough they spent an afternoon locked in their room with their hands tied behind their back. If they misbehaved they were whipped. In fact, whipping was the accepted punishment for all and sundry — including Mam-

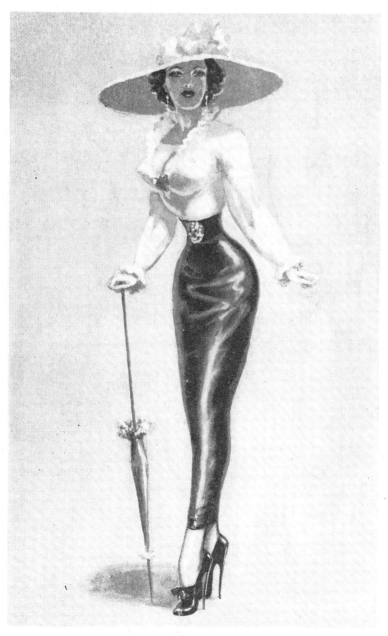

The Hobble Skirt (1910)

set — which was very long and quite prevented the wearer from sitting down — was not such a hardship after all. Sitting for any lady of spirit must have been a painful process most of the time.

But the wheel of fate kept turning and out rolled the Suffragettes — banners waving.

They set fire to churches. They jabbed policemen in the eye with hat pins. They chained themselves to railings in the park and spoke for all the members of the fair sex, and after a lot of really fruity skirmishings women got the vote and everything changed.

All the fancy clothes, the silks, the ruffles, the high heels, and the corsets, which the male had created for his own decoration now became the sole property of women — larceny, if ever there was, without so much as a by your leave or thank you! It became illegal to beat your wife with anything thicker than your little finger and the fair sex began to throw their weight around — at least as much as the hobble skirt and the harem skirt would allow. Life was still stern and home discipline strict, but the thin edge of the wedge was in. The downfall of man the master had begun.

ma (by Papa) and the under housemaid (by the cook). Whether the butler beat the cook if she burnt the main course is not recorded, but it is quite a likely supposition — he certainly "tanned the bootboy's hide" if the shine on master's shoes was not up to polish.

In fact so much of this chastisement went on, particularly by the male members of the house, that probably the extremely long cor-

☆　☆　☆

50

Dear Reader

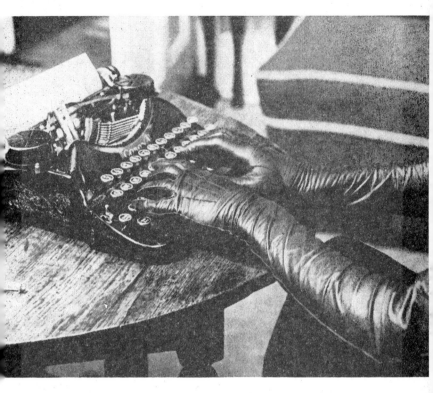

Now you will write and let us know what you think—won't you—

Our various contemporaries handle the latest from Paris or Hollywood in excellent detail — we will leave them to it — and ourselves concentrate on plain you and me with our own ideas and our own fancies. Old Fashioned? — Maybe! Conservative? — perhaps — but what of it? Must we all follow like sheep when some fashion expert or some self-appointed dictator says "this is correct"? Are we not supposed to be a free people — free to think as we wish — express ourselves as we wish? Aren't we? — Oh well, skip it!

BIZARRE

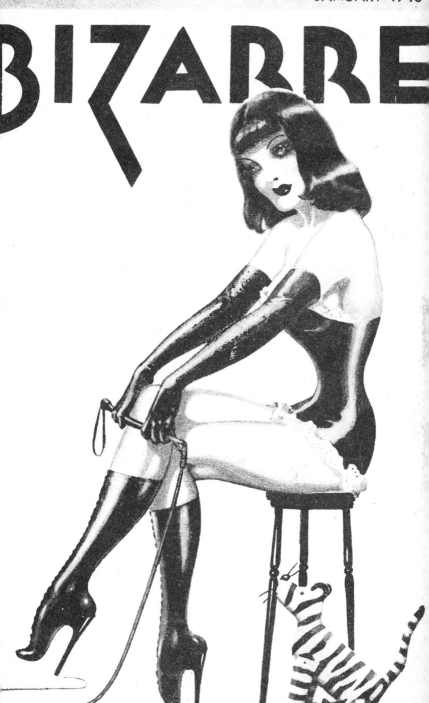

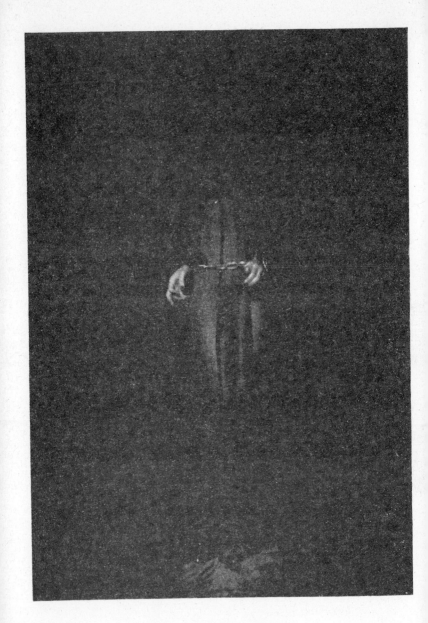

the spirit of fashion

BIZARRE

is, as its name implies — bizarre!

It has no particular sense, rhyme, nor reason, but typifies that freedom for which we fought (the entire staff incidentally volunteered for service with the armed forces in '39) the freedom to say what we like, wear what we like, and to amuse ourselves as we like in our own sweet way.

We therefore hope that by being an outlet for your emotions these pages will prove a good antidote to the worries and troubles which seem to be the aftermath of this war.

Contents

Ah, Love! could thou and I with Fate conspire
To grasp this sorry Scheme of Things Entire,
Would not we shatter it to bits — and then
Remould it nearer to the Heart's desire."

OMAR KHAYYAM

1

DON'T PAY ATTENTION

TO THE ABOVE ADVERTISEMENT!

Nor to the one for Photos on page 37

We simply re-print it (in 1953) as an epitaph

on the grave of lower prices and easier living.

The price of Bizarre is now $1 per copy — and

beer is 15c a glass — such is life!

We have to thank our many readers for their whole-hearted congratulations and favourable criticisms, on our first edition. We hope that this one will find them equally enthusiastic.

The trouble, of course, is that in producing a magazine to cater for those whose ideas on dress and so on are more conservative, or advanced, than the fashionable trend of the moment, we must cover a very wide field.

To please all our readers equally in one hit is an impossibility. Some like long hair, others short hair; some even delight in cutting it off. There are those who would like to be clothed in rubber, others love velvet, satin, patent leather or glace kid. High heels, low heels, short skirts, long skirts, tight frocks, each have their following. The shape of the figure and the manner in which it should be trained finds us with a controversial problem in itself, some insisting on rigid discipline — whilst others acclaim the advantages of open air and physical exercise.

Home life finds devotees of the domineering woman who will literally trample her husband under foot, on the other hand are those who would prefer to be kept in chains, the bound slave of their lord and master.

It takes all sorts to make a world, and it is a bit of a task to please everyone, but we will do our best, taking it in turns.

This ISSUE of Bizarre was first printed in Dec., 1945. The copy you are reading is a re-print made in 1953.

THE CORSET

In Egypt long ago there was known to be a cult of tight-lacing that was encouraged by the followers of Hathor—the Goddess of Feminine Beauty. The members of this cult only belonged to the aristocracy and its exclusiveness was carefully guarded. As might be expected this cultivation of a wasp-waisted figure met with considerable disapproval from members of other sects, particularly the women who devoted their time to culture and the arts, but who found their menfolk less interested in these pursuits and more inclined to follow the frail beauties of Hathor. This of course shows that the male of ancient Egypt was just as susceptible to a small waist and a trim figure as is the man of today.

In fact the corset, or as it is sometimes called, "stays," has been in and out of fashion for men and women for centuries, its shape and construction depending upon the material to hand and the style of dress in vogue at the time.

There has been much controversy, of course, in regards to its effect on the health of the wearer. Circumstances alter cases and many specialists maintain that for some people a form of body support is absolutely necessary. There are many of both sexes who believe in this and also derive a considerable amount of physical pleasure from wearing stays, and these, no matter how fashion changes, remain staunch devotees of the corset and tight lacing.

Sometimes the tight-lacing is carried to such extremes that actual physical discomfort results; yet the wearers are happy in the knowledge of the attraction which their slender waist creates, and by a strange and pleasurable feeling of constricted support.

Ultra tight-lacing if carried out properly from early childhood does not seem to impair the health in any way whatsoever. Our grandparents, taken in general, had a physique which many of our modern women might envy and suffered no ill effects from the practice.

The question often arises as to whether we shall shortly see a return to the corset proper. The war demanded freedom of action from women who were called upon in the emergency to take the place of men. Everything was rush. No one hand much time to

you simply MUST make it meet!

cultivate figure, or deportment, and the corset was in the discard.

Round goes the wheel of time and the lines of development along which the modern foundation garment is travelling are interesting, for they seem to be leading once more to a means of attaining a slender waist. This of course means the introduction of bones and lacing to conform the body to the required shape.

However, modern man, although as chivalrous as his ancestors, demands a certain amount of action from his women folk.

When the arts were part of our education it was the vogue for women to be feminine and helpless. The lighter and more frailly delicate their appearance, and the more helpless their manner, the more they were in the fashion, admired by their male acquaintances and envied by those of their own sex.

The girl whose waist was squeezed in to such an extent that even breathing was difficult, whose arms were imprisoned in gloves so tight that she could scarcely bend them and could certainly pick up nothing with her fingers, and was always obviously in need of assistance, had "oomph."

The young man of today would probably go in search of someone a trifle more active as a companion, and so those terrific affairs of bone and steel that held the figure in a rigid and vicelike grip are not likely to be popular.

At the same time it seems fairly certain that "stays" are coming back to life and we shall see a return of the laced corset.

It will then be easy to see why those who have always worn one are delighted, for they will have visibly stolen a march on others by already possessing a small and attractive waist.

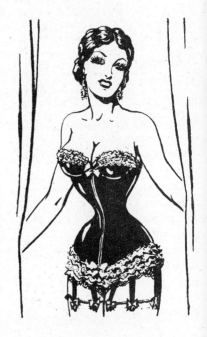

High Heels

by ACHILLES

THE WORDS, high heels, cover such a very great number of styles and shapes, not only of the heel but the shoe itself, that I will ask

the reader to remember that I do not wish to express an opinion, but will endeavour to point out certain aspects which will be of universal interest.

To start with high heels are attractive, and the higher the heel the greater the attraction. If it were not so why do women wear even moderately high heels? The attraction has a different reason with different people. Some like the shape it gives to the instep, others the precarious balance, the stilted step, the teetering feminine appearance, and so on. If when seen from behind the height of the heel causes a slight wobble—wobble is hardly the word; perhaps "hesitation in balance" is better —it gives a supple appearance to the ankles which pleases many.

Most people I find agree on certain things, however, and there is very little doubt that the higher the heel the smaller in appearance will be the foot — provided, of course, the shoe is properly made. At the same time a line is given to the leg and instep which is not unpleasant to the eye. A graceful taper, fading away to nothing — streamline if you like — is always attractive.

(*Continued on Page* 10)

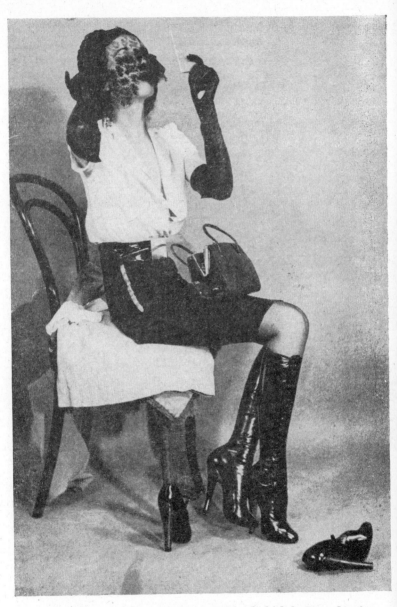

a smart pair of knee-length black kid button boots

with the added charm of the short very tight skirt

(*Continued from Page* 7)

The legs of a girl achieve this tapering grace in softly flowing curves from the hips to the ankle — then the foot sticks out at right angles! — Is it any wonder that an attempt has always been made, even in the time of ancient Greece, to raise the heel and so alter this sudden break of line. By raising the heel the length of the leg is also increased, and this gives more attractive proportions to the figure.

For anyone in my business to bemoan the shoddiness of boots and shoes is taken as a line of sales talk. Women, in particular, are guilty. Like the good soldier, they never look behind. They look down, see a shapely toe and leave it at that; but for those of us who see ladies' feet from all angles — and men, for some unknown reason, invariably look at a woman's foot first—there is no such treat. We see heels bent this way and that; low heels which spoil a pretty foot, or high heels so badly pitched that the foot is thrown out of shape.

To build a shoe with a very high heel is an art in itself. The reason that many people think that a high heel is injurious to the health is caused through ignorance of the full facts.

"But look how unnatural they are," you say.

To which I answer: "Are clothes, jewelry or silk stockings natural? And as regards bad health, are you so sure that it is caused by high heels; or that corns, fallen arches and sore feet which cause the body to strain itself in relief, are not brought about entirely by ill fitting footwear generally?"

To walk or stand on tiptoe is an exercise, and provided that your shoe conforms to the natural shape of the foot in this position and allows it to assume a normal posture, where is the difference? If to make your feet look smaller, you cramp your toes, or to improve the instep exaggerate the arch, don't blame the heel.

I regret that I have not yet been able to get back into peace time production but hope to do so in the near future. In the meantime though I cannot accept orders for footwear I shall be glad to receive your inquiry for a place on my waiting list.

ACHILLES.

a beautiful pair of thigh length boots with 5½ in. heels

Heigh ho! its an up and down life these days

FIGURE TRAINING

OUR PARENTS and grandparents
were brought up in the good old
tough school—so they tell us—
of "spare the rod and spoil the
child" — that, and "Take your
licking like a man Sir! Don't

pliance which were used on young
ladies to help them achieve deport-
ment and the body beautiful —
methods and appliances which
today we should probably con-
sider barbaric.

Snivel! — It's a habit that will
stand you in good stead through
life" were their pet sayings.

They thought nothing of the
mere physical discomfort caused
to a wife who was chained up, or
tied securely to the bedpost to
prevent her going out to make
whoopee,—and took as a matter
of course the methods and ap-

Imagine two charming maidens
of this year of grace dashing home
from a swim at a popular bathing
pool, and saying to their accom-
panying amorous male com-
panions: "See you worms later
on, we've got to do our spell on
the back boards." This meant
being strapped down firmly to a
hard, unyielding board for several

hours, to promote that straightness of back and an erect carriage.

Of course a lot depends on what a man expects in a woman. The cheerful companion of the golf course, pleasantly solid and capable, who never misses a putt or slices into the jungle, often finds her men folk looking with strange

the desired result

and intent gaze upon some fripperty, painted and powdered thing wearing a frock that shows a positively indecent amount of her anatomy.

In other years it never happened because women did not go charging madly all over the countryside, play squash, or drink cocktails. Their whole success depended on a small waist and a dignified carriage, both of which could be obtained, so fond mamas said only by much rigorous training.

Mama would say to daughter "You must be a success at the ball tonight, I hear that handsome Sir Reginald will be there — Fetch me the new training corset." A formidable affair of steel and whalebone would then be produced and clasped around the girls soft young body, and with much straining on mama's part (probably with the extra assistance of the maid)—and many gasps on daughter's, the thing would be laced in. Then probably her hands would be tied behind her to prevent her loosening the laces should her discomfort weaken her determination. This was not regarded as brutal. It was the

(*Continued on Page* 16)

14

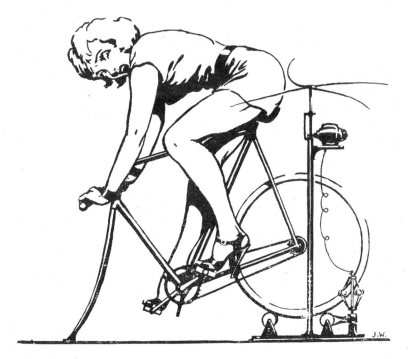

John Willie's Exerciser & Home Aid to Beauty
(Patented - and how!)

We asked our artist John Willie to look into the old fashioned figure training, and to illustrate its modern counterpart. Above you see the result, and below is his description.

Dear Ed.:

Have spent hours in libraries, and museums and am bung full of information. Grandma seems to have been most vicious. The modern miss likes exercise for beauty, so adopt the standard training bike on rollers (pedal like hell and get nowhere fast) and apply grandma's methods to make certain of proper activity — See sketch. The wheel works the governor and as long as she pedals she is O.K. If she stops the governor dies — electric contact is made — the electric motor starts, and the switches whirl smacking the lady's anatomy — If she objects strap her to it like granny would. J. W.

(*Continued from Page* 14)

accepted manner of keeping young ladies from meddling with their fingers.

No one ever pretended that training corsets, or other figure improving appliances, were comfortable, but they certainly produced results which was all that mattered to the ladies.

They often reached from chin to knee. The neck piece held the head proudly erect, or in other words bent it as far back as was possible. The bottom apron, apart from the fact that it made sitting down impossible, shaped the thighs and also curbed the stride by successfully preventing much movement above the knees. If this was considered insufficient the ankles were also shackled by a short chain and the trainee compelled to walk around the room to accustom herself to taking "little ladylike steps."

The shoulders also had to be held back, for which purpose a similar device to the modern shoulder brace might be used, or the simple method of a strap which passed round the elbows and was drawn tight, until they met in the small of the back.

The whole idea seemed to be that by a forced exaggeration of

posture, for long periods—(some corsets were worn all night) — the limbs when freed from the strain imposed on them would be reluctant to return to the normal position. The truth of this can be realized by the typical bearing of the regular army soldier. Men and women who have been trained to the army's 30-inch pace (120 to the minute) find it sticks to them. To go around the home for several days with the legs hampered in such a manner that only the tiniest steps were possible would also naturally have the same effect.

For girls who began their training when very young and whose limbs were supple there would be little more than the discomfort of restraint and of having to say in the one position for a fair length of time—a mere bagatelle to our tough old grandparents—but annoying enough to the young girl, who being temperamentally the same then as she is today, would much sooner have been climbing trees or throwing stones, or generally getting into trouble.

For young ladies who began late, however, it meant many weary hours of racking discomfort—but generally speaking the debutante of those years suffered gladly because by a "devilish

(*Continued on Page* 34)

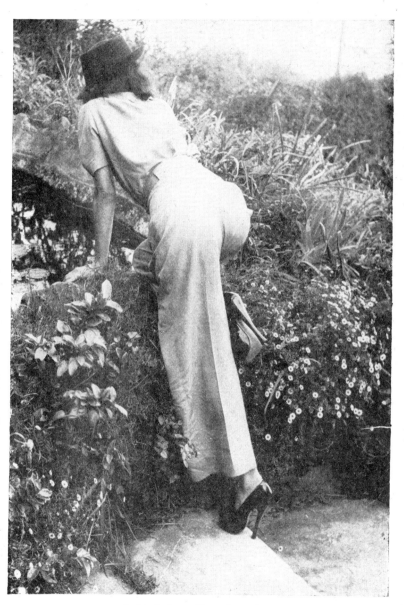

ooh look ! ... there's a frog

— *Got it !*

— *Missed it !*

Ye Goode Old Days

ye ducking stool

POETS, AND THOSE who live in the land of romantic dreams, see nothing but chivalry and beauty in the days of Old England — Merrie England! With befrilled high heeled cavaliers and ladies fair, milk-maids and buttercups, maypoles and dancing on the green; and to quench the ever pressing thirst great foaming tankards of nut brown ale! Everything music, life and laughter.

But don't be mislead. They had their troubles and their troublesome people just as we have, but they had a different way of overcoming these difficulties.

For many minor offenses there was a definite punishment prescribed, such as the ducking stool for gossips (which instrument is so ably described by G. Falstaff, who is an authority on the period, in the story commencing on page 27.)

All of these minor punishments seem to have been calculated to amuse the populace at the expense of the convicted wretches's discomfort, and humiliation. Some were worse than others, but most

of them did little harm to the victim. There was a good deal of the Gilbertian philosophy in our ancestors, and they enjoyed making the punishment fit the crime.

To ensure peace in the home their methods were simple but none the less effective. Consider the wife who nagged. All day long and all night her wretched husband got no peace — life was misery. Nowadays he can do little about it—but not so in the olden times. Every village had its "scolds bridle" or "Branks" to be used to cure the lady of her unpleasant habits.

Again we see the simple effectiveness of the punishment. A contrivance of iron, fastened with a padlock, was used as a gag. The variety was considerable judging from those still preserved as ex-

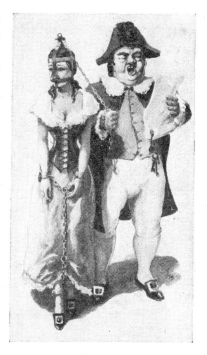

oyez! oyez! oyez!

hibits in museums. Some were simply constructed, others were quite elaborate and excellent specimens of fine wrought iron.

It was not necessary for one to be in every home, it might be a goad to domestic brawls, but each village had at least one which was the property of the authorities, and no matter if their styles differed, they were all uncomfortable for the wearer and very effective.

To some portion a chain was

a Branks or Scolds Bridle

attached. This could be used to

21

attach her to some object, or else for the beadle to lead her through the town.

On a fine sunny day the town crier would appear ringing his bell, and shouting his "Oyez! oyez! oyez!" The villagers flocked from their houses and there would be Mrs. 'Iggins in "scold's bridle" being led down the street. The dogs bark, the children laugh and throw mud — taking good care not to hit the beadle — and the grown-ups shout in derision. To be so humiliated would cure most wives — or would it?

However, the men did not have it all their own way. Mr. 'Iggins might be the trouble by too often coming home considerably the worse for wear from the "Barley Mow," after spending the entire day drinking. Not content with this, he might give Mrs. 'Iggins and one or two others, a piece of his mind — till one day he would regain consciousness earlier than usually and find his legs stuck. Further investigation would convince him of the fact that he was locked in the village stocks on the village green, with a mouth like a lime kiln. Across the green he would see the inn—full of cooling draughts of good ale — but his thoughts would be interrupted by a rotten apple hitting him in the back of the neck as all the kids of the neighbourhood gathered round to pelt him with decayed vegetables. Others, including Mrs. 'Iggins, would make crude remarks which he would have to put up with — his head splitting and his mouth tasting like an open sewer.

What a hangover — and what a cure!

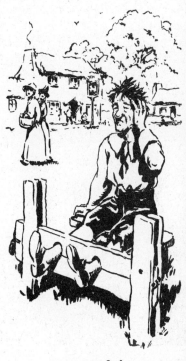

ye ende!

22

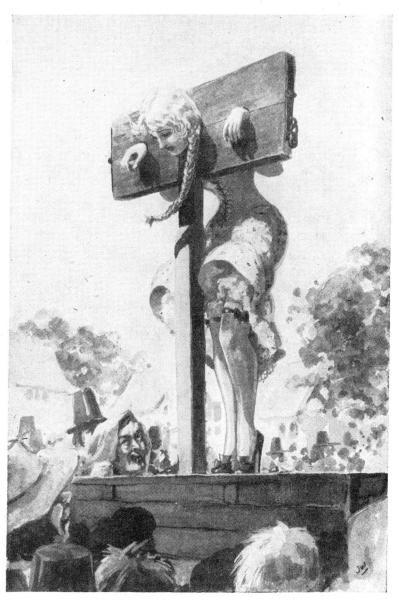

the pillory (*read the story by G. Falstaff in Vol.* 3)

Its all right—

— until you —

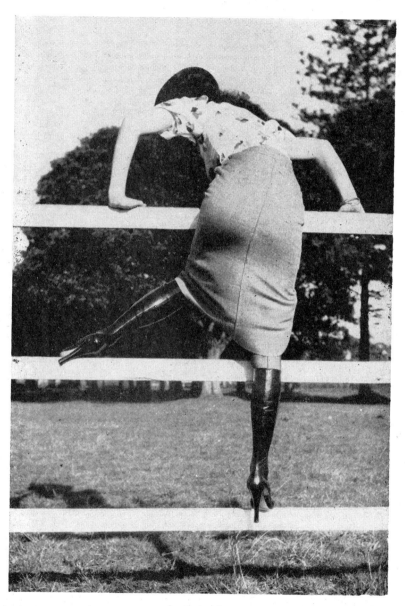

—start to try—

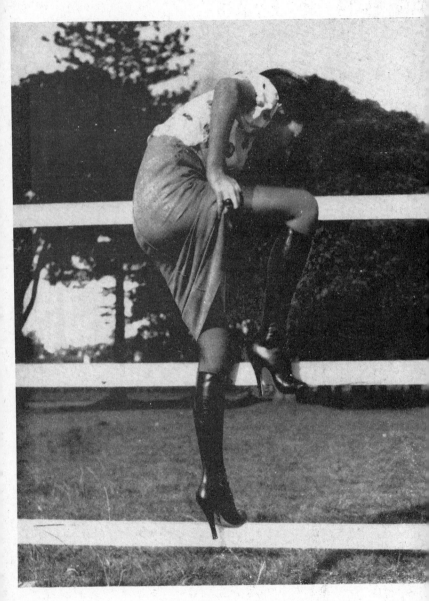

— to climb over the top!

The Ducking Stool

by G. FALSTAFF

The illustration on page 20 shows a very common punishment of the old days, the ducking stool. In those time, it was very often employed, and the women who had to suffer in it were of one class—i.e., those who talked too much.

From time immemorial, it has been a proverbial attitude of the mere male that ladies were altogether too much given to conversation.

Today we are used to gossip and laugh at it. Our ancestors were used to it too, but they had an ineffectual desire to do something about it. The laws provided for common scolds. And they provided in a severe way.

True, in the hearty old days, no doubt, women (alas, often lacking in education, for the people then gave slight attention to whether a girl could read or write), sometimes displayed talents for talk altogether out of proportion to their other talents. And if the women, young or old, displayed her genius for original composition by a too imaginative description of her fellow townsmen, she was not treated as a student in a modern progressive school. Mere expression of individuality got scant sympathy. A talent for abuse up to a certain point was respected and feared, but if it passed a very moderate point, the abusive lady was likely to be tried and convicted as a common scold.

The punishments which could be meted out to her were varied but in this case, one, in the opinion of our ancestors, poetically appropriate and unusually severe. Incidentally, however, it was something that the modern woman probably would not dread as did her great-great-great-grandmother. The horrible cruelty inflicted on our naughty ancestresses was DUCKING IN THE POND.

Do not be too contemptuous of your forbears, dear reader. They were not such a bad lot, and they were cleanly enough, but most of them washed bit by bit, and almost all of them had a perfect horror of being wet all over at once. One washed at a tub piecemeal. The writer recalls a poem or tale by A. E. Coppard about an aged provincial Englishwoman who, upon being admitted to the poorhouse, was cruelly forced to

take a bath, and never really recovered from the shock.

A modern girl, faced by the penalty of the ducking stool, would laugh for the only thing that worries her is getting her hair wet. But none of them mind being otherwise wet all over.

But great - great - great - grand - mama was very much afraid of the experience of being wet a hundred per cent at one time. She regarded the sentence to the ducking stool with horror; the punishment as not merely painful but dangerous to health. The brutal males who inflicted such tortures themselves had a horror of a bath, and it must be recalled that when they inflicted on a young or old woman who talked too much, what to us seems the mildest possible punishment, they were actually being both effectual — and pretty severe.

Suppose, your stenographer — forgive me, your secretary, misspells several words. Suppose you have — which you haven't — unlimited power over your employees. Suppose you told her that you planned a sound ducking as punishment for her general incompetence in the matter of spelling (a matter in which women of the 18th, 19th and 20th Centuries are particularly likely to be a

trifle deficient?) The charming creature would probably say "will you do it at the swimming pool of the Hotel Blank; may I wear my new swim suit, — it's cute, — and my bathing cap, and may my financee come along, because he is just such a big tease, and loves to push me under the water, or see anyone else do it?"

Not so your girl of the 18th Century. Sentenced to be ducked, she shuddered, she trembled, and — unless the boldest kind of bold young thing, (baggage was the old word), she knelt humbly and begged for mercy. Penalties involving hairbrushes applied elsewhere than to the hair of the head were less dreaded than those that involved being wet all over at one time.

The young woman in our illustration has obviously talked too much. One cannot say whether she has called the mayor a fool or his wife fat. "The more truth, the more libel" is an old saying. The young lady "hath gravely offended" and she has not managed to enlist the aid of enough persons of influence to save her from her fate of suffering in the ducking stool.

Clad in her ordinary garments, she has been led from the gaol, to

Home, James!

the side of the local pond where stands the ducking stool. Styles varied but here it is an ordinary wooden chair, fixed to the end of a long pole. This pole is fixed lever-like to a fulcrum arranged as a swivel so that when fixed in the chair on dry land the occupant may be swung out over the water. She has begged mercy in vain. She has explained that all she said was mere exuberance. The local justice of the peace has declared her a common scold, and sentenced her to the ducking stool. She is rather pretty, and the older and uglier females of the town are envious enough to be pleased. The young bloods are always glad to get a good view of a pretty girl, and when once she is thoroughly wet they hope her garments will show that she has a pretty figure. People have left their shops to see the fun. Her young man, William the butcher, the hoped for future husband, is not completely happy. He is of course terribly annoyed at her misconduct, he is doubtful whether a man of sense would marry a woman who is already known as a scold. But he considers that her punishment may reform her; he considers that she has, after all, shown him that she is a rather serious and lovable woman, and he is—like the poor

victim herself, terribly afraid she may catch cold.

She is seated on the chair, and the beadle who has done this office many times before binds her tightly and scientifically to it in such a manner that she cannot move her arms, but can wave her legs in quite ineffectual efforts to escape, for the greater amusement of the onlookers. It is her privilege to say what she likes while she can. She remembers witnessing the similar ordeal of the Widow Two Shoes, who cursed and reproached her persecutors in the choicest and most poetical language — the widow had formerly been a seller of fish at Billingsgate in London, and had with practised skill, cursed and reproached her persecutors during every moment of the ducking save those moments that her mouth itself was under water.

But Dorothy Winapple, for that is the name of our heroine, is not of such a decided mind. She is angry enough to curse, but cursing has already brought her "to this pass." Besides William, the young butcher, is present, and she is very fond of William. The men laugh at her, and the women ask her jeeringly if she has anything to say now. Dorothy submits to being tied to the chair humbly,

it looks like being a real holiday

and sniffles a little when she finds she cannot use her hands, and as each knot makes her a little more helpless. William and the young squire, Sir Thomas Farringham. are at hand with handkerchiefs to help her blow her nose. William is himself, despite his rough exterior, almost in tears, and Sir Thomas, who has been to London, and there taken great interest in the sentimental writers of the day, pats her on the back, and says, "Fear nothing girl, the Romans often willingly took baths."

Dorothy screams as the chair is moved over the water, and struggles frantically to escape, but the stout cords hold her securely, and as she is lowered into the pond the first time, she screams a second too long, and swallows cold water, at the same time that she is wet from top to toe. When she is pulled up spluttering and struggling, she is horribly uncomfortable. She is wiser when she is ducked again; she kicks her legs and screams lustily for mercy until the water reaches her bosom, and then she draws in a long breath, for the victim is kept under water for several seconds. The punishment is repeated several times but Dorothy holds her tongue, despite the jeers of the assembled crowd.

At last the ordeal is ended; the ducking stool is moved back to land, and her tormentors unfasten her. Bedraggled like a drowned rat, her figure showing through her sodden garments, the half fainting girl is freed from her bonds by the faithful young butcher and the cultured Sir Thomas. The latter produces a bottle of brandy, and forces a draught between her lips while William starts rubbing her arms and legs. When the two young men have also revived themselves, after their vicarious sufferings, by deep draughts from the same bottle one takes her head and the other her feet and Dorothy, half asleep and half awake, half cold and half warm from the reviving spirits, is carried to the waiting carriage of Sir Thomas, who takes them all to Farrington Hall, where his widowed mother assists them. Dorothy thinks of herself as a mere child, and dreams again of kissing in maidenly innocence, two big boys (William and Sir Thomas) at a time when she had denied other brutal males the same privilege.

Lady Farrington has ready a mustard bath for her feet; and other old fashioned preventatives against catching cold. Poor Doro-

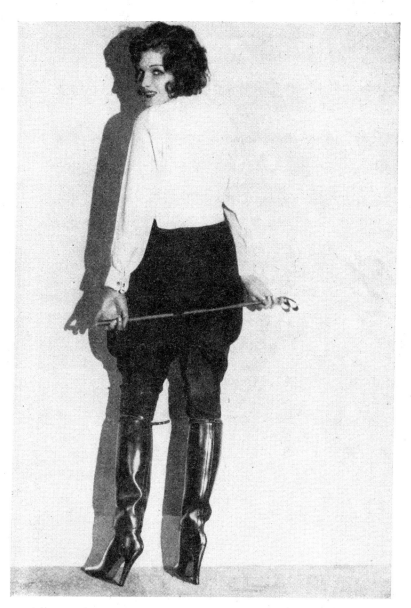

smart? — well we'd say so

thy is dosed for two days by the kindly old lady, widow of the former squire, and undergoes much that a modern young woman would think worse than a ducking. William and Sir Thomas visit her attentively. When they visit her in company, Dorothy displays much maidenly reserve. When one visits her—even under the eye of Lady Farrington, Dorothy bestows a maidenly kiss on her protectors.

Of course Dorothy married William some months afterward. Faithful Sir Thomas long remained single.

Our principal characters lived long and happy lives, except that poor William fell from a haystack at the age of forty, leaving Dorothy a widow at thirty-eight. What a subject for talk it was when the squire, good old Sir Thomas, married the still pretty widowed Dorothy next year. But nobody said *too* much. They recalled the horrors of the ducking stool.

───────

(*Continued from Page* 16)

────

smart figure" she stood a better chance of acquiring a "devilish rich husband." As one old Duchess was heard to say — "Every inch off your waist, my dear, means another thousand to your dowry."

Nowadays of course we go in for physical culture first thing in the morning. Exercises are invented from scientific study of muscle formation to create "curves," there are calories and proteins and vitamins and scientific diet.

But there are still gadgets on the market for training beauty. Gadgets which shape the nose, the lips, and the chin. The uplift brassiere and the foundation garment are only modern terms to camouflage the corset. It would seem therefore that the age of back-boards and shoulder braces is not dead, but dormant, and all it needs is for some woman to restart the vogue for a small waist and sparks will fly in the wild stampede for a smaller one.

Department stores will then feature the whole range of instruments employed by granny, displayed of course by wasp waisted attendants. Mademoiselle will buy and take home. So when the modern youth wanders round to take his divinity out for a spot. and

(*Continued on Page* 37)

THE CAN-CAN

What a lovely sight is that much discussed dance the Can Can — at least the Parisian version of it. Long slender black silk stockinged legs peeping out coyly, or waving gaily from a foam of white ruffles — glimpses of that little touch of bare flesh above the stocking top — the gayest of gay music — the whole dance a picture painted by graceful limbs. A picture of happy, joyous, abandon.

There is little wonder that we never tire of seeing it, no matter what our age may be — particularly in these days of hot music, boogie woogie, and the jitterbug.

Even those who prefer the modern cute and skimpy lingerie must pause to wonder if perhaps after all our grandparents knew a thing or two which has so far escaped them.

Here's to you ladies of the gleaming white frills — and here's to a speedy recovery to a gay city — with the final wish that your life may be long and as happy as your dance.

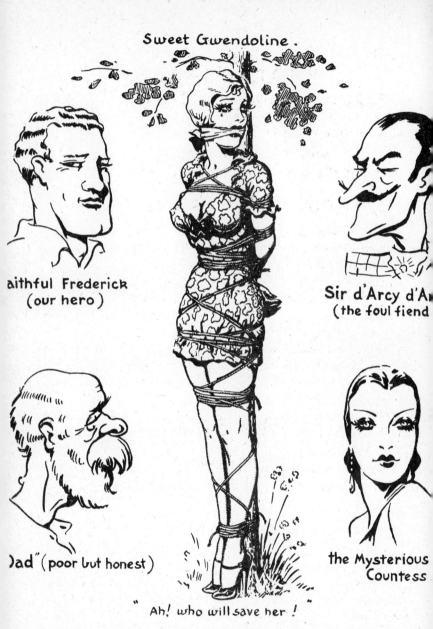

Sweet Gwendoline.

aithful Frederick
(our hero)

Sir d'Arcy d'A
(the foul fiend

)ad" (poor but honest)

the Mysterious
Countess

" Ah! who will save her ! "

ANNOUNCING! OUR ATOMIC SERIAL CARTOON
Starting next month in Vol. 3 - DON'T MISS YOUR COP

36

PHOTOGRAPHS

Enlarged Art Reproductions — (Actual photos in clearest detail) — of any of the illustrations appearing in this magazine may be obtained by writing the Editor,

"Bizarre," P.O. Box 511, Montreal, Canada.

Since 1946 this service has been discontinued.—*Editor*

OUR NEXT ISSUE VOL. 3

Contains some more excellent thigh boot and high heel studies. Illustrations of a series of novel party costumes and sports wear, corsets and figure training devices.

There is again a whole series of interesting correspondence — another article on Merrie England by G. Falstaff and a story about a new version of the Indian Rope Trick which is supposed to be true. If it is, a pretty girl out-Houdini's Houdini.

There is also another strange tale from the sea of an island where there are no horses, and the young girls are used in their place as human ponies; to say nothing of the first episode of our melodrama strip cartoon — a thrill in every spasm.

Order your copy now to avoid disappointment as paper shortage limits the number available. Bizarre, P.O. Box 511, Montreal, Canada.

SPECIAL VOLUMES . . .

Mail Order Only. Subscribers will be advised when printed.

(*Continued from Page* 34)

crashes into her room(as is usual these days) he must prepare himself for a shock.

There she will be, shoulders wracked back, arms helplessly strapped behind her and her slender silken legs secured in something like a "Chinese boot" (to make sure she does not walk "pigeon toed.")

Seeing her face transfixed with pain he will dash madly to the rescue only to be told to get-to-hell-out-of-it and mind his own damn business. It's all right she'll only be training her figure.

CORRESPONDENCE

How can we give you what you want unless you let us know what it is? We will gladly publish any letters, photographs, or sketches which you care to send in.

Under no circumstances will we publish either full names or addresses — and we regret that we cannot give introductions.

If something in these pages interests you, or if you don't like it, of if you have some new topic for discussion let us know.

Editor, P.O. Box 162, Montreal, Canada.

(Our address is now P.O. Box 511, Montreal.)

WELL TATTOOED

Dear Sir:

I am glad to see that you include tatooing in your fashions. This adornment has always been a weakness of mine, and the girl I have married has also fallen in love with it.

So far I have not had my whole body covered with hundreds of different pictures. I am having one huge picture done bit by bit. Starting in the centre of my chest it will finally extend all over my body, but each bit as it is added still leaves the unfinished work of art symmetrical.

My wife has had only two visits. In the centre of her back now is a beautiful peacock with tail outspread. In a low cut evening gown of white satin the effect is very arresting, and judging from the remarks of her friends she will soon have many rivals.

Please let us have som pictures of tatooing as soon as you can.

Yours, "Needle."

PIERCED FOR PLEASURE

Dear Sir:

I like the gentle pull of heavy earrings. It is some time since I first had my ears pierced, and I confess I was a little frightened, but the pain was nothing, and the pleasure I have had since has easily made up for it.

My favourite pair is a heavy gold ring fully three inches in outside diameter, and which caresses my neck every time I turn my head. Another favourite is a pair of long drop pendants of opal. Some people say that opals are unlucky, but I have found it otherwise—perhaps they have to be big opals—at any rate mine reach to my shoulder, and my husband has confessed that they were the first

38

thing about me that attracted him. He is continually buying me new sets and I never grow tired of wearing them so we find it easy to please each other.

I have thought of having my nose pierced, but, I have tried pinching it to see. The piercing of the septum must be terribly painful and I don't know if I am brave enough to go through with it.

Yours truly,
"Eugene"

A QUESTION OF HEELS
Dear Sir:

I notice that you have devoted considerable space to fascinating high heeled shoes. I think the photos were wonderful. But do you think it possible for the wearers to walk gracefully on such high slender stilts. I have an absolute passion for high heels. Not only do they look smarter, but I get such a delightful feeling by being

perched up on my toes which I find hard to describe. So far I have worn nothing higher than 4½ inches, more I cannot manage and I should like to know how it can be done. If anyone can give me advice I should welcome it, and in the meantime I hope you will continue to show us many more attractive h. h. pictures.

Yours truly, XYZ

AN ARGUMENT AGAINST SPARE
THE ROD
Dear Sir:

Although I am 22, I have been told by my parents that I will still be punished if necessary, as they have always punished me, in the good old fashioned way of a sound whipping. Candidly I prefer it to other methods. It's quick and simple and seems to clear the air so much that in spite of the possibility of being called a

freak or untruthful I admit I like it.

After all most of us get into scrapes when we are young. We do all sorts of things which may have serious consequences and it is our parents' duty to teach us. To be compelled to take one's meals off the mantlepiece is an excellent reminder.

If I was late for a meal, I had a whipping as an hors d'œuvre, but the food was kept hot in the oven by mother. In other families I suppose the child would have had to go without as a punishment —and as like as not the larder would then have been raided bringing further trouble.

With my parents the reason for the punishment was not "because I say so"—but because it showed no consideration for the cook.

I don't know if you will think this letter worth publishing, but as you asked for unusual topics I thought you might like it. There is much controversy about the subject of bringing up children at the moment and so it might interest people to know that all of us do not think whipping brutal.

To submit to my parents or school mistress is not a sign of weakness and a punishment which is quickly over but which has its

reminder is far better than one which lingers on and makes things unpleasant for everyone. As I have been brought up so shall I bring up my children.

Yours, I. J.

WRESTLING ENTHUSIAST OFFERS
A SUGGESTION

Dear Sir:

I have always found Physical exercise a great cure for poor health. Lately a lot of people have begun to realise that its application in scientific form is excellent for developing a pretty figure.

Incidentally, it's funny the way most experts frown on those little feminine touches which are so necessary for the modern "chic." They would have all us women devoid of charm it seems — lipstick! painted toe nails! impossible! — and so many remain spinsters! The sensible girl realises that games and physical training are necessary, but she also likes male society and hopes to marry and have a home of her own, so she plays tennis, netball, and lacrosse with just as much skill as her instructress, but still retains her womanly habits.

How the American women athletes, with their powder, lipstick and carefully waved hair

40

showed up the dowdiness of other teams at the pre-war Olympic Games—and how they triumphed in the games themselves.

Having decided that painted lips do not mean that we can't play tennis, or that our painted toe quick thinking and speed of move-ment will overcome brute force. That is why, before I close. I would like to point out that some sort of training in wrestling and jiu-jitsu is essential to the girl of today. Time after time we hear

DON'T LET THIS HAPPEN TO YOU . . . !

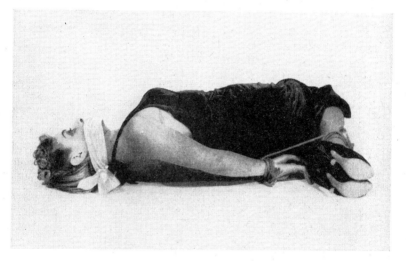

learn Jiu-Jitsu and the art of self defense

nails will cause us to drown in the swimming pool, we must consider what exercise we can take for beauty's sake.

In your last number you men-tioned wrestling — but some read-ers may consider it unladylike. This is entirely wrong. Wrestling is the sport not only of the strong but of the agile—a sport in which of crimes being committed against women, from bag snatching to murder, which would never have occurred had the victim had a small knowledge of how to defend herself. Wrestling is an asset. but its cousin jiu-jitsu has always been recognized as ideal.

I hope that you will devote some space each month to illustra-

tions and descriptions of these two subjects from the self defense angle. If I might I would like to suggest that you start a campaign for it.

An illustration showing a girl gagged and bound as a burglar would leave her, (with a suitable caption) might make women realize that it is necessary for them, and quite simple, to learn to look after themselves.

No other periodicals than those dealing exclusively with the subject seem to take any notice—I hope you—like your magazine —will be different.

Yours,

T. M.

Thanks for the suggestion — and here it is. Ed.

Too Much Lipstick

Dear Sir:

I am all for beautiful women but please must I have to take a bath after I have been out with one? I meet her—she is divine— and I come home looking as if I had measles. My face is smeared with red and black, my coat covered in powder — it's really too much!

It is quite possible to tint the lips with a little lipstick smeared well in I should think; a touch is necessary at times, but why is it necessary to put so much on? And if a girl has a pale complexion why is it necessary to change it by rouge? Then again, what a sight a girl looks with plucked eyebrows when the pencil mark is smudged.

All girls aren't guilty of this, but so many are, and I have a roving disposition. Is it too much to hope that some of them will read this and apply their cosmetics with a lighter hand.

Yours truly,

"Smudged."

Deportment Department

Dear Sir:

I hope your magazine will be the means of correcting the modern fashion of slip-shod dress, which is so marked in our young women. When I was six years old I began my training for deportment, and this was carried out until I was 19. Naturally as a child I was at times rebellious, for which I was punished. I can well remember the whippings I received for being naughty and cutting my corset strings—but my parents were wise. As I grew up I took a greater pride in my appearance, and as I began to realise the extra interest which men displayed in me, my aversion to my

figure training exercises diminished, and instead of a child I became the delighted young woman of training corsets, because I knew my figure and carriage were improved.

Every time I see the slouching slummocky young women who haunt restaurants and cabarets I think how untidy they look, and I'm sure modern man thinks so too, for although I am getting on in years I still have a host of admirers.

If you think they would interest readers I will be only too pleased to supply you with some details of the methods which should be employed to obtain proper dignified and feminine deportment.

Yours, J.A.

By all means send the details along — Ed.

A PLEA FOR PERFUME

Dear Sir:

Perfume was the creation of a witch, I am certain of this. In the long forgotten days of love philters—and potions most subtle, the old hag knew it and the maidens who visited her carried away their treasure and if it failed to attract their lover they tried again.

We all know the difference between a lovely smell and a bad smell. The one is pleasant the other—well nasty. It therefore seems quite feasible that perfumes have degrees of pleasantness. Is it too much to claim that their effect can be so pleasant that it is bewitching. Chloroform sends us unconscious, and so in a different way does scent.

Every woman knows the effect of a warm summer evening—the air quite still—the grass soft and fresh—everything clean and beautiful and then the faint suggestion of perfume in the heavy stillness, and if her choice has been correct, the increasing bewildering rush of it that leaves her companion dizzy and wondering whether he has died and arrived head first in paradise. What we must realise is that though one scent will do this another will fail dismally. There is no accounting for tastes.

France is still the home of all that is lovely and exotic to our nostrils. She never seems to fail to produce something new — something that is more alluring still, though how she can do it is a mystery.

Ordinarily scent should be used sparingly, a little touch behind the ears giving that faint suggestion which is so upsetting as cheek brushes cheek in a waltz. But a more generous application

—remember once again it must be of the right prescription—in fact "drenched in perfume" would describe it — is often ravishingly lovely.

The touch of a scented glove— the kiss on little perfumed slippers. what a thrill they can give us—and how easy it is for the woman who knows, to bring a man to his knees. She has held this secret of the flowers for centuries and she will continue to hold it away into the never never, and the end of time.

"Quelques fleurs"

HOBBLESKIRT CORRECTION?

Dear Sir:

May I correct you in your illustration of the hobbleskirt. The skirt you show would certainly hobble and allow I imagine a step of only a few inches — but it is extremely tight ALL the way down the legs. Actually I believe you will find that the hobble skirt was quite loose and baggy at the knees but, like the modern zoot suit for men, came in tight only at the ankles.

At any rate it is only a minor detail for the one shown was very attractive.

Yours,
"Hobbledehoy"

Dear Sir:

The world is judged by its feet. Why no one seems to know, and nobody cares. A smartly shod foot draws more attention than a new hat, and it follows that women of taste and understanding pay particular attention to their shoes.

Some people say that men have low minds because they like everything low — low stories, low habits, and low limbs. This is unfair. The reason feet play such an important part is because they are reflection of the wearer's character. Dainty feet belong to dainty people, and a very high heel makes them look smaller, neater, and daintier.

Yours, Anthony

44

LIKES THEM CHAINED

Dear Sir:

How charming the slave girl costume you showed. If you want to know my ideal for feminine apparel you have it right there. The whole costume is delightful and the chains, which I imagine could be made solid enough, obviously enable her to move only to a limited extent as a slave should. Please let us have more like it—the idea might catch on— or must I go back to the M. E. and start a harem.

Yours, "Gunner"

A HAPPY MONOPEDE

To those of us who are handicapped by the possession of only one limb, life may sometimes seem very black in outlook. I felt very lonely—no one wanted to take me out—and I had to hop along as best I could on crutches. Then I met my husband, and imagine my surprise when I discovered that for him my disability was an attraction. We became firm friends and I once more took a pride in my appearance. Over my one shoe I paid as much attention as I had formerly done with the pair, and at hubby's suggestion I tried a

a perfect pair of 5½ in. heels

45

higher heel. To my delight I found
that with crutches as a help I
could wear one higher than I had
ever tried before. My latest is
built just like a ballet shoe, which
not only perches me on actual tip
toe but is symmetrical in shape,
and unlike the others which defi-
nitely belong to the right foot.

My husband is wonderful, and
with his encouragement I have
learned to dance. It was frightful
at first, but he is so big and strong
that he carried me until gradually
I became accustomed to keeping
time. Now we get along famously.

I wish your magazine every
success, and I am sure it will help
other possessors of only one leg
to realise that life is a wonderful
thing after all.

Yours, "Hoppy"

NOT A WEAKLING SHE
Dear Sir:

Can you or anyone else tell me
why we women are supposed to
pander to men. For my dress-
maker's sake I suffer untold dis-
comforts at times—but unless the
costume pleases me I don't wear
it. I dress to please myself.

When, if ever, I marry it will
be a purely platonic affair. I like
men's company and the things
they do, but I like my own sex

and independence just as much
and I refuse to be a drudge—or
obey my husband, or any of those
silly old-fashioned ideas.

One poor youth is very sore
about it. Because I was going out
to lunch I put on my dressmaker's
latest creation. I have always
worn corsets, and my waist is on
the small side in consequence, so
that with a skirt which was so
tight that I could only take tiny
little steps, high heeled shoes and
long black kid gloves, I suppose I
looked quite the demure maiden
of the last century. Everything
was so tight that I wasn't com-
fortable and I became intensely
annoyed, when the poor soul I
have already mentioned, became
sentimental and wanted to help
me to do this and that, till at last
in desperation I went out into the
hall, took down a light riding
quirt and with this as a weapon I
did my best to impress on him
that I was quite active and capa-
ble. With several sharp cuts I
helped the idea to sink in, and I
presume it has for he hasn't been
back since.

I think your idea of a free dis-
cussion on our views is excellent,
and so if you wish you may pub-
lish this letter, and I hope it may
make some men realise that we

FREE XMAS COMPETITION

We are offering a PRIZE of one year's FREE SUBSCRIPTION to BIZARRE and in addition a 5 x 7 Photo reproduction of your "Preference Vote" picture (see below). There are no other prizes — but in the event of a tie EACH will receive the Full Award.

TO COMPETE — Pick out the picture (photo or sketch) you like best in this volume. This is your "Preference Vote." Then starting with your preference make a list of all the others in the order in which you like them (just give the page number — or a little extra description if there are two on one page) and send it to the Editor.

TO JUDGE — We sort out the "Preference Votes" placing them in order according to the number of votes each picture receives.

THE WINNER — Will be the reader whose list most closely coincides with this judging.

To give someone a Christmas present, and yet not disappoint late comers, we are innovating an unusual practice. The first judging will be on 22nd Dec. — (so if you want a surprise gift on Xmas day get your selection in quickly) — from then on judging will take place weekly on Thursdays. The competition closes when the result is published in Vol. 3.

If a winner is already on our annual subscription list the subscription which has been paid will be refunded in full.

If your favourite subject is not illustrated, or if you would like a certain picture better "if" . . . Let us know, and we will try to make amends in our next numbers.

women are not the helpless nit-wits they would like to think us.

Yours truly,

Mimi

A LADY WHO LIKES THEM TIGHT
Dear Sir:

How delightful the long skirt looked in your clever little magazine. I have been wearing the short service skirt for too long and now I just go to the other extreme for the sheer delight.

My evening dress is almost as tight as the one shown but I have not been able to get any very high heels which I love—where can I get them.

Yours, "Pamela"

Dear Sir:

May I congratulate whoever designed that riding costume in Vol. I, on the exquisitely "Bizarre" effect which they have achieved. Made as you say in black kid it would grace any wearer and her gallant steed could not doubt on seeing her ready to mount that he had met his master (or rather mistress) for I suppose even a horse can tell the difference between the amateur and the expert. Yours, G. G.

NATURAL HAIR PLEASE
Dear Sir:

If you want to know what I think. There should be a law to prohibit women cutting off their hair. It's lovely. It's marvellous. There is nothing on earth like it. Why must they cut it off. Let them tie it back if they must when working at home or in the office. Let them have it free at all other times for everyone to admire.

The Atomic bomb is going to destroy all civilization and those who survive are to return to the native. I will not mind. The native woman wears her hair long.

Yours, "Anticut"

PRINTED AND PUBLISHED BY
BIZARRE PUB. CO., P.O. BOX 511
MONTREAL 3, CANADA

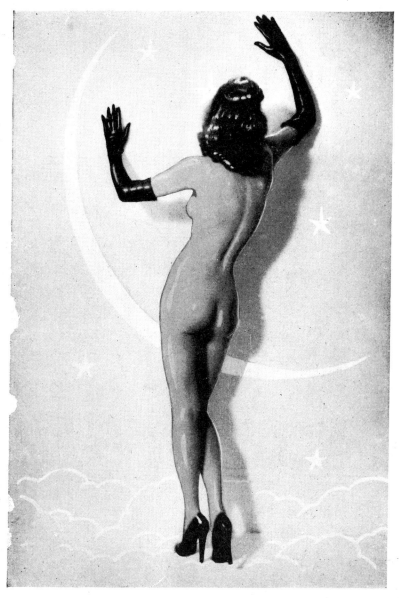

reaching for the stars

for slaves of fashion

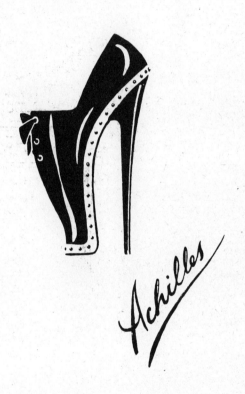

Achilles

theatrical footwear

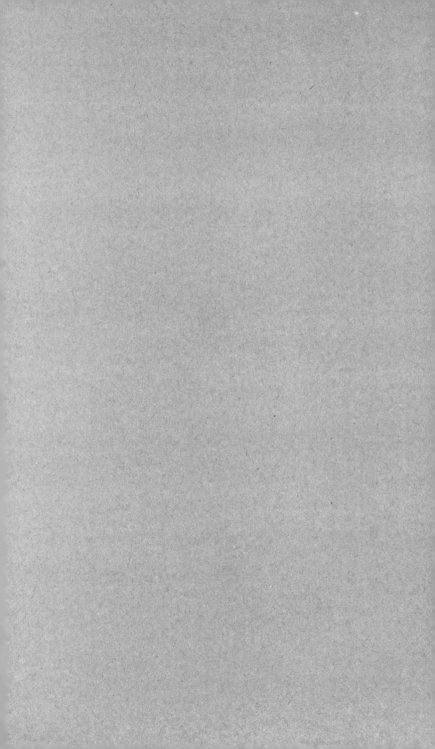

BIZARRE

VOL 3 1946

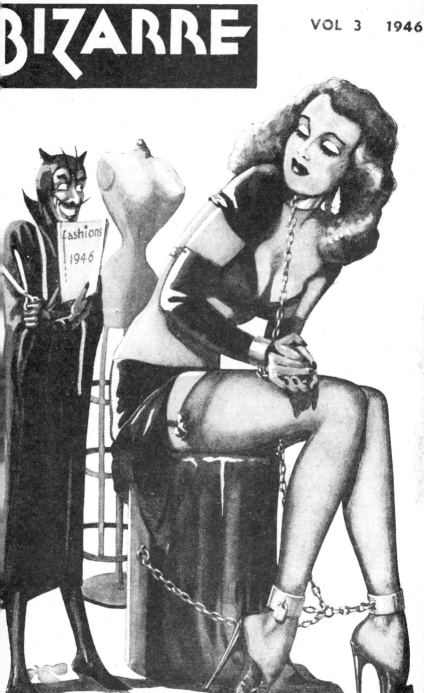

Fashions
1946

BIZARRE

The magazine for pleasant optimists who frown on convention. The magazine of fashions and fancies fantastic!

Innumerable journals deal with ideas for the majority. Must *all* sheeplike follow in their wake!

Bizarre is for those who have the courage of their own convictions. Conservative? — Old fashioned? — Not by any means!

Where does a complete circle begin or end? And doesn't fashion move in a circle?

Futuristic? Not even that—there is nothing new in fashion, it is only the application of new materials—new ornaments— a new process of making—coupled with the taste and ability to create the unusual and unorthodox to the trend of the moment.

Contents

> *"How long, how long, in definite Pursuit*
> *Of This and That endeavour and dispute?*
> *Better be merry with the fruitful Grape*
> *Than sadden after none, worth bitter, Fruit."*

OMAR KHAYYAM

We should like to take this opportunity of thanking all those who have subscribed and have been considerate enough to realize our difficulties — have sympathized — and waited patiently.

To put it bluntly we've been up the creek — and damn near lost the paddle. Maybe it would have been better to wait until paper supplies, etc. became normal. Maybe we should have done this and that, but we didn't.

Now in order to come out at all we've had to cut our circulation, and instead of expanding in size and number of pages we're still the same—and much of what we promised has had to be left out. Under the circumstances the only fair thing to do was to put everything into a hat and play blind grab as to what should go into Vol. 3.

Falstaff's Pillory story, the Island where girls are used as ponies, Figure training, and a whole stack of interesting correspondence have to wait for a future issue. We're sorry if you're disgruntled but that's all we could do about it.

New readers will notice that we no longer guarantee a regular monthly publication. We are of course trying to do so but that's all we can say. If you take out an "annual subscription" you take this chance: You will certainly get your 12 consecutive volumes but When (with a capital W) . . . is in the lap of the Gods.

So here we are at last, in the maddest of mad steeplechases, over our third fence. When and where Vol. 4 will appear we cannot say. We just know that it will—that's all.

Good luck—

EDITOR

[4]

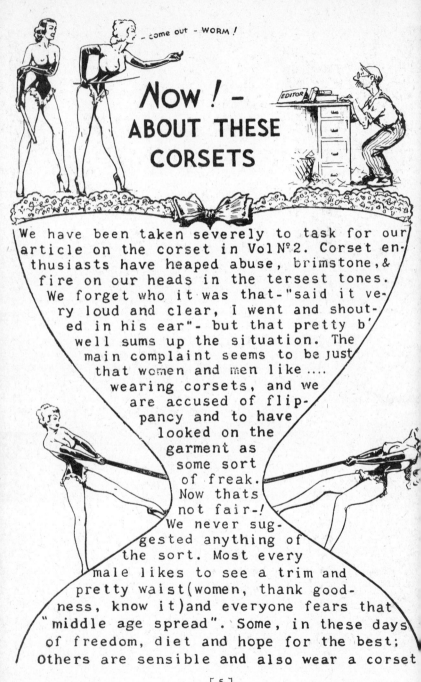

- come out - WORM !

Now ! -
ABOUT THESE
CORSETS

EDITOR

We have been taken severely to task for our
article on the corset in Vol Nº 2. Corset en-
thusiasts have heaped abuse, brimstone, &
fire on our heads in the tersest tones.
We forget who it was that-"said it ve-
ry loud and clear, I went and shout-
ed in his ear"- but that pretty b'
well sums up the situation. The
main complaint seems to be just
that women and men like....
wearing corsets, and we
are accused of flip-
pancy and to have
looked on the
garment as
some sort
of freak.
Now thats
not fair-!
We never sug-
gested anything of
the sort. Most every
male likes to see a trim and
pretty waist(women, thank good-
ness, know it)and everyone fears that
"middle age spread". Some, in these days
of freedom, diet and hope for the best;
Others are sensible and also wear a corset

[5]

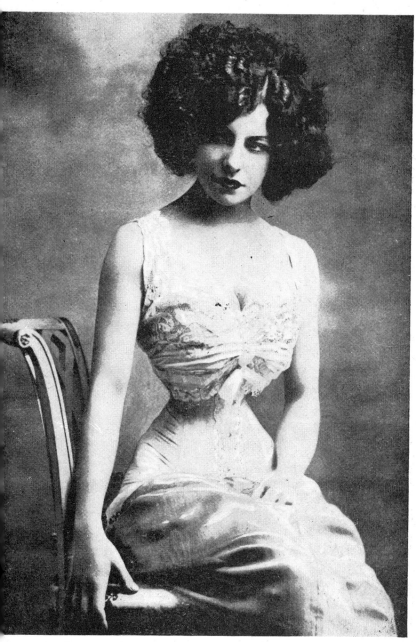

The 13 inch waist of the famous Mlle. Polaire

wearing the garment of your choice—many do you know—and in any case the male of the species will appreciate the result — or doesn't that matter?

We were going to give you some details of this figure training in these pages but, as space does not permit, that must wait for our next issue. In the meantime we have come across an interesting little item in an 1894 copy of TIT-BITS. We present it hoping that you will find it of interest.

THE CONFESSIONS OF A TIGHT LACER (TIT-BITS 1894)

I do not suppose there is one person in a hundred who would not thoroughly abhor tight lacing if they had been forced to go through a training such as I have had, and I pity most sincerely anyone who has been through a similar experience. I put down all my misfortunes to being early left an orphan, as my parents both died before I reached my tenth year. My father directed a gentleman friend of his to take care of me and see that I was well educated, but I am sorry to say that he did not fulfill that dying request.

My father left little or no money, and my guardian, if such he could be called, evidently thought that the best way of carrying out his instructions with the least trouble to himself would be

and rapidly attain as close an affection for the garment as the garment has for their soft tender skin. (Did we say that it was not so?)

But, we still say "Lady beware", for to attain the smallest and neatest waist is no quick and easy task. You must indulge in figure training a la 1846 as well as 1946. You must be prepared to spend hours of physical discomfort—but that too you may find as pleasant as

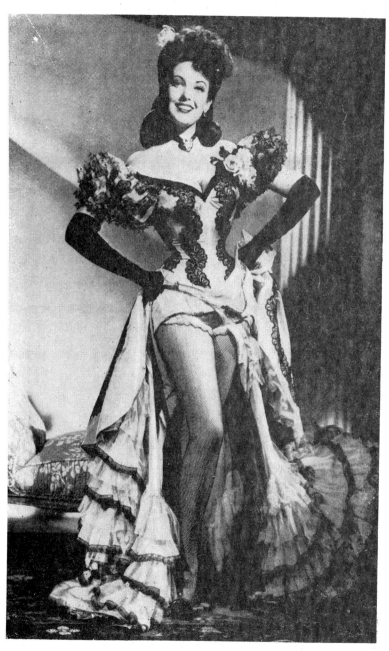

A figure the envy of all — Linda Darnell

to send me to a young ladies' home.

I was thirteen years old when I first went to the "home for young ladies," and I soon found that I had fallen on to anything but a bed of roses. For the first year I was strictly dieted, and after I had been there for eleven months, I was measured for my first pair of stays. These were strongly boned and padded, and did not "give" or stretch in the least. I was first laced in to about 23 in., which made the stays fit quite firmly. I did not mind this much, but when, some months later, my corset was tightened in a little every day, I began to complain, but my mistress told me that it was done to all young ladies, and I would soon get used to it. I had not, indeed, much cause to grumble then, as I could still run about, and was allowed to take my stays off at night.

Six months later I received a new pair of corsets with a waist of 19 in., and at the same time I was forbidden to take them off at all, being compelled to wear them night and day. They were, however, let out about 1½ in. at night, but this was only for a time, and I soon had to wear them at 19 in. continually, the stays being taken off only once a week.

I did not submit to this treat-

ment quietly, but wrote several letters to my guardian about it. However, I might just as well have put them at the back of the fire for all the notice they received; and I soon found out that this was the case with almost all the other girls.

My waist was steadily reduced month by month, and any misbehaviour was punished by being laced an inch tighter than usual, and the stays not being taken off for, perhaps, three weeks or a month, and I was more than once laced in until I fainted.

After being at school for three years my waist was a shade under 15 in., and it was continually getting tightened in. If I went out to a party or any other entertainment, I was still more severely treated, being laced into a pair of stays with a waist of only 13 in., which made it at first very difficult to breathe. I must say that the sensation of wearing these stays is delightful, although, as I have said, they are so tight that I can scarcely get my breath when they are first laced up.

At the end of five years' training my waist was slightly over 14 in., even after I had been obliged to lay aside my corset for three months through illness; yet there were several girls with smaller waists than my own, one

(*Continued on Page* 31)

THE MENTION of the Indian Rope Trick in your first issue was interesting but we have discovered one which is equally baffling and which for want of a better term we call the "Rope Trick" for it too is performed with rope.

It was in Calcutta last year and poking around on shore leave we came to a small side show. In a small open space was a canvas screen making three sides of a square, about ten by ten. The front was open and in this makeshift stage, or arena, or whatever you like to call it, were two posts stuck into the ground whilst a native was digging another hole for a third pole which lay on the ground. The poles incidentally were about four inches in diameter and when sunk about two feet into the ground left about 6 feet sticking straight up in the air.

An old native was playing away on a sort of pipe making weird music, but what really interested us was the girl who was doing a sort of hula hula dance. I don't know if she was Indian, or half caste or where she came from but she was a honey—the pin-up of all pin up girls. She would be about 5 ft. 6 in. in height, but it was hard to tell for she appeared much taller owing to the little red heels of her sandals which were the highest I'd ever seen. Otherwise they were the ordinary sort of moroccan sandal slippers, with the toes turned up—white satin straps decorated with jewels. The rest of her get-up consisted of a pair of transparent harem trousers of white silk—slit up the sides and a sort of compromise between a brassiere and waistcoat top side.

Naturally we stopped around to see what was going to happen.

The native doing the digging worked like a cyclone and soon had the third post up and the earth tamped down good and hard round it. Then seeing us, beckoned us over, and in terrible English asked us to test the posts to see that they were firm and secure. To oblige him we did, and they seemed solid enough. He then asked us to inspect the screen and that seemed a perfectly sound canvas screen staked to the ground by iron spikes.

We were then shooed away and

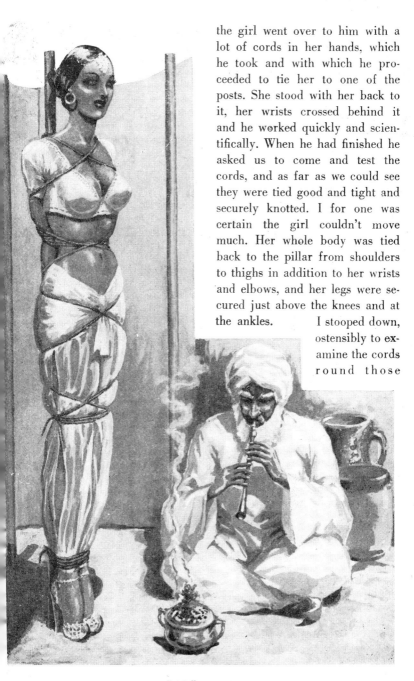

the girl went over to him with a lot of cords in her hands, which he took and with which he proceeded to tie her to one of the posts. She stood with her back to it, her wrists crossed behind it and he worked quickly and scientifically. When he had finished he asked us to come and test the cords, and as far as we could see they were tied good and tight and securely knotted. I for one was certain the girl couldn't move much. Her whole body was tied back to the pillar from shoulders to thighs in addition to her wrists and elbows, and her legs were secured just above the knees and at the ankles. I stooped down, ostensibly to examine the cords round those

pretty ankles. but what I really wanted was another look at those shoes. Boy they were cute! Her feet were small and those heels were as slender as a pencil, perching her on tipe toe.

Well having decided that so far as we could see the lady was trussed as tight as a chicken we went back to the noisy throng of spectators whilst our showman brought round the fourth side of the canvas screen which had been lying loosely from a corner post and we could see the fair lady no more.

The old geezer on the pipe then really went to town. The guy who had done all the work squatted down, threw some dust onto a little ornamental brazier (which began to give out a thick perfumed smoke) and went into a trance. He stayed like this for a few minutes, then suddenly jumped up. The music stopped in a dying wail and he threw the canvas flap open again.

There was the girl still as securely tied to a post as when we had last seen her. At first we didn't catch on but then we realized that it was to a different post.

The posts were in the form of a triangle — two near the front, and one near the back. She had been tied to the left hand one as we looked at it, and now she was tied to the right hand one.

Giving us time to recover from our astonishment the wizard closed the screen again. The music rose to a wild pitch, and again he did his stuff squatting on the ground; and this time when he opened the screen she was tied to the pillar at the back.

Once more the hocus pocus, abracadabra and she was back where she started from. We examined her again and I'm certain none of the cords had been untied or shifted, and I'm certain she could not have wriggled free for I doubt if she could even move. That native knew his business.

She was untied and once free came to us to collect the potatoes —and we all put in. Jim kept saying "Boy what a girl — what a girl' — but Jerry, who has been sailing since Noah signed on his motley crew, showed ten bucks put it back in his pocket and said he'd bet the lot that if he tied her it wouldn't happen again. She smiled—the old man smiled, and the Wizard smiled, and all said OK—so we started off.

First we examined those posts. We examined them for tricks and hidden catches but I'll stake my oath that they were honest to God solid timber from the top right into the ground and as firmly into it as a tree trunk, for we tried pulling them out but they wouldn't shift.

from

PARIS

Exquisite rose kid

platforms

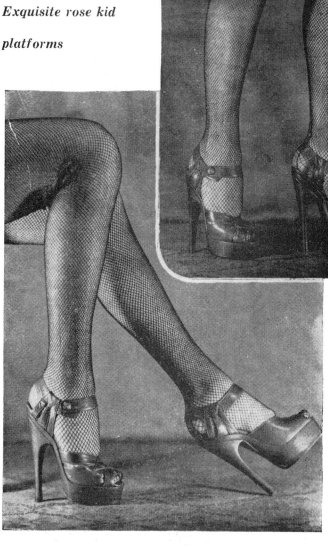

We examined the screen in detail. There were no holes or secret flaps—it was all one long piece sewn round each pole. They could of course get over the top but as it was only about seven foot high we thought we'd have seen them. Anyway they'd probbaly break the whole structure down trying to do it. Just the same we decided to take up positions so that we could watch next time.

Then we examined the cords. They were soft and smooth from much wear but strong and quite sound—so Jerry beckoned to the girl who took up her position as before. He said he was going to tie her damn tight and was that OK. She just smiled — (oh boy, what a smile she had) and said "OK"—and the other two smiled and said "OK Sailor, tie her goddam tight"—so Jerry got to work. He took a long length of cord, passed it round the post behind her neck—drew the ends forward over her shoulders, then back under her armpits—crossed it behind the post again about level with her waist and again drew it forward. He then passed it between her legs and up to her wrists fastening each wrist separately. He then worked back over the rope pulling it tight and reknotted it—and when I say he pulled it tight I mean tight. The clove hitch was then much in evidence. He

tied her wrists to each side of the post with one round each wrist, and then one round the lot and then round her thighs so that the more she wriggled her body the tighter the cords would get. He did the same thing to her elbows drawing them back until only the post separated them—and to draw the cords tight he'd loop one end and work through it. When he tied her legs he put twitches around the cords which heavens knows were already so tight that they were cutting into her flesh, making that lovely satin skin bulge. He even tied her feet at the instep.

I was glad I wasn't the girl for it hust have hurt—but when he stood up to survey his handiwork she just smiled and said "OK — you know how to tie damn tight— all I move is this," — and she wriggled her head and her fingers — so Jerry obligingly tied the latter flat against the post too.

Jim kept sucking at his pipe muttering, "Boy would I like to do that"—and the girl looked up at him through half closed eyes and said—"I like YOU to tie me —tight" at which Jim bit clean through the stem of his pipe.

Jerry tested his handiwork, then we bowed to the wizard and the piper and the show started. We took up our position, one where he could see the back of the screen

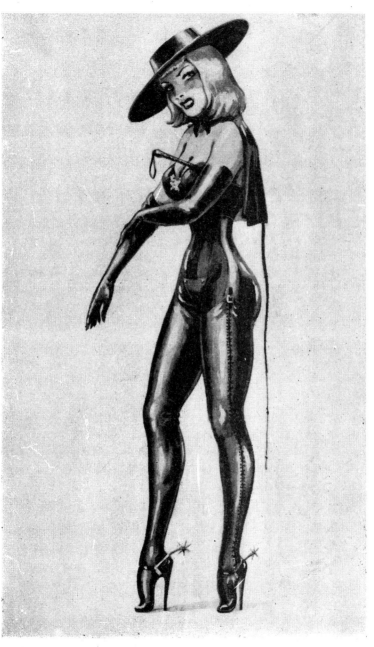

A smart leather riding costume

and the other two could watch the front and sides.

This time for our benefit the wizard got into a terrific huddle, squatting there chucking dust on the brazier and chanting away to himself while the smoke curled up, and the piper blew and the pipes squealed—it was most impressive, but when the screen was drawn aside it was the same old story. There she was tied to another post.

Jerry said "It's not possible — it's unnatural" and went over and examined everything again thoroughly but could find nothing wrong. Nothing had shifted, not a knot had slackened.

Well of course we knew what would happen the next two times, and it did. She simply changed from post to post as before—and Jerry did his sawbuck. Jim started to untie the girl but she told him in that husky broken English of hers that she liked being like this and wouldn't he like to leave her as she was, which made him fumble so much that I had to go and help him.

I suggested we all have a drink, hoping to worm some hint out of them. All hands were quite willing and the wizard lead us to a decent little spot, Jim bringing up the rear with the girl, massaging her wrists and arms which were still badly marked from the cords.

Well we plied them with buckets of alcohol. I tried bribery. Jim tried tying the girl in various ways which she didn't seem to mind in the least, and Jerry kept mumbling, "these damned heathens are unnatural," and drinking himself into a stupor—but they'd tell us nothing. They were entertaining devils and kept us amused with slight of hand tricks—but not a hint, not a single clue as to how they managed the rope trick could we worm out of them.

Now how in the name of all that's magic and mysterious was it done? No one is ever supposed to have seen the Indian Rope Trick where the boy disappears but here is one which we saw with our own eyes. The only possible thing we could think of was that each post had a secret catch somewhere which would enable it to be changed just above the ground —but we could find no crack or flaw where a joint might be—and who would do the changing? Tied as she was the girl certainly couldn't. If she were some sort of super Houdini she might possibly be able to wriggle free—though I doubt it the way Jerry tied her— but she most definitely could not wriggle herself back again into the same position.

Perhaps one of your readers can explain the mystery?

———————

FANCY DRESS

IF THE spirits of carnival and goodwill were present every day, we'd probably have less sour pusses succeeding in making life as miserable for others as they make it for themselves, and we'd certainly spend less time dragging about in mud or dust and heat trying to blow each other to pieces at all too frequent intervals.

Full of this great idea we therefore become champions of the Brighter Home Life Movement. There is no need to have a big party. It isn't even necessary to ask one or two intimate friends— just have one by yourselves.

Some of the accompanying illustrations would not be too successful for an evening at home. The Pony girl for example, seems more suited to a Fancy Dress Ball (an excellent costume for keeping down the evenings' expenses for once fitted into it your partner couldn't sneak off and knock over half a dozen cocktails on the side). The Rabbit or any of the others however, would brighten the dullest evening — and the little corseted "peasant" play suit could be worn anywhere at any time.

Well, what about it—do we or don't we? Yes? No? Have you any bright ideas?—send along a rough (no matter how rough) sketch and we'll illustrate it for the criticism of others.

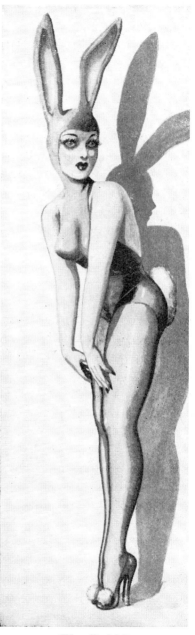

The Rabbit

[18]

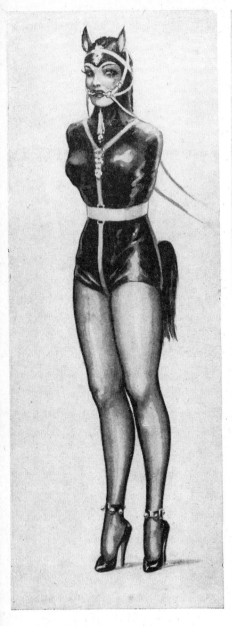

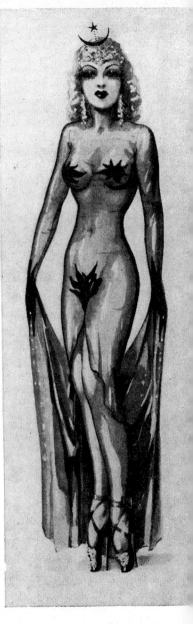

"The Pony" "Night"

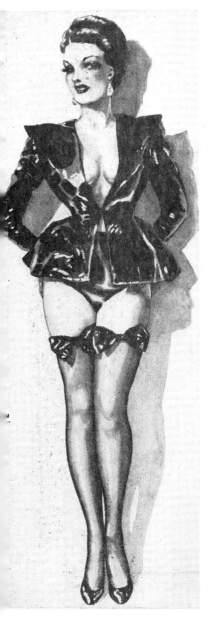

Rain

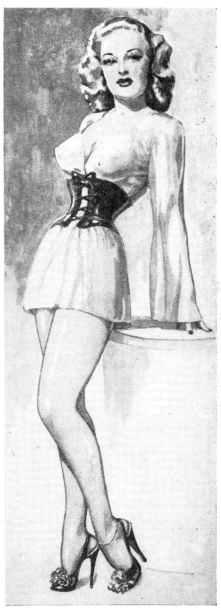

The Peasant

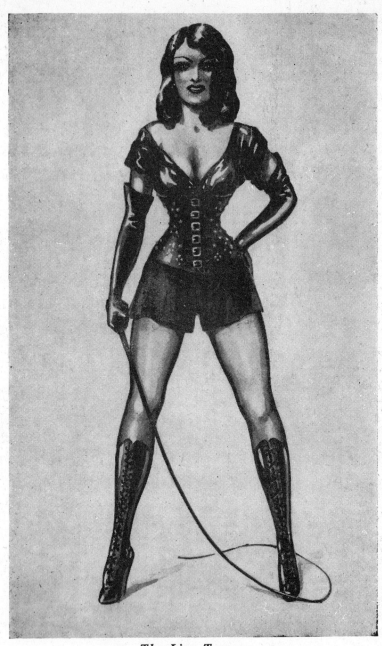

The Lion Tamer

YE BRANK OR
SCOLDS BRIDLE

IN OUR last issue we made a slight allusion to the Branks, or Scolds Bridle, a form of headdress for nagging women much in favor a couple of hundred years ago—

and still in use in some places at the beginning of the last century. A correspondent has sent us a whole sheaf of details and some rough sketches from his private collection which, owing to the shortage of space, we have had to condense.

Apparently some Branks were cruel torture for the wearer, but the majority were not, being little more than uncomfortable and humiliating. It really depended on whether or not a tongue piece projected into the mouth and if so the shape it took. Sometimes it was no more than a smooth piece of iron or a wooden plug—a harmless but excellent way of preventing coherent speech. This was a fact which had to be taken into consideration in those days of witchcraft, for if a witch could articulate she could say the magic word and transform herself—or you— into a cat or a toad or something unpleasant.

If she could only make noises you were safe and so the tongue piece was essential in the tricky business of handling a witch.

The ones which did not have a plain tongue piece must have been dreadful for the unfortunate victim. In Stockport (Eng.) there is one which is described as having a tongue piece or gag about two inches long. At its end is a ball with three sharp spikes on its upper surface, three more on the lower, and two facing the back. The contrivance once in the mouth would be very painful even if the wearer

made no attempt to speak.

Our correspondent has quite a collection of "actual relics" and "copies" some of which we illustrate opposite. Of these only two have a "tongue piece" — the one top right has a bar shaped like a W. The center fits into the mouth and the two outside wings lie back against the cheeks. To them are attached short pieces of spring steel and these are secured behind the head with a screw clamp. The screw for the wing nut fits into a slot on the opposite spring and is tightened, then a padlock is passed through convenient holes in this slot which

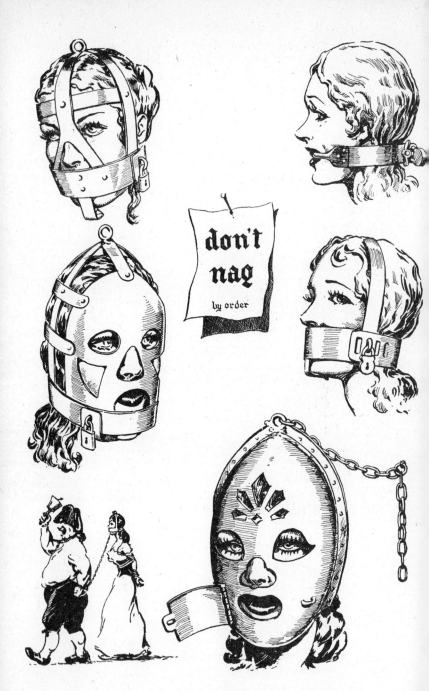

don't nag

by order

prevents the screw being taken out and also makes it impossible to loosen the nut.

The one below it has the piece covering the mouth studded with several short sharp spikes. When closed tight these obviously inflict great pain by pressing into the flesh around the mouth and the lips, but a pad consisting of a leather bag stuffed with down could also be used in conjunction with it, to mufflle the spikes and the only discomfort then became the effective manner in which the scolder was gagged by the leather pressed tightly over her mouth.

The others have no tongue piece, only a projection under the chin with a spike attached, a reminder not to let their jaws sag (or should it be wag).

The one at the bottom was privately owned and made of solid beaten silver. The trap door covering the mouth enabled the wearer

to eat—a necessary precaution as the helmet consisted of two pieces — front and back—rivetted together. The story goes that the irate husband—a wealthy man, condemned his wife to wear it 'till the day of her death — not for nagging

but for a piece of gossip which had unfortunate consequences.

Now the point is—should the Brank be revived? We can think of numerous instances where it would be of great advantage if used today. The humiliating experience of being lead through the street by the chain attached to it, and the hands tied and the feet shackled (if strenuous but ineffective opposition was offered) surely would dampen the most vicious "scold," but perhaps our humane public might object. Still what objection could there be if the woman was confined to her own home by the simple process of attaching the chain to a ring in the wall, or some solid object?

She might not be so shamed into keeping silence—but silence she'd have to keep—and her lord and master for once would get some peace. What do you think?

Of course the ladies won't agree to this. When they wish for a return to "ye goode olde days" they think of chivalry and knights in armour and knights errant and so on and so forth —
But that does not alter the old proverb— "Though woman's lips be like cherries her tongue is like a scarlet runner."

[24]

A beau

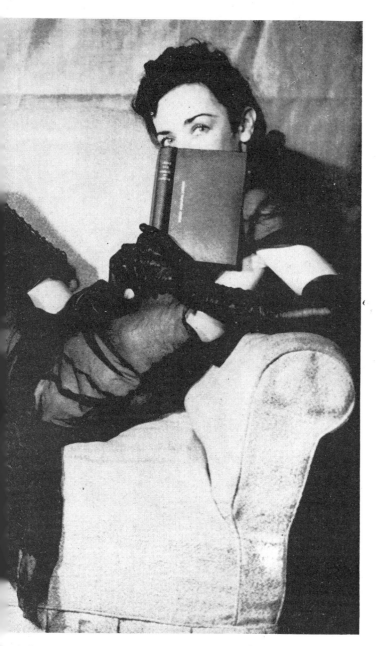

of boots by Achilles

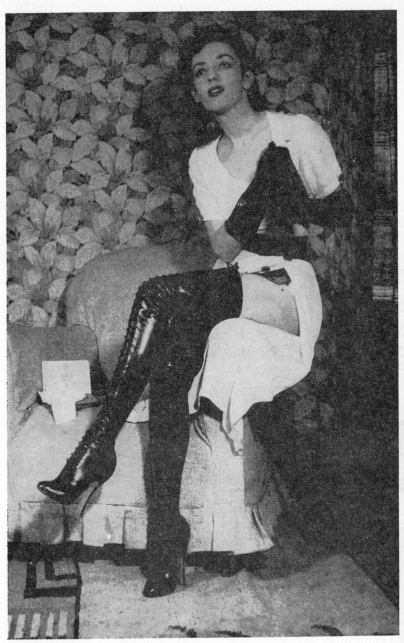

Achilles' boots are perfection

[27]

THE HOBBLE SKIRT

WOMEN SEEM to get a craze every now and again for the most unreasonable garments. The ancient Egyptians wore a skin tight one piece frock which showed every curve and in which only the tiniest of tiny steps could be taken, so tight was it way down to the ankles.

This is something that man can understand, for the more clingingly tight the frock the more it shows the figure (and that's all to the mustard) but the hobble skirt showed nothing—it simply hobbled.

Some women of course got a terrific kick out of this helplessness. One lady of fashion in the days of the hobble in fact went so far as to have a skirt made which fastened at the ankles with a small lacing—concealed by a wide satin ribbon tied in a big bow — by which her ankles were securely bound together. She could hardly stand—let along walk. Her maid carried her to the sofa and there she would recline, welcoming her guests and dishing out the tea and cakes.

Other women of course detested them. "Hobble Skirt Gertie," whose letter follows, is one with a few harsh words to say on the subject—but like true slaves of fashion they all wore them nevertheless. Without being too much like Sherlock Holmes it seems a fairly safe bet that nearly all women have in reality a secret slave complex which finds an outlet in wearing hampering garments and in following blindly— to their great discomfort (so they claim)—the slings and arrows of outrageous fashion. Now let's listen to Gertie.

Dear Editor,

Back in the days of Irene Castle we women endured the self restraint of self inflicted torture in the form of hobble skirts.

I should know! As a girl of twenty I wore this monstrosity. We were aptly described as "walking with a limp, or awkward step" —Shackle! Of course the step was awkward when wearing one. If you forgot to "toddle" and tried to take an ordinary step, you limped and sometimes nearly fell.

When trying to get into a car or streetcar you were embarrassed as you were not supposed to lift this atrocity (not that that did any good) of which the largest only measured about thirty inches around your ankles. The smaller it was the more fashionable you were.

The skirt nearly always had a rip or tear at the bottom after wearing it a couple of hours unless your dressmaker had put in a special band to strengthen it.

Those were the days of high heeled, ankle-high boots—and, of all things, cotton or lisle stockings,

"*1912 the anskles hobbled* *1932 knees as well*"

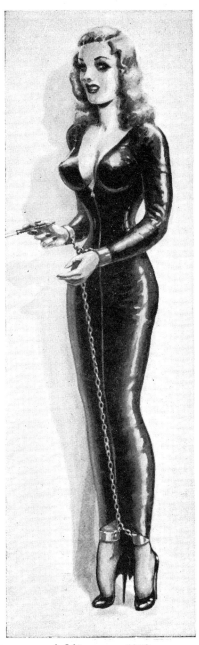

A bit more, 1952 **1972 Complete—the Mummy**

hidden from view of man and beast.

Here was helpless feminity in the "costumology" of an hour glass figure. Legs were called "limbs" then, but who cared, because hobble skirts hobbled them and concealed them from view!

A girl who went to a dance carried a pair of her mother's best scissors in her purse. Slyly she cut a slit to dance and hence was born, for a few years to come, the so-called "slit skirt."

Thank providence all this only lasted one season and has never returned from that bourne to which "old fashions" retreat.

There may it rest for ever in the forgotten limbo of vestal fashions.

Hobbingly yours,

HOBBLE SKIRT GERTIE

Don't worry Gertie, the Hobble Skirt "is not dead but sleepeth"— and worse is to come. You had a period of freedom and then came the long tight skirt which cluttered up your knees as well. Since then you've been free again. But the wheel of fate is turning—so next—and in the near future, the arms will also be immobilized, for which a few chains are suggested to make a shot bird of it — and then in twenty years time, if we aren't atomized, we'll have the streamline era for which what could be better than the Egyptian mummy for inspiration.

(*Continued from Page* 10)
in particular having a waist of under 13 in.

About this time I received a letter from my guardian, informing me that he could no longer keep me at school, and at the same time my mistress was requested to find a suitable situation for me. She at once apprenticed me to one of the most fashionable milliners and corsetieres in a large provincial town. I was here placed in the "trying on" department, and it was continually being dinned into my ears that still tighter lacing was desirable, and, after two months' work, I was provided with a corset fitted around the waist with a metal band secured in the front with a tiny lock, the key of which was in the possession of my mistress, so that I was again obliged to sleep in my stays.

Some of the young ladies in this establishment had even smaller waists than my own, and one young girl, whose waist was decidedly under 13 in., told me that for three years she had never had her corsets off for more than half an hour at a time, and that during all that time her stays had never been let out to more than 16 in.

Even now, when I am head of my department, my waist is under 14 in., but in my present position I am "privileged" to take off my corset at night.

FOR THEATRICAL FOOTWEAR —

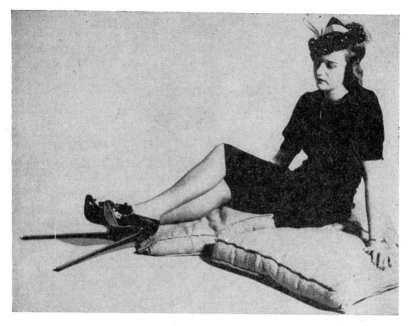

Exquisite perfection with heels of any height — Achilles

OUR NEXT ISSUE VOL. 4

Will give details of figure training and discipline to obtain a wasp waist and correct posture. There will also be the long promised pony story—all the usual editorial bilge—and of course more interesting correspondence. What else goes in depends on our luck with paper.

SPECIAL ISSUES

Owing to paper shortage, only a limited number of copies can be printed on 1st quality paper (as is used for the cover of this issue). These copies are reserved for annual subscribers.

FOR ANY OTHER INFORMATION, WRITE TO:
THE EDITOR, P.O. BOX 511, MONTREAL 3, CANADA

SIR D'ARCY D'ARCY — Episode 1

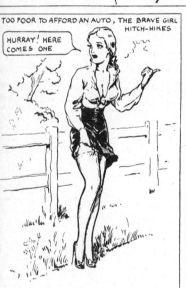

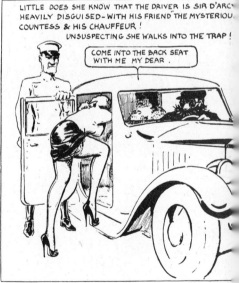

UR HEROINE IS EASILY OVERPOWERED & IN SPITE OF
ANTIC STRUGGLES IS SECURELY GAGGED & BOUND
S SIR D'ARCY SPEEDS OFF.

SO YOU WANT TO RACE YOUR FINE HORSE? I DONT THINK SO!

GWENDOLINE IS TAKEN TO AN OLD SHACK, HIDDEN DEEP IN THE WOODS! THE DEVILISH SIR D'ARCY CARRIES HIS BEAUTIFUL WRITHING CAPTIVE INSIDE—! DOWN INTO THE CELLAR!

NO ONE WILL FIND HER HERE

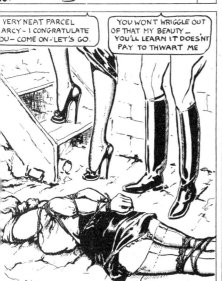

VERY NEAT PARCEL ARCY~ I CONGRATULATE OU— COME ON—LET'S GO.

YOU WON'T WRIGGLE OUT OF THAT MY BEAUTY — YOU'LL LEARN IT DOESN'T PAY TO THWART ME

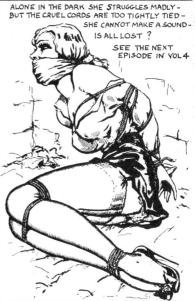

ALONE IN THE DARK SHE STRUGGLES MADLY—
BUT THE CRUEL CORDS ARE TOO TIGHTLY TIED—
SHE CANNOT MAKE A SOUND—
IS ALL LOST?
SEE THE NEXT EPISODE IN VOL 4

Correspondence

Don't be disappointed if your letter is not published—we'll try and fit it in later. It was just the luck of the draw.

In future if your letter appears in print and J. W. takes it into his head to illustrate it, you may obtain his original by simply writing in for it—for nothing.

Please don't say "I'll send photos if you like."—We DO like—

If you write please state whether or not your letter may be published. Under no circumstances will full names or addresses be published—nor do we give introductions—sorry.

THE GAGE IS THROWN DOWN
Dear Sir:

You say in your magazine that you welcome both criticism and suggestions from your readers. Well here is an idea I believe is a natural, for it will appeal to both men and women alike. I suggest that you set aside several pages of your correspondence in each issue and confine them to both letters and photos dealing with a single subject—The doctrine of "Feminism."

This part of your magazine could be given one of several appropriate titles such as — "The Battle of the Sexes," "Male vs. Female," or even such colorful captions as "Who Should Wear the Pants?" and "The Panties vs. The Trousers."

I believe that you would soon discover this part of your magazine to be the most popular of all and an incentive to many new subscriptions. I think you can readily see the possibilities of my idea.

Let's have more illustrations, preferably photos, such as the one which appears on the cover of your January issue. That young lady with the whip is the type of picture which would serve as an intriguing part of the page devoted to the feminine side of the "Battle of the Sexes." Brought down to small size it could be used as an insert on the first page

DON'T LET THIS HAPPEN TO YOU

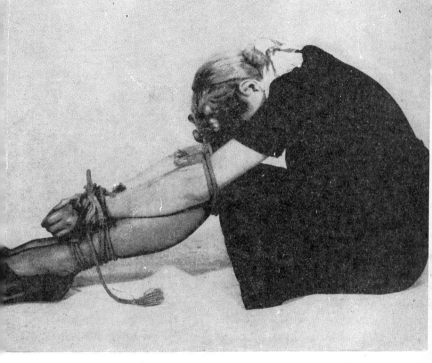

Learn Jiu-Jitsu and the art of self-defense

of the section reserved for the feminine viewpoint on "feminism."

In criticism of this one issue of your magazine I note that you totally ignore the peculiar attraction to men of sheer silk stockings worn *neatly rolled* and without any visible support from garter, garter belt or corset. In photos such as the one appearing on page 44 where high heeled pumps and not boots are worn the appeal of the model's shapely limbs would be greatly enhanced if she wore neatly rolled sheer hose.

<div align="right">Yours, S.W.</div>

Well, what have other readers got to say about it?—Ed.

Dear Sir:

I like your delightful little magazine, particularly the letter by Mimi. I can quite understand how she felt for men fawn and fall all over me too.

I wonder if she has found a man who will not, but will show quite conclusively that we women

are physically the weaker sex. My one desire is to meet such a man. One who will make me his helpless prisoner and humiliate me in every way. When, when, WHEN! will men realize that even if we are pretty, and feminine, all of us do *not* want to be treated like helpless dolls unless we are rendered helpless. Do NOT bring flowers, bring cords instead with which to bind us. Do NOT beseech our favours on bended knee but make us crawl to you to do your bidding.

Yours, E.V.E.

SMART HORSEFLESH

Dear Sir:

I hope you intend to feature ultra stylish riders and drivers, and think you will be surprised at the interest they will create. As you probably know, there was a craze during the Gay Nineties for "smart horseflesh" and it was considered very stylish to drive a pair of high steppers very strictly when tightly harnessed and with their heads kept exceedingly high by unsparing bearing reins and gag bits, just as it was "good form" for a smart little lady to make a spirited mount do her bidding with the help of a severe curb bit, a keen pair of spurs and an effective cutting whip. Milady knew it was "naughty" to repeatedly dig her wickedly sharp spur into her frantic side-saddler and then "ride the curb" but she liked the attention shown her as she cantered along with her prancing horse working himself into a lather while she calmly made him behave.

There is an endless array of such details to describe for those who admire Smart Horseflesh, either Victorian or modern; and while the effect in the past has been often discussed, very few know much of the extremely popular Gaited Horses in the U. S. Their training is a fascinating subject, and the setting of their spectacular high tails, etc., is being widely argued "Pro and Con" in the horsey set. A contest to submit ideas for ultra-stylish "Bizarre" leather riding habits, etc., might be popular.

Yours enthusiastically,
"Smart Severity."

CORDUROY VELVET FOR ALL OCCASIONS

Dear Sir:

My wife and I are interested in any article or correspondence you may have pertaining to the subject of corduroy velvet, if you have any will you please send it. We each have quite a few garments made of this lovely material and we both wear it quite often. When I first met my wife she was wearing a nut brown corduroy velvet bloomer suit which was well sea-

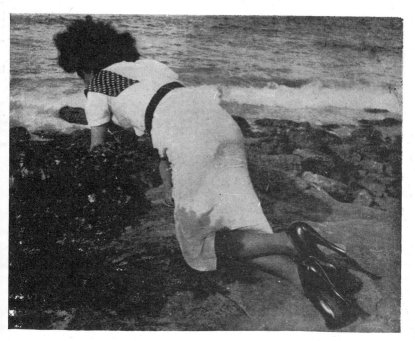

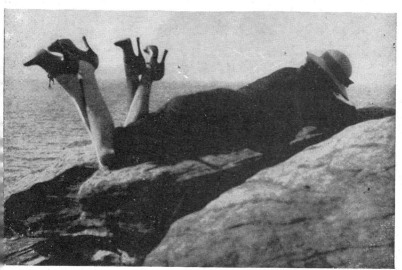

Snapshots sent by a Sydney (Australia) reader

soned and mellow. I was also wearing my old brown corduroy breeches. It was a case of love at first sight with us and two weeks later we were married. That was ten years ago and we are still as happy as the first day we met.

Well that is all for the time being, will write again if you wish after I hear from you.

Yours truly, S.E.G.

(Glad to hear from you at any time.—Ed.)

AN IDEA FOR THE LADIES

Dear Sir:

Let them write in describing when they wore their first high heels as junior misses, telling us their feelings on this great occasion, and how their youthful boy friends reacted to the novelty.

Incidentally at what age should a young lady graduate from bobby socks and flat heeled oxfords to silk hose and spike heels?

My niece has had her eyes on these fripperies since her 10th birthday. Now at 14, her parents have relented, and she trips daintily around in very high heeled patent leather slippers, with her long slim legs shown off to advantage in black silk stockings, and that most provocative of feminine ornaments—an anklet.

So write in, Bizarre readers.

Yours, E.W.

Dear Sir:

The school-mistress in your advertisement for subscriptions was so like one I knew years ago in France—except that she wore a knee-length skirt slit up the side. She always wore the highest heels and insisted that all the older girls did the same. She was quite sweet, but most severe, and always carried a light cane. However, her favorite punishment for a senior was to treat her like a baby and to make her stand in the corner— sometimes for a whole hour—a dunce's cap on her head and her hands tied behind her with a piece of ribbon.

"Yvonne."

Dear Sir:

The article on "corsets" was very interesting. Judging from displays in lingerie shops here the corset will be revived. Hope you will supply more of this intriguing data and photos to illustrate.

Also I agree with I. J.'s letter to the effect that a good sound whipping is to be preferred to a "bawling out" with its attendant emotional upset which has a tendency to linger on for several hours. I've often wished for a spanking in preference to said bawling out.

You state in your introductory page the preference some have in the line of clothing. I like satin and taffeta personally.

Yours, Le K.

[39]

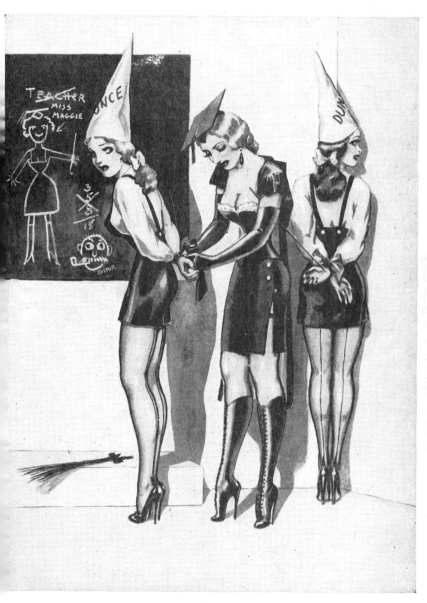

That's enough of this nonsense — Now you'll behave

BLOOMERS

Dear Sir:

When I first saw your magazine I was overjoyed because I have been looking for such for a long time. You ask for ideas. Here is mine.

My favorite article of women's clothing is bloomers. You know the type with elastic at the waist and legs. For a long time sex appeal and bloomers have been synonymous to me. Imagine my dis-

may some time ago when bloomers began to lose popularity with young girls. Instead they began wearing "shorts" which have no more appeal than men's shorts. Gone are the days when a girl can sit down, cross her legs, and bring any man to his knees with the sight of her bloomer legs peeping out at him. Please do all in your power to bring bloomers back to favour, especially with young women. With the war over elastic should be plentiful, and I hope bloomers will be too. I would appreciate drawings or photos of girls wearing bloomers in the magazine. Looking forward to a well bloomered Canadian young womanhood in the near future.

Yours, Bloomer Worshipper.

Hope you like J. W.'s illustration. Write in again if you want it.—Ed.

MEDICINE FOR A SICK WORLD

Dear Sir:

I am fascinated by a refined domineering type of woman, who believes in rigid discipline (alas, it seems almost impossible in real life to find her). I feel that in the relations between the sexes woman should be master and man should be slave. I think the world would be a better place if more men would feel as I do.

Yours truly, DR. L.

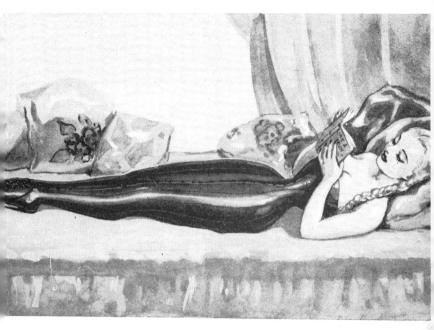

Dear Sir:

I was very interested to read your article on figure training in Vol. 2. When I was a girl of nineteen it was the custom to rest in the afternoon when going to a ball in the eveing. My rest was taken in a special figure training corset made of soft kid but heavily boned, which reached from my bust to my ankles. My feet were both encased in a single specially shaped bootee and the bottom of the corset fastened under the instep with a strap.

It had the usual eyelets in the front and lacing up the back — and it was most severe in shape. Though my hands were free it was quite impossible for me to remove it unaided and there I would lie reading or dozing off from 2 'till 4:15 when the maid brought in afternoon tea—but the corset was not removed until six when began the business of dressing for dinner and the ball.

I used to enjoy it. I thought you might be interested as you seem to like delving into the past and that revives old and pleasant memories for me.

Yours,

"Patricia."

Dear Sir:

Regarding the use of ear-rings, which has become so popular today (and which inevitably sug-

gests the question whether the use of nose-rings will also be revived by American women), it must be admitted that the present practice of merely pinching the rings or ornaments onto the ears does not afford the same pleasure, either to the spectators or to the women themselves, as when the ears were actually pierced. Once upon a time every girl looked forward eagerly to the day when she would have her ears pierced. And there is certainly much more fascination in noticing, on closeup observation, that the ring actually goes through the flesh of the feminine ear, just as those pierced earlobes themselves are an intriguing sight when minus any rings. But what reminded me of this is the very delightful and surprising discovery that ear-piercing has not gone permanently out of fashion, after all. as one might have supposed; for just recently I have noticed a number of high-school girls wearing ear-rings whose ears were unmistakably pierced. Like the revival of tight-lacing, this would seem to be another indication that girls and women are discovering those provocative arts of fascination that have been forgotten for too many years.

As ever,

Raymond V. Ford.

Dear Sir:

On New Year's Eve we held our first proper peace time party of the Modern Misses Club since Pearl Harbor. Four of our five boy members are back from the Services, and all the girls are back in New York, three of them having travelled many thousands of miles doing chorus work with the U.S.A. both in the Pacific and in Europe.

The party was held as usual in Betty's apartment, and as the only rule our club demands is that the members be original in their dress, you may be sure that we were treated to some wonderful outfits.

As space is limited I will only attempt to describe the winning costume. The winner was elected by popular vote, and it was only after much discussion that we were able to announce Anne as the "Super Girl of Tomorrow." The following is a brief description of her outfit which she had named "Miss Texas 1975."

A very brief black kid skirt with a fringed hem served to partially conceal a tiny pair of close fitting black satin panties. Above her bare mid-riff was a black satin brassiere to match the panties. Thigh length black kid boots (a p r e - w a r relic), with 7¼-inch heels adorned her very shapely legs, and her arms were encased

in black kid gloves, shoulder
length and fitting without a
wrinkle from arm pit to finger tip.

As her pride is her long plati-
num hair she wore no hat, but
had brushed her hair till it shone
like gold, falling loose over her
shoulders almost to her waist.

Her lips and eyes were very
heavily made up, and her only
jewelry consisted of heavy silver
ear rings, sufficiently large to
brush her shoulders as she moved
her head, and a pair of very large
and very ornate silver spurs
buckled to her towering pencil
heels. In her hand she carried a
small but business-like riding
switch. As you can imagine she
looked every inch Miss Texas
1945.

Lack of space prevents me from
describing other dresses at the
party in this letter, but if any of
your readers are interersted I could
perhaps send further descriptions
prior to the publication of your
next issue.

Anne's boots have been care-
fully put away during the war, but
we are running very low on our
stocks of high heeled boots and
shoes, lets hope Achilles gets into
production soon. Secretary,
 Modern Misses Club, N. Y.

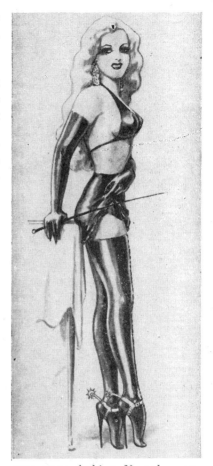

FINE FEATHERS FINE BIRDS
Dear Sir:

For years women have domi-
nated the fashion spotlight in their
glamorous clothing. Now the man
must come to the fore. The male
animal has always had the most
brilliant fur,, feathers, or whatever
the outer covering may be. My one
war against man's conventional
drab clothing starts from the in-
side. I have always found that
when I wear lovely lingerie, I face
the world with more assurance
and pride in my appearance.
Among my collection I have silks,

[44]

satins, nets, and others; fancy frilly things for parties and plain, tailored undies for everyday wear.

Odd, you may ask? I contend that it is not odd for a man to be as attractive and well groomed as any woman. Perhaps there are other readers who will agree with me. I have several friends, men and women, who are in agreement with me that men should wear lingerie as lovely as that worn by fastidious women. Could my request, and the requests I am sure you will get from other readers, induce Bizarre to publish photographs of lingerie suitable for men?

Yours, "Lingerie."

Well, I don't know — had we lived in the days of our Cavalier, Buccaneer, and tough old ancestors who were equally fastidious, the shops would be full of silk frilly things for men and to get photos would have been easy—but these days it's more difficult. All the same we'll look around.—Ed.

Down with Slaverettes

Dear Sir:

It is the contention of this writer that the greatest menace confronting us freedom - loving males today is not the atomic bomb, but the sleek well-fed masculine woman whose belief and philosophy if carried to their logical conclusion mean the end of the long ages of masculine dominance and liberty.

Most men unfortunately seem blissfully unaware of the hideous fate awaiting them if women everywhere suddenly decided to emulate the so-called modern woman and used their favorable position in life to wrest the reins of power from proud man, and due to the many preoccupations of man at present that could well happen unless we men take steps to prevent it.

Unknown to many of us there exists a new and highly dangerous type of woman whom I will term the "slaverette." This woman, creature, vampire or what have you has but one idea in mind, and that is to dominate and control.

Man is but a grown child in the eyes of this charming, fascinating creature—irresponsible, silly, and like a child willful and peevish at times, born into this world merely to serve the desires, whims and caprices of woman and when no longer useful to be discarded and cast aside like an old rag. Those of us who wish to escape a life of feminine slavery should beware of women who dress in a mannish manner, and who emulate men as much as possible, even to the extent of participating in typically masculine sports like wrestling, boxing, weight-lifting, body-building, etc., and we should avoid

for all these things are the signs of the modern woman or "slaverette" type whose modernism and dress are so strangely like those of the nineteenth century courtesan.

In conclusion let me point out two more sources of weakness in the "slaverette" type. Although she is usually intelligent, and in some cases as strong in body as a man, she still lacks a man's ability to reason and appraise things immaterial, and like all women she is subjective-minded due to her inability to grasp anything unless she can see a connection with her own sphere of activity, and also, and this is even more important still, she has partially lost her instinctive desire to dress and behave in such a manner as to captivate man by emphasizing her sex.

Yours truly, Fred Mack.

———

Dear Sir:

We like clothing made of rubber — please show some pictures in your next issue — enclosed is a photo of a shiny white macintosh which will show how lovely rubber looks and which you can publish if you like.

"Macfan."

We do like, and many thanks.
—Ed.

HIGH BUTTON BOOT STYLES

Dear Sir:

These pictures, may I explain,

those girls and women who smoke, drink,. pet, swear and dress like men, or who insist on dashing around bare-legged. wearing next to nothing in the way of clothes

exemplify the elegance of such boots, particularly for riding purposes as adopted by a charming though autocratic lady I knew in pre-war days. Her heels, however, were about two inches shorter than those you illustrate and the rippling attractiveness of the soft black glace kid was accented by a dianty pair of spurs, a feature you might explore interestingly.

The bright rolling points of these later, she explained, could modulate the most delicate reactions with minimum effort, unattainable by the whip. Thus attired she had ridden all kinds of mounts: horses, mules, and even natives, on jungle trails. The gait of the natives was delightful and the rides exquisite, she said.

Yours, A.S.

On the Seat of Government

Dear Sir:

The subject of child management is a very interesting one to me. I am not one to criticize modern methods of applied psychology but as I see what sometimes results from their intelligent use I cannot but think back to the days when mothers had less time to reason with a naughty child and had to get action — fast.

I wonder if any of your readers do not recall how this action was obtained and, perhaps from an historical standpoint, might not like to see it illustrated in your magazine.

I can see in my mind the mother in the standard position, seated in a chair with the child held firmly across her knees, face down, and with any little obstacle to a first class performance, such as an encumbering shirt or panty, pushed out of the way. Mothers, as I see it now, were of a more buxom type in those days with strong right arms and heavy hands that landed with a spank that didn't have to be repeated often to straighten out the worst offender.

Perhaps this is just nostalgic but really, don't you think sometimes nothing but a session over mother's knee clears up the storm clouds that are bound to gather at times?

I wonder if other readers will not agree with me as to interest in the days when mother, or sometimes it was auntie or nurse settled the question of who was running things in her house by appeal to the "seat of government."

Yours truly, H.S.

J. W. Illustrations

Dear Sir:

We hope you will settle an argument we are having or would it be giving away trade secrets to let us know whether your excellent artist John Willie works from a model,

[47]

DON'T PAY ATTENTION

TO THE ABOVE ADVERTISEMENT!

We simply re-print it (in 1953) as an epitaph

on the grave of lower prices and easier living.

The price of Bizarre is now $1 per copy — and

beer is 15c a glass — such is life!

or just imagination? If a model was used for Sweet Gwendoline on page 36, was she really as tightly and efficiently tied as depicted and how long was she kept tied up? It wouldn't be very comfortable and we wonder what the model thinks about it.

Excuse the inquisitive but there is a bet involved—and does he prefer blondes or brunettes.

Yours, d'Artagnan.

J. W. has no preference—he takes anything that comes along—ties her up as depicted and keeps her like that for hours. They don't seem to mind—Is that enough? Ed.

MINI MIMI

Dear Sir:

With regard to the letter from "Mimi" (I think she should have used the pen name "Meany") I don't believe she will have to worry about a husband, if she treats all her admirers as she did the "poor soul" she mentions in her letter. No wonder chivalry is dying out, although she says she was uncomfortable in the costume she describes, she must have made an exciting picture, and it must have been a thrilling experience to have been dressed as she was. I think she was to blame for the way the "poor soul" felt.

Yours, McC.

NOT SO MINI MIMI

Dear Sir:

I took particular pleasure from the contribution of "Mimi" on her manner of dress and the way she handled her man so capably, in which otherwise was rather a delicate situation. Although, if I had been him, I am sure I would had gone back several times for more of her admonitions—and eagerly that is.

On the matter of dress and accessories, however, there is one article that to me is particularly appealing and that is the slave anklet. One girl I know will not permit a kiss to be placed higher than the anklet and I recall many a pleasant moment in doing this while alternately she impressed on one the daintiness of her $4\frac{1}{2}$ in. heels.

Since returning from overseas and reading "Bizarre" the thought occurred to me that your magazine may be the means of forming clubs, as in England, where free discussion of the topics published in "Bizarre" might be held.

Best wishes — which goes for many Westerners, I am sure, as well as myself.

Sincerely, J. S.

Result of our Competition in Vol. 2

Pages 1 5 9 15 8 11 25 33 26 41 23 17 44 12 19 24 21 29 31 14 20 49 45 18 39 35.

Printed and Published by Bizarre Pub. Co., Montreal, Canada

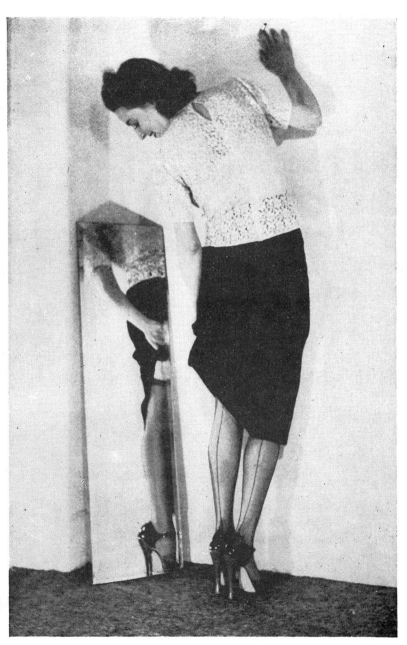

Reflections

for slaves of fashion

Achilles

theatrical footwear

BIZARRE

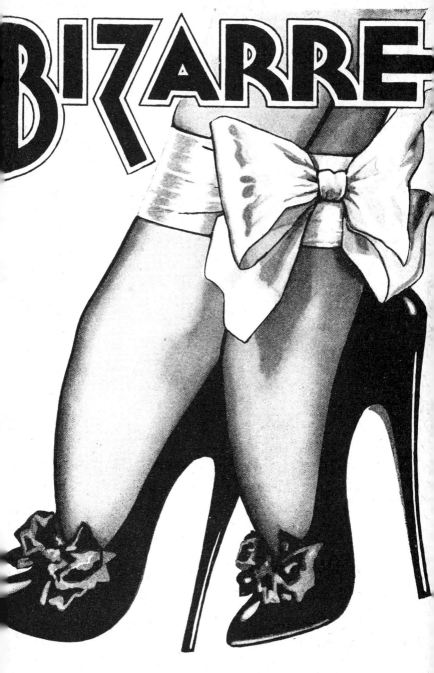

THIRTY-FIVE CENTS

for slaves of fashion

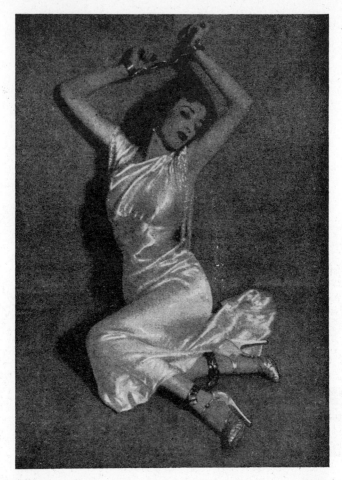

shoes by

Achilles

BIZARRE No. 4, Vol. 1, 1946
"A fashion fantasia"

CONTENTS

NEXT ISSUE No. 5

A limited edition available by Mail Order. Price 30c post free. (Stick 3 dimes to a letter with scotch tape.) A "correspondence" digest consisting entirely of letters from readers—describing their likes—dislikes—and experiences—in an amazing variety of subjects. Personal photos from readers and the usual J. W. illustrations.

As a Christmas celebration we are including not one — but two — TWO — more EPISODES of the adventures of our Sweet GWENDOLINE at the hands of the diabolical SIR d'ARCY. These two spasms alone make this issue one that everyone has been waiting for. J. W. has surpassed himself.

BACK NUMBERS

No copies of No. 1 are available — but a reprint of that issue will be made when paper becomes more plentiful. Only a few copies of No. 2 and No. 3 are left — price 30c post free.

PHOTOGRAPHS

We are temporarily discontinuing the sale of photographic reproductions of illustrations in these pages.

Readers will help us considerably in the meantime if they will write, indicating the page number of any picture or pictures of which they would like a 5 x 7 copy when production is resumed.

NOTICE

We are only able to print a limited edition of No. 5
— too small for ordinary distribution.

Therefore No. 5 will be available by

MAIL ORDER

Price 30c post free.

photos, J. W. illustrations etc.—and in celebration
It is our "CORRESPONDENCE ISSUE"— 32 pages full to the
brim with letters on all subjects by readers themselves—personal

THE NEXT 2 PULSATING SPASMS OF THAT EPIC

the devilish Sir d'ARCY and SWEET GWEN

Don't miss it! Stick 3 dimes in a letter — now!

EDITOR!

This really is No. 4 — and it will immediately be followed by No. 5 — but that does not mean that our troubles are over and that we will be publishing regularly each month from now on — far from it.

What has happened is briefly this: We received a Royal message from the great Panjandrum (our printer) to say that, being full of Christmas spirit and good cheer, he thought he had found a bit of paper and we could have some. We touched our head to the ground three times in humble gratitude — and then got the happy idea of spreading it out as far as it would go purely for the benefit of our subscribers who have been having a pretty raw deal so far.

We have therefore cut still further into our circulation, as regards No. 4 and thus are able to print a very limited run of No. 5 — too small for our ordinary distribution but sufficient for those readers who like us enough to write in and ask for a copy.

One of our main troubles is to try to fit everything into 48 pages. The correspondence we receive could alone fill 64 pages, twice this size, each month. In fact it has been piling up so high that we have decided to make No. 5 a "correspondence number" entirely.

It is quite likely that in trying to please all we shall please none — that's the chance we take — but as in these days when every business is so high-hat and nonchalant we ourselves are bizarre enough still to try and satisfy customers, we trust that even if you don't like us you'll write and tell us so — and why!

We give preference to any subject not covered by other publications. This fact may help those who are still puzzled about us (if they'll just take the trouble to think). That there is nothing about wrestling or boxing, physical culture, beauty aids, make up, hair styles and so on doesn't mean that we aren't interested, or that you who like these things are being neglected. We simply haven't the space at the moment.

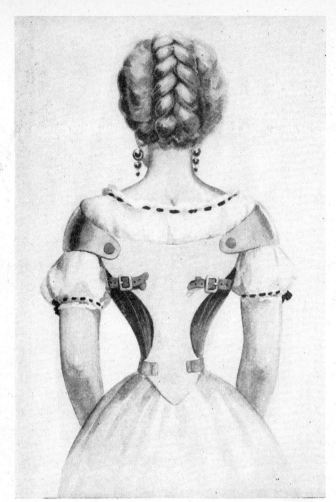

The back-board

This shows the material from which J.W. has made all the illustrations for this article —giving modern glamor with exactness of detail.

THE WASP WAIST
figure training
and deportment 1890

We have to thank L. R. for the cuttings from publications of the '90s. From this data we have endeavored to give in precis a picture of home life as it was in those days.

The old fashioned steel engravings — a sample of which is on page 6 — seemed a bit dull, so J. W. was called in. You may think some are exaggerated, but they are all exact in detail to the last stitch, and the end of the corset string.

The variety of exercises practiced today to improve the figure and deportment are the result of careful study by physical culture experts over a period of years. They are scientifically designed to put a curve on here and take a bulge off there. Whether or not they are always effective is another story.

The same applied in the days when a wasp waist was the vogue, but instead of exercises, the simpler and more direct method of brute force was applied — and it was always effective. You must remember that in those days physical pain and discomfort were not looked upon as barbaric but were taken as a matter of course. In fact it could only be due to this complete disregard for a young lady's feelings that the shapes in vogue in the "gay nineties" could be obtained. No amount of exercising as we understand it today could achieve the result. A fact well worth bearing in mind if, as seems likely, there is a return to the wasp waist.

The dress designers were as tyrannical then as they are now. They would decide that a certain style should be the fashion for the season and the corsetieres would get feverishly to work to design a corset which would be the proper foundation, as if the fair lady who was to wear it were merely a chunk of putty.

It is perfectly obvious that as the human body generally speaking is a soft boneless mass at the waist it can be given an outward appearance of any shape simply by squeezing it into a mould, and as you are dealing with something that grows over a period of years, the younger you start moulding the body, the better chance you have of achieving the required result.

It is much easier to stop the waist of a child expanding as she grows older than it is to squeeze another inch off the waist of an adult, so in wise old granny's day training of the figure began at the earliest possible age in all well-to-do families.

For this purpose the corsetieres had to design all sorts of devices which could be used by fond mamas, or sisters, or personal maids on the future breakers of hearts. Their variety was enormous and as they all acted on the principle of forcing an exaggeration of the ideal, all were intensely restricting and none comfortable.

Young children of course almost invariably objected and resisted strongly and it became a battle of wits between parental guile and childish ingenuity. Even the young matrons who did not dare to cease their training exercises anymore than does the girl of today (the bogeyman "Fat" was just as terribly present than as now) and who eagerly insisted that the maid should lace them in an extra inch, or tighten this or that device a trifle more, would often weaken in their determination after a few minutes and remove the uncomfortable contraption if they were able to do so.

It was therefore the custom to insure that the trainee could not free herself. Where expense was of no consequence specially made locks would hold everything in place and someone else would keep the key. Corsetieres of the period spent almost as much time inventing ingenious methods of preventing their clients from removing their training devices as they devoted to the art of corset making —and of course decorative ideas were used whenever expense would permit it.

The most commonly used and obvious method, however, was to fasten the hands of the girl so that she could not untie corset laces or undo tightly buckled straps. In these days of juvenile crime waves and "child psychology," a good whipping is considered savagery and bondage brutal, but in those days to tie a child's hands behind the back was the general means employed to keep little fingers from getting into mischief. It was al-

CURVE CONTROL — flexible

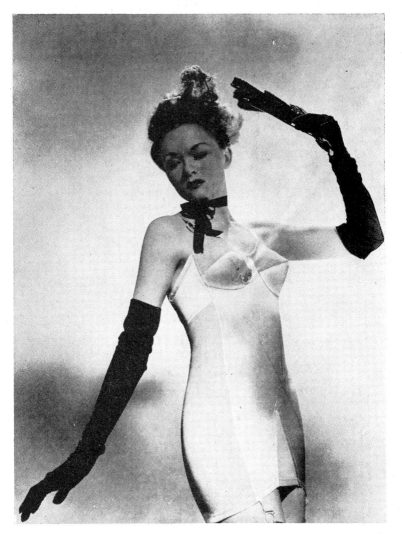

We have to thank the publication Beautify "Your Figure" for this, and the illustration on page 12 which form such an interesting comparison between modern times and the gay "nineties."

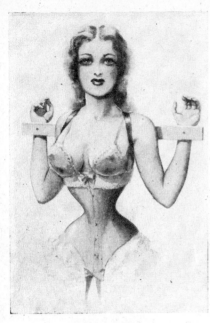

THE YOKE
**Used to correct rounded
shoulders.**

ways skillfully done—it had to be
for nimble fingers can wriggle in
an amazing manner, but yet it
would not be done so tightly that
it caused pain. The hands were
held gently but very firmly out of
harms way—just that and no more.
Kid gloves served as an excellent
protection against bruised wrists,
and if they fitted tightly. the fin-
gers were further hampered should
an attempt be made during mama's
absence to get at the knots. Gloves
were also supposed to keep the
skin soft and white and were
therefore almost invariably worn

during the figure training period.

Let us assume that we have a
magic carpet which carries us, in-
visible, back over the years and
into a lady's boudoir as she retires
to bed.

Our first visit is to the poor
working class district of a great
city. There we see Miss Maisie
laced in a plain, well worn, but
extremely tight corset. She picked
it up a week ago in a second hand
clothes shop, it having belonged
previously (so the shopkeeper as-
sured her) to a famous actress.
She lies on the bed trying to get
some sleep, but she is not com-
fortable. She, like every other
woman we are to meet this night,
hopes to gain a suitable husband
and she is pretty but not pretty
enough—her waist must be smaller
—it is only 19 inches, and she has
heard it whispered that a famous
society beauty who is the talk of
the town this season has one of
only 12 inches. She would very
much like to remove this steel
boned vice which is squeezing her
tummy and lungs so much that
breathing is difficult, but she can-
not because her younger sister who
has to share the same bed and
who laced her in with so much
effort has tied her wrists very se-
curely behind her back with a
piece of string. Some months ago
she had been to the theatre—a
great event—to see that famous

play "From Mill Girl to Baroness". According to the play the first thing that had attracted the eyes of the gentry had been the slim waist of that virtuous slave of the loom—but if this is what she had to put up with, Miss Maisie wonders if it is worth it, for she too has had to work hard all her 20 years of life and has only recently taken to trying to improve her looks—but the play was so real it might happen to her—who knows?—so, clenching her teeth she suffers in silence. Then, whissh! Presto!!!

—We are in the room of the daughter of a local shopkeeper. The room has better furniture than we have just seen, but the picture is the same. This young lady also tries to sleep with her waist and thighs compressed in a vice which holds her as rigid as a board. Her wrists are also tied behind her back with a small strap, but unlike Miss Maisie who finds the string beginning to cut into her wrists, this young lady's arms are protected by kid gloves and though she cannot get free, she is not unhappy about it. The gloves have seen much wear and they are now used only for training, but the corset is more elaborate in its finery and though ready made has some pretense at fitting. Business has been picking up lately and a prosperous father and a 15-

inch waist—if only she can squeeze those other three inches off—should ensure an excellent husband—and in spite of her discomfort, she sighs as she falls asleep happily—Whoosh! presto again!

We are in respectable middle class suburbia. One of the maids has obliged Miss Nancy. She is strong this maid, which is why Miss Nancy selected her for the

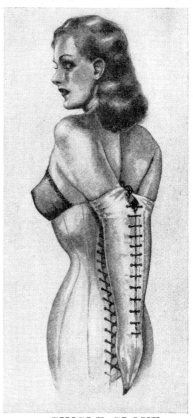

SINGLE GLOVE
To prevent slouching and stooping.

[11]

each to her choice

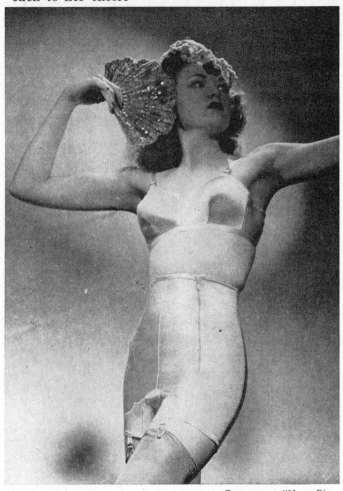

By courtesy "Your Figure"

task of lacing in her sleeping corset. This corset is made of satin. It has a 16-inch waist, and it is long, reaching from the knees to her breasts which are cupped as high as possible. In addition to her gloved hands being tied with black satin ribbon to match the corset, the corset laces have been tightly knotted and then cut. She has never succeeded in freeing her hands when the maid has tied them though on several occasions she has been tempted to try—so this waste of a good lace by cutting it seems unnecessary—but the maid takes no chances. Little does Miss Nancy know that the maid buys the laces wholesale and by claiming that a relative of hers makes them, is always commissioned to buy them. With four girls and a doting mother in the family each requiring a new corset lace each night she makes quite a handy addition to her wages of "$5 a month and found."—Then whisssh! and once more presto!

We are in the boudoir of milady of fashion, the toast of the season and the belle of every ball. Her room is expensively furnished in exquisite taste and in a large satin draped bed she lies on silk sheets, her lovely face framed in a tossed mass of silk and lace pillows. She is sleeping, her beautiful figure half-revealed by a specially designed night dress of sheerest silk

and her tiny 12-inch waist is squeezed in by a kid corset to match, trimmed with lace and which holds her immovable from knees to chin. Her arms, which have been praised by the leading artists (as well as the rest of her for that matter), are encased in creaseless kid gloves from shoulder to finger tips which fit like a second skin and her wrists are secured behind her back with a little pair of jewelled steel and silver handcuffs (a present from a doting admirer). Only one small link connects them which allows her a

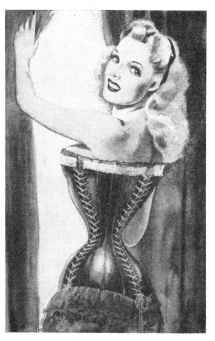

TRIPLE LACING
To obtain a perfect snug fit.

[13]

little, but very little movement—but she does not mind.

She has slept this way ever since she could remember and now, though there is no necessity for it, she requires her French maid Pipette to fasten her wrists each night for from habit she finds it more restful—and so we leave her and ourselves retire to rest.

The next day is Saturday and in the afternoon we take out our magic carpet and go back to find the first girl we visited.

She is working in a factory—her clothes are coarse and strong and her pretty little feet are in rough, wooden soled boots — but she holds herself proudly nevertheless for under her blouse is a home-made arrangement of iron and canvas which goes from her shoulders to her waist. The canvas passes over each shoulder and back under the arm pit to the iron bar where it is laced tight, drawing the shoulders well back—and a thoughtful sister has knotted and cut the string.

She does not stoop over her machine simply because she cannot. She stands erect or leans forward, and the boss passing, pauses, and twirls his moustache. "Yon's a fine lass," he thinks! "Now what am I doing this evening — ahemm!" — and he passes on.

The shopkeeper's daughter is helping in the shop. She also car-ries herself well as she wraps the parcels. She cannot reach the top shelves for, though the customers cannot see it, she is wearing a backboard under her blouse—and the straps around the shoulders and upper part of her arms (for this one is designed that way) allow only little movement of her arms above the elbows.

Her shoulders ache a bit and her back is as rigid as the board itself, yet she smiles and blushes prettily at the young men who seem to find it necessary of late to want such odd articles, take so long in making up their minds, and buy in such small quantities that they always have to come back for more—sometimes in the same day—which incidentally is why business is looking up.

Presto! and we are in Suburbia again. Up and down, round and round the play room goes Miss Nancy's younger sister, Miss Joan, aged 16. She walks almost on tip toe for her little feet are perched in soft kid slippers with five-inch heels. With cane in hand her new Governess watches her. In the morning Miss Nancy had her music lesson and her knuckles are still sore from the raps given her by the "Professor" when she made a mistake.

In addition, Mama had decided that she seemed to be stooping a little so she had eaten her break-

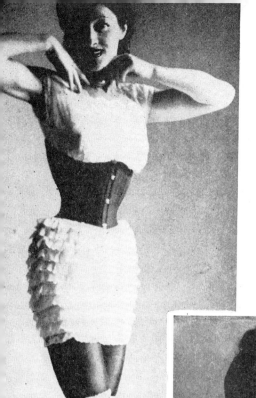

PRE-WAR EUROPE
to be or not to be—again.

y courtesy of a reader

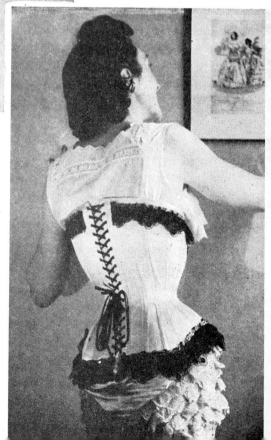

fast and lunch in the straight backed chair with the straps attached so that her soft young body could be held properly erect as she ate—"It is vulgar, my dear, to lean over your food"—and then all morning she had worn the hated back board.

After lunch the back board has been removed and now she is enduring further training. The governess who has spent years in India is trying a new idea copied from the native women—a book balanced on the forehead to give her correct poise—but as usual her ankles are shackled by a light 10-inch steel chain which joins two leather-covered steel anklets that fasten with a little lock. Her previous governess, to prevent the usual Tom-Boy activities, had insisted that she wear them whenever in the house or garden, to train her always to take little lady-like steps—and though she had often tried to pick the lock with a hair pin, she had never succeeded. Once she had been caught in the act and had been put across an ample knee and spanked with a hair brush (life is full of trials, it seems).

Under the stern eyes and ever handy switch of her governess, she continues to walk around the room. Her governess seems satisfied that her new idea is working out well—and Miss Joan is thankful for she knows that upstairs Miss Nancy is most uncomfortable.

The previous governess always insisted on the particular device which now trains her sister—but this new governess is really awfully kind—she does not believe in so much restriction. The ankle shackles are now worn only during training periods, and even though she uses a cane instead of a hair brush, has only given Joan two whippings since she arrived last week and this afternoon has only used the switch across the back of Joan's slender legs three times when she carelessly let the book fall.

Her sister, Miss Nancy, is old enough to chose for herself. Wisely (so her mother tells her friends) she choses a severe training every other afternoon. What would be the effect on her loving parents should she not do so, it is hard to say—but the idea never enters her head.

At the moment she is having her hair done. She sits erect in a chair before her dressing table mirror. She cannot sit any other way for in addition to a most severe corset she is strapped into a device which was given to her by her mother, who got it from her mother, and which Mama still uses herself on occasions.

(Continued on Page 48)

WAIST SPACE

"Inspiration"

"Investigation"

"Experimentation"

"Jubilation"

"Realization"

"Exasperation"

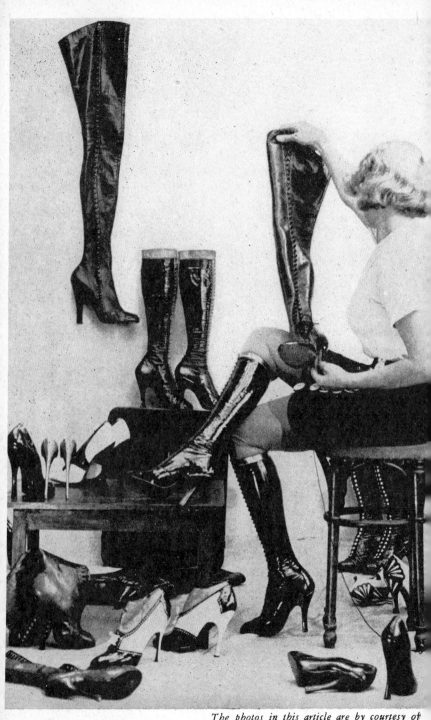

The photos in this article are by courtesy of

footwear fantasia

IT IS PLEASING to notice that the ultra high heel is once more making its appearance everywhere, and though we think that the average platform sole is—well, rather clumsy and therefore ugly, there are many styles which are definitely attractive, and enable the wearer to display a towering stilt which would not otherwise be possible.

And to crown it all—one New York shoe store has in the ordinary stock lines at $5.98 a black suede toe peeper with a full 4½-inch heel. In the smallest sizes the heel is, we think, too high for the last but in sizes from 4½ up the shoe is really most attractive. Some people of course are content with nothing short of six inches for all occasions but there are many who agree with Achilles, and consider that the height of the heel must be governed by the appearance of the foot and the ability of the wearer to walk gracefully. Nothing is more ghastly than a woman strutting along with knees bent, some even do it on 2 inch heels.

According to the manager of the store in question, the 4½ inch heels sell out as soon as they come in, there's such a demand for them —and Achilles is hopping mad at his inability to get organized and in production again. We think

that at least he could make his training shoe. It's a simple device which holds the foot in the position it should be in when wearing a full six inch heel—by constant home training there is no doubt that it does achieve results. Perhaps then women will demand that while heels remain the same, platforms will become thinner and thinner, and as a result feet become daintier and daintier—which will please us immensely.

An interesting piece of information came to us the other day. We are told that the late Sir Arbuthnot Lane—the famous physician and surgeon, stated that any woman who wore a heel lower than four inches wanted her mind read. He maintained that this height and higher gave the foot its proper stance as intended by nature. He pointed out quite simply that we are the only species that stands and walks on its heels. Every other living creature remains on its toes.

While not wishing to contradict so well known a doctor, it seems to us that he has overlooked one important point. Nearly every other living creature goes on all fours, therefore, only half the weight is carried by the legs. A human being on all fours walks on the toes, it's easy and natural,

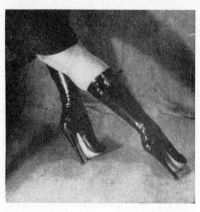

but when erect the heels sink to the ground for greater stability. Some people of course by training, or habit, are just as happy on tiptoe as with their heel flat on the ground. Believe it or not, Ripley showed a picture of a girl who has stood on tiptoe all her life. We wonder what her shoes are like.

Incidentally, the doubting Thomases who don't believe six-inch heels exist must remember that the height of the heel depends upon the size of the shoe. A 4-inch heel on a size two will have the same appearance as a six-inch heel on a size 7, or a seven-inch on a 9 or 10.

We asked Achilles his views on the subject and he stated quite simply that although women who continuously wear extremely high heels become accustomed to them, they never walk long distances on six- or even five-inch heels.

Most men who spend the day out with a wife who is cheerfully going around on six-inch heels would do well to take count of the amount of time actually spent in walking and the distance covered as compared to the time spent sitting down; and in addition the cost in taxicabs unless he has his own car.

When dancing there are many rests between dances and the natural position of the foot is on extreme tip toe—which makes it quite possible to go through a whole evening wearing five-inch heels, whereas the steady " 'ammer 'ammer 'ammer on the 'ard 'igh-way" (sidewalk to you) would tire her out in a matter of minutes. Probably the fact that in dancing the movement of the foot is in every direction, whilst in walking it is always in the same direction, has something to do with it too.

To sum up we can safely say that the wearing of extremely high heels is purely a matter of training—that it should be started at an early age with proper care paid to the fit of the shoe (remember, it is badly-fitting shoes and NOT high heels which cause foot ailments), and that for attractive feet the highest possible heel should be worn on which the wearer can move with grace.

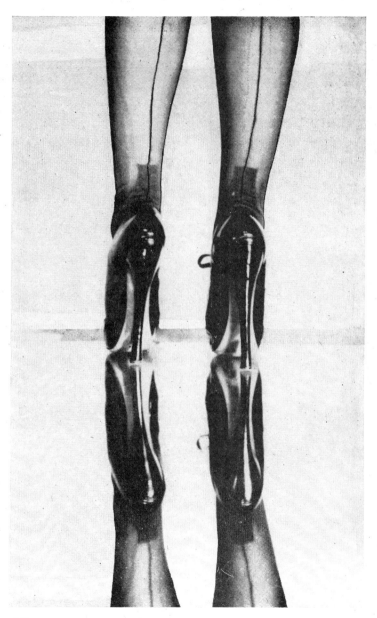

The glass of fashion—

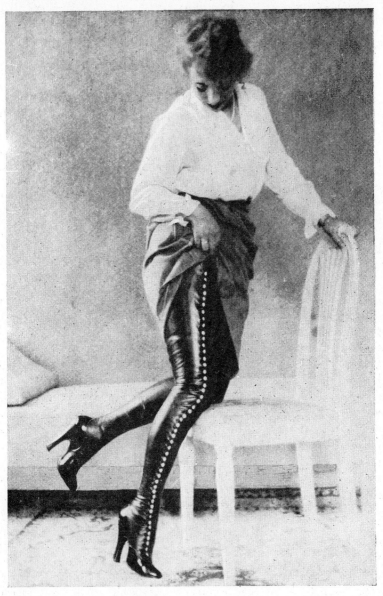

Quick to put on — with the Bizarre touch of white buttons.

THE MAGIC ISLAND

A tale from a bottle
No. 1

Dear Mr. Editor:

It occurred to me that the enclosed letters might be of interest to your readers. They were found in sealed bottles washed ashore on the coast of Chile and are from a nephew of mine—a good-looking young devil of 23 with more than his fair share of luck.

Yours,

J. McPherson.

Letter No. 1

Will the finder of this bottle please forward the enclosed letter to Mr. Jim McPherson, Chief Engineer, c/o G.P.O. London.

Dear Uncle Jim:

I have no means of telling whether you get this letter. I'm simply trusting luck to the sea. In any case there is no chance of your answering because I don't know where I am except that it's on an island—accessible only from one tiny beach.

As the Admiralty cannot know exactly what happened you'd better tell them that I believe we were torpedoed by a sub on the 15th December, and that I am the sole survivor. I was walking on deck when it happened—and the ship just blew up and by a miracle I found myself in the drink still all in one piece. I managed to find some wreckage to cling to and then it started to blow —and for two days and nights I was like a damned sub myself most of the time—but somehow I managed to keep topside until one night when I was just about ready to cash in I landed with a bang and a bump on good old dry land. I crawled up above the tide level and passed out completely.

I'll have to tell you the story as it happened to me, otherwise you'll think I'm the most awful liar for this is the most fantastic spot you could ever dream of—a real Utopia protected from the march of civilization as we know it by great unscaleable rock cliffs. An absolute paradise inhabited by the most charming folk it has been my good fortune to meet. But to continue with my story.

I was aroused from my collapse on the beach by someone shaking me and found myself surrounded

(continued on Page 28)

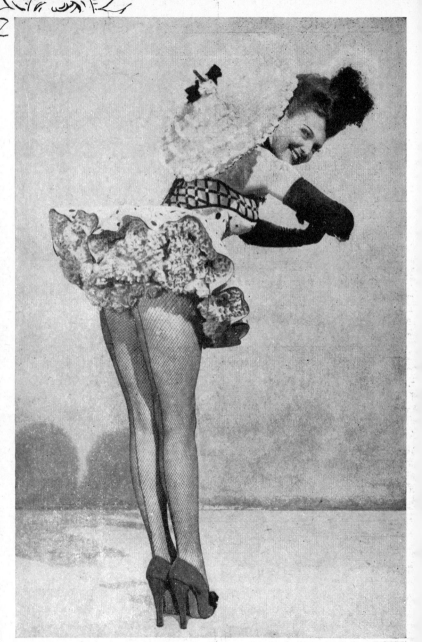

VIVIAN BLANE

FANCY DRESS

for special evenings

THE ILLUSTRATED suggestions for fancy dress in No. 3 have proved so exceedingly popular that we are making this a "must" in all future issues.

"Miss Texas 1945" had a terrific host of admirers, and again we shall be glad to hear what you think of the ones illustrated in this issue, and to receive your own ideas on what makes the "perfect party fancy dress" or costume for "special evenings."

We take this opportunity of thanking all those many readers who sent in "ideas" which are not illustrated. You will all realize that we're very lucky to have enough paper to print this issue at all (sorry to keep rubbing it in)—

Funnily enough our forecast on the hobble skirt for 1952, which with 1972 could make an excellent fancy dress, is not new. We have discovered that smart Parisiennes in the '20s, when the "sheikh" was the vogue, took to wearing chain ornaments—some of them perfectly genuine steel fetters, as restrict-ing as those worn by Miss 1952 in the previous issue.

One reader has sent in a delightful suggestion which will definitely come soon—a mermaid costume. A "zipper" arrangement opens the "tail", enabling the wearer to dance, but when seated this is closed, giving the full mermaid effect.

And now to describe the costumes suggested by our readers in this issue. (We again remind you that if you want the original J. W. sketch illustrating your letter, all you have to do is to write in for it.)

The arab costume incidentally is J. W.'s own suggestion, and his stock stand by if he gets caught unprepared. He makes it out of two sheets and a towel—one sheet goes round the waist like a sarong —the other is draped over the head and trimmed so to speak by the towel which is wound as a turban. Burnt cork applied skillfully makes eyebrows and whiskers.

The "bell hop" and the "convict" we're afraid would not be possible at the moment because the specifications call for silk tights which are still unobtainable. Whether you could ever buy striped tights we don't know—but anyway if you couldn't spend the time painting black stripes on white silk, you could always just wear it plain.

ON WITH THE MOTLEY!

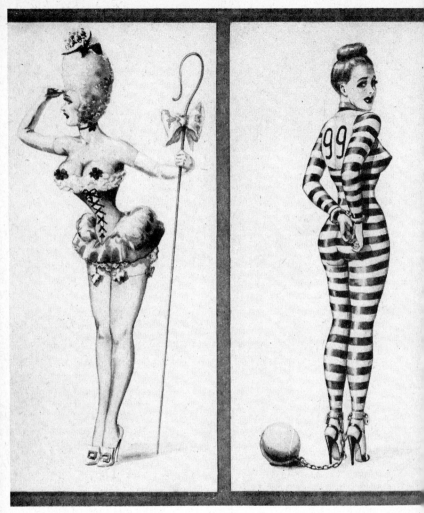

DRESDEN SHEPHERDESS. Much frothy white lace — white kid gloves set off by black corsette. Satin pumps with silver buckles and stockings to match — High, curled, white wig.

CONVICT. Black and white striped tights — handcuffs — leg irons and ball and chain (Ball can be cistern float).

ARAB. A simple costume to make — effective either in white or in coloured drapes. Chain ornaments, wristlets, anklets can be added.

BELL-HOP. Neck to toe skin tight tights. Stiffened collar — square padded shoulders. Jacket indicated by piping at waist and cuffs and buttons.

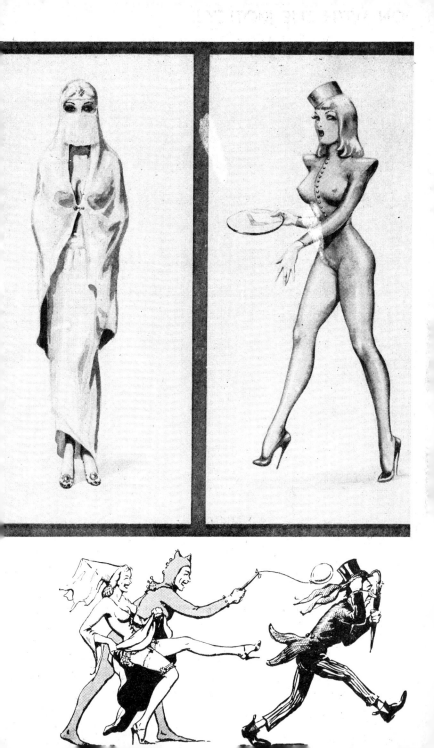

(Continued from Page 23)
by some natives armed with spears and the first thing I noticed about them was their fine physique and the character in their faces. They were more like bronzed Greek gods than natives.

They pressed a wet sponge to my lips and kept refilling it until my throat stopped burning like a lime kiln and I could talk. I asked them if they spoke English and after that my troubles ceased for they talk the same lingo perfectly without any accent.

They produced a gourd of excellent wine and some tasty little things to eat and when I was more or less able to sit up and take notice, plunked me on a litter and began to carry me over the rocks toward the towering cliff face.

My bearers moved smoothly and swiftly over the uneven going to the entrance of a small cave—here a halt was called while torches were lit and then in we went, deeper and deeper into the cliff. The cave seemed to get bigger and bigger and then we began climbing up one side. There was no regular path, just easy footholds here and there — then the roof seemed to come closer and we were in a natural tunnel—still climbing. We went on and on for heaven knows how long and then at last I saw the tint of daylight on the rocks ahead and rounding a corner we came at last out once more into the sunlight—and the most beautiful surroundings.

It is quite impossible for me to do justice to it, the whole darned island is the same — just a mass of tropical green — flowers everywhere all the year round — birds singing and a perfume which changes all the time as each different flower seems to take its turn in pumping buckets of scent into the air.

To crown it all there are no pests of any kind (human or otherwise), no snakes, no poisonous spiders or centipedes—and no mosquitoes. No heap of stupid rules and regulations — no liquor laws, and no morality laws except the very simple practice of good manners, tolerance, and consideration for the other fellow's point of view. As a result vice and crime are unknown. Everyone has enough work to keep life from getting boring. No strikes, no lockouts — no landlords — each man owns as much land as he can use for whatever purpose he requires — he cannot own more of anything than he can use. There are no witch doctors, ancient or modern. They say quite simply that the truth is no one knows what happens when we die—and so anyone who says he does is obviously a liar. All that is required of you as a citizen is that you do your part in making

life on this island as pleasant and happy as possible for everyone else so long as you live. What a place! But to continue—

We pushed our way through the undergrowth and there in a clearing was the most beautiful girl I'd ever seen coming toward me, her hands outstretched in welcome. (Yes I know you think I'm a most awful liar—but I can't help that —this is, as I've said, the most fantastic spot you've ever heard of—and it's all the truth.) I decided I wasn't dreaming but it was pretty staggering. Her hair was like a black satin cloak rippling to her waist in the soft breeze and her figure was absolutely stunning. I had plenty of opportunity to judge this and to notice that her skin was like silk, with a most beautiful even tan, for she wore nothing at all except an abbreviated sort of skirt of silk with a gay pattern in red flowers on it, and a pair of sandals with amazing heels (oh, I forgot the flower—she had a flower in her hair).

Like my bearers there was nothing of the native about her except in the grace of her movements — she looked more like a bathing beauty at a fashionable beach resort. She was just b . . . lovely at any time, anywhere, not just to a tired, and miserable sailorman washed up on the beach of a South Pacific island.

In perfect English (and her voice was like a caress itself—another of the wonders of all these wonderful people) she asked me how I felt, helped me off my stretcher to which I had been glued in astonishment—and then my eyes really did pop out of my head, for behind her in the shade of the trees to which she was leading me were three gorgeous blondes standing shoulder to shoulder in line abreast in front of a little rickshaw to which I saw they were attached by harness like ordinary pones. They had nothing on either except the harness and bridles and sandals, a tassel of coloured beads fore and aft so to speak, and a large plume attached to the brow band of the bridle.

Their hands were not much in evidence and as I mounted into this Island Rolls Royce I noticed that each girl's arms were folded behind her back and secured in this position with straps—but there was nothing of the captive slave in their behaviour—far from it — they smiled at me (as much as their bits would allow) — their great soft dark eyes twinkling under impossibly long curved lashes, and as my hostess arranged a cushion for me stamped their little sandalled feet and shook their heads in impatience.

Once settled comfortably, my

companion gathered up the reins, clicked her tongue, cracked her whip, flicked the shoulders of her unusual steeds and off we went. I turned to wave thanks to the friends who had carried me up the cliff and then fixed my attention once more on the intriguing spectacle in front of me.

The ponies needed no urging — they ran, in perfect step, with a smooth effortless grace that was a pleasure to watch—and did they go fast! with never a pause for breath. I have since found that any girl or boy here can do the 100 in 7½ sec. and keep up that speed for a mile.

I was naturally full of questions but though feeling much better was still too worn out to talk. My companion sensed it for after asking how long I'd been in the water said, "You must be very tired, just rest and we'll have you home in no time"—and instead of talking she sang softly in time to the runners as they flashed down the well worn winding track.

This, with the wine I had drunk (I still clutched the gourd—trust me for that), the scent of the flowers, and the sun as it flickered through the leaves, playing hide and seek on the satin skins of our ponies, and twinkling on the highly polished leather of the harness— made me drowsy, I was hypnotized by the rippling muscles of the gorgeous limbs in front of me, the little flying sandaled feet that hardly seemed to touch the ground, and the slender fingers now stretched, and now clenched to relieve the tension of the straps.

The gay red plumes of their unique headdress bobbed and waved in the air, challenging the brilliant colours of the birds which flashed overhead and the vivid butterflies which fluttered around the place.

One particularly large one of a most beautiful deep blood red and purple hovered around the heads of our ponies and then alighted on the shoulder of the one on the portside. This caused considerable excitement in the team—they suddenly ran even faster.

"That's lucky," said my companion, "for Gail, but not for me for it means I'll lose the finest team on the island. I know what you're thinking," she went on — "you're wondering about the ponies — every newcomer does — oh no, you're not the first shipwrecked mariner to land up on the beach," and her eyes twinkled.

"You see, we've got no horses, never have had—and it's been the custom for years for all the young girls from the age of 16 to 20 to take their place—I'll tell you all about it later."

"How do they like it?" I asked.

"They love it!" she replied. "It

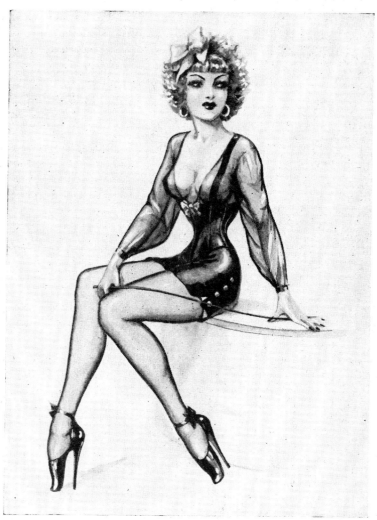

the dancing teacher.

is each girl's ambition to be in the fastest team. Why, that's what all the excitement is about at the moment. You see, Gail is over age for a pony but she asked the people's permission to stay on being in my team until after the annual races because of the other two and we're certain to win—but that particular butterfly settling on her shoulder means that she'll marry before the moon wanes— and then she'll simply have to go." By this time the ponies had got quite out of hand in their excitement — and were jumping and throwing their heads in the air while the rickshaw swayed drunkenly.

With whip and rein my companion collected the team until they were travelling smoothly again—but the butterfly still rested on Gail's shoulder. In silence we watched it, and then out of the corner of my eye I saw another, even bigger, butterfly of the same kind. I couldn't help grinning as the damn thing fluttered around my face and then rested on my shoulder. I looked over at the girl beside me and to my surprise saw consternation on her face, but suddenly another butterfly came out of nowhere and rested alongside the flower in her hair—and her expression changed to one of expectancy. Then her eyes sparkled and she laughed happily as those

two butterflies started chasing each other between us—now they were both on her, now on me.

The omen, after what she had just said, was too obvious.

The team sensed something was going on and Gail turned her head —immediately she drew the attention of the others to it and then they went plumb crazy. They threw their heads in the air. Their harness creaked as they strained against it—and if we'd gone fast before we literally flew now.

We shot round corners on one wheel, and even the butterflies decided to stop playing tig and to hang on for dear life. Gail's still clung to her shoulder, and I could feel mine somewhere up in my hair while the other had sought refuge on one of the beautiful breasts of the girl at my side.

She had given the team their heads and resting back on her cushions was singing again — a happy lilting tune, red lips parted, dreamy eyes half closed. Still we flew along.

The track widened and we occasionally passed a pretty little thatched hut tucked away amongst the trees—and little orchards and patches of cultivated land.

We passed other teams of ponies coming and going — sometimes a pair of girls in the shafts and sometimes three as in ours — and

I noticed with delight that all were equally as pretty.

My lovely companion came out of her reverie now and brought the team down to their long swinging stride again but they were most unwilling to obey and it was only after severe use of whip and reins that she managed to control them — in fact it really wasn't until the butterflies flew away that she gained the mastery but we were still going extremely fast and it was wonderful to watch her handling as we weaved through the traffic which was becoming more congested (and no darn traffic cops or red lights).

At last we came to the main village, but that hardly describes it; a fairyland is a better word — little huts almost hidden in an absolute profusion of flowers. Men and women waved in friendly greeting as, without checking pace, we flashed through a maze of wide paths until swinging across a little bridge over a little tinkling brook we drew up suddenly before a large shady verandah, and I clambered down.

I don't suppose it's usual — in fact I'm certain no rider in a stage coach, or buggy for that matter, ever did it before — but I couldn't help going over to the ponies and saying "thank you" — at which their eyes sparkled and they nodded their appreciation as they stood there on tiptoe—which made their harness jingle and the plumes dance gaily anew atop of their heads. They couldn't answer me because the wooden bits in their mouths, though thin and light so that they caused no discomfort, nevertheless made coherent speech impossible.

The chief with his wife and the rest of their family—for it was Malua, his eldest daughter, who had driven me in—welcomed me and helped me inside. As a matter of fact I'd finished the gourd of wine and was a bit tight but they took it to be plain fatigue. They were charming people and never have I met such gracious hospitality.

Before I quite realized what had happened I found myself bathed, and fed, resting on a couch in the shelter of a cool room—a delightful contrast to the harsh voice of the sea which I had heard at such close quarters for the last few days —and which now, as I relaxed completely, returned drumming in my ears. And I fell asleep to dream of mermaids harnessed to my raft drawing me across warm sunny seas in a glorious surfriding game of follow-my-leader.

(To be continued)

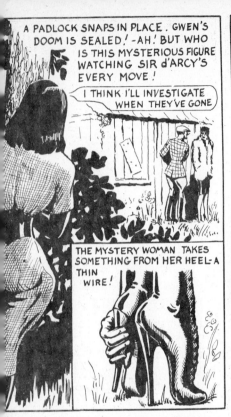

A PADLOCK SNAPS IN PLACE. GWEN'S DOOM IS SEALED! - AH! BUT WHO IS THIS MYSTERIOUS FIGURE WATCHING SIR d'ARCY'S EVERY MOVE!

I THINK I'LL INVESTIGATE WHEN THEY'VE GONE

THE MYSTERY WOMAN TAKES SOMETHING FROM HER HEEL - A THIN WIRE!

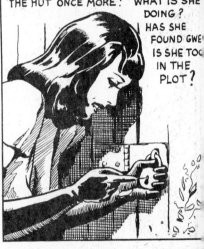

TEN MINUTES LATER SHE PICKS THE LOC AND ENTERS THE HUT! - TO REAPPEAR LATER FROM THE BACK! SHE RELOCK THE DOOR AND DISAPPEARS BEHIND THE HUT ONCE MORE! WHAT IS SHE DOING? HAS SHE FOUND GWE IS SHE TOO IN THE PLOT?

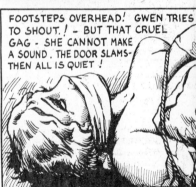

FOOTSTEPS OVERHEAD! GWEN TRIES TO SHOUT.! - BUT THAT CRUEL GAG - SHE CANNOT MAKE A SOUND. THE DOOR SLAMS - THEN ALL IS QUIET!

ALL HOPE IS LOST - GWEN'S STRUGGLES ARE IN VAIN - THE CORDS ONLY BECOME TIGHTER - EXHAUSTED SHE RESIGNS HERSELF TO HER FATE. THE DASTARDLY D'ARCY HAS DONE HIS WORK WELL! - BUT WHAT IS THAT SOUND UPSTAIRS?

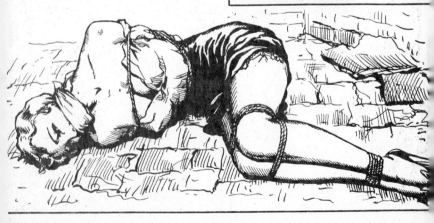

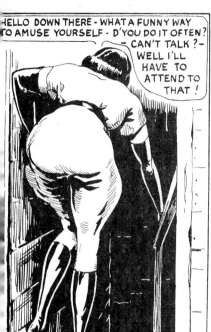

HELLO DOWN THERE - WHAT A FUNNY WAY TO AMUSE YOURSELF - D'YOU DO IT OFTEN? - CAN'T TALK? - WELL I'LL HAVE TO ATTEND TO THAT!

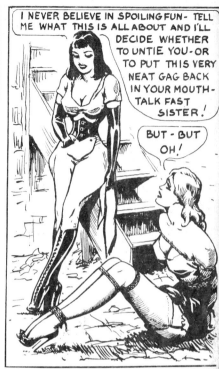

I NEVER BELIEVE IN SPOILING FUN - TELL ME WHAT THIS IS ALL ABOUT AND I'LL DECIDE WHETHER TO UNTIE YOU - OR TO PUT THIS VERY NEAT GAG BACK IN YOUR MOUTH - TALK FAST SISTER!

BUT - BUT OH!

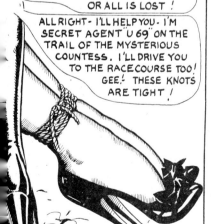

SO GWENDOLINE EXPLAINS -

OH PLEASE HAVE PITY - UNTIE ME OR ALL IS LOST!

ALL RIGHT - I'LL HELP YOU - I'M SECRET AGENT "U 69" ON THE TRAIL OF THE MYSTERIOUS COUNTESS. I'LL DRIVE YOU TO THE RACECOURSE TOO! GEE! THESE KNOTS ARE TIGHT!

WILL THE GIRLS ESCAPE IN TIME? SEE THE NEXT EPISODE.

CURSES! I'VE LOST MY LIGHTER! I'LL NI BACK - YOU WAIT IN THE CAR -

OH NO D'ARCY - I COULDN'T THINK OF YOU BEING SO ALL ALONE - I'LL COME WITH YOU!

COPR 1946 BIZARRE PUB Cº

Correspondence

On no account will names or addresses be published—nor do we put readers in touch with each other. All correspondence is handled by the Editor alone and all letters are read.

So many readers say "I'll send photos if you like." AGAIN we say "We DO like!" We welcome photos or sketches (no matter how amateurish) from readers themselves. Only one thing we ask in this connection—DON'T send photos you got from someone else and say they're your own.

Any reader whose letter is illustrated by J.W. may have the original by simply writing in for it.

Dear Sir:

"Fashions, fads or fancies." I suppose everyone in this life has one. Both my wife and myself are no exception. I include my wife as hers are exactly the same as mine. I consider myself fortunate in this respect but most probably she would not have been my wife if this had not been the case. Our particular fashion or fad or fancy is that my wife loves to wear high heeled shoes and the very finest of silk stockings and I love to see her wearing them.

Some of her shoes are truly astounding. The very first time I met her she was wearing a pair of blue glace kid court shoes with four and a half inch heels. Her feet are very small so you can imagine the delightful effect. Now that we have been married a few years she has quite become an adept at walking in higher heels. She never goes out in shoes with heels less than four inches and generally the rule is that her "walking shoes" have five inch French heels. She can walk literally miles in these kind of shoes.

Sometimes when we are going to the cinema or theatre, we go by car of course, she wears a pair of the finest silk fume stockings with a pair of black dull glace kid court shoes with five and a half inch heels. These, incidentally are my favourite shoes, the heels are so slender that they look as if they

will break at any time but she has never had that distressing experience.

Well, I could write for hours on this subject but as this is my first letter to you I feel that I should close now although if any of the other readers are interested I will drop you another letter describing some of the shoes that my wife puts on in the evening when she does not have any walking to do. These have high heels with a capital H.

Yours,
High French Heels.

Dear Sir,

I agree with B. W., bloomers are very attractive and most appealing. Since you must have many bloomer fans among your readers, why don't you run a whole series on this subject? This series might concern a single girl and be entitled "Bloomer Girl," or it might be about different girls or a group or girls and be called "Bloomer Girls."

With John Willie's excellent illustrations, I should think that you could devote a page or two a month to this subject, and I am sure that all of your bloomer fans would appreciate it. I suggest a full page picture or a group of connected pictures.

Yours,
Another Bloomer Fan.

ALSO TATTOOED

Dear Sir:

In your issue No. 2 of Bizarre was a letter from "Needle" on tatooing and as I'm well covered with "Needle work" I thought it may be of interest to others to hear something about it and perhaps stimulate this form of interesting and bizarre decoration.

My first design, a butterfly below my knee, was done when I was 14, and since then I have steadily added to the general scheme until I am more or less covered from knee to neck.

Rather on the lines of "Needles" big picture design, I have my back, sides and chest and stomach covered with a Chinese picture, with a big dragon completely encircling my waist, thighs and buttocks, this big colour scheme was done in London a few years ago.

As I do a lot of swimming, sailing and sunbathing, wearing the smallest of trunks, my works of art always arouse comment and admiration, but I am still looking for a girl who is sufficiently interested to be bitten by the "tattoo bug."

Best wishes to Bizarre.
Yours, "Needle Work"

Dear Sir:

I was very much interested in the letter of S. W. in the Vol 3 issue of your magazine. I com-

[37]

pletely agree that men are attracted by sheer silk stockings worn neatly rolled and without visible support from garters or garter belt. However, I feel that the important thing is that a certain amount (preferably a fairly generous amount!) of flesh should be exposed in *any* case. Such a breadth of lovely skin offers a wonderful breathtaking contrast between the smooth sheer stocking and the pantie clad upper thigh.

Do please lets have more photos . . . especially from readers.

———— J. D.

Dear Sir,

I read with a great deal of interest Dr. L's thought-provoking letter dealing with the refined domineering type of woman, and the role which he claims she should assume towards man.

The germ of it is as follows: "I feel that in the relationships between the sexes woman should be master and man should be slave. I think the world would be a better place if more men should feel as I do."

The above statements deserve applause among all truly refined, well-educated men and women, for here is a man who has both the courage and the tolerance to advocate what to many men and women would be slavish betrayal of man's traditional dominant role in sex-relationships.

Well done Dr. L! Very few men have either the courage or innate honesty to face unpleasant facts, let alone the wisdom and foresight to utter them, and especially is this true in regard to man's relationships to woman.

Lest this letter arouse undue controversy and speculation, I think it best that I refresh interested readers' minds in regard to the two main types of individuals on whom all enduring relationships are likely to be based—they are the dominant woman and the dominant man.

Both these individuals are usually, but not always, fitted by nature and environment to dominate and subdue their mate regardless of what he or she thinks, feels or does to prevent such submission, and all the criticisms by well-wishing but foolish friends and acquaintances directed against the subdued mate makes no real impression whatsoever, for a person held in such a state of love-servitude has no wish to escape, i.e. he(she) hasn't if the mistress or master is a wise discerning person who uses his or her power with moderation without brutality or hateful tyranny. —FM

HOUDINI?

Your campaign for self defense for defenseless womanhood is sound. However you seem to overlook the fact that a burglar

DON'T LET THIS HAPPEN TO YOU!

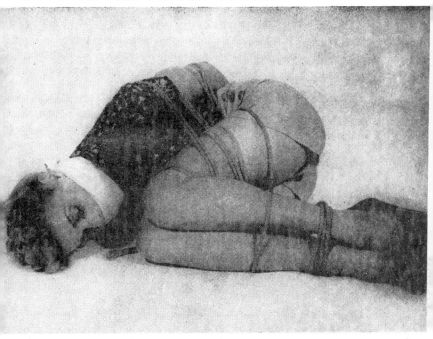

Learn Jiu-Jitsu and the Art of Self Defense.

As we have repeatedly explained, it is simply because so many books are available on the subject, and our space is so limited, that we do not as yet devote space to wrestling and jiu jitsu for girls.

But we are doing our best during the present troubled times by means of this advertisement (suggested by T.M. in Vol. 2) to encourage women to learn to look after themselves in emergency.

One reader has suggested that we go further and show methods of escaping from such an unfortunate predicament once the attackers have gone.

To be able to get free and summon aid quickly while the gangsters were still in the vicinity would be of considerable help. We will see if we can dig up anything on the subject and in the meantime hope that any readers who have any suggestion will write and let us know.

By courtesy, See letter by "Satin"

these days is usually armed—jiu jitsu couldn't be very effective against a gun, and once a body is trussed up it would seem pretty important to explore the bonds and know how to go about using to advantage any weakness or defect in their application.

Then on the other hand, supposing that by jiu jitsu you had succeeded in rendering your burglar or assailant helpless—where do you go from there? It might be pretty important to know how to tie the culprit so he or she would stay put while awaiting the police.

<div style="text-align:center">Yours,

"Kibitzer"</div>

All right—but we're not Houdini—suppose you or someone else tells us how?—Ed.

A LOVER OF SATIN

Dear Sir:

Enclosed are some photos of my wife. Thought you might be interested in them. They are only snap-shots, but really not too bad.

Your desire for freedom is most commendable, and pleasing everyone is impossible, and while I don't like everything, the general idea is there, and most appreciated. If you stick to high-heels, short tight-fitting skirts, thigh boots that shine, long clinging satiny gloves, corsets of all kinds in satin if possible (and "basks" too), silken hosiery, and lingerie of all descriptions, plus shiny garter belts and girdles, your magazine certainly will be enthusiastically received and be most popular.

My wife and I both love satin and she teases me and tantalizes me by having all her garments made of it and then by every means keeping me at arms' length. She delights in taunting and tormenting me by making me her complete slave. The idea that her silken, satin-clad self renders me

helpless and at her mercy delights her immensely.

With kind regards for continued success.　　Yours—"Satin"

Dear Sir:

Can anyone tell me why the smell of leather, particularly kid, should have such a fascination for some people? I have always been attracted by it, and although I suppose it really doesn't matter to me in the least, I would like to know if there is a reason.

"Leather Lover"

Some like Eau-de-cologne, some like musk, others Heure Intime — you like kid — why worry?—Ed.

Paddling For Peace

Dear Sir,

The girl friend and I have a ping pong paddle with which we settle all our disputes. The one who is at fault submits to a good, sound, old-fashioned paddling.

In case we cannot decide who is to blame we both take one.

I have never yet left her in an angry mood, and I am not sorry for the times we have decided I was in the wrong and I took my paddling.

It certainly clears the air and leaves neither of us with any feelings of old injustices.

We would like to hear through your pages if any other couples use this method and if it works out as well for them as it does for us.

Yours, E. A. B.

Oh For Ye Olden Times

Dear Sir:

I can't make your magazine out —but you do get the best ideas ever. I don't agree with your wasp waist enthusiasts and I think six inch heels look ugly—four inch is quite high enough, but I do like the idea of the scolds-bridles illustrated in Vol. 3.

I sincerely hope and trust that you may be the founders of a movement to see it re-installed—one in every home.

I could use one right now.

"Henpecked Harry"

With A Ti-yi-yippee!

My congratulations to E. V. E. Don't despair there are plenty of men who *are* men around. My husband caught me with a lassoo in Texas and has many times tied me with it since. I guess I won't ever be able to leave him because most of the time I cannot go any place.

On my thirtieth birthday which is also our wedding anniversary, only one thing will satisfy me — the identical costume of "a bit more 1952" from Vol 3. I think those chains are the cutest idea ever — but who does the housework in 1972?

Yours, "Dogie"

A Rubber Enthusiast

Dear Sir:

Perhaps if you publish this letter manufacturers of clothing may see it and then we may have garments and undergarments made of rubber. It is as soft to the skin as silk and more durable. It washes easily, its waterproof. It looks smart and feels wonderful. For my ideal of feminine beauty and for my own pleasure let all clothes be made of rubber.

Yours—"Malaya"

Dear Sir:

The letter written by the person who signed "Quelques Fleurs" in Vol. 2, was really wonderful. I do not see how any woman can consider herself well groomed unless she is well scented.

From head to toe, how can she demand the servility, that is due her charms, the homage? If there is one part of her that would offend the senses. What thrilling bliss to have your nostrils filled with the real delicate fragrance of delicious scent, clinging to each article of attire!

How eager it makes you want to kneel, to plunge your face into a well drenched heaven of delicious perfume and have her command all the tributes due her fragrant self! I noticed there was no pictures of Panties, soft, silky clinging. Please, are these not articles of well grooming? As necessary as long kid gloves or high heeled pumps?

To make up and ensemble breathes authority, then to be taken away carried on you, in memory of homage paid to one who demands it, as the beautiful and sophisticated of Paris, are used to having tribute paid their charms.

"Frenchy"

Dear Sir:

In the last issue of your magazine I find the name "Slaverette" mentioned by a reader who bitterly protests against the enslavement of men by their wives. I would like to tell that particular reader that no woman can enslave a man unless he wants to be enslaved.

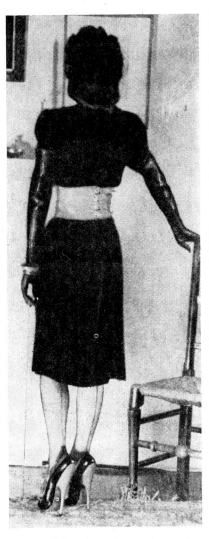

Smart and Very Attractive

I suppose I am the 'domineering' type. I have wanted to be boss ever since childhood and when my present husband proposed to me I made him swear that he would always obey me implicitly and I would brook no opposition to my wishes. He did swear, on his knees, and our marriage has been built on this premise—my absolute authority.

He must dance attendance to me, serve me in every way, do all the work around the house besides doing his job in the daytime. His pay envelope he delivers promptly, unopened — I give him pocket money. You may think only a nincompoop would do all that, but I assure you that he is a healthy, virile man. He enjoys doing his chores such as ironing my dresses and underwear, cleaning my shoes, dressing my hair and painting my finger- and toe nails. I have trained him in all the duties of a ladies' maid and, for the fun of it, often make him dress the part, too.

In spite of all his devotion there are occasions when we quarrel, but I have my methods of punishment. I make him stand in a corner until he is ready for the most abject apologies. Cruel? Not at all — I just believe in strict discipline. And he loves me the better the stricker I am.

Am I a slaverette? Maybe, but I believe we would have happier marriages if more women would

keep their husband severely in chain and dog collar.

"Ursula"

―――

Dear Sir:

Being one of those naughty girls in my younger days I naturally spent considerable time over mother's knee and so the letter by H.S. had a certain appeal. Even now despite the fact that I am a married woman of twenty-four years of age, my husband still appeals to the "Seat of Government" on certain occasions and I readily say that it gets results. At least it does for awhile with me.

I think a good spanking is good for any girl until she becomes emotionally stable enough to control her behavior, at whatever age such a balance may originate.

I also agree with Le K. that a bawling out is not a very good way for settling a dispute as it does leave everyone in a very high-strung mental condition. I would not change our way of discipline for anything.

Mother never nagged us. When we were naughty we were soundly spanked and I can assure you there was never anything between her hand and us when she did. My hubby uses the same method with me now and we get along very well.

I have a lot more respect for his wishes due to the fact that he does assert his manhood quite frequently by the use of a little force. I wouldn't have him change for anything in the world.

I wonder how many other couples use this form of discipline?

Respectfully,

A regular reader.

Dear Sir:

A famous American sporting writer has launched an attack upon girls indulging in athletic games. He thinks they are not beautiful, and forget about their feminine charms. This may be true enough, but there is no necessity for it. The modern maiden is health-conscious and her interest in wholesome athletic sport merits nothing but praise. Beauty must always be founded solidly upon health, and outdoor exercise is as necessary for women as for men. But there is no reason whatever why girls and women cannot retain their feminine allure while indulging in athletic games. The Victorian maiden played tennis while tightly laced into a wasp-waist corset, and the modern maiden can certainly learn to do the same. Nor is there any reason why she cannot play games with a cigarette between her lips adding to her piquancy. Her tennis costume can easily incorporate the daring low decollette in a blouse effect; or it can utilize the completely bare back and bare midriff

of the modern bathing suit. Her shorts can be alluringly cut, with slits on the sides. High heels will have to be foregone, of course, in certain sports, largely because of the surface on which the game is played (as in tennis); but this factor is somewhat compensated by the fact that the game itself, by its athletic nature, will cause

her to be on her toes, thus giving the alluring arch to her feet that high heels make permanent. In other games, it is possible for her to display the loveliness of her bare feet, beautifully painted.

My suggestion, therefore, is that your artist should present a series of drawings depicting the Modern Athletic Girl of Tomorrow. The accompanying rough sketch gives an idea for the Tennis Girl, for example. Golf, Swimming, Horseback Riding, Basketball, Fencing, and other sports, can all be presented in turn, in a way that shows that the modern maiden can get all the benefit of healthy and wholesome athletic activity without necessarily sacrificing the allurement and loveliness imparted to her by cigarette or cigar smoking, by tight-lacing, by lavish makeup, by seductive dresses, and by either bare feet or high-heeled shoes.

Sincerely yours,

R. V. F.

A MODERN CAVALIER

I am well built and have recently been discharged after four years overseas with the Commandos, and yet I have loved a high heel ever since I wore my sister's shoes when a small boy. That we shall see a return to the days of the Cavaliers, when men wore them in public, is too much to hope for. I frankly admit that I haven't the courage to start the fashion.

Yours—"H.I.J.K."

Correspondents will help considerably by enclosing stamps for a reply.

Thank you.

Ed.

WHOA!
STOP!　STOP!　STOP!

PLEASE DON'T CUT IT OFF!

We would be very glad to give the usual credit—for never was credit more deserved, but who this lovely lady is — we don't know. If someone will tell us we'll gladly oblige.

Ed.

Dear Sir:

I enclose a photo which I came across the other day showing what I consider to be the longest and most beautiful head of hair that I have ever seen.

I am afraid I cannot say who the beautiful girl is because I do not know (though I would very much like to know).

I bought the photo as is, no name, or other means of identification.

At the same time that this picture thrills me with its beauty it un-nerves me—for as you can see an assasin with a pair of scissors is nibbling at those wonderful tresses.

I cannot believe that she is actually going to have it cut off but the scissors are too close for safety—one slip and there will be the most horrible tragedy.

Perhaps if you publish this picture all those who delight in the beauty of long hair will join me in a mass appeal.　Yours—

C. L.

——————

Dear Sir:

Please give us some more "bloomer" pictures as on page 41, Vol. 3. I like them short or long, snug or full, cuff or gathered, plain, ruffeled, or fancy.

Thanks. Yours truly,

A subscriber.

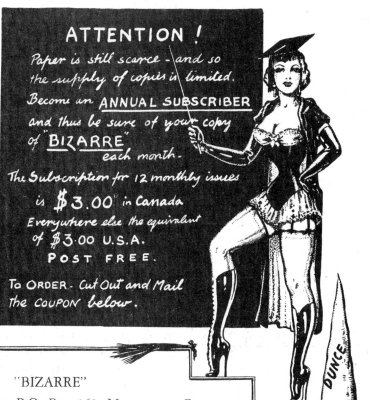

ATTENTION !

Paper is still scarce - and so
the supply of copies is limited.
Become an **ANNUAL SUBSCRIBER**
and thus be sure of your copy
of "<u>BIZARRE</u>"
 each month.

The Subscription for 12 monthly issues
is $3.00 in Canada
Everywhere else the equivalent
of $3.00 U.S.A.
 POST FREE.

To ORDER - Cut Out and Mail
the COUPON below.

"BIZARRE"
P.O. Box 162, Montreal, Canada

I enclose $3.00 as subscription for 12 issues whenever
they may be published.

Name...

Address..

...

**NOTE: We do our best but owing to the uncertainty of
the supply of paper etc., we do not guarantee to publish
regularly each month. Subscriptions are for 12 consecu-
tive issues.**

Copyrighted 1946 by Bizarre Pub. Co.

[47]

THE WASP WAIST

(Continued from Page 16)

It consists of a light piece of wood to which straps are attached. The leather and wood are mellowed with age. There is a wide strap at the top which goes around the neck, then two narrower ones at waist height. One of these goes around the waist and the other draws the elbows well back until only the thin wooden bar separates them. One at the bottom secures the wrists, placed palm to palm on each side of the bar.

With her arms in this position she cannot sit in an ordinary chair for her fingers and the bar are too long. So she sits in one which has been specially designed, so that she may lean against the back while her fingers project behind and below the seat.

This particular device is severe but what a proud elegant position it gives to her bust and shoulders! Her shoulders ache and if she relaxes her strained neck she almost chokes—but she does not notice the discomfort as the maid skillfully brushes her long, lustrous hair until it shines, the light glinting on the soft waves as they cascade over her almost to the floor. She loves having her hair brushed and always insists that this form of figure - training device is used when it is being done, revelling in the bitter-sweet comparison. She makes a mental reservation, as she sits with her eyes closed in ecstasy, that she will teach her future husband how to brush her hair and then live in a paradise of a world day after day with him.

Hurrussh! Presto again! And we are once more peeping at the lady of fashion. She too is no stranger to the device in which Miss Nancy is imprisoned, but she is trying out a new one which is not quite so uncomfortable but which her corsetiere assures her is equally effective in inducing one who would have chic to hold her shoulders back—and one which quite too definitely prevents resistance to the full period of training.

Little Pipette clasps her hands in rapture as her mistress views the effect in conveniently placed mirrors. Her corset does all that a good corset should do. Her full and beautiful breasts nested in frilly lace are thrust into prominence. Her waist is squeezed in to the full 12-inches and her ample thighs are compressed by the tightly boned corset apron which is attached to her silken stocking tops. She turns this way and that gracefully on her little six-inch heel slippers, to get the full view of the effect of the single fingerless kid glove which encases her arms, fastening with a single lacing from her knuckles to just about her elbows. At the top the lacing is tied

from PARIS

Her suitcase packed — and ready — studying the road on the map — dressed in carefree jumper, shorts and low heeled shoes for the week-end trip — the Parisienne still manages to add that little touch of chic to her toilette which is second nature to her — by the beautiful embroidery on her silk "pantalons."

[49]

to the high back of the corset. Her shoulders are drawn far back as she wishes them to be, but the soft kid which holds her arms so immovably behind her does not hurt even though the laces have been drawn in as tightly as possible, and as she can ordinarily make her elbows meet in this manner without any artificial aid, she is in no discomfort—but it will be most annoyingly uncomfortable presently nevertheless, for her maid will refuse to undo it for at least two hours, which is one of the reasons why she is so attached to Pipette and keeps her on in spite of the notice which she invariably gives her during the training period. Pipette is pretty and has the art of applying not only to herself but also to her mistress all the charm and chic of her French ancestors, but she is an artist and a tyrant when it comes to figure training. No matter how her mistress may plead, threaten, give her notice, or beg for mercy, she is adamant and the satisfaction of both is in the number of admirers who fall at milady's feet.

Well, there you have it. A picture of how "it", "oomph", or whatever you like to call it was obtained in Grandma's days when the wasp-waist was then in vogue. If the fashion for the wasp-waist returns (and from all present indications it is quite likely to do so), women will have to realize that though physical exercises and massage will do wonders up to a point, there is definitely a point beyond which they can do nothing, and then the simple old-fashioned method of brute force will have to be employed. Now you know what you are in for and don't say we didn't warn you!

These are only a few of the total number of devices employed. The total number and variety is amazing but there is not the space in this issue to go into them.

Printed and Published by
BIZARRE PUB. CO. - CANADA

PUZZLE?

WHAT GOES ON?

Where is she?

What is happening?

See the answer in next issue No. 5

VOL 1 No. 5

1946

BIZARRE

Correspondence Digest

By means of this "Correspondence issue" we are endeavoring to catch up a bit with the pile of letters which has been steadily mounting. We sincerely hope that you will write in and comment—favorably or otherwise—and we will then be in a position to know whether to repeat it.

This paper business is a worry—if it's not one reason why we cannot get any then it's another, and printing costs have just about doubled in the last twelve months. Old Marmion should have lived in these days when he said, "On Stanley, on!" I keep saying "On John Willie, on," but it makes no impression.

But to return to the letters in this issue. Once more we have just played grab—shaken them up in a hat and taken pot luck. If your views are still not expressed here don't worry, we'll come around to them in time.

R.V.F. is most profuse in his writing for which we take this opportunity of thanking him—but in future when anyone cuts pictures out of magazines to illustrate a point will they please mention the name of the publication and we may then be able to secure a print for reproduction.

And once more please "don't" ask us to take sides. For freedom of speech the Editor must be impartial—our only policy is to open our pages for discussion of this and that which other periodicals pass over. Perhaps you think that high heels or corsets are essentials, that all should wear them—or maybe you think them ludicrous and their wearers depraved—all right—but don't ask us to champion you and cut out the offending remarks—it's a free world and we try to be fair. After all, everyone of us is entitled to his or her own views and we would hate to see everyone compelled to wear ultra-high heels just as we would hate to see them abolished—it's not the heel that's the question, it is the simple word "compulsion" because someone else's views are different to your own. That is the whole crux of the matter.

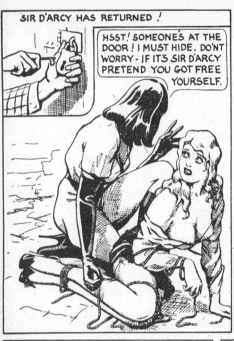

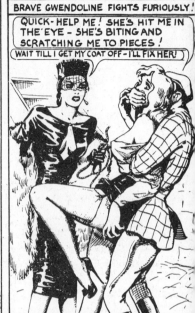

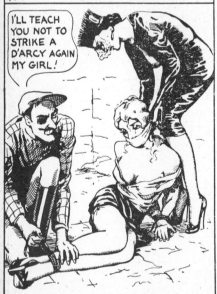

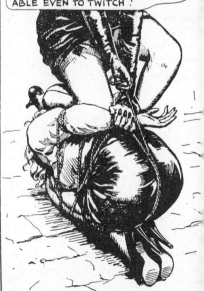

WITH A VICIOUS PUSH THE COUNTESS ROLLS HER HELPLESS VICTIM OVER ON HER SIDE

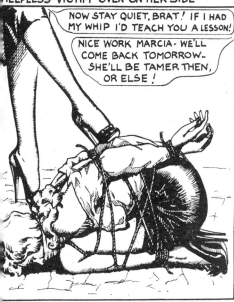

NOW STAY QUIET, BRAT! IF I HAD MY WHIP I'D TEACH YOU A LESSON!

NICE WORK MARCIA- WE'LL COME BACK TOMORROW- SHE'LL BE TAMER THEN, OR ELSE!

I DON'T THINK OUR LITTLE PIGEON CAN GET FREE. BUT WE'LL WAIT AWHILE "M"- THEN WE'LL HAVE A LOOK AT MISS HOUDINI! HAHA!

SO THAT'S THEIR GAME- WELL WE'LL SEE! HAHA!-VILLAIN!

CREEPING BACK TO THE HUT, U 69 QUICKLY UNTIES SWEET GWENDOLINE

SORRY TO BE SO LONG GWEN - THEY'RE COMING BACK SOON. BUT I KNOW A BACK WAY OUT OF THIS - FOUND IT WHEN I FIRST CAME IN. MY CAR'S QUITE CLOSE. I BET THEY'RE SUPRISED!

GEE! THEY USED ENOUGH ROPE ON YOU!

OH HOW CAN I EVER THANK YOU!

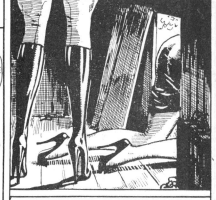

IN THE HUT 10 MINUTES LATER

GREAT HEAVENS! IT'S NOT POSSIBLE! HOUDINI!-THE CAR QUICK! WE MUST PURSUE HER!

WILL SIR D'ARCY CATCH THE TWO GIRLS & SEE THE NEXT EPISODE.

COPR 1946 BIZARRE PUB C°

[5]

orrespondence

Dear Sir:

My husband and I were so delighted with the picture of the white rubber mackintosh in your last number, as well as glad to learn there are others interested in rubber clothing. We love walking and sweethearting in the rain, for which we have a variety of costumes, capes, coats, hoods, boots and gaiters. Most of all, however, we like wearing bathing caps — thick, strong black ones in the chin-strap style — and long ago we found we simply couldn't get along together unless we wore them around the house, under the shower, in bed, etc.

As you can imagine, we had a dreadful time during the war, and though that period of rubber shortage is now mercifully over, we have both noted with dismay that bathing caps of rubber don't enjoy their former popularity on the beaches. Plenty of those stupid white resin ones, — but who cares for them? Gone, it seems, are the good old days when a girl at a beach or a pool had at least the chance of seeing some gorgeous man in a shiny black rubber cap, and perhaps even of inveigling him into some innocent aquatic horseplay, ducking him or being ducked! Dear Editor, please ask Mr. Willey to give us some photographs or drawings of girls and men in bathing-caps, won't you? My husband joins me in this plea.

——— "Madcap."

More Jewelry Please
Dear Sir:

Why don't more women realize the beauty of jewelry, and in particular earrings and pierced ears, and bracelets worn on gloved arms. It is so seldom that we see a girl who knows what a difference they make in her appearance.

Before the chemists discovered how to make such perfect imitations in paste — to wear diamonds and pearls required a large bank balance. Today jewelry, good imitation I mean, is within reach of all, and yet it is still conspicuous by its absence.

A long black velvet evening dress, very low cut — and long black shoulder length gloves form an ideal background for drooping sparkling earrings — and heavily jewelled arms.

It must have been wonderful to live in the courts of other years — what magnificent sights were there in every direction, what beautiful women, their dresses, their hair, their arms and even their ankles, and dainty slippers sparkling like the heavens on a starry night!

Perhaps women only like the genuine article and won't wear paste. I prefer it myself but I admit I am not such a connoiseur of jewelry that I can tell the difference between real and imitation, and if there is a girl who thinks as I do I will spend every penny I possess to see that she is gratified.

Yours—"Sparkle"

Dear Sir:

Like a previous writer, I also find bloomers a very appealing piece of feminine attire—especially if they are of sheer pink silk. The new style bloomerette panties are particularly attractive with their elastic waist and elastic high above the knees. I hope you can have more pictures of bloomer-clad girls. Would appreciate a picture of a young lady dressed in a bra, bloomerette panties, and neatly rolled silk stockings. Another favorite of mine is the girl wearing tiny, very skin-tight satin or silk panties.

I agree with I. J. and Le K.'s letters, stating that many prefer a good spanking rather than a severe "talking to." I know several girls who definitely prefer a painful episode—to an upsetting "lecture." How do others feel about this?

Perhaps many think the ideas of the writer, who signed himself "Lingerie," sort of silly. But why so? Indeed, why should women have the monopoly on colors and beautifully made garments? — I think it about time for men to stop being so plain and conservative in their dress. And I don't think it silly or effeminate to prefer frilly, pretty undies. I have always felt that "every one to his own taste." Must we all be "standardized zombies," as a prominent scientist has said? What we need is more stressed individuality.

Yours truly—L. J. C.

Modern Misses Club
Dear Sir:

This is my own design of an evening gown for summer time use, and it turned out to be beautifully cool and comfortable to wear, and I received many compliments on my turn out that evening.

The material of the dress is silver lame, and the belt and shoes are of black patent, the latter with 6-inch spike heels. I had to have

the belt especially made for me. It is a perfectly plain black patent belt, 9 inches in width, and fastening in front with lacing. It is reinforced and actually is used more as a corset than as a belt, and can be pulled in as tight as the wearer desires. I may say that it took my maid a good half hour to give me the 21-inch waist which I demanded of her.

Although it appears in the drawing that this is a three-piece dress, it actually is all one, the front edges of the gown being stitched in to the lining of the belt, the only way in or out of it being by undoing the front lacing.

The panties are very brief and are made of silver satin.

As I am not an admirer of the gap between stocking and panties, I managed to get a friend in Hollywood to get me a pair of sheer black nylon tights (horrible word) these were thrilling to wear and showed off to perfection my legs against the silver kid background of my skirt, and also drew attention to my glistening shoes with their towering heels.

A pair of shoulder-length black kid gloves completed the outfit, which judging from the many compliments I received during the evening, was a great success.

Yours very truly,

"Daphne"

A Corset Lover from N. Z.

Dear Sir:

I have always been interested in improving my figure and general deportment and, now that the war is over, my husband has promised to buy me any special appliances, accoutrements, etc., I may require to achieve my desires in this direction. Naturally I fully intend to make the most of the offer and I would appreciate advice from the readers experienced in figure training, etc.

I have always led an active life with plenty of golf, tennis, etc., but when not so occupied have preferred to be well corsetted and high heeled. My corsets are all well boned and when feeling tired and droopy I find great comfort in lacing on a high well waisted pair fitted with shoulder braces. Now, however, I intend to intensify my training and soon hope to have several pairs of special corsets, including one pair in black patent leather. With these will be high boots both knee and thigh length, long kid gloves and perhaps a special collar to enforce an erect carriage of the head. Later I shall endeavour to forward some photographs of myself undergoing training, if readers would be interested.

Yours truly—E. F.

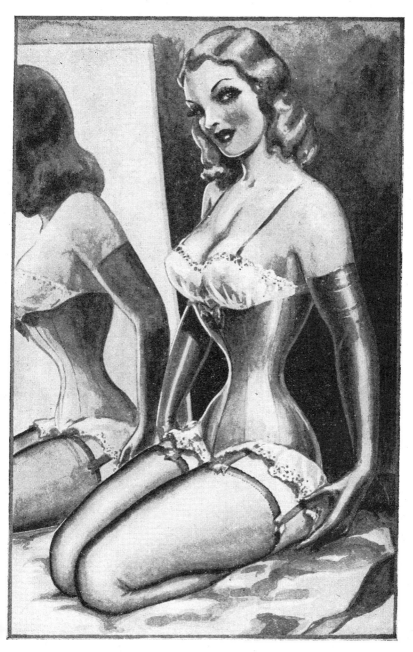

Looking into the future

THE ANSWER TO THE PUZZLE IN No. 4

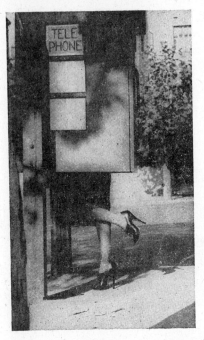

Just an old Telephone Box
in Sydney, Australia.

Dear Sir:

I have just read in Vol. 2 of your Bizarre Magazine where I.J. mentions the fact that although she is 22 her parents (I presume I.J. is a girl) still threaten to whip her.

I don't think that is so unusual at 22. Although I can say that a whipping generally is given with a switch or cane or a slipper or hairbrush, I don't approve of using anything but the palm of the hand. It just doesn't seem right to strike a girl with anything but the palm of a hand.

My wife is 26 years of age but she still goes across my knee and gets a good spanking on her silk undies when she needs it which is fairly often. There is nothing cruel or inhuman about the treatment. Our home is a very happy one and once the spanking is given the incident is closed. No arguing, no unpleasantness is involved. My wife, the one who should complain, sanctions this method of settling a dispute. We both think that other couples could derive a lot of benefit from this same method.

We would like to know thru your "Correspondence" Corner — how many other husbands spank their wives for punishment.

Sincerely,

"Hollywood."

Dear Sir: ———

J.W. again has some very fine drawings. I like those for fancy dress. How about some costumes for the males? Or are they supposed to sit around in business suits, while the girls disport themselves in costumes as shown? How about a white silk or satin blouse with very full sleeves, with deep cuff fastening at the wrist, with "V" or inverted "V" closed at the

throat, with or without standing collar at the sides and back, ruffled or plain, black satin knee breeches, or shorts, with wide patent leather belt at the waist, black silk stockings, with buckled or plain pumps, with medium high heel? Take it from there J.W.

I am in a sceptical mood today; about those small waists and high heels. Those 13-inch waists would have a diameter of less than 4½ inches, that I would have to see. And Anne's 7-inch heels, unless she takes about a size 12 shoe, I don't see how she could walk in them, or aren't you supposed to walk in heels of that height. Just for curiosity, I obtained a pair of women's shoes size 8 (which is a 10½ foot size), I ripped off the original heels, and built a pair of 6-inch, adjusting the arch support to take care of the different angle of the foot. I found it was just possible to stagger around with bent knees and just the tips of my toes on the ground, and impossible to stand upright, without throwing the foot bones out of joint, or breaking them. Maybe the girls, who are used to wearing high heels, are conditioned to wearing those extreme heights. But 7 inches????

I am in favour of lingerie for men, velvet satin and taffeta, for clothes. Let's have a clothing revolution. What say, fellers?

C. McC.

A Sensible Squire

Dear Sir:

I simply fell in love with the lovely pictures of pretty legs dressed in soft silk hose and uplifted by very high heels. Also the party costumes like Miss Texas brought me much delight. Before joining the Army I was lucky enough to be acquainted with a young lady that had much the same ideas regarding dress, especially High Heel Patent-leather Pumps, that I and so many of your readers have. Whenever I wanted to make her happy we would go shopping for shoes and all that goes with it, stockings to match, belt and gloves. Upon arrival at home she would then dress in those articles I desired to see on her, high heel shoes, black hose, black garter belt and brassiere to match. She was then my little goddess and I her slave. We had lovely times.

I often wish I could bring them back.

"Hi-heel Don."

Dear Sir:

I enjoyed your No. 3 issue even better than Volume 2, chiefly because of J.W.'s new serial, and his

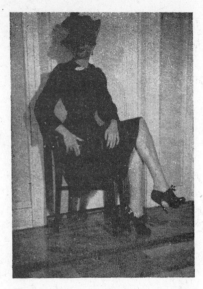

from a reader in New York

fascinating illustrations on pages 16, 21 and 44. The domineering, militant-looking young woman on page 16, particularly intrigues me. That young lady appears to be the type of woman I find irresistible above all others—the woman who, in her dealings with men, is a veritable "silk stocking tyrant"! I think it would be thrilling and exciting to be the well-disciplined male slave of such a fascinating creature!

Well, I see the oft-told tale of the beautiful young daughter, the mortgage, and the fiendish villain is back with us again. I have a hunch I'm going to have a new favorite comic strip, and also a new favorite comic strip character, —the latter being the exotic-looking Countess. Will our hero and heroine win out, as usual, or will they go down to ignominious defeat? Will poor Gwendoline be forced to marry the fiendish Sir D'Arcy? Egads! Wouldn't it be a "Bizarre" ending if she did!

—S. W.

Now! Now! don't be impatient! — everything comes to him who waits.—"d'Arcy."

Bootee Beauty

Gentlemen:

Your article on "High Heels" in the January issue has given me an idea, which I pass along for what it is worth. Achilles speaks of "a graceful taper, fading away to nothing—streamline if you like —is always attractive." To work to this end, why not eliminate the heel entirely? The enclosed sketch gives a rough idea of what I mean.

A boot would be made which would cause the foot to continue in the same line as the leg (similar to a ballet dancer's position on tiptoe). A specially reinforced tip would be required, and the ankle would perhaps require steel braces on either side. Then — why not eliminate buttons or laces by making a zipper the full length of the boot, causing it to fit snugly to the knee, or even the thigh?

Such a boot would be the ultimate in streamlined grace and feminine helplessness. I should appreciate a drawing or photograph in your next issue, showing a model with such a pair of boots.

Very truly yours—J. S.

Speaking from Experience

Dear Sir:

I think that those of your male readers who advocate such extreme heels should know what it's like to wear them—I do.

I carefully replaced one by one my wife's pairs of normal high heeled shoes with the highest I could get (this was before the war), until at last I had her perched on 5-inch heels all the time—a formidable height as she wears a size 4 shoe.

Though liking to wear them around the house she always complained of how uncomfortable they were for any length of walking—but I was adamant and would not tolerate the idea of lower heels for shopping or walks in the country.

One day she remarked that I ought to try them myself to see what it was like, to which I naturally replied that I'd be able to do it easily—and then forgot all about it.

About a week later my wife was all smiles one Sunday morn-ing and on my breakfast plate was a parcel with best wishes from her. I opened it and to my surprise found a pair of black kid pumps with five-inch heels of a very much larger size than those worn by my wife. She told me that they were for me and that if I really wanted her to wear five-inch heels for walking she was agreeable to do so if I could wear these—and as she pointed out, with a much lower-er heel by comparison than the ones I wanted her to wear.

When I went to dress I found all my shoes had been taken away —nor could I find any socks—instead a pair of silk stockings was lying on the bed. Well, I couldn't very well back down so I put them

from a reader in Paris

To get used to them I stopped on—but wearing my house slip-pers, carried the pumps out to the car, and we drove off on this fine sunny morning into the country for the great test.

the car along the road and put

them on and then continued to drive—they looked extremely neat and were comfortable, so I felt full of confidence. We turned down a side road and got out. I walked around with ease after a few moments of uncertainty and suggested that we now start on a hike. I had to take very small steps but I was going fine—for about 5 minutes. Then my toes began to burn and every bone in my foot seemed to begin aching, and those shoes became the most dreadful things I'd ever had on my feet. I daren't show it for then I would have lost to my wife. Finding excuses to stop and admire this and that was no use—they still hurt.

Somehow I managed to keep going — my wife urging me to go faster and me talking about enjoying the beautiful scenery, but I knew it was only a matter of minutes before I'd have to admit myself licked—and then, thank goodness, it started to pour with rain, so we took shelter under a tree and I carefully stood with my toes on a root so that the heels were less high. Then the rain began dripping through the leaves and I had a brain wave.

My wife was anxious to get back to the car and I agreed but refused to ruin my new shoes— or hers—and insisted that we take them off.

We padded back in our stocking feet and I found it necessary to tread in every puddle I could find. Oh, the coolness of the water on my tortured feet!

So now my wife still wears her extremely high heels but I no longer insist that she does so. If she does, to please me, wear them outside I usually insist that we take a taxi or street car and cut walking to the minimum — a compromise to which she is quite agreeable.

Yours—J. E. Y.

SOME INTERESTING CUTTINGS SENT IN BY A READER

From "The Girls Own Paper" July 1888.

It seems as if people were never weary of discussing the subject of tight-lacing. One of the weekly papers has had a running correspondence on the subject, which has been accompanied by illustrations of small waists, which were enough to appal the stoutest heart. Some of the letters, too, were very dreadful to read; and altogether one cannot help hoping that someday our girls and women will cease to make such guy's of themselves, and to do such a foolish thing as to risk the health and happiness of their lives.

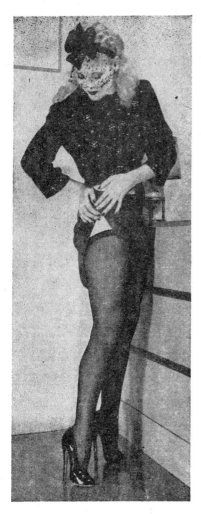

full opera length hose

*From "The Young Ladies
Journal"—Oct. 1892.*

SLIM WAISTED GIRL—(1) Yes,
your waist is decidedly small, con-
sidering your height, and from
measurements given, we should
say you have a very good figure.
The result of your tight lacing
when so very young might have
been serious, and the discomfort
you mention doubtless arises from
that cause; we advise you to lace
your corsets less tightly, and on no
account to sleep in them, as serious
internal complaints might arise.
It is a great mistake to sacrifice
health for the sake of a slim waist,
and you would surely regret it if
you became an invalid all your
life.

(2) It is not always possible for
girls to prevent their hands being
red, as defective circulation is fre-
quently the cause, especially among
growing girls. Let your sisters
sleep in loose kid gloves every
night, smeared inside with cold
cream. Before going to bed the
hands should be washed in very
hot water, rubbed with prepared
pumice-stone — dried with a soft
towel, and then lemon juice rub-
bed well into the skin.

* * *

From "New Family Physician",
1901.

Not aware of the consequences,
or defying them, the mother, as
we have said, too often compels
her child to submit to a constric-
tion of the waist. If she happens
to have two daughters, one more
robust than the other, she endeav-

ors to bring the robust one to the same size as her sister by the corset apparatus. Cries and tears are alike disregarded—the poor girl is forced to submit. In one instance, within our knowledge, a mother violently beat her daughter to make her submit to the process of compression.

* * *

Light on Dark Corners. 1896.

The most extensive and extreme use of the corset occurred in the 16th century, during the reign of Catherine de Medici of France, and Queen Elizabeth of England. With Catherine de Medici a thirteen-inch waist measurement was considered the standard of fashion, while a thick waist was an abomination. No lady could consider her figure of proper shape unless she could span her waist with her two hands. To produce this result, a strong rigid corset was worn night and day until the waist was laced down to the required size. Then over this corset was placed a steel apparatus. This corset cover reached from hip to throat, and produced a rigid figure over which the dress would fit with perfect smoothness. During the 18th century corsets were largely made from a species of leather known as "bend," which was not unlike that used for shoe soles, and measured nearly a quarter of an inch thick.

From Tit-Bits, 1894.

About a fortnight ago, I informed my daughter that it was my wish that she should not unlace her corsets on retiring to rest. To my great regret, I found that she had been reading some of the nonsensical tirades against tight lacing, in some of the papers, and has become impressed with the idea that being made to wear properly-laced corsets was equivalent to being condemned to death by slow torture.

On my telling her, the other night, that I was dissatisfied with her figure, and of my resolve that she should adopt the measures I mentioned, she declared she could never endure it, and, I am sorry to say, showed a very rebellious spirit. However, she wore them the first night, after much protestation, but on the second I found that she had taken them off after I had retired to rest.

I then took the precaution of fastening the lace in a knot at the top of the lace holes, and for a night or two this had the desired effect; but she was not long before she cut the stay lace.

I have punished her somewhat severely for her disobedience, but she declares she will have any punishment rather than submit to the discipline of the corset. She is now fourteen, has a very strong

from an admirer of boo

constitution, and is in perfect health. She does not complain that the tight lacing makes her feel ill —did she do so, her appearance would contradict her. Her only objection is that the corsets are uncomfortable and prevent her from romping about as she has been accustomed to do. My object in writing now is to ask if any of your readers will kindly give me their advice in this matter, as I cannot allow my daughter to gain the mastery. Perhaps some lady or principal of a school would kindly inform me what method she has adopted in similar cases, and what is the best way of preventing a girl from destroying her laces or stays when out of sight of her mother or governess. If anyone will do so, she will confer a great favour.

The Return of the Corset
Dear Sir:

Yes, the corset is back! Those women who really desire the ultimate in feminine allure now find it indispensable for the production of the tiny tube-like waist that men always found so thrilling and adorable in women. It is unquestionably true, as stated in the January issue of *Bizarre,* that even ultra-tight lacing, properly carried out, does not impair the health in any way whatsoever. As already

pointed out, our feminine ancestors suffered no ill effects from the practice, and possessed enviable and truly womanly figures.

Yours, "Staylace."

One may add that they proved themselves more capable of bearing and nursing children than most present-day women. The superstition of the harmfulness of tight-lacing is merely a result of the outmoded Puritan propaganda that sought to dissuade woman from practicing those arts of sexual allure that are so essential to the fulfillment of her inmost nature. But with the death of Puritanism, the return of tight-lacing and the wasp-waist corset is a certainty.

So Puritanism is dead eh?—well all we can say then is that it's kicking about in its grave.—Ed.

A Painted Mask?
Dear Sir:

I want to know where I can get, or make, Face Enamel. I remember reading that way back in 1900 or so, fashionable ladies used to paint their faces with enamel. When it was applied thickly enough, it was just like you had a china face. Your features were quite rigid, and you couldn't even smile.

My boy-friend likes me to wear the most extreme makeup. I live alone, and when he comes to my apartment I'm always made up in

a way that would fairly put a movie-star to shame. Now I want to go a step farther, and greet him with my face quite rigid, made up in the hautiest expression imaginable.

Can somebody held me, please?
Yours—Rene.

Beauty In a Riot of Colour
Dear Sir:

Achilles is quite right in stating that the notion that high heels are injurious to health is based on ignorance of the facts. Our feminine athletes, golfers and swimmers and tennis players, all wear high heels when not engaged in active competition; female dancers wear high heels even when performing graceful and complicated dances on the stage; and women, who have always worn high heels, live definitely longer than men do. George F. Jowett, one of the leading authorities on physical training, and former editor of "Strength" and "Body Power" magazines, writes that "women have more shapely lower-leg development than men do, because the feminine habit of wearing high-heeled shoes causes greater action and use of the calf muscles." Indeed, the high heel merely makes permanent the beautiful curve of the foot that appears momentarily in ballet dancing.

As for the silly objection made by a few foolish people that high heels are unnatural, one cannot do better than quote from Dr. Gerald Wendt in his book, "Science for the World of Tomorrow" (Norton, New York, 1939):

"We may assume that the real purpose of a style is attractiveness. And attraction may be found in many qualities. Attractiveness is not necessarily beauty. Above all, to be attractive is not necessarily to be natural. We need but look about us to see that style commonly tries to defeat nature, or conceal nature, and at best to improve on nature. A woman of today may

be dressed from head to foot in synthetic materials, and her very person is made unnatural by a long list of synthetic cosmetics. The words "unnatural" and "synthetic" have long since lost their reproach. The lady rightly has no love of nature. She knows, we all know, that it is only easy and effective but eminently desirable to improve on nature. In lipstick, rouge, and perfume it is impossible to deny that the cosmetic industry has succeeded in improving on nature. For the present it is still true that the goal of beauty experts is to enhance or exaggerate natural effects: to make the lips more red, the cheeks more flushed, the eyes more bright than is natural. The demands of style, however, are not likely to be always thus restrained. For it is not certain that the best that nature can do is the best possible. Even the African natives long ago discovered that the cosmetic arts can leave nature far behind, and that fascinating designs can be created with the human face and body that have no relation to nature. The years to come may see the adoption of purple, blue, green or other colors for hair dyes, with effects of strange but real beauty. We already have a vogue of deeply painted fingernails, now usually limited to shades of red. It need

hardly be stressed that all colors and all varieties of design are possible.

This was written seven years ago. Since then, a leading American nail-polish company, with a Chinese name, has advertised blue and green and purple and black as well as red nail-lacquer, with beautiful illustrations in color featuring daringly l-o-n-g fingernails. Open-sandal shoes with skyscraper heels have been introduced, together with the styles of bare legs and feet, and gaily painted toenails. Blue lipstick and purple lipstick have been added to the vivid shades of red; and now the latest, the thrilling jet-black lipstick. All of which is certainly unnatural, and yet just as certainly delicious and fascinating and wholly admirable.

It is for the women of today to make the first steps toward that fascinating world of more colorful feminine fashions which Dr. Wendt envisages for tomorrow. I am sure that many of your feminine readers will be eager to experiment in this direction at the parties they may attend, or when entertaining at home. Just as a hint of the possibilities, I suggest that they try this combination: bare legs; toenails painted bright red; open-sandal shoes with six-inch heels; a short ultra-tight

from a reader in New York

skirt; two-inch fingernails painted green; jet-black lipstick applied with the utmost lavishness and daring; eyebrows completely shaved off and reshaped with blue eyebrow-pencil. Perhaps some of your readers will let us know of their experiences in this direction. And perhaps we may also be favored with a picture of the delightfully feminine and alluring creation that I have just described.

Yours—Raymond.

The Knave of Hearts

Dear Mr. Editor,

My daughter showed me a copy of your magazine.

What a delightfully quaint little thing it is! You are to be commended for the freedom of discussion you allow your correspondents in their many unusual tastes. You chose a good name "Bizarre."

The letters which interest me are those which show that there are still many people who believe in the old saying "spare the rod and spoil the child." — I say "phooey" to all this nonsense of child psychology. Except in a few rare instances nature equips every mother with love for her child, and the desire to bring up her children as decent healthy citizens —and furthermore gives her the "know-how" to do it.

When I was a little girl I could not resist temptation when my mother made jam tarts. She made the most beautiful ones you've ever tasted.

In those days an "appeal to the seat of government" as one of your readers so naively put it, was the method of correction. This acted as a deterrant for much childish mischief but with me and jam tarts it had no effect—in fact it only whetted my appetite.

One thing many parents do not understand is that a whipping is useless if it does not achieve results — and to try to force obedience by repeated thrashings would not only be brutal but extremely bad for the child — engendering bitterness and killing all love.

My mother was wise, and seeing that a spanking had no effect, chose the obvious alternative course. First she locked me in my room while the tarts were being made — but I soon found a means of getting out of the window.

So the next time jam tart day came around she called me to her and gently but firmly strapped my hands behind my back and told me to sit on a chair. She was not annoyed she explained—just taking precautions. I remember that day well. I stayed there, my eyes

Learn Jiu-Jitsu and the Art of Self Defense.

watching every move as those love-
ly tarts came out of the oven—
they smelt even more marvellous
than usual and I gradually edged
off my chair until I was sniffling
at the table.

My mother stopped—dusted her
hands—and placing them on her
hips gasped, "Was there ever such
a child!"—but she still wasn't an-
gry. She left the kitchen (during
which time I tried to bite a tart
but as I couldn't use my hands I
only got my nose burnt) and re-
turned with a length of clothes
line. I obediently sat in a chair

once more and then she tied my
ankles to one of the rungs and my
waist to the chair back. I wasn't
in the least uncomfortable but I
just had to stay where I was. One

child expert I know screams in horror every time I tell of this, but no one then thought this cruel, I certainly didn't, in fact I was glad of it because I could *not* resist the temptation of the tarts and a whipping hurt mother as much as it hurt me.

After that it became the accepted rule. On tart day mother would say "get the strap" and I would obediently get it and the cord and would follow her to the kitchen. Sometimes I couldn't find the strap and the cord was used to tie my hands but I didn't mind in the least. Once I was helpless I had nothing to worry about. For an hour at least I could be sure of not getting into trouble whilst revelling in all the gorgeous temptation of those tarts taking shape before my eyes—and at the end there was always a wonderful piece for me—and no punishment.

My daughter had exactly the same complex and I treated her as I was treated. All our friends, just as mother's friends, thought it a good joke and now that I am entitled to be called "Granny" although I'm not yet 50, we are watching, my daughter and I, with a twinkle in our eyes to see if modern miss grand-daughter has the same uncontrollable family passion—jam tarts.

Yours—Beatrice M.

There's only one thing wrong with your letter, Granny—there were no tarts in it. Send some next time.—Ed.

The Debate.Starts?

Dear Editor,

In the suggested debate, on who should wear the pants, etc., will be interesting no doubt. But heres what I think—While there will be a lot of heated arguments to an fro by various individuals, none is likely to change their stand. Or new ideas exchanged compared to my idea for discussion which is corporal punishment. Let the determined individuals save their energy in discussing pants, there here someone has to wear em and as I said no one is likely to give em up or start wearing em due to any discussion. But in expressing his or her opinions on corporal punishment ideas will be exchanged and opinions will also be considerable more diverse. A man seldom tell how he spanks his wife or a mother disciplines her child. Neither is the subject outside of the topics discussed so far, fashion, character, is very alien to corporal punishment. Merely a very common method in obtaining results in the two mentioned topics.

W.K.

A Champion of the Long Hair

Dear Sir:

I do hope that you will soon be able to find space to encourage women to realise the beauty of their hair in its natural state. Nature never intended that women should mutilate themselves by cutting it off. If the rush of modern life makes long hair something of a nuisance then girls should learn

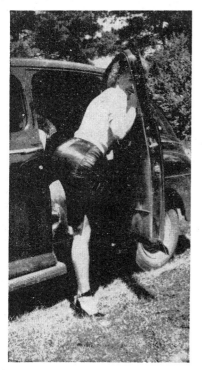

Another charming snap of Mrs. "Satin"
(*See letter in previous issue*)

the many ways of dressing it simply to keep it out of the way.

Though not very long what could be more attractive than the way in which the heroine of your cartoon serial arranges her hair—just a plain bow at the nape of the neck. Sensible and so easy to manage. Then if the hair is over waist length is a plait so difficult?

I can well remember as a child sitting up in bed watching my "nanny" dress. First she vigorously brushed and combed her long waving tresses—then in a matter of seconds divided it at the nape of her neck into three parts, and in almost less time than it takes to write she had it plaited to the end. The process of coiling it on the top of her head in a "bun" was most elaborate—but is that necessary? In the olden days it was the sign that a girl was grown to maturity when she put her hair up and her skirts down. Nowadays a woman wears what she likes—anything goes—and as they have chosen to shorten their skirts again why don't they run true to form and let their hair down?

I wonder if they ever pause to consider the beauty of the women of the middle ages whose braided hair hung in one or two glistening plaits over the shoulders.

Yours,

"Anticut"

From the *New York World Telegram* (*columnist Frederick C. Othman*)—*we quote*:

A CHAINED BEAUTY

Atlantic City, N.J., Sept. 9. — This dispatch probably should appear in the hardware dealers monthly; it is about a chain you snap to your wife's ears.

It loops handily under her chin. Grab the chain and lead her wherever you want. You could rivet an iron hoop in her nose and get the same effect, by attaching a rope, but slave earrings are better. With them you can guide her almost as well as if you had a bit in her mouth.

You think I am spoofing? — Touched by the heat? — Drunk?

The most beautiful woman in this nation wears a chain from ear to ear. Name of Marilyn Buferd, of Hollywood, Calif., now Miss America. Most beautiful of all the beauties at the Atlantic City beauty pageant.

I grasped Miss America's chain and led her for a spell. It worked fine. Where I went, she went and all she said was, "Ouch."

The tall and stately Miss Buferd made a deal with a Hollywood genius (who probably would be embarrassed if I mentioned his wife-leader here) to keep her ears chained whenever she appeared in an evening gown. This was her first commercial commitment, while she still was only Miss California. Now she's making the boys with the contracts stand in line.

A Page-boy costume suitable for either sex.

Another Champion of Frills

Dear Sir

If I may extend constructive criticism, I would suggest you come right out plainly with information, historical or practical, on

[26]

the use of corsets and high heels by the male. We both are perfectly aware of the fact that a very great many men enjoy the use of these supposedly feminine garments and you have made allusion to this fact in both issues I have read. It remains, and I think you'll agree, for someone to courageously and openly discuss this practice with the view of acquainting the subscribers and their friends with the plain fact that many thousands of men like to wear these garments but are forced through unjust, harsh criticism to undergo the pleasure of wearing these in private, behind locked doors.

History has given proof that practically every artice of clothing worn by women through the ages was first devised and worn by men. The corset, for instance, was adopted by women through their envy of the sleek, small waists achieved by men who went in for tight lacing; high heels were first introduced by Louis IV, and his example was naturally followed by the men of the upper strata or the French Royalty. They were adopted by women who admired the longer lines given to the legs, and the slimness they afforded to the ankles. I find little to criticize in the use of very high heels by men when I consider the fact that the stalwart men who fought in battle and private duels in earlier years wore the silks, satins, velvets, and lace. The warrior felt undressed if his waist was not laced to a tiny degree and his feet encased in pumps with very tall heels; and, we find that even as of today, the very he-mannish men of the western United States can be found to be wearing high heeled "cowboy boots" on the streets and plains. Are we to point a finger and scold, "Sissy, sissy!" at these six-foot, broad-shouldered giants of Texas just because they happen to wear two- or three-inch heels on their boots?

There is a fear among men, and women, that they are committing a crime, because the law says something about prohibition in regard to wearing the clothes of the opposite sex. But what is "clothes or robes of the opposite sex?" Which sex wore these articles of clothing first? If men wore corsets and high heels first and chivalrously gave them up to the female sex, did they lose all identity as male garments? Men wore trousers for over a hundred years, have they, too, become "female" garments just because our girls and women of today wear trousers which they choose to refer to as "slacks"? What does society call it when our teen-age girls of today go around sloppily dressed in men's

shirts, dungarees, low heeled shoes and socks which fall around their ankles? If the use of these male garments by females means they have become strictly feminine garments, what the hell are we men going to wear that we can call strictly male clothes?

Ever heard of Adam?—Ed.

The main trouble with our present day girls is that they choose to take life as easy as possible. The adoption of sloppy male garments is evidence of laziness on the part of the general run of women today. They cannot be bothered with a corset for the simple reason that they are too lazy to lace it on. They cannot be bothered to wear articles of clothing which restrict their free movements, no matter how glamorous, for the simple reason that they have chosen to regard themselves on the same level as the male in regards to activities in sports and society. They like the idea that no matter how uncouth they look, the male is just as fond of them and will come a-running no matter what they have on.

The fallacy in that line of thinking is that the male is unchanged in his sexual instincts but has to suffer through this undecorous period of female adornment because it is necessary to pay court to the opposite sex or lose his identity as a man. But, and it is a big BUT, he proposes to the female only when he is lucky enough to catch her in frilly things. If a love-struck male proposes to a girl in sloppy clothes, it is only because of his memory of her in something decent. Should the female condone the use of, and practice of the male in wearing tight, small waisted, curvaceous corsets and slippers or boots with very high heels? If our present day girls happened to live back in the days when men wore corsets, high heels, silk stockings, lace on cuffs, and on knees of velvet breeches, wigs, powder and rouge and beauty spots and perfume and sniffed daintily and graciously out of snuff boxes, what would be their reactions? Would they regard them less as men?

Now, present-day convention prohibits the wearing in public of high heels (except in the wild and wooly west) but why should it not be the privilege of men to wear undergarments consisting of tightly laced corsets and silken underwear? Many thousands do—but they do so surreptituously, in fear that they may be labelled as unfortunately queer persons! If a man finds enjoyment in tight lacing and extremely high heels, silk stockings and underwear, he is merely reverting to the same urge

[28]

that prompted the men of earlier days, as mentioned in the foregoing paragraph. This should be appreciated and recognized by the members of the opposite sex and they should bend every effort to assist in that enjoyment. Why in the name of all that is right, should a woman be satisfied with a husband who stands round shouldered, his chest as flat as a pancake, his abdomen hanging over his trouser top or swinging in pendulous abandon like a dropped bag? If she were a thoughtful, concerned wife, she would encourage the misshapened hulk to train that abdomen with a good corset—a corset which would hold his abdomen flat, lift his chest up and out, cause him to sit and stand with his shoulders back and, above all, cause him to have some pride in his appearance. In private, she should help him to lace in, to enjoy the rapture created by curvaceous, tight corsets and, if he chooses, to wear boots or slippers with heels of extreme height. She should remember that these garments first belonged to the male and if her man likes to wear them, he is no less a man than his forebears who dressed like that as a matter of fashion.

Personally, I find wonderful relaxation from the hard work of the day by donning a corset with an eighteen-inch waist, silk stockings and slippers with five-inch heels and lounging about the house in a silk robe. I get a wonderful uplift, a surging exhilaration when so dressed, even after the hardest day's labor and I work damned hard at physical labor. No living person can challenge my right to the claim of being a man's man— for I have never been beaten in over one hundred fistic encounters with bullies in public and in the ring. I have "flattened" a dozen men with one punch and I haven't a feminine gesture or mannerism in my entire system! I have worn corsets and high heels for twenty years and I expect to enjoy them for a lot more. I am proud of my small waist, I am proud to say that I enjoy all the fine things of life and the finest of these are lovely corsets, heels and silks—I draw the line at make-up and perfume, let the girls have them, it is they who need the artifices for facial beauty. Myself, my beard shows too damn strongly and I dislike the very thought of painted men. They really are sissies!

Why? our tough old ancestors did; you said so yourself; be consistent.—Ed.

Yours sincerely,

Hank B.

This is not a reproduction of an old instrument of torture from the Inquisition—it is merely what a "Modern Miss" will look like if she takes up figure training "a la 1880", according to the old steel engraving picture sent to us (see accompanying letter).

Dear Sir,

I enclose a cutting from an old fashion journal which may interest your readers. I suggest J. W. uses it as copy for an up-to-date version. I am sure it will make all

"Modern Misses" extremely anxious to go in for wasp waists (I don't think).

The description says that the heavily boned leather collar gives that proud tilt to the chin. The shoulders are braced back by the straps around the elbows and the correct poise is given to the body by the straight busk of the corset.

Personally I would say that it would give the wearer a pain in the neck in more ways than one. Still women are crazy enough to do anything—so one never knows.

Yours—R. S. L.

Wartime Skirts

Dear Sir:

The war, as I hoped would be the case, had one saving grace—it brought in the return of the short skirt. This was offset by the rationing on the height of the heels of shoes. I love to see a girl wearing the shortest of short skirts —thinnest of silk stockings and highest of high heeled shoes.

What's the idea of asking? do you think you can influence fashion? — more power to your elbow brother if you can.

Yours—T. P.

Rolled Stockings

Dear Sir:

I heartily agree with S. W. in regards to sheer silk stockings rolled neatly just above the knee, there is nothing more attractive to

my mind, please let us have some photos showing stockings rolled thus, who is there of the lady readers who will oblige? and what about some photos showing a glimpse of lingerie?

Wishing "Bizarre" every success and looking forward to the next issue, also hoping you will have some photos of rolled stockings. Believe me

Yours sincerely,
"Roly."

Short Hair?

Dear Sir:

Reading your magazine brings back memories of the delightful and intriguing mannish haircut and coiffure which one saw a quarter of a century ago. It appears that this style is being revived. This suggests a few pertinent thoughts.

First of all, the so-called glamour hairdo illustrated on page 44 of Bizarre's Volume 3, or in the 1952 picture on page 30, is unquestionably lovely and desirable; and one hopes that this style will never be lost. Secondly, on the other hand, variety is the spice of life; and provided we have enough lovely ladies with shoulder-length glamour hairdos, we may find it particularly provocative and attractive to see some women with completely mannish haircuts and coiffures.

Thirdly, the objectionable feature of the earlier style of mannish haircut, which eventually led to its abandonment, was that it was combined, unfortunately, with unfeminine characteristics of dress and figure; with suits (always an abomination on women) and with the style of the "boyish form" (a ridiculous travesty!). On the other hand, if the mannish haircut (so-called, for there is nothing essentially masculine about it; Siamese women have always worn their hair short, while Englishmen in the days of knighthood wore their hair long) were combined with an ultra-feminine figure, with a tightly-laced corset and its resultant waist wasp, and with feminine shoes with 6-inch heels, then the truly intriguing nature of the style would be revealed.

To demonstrate its provocative and tantalizing allure, I would like to see some illustrations similar to those on page 44 of Volume 3, pages 9 and 10 of Volume 3, and pages 5 and 6 of Volume 2, BUT with a *completely* mannish haircut and coiffure. I am sure that many readers will be intrigued. (Whether ear-rings should be worn, or not worn, with this style, I cannot decide until I see examples of both. Perhaps both styles would have their special allurements.)

R. V. F.

THE GIRLS ARRIVE AT THE RACE-TRACK AHEAD OF THE VILLAINOUS SIR D'ARCY.

DAMMIT D'ARCY! THERE SHE IS! NO WONDER WE COULD'NT CATCH HER. LOOK AT THE CAR SHE GOT A LIFT IN!

CURSES COUNTESS! I MUST PHONE THE CASTLE. I HAVE A PLAN. YOU WATCH HER EVERY MOVE

OH LOOK! THERE'S THAT HORRID WOMAN. HOW I HATE HER

YES, BUT WE'VE TIME FOR A SPOT.

BACK IN THE CASTLE THERE IS ACTION AS SIR D'ARCY GIVES HIS EVIL ORDERS

YEH BOSS- ITS SPIKE BOSS- OK. BOSS GOOD AN' TIGHT- SHE WON'T GET AWAY AGAIN- HOUDINI? HUH- RIGHT NOW BOSS.

HER HORSE ENTERED FOR THE CUP GWEN IS DRIVEN HOME HAPPY.

YOU'VE BEEN WONDERFUL! NOW EVERYTHING IS ALLRIGHT

I'M NOT SO SURE- IF YOU KNEW THOSE TWO AS WE DO!- HELLO WHAT'S THIS

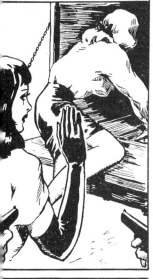

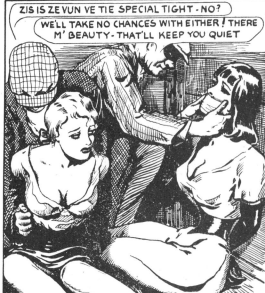

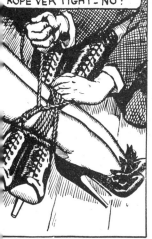

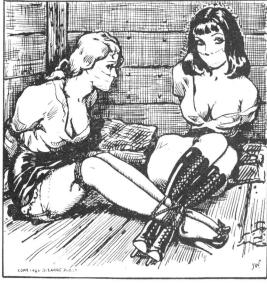

Ye Knight Errant

Dear Sir:

Oh to have lived in the golden days of King Arthur and the round table — life was good — all wine and song, and for women? Well, all that it was necessary to do was to ride off into the forest and there you eventually found one chained to a tree waiting for a dragon to come along.

The sight of a beautiful woman in chains has always fascinated me so much that I go miles sometimes to see a show or a film where the heroine is in fetters. It's a nuisance that I can't ride home in shining armour on my palfrey —the street car is a poor substitute — and unless some maiden takes pity on me and chains and padlocks herself to a gate post, and leaves a note at my place to say where she is to be found, I cannot see much chance of satisfying my yearning to be a knight errant and rescue her.

"Perseus"

Corsets for Uplift

Dear Sir:

Few days ago I saw Vol. 3 of your new magazine Bizarre. Unfortunately I missed the first two issues.

I certainly have to congratulate you on your new idea. The glamour of proper fashion to bring forth all the beauty and attraction of real feminity must find its proper place among publications. This subject has been surprisingly entirely neglected. It is especially noticeable in the way the kind of corsets worn in the gay nineties has been lately abandoned. Women do not realize how much they emphasize their feminine shape and attraction by wearing tight laced corsets which, reducing the waist, at the same time uplifts the bust, glorifying the fullness and beauty of woman's breasts.

This contrast of fully developed bosom emerging from a tightly laced corset brings forward all the glory of woman's attraction through proper garments and fashion. The more photographs you could bring in your magazine of pretty girls in tight laced corsets with full bosoms gloriously uplifted, the more unique and valuable your publication would be. This is something which has been missing for a long time and which I am sure will bring you many subscribers.

Yours—"Aramis"

We hope you will let us know whether or not you like this correspondence Number.—Ed.

Printed & Published by
BIZARRE, Canada, 1946

BiZARRE

N° 6

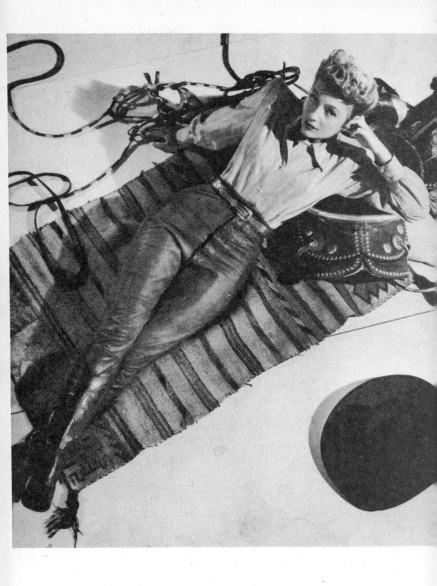

for your leather moments.

BIZARRE

"a fashion fantasia"

No. 6

"But leave the Wise to wrangle and with me
The Quarrel of the Universe let be
And in some corner of the Hub-bub coucht
Make game of that which makes as much of thee."

CONTENTS

NEXT ISSUE No. 7

Again a limited editon—and a bumper number—so order your copy now if you have not already done so. Price $1 post free.

It contains more on the punishments of the wayward in bygone years —odd figure training gadgets from Granny's days—the return of the hobble skirt—and we hope a whole stack of letters—topped off with more of our chiller diller serial, "The Wasp Women."

BACK NUMBERS

We have available only about 20 copies of No. 2—shop soiled— and a few of No. 4—price $1 each post free.

Sorry—that is all there is—the other issues are sold out completely.

Printed and Published by The Bizarre Publishing Co., P. O. Box 511, Montreal, Canada
Copyright. All rights to these titles reserved. 1951

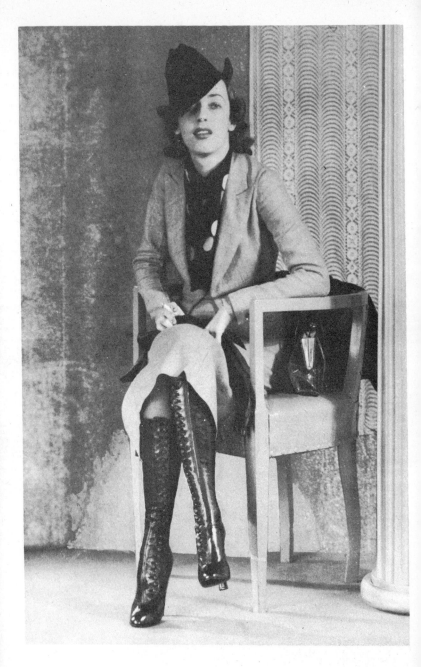

button boots by Achilles.

Some of our readers are like good friends—others are an absolute Pain In The Neck.

Sometimes we meet by accident.

Mr. P. I. N. says, "I picked up a copy in Somesuch Town—liked it immensely—been trying all over the place to buy more—but no luck —tell me, where can I buy more copies?"

We breathe heavily and count ten. "Why," we answer, "why the blazes didn't you write to us? If you want more beer and every barman says, "There ain't none," do you just stand around with your mouth open like a dying fish, or do you ring the brewer and order a keg to be sent to your home?"

"Have you never heard of an organized boycott? Do you think that the "stand over" tactics of the gorilla apply only to the bootlegging business?"

This invariably produces a flood of excuses from Mr. P. I. N.

We have had the remarkable achievement of 100% sales but we ceased publication because our distributor claims that Newsdealers and Bookstores haven't paid him, and so he cannot pay us (mit tongue in cheek). Had Mr. P. I. N. written, it would have made all the difference. As it is, in the great game of "who pays who what" we are not included.

We've taken an awful beating but we're not licked yet. Which is why we have produced No. 6 after 4 years silence.

If, therefore, you really do like Bizarre, and want to help us carry on, please don't be like Mr. Pain In The Neck—but write and order from us direct.

This is how you order. Send your name and address and enclose $1 to

<div style="text-align:center">

The Editor, "Bizarre"
P. O. Box 511
Montreal 3, Que., Canada

</div>

Thank you.

Lingerie

WE HAVE BEEN very interested in the trend of lingerie over the years and decided that an article on the subject might not be out of place — but these days there is really so very little to write about.

It all seems to have begun when Mother Eve started monkeying about with a fig leaf. Hitherto she had been simply nude—now she was positively naked! — and Adam sat up and took notice.

The serpent so we are told put the idea into her pretty little head. Having got so much success with just one little hiss you can bet your life that that snake-in-the-grass wasted no time in hissing again; firstly—that leaves fall in Autumn, and secondly that leaf "skeletons" were not intended only to be pressed into little girls' school books as markers, but being at the same time quite lacy and transparent were much to be preferred to the foliage of the common fig. From then on the mistress of Eden took over.

Be that as it may it is quite certain that since time immemorial the fair daughters of Eve have insisted on frills and lace here and there out of sight, even though topside and to all outward appearance the outlook was severe and forbidding.

In fact, the more prim and proper the exterior the greater the contrast and the more inviting the unknown—a consideration which annoys the sex-terrified puritan to no ordinary degree—as Eve knew it would. The stern, and somewhat mentally warped male who in grandma's day could insist on this dull overall drape and thus hope to calm his fanatical terror of the thrilling idea that a woman was an alluring creature, could not in all consistency dare to investigate. He could not rap with his stick on the floor and say "Come ma'am! Up with those skirts!" The damsel would have swooned and everyone would have said "Fie on you"—or something like that.

All the reformer could do was to hope that the wind would blow, but even then the damsel could flatten him—if he reproved her—by demurely saying "Sir! — you

6

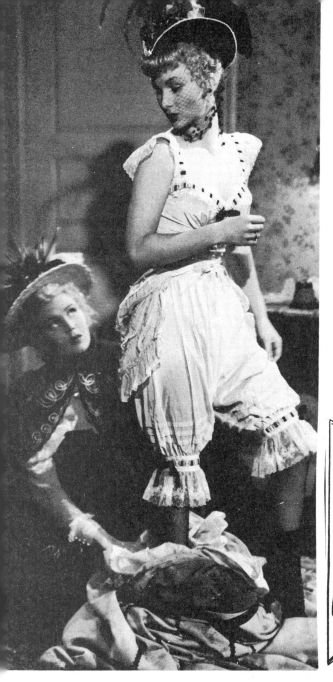

Mabel! you're positively naked

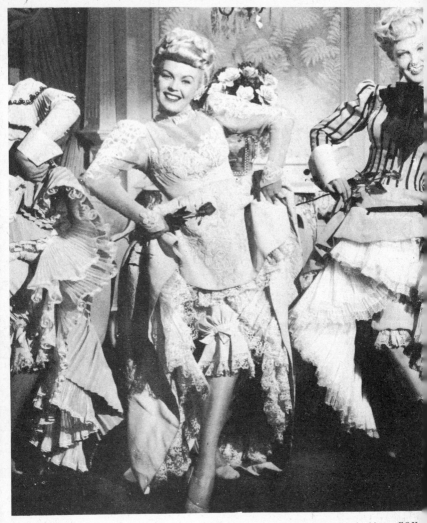

three little girls in blue. FOX

great trees from little acorns grow
and springs to mighty rivers flow
while all this frothy frilly show
came from a fig leaf—long ago

Wait a minute! I've got to get into the picture somehow

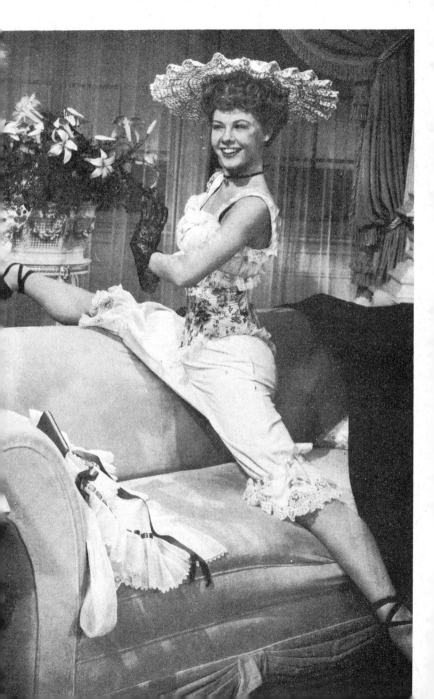

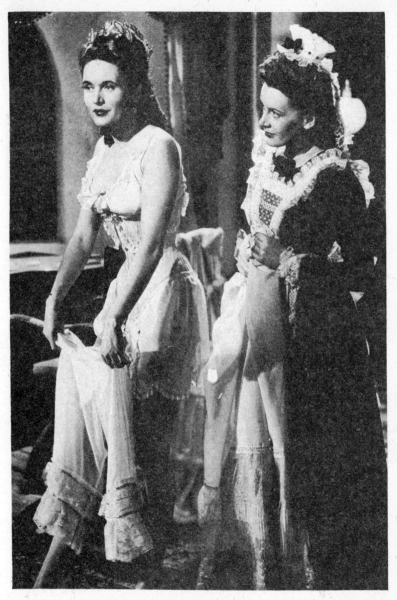

heard the story about the three wells, Susan?

no ma'am!

Well! Well! Well!

should have covered your eyes! You, sir—are no gentleman!"

As a matter of fact, this annoying uncertainty of what the fair one is or is not wearing underneath affects all of us for the same reason—only some—like the puritans like to pretend otherwise. We are therefore wondering if one of these fine days, some robust old General (or Admiral) will startle a parade of WAACS, WRENS, WAVES, WAAFS, or other wild fowl of the armed forces, by demanding a raised hem at inspection—to ascertain for certain that all garments are proper government issue. It's an idea with plenty of possibilities and one well worth following up by the General Staff —all we ask in return is to be there when it happens.

Somehow or other, we like those "olden days." Life moved at a much slower pace, and woman could take her time in attracting the male—which was much more fun. She could handle a needle and thread like nobody's business and took great pride in her skill. Everything was a mass of cunning stitchery. She had dozens and dozens of "unmentionables"—and apparently wore them all at the same time.

Just imagine what it would have been like to write an article of this sort in those days. Instead of taking shots of some model charging about the studio in some-

thing like a "Bikini" which the moths had got at, we would have been plying Miss Priscilla with tea and crumpets while we examined (with many ohs! and ahs) Miss Priscilla's feather stitching here and her hemstitching there, and the little bows, and the tucks and the pleats and the lace, and J. W. would have made the most intimate sketches of first the frock— and then when that had been removed—of the first petticoat (or whatever they called it). Then off that would come—only to disclose another petticoat, and another (they probably worked them like a car gear box, starting in first and gradually changing up into high as the temperature rose) and so it would go on—endless frills and flounces—J. W. gnawing the end of his pencil in exasperation until at long last, with a little ladylike squeak, the damsel would stand in her frilly pantaloons—but as far as we can gather, they even wore more pants and what-nots under this seemingly last obstacle.

Nowadays, everything is as brief as brief can be. Some claim this gives everything more sex appeal. However, it by no means infers that the modern miss is approaching life with a greater abandon and zest than her grandma. There is a very simple reason back of it all.

You see—she can't, or won't (which amounts to the same thing)

so that's where they used to wear falsies

we won't look

. we'll turn our backs

—sew! So! Everything has to be bought at the store. Behind the storekeeper is the manufacturer— a hard-headed citizen with his attention centered on the market and costs of production. He gets a ring on the phone—grunts a few times —then turns to his designer and says "Hell! Nylon's gone up 10% —cut that much off the material— No! cut 20%—we'll get a bit ahead!" The result is skimpy.

Then the cloth maker gets the bright idea of cutting costs by putting less threads to the inch in his weave—to save yarn—and the result so far as lingerie is concerned is sheer nonsense.

We—as fashion experts—must of course keep up to the minute and so we have for some time used a simple method of finding out what is being worn around town, but we are getting so tired of the long wait between subway trains—and so many of the fair sex never walk over the gratings anyway—that we are working on a patent two-bit piece.

A clever spot of camouflage— to which a string is attached— makes the coin unnoticeable as it lies there on the sidewalk. We just lean against a lamppost and wait. When a damsel passes the comouflage is whisked aside (giving a loud "honk" in the process to attract attention—and revealing the quarter in all its pristine beauty. Delighted at this unexpected find —and quite unsuspecting, she of course stoops to pick it up—but as soon as it is touched, the quarter emits a powerful upward blast —the result?—you can have our assurance that black nylon with a frilly edge is still as popular as ever and that garters appear to be coming back into favour—worn well above the knee.

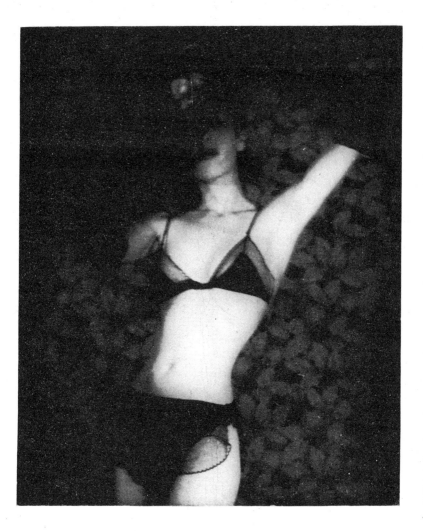

how do you like my hat?

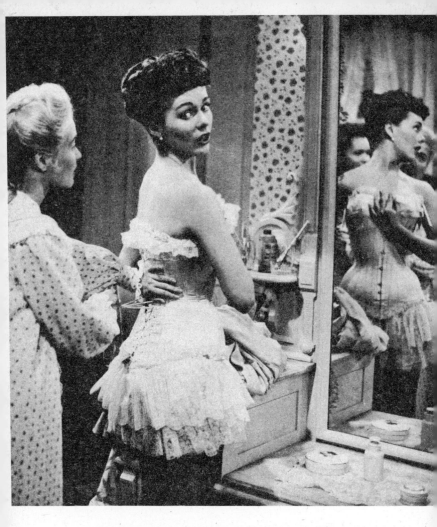

hey! you aren't supposed to be in this

footwear fantasia

by "Achilles"

The other day I made an interesting discovery — interesting because it explains the attitude of many Americans toward the ultra high heel. One of the readers of Bizarre refused to believe that anywhere in the world would you see a woman going about her everyday affairs in extremely high heels of 5 or 6 inches because he had never seen one. He has travelled extensively in the U. S. A.—though he has never been abroad—and because it didn't happen in America he was firmly convinced that it could happen nowhere else —period!

I in my turn cannot quite believe his claim to have been "everywhere in the U. S. A." for when one considers how often one sees women in all walks of society on the Continent and in Britain wearing extreme heels—at least the 5 inch variety—it seems strange that this particular form of "chic" is not to be found on this side of the Atlantic—anywhere.

I have discovered some people think that to wear extreme heels shows a depraved taste, a remark which shows quite clearly that it is not the wearer's taste that is to be regretted. Others consider them absurd and freakish—which can be quite true if the wearer cannot stand and move gracefully in them.

My own opinion is, and always has been, that as they can only be worn by the few women who have really beautiful feet—inasmuch as they tend to exaggerate every tiny fault—the average woman is afraid of them. The cost is always high and the experiment may not be worth it.

On the other hand, the woman who can and does glide around on these towering stilts can be assured of the admiring glance of every male and the jealous glint of every female.

In pre-war London alone, there were several shops within stone's throw of Piccadilly whose windows displayed an abundance of boots and shoes—but none had a heel lower than four inches—the majority were 5 or 6 inches and pencil thin. There were court shoes and sandals in all colours, sizes and materials—knee boots, thigh boots, lace boots, button boots, in every style and design which could be imagined.

Further afield were the small "custom-made" shops with, perhaps but one exquisite shoe in the window. Anyone of these could be relied on to carry out the most

exacting details which the customer demanded.

In France and Belgium, the shops were legion.

What the situation is now, I cannot say—but probably even if disrupted by the war, it is getting back to normal again.

Unfortunately the real shoemaker is a dying race. It is almost impossible these days to find anyone with the necessary skill as a tradesman, and the "I-can-make-em's" are too dreadful to contemplate either in workmanship or price. It is extremely difficult to make these shoes—it is an art in itself—but the way modern machinery is advancing, it may be that in the not far distant future, a line of 5 or maybe 6 inch heels will be put out by some manufacturer.

Unfortunately women find that even a 4½ inch heel slows them down—like the sheath skirt from Paris, and in N. Y. C., they don't want to move slowly—they want to go around in a mad rush, scared of missing something. This is a pity, for they miss so much of the simpler and more genuine pleasures of life.

But to change the subject. I am often asked how the height of a heel is measured. As I think I have explained before, in the shoe trade it is measured in eighths of an inch down the centre. The ordinary customer however measures it in a perpendicular line from the back at the top to the ground. Therefore a 24/8—or a "twenty-four" heel—or "three inch" heel to the trade would actually be a 3½ or 3¾ inch heel to the customer. Many shops knowing this use the customer's method when advertising their wares.

I can also state quite bluntly that a six inch heel without a pad under the ball of the foot, or an extension of the sole at the heel giving a distinct bulge effect, is impossible for the average foot—unless—the wearer is standing on tip-toe, and I mean the actual tip of her toes, inside the shoe itself. This is not comfortable, but as many say—"who cares about comfort — see how wonderful they look." Oh, well, each to his or her choice but only an elementary knowledge of geometry is needed to see the truth of my statements.

Please don't misunderstand me. Six inch heels do exist—but the wearers do very little walking. The wife of an old friend of mine invariably wore a full six inch heel —and looked extremely attractive too—whenever she went out to dinner, the theatre, or to the races; but the only walking she did was from the house to the car and from the car to her seat when she reached her destination. At the races of course she moved about a bit, but even so it was still very little.

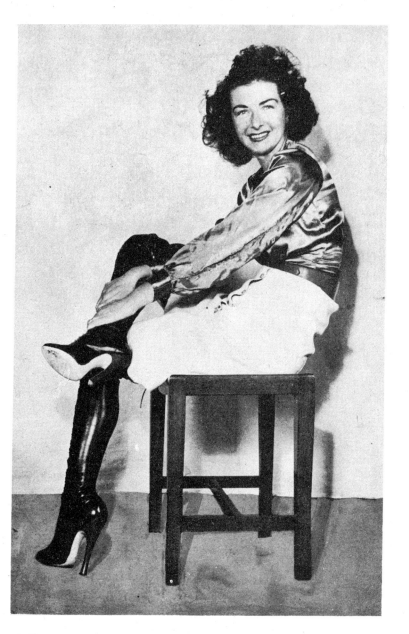

an excellent example of well-fitting boots

tale from bottle No. 2

WHEN I BEGAN writing, it was with the happy idea of sending off one letter in a bottle, and then following it with the same letter in another, and so on—trusting to the law of averages that one of them would eventually get through to its destination. However, it was obvious, once I had started to write, that I could not possibly tell you everything in one letter.

Then it occurred to me that if a suitable reward were offered for safe delivery and one bottle got washed up somewhere, whoever found it might think it worth while to look around for more. Obviously if I dumped them into the drink here at the same time of tide each day, they should all arrive more or less in the same spot somewhere—at least, I hope so.

I am therefore writing a sort of diary and as each spasm is finished, I'm sealing it up and consigning it to the tender mercy of Old Neptune's postal service. Now to get back to my story.

I awoke with a bit of a jolt, but then I remembered where I was and lay back on the pillow to take stock of the situation. By the slant of the sunlight which filtered through the blinds, I figured it was late in the afternoon so I propped myself up and looked around with a general idea of getting up—but with no great determination—the bed was too darn comfortable for that. Then my eyes spotted a pitcher and a carved coconut cup on a table beside the bed—I investigated, expecting to find water—but to my delight, the thing was full of a sweet perfumed amber coloured drink which a sample showed was contrary-wise pleasantly dry to the taste. A couple of good swigs and I felt fine and the idea of getting up seemed more reasonable—but still there was something soft and insistent about this bed and it puzzled me.

I was as naked as the day I was born but I felt as if I were wearing silk pyjamas and I discovered to my surprise that the sheets were indeed silk. This naturally shook me a bit but as I later discovered, almost all the cloth on this island, with the ex-

22

ception of the towels, is silk, thanks not to any silk worm or spinning wheel, but to an industrious little water bug. I'll tell you about that in due course. At the moment, all I could think of was that I had quite definitely landed in the lap of luxury.

My wandering gaze took in the fact that my shirt and trousers had been washed and ironed and with a towel were hanging over the back of a chair. So my curiosity as to the rest of my surroundings getting the better of the beckoning of the bed, I swung my legs over the side, put on my pants and picking up the towel wandered off in search of the shower—which I duly found. There was plenty of cold and hot water with ample room to splash around in so by the time I was through I felt one-hundred per cent. On my way out of the bathroom, I ran slap bang into Malua.

"Good heavens," she exclaimed, "what are you doing up like this. We thought you'd sleep the clock round."

"Well, I have done — just about," I replied. "The moon was only just up when I hit the beach if I remember correctly, which means that I snored off first around 10 last night. What's the time now?"

"Oh, about half past six"—

"Well, there you are!—Let's

see—with only the short break while I was being brought up here—that's 18 or 19 hours—I haven't had that much sleep for ages—all in one wallop."

"Then you feel all right?" she asked.

"Fine, but a trifle peckish—can I raid the larder?"

Malua laughed and taking my arm led me forward. Now I don't know—I've been arm in arm with a girl before but there was something about the way she did it that was different and which somehow made feel rather daft and light-headed. Everything about her seemed so soft and inviting, and the perfume she used made you dizzy. Somehow her shoulder seemed to brush mine, and somehow her hands sort of caressed my arm, and maybe I had a heavy roll in my walk because I swayed towards her and for an instant my cheek seemed to brush against her hair. This apparently surprised us both because as I turned my head—to regain my balance of course—she raised hers and I found my lips pressed against her cheek—at which point she laughed and tugged on my arm—which naturally meant that she had to hold on tighter as she dragged me towards the living room. It was all very disconcerting.

She pushed me into an easy chair and told me to relax while she got me a snack, explaining that

supper would be on in about an hour, and then turned to go but stopped suddenly, spinning round on her toes. "Oh, I'm so sorry Jimmy—I forgot—do you smoke?"

When I replied that I did, she went tripping away on her towering heels to a sort of sideboard affair to return with two boxes. The one containing those cigarillo things and the other, large matches.

I helped myself and examined the matches with interest. They were unusual.

"Where on earth d'you get these," I asked, "don't tell me you make them here?"

"But of course," she replied. "Why not? It's only a twig dipped into some chemical stuff that the professor and his assistants concoct—sometimes they let me help—look—it works fine" and picking one up she struck it on a rough green coloured stone which had been cleverly set in the lid—then resting one hand on the arm of my chair leaned forward to light my cigarette.

As she did so, I glanced up and found her looking at me and there was something in her eyes that made me feel as if I were looking into the golden brown deep of a pool in a highland stream—you remember that one below Bucchanty Falls?— on a sunny day?— the way it used to bubble and sparkle?—Well it was like that— only this one was shaded with a dark mist of the most impossibly long curved eyelashes.

The match burning down to her fingers put an end to this mutual looky-looky business.

"How'd you like our tobacco?" she said blowing it out.

I tried to draw slowly and deliberately on my cigarette but only succeeded in chewing off the end. With a mouthful of tobacco, I mumbled something like "marvelous" or "excellent"—it really was too—and there was an awkward pause in which neither of us seemed game to look squarely at the other. Then apparently satisfied that I now had everything I needed for the time being she straightened up—slowly—like a cat stretching and once more headed off toward the kitchen, those amazing pencil-thin heels going clickety-click on the polished hardwood floor.

I spotted another flagon and some cups within reach so I poured myself a generous drink as a nerve tightener and then sprawled back in the chair. After all I'd been through, the whole thing was incredible and I pinched myself just to make sure that I really wasn't dreaming. It seemed impossible that anything or anywhere could be so utterly remote from the beastliness of everything that made up the world of today.

The stuff I was drinking and the gentle breeze which came drift-

"the whole room seemed to fill with music

ing across the shaded verandah to explore the room, carrying with it the scents of all the flowers it had brushed against on the way— just because it was too darn lazy to drop them—made me feel half tight—or maybe it was Malua.

We'd only met for about half a minute so to speak and yet that I was nuts about her and that she seemed more or less agreeably inclined toward me seemed rather evident,—and there was that business of the butterflies. But then it occurred to me as a bit of a damper, that anyone quite as lovely as she was couldn't look anything else but adorable and must surely be tangled up with some bloke or other, and it might be all my imagination. If it was so, it was so, and there was plenty of time to find out for certain. Meanwhile it would perhaps be a bit boorish to chance abusing what after all might be nothing more than really wonderful hospitality.

I was thinking this way when she came back, and so instead of kissing her well and truly then and there, I decided to wait and see.

I was pretty damned hungry so I helped myself to come down to earth by concentrating on the wooden platter covered with all sorts of savory looking things which she placed close to my hand —but it was an unequal battle because once she had made sure that everything was hunky-dory, she

drew up another chair and curled up in it. Then stretched out and crossed her slender ankles in front of her—in the process arranging them so that I had an excellent opportunity of appraising their beauty and the fascinating lines of those stilt heels.

I'm afraid that I didn't behave like a connoisseur of food and wine and tobacco at all—I just stared and began to eat in such a vague manner that I missed my mouth, at which Malua laughed merrily.

"You know, Jimmy," she said, "I think you've got something on your mind. Have you?"

Her eyes were shining with mischief, but before I had a chance to tell her what it was we were interrupted by the sound of running feet and a shriek of laughter

I glanced up to see two teen age boys thunder across the verandah.

Almost as suddenly they stopped. and there was a loud "Ssh! Hey we forgot that sailor! He'll be sleeping!"

Malua and I sat still. Apparently coming in from the sunlight they had not spotted us in the shade of the room inside.

"Here come my brothers," she whispered, "they'll get a shock when they see you up and about, the last two were laid up for days, one was terribly burnt, poor boy," and she shuddered—"but he's all right now."

Then the two kids, dressed in nothing more than the usual sarong of the islands entered on tip toe. For a moment they were so busy with this "Ssh"ing business that they didn't see me—but when they did they stopped with a jerk —mouths wide open.

"Gosh, it's Jim," said one. "Aren't you tired?" said the other.

I got up grinning and as we shook hands, assured them that I was quite O.K.

They were a couple of wholesome-looking infants — tall, well-built and obviously fit as fiddles. "Now, you've got the advantage of me," I said, "somehow you seem to know my name's Jim."

"Oh, that was Malua"—the one cut in—"she looked at your identification disc when she took your clothes away to wash them."

"And she took an awful time to get them too"—said the other looking blandly at the ceiling— "but girls are always like that. I bet I'd have done it in half the time."

"The names of these two reptiles" — Malua interrupted — "is Mutt—on the right, and as you might imagine Geoff—on the left. They're twins—but they're easy to distinguish because Mutt has a little scar on his cheek" — then turning to them — "Where's daddy?"

"Oh, he's with mother, down having a look at the new bridge"—said Geoff—"He said you weren't to wait for him for supper—but I don't expect he thought Jim would be up—I'll tell you what" —and he paused—then with the rush of a bright idea—"Mutt-and-I-will-get-supper-while-you-talk-to-Jim-how's that?"

"Sometimes I feel almost a brotherly love for you"—said Malua, settling back in her chair— "That's a wonderful idea. Go to it, my warriors!"

I sat down again too and for a few moments there was silence except for a murmur of voices, laughter, and a clattering from the direction of the kitchen.

The sun had just disappeared behind the blue hills and from where I sat I could see the ever-changing riot of color it discarded like a parting gift to a happy little land at the end of another day.

Every now and then as the shadows deepened a little twinkling light would spring out—then another and another winking and peeping through the leaves like elves coming to life to change the gathering darkness into a fairyland.

It was all so unreal — those friendly little lights—no blackout — no blitz — just happy people home at the end of the day. I began to feel rather uncomfortable. It seemed all wrong for me to be sitting here like this in such contentment and peace — and — any-

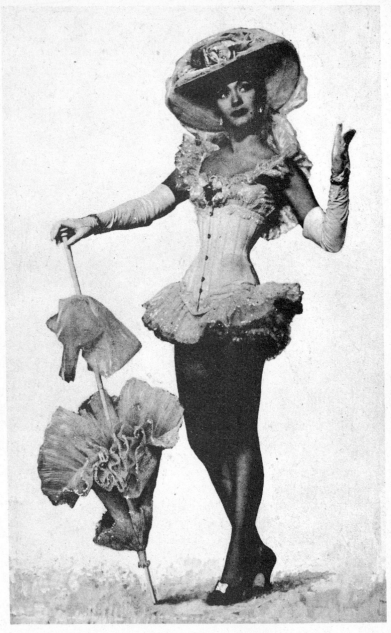

of course you can like this

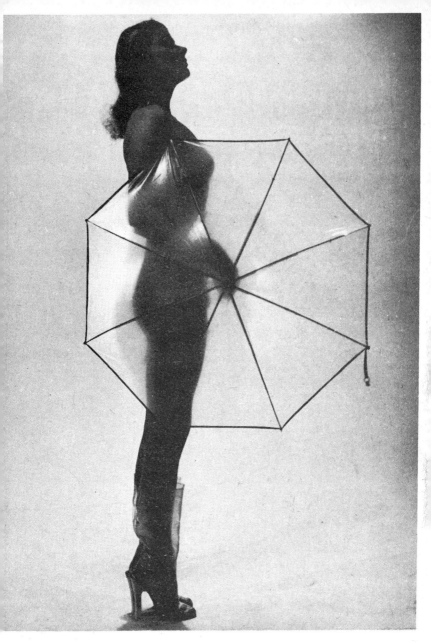

*but experience shows
this is more suitable*

way, could it last? Could even this little paradise escape the destruction and the beastliness of our so-called civilization with its endless procession of crackpots claiming to have the salvation of the world at their crushing finger tips—and trampling everything and everyone underfoot in the wild triumphant march of their insane ideology. The thought made me shudder.

I felt my hand trembling and glanced down to see the white of my knuckles showing from the force with which I was gripping my goblet. I had a mad desire to smash it to the floor.

Malua seemed to sense my thoughts for she came over and sat on the arm of my chair and gently stroked her fingers through my hair.

"Don't worry, Jimmy," she murmured, "just rest"—and then somehow she was in my arms and everything was sort of chaotic.

Certainly I'd had a pretty tough time I suppose—and maybe the ship blowing up under me might have had something to do with it —but if it was shock—then there was as much in what had happened in the last few hours to make it worse. The change was too sudden and I really felt worn out flat—all I could do was to hold on to this wonderful girl as if my very life depended upon it. I felt a bit of an ass but Malua went on murmuring sweet noth-

ings in my ear which was all I cared about—and then I felt her stiffen slightly.

"Jimmy," she said, "have you got a girl you're fond of back in England?" I shook my head.

"Anywhere else in the world?" —again I shook my head. I felt her looking at me, studying my face. Then she gave a happy little sigh—kissed me full on the lips— a slow lingering kiss which knocked me for a row of hoops, and then pushed herself out of my arms.

She didn't seem to walk away from me, she just floated off into the shadows of one corner of the room—a shadow herself—to drift back again and sink to the floor at my feet. In her hands she held a guitar and as she began softly to pluck the strings almost imperceptably the whole room seemed to fill with music.

I hardly noticed that the clamour from the kitchen had ceased and that Mutt and Geoff were standing in silence silhouetted in the doorway.

Never before have I heard anything like it. The strings sang an accompaniment to that wonderful voice—and though the words were in the soft native dialect—there was no mistaking their meaning. I felt that I was held fast by an irresistable force—as if everything were being drawn out of me and that I was being carried away and

away on a magic carpet through a starry sky—floating on and on until at least as gently as it had begun the melody faded, and with it the stars and the magic carpet, and I realized that I was still sitting in my chair, the room once more full of the quiet of the evening. Or was it quiet? There still seemed to be music everywhere.

The tension was broken by Geoff — brothers fortunately are most unromantic.

"Mutt," he said, "did you ever hear her sing like that before?"

Mutt grunted and shook his head.

"Then I'll take ten to one that old Mouldy's a pony again before very long"—and they went back into the kitchen chuckling.

"Who's Mouldy?" I asked.

"Me," said Malua in a small voice, "brothers have a nice taste in names, don't they?"

I digested this for a moment, found I was too fuddled to add it up and then asked—

"Well, what's this about a pony —were you once a pony, too?"

She nodded—"Of course."

"Then why should you become one again?"

Malua put the guitar down by her side and looking down at the floor began tracing invisible patterns on it with her slender tapering fingers.

"It's a wedding custom." She spoke softly, her voice scarcely au-

dible and yet so clear that I could hear every word. "A very old custom—you have your old customs in the outside world, too, don't you, Jimmy?"—she looked up and puckered her nose.

I nodded.

"And you like to keep them," she went on, "because they bring good luck—we're all a bit superstitious, aren't we?"

"We throw rice and old shoes," I answered, "and carry the bride over the doorstep and that sort of thing. What happens with you people?"

Malua half rose and then sank back on her heels.

"It starts at eight on the wedding morning"—she dropped her eyes and then kept glancing up at me through that mist of eyelashes. "The four most recent brides lead the "bride-to-be" off into the woods—and no one else knows where." She paused and began tracing patterns with her fingers again. "Then they tie her to a tree so that she cannot get away—one that is well hidden—and tie up her mouth so that she cannot make a sound, and then leave her.

Her future husband has until noon to find her.

If he cannot, then we take it as a sign that his love for her is not strong enough and the marriage is postponed — but if he succeeds he brings his bride back to her father's house and everyone

joins in the feasting. That goes on until sundown."

She stopped twiddling her fingers and looked up smiling.

"Then the bridal carriage is brought out — it's very light and built to be drawn by only one pony and to this the bride is harnessed. Then"—with a wave of her arms—"her father hands the whip and reins to her husband and he drives her off to their own home—and that's that, Jimmy."

"Hm," I grunted grinning, "the bride seems to have a pretty tough day of it, and for the bridegroom the start-off must be rather like looking for a needle in a haystack. Does he ever miss out?"

"That's the odd thing about it," she said, rising to her feet. "There must be a catch in it somewhere because I've never known a time when the bride was not found— even though it's always at the last minute—but I don't know for certain if there is a trick to it and that's what makes it so unsettling."

"Just think of it," and she turned and leant on the arms of my chair—"He can be ever so close to her and still be unable to see her and no matter how much she might want to help him, she can do nothing. She cannot call him—she cannot make a sound— and he might walk past again and again and never find her.

I always think it must be terrible for her. I know that it happens like this because the girl's arms are always red and bruised from her struggles against the ropes.

Are you good at tracking, Jimmy?"

I shook my head.

"Lousy," I groaned, "I reckon I'll have to remain a bachelor whether I want to or not. I was never any good at the boy scout Indian chief act."

"Oh dear," said Malua, "I'm— I mean the poor girl you want to marry will go frantic," and she covered her mouth, wide in dismay, with the fingers of both hands.

The matter certainly seemed to present problems. All the ordinary men and boys on the island would of course be skilled hunters, and tracking would present little difficulty to them—but with me it would be a very different matter.

"They'll have to alter the local rules in my case," I said—pouring myself another drink. "I know what—I'll tie the bride up, close my eyes—count ten—and then find her—how's that?"

"Oh, that doesn't come until much later, Jimmy."

"What doesn't?" I queried.

"The husband tying up his bride," she answered smiling — her eyes wide as if I should have known all about it. "The last thing in the wedding night before

(*Continued on Page* 62)

FANCY DRESS
for special evenings

WE RECENTLY READ a most interesting article on the leading designers of fashion in Paris. It pointed out, among other things, that some of the creations were quite useless for the American market because no machine could hope to make them. They required the skill of the little midinette and her needle. To us this was a warning note!

In the competitive rush of modern business under private enterprise you must sell at a keen price. To do this you standardize and mass produce by machines. The "custom maker" is going out fast!

Now on the other side of the iron curtain there is--so we are told—standardized massed production by the machines of a state-controlled garment industry.

It is an alarming thought for us ordinary people that either way it goes, in this titanic battle for supremacy between the two systems, we will be crushed and trampled into a shapeless mass of automatons. On either side of that iron curtain individuality must go

by the board. Designers will be forced (by different circumstances) to simplify simplicity and standardize until only one survives—with one design! This we must buy or go naked (and it's so dreadfully cold in winter).

However, on thinking it over we can see one very bright spot in this dim outlook.

Eventually by a process of time saving elimination only lengths of cloth will be made—to be worn as a "lap lap" or "sarong"—the one final design to be worn by all concerned. Again competition (or order) will force this to be of minimum length and width so that for it to be worn a la Hollywood Lamour will be impossible. The fair sex will be able to cover up here — OR — down there so to speak but NOT both places at once.

Forced to make the choice (a real Sir d'Arcy trick) the damsel presumably will wear the thing as it was originally intended to be worn — around the hips (three cheers)—or did we hear a voice say "compromise! pull it tightly round the waist alone—like a corset."

Maybe we shouldn't worry—it's looking pretty far ahead and by that time who knows—we may have developed into a super race of headless morons which from the current trend appears far more likely than the "all-head-no-body"

ON WITH THE MOTLEY!

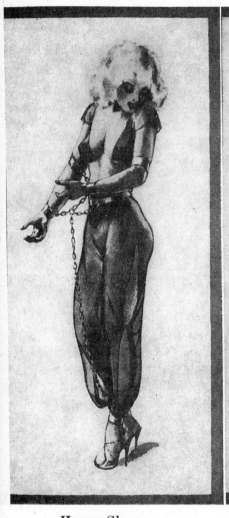

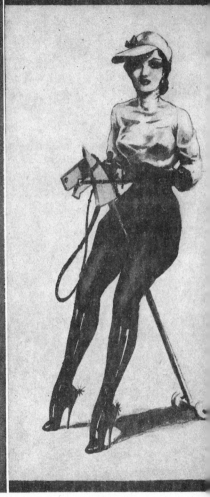

Harem Slave

mental wizards forecast by some
scientists. In the meantime let us
enjoy our freedom with the fanci-
est of fancy dress.

Jockey

Most of these costumes spea
for themselves — except perhap
Ophelia—she, if memory serve
went slightly ga-ga and floate

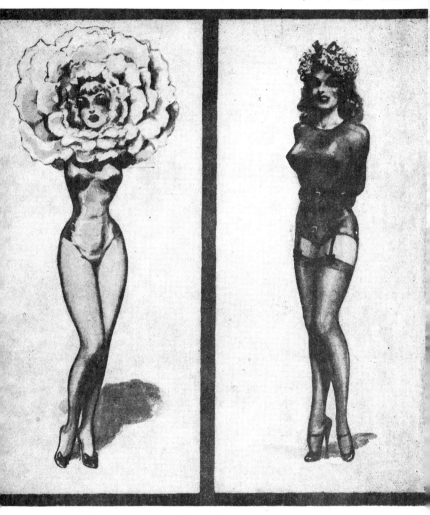

Flower

Ophelia

downstream with flowers in her hair. A long armed pullover with suitable straps attached can be turned into a simple straightjacket.

The "flower's" arms are conspicuous by their absence somewhere up inside the petals, so she would probably need some assis-

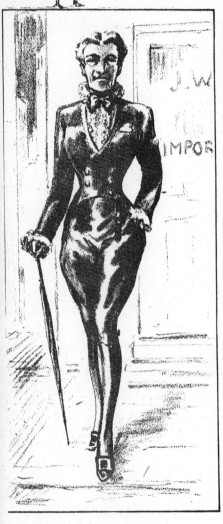

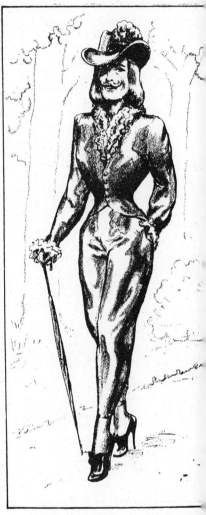

Business Executive

tance at the supper table.

The suggestions for the male of
the species also sent in by a reader
would not have been "outlandish"

Gentleman of Leisure

a century or so ago—particularl
the business executive.

The "week-end" — with lowe
heels and a closer hair cut can b

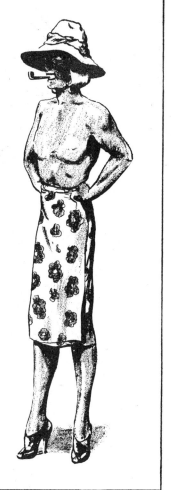

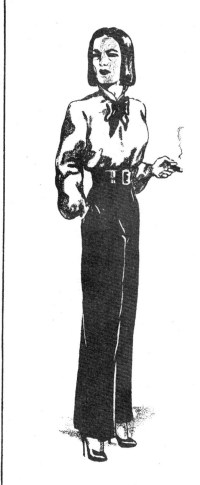

Week End

Informal Evening

seen anywhere "East of Suez".
Anyone who has wandered out to
these parts can testify that for
comfort in hot weather you cannot

beat a sarong.

The shorter version is the kil
Ask any Scotsman what he thinl
about it.

37

orrespondence

Dear Sir,

I am happy to see the corset displayed so prominently in the pages of your unique magazine, and if you want to know what my choice of garment is—well, it's the corset.

The corset to my way of thinking should form an indispensible adjunct of every discriminating lady and gentleman's attire, and figure training should constitute a necessary part of every truly cultured intellectual lady or gentleman's education.

The reasons are fairly obvious. Consider first the absolute need of suitable support to minimize the ever-present danger of rupture or muscular strain to which uncorseted people are ever exposed, due to forgetfulness or carelessness in their daily habits.

Also consider, and this is also important, the esthetic aspect of proper corseting — a neat, trim waist giving a lady or gentleman a beautiful, graceful appearance by abolishing the gorilla-like waist of man and the amazon-like waist of woman.

The cultural aspect of corseting for gentlemen is not new, neither is it a mere fancy or fad, for in Queen Elizabeth's day the nobles of her court had waists that would be the envy of many modern ladies, and despite the assertion that the corset originated in seventeenth century Germany, I firmly believe historians are mistaken for how are we to explain the definite wasp-waist of Queen Elizabeth's courtiers except through some mode of figure training, and that means of course that some form of corset was then in use among the ladies.

I should like very much to see the ultra-fashionable ladies and gentlemen who constitute the majority among the readers of Bizarre adopt the corset as did the above nobles of old, and thus by founding a corset cult we could in time win over the cultured elite of society to our way of thinking.

However, the matter is entirely up to you cultured ladies and gentlemen, I merely express my preference and offer this suggestion for what it's worth.

Yours,

F. M.

A Peep Into The Past

Dear Sir,

I am enclosing some cuttings from some old time periodicals. I think that they might interest your readers who advocate the return of the corset.

"The Young Ladies Journal." Oct. 1, 1892

Slim waisted girl.—(1) Yes, your waist is decidedly small, considering your height, and from measurements given, we should say you have a very good figure. The result of your tight lacing when so very young might have been very serious, and the discomfort you mention doubtless arises from that cause; we advise you to lace your corsets less tightly, and on no account to sleep in them, as serious internal complaints might arise. It is a great mistake to sacrifice health for the sake of a slim waist, and you would surely regret it if you became an invalid all your life. (2) It is not always possible for girls to prevent their hands being red, as defective circulation is frequently the cause, especially among growing girls. Let your sisters sleep in loose kid gloves every night, smeared inside with cold cream; before going to bed the hands should be washed in very hot water, rubbed with prepared pumice-stone, dried with a soft towel, and then lemon-juice rubbed well into the skin.

"The New Popular Encyclopedia" 1901.

There is another error in relation to corsets as prejudicial as it is general, and calling for the serious attention of all those concerned in the education of young ladies. This error is the belief that girls just approaching their majority should be constantly kept under the influence of corsets in order to form their figures. They are therefore subjected to a discipline of strict lacing at a period when, of all others, its tendency is to produce the most extensive mischief.

Chamber's— Information for the People." 1842.

Errors in dress: It is painful to reflect, that parents, so far from discouraging the practice, are so ignorant as often to force it upon their children. We have heard of a young lady whose mother stood over her every morning, with the engine of torture in her hand, and notwithstanding many remonstrative tears, obliged her to submit to be laced so tightly as almost to stop the power of breathing.

Gunn's. "New Family Physician." 1901.

Not aware of these consequences, or defying them, the mother, as we have said, too often compels her child to submit to a constriction of the waist. If she

happens to have two daughters, one more robust than the other, she endeavors to bring the robust one to the same size as her sister by the corset apparatus. Cries and tears are alike disregarded—the poor girl is forced to submit. In one instance, within our knowedge, a mother violently beat her daughter to make her submit to this process of compression. The girl's health was ruined, and she died from the effects of tight lacing.

"Light on Dark Corners." 1896.

The most extensive and extreme use of the corset occurred in the 16th century, during the reign of Catherine de Medici of France and Queen Elizabeth of England. With Catherine de Medici a thirteen-inch waist measurement was considered the standard of fashion, while a thick waist was an abomination. No lady could consider her figure of proper shape unless she could span her waist with her two hands. To produce this result, a strong rigid corset was worn night and day until the waist was laced down to the required size. Then over this corset was placed the steel apparatus shown in the illustration.

This corset cover reached from the hip to the armpits, and produced a rigid figure over which the dress would fit with perfect smoothness. During the 18th century corsets were largely made from a species of leather known as "bend," which was not unlike that used for shoe soles, and measured nearly a quarter of an inch in thickness.

"The Girls' Own Paper." July 28, 1888.

It seems as if people were never weary of discussing the subject of tight-lacing. One of the weekly papers has had a running correspondence on the subject, which has been accompanied by illustrations of small waists, which were enough to appall the stoutest heart. Some of the letters, too, were very dreadful to read; and altogether one cannot help hoping that some day our girls and women will cease to make such guys of themselves, and to do such a foolish thing as to risk the health and happiness of their lives.

TURN BACK THE CLOCK
A CHANGE IN THE WEATHER

Dear Sir,

Why don't you give us readers a little more variety? You say you cater for all tastes but so far all we see is corsets, corsets and more corsets, high heels and the foul Sir d'Arcy.

Be generous and realize that women look pretty in other garments. May I suggest the macin-

40

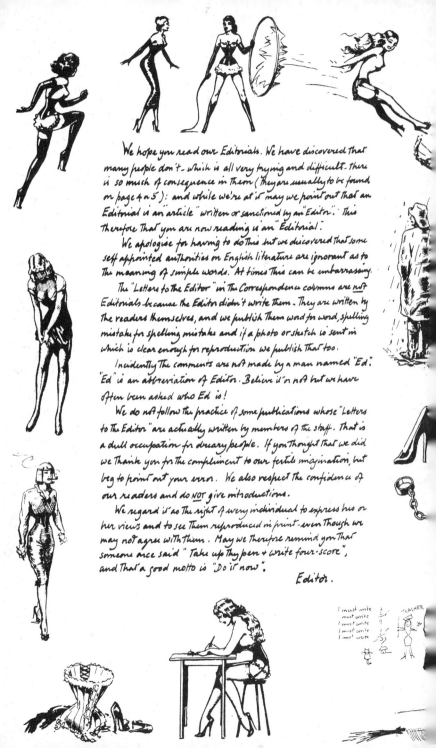

We hope you read our Editorials. We have discovered that many people don't - which is all very trying and difficult. There is so much of consequence in them (They are usually to be found on page 4 & 5): and while we're at it may we point out that an Editorial is an article "written or sanctioned by an Editor". This therefore that you are now reading is an "Editorial".

We apologise for having to do this but we discovered that some self appointed authorities on English literature are ignorant as to the meaning of simple words. At times this can be embarrassing.

The "Letters to the Editor" in the Correspondence columns are not Editorials because the Editor didn't write them. They are written by the readers themselves, and we publish them word for word, spelling mistake for spelling mistake and if a photo or sketch is sent in which is clear enough for reproduction we publish that too.

Incidently the comments are not made by a man named "Ed". "Ed" is an abbreviation of Editor. Believe it or not but we have often been asked who Ed is!

We do not follow the practice of some publications whose "Letters to the Editor" are actually written by members of the staff. That is a dull occupation for dreary people. If you thought that we did we thank you for the compliment to our fertile imagination, but beg to point out your error. We also respect the confidence of our readers and do NOT give introductions.

We regard it as the right of every individual to express his or her views and to see them reproduced in print - even though we may not agree with them. May we therefore remind you that someone once said " Take up thy pen & write four-score", and that a good motto is "Do it now".

Editor.

tosh for an example? It does not matter whether it is the sleeveless kind of cape or the belted and buttoned sort, as long as it is made of rubber. The modern plastics have none of the beauty of the prewar rubber.

You can have your sunshine and your bathing in the sea but give me the rainy-days. The rain makes the flowers grow and it makes the girls look prettier than ever—in a macintosh.

I hope you will publish this because it might encourage other readers to express their views on this subject. Perhaps if you got enough women might take an interest and realise that the change they have made to "plastics" is not a change for the better.

Yours,

McLover

A NEW WAY TO RELAX

Dear Sir,

I wonder if any of your readers are interested in masks? A mask always seems to add an air of mystery to the wearer from the beholder's point of view, and to the wearer it can either be a disguise or, if complete like the one shown in the enclosed photo, an excellent and incomparable adjunct to relaxation.

The eye bandage or blindfold which so many people of both sexes wear to induce sleep is ef-

fective, but not nearly as effective as one which also deadens all sound too. Where speech is also impossible you have reached the ultimate.

The strain that everyone is under in this post-war chaos has induced people to fly for drugs which too often have brought dire consequences. If any of your readers find it hard to rest I would like to recommend a mask as being a simple, more convenient, and much better means of "getting away from it all." It is certainl much cheaper than the vacation in the country which doctors are in the habit of recommending.

Yours,

"Silent"

THE MASKED MARVELLE

Dear Sir:

The interesting way your correspondents have been describing ideas of dress and confessing to indulgence in all sorts of thrilling ideas, prompts me to confess to one of my own.

I have great fondness for being blindfolded. Being robbed of my sight for hours at a time is to me a tremendous thrill.

Even as a child, I loved to play blindfold-games, and even invented several of my own. When those "Sleepshades" came out, some years ago, I was still in school, but I rushed out and bought one, and

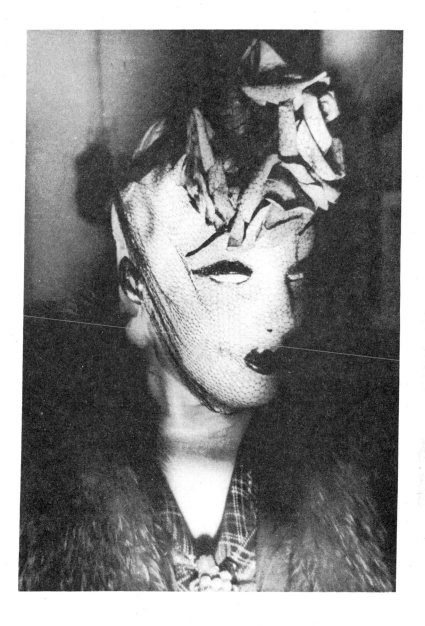

*this rubber mask affords complete disguise
—but why no false eyelashes?*

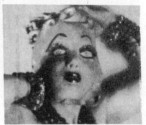

well? guess who?

made all sorts of excuses to wear it around home.

At the time of my marriage, about a year ago, my husband already knew about my hobby, and rather approved of it, since it made me so helpless and dependent on him. When he carried me, his bride, across the threshold of our house for the first time, I was tightly blindfolded; I "saw" the house from top to bottom the first time, entirely through my fingers, just like a blind person. I have spent so much time without the use of my eyes this past year that I move about the house with perfect confidence and can put my hand on just about anything in it,

even if I can't see it.

The first month or so of marriage I was content with a tight bandage-arrangement around my head, holding a soft pad of cotton firmly against each eyelid. But as time went on, I wanted a greater sense of restriction and pressure. Then my husband decided that if I was blind I might as well be dumb too.

So now, when we are going to have a "session," I first put on my special costume, with a skin-tight blouse, a very short tight skirt, tightly suspendered opera hose and my highest heels. Then I sit in a straight chair and my husband ties my arms, legs, waist and

44

shoulders to it so that I can't "interfere"—not that I want to; but it increases the thrill.

Then he pushes a folded handkerchief into my mouth and seals my lips with a wide piece of adhesive tape. I'm as quiet as a mouse after that, I can assure you. Then he tapes a pad of cotton over each eye, and then the really thrilling part begins. He takes a length of flesh-colored jersey-cloth and winds it tightly around my head; he uses a dozen or more strips until my head is swathed with yards of cloth, covering it completely, except for my nostrils. The bandage is carefully smoothed out and fits without a wrinkle anywhere. The pressure around my eyes, cheeks, mouth and over my whole head is wonderfully thrilling. I wouldn't want to take it off; but to make sure I don't, my husband puts a tight leather motorcycling helmet of black leather on my head, draws the chin-strap very tight and then fastens it with a special buckle-and-padlock arrangement. After that, he unties me and I am on my own.

I am in utter darkness and unable to make a sound. I can hear and I can obey. My husband makes sure I do both.

Quite often now I am "swathed" as we call it, from early Saturday evening, in bed all that night, all Sunday and all Sunday night. Of course, my husband uncovers the lower part of my face and takes my gag off to feed me. But my mouth isn't free very long. To make sure I don't move and make him spill anything when feeding me, I am tied to my chair again.

On Sunday mornings, he reads me the papers, and I recline beside him on the big couch in the living room. Since I don't need my arms at a time like that, they are nearly always folded behind my back and tied in that position. My legs are sometimes tied, but not often. My husband says that Opera length hose look better when the legs inside them are free to wriggle. It's amazing what a short tight skirt will do when you can't pull it down—I can feel where it is, even if I can't see it.

Yours, Blindly,

"Blind Girl Fluff"

MORE ABOUT SHOES

Dear Editor,

Well, here's the letter that I promised you the last time that I wrote to you. In a previous letter to your readers I said that I would give a description of the shoes that my wife wears for the evening. Whilst I am quite willing to do this, I feel that I must describe an event that took place sometime ago. I feel that all lovers of high heels will appreciate it.

My wife, by the way her name

is Gayda, and myself decided to go dancing one evening and as usual we generally go with another couple who are our close friends. Their names are John and Sandra.

Gayda and Sandra are particular close friends chiefly because they can discuss for hours that age-old subject that women love to talk about—clothes. John is about eight inches taller than Sandra so you can see that Sandra's shoes have to be some real skyscrapers to get up to his height.

Well, as this dance was an extra special one, both girls decided to make themselves really attractive. To begin with, I remember that they spent all the afternoon at the hairdresser.

John and Sandra called round in the evening to collect us. Sandra looked definitely stunning. She was wearing a lime green sheath frock with elbow length white kid gloves, beige silk stockings and white kid low cut court shoes with 5½″ heels. Sandra, in my opinion, looked even more glamourous. I can give more details as to what she was wearing. She had on a black water silk dress that looked as if she had been poured into it, black elbow length kid gloves, all her undies were of black silk, a black corset, black sheer silk stockings whilst her shoes were dull black kid court, also very low cut with fine pencil

heels 5½″ high.

The two girls certainly made us feel proud although it was difficult to see their high heels on account of their long dresses.

Everything being ready, off we went to the dance. It was quite a nice dance and we were enjoying ourselves immensely. Just after the interval another couple, who we knew fairly well came and sat with us. The girl's name was Joan and she is inclined to be rather domineering, so much so that usually our wives keep clear of her. They could not do that this evening and began to talk about shoes, amongst other things. I did hear Joan remark that she always went in for shoes with very high heels as she considered that they beautified the foot, also that her husband liked to see her in them. Then Sandra asked what kind of shoes she had on at this dance to which she replied, "Quite the highest in this room, I would like to see some higher." She asked us to see for ourselves and lifted up her long dance frock to show us. She was wearing a silver pair of court shoes with heels about 4″ high, quite smart they were but I could see that by the look in our wives' faces that she was going to get a surprise. Sandra started by saying, "'Fraid that you have not the highest heels in the room, my dear, look at mine," and she lifted up her frock and showed her white

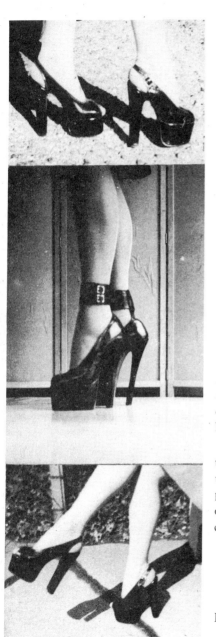

5½" heels. Then she turned to Gayda and said, "And your's are higher too, aren't they, Gayda," to which Gayda replied and surprised us all by saying, "Yes, I think that mine are really the highest here." She then pulled up her frock and showed us a pair of black patent shoes with a fine strap round the instep with 6" heels, so fine that I wondered how she managed to manipulate them. To cut a long story short, she had brought these shoes along with her and put them on during the interval unbeknown to any of us. She normally only wore them at home in the evenings but I had heard her say how she would like to go dancing in them and had taken the opportunity to try them out at this dance. They really were a most fascinating pair of shoes and I found that she could dance even better in them than any of her others.

Well, I guess that's all this time, Ed, I have a host of stories that I could relate to you but paper being short, I reckon that other readers also must have a chance.

Cheerio,
High French Heels

A MATTER OF OBEDIENCE
Dear Editor:

Congratulations on a wonderful magazine. I like to read the frank

7½ in. heels—2 in. platforms

expressions of others about their intimate interests and beliefs. I have been thrilled to find so many sharing ideas of mine that I thought were believed in by few today. I refer to Dr. L's statement that between the sexes, women should be the master and man the slaves. F. M. and "Hi-heel-Don" agree and "Satin" loves to be a complete slave to his wife and from the photo of Mrs. "Satin" in No. 5 I can well understand why. Frenchy is eager to kneel and obey commands in the true French fashion, and S. W. thinks it would be thrilling to be a well disciplined male slave.

Ursula's letter was enchanting. Perhaps no woman can enslave a man unless he wants to be enslaved — BUT — a woman who with a deep feeling of feminine power, uses her graces and charms to become bewitching and ravishing, can make an admirer want to be her abject slave.

I would like to read letters from Mrs. "Satin" and all the other adorable "Slaverettes" telling how they treat their slaves and showing that their slaves enjoy being completely subservient and submissive and are very eager to lick their boots when commanded. I'm sure that some use sterner methods of discipline than Ursula and I believe they should.

Best wishes and you'll hear from me again, since you insist you like the letters.

"Carpet-Knight"

IT'S IN THE BAG

Mr. J. Willie:

I don't believe that U69 could free herself if her arms were folded behind her back—her left wrist tied firmly to her right elbow and vice versa. Her knees and ankles would be tied together tightly also. Then a bag would be slipped over her that would cover her from neck to foot. The bag would be made of the material similar to the seals put on bottles, which shrink around the object on exposure to the air.

This bag would shrink until it would fit her skin tight all over and would prevent the least bit of movement. I think this would make a neat package.

Would like to see the Countess tied up sometime, but escaping for other adventures.

L. R.

INITIATION JOCKEY

Dear Editor,

Joining a girls club I was initiated in a very silly but cute costume. I wore a dog collar, a kid's play suit, biggest size but terribly tight for me, and western riding boots with high heels, and big gauntlets. Clad thus I had to ride —a rocking horse. Oh, yes, I had a derby hat, and spurs!

H. F.

HOME SWEET HOME

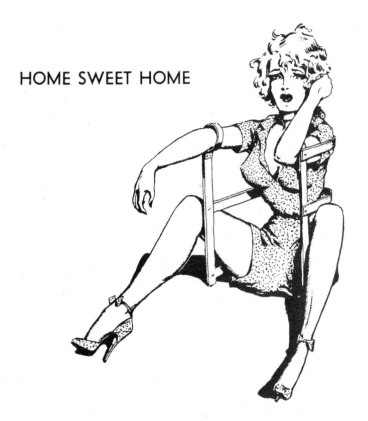

The picture above illustrates one of the most ingeniously simple contraptions for ensuring peace in the home that we have yet come across, and we are eternally grateful to the reader who sent in the particulars.

There seems to be some doubt as to its origin but it appears to have been used by the Chinese many centuries ago, to make the uncomfortable life of a prisoner still more uncomfortable, for it compels the victim to remain more or less in the one position. However, as the device is quite a loose fit, it would be little more than extremely annoying for the first few hours, and so what could be better for a reminder of who's the boss about the place in moments of domestic argument.

The prisoner can smoke, drink, or read a book if these things are placed within reach—but she cannot with any degree of accuracy throw the matches, the bottle or the book at her lord and master's

head if his decision as to the length of time she should remain uncomfortable does not coincide with her's. She can wave her arms freely below the elbow, and waggle her legs madly if she feels like it—for all the good that will do her—but as regards the rest of her anatomy she can only just wiggle a bit. Quite definitely the thing is most effective.

As you can see, the gadget consists of iron rods—like a three-barred gate bent into a "U", with rings for the arms and an iron collar which locks around the neck —the only lock on the whole outfit.

To put it on, the victim steps into it and it is then pulled up like a pair of overalls, the hands being introduced into the arm rings and then pushed through until the ring is above the elbow— by which time the legs are also in the proper place. The collar is then locked and there you are— all set for a quiet afternoon with plenty of time to think over the matter of that last dressmaker's bill.

We are thinking of making one to try out on our typist and thus get a first hand account of what it's like. At this juncture, we must point out that it needs careful handling. The Chinese, when they felt so inclined, would place the victim on his, or her, feet. Even-tually, of course, the unfortunate wretch would overbalance and the result would be a broken neck. We will therefore make a point of placing our typist in a sitting position when making the test.

We quite admit that there are times when we consider laying violent hands on Miss Myrtle but breaking her neck doesn't seem to fit the bill.

When in this mood the idea that appeals to us most strongly is to grasp the neck firmly and twist it round three or four times one way, and then unwinding it so that it can be twisted three or four times in the other direction.

But to return to this gadget which we recommend, and which not being patent will promptly be snapped up by some smart manufacturer and placed on the market. Have you seen anything simpler and more effective? We welcome your comments.

Editor

Hurrah for Progress

Once again, as in the days when demure Helen Wills came out of the tennis west to amaze Eastern galleries with her precocious skill, pigtails are back in style for the little girl of 10 to 12 years of age. But now, with the added spice and sugar of lipstick, gayly painted fingernails, and cigarettes. Every modern mother has smoked cigarettes since she was 12 years

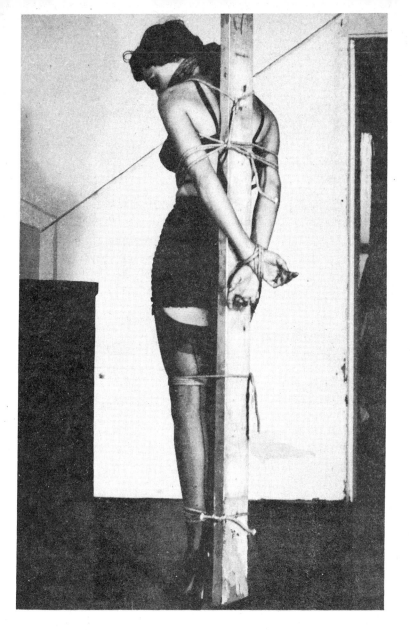

DONT LET THIS HAPPEN TO YOU

learn jui jitsu
and the art of self defense

of age, but in her own childhood days she had to smoke secretly, because of the disapproval of adults in those earlier days, now happily gone forever. Today, therefore, with mature wisdom, she views with a tolerant and understanding eye, her young daughter's interest in these feminine vanities; and her ten-year-old daughter can smoke openly, and as much as she wants. In the same way, the modern mother encourages her daughter to use vivid lipstick and to paint her fingernails and toenails as soon as she shows the slightest interest in thus adorning her little body and adding to its childhood attractiveness and gaiety. There is also a growing revolt against the unesthetic habit of wearing clumsy, flat-heeled shoes in childhood, with increasing realization that, to train a child in ways of beauty and feminine grace, it is desirable that she should begin to wear dainty and attractive high-heeled shoes by the time she is ten or eleven years of age—in other words, about the same time as she begins to smoke and use lipstick. All this, of course, would have scandalized an older generation, but it is the inevitable way of progress. Now that women have been fully emancipated from the old puritan taboos that shackled their efforts at attractiveness, the emancipation of childhood is the next step, and nothing can stop it. Ten or eleven

is also the proper age to begin the practice of tight-lacing and training for a tiny waist. As the twig is bent . . .

Yours,

R. V. F.

A TAFFETA TALE

Dear Sir,

My mother practiced "Petticoat Punishment" on me as a disciplinary measure. On my return from school, she would dress me in elaborately frilled girl's clothes for various periods—an afternoon or several afternoons, depending on the extent of my unrulyness. I was never "Shown-off" to guests, only my Mother and the family maid knowing how I was being punished.

On one thing, she was adamant —I must wear two taffeta petticoats which she designed and made herself, for as she was wont to say—"I can always tell what you are up to," and "They will serve to remind you of your frillies."

After the first few times of being arrayed in this fashion, I came to take delight in wearing this attire, and would dress-up in them, if I were left alone, standing before a mirror tossing my skirts about to make them rustle sweetly. Of course when "ordered" into petticoats, I made a great fuss and to-do.

When she discontinued the practice, I used to dress-up at

52

every opportunity in them—as long as I could get into them. After that I transferred my attention to her clothing. Later, when I took up residence on my own, I purchased a very complete array of feminine fripperies — yes, even stays and high-heeled slippers and boots—custom-made. The character of the costume varied with my whims—I could be a little girl in elaborately frilled undies and knee-length sash frocks—a smart maid in black taffeta with cap and apron or a young lady of fashion—in fact any character I decided to mimic.

Petticoat Slave

BARELY BALI

Dear Sirs,

My wife is very feminine which is to my liking, she enjoys all the tricks of allure except she never wears a girdle and rarely a bra, being very proud of her figure.

Jean is employed in a beauty shop so keeps up to the minute on all the latest beauty trends. One delightful trick she has is that I never know how she will look when I greet her after work, her hairdos go up and down, from fluffy to smooth and her make-up from the fresh scrubbed look to the sophisticated. Her favorite pastime for an evening at home, I find enjoyable and fascinating, she likes to make-up in the most ex-treme manner possible using powders, lipsticks and eye make-up of the colors in the rainbow, sometimes actually it's a cosmetic mask.

I started Jean on a style when I brought her home some sarongs from the South Pacific she started wearing them around the house right away and became a bare bosom fan. Since then she has found many ways of dressing with either one or both breasts bare. I protested at first, very weakly, but now I think it's grand, my favorite outfit is an evening skirt, sandles and gloves long or short.

Exotically made up and dressed in the above fashion, I'm sure she would make a Puritan forget he was a Puritan.

Good luck again from both of us.

Hank

PAINTED NAILS

Dear Sir:

One of the most charming fashions of the modern woman is her practice of adding to the beauty of her hands and feet (which she now reveals in everyday life for the delight of men's eyes) by painting her fingernails and toenails. What has made this fashion especially thrilling and seductive has been her discovery that men disliked mild and timid coloring, but were tremendously thrilled by toenails and fingernails painted the

darkest shades of red, black-red, and glossy jet-black. And the next discovery was that she could add even more loveliness and thrill-value to her fingers by letting her painted nails grow extremely long, far beyond the length of her fingers. And yet these elegantly l-o-n-g dark fingernails are not nearly so common as men would wish, doubtless because so many women now work for a living, in fields where long nails would be inconvenient. Yet for the woman who wishes to charm and allure the masculine eye, there can be no greater aid than ultra-long painted fingernails, which have the same essential beauty, and the same exciting element of "daring," as the tightly-laced corset and the six-inch heel.

A few years ago, a beauty-expert of Hollywood, California, grew fingernails three inches long, just to show her clients that such nails were thoroughly practical. These nails, painted dark red, were shown in photographs of her hands in magazines and newspapers. They were of course quite fascinating and attractive; yet I would say that still more attractive and thrilling were the much shorter and yet still extremely long painted nails of the Chinese entertainer, Noel Toy. Her nails were excitingly long and curved, and such as any woman who values feminine allure will be well advised to emu-late. I feel sure that many of your feminine readers must have appreciated the thrill-value of very long painted nails, and I suggest that they send in photographs of their hands showing what they have accomplished in this direction.

Raymond

YES! — BLOOMERS

Dear Sir,

I found a copy of your magazine folded to the letter about bloomers on page 41. I used to wear bloomers, before the war, when I could get them. I liked the smooth way they felt above my stockings and I know my husband liked them.

I got out the only two pairs that I had left but they are so badly worn that they are only fit to wear in the apartment. I have been unable to locate any bloomers in the local stores. If you know of any stores in the U. S. A. selling bloomers, would you please publish their names? I am sure that my husband would be glad to see me in bloomers again.

Yours,

Dolly

NO! — BLOOMERS

Dear Editor,

My cousin received Vol. 3 of your grand magazine and passed it on to me to read. I got quite a chuckle out of the person wanting us to go back to wearing bloomers

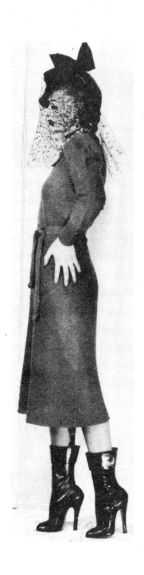

this photo from a reader shows to our way of thinking boots as smart as anything we've ever seen.

again. Not for me with tight elastic around my legs. Let's keep our freedom. The silk stocking advocate is right for I have myself noticed that legs look better encased in silk and do they bring on the wolf call.

Regarding H. S. on the seat of the government. It has its good points as a bawling out lingers on and brings only resentment. Her picture of the procedure brought painfully to my mind my last spanking which happened a week ago.

I remain feelingly,,

R. B.

MORE ABOUT CORSETS

Dear Sir,

In his book, *Why Women Wear Clothes* (Faber & Faber, London, 1941), Mr. Willett Cunnington writes as follows: "The waist is so distinctively a feminine feature of the body that it has always been attractive to Man. The craving to possess a small waist has exercised Woman's mind from time immemorial; and it has the additional advantage that it throws into high relief the bosom above and the hips below. The apparent smallness of the waist is accentuated by a thousand devices, and in particular by the use of a tightly-laced corset. In skillful hands and by long practice it is capable of reducing the normal measure-

ment of the waist to nearly half its size. No woman can surely ask a greater miracle of the art of costume than that it should double her charm by cutting her in half.

"Of all garments used mainly to attract Man the most ancient is unquestionably the corset. Man has always approved of the corset, partly because of its shaped curves and partly because of its symbolism. It is only from the 19th century that we can obtain accurate information about the fashionable stays and their circumference. A great mass of contemporary evidence makes it clear that waist measurements of 16 and even 15 inches were common. But we also learn that the practice of tight-lacing was not solely to enhance physical charm. the pressure provoked very agreeable sensations of an exciting nature. It is significant that the mannish female disdains the use of corsets."

In recent months, half a dozen beauty magazines have published photographs showing American maidens of today, who have taken up tight-lacing with enthusiasm, corsetted so tightly that their waists are compressed to a thrillingly tiny 17, 18, or 19 inches. Admirable as this is, it is only the beginning! Cunnington quotes the following passages from letters written by girls of the last century:

"My eldest sister, aged 21, wears stays which allow her waist only 14 inches, and even when playing tennis she allows her waist to be only 2 inches larger. My next sister, who is 18, has a waist of 13½ inches, and I have seen her indoors with a waist of only 12 inches."

"Although now 25, my waist is only 17 inches. My eldest sister has a waist of 15, and the youngest, who is 18, has one of 14 inches."

"I myself have worn stays since I was a child and now, at 30 years of age, have a waist of 17 inches and a bust of 38 inches. I can row and play tennis as well as any one I know."

"The sensation of wearing tightly-laced stays I find most delightful, although they are so tight I can hardly breathe. My waist now I am 19 years old is 14 inches. I generally sleep in stays."

"When I had drawn in to 12 inches the sensation was acute, and at last I vanquished my rival—my waist was only 11 inches."

All of which may serve as an inspiration to our modern maidens! For a New York newspaper, the Brooklyn Daily Eagle, not too long ago printed the following item on its women's page, in reference to the return of the corset, which is now an accomplished fact: "Another development is that many stores are planning exclusive corset departments for the younger

in many years. With girls once again wearing corsets from early childhood, and beginning the practice of ultra-tight lacing at the age of 11 and 12, we may confidently expect that in a few years our modern women will be able to achieve the thrillingly tiny waists of 12 to 14 inches that made the women of yesterday so attractive. And combined with the far more alluring and abbreviated modern costumes and the more lovely modern hair-styles, and with bare-foot shoes with six-inch heels, the tightly-laced corset will make the women of today and tomorrow the most seductive, the most fascinating, and the most excitingly feminine of any period in history.

Yours truly,

R. V. F.

at the request of a reader we print this illustration from the article on figure training vol. 4, page 16

crowd. The more modern stores will even have youthful clerks to help out teen-age buyers. The 11 to 15 years crowd will have their figure-molders in black, yellow, blue, or pink."

This is the most admirable and important fashion announcement

DAMMIT COUNTESS, HERE'S A CAD

Dear Editor,

I get a big kick out of reading the correspondence from your other readers, and think the correspondence issue was a good idea, and I hope you will publish other correspondence issues in the future.

Personally, I would rather see the space devoted to D'Arcy, used for more correspondence, or other illustrations of readers' fads and fashions.

I was particularly interested in

the letter from Hank B, which expresses the same ideas I have myself, although he seems to be in a better position to indulge himself, than I am. Apparently, our Courts do not take into consideration, the origin of fashion, when a male is caught "masquerading" in feminine clothing, and usually treat him as a mental incompetent, or "Moron" and yet the official Court Costume, is designed along so called "feminine" lines with long flowing robes, wigs, and silk stockings and breeches. No objection is usually taken by the courts to females parading in public, in so called, or adaptations of "male" attire.

I maintain that if a man wishes to wear clothing, which is not authentically male, in the accepted sense, that is entirely his own business, and if more men dressed as they pleased in public, there would be an end to the objection, and ridicule which accompanies any effort to break away from the present accepted ugly clothing men are compelled to wear by the conventions of our "modern Society(?)"

Yours sincerely,

C. H. McC.

A few years ago the Police in Melbourne (Australia) arrested a man in the street for appearing in public dressed as a woman. The judge dismissed the case contend- *ing that wearing female clothes was no offense in itself. To call it masquerading would depend on how the wearer behaved when so attired.*—Ed.

DON'T BASH THE BRAT

Dear Sir,

I like Bizarre very much. I like the column where one can express their views on various subjects. I will speak on a subject that is often discussed whether or not children should be whipped. I do not have any time for parents that are brutal to children. But I think where children are naughty and disobedient, a good old fashioned pants warming is sometimes effective, for striking a child about the head or face can sometimes cause serious injury.

Yours truly,

P. W.

SWITCH TO THIS

Dear Sir,

I agree with Le K that a good whipping is sometimes necessary and preferable. How about an article on this subject, perhaps discussing the various methods of discipline? The various methods, such as the switch vs. the hair brush, etc., would, I believe, be of interest to your readers.

Although our daughter is 17, when she is naughty, she is whipped soundly and never sulks afterwards. She is taught to bring me

58

how do you like this for a pair of plaits?

the switch from the hall closet, then places herself over the arm of an overstuffed chair, and then waits for me to deliver a few vigorous strokes on the backs of her legs or upon her "seat of government."

Am looking forward to the continued success of your magazine.

Yours truly,

M. O.

APPLE SAUCE

Dear Editor,

Like most men, Bizarre's editor seems intent on putting all girls into the highest heels, tightest clothes, and most restraining discipline. Why not give men a taste of their own pet medicines? Lace them, make them wear narrow sheath skirts, hampering sleeves, and skyscraper heels and see how long they can take it without complaining! What is sauce for the goose is sauce for the gander. Or isn't it?

Carolyn

And I am a brother to the old wild goose.

WOULD HUSBANDS STAY?

Dear Sir:

I think that "Smart Severity" really has something. It is a titilating to think of a lovely lady mounted on a handsome horse whose fractiousness she controls with a severe curb bit, the while she uses her silver spurs and wicked little whip, to make him prance and cavort.

Why could not the same lovely lady rule a husband in precisely the same manner? Her control and mastery of him would never be lost for even a moment. She would be the beautiful, arrogant mistress,—he, the humble, uxorious slave!

The old-fashioned double standard would apply to this marriage, —but in exact reverse. For if the husband even looked twice at another woman he would be punished as the vilest slave is punished; while the wife would be free as air.

If she chose to exhibit him to her friends, he would be handsome, polished, gallant, — everything that a husband should be, but always he would watch with anxious concern. the face of his Mistress, for the curl of her lip, or the lifting of an eyebrow, that might signal her displeasure. This was the sign that he dreaded with a mortal dread for he knew what inevitably would follow when they reached home.

Yes, the lovely lady of this fable would lead a happy life,—and the husband? Well, perhaps he would be happy, too!

Yours,

P. A.

FOR MODERN LACING

Dear Editor,

Some of the articles, particularly the corsets and high heels, intrigued me greatly even if I do feel that most of them are considerably exaggerated. But when are you going to bring these corset stories and pictures up to date? Some of the more severe of the modern figure controlling garments would afford pretty snappy descriptions and some wonderful photographs. Maybe first some beautiful young model getting herself firmly laced into one of the longest and heaviest of these harnesses, then a few progressive shots of her doing some familiar act the hard way, something like the girl in volume two trying to climb the fence.

Why don't you and J. W. do a little research, some personal reconnaisance, to discover and picture for us just how far, to what extreme, modern woman will go to attain and preserve the 1947 silhouette with the nipped-in waist, the long sleek hips and snugly-encased thighs. (*We're out on the prowl.*—Ed.)

60

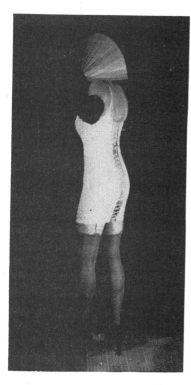

Just to give you an idea what I mean and a start on the series, I am enclosing one picture from my own collection. This kind of corseting seems just about as drastic as some of the old-fashioned figure training devices, yet this one was ordered right out of one of the big mail order catalogues for every-day wear by the young lady in the photo who says they are not so bad after you get used to them and find out the things you just can't do when you have your corsets on.

The corset in the picture is minutely described in the catalogue as 36 bust, 27 waist and 38 hip with an 18 inch skirt from the waist down. They come, of course, in smaller sizes and even longer skirts as much as 20 inches for the very tall. Yours truly.

the lady and the fan H. T.

they go to sleep—the husband ties her up—and to prove the wedding she must try and get free before he wakes up in the morning. If she succeeds then she has the final decision in future arguments—but if she cannot get free—then the husband rules the roost." And leaning over my chair once more until our two faces were only inches apart—she put a finger on the tip of my nose and wiggled it—"and for your information, Jimmy, I'm pretty clever at wrigging out of knots."

I grinned. "Then obviously you wouldn't want to get tangled up with a sailor, would you?" I replied.

Further discussion was unfortunately stopped by much clattering and noise as the two boys re-entered the room each carrying a huge tray laden with the most appetizing food.

I shall never forget that evening.

While the boys were setting the table, I slipped out and changed my clothes. Like the others I wore nothing but a sarong as we sat on little stools around a low table in the soft light of the lamps.

The food was fit for Lucullus and I washed it down with copious swigs of that same amber wine that I found by my bed—and then topped it off with excellent coffee.

Mutt and Geoff were a cheerful pair. They kept up a merry prattle—and did all the chores, which earned the eternal gratitude of Malua.

She and I said little—there was no need. Occasionally, I asked a question but more often than not, my mind wandered from the answer to the vision of the girl opposite me, her lovely face framed in the shimmering dark mist of her hair in which was an enormous scented hibiscus (incidentally, I've never heard of this species anywhere else before—it smells like Lily of the Valley.)

From her ears hung long earrings—so long that they brushed her shoulder and flashed and sparkled at every movement, while round her neck she wore a string of exquisitely matched pearls.

I was dining with a goddess on the food and wine of the gods—I was sitting on a cloud away above Mount Olympus—I had another drink of wine and the cloud floated a bit higher.

The spell was broken by the unromantic twins Mutt and Geoff demanding that we take ourselves elsewhere so that they could fix the table for late comers, so Malua and I collected drinks and cigarettes and wandered back to our arm chairs.

(To be Continued)

Sir d'Arcy & "THE WASP WOMEN"

ADVENTURE N°2　　by John Willie　　　　　　　**EPISODE N° 1**

FLAT BROKE AFTER HIS FAILURE IN THE RACE FOR THE GOLD CUP SIR D'ARCY IS IN DIRE STRAITS.

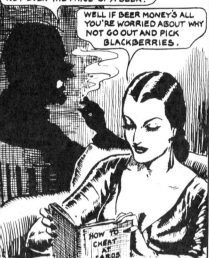

GAD!- THIS PENURY IS GHASTLY!- NOT EVEN THE PRICE OF A BEER!

WELL IF BEER MONEY'S ALL YOU'RE WORRIED ABOUT WHY NOT GO OUT AND PICK BLACKBERRIES.

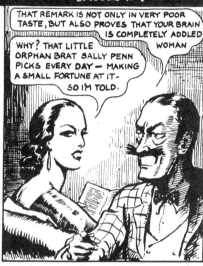

THAT REMARK IS NOT ONLY IN VERY POOR TASTE, BUT ALSO PROVES THAT YOUR BRAIN IS COMPLETELY ADDLED WOMAN

WHY? THAT LITTLE ORPHAN BRAT SALLY PENN PICKS EVERY DAY — MAKING A SMALL FORTUNE AT IT- SO I'M TOLD.

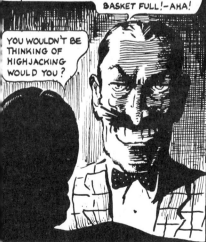

YE GODS! A D'ARCY IN A BRAMBLE BUSH! BAH! -HM!- WAIT THOUGH - WHY NOT LET HER PICK 'EM, AN' WHEN SHE HAS HER HORRID LITTLE BASKET FULL!-AHA!

YOU WOULDN'T BE THINKING OF HIGHJACKING WOULD YOU?

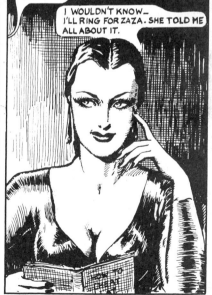

GOOD LORD.YOU MUST BE PSYCHIC OR ·SOMETHIN "M"!- HOW THE DEVIL'D'YOU GUESS?

I WOULDN'T KNOW— I'LL RING FOR ZAZA. SHE TOLD ME ALL ABOUT IT.

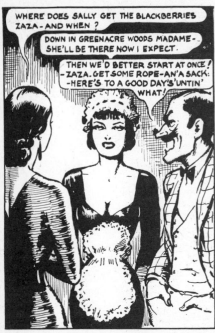

WHERE DOES SALLY GET THE BLACKBERRIES ZAZA - AND WHEN?

DOWN IN GREENACRE WOODS MADAME - SHE'LL BE THERE NOW I EXPECT.

THEN WE'D BETTER START AT ONCE! - ZAZA. GET SOME ROPE-AN' A SACK: -HERE'S TO A GOOD DAY'S 'UNTIN' WHAT!

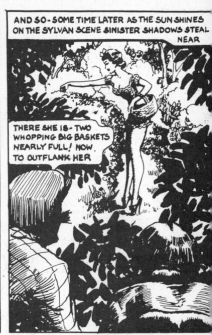

AND SO- SOME TIME LATER AS THE SUN SHINES ON THE SYLVAN SCENE SINISTER SHADOWS STEAL NEAR

THERE SHE IS- TWO WHOPPING BIG BASKETS NEARLY FULL! NOW TO OUTFLANK HER

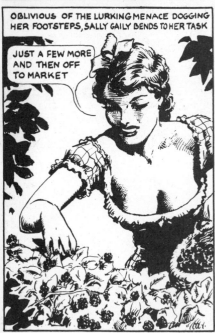

OBLIVIOUS OF THE LURKING MENACE DOGGING HER FOOTSTEPS, SALLY GAILY BENDS TO HER TASK

JUST A FEW MORE AND THEN OFF TO MARKET

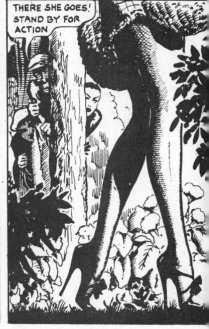

THERE SHE GOES! STAND BY FOR ACTION

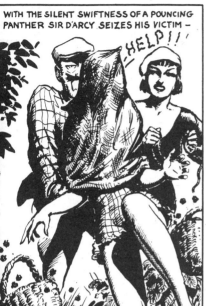

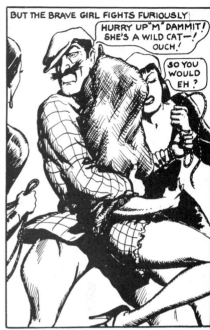

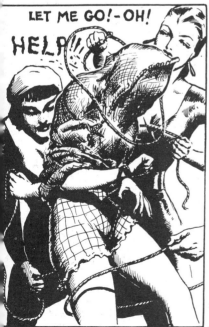

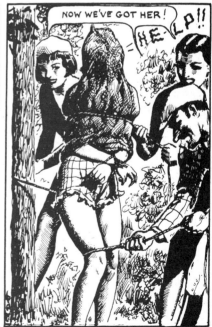

65

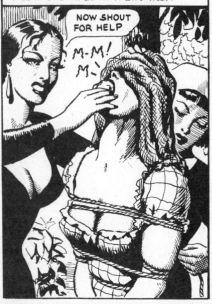

WITH CALLOUS THOROUGHNESS THE VILLAINS COMPLETE THEIR TASK

NOW SHOUT FOR HELP

M-M! M-`

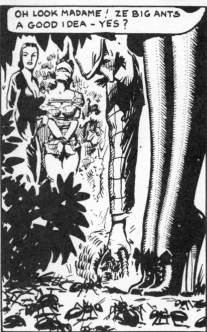

OH LOOK MADAME! ZE BIG ANTS A GOOD IDEA - YES?

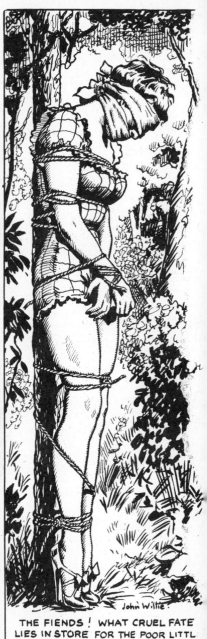

John Willie.

THE FIENDS! WHAT CRUEL FATE LIES IN STORE FOR THE POOR LITTL ORPHAN? SEE NEXT EPISODE.

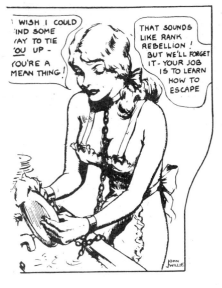

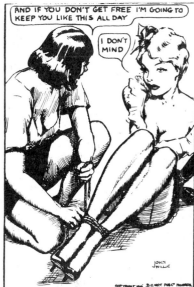

Every cartoon has its "interested readers" and it has its "fanatical fans." Many of the latter (God bless 'em) insist that my cartoon should come out at least once a week. I agree—and—

IT CAN BE DONE if the cost of production and mailing is justified. Hitherto, most of my bright ideas to get out of the red have only put us in deeper—so we are now looking before we leap.

The idea is to mail to you—each week—4 (four) pages of Sir d'Arcy & The Wasp Woman (as in this issue) and thus fill in the gap between each issue of Bizarre.

Therefore, oh faithful fan and follower of the foul Sir d'Arcy, write now if you are interested in the weekly proposition.

John Willie

P. O. Box 511
Montreal 3

and for heaven's sake, DON'T send any money. I just want to know where I stand.

AND I REFER YOU TO PAGE 61.

for slaves of fashion

Achilles

theatrical footwear

BiZARRE

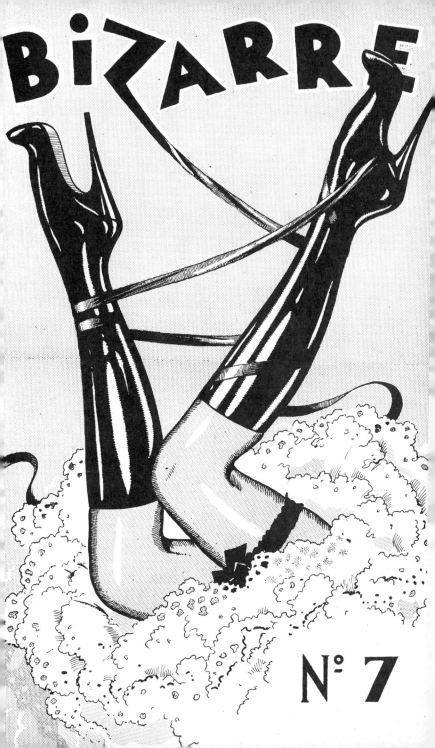

N° 7

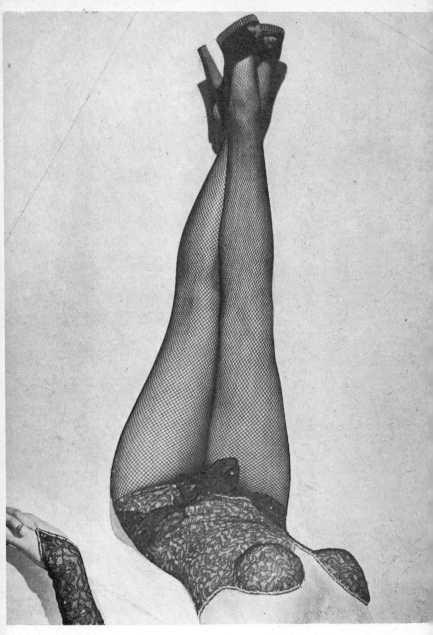

Kollar N. Y. C.

The net result

BIZARRE

"a fashion fantasia"

No. 7

"Ah, make the most of what we yet may spend,
Before we too into the Dust descend;
Dust unto Dust, and under Dust, to lie,
Sans Wine, sans Song, sans Singer, and—sans End!"

CONTENTS

NEXT ISSUE No. 8

No. 8 will be more like No. 5—mainly correspondence, photos from readers, illustrations by J. W., not forgetting the bloomer fans, the punshments of bygone days and the figure training gadgets, topped off with more of the foul Sir d'Arcy and the Wasp Women!

BACK NUMBERS

Only No. 4 is available—all other issues are 100 percent sold out, but if enough requests come in we will consider reprints.

Printed and Published by The Bizarre Publishing Co., P. O. Box 511, Montreal, Canada
Copyright. All rights to these titles reserved. 1952

Oh, dear! It's a nip an' tuck existence

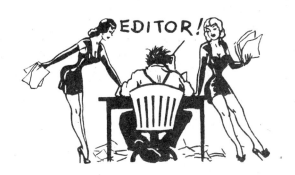

Well, it's happened! ... This really is No. 7! ... Gosh!

We hope it lives up to your expectations.

And will those "anonymous" writers who send in rafts of clippings from other magazines, etc., PLEASE give the name and date of publication. Maybe we can then obtain the original photo and reprint it for the benefit of the other readers. There is nothing more exasperating than to receive a lot of clippings, with no clue as to where they came from, in a letter signed "Jiminy Cricket, Chicago"—or some such moniker. We can't write back and ask for particulars—we don't know where to get the pictures—in fact all we can do is swear. We seem to do a lot of that for one reason or another these days.

So far as this issue (No. 7) is concerned we had to take out our promised discourse on the punishments of olden times because, owing to the long delay, we had a mass of correspondence. In fact it has piled up to such a degree—and we hope goes on piling up—that No. 8, which we now expect to publish—brace yourself for it—in 2 (two) months time, will be more like No. 5.

Please keep up the good work of sending along letters, photos and sketches for publication because it looks as if we may have overcome our distribution problems at long last, which means that we can publish regularly from now on every two months, maybe more frequently. Keep your fingers crossed and wish us luck.

Incidentally, if you write to us and get an answer back in strange type it's "Liza." Liza was rash enough to poke her nose into the joint one day—with her own typewriter, too (foolish girl) and before she even had time to take off her hat we had one ankle shackled to the desk. (Note—You can hold a secretary just as easily by one leg.) She now gets her own back by the way she types and the things she says in her letters.

And while we think of it: Again the bloomer brigade have been neglected, but we'll get J. W. to work on your suggestions and include them in No. 8. That's a promise.

PLAITITUDES

WE ARE always glad when readers in other countries write telling us about fashion trends and so on. Though daily fare to them it's news to others.

from a Correspondent in Paris—

THE CHIC, slim-waisted *Parisiennes* are wearing their hair longer and longer and loud hurrahs are heard from the male side. The Frenchman likes his women small, short-skirted, very high-heeled and especially with long tresses. The girls usually wear their front hair piled extremely high in a mass of waves and curls with the remaining back hair hanging loose or held in a net.

A few months ago, a vogue for "les fausses tresses" or thick braids of false hair came into the fashion spotlight. Now one sees a comely creature slithering her lovely slim waist down the "trottoir" and perched on her head is a beautiful thick plait of hair. A lover of beautiful hair turns his head ... but the sharp-eyed can see the piece is false and the girl has only short hair with the ends rolled around the braid ends. A disappointment, indeed.

One hears that the vogue for long hair started when the Americans arrived in Paris. Before that, practically all the feminine world Paris wore their tresses rather short knowing that the German soldiers didn't care for that fashion. Their ideal is a long-haired blonde type ... and the *Parisiennes* were not wont to please. But the G.I. liked his women with a long bob and thus hair started growing and the scissors were put away. The longest of the long-haired are usually found among the "poules" or girls who make their living on the street. They aim to please the G.I. and thus long hair is the rule ... and the little tantalizers are often seen wearing their gorgeous locks hanging below the waist as they promenade the Boulevards.

Well, there is my version of the Paris hair doings. Hope it can be used. H. C.

Rosalind Russ

Loretta Young

The NEWEST NEW LOOK

no patent pending

IT ISN'T EASY to come up with something really new these days—particularly in the field of "fashion"—but this time we've done it. We've come up with something so completely new that it'll cause a stampede!

Brace yourself! Hang on to your hat! And keep your legs crossed. Here's how it happened...

As usual, around 10 p.m., we were there, all four feet in the trough, mopping it up at the same bar that we've been propping up every night since we found it back in October '45—which speaks a lot for the excellence of the beer, with its welcome absence of collar (except when Nick dishes it out on Saturday night) — the pleasant company, the peaceful surroundings, and the way the joint looks after homeless wanderers like ourselves (and if that doesn't make his nibs turn it on for once nothing ever will).

Well, there we were on this particular evening, gills awash, musing on the sorrows and troubles of this badly mismanaged world—when the Editor, pushing his glass across for a refill, said:

"You know, this business is getting pretty damn monotonous. Everything we've forecast has come off—4 and 5 inch heels are around everywhere. All day and every day the ads talk about 'waist nippers,' 'hour-glass figures,' 'the new pinched look' and so on. Talk about the Spectre of the Rose—whatever that was—your modern damsel is now haunted at every turn by the spectre of the 'corset' and its accompanying 'figure training gadgets'—which reminds me, we're due for another article on that soon."

He paused to sip his beer and lapsed into silence for a moment, then continued: "Yes, as fashion forecasters we're second to none. Take that mummy idea of yours in Vol. 3, John Willie, which I thought a trifle far-fetched, and what happens? Fath, according to the scribes, has now come out with a dress which is identical—at least they say the wearer is literally swathed like a mummy from top to toe.

"Yes, and then there's that belt and bracelet by Hermes of Paris, with padlocks and most convenient rings—all you need to do is to attach chains and you have our forecast for—what year was it? 1952—'53—anyway it was somewhere around there, wasn't it?"

John Willie nodded assent. "There's nothing very brilliant about it," he sighed. "It's just a dull dreary routine. There's nothing new under the sun. What was that classic ode I once wrote for that other outfit:

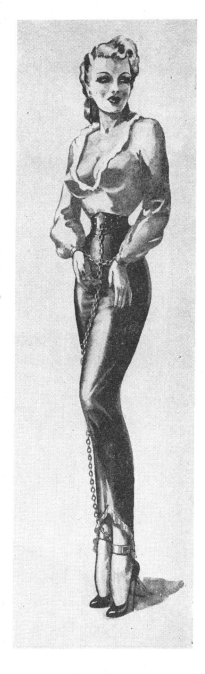

"So Fashion goes like wheels
around with silks and frills
and laces

For mariage comes not to the
chaste but to the wench
wot chases.

"Consider skirts for example.
They're long, they're short, they're
tight, they're loose—the same old
routine—going on round and
round, up and down, down and
up. In a year or so skirts'll prob-
ably be monstrous affairs, but at
the moment they're still flirting
with the 'pencil silhouette.' They
haven't as yet reached their zenith
in that direction, unless this new
Fath business is really all it's
cracked up to be. Yes, it's just a
dreary routine," and he lapsed
into silence, taking a long drink,
moodily, holding the glass with
both hands, while gloom spread
over all three of us.

Then suddenly John Willie sat
straight up, put his glass carefully
on the bar so as not to spill it, and
exclaimed, "I've got it! I've got
something completely new! Some-
thing which has never been tried
before and which is so absolutely
shattering that it's terrific—the
greatest invention since the fig leaf
and the falsie! Let's have another
beer while I go into this thing!"

So we all pushed our pots over
for a refill with a meaning look at
Liza (the General Manager and
Keeper of the Petty Cash) and

that Skirt

it's long—

it's short

—it's short
it's tight

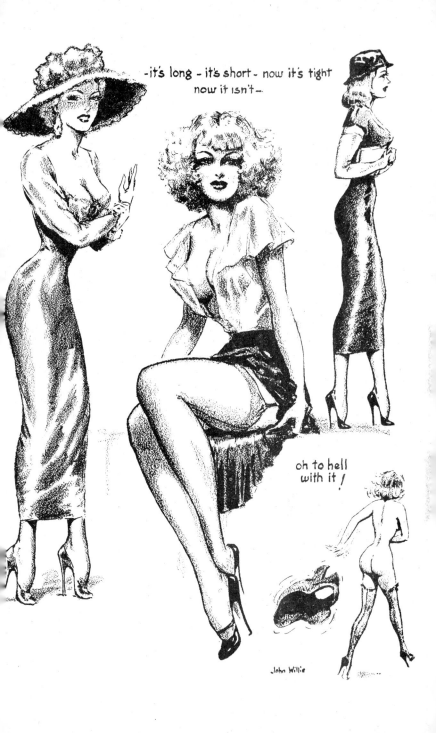

then sat back to listen to genius.

"You may remember," said John Willie, who in the meantime had acquired a pencil and beer menus from Ray, "that at the beginning of the century when skirts were fairly full and just about brushed the floor it was a common practice for husbands with nagging wives, or kids with bossy grown up sisters, to even things up and obtain a little peace by the simple process of hoisting the skirts up over the damsel's noisy head, and then tying the top like a bag, which Miss or Mrs. Nuisance couldn't remove because her arms were imprisoned inside, and pretty firmly, too, if the skirt was tight enough. All very simple and very effective, if I may say so," and he began sketching— the spilt beer, which the paper absorbed from the bar, giving it a somewhat mottled effect. The Editor and Liza looked on.

"Here's the layout," said J. W., breathing heavily all over everything. "Here's a sketch—tired business man and nagging wife—then here, full column on the next page, shows how he coped with her—the damsel expressing muffled annoy-

ance—he'd use his tie to fasten the skirt over her head, I suppose, and then, over here, a small sketch to show him now able to sit and read his paper — all happy and undisturbed."

"There's nothing new in that," said the Editor, "but it's a good idea for the next issue anyway—"

"Ah, but wait," J.W. continued, "here's the brainwave. Right at the start we'll have as a memory jogger a picture like that damsel in Vol. 3— tight skirt and chains—remember? For 1952 you said, didn't you? That's just to show how good we are at the soothsaying business, and now we forecast again in our own unerring style—see?"

"No," said Liza, "I don't—but go on."

"All right," said J. W. "We want something entirely new in the way of skirts, don't we? Right! Something completely and abso-

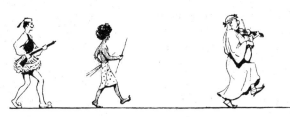

lutely without precedent in the annals of fashion design and frills. That's our base of operations—

So why not wear them the other way round — have them hanging *up*—tailored to fit, of course—instead of hanging down." And he began clothing the naked figure he had already drawn, to the annoyance of a bloke who, glass in hand, had been peering over his shoulder.

"Here," J. W. went on, "we have a lady of fashion in 1952—I say '52 because I bet this'll catch on quick and spread like wildfire. The lady's in Bond Street or Fifth Avenue or someplace. She has a somewhat peevish look because she has a smut on her nose, or it itches or something and she can't get at it."

"She'll need something more striking at the bottom," Liza interrupted. "That looks as if she's just got on ordinary scanties."

"Well, why shouldn't she," J.W. replied. "Do you want her to go around bare? Oh, I see what you mean; something terrific in the way of pants. Enor-

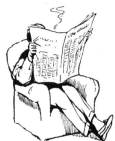

15

mous bows?—A wee monogram of her favorite boyfriend?—J.W. of course—picked out in old lace, that sort of thing. Here, how's this?" and he scrabbled away happily.

"That's all right," commented Liza, "but you'd better make the bows bigger still. From here they look as if she's got spiders running up her legs."

John Willie made the necessary alteration and mumbled on. "Of course, over here we'd show something different for evening wear at home—being out of the vulgar public's gaze it can be more intimate. You cover the whole face. That'll please Blind Girl Fluff and her fans. It'll be likewise tailored to fit, of course, so it's got a really smart appearance. We'll make one for you, Liza! We'll make it out of mink, and instead of the metal collar and padlock you shall have a diamond choker!"

"I'll settle for another beer," said Liza.

"Pity," said the Editor. "Great pity. But perhaps you're right though—three more, please, Ray —and somehow I have a hunch that although so far we've been right in our picking, this time we're putting our money on an outsider—a moke of mokes, in fact —but we'll see. Fashion designers can have the idea free gratis."

And that, dear Reader, is how this newest of new ideas—the up-

sidedown skirt—came into being. "What happens about the corset and the wasp waist?" Many readers have often mentioned the "Venus" corset, and that seems to be the solution. The Venus corset, as its name implies, was designed to encase the arms and body, with the arms folded inside it. That, worn under the "Upside-down" skirt (or U.D. for short) would look very sleek; in fact, since our conversation in the bar, we are becoming more enthusiastic about the idea. It has so many possibilities.

For one thing if a fair damsel cannot get at her purse she cannot spend money. Imagine the saving in the family budget that would result.

So far as wage plugs like Liza are concerned, problems of a different nature arise, but these can be overcome. Typing, shorthand and boiling the kettle, or extracting the cork can be done quite easily with the toes, after a little practice. As it seems only fair for us to test all the angles before really giving the U.D. skirt a solid promotion, we have decided to experiment on Liz. Having tied her skirt up around her neck, and having removed her shoes and stockings, we will seat her at the typewriter and see what happens.

If anyone else likes to experiment in a similar manner with the typist we will be glad to exchange notes. It's a noble cause.

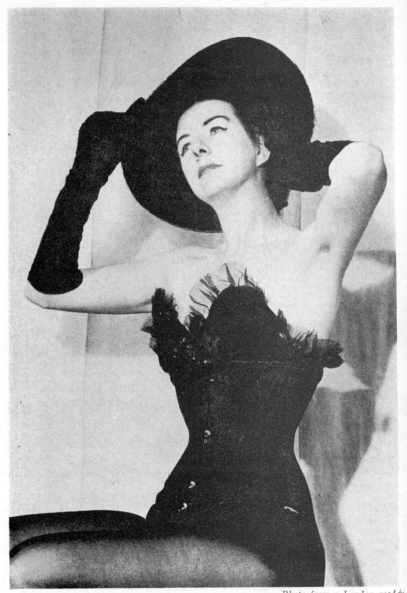

Photo from a London reader

Ideal for that special evening

FANCY DRESS
for special evenings

A lot of people regard Christmas as the "party season."

We have never been able to understand why only "Christmas." Any time's kissing time and any time's party time so far as we're concerned.

In this issue we present as usual some ideas sent in by readers. Some are simple like "Little Miss Muffet" and "The Dunce"—even the costume for "The Burglar," which is just black tights—and can be obtained at almost any theatrical costume store.

But the others present problems. Here on this page is an elaborate glimpse into the future—"Streamline." As the idea is for the wearer to be projected through space at high speeds the thing fits like a second skin and holds the wearer more or less rigid.

The last idea—the photo—is simply effective, and should suit Blind Girl Fluff and Co. perfectly.

Anyway we hope you'll have lots of fun and nonsense on your "special evenings," and send along those new ideas for J. W. to illustrate.

streamline

19

ON WITH THE MOTLEY!

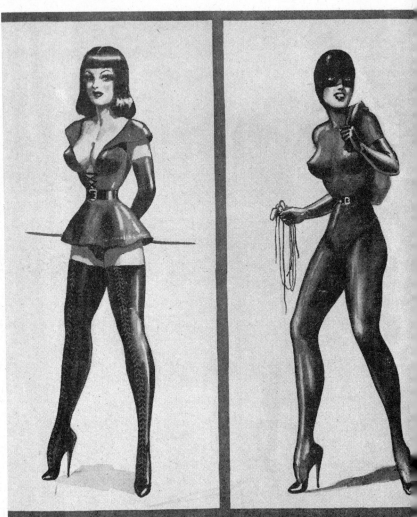

Robin Hood *The Burglar*

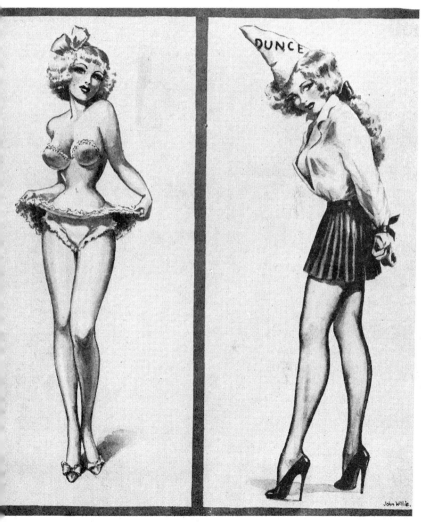

Little Miss Muffet *The Dunce*

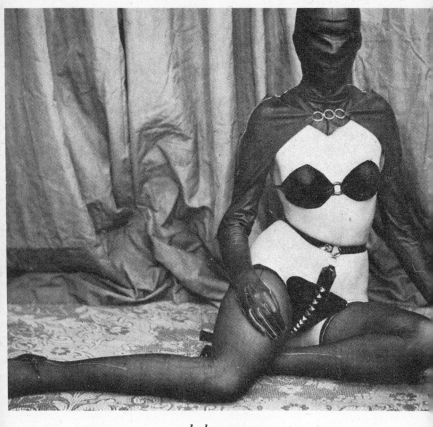

bal masque

THE MAGIC ISLAND

tale from bottle No. 3

WE WERE lazing back in our arm chairs when the others returned and with them a cheerful grey haired bloke who was introduced to me as Dr. Macintosh.

"So this is the invalid, is it," he said chuckling. "Come into the light, laddie, and let me see how you look."

Malua followed as we moved into the glow of the lamps, which for greater brilliance, the boys grouped together—and I found her by my side as the old doctor turned, studying my face keenly. Behind him stood the others.

Looking down, he took my wrist and felt my pulse. Then he took my temperature and so on.

He seemed quite well satisfied with what he found and finally, after a few questions about any aches, pains and so on, of which I had none, the inspection was over and we all sat down—Mr. and Mrs. Saunders at the table where Mutt and Geoff looked after their wants, and Mac, Lua and myself back where the bottles were handy.

Mac asked me unhurried questions about myself and in the conversation that followed, I discov-

ered that he had been on the island for twenty years and that to him the war had brought one blessing— a small scow, shot to bits, half burnt out and abandoned by her crew, but still sufficiently bouyant to float into that one tiny beach— her hold undamaged and full of enough medical supplies for a complete hospital.

"And now I've got all these saws and knives to cut people up with, no one gets sick, Jimmy." He paused as Malua refilled our beakers. "Why, good heavens, there's not even a bad tooth on the whole island! Young William, who died the other day at the age of 95 was typical—broke his leg as a boy but never a day's sickness. He still had every one of his tusks—all as sound as a bell right up to the end —Heuch aye!—I'm sorely out of practice as a sawbones."

Finally the others joined us and the conversation became general.

For a while, it centered around the new bridge which Pop had been inspecting. Then under the influence of Mutt and Geoff it got around to hunting and sports generally and this subject started a

discussion on the forthcoming pony races.

"What's this I hear about your team bolting and breaking all records today, Lua?" said Mr. Saunders, smiling. "I hear you just about pushed Mrs. Tomitte and her load of vegetables into the ditch."

"Oh, that was Gail's fault," Malua answered. "She was caught by a Cupid—a beauty too—and then I got caught by another—and" she suddenly blushed crimson, "Jim got caught too." At which everyone roared with laughter and Mac and Pop winked at each other.

"And so my team is all bust up," Malua went on when the riot died down a bit. "It's too bad—they're the fastest I've ever seen."

"Not faster than the one you ran in yourself your last pony year surely?" asked Mrs. Saunders in surprise.

Malua nodded. "I'm sure of it. Ask Jimmy—he had to hang on for dear life."

"Well," I said, "I'm hardly in a position to judge because I've never really seen any teams racing. All I can say is that never in all my life have I believed it possible that human beings could travel at such a fantastic speed, and apparently with such little effort.

"As a matter of fact, the whole thing has me a bit staggered you know," I went on. "What on earth is the reason for it and how did all this pony business start anyway? I think it's a perfectly wonderful idea."

Again everyone laughed.

"We all say that," Mac chuckled. "Go on, Wendy—you explain it to him."

Mrs. Saunders took a sip of her wine. "It's really quite simple, Jimmy," she began. "You see there have never been any horses on this island, and so, years and years ago —maybe two or three hundred or so—when the older folks got tired, they liked to have the children pull them around in wheel chairs and, as you'll find out, though we may grow old in our bodies, we still stay young and happy in our minds. So the old folk started to boast about how fast their pullers could go, and it wasn't long before they were racing each other in their wheel chairs and betting like mad.

"Naturally the wheel chair changed in design—so that it could be light and handy—and instead of one, two or three girls would pull so that for each the load was even lighter.

All the young boys of course were busy learning hunting and fishing and building and doing the heavy work and so the business of pulling the 'gigs,' as we call them, became the sole duty of the girls from 16 to 20.

"Everything went on happily until one day there was a tragedy

One old lady had had a bad day. She'd come in last in every race and she blamed it on her team of two girls, although they'd done their best—and on the way home, she kept prodding them and smacking them with a stick until the girls lost their tempers, turned around and pushed the gig backwards into the bushes at the side of the track, tipping the old lady out—a favorite trick at that time. There was a wild shriek and she disappeared completely.

"Realizing that something unforeseen had happened, the girls went back to investigate and discovered to their horror that the bushes concealed a deep crevice in the towering cliff and that the old lady had fallen to her death on the rocks far below.

"Of course, there was a considerable to-do about it and, though it was a pure accident and the girls were not really to blame, the Chieftain decreed that from that day on all the ponies must be harnessed with their hands tied or secured in some way so that they were completely helpless and could not play tricks and that, to control them, they must have a bridle and bit.

"For the other side it was decreed that no driver should carry anything other than a very light whip. And," with a shrug of her lovely shoulders, "there you have the whole story, Jimmy."

"How did the girls of those days take to the new ruling?" I asked. "I mean the one about being strapped up in harness."

"They didn't mind in the least," Mrs. Saunders replied. "They were having as much fun with the racing as their aged drivers—and when the younger people, seeing no reason why only the old folks should have all this fun, began racing too, with all sorts of fancy and pretty strappings, it became so universally popular that finally all the carrying was done by the pony teams, as you could see this morning."

"That makes sense," I said. "And apart from this 'work' you have races? You were talking about them just now. Do you only have one meeting a year?"

"Oh, no!" Malua cut in. "There are always races going on—one team against another as a private wager, and also there are regular monthly meetings; but the one that is coming up—the one we were talking about—is THE show of the year.

"There are lovely competitions for the best turned out team, the best looking, the best in the parade at walking, running and prancing and so on. Oh, dear!" and she suddenly gasped. "You, of course, will have your team and you've almost no time to train them."

"Oh, so I get a team, too, do I?" said I, sitting up and taking notice.

Oh, don't go in the lion's cage, Mother darling,
The lions are ferocious! — and they bite!

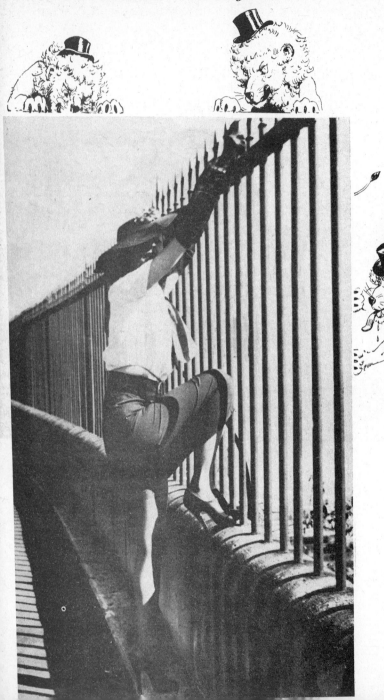

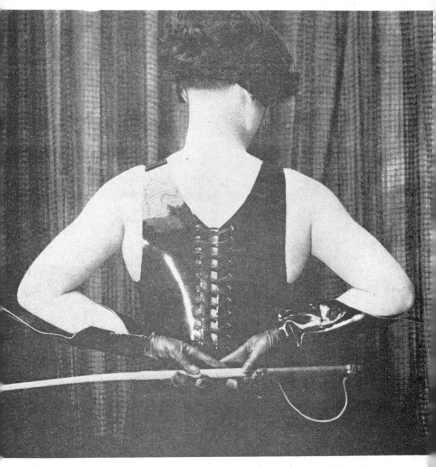

What! — and me dressed to kill — any lion!

"Of course you do," said Mac, chuckling away as merrily as ever. "How else would you get around?"

"Hm!" I grunted. "Walking would be a bit slow wouldn't it?"

"But where do I keep my ponies when I'm not charging about the countryside—in a stable?"

"But, of course," said Mrs. Saunders. "At least a sort of stable. The groom—a younger girl, not old enough to be a pony—brings your team around at 6 in the morning, feeds the ponies and grooms them. And then, when you have decided on what harness you need, puts it on them. They are then at your disposal all day until 6 in the evening, when the groom takes them back home again. Sometimes, like tonight with us for example, you may want to keep them later than 6—but it's only done when there is some special reason."

It looked to me as if I was going to have a lot of fun, and without any unnecessary delay either, for Pop and Mrs. Saunders agreed that I had better start looking around the next day—if Mac said I was fit enough—a matter on which I had no doubts myself.

"I still don't quite understand how you people have achieved this terrific speed," I remarked, still inquisitive. "And without the use of the arms for balance."

"Oh, not using the arms makes no difference." Malua said. "We always run that way. As soon as a baby is old enough to walk she asks to have her hands tied behind her back to practice running; that's all we think of—to be in the fastest team and to win the right to wear the jewelled hee's. Not being able to use your hands for anything is of course a bit of a nuisance at times, but that's all. The harness isn't the least uncomfortable—the ordinary one isn't anyway."

"Have you some extraordinary harness?" I queried, and again everyone found my simple question extremely amusing.

"Little girls are not always as good as they should be," said Mrs. Saunders. "And sometimes they have tantrums which, of course, cannot be allowed. So we have 'punishment harness' which is very uncomfortable," and training harness, which is almost as bad if your carriage is not up to the requirements of your driver." Then turning to Pop. "D'you remember that time before we were married and our evening was spoilt because Mrs. Ahuee kept me out late, and so I made a fuss, and nearly ran the gig into the ditch?"

"Do I not?" said Pop. "And she kept you strapped up in harness for a week and a punishment rig every other day. But it cured you Wendy, my dear—or did it?" and both he and Mac grinned.

"It was nothing to laugh about, Jimmy, I can assure you." she said

turning to me. "It was beastly uncomfortable. And Pop there trying to sneak ice cream into my stable at night didn't make it any better, because kind Mrs. Ahuee had put a gag bit on me which only she could take off because—oh, my goodness! Talking of ice cream, and I've suddenly remembered that I've got a bucket freezing its head off in the larder—who wants some?"

"There was a general chorus of 'me'," and as she stood up and turned, I noticed for the first time that she was standing and walking with perfect ease and grace on towering heels—like Maluas.

I must have gaped like a fish, because old Mac chuckled. "Go on, Jimmy, you'd better ask another question. Those heels, tell him, Wendy."

"No, I'll leave that to Malua," she answered. "I've important ice cream business to attend to."

"I'll help," said Mutt.

"Me, too," echoed Geoff and they scampered off together. I looked at Malua and then down at her feet, which she obligingly proceeded to turn this way and that so that I could fully appraise their beauty and the exquisite lines of those heels.

"Again it's an awfully simple explanation, Jimmy," she began. "As little children, we not only run on our toes, but to strengthen our arches for speed we walk and stand on tip-toe all the time. When we are finished as ponies, there is no need to continue the exercise and so we simply add a heel to our sandals which fits the height as we stand—we don't fit the heel—the heel fits us."

"As a matter of fact," said Mac, refilling our beakers, "this custom of standing and walking on tip-toe is quite in keeping with nature, and as you've no doubt observed"—his eyes twinkled—"the feet of the girls here are exceptionally beautiful, not particularly tiny, which is considered such an attraction in the outside world, but very slender and, as I've said, maybe more beautiful. Their arms and bodies are just normally healthy and strong, but the strength of their legs is something quite astonishing." He paused and took a long swig of wine and then went on. "It's been one of the pleasantest professional studies I have ever undertaken—hrumph!

"I've been making a most intensive and close study of this subject for the past 20 years and I'll stake my reputation—which was once and still is considerable—that there is not one single girl here who would not be acclaimed without dispute as having the most beautiful legs in the outside world —if she was ever fool enough to go there—and a figure to match for that matter."

Further discussion on this very

interesting topic was cut short by the entrance of the ice cream, which Mrs. Saunders began dolloping out in huge heaps for Mutt and Geoff to pass around.

"Is Cinders coming round for you later?" she said, turning to Mac. "Anyway I've plenty of ice cream for her."

"No," said Mac, his mouth full of the wonderful stuff. "I told her I'd be back soon. Jimmy, in spite of being to all outward appearance a husky young devil, has had a pretty tough time. You can't be blown up without any adverse effect on the system, and I want to get him to bed in reasonable time" —gulp—"got some pills I want you to take before you turn in, Jimmy"—gulp—"just to make sure you do get a good night's rest."

As a matter of fact, I was beginning to feel a bit ragged. I finished my ice cream and lit another cigarette, letting the others do the talking.

Finally Mac announced that he must go and that he wanted to see me off to bed before he did so. Malua rose, too, and said she must check that my room was O.K.

I said good night and Mac and I walked slowly to the door—then Mac found he had no cigarettes so he turned back and I went on alone. I met Malua in the doorway of my room, silhouetted in the light of the single lantern by my bed. "Pleasant dreams, Jimmy," she said, and we began to say good night in the logical manner. Unfortunately, we were disturbed by a heavy stumping, and old Mac yelling that his leg had gone to sleep again. Malua broke away with one last quick kiss and nearly collided with Mac as she turned the corner. Mac's eyes twinkled as he handed me the two pills. "You've got a far away look in your eye—high blood pressure probably—hrumph—now get into bed and swallow these, and take it easy tomorrow. I'll be around sometime to see how you are. You'll need to be in good form to pick your pony team. Good night, Jimmy, I'm glad I've met you"— and with a fatherly pat on my cheek, he was gone.

So I got into bed, took the pills, blew out the light, and was soon on the surfboard again; but the mermaid now looked exactly like Malua—which I didn't mind in the least.

ILLUSTRATIONS

Space is too limited for us to include here the illustrations which J. W. has done for this story. We have, therefore, printed them separately and as they are designed to fit in with the format they can easily be inserted. They are sold as a separate item. Write for particulars to the Editor, P. O. Box 511, Montreal 3, Canada.

FOOTWEAR FANTASIA

Many people wonder if the boot —whether it reaches to the ankle, the knee, or the thigh—will ever again become the common sight that it used to be among all smartly dressed women.

There is no reason why it shouldn't because nothing can quite take its place. Not only does it look smart but it feels smart. I have known a number of women who at first ridiculed the idea of boots but when they had once worn a pair they became more and more devoted to them.

First of all there is the feel of support they give. "Heavens, I could never walk with those heels —but aren't they lovely?" Mademoiselle says. "Why did you have to put them on a clumsy pair of boots?"

Then she slips her foot into the boot and feels the unusual caress of the leather—still unlaced—all around it. Then as the laces are tightened the soft touch of the kid as it moulds itself firmly to every line of her arched instep. The lacing takes time, for it must be done carefully; but at last it's finished and milady is helped to her feet, to pirouette and turn this way and that before the mirror.

To her delighted surprise she finds that she can stand with ease on the towering, tapering, pencil-thin five-inch stilts which serve as heels and that the boot gives her ankles a new and welcome support.

She now looks at them in the mirror with greater attention.

"They don't look clumsy at all," she says. "No, they don't, do they? They look kinda cute." And then, after a few more turns: "Oh, they're lovely — I never thought they could be so wonderful! May I keep them on? I'd like to go out in them."

This sort of thing has happened not once but dozens of times. Of course you occasionally strike some dull, unimaginative clod. She has no taste in dress and ,unless she has the money to go to someone who can arrange everything for her, she invariably looks a frump. She usually hasn't even the saving grace of being a good cook.

The whole idea of boots is ridiculous to her and anyone who would consider wearing them is, to her, some odd creature; a man-chaser, a lady of easy virtue, and "Oh, didn't I read it somewhere that only a pervert would wear boots?" Is it any wonder so many

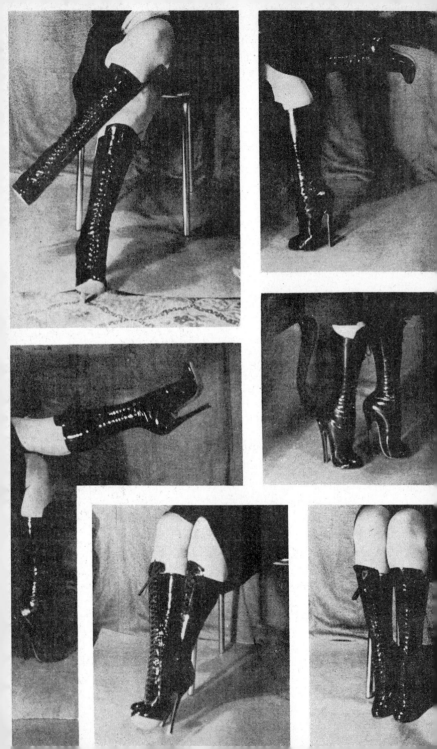

men lead double lives, sleep with their mistresses and adopt children?

As a matter of fact, boots have one fault. They show up any bad features in the leg; a thick ankle looks thicker still, but a thin calf can be conveniently padded as ladies found years ago when boots were in vogue.

Another complaint is that they take time to put on. This of course doesn't matter in the least when someone is there to do it for you— and the constant caressing touch of the boy friend's hands as he smoothes the leather and tightens the laces, one by one, is quite agreeable—oh, yes, quite!

One fair lady of our acquaintance found that to lace her thigh boots took exactly 50 minutes per boot. This puts the rush hour typist right out of the race. However, the ordinary hook, common to men's boots, is made in a smaller, neater style and one pair of thigh boots was made with these. You have seen photos of them in previous issues. To put them on took only a matter of minutes.

Then there is the button variety such as you see in these pages. The one trouble about buttons is that if the boot is to fit tightly, as it must, there is an annoying tendency to pinch when using the button hook. Besides, buttons do sometimes come off and when this happens it is always at a most awkward moment.

But at last milady is ready—her legs encased in smooth, gleaming kid that fits like a second skin. With her ordinary dress, the appearance is excitingly different than the usual expanse of nylon. Indoors or out she is alluringly smart —and out of doors!

The rain comes beating down, cars splash the water from puddles, the gutter is running a banker— who cares! Let it freeze, let it snow, sleet or hail. "I've got my boots to keep me warm—even if my love isn't around at the moment —or is he? I wonder if my boots love me as much as I love them,"

"Why don't makers turn them out?" people ask. The answer is probably that they don't realise how popular they would become and how little extra they would cost.

Leather is expensive and the cheap shoes which every girl buys these days aren't made of leather. A boot that won't wear is useless and so good leather is imperative. Speaking from the experience of many years as a custom shoe maker I can assure you that there is a slight extra cost for the patterns, the sewing and the leather, that is all. People charge fancy prices because customers will pay fancy prices—but there is no need.

Leather is sold by the square foot and in the ordinary course of events the cost of the leather is only a fraction of the cost of the

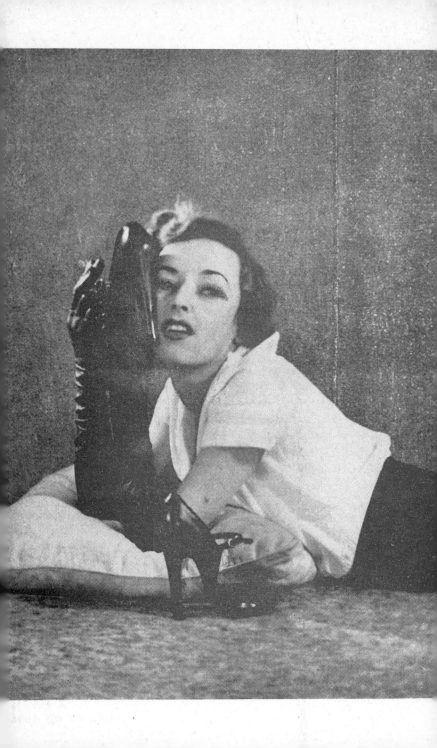

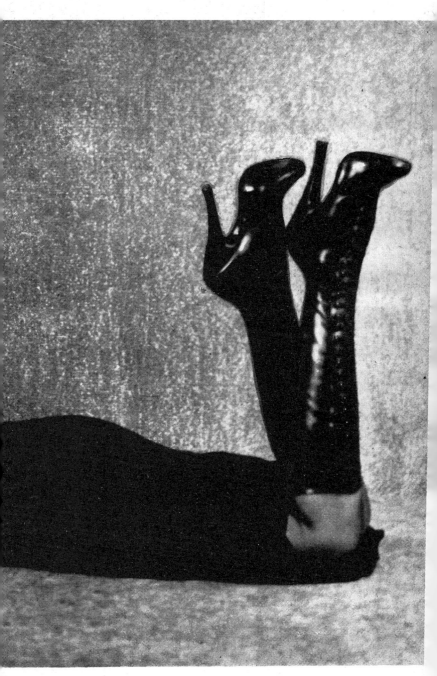

Footwear by Achi

shoe. So far as the actual making of a boot is concerned, it involves no more work on the part of the cobbler—it's just the same as making a shoe.

When you come to think back you will remember the popularity of the "Russian Boot." They were, along with rubbers, the almost universal winter wear. Certainly no "fit" was needed around the ankle and calf but to make the alteration necessary for laces was a simple matter.

To sum it up, I'm tipping that boots will come back. The trade is so competitive today that it cannot stand still. There is that plastic which the meat packers use for sealing a carcass. When kept in low temperatures it is pliable and stretches, but when exposed to warm air it shrinks and becomes firmer. If that plastic can be developed, say in black, what could be simpler? The boot is made with a line of lace holes set in leather or some non-shrinking stable material, but the rest of the boot is like a bag. The only thing to be fitted is the sole and the heel height. That done, the bag is laced and then the salesman produces an ordinary hair dryer and the plastic shrinks conforming to every delightful curve in the girl's foot and leg.

It would look perfect, but it wouldn't be quite the same as kid, would it?

FIGURE TRAINING
à la 1890

FOR THE benefit of those who did not see all the earlier issues, this is what happened.

A long way, way back, we received from a reader some aged steel engraving prints, illustrating various figure training devices used in the "Gay Nineties" or thereabouts, to give Mam'selle the right shape. So we put J. W. to work and all he did was to redraw them in his own style—but so far as the corsets and gadgets were concerned, sticking punctiliously to the detail.

In regard to the general idea of "figure training" a la mode 1890 we can only repeat what we have already said, namely, the idea seemed to be to hold the body in an exaggeration of the desired pose or shape so that when in public— where restraining devices could not be worn—the "trainee" would look and deport herself in the required manner.

It requires little imagination to realize that if a damsel went around day after day wearing a high stiff leather or steel collar which forced her to keep her head bent back to the limit she would also carry her head "proudly erect"

if the collar were removed for a few hours, from the inability of her neck muscles to adjust themselves to the more normal position, and the same thing applies to the rest of her anatomy.

As the "training corsets" were always just "too tight" the girl would like as not become rebellious so it was, of course, the common practice to tie her hands so that she could not loosen the laces for some comfort. As she could probably make her elbows meet behind her back anyway, these would be strapped together, too, to hold her shoulders back.

On the next page, apart from the corset and collar, we see a well known device—the shoulder brace. A simple and comfortable arrangement of straps.

Webbing type shoulder braces are a common sight in shops today, and it would be interesting to know how many damsels do actually wear them when not dressed in off-the-shoulder gowns — particularly in view of the current trend in the bust business (which seems to be either "All hands man the breastworks and beat off attackers" or "Look what I got").

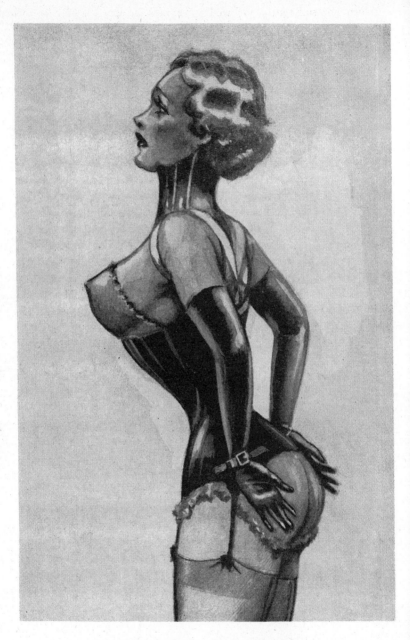

training corset and shoulder brace

When not sufficiently endowed by nature, the modern siren wears the falsiest of falsies, and holds her shoulders well back for greater effect. You feel as if you are being smacked in the eye. You see one walking down the street, her bust cleaving through traffic, like the prow of a battleship steaming into action, and you wish they would revive the old Pennsylvania public office of "corset prodder," you, of course, being "it." In case you don't know it, they used to have a citizen whose duty it was to carry a stick with which to prod any damsel he suspected of wearing a corset which, along with high heels, rouge, wigs and wooden legs was considered a "fake to lure men." Nowadays, of course, you'd prod higher than the waist to test the real from the false—or would you pinch? Anyway, it's a happy thought.

We only try to please, and if we can help by offering ideas which were in vogue long, long ago, we're only too glad.

So consider the other illustration, if your friends say you slouch. Nothing could be simpler—just a bit of 1 x 2 lumber and four straps —one very wide for the collar. Tack the straps onto the wood and you're all set.

All you do (or, rather' someone else does it for you) is buckle the collar loosely, with the stick hanging down your back. The elbows are next strapped together, then the wrists, and then the waist belt is pulled tight. Finally the throat strap is adjusted, and there you are. Figure training par excellence for a couple of bucks, whereas corsets cost a small fortune—if you can find anyone who still knows how to make one.

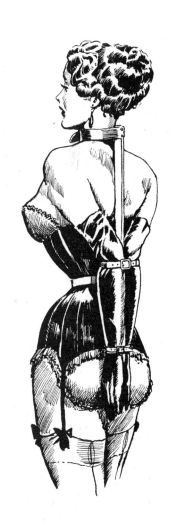

Correspondence

Under no circumstances do we publish names or addresses. If photos or sketches are sent in, please write a short commentary and please do NOT send in photos which you got from someone else.

THE MODERN TREND

Dear Sir,

I hail you as a true prophet! There is now a definite trend among the fashionable towards a slender waist, and I noticed with a great deal of satisfaction that a certain woman's catalogue, which I have always regarded as conservative, now displays the old-fashioned high-waisted backlacer along with the so-called modern girdle.

Then of course the present attitude of fashion designers may be taken to indicate the coming style, who while they seemingly deplore(?) this reversal of milady's figure requirements, yet at the same time ask their clients and friends to do something about that mannish waist, and modern ladies are now demanding to know how to achieve a slender waist.

In Life magazine for September 23, the fashion designer Bernard Rudolfsky "sounded-off" about what he calls "an atavistic imitation of cavemen and savages" in present fashion trends, and when he ridiculed all fashions unless they were ultra-modern and futuristic I was pleasantly surprised to learn that nearly all those to whom I showed the article violently disagreed with Rudolfsky, and when I pressed them for an explanation they finally acknowledged that they favored fashion ideas such as Bizarre has advocated, saying that the *modern woman must cease looking a man and begin looking like a lady.*

Sincerely yours

FRED S. MAC

FUN AT A FANCY DRESS PARTY
(letter dated 1946—but why worry)

Dear Sir:

My room mate, Betty, and I are

members of a small club called "The Tomorrow Club." It's called that because we try to do today what we think other young people will be doing tomorrow. The club gives four dances a year at the very lovely house of our President, Sandra. (Of course we hold other meetings too, but these four dances are the only things to which non-members are invited.)

A week or so before the dance, Betty brought home the third issue of "Bizarre," and we scanned it eagerly for costume suggestions—I forgot to say that our dances are all fancy-dress affairs. We thought two or three of the sketches were simply out of this world, but we couldn't copy them for one reason or another. Betty would have liked to go as the pretty little Bunny Rabbit; but we felt that the close-fitting helmet and the ears were beyond us. I would have given anything to go as the Pony, but we couldn't decide how my arms should be held in place inside the tunic, and besides, the harness, and especially the bit, were quite beyond us.

Then we saw the picture of the two school girl dunces standing in the corner with their hands bound behind them being punished. That, we decided at once, was most definitely for us, and we started to work at once on the costumes. We are each the proud possessor of a pair of five inch heeled black patent court-shoes. We had no black silk hip length stockings, because the war took them off the market before we left high-school. But we were able to use our black elastic mesh stockings, and in one way they were better than ordinary silk stockings—we were able to pull them right up to the waist at the sides, and fasten them to the waist-band of our super-brief black satin panties. These were of the type known as "dancers' belts."

The blouses—plain white, long sleeved, and rather thin, we also already possessed but the tunics we made ourselves, out of black velvet. They were really skin-tight through the waist and down around the hips; flaring out just a little bit down to the hem, which was only an inch or so below the tops of our legs. The bib part, in front, came up to the center of the bust, and fairly wide suspender-straps went back over the shoulders to button to the waist-band of the skirt at the back, with two big red buttons, the only touch of color on the costumes.

On the night of the party, we made up very heavily. Betty and I look rather alike, save that she is dark and I am blonde. We've been taken for sisters sometimes. In making up, we accented our similarity, and with identical hair-dos, we looked almost like twins. We combed our hair straight back, and tied it at the nape of the neck

with a wide red ribbon, just as you had it in the picture.

With our tall dunce-caps, which we had made out of heavy white shiny paper, at a becoming angle, we took a look at ourselves in the mirror. Putting our hands behind our backs to get the proper effect, we decided that we looked pretty special—even if I shouldn't say so.

Then, with the caps and two long pieces of red satin ribbon safely packed in a big envelope, we put on our coats and left for the party. Betty, who is a little braver than I am, couldn't resist letting her long coat "accidentally" slip open a little, giving the taxi-man a generous view of one black mesh-covered leg. But he got so engrossed looking at it in his rear-vision mirror that he drove right through a red light—so she decided she'd better stop teasing him before we all got killed.

We arrived at Sandra's rather early, as we thought we might have to explain to our hostess about how we wanted our hands fixed. But she'd seen "Bizarre" too, and knew what we had in mind as soon as we appeared. Naturally, she was eager to help, and pointed out that the ribbon would never do to tie our hands with for a whole evening. It would soon work down into a thin cord, which wouldn't look pretty, and would also probably cut. But she said she knew just the thing, and to leave it to her, so we

said go ahead. She crossed our wrists behind us, and fastened them with several turns of wide adhesive tape. Then she tied the ribbon over that, being careful to finish the knot with a big bow.

When the other guests began to arrive, they found us standing in opposite corners of the big living-room, faces to the wall, like a couple of naughty kids. As each new arrival came in, Sandra explained that her two little nieces had been disobedient, and were being given the corner-and-dunce-cap punishment. Everybody let us stay there, too, even though we stole "penitent" glances over our shoulders, until the dancing began. From then on we didn't have a moment to ourselves. Every man in the room had to dance with the two prettily helpless school-girls. We were cut in on continuously and were quite the belles of the ball. We didn't find dancing at all difficult, either. We were able to follow our partners' lead quite easily, even though we couldn't hold him in the usual way.

When supper was served, our shoulders were very cramped from having our arms held so long in one position, and we asked Sandra to untie us, but she wouldn't hear of it, and neither would anyone else. We really tried to get our hands free then, but it was hopeless, the tape wouldn't give the least bit. Our pleadings and futile

struggles only amused everybody, and all the men began offering us huge prizes if we could get free.

Finally we gave up, secretly pleased at all the attention we were getting, and went around begging our suppers—a bite from somebody's sandwich here, and a drink from somebody else's glass there.

It was nearly dawn when the party broke up, and for a while it looked like there was going to be a fight over who was to take us home. But Bill, who had been monopolizing Betty for the latter part of the evening, and Van, who had appointed himself my protector, won out.

We asked to have our hands released, so we could put our coats on, but neither Bill nor Van would hear of it. They draped them around us like cloaks, and led us out. Bill's car was on one side of the block, and Van's was on the other, so we parted at the door of the apartment house.

As soon as we were out of sight of the doorman, Van looked around, and as there was nobody near, he slipped my coat off, and left me, in my very abbreviated costume, with my hands tied behind me, in a public street. I felt terribly embarrassed and begged him to put my coat on again, since I couldn't do a thing for myself. But he simply laughed, and pretended he couldn't remember where he had left his car. I

couldn't run away, and so I had to walk slowly along with him as he pretended to examine each car we came to. It was nearly light by that time, and I was in a panic for fear somebody should see me.

After about five minutes, Van "located" his car, opened the door and let me get my long mesh-covered legs and bound hands out of sight. I wanted to go straight home, but he wouldn't hear of it. He drove first to a little drug-store that was open all night, and went in, leaving me cowering down in the seat, afraid a policeman or somebody would decide to look in the car. Finally Van came out again with a couple of containers of coffee and a fried-egg sandwich each. He had to feed me like a baby, of course, and after I got used to it I enjoyed the thrill almost as much as he did.

Then he took me for a drive around town, saying that the only time to see it was just at dawn.

It was almost eight o'clock when, with my coat around me again, he took me up to the apartment and released my hands. Betty and Bill had got in only a few minutes before. I don't know who had been more thrilled by our evening as naughty school-girls, Betty or It.

The biggest thrill of all? Being kissed with your hands bound behind you. Try it!

Yours, NIKKI

A Tyrant on Toes

Dear Editor:

THE ALLURE of women's feet for the male sex might best be illustrated in a story I heard when just a boy. It is almost too fantastic to believe, but was sworn to by three service men of World War I.

Those who saw the silent movie, "Farewell to Arms," with Helen Hayes, Gary Cooper and Adolph Menjou, may recall the Parisian scene where an unknown girl was sitting on the table and after her slipper was removed and served as a goblet, ran her bare toes thru Gary's hair.

I distinctly remember how fascinated I was by this scene. So much that I saw the film over five times. At the time I thought of the incident as a movie concoction, but a few years later at an American Legion convention I heard the following told by two ex-sergeants and an ex-major who had served all thru World War I.

It seems that there were several cafes in Paris that hired girls to sit on the tables to amuse their gentlemen patrons. Most of them only had their feet kissed and their slippers used as goblets, but in one particular place the male patrons went in for more exciting pleasures.

There was one girl, Melisse, whose toenails were sharpened by a pedicurist to a razor's edge. She specialized in making incisions on the lips and cheeks of her ardent men patrons. Often these incisions took weeks to heal but it was said that the recipients invariably came back for more; and the most ardent

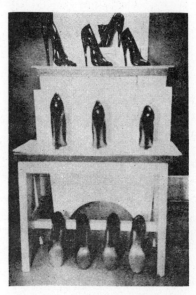

from a reader's collection

ones seemed to be those of the Yankee allies. Then there was a twelve year old who wore just as high heels as her older sisters, who, upon being asked why she was there, replied, "Because I like it when they tickle my toes and they taste them, and it's exciting to see them wince when I press their fingers under my heels." It seems that this little girl was used by several males as a test for fortitude. They would come in pairs, trios or groups. Each would place

a designated amount with the management or some kind of judge or referee and little Marie (or whatever her name was) would go to work with her little high heels. The one who could endure all of his ten fingers ground under Marie's little high hee's would leave with the Jack-Pot.

In the same institution there was a third girl who would kick the faces of her patrons until they were black and blue. It was said that this girl received unusually high remuneration for her services.

Why couldn't there be just such places of excitement here in our U. S. A.?

EDMUND LIVINGSTON

THE OLD-FASHIONED IS BETTER

Dear Sir,

Since last writing to you I have been fortunate to be able to purchase a number of old fashioned wasp-waisted corsets of the types worn in the years 1903-05. They have waists varying from 19 to 22 inches and are of different lengths and strength. I have given them all a good trial and can really say that, after the first strangeness of wearing a corset higher in the bust, stiffer in the boning, shorter on the hips and much tighter round the waist than the types now offering I felt much more comfortably supported in my old fashioned stays than I ever felt in modern corsets.

They impart a sense of well being which has to be felt to be appreciated. I am sure if many more young ladies had the opportunity to do as I have and could, at their leisure, give real stays a proper trial they would be doing as I am now—that is wearing them quite often and lacing my waist well in and what is more, thoroughly enjoying doing so.

Yours truly
CORSET LOVER FROM N. Z.

NOT SO FANTASTIC

Dear Sir:

Probably numerous readers have taken you to task for a statement made in Part One of your story, "The Magic Island." The statement I refer to is the one to the effect that any girl or boy could run one hundred yards in seven and a half seconds. Nobody, these readers will say, can run that fast.

Perhaps they are right. But can we be sure? The records these people will cite will be those of known runners. But is this a true comparison? Here's what I mean. The present record for the Running High Jump is six feet, eleven inches. Some years ago I saw some moving pictures taken by a friend of mine during a hunting trip from Cairo to the Cape. He had some quite astonishing pictures of a tribe of mixed Arabic-Nubian stock, somewhere in North Africa. These people specialised in high jumping.

But they didn't go at it the way our "civilised" jumpers do, namely, "rolling" over the bar in an almost horizontal position. They went at it straight on, went up in the air with the head vertically in line with the spine, and came down that way. As I remember—and it is some years since I saw the picture—they took off with both feet together and landed that way.

In spite of this, they were able to clear a stick held by my friend, as high above his head as he could hold it. As he was something over six feet, this means that they—and when I say "they" I mean six or seven members of the tribe—were clearing a good seven feet, six inches.

If these jumpers could clear such heights, I see no reason to doubt that there may be runners who can do one hundred yards in seven and a half seconds.

Yours,

"MAJOR"

FOR A DAY IN THE COUNTRY

Dear Ed:

I have been enjoying Bizarre through all the issues and although I agree that women are entirely attractive in some of the costumes proposed by the contributors to your "letters from readers" I would like to submit my idea of something attractive and yet more practical for, say, a day in the country: Riding breeches and matching brown leather boots and jacket.

Have any other readers submitted similar ideas?

B. D. E., Lexington, Ky.

See letter by B.D.E.

BUTTONS AND BEAUX

Dear Editor:

THE IMPRESSION of a childhood memory was best brought back to me when I first saw your volume No. 2, page 8.

When a boy, aged 9, I went to live with my aunt and uncle. In the next apartment building lived the minister of the church my family attended with a daughter who

resembled a composite of Shirley Temple and Lana Turner. I was a sickly child who couldn't attend school. One afternoon this girl returned from high school and as I sat on the front steps as usual watching for her, she kissed me very affectionately. This was my very thrilling introduction to the opposite sex. This went on for several days. One day she and her girl chum came along as usual, but Bess, the object of my secret worship, wore a new pair of beautiful black kid button boots. Instead

not button but very beautiful

photo from Mme. D., W. Africa

of kissing me, her girl chum suggested I kiss her new button boots, which I did most eagerly. The next day the girls took me into the apartment vestibule rather than make a public display of the incident. Each of Bess' boots had 16 buttons and for many weeks I

daily kissed 32 shoe buttons while my goddesses giggled. One afternoon however my Bess' mother caught us in the act and it terminated therewith.

The photos and articles in your delightful magazine revived the thrill of the incident—which illustrates how vivid and permanent a childish impression can be.

A. E. H.

MODERN MISSES CLUB
Dear Sir,

Perhaps some of your readers may be interested in the following description of an outfit which I had made for our New Year's Eve party which was held at the Headquarters of our Club out on Long Island.

The outfit represented a "Bizarre" interpretation of a cowgirl's costume. Instead of the usual "blue jeans" I had a pair of black kid trousers made. These were cut exactly one quarter inch smaller than my actual measurements from waist to ankle. In order to be able to get into them, they were opened or cut the entire length on the outside of each leg, and a zipper inserted on either side from waist to ankle. The object of cutting them one quarter inch too small, of course, was due to the fact that fine kid is liable to stretch. Actually it took my maid nearly half an hour to zip me up on both sides, but the result was worth the effort,

as the straining kid fitted like a second skin, and was, to say the least of it, most flattering to my thighs and legs. A little thonged fringe ran down the entire length of each zipper and when the zipper was done up it was hidden under

a well-laced figure

photo from Mme. D., W. Africa

this fringe. To go with the outfit I had had made a pair of patent leather cowgirl boots, with 6½ inch heels, attached to which were an ornate pair of silver spurs.

Except for a pair of black kid gloves, with enormous gauntlets, the only other item of apparel was a little top, cut something after the style of the top of a beach play-suit, but made of the very finest chiffon, and leaving the mid-riff, shoulders, and arms uncovered. This I had cut to accentuate rather than conceal my curves, and it fas-

tened in front between the breasts by a small piece of cord, tied to represent a lariat.

To bring out the "highlights" of the outfit, I dressed for the party during the early part of the afternoon, and had my maid Yvonne polish the kid of the trousers with leather polish and brushes until I gleamed as if sheathed in patent leather from my waist to the tip of my toes. I must admit Yvonne had to put in a little over three hours of polishing before I was satisfied with the degree of brilliance, but as I had already told her that she could come to the party to help look after our guests, and had fixed her up with the usual French maid's costume (a very brief and very well fitting black satin dress with the back cut down far below her waist, long black silk stockings, and a little white linen head-dress trimmed with black satin bows, in which she looked very cute) she really had no complaint. But I digress; to get back to my own costume, it was voted well up to the standards of the Club, and I think was the admiration of the men and the envy of most of the girls. The only disadvantage was that owing to the skin tight fit it was almost impossible to sit down in it, but I found that I could perch most comfortably on one of the high stools at the bar. For dancing it was perfect, giving a wonderful feeling of sup-

photo from a reader n N. Y. C.

port to the lower part of the body, and for some inexplicable reason making it very much easier to walk and dance on my towering pencil heels.

Except for the spurs I wore no jewelry at all, but applied an almost theatrical make-up, vivid scarlet lips with a touch of the same color in each nostril and on the lobe of each ear, a heavy application of mascara on my eye lashes, silver eye shadow, and dead white powder on my arms, shoulders, and mid-riff. The top part of my costume being made of the very sheerest chiffon I was again faced with the most controversial question as to whether a girl's breasts are enhanced or not with the aid

of cosmetics. Personally I feel that if a girl feels that her breasts are sufficiently attractive to either leave nude or to cover only with a transparent material, then she should use cosmetics to accentuate the attractiveness of her figure. For myself I always use it, and on this occasion I deepened the color of the nipples to match the color of the lips. This matching of color I think is most important. I have seen so many girls careless on this point, thereby ruining an otherwise perfect appearance. By the way, any girl who is experimenting with this type of make-up may well take notice of the following hint sent me recently by a girl friend of mine in Hollywood. She had just bought one of the new evening dresses which I gather consisted of little more than a long skirt, and had carefully made up her breasts with an ordinary lip stick. Everything went well until she started

photo from a reader in N. Y. C.

49

to dance, when it was noticed that her partner's stiff shirt front was getting very liberally smeared with her make-up. This is not the way to remain friends with your boy friend. I use a specially made coloring which I am told will be obtainable in the store within a few weeks.

Our party was a wonderful success, and if this letter wasn't already so long I would describe some of the other costumes. There were some very outstanding ones; perhaps later on I will send you some more details. In the meantime best of luck to both Bizarre and its readers.

Yours very sincerely,
DAPHNE ATKINSON
Secretary, Modern Misses
Club of N. Y.

for those readers who want to know who was under the mask on p. 43, Vol. 6—here you are.

MODERN MAKEUP

Sir:

Feminine makeup has been frankly and boldly artificial ever since women discovered that men would regard it as a piquant and intriguing gesture to see them apply lipstick publicly, and also since young women realized that the more lavishly they painted their lips the more certain they were to be kissed. In the eyes of the modern male, there is no such thing as "too much lipstick." It is not surprising, therefore, that frankly artificial eye-makeup has recently entered the fashion picture; and the most

recent American beauty-magazine illustrates eyebrow pencil that marks the skin beyond the eyebrows (or wholly replaces the eyebrows), mascara that may be black or blue or green, eye crayon on upper and lower lids and extending outward beyond the eye, gold and silver eye-shadow, and long artificial eyelashes. Even such makeup, of a sort once condemned as "theatrical artifice," and now regarded as essential by women and welcomed with enthusiasm by men, does not go far enough.

Yours truly,
GERALD MOULTON

Ponies thru the Ages

Your mention of girls being used as ponies—a story which I hope to read in your next issue—is by no means unusual.

This was a common practice in the South in the early days of the planters. In those days of slavery women and men, if they had the misfortune to be coloured, sometimes even if they were white, were treated like "things"—and not like human beings at all.

I have read many books on the subject and even if the whole idea was too barbaric to be tolerated today — although instances of "Pony girls" still crop up in India and the East where Rajahs and Potentates reign supreme. (There was an incident of this kind written up in a Canadian newspaper not so long ago.) There was such a bizarre variety in the decoration of some of the ponies that I am sure it would prove of interest to your readers.

Gaily coloured plumes and elaborately decorated harness made a spectacle as attractive as any modern stage presentation—such as the famous "Dolly Sisters" pony dance. Actually the only difference was that the slave ponies wore strong leather harness which made them completely helpless—an uninviting position to be in under a tyrannical master. In general the harness was designed to immobilise the arms and thus prevent any resistance—but in such a manner that the pony could run and move swiftly. Bridles and bits somewhat similar to those ordinarily used on horses were employed—and harnessed to the shafts by straps, with a trace chain to assist in pulling, the pony was not too badly off provided she obeyed the dictates of the driver.

Some records however show that often harness of a most cruel type was used, forcing the pony's arms up between her shoulder blades—pulling the head back and a bit in the mouth as cruel as the Stockport Branks mentioned in No. 3. It would perhaps be as well if those "Southern gentlemen" who still lament the freedom of the coloured people would remember to what extent "slavery" was carried (Yes, by my ancestors, Suh!).

We have just experienced an example of one nation trying to enslave the whole world—and to some of their practises the customs of the South are gentle by comparison. It might be as well if some of your readers who do not fully appreciate what freedom means were to learn a bit more about what once went on and can go on again if some despot or organisation gets supreme power. If you would care for further details I will see what I can find. Most of my records have been unfortunately lost or destroyed during the war

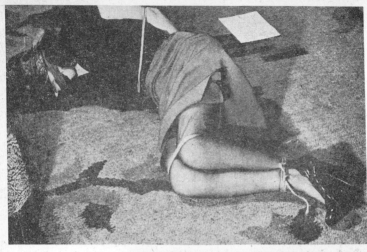

the
secret
plans

The spy
attacks!

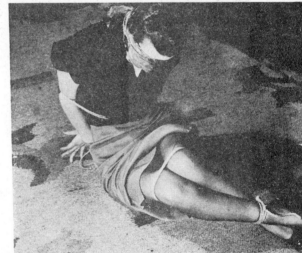

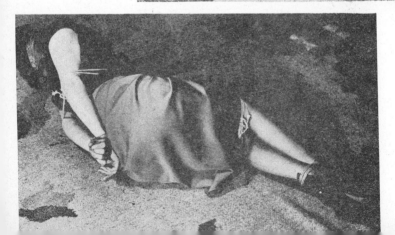

alas
poor
Ger

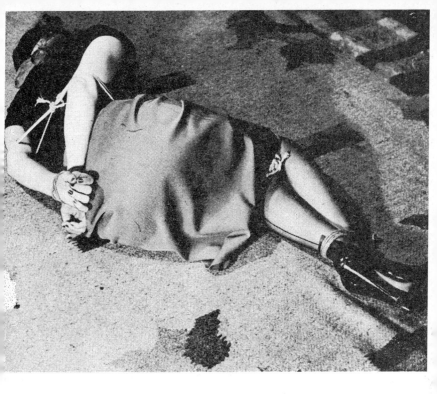

DON'T LET THIS HAPPEN TO YOU

learn jiu jitsu
and the art of self defense

—but I will see if I can find anything among the wreckage.

<div align="center">Yours,

O. K. P.</div>

We hope you can find something on the subject.—Ed.

A READER'S FASHION FORECAST

IN A RECENT issue of "Bizarre" there was a series of pictures illustrating an article, in which the author discussed the "Hobble Skirt." He implied that in the course of a couple more fashion cycles—by 1972, to be exact—a fashionably dressed girl would be nothing but a mummy, dressed in a sort of envelope, covering her completely from neck to toes.

It is your writer's theory that Hobble Skirts were popular because of the feeling of pleasant helplessness they gave the wearer.

I beg to differ.

To my mind (though the desire for helplessness may have been the appeal for some women) the principal reason for their popularity was the opportunity they gave their wearers to show their legs. Granted that the Hobble Skirt was long, when thoughtfully designed and made of the proper clinging material, it could give a very fair idea of the "limbs" it was supposed so modestly to conceal.

If present trends continue, it is my belief that legs will be more and more fully displayed as the years go by. They will not, however, be bare—except for active sports, of course, but that is a matter outside the scope of this article—women are rapidly learning that a moderate display of a leg in a stocking has much more "interest" for the opposite sex than a very much more generous display of bare limb. With legs, as with almost anything else, a little covering, a touch of mystery, heightens the interest.

Another trend I expect to see is the return of the corsetted waist. Women have abandoned corsets many times in the past, but they always go back to them. The ladies know that a slim waist is full of appeal for the masculine eye—and arm. The girls will complain about the "foolish" fashion, but they'll follow it. They'll follow it, and by their very cries of protest point out that they are following it.

Of course, tiny waists mean full bosoms. Girls have only to note the appeal of full fashioned girls like Jane Russel to know that every inch gained around the bust is another feather in the cap—if I may mix a metaphor.

Heels will continue to increase in height. There has been a steady thrust in this direction for a number of years now. The height of heels as worn by the "average" girls who want to make a nice appearance is about three inches

<div align="center">54</div>

for every day wear, going up to three and a half or four inches for "dress" wear. At least one chain shoe-store in New York is now offering a four and a half inch heel, and chain stores don't bother to put out a model they are not sure of selling.

Bearing these trends in mind, I would like to forecast what the style-conscious girl of 1960 will wear.

For evening, from toes to shoulders Miss 1960 will be covered by perfectly fitting tights—gleaming pink, in our example. Tights will take the place of the long skirt because like the Hobble Skirt we discussed, they cover completely, but reveal what they pretend to conceal. She will be poised a-tip-toe in pale blue sandals made of gleaming plastic. These sandals will carry heels of six inches, or even more if the length of foot will allow. Her shoulders will be covered by a matching blue bolero jacket, while her arms will be sheathed in full length gloves of black patent. Around one wrist will be a gold bracelet, with a corresponding gold choker about her neck.

The corsetted waist will contrast dramatically with the high full bosom, the latter being further set off by the lace-effect of patent leather around the low-cut neck line of the tights. In the evening, dining and dancing is in order; our young lady will be either seated across a table from her escort, or in his arms on the dance floor. In either case, the bosom is the center of interest, so the entire costume is designed to draw attention to it.

For daytime, however, as Miss 1960 goes about her affairs—strutting busily about an office, perching daintily on a lunch-counter stool or running for the five-thirty 'Copter-bus to go home—the legs will be the featured attractions.

Therefore our young lady will clothe her upper body plainly, in a perfectly fitting jacket of brown, with a wide white Eton collar sporting a red silk bow. Matching red kid gloves will cover her pretty hands while spind'e-heeled red kid shoes will set off her high arched feet.

But her lovely legs will hold the eye by the very lavishness of their display. The ultra short, pleated skirt, in a bold pattern of yellow, brown and red, will draw the eye away from the arrogant bosom and wasp waist, attractive though they be. Under this skirt will be a froth of yellow lace, with a narrow edging of black. But this under garment will be so brief that part of the garter welt of the opera length stockings, and even the tip of a gleaming red plastic suspender-clip will be displayed.

The effect that Miss Daytime 1960 desires to achieve is to seem "all legs." In fact such nicknames

as "Legs" or "Gams" will be esteemed as high compliments.

The proper nickname for Miss Evening 1960? Well

EXERCISE AND KEEP FIT

Dear Sir:

I am a women athlete, quite well-built, and one of the methods my husband has devised for helping me keep in training at home is distinctly bizarre! However it has worked wonders in keeping me fit and you might like to pass it on to your readers.

We clear the floor in our main room and I am dressed as follows: very high heels, black mesh elastic stockings extremely tightly gartered at the thigh, a tight rubber skirt which goes just below my lap and a heavy wool turtle-neck jersey. My long fair hair is put into pigtails for the occasion and finally I have to wear a belted rubber mackintosh which reaches to just above my knees.

In this garb I am put through a rigorous set of exercises—everything imaginable, double-knees bend, knees raise, and a great deal of toe-touching with my legs absolutely straight. You can imagine that after a bit of this in a heated room I get very warm—indeed pink all over!—and lose pounds. For the more strict exercises still, on the bare floor, I am allowed to take my mack off, but by the time

I've finished I'm really perspiring. At the end—to stimulate my circulation, so he says!—I bend down and get a dozen swishers from a whippy little birch, usually on the bare since my skirt has, after some solid work on the floor, climbed up so high as to give no protection! Then I have to stand in the shower and hold my breath while he goes over me in my clothes with a needle hose of icy water! That really makes me gasp. Afterwards I strip and take a hot shower. In spite of the apparent severity of the treatment it really makes me feel good.

Yours,
ATHLETE

A MACKINTOSH IN RUBBER

Dear Editor,

"Macking" is a word that stumped me for a bit, but I finally figured that it had some connection with mackintosh and hence rainwear or rubber clothing. Am I right? Let it go. Here in the States we seldom use the word mackintosh and it has an unfamiliar ring to me. Personally I prefer using the words rubber capes or raincoats. But it is all the same, I guess, in the satisfaction given.

The sleeveless cape came into fashion about the time of the World's Fair in Chicago, I believe, along about 1932 or 1933. They were quite popular, and it was not long before other varieties of rubber garments, insofar as rainwear

56

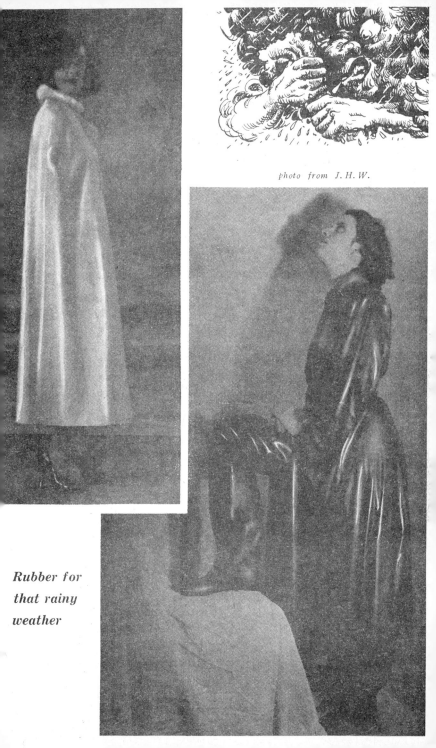

photo from J. H. W.

Rubber for that rainy weather

is concerned, appeared on the market. From the sleeveless cape, which hung so neatly about the wearer, came the cape with slits in the sides to permit the wearer to carry objects without uncovering her clothing to the rain, and at the same time keep the cape tight about her body. Other manufacturers brought out other kinds, some with hoods attached and then some with large flowing sleeves. Then there was the regular rubber coat, just that and nothing more.

They came in all different colors and sizes, as would be expected. However, the one that really appealed to me was one of the first that I bought. This was an ancestor of the first reversible coat, I believe. Rather, I should say it was a cape. One side of the cape was black, the other a clean white. The collar was cut and attached so that the color of the collar was opposite to the color showing on the cape. It could be worn either side showing the two colors. What I liked about it was the long length of the cape and the heavy and yet so soft pliability of the cape itself. Along towards the beginning of 1937 there appeared on the market a combination cape and rain coat. It was simply a coat with a half-cape attached. Similar to the dress coats that are worn by cadets at West Point Milit. Academy.

That just about covers the rainwear. It is quite possible that some other Macfan may be able to add to this. There is not a lot in the way of rubber clothing that can be bought on the market. Rubber gloves, girdles, bathing caps, galoshes or rainboots, raincapes and coats (practically not being made now) and rubber aprons and sheeting have been my stock in trade. I have used regular hospital sheeting to fashion clothing from, and it is very satisfactory. The only drawback is that it does not hang so softly about the body when worn about the house. On the other hand, the thin material of which the above mentioned raincapes and coats were made, tore too easily. I will say this for sheeting, it makes clothing that will stand hard wear.

I am sorry to say that I have no snapshots to send you, never having taken any of anyone in rubber clothing. However, if John Willie can cultivate his imagination a little, I can give him some ideas.

Yours, R. P.

DISCIPLINE A LA FRANCAIS

Dear Sir;

I have been most interested in the "seat of government" controversy in your columns, especially as I have just come back from a year in France where I lived with a family for whom c.p. was definitely *de rigueur!*

Cecile, their only child, was a

slim brunette of sixteen and I can testify that she was strictly brought up. She was always rigorously dressed. Very high heels, dark silk stockings with impeccably straight seams and a tight skirt of well-worn blue serge which was not allowed to come lower than four inches above the knee—this, I learnt later, was to remind her she was still a young girl.

For minor offences, such as bad report cards from school, it was "la corde"—administered by her papa in his study, with Cecile bent over the desk. I never witnessed one of these sessions but I often met and consoled a smarting Cecile afterwards! "Ca mord comme un serpent" (It bites like a snake), she said to me once after one of these whippings. But they were soon over and done with.

It was, strangely enough, her mother who was the more severe parent. With her it was invariably "la cravache," a lean whippy riding switch covered in leather. "Ca leche la peau comme une langue de feu," (It licks the flesh like a tongue of fire) was Cecile's comment to me on this instrument which she heartily dreaded. "C'est pas a faire rire," (It's no laughing matter) she would add.

Indeed it was not, as I had occasion to observe when I attended a correction with it in her mother's bedroom. I was called in by her stern parent "pour aug-

menter la honte" (to increase the shame). Cecile had to bend over and touch her toes in the middle of the room. Her skirt was raised on to her back and after a moment a dozen stinging blows fell across her upper legs. I was amazed at the severity of this castigation and watched it, I confess, dry-mouthed. The strokes were delivered in a slow measured way, allowing the pain of each one to sink in fully. But I was even more amazed at the docility and submission on the part of Cecile. Each cut into her tender flesh made her flinch a little and bend her knees, but beyond this, and beyond gasping out increasingly loudly, she bore the entire correction tranquilly. Only when she eventually rose could I see her face twisted with pain. "Ca cuit un peu, hein?" was her mother's sole comment as she turned and replaced the cravache in its cupboard (That stings a bit, eh?). I heard, but I never knew of one when I was there, of even more severe occasions, when poor Cecils was given "deux dou-zaines des meilleurs, des plus cin-glantes" (two dozen of the best, of the most stinging) standing up straight, her legs together, and holding her skirt up. If she winced away from a cut during this operation she was made to take it again. And each one had to be counted out in a clear voice.

Nevertheless, Cecile bore her

mother no grudge. I can vouch for it that she seemed the happiest child imaginable—except of course when bent over under "la corde" or "la cravache."

Yours,
GERTRUDE M.

WISTFUL MEMORIES

Dear Editor:

Congratulations to your "Bizarre No. 6," which is a wow. I like particularly the lovely girls in their neat corsets shown on pages 9, 10, 14, 17, 28, and especially the one on page 57. These pictures remind me of my youth, when a girl did not consider herself properly dressed, unless her waist had been well laced in. Round shoulders and a poking head were considered vulgar. The tight corset prevented both, insured an erect posture and a nice figure.

How well I remember, when my mother dressed my sister Helen for her confirmation. My sister was then fourteen, very pretty, and much delighted, that she had reached the age when she would be permitted to dress like a "grown-up" young lady. Two hours before church time, my mother began dressing Helen. She put on her first "woman's corset," a long-waisted, stiffly boned affair of white satin with long silken lacers. The corset reached well up under the arms, upheld the bosom, and was very high in the back. With

experienced hands, Mother quickly tightened my sister's stays, making her waist about four or five inches smaller than it had been before. Helen was visibly uneasy under the unaccustomed constriction, her young bosom heaved with each quick breath, and she was held rigidly erect by the tight stiff corset; yet, she did not complain.

Next, tight-fitting new slippers with tapering high heels and rather pointed toes were put on her feet by Mother. It was somewhat of a struggle to get them on; but. with the aid of talcum powder and a shoe horn, my mother soon managed it. I still can see how Helen proudly turned around before the mirror, beholding for the first time her slender waist and elegant high heels, before continuing with being dressed. An hour later, accompanied by the family, a happy, though perhaps a bit uncomfortable Helen daintily tripped to church with mincing steps.

Afternoon and evening was given over to celebration of the event and my sister did not miss many dances; if she felt oppressed by her tight corset and slippers, she never betrayed the least sign of it. Perhaps I was then too young to fully appreciate it; nevertheless, I do remember that Helen did look beautiful with her trim little waist, slim ankles, and high heels; and the many compliments she received on account of her nice appearance

Fausta walks

from a reader's collection

were as much deserved as they visibly pleased her.

From that day on, my sister never stepped outside of her bedroom, unless well corsetted and shod. Being an ambitious young lady, she began to lace tightly and at sixteen had a delightfully slender waist of about sixteen inches in circumference; yet, she was a healthy, vivacious, active girl, danced, skated, walked a great deal, and sang at every opportunity.

I think women appeared more charming and more feminine, when they wore the hour-glass style of corset and laced themselves into becoming slenderness, and I cannot help but look back wistfully to the days when Lillian Russell, Lily Langtree, Fritzi Scheff, and others had their gorgeous figures portrayed in the journals of the day. There is not the least doubt in my mind that even today any lady, who wants to appear especially charming and attractive, need merely don one of these old-style corsets, pull her waist from three to four inches, and she will be amazed at the transformation of her appearance, the comfortable support she will enjoy, and the admiration which will be hers from admiring males. All she need to do is to give herself the chance.

Yours, Gallant Oldtimer

START THEM YOUNG

Sir:

The general feminine public is beginning to adopt shoes with sensible, attractive heels. While these shoes are not being presented especially for children, the wise modern mother will realize how valuable they can be in the proper training of the young foot. Every-

Fausta sits

one has noticed how delighted little girls of 5 or 6 years of age are, when they are allowed to wear their mothers' high-heeled shoes (which are much too large for them, of course). This natural tendency should be encouraged, of course; but the child should be provided with its own properly-fitting high-heeled shoes. Thus her feet will adapt themselves naturally and gradually to shapes of true beauty, so that by the time she is 10 or 12 years of age, she will be wearing these 4¾ inch heels. In that case, we may be sure that, by the time she is a mature young woman of 18, the glorious, alluring 7¼ inch heels of Miss Texas will be, for her, not a mere wishful dream, but a glorious reality of miraculous foot-beauty with which she can charm the eyes of men.

Yours RAYMOND V. FORD

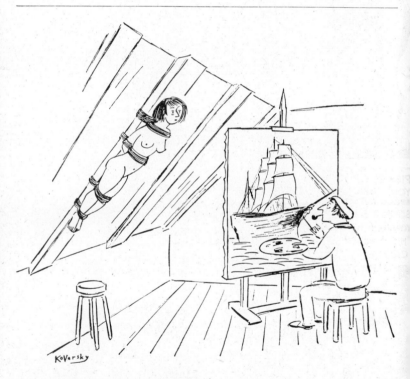

We thank the readers (several) who mailed in this cartoon from the "New Yorker," all with the same question; but you're all wrong—this is NOT John Willie in his studio—but it could be.

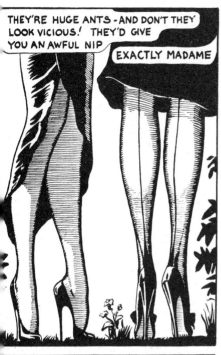

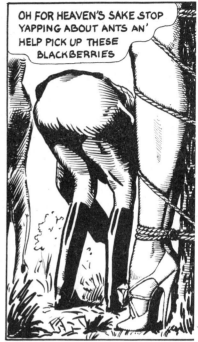

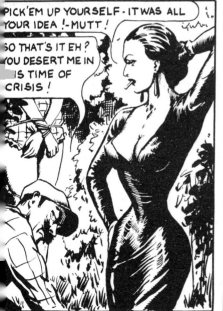

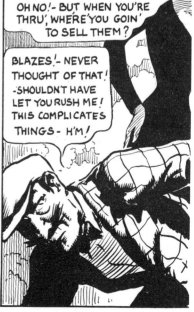

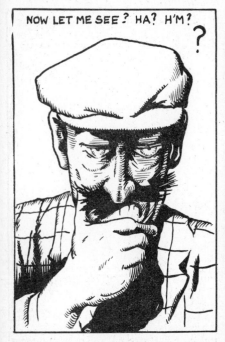

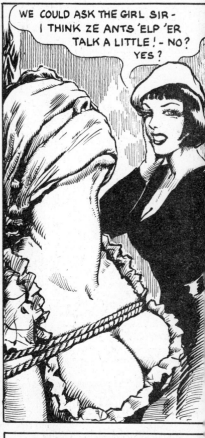

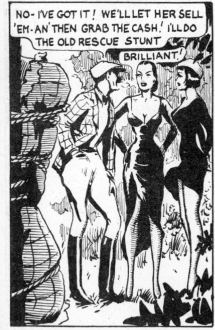

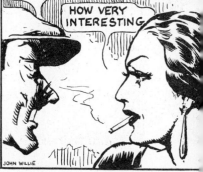

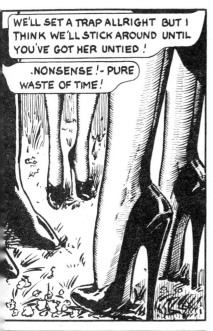

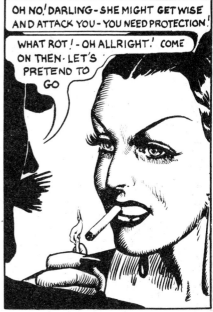

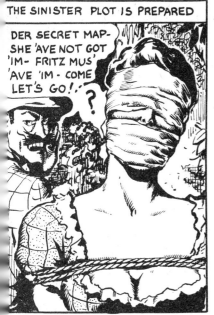

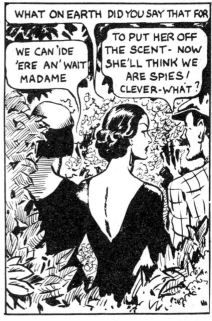

ALONE IN THE SILENCE OF THE WOODS SALLY STRAINS WITH ALL HER STRENGTH TO GET FREE: BUT THE CORDS ARE CLEVERLY TIED - THE GAG CUNNINGLY SECURE -

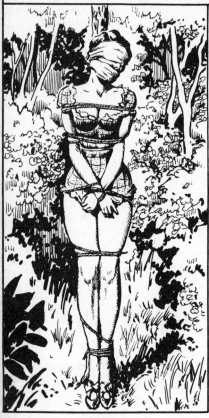

HER HEAD SHAKES

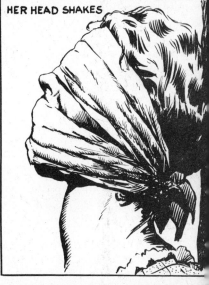

HER FINGERS FLUTTER-BUT THAT IS ALL

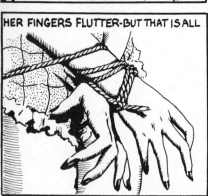

WHILE AS TIME DRAGS ON THE VILLAINS LURK IN HIDING, WATCHING, WAITING!

5 MORE MINUTES THEN WE'LL START

WHAT A PITY I COULD WAIT AN HOUR

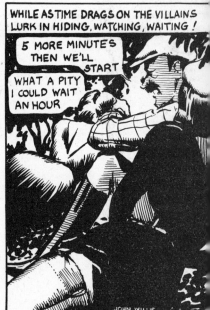

JOHN WILLIE

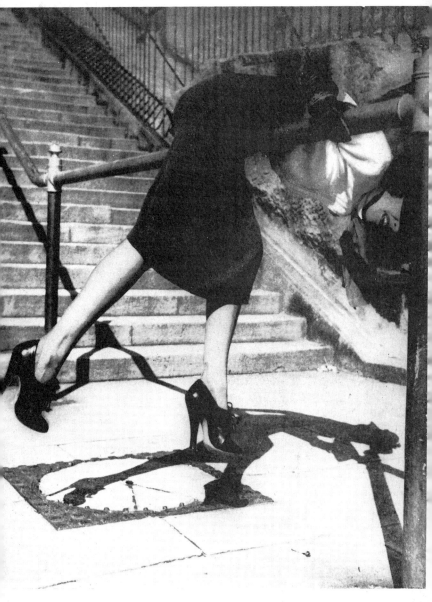

so round we go again

for slaves of fashion

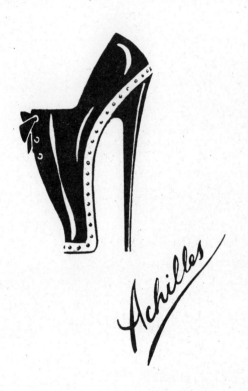

Achilles

theatrical footwear

BiZARRE

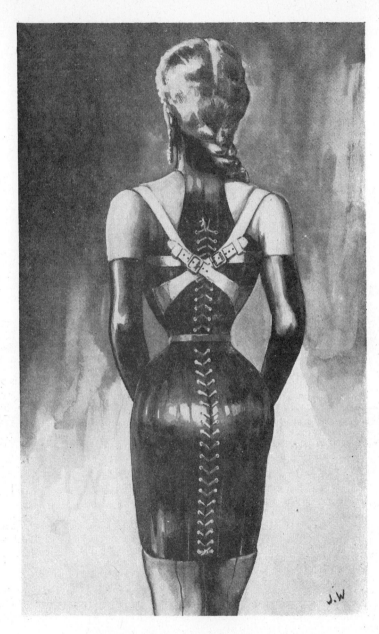

training corset with shoulder brace

Lo! some we loved, the loveliest and the best
That Time and Fate of all their Vintage prest,
Have drunk their Cup a Round or two before,
And one by one crept silently to Rest.

OMAR KHAYYAM

This issue—No. 8— is almost entirely correspondence. We hope you like it. And while on the subject of correspondence may we ask you *not* to be disappointed if your letters are not answered personally by the Editor and Co. We get so many every day that it's quite impossible.

And another thing: if your letter is for publication please try to keep it short, or if that is not possible—which is often the case—please try to arrange it so that it can be split into two halves. As we have previously stated we publish letters just as they are. We make no precis; we do no rewrite job; but we do at times cut out all irrelevant or repetitious material. As examples of what we mean, the letter by "Enchanted Slave" could be split, so the second half—a delightful piece of fantasy in "The Year 42 F.E."—will appear in the next issue. On the other hand, the "Experiment of the Nipped-in Waist" could not be cut, so it rambles on over five pages.

If a letter runs to two or more pages it means less variety of subject matter. Of course you personally might like to have an issue devoted entirely to corsets, but the boot brigade and the glove group will raise Cain. It takes all sorts to make a world.

Now, if it so happens that you find no mention in these pages of your favorite subject, just write and tell us about it. Even if we don't always succeed, we are trying to do just one thing, i.e., to please you, the Reader.

And last but not least—Achilles is *not* making shoes these days. We hope he'll start again but it is extremely doubtful.

3

THE MAGIC ISLAND

tale from bottle no. 4

I awoke as the morning sun was starting to peep through the trees, and I rubbed my eyes to make sure that this wasn't all some wonderful dream.

I could still seem to hear the pounding of the seas ringing in my ears. When was it that I'd hit that beach? The day before yesterday? Last week? What did I care; I could just stretch out here on the soft silk sheets and snore off again.

Then all of a sudden I remembered that today I was to pick out a pony-team of delightful damsels all for myself. This jolted me wide awake and out of the bed with a leap and a bound, and I hurried off to the shower.

As I was shuffling on my way I smelt coffee, and while I was cheerfully splashing about a gong sounded so I hopped out, dried myself and, arrayed in sarong and sandals, went in search of breakfast.

It was a pleasant unhurried meal in the course of which it was decided that, as Wendy had a lot to do around the house, and Pop had his construction business to attend

to, Malua should conduct me on the shopping expedition to select my team.

"But, though she knows a fast one when she sees it, Jimmy," Pop said, pushing his cup over to Mrs. Saunders for more coffee, "you decide for yourself. If you can't spot a winning outfit for speed, you can at least get a good-looking one— and points for that add up." Then leaning back, called out loudly— "Tee - na!"

There was a scampering outside on the verandah and a pretty, dark-haired girl of about 14 came into the room, tripping merrily along, high on tiptoe, her waist pinched into vanishing point by a little corset—or very wide belt, or whatever you like to call it. Anyway, all the grooms wear one.

There was a cheerful "good-morning" all round from everyone, and then Pop asked for his gig to be brought round in five minutes.

"And mine, too, please, Teena," said Malua. "And just tell Jane to remind them that if there's any more of this bolting business today, there's going to be trouble.

4

They've got the No. 4 harness on, I hope," and as Teena nodded, "Good. Just let them know that it's not there for fun. After yesterday's performance, we won't be able to get a decent bet on anywhere."

As merrily as she had come, Teena departed to get the teams while we finished our coffee and got ready for the day's work—if you could call mine work———and then, as I pushed my stool back to get up, I noticed Malua's feet.

They were literally a mass of jewels flashing and blazing with all the colors of the rainbow. I just gaped.

Malua's eyes twinkled. "Like them, Jimmy?" she asked, and obligingly raising one foot, pressed the tip of that slender, tapering heel against my knee as a pivot while she turned it this way and that for my inspection.

For quite some time I did not notice the thin straps which held the thing on her foot, so perfectly did they match the skin, and so terrific and diverting was the sparkle of the jewels. It just looked like a foot with jewel-studded toes which had somehow grown six inches of flashing lightning for a heel.

Finally, I got my breath back, took this lovely thing in my hands, bent over and, starting at the big one, kissed each toe—which seemed

the logical thing to do.

As soon as I had finished, Malua took the foot away but quickly replaced it with the other one.

"You can't have me limping, darling," she murmured. "One foot all covered in kisses and the other one quite bare." So, I gave this one a double dose, and pointed that out to Malua, which meant I had to even things up on the other foot again. We had quite a time.

When I eventually got out on the verandah, Pop was just clambering into his gig, while Teena stood stiffly at attention, looking awfully important, holding the bridle rein of the near side "steed" —a gorgeous girl with blue-black hair in two thick plaits hanging down to her knees.

Her harness was black, shining like patent leather, but the brow band, instead of being plumed, was set off by a large front piece of shining black leather, the rim softened by a fringe of short, bright red feathers, and in the center a jewel-studded gold emblem—the sign of the chief.

The off-sider was to all intents and purposes her twin, but the center one was different. Her hair —dressed in the same manner— was an absolute white, and her harness was white, the leather so highly polished that it reflected the sun like a mirror. Their bodies, a beautiful golden tan, shone as if lac-

quered, and they stood absolutely motionless, stiffly erect on tiptoe, eyes shining with delight but looking straight ahead.

"Now, there's a well-disciplined team," Malua said quietly in my ear. "Not like my rambunctious monkeys—even if mine can run rings around them any day."

"Doesn't Pop worry about winning a race?" I asked, surprised.

"Oh, yes, with his racing team," Malua answered. "As the chief he's allowed two. This is his working one. They're not fast but there's hardly another one on the whole island that can wear them down over distance. You ought to see them in their fancy rig—they're really something to look at then."

Further comment was interrupted by a cheerful "G'bye," and a click of the tongue from Pop, which sent the ponies springing off in perfect unison, to be running in a few seconds at what to me seemed an incredible speed as they disappeared into the riot of colors of the winding street—gay with its fruit and flower stalls and the awnings of the other little shops.

Then Malua's team was led forward by another pretty little groom and though I at once noticed that the harness was different from the one I had seen before, it didn't seem to me to have any particularly unusual or forbidding features. Certainly a stiff wooden

bar, instead of a light leather strap joining the bit rings of the ponies meant that if one turned her head all must turn; but that in itself seemed no great threat.

The rig presumably meant something to the ponies, however, because though they smiled a greeting, they held their heads erect and steady, only glancing at me out of the corners of their eyes, alive with twinkling mischief. This look in their eyes did not escape Malua, for she paused as she was climbing into the gig and looking at the backs of the team said, "Just to show you I mean business, my beauties, I think I'll take in those bearing reins a couple of holes. Here, Jimmy, you hold the reins while I fix things." Then, stepping over the traces, she went from pony to pony tightening a strap which I now saw went from the bridle at the top of the head down to the back strap, dragging back the ponies' heads in the process—not right back, but just enough to make the control felt.

I lit a cigarette and watched the proceedings with interest. With this harness, each girl's hands were secured to her sides by a wrist strap attached to the wide, leather waist belt and, just above each elbow, there was another leather strap, these two elbow straps being connected by a light, round-linked chain. In addition to this, a snap-

hook dangled from the strap round the right elbow.

As Malua went from pony to pony tightening the bearing rein, she also shortened this elbow chain by the simple process of forcing the ponies' elbows closer together and then taking up the slack in the chain by the snap hook, which now, of course, became part of the chain itself.

When she had finished, each pony was standing very stiffly erect, head and shoulders well back, held in that position by the harness and quite unable to relax or ease the strain for an instant.

Satisfied with her work, she climbed in beside me and took the reins. The groom stood clear and with a crack of the whip we were off, my companion holding the team in check with a tight rein.

The loose links of the elbow chain, which dangled down now that it had been shortened, jingled away merrily to the rhythm of the flying feet and I decided there and then to put bells all over my outfit.

The sun shone, the birds sang and everything everywhere was beautiful in the best of all beautiful worlds.

It seemed that we were going extremely fast, but that it must have been slow for the ponies was evident by the high-stepping stride they adopted. How they managed to run at all, trussed up as they were, I couldn't fathom and mentioned it to Malua.

"Oh I didn't tighten the harness up as much as I might have done," she said. "I've just taken up a couple of links to remind them what they've got on. If you want to make them feel it——and you can—you tighten all the straps and that chain to the limit. The bit they've got in their mouths today can also be pretty vicious."

This immediately became evident by muffled squawks and twitching shoulders as Malua tugged the team sharply to the right to overtake another gig.

"I'll drive them like this as far as 'Tatts'," continued Malua, "and then loosen the harness again. We've probably got a long haul ahead of us and I don't want to tire them out."

"I don't quite understand," I said. "I thought the place was quite near."

"Tatts is—yes," said Malua, pulling the team with difficulty to a walk to avoid a traffic congestion, "but we may not be able to find anything good at the Sale. If that happens there are a couple of girls I've had my eye on for some time who won't be on the market, but we may be able to do a trade of some sort." Then, to the ponies who were fretting and straining at their harness. "Steady there — steady."

"Their owners may be in town with them today, but I don't want to take any chances in case we have to go out to their homes."

The obvious impatience of the team now occupied all Malua's attention—but once clear of the traffic she gave them their heads again —as much as the bearing rein would allow, anyway—and once more we were off at high speed.

"Do your ponies ever tire?" I queried. "Gosh, they move so easily and so darn gracefully that they just seem to be floating." And then I had to duck quickly to avoid being hit in the face by another of those enormous "Cupid" butterflies which blundered around and then hovered, its glorious wings fluttering, over our heads.

"Oh, not again," gasped Malua, her eyes shining. "Thank heavens I've got this harness on these monkeys. They'd bolt right up the middle of the main street if they could turn their heads and see what's going on." I was chuckling to myself, remembering what had happened before and wondering how Malua would cope with a similar situation today.

I watched the lovely flying legs in front of us, but they never missed a beat in their steady flying rhythm.

I looked at the plumed heads, the hair in a tight coil at the nape of the neck, but they never turned

—they could not. The bit bars and bearing reins held them too firmly steady. There was no way for the ponies to sense the tension in the drivers seat behind them. Neither of us spoke while old faithful continued to flap around. But at last he apparently decided that it would be more fun to go off and ravish some captive flower than to play tag with two humans, and obligingly fluttered off.

I heard Malua give a big sigh of relief and she relaxed her hold on the reins which had been so tight that I thought it would pull the team's heads off. From then on we drove easily without further incident for about a mile until I saw by the number of teams and the crowd that we must be getting near our goal.

"Here we are," said Malua, guiding the team cleverly through the crush. "This is 'Tattersalls,' the pony market! They tell me it's called after some similar place in 'The O.W.,' is that right?"

"Could be," I answered, grinning at the thought of the difference there would be in the attendance if the same sort of fillies were put up at Tatts as we had here.

We wheeled in through wide swing gates and Malua brought the team to a halt, whereupon a smartly attired little groom came forward and took the heads of the

ponies, holding them while we got down.

"All right, Jojo," said Malua, "take them away and loosen that harness," and then to the team, "and just let that sink into your pretty heads—any fancy running today and it goes back on—hard!"

The ponies, of course, could make no movement to show that they understood, but I was perfectly certain that I could see no sign of penitence in those twinkling upturned eyes. In fact, I doubted if the severest and cruelest harness could quiet those imps for long. They were too thoroughly full of the joy of living.

Jojo led the team away to the cool shade of some enormous poinciana trees under whose flaming canopy other ponies were already grouped, still in harness but free from their gigs. With the bits out of their mouths, they were chatting merrily to each other—a chattering and laughter which increased when they saw Malua's team in their rigid harness.

The grounds of Tattersalls were like a formal garden, the hardbaked walks winding through beautifully kept lawns and flower beds in full bloom. The whole place seemed to be a mass of colour in constant motion, with the gay sarongs, the wide-brimmed hats, the flowers in the hair of those who didn't wear hats, and every now and again the flash of jewelled sandals denoting, as I told you before, that the fair wearer had once been in a winning team as a pony.

Everyone was in a cheerful mood and we exchanged greetings with all and sundry as we walked over to the "Sales ring." This was a small circular space, almost completely enclosed, by two long shaded huts: around one side were the "stalls," about which people were milling, and on the other side the "Sales Pavilion," a fair-sized hut with tiers of seats for the buyers.

"Come to think of it, Jimmy," Malua said, her hand resting against my arm as she steered me toward the nearest end of the stalls, "you're pretty lucky. This is the last market day before the races. As I said just now, I don't suppose we'll find anything good, but we'll have a look around."

When I got nearer, I saw that in actual fact the stalls were not really a hut insofar as structure went. They were composed entirely of Bougainvillea, from a light vermillion color down to the deepest crimson. It must have taken years of careful training to grow, for the uprights holding up the "roof" were the solid stem from which the vine-like branches spread, so interwoven and covered with foliage and blossoms that they formed a perfect covering.

9

Also, by some trick, the shelter seemed to trap the perfume of the frangipani trees which screened the far side, and whose fallen petals formed a mozaic with the smooth brick-red tiles which comprised the floor.

And then I saw the ponies! Oh, my revered Uncle—Oh, me, Oh, my! There were about 50 of them!

I've already told you that any girl here would win a beauty contest in the Outside World, any time, hands down, so there's no need to reiterate and go into details. All I will say is that I began to wonder why it was that I felt "that way" about Malua and how long the feeling would last.

All of them were naturally in their "birthday suits" except for a little tasselled "G" string arrangement—and there they stood in a row which followed the curve of the shed, on tiptoe, their wrists crossed and tied behind their backs with cord.

They were tethered by a halter round their necks which was attached to a ring above their heads on a long pole that ran the full length of the place. By each ring was a slot for a card with the girl's name on it.

Some were, of course, taller than others; some had blue eyes, some had green, grey, brown and what-have-you. All had red, inviting lips, tinted with various shades of the same red dye which all the women here use for lipstick and also to enlarge the nipples of their breasts.

Some had dark hair, some fair, in all shades and all lengths from the shoulders down; the really long tresses being held in check by a ribbon at the nape of the neck.

Most of them were up for "trade" for some reason or another, but there were one or two "fillies" who had never been in a team before, and for whom this was "presentation day."

They all knew Malua was well satisfied with her team but I was a very, very newcomer, obviously in the market and so, though the ponies just smiled and returned Malua's greeting as she appraised them with the eye of an expert, the looks they gave me were quite different—and quite disturbingly inviting.

I've never been ogled by so many lovely, laughing eyes in my life. The little imps that lurk behind that dark mist of lashes, giving me the come-hither until my head was spinning and I could no more concentrate on the good or bad points of each "steed" than fly to the moon—at least until we came to Su-hanee.

She was about three-quarters of the way along the line, and there was quite a group of traders gathered around her. In fact, at first

all we saw was the group and heard the hum of conversation.

We eased our way in and then I saw a blaze of color and light which at last resolved itself into a head of hair: long, waving, curling hair that flashed a different color at every turn of the head. Now a blazing crimson, then maybe a sudden change to misty, greenish blue, then copper or gold, or green or yellow.

I stood staring in amazement, but I felt Malua's hand and she whispered, "Another Radiance—and what a beauty."

"That," I whispered back, "is for me—just what the doctor ordered, but I suppose I won't be in the hunt, everyone will want her."

"Oh, no," Malua answered, shaking her head. "Probably no one will want her at all, and she's no good for you either. She's never been in a team before, she's never been tried out, and so no one knows whether she's fast or not."

She paused, studying the girl intently, then continued. "The trouble with a Radiance, which is what we call ponies with hair like that, is that they're either very good or no good at all. There's no half way. There's only one other of pony age on the island at the moment and she's not only no good at all, but very, very bad. Almost any child can beat her over just a quarter mile."

"Well, O.K." said I, "I'll remember Pop's advice and get this one for her looks. What's the name on the tag there? Suhanee!"

Malua frowned. "It won't work out, Jimmy. For show, you have to have at least a two-pony team— just one isn't allowed. If you had two Radiances I'll agree that it would be almost certainly a winner, but that only other Radiance just won't parade. Several people have tried, but she always does something to spoil it."

"Then we'll forget her and I'll match this filly up with a couple of blondes. How's that? She'd look good in the middle."

But still Malua shook her head. "Look. You see the way her arms are also tied at the elbow," she said.

"Yes," I answered, "I'd noticed that." Along the line there had been one or two others who, like Su-hanee, had their elbows drawn right back and tied—obviously tightly—as well as their wrists. "What's the idea? It certainly makes them hold themselves very erect, with their chests stuck out in a most attractive manner."

"Oh, it's not for looks," said Malua. "It means she's a wriggler —that is, she's pretty clever at getting her hands free. With her elbows tied back like that, she cannot move her wrists enough to wriggle them loose. She's all fire,

is that one, and you'd have one big job keeping a harness on her. She'd be just more trouble than a barrel of monkeys. Come on—let's find something more reliable."

But I wasn't convinced, and anyway I thought I'd like something on the wild side.

I took another look at Su-hanee. Her eyes caught mine, and there was a message in them, if ever I saw one, which said as clear as day: "I'm untried, but buy me and you'll find I'm a flier."

I felt Malua tugging my arm, but I stayed rooted to the spot. It was only a hunch, but I felt like playing hunches today—so I put my finger alongside my nose and gave a wink, at which Su-hanee tossed her head merrily. As far as I was concerned, the deal was complete.

Turning to Malua, I said: "I've made up my mind, oh Wise One, I want Su-hanee."

"But you can't, Jimmy," she answered. "Listen, you've got to have a team which is really fast—proved fast! You can't tell whether Su-hanee can run until you've seen her in a race."

"And that will be too late," I cut in. "Look here, you've got a wizard team, so the only chance I've got to beat you is to try the unknown. I'm only playing a hunch, but I've been pretty lucky these last few days and I believe

in following it up. Let's get her. How do I go about it?"

We argued away for a few minutes, but at last Malua said, "O.K., you're the boss. The sale starts in about half an hour. We'll look around for the rest of your team and then we'll have a spot before the bidding starts. Blondes you wanted, didn't you?"

As we began to move down the line, I turned my head and noticed two or three other buyers studying Su-hanee carefully, and then Su-hanee looked at me, her eyes pleading, and her fingers twisting and turning in an obviously useless effort to get free. So I again held up a finger and nodded, at which her face became all smiles once more. I thought I saw her wink, and then it seemed to me that she deliberately slumped for an instant, and lowered her heels to the ground.

Malua, who had caught sight of the movement, gasped. "Oh, Jimmy," she said. "Oh, no! What a pity! That's the worst sign."

"What's the worst sign?" I asked, puzzled.

"Lowering the heel," she answered. "That only happens when there's a weakness in the instep which can't be controlled. Then it happens any time."

"Couldn't she do it on purpose to rest her feet?" I queried.

"Good heavens, no!" Malua exclaimed. "She knows that if she

did, no one would want her. No one! So she just *wouldn't!* She can *never* be a pony. Oh, what a pity, she's so lovely."

I could hear the murmur in the group and saw them moving away, including one old codger who previously had been showing marked interest.

I caught Su-hanee's eye again, and again she lowered her heels, raised them again without effort, and this time there was no mistaking it. She gave me a dirty big wink which no one else saw—and then the idea came to me.

Two Radiances would be a knock-out team for looks. Here was one—a monkey, if ever I saw one—deliberately (I was certain it was done deliberately) doing the one thing which would ruin her prospects of ever becoming a pony, and so put everyone else off, just to be in my team. And the other,

one whom no one could train—no one could discipline. Well,˙ maybe I could find the right technique. Even if I wasn't successful, the experience would certainly be interesting. But somehow I felt I was going to be successful; I felt sure my luck would hold.

"Come on," I said to Malua, putting my arm on her waist. "I'm not going to bother about looking at the other ponies. Let's go and have a drink." Malua gaped at me in astonishment. "A good long drink," I went on. "I'm going to buy Su-hanee."

Malua's mouth opened wider and wider in speechless amazement and then I thought her jaw would drop right off, for I said: "And after the sale you're going to drive me out to get that other Radiance —the one that you say is no good either!"

(to be continued)

SHOPPING SERVICE

We cannot act as buyers for out of town readers, but what we can do is let you know where you can purchase shoes, stockings, lingerie or accessories, etc., for the shortest, tallest or, shall we say, most ample woman. Just write and ask us.

ILLUSTRATIONS

Space is too limited for us to include here the illustrations by J. W. for this story. They are printed separately, and as they have been designed to fit in with the page format they can easily be inserted in the magazine.

They are sold as a separate item. If you are interested write for particulars to "Editor," Bizarre, P. O. Box 511, Montreal 3, Canada.

FANCY DRESS
for special evenings

Overleaf are some more suggestions for party or special evening costumes. The French Maid and the Mistress are simple and straightforward enough for anyone handy with a needle.

Diana should obviously be clothed all in leather—skin tight glacé kid for preference—but the ordinary theatrical one-piece costume would do. In 1962 she will of course carry a man size butterfly net instead of a bow and arrow; and some cords to secure her captive, once she has netted him.

The cracker should be made of starched calico. Whether or not the usual motto on a piece of paper should be enclosed with a gift inside is a matter of choice. The only snag is that it's another of those costumes which make it necessary for someone to feed her with the good wine and food of the festive season. Oh yes, she can dance— with small steps. Blind Girl Fluff enthusiasts will of course insist that the top should come higher than the top of the head. She can then only see the ceiling—or nothing.

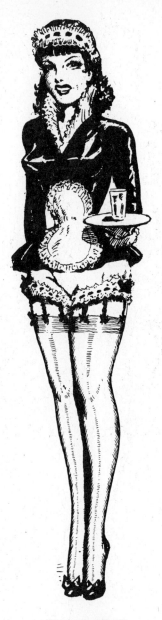

French Maid

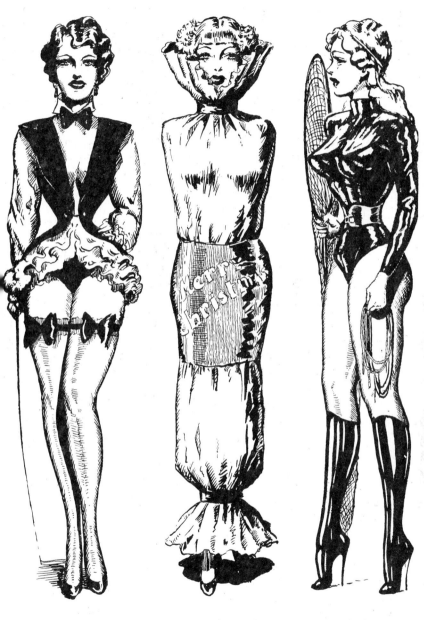

Mistress　　　　　**Cracker**　　　　**Diana**

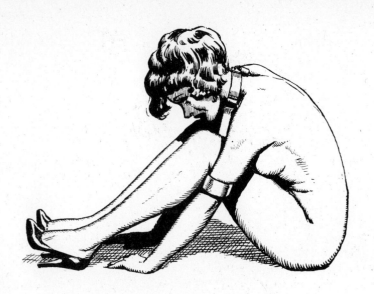

THE PORTABLE PRISON

An Asset to the Ideal Home

Our ingenious old ancestors devised many very simple but extremely effective gadgets for punishing wrongdoers, and for ensuring peace in the community.

The Stocks, Ducking Stool, Scolds bridle, Drunkards cloak and Pillory are well known, but here we have another device which today could also serve the excellent purpose of making a home a sweet home.

Does your husband (or wife) stray? The patent (expired) portable prison shown above will prevent it. Does your wife throw the crockery at your head? Then use this gadget for a quiet life.

All it consists of is a "T" made of stout iron. Each stroke of the T ends in a ring—the ring on the down stroke of the T opening on a hinge. The contrivance is placed under the malefactor's knees as she (or he) sits on the floor. Then the arms are introduced into the two rings on the cross of the T. The down stroke, with its open neck ring sticks up between her legs. Bending over the neck is placed in the proper place, the padlock is snapped shut, and there you are. The victim is not in the least bit uncomfortable—at least not for a time—but quite definitely unable to do much about anything.

orrespondence

Under no circumstances do we publish names or addresses. If photos or sketches are sent in, please write a short commentary and please do NOT send in photos which you got from someone else.

VENUS DE MILO

Dear John Willie,

There's a particular type of girl I'd like to meet that I've tried to find for years, but with no success. Perhaps your artist could draw a picture of her—it's just a picture of a beautiful girl without arms.

In "Bizarre" you pictured "1972 The Mummy;" your fancy dress "Pony Girl;" and in your last issue your "Flower Girl;" all showed the figure with arms completely hidden—I'd like one of your very attractive girls in a strapless or off-the-shoulder dress —with no arms at all.

My second wish is to see her "on her toes" actually—as with hard-toe-Ballet slippers. She could be standing or seated or walking— but her feet would have to be arched—resting on her toes (if she were seated).

She could wear any of your excellent revealing costumes—from the French Maids abbreviated skirt to the full length gown— slit up to the waist to reveal the legs.

Anything will do but—no arms.

Sincerely, J. D. J.

A CHALLENGE TO CAROLYN

Dear Sir,

Now for a few brief comments on your Correspondence section, which to me is by far the most interesting portion of each volume. More letters and less Sir D'Arcy would p'ease me greatly. Incidentally, the bit addressed to "Carolyn" I hope to see published in some f u t u r e issue even if nothing else is. So now to work...

I was greatly intrigued by the item titled 'Masked Marvelle' by "Blind Girl Fluff" ... It sounds like a most interesting idea.

I like too the item from 'Hi French Heels' since Heels and tight lacing are my especial favorites. You know I have never yet found heels high enough to really please me.

I heartily agree with the idea of

C. H. McC. I wear clothing which is not authentically male at every opportunity (tho not often enough) but that as he says is due to the stupid conventions of our so-called "modern society."

And here we come to where I ask another favor . . . if at all possible would you please see that correspondent "Carolyn" receives the following message?

Dear Carolyn: Know what I think? I think you made your statement *only* because you were hiding behind the security of the anonymity furnished by our friend ye editor.

Here is my challenge to you dear . . . I will lace tighter—wear narrower skirts—more hampering sleeves and higher heels (your own prescription) and *guarantee* to "take it longer without complaining" (again your own words) than you do!

What say you now, Carolyn?

Thanx, Gauron

REMOTE CONTROL

Dear Sir:

Ursula's splendid letter in Issue 4 certainly intrigued me—as I know it must have enchanted others like myself who are voluntarily enslaved to the object of their deepest devotion.

For the past year my fiancee and I have been separated by the Atlantic and have, therefore, been forced to carry on our courtship by daily air mail letters on my part— weekly boat mail on hers! How I am looking forward to the time when we can be together and she can quote me Joyce in person rather than in correspondence: "Feel my entire weight. Bow, bondslave, before the throne of your despot's glorious hee's, so glistening in their proud erectness." (Ed. *Ulysses,* Random House edition, 1934, p. 519). For she is well aware of and delights in my weakness before a pair of high, pencil-thin heeled kid opera pumps, particularly when the legs above them are encased in sleek black silk stockings and the thighs still yet above are discreetly hidden in a revealing froth of black lace.

When I recently sent my friend an engagement ring, she demonstrated the knowledge of the power she enjoys. For, in return, she mailed me a little package containing a real surprise. It was simply about 18 inches of stainless steel chain with a shiny padlock at each end. Her instructions for its use were thoughtfully included and are now hanging in a frame over the fireplace in my room. They read as follows:

"If you really mean what you have so often written—that you wish to be my slave for life, then wear this chain around your ankles every evening when you write your daily account of all your thoughts

18

and actions, of every single one of them, remember.

"Simply loop each end of the chain tightly around an ankle and use the padlock to fasten it securely in place. Then you will be able to fidget around in your chair as much as you want, listen to the delightful tinkle of the links as you move your feet, even fix yourself a drink—if you take small enough, lady-like enough steps. But you will not be able to forget, even for a moment, that you are owned by me.

"On each Saturday night before six o'clock—and not a minute later mind you, I want you to do this. First be sure the padlocks are open; they will lock automatically enough you will learn! Then address a special delivery letter to yourself, place the two keys in it, and go out and mail it in the same box in which you mail my letter each evening. When you get back, I want you immediately to prepare to retire. Then lock your wrists in the same manner that I have ordered you to lock your ankles each time you write to me.

"When you have done that, darling, you have my permission to do whatever you want! Isn't that generous? Please say 'Thank you.' Yes, you will then be completely "free" to do as you will until the mailman delivers the envelope early Sunday morning. In this way

I can rest assured that you will be a good boy each Saturday evening."

I confirmed my understanding of these instructions and if *Bizarre* is interested in what happened the first Saturday evening of the new regime, I shall be glad to recount the sensations of restrictions imposed and voluntarily accepted by remote control.

Yours, "Pleased to Receive"
We'll also be pleased to receive further details.—Ed.

NOW SHE'S IN THE MOVIES
Dear Sir:

You never know what the effect of a chance remark can be. I began to find that out a little while ago, and, believe me, I'm still finding it out.

It all began one evening when my husband had brought home a copy of Bizarre—Volume 2, for January 1946, I remember the issue very clearly. As usual, he was busy with his great hobby, amateur movies. He was editing some film he had shot a few days before (oh, he's really a little crazy on the subject; he even processes his own film after he's shot it, and they say you have to be a real movie nut to do that) my sister-in-law, who lives with us, was busy drawing something (she's really a wonderful artist) and I was curled up on the couch, reading your little magazine.

19

Suddenly I looked up and, not realizing what I was letting myself in for, I remarked brightly that with a little make-up, a bristling black moustache and so on, my husband would look exactly like Sir D'Arcy D'Arcy. He grinned a bit, and then went back to reeling and unreeling his film. Then I went ahead and completed making trouble for myself by pointing out that with the proper hair-do, eye-make-up and long earrings, my sister in law would make a very fine "Mysterious Countess."

My husband slowly turned towards his sister, and she looked at him. There was silence for a few seconds. Then Sir D'Arcy — I mean my husband—turned to me and said gently, "Stand up a minute, dear." "Why?" I asked, rather uncomfortably. "Stand up, dear." he said. He had that look in his eyes; so feeling very self conscious I stood. People say I have a pretty good figure, and I guess I dress to show it—especially at home, by my husband's request.

His eyes started at the top of my head and moved down as he murmured: "Blonde hair, that's right; right kind of face; very good in the er - bosom department; right kind of waist and hips . . . Pull up your skirt, darling." When he speaks to me in that gentle voice I know better than to say 'No;' so up came the skirt. I found myself blushing, but at the same time glad that I was wearing a pair of my longest operas, so my legs were looking their best. "Nmm-hum" murmured Sir D'Arcy, "You're a dead ringer for Sweet Gwendoline. So, if the Countess agrees, we will make a movie, a chapter a month, following the adventures of Gwendoline as they appear in Bizarre. How about it, Countess?" She smiled a sinister smile, that made her look exactly like the lady in your magazine, and said, "Why, I think that's a wonderful idea. When shall we begin?" "We can begin to lay plans at once," answered Sir D'Arcy, "we'll have to think of people to play the other parts, for instance." I was so furious at not even being consulted, that I forgot I was holding my skirt up around my waist somewhere. "Hey!" I grated, "Just a minute. If you think I'm going ot let you two tie me up and gag me, you're—" That's as far as I got. Sir D'Arcy grabbed me, and slapped his hand over my mouth. I tried to struggle, but he was behind me, and had his left arm around my waist, pinioning my arms to my sides; then he lifted me off the ground, so that my five inch heels were flailing around in the air. "Oh Countess," he said, "it looks as though we will have to

begin by showing Miss Gwendoline that it doesn't pay to argue with us. Will you get some, er, rope, or something?" She hurried out and was back in a short while with some rope, one of my husband's big handkerchiefs and a roll of adhesive tape.

Before I knew what was happening, the handkerchief was stuffed in my mouth and my lips were taped shut with the adhesive. Next my hands were tied behind me at the wrists and elbows and I was tossed on the couch while they bound my legs together at the ankles and knees. Then they left me, bound, gagged and helpless, struggling wildly to free myself, while they calmly mixed themselves a couple of drinks and settled down in comfortable chairs to lay plans for the forthcoming film. At one point the Countess glanced at me and remarked, "Oh, she'll make a wonderful Gwendoline. Look at the way she's worked her skirt up to show off her legs." "Damn fine legs they are, too. Don't blame her for liking to show them," leered Sir d'Arcy. After an hour, they untied my legs; but they kept my arms bound and my mouth taped up till bed-time.

Yours,

"Gwendoline the Second"

The account of the first Saturday's filming will appear in the next issue.

A SENSIBLE SOLUTION

TO: BIZARRE:

I have studied your charming little magazine and I come to the conclusion that men are just as fond of finery and pretty things as women. The barrage of advertising that tells women constantly how to be beautiful finds a great number of victims among men, too, it seems to me. My own husband is sample case of this theory.

I am a divorcee; my first husband was thoroughly masculine and led me a hell of a life with his gambling, drinking and unfaithfulness. After my divorce I met my present husband whom I found shy, sweet but also somewhat drab and dull—until one day he confessed to me that he was irresistibly attracted by female clothes and ardently desired to wear pretty things. Well, I made him dress up for me one night and when he entered the room in a powder blue satin dress, jewelry, high-heeled shoes and expert makeup on his face I was simply stunned with surprise. He was a changed person, gay, witty, charming and I fell in love with him in his disguise. We were married and I made it a standing rule for him to wear women's things around the house exclusively. I buy him housedresses, pretty aprons, rustling petticoats and in our married relations I am only

must satin always be black?

satisfied if he wears the most ex-
quisite nightgowns. I taught him
to embroider and crochet and love
to watch him do it.

I have two lady friends, both
divorcees and somewhat sour on
men and the idea of marriage.
One Halloween I made 'Mar-
jorie' (my hubby's nickname)
dress up as a girl and my friends
were enthusiastic! They insisted
that "Marjorie be one of the girls"
and now we have wonderful fun
at our weekly card games with
'Marjorie' as elegant and good-
looking as any of us three.

We lead a harmonious, happy
married life and never quarrel.
My advice to you girls is—if he
likes skirts and aprons, don't feel
that there is anything wrong—let
him wear them and make him
happy!

<div align="right">Edna K.</div>

<div align="center">PRACTICE MAKES PERFECT</div>

Dear Editor:

After four blank years it is
good to see your fine magazine
again, with the opportunities it
offers readers of expressing their
own opinions and describing their
own fancies. I, for instance, am a
man (a genuine one!) who enjoys
wearing sheer nylons and opera
pumps with very high heels, and
I would like to describe some of
my experiences for the benefit of
other males who may be thinking
of experimenting with this fad.

My first high-heeled shoes were
simple but elegant black calf pumps
with open toes and closed heels
purchased in an ordinary retail
shoestore. The heels were the
h i g h e s t commonly obtainable:
about three and seven-eighths
inches, measured vertically at the
back, which Achilles points out
amounts to around 24/8ths or
three inches in shoe-trade termin-
ology. It is a common misconcep-
tion that ladies' shoe sizes run
much smaller than men's. Actually
the numbered sizes are quite the
same. For instance if you take, as
I do, a size 9AA man's shoe, then
a size 9AA woman's shoe will
probably fit you. Because sheer,
smooth nylons allow the foot to
slide easily into a smaller space,
the woman's 9AA shoe *is* in ac-
tual fact slightly smaller than the
man's. But it appears *much* small-
er for several reasons. For one
thing, it has a dainty thin sole,
with no projecting welt. Also the
woman's high-heeled shoe (except
for that abominable "baby doll"
style) achieves a smaller effect by
its more pointed toe—and of
course by the high heel itself.

In August of 1946, as noted in
an earlier issue of *Bizarre,* one of
America's largest chains of retail
shoestores placed on the market, at
a price of six dollars, an open-toed
black suede pump with a four and
one-half inch heel. A pair of these

was my next purchase. Although the heels of these shoes were not as thin and delicate in appearance as might be desired, the charming sensation of walking in high-heeled insecurity was considerably increased by the added heel height. I still find these pumps quite graceful and comfortable as walking shoes. In 1947 the same shoe was offered in black patent leather and in black and brown calf.

However the workmanship and materials in these inexpensive factory-made shoes was not of course the best; and besides I was eager to experience the sensation of wearing even higher heels. So at this point I turned to a custom bootmaker specializing in extreme high-heel styles. (In New York almost any of the masquerade costumers listed in the classified telephone directory can furnish the address of such a bootmaker. The price of beautifully hand-made shoes with heels up to seven inches in height is around fifty dollars for the simpler styles and materials. I determined by simple measurement with a ruler that a six-inch heel was the highest I could wear with the ball of my foot resting flat. (Achilles correctly states that the smaller foot of the average woman can be accommodated to a six-inch heel only by a slanting pad under the ball of the foot, so that in such shoes she literally walks on her toes.) I decided on a simp'e black patent opera-pump style with closed heel and open toe. Here the high-heel novice should be given a warning. Open toes are fine, since they make the foot appear shorter, but if you order open-toed shoes, have the opening made quite small. Otherwise you are liable to find your foot sliding down and your big toe sticking out in a most unsightly manner. Rather tiny open toes do not appear out of proportion, for you will find that these custom bootmakers can fit the whole ba'l of your foot into a tinier space than you would have dreamed possible. And with extreme heels this is absolutely necessary to prevent the foot's sliding down. Which brings us to another point: standing and walking in six-inch heels is—we may as well admit it —definitely painful. To do so

gracefully is an art which requires much experience and practice. In the thrilling moment when I first tried on my six-inch-heeled pumps, I found that I could scarcely stand without bending my knees. But as the muscles at the sides of my calves gradually stretched to accommodate the vertical angle of my foot, it ultimately become quite easy to walk with that stitlted and tentative, yet graceful, stork-like gait of the professional model. (Scoffers and sceptics about extreme high-heels p l e a s e take notice!)

The stunning appearance of t h e s e stilt-heeled, pointed-toe pumps and the gently accented swell they impart to arch, calf, and thigh has more than repaid their initial expense and the time and discomfort involved in learning to walk well in them. My next venture is to be a pair of laced black calf bootees with six-and-a-half inch heels.

Yours,
"Extreme High Heels"

Re shoe sizes—women's are usually smaller than men's. Ed.

IN PRAISE OF MISS 1952
Sir:

It will be generally admitted that the four most valued and indispensable enhancements of natural feminine allure, for the modern woman, are lipstick, high heels, cigarettes, and perfume.

And the most alluring and irresistible women are those who use the most vivid lipstick with the utmost lavishness and daring; who wear the very highest heels they can obtain and are able to walk in; who smoke constantly and continually when in the presence of men; and who use the heaviest and most intoxicating perfumes. (parenthetically, nothing is more fascinating to masculine eyes than the sight of a pretty girl smoking, blowing a cloud of smoke from her lovely lips, and exhaling twin streams of smoke or letting little twists of smoke drift from her dainty nostrils.)

The modern girl presents an ideal of womanhood never equaled in the past for sheer femininity. She is absolutely perfect in every way, completely flawless and utterly adorable from her glamorously coiffured h a i r t o her supremely kissable feet (so charmingly revealed in all their naked beauty by modern cutaway shoe styles).

Yours, G. M.

PIERCED EARS RETURN
Dear Sir:

The most wonderful recent addition to womanly attractiveness has been the sudden, unexpected revival of popularity of pierced ears, plus the marvelously elaborate, heavy, and decorative earrings that are being worn. Now I

have noticed that while in many women the piercing is a tiny pinhole, in some women it is noticeable as an actual slit, tiny but of definite length, from the bottom of which the heavy ear-ring depends. I feel sure that most men find this little slit in the ear-lobe somehow more fascinating than the almost invisible pin-hole, and it should certainly be encouraged if it is the result of choice or any voluntary action.

Gerald Moulton

Dear Sir:

THE RETURN OF BLOOMERS

My dear Mr. Editor:

I recently came across a full set of your magazine's issues under the most amusing circumstances and I find its fashion ideas most interesting—especially the ones concerning old-fashioned women's clothing such as bloomers, heavy-duty corsets and high boots. In fact, the fashion ideas have a personal application to me which your other readers may be interested in. Many of your readers bemoan the passing of old-fashioned styles but why don't they do something about it? I did, with the most wonderful results!

Now, I know something about old-fashioned styles and style-changes first hand. I'm fifty-three years old (a lady should never tell her age, should she?) and I've gone through most of the changes.

I was brought up in a strict, Victorian atmosphere where modesty was considered absolutely vital. My mother was an extremely beautiful woman but I remember that she always wore the stiffest of full-length corsets, long skirts and high-button boots. What's more, she always looked attractive in them. When I was a young woman, my mother made me follow her example although styles were changing rapidly and I hated having to wear unfashionable things. As soon as I got away from home, in the early 1920s, I stopped wearing corsets and long dresses and got into the swing of things.

I rolled my stockings below my knees and wore my skirts above them in the best "flapper" style. As the years went on, I kept up with the very latest fashions and because I've always been pretty and kept my figure I never had any real problem of keeping in the swim. Up until a year ago, I was the up-to-date modern woman who wore a light girdle, uplift brassiere, nylon briefs and sheer nylon stockings, a light slip and a fairly short dress. I never went in for the "New Look" because I liked showing off my nice legs. Although I was more than fifty, I had many admirers and many "dates." But today I feel rather like the man in those advertisements of a few years ago that went "J. J. Jones has

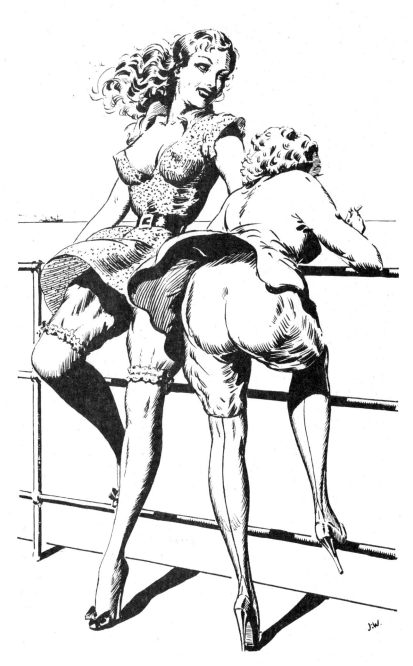

the bloomer girls

switched to Calvert" (or whatever whiskey it was). Only in my case it might be "Mrs. Leblanc has switched to bloomers!"

One day I was rummaging through my storeroom when I came across an old trunk I hadn't thought of for years. I opened it up and I started to laugh as soon as I saw what was in it.

It contained almost everything from my "hope chest" and the first thing I saw was an elaborate set of back-lacing corsets! They were beautifully designed and covered with sleek, dark-blue satin but there was so much boning in them that they looked like a suit of armor stretching from armpits to thighs. I wondered what else was in the trunk so I took the things out and started looking them over. My, it was amusing! There were be-ribboned camisoles and chemises, stiff petticoats adorned with lace, long black stockings of heavy silk, and fancy garters, and several pairs of high, kid boots. Everything was terribly elegant because Mother had ordered everything from a marvellous seamstress who really was expert. Almost all of the underwear was of silk, of course, because they didn't have nylon in those days.

I was halfway down the trunk when I came across a pair of silk bloomers. Today, bloomers seem to be the symbol of middle-aged dow-diness, great baggy affairs worn by heavy women. But it wasn't that way thirty years ago. These were beautifully tailored bloomers of pink silk, generously cut and with elastics at the waist and knees, of course. I hadn't worn bloomers for more than twenty years but these looked surprisingly nice. Of course, I wondered if these things still would fit me so I decided to try them on. So I slipped out of my light linen dress and nylon slip and got out an old-fashioned outfit. There was a full length mirror in the storeroom and I looked myself over in it before I changed. I guess I looked like any other modern woman in my brief panties, net bra, light girdle, sheer, flesh-colored nylons and oxfords. Anyway, I took off my shoes and stockings and s'ipped out of my undies. Then I put on a diaphanous silk chemise out of the trunk and tried on the corsets. I hardly remembered how to handle them and I had a terrible time getting them laced up the back but finally I managed to do it. I thought I would suffocate at first but I still have a pretty good figure and it didn't do me any harm at all to be pushed into shape. The corsets took several inches off my waist and although they made me move stiffly they gave me a lot of support too. As soon as the corsets were laced up tight, I put on a pair of the black silk stockings

that came well up my thighs. I hadn't remembered how flattering those heavy-gauge silk hose were to legs until I had them on—or the lovely way they felt. A pair of loose, pink, silk bloomers followed and I carefully adjusted the elastics about three inches above my knees, then donned fancy garters and a pair of black, high-heeled boots that came to just below my knees above my calves. They looked very smart on my calves and ankles when I laced them up and they felt awfully good too.

When I looked at myself in the mirror I rather liked the picture I made. Certainly the corsets gave me a better figure, with a small waist, high bosom, trim hips and erect cariage. The pink bloomers, brocaded-satin corsets, black stockings and boots gave me quite an air of elegance. I especially liked the feel and look of the bloomers which felt lovely on my thighs.

At the time, I was living alone in my house with a young niece who was a pretty, scatter-brained girl in her late teens. I thought it might amuse Nona to see her aunt in such a get-up so I went down stairs (teetering a bit on those unusually high heels) and entered the living room.

That was the most embarrassing moment of my life!

One of Nona's friends, a good-looking young man named Billy, was sitting on the chesterfield. Later, he told me Nona had invited him for tea but that she had been called out for a few woments. But there I was in front of him in my bloomers and corsets! I guess I was sort of frozen by embarrassment because I couldn't seem to move. He was startled and embarrassed too because his jaw dropped open and his face flushed.

If you care to publish this I will write again to let you know the delightful outcome of this experience.

Yours,
Mrs. Billy T.

IN FAVOUR OF TATOOING
Dear Sir:

Your admirable pronouncement of policy, in favor of the "freedom to wear what we like, and to amuse ourselves as we like in our own sweet way," taken in connection with the letter of the woman who signs herself "Eugene," and who mentions her hesitant desire to have her nose pierced for a ring, reminds one irresistibly of the chapter in Tiffany Thayer's novel, *The Greek,* wherein he summarizes the laws and customs of his ideal Future State, which (in H. G. Wells fashion) he imagines as an accomplished fact. Among those promulgations is the following:

"Aigrettes and birds of paradise and all other rare feathers were again admitted as part of Milady's

wardrobe, and she was invited to add a nose-ring or any other barbaric ornament she cared to—if she were in herself comely and her decorations did not interfere with any of her animal functions."

As for tattooing, the only argument against it is its permanence (for those who may change their minds!) Of course, tatooing would never do for most people, both because a clear and naked skin has its own fascination, and because one of the very fascinations of tattooing is that it is unusual and daring, especially for women. As a matter of fact, many more women are tattooed than most people realize; and quite a number of young girls have had butterflies or other attractive designs tattooed on their thighs.

Yours,
Raymond V. Ford

OH, MY ACHING BACK . . .
Dear Sir:

Your magazine has caused me considerable pain and discomfort of late due to the fact that my husband takes to heart everything he reads in it. He read that part about the party who preferred the spanking to a good bawling out and since then every time I've been bad-tempered I've been spanked but good. In fact it has not been but five minutes ago since I got up from across his knee. Now I'm really good and sore and red due to the fact that a pair of silk panties is not much protection from a hard wood hairbrush. Needless to say I really deserved every spanking I've gotten. I'm really not complaining but I would like to raise the question in your correspondence column of how old a girl has to be before she is too old to be spanked. I'm 28 years of age. I do hope I can sit down comfortably when I get your next issue.

Respectfully,
Mrs. J. G.

A MASKED MATE

Like your correspondent who signs herself "Blind Girl Fluff," I like to have my eyes bandaged, but even more than that I like to have my hands tied or fettered. My husband indulges me in this, so that my hands are secured whenever he is at home—meaning evenings and week-ends.

When I have housework to do, I am handcuffed, which permits plenty of freedom for cooking, washing dishes, etc. for lighter work, my crossed wrists are tied in front. (This letter is being written with my hands tied in that manner.) Whenever I will not need to use my hands, my arms are tightly strapped behind me. I love the helpless feeling of being bound, and know that it improves my carriage. Naturally, like many girls who have learned the pleasure of feeling helpless, I sleep

my arms are strapped behind me, while my husband leads me along by a leash fastened to a dog collar buckled around my neck.

On occasion, when I deserve it, my husband gives me a good old spanking with a ruler. I am naturally tied on such occasions.

Sincerely, "Shackled Susan"

NIPPED-IN EXPERIMENT

Dear Sir,

I am enclsoing a copy of part of some very interesting letters I have been receiving from a young lady I know in England, who knows a group there who have evidently been conducting various experiments. It was quite a job to decipher her almost illegible handwriting but I managed to take off quite a bit of it. I don't know of any of the group she refers to and she is not inclined to tell me any more.

EXTRACT FROM A REPORT DATED OCTOBER 1945

Describing a series of experiments conducted by an English Doctor in London, covering the psychological and physical effects of very tight lacing and the wearing of high heeled shoes. A number of subjects were used for these experiments, ranging from the novice, young girls having no previous experience, or inclination for constriction of the waist or elevation of the heels, to girls, addicted from childhood to both corsets and

with my hands and feet tied every night.

When my husband must leave the house on a Sunday, he fastens me securely "so I will not run away"—as though I would try!

We spend summer week-ends in a rather isolated house in the country, and when we take a walk

heels, and with insatiable desire for the extreme. All of the subjects used including the novices submitted voluntarily and eagerly to the experiments, and while some of the inexperienced girls were almost immediately intrigued by the new and strange sensations they experienced, others saw only discomfort and annoyance in the various devices used. Sandals and pumps with heels from four to six inches were used, and a number of different corsets all with the old fashioned small waist and back lacing. Waist sizes were from 15 to 18 inches, and all of these corsets were newly made copies of genuine corsets. Several types of shoulder braces were used with the corsets all copies of models used in the last century for pulling a girls shoulders rigidly back to an extreme degree if desired. An old fashioned very high boned lace collar was tried in one instance, and a number of leather belts from one to five inches wide were used for extreme constriction.

* * *

The following excerpts from one of these experiments, describes the use of a leather belt for tightening the waist of a young girl seventeen years old, who had always had a desire for tightness about her waist since she was a very young child. When she was about six years old she very vividly recalls some boys she was playing with, tying her up to a fence post and in doing so they had wrapped a clothesline around her waist several times pulling on each end as they did so and then round the post several times, and resulting in her waist being very tightly bound. They left her there for some time and she has never forgotten the pleasant feeling she experienced from the tightness about her waist. On several occasions after that time she recalls asking these boys to tie her up again and each time she secretly enjoyed it. Also as a child she had been greatly impressed by her mother's high heeled shoes and had always begged to be allowed to have high heels. She had worn high heels from the age of 14 years, and when these experiments were conducted was wearing small patent leather open toed pumps with full four inch heels which she said she wore most all the time. She was five feet three inches without shoes on, and weighed 108 lbs. Her natural waist measured 22 inches and for the experiments she wore only a pair of abbreviated silk panties, a bra, and her shoes and stockings. She had always wanted to see how an old fashioned hour glass corset felt but had never had a chance to try one, and when told about the experiments she was naturally most eager, and curious. She had always

worn as tight a girdle as she could manage and said she enjoyed this.

* * *

To begin this experiment a one and a half inch solid leather belt with holes every half inch was used, and it is most interesting to note the partial immobilization of some of the muscles of the waist and hips and the involuntary motions caused by the gradual tightening of this belt. She wanted to draw it as tight as possible as soon as it was on and it was with difficulty she was induced to do so gradually a half inch at a time and go through a prescribed routine each time so that complete notes could be made of her reactions and sensations.

The belt was tightened to start with, four inches which was not hard to do and which gave her an eighteen inch waist over the belt. She was able to walk easily about the room and go through all of the routine with little difficulty. It had been suggested that she go through the experiment in her stocking feet but she had asked to be allowed to wear her shoes which had four inch heels, and it was decided to let her start with them on. With her small size of four and a half these heels put her pretty well up on her toes but she walked easily and attractively on them. From the first tightening the belt was drawn in one half

inch at a time and the same routine was accomplished without noticeable change until a waist measurement of sixteen inches was reached, except that subject enjoyed the sensations caused by the constriction. When the measurement of sixteen inches was reached the hips had a slight jerky involuntary sway and in walking about the room subject had to step to one side or the other to maintain balance. When fifteen inches was reached there was a definite increase in this unbalance and involuntary motion of the hips and an obvious disfunction or lack of control of the abdominal muscles. Subject repeatedly expressed delight in this involuntary motion of her hips and said it made her want the belt even tighter. Walking was more difficult now and it was impossible to walk straight. Unsteadiness of the ankles on the high heels was continuous even when standing still. When fourteen inches was reached there was a definite involuntary sway to the upper part of torso with a compensating motion to the lower body, even while standing, and when subject started to walk the hips threw violently from one side to the other in quick jerks and subject staggered and almost fell. She was asked to take off her high heeled shoes and they were taken off, after which she was able to

walk more easily but still not in a straight line. Subject still insisted she enjoyed the feeling of extreme tightness about her waist and expressed a desire to continue the experiment. The belt was now drawn in to eight inches smaller than her normal waist of twenty-two inches. Tightening the belt another inch caused a marked increase in the reactions noted previously and subject felt the tiny waistline furtively and with a noticeable apprehension. However she said it felt delightful and she still wanted it to be tighter. There was now a most peculiar independence of motion imparted separately to the pulmonary or upper half, and the pelvic or lower half of the torso. It was found that the dorsal muscles only were in any degree under control. This independence or freedom of motion above and below was a peculiar and almost violent sway or jerk in several directions, immediately above the constriction, this motion throwing subject off balance and compelling an immediate attempt to steady herself.

Subject all the time continued constriction of nine inches and kept putting her hands about the small belt line of her waist as she tried to walk and keep her balance. She said it gave her a pleasant feeling in her hips and the pit of her stomach as she walked and that the violent throwing of her upper and lower torso greatly increased this pleasure. Suddenly without saying a word subject drew herself in as much as possible and taking the loose end of the belt, with considerable effort, drew the belt in another inch making a ten inch constriction from her normal waist. The involuntary motion of hips and upper body was now almost continuous even as she stood panting from the effort she had made, and as she attempted to walk, the compensating hip motions were accentuated to extreme and at times so violent that she would have fallen if she had not been assisted. Regular dance steps had been part of the routine each time the belt had been tightened and from a constriction of seven inches these steps could not be followed alone but were done nicely with the aid of a partner. Now that subject had imposed a constriction of ten inches on herself, she expressed a desire to try the dance steps with partner. The step pattern and rate caused the upper torso to sway and throw so violently that the hips could not compensate, even with the aid of a partner to hold her up and lead, and it was necessary to repeatedly stop and establish balance. After the dance steps however subject walked about the room with remarkable degree of balance and a

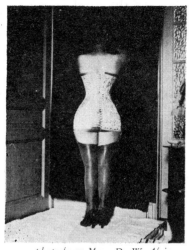

photo from Mme. D., W. Africa

definite rythm and grace as her balance shifted furtively and daintly from one foot to the other.

Subject repeated that sensation was delightful and didn't want to stop walking back and forth. Subjects expression gave evidence of the pleasant sensations she was experiencing.

Normally subject can stand indefinitely on either shoeless foot and bend the other leg up horizontally at the knee balance being maintained by a slight movement of the ankle. This was done each time the belt was drawn in and each time balance was kept for a shorter time. With the ten inch constriction she was only able to hold the right foot 45 seconds and the left 75 seconds. While the high heeled shoes were worn the foot she was standing on swayed most unsteadily but she retained balance pretty well and said she liked the unsteadiness her heel caused. As soon as the foot was lifted sway began with reflexsive hip motion becoming diverse, extreme and violent with each degree of constriction, and with the ten inch constriction subject fell before the right foot could be let down to keep balance.

Standing subject was given a slight push to the side and it was necessary to step quickly in that direction to prevent falling. She could stand a greater pressure from the back however. Sitting on the edge of a bed with feet on the floor a very slight push caused her to fall over on her back and she was only able to recover the sitting position with difficulty using her arms. Upon a flat surface, feet level with the buttocks she could not sit upright without using her arms or when raised to that position, she could not maintain it without using arms and hands. Of twelve falls from this sitting position nine were on the side and three on the back. If she sat with her weight slightly more on one buttock than the other she found she would fall to that side. Three times she fell in the opposite direction because she tried to restore balance by leg pressure. From the supine position she was reluctant to try and get up but found it

pleasant to lie there and try and flex her waist muscles. After over an hour of this extreme constriction (over three hours for the entire experiment) subject said she felt a slight numbness around at the point of constriction but she insisted the sensations were even more pleasant especially in her hips. She was curious and definitely amused by her lack of control and her involuntary and unpredictab'e movements, laughingly saying she couldnt tell which direction she would go next. She was still reluctant to release the belt when told the experiment was over, and asked if she could try the extreme tightness with her high heels on. They were slipped on for her and as she stood up on the ta!l heels she gave a little exclamation of surprise and pleasure saying it made her feel so funny through her hips. She tried to walk but the throwing of the hips and upper body was so violent she would have fallen without help. She then begged to be allowed to dance once more with the partner saying she wanted to see how it felt with her heels on, and a slow waltz was put on the phonograph. She said it was delightful and felt like floating around without any effort or control. Subject was finally induced to release the belt when it was suggested she should now try a

36

tight corset. She said her waist was a little numb when it was taken off and there was a red line about her waist where the belt had been. She had never had an opportunity to try a tight corset before but had worn tight girdles for some time. She was obviously eager and curious as a short boned corset with a fourteen inch waist and twelve inch busk was clasped about her waist. She was delighted as the back lacing was gradually drawn tighter. She was not able to stand being laced as close as the corset would go and when she asked that the lacing be stopped her waist measured just over fifteen inches. She said it was very tight and felt different to the tight belt. This might indicate that constriction to twelve inches with a narrow belt was equivalent to about fifteen inches with a corset and its extra support and constricted area. The same involuntary movements were experienced with the tight corset but the added support made these motions less violent and seemed to connect the upper body with the hips to some extent and give some semblance of control between the two. She had the same pleasant sensations as with the tight belt but thought the tight corset felt even nicer especially when she walked as it seemed as though the violent involuntary motions of either half of the torso were pro-jected through to the other half. The pleasant feeling in the hips was different she said but more sustained and extended into the thighs, which effect was more pronounced with high heels on. Walking while wearing the tight corset was more controlled than with the belt though both the hips and upper torso threw violently to either side occasionally, subject still delighting in the sensations this motion caused. Walking was accomplished in stocking feet and wearing her high heels, but she definitely preferred the heels which she said added to the nice feelings the tight corset gave her. After being laced to fifteen inches for some time she expressed a desire to try being a little tighter but it was explained that it might be safer and better to let it wait until the next time. She then wanted to wear the corset home and keep it on all night but she was finally convinced that this was not good the first time.

Yours, "C"

It All Ends in Smoke

Your correspondent R.V.F. is quite right in stating that the taboo against smoking by children and adolescents has disappeared, and that boys and girls now smoke openly with the full approval and even encouragement of their fathers and mothers, whereas former generations of youngsters had

to deceive their parents in order to enjoy the pleasures of tobacco. It would be impossible to maintain adult disapproval in face of the fact that more than 16 million cigarettes are smoked in a year by American teen-agers today. The typical girl of 15 today is a chain-smoker, and I have seen a girl of 11 smoke a dozen cigarettes during a movie show. As *The American Smoker* said in an article last year, "adolescent smoking has come to stay." The article pointed out that many thousands of boys and girls of the finest character are cigarette addicts today; that neither parents nor educators see any reason whatever for disapproval of teen-age smoking by either boys or girls; and that many high schools have opened smoking-rooms and permit smoking on the campus, while many other schools are planning to do so.

The peoples of the Orient have always allowed children to smoke. In Burma it's cigars as soon as she learns to walk. Today, in most American cities, our junior high-school girls light cigarettes on the street, on the way home from school, and adults smile indulgentlly at the sight. I have seen girls as young as 9 years smoking openly in movie theatres. And Dr. Flanders Dunbar, in her recent book *Your Child's Mind and Body*, states definitely that chil-

dren should be given freedom to make their own decisions; and she gives smoking as an example of this, stating that if a pre-adolescent girl, seeing her parents smoke at the dinner table, asks to be allowed to smoke herself, she should be given a cigarette instead of being told that "Cigarettes are not for little girls." In this progressive school in England, Andrew S. Neil has always allowed the children to smoke if they wished, no matter how young they were. The very latest popular book on Hygiene, with an Introduction by Dr. Morris Fishbein of the American Medical Association, states definitely that smoking is harmless for adolescent boys and girls; hence parents need not hesitate to allow their children to smoke as freely as they wish. The cigarette adds so much to the attractiveness of a young girl, and is so indispensible a part of the feminine fashion picture, that girls should be encouraged to smoke at an early age, so that they may learn to smoke gracefully and with full enjoyment; and then, perhaps, by the time they are 16 or 18, they may decide to experiment with pipe-smoking or cigar-smoking, aware of the fact that a pretty girl smoking a pipe or a cigar is an extremely piquant and intriguing sight to masculine eyes.

Yours truly, A. B. C.

Editor Bizarre:

In your No. 3, E.V.E. says:— "that she is looking for a man who will make her his helpless prisoner and humiliate me in every way." She says to her man:—"do not bring flowers bring cords, instead, with which to bind us * * * make us crawl to do your bidding." LeK. says that she "has often wished for a spanking." Well, out here in the West where "men are men," three of us girls have found men who are ideal from that point of view.

R is the leader of this sextette. The bunch is constantly together for parties, dances, shows or dinners but we girls have to toe the mark and abide by a system of punishments to keep us in line. We are punished for being late for our dates, for being "Snooty" and for a thousand and one other things that the boys can invent. It is not difficult for them to find offenses on our part and, to be truthful, we do not have a lot of objections to being punished by them. It's a lot of fun if you ask me.

It is a matter of general knowledge that English girls like to be whipped. (? Ed.) We are told that teen-agers are spanked by their boy friends and love it. Older girls appreciate a birching by their lovers and wives delight in being stripped and whipped by their husbands.

Why not make a survey? Ask your readers for their experiences in this subject. It would be of interest to us all.

Yours truly, Agnes

Improving on Nature

Dear Sir:

Nature has made woman beautiful, yet she cannot be content with the beauty that nature gave her. The very essence of feminine charm is to artificially improve on nature, creating vivid new beauties that nature never dreamed of. Extremely high heels, ultra-tight lacing, lavish lipstick, and modern makeup in general, are the most important and the most delightful of these artificial aids to beauty that are at the disposal of the modern woman.

As Dr. Wendt points out in his book on the World of Tomorrow, women must cast timidity aside, and daringly create new patterns of bodily beauty that owe no allegiance to nature. As he wisely states, the woman of today and tomorrow cannot afford to look natural. She must resolutely turn her back upon nature, and become an imaginative creative artist with her body. The wonderful civilization of China discovered this long ago, and by means of foot-binding created gracefully tapering feminine legs that streamlined into amazingly tiny feet, and caused an

uncertain swaying walk that was delightful to see. But this admitted beauty was attained at too great a cost, for although the tiny feet of Chinese women were adorably pretty when clad in shoes, their mutilation made them ugly and unkissable when seen naked. The woman of today gets all the advantages of foot-binding with none of the disadvantages, by the simple process of wearing shoes with six-inch heels.

Tattooing is a method of adding fascinating new patterns of beauty to the feminine body without in any way distorting or mutilating it. Tattooing will unquestionably grow in popularity with girls and women as they discover its delightful possibilities for adding to their charm and attractiveness.

Yours, "Anon"

DOWN WITH DUNGAREES

Dear Sir:

I would like to thank you for putting out a mighty fine magazine. May it prosper to the point where you can put it out much oftener than you now do.

I consider myself something of a shoe designer. That may or may not be true. But a person does not have to know very much about shoes to realize that the young girls of today leave much to be desired. Not only in the shoes they wear, but in their whole mode of dress as well.

I see some one coming down the street dressed in blue jeans, grimy ankle sox, and dirty saddle oxfords. I am often not sure whether it is a boy or a girl until I come abreast of them. Then when I find that its the female of the species I wish that it were a boy. For it is very sad to think it is a girl, dressed as she is when she could look so much nicer, when she could look like a woman should look.

I do not blame them altogether. I think part of the blame lies in the young men too. They don't seem to care what the girls they date look like.

What can I or any one else do to get them interested in being at least a little more feminine? What can we do to let them know that a gob of lipstick is not all that is needed to make them look feminine, What can we do to let them know that they would look far nicer, far more appealing and far more attractive dressed in dresses and high heels.

It seems to me that the correction should start at home, that the parents should start making them realize that they are girls and not boys.

I have seen girls of 18, 19, and 20 that look like bulls in a china shop when they get into high heels. I'm a man and proud of it. But I'll be darned if I couldn't wear

high heels better than the most of them. It would be a sad, sad thing to see what wou'd happen to them were they to try wearing 6-inch heels. Come on girls! Be girls! ! !

I have enclosed three of my designs. They do not show up as well as they might for I seem to be a terrible photographer.

I. B. O.

They're fine—and thanks a lot.
Ed.

OLD-TIME SEVERITY

Dear Sir:

I must say I have to laugh when I read some of your letters from your girls who raise such a hulabaloo on being spanked by their parents although they are grown up. These girls don't know what a really good spanking is like. My girlhood was spent just prior to the first World War, and I will say that spankings in my time were something to be avoided if possible. But quite often our girlish transgressions would lead us astray and we'd have to pay the piper. Mother's favorite instrument for chastising was an ivory-backed hairbrush, but at times resorted to a black leather strap which hung in back of the kitchen stove. Age certainly didn't determine our spankings. Mother said if we insisted on acting like children, she'd continue to whip us as such. I once saw my eldest sister whipped for smoking and although she was

twenty-one, over mother's knee she went, and after a few necessary arrangements of her clothing the hairbrush was applied vigorously twenty or twenty-five times. She was weeping bitterly when mother released her. I had experienced that punishment many times and I knew just exactly how she felt. Your older readers will know the great quantity of clothing which the women wore in those days, and to prepare a girl for a sound spanking was quite an elaborate affair. I was married when I was nineteen but up until that time I was whipped when deserving of such. If I thought I was to escape the humiliations of a spanking by getting married I was sadly mistaken. My husband was one of those men who believed that a good application of his hand or a hairbrush to his wife's un-bustled posterior did a world of good. I remember very vividly my last parental whipping. I had my parents permission to attend a dance with definite orders to be home before midnight, or else. I not only came home way after midnight, but was discovered by my mother, kissing my gentleman friend in the summer house.

After mother had berated my friend unmercifully for bringing home a girl at that hour of the morning, she led me into the house by my arm. As we made our way

42

through the kitchen mother unhooked the strap from the nail. Right then and there I knew I was in for a hot time and didn'' relish the idea at all.

Sitting down for the next day or so was mighty painful and I had the marks of that strap on my anatomy for three days. So you see girls today after all aren't treated too harshly.

Adeline R.

CYCLOPS

Masked Marvelle keeps mum. Chicago.

KEEPING GIRLS QUIET
or
IT CAN BE DONE
by
Futurus

"Bizarre" has made several mentions of devices like the Scold's Brid'e, or Branks—things designed to keep girls or women from talking out of turn.

But in Grandmother's day there was another device, which went further than that—it prevented the wearer from making any noise at all.

This interesting little item, which should never have been allowed to fall into disuse, was the Discipline Helmet. Actually, there were two types of helmet made— the Punishment Helmet, and the Training Helmet, which was different in purpose, but similar in appearance.

Both types of helmet were used in the old-style Finishing School, especially on the European Continent where figure training was rigorously carried on. M a n y schools, particularly those in Austria, guaranteed a specific waist-reduction in their graduates.

So severe were the corsets they employed, and so tightly were such attendant devices as shoulder-braces and high heeled boots adjusted, that it was quite common for a girl to lose her self-control and go off into hysterics.

Since one of the first principles of any finishing school was that Vulgar Displays of Emotion are Unthinkable, steps had to be taken to bring the rebel ious Miss back into line. And that's where the Discipline Helmet came into play.

At the very first scream, our little lady would be seized, her hands ' tied behind her, and the helmet laced tightly into place about her head. The helmet was made of leather, usually black kid, and shaped to fit the subject's head and face like an unpleasantly tight glove. Once in place, and laced tightly down the back, it did its work perfectly. Since there was no opening for the eyes, Miss Rebel could not see; since there was no opening for the mouth, she could not make a sound, and, as the part of the helmet over the ears was usually padded inside, she couldn't hear either.

So, there she stood, deaf, dumb and blind. She was cut off completely from the world around her, and since silence, darkness and isolation have always been the best cure for hysterics, it is needless to say that it did not take very long for our young friend to get over her attack.

Of course, fainting was something else again. If a girl fainted as a consequence of the severity, she was not punished. She was allowed to lie down until she felt better—nothing was loosened, naturally; but then she was not punished either, since fainting was, after all, a ladylike thing to do. But hysterics—that was merely vulgar and called for immediate application of Punishment Helmet.

The Training Helmet was made and fitted exactly like the Punishment Helmet, except that it had eye-holes and no padding over the ears. Thus, the wearer could see and hear. She was simply gagged and expressionless.

In schools where the Training Helmet was employed, each girl had her own, made to her individual measure and so fitting to perfection. The helmet was worn regularly during the Deportment Training Period—at which time, of course, corsets and so on were pulled in to their tightest. The function of the helmet was twofold. First, there was the matter of discipline; the silent girl—one who could not communicate with her companions even by her expression—was obedient. Further, "shut-in" as she was, her concentration was better, and she learned such things as coming downstairs with a book on her head and a glass of water balanced on the back of each gloved hand, more readily than she would otherwise have done. Second, there was the matter of endurance; it was found that if a girl could neither look

44

for sympathy in the faces of her masked fellow-pupils, or make the necessary first sounds in an attack of hysterics, she could stand being much more tightly braced and booted than otherwise.

The Training Helmet was frequently used for other things. If, for instance, a girl was caught whispering in class, she would be sent to get her helmet, and would spend the rest of the period in enforced silence. The fact that she couldn't answer oral questions when they were put to her merely meant that her standing in class suffered as though she had made all answers wrong. An exception to this rule were the classes presided over by certain ardent disciplinarians who made their students wear their training helmets at all times. In such a case, of course, all answers to questions had to be in writing.

A favorite punishment among teachers in these establishments was so many hours of leisure time to be spent laced into a training helmet. It was simple to prevent unauthorized removal of the helmets when out of sight of Authority. The rule was that the teacher awarding the punishment laced the helmet in place, tied the lace in a hard knot, and cut the ends off short. At the expiration of the time set, the girl had to report back to the same teacher to have the helmet removed. If there had been any attempt at removal, it would show up, since the lace would be too short to be retied.

It was a common sight on fine summer evenings, when classes and preparation were over to see two, three, or even more girls, strolling hand in hand, about the school grounds, in their light summer uniforms, their heads tightly enclosed in gleaming leather. Many girls learned the deaf-and-dumb alphabet, so they could communicate even when their lips were sealed.

The girls undergoing helmet-punishment — who were called "Leatherheads" or some such nickname—banded together for a very good reason. In most schools where the helmets were used, the other pupils used to enjoy baiting the Leatherheads in various ways, and the latter found from experience that Union is Strength. A favorite method of plaguing the Leatherheads was to tie their hands, making them still more helpless. Sometimes a leatherhead's arms would be bound behind her and then her skirt and underskirt would be shortened by use of her waist-belt so that her silk-stockinged legs would be displayed for many inches above the knees. Authority, naturally, frowned officially on such horse-play but unless it got really out of hand, they did

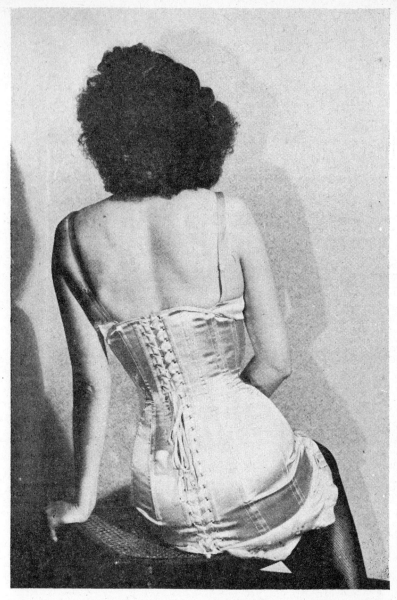

above—*The hour-glass figure of a London reader. And on the opposite page* ➡

At the request of many readers an enlargement of the illustration in No. 5 of this figure-training outfit, popular in exclusive finishing schools—il faut souffrir pour etre belle.

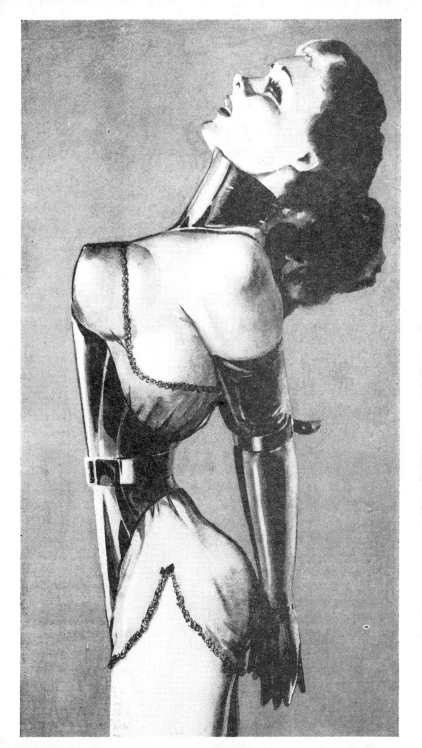

little about it, since it was felt that being at the mercy of her companions added to the punishment.

<div align="right">New York City,</div>

Dear Sir:

Your reader who signs himself "Smudged" is justified in a personal dislike for being smeared with lipstick by his girl-friends, and doubtless there are a number of men who will agree with him. However, a recent newspaper questionnaire in New York definitely proved that most men thoroughly enjoy kissing a woman's lipstick, and the more lavishly she applies it the more they love to kiss her. Indeed, the advertisements make it quite clear to women that the lavish use of glowing, vivid, daring lipstick is an irresistible lure to kissing for men. And so it is, in most cases.

Your correspondent, I am afraid, has the old-fashioned idea of makeup, whereby it was supposed to be used in moderation as a timid aid to natural beauty. But this attitude was the result of a Puritanism that has passed, except for a few reactionaries. This outmoded idea of makeup was responsible for the dictum, printed in etiquette books some fifteen years ago, that it was not good form for a woman to apply lipstick in public.

But makeup today is no longer a secret form of deception. Lipstick today is a frank and open application of a vivid new beauty and allure that Nature never dreamed of. Even our high-school girls apply lipstick with a daring and lavishness that is breath-taking, and hence delightful and wholly admirable. And the use of lipstick has already made serious inroads in the elementary-school classroom, younger and younger girls adopting the practice every year. As a result, our latest beauty-etiquette books fully accept the public application of lipstick as in perfect good taste; indeed, they relaize, as Carl Crow puts it, that men regard it as a graceful and intriguing gesture, and derive a definite thrill of pleasure from witnessing it.

In the same way, the woman who really wants to appear alluring, is not content with painting her lips alone; she is careful to see that the lipstick is clearly visible on the skin of her face both above and below the line of her lips themselves. She knows that this means extra sex-appeal; and for the same reason she lets the mark of her eyebrow-pencil be clearly seen on her skin beyond her eyebrows. Indeed, if she is sufficiently daring, she shaves her eyebrows completely and replaces them with clearly pencilled ones, thus making

herself still more fascinating to the thrill-hungry male. It is because makeup is now a frankly artificial and thrilling vivid addition to natural beauty, that we get such stunning effects as lavishly applied *blue* lipstick, and now the latest and most daring *black* lipstick, to fascinate and allure the worshipful eyes of men.

Yours,

Raymond V. Ford

A QUERY ON EAR PIERCING
Dear Editor,

Several months ago I was happy to become acquainted with *Bizarre* your very interesting magazine. My wife and I get a real thrill from it, particularly the letters from other readers.

There are two questions we would like to ask. Both of us are very much thrilled by a pretty foot and ankle encased in a sheer black stocking with patent leather pumps with extremely high heels. You show many photos of such dainty items and I would like to secure some as a surprise for my wife. I have been unable to find shoes with anything more than 2½ or 3 inch heels at best. Can you tell me where I might find such boots or pumps as you illustrate? Are they available in New York? I go there frequently and could look for some if I knew the name of a shop to go to. [*Many shops stock 4 inch heels these days. Ed.*]

And another question. In volume 3 Raymond Ford writes about pierced ears. Can you or your readers tell me how the ears are pierced? It seems to be a lost art around here. [*Answers to this question welcomed from other readers. Ed.*] I love to see my wife wearing long heavy earrings but she complains the type that screw on will not stay on unless screwed up tight and then they hurt so she cannot keep them on for any time. She has agreed to let me pierce her ears if we can find out how it is done. Too our daughter, just turning thirteen and just commencing cigarettes and high heels would like to wear her grandmother's diamond ear screws but cannot until she can find some way to pierce her ear lobes.

Well this is getting lengthy and I should not take up any more of your time. Would like to see more letters from "High French Heels" Raymond Ford and others who seem to thrill at the same things we do. Would also like to see this letter in your next issue. Awaiting your reply with much interest. Will write you about the ear piercing if you will tell us how it is done, and you care to hear.

"Pierced Ears"

A MASK FOR MASTERY
Dear Sir,

I have had a face mask made in leather for my boy-friend. It is skin

tight, black leather, and laces down the back of the head. Once the laces are drawn in with my able fingers, he is completely in my power. There is a very small hole cut out for his mouth, and two slits for the eyes, but when it is laced down properly he is unable to speak, and can only make animal noises. I blindfold his eyes with a strip of rubber six inches wide, and a yard long, so that he has to rely on me completely. I then go to work on him.

I corset his waist down with a pair of my training corsets, and then a tight belt to complete, and to add to his discomfort, also shoulder braces which are buckled in as tightly as possible.

I then put him into a long rubber mackintosh, belt and button it completely, and over that a white mackintosh cape. I pull his wrists through the slits of the cape, and then handcuff them, with six inches of chain, so that he can use his hands.

When I do not want to hear him talk, I put a bit in his mouth, and lock it behind his head. When I want him to wait on me, I unbandage his eyes. I thus have him completely under my heel, and he does exactly as he is told.

If readers are interested in this little account I will send more details of my training programme for him. I am thinking of using 5 inch heels on him, and lace up boots, but at the moment I have to find someone to make them.

If he wishes to marry me, then he must be trained as my slave to wait on me, and serve my purpose. He knows this, and that there will be no let up on my part.

I would mention that I keep him on a collar and lead at times to remind him of his lowly position— a position all men should be made to adopt. For readers benefit I am a very keen mackintosh, boot and corset fan.

Sincerely, Norah Clark,
Slave Mistress

DON'T SPARE THE ROD

Dear Sir,

Your magazine is very unusual to say the least and it is really a pleasure to get away from the usual cut and dried type of publication. The only bad feature of your magazine is the long wait between issues.

I particularly enjoyed the Correspondence section of your magazine. It makes good reading to see what other people think and get opinions from all over the country.

I was especially surprised to read the articles on what I really believed was a "Lost Art." That is that sort of punishment often referred to as "an old fashioned spanking."

In these modern days of ours where we hear so much about "Ju-

venile delinquency," it would be the best thing in the world if this form of correction were used more often. It wouldn't matter, in my estimation, who deserved it or their age, a sound spanking properly applied makes a more lasting impression than any other possible form of guidance

Thanking you for many pleasant hours of reading to date, I am,

Respectfully yours, J. G.

WELCOME! OH ZENANA!

Dear Mr. Willie,

I enclose a little drawing as an idea for the "Beaux Arts Ball." What fun the girl could have flapping helplessly about in her sleeveless clown costume—just tantaliz-

ZENANA

ingly not able to do anything much with her arms enclosed in her costume and deliciously attractive because of it! Perhaps she could wear a painted "clown" mask as well, with blind eyes—and she'd be even more beautifully helpless. The costume would not be difficult to make and could be constructed of strong gleaming satin.

I also enclose a photo of a "Purdah" or veiled lady, which you may find intriguing. It is, as it were, trousers and cloak in one, and when drawn up over the body of the lady, *completely* encloses her, as in a bag with no outlet for her arms.

Yours, Zenana

NEW SHOES FROM READERS

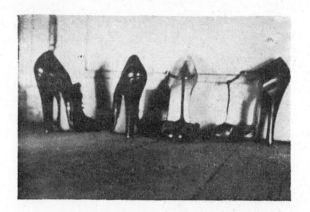

The photos on these two pages are from different readers, none of whom unfortunately sent in any further details than the height of the heel and the platform.

We are quite sure that it is of greater interest to readers when other extensive details are given, or when photos are accompanied by a letter on the subject in general.

shoes by Victor
8 inch heel, 2½ inch platform

Dark blue — heel-less

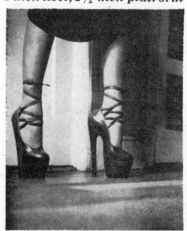

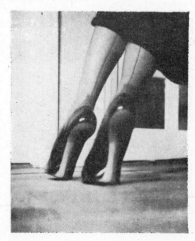

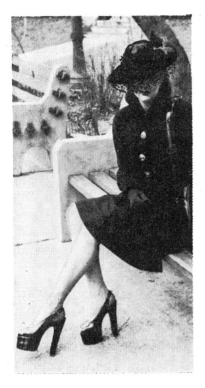

There is a considerable difference of opinion in regard to platform soles, and we hope that readers will write, stating their views for and against. It will make an interesting discussion.

That is about all we can say on the matter, except that we hope the readers who sent us these delightful snapshots will send us more. And please, this time, together with a short letter.

Editor

7 inch heel, 2 inch platforms

One rather novel feature is the pair of shoes with no heels at all. The whole weight of the body is taken on the shank which is extremely strong, and which, owing to the very high pitch, acts in a similar manner to an actual heel.

The platform soles, particularly on the lace-up pair of shoes, show to what an unlimited height it is possible to take the heel. The thicker the platform sole the higher the heel, but so also, some readers claim, the clumsier becomes the shoe.

He Admires a Small Waist

Dear Editor:

It is amazing how widespread is the belief that a tightly laced old-style wasp-waist corset is painful to the wearer and detrimental to health. Yet, is this belief justified? I believe an ounce of experience weighs more than a pound of surmise based on prejudice. The proof of the pudding is in the eating thereof.

When about thirteen, I came under the tutelage of an aunt, a confirmed tightlacer, whose two daughters were brought up the same way and who at sixteen and eighteen had delightfully slender waists as the result of rigorous tightlacing. To cure my propensity to stooping and to improve my posture, my aunt put me into a stiffly boned, small-waisted corset, which she laced tightly, making me wear it beneath my boy's clothes. My protests were unavailing, for Aunt Jane remained adamant.

As soon as I was unobserved, I unlaced my corset and took it off —not because it hurt me, but because I felt stiff and awkward under the unaccustomed constriction, and also because I did not like the idea of wearing a corset at all. Little good it did me though. As soon as my aunt discovered what I had done, she punished me severely for my disobedience and then laced me up as tightly as ever.

Insubordination was something my aunt did not tolerate.

To escape Aunt Jane's strict discipline, I did then a very foolish thing—I attempted to run away that night, was caught in the act and put to bed by my aunt who made sure that I could not repeat my attempt to escape during the remainder of the night.

The next morning she took a step which was as ingenious as it was effectual to prevent me from ever again trying to escape her control: She took away all my clothes and locked them up. Then she informed me that henceforth I should be dressed like a girl. My protests, more emphatic than tactful, earned me a sound whipping and soon convinced me that it did not pay to rebel against my aunt's orders. Since my size was the same as my younger cousin's, I was speedily laced up in my corset, my feet were squeezed into a pair of tight-fitting pumps with tapering high heels, and I soon found myself dressed up like a girl. Of course, even when laced, my waist was too large to get into my cousin's form-fitting dresses; therefore, I was made to wear only loose dresses over my tight corset, until my waist had been sufficiently attenuated.

Henceforth, after my morning ablutions, I had to don my high-heeled slippers, tighten my corset

54

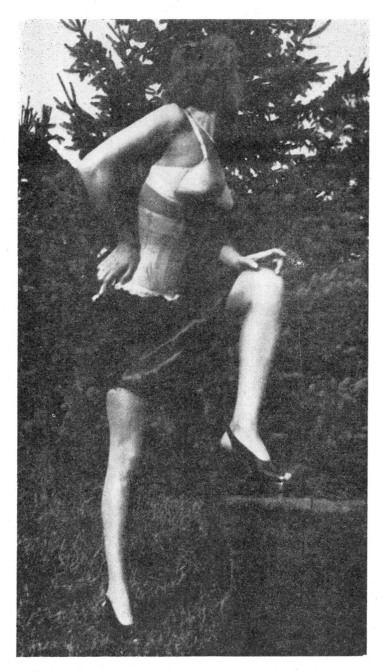

Mrs. Satin surveys the scenery

lacers until my waist was the size ordered by my aunt 'I had to reduce it a quarter of an inch each week) dress, and then present myself for inspection before my aunt, who was exacting in the matter of dress. No relaxation of the lacers was permitted during waking hours, nor was I ever permitted to doff my slippers before bed time.

The high heels bothered me at first. The muscles of my feet and the calves of my legs ached, so that I was barely able to walk; but neither tears nor pleas for permission to take off my slippers even for a few minutes were of avail. *"You are no worse off than any girl who wears high heels for the first time; you will soon get used to them,"* was Aunt Jane's verdict—and I had to suffer until time proved her to be right.

Of course, I felt oppressed and uncomfortable in my stiff, tight corset, as it was laced tighter and tighter, week after week. I could no longer run, jump, and romp about in the accustomed manner, but was obliged to walk about with dignity and decorum. At no time, however, did I suffer pain—discomfort, yes. I must admit, however, that the irksomeness of the constraint was also accompanied by a rather pleasant feeling of comfortable support in the unrelenting grip of my tight corset. Soon I learned to breathe with the

upper chest and after a few months, my waist had been reduced to the same size as that of my cousins, about sixteen or seventeen inches, and no further attenuation of it was considered necessary.

After I had worn my corset thus tightly, the feeling of discomfort and irksomeness gradually disappeared and I began to enjoy the sensation of being held in the firm grip of a very tightly laced corset.

Thus, for nearly three years, as the pupil and ward of my aunt, I was as severely corsetted as any girl; yet, I suffered no pain, my health was excellent and I did not have a day's illness during all that time. At sixteen, I left my aunt's and resumed male dress; however, I have never lost my admiration for a tiny corset and I sincerely regret that the delightful practice of tightlacing has gone out of fashion; especially, since I know from personal experience that the usual objections to it are unfounded. If women today would only realize what a remarkable improvement in one's figure an old-style hour-glass corset can bring about, even if it is only moderately drawn together. Not only that it "does things" to a woman's figure, but it also provides a comfortable uplift support which no modern corset or girdle can give.

Sincerely yours, H. H.

COME YE AMAZONS!

Dear Sir:

"Carpet Knight" expresses my sentiments exactly. I have always found the refined, domineering type of woman a fascinating creature. She has intelligence; bold beauty and eyes that literally devour one, and her voice holds a strange, bewitching note that speaks volumes without expressing much in words. Truly she is an entrancing, alluring creature of great physical and mental powers as different from ordinary women and girls as day is from night.

Yes, it would be delightful to be the well-trained slave of such a lovely, exotic creature, and the greater the degree of one's slavery the happier he would be, provided the lady candidly told him of her purpose like "Ursula" did, and made him swear on his knees to obey her in all things.

Of course the lady has the right to enforce obedience just as "Ursula" did, and what better way than to compel him to wear a tight-fitting corset; high heels and hobble skirt; hobbled at ankle and knees and encasing the body like a sheath. This would be just about perfect as a form of chastisement from the lady's point of view—the real lady, not the one wearing the figure-flattering outfit.

Ah, could it be that the charming Carolyn, or the delightful Ursula have used this delightful method of keeping would-be erring husbands under their watchful eyes; rigidly and firmly corseted to keep them out of mischief, and a positive guarantee of future behaviour? I wonder if they have, and considering the problems these ladies have to cope with, one could hardly blame them if they resorted to such drastic means of discipline. What woman hasn't sighed for some such method when hubby insisted on coming home from the office at midnight with long yellow hairs on his coat lapel and powder on the front of his jacket? Yes, indeed, and who could blame her if she were to use some of the restraining devices I mentioned?

Yes, Carolyn has the right idea. Imagine the consternation of men if women ever decided that man after all was a rather inferior breed, and that women should be the real masters and men the slaves. Just visualize men being compelled to live a restricted harem-like life, with powerful female eunuchs to see that they stayed put, and men as slaves and concubines to beauteous, husky amazon women and girls who wore the pants (slacks to you, my dears) while men were forced to wear hampering, tight-fitting long skirts, heavily boned, severely tight stays; ultra-high heels, and last but not least heavy masks and veils

to conceal their beauty from the stares of the vulgar common female herd. Delightful picture is it not? I'll just bet some of you ladies have dreamed of an idyllic life of this sort. Now, be good sports and admit that you have had some such delicious dream.

Yours,

Enchanted Slave

Dear Sir,

I especially enjoyed the articles by C. H. McC. and Carolyn in No. 6. I agree with both.

As for Carolyn I would like nothing better than to be made to wear narrow skirts, skyscraper heels and tight corsets.

I've enjoyed all of feminine dress from the very lacy panties, slips, petticoats, fancy hose, high heel shoes, cosmetics and sweet perfume. I wear these as frequently as I can and there certainly is no more wonderful feeling and I doubt if many girls enjoy wearing fancy clothes as I do.

Yours,

A. M.

IN FAVOUR OF CORSETS

Dear Sir,

The numerous plates depicting high-heeled boots and shoes are positive gems and a vision of beauty to devotees of the ultra high heel. I am sure readers will appreciate the kindness of those who forwarded the photographs to you in order that we other readers might share their pleasure.

It is interesting to note that the correspondence section features letters from well beyond your own borders. I was particularly interested in the observations of "Corset Lover from New Zealand." I am able, from personal experience to confirm her remarks on old fashioned stays. Although my corsets are not original models they have been created by a corset maker of the old school. Having worn corsets for some years I can positively state that the comfortable support and feeling of well being they impart is almost beyond verbal description.

I do not wear stays from a sense of personal vanity, as they are absolutely unnoticed when I am dressed. One model is in exquisite brown satin, heavily boned, with inflexible busks and a front lacing skirt. The perfect hour-glass waist of twenty inches it creates when fully laced is delightful. I only wear this corset when at home for the evening, and always I am perched up on black kid court shoes with six inch heels, or black kid knee high boots with a similar heel height.

In addition I have several other corsets—one in sheer black satin which covers my shoulder blades at the back and fits high in the chest, and reaches well over my thighs. This particular corset when

fully laced creates a "V" shaped figure, the base of the "V" being my twenty inch waist of course.

The others are, one in pink satin covered with embroidered gold dots, twenty inch waist, white satin, severely boned, with very stiff busks, eighteen inch waist, and a perfect gem in black and red satin, with a seventeen inch waist, and a stem waist of one and a half inches. Corset lovers will, I am sure, be conversant with the stem waisted corset, this delightful elongation being most sought after some years ago by ambitious tightly laced young ladies.

I was pleased to note that another male corset and high heel enthusiast had contributed an interesting letter in a recent issue—surely others exist? If so, it would be of genuine, general interest to other readers to hear from them.

My initiation to corsets was not of course with the models I now wear—far from it. My progress has been slow but sure, and I would not dream of putting a foot out of doors unless I was firmly corsetted.

My initial efforts with high heels were rather laughable but with time and patience I have succeeded, and am able to walk with ease on a six inch stilt. I frequently wonder if women realise how fortunate they are in being able to wear high heels out of doors.

The leather collar illustrated in the current issue is in more general use today than some may realise— a young lady of my acquaintance is made to wear one every evening, it is in black satin, very high, and quilted with whalebone and fastens at the back with tiny buckles. For additional discipline a kid face mask with a gag for the mouth, and a detachable eyeband can be fitted.

Judging from the results this contrivance is most efficacious. The young lady concerned is constantly high-heeled, tightly laced and subjected to firm discipline.

Since becoming a regular reader of *Bizarre* I have not observed any lengthy mention of sleeping corsets in correspondents letters. Many readers do, I am sure, avail themselves of the staylace when retiring for the night. A softly boned night corset is most comfortable. Having become accustomed to the firm support of my day corsets I used to feel most uncomfortable when I unlaced at night, and quickly decided to do something about it.

How many other readers are laced up day and night- Letters on this point would, I am sure, be of all round interest.

Best wishes to you all.

Sincerely,

M. S.

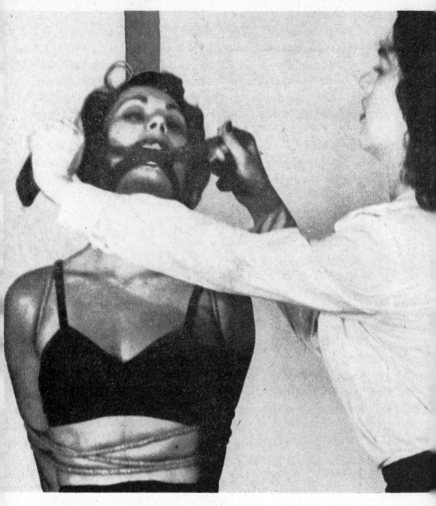

DON'T LET THIS HAPPEN TO YOU

learn jiu jitsu

and the art of self defense

To the Editor:

Of the various intriguing items included in your issue No. 6, the letter signed "Blind Girl Fluff" interested me most. Although I am of the opposite (some say contrary) sex, her ritual experiences in the realm of darkness gave me a keen fellow feeling for her. May I explain briefly?

It has always been my contention that the sensation of being blindfolded, especially by or in the presence of members of the opposite sex, may be said to be both negative and positive — paradoxically enough. It is negative in that it is a denial or restraint of a normal function; but it is positive also, since it serves to sharpen and concentrate one's remaining untrammelled senses in desired or specified channels. Several girls of my acquaintance, and latterly my wife, who is especially talented along such lines, have been fully aware of this and have not hesitated to conduct themselves (and me!) accordingly.

Madame, for example, maintains a blindfolded lover is a lover who devotes himself exclusively and far more ardently to the "business" of effecting a maximum of sensual pleasure—if not for himself, then for his partner, which she considers more important. She also feels, and I have reason to know it well, there is much to be said for enforced silence—that is, complete elimination of both speech and hearing—under certain conditions favoring these forms of restraint. She is a past-mistress in the ceremonial usages of ropes, straps, chains, padlocks, and (I shiver when I say it!) special costumes she considers appropriate on occasions when partial or complete restraint is employed. The amorous ritual is right down her alley.

Formal uxorial discipline, as such, also comes well within her province, she has always felt. Ask the corrected! One of her favorite, or at least most frequently used, methods involves solitary confinement for a thoroughly discomfiting interval, say in a pitch-dark locked clothes closet, in complete physical helplessness and enforced silence, while she busies herself about the apartment or even leaves the premises for a leisurely shopping tour. How many of your readers would be astonished to know that exquisitely effectual punishments she has dreamed up and administered have included requiring her erring mate to appear to acutely embarrassing disadvantage in the amused presence of other persons, one or more of her girl friends? Once, wearing a black lacey chemise of hers, the bodice of which was plainly visible through my open shirt front, and a dog collar and leash, with my

photo from a reader

wrists handcuffed behind my back, I was led into our living room and (with Madame brandishing her vicious little riding whip) there directed to get down on my knees in front of another girl and apologize for being rude to her at a party the night before.

See what I mean? It would be less than truthful not to acknowledge that on many occasions when Madame does her inspired "stuff" the pleasure is not only mutual, but equal—at least as far as I am able to testify, and I cannot be more than 50 per cent wrong. Luxurious gratification is not so difficult to detect even in a surpassingly clever woman.

So I know exactly how "Blind Girl Fluff" feels when her delightfully cooperative husband takes her in hand. Such willing bondage one want to hear more?

ESNE

EARRINGS FOR CONTROL

Dear Editor:

The adornment value of jewelry, especially earrings, should not be neglected.

I agree with Raymond V. Ford and "Sparkle" that earrings which clearly pierce the flesh of the ear lobe are much more fascinating than the screw-on variety. The news item in issue No. 5 describing the charming fad of chaining pierced ear lobes together suggests that the reins of the pony girls in "Tale From a Bottle" might well be attached in this fashion. After all, a bridle bit in the mouth of a pony girl must quite obscure the beauty of her lips and teeth; but a tug on reins attached to heavy slave earrings piercing the ears should be an equally effective form of control.

Yours,

J. A. B.

Notice to Correspondents

If an answer is required, please enclose stamped and addressed envelope for your reply.

Printed and Published by The Bizarre Publishing Co., P.O. Box 511, Montreal, Canada. Copyright 1952. All rights to these titles reserved.

THE SUBTLE SCHEME DEVELOPS AND SALLY IS COMPLETELY DECEIVED BY IT

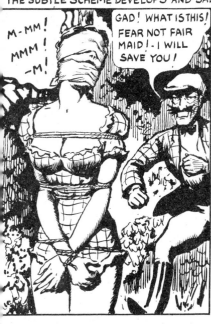

M-MM!
MMM!
-M!

GAD! WHAT IS THIS! FEAR NOT FAIR MAID!-I WILL SAVE YOU!

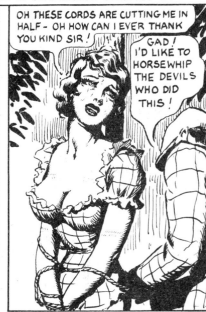

OH THESE CORDS ARE CUTTING ME IN HALF - OH HOW CAN I EVER THANK YOU KIND SIR!

GAD! I'D LIKE TO HORSEWHIP THE DEVILS WHO DID THIS!

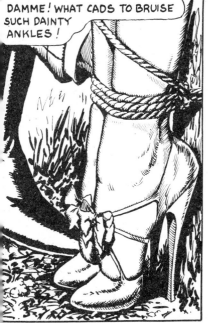

DAMME! WHAT CADS TO BRUISE SUCH DAINTY ANKLES!

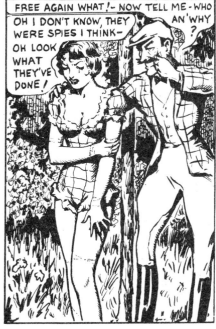

FREE AGAIN WHAT!- NOW TELL ME - WHO AN' WHY?

OH I DON'T KNOW, THEY WERE SPIES I THINK- OH LOOK WHAT THEY'VE DONE!

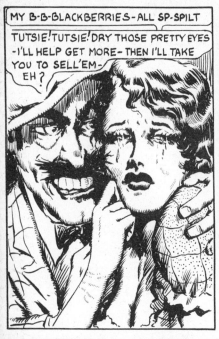

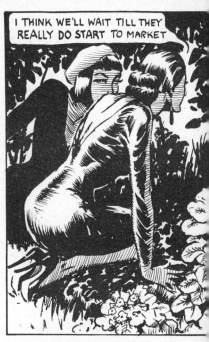

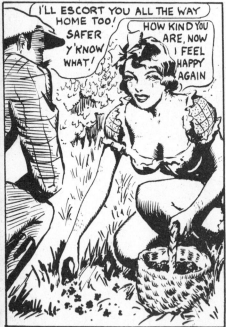

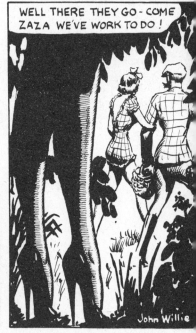

John Willie

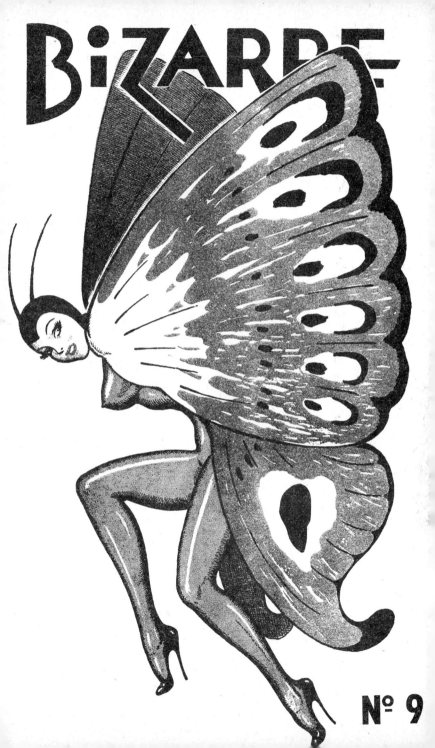

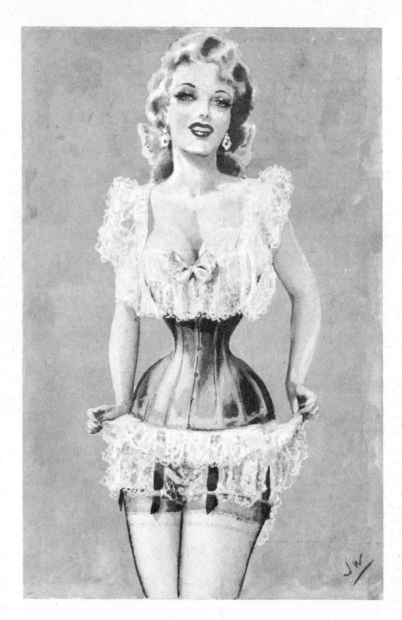

"Susan"

BIZARRE

"a fashion fantasia"

No. 9

Ah, fill the Cup; what boots it to repeat
How Time is slipping underneath our feet;
Unborn To-morrow and dead Yesterday,
Why fret about them if To-day be sweet!

Contents

NEXT ISSUE No. 10

No. 10 is our Home Sweet Home number consisting of suggestions for dress and gadgets and ideas for a happy home life. It will also have the "Tale from Bottle No. 5" which is omitted from this issue.

BACK NUMBERS

Back numbers available at $1 each are: No. 3, 6, 7, 8. All other issues are 100 percent sold out.

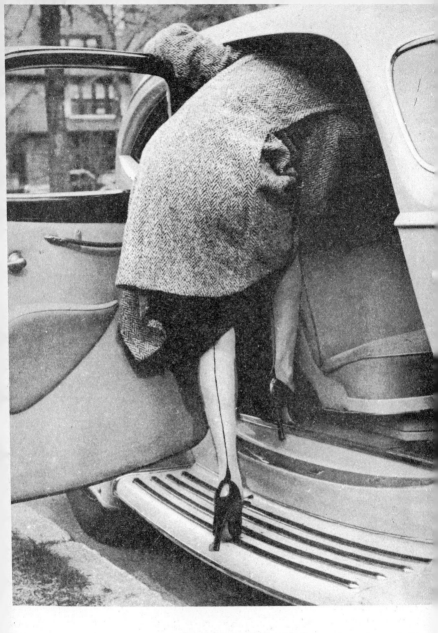

wonder what's inside?

Creaking more noisily at every joint we present here for your enjoyment No. 9. We hope you like it.

The creaking is caused by added impetus, which in turn is caused by more hands pushing the old Bizarre buggy over the bumpy road of life. To quiet the squeaks and further accelerate progress all that is needed is a little more oil for the works, then publication will be as regular as any good clock.

And now an apology. The "Tale From Bottle No. 5" is missing from this issue, as well as "Sir d'Arcy and the Wasp Women" because we simply had to cut down the pile of letters from readers, and articles from readers, and photos and so on.

In any case there is too long a wait between episodes of the cartoon so we're working on some new and more suitable means of putting it out. The Magic Island story will be in issue No. 10 without fail.

And in regard to No. 10—This issue will be devoted to various devices, costumes, etc., designed for the purpose of insuring "peace, perfect peace" in the home. If, therefore, any of you have any ideas on the subject by writing at once we may be able to include your suggestions in the next issue.

We have a whole stack of suggestions as it is, and this means a lot of work for J.W., so photos will be fewer and J.W.'s sketches more plentiful in No. 10.

It always seems to us that if a wife (or a husband) can't move too freely—if at all—and cannot yattertayatteryat, that married life would be much more restful, and permanent—in fact quite a pleasant existence.

Incidentally, we expect to publish regularly at least bi-monthly from now on and for those readers who have no local dealer we will be reopening an annual subscription with the New Year.

And in closing may we ask you once more, please—if you want an answer to a letter, write your full name and address. No matter how long you have been corresponding with us, please do it. Sign it Hank or Jim or T. E. or Bessie if you like, but give us a clue as to what your full name is by writing that down, too.

THE EDITOR

5

FASHIONS MAKE ME SICK !

By Tempe Newell

I shall never cease to be surprised at the gullibility of women when it comes to questions of style. We are in such awe of great names that though a few loud protests are heard at each sudden, drastic change, these are silenced almost immediately. The majority, by raised eyebrow, infer that dissention is due to poor taste if not plain ignorance.

It is nearly impossible accurately to point the accusing finger at the parties responsible for these overnight changes. If you ask an expert, you receive a lecture with a great deal of double-talk and gobbledegook that conveys the impression—if it conveys anything at all—that everything stems from some intangible force—intangible because it is the direct result of our being the kind of people we are.

Actually, I have an uncomfortable suspicion that "chic" is in fact the result of a well-organized conspiracy by designers of fabrics, manufacturers, and advertisers. It all works too smoothly to be a simple matter of chance.

It is illogical to regard fashions as true expressions of our state of mind, since other indications of changing times, such as trends in art, literature and politics develop gradually. Only women's fashions are subject to an overnight turnabout.

Fashion has become a religion to American women; the Designer is "The Great Panjandrum Himself," the Cutter the Medicineman, the Seamstress the High Priest for whom we, the Vestal Virgins, keep the lamps burning. We dare not disobey!

Or is it perhaps that our faith is due to a simple childishness, for we are so easily convinced that all this new hocus-pocus will indeed make us the beautiful and desirable creatures we secretly feel we ought to be or, better still, can be!

With a complete disregard for consistency we decide that yesterday's "rituals" in dress were just a phase, and try to laugh with all the other sheep at each new, embarrassing, and awkward change.

It seems to me that if we women would concern ourselves more with

6

being real people instead of spending such a shocking amount of time and money on our exteriors, we should achieve this much sought-after "desirability" more surely, more simply and permanently.

Few of the women famous in history for their charm have been pretty. Some have been positively ugly. Yet, something about them has drawn men and women to them like a magnet; has made them sought after, courted, desired.

The truth is, of course, that "she" was woman eternal. "She" had those qualities which few in our mercenary times even think of trying to develop. Good manners and a real interest in others with a sympathetic understanding are not cultivated today. We have no time. It is much easier to buy the latest from Max Factor, from Fath, from Palter de Liso and then, like peacocks, preen our feathers and strut. A pretty bottle with nothing in it.

Yet even today at a party, a luncheon, or a reception, one woman will gradually become the center of attraction. We meet her, we talk with her, and we leave convinced that she was the most beautiful woman we have ever seen.

What was she wearing? Who knows?

To which we reply:

Dear Tempe:

We—Bizarre—could not agree with you more heartily. From the male point of view it is all too dreary these days. You see some staggering vision that at first glance knocks you dizzy—but you have only to look at her face a second time for five seconds— sometimes it takes ten—and you wonder what on earth made you think she was lovely—and you simply dread what's going to happen when she opens her mouth. Photogenic as all get out perhaps, but personality non-existent.

However we do offer one criticism. We seem to remember often hearing the remark: "Tell me, who is that perfectly delightful creature in the so-and-so?" So, though we will agree that a charming woman is just as charming in a pair of old slacks, her hair all over the place and a smut on her nose, we nevertheless think that she should at least make life for us even more enjoyable by pandering to our whims a bit in the matter of dress. (*Cont'd on last page*)

PLAITITUDES by H. C.

Knowing of *Bizarre's* interest in cultivating the fashion of wearing long hair in the women of today, here is a report on my interview with Miss Hanka Kelter a few years ago when she was receiving star billing as the "Woman With the Longest Hair in the World," while appearing in a side show attraction of Ringling Bros. and Barnum & Bailey Circus.

One of the leading female exponents of the forgotten and long-ignored fashion of wearing beautiful long tresses, Miss Kelter has without a doubt an authentic claim to her title. Her gorgeous locks are a rich shade of dark brown, exceptionally thick and blessed with a slight wave, and when worn loose tumble all the way down to her dainty toes, and touch the floor—a magnificent shower of tresses more than 60 inches in length.

While waiting for her act to go on, she usually wore her "crowning glory" wrapped up in a tremendous snood which looked extremely bulky and heavy with the weight of the hair. When the barker's fog-horned voice dragged the curious crowds along to Miss Kelter's small stage, she quickly unfastened the snood pins and allowed her lovely locks to spray down to her shoes. With a fling

of her head she flipped this beautiful mass of hair back and forth for all to see and admire its unusual length and sparkling beauty. Miss Kelter then combed and brushed her treasure of hair for a few seconds giving the spectators a chance to see this gorgeous array from all angles.

The men in her audience all seemed particularly interested in this display and the admiration on their faces showed them to be true lovers of long hair. The female section of the audience gaped in wonder at so much hair, picturing to themselves the difficult job of washing and drying involved, and then turned away to the next attraction, secretly envious of Miss Kelter's beautiful tresses but also thankful they did not have the trouble of caring for them. The men withdrew from this dazzling display of the longest hair in the world only to glance momentarily at the ugly, short, frizzled ratnests on the heads of their wives, shrug with disgust and despair, and pass on.

After the show I interviewed Miss Kelter for my paper, and she disclosed to me how her hair had always been very long until 1935 when, in her native Poland, she cut and sold it. She then allowed

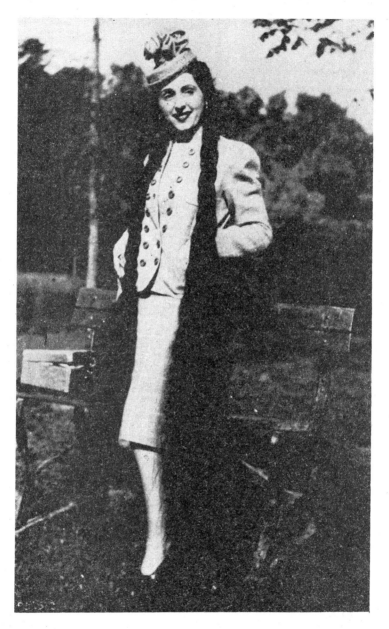

Miss Kelter

her hair to grow again and the luxurious locks lengthened rapidly under loving care, giving her after a period of ten years, the most beautiful crown of hair in the world.

Miss Kelter employed two maids who spent most of their time combing, brushing and arranging this mass of hair. Washing it is a tremendous task, she said, and for drying she sat under a long clothesline in her apartment, and read while dozens of separate strands of her hair were spread out to dry n a huge fan-like arrangement, the ends pinned to the line with clothespins.

Miss Kelter agreed with my theory that long hair is one of woman's most prized possessions and should be cultivated by any wife who is really interested in making her husband happy. According to Miss Kelter, the man should share in the care of his wife's hair if he wishes her to wear it long. He can at least help with the brushing and combing, and very definitely should aid his loved one with the washing and drying, plus the job of untangling.

As I parted reluctantly from Miss Kelter, secretly wishing I could by some strange stroke of fortune be allowed to brush and comb those magnificent tresses, she presented me with several pictures of herself. Here they are.

The Mask of Birchdale

by N. Y. C.

There was a leather helmet arrangement that far antedated the so-called Discipline Helmet mentioned in the last issue. It was designed and used in London in 1669 or 1670.

In England at this time, it was quite usual for a lady of fashion to wear a vizard mask when going abroad, and especially at the theatre. The vizard was made, usually, of black velvet on a cardboard or thin wood frame. It was formed to cover the whole face, save for fairly generous eye-holes and was held in place, almost invariably, by a wooden button fastened to the inside and held between the wearer's teeth. This seems an odd way to do it, since having to hold a wooden button in the jaws made it impossible to speak—or at any rate to be understood. But there was a reason back of this.

The Theatre, which had been abolished during the Commonwealth, was still a pretty daring place for a Lady to be. While it was a very delightful place to go, it was advisable not to be recognisable. So, since a woman can be recognised by her voice as well as

her face, the button between the teeth was an ever present reminder to the lady to keep quiet as well as covered.

At the time I mentioned, there was an elderly merchant—we'll call him Mr. Samuel Steel. He had a lovely eighteen year old daughter named Joanna. As he had social aspirations, he allowed her to go to the theatre regularly, accompanied by her personal maid. Needless to say, they both wore the fashionable vizards.

Mr. Steel, whose fortunes had suffered greatly in the Great Fire of London, saw a chance to recoup by marrying his daughter to the elderly Sir Timothy Kirk. (You understand I am changing all the names, since the family of the principals is still very much in existence, and I got the facts of this story from one of them.) Sir Timothy was rich, but he was also quite elderly, very gouty and extremely ugly. Needless to say, Joanna wanted no part of him; she was much more interested in Lord Birchdale, who was young, healthy, handsome and only moderately well off. Joanna met him

12

at the theatre, while she was supposed to be out shopping or bettering her father's social position.

Of course, her father found out about this secret romance and hit the ceiling in a fine seventeenth century fury. First he threatened to send the girl into the country and keep her there, a virtual prisoner. But as he was highly vindictive and more than a little sadistic, he thought up what he deemed a fine punishment—one ideally suited to a disobedient girl.

He had a leather helmet made which covered her entire head, and laced tightly down the back. In front, above the narrow eyeholes, he added "eyebrows" in black stitching, and in front of the mouth a pair of faintly smiling lips in red kid. Thus, no matter what the wretched wearer's feelings might be, she presented a bland white face and an enigmatic smile to the world. To conceal the lacing of the helmet, he provided a close-fitting bonnet of leather and velvet which came down and closed around the neck with a lacing in front.

While this device was being made, Samuel kept his daughter a close prisoner, and discharged her maid—who, of course, had been a party to the clandestine romance. In her place he had engaged an elderly hatchet-faced duenna named Emma as a combination maid and spy. Emma knew her job depended on reporting everything Joanna did.

When the helmet and bonnet arrived, old Samuel was in a transport of joy. A little while before theatre-time, he sent for his daughter and, with Emma holding her, he forced a tightly folded kerchief into her mouth and laced the helmet as tightly as he could. Doubly gagged as she was, Joanna was unable to make a sound.

Samuel next adjusted the bonnet, fastened the lacing in front and sealed it with a spot of sealing wax. Now to get her bonnet and helmet off, Joanna would have to break the seal, and so she was as much a prisoner in her leather helmet as was the Man in the Iron Mask.

Instructing Emma to put on the girl's cape, Samuel sent them to the theatre. He chuckled as he watched them leave in his coach, Joanna silent and unrecognisable behind her smiling mask, and Emma watching her like a hawk. Samuel reflected happily that undoubtedly the young man would be hanging around the theatre, that Joanna might even see him, but she would be unable to attract his attention, and he would never recognise her, and even if he did, what good would it do with that battle-axe of an Emma watching them?

Every day for some weeks, when-

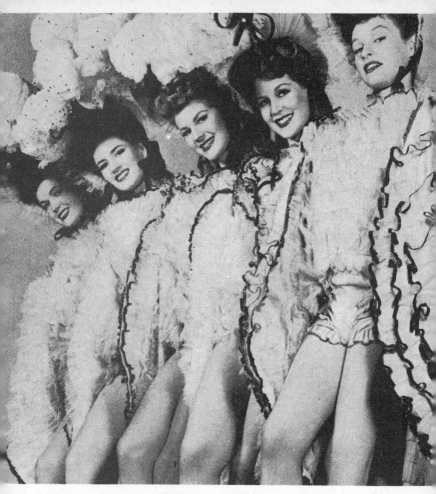

Isn't this a dazzling display?

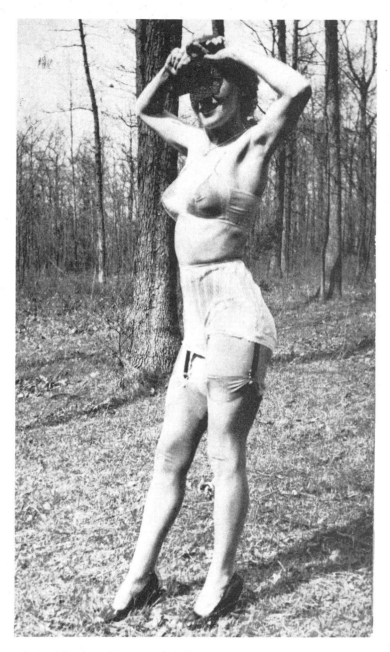

Quite! In fact it's a total eclipse

ever there was a theatrical performance, poor Joanna was gagged and masked, bonnetted and sealed and sent off, to sit in a conspicuous position, her identity concealed behind her bland leather face.

To make her punishment still sharper she was often sent shopping with Emma, but was obliged to stand, mute as a post, while the older woman did the talking. On occasion she even had to try on gloves or shoes and to make her feelings known by nods or shakes of the head.

Her mask caused a certain amount of interest, but nothing out of the way. People regarded it as a rather logical extension of the vizard idea, and two or three women even asked where they could get one made. In these cases it was especially galling for Joanna to have to remain silent as a statue while Emma discoursed on its advantages "especially, if I may say so, m'Lady, as a curb for young tongues as wag too freely."

But Joanna was not without hope that Lord Birchdale would rescue her. Needless to say, he did. He had had his men watching Samuel's house day and night, and when the unhappy Joanna first issued forth, masked and supposedly unrecognisable, Birchdale was informed and took up an inconspicuous position in the theatre within ten minutes of Joanna's arrival.

It took time to make his preparations, as he proposed nothing less than an elopement—or a kidnapping, depending on how you look at it.

Then, one afternoon, one of the theatre attendants, whose palm had been well oiled, quietly told Emma that Mr. Steel, her employer, was outside in his coach and must see her at once. Not stopping to think that she was leaving her charge unprotected, Emma hurried out and was directed to look for the coach at the corner of the next block. Full of concern, she hurried off. A moment or so later a serving man in a quiet livery leaned over and told Joanna that her woman had been taken ill and was asking that she come at once. She followed the serving man as he led her out.

Once outside the auditorium, he led her directly away from the route taken by Emma, and round into a deserted ante-room and closed the door for a few moments. When he opened it and led Joanna out, her cloak was carefully pinned together in front, concealing the fact that her wrists were bound together in front of her slim waist, and her arms were further prevented from moving by a rope around her elbows and behind her back. Whether she made any attempt to cry out is not known, since she was completely dumb in any case; however, she made no

attempt to struggle against her bonds, and gossip even had it that she held out her wrists for the cord when she was being bound.

She was most docile as she followed her captor to a waiting coach in a quiet alley. He lifted her in, bound her legs at ankles and knees, slammed the door, jumped up on the box and drove off.

Safely outside London, the serving man stopped the coach, picked up a driver, and climbed into the coach with his victim. Here, as the vehicle rattled along, he removed his disguise and showed himself to be, as you have already guessed, Lord Birchdale.

Though he unbound Joanna's legs at once, and her arms when their journey was nearly over, he kept her in her bonnet and helmet until they had crossed the threshold of the Birchdale country home.

They were married the following morning and as soon as the ceremony was over, Joanna found herself silent, masked and bonneted again, sitting at the side of her lord and master at the wedding breakfast, but unable to eat or speak. Birchdale explained his action to his guests by explaining that he had a theory that silence and obedience went hand in hand.

Once the wedding was over, there was nothing that Samuel Steel could do—especially as Birchdale had entry to the Merry Monarch, Charles II who, tradition says, was entertained many times at Birchdale House, each time insisting that Joanna wear her helmet and bonnet.

There is still a tradition in the Birchdale family that until the first child is born, a fancy dress ball should be given each year on the anniversary of Joanna's abduction, and that the current Lady Birchdale shall appear in a copy of Joanna's famous outfit, and that she shall preside at the revels, masked, silent and, be it said, obedient.

17

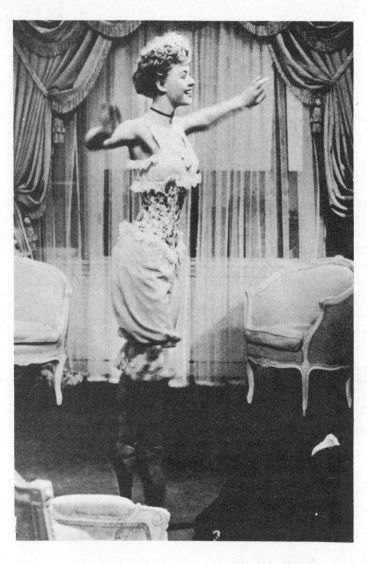

YOO-HOO!

it's my piggyback next

18

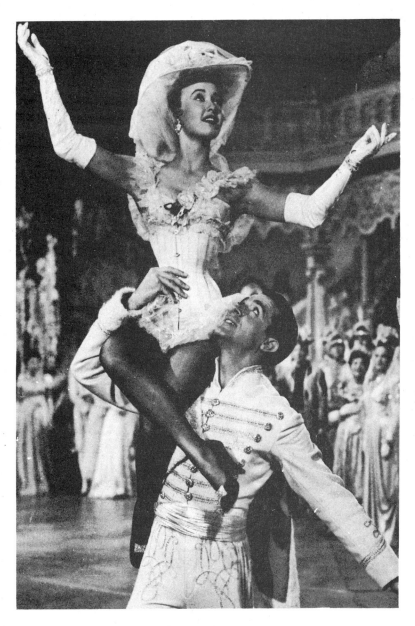

I saw him first!

19

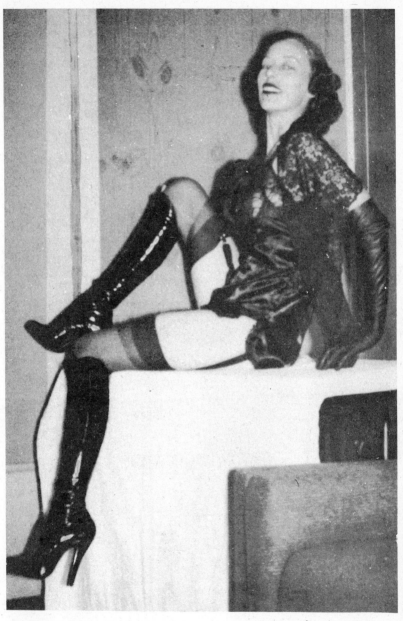

A reader's idea for a party costume

20

FANCY DRESS
for special evenings

Now that the festive season is approaching greater interest centres on "fancy dress."

Zenana presents a happy idea—"The Slug"—in which the lady will obviously require much attention, and thereby attract attention, to her great delight.

However, overleaf we have offered some ideas which, though suitable for masquerade, are originally designed for Drum Majorettes.

The wearer of the all leather affair, complete with thigh boots, would not be able to do much of the usual high kicking, turning cartwheels and generally behaving like a mosquito worm in a tank, but she could certainly achieve a most magnificent, dignified and imperious strut.

Actually to our way of thinking march music does not lend itself to prancing players and pirouetting drum majorettes. The Drum Major in is charge and should show it by "her" manner.

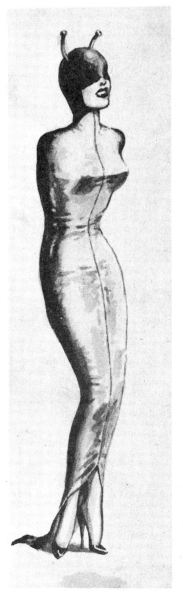

Zenana

The Slug

21

THE DRUM

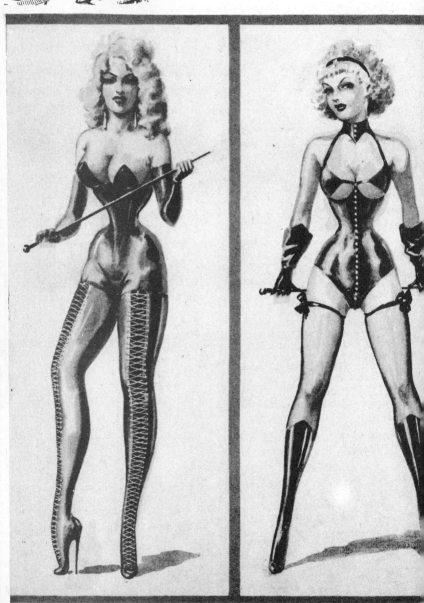

MAJORETTES

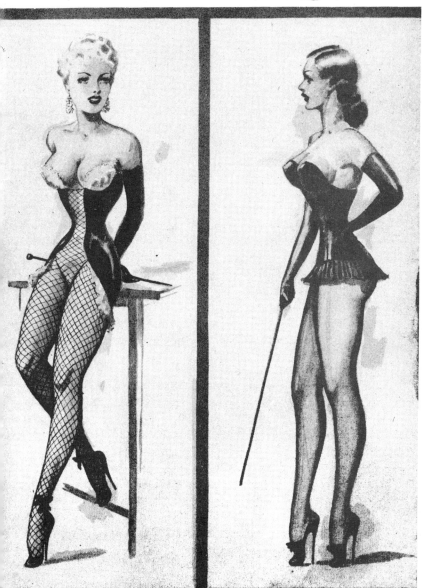

the Great Revolt

By "Enchanted Slave"

Now, dear reader, let us soar on the wings of fancy.

It is the year 42 F.E. and women everywhere are the proud masters of our great and complex present day civilizations which baffled the greatest male minds of The Atomic Age. Within a short space of a mere twenty years after the Great Revolt, civilization as we dominant males know it ceased to exist. It ceased to exist because women were just too busy chasing fugitive males; ferreting them out of their hiding places, and building harems in which to put them under lock and key. No one had the time to think of civilization.

When the last male under forty had been safely consigned to the delightful life of a harem slave except a few hardy and elusive Outlanders there just was no civilization to worry about. Women everywhere breathed a long sigh of relief; now they could live the wonderful, gay romantic life just as men had lived it in the Middle Ages. Men were no longer able to spoil a lady's harmless sport of breaking hearts, and just for the fun of it every once in a while a few slaves would be aided to escape, only to be brought back in chains after an exciting chase on horseback.

Yes, on horseback! You see, there just were no cars or airplanes anymore. Gas had been so badly abused in The Atomic Wars that it had finally given up the struggle of trying to keep pace with man's craze for speed—and more speed. And while the ladies were having their grand frolic known as the Great Revolt the end came suddenly—so suddenly that autos and planes everywhere gave up the ghost at about the same time. Did this daunt the intrepid Revolters? Not the slightest! Within a few months they were all mounted on horseback and busily engaged in the delightful, exciting sport of crushing the enemy who was foolish enough to resist their ultimatum—Lay Down Your Arms, Worms! Surrender And Be Slaves! After that few men had the will to resist. How could they? Man had so long been accustomed to insidious feminine trickery that the Great Revolt was

almost over before he was even aware that there was a revolt, and the few misguided souls who resisted were under the impression that they were fighting an invader from Venus or some such place, thanks to the exciting video programs of space invaders which had long been the rage.

Ah, yes, dear reader, the Great Revolt is over, and man is safely and comfortably housed in the harem where the ladies of the Great Revolt have seen fit to put him. The good old days are now a thing of the past. No longer will man drink beer, pay taxes and damn the politicians to everlasting Hell. There is no beer, there are no taxes, and the last politician died from the shock of it. His mummified body is now on display in the Museum of Ancient American History in Helenapolis.

Men now sigh for those good old days. Then at least they could indulge in some good old-fashioned swearing—now they can't even say damn. Their wives see to that. If there's any swearing to be done the ladies (?) insist on it as their just right. Swearing is for females only. Besides, men just might get ideas if they ever formed the habit of swearing—not that they could do anything about it. But, well, why give them even a chance?

The ladies (not the she-males of the harem) of the Feminine Era 42 are as fascinated by the wasp-waisted fashion trend as they were in 1885, two hundred years before the glorious era of feminine emancipation was proclaimed to a victorious female citizenry at Helenapolis.

Yes, but there is a horrible difference which would have shocked the ladies of 1885 into their graves: men now wear the flounced petticoats; the heavy silk or satin bloomers; the lovely under-vests; the rigid, heavy-boned wasp-corsets, and the long, hampering skirts; the exquisite glace kid shoes and boots with their tiny spike heels; and last of all the neck-choker, long sleeved, dainty blouse of the Eighties,

Every female looks cheerful. Women no longer glare suspiciously at each other when they meet; nor do they use the honeyed words of 1885. No, siree! This is not 1951: nor is it 1920, or most horrid of all—1885. Women are free—as free as the birds. Sure, they still marry, but merely to prove their worth as women and to have fun. Imagine a woman without at least three husbands! Why, the rich have at least eight, and at the very least—twenty concubines. Anyone can buy a husband. They're to be had at good prices on the local market, and there's always bargain day every Wednesday morning.

Ah, imagine some lady (the pants-clad type) saying, "Lola, here's a good slave. Just what you need for your collection."

Then the eyes of the unfortunate slave meets that of the stern, handsome woman in the lovely purp'e knickers, and he shivers. Yes, he truly does, although it is mid-Summer, but whether from fear or some other more pleasant sensation I leave it to our lady readers to decide.

"Yes, my girl, this one will do nicely," the balloon-hipped lady says to her slim, long-limbed friend, Myra. "Quite an interesting addition to my valuable collection of husbands, and all bought at bargain prices."

A gasp of amazement from the lady slave buyer start'es Myra. "Oh, Myra! look at that cowlike waist! Isn't it just dreadful?"

There is a pause as the lady thinks this over. At last she sighs: "Oh, well, he's doubtless one of these Outlanders from the vast forests around ancient N'york. Clumsy and ignorant and full of silly old-fashioned ideas, but I'll take him in hand."

"Yes, Myra, I do believe it'll be something to divert me. I'm bored stiff, and I gained ten more pounds—ten pounds, imagine that, and I eat so little. And in one week, too!"

"I would add a few," murmurs Myra, "but what are you going to do with this—this great hunk of blushing man."

"Oh, that! Well, a starvation diet; exercises in a rubber suit; severe figure-training corsets; extra-heavily boned and triple laced will soon reduce that hideous waist to a neat twenty inches. Ah, but it'll be a pleasure to start training that - that creature! I'll mould him into a wasp-waisted concubine if I have to lace him in four inches a month, and if he's slow or clumsy —well, I have a nice heavy strap on hand for husbands or concubines who displease me."

"Oh, Lola! How strict you are."

"Sure, I'm strict, but you've got to be. A good, effective spanking across the bare backside always makes husbands behave properly."

Horrible, is it not? Yes, indeed; even to an ardent admirer of the lovely, domineering type of woman like myself. Of course, it could never happen except in a nightmare after eating lobster salad. Women, bless them, are just too busy chasing men to ever dream of this idyllic feminine paradise. Why, even science-fiction writers probably never thought of it, so why should women who are always too busy with their constant round of activities.

Ah, that's it; you he-men keep

(*Continued on page* 28)

26

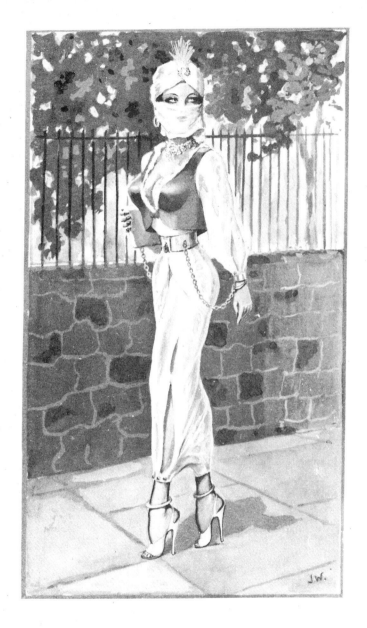

A revival of the harem skirt

women a l w a y s busy — always working hard and they will be too tired to think. Do that and you need never worry about women. Save your worry for the big super-super bomb.

Now, I do hope all you aspiring male slaves are quite satisfied. I trust so, because while absolute feminine control and female slavery can be imagined, I think we had better leave it where it really belongs—in the realm of the imagination or the bizarre.

Now She's in the Movies

Continued From No. 8

The filming of "Sir d'Arcy d'Arcy" actually began on the following Saturday, and has continued almost every weekend since then. The weekends, of course, are the only times when my husband is home from the office and we have the necessary daylight for shooting. Fortunately we live in California, so the weather has been no problem.

That first Saturday went in filming the background for the titles. For locations we went out to the rather tumble-down ranch of some old friends of ours, a few miles outside the city. My husband decided the background pictures should be of Gwendoline as she appeared in your first announcement of your Atomic Serial Cartoon. For a costume I had taken an old flowered print dress, made the neckline much lower and cut a

good eight inches off the skirt. With tightly drawn opera-hose, five-inch heeled black kid shoes and a very heavy make-up, I was told that I looked pretty special.

The first thing Sir d'Arcy did was to pick out a suitable tree, and tie my hands back around the trunk. Then he forced a tightly folded handkerchief into my mouth and tied it in place with another handkerchief through my mouth and knotted at the back of my head. I was gagged and no kidding, as I found when I tried to protest at the way he was continuing the tying-up process. The only sound I could make was "Mmmmm-mmmm" and that was so soft you could hardly hear it. When our villain was through, I was bound, cord for cord, exactly as in your picture. I was really helpless too; about all I could do was wiggle

my fingers and move my head.

It wasn't till *after* I was tied up that Sir d'Arcy began to worry setting up his camera. By the time he was through shooting, and it always takes him a long time, as he likes to go in for "angles" I had been bound to that tree for a full three hours.

By that time, of course, word got around among our friends about the kind of picture that was being shot, and so, in all, about fifteen people had congregated— all blandly claiming that they were "technical advisers" or "set dressers" or "third assistant directors." It's a funny feeling to find yourself bound and helpless in the presence of so many people; it's even stranger to hear them offering all sorts of advice, both to the cameraman and yourself, and be unable to take any part in the discussion.

When Sir d'Arcy was putting his camera away, our host suggested that we all go back to the ranch-house and take a little something to keep out the evening chill. The idea was very well received.

Finally my husband came over and began untying me. When he had nearly all the cords off, he asked me, "Do you want me to take that gag out of your mouth or not?" Of course, I nodded my head wildly. Then I got a nasty surprise when he said blandly,

"Oh, you mean you don't want it taken out." Thinking he had misunderstood me, I tried shaking my head. Then he said, "That's what I thought. You don't want it taken out. Okay. If you like it it's okay with me. But we better tie your hands—you never know but you might get hold of a sharp knife or something and hurt yourself." So, in spite of my feeble attempts to struggle, he bound my arms behind me, with my right wrist tied to my left elbow and vice-versa. There I was. Except for the fact I could use my legs, I was just as helpless as when I was tied to the tree.

Then we all went back to the ranch-house. The first thing we knew, the affair had turned into a party, with plenty to eat and drink for everybody—everybody except gagged and helpless Gwendoline, that is. I didn't want for attention, though; everybody, especially the men, looked after me. In fact, as our host said, I was quite the Dumb-Belle of the Ball.

More of my Tragic Adventures at the hand of the Villainous Sir d'Arcy in the next issue.

Yours,
Gwendoline the Second

Oh yeah? That's what she says. So far we haven't received a second letter of adventure. Untie her, Sir d'Arcy, and let the girl write. Ed

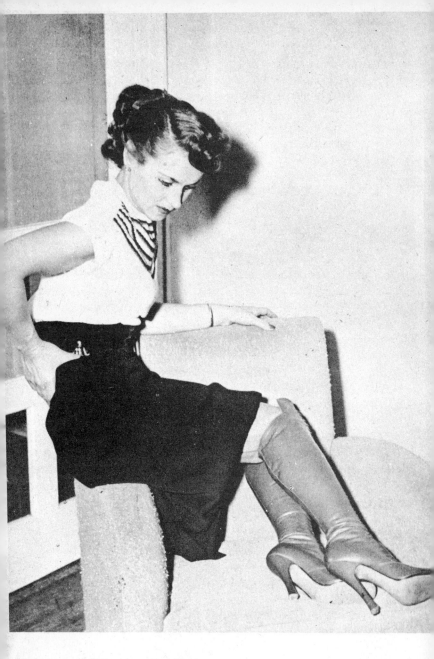

I wore red boots to read No. 5—so ...

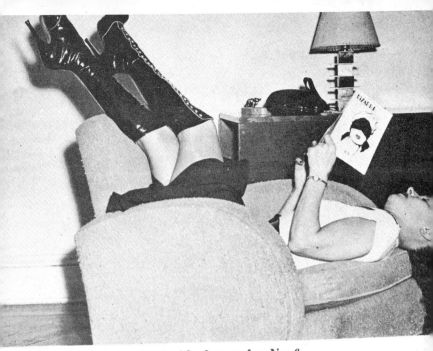

it's obviously the black ones for No. 6

Now what will I wear for No. 7?

Correspondence

By which we give you the opportunity to express yourself. Under no circumstances do we publish names or addresses. Nor will we forward names and addresses to other readers. If photos or sketches are sent in, please write a short commentary for publication.

In reference to
THE GREAT REVOLT
(page 24)

by the Author

I must confess I'm undecided and rather timorous about this whole thing. Yes, I know—it does have its charming side, but what could women really do to a man if they had him where he couldn't draw a deep breath without feeling the constricting pull of his corset, or walk a real step without tripping over his skirts. Yes, what would they do? I wonder, and you?

Perhaps some intelligent literary minded lady like the charming, talented Ursula, or the righteous, indignant Carolyn could enlighten us? How about it, ladies? I for one am quite serious and very—very candid about this. Let's have a debate on it? The ladies expressing their point of view with that degree of feminine logic intelligent and cultured women know so well.

I should be delighted to examine your ingenious arguments either in favor of a future civilization run by women with men in the position of nice, handsome slaves on the auction black, or for a perpetuation of the present day, masculine culture. Well, ladies and gentlemen, which do you prefer? The present atomic civilization with all its delightful, rowdy quarreling nations, and it's fanatical ideologies and bombastic nonsense; or the quiet peaceful type, ruled by women who detest war so heartily that no woman would ever fight, but who would enslave you in a harem, and force you to wear the clothes they wore long —long ago.

Enchanted Slave

Correspondence continued on p. 36

A black nylon negligee

to appreciate how sheer it is, turn the page

33

his is not an old master but a photo taken by a reader

34

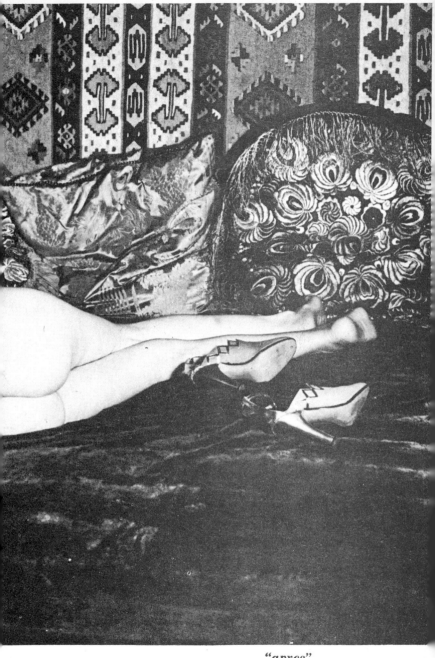

"apres"

THE MATTER OF MAKE-UP

Dear Editor:

For an example of how extreme (virtually ancient Egyptian) modern eye-makeup has now become, see the lower photograph on page 124 of the April issue of *Harper's Bazaar*. One could not ask for a better example of frank body-painting.

Looking through some old magazines in a bookstore, I came upon the enclosed splendid tribute to American womanhood (on page 60 of the October, 1948 issue of *Beauty Parade*) by a writer who has appeared also in *Bizarre*. I agree heartily with everything Mr. Raymond V. F. says in this letter (as what man would not?).

Since he wrote, the fad for pierced ears has sprung up and spread like wildfire, and ear-rings have become larger, heavier, and more elaborate than ever. Pierced ears, of course, are simply fascinating to masculine eyes.

I feel especially sympathetic with Mr. R.V.F. when he speaks of the modern girl's "lavish and terrifically exciting use of lipstick," and also when he refers to her "supremely kissable feet" and her "delightful new habit of revealing the naked loveliness of her feet and her cute little toes, beautifully painted." Nothing is more admirable about American girls than the way they use lipstick without stint or limit, making their lips irresistibly kissable; and no words could express the allure of bare feminine feet as they are so provocatively displayed and flaunted today.

Gerald Moulton

MORE AGIN THE DUNGAREES

Dear Ed.:

At least once in every issue I find someone with whom I could not agree more heartily. This time it's I.B.O., who writes concerning girls in pants . . . call them dungarees, slacks, pedal pushers, etc. . . . *they are not right!* Girls, please stick to your skirts . . . or give me the same privileges with your clothes.

What can we do to convince you that you look so much better in the clothing belonging to you? My friend I.B.O. says he thinks he could wear hi heels and look better in them . . . I know I could, because I have and I do . . . unfortunately we are not fighting this battle on equal terms since you can wear my pants and loafers but you won't let me wear your skirts and heels . . . In a country supposedly a democracy . . . *is that fair?*

One thing I notice about these correspondents is that most of them are married: "Blind Girl Fluff" and "Shackled Susan" have husbands to help them and "H.H."

had an aunt responsible for his experience. What are we un-married people without such obligingly cooperative relatives to do? It makes it tremendously difficult without someone to confide in or share our pleasures with. Suggestions, anyone?

You may remember me as the challenger of Carolyn's statements (in No. 8). I'm glad to see that I am not alone (see note by A.M.) but this only brings up the question once again. What can we do singly? As I see it now the answer is nothing . . . which is rather frustrating to say the least.

In closing may I mention two more items which interested me? To Edna K. I would say: O how I would like to meet you, or someone like you. But how can I when our pal the editor refuses to give the slitest clue to your real self?

And to Shackled Susan I say: Your photo was most interesting. How about another, this time from the front?

Sincerely, Gauron

CONCERNING HOUDINI-ITES
Dear Mr. Willie:

You apparently have quite a time catering to the special interests of your different groups of fans. Without detracting from appreciation of your rendering of the female form in revealing detail, and the entertainment afforded by your novel conception of interesting costumes and distressing predicaments, my own special interest centers about the latter, particularly as they may lend themselves to escape artist technique.

The exploits of Harry Houdini have laways intrigued me, and whether the escape was real, or the result of some carefully arranged fake in the set-up of the predicament the performance was sensational and an effective demonstration of strength, endurance, courage and resourcefulness. It has been one of my hobbies to examine the predicaments which you have illustrated with an eye to considering if, and how, they might be escaped from, or what changes would be necessary in the tie-up to give the same general effect—but be escapable.

As you can understand, this hobby has developed several original ideas, some of which have since been approximated by similar situations in your product, but which have certain features about them designed to make the seemingly helpless position an escapable one provided the "victim" has the know-how. I am not a "Houdini" myself, and can't pretend to be able to demonstrate any of these theoretical escapes, but as a hobby they lend themselves to literary treatment which may be intriguing to your readers in "Bizarre."

The enclosed is the opening page of one.

Do you too often find yourself tied up, with a number of annoying details—such as a stout rope about your wrists, another at your ankles, and perhaps a stuffy gag in your mouth? That may be a sure way to escape from a humdrum life as a sedate home body, or from the active but monotonous requirements of going to business, but fun is fun, and repetition can get a little exasperating—or doesn't it?

If it is your private pleasure to surrender as a protesting but not unwilling victim to some friend whose idea of entertainment is inclined to be unique and fanciful (not to mention bizarre); or if your face and figure have projected you into the field of commercial modeling which specializes in illustrations of ladies in distress, tied to a chair with a slavering foul fiend threatening to carve your luscious charms to bits before the arrival of the hero (the police, or maybe it's only the literary censor); or if it has been your less enjoyable experience to be the trussed-up victim of a real-life robber, burglar or some other despicable character: these remarks are intended to help you, either to escape, or to ease the discomfort of any future tie-ups which threaten to occupy too much of your time.

It is a large order to make a group of veritable Houdinis out of my readers—but confidence is the keynote of success and as long as I don't have to prove it, I shall be indomitable and serene in my own belief, and shall leave it to my readers to test and report concerning situations wherein my instructions have failed them in their hour of need. (In reporting, please send pictures.)

Yours, W.K.
(*Now take over, dear Reader. Ed.*)

How To Pierce Ears
Dear Editor,

You asked that we write to describe the "ear piercing" operation if and when it was accomplished. Well, the ordeal is done and what a thrilling episode it proved to be. Sally and her mother decided it would be fun to make a party of the piercing "a la the Countess" etc. They both dressed alike in low cut, revealing white satin blouses, short tight black satin skirts, tight girdles, black sheer nylon stockings rolled tightly just above their knees and black patent opera pumps with open toes and 4½ inch spike heels. A truly beautiful study in black and white. Lipstick and makeup were lavishly applied and a generous dash of an exotic perfume behind each pretty ear. A lovely setting for our little party with two daintier or more alluring girls hard to imagine.

38

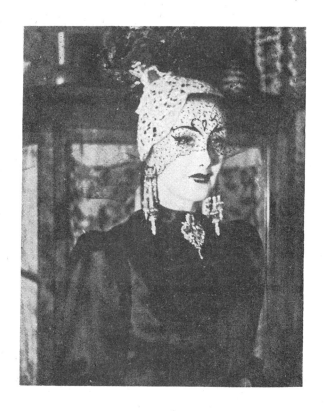

When I was once in Russia, I bought there from the
Kremlin treasure (which was partly for sale at that time)
a pair of gorgeous ear pendants such as you and "Pierced
Ears" have probably never seen. I enclose a photograph
(*above*) of a friend in Paris wearing them. The pendants
are very heavy, more than 3 ozs. each. They were made in
Buchra, India, between 250 and 300 years ago. Their
value is about $400. Smaller ear pendants of similar design
have been copied by a goldsmith in the Rue du Faubourg,
St. Honore in Paris.—"K"

We secured heavy leather straps and a high straight backed chair. My wife had purchased an unusually large darning needle for our "instrument of torture" and I purchased two pairs of plain gold earrings for pierced ears and two pairs of extremely heavy and ornate round filigree ones that just brush the shoulders when depended from the holes in the ear lobes. They are a lovely addition to two already most attractive and alluring girls.

Being all equipped for action Sally insisted her mother be the first "victim." So with small straps we firmly bound her arms behind her back at elbow and wrist as in figure training picture, so that they could not be moved. She was then seated in the chair. In so doing the tight skirt slipped up above her knees revealing the tightly rolled hose and a generous portion of silky white skin of a very shapely thigh which contrasted alluringly with the roll of the black nylon stocking. A lovely picture. She was then strapped tightly in the chair at ankles, waist and forehead, securely trussed to avoid any possibility of jerking when the needle is applied as "Dr. DeArcy" starts the "dirty work." She was becoming a little apprehensive of all this preparation and asked for a cigarette to soothe her nerves. Sally lighted one for her, since she could not use her own hands, and after several deep inhales to get it well started she slipped it between her mother's heavily rouged lips, removing it from time to time as the smoking progressed which seemed to quiet her mother's fears and she requested we proceed. So "Dr. DeArcy" went at his work with savage glee. Inserting the needle in a cork leaving about one half inch protrude we held another cork behind the ear lobe and placing the needle at just the desired point we squeezed the corks together and with a little squeal of pain and delight from my wife the needle went through that pretty flesh, leaving a neat and dainty hole on its removal. We had all decided to use the earrings to maintain the puncture instead of a "sleeper" wire as both girls insisted they wanted to use the new adornments at once. We immediately inserted the gold rings and fastened them in securely. It was a lovely picture.

To repeat the story of Sally's turn would be but repetition except that she seemed more nervous than her mother requiring that she be trussed up more securely, she inhaled her cigarette copiously, and her squeal of pain and pleasure was more thrilling. After all was finished and the girls had turned their heads from side to side before the mirror we all sat down for refresh-

ment and chat. Now the conversation turned to me and what a handsome woman I would make. With much discussion as to the details, and having read of "Margery" in Volume Eight they decided that would be our next experiment. I demured but was quickly overruled and quite frankly I was rather thrilled at the idea of extreme high heels, pretty dresses, tightly laced corsets and silky lacy lingerie. It all seemed quite alluring. So figure training for me is next on the program and I find the anticipation rather a thrill. Will write you my experience if you would care to have it to publish for your other readers with thoughts along these lines.

We fear this has gotten quite too long but hope you will include it in your next issue. We all enjoy seeing our letters in print and your little magazine is awaited eagerly by us all. It only comes out all too infrequently. But now until the next time we hope you and your readers will find some pleasure in reading of our "Ear Piercing" party.

Sincerely, "Pierced Ears"

FIREMAN, SAVE MY CHILD
Dear Editors,

The picture you published in your No. 7 of the girl in boots and raincoat brought vividly to mind an experience of my own.

Shortly after we were married my husband joined the Volunteer Fire Department in our town and I kidded him unmercifully about doing it to wear a uniform. He was very serious about it and denied any interest in the uniform, saying the true uniform of the fireman was rubber coat and boots.

Some time later I lost a forfeit to him. (That is the only thing he will ever bet me, claiming that with anything else he loses even if he wins.) The following Friday night when we were leaving for our summer place for the week-end he stopped at the firehouse before we left and picked up his boots and coat. He wouldn't tell me why until that night when he said, "This is your forfeit. Tomorrow morning you can wear the Fireman's Uniform. I'll let you wear my coat and boots while you work in the garden." So the following morning I put on sweater, jeans and loafers and then he made me put on the high rubber boots. They were so big they went on over my shoes and he pulled them up around my thighs and fastened them. Then the heavy rubber coat was added and buckled up from knee to neck. Then he sent me out into the garden.

It was a warm spring day and I was very uncomfortable. In fifteen minutes I was perspiring freely but my husband kept me

hard at it until noon, nearly two and a half hours. I've never been more uncomfortable in my life but at least there was no one else around to observe my misery. I'll bet I lost five pounds lumbering around in that heavy outfit. At noon he let me take it off and I've never mentioned Fireman's Uniform since.

I never see boots and rubber coat to this day without being reminded of my experience.

Yours truly, Eleanor

BY MUTUAL AGREEMENT

Dear Sir:

In your No. 6 issue, "Carolyn" complains about men always wanting to put women into tight clothes, restraining discipline, and so on. She thinks men should be given a taste of that medicine.

Often they are, Carolyn! For example, my wife and I have an agreement whereby I am the boss for six days a week, but she is the boss on the seventh day. On that day I must dress as a woman for the full twenty-four hours—and I am convincing enough so that we can go shopping or to the movies together.

On this day, she calls me "Jane" and I must do anything she tells me. If she has any complaints of my conduct, she subjects me to whatever discipline she thinks best —and it is sometimes very severe!

On occasion I have been compelled to stand for an hour with my hands tied above my head, and have then received a sound whipping with a long ruler, and with my skirts pinned up so I would feel the full sting of the whipping.

One thing is a set rule on those days, that I go to bed with my hands and feet tied and my eyes tightly bandaged. Sometimes I manage to get free, sometimes I doze off and spend the night tied that way.

But, of course, there is always one thing that keeps my wife from inflicting *too* severe discipline upon me when I am playing the part of "Jane." She knows that I could do the same or worse to her next day!

Yours, "Jane-in-Chains"

LESS CLUMSY PLATFORMS

Dear Sir:

I enclose some snapshots of shoes. These are black kid, with a 5 inch tapered platform and 10 inch heels. They represent an attempt to use a high platform without the usual clumsy, club-footed appearance. A person can stand quite easily in these shoes. A person can also walk when wearing them but cannot forget them and get careless. The short "wheelbase" makes them tricky. With a little change in de-

photos referred to

42

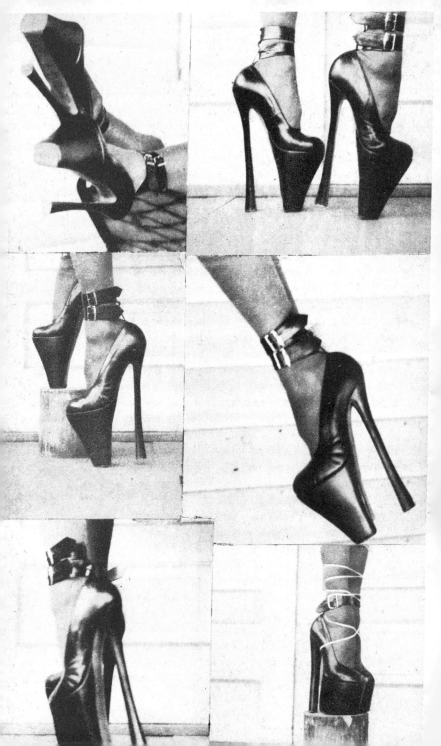

sign I think that this style of platform would be quite practical for dress wear and dancing.

These snapshots are not too good. If you can use any you are welcome. May have some better ones of these shoes and of some other footwear a little later.

 Yours, U. C.
(*We hope so. Ed.*)

No Stockings for Beauty
Sir:

As we know, beautiful feet are one of the most attractive elements of the female form, to masculine eyes; and feminine feet unquestionably reach their supreme beauty when their tiny toes are squeezed into tight shoes with glorious six-inch heels. There are two other details, however, which often lend a special allure to a woman's foot, in the view of many men. First, if the position is such that it forces a very marked outward curve of the instep. Second, if the patent leather shoe is worn so tightly that it bites into the flesh making a very marked indentation, and causing the flesh to bulge outward above the shoe. But for its full effect, bare legs and feet are essential; no stockings should be worn.

One would like to see the simply beautiful picture on page 5 of No. 2 reprinted for the benefit of later subscribers; and the same is true for the splendidly-heeled shoe on page 7 of the same issue (bottom, right side, of page).

One must again express great pleasure over the picture of the wondrously alluring short tight skirt on page 3 of No. 3; but such a picture really should have a caption emphasizing its appeal. It would be excellent to have a series of such photos, showing this model, from the rear, WALKING in this skirt. Such garments as shown on page 9 of No. 2 and page 29 of No. 3 (1932 model) are of immense appeal, and one cannot see too much of them. They are undoubtedly a fashion of the future for the woman who really wants to fascinate men's eyes.

The shoe on page 21 of No. 5 (upper left-hand corner of page) is also a wonderful and admirable device for beauty. It should be worn with bare feet, and would be even better if cut in the back so that the bare flesh of the lovely feminine heel is revealed.

 R. V. Ford

Information Please
Dear Sir:

As you say, you cannot devote an entire issue to corsets, boots, or torture devices. However, I believe there is a segment of your public to whom you are indebted to the extent of devoting more space than you do.

That segment is the men who

are really MEN—but who enjoy the clothes and, to a certain extent, the life of a woman. Possibly this springs from the fact that the average woman has so much we men admire—and envy!

In my case my wife and I are so nearly one size that with the aid of a modern-day corset I can wear her clothes and since I make a very presentable looking girl when in make-up we have many enjoyable times together. We even go out in public that way at times —and get away with it!

Now I feel sure that there must be a great many of us so why not devote a fair amount of space to our problem of obtaining a feminine figure—not just tight lacing, as such. Undoubtedly you could also obtain many pictures of successfully corseted men showing us what others have been able to do.

So, Mr. Editor, how about some dope on how we men can be as attractive in face and figure as our wives?

If you will be kind enough to publish this I am sure we will get some of the desired information.

Very truly yours, "B. H."

MAGNETISM OF HIGH HEELS
Dear Editor:

The following story has a moral which I hope readers will note.

One evening at a skating rink a party of eight—four boys and four girls—all about 18 or 19 years old— sat in a box close to mine. The girls wore the usual long sleeved low necked velvet costumes with very tight bodices and very, very short skirts, opera length silk stockings and skating boots. They all looked very attractive— particularly one. She was a blonde who was gorgeous. This blonde was drawing all the attention off the ice and on it—for she was an excellent skater.

But one girl—also very attractive to my way of thinking—a brunette, gradually seemed to fade more and more out of the picture. She couldn't skate and though for a while the boys would take it in turn to help her along, before dashing off to waltz with the blonde or one of the others, it wasn't long before she was just left on her own to wobble around as best she could holding onto the rail.

In the intervals, so far as the group was concerned, she was almost non-existent. The blonde outshone everyone as they sat chattering merrily away and, eventually, when the others trooped back onto the ice, the brunette stayed behind and began taking off her skating boots—to put on in their place a pair of black patent unusually high heeled court shoes. The heels I guessed were about 4 or 4½ inches high and the shape they gave to her feet and her long black silken

45

legs was quite delightful. She had very pretty legs, and as she, of course, still wore the very short black velvet skating costume, there was no difficulty in appreciating this fact.

She sat smoking a cigarette, her feet up on a chair, watching the others whirling around on the ice, and somehow it seemed to me that the other skaters were watching her, too. Men, anyway, were continuously glancing in her direction as they passed.

In the next interval what a change. There was still only one girl in the picture, only one getting all the attention. But not the blonde; not the others; just the little lady with the high heel shoes. Before, it had been merely a skating costume—now it was a riot. Same girl, same costume, different shoes—that's all.

Spectator

SIMPLE BUT EFFECTIVE

Dear J. W.,

Some months ago my husband wrote you that he would make me spend some time on the chain for having written you without his knowledge. (*Naughty girl!— but ssh! do it again. Ed.*)

The enclosed photographs are proof that I hung on the chain. I can assure you that the sentence was long enough, that I will not be writing any more letters without his knowledge. (In other words I hung around the house longer than I wanted to.) (*Don't let a little thing like that stop you. Ed.*)

The long delay in sending you this letter and photographs was because we had to learn photography to get the pictures. You can see how amateurish they are. (*They're fine. Ed.*)

The little mitten is made of a single piece of black leather, and laced with three strings. It is perforated for good ventilation. It is quite comfortable and very effective.

The mask is made of the same black leather in the form of a bag, with a draw string. There is a rubber tube inserted to breathe through. There is absolute darkness inside, as no light can come through the leather or the breathing tube. The mask is not uncomfortable at all.

Believe me, with the mask on and my hands behind my head I am completely helpless. It is impossible to turn a doorknob or even take my shoes off if buckled.

When I am in this helpless position my husband frequently spins me around until all sense of direction is lost. Then he moves me about from room to room until I do not know what room I am in. It is quite difficult to find out by feeling with your feet.

When I am being punished, a

46

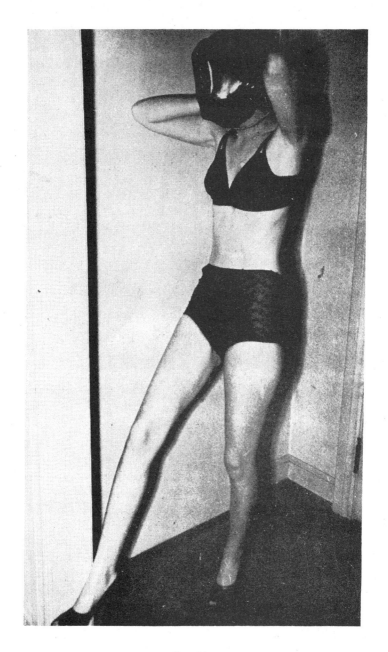

Lost!

47

from "Chained Letter Writer"

chain is placed around my waist and is fastened on a hook on the ceiling and I then "hang around the house" for hours at a time. The chain is not tight, but it is just the amount of time I spend just standing that is so bad. I enjoy getting into this predicament every once in a while, except when he takes my shoes off and my heels want to touch the floor. It only takes about 10 minutes of this to become very tired, and then it is real punishment.

You will notice my odd shoes in the photograph. They are figure training shoes my husband made by adding a platform to a regular pair of shoes. The purpose is to exercise the calf of the leg, and thereby increase its size. The heel on the platform has been cut away from under the foot until constant tension of the calf muscle is necessary to prevent the foot from rolling backward. I started off wearing them an hour a day. Even though they are not uncomfortable they do tire my legs. I can wear them almost all day now. The calf

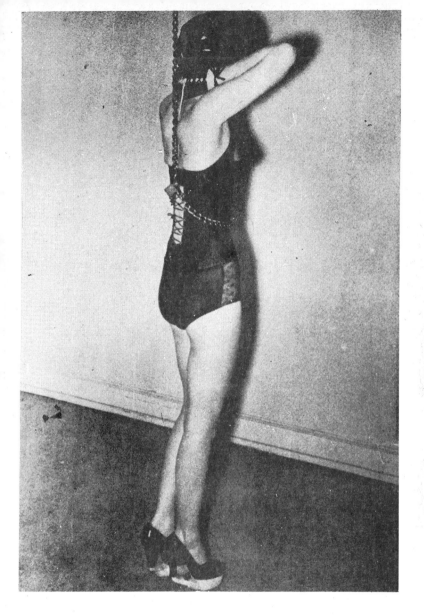

of my leg is getting larger and
my whole leg more shapely. That's
one compensation but I wonder if
any other of your readers have

husbands who keep them in order
like this.

The Chained Letter Writer

THE RETURN OF BLOOMERS
(2nd Installment)

Dear Sir:

To continue with my previous letter:

I suppose I must have stood there for nearly half a minute before I collected my wits and started to run out of the room. But the fates seemed to be against me. I promptly stumbled in my high-heeled boots and fell down. I had twisted my ankle and Billy had to assist me to my room! He was a serious boy and very considerate and despite his embarrassment he wouldn't leave me until he had looked after my ankle. He insisted on taking off my boot and while we both blushed, I pulled up my bloomer elastic on that leg and unhooked the suspenders from my stocking so I could roll it down. Then Billy applied salve and a bandage and left me. I wondered, of course, what he thought of the whole situation. It must have startled him considerably to see me trotting into the living room in such a get-up, and I hardly knew whether I could speak to him again. I told Nona about the incident and she just laughed.

But a few days after, a parcel was delivered to the door with a note from Billy. It was an awfully nice note in which he apologized for embarrassing me by being in

photo from C. G.

the house, adding that he hoped my ankle was better and finally had a shy paragraph in which he said he thought I was "awfully attractive" in my costume.

And the parcel contained a brand-new pair of silk bloomers and a pair of silk hose!

Naturally, I was most intrigued with a young man who reacted in that way and I asked Nona to arrange a "date" with him. I donned my ancient corsets and high boots and, of course, wore the attractive hose and bloomers he had sent me. It goes without saying that I was fully clothed when he entered the house! I wore a rather attractive, tight-fitting dress with a skirt that came only to the knees and showed off my legs well. Billy smiled when he saw my stiff, sternly-corsetted

figure, my boots and my dark stockings and he gave me a big box of candy as a present. I found that evening that he was an awfully nice boy and it didn't hurt a bit that he couldn't keep his eyes off me! We got along so well that Billy made a date to take me to the movies the next Saturday. I was terribly thrilled at having a handsome young man like Billy squiring me around but although I had taken to trying on my old-fashioned underwear often, I didn't feel quite free about appearing in public dressed in such a way. So I wore my newest clothes from the skin out. But the funny thing was that Billy's face fell as soon as he saw my sheer nylons and open-toed pumps.

You can bet your bottom dollar that I wore Billy's favorite styles on our next "date"! I was getting used to the feel of corsets and boots again and I was thoroughly enjoying the feel and look of bloomers and silk stockings on me. I was getting quite reckless, too, and I permitted Billy to take me out in my antique costumes although I must confess I blushed a good deal when I saw some of the curious glances that were cast at my high, shiny boots and stiffly corsetted figure. Billy was awfully shy but terribly proud of himself because he knew I had dressed to please him. We were walking along the street when he asked me, oh so shyly, "Did you, er, like the first present I sent you?"

I decided to tease him a bit so I asked him if he meant the candies. He fumbled around and said no. I took pity on him and told him that I liked the bloomers and hose very much. I even said I was wearing them and mischievously flipped my skirt up to give him a glimpse. He blushed fiery red and was pleased as punch.

Well, we went out together quite a bit after that and we got along very well indeed. I think he finally fell head over heels in love with me when I showed him the entire contents of my hope chest

photo from C. G.

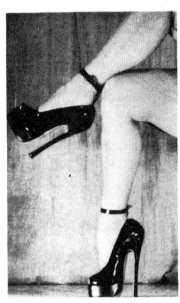

and gave him a fancy garter as a souvenir.

It was only a few days after that Billy proposed. I suspected he was falling in love, naturally, but I didn't think he was so serious. I accepted, of course! What girl wouldn't? They say these May-and-December romances aren't a good thing but how can you stop people from falling in love? And Billy is a simply adorable and adoring husband. We were married in a few months despite the gossip.

It was on our honeymoon that I asked Billy why he liked women in bloomers and corsets and he shyly confessed that he had always felt that way. Then he showed me copies of "Bizarre" with the letters in them from bloomer lovers. I was delighted to see that other people feel the way Billy does.

Today, I'm on a honeymoon trip to New York with Billy and I thought I would write to you about it. Billy insists that I never wear anything else but corsets and bloomers and boots and silk hose (under my outer clothes of course) and I must confess that I don't mind the change at all. Billy supervises all my shopping for underwear and he's quite expert and getting me just the right thing in bloomers. I enjoy the whole situation—and we're both blissfully happy.

Best wishes to your magazine and your readers. And I hope more women find more bloomer-lovers in this world! They're fun to get back into!

Yours sincerely, Mrs. Billy T.

FOR BETTER POSTURE
Dear Sir,

Many readers will be thinking that the old fashioned shoulder braces are no longer worn by young ladies whose round shouldered or stooping deportment has caused them either under compulsion or voluntarily to adopt such a means of figure correction. The following recent experience may interest quite a few of your readers.

A young lady friend aged about twenty-three was spending the week-end with me some months ago and in the course of conversation complained about her figure problems which were obviously rounded shoulders and the usual accompanying drooping bust line and protruding abdomen. Also she said how tired she always felt after a hard day at the office desk and counter.

I suggested that surely a good corset and a pair of firm shoulder braces would soon set her up and relieve both her tired feeling and figure faults. She agreed that she would try a more supporting corset but said she could not possibly bear to have her shoulders strapped up in some leather and steel con-

traption. I then explained that ladies' shoulder braces need be no more uncomfortable or restricting than any well fitting bra. She agreed that if that was possible they seemed to be just what she needed but had never thought of buying a pair. I then asked would she care to try on a pair to which she agreed enthusiastically and was soon fastening on an old pair I had kept from a period some years ago when for four years I wore braces to correct and maintain my figure.

They were of the cross over type, well boned at the back well padded at the armholes and fastening in front with a wide belt and straps. They could be pulled up just as tight as the wearer could stand the strain.

Being of much the same size and figure as myself we found that the braces fitted her almost perfectly. She fitted them on and strapped them up quite firmly and at my suggestion spent the rest of the day in them as a trial period. She said it felt rather strange to be so trussed up but not really uncomfortable.

She was most enthusiastic about the way they improved her figure, how they held her up straighter and improved her bust line.

When it came time to leave for home she asked if she could borrow the braces for a longer trial period and to this I gladly agreed.

Some weeks went by before I saw her again and this time was when she called to return the braces and report that she now had two pairs of her own. She had liked them so much that she had decided to continue wearing braces and had visited a surgical appliance maker to be properly fitted with the result that she now had one light but very effective pair which she wore every day in the office and a special corrective pair which she wore at home.

Several months later she called again to tell of her recent engagement and to confide that it had all come about because of her shoulder braces. Her boy friend had been first attracted to her by noticing how well she held herself (thanks to the braces) as compared with the other young ladies in her group of friends. She still wears the braces and intends to continue to do so not only because as she says "I like to feel well supported and besides John likes to see me well braced up and upright."

Therefore girls the braces, backboards, collars and figure training corsets, etc., of our great grandmothers probably brought more romance into young girls' lives of the day than is realised, and even today the same principles applied perhaps with less vigour would go a long way towards bringing popularity and romance to many an

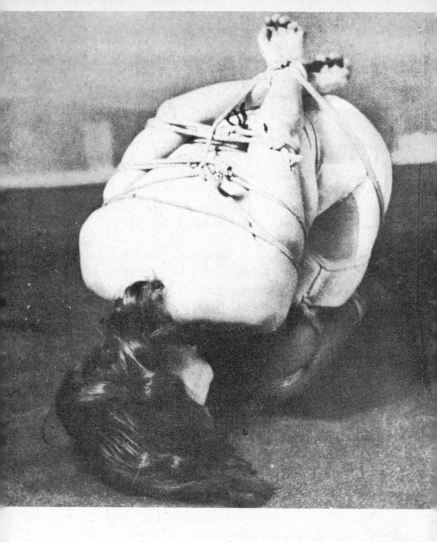

DON'T LET THIS HAPPEN TO YOU

Learn jiu jitsu, the art of self-defense

*On the opposite page, at the request of readers
two other views of the victim on p. 51, No. 6*

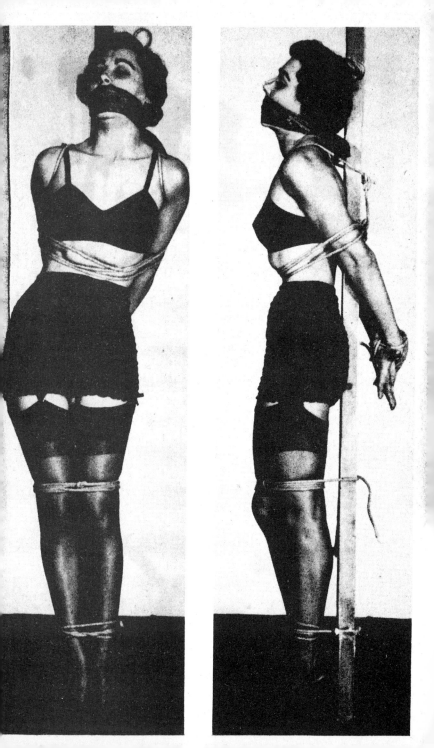

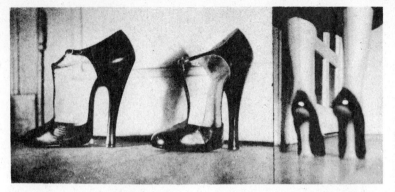

high heels **no heels**

unattractive flat - chested young
lady.

After all we cannot all have
beautiful features but a beautiful
figure and carriage can make up
for a lot.

Perhaps potential breakers of
hearts will take heed and the Edi-
tor will be besieged with requests
for information on more old fash-
ioned figure training gadgets, who
knows?

Yours truly, Mrs. U. P. Right

ETERNAL TRIANGLE SOLVED
Dear Editor:

I send this with the knowledge
that you wish situations of domi-
nation relative to the ties of mar-
riage. I have read much and varied
data in your fine publication "Bi-
zarre" and I feel timid in trying
to write a bit for the information
of your many readers. However I
realize you are mainly after facts
and not being a great author or in
my case it would be authoress—

medium heels

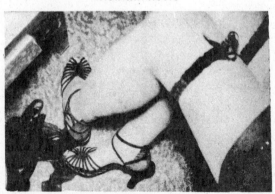

what do you say? Let me tell you as a wife a true situation that solved all domestic problems. All were solved when I became an all out "Slaverette."

I caught my young husband in a very awkward situation; one of those "sweet young things" affairs. Well to make it short and to get to the point, he faced losing me, his position and all he held dear if he did NOT follow my orders and serve his most unique "sentence."

From now on for an indefinite period my husband must "report" right after work to me, at 4:00 P.M. to be exact. This also includes every Saturday and Sunday, for "Sentence," and "Sentence" and punishment it is!

He must dress as a cute little French Maid and wait upon me hand and foot and I DON'T MEAN MAYBE!!! When I say he must dress the part I mean 100 percent—ALL OUT—or should I say throughout? High heels, lacy cap and lacy apron, long black silk hose, little short black silk maid's dress, AND a beautiful black hair wig! AND the "unmentionables" —Well—oh, brother! The finest of lacy French imported too! Oh to see him mince and dance attendance upon his strict and firm "Slaverette" . . . He must also serve myself and girl friends when we have a "hen party"—one false

move, one wish of mine that "Milly" does not anticipate, one tiny bit of mis-behavior and I give a look that spells a session in private later!

I use various punishments, it is all according to the offense, standing in the corner, kneeling in the corner, the wearing of the punishment rompers (pink silk ruffled full knee length bloomers worn without a dress, these to humiliate "Milly"). I of course believe in and administer good old fashioned discipline; my bare palm, the hairbrush, the strap or a small switch-type whip, these are all most effective; all this has made him into a most dutiful and obedient husband and besides I have a good and efficient French Maid—I won-

"no heels" walks off

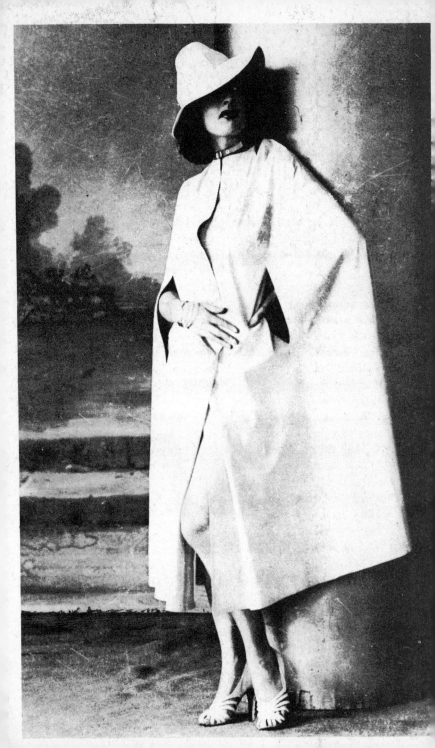

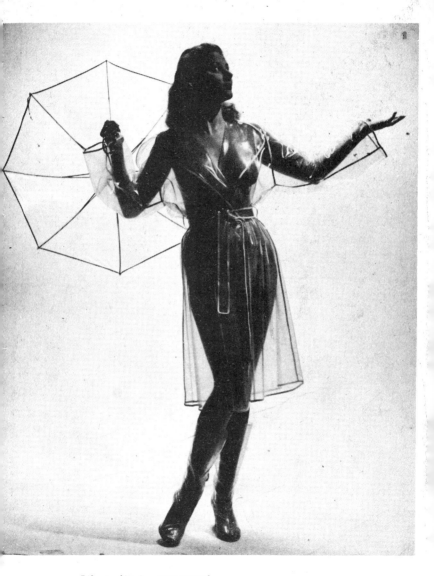

It's quite transparent
that plastic does not
give as much protection
as the rubber macintosh cape

der if you have any more correspondents, "Slaverettes" like myself that have "a Milly"?

Very good luck and good by for this time,

Sincerely, "Babs"

Corset Model and Cautious Husband

To the Editor of *Bizarre,*

I want you to know how much my husband and I enjoy your publication. We think it is a wonderful and extremely interesting magazine and we hope that you can find some way of shortening the time between issues.

I for one will vouch for the editorial comment that men like small waists and high heels on their women. As an ex-corset and lingerie model in metropolitan New York I wore a number of different types of girdles, but noticed that when one did a good job of reducing the waist line that it drew much more attention than the common variety.

My husband and I met at a costume party and he says that my outfit attracted his attention immediately and I was dressed as a "gay nineties belle" with a genuine wasp waist corset that gave one an 18 inch waist. The dress fitted tightly and left my breasts half bare.

Since that first time my husband to be saw me he has asked me to

photo from a London reader

wear corsets and I have, except for swimming or golfing. He takes great joy in lacing me to the smallest diameter as possible. Some of my girl friends have told me that they just can't wear a tight corset but I know that they have just not given them a fair trial. It takes time to get used to it and perseverence. There is another point about corsets that is not generally understood. Unless they have body enough to hold their shape, and are well boned and are laced closely

together the pressure on the waistline will result in a tightening over the hips and at the bosom which may cause discomfort. A corset should be laced in the back and from the middle of the garment and the waist should be tight with some freedom at the top and bottom for hips and bosom.

In looking through the current issue of your magazine (No. 7) I was greatly amused at the experience of Nikki and Betty when they went to a dance and were at the mercy of their friends Van and Bill. But what if they were a woman whose husband made them wear a Chastity Belt. My first experience with such a garment came about during our visit to New York six weeks ago. My husband is in a business which makes it necessary for him to come to the city at frequent intervals and since I have many friends there quite often I come with him.

We arrived late one afternoon and after checking in to the hotel we dressed and went to a nite club. Yes, I wore a wasp waisted corset and high heels—6 inch ones and from the way both women and the men looked at me I know that the former were jealous of me and the latter envious of my husband.

The next morning I stayed in bed while my husband got ready for his business calls. I must have dozed off for the next thing I knew he had slipped a little pair of handcuffs on me, and behind my back. I was of course helpless and then he said he was going to make sure that I behaved. He was very amused and I didn't know what was coming next.

Then he buckled a two-inch leather belt around my waist, fastening it in the back. Suspended from the front, also with two belts was a smooth polished aluminum plate in a smoewhat triangular

photo from a N. Y. reader

Legs: *Imported*

Shoes: *American, by Salvatore Gervasio*

Material: *Gold kid; six inch heels of green snake skin*

shape. There were two other belts fastened to the third corner. These he passed through my legs and buckled to the back of the belt and fastened with two small padlocks.

Then he unfastened my arms. The "chastity belt" fitted close to my skin and followed the contours of my body but there I was—embarrassed, a bit angry but helpless. He gave me a parting kiss and laughingly said "have fun" and went out the door.

For over an hour I tried to get out of the garment but of course without success so I had to wear it all day until he returned at night and released me. I have worn it several times since—under protest—but the threat is always there —"Behave," he says, "or I'll put the chastity belt on you."

I'm looking forward to your including at least part of my letter in your magazine as I wonder how many other wives or unmarried girls have had the experience of wearing a chastity belt.

Yours very truly

Mrs. R. W.

THE STORY OF
A VERY SENSIBLE WIFE
To the Editors:

The brief references in your magazine to rubber devotees leads me to write and tell you my own experiences.

My husband is an ardent admirer of the rubber boot—on the other sex. Nothing gives him greater pleasure than to see my high heeled shoes encased in shiny black rubber boots or even shiny black rubbers. As a consequence I am required to wear them any time there is rain, snow or even wet walks.

I knew before I married Jim that this would be the case and to confirm my acceptance of this condition I agreed to and carried thru, the hardest stint I've ever done. Beginning on New Year's Day and continuing until the first of March I never put my foot out of doors uncovered. I did not go to work, to church, on dates, or even to the corner newsstand for cigarettes or a magazine, without putting on over my shoes a pair of shiny black storm rubbers. Altho there is bound to be a certain amount of bad weather during the winter, that year there was little snow and there were many days I walked down the street in bright sunshine. To my curious friends I merely did some doubletalk about "doctor's orders." Otherwise I suffered in silence, and I mean suffered, both physically and mentally. I dated Jim several times a week and he was wonderful but never made mention of my discomfiture. Shortly after March we were married and Jim promised he would

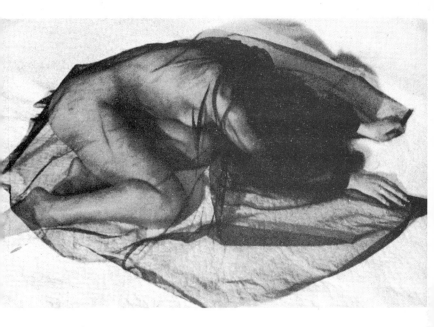

"submission"

never again ask me to wear them publicly unless the weather required it.

It was not more than a year or two after we were married that the zipper boot came out—the kind that goes on over your shoe and reaches part way up the calf. Prior to this I had always worn rubbers because Jim thought galoshes were clumsy looking but when he saw these he immediately insisted I get a pair. I did at the first opportunity and that night after dinner I put them on in the house to show him. When he saw what those shiny, sleek, black high heeled boots did to my legs he fairly drooled. He didn't want me to take them off and I kept them on for over an hour to give him a real thrill while I read the papers. Now he much prefers them to rubbers and I usually oblige. Since the

war, it has been impossible to buy shiny rubbers and dull ones have no appeal to him. I still have several pairs which I had before the war which I use sparingly knowing they cannot be replaced.

Many of my friends now know the reason I wear boots oftener than any of them and most of them say they simply wouldn't do it. I feel however I'm fortunate. Jim is wonderful to me in every respect as long as I humor this one fetish, I have more and better clothes than any of my girl friends and a fine companion as well. In fact now when we are going for a long drive alone I frequently wear boots at least part of the time so he can feast his eyes on them.

Satisfied

THEY'RE A HARDY RACE

*"A brace of guid swats,
And an auld Scottish Song"*

—Burns

Dear Sir:

Coming across a copy of *Bizarre,* some of us were interested in the letter about discipline in France: I can assure you that corporal punishment is still used, though with discretion, in girls' schools in Scotland today.

A few years ago I left a typical boarding school for girls between twelve and university age just outside Edinburgh and can vouch for it that the scale of corrections we received then is still in force now. For offences in class, such as inattention, laziness, whispering, and so on, the girl is well cautioned by the undermistress in charge, then, if she persists in her fault, called out. She has to bend over a desk in front of the class, have her tunic skirt taken up, blue wool knickers pulled up tight, and suffer four to six strokes from that good old-fashioned Scottish instrument of correction, the tawse or tailed strap! The strap is thick, heavy, and makes a sort of hollow whack when it falls. It stings a good deal but has no ill after-effects. The tails, however, which are sometimes hardened in the fire, can cause considerable pain; but this form of correction was usually only resorted to after recitation, copying lines, and so forth, had failed. One mistress, I remember though, was in the habit of making us lean forward over her table and striking from in front, so that the tails fell down our sides and landed on the base of our tender sit-upons! We always dreaded it when she took "prep" or preparation!

Only the "head," or headmistress, used a cane, and inflictions with it were rare. During five years I suffered only two canings, though that was more than enough! After an interview with the "head" you are told "I shall have to see you later." There follows a short

bend over in front of the fireplace and grip the low rail of the grate. Then skirt up and, in this case, panties down. There follows a horrible pause, then the "head" takes a pace forward and the long, yellow cane makes a high swish completed by a sound like a twig snapping as it meets your exposed flesh! Each cut hurts a lot and is counted out loud by the mistress who acts as witness. A good interval is allowed for the pain to sink in, but though a count of twelve given on "the bare" in this way from a lithe, elastic cane, can be well nigh intolerable, it was always a point of honour with us

miss mystery

For Further Details See the Next Issue—No. 10

wait (during which she telephones your parents for permission) and you are sent for. The duty mistress for the week opens the door and tells you, "You are about to be beaten for insubordination (or whatever it is) ; you will receive six (or nine, or twelve, never more)." The "head" then advances and says "Bend over." You have to

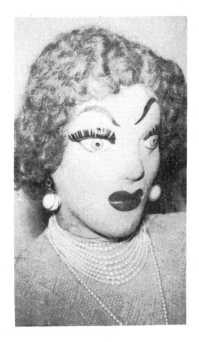

65

girls to bear it bravely; though impossible not to gasp and flex the knees, we usually managed to keep hold of the bar.

Yes, though French girls may be well trained, believe me, we in Scotland too can take it, as you say!

Yours sincerely, Christine Douglas

FASHIONS MAKE ME SICK
(Continued from page 7)

We do not suggest that, like dear old Eve, she should trot around all bare and bottomy but we'll guarantee that no one in any room would afterwards say "Now what was she wearing," if she was dressed in the UD skirt or some of the other "ensembles" suggested by our readers.

To the average male in general, and the readers of Bizarre in particular, the new season's styles don't mean a thing. If it's long tight skirts that he likes you in then it's long tight skirts for you for the term of your natural. Boots? Corsets? The same thing applies.

All of which boils down to this: Oh! ye fair and beauteous ladies! Take note of Tempe Newell's remarks, and dress to please your husband for a change, instead of the dress designer—and the Jones next door——at the expense of the old man's pocket.

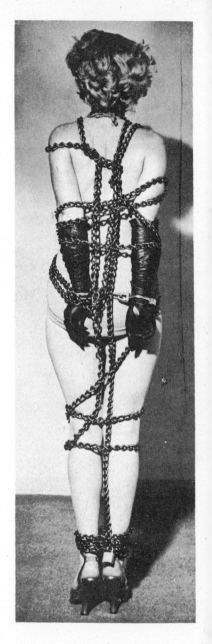

BiZARRE

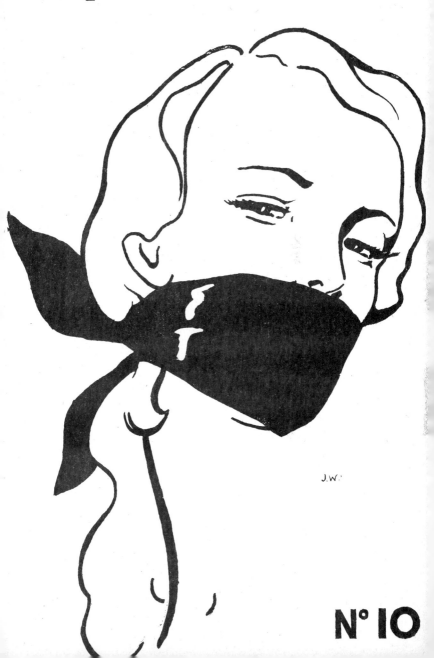

J.W.

N° 10

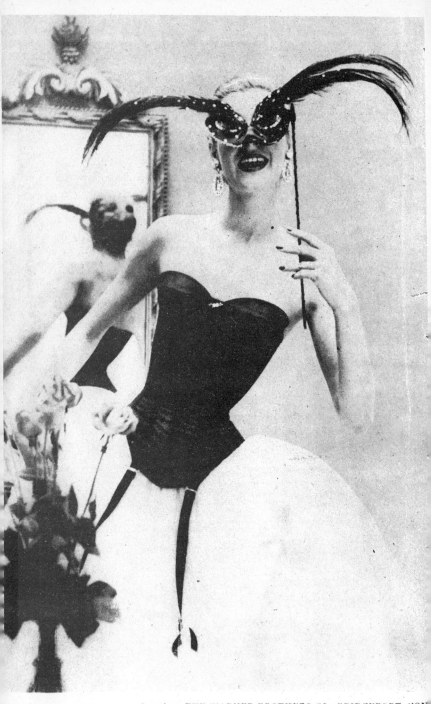

for a "glove fit" it must be leather

BIZARRE

for those who dislike
the conventional
in fashion and fancy

BIZARRE

"a fashion fantasia"

No. 10

Ah, make the most of what we yet may spend,
Before we too into the Dust descend
Dust into Dust, and under Dust, to lie,
Sans Wine, sans Song, sans Singer, and—sans End!

OMAR KHAYYAM

Contents

NEXT ISSUE No. 11

No. 11 is our Christmas Issue. Order your copy now from your newsagent or write to the Editor, P. O. Box 511, Montreal 3, Canada.

BACK NUMBERS

Back numbers available at $1 each are: No. 6, 7, 8, 9. All other issues are 100 percent sold out. Sorry.

Printed and Published by Bizaare Publishing Co. P.O. Box 511, Montreal 3, Canada.
Copyrgiht 1952. All rights reserved.

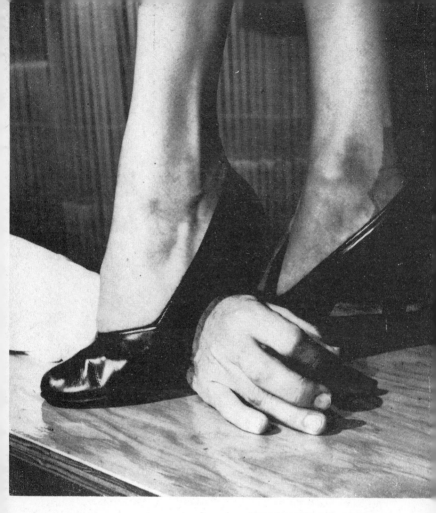

ENOUGH OF THIS!

The hieroglyphic on this ancient stone reads "Home Sweet Home" - hence this article.

There comes a time when — as the great film star Thumper so aptly put it — man becomes "twitterpated." This unfortunate condition can have far-reaching and quite unforeseen consequences. The disease starts with maybe just a glint in the eye, but one thing leads to another; knees become jelly; the pulse pounds; all sense of reason vanishes; he hears birds singing where there are no birds; and, before he realizes what has happened, he is saying, "I do."

Then the roof falls in.

Having got him securely hooked, his dear little "ducksie-doo" turns out to be 110 pounds of dynamite, with a nice turn of speed and a deceptive curve on a flying plate. Shedding her skin like a snake, she strews tacks on the floor and traps her unwary, milk-returning, shoes-in-hand, sock-toed breadwinner. His life becomes misery, and he doesn't know what to do about it — so he consults a psychiatrist or writes to us. We, like kind-hearted Arthur, lend a sympathetic ear.

His primaeval ancestors, of course, had no such difficulties. They used a club.

That now is unlawful simply because women have sabotaged society and have the upper hand. If you doubt this, why then is it that in the few remaining countries which make any pretence of civilization, law and order, a wife cannot sue for divorce if her husband beats her with a stick, provided that the stick is no thicker than his little finger—but no limit is placed on the size, weight or thickness of the weapon a wife may use on her husband (oh, mockery!).

Provided she doesn't actually kill him — which is considered unfair even in sporting sewing circles — she can, if the fancy takes her, beat the poor boob to a pulp with a blunt battle axe.

This, of course, is radically unfair!

Under the circumstances, it would seem that a few suggestions on how to overcome the problems of married life might not be unwelcome to the harrassed housemouse.

A careful study shows clearly that the beginning of the downfall of man can be pin-pointed to that woeful day in the dim, distant past when he became civilized and gentle, discarding his skull-cracking and hair-dragging technique in favour of the scold's bridle, the chastity girdle, and the castle keep (at whose narrow window my lady could sit and

5

weep for some errant knight).

And the result of this kindness? As the world has recently found out, appeasement has no end—particularly when dealing with a woman. Even at the beginning of the century a wife knew her place and there was always a horsewhip hanging around on a wall somewhere, a convenient, if unintentional reminder of what would happen should she be forgetful. Married life was peaceful in those days — peaceful! — No nonsense!

But the invention of the automobile put an end to that. With rattles, noise, and foul-smelling smoke it brought mayhem to the Manor, and gave woman the chance she had been waiting for.

The horse was forgotten.

No longer the mellowed peep of the feasting sparrow sounded in sweet symphony to the clip-clop of hoofs on cobble stones. The coach house became the garage; the stable, a greasy workshop and junkshed, in which the ghosts of Boxer and Don and Dolly could whinney and kick in vain for the loving slap and the lump of sugar from the master.

The whip unused and covered with dust, rotted — until at last it was thrown — and with it man's mastery over woman — into the ashcan.

Man the "MONSTER" became man the mouse.

Relentlessly following up this tactical gain by church-burning and jabbing policemen with hat pins, the Suffragettes had little difficulty in consolidating the position by getting votes for women and equal rights made official acts of Parliament and Congress. But by equal they meant equal with man as he had been: Man the "MONSTER" — NOT man as he now is man the mouse and the mouse being a mouse couldn't see it.

The solution, of course, is to begin putting things back on an even footing.

Unfortunately, there's a slight snag, for though a whip in the great hall of the old baronial homestead would be in good taste, in this machine age it would look a bit odd on the wall of a 1½ rm. apt. wt. utl.! (But perhaps not too odd at that.)

However, when all is said and done, the majority of women use the fog-horn apparatus as their main weapon, and this alone can be too

completely nerve-shattering. To stop it, all that is needed is an effective gag; it's really as simple as that — so why not do it?

Women, and the extremely odd male characters that come to their

support on all occasions by championing mothers' meetings, civic groups, and other quaint collections of wild fowl, will immediately howl in protest that the suggestion is an outrage. A gag to them is brutal torture because the mere thought of being unable to blither is absolute agony.

In actual fact, a gag is nothing of the sort. If you don't believe it, try one on yourself. Get used to a gag, fair maiden! Remember that famous saying: "What *Bizarre* begets today, fashion features tomorrow."

Although now we admit that the very suggestions of such a muted existence will cause violent indignation and threats of reprisal, this idea of ours, like the U.D. skirt, is bound to catch on like wild-fire once the fair sex sees the possibilities in design of the tricky gadgets which will be worn. What woman could bear to be out of style?

Be prepared! Shortly you will see "matching scarves" featured as an accessory must for every dress, costume and gown—their sole purpose, of course, being to cover the gag, should the material used in that clash with the general colour scheme.

And so that blissful day will come when every female from the age of two goes about in silence— an enforced silence it's true but still!—silence! What peace!

Once more, home will be in truth "Sweet Home." Attorneys who make divorce their business will be on relief or become ambulance chasers; the yellow press will start featuring the sins of the newt and the love-life of the bollweevil

(*Continued on Page* 10)

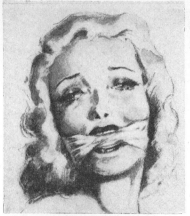

"Burlington"

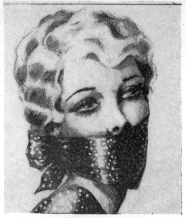

"Perfecto"

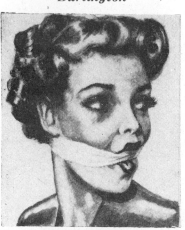

"Nautilus"

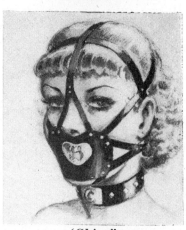

'Chien"

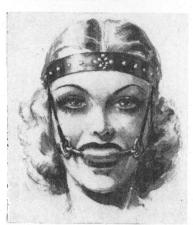

"Roehampton"

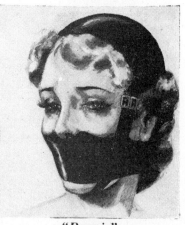

"Beanie"

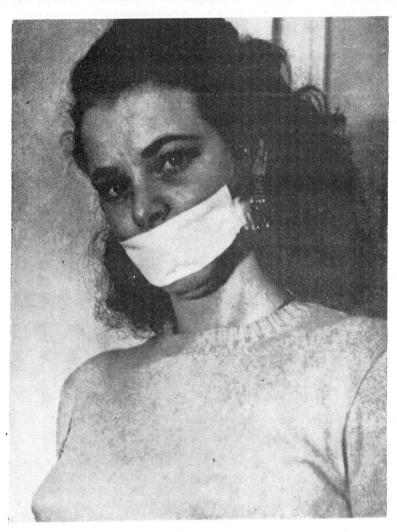

Peace Perfect Peace

"*a la Nautilus*"

"Yashmak"

on page one; and the happy home-coming breadwinner on Friday nights will be greeted by a sweet vision holding out to him a cute little arrangement, cooing: "Look at this lovely gag that I bought today, darling, and it only cost . . . oh, so little! Please put it on me." Disarmed by this delightful gesture (should we say submission?) the poor boob will forget to tie her hands, and so a slender loving arm will go around his neck as he adjusts things, whi'e the other quietly extracts the wallet from his pocket . . . as usual.

And now a brief description of the few designs we show here.

First of all, there is the "Albemarle," recommended with the "Nautilus" for those with light purse strings. This chic ensemble features a suitable pad in the mouth held in place by a scarf, nylon stocking, or what have you. Beside it we illustrate the "Perfecto," as are called all ensembles which include the matching scarf. (This title, oddly enough came from our typist, who, the first time we tried it on her, said, "Perfect! Oh!. . . ." and then nothing more for the rest of the day for obvious reasons.)

The "Chien" carries out the muzzle motif of the Mastiff or Peke. Quite stunning in red kid with chromium-plated rivets and chromium monogram — or name-tag.

The "Beanie," the "Ultra" and the "Yashmak" (worn over a "Nautilus-au-naturel") really need no further comment, except that the zipper on the "Ultra" is most convenient to cut short an argument.

Then, of course, for the horsey set, there is a vast range following the lines of a bridle and bit (the latter padded or studded to choice). The "Newmarket," the "Hialeah," the "Roehampton" (shown here), the "Longchamps," the "Flemington" and many others. A delightful touch with these — as with the collar and leash of the "Chien"— is that reins can be attached. In fact, we will probably find the old-fashioned hitching posts in miniature form studding every bar and hotel lobby.

With the "Nautilus," adhesive tape, folded or padded with face tissue at the back of the neck to avoid hair entanglement, is pulled across the corners of the mouth, pursing the lips together sideways between the teeth into a not unattractive fish-like shape. (It is therefore referred to in some circles as the "Billingsgate," the "Spey" (*North of the Tweed*) or the "Fulton" or the "Fisherman's Wharf"). A very small pad such as a nylon stocking or small handkerchief is then in-

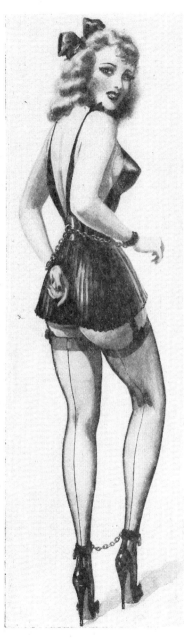

serted between the lips, the tape preventing it from entering the mouth, and the whole bugle trap finally well sealed with more tape. Heavy make-up and lipstick to give any desired shape of mouth may be applied if desired, and in this form, the gag is known as the "Nautilus-au-naturel."

Should your taste run to the more elaborate, there is the "Branks" or "Scold's Bridle" in which the possibilities of fine wrought-iron work and novel design are almost unlimited. Exquisite jewelled models will be featured by Tiffany and Cartier's while cheaper styles will be on sale in all bargain basements and Woolworth stores.

But sometimes, we must remember, it is not convenient to have a wife silent, yet one who nevertheless must be unable to indulge her pot-throwing, face-scratching propensities. So, for this reason, we offer three creations: "Ninnette," "Nini," and "Ninon." The subtle touch about these being that the long sleeves are joined from shoulder to wrist by a sort of cape. The

"Ultra"

"Andromeda"

11

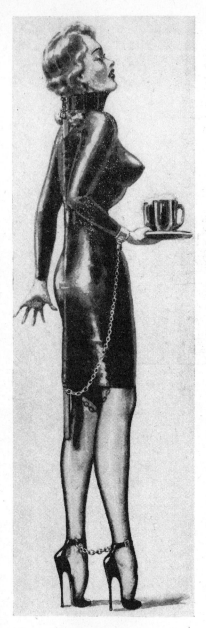

"Cleopatra"

skirts, long or short, are extremely tight, and thus Madame is considerably handicapped.

The picture of "Ninon" shows clearly how essential these models are at the breakfast table. In fact, it is advisable to have several which will be worn instead of a nightgown to sleep in to ensure that no argument takes place on arising.

Of course, as soon as the commuters have made their mad dash for the 8:15, there will be another unanimous mad dash — or rather hobble — everywhere — to the house next door, or the next apartment, so that Mrs. Jones can help Mrs. Brown out of the thing, and vice versa — a change into a robe allowing more freedom of action being indicated to enable the housework to be accomplished with greater ease. Of course, if the zipper is fastened with a padlock, and the old man has the key, that's a different matter.

Perhaps you prefer the simple chain of the "Andromeda?" Observe the chain sliding through the belt ring giving considerable freedom of action; or the "Cleopatra," which consists of nothing more than a wooden stick to which a locking collar is attached at the top end and a snap hook at the bottom. There is also a chain. Slipped up under the dress the collar is buckled round the neck, a ring at the bottom of the skirt is attached to the snap hook, and the chain attached to the wrist of the throwing arm. Most women are rotten shots with one arm anyway and quite hopeless with the other.

At this point, it should be indicated that with the "Nautilus," the

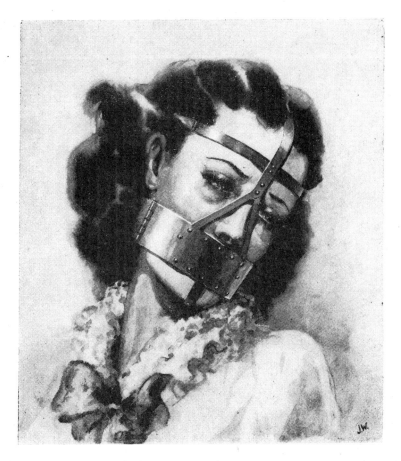

Scolds Bridle

"Albemarle," etc., Madame must be prevented from using her hands to
remove them. For this purpose, if the complete helplessness caused by a
well-knotted piece of wrist cord is not desired, there is a very simple
adjunct to a gold or jewelled bracelet; a light steel rod attached to the
bracelet extends up inside the sleeve to the armpit (like a splint), being
attached there and at the elbow with straps or close-fitting rings. The
bracelet itself, of course, locks. Madame, therefore, cannot bend her
elbow — most convenient.

It follows that a lot more readers will have a lot more ideas of their

13

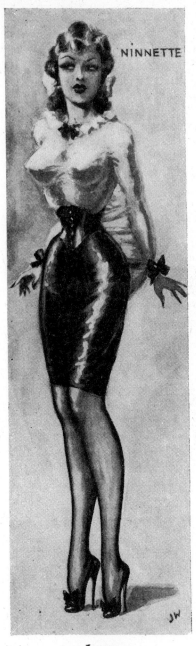

NINNETTE

1 p.m.

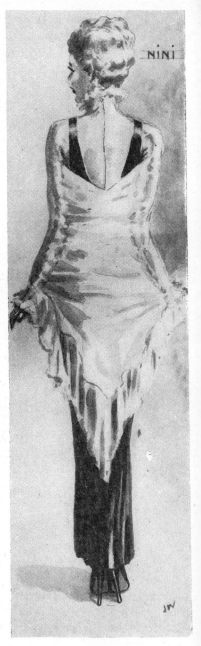

NINI

8 p.m.

14

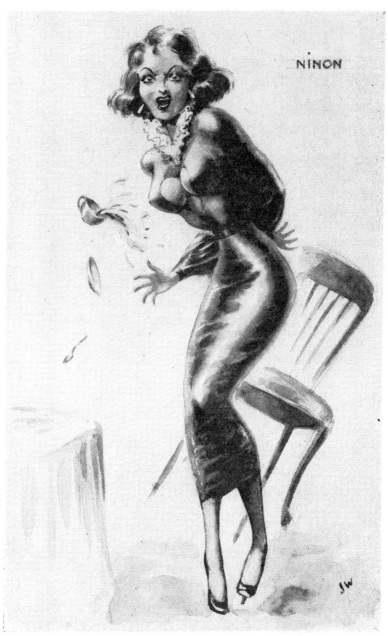

7:30 a.m. — "You and your 3-minute eggs!!!"

15

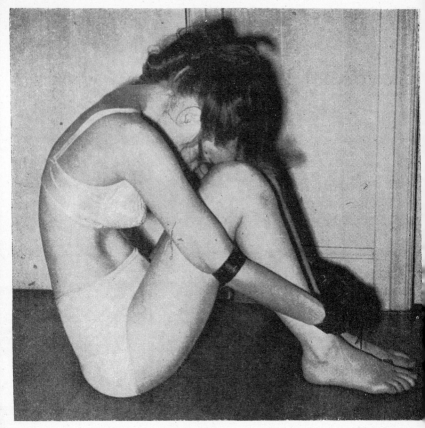

(*Continued from Page* 13)

own, such as the illustration from C L W, page 16; so, by all means, send them in and let's discuss them.

Before closing, we must in all fairness point out that all these ideas could be applied equally well to a husband. A ship without a rudder is in a sorry state and a house without one figure that can dominate in a crisis won't stand for long. If the crisis demands strong measures, then use them! And by the same token, strong measures will prevent a crisis! Yes, No?

The ancient stone (an exact copy of which heads this article) was found in darkest Africa and, besides its message, completely debunks the claim that baseball was invented by Abner Doubleday at Cooperstown, N. Y. in 1839, and was first played at Elysian Fields, Hoboken, June 19, 1846.

FOOTWEAR FANTASIA

by Sylvia Soulier

Dear Editor:

Havings seen a copy of your attractive little journal *Bizarre* it appears to me that over your side too you have readers who still adhere to many of those old time fashions of an earlier era, and I hope that a few actual illustrations of some of my own footwear may help others to know that they are not alone in their fashion fancies. I have numbered some snaps for your little journal hoping that they are clear enough for your reproduction.

The first shows my outdoor black kid lace-up shoes with their actual seven-inch heels worn with some of those American net hose. 2. Shows me ascending my stairs to my roof garden. 3. Shows that I made it with complete command of my short steps. 4. Once on the roof garden I donned a pair of the more usual nylon hose and my longest black kid gloves, (who said women couldn't stand in such heels?) 9. Shows a new pair of inch-soled gold kid evening shoes with their five-inch heels, quite dainty, eh?

Now some people assume that those lovely old-time soft kid knee boots have gone for good, may I contradict that one right away, for in 5 and 6, I show myself wearing, my softest bronze kid lace-to-knees boots. I admit that for outdoor wear the heels here are only five and a half inches high, and have brass tips on their bases for wet days, also they are slightly more of the old-fashioned style Louis heel. These boots are lined through with Cambridge blue and were made by a maker here holding a Royal Warrant which is stamped inside their linings; the sole are so thin that they may be folded completely backwards in the hand.

My next two are my very high lacing patent kid with their sheer $7\frac{1}{2}$-inch heels of bright red. These heels are, as you may be able to see, little more than the thickness of a pencil, the tips being just a quarter of an inch circle. I obviously have no difficulty wearing these around the house. 10. Shows you, I hope, that six-inch heels do not, as people suggest, make one turn over one's shapely ankles; to the con-

1

markable waist. Her favourite corset was a delicate but firm little creation made in black satin with back lacing. Its actual taped measurement was some sixteen inches round, she also had made a curved two-inch deep solid silver belt that specially fitted over this corset when it was fully laced in; this silver belt measured a dead sixteen inches and when clasped in place was fastened with a small specially made silver locket.

So dear readers do not imagine that such little reminders of a more Victorian Era have completely died out, and though fashion 1952 has not brought us back

2

trary I find they give me a feeling of good support necessary to remind a wearer that control and proper deportment are only part of fashions dictates.

The gleaming patent leather corset was made for me by a London maker, and whilst I make no silly claims to dimunitive waist measurements, believe me these give good support and are amply boned throughout with back lacing, and certainly allow little argument as to their rigidity. Worn with a smart clinging evening dress they definitely enhance one's grace and deportment.

A friend of mine had a quite re-

to the Crinolines and Bustles, we can still flit around prettily in our highest heels, enhanced by our tiny little stiff waist, and with all the elegance of our delightfully attractive long, long black or coloured kid gloves with their tightly buttoned little wrists, looking as feminine as we used to do or rather as our Grandmothers did, I suppose.

Admittedly, no one just buys

3

4

continual patience and, slowly increasing those daring heights of heel and strictly decreasing the waist before these little merciless corsets can be worn with impunity.

Dear Editor, I hope that this letter has not gone on too long, and that these few little illustrations of my own actual footwear will encourage more who secretly desire some return to a more elegant woman's era of not so long ago. Perhaps you would like me some time to write again and give you some of my experiences in attaining what I believe every woman admires, that smart look that is different without being — shall I say too bizaare for *Bizarre*.

these pretty things and gets straight into their rather irksome and dominant control without a certain amount of very irksome training first of all. *Au contraire Madame,* for if you wish to have "Chic" in such things with correct deportment — well! it's a case of

19

5

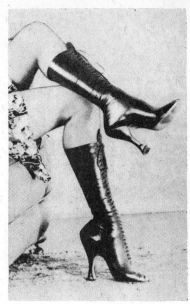

6

7

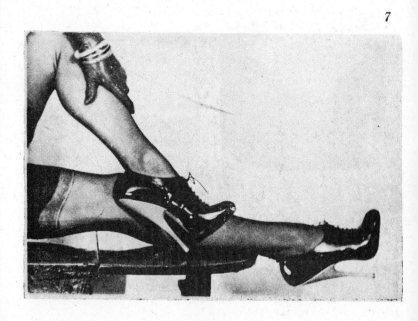

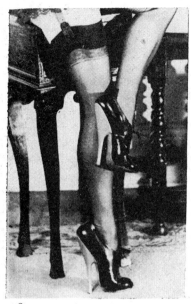

8

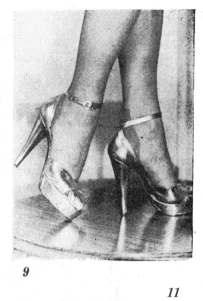

9

10

11

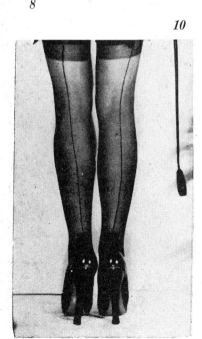

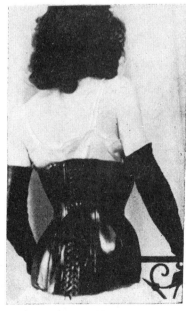

yours sincerely,
SYLVIA SOULIER

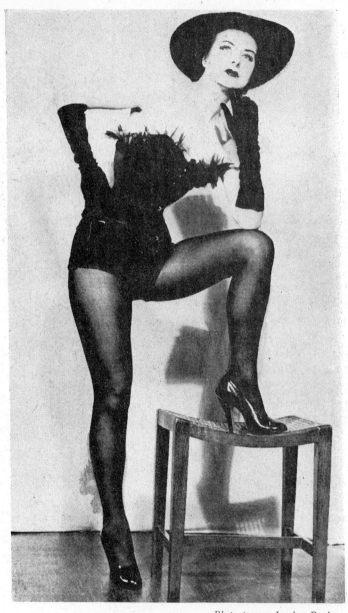

Photo from a London Reader

for that "special evening"

22

FANCY DRESS
for special evenings

A tall man in a short man's suit, and vice versa, looks extremely comical or ridiculous — depending on the circumstances — simply because the clothes were not made to fit him.

It is for this self-same reason that the average man looks out of place in so-called "women's clothing." It is not because of the frills, the nylon, and the lace, but simply because the clothing was designed for the female figure, to set off the beauty and enhance the charm of the female figure, and not the male.

From a designer's point of view, the two figures are much the same from the waist down; in fact, men in general tend to have more shapely legs—if heavier ankles and feet—than women. The shoes, the stockings and the costumes of one therefore will almost invariably suit the other. A plump damsel with massive hips and bottom looks most ungainly in slacks—so does a man. Both would look far better

"The Hunter"

 fine feather forecas

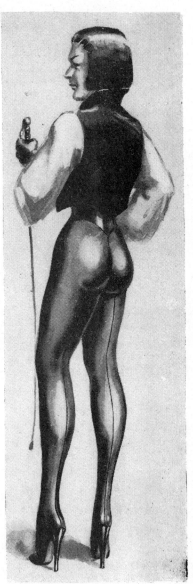

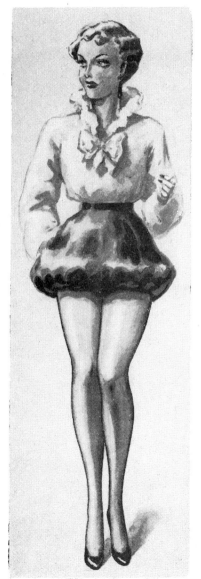

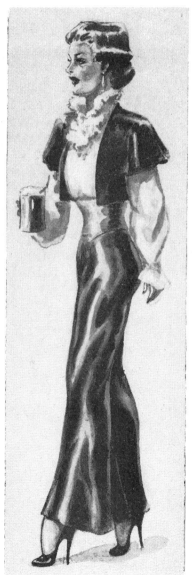

in a sarong or skirt which came half-way down the calf of the leg.

If the legs are shapely, why worry about showing them—and though trousers may possibly be warmer in winter, there is no comparison between trousers and the cool comfort of shorts or a sarong (i.e., a skirt) for summer.

So much for the nether regions.

From the waist up, generally speaking, the two figures are quite different—the man having broader chest and shoulders, and a heavier neck. Therefore the clothing designed to show off these graceful lines in a woman will fail dismally on a man—if they don't just make him look plumb ridiculous. But that's nothing to worry about. Silk or nylon is much pleasanter next to the skin than coarser material. Frills and lace can hide many a defect—and soften the appearance. Or is a man only tough by going around looking like a gorilla?

Admittedly in a suitable climate, or a warm room, nothing is more comfortab'e than complete nudity, but a great hairy chest and hulking arms aren't exactly an ornament in a tastefully decorated apartment. It may be a good idea for a man to let a woman know he has these a.tributes of robust health—and a woman may like to know it—but the better way to do that is by a practical demonstra-tion. In the meantime, it would perhaps be more gracious to show some appreciation of the lady's charm by trying to fit — from a decorative point of view — more suitably into the surroundings.

We have therefore worked on some designs for male clothing which are somewhat revolutionary because we have shut our eyes to convention — as usual — and have gone ahead with an open mind for nothing else but appearance and comfort alone.

Even the hair styles are possible —except for the bald, but there is always the toupee, isn't there?

That all but one look like rather attractive little ladies is, John Willie's fault. He gets difficult at times.

That a man wearing silks, frills, silk stockings and high-heeled shoes is not admired by women is not true. You have only to see the attention which a gay cavalier or a velveteen-clad "Little Lord Fauntleroy" gets at a costume ball. Some women like the one and not the other, maybe—but all like one or the other. Which is the way it should be.

Anyway, we would appreciate hearing from readers what they think about them—favourable or unfavourable—or any other suggestions you may have to offer.

? ? ? ? ? ? ? ?

THE MAGIC ISLAND

tale from bottle No. 5

As you can easily understand the explosion produced by this statement of mine rivalled Krakatoa.

We moved to the bar, Malua expostulating, and arguing, and getting madder by the minute. As drink followed drink, her friends joined in adding fuel to the fire, but the more they tried to persuade me to change my mind, the more obstinate I became. Fortunately, before Malua could blow her top completely and crown me with a gourd or something, a gong sounded to announce that the sale was about to begin. This quickly cleared the bar.

Full of cheer I followed Malua, who stamped ahead in silence, sparks flying from her eyes, and her nostrils breathing fire. Without a word she plunked herself down on one of the tiered benches around the arena and gave her sarong a tug as if to keep it clear of vermin as I took my place beside her.

The show began with a lovely girl, encased in gleaming black leather from neck to toe, marching to the centre of the ring, her jewelled heels flashing in the sun.

On each side of her, keeping step, were two others similarly attired in red leather, each carrying a jewel-studded horn, on which as soon as they halted they blew a fanfare. The girl in black then took a couple of steps forward, the leather, which fitted her like a second skin, showing every line of her body, and in a loud voice announced the terms of sale, rules, regulations, and so on. There was another fanfare on the horns and the Parade began.

It really was a terrific show, and I was so spellbound that all I could do was just sit there and watch as, with halter held loosely in the left hand and quirt hanging by a loop from the right wrist, the little booted and belted grooms lead their lovely captives around, close to the spectators. The girls held themselves magnificently, walking along with just a flexing of the instep like a thorough-bred race horse, slender hands automatically twisting and straining, to get free from the cords which bound them. Whenever a playful breeze blew a silken whisp of hair across a pair of laughing eyes, and

then a delightful tossing of a pretty head would try to do what the hands could not. Hanging from the halter around the neck in front was the numbered card—not that any card was needed for Suhanee. She moved around with her hair flashing like a multi-coloured beacon, which no one could miss.

For a while she drifted along with such graceful rhythm that she even stood out from the others for that alone, and I glanced out of the corner of my eye to see Malua studying her keenly. She came nearer, and then, when dead opposite me—slump! down went one heel—throwing her head back, her lips parted and eyes twinkling as she did so.

There was a prolonged gasp of amazement all around the ring while I just about split my sides, doing my best to cover up by much coughing and blowing my nose. Malua was so mad that she didn't notice my mirth until Suhanee, on the second time around, did it again, and then gave me one hell of a come-hither smile out of the corner of her eyes. Malua, her fingers biting into my arm, started to tick me off again, caught that look, and stopped suddenly in the middle of her tirade.

She studied my face keenly, then looked back at Suhanee, who was now floating along like a gazelle once more. Then she gave my arm a vicious tug. "What have you two been up to?" she whispered viciously.

"Nothing," I mumbled, "what on earth do you mean?"

For answer Malua first kicked me on the shin with a side swipe of her heel, and then dug the tip of it into my other foot, as I jumped with an "ouch!" Nothing more was said for a few seconds but I could hear her blowing like a steam pipe. Then I got a pinch and another jab with that heel.

"Fox," she said between her teeth, "if it's what I think it is, you just wait." Then another pinch, so I quietly grabbed her hand, which immediately began to wriggle violently, and held it, putting my feet on the hand rail in front of me out of the way of those stabbing heels.

The walking parade over, the ponies lined up on the far side and then were brought out one by one, attached to a long lead line. With the groom walking slowly in a circle in the centre, each girl would break into a run around the ring, first with a high-stepping gait, then with that smooth, effortless characteristic run which I had so often seen.

When eventually it came to Suhanee's turn, I wondered what she would do, but she pulled nothing dramatic. I suppose she realized that nothing she could do could mask the effortless power of her lovely legs.

Some time ago in Africa, I was lucky to be out on the veldt and to see for myself "the flight of the Impala." The only thing I can say is that the impala had nothing on Suhanee's high stepping. It was fantastic.

Malua had remained silent for quite a while, her hand, no longer wriggling, still in mine; but as Suhanee passed, she again tried to tug it away, and failing to do so, quickly gave me a pinch with the other one.

"Jimmy, you devil," she said, "you're nothing but a low-down horse trader. "You've got a winner there, if I saw one—but the other one for your team—you'll take a toss on her. Why not change your mind? Look, you see that dark-haired one, four back from Suhanee? She's good and I've heard quite a bit about her."

The girl she indicated was certainly a stunner, with long black wavy lustrous hair almost sweeping the ground, but I remained obdurate, and the show over, the sale itself began.

For some ponies the bidding was spirited. One snow-white blonde with a greaty fuzzy mop of hair like a gollywog, and the dark-haired girl whom Malua had mentioned causing considerable attention. The latter, obviously a solid wriggler had fought the cords which laced her arms from wrist to shoulder with every turn and twist she could manage continuously, even while running, for strands of that b.ack mist had constantly crossed her face. I thought the rebellion on her part would be a deterrent and said so, but Malua pointed out that it didn't matter. A special harness was used for wrigglers from which it was impossible to escape, and that she was obviously unusually well coordinated and high-spirited for in spite of the contortions of her body in even her most violent struggles, she had never lost the even rhythm of her run.

No one, of course, except yours truly was interested in poor old "heel-flopping" Suhanee, which was just as well, for I hadn't a cent of my own and had had to tap Pop Saunders's purse strings to be able to bid at all, and so the less I had to pay back the better. There was a murmur of protest when I claimed Suhanee, the crowd thinking that I, a newcomer, was getting a raw deal, but I remarked loudly that I knew what I was doing, and that as long as I was satisfied what did it matter.

One old bloke, however, took me up on it, by leaning over and offering to lay me a hundred skins of wine to one (a skin is about five gallons) that she didn't even finish a race, a bet which I promptly and gladly accepted.

At last the sale was over and we

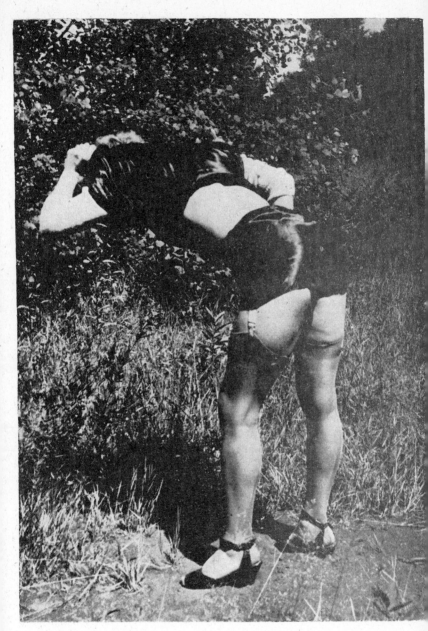

Photo from Mrs. Satin

ANTS !

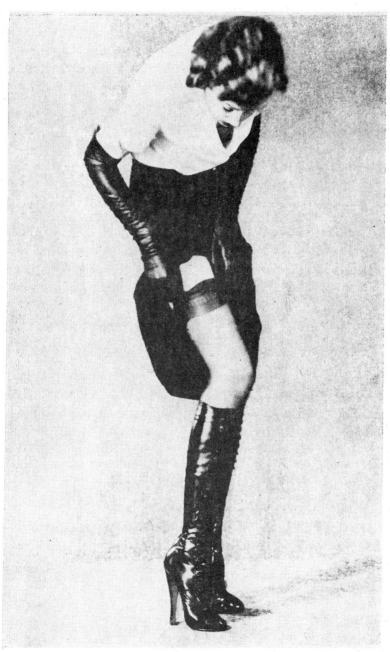

Achilles

again sauntered bar-wards where the grooms, their steeds once more tethered to the hitching rail in the stalls, went from new owner to new owner for orders and instructions.

When Suhanee's little groom approached me, I pushed my drink down my neck quickly and said I'd better see her myself, and started off at once for the stalls. There I told my lovely prize of the arrangements which had been made with Pop in regards to sharing the family stable until I got fixed up with a shack of my own.

She was obviously as happy and excited about it as I was, and kept nodding, her eyes shining, and her body squirming, her fingers stretching and clenching as if, I guessed, she wanted to do the normal feminine act of expressing pleasure by throwing her arms around my neck. This made me notice that the cord drawing her elbows back seemed to be cutting into the soft flesh pretty vicious'y. She had made no complaint, but nevertheless I thought it could be pretty uncomfortable. Then it suddenly occurred to me that I could loosen it or tighten it if I chose. She was all mine now—to be kept helpless or not as my fancy dictated — a perfectly delightful thought. I decided to ease it off, but putting my intention into practice was not too easy. The thin cord had been

passed three or four times around both arms, cleverly and tightly tied and multiple-knotted in a most ingenious manner. It took time, but at last I got it loose and as I gently rubbed the red weals which it had left on that satin skin, I heard a low "ooh! thank you" followed by a very audible sigh of relief; then slowly and gingerly she eased her arms, flexing them as much as her still captive wrists would allow.

I watched her wriggling fingers closely for a few moments to make sure that her hands would remain tied, and it occurred to me that whoever had done the tying knew what they were doing. It was very neatly and efficiently done, never shifting or slackening a fraction. I was sure that she could never get her wrists free and I told her so, and then added grinning, "but a wriggler is a wriggler, so I'm told; and in future I intend to leave nothing to chance. I just happen to be in a kind mood at the moment, Miss Mischief, that's all."

As I turned to ask the Tatt's grom what happened now, I noticed a little golden-haired girl of about 15 talking eagerly to Malua. Then they both looked up at me smiling.

"Go on, you ask him," Malua said, pushing the kid forward — then to me, "her name's Joanne,

32

Jimmy, and she wants to know if she can be Suhanee's groom."

"Is that so?" I replied—trying to look very solemn. "Are you fully qualified for that important position?"

"Oh, yes," said the lovely imp eagerly. "Suhanee and I are friends, she hasn't got heel trouble at all, and I know how fast she can run — it's been a secret — a really and truly secret secret and only she and I know it — and I haven't told anyone either—'cept you."

"Well, well, well," I answered in my most austere voice. "That is really sump'n! But can you manage a wriggler like Suhanee?" "Oh, yes!" said the child wonder, "I'm very strict! When we're training, I beat her really hard if I don't think she's trying, and I can tie her up too—really tight! She never gets free when I tie her —not even if I only tie her hands! But I like doing a lot more than just tying her hands! I'll make ever so sure she can never escape from you."

"Ah'm," I grunted. "Is this a sample of your handiwork?" and I pointed to Suhanee's wrists.

The kid nodded—all smiles.

I looked up at Suhanee. She was standing there no longer wriggling, her lips half parted and a far-away look in her eyes. "Well?" I asked her. "How d'you like the idea?"

As if in a trance, she nodded.

"Then I guess you'll do," I said to Joanne, holding out my hand which she took gravely. "Keep her in tiptop form because we've got a hard job ahead of us"—and leaving my pony to the tender mercies of this little tyrant, I followed Malua out to the parking lot.

On our way out I looked back once, and I'm damned if Joanne wasn't tying Suhanee's elbows again — dragging her arms back with all the strength of her little hands — a look of stern determination on her face.

I wouldn't have to worry about my ponies being kept on their toes and well disciplined — that was certain — but if this other one was as bad as Malua said, would Joanne and I between us be able to get her to run? It promised to be an interesting experiment.

ILLUSTRATIONS

We have not the space here for illustrations of this serial. A complete set will be printed at a later date. If you are interested, write to the Editor. We will put you on our list and will advise you when we publish them.

The Mo

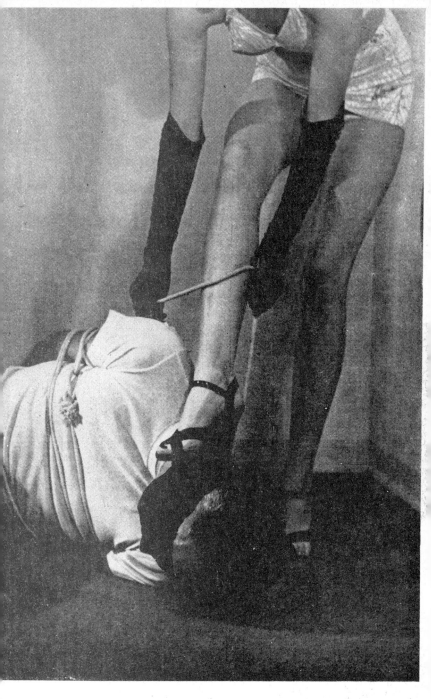

enge

THE RETURN OF THE CORSET

(we publish the following clipping without further comment)

from The "Journal American"
WASP WAIST IN WHALEBONE

By JAMES PADGITT

Hollywood, Jan. 26.—Gorgeous Lana Turner, who created a bull market for sweaters by the simple expedient of undulating before a Hollywood camera, came up today with a boost and a knock for granny's corset.

The beautiful blonde star, just up from the catacombs of a movie in which her torso was encased for weeks in a corset, said:

"It's been said that grandma never sat down. That she seldom took an afternoon nap. That her work was never done. I'm sure that is all true. Since I've had this corset on, I hardly ever sit down either."

Good for Bait

But the curvaceous star admits "girls with the hourglass figures, set off by those tiny waists, had the right idea if beau-catching was the idea."

Her co-workers in the movie agree.

Director Curtis Bernhardt beamed:

"Lana Turner in a white satin corset trimmed in lace and blue satin ribbons is enough to make anybody pine for the good old days."

Lana appears in the vintage clothes in "The Merry Widow."

Crewmen, who drop everything when they pour Lana into the corset, say that, if Lana does for the corset what she did for the sweater, a market run is assured.

Won't Come Back

The laces on Lana are pulled to a trim 21-inches. With other natural attributes, the movie moguls came up with an hourglass figure even the sands of time would regret leaving.

The assumption that Lana's corset would recreate the 1890 urge for the wasp waist, aided by whalebone, brought a scoffing report from fashion designer Helen Rose. She said:

"No chance for corsets to come back into vogue.

"Perhaps a nylon waist-pincher for evening wear; but nothing more.

"The girls of today are too active, too fond of exercise to become slaves to corset staves. I agree there is nothing more feminine than the corset, but the modern girl wouldn't stand for it."

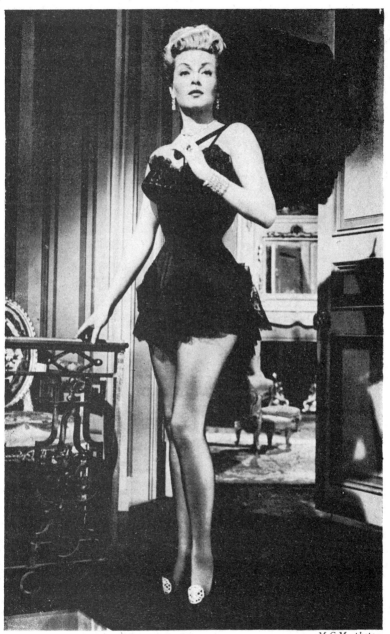

Lana Turner

37

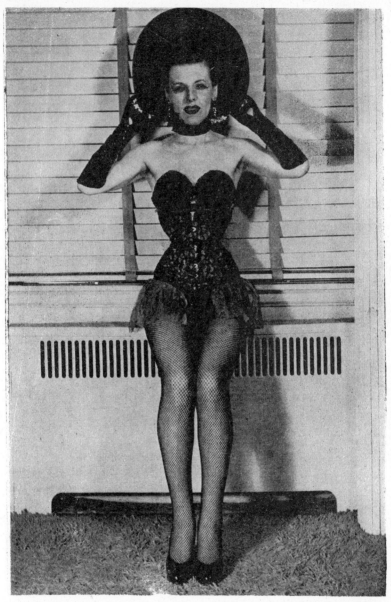

a smart corset in red satin and black lace

orrespondence

Under no circumstances do we publish names and addresses, nor do we put readers in touch with each other. If photos or sketches are sent in, please write a short commentary and please do NOT send in photos which you got from someone else.

THE NIPPED IN WAIST

To the Editor:

The English medical report on the experiment with tight-lacing and belt-constriction, as printed in No. 8 *Bizarre,* is both fascinating and extremely valuable. The figures given show that a modern girl, by means of a laced corset, can reduce her waistline to 68 percent of its normal circumference and that, by means of a tight belt, she can reduce her waist to 54 percent of its normal size. And since this was the first time the girl had tried the experiment, it is obviously possible for a young woman, by artificial constriction such as a tight belt, to reduce her waist to as small as *half* (50 percent) of its normal size! Since the average woman today has a bust of 34 inches, waist of 26, and hips of 37, we may estimate "ideal" hour-glass proportions as 34 bust, 13 waist, and 37 hips for the average woman.

Referring to the letter of R.V.F. (Raymond Ford?) in No. 6 *Bizarre,* we find that the average

corsetted waist-size of the 8 Victorian maidens cited was 14¼ inches, and the smallest waist mentioned was 11 inches. The 1945 medical experiment shows, apparently, that a tight belt can reduce the female waist to 80 percent of what a laced corset can reduce it. On this basis, the Victorian maiden with the 11-inch corsetted waist could have achieved a waist of slightly less than 9 inches with a tight belt—an amazing triumph of femininity!

However, a 12-inch belted waist is a sufficiently thrilling achievement for most women of today! No man could ask for more. Such a waist would be smaller than the average woman's calf, and only slightly larger than her neck. Let the reader take a pair of compasses and make a circle on paper with a diameter of about 4 inches (point of pencil and point of compass about 2 inches apart) and he will appreciate what a tiny tube-like marvel a 12-inch waist is.

Especially important in the Eng-

lish medical report is the fact that the girl in the experiment found the constriction delightful, and experienced very pleasant sensations in her hips and the pit of her stomach no matter how tightly the belt was drawn; that the subject delighted in the violent involuntary motions of the hips and upper torso and also liked the unsteadiness caused by the high heels worn; that the corset augmented the pleasant sensations and extended them into the thighs, as compared with the belt and that wearing high heels added to the pleasant sensations produced by the tight corset.

This 1945 experiment fully confirms the statements in the letters of Victorian maidens printed by Willett Cunnington in *Why Women Wear Clothes,* which showed that "the pressure provoked very agreeable sensations of an exciting nature" (to quote one letter: "The sensation of wearing tightly-laced stays I find most delightful, although they are so tight I can hardly breathe.")

Your correspondent, M.S., in No. 8 issue, also speaks with favor of "sleeping corsets" and remaining "laced up day and night." The Victorian maiden just quoted added: "I generally sleep in stays," and it is interesting that the girl in the English experiment "wanted to wear the corset home and keep it on all night."

Because tight-lacing and wasp waists are so thrilling and fascinating to men, and also because the nerve-stimulation and massage of the internal organs produces such pleasant and delightful sensations in the woman who artificially constricts her waist to an extreme degree, tight-lacing and the use of extremely tight belts offer very tempting rewards to the modern girl. The tight-belt fad is growing in popularity, and any feminine readers can conveniently try experiments along the lines described by your correspondent.

G. M.

Converting Low Heels to High

Dear Editor:

The enclosed photos show what can be done by way of adapting ordinary shoes to more aesthetically pleasing lines. Although I have made some styles with heels measuring 8 and 9 inches at the back, by way of attracting attention to the possibilities of the method and the manner in which Stratosphere Styles appear to cut inches off the feet of those who wish to reduce their apparent size, my chief interest is in popularizing the 6-inch heel among women in general. I should say, the average woman. The woman who is so fortunate as to be able to squeeze into a size

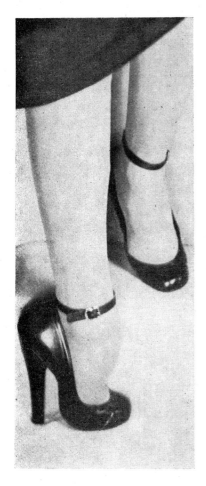

greater walking comfort they provide and the fact that the initial discomfort experienced in standing is completely overcome after a week or ten days of 10 or 15 minute saunters "on their toes." Having found 24/8 heels even more uncomfortable than 22/8 heels, the average woman concludes that a 36/8 heel measuring 6 inches at the back would be even more uncomfortable. My interest is in getting her away from this false notion so that production of the heels on a mass-producing basis will be warranted. The more of these heels I can get on the street and the dance floor, the sooner this re-education will be completed. On the street they arouse obvious admiration on the part of men, but most women seem unable to believe their own eyes! At dances they show their interest and try them on, often becoming at home in them right away. The 6-inch heel is fine for South American dances, but a bit too high for waltzes; however, they are worn even for jitter-bug by those who are accustomed to them and love the elevated feeling they give.

Sincerely, G. T.

ANYTHING CAN HAPPEN
IN BROOKLYN

Sir:

Nobody would ever see a news item about it in any of the New York papers, naturally, but that

3 or 4 needs only a 5-inch heel to round her arches forward and relieve her metatarsals of the pounding caused by ordinary heels. A size 8 need a 6½- or 7-inch heel, and fitted with such a heel, is usually judged to be a size 4 or 5.

Such heels may be expected to come into general use when more women become aware of the

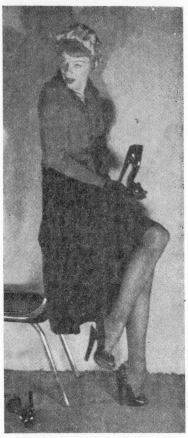

See letter from G.T.

by a leash attached to a dog collar around her neck. Her hands were manacled behind her with a chain-and-padlock device. The whole thing was being done openly, seemingly without the slightest effort to hide it from anyone the pair might meet while walking along.

The officer almost blew a fuse, according to private information reaching me, until the fellow told him he was merely disciplining his bride—who immediately confirmed the explanation. I am unable to report on the nature of her offense, unfortunately.

The cop scratched his head—you can visualize him wrestling with that one!—and finally decided the matter was outside his province. Not a single law he could think of was being broken.

He told his wife about it. She told my wife. K. van K.

Lucky Stiff

Dear Sir:

Brooklyn policeman who started to make an arrest in Prospect Park one evening recently, but decided it was a private matter after all, learned something new anyway. At least it was new to him.

What the cop ran into on a comparatively deserted section of the park, a thinly wooded tract, was a young fellow leading a pretty girl along one of the pathways

I have a weakness for pretty legs. About the only movies I will go to see, for instance, are the musicals in which the Grables and the Hayworths and the Havers, not to mention the pretty chorus girls, get a chance to show off their opera hose.

However, the prettiest legs I know of are attached to my wife. Fortunately, she knows it; knows

also my fondness for a well turned knee and a shapely thigh, and is not averse to pleasing me.

When we are going out together, it is my delightful duty to put on and adjust her opera hose. She begins dressing by putting on what she calls her "display" underwear. This consists of a very powerful uplift brassiere and, instead of ordinary underpants, she wears what is called a "dancer's belt." This is made up of a wide band of elastic that goes around the waist, while a fairly wide strip of heavy shiny satin is attached to the lower edge in front, going down, getting narrower as it goes, under her body, and up to join to the elastic waistband in back. Of course, it fits like a second skin and is tight enough to make sure that her diaphragm is held absolutely flat. She has several pairs in white, flesh and black, on nearly all of them the satin part is attractively edged with matching or contrasting lace. The final effect is very feminine and very—shall I say—Streamlined?

When these undies are on, I am called in. My first job is to adjust the shoulderstraps of the brassiere. The usual thin straps Cathy replaces with a much wider ribbon, so that I can pull them up very tightly without cutting her shoulders. The effect, needless to say, is to pull her naturally full and

shapely bosom up extremely high. The result is both youthful and startling.

Next I help Cathy to sit up on the chest of drawers. Once in place, she folds her arms behind her, where they won't get in the way, and I start to put on her stockings.

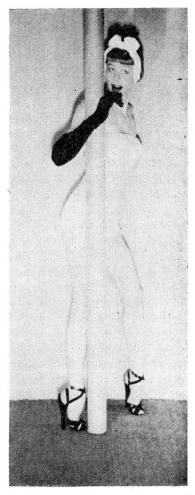

See letter from G.T.

43

I slip them on over her very shapely little feet, and on up to her knees. Then I get the shoe-horn and put her shoes on. My wife is very vain of her small feet, and wears the smallest shoes she can squeeze into—size four for special occasions. She never wears low heels, claiming they are bad for the arch; and when we are going out together, she always wears at least a four-inch heel.

Shoe on, I lift her down, and put on her special opera-hose suspender belt with four suspenders to each leg. Then I pull up her hose, attach them to the suspenders and adjust the latter so the stockings are pulled up to just short of bursting-point. If she gets a runner, that's my responsibility—and my expense. But better a runner than a wrinkle, is the way I look at it. Besides, while we're out, Cathy carries at least one spare stocking in her purse, just in case.

My duties are over at this point, but we always have a kiss before Cathy is allowed to unfold her arms. With me out of the way, she does her hair and make-up. Without make-up, she is not very striking, as she has little natural color. But she has excellent bone structure, and when she has finished with the rouge, and eyeshadow and mascara and so on, she is really terrific.

Make-up complete, she puts on her dress and accessories. Then comes the hat and gloves—these last extremely tight fitting—and with her coat over her arm, she comes floating out into the living-room where I am waiting.

At this point comes what is, for my money, one of those things that make life worth while. Tossing her coat down, Cathy gathers up her skirt in her gloved hands until her suspenders are generously displayed. Then she parades back and forth in front of me, like a particularly lovely mannequin. We justify what we call her "leg parade" by saying that it is to give me a chance to make sure that her stockings are adjusted properly; no wrinkles, seams at the back straight, and so on; but we both know what the real reason is. After all, Cathy is a young and lovely wife, and I am a young and loving husband.

Leg Inspection over, we go out. Her progress down the street is frequently punctuated by expressive whistles. For one thing, I insist that all her skirts be cut tight enough to keep her stride very short and to outline her legs—plus the fact that she has all her skirts at least an inch shorter than the prevailing fashion. For another, there is that breath-taking bust. Cathy is very proud of it, and has her dresses shaped to stress its outline. She has one very plain black

crepe dress, for instance, that fits over the bosom exactly like a brassiere. And as the skirt, in addition to being short and tight, has a generous slit up the front as well. . . .

While we are out, my wife is always thinking up ways to give me a pleasant view of her legs. In the car, for instance, she simply pulls her skirt up all the way—explaining, of course, with a shy little smile, that "it's more comfortable, if I don't mind." In the movies, we try to sit so we cannot be overlooked, and pretty soon that skirt is creeping up again. Cathy is blissfully "unaware" of what is happening, of course, because she's so busy watching the screen. If we happen to be alone, say, waiting for an elevator, she will simply pull her skirt up and ask me to check her stocking for proper fit.

I think you'll agree that I'm justified in signing myself,

LUCKY STIFF

"MORE CORSET CONVERSATION"
Dear Sir:

My wife and I liked No. 7. We hope for more emphasis on corsets and figure training in future issues. My wife disagrees with your statement on page 39. She says there is no substitute for corsets in the process of figure training. And adds that there are still a few competent corsetieres in this country and several abroad who know how to make fine corsets in the various shapes of the 1890-1910 era. She will be glad to supply names and addresses on request.

Sincerely, D. K. P.

"BLOOMERS FOR MEN"
Dear Sir:

I wonder if it has ever occurred to you that not all the members of your loyal "bloomer brigade" are women. With me, it's just a hobby as ordinary as collecting stamps— and when I dress like this for pleasure, I wear bloomers and enjoy them more than any other part of the costume.

I love their soft feel next to my skin, and with them I usually wear a pink slip, with lace at top and bottom.

Fact is, I even wear bloomers under my male street clothes, and have for years—though I spend most of my time in skirts, at home. I'd wear these clothes all the time, if I could, but one look would tell you that I would not get far if I tried it in public.

How did I get this way? I don't know. I have preferred and worn female underwear as long as I can remember—all the time—though I don't think it's anybody's business but my own. I just happened to like it.

When I was a kid, I had a sympathizer—my aunt who raised me, and I told her quite candidly that

45

I would like to wear girls' clothes. She agreed, and I spent the happiest six years of my life living as a girl, until I got too masculine to get away with it any longer. In those days, I wore silk bloomers all the time, and never got over wanting to wear them. So, I still do. So there.

B. J.

And your friends don't mind and the rest don't matter. Ed.

BLOW BLOOMERS BLUE
Dear Sirs:

More congratulations for your grand magazine.

In support of your correspondent on "bloomer" fans. I would like to add my approval and delight of this very effeminate garment, and hope for more illustrations of it.

My experiences as a schoolgirl with bloomer fashions may interest your readers.

One day our form mistress lifting a pile of books to give out to the class, caught the hem of her short skirt in the books, and behold a beautiful pair of pale blue bloomers, carefully embroidered with floral designs in a deeper shade of silk. The elastic at the legs had been exchanged for ribbon, which was tied in a pretty bow in front.

A short gap of flesh, and the tops of her black silk stockings gave a beautiful finish to the effect. I gasped loudly with admiration

and was promptly ordered to the front of the class. The mistress set the books down, her skirt falling into position, she totally unaware of her brief exposure. I was asked to explain my conduct, but hesitated knowing how ably she handled her cane.

"Very well, you can stand in the corner and remain behind after classes, perhaps careful meditation will make you explain yourself," she said.

My meditation consisted of standing erect, facing the wall, upon which hung the cane, revered by all.

After classes, I was again asked to explain my unlady-like exclamation. All the excuses I had thought of would not have saved me some punishment so I told the truth and explained what had happened.

"How dare you!" she gasped, and reached up for her cane, revealing once again the ribbon clad legs.

I was held over with one hand my skirt and bloomers whisked aside with the other, and in that position soundly whipped. It was the first time my mistress had caned me in private and without the protection of any undergarment. My sobbing did not lighten her stroke.

The next day, the form mistress' beautiful bloomers were in the news again.

46

During the time she had been taking her morning bath, someone had played a joke on her, and stolen her bloomers, leaving their own black school panties in place.

When the mistress informed the class of this prank, she glared at me, and I wriggled painfully on my chair.

No girl offered to admit the joke.

"Very well — you will all stand on your chairs, and raise your skirts above your waists, and if I find any girl in lingerie other than the school dress, she will kneel over my chair and receive the soundest whipping of her life." She was certainly very annoyed.

We all obeyed, and amidst the sea of 23 pairs of black bloomers the pretty pastel blue pair shone out.

The mistress was as good as her word and the culprit was lectured and ordered over a chair before the class.

We all had a wonderful view of those thin silk drawers as the girl was positioned by the teacher, and all the time the girl had not appeared as nervous as was usual at punishment.

The caning was very severe, and it surprised us all, that the victim did not cry out until the seventh stroke after that she sobbed loudly with each stroke.

In the dormitory that night the girl proudly showed her weals, and said she had accomp'ished her ambition. To be caned across a pair of silk bloomers, and she had purposely taken the mistress's, knowing she would be caught. She admitted that the caning had been more severe than she wanted. But that the first six strokes had thrilled her.

Later I was sent for by the mistress.

She thrust a handful of silk toward me—the blue bloomers, and said:

"The other day you made an exhibition of yourself, unbecoming to a lady. As an additional task you may take my lingerie, that you so admired, wash and iron it, and fetch it to me for inspection. If I am not satisfied with your ironing of the garment or ribbons, you will be called to account—painfully."

I was overjoyed and that night paraded the dormitory in them to every one's envy, and finally crept into bed and slept in their luxuriousness silkiness.

The following day I carefully washed and ironed them.

My first ironing did not really meet with her approval, but the punishment I got was extremely light for such negligence with so beautiful a garment.

It was worth all my trouble, when I next glimpsed the mistress's silken bloomers as she sat at

her table, legs neatly folded.

Have any of your readers any pleasant recollections of school days?

Perhaps this is too long to publish. I hope not.

<div style="text-align:right">Sincerely,
Jean R.</div>

Knock-Knock

Dear Sir:

In reference to ancient punishments.

Thomas Ellwood, visiting Bridewell in the 17th century, when it was under the care of "two honest, grave, discreet, and motherly women," Anne Merrick and Ann Travers, was taken into a room where "the walls being laid all over from top to bottom in black, there stood in the centre a great whipping-post, which was all the furniture it had." He relates how "the manner of whipping there is to strip the party (often a woman) to the skin from the waist upwards, and having fastened him to the whipping-post, so that he can neither resist nor shun the strokes, to lash the naked body with long but s'ender twigs of holly, which now bend almost like thongs and lap around the body, and these having little knots upon them, tear the skin and flesh, and give extreme pain." Years later, Ned Ward corroborated this practise in Bridewell courtroom, when he saw a young woman forced to strip to the waist and whipped severely till the master of the tribunal dropped his hammer. Such is the origin of the old Bridewell cry, "Knock, good Sir Roger, knock!"

(Paraphrased from Alfred Copeland, *Bridewell Royal Hospital,* London, 188, p. 71, 75.)

English Pedagogy, II, p. 336 ff., has accounts of punishments in English schools of many kinds, while the records of charity schools, and the reminiscences of old pupils, contain strange instances of deportment devices.

<div style="text-align:right">Sincerely,
Gewa</div>

For the U.D. Skirt

Dear Sir:

I think the upside-down skirt idea is really something. I tried this same idea out about five years ago—or at least the same thing in effect. Mary and I packed a lunch and a basket of iced beer and set out for a Sunday picnic. We found a nice secluded spot—spread out some blankets—got out the lunch basket and the beer bucket—and then I went to the side pocket of the car and got out and old tee-shirt and a 4-inch leather belt. I pulled the sleeves inside the shirt and then slipped it over Mary's head. She folded her arms tightly around herse'f and I drew the shirt down and buckled the belt tightly around her waist—with her arms securely fastened inside the shirt. Since it was a hot summer

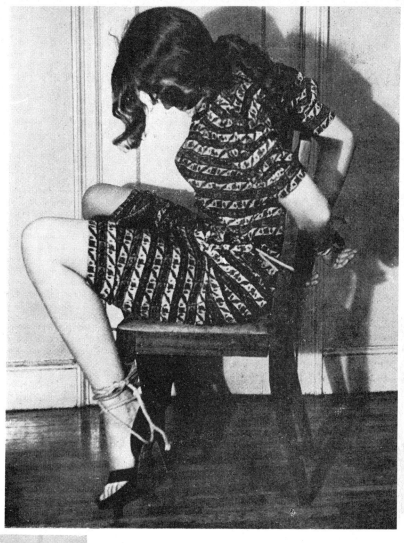

DON'T LET THIS HAPPEN TO YOU

learn jiu jitsu
and the art of
self defense

SWAG

day, she was wearing very brief white shorts, and she was most adorable and desirable in her helplessness. I fed her sandwiches and beer and kisses—and I don't know which one enjoyed it the most.

Yours,

J. D. J.

THE LATEST 4-H CLUB
High Heels Happy Homes
Dear Ed.:

My experience with high heels may be of interest to others. Husbands are, as we all know, more or less polygamous animals and if they are not too strict or too primitive, they will look out for pleasures on the side, if they cannot get at home what they like. I think that more men are fascinated with high heels than most of you would suppose, they just do not talk about it. My husband likes, with all beautiful things, natural or artificial, beautiful women with custom-made, six-inch high-heeled shoes.

Before we married, he was under the spell of sirens who gave him the pleasure he did not find with his first wife. I have always liked shoes and boots with very high heels for my own delight, but I am not a "slaverette" nor do I like to be whipped and tortured, I just love these things and so does my husband.

When he comes home from the office, he is always pleased to see me in gorgeous silk pajamas and custom-made, six-inch high heeled shoes of all designs and colors, generally designed by himself and built by a skilled shoe maker, and our marital relations were always adorned with these attributes.

For special evenings (with champagne and lobster) in our home I have the following outfit: First of all a pair of very high boots with 6-inch heels made from the finest gold kid skins. They have an invisible zipper and are held up taut with elastics from a corset-girdle, made from gold snake skins. The brassieres are made from the same material with nipples made of a cluster of small synthetic rubies.

Above the girdle I have a black satin skirt, or at times panties made from black kidskin. My gloves, almost reaching to the shoulder, are of gold kid.

I know that nowhere else could my husband find so much of what he likes and all for him alone!

After 20 years of happy marriage I have maintained my full youthful figure and appearance and nothing has changed. We love each other as much and more than the first day. No longer is my husband interested in other women, and we both adore each other.

This is not just one experience of 1952. Almost 200 years ago, the French Novelist Restif de la

Photo from Melissa

*Of course you must know the story of
the old lady who fed her cats on cheese?*

Bretonne (1734-1806) wrote in the introduction of one of his many books, "Le Pied de Fanchette," dealing with life in Paris in the 18th century and the beauty of high heels:

"Sometimes very little is necessary to bring a man in love up to his ears. If it is a natural charm, it las s as long as it is young and fresh, if it is artificial, it will last for the whole life."

And: "There is probably nothing more voluptuous than a white shoe with a high, slender heel, accentuating the beauty of the ankle."

Remember, sisters, this was written almost 200 years ago. Therefore, if you want to keep your husband, better join the 4-H club! Never present yourself to hubby or shuffle around the house in heel-less sloppy slippers. They are poison for a happy home and a happy marriage with a refined, sensitive man.

MELISSA
or: Militta (*Greek for "Honey"*)

A READER TAKES A POLL
To the Editor:

It recently occurred to me to inquire what modern parents think about the upbringing of girls in relation to the fashion picture, and I therefore asked five married couples of my acquaintance to answer a questionnaire on the sub-ject. These ten men and women are all between 25 and 36 years of age, and so probably represent enlightened contemporary opinion very well. The results might interest your readers. The questions and answers follow:

At what age should a girl be encouraged to paint her fingernails and toenails? Three said at 6, four said at 8, five said at 10, four said at 12. The vote favors the age of 8.

At what age should a girl be encouraged to use lipstick? One said at 8, five said at 10, four said at 12. The vote favors the age of 10.

At what age should a girl be encouraged to smoke cigarettes? One said at 10, four said at 12, three said at 13, two said at 14. The vote favors the age of 12.

At what age shou'd a girl be encouraged to wear high heels? One said at 12, four said at 13, three said at 14, two said at 15. The vote favors the age of 13.

At what age should a girl be encouraged to wear earrings? Two said at 10, five said at 12, three said at 13. The vote favors the age of 12. (Italian and Negro mothers commonly decorate their infant girls with earrings, but my couples were all of English or Northern European descent.)

Should a girl have her ears pierced when she wears earrings?

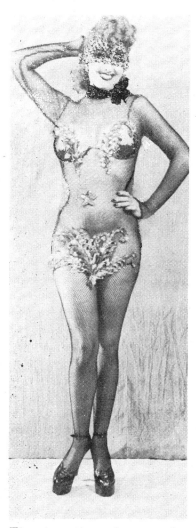

The photo above shows not just "tights," but an entire costume of elastic nylon mesh. The decorations are, of course, added by the wearer. It can be obtained at most theatrical costumers. Unfortunately, the demand seems to exceed the supply.

Ten said yes, none said no. The vote is unanimous for pierced ears.

At what age should a girl be encouraged to use eye-makeup, mascara, eye-shadow, and eyebrow pencil? Two said at 13, three said at 14, four said at 15, one said at 16. The vote favors the age of 15.

Should a teen-age girl use lipstcik lavishly and vividly, or with moderation? Six said lavishly and vividly, four said with moderation. The vote favors the lavish and vivid use of lipstick by teen-age girls.

Should a teen-age girl use eyebrow pencil as a supplement to her eyebrows, or should she shave off her eyebrows completely and replace them by pencilled brows? Six voted for supplemental eyebrow pencil, four voted for completely shaved eyebrows. The vote favors real eyebrows supplemented by eyebrow pencil.

Should high schools and junior high schools allow boys and girls to smoke on the campus? Ten voted for smoking on the campus, none voted against. The vote is unanimous in favor of student smoking on the campus.

Should high schools allow girls to wear snug sweaters in the classroom? Seven voted in favor of permission, three voted against. The vote favors allowing girls to wear tight sweaters in high school classrooms.

Should high schools allow girls to atend classes in bare feet (without either shoes or socks)? Six voted in favor of permission, four against. The vote is in favor of allowing girls to come to school in bare feet, minus both shoes and socks.

Should high schools allow gir's to attend classes in shorts? Six voted in favor of permission, four against. The vote is in favor of allowing girls to come to school in shorts.

Should girls be allowed to attend classes in slacks? Eight voted in favor of permission, two against. The vote favors allowing girls to come to school in slacks.

Should girls be allowed to attend classes in dungarees or blue jeans? Ten voted against permission, none in favor. The vote is unanimous for prohibition of feminine dungarees in school.

Summing up, enlightened modern parents favor girls using red nail-polish at the age of 8, using lipstick at 10, smoking cigarettes at 12, wearing high heels at 13, having their ears pierced and wearing earrings at 12, using eye-makeup at 15. They favor teen-age gir's using lipstick lavishly and vividly instead of with moderation, and they favor real eyebrows enhanced with eyebrow pencil instead of completely shaved eyebrows. They favor high schools and junior high schools allowing students to smoke on the campus and in special smoking rooms, but not in the classroom. They favor high schools and junior high schools allowing girls to come to school in slacks, or in shorts, or in snug sweaters, or in bare feet, but not in blue jeans or dungarees.

Yours truly,

GERALD MOULTON

MONEY MAKER AND MAID

Dear Editor:

"Ursula" and "Slaverette" remind me that I have facts that are much rela ive. I have trained my husband to really fear, respect and love me; he has through my efficient training become the perfect ladies' maid.

Immediately upon arrival home from the office at 4:00 P.M. each day he must go to our bedroom where there are awaiting him is his French Maid's outfit, high-heeled slippers, long silk black hose, very fancy garters, a wig of beautiful long hair, a lace petticoat (not slip), very lacy ruffled panties and a short black satin dress, apron and cap (frilly), he puts these things on and is ready for his duties. He must do all the house work and he must obey me without question.

For disobedience I use part of "Ursula's" method, that is, I make him stand in the corner and medi-

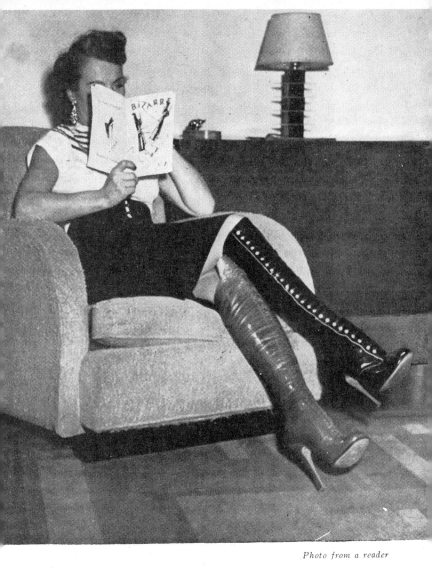

(*Continued from No. 9, page* 31) **"but, of course! —**

and I've got another pair just like these."

tate, after a good while at this he must go to the closet and bring me the heavy black strap. I use the strap with much energy and I use it in the good old fashioned way so as to cause much "beneficial humiliation," of course, I also have a switch and a hairbrush.

I tell you I have an obedient husband and he adores me.

On week-ends he dresses this way straight through as my maid; on Sunday he is laced tightly into a corset and you should see him dance attendance upon me, if he don't dance attendance as my maid I see that he dances to the tune of my switch.

We are a happy couple, I assure you!

Sincerely,

ELSA

RUFFLED REPENTENCE
Dear Editor:

"Petticoat punishment" took me back. I was raised by a step-mother and a two year older step sister. When I was 16 I was getting a bit out of hand and I received often from that time on until I was 21 (once for a whole summer's vacation) what they called "Ruffled Repentence" I was dressed in my step sister's most lacy and ruffled garments and I had to go out in the yard and face all her girl friends, what fun those girls had! The worst part of it was my short dresses and the very

frilled lace panties I had to wear.

It sure cured me of being a tough bully!

I got so I liked the dainty garments, but it was always a humiliating punishment and I begged and begged to get out of it but never did, I also received old fashioned spankings which made me all the more punished due to my girl's clothing.

Yours truly,

BILLY

CORSET CONSCIOUS
To the Editor, Bizaare
Dear Sir:

Your correspondents keep asking for the experiences of genuine corset wearers, and as I have been one for very many years you may care to publish this letter. I came of a very corset conscious family; my father, a Guardsman, wore very small waisted corsets and my mother was famous for her very tiny waist (she had corsets in all sizes down to thirteen inches), so my two sisters and I were accustomed to tight corsets from an early age, and we wear them still; my sisters in the early 1900's had waists of 16 and 15 inches, and today they wear specially made corsets both measuring 18 inches over them; I was laced unusually tightly from a child, so that I have a full bust line and my waist today is nineteen inches over my corset. I used to be laced to sixteen inches

56

as at one time I was dressed as a girl, and but for the early death of my father in an accident, I expect I would have been trained as a girl for always; now I dress as one when at home and my sisters and I are often taken as a girlish trio. I wear a corset at night always as I do not like the feeling of being without one; it is high and deep, covers my bust without pressure and envelops my thighs fairly tightly; my day corsets are the same size (19 inches) but they end below my bust and come down on the hips very deep but they end just to be clear of a seat when sitting down. I wear size 7 shoes with heels 5 inches measured centrally, and I am perfectly comfortable and natural in this outfit, I can wear a higher heel but am unsteady on anything over 5 inches; my sisters wear five-inch heels also, the one with size 3 shoes looks marvelous, the other wears size 5¼ and although the heels are the same she does not give the appearance of being so high-heeled. We have several friends of both sexes who come in occasionally for an evening, or sometimes for a week-end, and we have a good time trying on one another's corsets and clothes, etc., and we all have some special corsets which are a bit trying to wear but very nice about which I may write on another occasion.

My sister Margaret says I should have mentioned that both she and Ellen can (and do often) lace down to 16 inches again, and that all measurements are taken over the corset when worn, *not* corset sizes.

Yours truly,

Damon

"On to the Revolution!

Dear Sir:

I read Frank B's letter championing the wearing of corsets, high-heeled boots and shoes, and frilly underthings for males, and as a husky five-foot eleven, 160 lb. man, I should like to thank the writer for his candidness and courage in not only discussing such a taboo subject (to the modern Puritans), but also his frank and open avowal that he obtains much pleasure and happiness in vivacious corsets and high heels.

I agree with a previous writer on the subject that what we need most among discriminating men is a clothes revolution, which would abolish the unglamorous, somber attire now worn by the unfortunate, dissatisfied male, who is still suffering from the 19th Century Puritan revolt against all that was beautiful in either nature or life.

Even in my extreme youth I was rebellious against the foolish and pernicious sex- and clothes-taboos foisted on us by well-meaning, but ignorant puritanical men and

women, who believed that everything beautiful was a lure and a snare set by Satan, and that music and dancing were also devices of the Old Boy.

Let us men, who have a true aesthetic nature, and who may call ourselves aesthetes, therefore not only continue to wear beautiful curvaceous corsets and high heels and frilly underthings, but let us endeavor to gain the support of our wives, mothers, sisters, and girl-friends, for only through their sympathy and support can we break the shackles of puritanism; only through them can we hope to emerge in the gay, glamorous attire that was the perogative of all males of the human species since the dawn of history.

GAY GARMENT LOVER

A ROSE BY ANY OTHER NAME

Dear Sir:

Since our return to U.K. over four years ago, we have continued to take a close interest in matters relating to high heels. In fact, England provides plenty of scope for lovers of high heels and we have now formed a very select club of fellow enthusiasts.

It is well in keeping with the Bizarre outlook. All our members are quite free to do just what they like, when they like and how they like.

On matters of dress the same applies. The girls are quite free to wear just what they like, but as the main object of the club is to promote the wearing of ultra high heels, the one and only exception to the free and easy dress rules is that the girls must wear high heels.

As the words "high heels" cover a mu'titude of heights, I feel it might be of interest to readers that we have gone so far as to definitely state actual heights that our girl members must accustom themselves to. Accordingly, all members agreed to observe the following: A four-inch heel is classed as a "low heel"; a five-inch heel, a "medium heel," and six-inch heels are "high heels." Size of shoe does not come into it so the smaller-footed girls are handicaped. Gayda is in this class since she on'y takes a small size 5. The rules relating to the wearing of these various heights are enforced as follows: No member must ever wear shoes with heels less than 4 inches. At ordinary club meetings a medium heeled shoe is expected to be worn (5-inch heels) and on special occasions such as a fancy dress dance or when first joining the club high heels are insisted upon for all members (6-inch heels). Failure to observe these rules means expulsion from the club.

I am pleased to say we have had no expulsions, the girls are only too keen to wear their highest of heels, and, of course, it could not

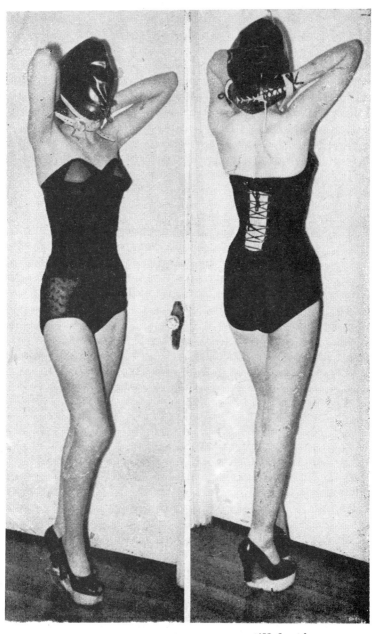

still lost!
Letter by C.L.W. No. 9

be otherwise since the whole object of the club is to provide a means of a get-together for all high-heel enthusiasts.

Apart from this one strict rule, the club asks its members to try to dress in the "Bizarre" style such as: Members are asked to tight-lace as tight as they possibly can. Nylons are to be worn in place of silk and are to be as long as possible—opera hose are the ideal. Skirts may vary in length and believe me they do. Some girls prefer the short, tight skirt and others favor the ankle-length skirt. Most members possibly overdo their make-up and I have noticed heavy gold earrings seem to be getting popular.

Taking all in all, the girls are a fine crowd and we are most proud of the exclusiveness of our club. Incidentally only the wives can be full members, husbands are only honorary members although the mere males play a large part in formulating the rules.

Well, in conclusion, I will give a description of how Gayda and Sandra (we are fortunate in having Sandra living close to us) were dressed for a fancy dress party. I'll start with Gayda from the head downwards. She went as "Night." Her hair was beautifully set, large gold earrings and a reasonably heavy make up. She wore a low-neck, white satin blouse with short sleeves. Black kid, elbow length gloves. A very tightly laced black patent corset outside of a short black satin skirt. Stockings black opera length nylons. High-heeled (6-inch heels) black patent court shoes. A black kid coatee completed the ensemble.

Sandra, in contrast went as "Dawn." She also wore gold earrings. She wore a dove grey satin blouse with short sleeves. Grey kid elbow length gloves. She was very tightly laced in. Her skirt was very short indeed and of dove grey satin. Sheer champagne nylon opera hose. Grey laced kid knee-boots with heels just over 6 inches completed her ensemble. Both girls were highly commended and certainly did us credit. In my next letter I will describe the prize winner, also some outfits of Gayda's that she likes to go shopping in.

Cheerio, Editor and all fellow enthusiasts.

"Six Inch Heels"

Note—We are changing from "High French Heels" to six inch heels.

Translated from Greek Mythology
by a reader.

I, Hyppolyte, queen of Amazona, do hereby subscribe to the following pledge by which I solemnly swear to abide on my queenly oath. In combat with the hero Jason on

the Island of the Oranges, I was overcome and conquered in fair battle with said hero. I was then bound by him, as is the custom, and became his captive to be led prisoner in bondage to his own country where I am to become his own slave—the price of defeat.

Hero asked me as to his treatment at my hands had our roles been reversed. I honestly told him that I had planned to enchain him and lead him in triumph through the streets of Amazona. My triumph and his shame would have caused me great satisfaction and joy, I said, as capturing so great a hero would have made me the greatest of all of the Amazon queens. Would such joy—if but for a time, then give you a lifetime of pleasurous memories, he asked? To my surprise, I realized that it would and so replied.

Again to my surprise he then said he was a great scholar of human nature and would, with suitable safeguards, permit me this triumph temporarily. In this way he hoped to fathom the mystery of the Amazon race, he explained. I therefore made the following agreement with him. That for 30 days he be made to appear my captive for my satisfaction. My people would understand that I had overcome the hero and brought him back as my captive in chains. After the passage of 30 days I will re-

turn with him to his land and be his slave. However, I must vow not to seriously injure or cripple him nor will I permit others beside myself to torture him physically. The populace may jeer and torment him but only I may appear to physically cause him pain. This may be done by striking or whipping or otherwise pretending to injure him but in actuality, I would cause him only slight pain, albeit the appearance and pretention of torture would pervade. He for his part agrees to add to my enjoyment by pretending pain, shame, humiliation, and the usual chagrin mixed with hatred and fear and dazed wonder usually shown by male warriors when captured by Amazons.

During the 30 days while he is to be my captive, I agree not to deprive him of sufficient food or drink. I promise to visit him at least daily in his dungeon at times when he is not chained or bound in my throne room or in my private chambers. I further agree to supply him, surreptitiously, with wine when no onlookers are present. For fear of exposure of the plot with consequent catastrophic results, I will not release him from chains, fetters or cords, even while alone but this pretense of cruelty would not prevent certain kindnesses to him should I so desire.

At the end of this period, alas, I

will lead him, without my people's knowledge, back to the Isle of Oranges, where I will according to this oath and promise, release him from bondage and again submit by surrendering myself into his possession and to his mercy. I realize full well and of my own knowledge, that for this favor done Hero, I am not to expect any recompense or added merciful treatment.

H.

We've never read this story in Greek mythology before—but anyway it's a good story. Ed.

RUBBER CLOTHING STORES

Sir:

To me there has always been something delightfully fascinating about rubber. I like its soft, rustling sound; its pleasurable and delicious feel, and best of all I like the sheer ecstasy of wearing it.

For many years I have worn rubber boots; coats; gloves and aprons with a great deal of pleasure. Lately I have discovered an even greater pleasure in a four-piece rubber suit consisting of rubber overalls, jacket, boots and gloves.

This excellent outfit is used by chemical workers who handle corrosive acids, especially that good old standby caustic soda. It is employed by all those who work around acid vats or who use acid for cleaning cement floors or kettles. Rubber is the only suitable thing to wear for such work, and manufacturers who attempted to use plastic as a substitute quickly found that it was soluble in acid and hence useless.

There is surely no finer outfit than the rubber acid suit for all lovers of rain wear. It is comfortable compared to plastic, because unlike plastic it has friction-proof

lining, thus one does not tend to perspire much. True, this suit is made for men, but it can be worn by ladies who are either medium-sized or over. For suburban or rural areas during heavy rainy weather the rubber acid or rain suit is ideal.

In Canada such a suit can be purchased from the Miner Rubber Co. This company manufactures a wide variety of rubber clothing of the best grade for diverse uses. There is also a store on the north side of Craig St. just east of the tramways terminus that sells the suit I have just described.

I disagree with R.P. when he or she says there is not much in the way of rubber clothing that can be bought on the market. The only articles of rubber-wear practically non-existent today are dress coats and capes for ladies and gentlemen, and the rubber body-boots or waders formerly used by fishermen, now largely replaced by plastic.

Both light and heavy rubber gloves, ranging from ordinary gloves to eighteen-inch gauntlets are obtainable from any of the larger rubber companies in the U.S., Canada or Britain. Consult the classified section of your phone book for name and address; then write for particulars. Large drug stores sometimes carry rubber gloves for acid work as well as household gloves of latex.

Rubber coats are still sold for outdoor men. These are non-dress coats, except in the case of police officers who wear the best in rubber. They come in a variety of lengths and sizes. Capes are not as plentiful as coats, but they are still sold on the market. Many second hand stores still have ress rubber coats selling at high prices which can, naturally, be worn by ladies if they should so desire.

So far there is no scarcity of rubber boots. All lengths and sizes are still sold. Women and girls who wish to obtain over-knee (thigh) boots or hip boots can easily do so by buying men's rubber footwear. Heavy woolen socks and inner soles will enable a lady

to wear a size eight or nine when a six or seven is not obtainable. Even if she has a size five she can wear a seven or eight by using the right amount of inner soles and socks.

I thoroughly enjoyed the lovely photos of rubber-wear for ladies on page 37 sent in by J.H.W. It is delightful to see a lady actually wearing a pair of real rubber boots, and a bewitching, shiny black coat to match. How truly feminine and alluring she looks! Such a lady by exhibiting her charms in rubber, would quickly discover that she had a host of masculine admirers, and she would never be lacking for male companionship or lovers.

It is understandable that rubber enhances and glorifies a woman's natural beauty. There is a glamorous appeal to rubber dresswear that is sadly lacking in plastic or ordinary waterproofs. This undoubtedly is due to the sheer beauty and snug fit of a real rubber coat or rubber "Mac."

All lovers of rubber-wear should form a rubber club through the medium of "Bizarre." It can be done only if a large enough number favor such an idea, and are willing to co-operate by exchanging their ideas through letters and photos. If there were enough of us to make it worthwhile the editor of our magazine would no doubt be willing to add a rubber section to "Bizarre."

(*O.K. We'll do our best. Ed.*)

Later it might be possible to induce rubber manufacturers to make a limited number of rubber coats and capes for ladies like the ones on page 57. Naturally, the cost would be high, but I imagine that even the poorest rubber lover would be willing to meet it to possess lovely rubber outfits like those on page 57 of Volume 7.

Well, it's entirely up to you ladies and gentlemen. Write to the correspondence section if you are interested and let us know how we stand.

Sincerely yours, Fred Mac

MISS MYSTERY
(*Photo in Previous Issue No. 9*)
Dear Sir:

I believe I know how "Blind Girl Fluff" feels because I have lived in darkness or semi-darkness for many months now. You see, it all started when I had a bad case of acne or pimples and couldn't use any makeup. This was very discouraging to me as I'm not naturally pretty and always felt more confidence in myself when I used real heavy makeup. I was expert with it too, as I had training and practice in the theater. My husband always encouraged it, too.

I felt so embarrassed, even "naked," when the doctor told me, "no more cosmetics—ever" that I

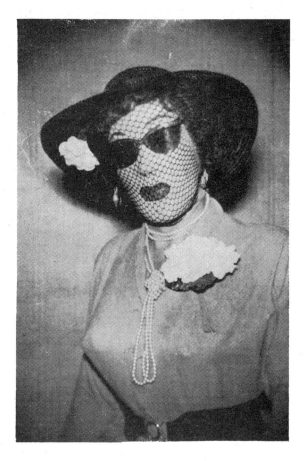

came home and cried. To make matters worse, he gave me some salve to keep on my face—all over —that was a sickly yellow and messy. My husband put up with it for a few days, but I could tell he was nervous and displeased. Then he made a suggestion that I fix my face with the ointment and pull a large white cotton stocking over the whole mess, fastening the stocking with an elastic band around my neck to keep it smooth and in place. I tried this and it was a big improvement. I only raised the lower part to eat or drink. I could see through the stocking fairly well, though being white, it made things blurred like a heavy white veil (dark veils are seen

through much more easily).

As time went on my husband amused himself with cutting out paper eyes and lips and pasting them on my blank face. He said it was fun to make me look like anything he wanted, to order. But soon he tired of the white mask. Although he enjoyed the idea of being able to do things or say things to me and not be able to see my expression if they hurt, he said he still had a feeling that I was watching him all the time.

Then one night we had a chance to go to a party. Over the white mask or stocking he pulled a heavy shiny black silk one. He was much pleased but the white showed through and also I could see better. Over the first, he pulled a second black stocking. The double thickness made it look coal black and all these stockings being stretched real tight, my nose and features were smoothed together so my face looked like a shiny black oval. My husband was in ecstasy. For the party he got a white wig. I had a white coat and wide black hat with long black gloves and dress, I was a fascinating study in black and white—only I couldn't see anything but large shadows.

Then my husband seemed to change. He said if I couldn't see and nobody could see me, why should I be able to hear or talk? He taped my mouth shut with wide adhesive tape. He softened some beeswax and plugged my ears together which shut off the sound completely. For the party I had dressed in my long black dress. Underneath the tiered skirt he put a narrow ankle-length petticoat only a little wider than a trouser leg. On my feet I had new tight extra-high-heeled shoes. And, as usual, he had laced me in the long stiff black corset that he loved so well—extra tight this night of all times. At the party I was helpless. He stood me in the corner. I couldn't see or hear. If somebody came up to me or brushed me on the way by, I couldn't speak—just stand there on feet that fast were getting like a bundle of red-hot needles. After what seemed like hours and hours, somebody led me to a chair. My corset hurt worse but my feet not as bad. Anyway it was a change.

Finally it was time to go home. My husband half led and half carried me to the car. At last this was over, I thought, and I'd get some relief. But when we got home I was to find it a different story.

If your readers would like to hear further about my experiences, I'd be glad to tell you what happened after that.

Sincerely yours,
Mrs. E. G. R.

66

So long — it's been good to know you

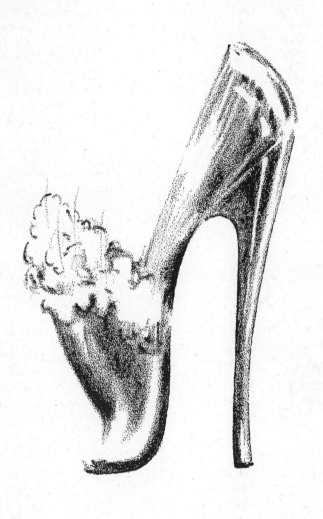

BIZARRE

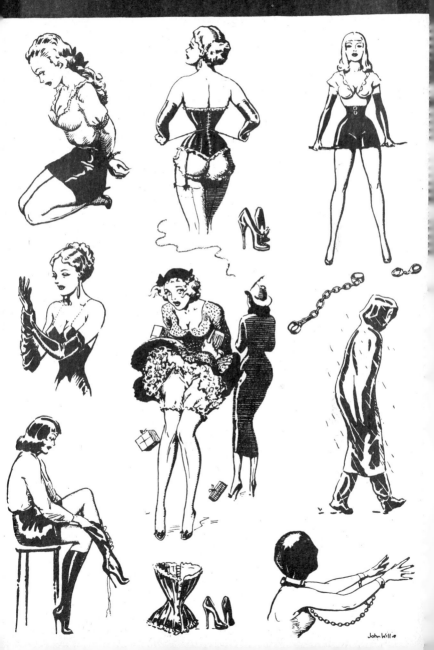

John Willie

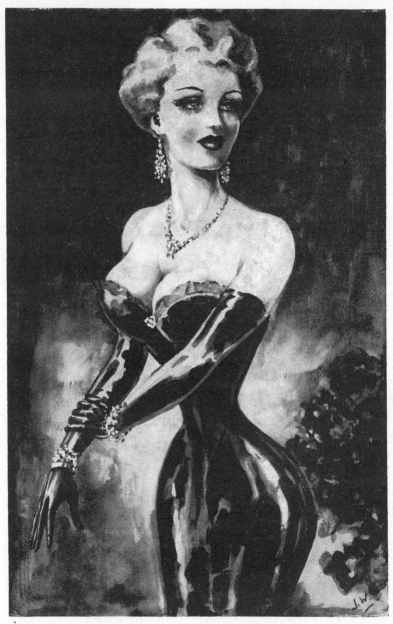

"Miss Wasp-Waist, 1953"

BIZARRE

"a fashion fantasia"

No. 11

Ah, Moon of my Delight who know'st no wane,
The Moon of Heav'n is rising once again;
How oft hereafter rising shall she look
Through this same Garden after me — in vain!

OMAR KHAYYAM

CONTENTS

Back Numbers

For back numbers see your local dealer or write to:
BIZARRE, P. O. Box 511, Montreal 3, Canada.
All copies are $1 each.

———————

Bizarre is published by John Willie. If you want his sketches and cartoons write to him direct at the above address.

Printed and Published by Bizarre Publishing Co. P.O. Box 511, Montreal 3, Canada.
Copyright 1952. All rights reserved.

Merry Christmas

4

EDITORIAL

Well! Well! Well!

We publish the following clipping without comment other than "Isn't this what we've been saying all along?"

(*Extract from the N. Y. Times—11 May '52*)

Sociologists have proved that scientists and artists respond unwittingly to the aspirations and the reasoning of the world in which they live. It is no accident that Italian artists of the fifteenth century painted many madonnas and saints, or that Louis XV danced the minuet and not the waltz. The last report of Cycles indicates that all this applies to fashions in women's clothes as well as to the subject-matter of art. If the couturiers of the Rue de la Paix imagine that they are free agents they will be disillusioned by this report, which is a recapitulation of the findings of Mrs. Agnes Brooks Young. The couturiers probably don't know it, but what Mrs. Young calls the present bell-shaped skirt will endure until perhaps 1970. If the couturiers want to know the shape of the skirts that they will be designing in 1980 and thereafter Mrs. Young is the woman to tell them.

There is no guessing about this. Mrs. Young has plotted fashion cycles from 1760 on, and shown that skirts change in style every third of a century or so. Why every third of a century? Because there are only three types of skirt "back-fullness," "tubular" and the "bell," which went as far as it could go with the hoop skirt. If Mrs. Young had taken the trouble to go back to ancient times she would have found bell skirts and hoop skirts in some very old Greek statuary. Within her cycles there are variations, but they are held within an iron framework. The transitions are not sudden, which helps to create the illusion that the fashion designers may be as whimsical as they please. Back in 1937, when the tubular skirt was still with us, Mrs. Young predicted that bell skirts would "come in" again. They did.

All this supplements the work that Dr. Alfred Kroeber and other social anthropologists did years ago. Like Mrs. Young, they dispelled the idea that the fashion designers are free agents. Who dictates what will be worn? The common people, it seems. They do it—but how? There is no answer they just do it.

FOOTWEAR FANTASIA

by Sylvia Soulier

Dear Editor,

My story starts after my 120-mile drive, when my seven-inch heels really stepped out! — and all just after an awful thunderstorm! The car stopped dead.

Baby! said I, this is where your pretty little highly polished shoes must (for your vanity) suffer. So

out I stepped on the soaking countryside — then to add to my dilemma, a suspender popped!

I had no sooner sat safely on the back of my car, and put that right, when "Pop" went the other one. So please 'scuse my back a moment. Et voila c'est fait!

Now, of course, my real trouble. Yes! There it is right away down in the engine room. You don't expect me to smile, do you. You keep your eyes on my heels; I'll attend to my job—Get my heels muddy? Don't be silly. I've worn the highest of heels for years. With those slender pencil like stilts you learn to use your toes. These heels are slightly thicker than my very high scarlet ones, but one needs that, car-driving. My driving attire rather forbids tight corsets, of course. I prefer my ordinary seven-inch lace kid shoes and if with a summer dress, the longest tightly fitting French kid gloves and a good studded five-inch deep heavy belt.

No more now, Mr. Editor, and hope the snaps are clear enough for reproduction.

Yours sincerely,
SYLVIA SOULIER

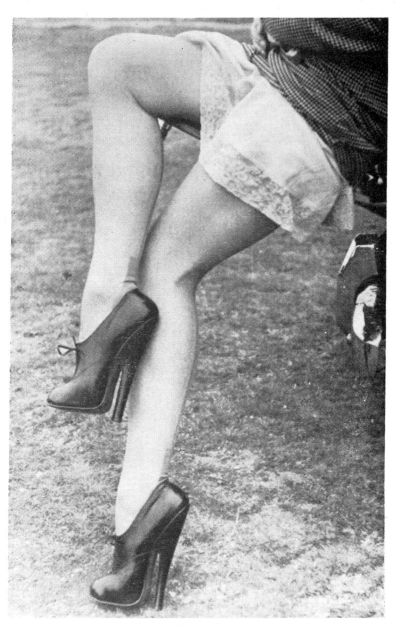

pop goes my suspender!

7

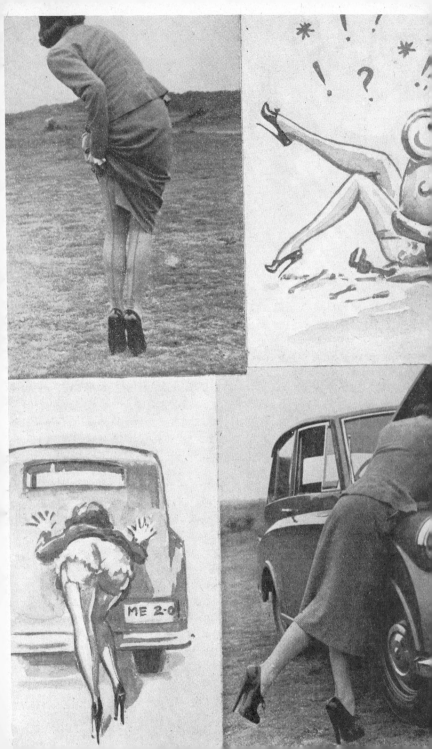

PIRATE PRISON

or a play-pen for
the happy housewife

from a reader

Dear Editor :

The following story about Chinese captivity a hundred years ago has ben taken from authentic documents. It might interest you.

P.M.

"My experience in China was terrible. I went there as a bride and had spent only a month or two after my marriage at the missionary station of Kiang Hwa, when my dear husband was suddenly called to headquarters at Hong-Kong. Believing the whole section quiet, he went off for a week's journey, leaving me at the compound.

It was the very moment that the local pirates chose to begin their activity. A band of them came down the ordinarily peaceful river and marched grimly upon the town of Kiang-Hwa. There was no resistance. The peace-loving inhabitants were in a complete state of panic and surrendered their more easily transportable treasures without a word of protest. But the worst of all was a demand for the three prettiest girls in the town.

Two perfectly sweet girls of seventeen were selected from a group which had been lined up for inspection. But when it came to the third, the grim pirates, mad for money above all things, agreed that I—as a foreigner—might produce a good ransom. In consequence, my hands were quickly and securely tied behind my back with a thin cord, that cut cruelly into my wrists. Then I was dragged aboard a pirate boat, and thrown into the hold, accompanied by the two Chinese girls.

There we were bound more securely with ropes about our elbows which then were tied to rings bolted in the deck. Our ankles also were tied and drawn up to our wrists by a short cord which was most uncomfortable.

My knowledge of Chinese was very slight; the two captive girls understood little English, so our talk, in the dark hold of the pirate boat was almost nothing. Every now and then one or the other of us would moan and stir — hardly

9

any other movement was possible —in a vain effort to ease the cramped position. Tied as we were we could not aid each other and hour after hour we lay there helpless in pain and misery as the boat sailed on.

The arrival at the pirate stronghold of Wan Lung was terrifying. Our feet were untied but with our arms still bound, my fellow-captives and I were conducted from the boat to a sort of shed. Here I was told that letters demanding ransom had been despatched; that failing payment in about three weeks, I would be sold to the owners of the "pleasure boats"—and that meanwhile, we were all to be confined in a way that the Chinese had long used.

We were led through the village into another shed, where I saw three curious box-like cages on the ground. Each was made of bamboo. The dimensions of each cage were about 3 feet long, 2½ feet high, and 1½ feet wide. The hinged lid was in two sections— the larger one having a small opening on the edge to contain the neck so that the head when the cage was closed would be outside. On seeing these dreadful prisons, I drew back in horror. Not so my Chinese girl companions, who, with Oriental passivity, seemed to be resigned to an uncomfortable captivity. Our captors untied us

and motioned to us in a way I could not fail to understand. I was sick to my innermost being, but I saw no sense in refusing to comply, since a horrible heavy whip was displayed for our benefit.

A few brief commands were given in Chinese dialect, and my two companions-in-misery divested themselves of their coats and trousers. A crowd of idle people of the town had assembled, and laughed heartily, especially at my own awkward and absolutely terrified emulation of their actions. We stood birth naked, and then one of the girls climbed into a cage. The other girl and I followed her example.

I had to sit with legs drawn up. Willing hands held me in place while the half of the lid with the opening in it was closed in front of me. Then my neck was pushed roughly forwards into the opening and the other half of the lid slammed down behind my head. The lids were then securely fastened down with riveted iron bars.

Our captors mixed cruelty with kindness; they seemed to regard our cramped position with amusement.

The two Chinese captives took everything with typical resignation. I could not do that, but I tried to be as brave as possible. I shifted my hands, the only part of me even partially free, from

around my upper legs to my sides and in front of me. I tried to keep back my tears, because I knew I could not wipe my nose.

But "feeding time" was a strange procedure. A young woman of perhaps 25, my own age, had charge of me.

At first, I refused food, until she displayed a pointed stick, which I saw was meant to be used to poke my bare skin. But when I nodded that I would obey, she put the food in my mouth and gave me cups of tea to drink, smiling broadly.

What was I to do? This woman, a member of the half-savage tribe of pirates had captured me, regarding me as chattel, and who herself must have regarded me as a kind of beast. Yet, she smoothed my hair, and even in a burst of enthusiasm, kissed me.

I suffered excruciating torture from cramps upon the hard bars of the cage.

At one time I lost all control of myself and began screaming and tearing at the bars of my prison. This quickly brought my attendant and another girl, but instead of making any effort to release or comfort me, they callously gagged me with a large wad of silk cloth which they forced into my mouth, tying it there by a long scarf wound tightly around and around my head. Then they left me and I

thought I would lose my sanity.

I was wretched and miserable. I suffered horribly; my bent legs were so terribly uncomfortable. Mentally I suffered terribly too, for although I knew my cramped position was modest enough, my body showed through the open bars of my cage and I had no feeling for days save that of utter and complete nakedness. But the kindness—even perhaps the temporary kindness—of my captors touched me. The young woman who took care of me seemed to take my torture as a matter of course, her own ability to make me a bit more comfortable, in the same way.

After a couple of weeks, the ransom arrived, not just for me, but my Chinese girl companions. We were released out of our cages, dressed in pantaloons and coats, and taken again aboard the pirate junk, to be returned to our families. I felt utterly degraded and tortured. But I kissed the girl who had taken care of me with a feeling of utter affection. I suffered horribly, it is true, but I want my descendants to know that even among pirates and savages (or half savages) I met with humane feelings.

Now this isn't a bad idea at all. There's a play pen for the kid, so why not one for the wife when you want a quiet evening. Ed.

11

How her feet tempt!
> *How soft and light she treads,*
Fearing to wake the flowers in their beds!
Yet from their sweet green pillows everywhere
They start, and gaze about to see my fair.

POET ANONYMOUS. A.D. 1653

FIGURE TRAINING

for that wasp-waisted figure

We are watching the slow but steady trend toward an hour-glass figure with increasing interest. Waists ARE getting smaller and laces are appearing more frequently, with accompanying boning.

Without boning the foundation will simply ruck up like a concertina, and by the same token you cannot use bones without making everything considerably more rigid.

The average energetic modern miss will revolt strongly at the idea of the old-fashioned corset, but when she finds the effect that the hour-glass figure of the girl next door has on her boy friends, she will—like it or not—make only one decision; and this brings up the problem of posture.

The simplest way to correct posture is to make the elbows meet behind the back and strap them together in that position. At the start they probably won't meet and the whole business will be most uncomfortable—but after a few weeks of steady practice they will. How far back can you bend? How high can you kick? Not at all? It's the same thing. It is only training that makes the contortionist and the high kicker.

Another simple device, an exercise in modern Swedish drill, and much used by grandma (with suitable straps so that Miss Trainee could not remove it) is the yoke. In Swedish drill a stick is held in position; with figure training it is strapped in position.

To hold the head up one of the gadgets Granny used was a simple arrangement of straps. A wide one passed right around the face, with two more across the face to keep it in place (and incidentally keep the trainee quiet.) Then the strap over the back of the head was tightened to pull the head back.

Some women don't care what they look like, or deliberately dress in a dull manner—"because that hussy you and all the other men gawp at is nothing but a tart! The way SHE dresses! Not me!" And so another husband is telling some girl in some bar somewhere that his wife doesn't understand him.

However, in this age of free-for-all, dear ladies, you have to please your man to hold him. So if you find him straying to some small wasp-waisted siren, you'd better start corsetting yourself AND figure training. Someone will have to fix the gadgets, so you might as well ask him. He'll probably find that he likes it—yes, quite likes it.

(For gadgets see overleaf)

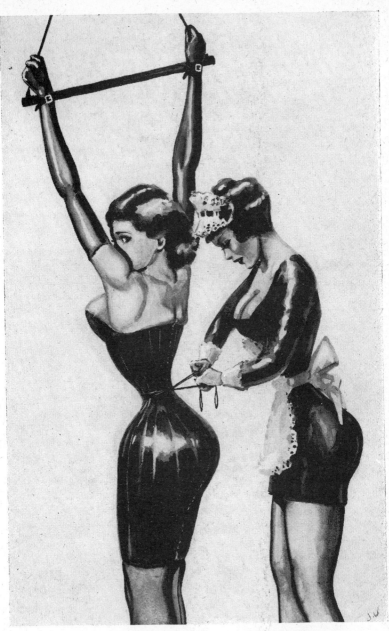

observe my fair one! *plenty of this —*

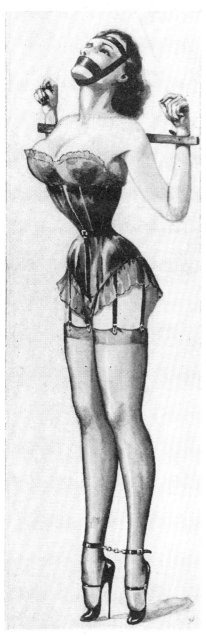

and lots of this —

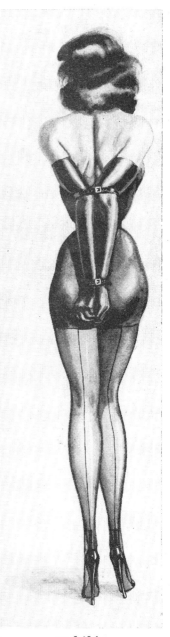

and this —

15

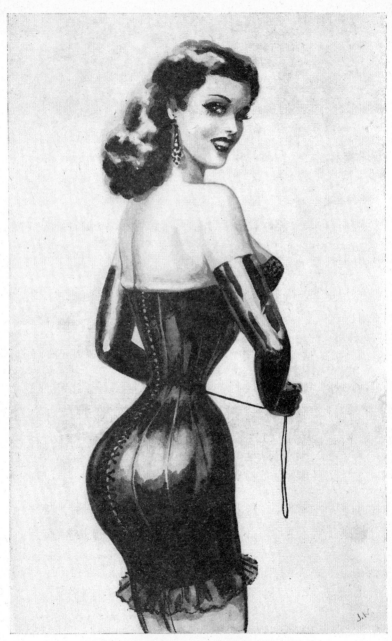

and you can lace yourself in like this!

16

THE CHINESE CUSTOM OF FOOT BINDING

extract from "My Country and My People."

The following material is taken from My Country and My People by Lin Yutang, New York, The John Day Company, 1939.

"The nature and origin of foot-binding has been greatly misundderstood. Somehow it has stood as a symbol of the seclusion and suppression of women, and very suitably so. The great Confucian scholar Chu Hsi of the Sung Dynasty was also enthusiastic in introducing foot-binding in southern Fukien as a means of spreading Chinese culture and teaching the separation of men and women. But if it had been regarded only as a symbol of the suppression of women, mothers would not have been so enthusiastic in binding the feet of their young daughters. Actually, foot-binding was sexual in its nature throughout. Its origin was undoubtedly in the courts of licentious kings. Its popularity with men was based on the worship of women's feet and shoes as a love fetish and on the feminine gait which naturally followed, and its popularity with women was based on their desire to curry men's favor.

"The time of origin of this institution is subject to debate, which is somewhat unnecessary, since it would be more proper to speak of its 'evolution.' The only proper definition of foot-binding is the binding of the feet by long yards of binding cloth and the discarding of the socks, and this seemed to be first definitely mentioned in connection with Nant' ang Houchu, in the first part of the century or before the Sung Dynasty. Yang Kweifei (Tang Dynasty) still wore socks, for one of her socks was picked up by her amah and shown to the public after her death, at the admission rate of a hundred cash a person. Rapturous praise of women's small feet and their bow shoes had become a fashion in the T'ang Dynastynasty. The bow shoes with upturned heads like the bow of a Roman galley, were the beginnings of rudimentary forms of foot binding. These were used by the dancing girls of the court, and in this luxurious atmosphere of female dancing ,and court perfume and beaded curtains and rare incense, it was natural that a crea-

tive mind should have appeared and put the last finishing touch to this sensual sophistication. This creative mind belonged to the ruler of Nant'ang (Southern T'ang, a short-lived dynasty), who was an exquisite poet besides. One of his girls with bound feet was made to dance with light tip-toe steps on a golden lily six feet high, hung all over with jewels and pearls and golden threads. Thereafter, the fashion was set and imitated by the public, and the bound feet were euphemistically called 'golden lillies' or 'fragrant lilies' which enabled them to pass into poetry. The word 'fragrant' is significant for it suggests the voluptuous atmosphere of the rich Chinese, whose chambers were filled with rare and fine perfume on which whole volumes have been written.

"That women were not only willing but actually glad to be fashionable and 'a lad mode' at the expense of bodily comfort is nothing peculiarly Chinese.

"As late as 1824, English girls were willing to lie on the floor while their mothers by foot and hand were helping to squeeze their bodies inside the whale boned corset. These whale bones must have greatly assisted the eighteenth century and early nineteenth century European women in fainting at the proper moment. Women may be frail in China, but it has never

been the fashion to faint. The tip-toe dancing of the Russian ballet is but another example of the beauty of human torture which may be honored with the name of an art.

"The small feet of Chinese women are not only pleasing in men's eyes but in the strange and subtle way they influence the whole carriage and walking gait of the women, throwing the hips backward, somewhat like the modern high-heeled shoes, and effecting an extremely gingerly gait, the body 'shimmeying' all over and ready to fall at the slightest touch. Looking at a woman with bound feet walking is like looking at a rope dancer, tantalizing to the highest degree. The bound foot is indeed the highest sophistication of the Chinese sensual imagination.

"Then ,entirely apart from the feminine gait, men had come to worship and play with and admire and sing about the small feet as a love fetish. From now on, night shoes were to occupy an important place in all sensual poetry. The cult of the 'golden lily' belonged undoubtedly to the realm of sexual psychopathology. As much artistic finesse was exercised in the appreciation of different types of bound feet as was ever expended over the criticism of T'ang poetry. When one remembers that really small and well shaped feet were rare,

perhaps less than ten in a city, it is easy to see how men could be moved by them as they might be moved by exquisite poetry. Fang Hsien of the Manchu Dynasty wrote an entire book devoted to this art, classifying the bound feet into five main divisions and eighteen types. Moreover, a bound foot should be (a) fat, (b) soft, and (c) elegant; so says Fang.

"Thin feet are cold, and muscular feet are hard. Such feet are incurably vulgar. Hence fat feet are full and smooth to the touch, soft feet are gentle and pleasing to the eye, and elegant feet are refined and beautiful. But fatness does not deped on the flesh, softness does not depend on the binding and elegance does not depend on the shoes. Moreover, you may judge its fatness and softness by its form, but you may appreciate its elegance only by the eye of the mind.

"All those who understand the power of fashion over women will understand the persistence of this institution. It is curious to note that the decree of the Manchu Emperor K'anghsi to stop footbinding among the Chinese was rescinded within a few years, and Manchu girls were soon imitating Chinese girls in this fashion until Emperor Ch'ienlung issued an edict and forbade them. Mothers who wanted their girls to grow up into ladies and marry into good homes had to bind their feet young as a measure of parental foresight, and a bride who was praised for her small feet had a feeling analogous to filial gratitude. For next to a good face, a woman was as immeasurably proud of her small feet as modern women are proud of their small ankles, for these feet gave her an immediate distinction in any social gathering. The bound feet were painful, unmercifully painful, during the growing time of youth, but if she had a well shaped pair, it was her pride for life.

"This monstrous and perverse institution was condemned by at least three scholars, Li Juchen (author of a feminist novel, Chinghuayuan, written in 1825), Yuan Mei (1716-1799), and Yu Chenghsieh (1775-184-), all scholars of independent minds and considerable influence. But the custom was not abolished until the Christian missionaries led the crusade, a debt for which Chinese women ought to be grateful. But in this the missionaries have been fortunately helped by the force of circumstances, for the Chinese women have found in the modern highheeled shoe a tolerable substitute. They enhance the women's figures, develop a mincing gait and create the illusion that the feet are smaller than they really are."

19

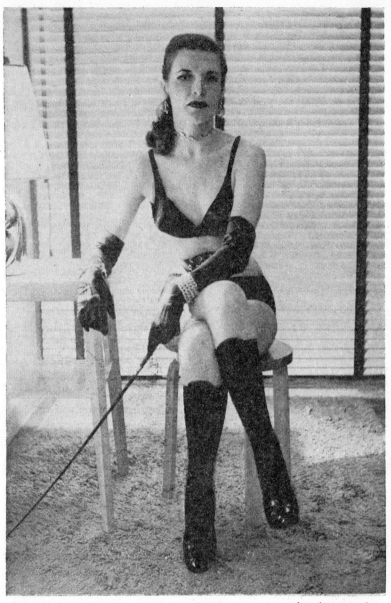

The Lion Tamer

20

FANCY DRESS
for special evenings

Now that the festive season is upon us, fancy dress becomes even more important.

On the next two pages we present two ideas which were sent in by a reader, and two which came to us as a result of it.

The reader suggested the member of the PBI complete with a most convenient pack to enclose the folded arms—and the cowboy or Arizona amazon. It's a great costume for shooting up the town if she could just get her hands out of the holsters to which they are unfortunately secured by straps.

Finally with so much military stuff around (the wooden soldier was our idea with good stiff cardboard trousers and arms) it seemed only logical to include something nautical.

Somehow we thought of Nelson —but then couldn't remember which eye and which arm had gone. This caused an impasse until we solved the problem in the logical manner as shown.

Epaulets could of course conceal the tucked-in sleeves to give it a neater appearance—but even as it is it ought to please "Blind Girl Fluff" and Co. no end. Happy Christmas.

Which brings us to the matter of party games which can be a ton of fun on a dull winter's evening.

There is one which a couple we know play every Friday night. When other citizens are at the local tavern for a few (which means many), these two are home.

A carefully budgeted income leaves $10 to spare, so every Friday Jim brings home 40 quarters. The ritual then is as follows:

All the furniture is pushed to the side of the livingroom and the "hunter" (who alternates every week) has his (or her) hands tied behind the back and is blindfolded.

The quarters are scattered over the carpet and, using the nose as a feeler, the hunter keeps as many as can be found and picked up in the mouth in 30 minutes.

We attended the party one evenin—making six of us—and each man contributed $10 in quarters, and the women were "it."

There were also side bets as to who would get the most.

The race was a disgrace. There was constant interference, bumping and boring but instead of calling all bets off, we decided to keep the hunters as they were for the rest of the evening.

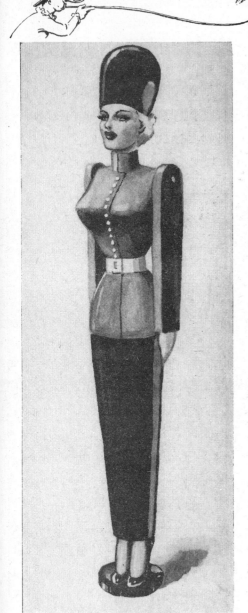

Wooden Soldier

P.B.I.

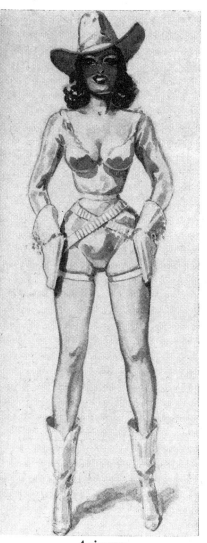

Arizona

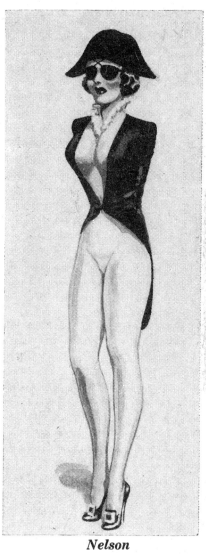

Nelson

FROM GIRL
TO PONY

By N. Y. C.

I was returning from a short business trip to England; the boat was crowded, the passenger list unusually dull, with the exception of Bill Parsons and his wife, Evelyn.

I remember Bill and Eve very clearly and for a number of reasons. For one thing, they were most amusing travelling companions, and for another, their manner towards each other was very odd. They were devoted, yes: probably the most devoted couple I've ever met. But there was something else.

Eve was one of the most beautiful girls I've ever seen: rather on the tall side, blonde with a lovely face and an absolutely perfect figure. Bill was simply nondescript: medium height, well enough built, not ugly, but certainly not good looking. In every way he was "just another man."

By herself Eve was as opinionated as any other beauty, but when Bill was around she deferred to his wishes in everything, never questioning his judgment and obeying his slightest whim.

Bill was just the other way. When matters didn't have any bearing on Eve, or when she wasn't around, he was pleasantly free-and-easy-going. But where Eve was concerned, he was as crisp and definite as the master of an old-time windjammer.

I was determined to find out how this ill-assorted pair came together. It's a curious fact, but people on shipboard will tell you things they'd never dream of telling you on dry land, and I was fairly confident that if I kept my patience and posed as a good enough listener, the story would come out sooner or later. Sure enough it did. The last night out, after the usual excitement of packing was over, Bill and I got together in the back of the smoking room over a drink or two. He had told Eve that she'd better get some sleep, and, as usual, she obeyed orders. She bade me a very charming good night, and trotted off like an obedient child.

After the second drink, Bill turned to me suddenly and said:

24

"You're wondering how Eve and I ever came to get married, aren't you?"

Rather surprised at the accuracy and unexpectedness of his accusation, I admitted I was, and hinted that I thought our fellow-passengers were too. Bill grinned.

The whole thing began (he said) a year ago last June. I had taken a house about twenty miles from London for a month or two of complete rest. I chose that particular house because it was off the main roads, which meant that it was quiet, and because of the huge secluded garden. After months of living in the middle of New York City, a little greenery is welcome. My house and the one next to it were the only ones for half a mile or more all around, and even they were separated, except for a few yards near the road, where a rather broken-down wire fence and a thinnish hedge served as a dividing line.

I'd only been there a couple of days when I began seeing Eve—Evelyn March, as she was then, of course—and while I say I saw her, it certainly wasn't any more than that. Eve definitely didn't have any ideas about making friends with the young man next door.

So, such glimpses as I got were when she went out for a run in the car, or occasionally when she played with her dog in the garden.

Naturally, I began making plans as to how I could start acquaintance, but for two or three weeks I got nowhere. Then one afternoon I was sitting under a tree reading a book. It was a very unusual and interesting book, dealing with the use of Human Ponies in different parts of the world. I was deep in a chapter on the Turkish use of Russian girls to pull their carriages in the Middle Ages, when I heard Eve's voice. She was romping with her dog near the hedge between the two gardens, and calling back to her aunt, who must have been sitting somewhere near the house. Apparently I'd "tuned in" on the middle of a conversation, so to speak, because I heard Eve say: "Who, him? I wouldn't marry him if he was the last man in the whole world! . . . Why? Because he fawns on me, that's why! Life with him'd be like being married to a spaniel! I won't marry any man who isn't man enough to show me who's master. . . . Jack's just like all the others. He wants to put me on a pedestal and worship me like—like a little goddess, or something. I want a master or nothing."

There was some more after that, but I couldn't pick it up as she moved out of range of hearing. But it was enough. Eve wanted a master, did she! Anything to oblige, I thought. If it's a master

25

she wants, she'll get one. The book I'd been reading on Human Ponies started a very interesting train of thought, so I put it down to do some very heavy planning.

The next day I drove up to London, went to two or three shops, bought several things, ordered some others to be made, and then came back. Most of the stuff I needed I was able to make myself, having always been handy with tools, which was useful as I didn't know where I could have gone to get them made.

One of the things I brought back was a special bag of dog biscuits, because the first part of my plan was to make friends with Eve's dog, Cocktail, an intelligent and amiable animal of confused ancestry.

Everything went smoothly. Whenever Eve wasn't around, I made a habit of inviting the dog over to play; then after a while I would wander carelessly into the old stable at the back of my house and give away a little light refreshment. In no time, Cocktail caught on to the fact that a trip to the stables meant biscuits, so once he and I were headed in that direction, no power on earth could turn him aside.

I think it was on the third day that Eve decided to have another game with Cocktail. It was a gorgeous day and at about three in the afternoon she appeared in the garden. She always dressed to display her figure to advantage and that afternoon she had on her usual play-outfit, which consisted of a crisp white linen shirt, cut to fit closely and display her very shapely bust; a pair of very short-legged shorts to match, which fitted like a coat of paint; opera-length silk stockings of a sun-burn tint; a pair of round-toed, low-cut, lace-up brown shoes with four-and-a-half inch heels; and a narrow brown leather belt pulled tight about her slender waist.

I watched from the seclusion of the trees. She ran about with amazing ease, considering the height of her heels, and I waited till I saw that Cocktail was beginning to tire of chasing the ball that Eve was throwing for him. Then I called him, very softly. His mistress didn't hear; but he did. Immediately his thoughts turned to biscuits. Without the least hesitation, he wriggled under the fence, through a hole in the hedge and came running over to me. Eve, of course, came over to see what was going on. When she saw her dog jumping about and making a great fuss over a stranger, she called to him. He paid no attention. She called again and whistled. Still no answer; Cocktail was thinking of biscuits, and biscuits alone. Finally, she summoned her most charming

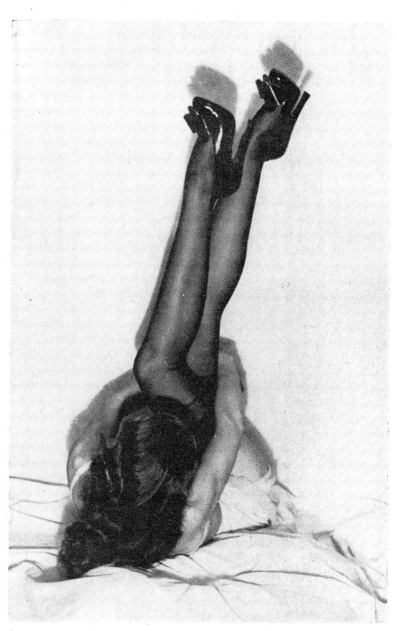

well — aren't they lovely?

27

smile and called: "I say! Would you mind letting me have my dog back?"

The whole success of my plan depended on my getting her to follow me, so I looked her up and down rather contemptuously and then without a word, I turned and started slowly for the stables. Cocktail, seeing that I was headed in the right direction, started barking happily as well as jumping up and down. Of course, I couldn't spoil things by looking around, but I heard Eve give a gasp of angry amazement. She called Cocktail again once or twice, without effect. Then I heard the sound I had been waiting for. Eve was thrusting her way through the hedge over the remains of the fence.

As I heard her footsteps on the gravel behind me, I walked a little faster, for I didn't want her to catch up till we were inside the stable. She tried once more to attract my attention, but I took no notice. And so we made our way, Cocktail frisking along beside me and Eve half running and half walking along behind, trying to catch up.

She was right behind me as I stepped into the stable. I walked through it into the harness room, where, as soon as she was inside, I turned quickly and locked the door. At that moment I think her eyes were actually throwing sparks, she was so angry; but she tried to keep her voice calm as she asked: "What is this? Some sort of game?"

I still wasn't saying anything. I opened a drawer, got a handful of the biscuits, tossed them out of the open window, and picking the dog up, lowered him after them. Then I closed the window and locked it.

There were two short leather straps hanging ready on a hook, so taking them in my hand, I walked back towards Eve. By now she was so angry that she doubled her hand into a fist and took a long swing at me, as hard as she could. Luckily it wasn't a very scientific blow and I had no trouble stepping back out of range. The force behind the blow turned her half around, and before she could recover her balance, I spun her around the rest of the way so that she was facing away from me. Before she knew what was happening, I brought her wrists together behind her and strapped them there. Then I turned her back to face me again.

She was so surprised that a man should dare to lay a hand on her, that for the moment she just stared. Then her anger getting the upper hand again, she began to tug at her bound wrists. She launched a kick at my shin, but as that was obviously the next move, I succeeded in side-steping it, and

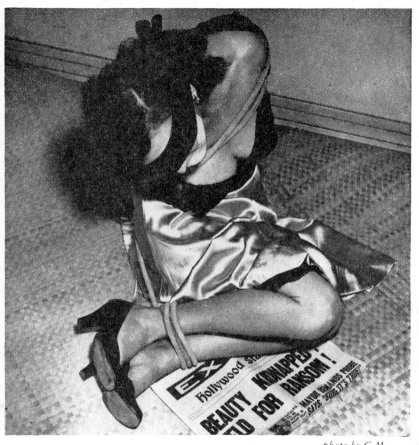

photo by G.M.

DON'T LET THIS HAPPEN TO YOU

learn jiu jitsu

and the art of self-defense

29

in a second had the other strap buckled about her two slim ankles. Then I asked pleasantly: "You remember what you said a few days ago?"

"I don't care what I said a few days ago! Unfasten these straps and open that door at once!" Oh, was she mad! She struggled like hell to get free.

"It's no use squirming like that, you'll only fall over and hurt yourself," I smiled. "You can't get away, so you may as well answer my question."

"All right then, I don't remember what I said. I don't care, either!" she flared.

"Then I'll remind you," I answered. "You said you wanted a man who could master you. Well, here he is."

"You—you shrimp!" Eve almost screamed. "If I didn't have these straps around my wrists, I'd show you who was master!"

"Not straps," I pointed out, "just one strap. Well, we shall see what we shall see."

I went over to a peg in the wall near the door and lifted down a wide leather strap with several others attached to it, and, bringing it back, I fastened the wide strap around her waist, pulling it good and tight.

"What're you doing?" Eve asked.

"Ever hear of a human pony?" I asked.

Suddenly she realized what I was up to. "No! No!" she screamed. "I won't! You don't dare! Undo these straps and let me go at once, or I'll scream the place down!"

"Go right ahead and scream if you feel like it," I said. "But I warn you that no one can hear you, and you'd much better save your breath for later.

There were two straps attached to the upper side of the belt at the back. I brought these up and over her shoulders, crossed them on her chest and fastened them, about six inches apart to buckles on the front of the belt. Eve was struggling wildly, but it didn't do any good. A third strap went from the lower edge of the waist belt at the back, under her body and up to fasten to the center of the belt in front.

There were two special leather cuffs, one for each of her wrists, in the drawer of the table. I got them out and put them in place, fastening one wrist temporarily to the waist belt while I forced the other up behind her back so that it rested between her shoulder blades, holding it there by a short strap which went from the cuff to a buckle on the strap over her shoulder. Then I fixed the other wrist in the same way.

At this point I stepped back to

see how my handiwork looked. Of course, I had copied the harness from that book. I'm bound to say that considering I had had to make everything by guess work, it fitted amazingly well.

Eve looked very appealing as she stood there, writhing futilely to free herself. Her eyes fairly snapped as she glared at me. "Listen, Mister," she said threateningly, "I don't know what your name is, but you're going to suffer for this!"

"Perhaps," I agreed, as I got the bridle out of the drawer, "and on the other hand, perhaps not."

I had no trouble in strapping the bridle around her head because she apparently realized that further resistance was useless. In addition to the brow band, from which two long thin straps for the bit rings dangled down each side of her face, there was, of course, a chin strap, which also passed over the top of her head.

The bit, which I had made myself out of a quarter-inch rod of stainless steel, was covered with a piece of rubber tubing where it actually went in her mouth. The idea of this was to prevent any injury while still allowing it to be effective. In the center the bar was bent into a "V" to go deep into the mouth, and sticking up and down from the point of the "V" was a longish metal stud.

Naturally, when she saw the bit, Eve refused to open her mouth. So I simply placed by left hand over it, pinching her nostrils closed between my thumb and the side of my first finger. I held it there till I judged she must be running pretty short of oxygen, then I let go. Automatically, she opened her mouth to gasp in a lung full of fresh air and as soon as she did, I popped the bit in with my right hand and fastened it in place by passing the dangling straps from the head band through the bit rings and pulling them back to fasten at the back of her neck. A short thin strap went from one ring to the other under the chin. This I pulled quite tightly to hold the bit in the bottom of her mouth, with the stud pressing on her tongue.

"How do you feel now, Pony?" I asked. She tried to say something in reply, but found that she could only mouth wordlessly, the bit preventing any intelligible speech and incidentally causing her to dribble. Pausing only to attach the driving reins, I unfastened the strap about her ankles and unlocked the door. As I expected, she drew her foot back, preparatory to launching another kick. But as she did so, I gave the reins a sharp jerk. With a gasp of pain, she hurriedly lowered her foot.

Without another word I started

out of the harness room and headed for the coach house, my bitted and bridled pony following, snorting in a most unladylike manner, but outwardly docile and obedient. Leading her inside, I backed her between the shafts of a special very light four-wheeled carriage I had had built of light steel tubing by a firm of bicycle makers, using bicycle wheels on ball bearings so it would run easily. The shafts attached to metal clips on the sides of her waist belt. Then I opened one of the big doors and led my pony and carriage into the stable yard.

After first tying the reins to a post, I went back into the coach house to get a light whip — which I wanted mostly for effect—and another strap, but before going out again I stood in the shadow of the door, where Eve couldn't see me, and looked at my unusual turnout.

What a picture it was, too! The bright, shiny new carriage and the lovely little pony between the shafts. Her pretty little feet, poised on their proud heels, her shapely legs, gleaming dully in their silken sheaths ,her body, set off by the white shirt and shorts. The polished brown harness showed up sharply against the white and glinted in the sun as she writhed and twisted in a last frantic but quite vain effort to free herself from the straps which held her so smartly helpless, fretting at the bit and bridle which turned her from a girl to a pony.

After admiring the picture for a whi'e, I went out, fastened the extra strap in place from the top of her head-harness to the back of her waist-belt. I pulled it up tight enough so that she held her head tilted back, proud chin high, and bosom thrust arrogantly forward.

Then I got into the carriage, took up the slack in the reins and said "Gee-up." But Eve stood stock still.

(*To be continued in next issue*)

J. W. ILLUSTRATIONS

for these and other anecdotes are sold separately as space does not permit their inclusion in these pages.

These supplementary illustrations are printed in a suitable size to fit in the magazine. Size of actual illustration on page, *single page* — 5¼ x 6½ . . . *double page* — 10½ x 6½.

For further information write direct to:
JOHN WILLIE, P. O. Box 511, Montreal 3, Quebec, Canada.

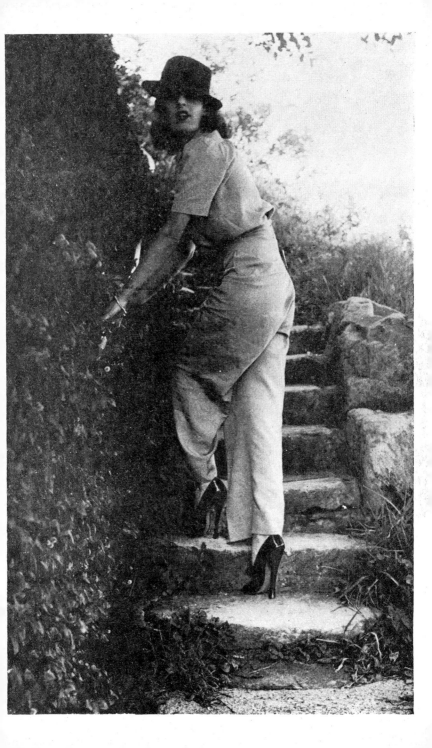

MISS BIZARRE

If a fair maiden finds the light of her life reading *Bizarre,* she will realise that something is in the wind. The question is what? What must she do? What must she wear to please him? One false step and a beautiful romance may be loused up — but don't worry! We're right with you in your hour of crisis! Just leave it to Willie.

It is assumed that you are already an expert in wrestling, judo and boxing. Therefore if you are required to take the dominant role you will be able to cope with the situation, but it may be the other way about so you must appear very helpless and feminine.

He may like boots, so you wear one boot; long sheer stockings, so you display one on the other leg — held up tightly by at least six suspenders. Similarly you have a bloomer and fancy garter on one leg, and over it a pair of brief frilly scanties.

The extremely wasp-waisted corset of black kid has convenient rings to which shafts can be attached should you be required to serve as a girl pony; and the ring in the nose in this case is an excellent substitute for a bit to which the reins are attached.

Your makeup must be extreme, including a tattoo on your left shoulder, and you are drenched in perfume. You are covered in jewels but the bracelet on your right wrist is simply a pair of handcuffs. Your long hair, scarcely visible from the front (he may like it short) cascades down your back unbraided under your black gleaming rubber cape whose hood can be brought forward to cover the face (a la Blind Girl Fluff).

Having rigged yourself up in this ensemble you strap one arm tightly back at the waist. Then your head held high by the stiffly boned collar, your earrings brushing your shoulders, you pick up a riding quirt, and with the shackles on your ankles jangling, go and interrupt his reading.

Now we don't guarantee that this is going to be absolutely perfect. We may have overlooked something but at least it will show an enthusiastic desire to cooperate; and we present the idea with our best wishes for a prosperous and happy New Year.

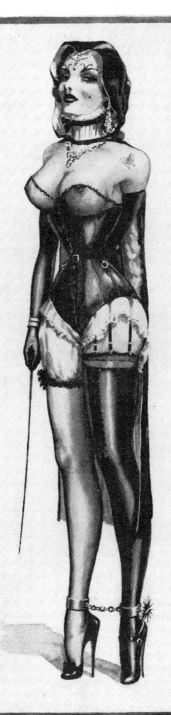

FRILLS and SCANTIES

When the wind blows high
Your skirts will rise,
But God is good and mighty wise,
He blows the dust in the bad man's eyes.

orrespondence

To the Editor:

Why should a costume not be merely a PAINTED one? The present trend is definitely in the direction of complete painting of the entire female body. So why not painted dresses? In recent years we have seen painted stockings substituted for real stockings. Why not extend this fascinating innovation to the complete ensemble? A cellophane skirt might be used in some costumes, with the undergarments painted upon the skin.

Daring, you say? Certainly, but half of woman's charm lies in being breath-takingly daring in her dress and makeup. Perhaps some lady readers will try this suggestion and let us know about it.

The suggestion of J. S., regarding a ballet-dancer type of shoe to streamline the feminine leg and make the foot continue in the same line as the leg, is esthetically sound and valuable. Your picture of the "dancing teacher" on page 31 of No. 4 is a very beautiful example of the possibilities in this direction. The whole picture, in facial loveliness and seductive costume, is most delightful — except for the unattractively short fingernails.

J. S. mentions the "ultimate in streamlined grace and feminine helplessness." the allure of the hobble-skirt is an example of the attractiveness to me of this "feminine helplessness." And the upper left picture on page 5 of No. 5 is an excellent example. It strikes me that if a woman were to be tied up in just this manner exactly, omitting the gag, of course, and were to receive her men friends while in this position, she would make an especially attractive hostess. Her maid could tie her up when she expected a male visitor; and ribbons or soft ropes of a decorative character should be used (such as the girdle-rope of a bathrobe). Beside the general attractiveness of the position and the appeal of its helplessness, some of the details of this method of tying are extremely piquant (and clearly

shown in the lower right picture on page 4). As a variant, many women may prefer to have their men friends tie them in this posiiton after arriving for a visit, and either untie them before leaving, or else leave them tied up for the maid or a woman friend to untie. In any case, talking to a gentleman friend or to be embraced and kissed while tied in this position would be a delightful experience; and perhaps some of your lady readers may relate their experiences in this direction.

RAYMOND V. FORD

SPANISH STEP AND SADDLE STRAP!

Dear Editor:

The fine photo titled "bal masque" in No. 7, p. 22, reminded me of an item of deportment correction that seems to have slipped your pages—and it's certainly bizarre. I refer to that instrument of correction, much in use with our great-grandparents, the saddle-strap. As in my youth I was once in a household where it was still in use, I can assure you it can be really mean!

When I was twelve I was sent to stay with an aunt who had a big house in the South and was a high-heel faddist par excellence. She always wore immaculate six-inchers herself and brought her two teenage daughters, Shirley Mae and Jean, up to them too.

As my stay was unexpectedly prolonged, Mother gave Aunt Helen full authority over me and I was soon under the regime with the others. Even though it's more than twenty years ago now, I still remember every minute of it!

We had to wear our stilt heels everywhere we went, even on lonesome walks over rough paths and ploughed fields, or helping in light farm work around the stables. If we were ever caught taking them off without permission, we were for it. And we had to walk fast, too. Once I remember Shirley, the elder, a big dark girl, being taken off into a wood and given several severe cuts with a whippy ash-plant for falling behind and complaining.

Every now and then, when Auntie thought we were getting slack, or one of us had been found stumbling too much, she took us through exercises designed to improve our balance, and these were held in a disused ballroom at one end of the house. These occasions, I recall, usually took place on a sultry summer afternoon, yet despite this, the curtains were always drawn and the chandeliers blazed on. Our costumes for these performances were simple, consisting of our most excruciatingly high-heeled glace kid courts, black silk stockings suspendered from a narrow garter-belt, and a hip-length sweater of heavy wool belted with

a special wide leather belt drawn terribly tight. Like this we had to go through many exercises on the waxed parquet floor, such as doing high kicks, running (sometimes with a light fetter-chain at our ankles, too), jumping over a bar, through a circus hoop, hopping across the room on one leg, and having races with wrists manacled to ankles (or other such devices), the loser receiving a few nasty cuts from a switch.

Unpleasant as these exercises were, the one form of disciplining we most dreaded, however, was known as "Spanish Step." To do this we had literally to prance round the room, making sure to raise our knees chest-high each pace, while Auntie stood in the center and counted time. It was terribly hard to balance, and we frequently slipped on the polished floor, especially when the time got fast. For this we were called out, made to stand up straight with hands stretched over our heads, and given a dose of Auntie's switch where it hurts most! It was no fun because after a few rounds of Spanish Step your sweater slipped up and left you quite exposed in the vulnerable part!

When Auntie wanted to be especially strict, she had us roll up our sweaters under our armpits and put saddle straps on us. Now each belt we wore had a steel ring

hanging down in front (like the picture in No. 7), and a buckle, as well as another ring, stitched on to the belt at the back. To fix the saddle strap, a thin leather strap was harnessed to the front ring, drawn through the legs and hauled up as tight as possible to the buckle in rear. You can imagine it was no fun doing Spanish Step like that. But we just had to go through with it and if one of us stumbled she'd join the ranks a moment later with a face as if she'd swallowed a quart of castor oil!

Aunt always saw to it that the saddle straps fitted snugly. She had the wickedest straps, too. Some were made of glacé kid, others of light, flexible steel, of tarred rope —and one I once saw seemed to be made of horsehair, which must have cut in dreadfully. There were also corsets fixed up with saddle straps, and I remember Jean having to wear one for two whole days for clumsy walking in high heels.

One of the worst saddle strappings I witnessed happened to Shirley Mae, though the girls told me such severity was by no means uncommon. It was one afternoon she simply couldn't stand straight. She had, and still has, a heavy body, and the slender stems just wouldn't seem to support it without turning over. Came a moment

shrimp boats is a-comin'!

41

when Aunt Helen lost her temper. Shirley had to stand out and take a real old-fashioned whipping. The strokes just seemed to go on and on; Auntie drew out the cuts and came at her very low, which always makes it much worse to bear. Afterwards Shirley had to take off her sweater and put on a severe, whaleboned corset with a crude front busk from which dangled a pretty little gold chain of some length. Her arms were next strapped behind her at wrist and elbow and a small bit clamped into her mouth. Then the chain was taken in between her legs, up through a ring in the back of the corset, through another ring behind the bit-brace on her head and fastened back again to a hook on the straps round her wrists. With her hips cambered by the corset, her chest arched, head thrown back, she could be seen visibly straining to keep her bound arms up away from her body, for the least additional tautening on the chain made the pressure well nigh unendurable. But Auntie was relentless and in this position Shirley had to do four breathless turns of the room before being released. I know for a fact she didn't turn over on her heels for a good week after!

Rigorous as my short spell with Aunt Helen was, I am convinced that it is responsible for my ability to walk well in high heels now; Shirley Mae and Jean have both married happily and both retain the most graceful figures of any of my acquaintances.

DOROTHY, Bronx

JUDO GETS YOUR MAN
Dear Mr. Willie,

I am very much in favor of your crusade to encourage women to learn jiu-jitsu. You see, that's how I got my husband.

Before our marriage, my husband dated my girl-friend more than he did me. She was a very athletic type, a girl who enjoyed the same things he did, and while they attended football and baseball games together, or played tennis or went hiking, I sat in my apartment and fumed. Of course, on those

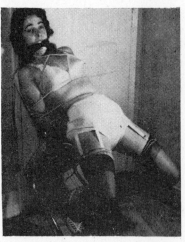

rare occasions when he wanted to go dancing or night-clubbing, he escorted me. I like nice clothes and

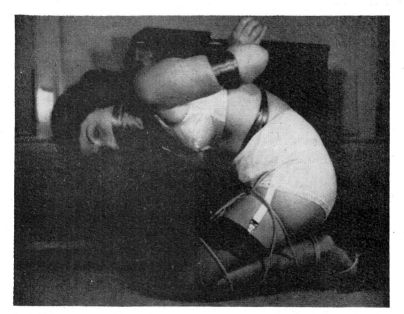

feel quite comfortable in shoes with ultra-high heels, and I suppose he felt I was better suited to dancing than she was. At any rate, on one of my shopping tours I discovered a quaint little magazine named *Bizarre* at a newsstand and unknowingly reached a turning-point in my life.

To a girl in my predicament, your page advocating jiu-jitsu presented an association of ideas, the first of which I put into action at once. In less than three months, I had mastered enough jiu-jitsu for my purposes and it was time for the second idea to be carried out. Here, to interpose for a moment, I might state that during my lessons in jiu-jitsu I had made a point of being seen at all the athletic

events my future husband and my girl-friend attended, apparently enjoying myself immensely.

My girl-friend lived on the floor above in the same apartment house. Thus, when she boasted one Saturday afternoon of her pending date that evening with the man I loved, I decided the time was ripe. My preparations were simple and an hour before he was due to arrive, I knocked at her door. I told her she wasn't going out that evening, and when she laughed and dared me to stop her, I opened the tiny traveling bag I was carrying and spread its contents out on the floor.

She took one look at the rope, pieces of sash and cloth, and camera with flash, and immediately attacked me. Needless to say, my

training stood me in good stead. In less than fifteen minutes she was bound to a chair propped against her front door, I had my picture and was out her back door and down the fire escape to my own apartment. It was I who was escorted to the fights that night. My girl-friend, released upon my return, promised fervently to let my man alone from that date on.

Of course, human nature being what it is, she didn't keep her promise. Moreover, she told my man what I had done, and when next he saw me, he asked if it were true. I answered in the affirmative, but he didn't believe me. I felt the need for something drastic, so once again I went upstairs with my small bag and this time accompanied by my future husband. Before his astonished eyes, I bound her in a kneeling position, gagged her, and kept her thus until my future husband made his choice between us.

The accompanying photographs will prove my story, and should convince all women of the need to learn and master the art of jiujitsu.

Sincerely,
DOROTHY LAMAT

THE CHASTITY GIRDLE

Dear Sir:

Congratulations on No. 8 and its ingenious cover design. My only suggestion is that you should use a slightly smaller size of type, in order to squeeze more into the same number of pages. And, talking about squeezing, I thought you might like to have the enclosed photograph, which is of a "Ceinture de Securite" which I bought in Paris a few years before the war.

It consists of a strong patent leather belt, which is fastened round the wearer's waist by means of a pair of stout metal pins, perforated with a hole in which a tiny padlock fits. There was evidently a series of holes in the other end

of the belt to permit of the waist measurement being adjusted to suit persons of different sizes, but the belt has been cut so that only the last pair of holes remain. When fastened, therefore, the wearer must be laced into a waist measurement of less than 20 ins.

I bought this ceinture a long

time ago in a little shop in one of the back streets of Montmartre, and the shopkeeper to'd me that he did quite a trade in them with some of his more "jaloux" clients, who liked to think that their ladies were above suspicion when left by themselves. Also, he said, when the belt was padlocked around the waist, it was impossible to loosen the corset in which the Parisian male insisted that his inamorata should retain and improve her curves so that he could claim to possess the most shapely woman in his own particular set. Such rivalry, it appeared, was intense, and, although the ladies themselves were usually as keen as their men to score over their friends, the ceinture was looked on as being a useful method of preventing any slackening.

The little padlocks are beautifully made miniatures, but they are nevertheless quite strong, and each has a different key. Incidentally, there was only one key with each lock, but I forgot to enquire whether spares could be bought! My wife, who can lace herself down to 20 ins., has on occasion tried on the ceinture, and we can both vouch for its security; it would, however, be a cruel garment to wear for any length of time.

Yours faithfully,
"CASTIGLIONE"

SHE RULES

Dear Sir:

Your magazine change my life. My wife read a copy. It made her decide to *rule* our marriage. She now uses the rod. I jump to obey— or else. Our life is now a happy one thanks to you. No more quarrels, no sulks. She commands and I jump.

And I like it. Don't ask me why —but I like to obey. She uses a dog whip if I don't. It hurts.

More men would be happy if they submitted to wives wielding dog whips.

F. E. M., JR.

WE'VE BEEN CAUGHT NAPPING
Sir:

It sems to me that you have allowed yourself to become a bit inconsistent when you suggest that the wearer of a Venus corset and/or "Upside Down Skirt," learn to use her toes for—"Typing,

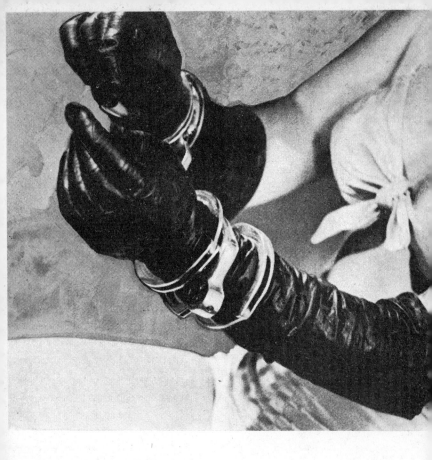

the prisoner of the gloves

photo from a reader

shorthand, and boiling kettle, or extracting the cork—" Because toes so capable could circumvent your preceding remark that ". . . if a fair damsel cannot get at her purse she cannot spend money." This in enthusiastic consideration of the advantages of the Venus corset. Indeed, the inconsistency increases, because do you not espouse the cause of skyscraper heels and high boots? How can you recon-

cile trained toes with such things?

Better, I would say, to subject your fair damsel to a Venus corset, upside down skirt over a Blind Girl Fluff helmet, and thigh-high laced boots with stratospheric heels, and I feel quite convinced that a fair damsel so costumed would find considerable difficulty in getting at her purse.

Yours,

MARGE

HIGH HEELS FOR HAPPINESS

Dear Editor:

My husband and I find your magazine fascinating, especially the letters and photos from readers devoted to high heels. I love high heels and since my middle teens have worn them almost exclusively, and as my feet are very small (size four) even ordinary high heels make walking delightfully precarious. My husband admits that my dainty spike-heeled feet were what first attracted him to me. Even before our marriage, he wanted me to wear higher heels, but at that time I could never seem to find any shoes with extra-high heels except platform shoes which we both think clumsy. It was not until about a year after our marriage, when we moved to the large West Coast city where we now live, that we began frequently to see women tripping along in heels definitely higher than average.

And then one memorable day I found myself looking into a shop window displaying nothing but tiny shoes with full four-inch "skyscraper" heels. I could hardly wait to enter, and a few moments later I was parading before a mirror in a delectable pair of low-cut calf pumps, their slim stilt heels making my instep a completely vertical continuation of the line of my leg.

My husband was delighted, and at his insistence I have now replaced all my shoes with "skyscrapers" and have literally worn nothing else since.

On my last birthday he presented me with some custom-made black satin lounging mules. They are open-toed, cut high in front, and their delicate heels measure exactly four and three-quarters inches! I am in love with them and wear them at home in the evening at every opportunity, even though I can barely balance in them.

Thus for years now I have hardly taken a step, even in my own boudoir, in heels lower than four inches. As a result my heel tendons have shortened to the point where I walk with the greatest of ease on my four-inch stilts but am completely helpless without them. Strangely, the notion that I am utterly dependent on high heels makes them even more attractive to both of us.

There must be many women who, like me, are utter slaves to ultra-high heels, and I hope that more of them will be encouraged to write in.

Yours,

HELEN

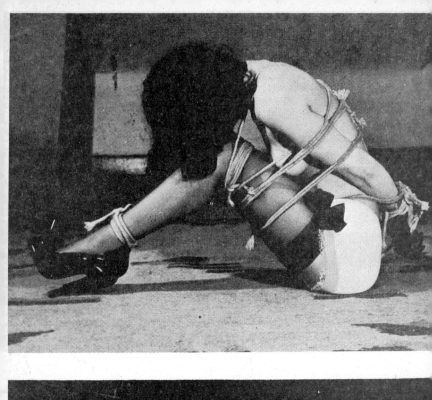
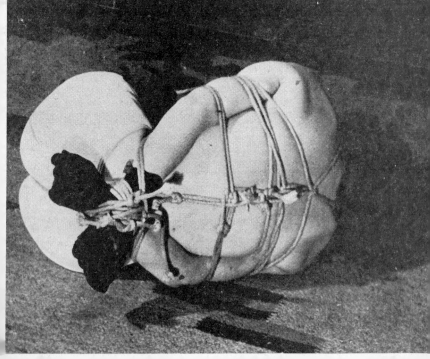

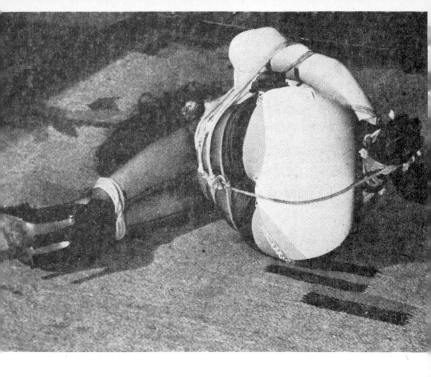

OF COURSE YOU CAN BE LIKE
MISS HOUDINI

and get out of this in 10 minutes flat!
(once you've fallen over on your side)

but it might be easier to take care you
don't get into such a mess in the first place.

So — we repeat —

LEARN JIU JITSU
and the art of self-defense

"SISTERS" IN BUSINESS

Dear Sirs:

I want you to know how much my husband and I enjoy your grand publication. *Bizarre* fills a need and offers a medium for exchange of ideas of those who do not believe or who are forced by circumstances to indulge in the unconventional. It was only less than a month ago that we were introduced to your magazine and truthfully we are extremely sorry that complete sets of the back issues are not available.

At the present moment my husband is seated in his favorite chair reading volume 8 and it is with his specific permission that I am writing this. If you were here you would immediately ask, "Where is your husband?" for instead of a man you would see a glamorous "girl." At the present time he has all the attributes, outwardly, that is, of a woman—dark curly hair—makeup — figure revealing blue crepe dress—nylon clad legs—and high-heeled black patent leather pumps. Beneath the dress I know he wears a slip, a waist cincher girdle, and a 36 cup bra.

For over three years now he has been, outwardly, a woman and to the world we are "sisters" as well as business partners. The fact that we are "sisters" was brought about by circumstances which made it advisable for us to be unconven-

tional. About six years ago we opened a small dress shop in a middle size town in the midwest. At first I ran the store by myself while my husband worked in an office. I needed help at times and he came to my assistance. It was embarrassing though to our trade as a woman has a bit of reticence when it comes to buying a girdle or a bra from a man.

One evening, after a trying day I said, "Oh, if you were only a woman!" to him and he laughed and said, "Let's go out for dinner and a show and you'll forget your problems." We went out for dinner and to a night club. One of the acts there was a female impersonator. He was very good, and it was not until the end of the act that the audience realized that the entertainer was a man and not a woman. That nite he said that he had the solution. "What if he became a woman—to trade and all others a woman; my sister instead of my husband."

We took it as more of a joke at first but the more we thought of it the better the idea seemed to be. Then we tried it out in the privacy of our apartment. It was a simple matter to obtain the clothing and his figure was quite adaptable being not too tall and also slender and he had legs that most girls could envy—slim ankles nice calves and thighs.

The first time he dressed as a woman, complete with girdle, padded bra, slip, hose, dress, and high-heeled shoes, he said that he enjoyed the luxurious feeling the feminine garments gave to him. I was amazed at the transformation. He made an extremely attractive woman. That first night we made our plans. He would go in to training as a woman for a year or so while I would search for a new shop in a larger Eastern city. If at the end of a year he could pass close inspection as a "woman" we would then make the change.

Training nites were Tuesdays, Thursdays and Saturdays and all day Sunday. During those times I was a Queen and he was a "Lady in Training." He had to learn to walk like a woman and to become familiar with high heels. His figure had to be remade as his waistline was that of a man rather than that of a woman. He wore high heels around the house at every opportunity, at first ones with heels about 2 inches high, then when he got familiar with them we boosted the heel heights to 4 inches, about as high as any commercially available. On all occasions he wore silk or nylon hose tautly gartered to a girdle.

The most difficult training for him of course was to get used to a girdle—or rather, in his case, a lacing type corset for that was the only thing that could reduce his "enormous" waistline of 28 inches to feminine one of 22.

As we sold corsets, girdles and bras of all types in the store, it was a simple matter to obtain a special back lacing type to be used as a training garment. For the first six months he wore the garment laced as tightly as I could pull it during the training period. At other times, even at night he wore a tightly boned elastic waist confining garment. His bit of suffering bore fruit as his waistline gradually got smaller and smaller. At the end of six months, he measured 24 without the girdle and we cou'd, by tight lacing of the original garment, achieve 21 inches.

By the end of the first six months training period we were quite sure that he could pass inspection as a woman. With a transformation and makeup, gowned in a figure revealing dress or suit, and tightly corseted and wearing high heeled pumps he could, I was sure, draw the attention of most men and an envious glance from many women. By that time we turned our attention to his beard. Fortunately it was light. He made an appointment with a beautician in a nearby city and made arrangements to take treatments to have it removed by electrolysis. This took several months. The hair on his legs we removed by one of the

several commercially available compounds for such purposes.

It was about then that I heard of an opening for a dress shop near Philadelphia. We went down to look it over and at the same time to have a bit of a vacation and also to check whether or not he could really pass inspection as a woman. We drove over in our car. The clothes in both bags were completely feminine. As we left our apartment, he wore a long sleeve black sweater and slacks and loafers, but beneath he wore a bra (without the pads), a girdle and nylon hose.

When we were safely under way he made the change to a woman quite quickly. First the transformation which gave him long curling black hair, then the C cup bra pads which gave him the specified feminine curves. With the tight sweater he was quite an attraction. The slacks were replaced by a skirt and the loafers by high-heeled pumps. Makeup completed the change.

He was a bit nervous when we stopped for lunch on the Pennsylvania super-highway, but I told him to relax, that he looked fine. We both entered the "ladies room" and I'll say that he was marvelous. He straightened his stocking seams like any woman, tugged down on his girdle and reapplied makeup just like the rest. After that test everything was smooth sailing. We looked the store over and decided to make the move.

After a week of living as a woman, he said it was hard when we got back home from our survey trip to again become a man. Everyday until we left permanently for the east he wore women's clothes at every opportunity. The day before we left I sold all his male clothes—shirts, hose, suits, hats, shoes—everything.

Within 20 minutes of the time we left for the east, he was a woman and has been ever since. He says that the three years have been delightful. Our business has prospered, we have quite a number of women and girls who are our customers and not once has anyone even questioned that Bobby's real name is Robert and not Roberta. He has had numerous requests for dates, particularly from salesmen, but never once has he accepted. He is still my "date" and a very fine husband.

When I started this letter, I did not realize it would be as long as it is. I do believe, however, that the readers of your grand magazine will be interested in the fact that this experience of ours is proof that a man can become a woman and enjoy a woman's clothes. It takes practice perseverence and quite a bit of training. Bobby is enjoying his life.

table decoration

photo from G.K.

"Babs" on page 57 of No. 9 punishes her husband by forcing him to dress as a French maid and serve her. I don't believe in being a Slaverette. My Bobby is better than any French maid because he waits on me without force. I get anything I want because Bobby wants it that way. We rea'ly enjoy life.

With best of luck to *Bizarre!*
BETTIE C.

SOLVING THE MAID PROBLEM
Dear Editor:

It seems that your readers are getting quite interested in figure training for boys through the wearing of girl's clothes. I, personally, am all in favor, of this kind of training and experienced it on my husband. My husband's transformation is now complete. He wears size 8-A shoes, and size 14 clothes with a 26-inch waist. With dresses which look best with a wasp waist, such as blouses and wide skirts, he wears a corset which brings down his waist measure to 22 inches.

I expect him to come straight back home, as soon as his work is finished, and to change clothes immediately. I taught him, of course, to cook, sew, wash and iron and

"Gisele" is to me a perfect and obedient maid.

I had to be firm and strict at the start. My husband tried to rebel but tight lacing, high heels and good discipline soon had him subdued. He has now become quite fond of dressing, acting and living at home like a girl. We even go out together and nobody suspects anything, so completely girlish have become his walk, his gestures and his manners. I have to check his shopping sprees: Shoes, dainty lingerie, costume jewelry, etc., he just can't resist to buy them.

Though he is entirely used to his way of life, I still submit him once in a while to a whole week end of "discipline" so that he does not forget who is the mistress of the house. During such week ends, he is kept tightly laced, gagged and shackled, or with his arms tied in the back which is excellent anyway to improve the posture.

I am now thinking of moving to another town and to open a lingerie shop. "Gisele" can then work with me as a salesgirl and discard once and for all a masculine attire which has become as repulsive to "her" as it is to me.

Yours, NICOLE

MAIR SWATTING

Dear Sir:

I understand my friend, Miss Douglas, recently wrote to you concerning an issue of *Bizarre*

which we oddly came across together in Scotland, and in particular a letter in it concerning discipline in France. Miss Douglas, who shares a house with me in Edinburgh, showed me her letter and there are one or two comments I should like to add myself.

During the last century the whipping of girls at school was considered a necessary and salutory part of their education. This is definitely proved by the correspondence columns of *The Queen, The Englishwoman's Domestic Magazine, Public Opinion,* and such like, during the middle of the century. Intrigued by your letter on this subject I turned up some issues of these journals that have remained in our family and thought your readers might care to know my findings. Incidentally, these are bonafide testimonies from actual witnesses (victim and inflictor), for all these papers were respectable Victorian organs and the editress only printed letters with name and address given.

Perhaps the most interesting controversy was begun at the end of the sixties by a letter in the "Conversazione" section of *The Englishwoman's Domestic Magazine;* a perplexed mother asked advice on how to deal with an un-

chained letter writer (see letter in No. 9) ⟩→ ***still at it***

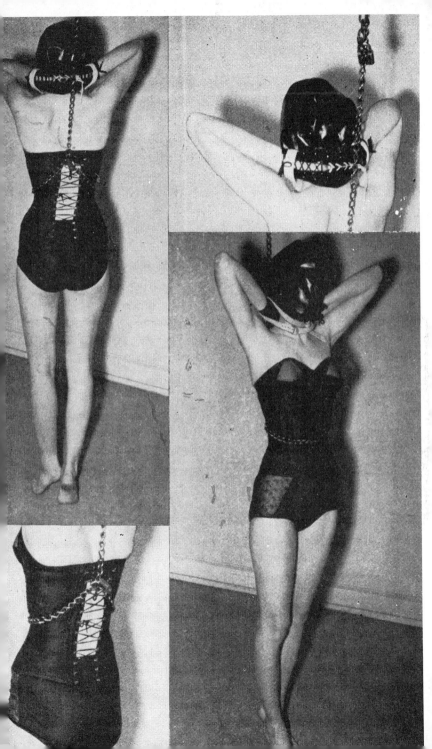

ruly and insubordinate daughter, aged fourteen. She was promptly told by the editress that a sound whipping with a birch-rod, administered on the spot and in private, was in order. This touched off such a correspondence that the journal had to print eventually a small supplement to contain it.

On the whole, all mothers seemed to regard some form of corporal punishment as a necessary part of both school and home discipline up to the age of sixteen, for both girls and boys. There were a few total dissentients and of course the degree of punishment to be inflicted was highly controversial. It would be impossible to give a fair sample of all shades of opinion in a page or so, but here is a representative selection.

Nearly all correspondents were agreed that however often one did decide to punish in this way, the actual infliction should be severe. A mother of three daughters advised the birch as giving "the most exquisite" pain, while a clergyman's wife recommended the tawse, or tailed strap still in use in Scotland, as being "far more intense than the birch." Some mothers used slippers, but one mistress replied, "No punishment worthy of the name can be given with a slipper." She counselled the "twigs" or cane ("the cane can be very severe."). A birch-maker at a famous English public-school wrote in, advising that the switches be picked when green and actually "in bud." The handle, he said, should be of the thickness of the wrist.

The area of operation seemed to be nearly always the "lower back," as our polite Victorian grandmas put it! Some preferred the shoulders, but most mothers recognized that the Sitzplatz was admirably adapted.

There was considerable discussion as to whether the delinquent should be whipped *supra dorsum nudum* or not. Most agreed that she should be, some adding, as an extra refinement, that the correction should be invariably carried out in the presence of a sister, since the shame caused was so effective and beneficial. The positions varied considerably in choice, but several letters advocated lying over a bed or ottoman. Girls' schools seemed to have whipped almost invariably over an ottoman or stool known as a "horse." Nearly all seemed agreed, interestingly enough, that administration should not take place until at least half-an-hour after the fault, so that the corrector should be quite cool. But no touching toes!

To us girls educated in Scots schools none of this seems so very extraordinary now; what does seem amazing is the number of

strokes our nineteenth century ancestors seem to have endured at a time for their misdemeanors. "Never less than a dozen and a half" is the advice of one matron with a disobedient daughter of sixteen, while another wrote in, corroborating this, telling how she had only given her girl twelve and the little thing had laughed at her. However, on the next occasion she administered no less than fifty "deliberate stripes of the most severe nature imaginable" and "the effect produced was excellent." I can well imagine it was!

On the whole, I conclude after reading this correspondence that the Victorian parent and mistress was determined to be strongminded. If she decided to whip, she whipped. Or she sent her refractory daughter to an establishment where the rod was in use. And from the letters from those who attended such seminaries, one can see that the mistresses were regular martinets.

In all cases the strokes were laid on with a measured rigour, eliciting gasps as of being plunged in icy water, and then, often enough, cries and pleas for mercy. Many times it seems to have been the custom for the cuts to have been counted out loud (as in the letter from France in your columns) by victim, servant, or inflictor. Despite the pain, the full count was always given, and afterwards the girl had to kneel and kiss the rod. After she had then composed herself and adjusted her dress, she returned with the book to the principal who either kissed her, shook her hand or smiled at her, and bade her be a better girl in future.

It does not seem, on the whole, to have been common practise for these principals to carry out correction themselves, though there were notable exceptions. And to give you an example of the strictness of these alarming ladies, let me outline briefly the confessed procedure by a vcitim of one of them.

(Actually such cases of (to us) extreme severity were not entirely uncommon, and they are recorded now in these pages for posterity to see.) This lady relates (with gratitude!) how she was a spoilt, rude little girl until sent to a training school which used c.p. In her case she was tied up to a hook in the wall by the wrists, so that she was on tiptoe—and given a severe dose of Madame la Verge. However, she was a hardy young miss, it seems, and her spirit unbroken she replied with a tart "No" to the question as to whether she was sorry. She was left secured for an hour and whipped again. This time it was too much, even for her. She begged forgiveness. But not until

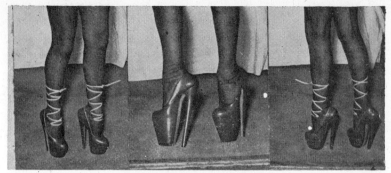

one reader's new shoes

she had had two more doses of this unpleasant medicine, again at hourly intervals and each time with a freshly pickled birch of the lithest and toughest variety, was she taken down. Then, to her despair, she was ordered to her knees to request correction in the humblest tones, instructed to kiss a new rod, and had to lie over the bed in a docile way for yet another application.

These accounts should not end without mention of the numerous references to and by home governesses. They seem to have been the most vociferous advocates of c. p. among our grandparents. Responsible for their jobs to the behaviour of the children under their command, they simply could not afford lax behaviour. It was in this group that I found reference to the dreaded "soko" or birch composed of thin strips of whalebone which could reduce the most stubborn temper to "the suppleness of a glove." The governesses also relate their experiences with girls whose parents insisted on tight-lacing and of the corrective devices they were forced to use, to prevent their charges from becoming "Cutters" (corset strings!) and so on. Of course, the rod was not the least of these! I hope this report may have interested you and, perhaps, your readers.

Yours truly,
(Mrs.) Ella Guthrie

Practice Makes Perfect
Dear Sir:

I have just finished reading No. 9, the first time I have seen any copy of your magazine, and I find it most interesting. I particularly enjoyed reading those letters dealing with the subject of corsetting, as I myself am an ardent tight-lacer. I have been now for two years.

I first started wearing tightly laced corsets on the suggestion of my husband. We had been married

just over a year, and it had been my aim always to dress to please him. By hints from him I knew that he liked to see me wearing the highest possible heels and tight hobble skirts. In the evening, I was always lavish with make-up, and wore frilly, rustling petticoats under my dresses. But somehow he was never entirely satisfied, and so I tackled him about it one evening. At length I got it out of him. He wanted me to tight-lace, but had never liked to ask me as he did not want me to suffer agonies for his sake. But I was prepared to please him even though it might mean a painful ordeal. Also the thought of being laced in by him into a tight corset gave me an overwhelmingly scaring but thrilling feeling which I had to satisfy.

At length, after writing numerous letters, I discovered a corsettier who specialized in making tiny waisted corsets. I was measured carefully, and then about four weeks later the exciting garment arrived by post. It was a beautiful corset, made of French Broche,

but looked as if it was going to be terribly uncomfortable so rigidly was it boned throughout its length, with the long line of lacing at the back. I waited until my husband had come home, and then after we had had a drink I told him I had a surprise for him if he would come up to the bedroom in five minutes. I then went up and laid out the corset on the bed, together with a pair of black silk stockings and my highest heeled shoes. Then I undressed and made my face up in the most exotic manner. I heard my husband come in and heard him gasp as he saw the corset. "Lace me in now darling," I told him, "I'm quite ready."

I shall never forget that first experience of being tight laced. I had clasped a bracket on the wall so that my arms were reaching straight up above my head. Then I felt the laces gradually tightening, first below then above and then at the waist. Then again. It took my husband about fifteen minutes to lace me right in, and by that time I was wondering with

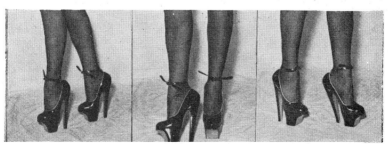

panic, whether I was going to be able to bear the vice-like pressure. He tied the laces and letting go of the bracket I ran my hands up and down my unbelievably firm, smooth body and clasped my hard tiny waist. It was torture, but exquisite torture. My husband was completely smitten, and looked at me with an adoration I had never seen before. I felt a bit faint and very breathless so asked him to help me to lie down. I lay on the bed feeling completely helpless, but very thrilled in my new exciting harness.

After a time I felt better and after I had been helped up I dressed in a negligee and went downstairs to the lounge. There we sat for the rest of the evening discussing clothes to go with my new figure, for I had determined by this time to persevere with my lacing. At the time I had been laced in from a normal waist of 25 inches to 20 inches. My aim was to get down to eighteen inches eventually, which, the corsettier had said, could easily be done with perseverence.

Well, I did persevere, although at times I nearly gave up. The first month was the worst, and after that my body became more accustomed to the restriction, and submitted itself to the tyranny of my corset. But I have let this letter become too long and will leave the description of my subsequent training until I write again, if your readers are interested enough. Suffice it to add that after years I now lace in to 17inches without any trouble at all.

Yours truly,
WASP WAIST

BREECHES AND SPURS
Dear Editor:

I agree with B.D.E. in Bizarre No. 7 for "a day in the country" nothing is more practical than a pair of riding breeches and riding boots. What I have especially in mind for "Miss Severity" is a pair of riding breeches with reinforced leather seat and inside of knees. Also tall riding boots like the ones shown in a photograph in No. 2 of Bizarre but adorned with shiny, mean looking sharp pointed rowel spurs, that serve so well in breaking the spirit of the mount. A well worn riding whip in the hand of the "Severe Mistress" should complete this picture.

It would not surprise me at all if such an adorable creature riding on her light horse should encounter many humble admirers along the bridle path.

Yours faithfully, E.G.

BRAND YOUR MAN
Dear Editor:

I have been a reader of *Bizarre* since your first issue. Regret that many of the issues are out of print

as I was foolish enough to "loan" 5 and 6. Some of the situations your readers describe are truly novel. Have not seen anything of the precise nature of my most interesting little experience.

About a year ago I had a very definite domestic problem. Friend husband made "out of town trips" so he said. A bit of checking and it was apparent his interest was not business but "monkey business." She was blond, much younger than I, a girl in the theatre, lived alone, near the downtown district of our mid-western city. Husband met her in connection with his business and it became serious. Ten years of marriage, his career and our entire future seemed blasted. For about two weeks I fretted and worried, finally confided in a friend with wide and varied experience and followed instructions. Hubby was about to make another business trip, and the night before leaving as was his considerate custom he spent with me. As soon as he was asleep I left my twin bed and secured from the linen closet the handcuffs which had been so carefully hidden that afternoon. He stirred but did not fully awaken as they snicked shut over each wrist behind him. I changed to a sheer negligee purchased for the occasion and smoked a cigarette in the living room until after stirring

and muttering the boy appeared at the entrance. At my suggestion he came and knelt before me, I gave him a couple of puffs and then told him what I knew, explaining the consequences and giving him an alternative. Conversation was his forte and it became apparent that his promises would be merely words. We entered the bedroom and two pads of kleenex and one of his hankerchiefs solved any possible distraction thru sight. A piece of store cord looped over a toe of each foot and under the bed completed any practical difficulties as to poor workmanship due to movement. The tatoo artist who had soldered the four small needles together for me said to follow the fountain pen outline of whatever I wanted to inscribe by tightly stretching the skin as the four needles carried the draftsman's ink below the layers of the skin. More time was consumed than expected because I wanted a nice looking result but in the course of an hour including the interruption to stuff a pair of sox where they would keep things quieter the gentleman was branded and I mean not maybe. The right ankle announced "Wed to" horizontally and my name vertically. Then the lather and razon for a "clean sweep" and just an initial elsewhere. After release of all save the cuffs, a drink and some coffee our conversation

was resumed. I now have a very attentive husband. He called the girl in my presence, tho I offered to take a walk, and stated that it was over, I gathered he had been paying her rent because he said "yes" several times. He now finds less need for out of the city activities—lights my cigarettes, agrees with any thing I say and all that is required to bring him up close and quick is in company to ask how his ankle feels. There has been one little incident—a cute trick we met in Florida last winter—I invited her to go to the beach with us unbeknown to him, when she arrived it did not require much skill to set the conversation on ankles and feet so that there was sufficient embarrassment on both her part and his to destroy any interest. Of course, I still have the handcuffs —and the ink and needle. I use the former once in a while—shall we say—just as a reminder. My adviser in the ink says the colors fade or can be bleached out if competently done but the carbon ink— never. Maybe the letters of my name should have a red border???

LET WOMEN BE WOMEN

Sir:

I liked Mrs. Billy T's letter on old-fashioned styles. This lovely, well-written letter of a modern woman's discovery of feminine loveliness is a masterpiece of exquisite beauty. What a delightful experience for a lady to have!

Every lover of the alluring hour-glass figure cannot but visualize the charming picture Mrs. Billy must have presented as she descended the stairs to surprise her niece. Personally, had I been in the shoes of Nora's friend, young Billy, I should have been delighted and charmed—not frightened or embarrassed. But then, of course, I am not a youngster, merely a middle aged man who has a fine sense of discrimination for genuine feminine loveliness.

It is highly gratifying for me to know that modern woman ha both the curiosity and the courage to find out the truth for hersel' about such so-called antiquated articles of feminine apparel as heavy gauge silk stockings, tailored silk bloomers, old-fashioned heavily boned stays, and knee-length high-heeled kid boots.

The feminine world lost much with the passing of the charming wasp-waisted mode of the late nineteenth and early twentieth century. What women gained in social and political equality they lost in feminine beauty. This, of course, was inevitable, since by adopting unfeminine styles and a way of life patterned after the supposedly superior male women ceased to be real women and became instead, mere feminine copies of the male.

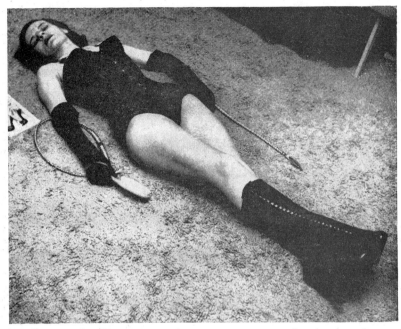

for my leather moments

photo from a reader

No, I am not old-fashioned in the sense that I am opposed to mannish attire for women. Far from it! I oppose mannish attire for women only when it is not suitable for them. What is pleasing, flattering and alluring may advantageously be worn by women: knickers, bloomers and breeches of silk, satin, nylon or rayon look exquisite on any woman. Tailored slacks of satin, nylon or rayon may be worn provided that the feminine figure is beautiful and feminized. But one should exercise care to prevent sloppiness and on no account should the slacks be rolled half-way to the knee.

Knickers and breeches all flatter a woman's figure, but unhappily the same cannot always be said for slacks. Of course, if women want to hide their legs, slacks are most ideal for this purpose, but personally, if I were a woman I would rather be dead than be seen in slacks.

One might well ask why should bloomers, particularly of the gym variety be so pleasing to some masculine eyes considering their bulkiness. Well, the answer is that firstly bloomers are essentially feminine anyway; second, they tend to emphasize a woman's hips which to be really feminine should nat-

urally be fairly prominent; third, if they are of satin, sateen or heavy silk they attract and hold one's attention.

I have been asked many times if there's such a thing as a natural feminine figure. No! Nature is not in the least concerned about the artistic or decorative aspect, it's the perpetuation of the race that matters and nothing else. Beauty for this reason must always be a highly artificial product of a specific environment designed to give women the shape and contour most alluring to the male.

We are now living in an unfeminine age which stresses youth and health. In fact, there is such a fetish about both that unless a fashion revolution comes along soon, there is a possibility that a new philosophic or religious system may arise based on these false ideologies.

Fred Mac

A Critical Commentary
Dear Editor:

"Blind Girl Fluff's" letter was interesting, but doesn't she ever have any neighbors popping in for a half an egg, or a teaspoon of sugar to complete a recipe. If they had any idea that there were any such goings-on they would probably be a big bother—with some people a closed door doesn't mean a thing, you have to lock it. And a locked door is a matter of curiosity —why?

The fanciful contraption on page 49 ought to stir up some comment. For instance, as a suggested improvement: the arm loop ought to be located further back on the top bar—closer to the shoulders, and away from the top corner of the frame so that there would be space for the elbow to be bent between the loop and the corner and so protect the arms from being broken if the whole business got tipped over forward. Then the wearer of the cage would be on hands and knees in an equally ungainly position—exposing the seat of government to correction—which might be desirable.

The model in the "don't let it happen to you" series looks as though she earned her fee. Don't you feel like a skunk persuading your models that it is for a "worthy cause," and only for a moment "while the camera and lights are being focussed." [*Who said it took only a moment to focus a camera? It takes J.W. hours. Ed.*] I am particularly interested to know whether any of your readers think they could free themselves from the tie-ups which you have shown. I hope some adept escape artist will rise to the bait and give us the inside story.

And of course there is considerable difference between a willing

and an unwilling captive. "Don't let it happen to you" implies an unwilling captive, while the usual Bizarre slant concerns the "joys" of being a willing captive. Ain't we got fun?

All for now, yours,

Kibitzer

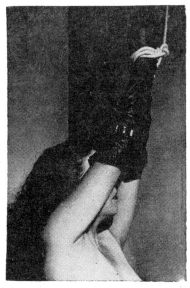

this is the top half—after a gap—of page 4 turned upside down

HOURGLASS HAPPINESS

Dear Sir:

As for our likes and dislikes — our likes have been centered around corsets and high heels with my darling little wife continuously laced in, night and day and proud of her hour glass figure. Her heels are never less than 4½ inches and highest are 6 inches. Her six-inch heels are worn mostly at home and she wears them with the greatest of ease as though she was wearing 4½ inch heels.

We have had many experiences listening to ones who have varied their ideas and opinions over my wife's hourglass figure and many who have a desire to put their hands around her waist. Other marvel over how she can wear so well the height of heels she does.

Sincerely,

S. W. D.

IMPROVEMENT BY
SHOULDER-BRACES

Dear Sir:

Perhaps your readers will be interested in a recent experiment I made with a foundation garment of my own design.

With the present figure trend emphasizing the small waist and more upright carriage again I took stock of myself and decided that perhaps I would try one of these "waspies." Then I thought again and noticing how slack and stooped I had become, I decided perhaps a shoulder brace or very long corselet would be more effective.

A visit to a corset specialist soon settled the matter and after discussing my problems with her I left, still doubtfull whether I had done the right thing, because upon her advice I had ordered a new type of garment namely a com-

bination of a "waspie" and shoulder brace.

When it was ready, I called in to be fitted and when properly adjusted I had to admit that it was a wonderful success. Never had I experienced such a feeling of trimness and well being as that garment gave me, in fact, I insisted upon wearing it away from the

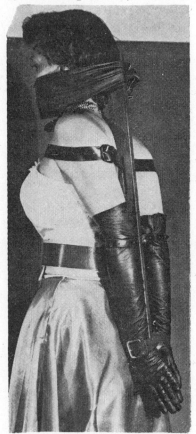

photo from G.M.

***a simple gadget to ensure
an upright posture***

shop then and there.

Since then several of my friends have had them made with equal success.

Yours sincerely,

ELSIE M.

MISS MYSTERY

Dear Editor:

"Blind Girl Fluff" sure started something by her blindfold story in *Bizarre*. For a "fancy dress" idea, to a dress-up party our camera club had recently, I was supposed to be "Miss Photo Negative of 1952." Like a negative all the dark parts were light and the light parts dark. It was an exciting party and I got an extra thrill out of my costume even tho the other people of the party didn't know it.

You see, my husband read about Blind Girl Fluff and immediately tried it on me. In fact, I've been blindfolded so much of the time in the last three months, I've almost forgotten I can see. I find my way around the house alone all day while he's at work—even get stuff ready for dinner—then when he comes home he cooks it. You see my corset and stiff leather collar keep my head and body upright so that short chains from my wrists to the belt prevent me reaching up and taking off the blindfold, but still allow me to do a lot of things around the house.

But as I started to say, after being blindfolded a few hours, I

photo by G.K.

the dance of the slippers

got used to the blackout sensation and while it is always exciting to be so helpless, it lost some of its first thrill. Then came this new idea—the black mask over the head permits seeing shadows such as a window outline in the daytime or a bright blurred spot from a light at night. But the white covered sun glasses makes it black except the dim light and shadows around the edges of the "glasses" and these shadows have a very exciting effect. I noticed it at the party the first night I wore the costume. Instead of the "blackout" I'd been used to, the light and dark as I moved cautiously around made me conscious of the *lack* of seeing. I'd keep trying to peer out of the sides —turning my head as if to get a better view which, of course, I couldn't. But it was frustrating and half irritating—much more a real sense of helplessness. I couldn't let on or show it at the party but could only stand around and hear people, trying to imagine what they were doing and when somebody asked me to dance and led me to the floor, I could only guess who it was and what they were like by the voice and a touch on the arm.

Never did I have such a thrill, I hope some of your readers will try it.

Sincerely,

S. R.

BIZARRE

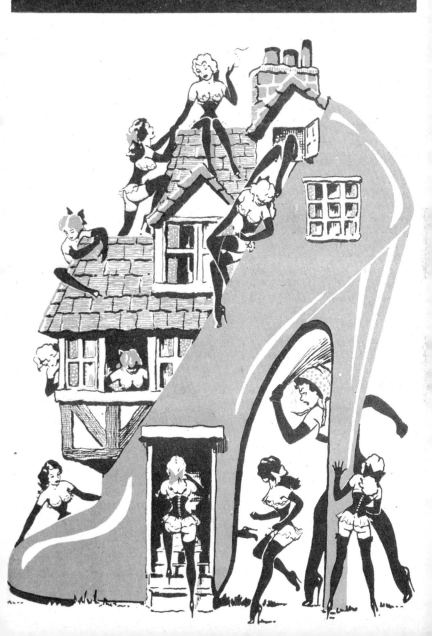

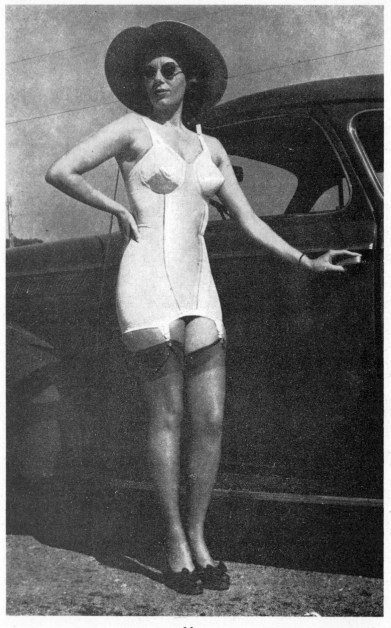

cool! ... see page 41

BIZARRE

"a fashion fantasia"

No. 12

Ah, my Beloved, fill the cup that clears
TO-DAY of past regrets and future Fears—
TO-MORROW?—Why, To-morrow I may be
Myself with Yesterday's Sev'n Thousand Years.

OMAR KHAYYAM

CONTENTS

Back Numbers

For back numbers see your local dealer or write to:
BIZARRE, P.O. Box 511, Montreal 3, Canada.
All copies are $1 each.

Bizarre is published by John Willie. If you want his sketches and cartoons write to him direct at the above address.

Printed and published by Bizarre Publishing Co. P.O. Box 511, Montreal 3, Canada.
Copyright 1953. All rights reserved.

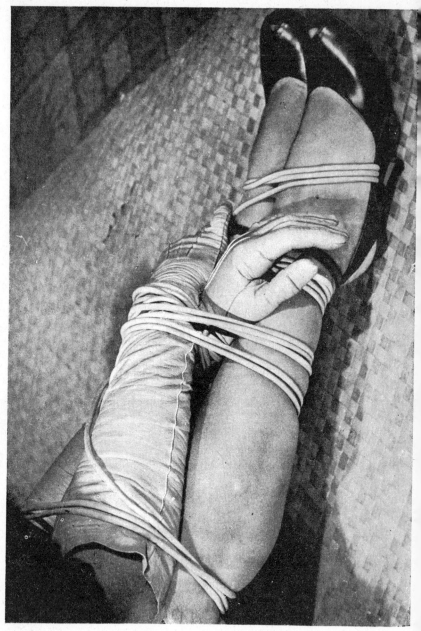

don't get too wrapped up in yourself!

WE ARE GOING TO HAVE A REST!

As soon as this issue (No. 12) is published we are shutting up shop for two weeks. We are going on a vacation! All of us! And believe you me we need it!

For the past six months this place has been a rat race. The trouble started because sometime around the middle of last year John Willie got fed up with forever dipping into his own pocket to keep *Bizarre* on its feet. Why make money drawing cartoons and then lose it all on a small pocket size magazine?

It wasn't as if *Bizarre* wouldn't sell. It was simply that not enough people knew of its existence. So the obvious thing to do was to advertise; scatter the good word around and generally make a bit of noise—or close up the publication.

So we placed an ad here and an ad there and got busy with No. 9 and No. 10. Then the flood started. It just came with a wallop around Christmas time and, before we knew it, we were bogged down with mail.

Somehow we got No. 11 out but we had to forget about No. 12. The muddle was fantastic! Extra help came—went nuts—and passed on, adding to the confusion. Orders got jumbled, important letters forever lost, accounts muddled, until finally all hands and the cook (meaning J. W.) had to quit what they should ordinarily be doing and lend a hand.

We plugged the main leak by the simple process of stopping the advertising and gradually the flood subsided. Now we can more or less breathe and here, very late and rather damp at the edges, is No. 12.

Fortunately the results of all this nonsense have been satisfactory for us and out of the mountain of mail we have acquired sufficient new readers to put *Bizarre* on two feet—a trifle wobbly it's true but "feet" nevertheless—for once in its lifetime. Under the circumstances you might say that this is not the time to rest but, frankly, "we've 'ad it."

The reprints of all the back issues are now in hand, but the printer can handle them without our assistance, and in due course you will be able to complete your collection. In the meantime, for the next two weeks to be exact, remember, there'll be no one here to answer your letters.

Have fun and wish us luck.

5

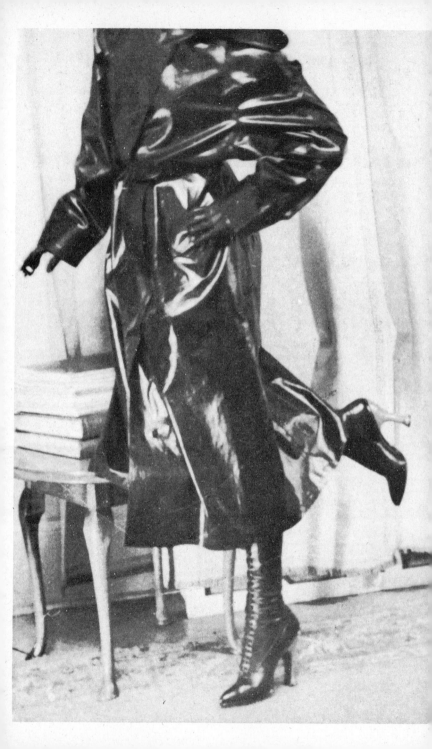

FOOTWEAR FANTASIA

by Sylvia Soulier

Dear Editor:

I noticed in *Bizarre* that some of your readers occasionally mention macks, and it occurred to me that you might care to have these few further snaps of my own wet weather black mackintosh.

My mack is very shiny and of a gleaming black rubber, not too heavy for shopping and with a wide tight belt and hood for emergency use. As you will see from the photos I always wear a pretty little pair of calf length laced black kid boots which have scarlet heels about four and a half inches in actual height. I measured them. The boots, I should add, are rather a tight fit but very warm and comfortable for shopping jaunts, the heels not being too high for wet weather, I think you will agree — or would if YOU had to wear them shopping for hours.

I took a couple of closer shots for you which will give you a better idea of the actual boots. They are also custom made like my bronze pair which you have already seen. Believe me, lacing those little boots when you happen

to have gotten already to go out, is quite a business, as I have depicted in my photo, but as you see it can be done, eh? But to return to the rubber mackintosh, with its wide sleeves I find I can wear full length over-elbow black kid gloves for warmth, (*rubber gloves would be warmer still. Ed.*) a type of glove I normally wear in summer

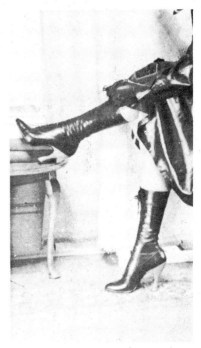

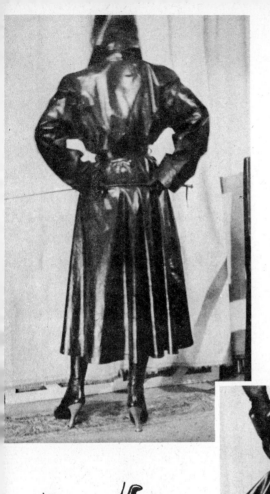

look out Noah!

here I come!

over here, only of course in summer I wear short-sleeved dresses and always long, coloured, kid gloves which I think have a great attraction to the eye.

As I daresay some of your more experienced wearers of high heeled footwear know to their cost, one has to be pretty supple from a muscle point of view, and I have tried to portray for your readers a few simple little exercises that I find help me a good deal. I call them my "Cycling strokes." Sitting on a stool and extending first one leg and then the other is one matter, but lying on your back and "cycling" is quite another for some fifteen minutes every now and then during the day to keep in trim, anyway it teaches you to see that the insteps are kept well vertical when standing, for nothing looks worse than women who wear high heels and so obviously cannot really stand in them at all. Personally, I seldom wear anything lower than a four-inch dead height heel. Even to and from business, I wear my standard four-inchers.

Until recently we were not able to get the lovely American "Betty Grable" style thigh length elastic hose, but at last we have a few coming over here and very attractive they are too, though they have a slightly strange feeling after our long accustomed cobwebby black silk hose, and after those little exercises I had been doing, I pulled a pair up specially tight and had a little recreation and read, wearing shoes made in reddish-tan kid which in this instance have a pair of actual five-inch heels. As you can see, these on a size five (English sizes) are quite comfortable in daily use if you have a fairly straight instep, which I happen to have, I imagine, from wearing ultra high heels since I was quite a little girl.

Our old friends, the Bronze boots, have crept into this letter again, a close up of being laced up indoors, where sometimes I think they look quite attractive with the right things.

I must not take up any more of your valuable space now, but hope that some of your readers like to have actual examples of these at-

 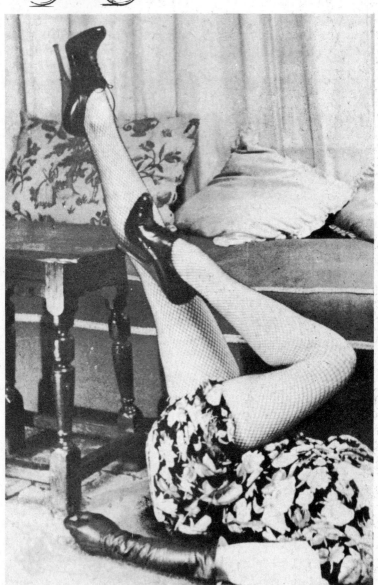

with some cycling exercises

thrown in —

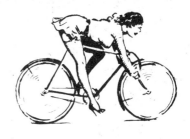

tractive little adjuncts of a woman's dress, the Glove, the Boot and the High heeled shoe.

I find that with my highest heels a really tight corset not only adds to one's deportment, but also gives that sense of support necessary with extreme heels like my seven-inch red heeled patent lace ups.

Well! dear Mr. Editor, again I am wandering on far too long, but I am afraid like most women, once you get me on my pet subject I could go indefinitely, I suppose some people like wearing pretty hats and dresses, so do I, BUT I MUST have my highest heels at all times and my gloves at all times.

O.K. Mr. Editor, I'll tell you this little, I am still in my thirties and have worn high heels since I was about eighteen so work it out, and I know pretty well what can be worn and what can't, believe me Mr. Editor. Personally, I would prefer a girl, if I was her hubby, who could wear a five-inch heel to one who talked about her five- and six-inch, and as is so often the case, couldn't keep her little pretty shaped knees straight in 'em.

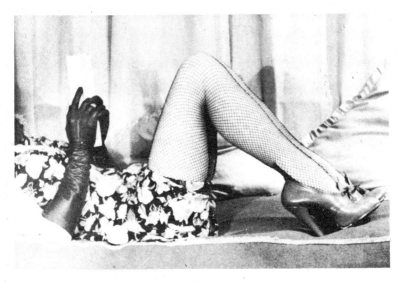

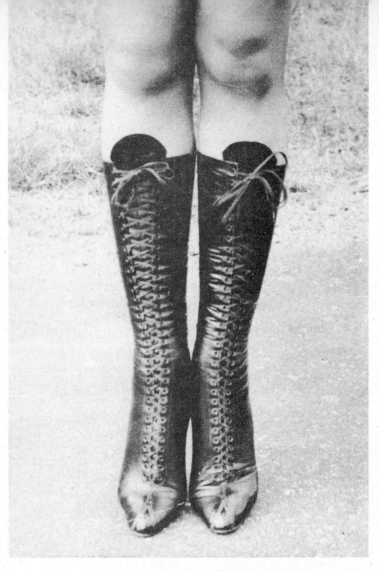

Yours sincerely,

SYLVIA SOULIER

FROM GIRL

TO PONY

By N. Y. C.

Continued from Previous Issue

I flicked her gently with the whip, and said "gee-up!" again. Still no effect, so I got out of the vehicle and tightened up her harness. I pulled the waist belt in as far as I could, the shoulder straps each up a hole, the strap under her body two holes. I forced her hands still higher between her shoulder blades; then I tightened up the bit straps, forcing the bit still further into her mouth. Eve tried to say something that sounded as though she were promising to obey, but, of course, the bit prevented anything save a vague chattering sound. I told her very sharply that ponies couldn't talk and those that tried got their bit straps pulled still tighter. As a final touch I pulled the check rein up several holes, dragging her head still further back, arching her neck and forcing her chest out like a pouter pigeon's.

Then I got back into the driving seat, clicked my tongue, and my pony started off at a smart walk.

Thanks to its light construction the carriage went very easily, and I let her keep walking for some time, till she got used to pulling it, and until she learned how to obey the bit.

To give her a little rest, we stopped for a while, and I got out and schooled her in how to stand, with her feet together and knees smartly braced back. The rest of her body I didn't have to bother about, since her harness held her rigidly in the proper attitude.

When we started off again, I made her break into a trot, by means of a light flick of the whip. And a very pretty gait it was too. The height of her heels and the way her harness held her prevented her taking very long steps. Pretty as it was, I had a feeling that something was wrong, and then realized that the old time slave ponies had to trot with "High Action," that is, each knee had to be raised so that the toe of the raised foot was level with the knee of the other leg.

So to teach her properly, I drove to the edge of the lawn at the back of the house, stopped, and took my pony out of the shafts. Leading her onto the lawn, I unfastened

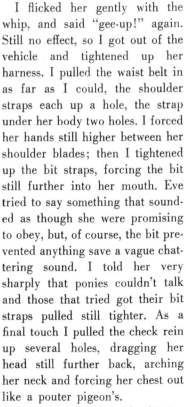

13

the driving rein from one bit ring, so that it was a single rein of double length. Then I stood and made her trot around me in a circle. Every time she failed to raise a silken knee high enough, she got a warning flick of the whip.

In a very short time she was doing a very beautiful "High Action" trot, as dainty and springy as the steps of a ballet dancer. Then, back in the shafts again I drove her into the wood at the end of the garden, insisting on high action. Whenever she slackened her pace, I found a twitch on the bit, or flick of the whip would do wonders at making her mend her speed, but as she was now obviously tired, though she had little enough chance of showing it since her harness held her so rigid, I only drove as far as a little summer house in the middle of the wood.

Here I unhitched her from the cart again and slackened off her bearing rein and bit straps several holes, so that she could get a little rest, but left the other straps tight, so that she wouldn't forget that she was a pony.

There was a little natural spring in the wood nearby, so I led her over and gave her a drink from a folding cup that I carried. She took it thirstily. After I had had a drink myself, I led her back to

the summer house, where I sat on a bench for a smoke. Meanwhile, I had taken off the pony's driving rein, since I knew that harnessed as she was, and poised on such high heels, even if she did try to run away, I'd have no difficulty in catching her. So now she had an opportunity to wander as she pleased. Once or twice she walked away further than I liked, but when I whistled to her she hurried back at once.

Soon she stopped walking away at all, but hung about near where I was sitting. Then very hesitantly she sat on the end of the bench I was using. Reined up as she was, sitting wasn't very easy, in fact she could only manage a bolt-upright, wooden soldier posiiton, with her knees held tightly together.

When she sat down, I made no sign at all, but went quietly on smoking, as I wanted to see what she would do.

Before long, she began edging along the bench towards me.

She did it very slowly, and stopped if I made any move. Finally, she was right next to me, looking very appealing and defenseless in her tight harness. Her head was still held back by the bearing rein so that the subdued light in the wood fell on her upturned mouth, its corners pulled back by the bit between her teeth,

14

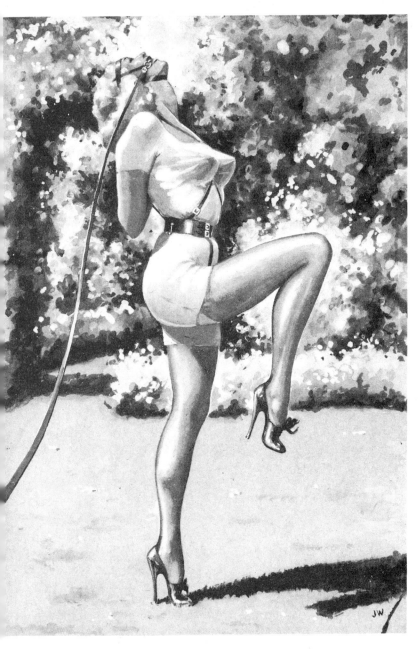

she was doing a very beautiful "high action" trot

her lips parted by the steel and rubber that robbed her of the power of speech.

As I still did nothing, she leaned against me gently, so after a moment, I put my arm lightly around her arched shoulders. With a sigh she relaxed or tried to relax, her harness preventing anything much in that direction. I looked into her eyes and found the anger quite gone out of them, and in its place was a strange light that I didn't understand at that moment.

"Well," I asked, "do you like being a human pony?" I wanted to see if she would fly into a temper again. Greatly to my surprise, she nodded. It wasn't much of a nod, as the bearing rein held her head all but rigid.

"Would you like me to un-harness you?" I went on.

Again she surprised me. She shook her head. "You mean that you're prepared to remain a pony, wearing a harness and bridle, with a bit in your mouth till I get ready to release you?" She nodded and tried to say something which her bit choked into a murmur.

"In other words, then," I went on, "you've found someone who can master you?"

This time she didn't nod. She turned slowly as much as her straps would allow, and offered me her bitted lips. Need I say that I availed myself of her offer?

It was quite some while, by the way, before I decided it was time to put the carriage away and release my pretty pony.

But finally I reattached her driving reins and fastened her once more between the shafts. Getting up into the drivers seat, I clicked my tongue. To my surprise, my pony refused to move. I flicked her with the whip. Still no move. Then I realized what she wanted.

Getting down off the seat, I went over her harness again. Since she had had it on for some time and it had adjusted itself to her figure, and vice versa, I was able to get the belt in another hole, the shoulder and under straps each up a hole. Of course, I had slackened the bit straps and bearing rein when I had taken her from the carriage and now I pulled these up as tight as they had been before, then gave the bearing rein two extra holes, so that her chin was almost in a straight line with her neck, and pulled the bit up another hole on each strap.

Then I got back in the seat, gave the reins a flick and off we went. My pony broke into a high action trot of her own accord and kept it up all the way back to the coach house, her lovely silk-clad legs rising and falling in mettle-some rhythm like the fore-legs of a thoroughbred trotting pony.

She was gasping for breath by

the time we reached the stable yard the tight belt around her waist forcing her to breathe from the chest only; her beautiful bosom, thrust out by the tight check rein, straining at its white linen covering, as she gulped for air through her wide-open bitted mouth.

I got out of the carriage, and walked my tired pony into the coach house; here I put the carriage up and then led her, still fully harnessed, into the harness room. In a second I had the check rein off and was taking the bit out of her mouth when she gripped it with her teeth and made me understand that she wanted it in her mouth a moment longer. So I fastened the straps again, but only tight enough to hold it in place.

The she nudged me into a chair, and when I was seated, immediately sat on my lap and presented her bitted lips for a couple of final kisses before she ceased to be a pony.

Well, Bill told me a lot more than that, about subsequent adventures with this girl who desired nothing more than to be his pony, to let him strap her into a tight harness, with a bridle on her head and a bit in her mouth, and then obey his slightest wish, but I think this story is long enough.

N.Y.C.

For the Supplenmentary Illustrations for this first part of this article in No. 11 write to the Editor, P.O. Box 511, Montreal, Canada.

FANCY DRESS
for special evenings

and

the
PEACOCK
PARADE

The fancy dress pages in this issue could better be described as "Muddled Musings."

We began by trying to concoct some more costume designs for the "Peacock Parade"—something which though frilly, silky, and what not, would look good on the male carcass.

It seemed to us that though the costumes on pages 24, 25 (*Bizarre* No. 10) were all that they should be, we had somehow missed the boat. The faces were too feminine to prove our point.

We decided that this time we would start by getting J. W. to draw a muscley-mass-of-man in his birthday suit; then we would begin to "tiddley him up"—starting with "bloomers"—which must show!; then we'd do another in scanties and waist nipper getting into a fancy shirt, both novel ideas and obviously original! But what happens? All we get is what we've always got before when we try to do this page—a "dandy" *circa AD* 1700!—even to the long hair! We're certain we go about

it with an open and unbiased mind yet it seems quite impossible to get anything different from the clothing worn by those gay cavaliers and buccaneers—which is understandable when you consider that they were past masters in preening their magnificent feathers and strutting—whereas we, the modern tailor's dummy (meaning dolt) are not.

Of course, the greatest obstacle that confronts us today is the rush of modern life itself. The cavaliers led a leisurely existence in a leisurely old world, and there were always dozens of comely serving wenches to stitch and sew and wash and iron for nothing more than a penny a day and a friendly pinch on a plump bottom.

Few males these days can live an easy carefree life. The competition in business is too keen and keeps your nose to the grindstone, (and the seat of your pants shiny) just trying to make ends meet. We're trying to do our best to make life brighter by promoting the return of the finest of fine

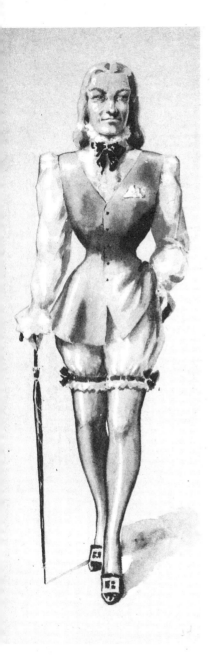

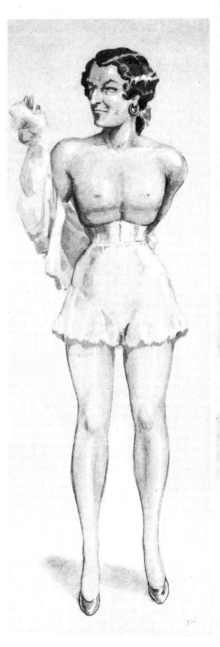

Colonel Bloomer *Captain Cincher*

feathers for men, but we have a feeling that it is a lost cause until that day dawns when everything is mechanized, and the one button is finally pushed to keep all buttons pushed and the machines going to provide us with everything we need. We can then give a sigh of relief and devote ourselves more to a sweet life of nothing but wine, women and song—which is all as it should be (but as the sage said, the wine and the song must be good)—HoHum! . . . Z-Z-Z-Z-Z! !

At this point we gave up, and for a change tried to do something about fancy dress for damsels, but we were so fuddled and wuzzy that all we could think of was trying to concoct "women-without-arms."

Venus de Milo is the obvious start, but that lady is no Venus if she wears anything above her waist . . . and the postal laws and regulations frown on pictures of the nude breast . . . and the Postmaster General sends the F.B.I., the U. S. Calvary and the Mounties (to say nothing of Dick Tracy) after you with guns if you show just one nipple in print and send it through the mails. (Which when all is said and done is udder nonsense.) Soooo — we switched off Venus and tried other ideas. A Mermaid?—no you have the same problem, and anyway she has arms even if she hasn't got legs.

Finally we settled on the arm-

less "milk maid" or "peasant wench." It's quite a sound idea. The black corset arrangement (which all maids wear in the country (at least in every picture book we've ever seen) enables the arms to be squeezed in close and held quite immoveably in place—well concealed by the puffy-shouldered sleeves. The very futuristic "Miss Spaceship" (half tangled up with the head gear motif of ancient Egypt), living as she does in AD 2053, won't need arms at all—neither will she have to walk; the master push button has been pushed by then. She just hasn't any need to do anything but look pretty. Incidentally the one really bright idea about this costume is the top of the dress—or the bottom of the top half—whichever you like to call it. Women always have a problem "holding the top up." and with a very decollete gown something often keeps popping out (three cheers!)—but in this case, being up side down, it automatically falls in place (the dress we mean) covering this and that, and stays there—unless the wind blows—which is why all space sirens will travel head first toward their target.

P.S.: We've discovered why J.W. is enthusiastic about women without arms—it saves him so much work not drawing the hands.

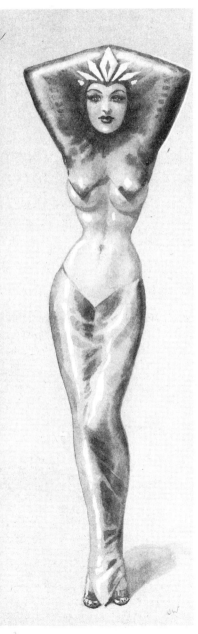

Miss Spaceship

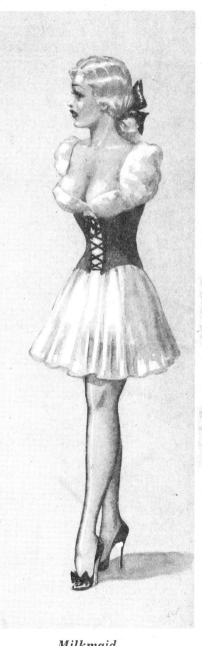

Milkmaid

The Chinese Flute

Our ancestors really had this "Home Sweet Home" business down to a fine art.

Sit back, relax, and consider for example "The Chinese Flute" which we unearthed the other day from an old pamphlet and now present here for your appraisal.

Like the "Scolds Bridle" and all the other old time gadgets it is simple and effective—extremely so in it's original form. We have not shown the original form because it made the illustration too involved, but we will describe it to you.

In general it was the same as the thing shown on page 23 except that it had in addition a large wooden plug (with a hole through the center) which went into the victim's mouth. This plug was more or less cone shaped and so designed that it would fill any mouth completely, and distend the lips until they formed an air tight clamp around it.

The plug was attached to the main gadget by a short upright bar, and a screw arrangement enabled it to be forced into the mouth. To prevent the victim from drawing her head back there was another upright bar behind the head—to which a curved cross piece was attached (like the cross of a "T") to form a head rest.

And now we come to the point of the hole in the plug. When properly fixed up the captive could breathe through her nose but having her mouth open she would automatically also breathe through the hole in the plug—and so into this hole our revered ancestors stuck a little whistle. Everytime my lady breathed the whistle went "tweet"!—in fact, no matter what she might feel about life in general she could do nothing but go on going "tweet! tweet!" tootling willy nilly on her flute (the monotony of the melody being considered similar to Chinese music—hence the name).

It takes little imagination to realize the effect this would have on a bad tempered wench when one fine day she would be hauled into court, where an unsympathetic judge would prescribe "The Chinese Flute" for a spell. To the great delight of the onlookers the beadle and his stout hearted as-

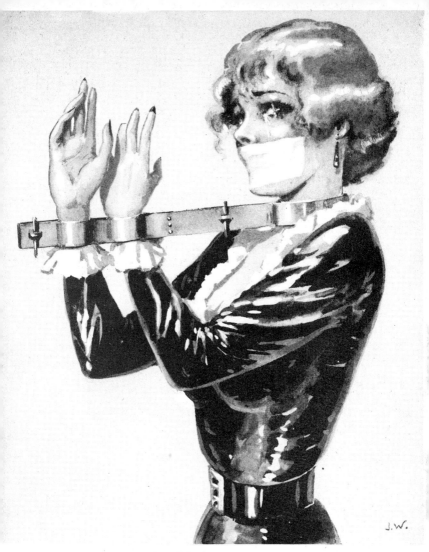

The Silent Piper

(dig that crazy axe!)

sistants would lock the thing in place (on court order), screw the plug home and let her loose. With short chains hobbling her ankles, she would be unable to move very fast, or kick anyone, and everyone would be laughing and jeering at her.

She would try to tell them what she thought of them in a few well rounded phrases, but the only sound she would make would be "tweet tweet." She would try to curse and swear but instead of ripe invective she'd still hear nothing but that wretched "tweet tweet." and if a day of this treatment didn't cure the most bad tempered wench of her unpleasant habits she'd be pretty tough.

What a boon for the present day henpecked-house-mouse! But!—we DON'T recommend the flute! A dripping tap would be a lullaby in comparison; but that's no hindrance; after all you only want a little peace and quiet for a change and so you could have a "silent piper"—Why not?

You can still use the gadget to secure honey-bunch's wrists and neck, but you have a gag that's quite separate, and not attached to it in anyway. Though her fingers will be close to the thing that's stopping up her mouth, she will be unable to remove it—so near and yet so far—a condition which will no doubt annoy her considerably, causing her to grow red in the face, breathe heavily through her nostrils, and curl and uncurl her fingers in suppressed emotion—thus giving a very good but very silent impersonation of Harry James playing "The Flight of the Bumble Bee."

Eventually the would be nagger will simmer down and like any other dutiful wife beg for forgiveness by meek and appropriate signs, probably with a tear or two thrown in—but don't weaken! Stiffen the sinews! Be firm—but kind. A little improving literature would be a good lesson, and so you should have a clamp arrangement to stick on the end of the gadget, like the bandsmen have on their trumpets and things so that as they march they can know what note to play. On this "book rest" you place a copy of Dale Carnegie's "How To Make Friends and Influence People" and oblige cutie-pie by turning the pages for her when necessary.

It's really an idea with great possibilities, and so simple to make that anyone with half a workshop can knock one up in a couple of hours—in fact, we will be pleased to supply a complete set of working blue prints if you want them. Just write to the Editoress of our "Happy Homes and Household Hints" section.

Correspondence

Under no circumstances do we publish names and addresses, nor do we put readers in touch with each other. If photos or sketches are sent in, please write a short commentary and please do NOT send in photos which you got from someone else.

KORSET KEEPSAKE

Dear Sir:

A few years ago, a lady friend of mine asked me if I would like to have her "Old Style Hour Glass" corset as a keepsake. She, of course, knew that I was a fervent admirer of her wasp waist and she herself, at that time, was requiring a smaller size corset. I was delighted at this unusual gift and was prepared to place it with other souvenirs of lingerie I had collected.

On the day she started wearing her new and smaller corset, she brought me her old one and to my complete surprise she insisted that I tried it on there and then. After pulling the laces with all her strength she securely tied them and asked me not to remove the garment for a week. As I was not used to wearing a corset, after a couple of days, the physical discomfort became too much for me and I asked her permission to remove those tight stays of hers. I was amazed at her answer: "If I

as much as let out the corset one inch and let alone remove it, I would lose all her respect and esteem." She quoted the proverb: "What is good for the goose is good for the gander." I did not want to lose her friendship so I became a willing party and endured her tight laced corset stoically.

To begin, the laces were drawn in to just under 2 inches from closing and the corset itself measured 23 inches round the waist. My waist thus measured just under 25 inches. After one week, I was allowed to remove the corset for half a day, but she insisted on tightly lacing me in again, next morning, by placing her knee on the small of my back and pulling the laces with her upmost strength. She took it upon herself as a duty to reduce my waist a fraction of an inch each week. She made sure of this by marking the position on the lace against the eyelets at each juncture.

After one month the feeling of

25

pain diminished and I began to enjoy the physical discomfort brought on by tighter and tighter lacing. After ten months the corset I was wearing was quite closed and my waist measured just under 23 inches. My friend's waist was just under 21 inches at this time, and we mutually agreed to continue reducing the size of each other's waists as much as possible. I needed a new corset to get down to still smaller sizes and she arranged for me to be personally fitted by her own corsetiere. After two years of figure training my waist measured just over 19 inches and I had to be fitted for a still smaller corset.

At present, I measure just a fraction below 18 inches round the waist and the lady who introduced me to the delights of tight lacing measures just over 15 inches. I can easily span her waist with my two hands without using any pressure whatever. My corsetiere has one client with a waist measuring under 14 inches and has gained a world reputation as a tiny waist specialist and this is in 1953 (not as might be expected during the gay nineties.) She has a large number of male clients and is quite used to making corsets to measure for either sex. Her corsets are really beautiful, well boned, made of the finest French materials and trimmed with lace.

With firm resolve and reasonable patience it is really surprising what can be achieved in giving one's figure the true wasp waist.

In the woods, there are male as well as female wasps—why are not more gentlemen as well as ladies emulating them in the cities?

Yours,

"ANDRE"

FOR FEMININE FINERY

Dear Sir:

Having read all your issues, I am pleased to see that you devote space to such articles as "Marjorie," "Ursula" and other cases of men who wear the satins and laces of women.

Since high school, I have worn dresses, lingerie, makeup around the house whenever the opportunity presented itself.

I purchase my own clothes, and the salesladies know why I buy them and help me out. One woman friend of mine lets me dress up in her house and she comments on my dress and the details of my wig, makeup, walk and talk.

As "Barbara" she will talk and be friends with me. As a man she hardly knows me. She encourages me to be feminine and I thoroughly enjoy it. I am tall, but several women have said I could be a model and one man wouldn't believe I wasn't a young lady.

Whenever dressed, I wear a

girdle and am trying a waist nipper and have reduced my waist to 23 inches with a hip and bust measurement of 38 inches.

My men's clothes are all heavy and harsh, such as wool, tweed, etc., and I see no reason why men's clothes have to be so heavy, ugly and rough and women's so light, smooth, and attractive.

I am still single but would like to marry a woman like Edna K. or Norah Clark if I could have my dresses and wardrobe and dress my wife and myself as twins.

Keep up the good work *Bizarre*.

"BARBARA"

MARITAL MORNING EXERCISES

Dear Editor:

I was very much interested in the letter from "Elsa" Money Maker and Maid, and made my husband read it too.

We have been very happy together for many years, and I think one reason for this is that I have trained him to start the day right.

Every morning, usually when he arrives at the breakfast table, he must kneel at my feet with his head to the ground. I put my foot on his neck so as to make him feel that he is "under my heel" then he repeats: "I promise to love, honour and obey you my dear wife in the sure and certain knowledge that you will keep me under strict discipline at all times and that you

will enforce it by whipping me whenever you think it beneficial." After this rededication, he is usually in an obedient and docile frame of mind for the rest of the day, and though I do not make him do much housework he must serve me in very humble and devoted fashion or feel my whip where it does the most good.

Your truly,

SANDRA

TEST YOUR OWN INVENTIONS

Dear J. W.:

I made a model of the portable prison shown on page 16 of Volume 8 and as I had concluded from the drawing the prisoner was able to move her shoulders back enough to get her arms out and then her legs.

To prevent her getting free I decided to put her hands in a single leather mitten which laces up. I made another change in design which is more effective. A strap for the elbows is much more comfortable as the metal digs in when lying on the side.

My wife was very helpful with my efforts to prove my mechanical genius and when the above research had been completed she obligingly, and a little too eagerly, laced my hands in the mitten only using a belt to pull the elbows in. At this point she got a book and made herself comfortable in an

overstuffed chair to observe me. I knew from her uncooperative attitude that I was in for a spell.

I found, as she had, that this is a *most secure* means of confinement. I started off in a chair where it is easy to be "put in." This is not at all uncomfortable. It is just darned inconvenient and awkward I found I could walk around and sit in any chair easily enough. But after an hour of this, I was ready for a change and decided to lie down on the floor. I bumped myself good getting on my back. It was difficult to keep balanced this way and my back bones were digging holes in the floor so I flopped over on my side and soon the weight of my legs on my arm was uncomfortable but I couldn't change positions. Try as I might, I couldn't get enough leverage against furniture or wall to roll over. It was impossible to get back on my feet. If I had it to do over again, I wouldn't get out of the chair.

I gave up trying and asked my wife to put me on my feet and found her not inclined to help. At the end of two hours (from start) she agreed to put me on my feet again, but it would cost me another hour "in jail" as we call it. I figured it was worth it as I had in mind getting in bed where I might be more comfortable. But when I arrived at the bed (it was quite high), I couldn't get in it. I could only sit on it. My weight was off the bed and I had no means of getting in. After much effort and no success I was really worried. I had already been "in jail" for a little over 2 hours, and this thing was really getting tiresome. I still had most of an hour to go — and perhaps more if she thought of something to punish me for. It would be fair because I work it on her sometimes. Punishment begins after the *fun* of a new adventure or session has worn off. This doesn't happen too often as the punishment has to be for some real offense such as my forgetting to put out the garbage can or her failing to put out milk bottles for milk and many others.

I was in such a predicament that I asked for help again and almost got the leather helmet and gag for bothering her, but for an additional hour she helped me into bed. My condition was much improved but still tiresome and very confining. I dozed a little at a time and spent much time searching my activities for the last two weeks for anything she might punish me for. Also resolving to be more careful in the future not to forget the garbage can, etc. Finally my time was up and she let me loose. I served four hours in all.

Left to myself I would have been "in jail" forever. I was com-

pletely helpless and it is absolutely impossible to get out.

JAIL BIRD

Miss Mystery

Who is the Mystery Woman in the old moated grange? Why does she always appear masked and silent with her faithful servant? What is her secret? A terrible disfiguring accident? A lost love-life? What?

You guess, and let us know.

MALE FOOTSTOOL

Dear Mr. Editor:

Thank goodness you are publishing again. My husband and I can hardly be without your magazine. You see we are not an ordinary couple, and often feel alone in the world.

We feel that the husband should be subject to the wife, and that for a truly happy marriage the wife should play the part of the silk stocking tyrant to the fullest. So it has been in our life together. I punish my husband for any impertinances, and if he commits none, he receives a whipping anyway to remind him of his marriage vows to me. I enter all of his offenses in a punishment book, the current volume of which he is required to wear on a chain around his neck. He really enjoys being humiliated in this way and others, and since he worships me like a God, I have an enjoyable time of it. As in other instances, we have read of in your magazine, he is forced to serve as a lady's maid whenever he is at home. On winter nights when he has finished his chores he enjoys curling up in front of the fireplace under my feet, while I read the paper.

We both enjoy your magazine and feel that it is the duty of people like ourselves to contribute to its growth and survival.

Yours truly, MRS. XYZ

LADY BEWARE !

don't make yourself too pretty for the Party!

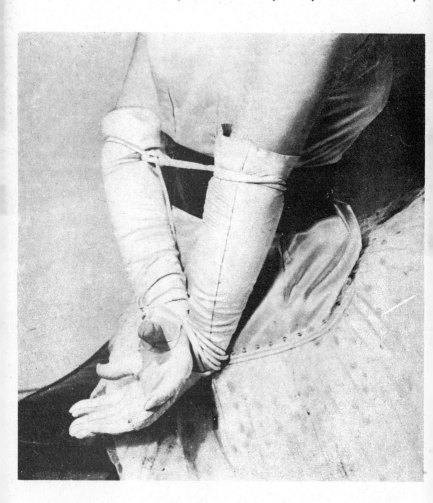

the boy friend may decide it's not safe to let you go out!

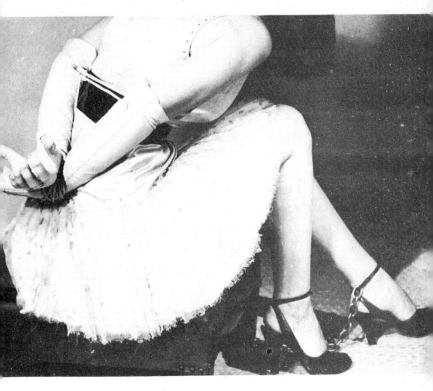

he'll want to keep you all to himself!

*and take simple
measures to
ensure success*

so —

*whatever you do,
don't wear ankle
strap shoes*

YOU CAN TURN THE TABLES ON HIM

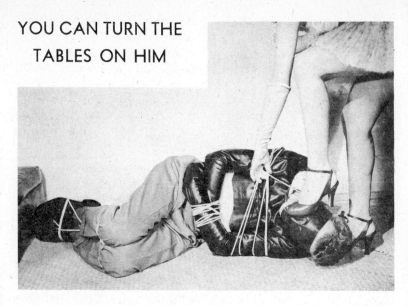

If you follow our advice — Learn Jiu Jitsu!

Forewarned is forearmed!

PETTICOATS FOR PUNISHMENT

Dear Editor:

It may perhaps be some consolation to Billy—remembering his own days of ruffled repentance" when forced to wear his stepsister's short frocks and frilly knickers—to know that here in London there is at least one young man of 18 who is still regularly made to submit to a similarly humiliating ordeal. Indeed, my delightful and very much ashamed-looking "petticoat penitent" is standing in front of me as I write this.

No doubt some readers will be surprised to find him dressed in such extremely "little girl" fashion, but there are good reasons for this. "Petticoat penitence" is designed to humiliate him and make him feel ashamed, and I find from experience that this is best achieved by forcing him to wear very childish clothes, with lace-frilled knickers and petticoats well displayed like a little girl's, under his tiny, baby-style frock.

Moreover, he has the added bitter humiliation of knowing that these clothes are an exact copy of

those at present being worn by the little girl next door, Nancy—aged four! ! For it is Nancy's mother, an attractive young widow and an expert needle woman, who made both outfits! She has always been very interested in my system of "petticoat penitence," and soon after Nancy was born she herself suggested that it would be an amusing idea to "bring them up together." And so it has proved.

The boy, of course, hates his clothes, and there are always tearful protests when he knows he is to be put in them. But he knows that my orders must be obeyed, and that he will stay petticoated and penitent until I release him.

Yours truly,

"A MODERN MOTHER"

HUMILIATE HIM FOR HAPPINESS

Dear Sir:

How very right Elsa is when she talks of the "beneficial humiliation" which a husband experiences when trained and dressed to "play the maid" at his wife's bidding.

I have a sister whose husband is absolutely under her thumb. Every evening he is made to change into long, tight, satin corsets, frilly knickers, a well-starched white lace petticoat, and a black high-necked taffeta dress with a short well-flared skirt which shows off the lace frills of his petticoats and knickers.

Dressed like this, he prepares tea and waits on her until she has finished when he is allowed to have his own meal, in the kitchen. If I visit her or any of her other lady friends, he waits on us in the same way.

He makes an excellent "maid," but is obviously very self-conscious, and feels the humiliation of his position keenly. Especially the humiliation of wearing such very short skirts knowing that we can see the little lace frills of his knickers and petticoats.

Taking Ursula's' tip, my sister punishes him by making him "stand in the corner" like a naughty child. For such punishments he wears special "naughty girl" rompers—a pair of very full white silk bloomers, to which she has sewn a bit of the same material. I have seen him several times like this, and he looks more humiliated and ashamed than ever. The threat of a spell in his "bib and bloomers" is always enough to quiet any attempt at rebellion.

Yours sincerely,

JANE

BLOOMERS FOR BEAUTY

Dear "Mrs. Billy T":

It certainly was with a great deal of enthusiasm that I read your interesting account of you

a zipper can be a nuisance

putting on *bloomers*. I simply adore bloomers, especially the right kind, silk or rayon and either white, pink or blue. The most important thing is the right figure to put them on. They should not be too big and should pull tight when "my lady" bends or stoops, etc. I would give a lot to be lucky enough to know a lady who wore them and who was all dressed up lovely, and when she crossed her lovely curvy leg to all the delightful bloomers showing on the thigh that is crossed. It is lovely too to see "my lady" getting in or out of a car and showing her bloomers.

Yes, dear Correspondent, I am one who bemoans the sad fate of the bloomer. I pray they come back because a woman's' charm is greatly enhanced by wearing bloomers of an assortment of colors.

I can imagine how LOVELY you must have looked that day you dressed up and ran into that young man. I only wish I had been that young man. I believe, dear lady, that you must have a good figure and good leg. Your figure will be plump (*as it should be*) and matronly. How wonderful it would be to have photos of you wearing the outfit you describe. A lovely *corset, with uplifts*, nice *black hose* wearing lovely, heavenly bloomers.

Do write again, dear "Mrs. Billy T." Perhaps you'd like to send photos of yourself. Maybe you'd even get someone to take pictures of you dressed as you pictured yourself in your MOST entertaining article in that past issue of *Bizarre*.

If *only* something could be done to bring bloomers back into *fashion*. Women are a thousand times more luscious in the days when lovely bloomers are worn.

Sincerely,

G.B.H.

MAN SHOULD BE MASTER

Dear Editor:

I am getting sick and tired—not to say downright disgusted — with all this slavarette nonsense of women dominating man. This is going directly against Nature's fundamental and immutable laws and is no good for anyone. And though this may sound strange to modern ears, it's even worse for women than it is for men. For it is Nature's law that men shall run the show. To go against Nature is to be destroyed.

I am just waiting for someone to come back at me with the business of the bees. Well, bees are bees, and that's fine for them. But who eats their honey? Human beings—Not human bees. Well, what about the Amazons? someone else will ask. So what about them? Where are they today? They were

nothing but a bunch of women who went against the laws of nature and they were destroyed.

This sad state of affairs has come about, I am convinced, by the decline of the proper whipping of girls when they are young; plus the still rarer, and even more vital, continuance of this discipline of young women through adolescence until they are ready for maturity.

The result is multi-millions of untrained females. Any one who knows anything at all about training dogs realizes that they must be properly housebroken, for the good of the dog as well as its owner. Otherwise the dog will be nothing but a wretch—and a wretched nuisance. If it isn't run over because it's incapable of obeying its master's' command, "Come back-" then it will have to be destroyed because it bites the baby or is just plain unbearable. And how is a dog, or a bitch, properly housebroken? Through proper training and discipline, in which the whip is basic. This is not to say that dogs should be brutally and indiscriminately beaten, but whipped with skill, science and understanding. The same applies to the females of the human species. Women's job is the perpetuation of the human race, and in this job they play the major, by far the most painful, and certainly the most dangerous part. In order for them to underatke this job, the man must be out wresting a living from the earth or from other human beings. The house is like a ship at sea—and the housewife is the same: she must have only one captain. Nor can the ship command the captain. By Nature and necessity, the woman's role is passive, the man's active role.

GEOFFREY PETERSON
New York City

"HE CAN KNIT, TOO!"
Dear Bizarre Magazine:

My husband and I would like to read more articles on homes where the husband is allowed to take the wife's role such as is mentioned in your present issue.

When my John revealed his liking for feminine things, I bought him a few things like a dress and underthings. He was ever so happy and now after three years, he has a splendid wardrobe of lovely clothes which I encourage him to wear at all times.

I have taught him to cook, sew, wash and iron clothes, and now he does these things beautifully and with true womanly feeling.

In the evening we both sit and watch the TV. He is dressed in his lovely clothes and knits and mends.

Last month we bought an expensive wig of human hair and when properly madeup, he looks like any woman.

We do not go out dressed up as some of your readers appear to do but we may do it soon.

Our life together is wonderful now. John is always cheerful and a close companion now that he is more lady like.

And if you saw us together, you would never guess who is which.

Thank you,

(Mrs.) J. S. S.

Skirts for Men

Dear Mr. Editor:

Hurrah for skirt-wearing men! At long last a publication is showing long-needed approval of that unusually large group of men in the U.S.A.—and other countries of the world — who appreciate, admire and desire to wear the beautiful, colorful and comfortable garments of the feminine sex.

Granted they cannot all wear them in public due to the restrictions of modern social law, but they can at least enjoy them in the privacy of their homes.

In my opinion, any man who has experienced wearing the smooth rich texture of nylon hose —the sturdy support of a well designed girdle—the cool clinging softness of a lovely, lacy slip, petticoat, panty—the swish of a chic skirt around the knees—the soft beauty of a lovely blouse—will never again be truly comfortable in men's clothing.

To the above add the lovely feel of snug high heeled pumps and the wonderful scent of good perfume and the flash of good-looking accessories . . . and life is again beautiful for those men refined and cultivated enough to appreciate these things.

Let us have more interesting stories from the pens of men who have the courage and appreciation to wear these beautiful clothes.

Yours sincerely,

T. D. W.

The Gentler Sex

Dear Mr. Editor:

I enjoyed the letter from Edmund Livingston in Number 7 very much. I would like to point out to your readers and Mr. Livingston that here in the U.S.A. we do have, if not the same, at least a variation on the Parisian places of excitement described by Mr. Livingston. Here they are to be found in states with legalized gambling laws, since they take the form of gambling establishments —often with a cocktail lounge, or sports arena in conjunction. In the U.S.A. finger grinding is a game of chance in which the loser of a round receives a whipping from the little lady to whom he has lost. The nose and face also come in for grinding under spike-heeled little feet both facing up and facing down. Boxing is also a popular

38

amusement. In the game of chance, the gentleman agrees to pay and submit unless he can stay in the ring with the cute little spike heeled boxers (who usually end up sitting on top of their opponents or leading them around the ring by the nose) a specified number of rounds.

Of course, the gentleman is not allowed to use hands, feet or head, and some establishments go so far as to handcuff and fetter the clients. Races in which the girls ride their admirers across the length of the room are also popular. Some establismments also have a dance hall in conjunction where rhythms are beaten out by whip snapping young girls.

I advise Mr. Livingston to have his state gambling laws revised or migrate to a state where such laws are not so prohibitive if he wants more of Paris in the gold old U.S.A.

Yours truly,

H. C.

EXPERIENCE WITH WASP WAISTS

Dear Editor of *Bizarre*:

I have always liked tight belts and your pictures put the idea of a lacing corset into my mind. In a costume store I found a 1903 Warners Bros. and a Gossard front-lacer. I found the Gossard better to handle by myself. I have a rather full-figure but am generally not thought as fat, and I thought these corsets would fit me, but I found I broke laces in trying to bring the waist part together.

I had heard that ladies long ago used a leather belt over the corset when they had such trouble. In a spirit of helpfulness I pass my experience in getting my 36-24-37 figure down to 36-17-37.

I laced the corset as tight as I could, but the waist insisted on spreading, so I put on the belt and tightened it till the waist section string (there were three strings, one above, one middle and one around the hips, tied separately) —till the waist section string was loose. Then I tightened the string. Then I tightened the belt. Then I was able to tighten the string again. Finally I hooked the belt end over the hook and leaned back with all my weight and was able to tighten the strings again.

By persisting thus over a week I was able to reduce my waist from 24 to 19, the next week I was down to the present 17.

It hurt quite a bit but I didn't mind. I slept in them and took them off only to bathe. I felt dizzy only once, and after a rest went right on with it. The corset has a very exaggerated forward thrust in the breast region and pushes the abdomen way back, so I am forced to walk with up thrust chest and protruding derriere. It is so long that I cannot stride, but walk

in small steps. I can not find heels as high as some of your correspondents wear, but I can walk nicely in a pair I also found at the theatrical costumers which measure 4 inches from heel center. Since this puts me quite on tiptoe with my naturally small feet, I think I would have to wear platforms which I do not like to get along with higher heels.

Although I am plump in the breast region, I find they sink into the top of the corset. It was probably made for one of those extremely busty women one admires so much from the pictures of the gay nineties. So I pad *under* the breasts and they stand up nicely pushing well in front of the corset when I breathe.

I have remade all my clothes to the new figure and get utmost satisfaction from viewing it in the mirror as I dress.

Do any of your correspondents know where I can get a 36-16-36 frontlace? I think I could get down another inch or two if I could get the proper corset.

Yours, SALLY MONSON

UNDIES FOR OUTIES

Dear Editor:

I have read several issues of your publication and think they are so interesting. I noticed that such things as underwear and personal preferences are discussed quite frankly and it occurred to me that this might be the place to express a question that I have had in mind for some time.

The question is: Why isn't a girl just as decently dressed in panties and brassiere as she is in a two-piece swim suit?

I regret very much that convention frowns on one and not the other, because I have to be governed by that convention. There are several reasons why I think it is silly.

First is the matter of comfort. Girls wear panties and bras all day every day. For this reason manufacturers make them with utmost practicability and comfort in mind. I have perma-lift, bias cup and perfection bras in net, nylon. satin and broadcloth; flare leg panties in nylon and satin, elastic leg briefs in sheer or nylon, even a long-line bra and knee length "snuggies" for cold weather. Without exception, all of these items are completely comfortable. I cannot say the same for any of the fine bathing suits I have. All of them are lined, which gives them bulk, none give a good uplift, and

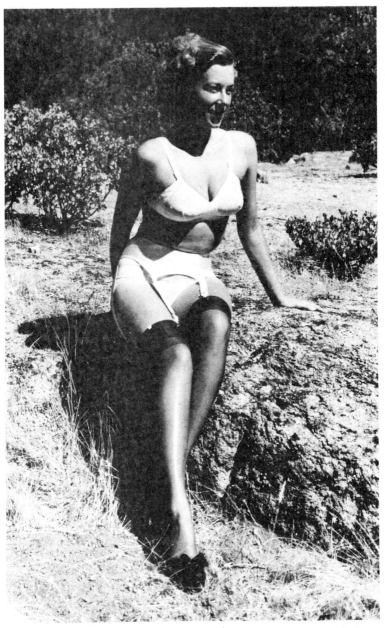

calm! ... *see page 43*

41

most of them bind or sag in the wrong places. My guess is that bathing suit manufacturers are more concerned with decorative gimmicks than with comfort.

Second and probably most important is the matter of convenience. Panties and bra are something a girl has with her always. I like outdoor activities and do a lot of hiking and fishing. When I find an inviting looking swimming hole, I see no reason why I should be denied a swim just because I have no suit along, when I have perfectly decent panties and bra on under my jeans and blouse. Or if I am on a long and tiring drive, why shouldn't I be able to slip off my dress and stretch out for a rest in the sun by the side of the road.

On a warm evening, when it is time to do the dishes. I don't add an apron—I subtract a dress and slip, and seldom bother to put them on again. Why should I have to dash for a housecoat when the door bell rings? When I wash the car, I strip to the bra and panties and splash to my hearst content. If I get wet, the nylon dries in a few minutes. Such hot and messy jobs as mowing the lawn or digging in the garden are so much less effort if I am dressed lightly. And if I get my things messy, the nylon washes in a few seconds. Often I slip into the tub with my panties and bra on and wash them on me.

Third is the matter of economy. My swim suits cost me from six to fourteen dollars. My average bra and pantie combinations cost me not much over three dollars. And when I am doing "chores." I save the cost, wear and tear on the dress or slacks that other girls wear in addition to the items I wear.

To illustrate my point, I am enclosing a number of snapshots which show me going about my business in "comfortable" garb.

A few years ago a brassiere was quite unmentionable. but today I can get away with wearing a sheer blouse over just a bra, so maybe the trend is in the right direction. I wish I could speed it up.

To prove I am sincere in my statements, I give you permission to publish any of the enclosed photos. I consider myself perfectly decently dressed in all of them.

Yours, D. H.
and thanks a lot Dell! Ed.

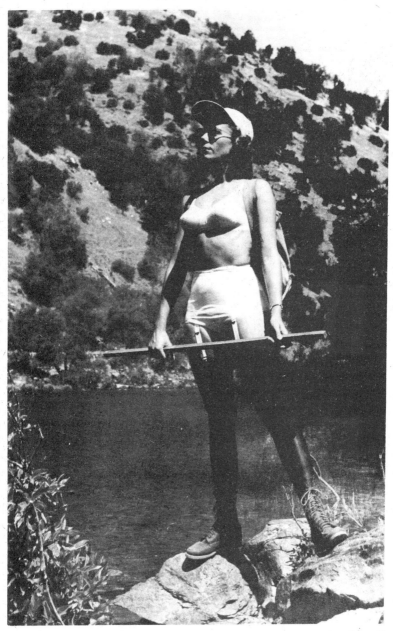

and collected! *see letter "Undies for Outies"*

Where Are the Rubber Boots?

To the Editor of *Bizarre*:

The suggestion of Fred Mac in No. 10 about a rubber section is appealing but I'm afraid would not be very popular. I too love nothing better than to see glistening black rubber on a woman. But it is a dying cause. Apparently there are no women who feel as we do, who either enjoy the looks or the feel of rubber clothing; and almost none who, not enjoying it, are never willing to wear it to please husband or sweetheart. For them rubber coats or caps are unknown, high rubber boots nearly so and even the rubber zipper boots which go over the shoe, and rubbers themselves are losing out to plastics which have no allure and are cumbersome as well. Even on stormy winter days a considerable percentage of women distain rubber footwear and at any other time there are virtually no wearers.

I remember though when the first rubber galoshes came out, replacing the shapeless "arctic" of an earlier day. Many women welcomed an opportunity to wear them. A girl on our block wore them to work daily throughout the winter rain or shine; she told me that for the first time in her life she felt her feet stylish and comfortable in cold weather. My older sister had small pretty feet and was very proud of them. She bought expensive shoes and realized that women's shoes need only to be wet once to loose their shape and beauty. Many a morning in those days, in threatening weather, I saw her start for work carrying an umbrella and wearing rubber even though it was not actually raining. She would wear out a couple of pair a year.

You have many readers who admire high boots and I do myself but I long to see similar examples of high close fitting *rubber* boots. Even more I'd like to hear of more women who like the feel of rubber and enjoy wearing it. Indeed I think the husband of "Contented Wife" in Vol. 9 is very fortunate to have one who will display rubber covered legs purely for her husband's enjoyment. How about it girls?

Crazy Over Rubber

Small Waist—But Odd Shape?

Dear Sir:

Like many of your readers I am a confirmed and enthusiastic tight lacer, and my husband encourages me to buy all the dainty, delightfully rigid, wasp-waist corsets I desire. He has never been able to lace me in tightly enough to cause me to faint, though the idea of having this done is fascinating to me and we have often

tried. After experimenting with many styles we found that the tiniest waist is achieved by means of a corset which holds the back in a straight, rather than arched, position and indents the waist from front and sides, the part of the corset over the abdomen bulging out somewhat and fitting snugly but not tightly. I also prefer the corset to constrict the lower part of my ribs and chest as tightly as possible, forcing me to breathe with a definite rise and fall of the bosoms. When I am extra tightly laced in this way my breathing becomes quite rapid, and, my husband tells me, especially attractive. Incidentally, we have found that a heavy braided nylon cord is best for corset laces. It is extremely strong and durable and much smoother than cotton lacing and makes drawing the laces tight definitely easier. For those who are interested, I am 5 feet $6\frac{1}{2}$ inches tall (without high heels), weight 122 pounds, and when tightly laced my measurements are bust 37 inches, waist $17\frac{1}{2}$ inches, (normal $22\frac{1}{2}$ inches) hips 38 inches.

Since reading *Bizarre* I have tried several other devices described by readers. For instance, I have recently had my ears pierced and now have acquired several pairs of very long heavy pendant earrings. *Bizarre* also

introduced me to the excessively high heel. Five-inch heels are the highest I can as yet really walk easily in. However, with my husbands arm to steady me I can manage to balance in some special $6\frac{1}{2}$-inch heeled pumps in which I walk on the tips of my toes like a ballerina. We have also had fun experimenting wth exotic make-up styles including unusual colors in lipstick, eye-shadow, and nail polish.

I love full arm-length kid gloves and my husband has now promised me some skin-tight thigh length boots with 6-inch heels and a matching black leather corset. Rubber garments, blindfolding, birching, etc., have no attractions for us, but I hope readers will continue to write in about other bizarre costumes and customs we might try.

Yours sincerely,

Mrs. L. H.

Scanties and Bra Brigade
Dear Editor:
You have practically covered all types of feminine clothing that

not go modern in one of your issues once in a while instead of always going primitive. I like *Bizarre* very much and I am sure I would like it much more if you'd pay attention some time to modern day corsetry—namely, the girdle and brassiere. So how about it? I hope that you will surprise me in some future issue. Thank you.

Sincerely yours,
A GIRDLE AND BRASSIERE LOVER

WELL! OUR TABLES TURNED!
Dear Sir:

Your delightful article "Home Sweet Home" with its novel and fascinating restraining gags and costumes will I'm sure inspire every "lady-master" or "slaver-ette" to enforce that perfect obedience and abject submission which is so necessary in every properly disciplined home. No longer will the dominant and masterly female have to concern herself about how to secure that golden silence and utter helplessness which she knows is so important a part of the discipline of

one can think of, but I am disappointed and sorry to say that you have pretty much ignored one aspect that is so much in use in this modern age that it would seem to be difficult to overlook. I am speaking of the girdle and brassiere. *Bizarre* has not had any articles or drawing on this subject and has had only one photo on it that I can recall. It has had numerous repeats on certain articles of clothing, so why not give us a little more variety and cover something that I believe would be interesting since it is the common and most popular fad, as there's no getting away from it. Plenty could be said on the girdle and brassiere and numerous photos are in existence and available, so why

her submissive but philandrous mate.

With such highly effective restrainers as the "Roehampton"; the "Beanie" and the "Ultra" ladies like Norah Clark; Babs; Ursula and Elsa could enforce the severest and most relentless of discipline on their "husband-slaves." Speechless in their restraining gags or masks, and wearing such restraining costumes as the "Cleopatra," or adaptations of the "Andromeda"; the "Ninn-ette" or "Ninon," or perhaps some other restraining outfit designed by one of these clever ladies, their hubbies would be utterly helpless and completely in the power of their wives.

"Well! Wouldn't that rotate you!—and after all my efforts to help the downtrodden male." J.W.

Elsa has the right idea. A husband can be trained to really fear, respect and love his wife. It's all a matter of using the right method to domesticate him. Needless to say no man, unless he's a human brute, has the power to resist a woman who has radiant health, charm and genuine sex-appeal, and who know's how to dress in such a manner that her attire enhances her womanly beauty and charm.

I firmly believe that all the really great seductive beauties of history like Cleopatra; Queen Zenobia of Palmyria; Empress

w-w-will it or w-w-w-won't it?

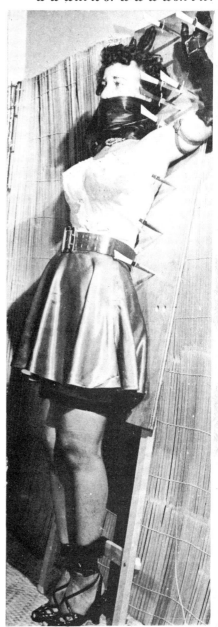

47

Theodora of the Eastern Roman Empire; Catherine The Great of Russia, Nell Gynn, etc., had three things in common—great sex-appeal; seductive charm and brains. All men were clay in the hands of these sirens to be molded, trained and enslaved as they saw fit, and even the enemies of these women did homage to their beauty.

The great mistake modern women make is taking too much for granted. Men notice even the smallest item of a woman's apparel, and if she dresses not to attract men, but to please her friends she's a fool and a dull clod as well. Remember, even women with plain, unattractive features have married handsome, successful men because they were clever enough to know how to dress in such a way that it enhanced their figures.

Never in the history of mankind were women so dull or uninteresting, and never did they dress so unseductively or so childlessly foolish. I have been in many of the larger cities of both Canada and the U. S., including Montreal in which I now live, and everywhere it's the same—sad, sad story; women have forgotten how to dress.

A babushka, pulled tight around the head; a pair of sloppy slacks or soiled dungarees plus an over-coat for either snow or rain and they feel dressed enough to go shopping or visiting. Of course, if they are going either to a party or to church they dress up, but these are really special occasions. The truth of the matter is that the average girl or woman has about as much sex-appeal as a stick of dead wood, and is just about as much alive.

Bizarre is rendering a really great service to every intelligent, broad-minded reader by making us all aware of just how great a difference exists between us today and our grandparents of Victorian days. In dress; manners; courtesy and kindness the Victorians were at the apex of civilization; now we are living in a dull, barbarious, mechanical age that is as unnatural and just about as beneficial as a third leg.

FRED MAC

KEEP 'EM WITH CORSETS

Dear Editor:

I am, and have been since 1939, very enthusiastic about corsets and tight lacing and can assure your readers that it is not a passing fancy. I advise girls and wives that one way to keep a man's interest is to keep your waist small.

My first corset was one I got for my trousseau. It was similar to that introduced to high fashion about that time by Mainbocher.

My bridesmaids had a lot of fun lacing me up in it. It was quite heavily ribbed, fit high over the hips and had half cups under the bosom. They really loved me in it. I was so excited at what it did to my figure. That night my husband got his first experience with a corset. He was very pleased and highly complimentary about it, and so during our entire wedding trip I wore a tightly laced corset.

John took great delight in helping me and I will say that he did a good job and he says his favorite task is to lace me into my corsets.

As time passed I acquired quite a collection of various types of front or back lacing corsets. At first I was satisfied with a waist reduction of about four inches. As I grew accustomed to being confined I modified some of my corsets by taking in the waist until it was possible to obtain a six- or seven-inch reduction and thus give me an 18-inch waistline.

I had often discussed with my husband about "going into training" a la *Bizarre* to get an even smaller waistline. The war came along and my husband went into service and I went into a defense plant. In spite of his absence I continued to wear foundation garments with tightly confining waists. We girls at the defense plant wore sweaters and slacks. During my employment I will say

that I got more than my share of whistles. A trim tightly belted waist between a 37-inch bust and 36-inch hips encased inside a snug sweater and slacks is something to whistle at.

As the war neared it's end John said in his letters that he couldn't wait to get back and was looking forward to seeing me—and to "my most extreme hour glass corset." That phrase set me to thinking, and I decided to go into training and achieve the smallest waist possible—not an 18- or 19-inch one—but a genuine honest-to-goodness hand span wasp-waist!

To reach this goal I made a plan of action and followed it to the letter. As I lived alone it was a bit difficult as I had no one to lace me and had to do it myself. I took two of my most extreme corsets and modified the waist of one so that it closed at $16\frac{1}{2}$ inches, the other at 15 inches. Immediately after returning from the plant I bathed and got into the first corset lacing as tightly as I could. I wore it until bed time and then changed to a lightweight

small waisted sleeping corset. The 15-inch corset I wore on weekends tightening the laces on it from time to time during the period. Within six months I achieved my goal and could make the opening close with ease at 15 inches.

About that time I got word from my soldier husband that he was due to be discharged in 90 days. I then set about designing a corset for the "welcome home" and had it made by a corsetiere. It was lined with white satin with a strong brocade base with many long spiral ribs of steel. The laces were of black corded silk and the outer part of the corset was covered with black velvet trimmed with red sequins. It did not come over the breasts but had half cups that acted like shelves thrusting them up and out, and ended it just below the broad part of the hips shaping them into a perfect voluptuous curve. As I could wear nothing under the garment without spoiling the effect the corset had a net skirt that reached mid-way to the knees.

One evening I got a phone call from my husband saying that he would be home at 2 the next afternoon. I started early in the morning to get ready, bathing and drenching myself with powder and perfume. I put on the 15-inch corset and laced it till it closed.

A couple of hours later, about one, I took it off and put on my special garment. As I pulled the laces tighter and tighter the long ribs bit into my flesh and my waist got smaller and smaller, but as the garment got smaller it became increasing difficult to pull the laces. By using all my strength and ingenuity I finally got the corset to close from top to bottom. Then I fastened long sheer black silk hose to the skirt garters beneath the skirt and put on my highest heeled patent pumps.

Shortly after the door bell rang and I slipped on a sheer black negligee and welcomed him home. It was a joyful homecoming to say the least. He went into raptures about my figure—he loved the hand span wasp waist I had achieved. After a while we measured it—it was 14 inches OVER THE CORSET.

Since then as time went by I have continued to wear extreme laced corsets for all special occasions. We both are confirmed lovers of the fashion. I love to wear them because of the delightful feeling they give to me—my husband loves them because he gets great pleasure out of lacing me and is extremely proud of the exotic and spectacular figure they give me.

A Real Corset Lover

BERNADETTE BROWN

The "6" inch Heel ___

fig ①

②

6"

3"

A B C D

A 3" B D

Elementary mathematics

③

6" 5" heel

A B 3" 3.33 D
(approx)

④

6" 6" heel

A B D
3"

⑤

$4\frac{3}{4}$" Heel

⑥

shaded portions are empty space

6
5
4
3
2
1

⑦

6" Heel

how the impossible
is made possible
for the average foot.

51

Rubber Club

Dear Editor:

After reading the article by Fred "Mac" in volume 10 of *Bizarre* magazine in which he mentions the idea of having a Rubber Club composed of fans of this material, I should like to inform him through you that we have formed such a club. There are four of us so far, and we actually have meetings whenever we can get together. Usually we have these meetings at one of our houses. Discussions of new ideas concerning rubber and the various uses it can be put to go on for hours. The clothes we usually wear consist of the following: (a) rubber girdle, (b) hip length rubber boots, (c) long black rubber coat, (d) very soft elbow length rubber gloves, and (e) occasionally thin or thick rubber bathing caps. Also we have between us a large number of rubber skirts made from a very thin rubber sheeting called "dental dam." This material is almost identical with the soft rubber used in the rain capes which were in vogue in the 1930's and early 40's. It can be purchased at the American Surgical Supply Co., 95 Madison Ave., New York City. This was thought of and procured by a doctor who is one of our members. Also the soft elbow length rubber gloves were his idea, and he got them for us.

I am wearing a long, shiny, black rubber coat while writing this letter, to put me more in the mood. I always work or play better when wearing this coat. It is the best one I have ever seen, made of heavy, shiny rubber, which I bought about sixteen years ago. It has never shown any signs of wear, although it has been through much hard use, both outside, and in the house. If any of your readers would like to see it, I can send you a picture of it being worn by a very pretty girl friend of mine, who is also wearing a pair of hip length rubber boots which I bought her (size 7), and a shiny black fisherman's rainhat—and frankly very little else. She knows about my ideas, and seems to like rubber a great deal herself.

I find the exchange of ideas between people who are really interested in any subject—in this case Rubber—extremely stimulating to all concerned. I hope to hear more from fans

We have numbers of *Bizarre* which were mailed out and returned to us *"Not Known at Address"* Make sure you ALWAYS GIVE THE CORRECT ADDRESS.

through the splendid medium of your magazine *"Bizarre."*

Sincerely,

R.U.B.

Effective Punishment

Dear Editor:

Several of the letters of your correspondents recall a most unpleasant situation in which I found myself at the age of sixteen. At the time, I was living with an aunt, my father and mother were on an extended tour abroad. Next door there lived three sisters, the youngest, a girl of my own age, with whom I spent many pleasant hours. One afternoon we got into an argument, which became quite heated, and in a fit of anger, I gave her a shove. She tripped and fell to the ground, her skirts flying up to expose lace frilled underclothes. Somehow the incident struck me as ludicrous, and I started to laugh. She rose to her feet, her face crimson with embarrassment, tears flowing down her cheeks, and ran into the house, calling me "nasty and horrid." Almost immediately, her two sisters came out into the yard and started upbraiding me for being a nasty person, and threatening to tell my aunt about it. Unfortunately for me, I choose to be impertinent.

Some time later, I went into our house to find my aunt and the two sisters seated in the living room discussing what I had done. Aunty ordered me into the room and gave me a tongue lashing for being a bully. The matter of a suitable punishment was brought up, and one of the sisters suggested that as I found girl's underclothes so amusing, it would be a proper penalty to have me wear them, offering to loan their sisters for the purpose. To my utter consternation, my aunt agreed, and it was decided that I should be taken over to the sister's house, there to be petticoated and serve as their maid. I begged and pleaded with my aunt not to do this terrible thing to me; but she only turned a deaf ear.

The two young women took me in hand and marched me over to their house and to a room upstairs. They left me there, ordering me to undress myself, while they gathered my new attire, and taking the precaution of locking the door behind them. I laughed to myself at the thought that these two women could force me to do their will, for I was an athletic young man, and weren't women the weaker sex?

A short time passed, and they reentered the room, carrying an armful of frilly girl's clothing—a silk vest, the neckline edged with lace; a pair of drawers with elastic at the waist and legs, these frilled with a lace ruffle, and pert ribbon

bows had been sewn to each leg for additional adornment; a pair of ribbon covered elastic garters; long black silk stockings; patent pumps with heels; three starched petticoats, the hems daintily frilled with lace ruffles and a black taffeta dress with a rather short skirt (I was to learn the reason for this later on). They arranged the garments on the bed, then turned their attention to me. To my utter humiliation, these two strong young women grabbed me, and despite my struggles and protests, removed all my clothing and started dressing me in the girl's clothes.

When the vest had been pulled down into place, the stockings pulled up over my legs and gartered on, they forced my feet into the slippers and arrayed me in the drawers. With that they marched me over to the mirror to view myself, and I wept when I saw myself standing there in those garments. I was forced to remain before the mirror while the petticoats were fitted to me and the dress pulled on and buttoned at the back. It was then that I learned the reason it was so short—it allowed the frilled hems of my drawers and petticoats to show from under the hem of the dress. A be-ribboned bonnet was placed on my head, and as a final flair, makeup was added. I shuddered

when I realized that everything masculine about me had been suppressed. I actually looked like a girl.

I soon found that having to wear the girl's clothes was only a part of my punishment, for those determined young women marched me downstairs and out into the back yard, where a group of giggling, jeering girls, summoned by the youngest sister, had gathered. Their comments were very cutting, to say the least; but worse, the older sisters ordered me to parade up and down before them to model my clothes, even to having to raise my skirts to expose the underclothes.

Aunty came over and joined the group, and I begged her on my knees not to make me endure this utterly humiliating experience. She only laughed and told me that it would teach me a lesson not to be a bully.

For the next two months, I wore girl's clothes, was called by a girl's name and forced ot act as a maid, doing the housework and such for the three sisters.

ASHAMED

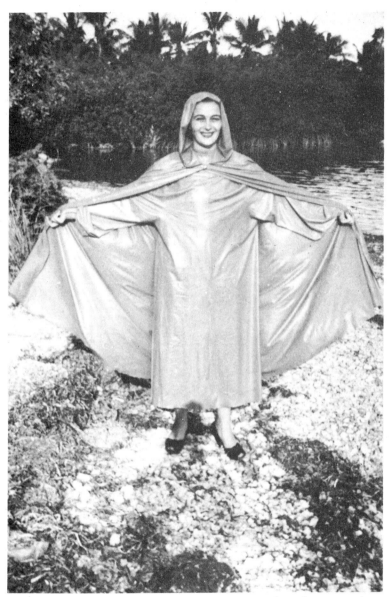

photo from a reader

Rubber for all occasions

WELL TRAINED CHILDREN

Dear Sir:

The Correspondence pages of your excellent magazine remind me vividly of my acquaintanceship and later deep friendship with a lady in London, England, before the war. She was a great believer in many of the opinions expressed in your pages, and being quite wealthy, with a large house and a handful of servants, plus the added advantage of three teen-age daughters, she had every opportunity to put her ideas into practice. I remember the first time she took me to her home and introduced me to her daughters; they were dressed in what their mother described as their usual form of housewear, even Elsie, the eldest, aged nineteen, this consisting of a tight but well-fitting white blouse—with no brassiere or indeed any undergarment beneath — a red pleated skirt that ended just below the tops of the thighs, black, almost skin-tight bloomers, the legs of which came half way down the thighs so that they were well visible below the skirt in any position, black silk stockings and shoes with heels which I then considered to be very high, about four inches. All three wore a great deal of make-up, and this intriguing mixture of sophistication and young girlishness both astonished and interested me, so that I could hardly take my eyes

off them, much to their embarrassment. I soon learnt that their mother delighted in showing them off, dressed in this or similar attire, to her friends. Around their waists they wore a broad leather belt, fastened with a tiny padlock and seeming to nip their waists in more than a little; fastened to the belt at the back were two small leather loops, and I discovered that for the slightest offence their mother would buckle the culprit's arms in these, so that they were behind her back, forearms together and parallel, wrist to elbow, and would leave her so bound for an hour or more. During my first visit I witnessed Elsie and Winnie, the fifteen year old "baby" of the family being given this treatment; as an added penance they were then made to walk around the room twelve times before being told to stand in a corner. They were all well-developed, and you can imagine the sight they presented, particularly the jouncing of their breasts which were thrown into even greater prominence.

My second visit was even more thrilling when I had the pleasure of seeing Joan, who was just seventeen, paying forfeit for clumsily upsetting her cup at the tea-table. She was sent into the drawing-room, in the company of a maid, to await her correction, and when we followed about ten

minutes later I saw that her arms had already been buckled to the back of her belt, obviously by the maid who was waiting with her. Joan was apparently well-trained, for scarcely a word was spoken as my friend took a seat on an ordinary high-backed chair whereupon her daughter, blushing beneath her make-up, came and deposited herself face downwards across her knees. The maid then left the room and returned in about a minute with a wooden-backed, paddle-shaped hair-brush which she handed to her mistress, and my friend showed herself adept at its use as she administered about a score of good hard spanks.

I had a great many experiences with my friend during my stay in London; if readers are interested I may recount one or two.

Sincerely,

DOREEN M.

SLACK SUIT

Dear Editor:

The feminine sex wants to wear the pants nowadays. In winter they wear slacks because they are supposed to be warmer, and long underwear can be discreetly worn under them, and in summertime the slacks are supposed to be more convenient for playing, housework, sitting on the steps, etc., etc. Furthermore, someone in slacks doesn't have to watch her step all the time, the slip might be showing, you know! Slacks can't be worn for social affairs, office work, etc., etc.

So here is my idea:

I might call it the slack-suit; it would consist of a blouse and skirt, possibly of velvet or corduroy, the skirt to have a row of buttons on the side. Bloomer-like pants, to reach down as far as the skirt would be worn with this, to reach as far down as the dress. No slip would be worn with this. This would be ideal for play, driving, cycling, etc. For office work the wrap-around would be worn, for play it could be taken off.

. . . And I might add with an afterthought, if you don't behave, girls, the corduroy pants will give more protection against a hair-brush than lace panties will.

"PLAYFUL FREDDY"

MARTINIS IN MANACLES

Editor of "Bizarre":

If I had discovered your exciting magazine with its correspondence section sooner, I could have reported this astonishing experience right after it occurred last summer.

My boy friend and I were having cocktails before dinner one evening in a ground-floor restaurant and lounge-bar in the Empire State Building in Manhattan. At

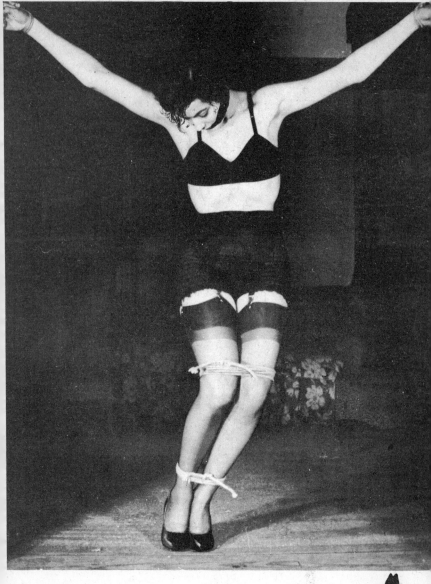

DON'T LET THIS HAPPEN TO YOU

learn jiu jitsu

and the art of self-defense

— particularly if Ivan wants the secret code!

the next table—oh, not more than six or eight feet away—was another young couple. That is, the girl seemed to be about my age, maybe twenty-two; the man was considerably older. We were waiting for our first round of drinks.

What attracted my attention to the other couple especially was something I caught sight of out of the corner of my eye, which caused me to look again—and afterward as often as I could decently steal a glance. When the man raised his highball to his lips to take a sip he did it with BOTH hands, and with good reason. He was handcuffed!

A rather heavy, chromium-plated chain such as you see large dogs being led around with nowadays circled the captive's wrists and was secured between them with a small matching padlock. He made no effort whatever to conceal his "bracelets," which my friend and I concluded must have been locked in place right there at the table by the girl, his mistress in more than one sense of the word, obviously. In fact, once as he was about to take a sip from his glass she stopped him momentarily to push back the sleeves of his sports jacket, apparently to make the manacles even more noticeable (conspicuous) in case anyone was looking. Someone was, besides us—the pretty waitress who was serving that group of tables, and a matronly woman seated about as far away from the couple as we were, but on the other side. Both were plainly startled by this sight. Who wouldn't be?

The willing (?) captive and his mistress were blissfully happy. Anyone could see that. But as they got up to leave, perhaps thirty minutes later, we noticed that in the meantime, probably by an under-the-table manoeuvre, she had freed his wrists. He paid the check and they left.

Well! "How long has this sort of thing been going on?" my boy friend asked. (He knows a lot more about it now, believe me.)

WANDA S.

RUBBER GOT THE JOB

Dear Editor:

I enjoy every page on every subject, although my keenest pleasure is in wearing chic rubber overshoes, and high-heeled, rubber, zipper boots. Can't you lend your sympathetic pen, Mr. Willie, to encase the lovely feet of either Madame, Za Za, or Sally (or all three) in gleaming rubber for at least *one* episode? We girls would just love you for it if you would!

I answered an ad for a secretary-steno one clear but cold morning over a year ago, and the cold gave me a good excuse to wear

my zippered satin-finish rubber overshoes with their perky rubber cuffs hugging my nylon calves.

When I entered the two-room office in the Wall Street section, there were several other applicants waiting, and I was the only girl with her rubbers on. But when the business man came out of his private office to give us a "Good Morning," I noticed the interested stare he directed at my trim galoshes as he asked me to come in first.

I sat beside his desk with my ready notebook on my crossed knees and took a letter, then read it back to him while he feasted his eyes on my high-heeled, shiny, rubbered feet.

Satisfied with my work, we discussed the duties and the salary, and then he said with an odd smile, "Will you be willing to wear rubbers while in the office if I request you to?" And at my enthusiastic affirmative, he at once dismissed the other applicants while I took off my hat and coat and, with my high-heeled rubbers planted firmly under my new desk, I transcribed the letter he had dictated.

My "Boss" 'is a fine man to work for, and in giving him pleasure by wearing rubbers in the office while I myself enjoy their good looks and resilient feel on my feet, we are both afforded an outlet for our personal desires!

Very truly yours,
RUTH IN RUBBERS

Miss Mystery's Fancy Dress

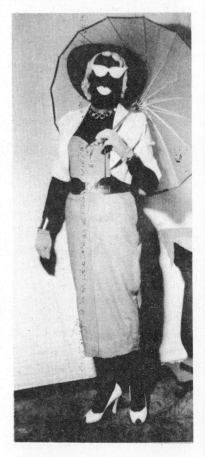

Dear Editor:

You say several readers want a photo of me as "Miss Photo Negative of 1952." Well here it is.

Sincerely, S.R.

LINGERIE FOR COMFORT

Dear Editor:

Your various letters in recent issues concerning the wearing of feminine underwear by men impelled me to write you of the manner in which the writer became an addict of this luxurious and piquantly pleasurable form of clothing. Most of us "bloomer boys" it would seem first had their bloomers, petticoats and dresses forced upon them as a form of punishment by the female rulers of their childhood. Generally they were made to dress up in frilly panties or silky bloomers and dresses belonging to their sisters and then humiliated by being forced to endure the shame-making and giggling of their outside friends. Following the first few times of this "punishment" most of the boys so shamed discovered that their punishment garb was in fact quite pleasing, that silk undies hugged their skin so smoothly, that bloomers were snugger and pleasanter than boys' drawers, that the feel of petticoat ruffle and skirts around their knees was rather thrilling, and these boys in time became the many men of today who still find satisfaction in continuing to wear the pink and lacy silks of feminine luxury.

The writer did not himself come to being an advocate of bloomers from punishment, but rather from a curious error in understanding. When I was thirteen, my parents booked themselves for a two-months' vacation in Europe one summer and decided to send my two sisters (aged fourteen and twelve at that time) and myself to a lady friend of my mother's who had a large place in the country and asked to take care of the three children. As it happens, this lady had never actually met any of us and knew us only by our names. She said that she had clothing for all of us, for apparently she had boarded children before, which relieved my parents from having to supply with any great amount of clothing. So, when my parents left, the three of us were shipped off by train to our summer guardian.

When we arrived at our summer home, which was several miles from town on a pleasant estate, and the three of us trooped in to meet our summer guardian—an unmarried lady—she was greatly surprised to see that one of us three was a boy. She had assumed from my name, Leslie, that I was a girl, for my name, is sometimes associated with girls, and she had prepared identical clothing for all of us. She had identically designed dresses, middy blouses, athletic bloomers, and so on. She had no boy's clothing on hand at all!

After some hesitation and con-

sternation, she approached me on being a "good sport" and dressing for the summer as my sisters. Naturally, I was averse to the idea, but since the place was isolated, and there really wasn't anything else I could do anyway, I finally agreed. So that entire summer I wore the same girl bloomers and chemises and skirts my sisters did, slept in a pink and lace-frilled nightie, exercised and played in blue gym bloomers and middies, and—had the best summer of my life. When it came time to go home, I naturally took my new clothes home with me. After my parents' confusion and my insistance, I continued occasionally to wear at least my feminine undies in the city.

After my parents got used to the idea, and found that after having learned to act as a girl that summer, I was a better behaved son, they continued to buy me the pink silk bloomers and vests I enjoyed. To this day I continue the habit, and, although I am now a successful businessman and a married man, I still wear the same type of underwear as my wife.

At first the girl I married got quite a surprise from my addiction, but now she takes it as a matter of course that my bureau has just as many dainty and filmy pieces of lingerie as hers.

LESLIE R.

PRAISE FOR POLAIRE

Editor *Bizarre*:

Have any of the lovers of tight-lacing ever heard of Mlle. Polaire, an actress active in Paris as late as 1911, but whose pictures appear in Harper's Weekly during an American tour in, I think, 1905.

I saw Mlle. Polaire twice in Paris, and I believe her to be one of the most extraordinary examples of tight lacing I have ever seen or heard of. A very good picture of her as *Alil* in a show called Coq d'Inde, which appeared at the Capucines Theatre in Paris is published in the French magazine *Le Theatre* of 1908 and others appear in 1907 (*and another excellent one in Bizarre No. 3 Page 6, Ed.*). It appears to me that some of your readers would find these exceedingly interesting and that they are worthy of re-reproduction. Your efficient research staff should have no trouble finding them.

I saw and liked Anna Held in her hey-day and most of the other ladies who used the wasp waist as part of their charm but I never saw anyone who went in for it to the extent that Mlle. Polaire did and I think we should know more about her.

I first saw her in a vaudeville act at a little theatre which I believe was called the Bobino. The act consisted almost exclusively of seeing Mlle. Polaire laced up by

two strong men. Every device imaginable was used until she finally piroutted across the stage with a waist of only twelve inches. The audience simply roared approval.

I hear that some nobleman took up with her and gave her a further career, but I know little more than that. I also heard that she had a rib removed in order to be able to lace yet smaller, but I can't vouch for that either. Could someone find out more about this extraordinary virtuoso of the wasp waist?

Yours,

PETE

BLOOMERS FOR PLAY SUITS

Dear John Willie:

I particularly enjoyed your articles on BLOOMERS in the correspondence section and the illustration of a Bloomer costume in the "Fancy Dress" section.

Bloomers have fascinated me as long as I can remember. Silk or nylon bloomers are fine to wear under one's outer clothing and rubber hospital bloomers are fine for lounging at home. The hospital bloomers should be extra large as the additional fullness lends delightfully to the appearance and to the hampering qualities. My first love, however, are gym bloomers and/or gym suits in regulation blue gathered at the legs with stout elastics; such gym suits are made primarily for school girls' gym classes, but I have fancied them beyond this period. Since the last war there have been periodic revivals of the bloomer style in playsuits and this coming summer (1953) should see quite a number of fetching playsuits and bathing suits finished with a bloomer bottom—according to the fashion magazines and the newspapers.

Yours,

BLOOMER FAN

"THE MERRY OLD LAND OF OZ"

Dear Editor:

Many thanks for that charming "Lion Tamer" in No. 11. If our local Lions Club had a trainer like that I feel sure the membership would go up by leaps and bounds. That severe expression would strike terror in the stoutest Lion's heart and bring him to heel in short order and if an order from that stern mouth were not obeyed instantly that dainty whip she holds so gracefully would soon reduce him to fawning submission.

Yours for many more Lion Tamers!

COWARDLY LION

Dear Editor:

I am a man beseiged by females in my own home and though one of them is my very lovely red headed wife, Joan, and the other is my equally good looking sister, Barbara, I have to be constantly on my mettle or I find myself being tricked into doing what they have decided they want done.

While I've been married for six years now and am three years older than my wife and one year older than my sister when they gang up on me it's darned difficult to keep up with them. To give you some idea of what I'm up against would require a brief history of both gals. And for the rest of my letter to make sense you have to have some understanding of the two rather unconventional females that share my abode.

Joan is a natural born flirt that was reared by her very strict Aunt and Uncle, and until she was 18 when we were married she was kept rather sternly in hand. Both of her relatives were firm believers in spare the rod and spoil the child, and to Joan's chagrin she remained a child in their eyes right up to the time she married me. I suppose it was only natural that having been repressed for so long that when she reached the comparative freedom of marriage she tried to make up for lost time.

Aside from her tendency to flirt and tease with malice of forethought, Joan soon found that there were a lot of things concerning fashions, styles, and other social graces that her rather backward Aunt and Uncle had never bothered to teach her. While she was a very good cook and an excellent housekeeper, Joan once away from her Aunt who had enforced her will with a braided leather whip, grew more and more lax in maintaining our home. To make a long story short, I was forced to write up a set of rules for her to abide by. Strangely enough Joan took them in fine spirit and though she did not always live up to them, she did accept her discipline as both right and just.

Fortunately for me my wife and my sister hit it off wonderfully well right from the start. In fact, the reason my sister who is a very fine free lance photographer came to live with us was Joan's begging both Babs and I to let her. As Joan explained it there were many things that she was quite conscious of not being to well versed in and Babs could help her acquire some of the sureness and polish she felt she needed. At first Babs was not too fond of the idea but finally she agreed to try it on an experimental basis to see how it would work out. Within a month she was

ready to call it off to Joan's great disappointment. Finally after much discussion during which we all aired our various gripes, it was decided that Babs would stay on for another month only this time we set up rules for everyone, so we could keep out of each others hair. Strangely enough with each person's conduct governed by those rules and also backed by rather stringent prescribed methods of punishment for each infraction of them, we became a very happy contented household.

By nature neither Joan or Babs could be regarded as conventional and frankly I hated the boring rules that society had decreed we abide by. So by a process of like seeking like our circle of intimate and close friends widened until today we have three other young married couples who enjoy the same unusual things we do. Then, of course, there is Babs' boy friend and a girl that Joan went to school with and her boy friend. Of course in public we do observe all the regulations required but most if not all of our social life is confined to our own circle where we can let our hair down and do as we feel nearly everyone would if they had the courage.

Having given you the background, I'm sure you can understand that *Bizarre* is a very welcome publication around our place. In fact, our only complaint is that it isn't published often enough, and secondly we fight over who gets to read it first. Issue No. 7 had a decided effect upon not only us but on our friends as well.

Whenever J. W. springs one of those ideas of his like the U. D. skirt things have a habit of becoming darned active. Actually the thing that started it all was Joan heckling Babs as my sister having won the right to read it after me was just finishing the U. D. story. After several warnings to Joan, Babs finally grew a little irritated and before my very surprised wife knew what had happened she was prone on the floor her dress and slip were gathered up over her head as Babs sitting in the small of Joan's back pinning her down proceeded to tie that enveloping clothing close to the top of Joan's red tresses. Even an impromtue improvision such as Babs had made demonstrated the worth while aspects of the U. D. and despite the rather plain pants and garter belt Joan was wearing, she did make an attractive and exciting picture. Of course, she didn't like the idea at all, but I managed to calm her down by pulling her down upon my lap until Babs had finished reading. Joan was a very chagrined gal but when she settled down to read *Bizarre* she

soon caught on where Bab's idea had sprang from. The upside down skirt soon became the vogue around the house and hardly a night went by that I didn't come home to fine one or the other of them nicely trussed up in the tight confines of her U. D. I will say one thing, there was no such thing as wearing just any old thing under their dresses any longer. Shoes became high heeled, stockings very sheer and lovely, garter belts or garters extremely stylish, and pants turned from routine every day nylon to frilly trimmed lace inserted dreams.

The next step of course was only too logical. The gang was coming over for a valentine party and with a rivalry that would have shamed Dior and Fath, my wife and sister designed two complete outfits of U. D. skirts and making a deal to help each other with the tailoring they completed them in time for the party.

Joan's U. D. was made of black tightly woven jersey, and she cut it a half size smaller than her actual size. Both she and Babs had made one improvement they felt on J. W.'s original idea and that was the placing of the arms behind the back. Of course, both having been endowed by nature with breasts that needed nothing to make them most attractive may have had something to do with

their idea. In any event it opened in the back with a zipper that ran from the tailored head to the waist band. It fastened at the waist to a wide inside elastic band as she wanted to make sure it would stay snug about her waist. When she saw how Babs had handled the bust problem Joan took and cut two heart shaped openings in the front. Trimmed and reinforced them with red ribbon and then taking a sheer black nylon stocking cut out inserts and sewed them inside the hearts. Using the hearts as the theme of her U. D. Joan made herself the briefest pair of pants I've seen in quite a while. An elastic satin band about her hips. Two red silk hearts formed the crotch of the pants and the black lace trim. Then to give it that special touch she placed her initials on the front heart and mine on the one in back with lace inserts. Four and one-half inch black pumps and sheer black stockings with garters trimmed with hearts completed the picture.

Basically Babs was on the same lines, but her material was red velvet and she used the diamond as a theme. I'm afraid she was even more daring in her ideas than Joan had been. First of all she used the reinforced bottom of her U. D. to hang her bright yellow garter straps upon. Front and back from shoulder line to bottom Babs

cut out two rather large, long diamonds. Edged them with yellow ribbon and then using net of a rather close mesh inserted it into each diamond. As with Joan my sister carried her diamond idea into the construction of her panties and aside from the shape of the yellow diamonds they were nearly the same. Of course, the lace was red. Five-inch red shoes that she had specially made and pale yellow dyed nylons completed the picture.

Well, even our rather unconventional gang was impressed to say the least when Joan and Babs came strolling into the room after every one had arrived. The party was a huge success and reached a climax when Joan proposed and Babs seconded the idea of staging a U. D. contest to see which husband and wife team could with only the materials at hand make the best looking U. D. The idea was a huge success and even the blushing winner gave her approval.

In closing I might add that seldom do we receive an invitation that it doesn't read under dress; "U. D."—as it has become almost mandatory party equipment with our circle.

May you continue to bring out *Bizarre* and feature your unique ideas.

C. L.

The Dandy's Return?

Dear Mr. Willie:

We wish to comment on your article in Bizarre No. 10 anent frills and fancies for masculine wear. My wife and I think it is about time that men be given the chance to wear the type of clothing that heretofore has been reserved to glamorize the feminine figure. We are not of the opinion that clothing of this type must of necessity be *designed* for feminine wear. Why will not some of the more "daring" manufacturers of men's underwear design shorts, pajamas, socks from materials such as lace, velvet, transparent nylon, satins and other luxurious materials? There are hundreds, if not thousands, of men who would receive the greatest delight in wearing such garments. They could be as lovely as anything yet created for feminine wear.

Since such is not readily available we have designed our own, including shorts made from lace, satin, and nylon. We also designed pajamas made from the sheerest of black nylon. In each instance they are patterned after masculine lines, but are so beautiful they would be just as attractive on the female as well.

Sincerely,

L. and T.

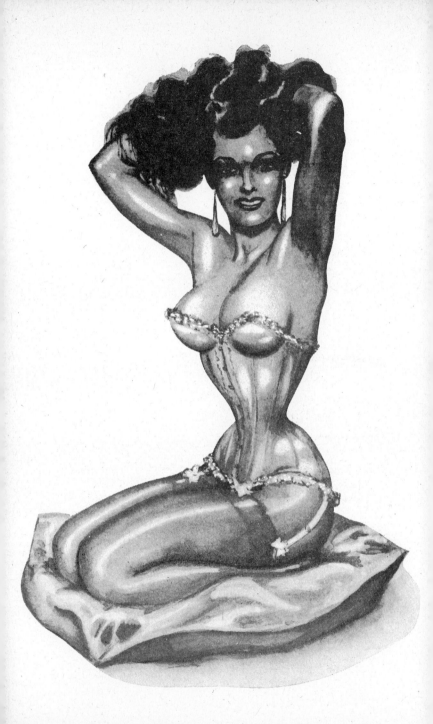

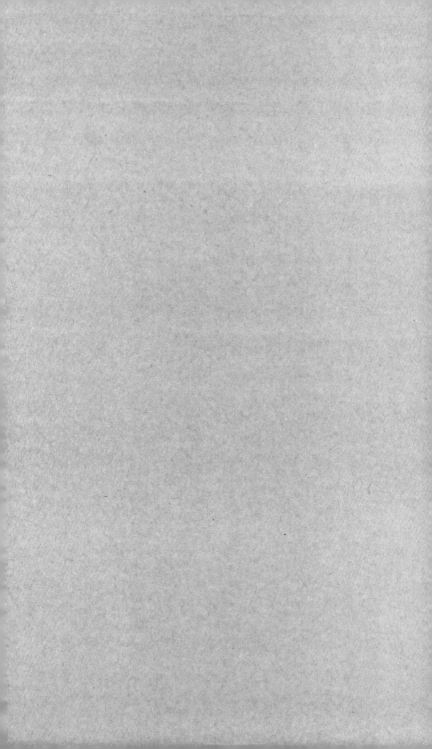

Why! Sir Walter!—You too?

BIZARRE

Copyright 1954 U.S.A. by John Coutts

"a fashion fantasia"

No. 13

Look to the Rose that blows about us—"Lo,
Laughing," she says, "into the World I blow:
At once the silken Tassel of my Purse
Tear, and its Treasure on the Garden throw."

OMAR KHAYYAM

NEXT ISSUE No. 14

We've been let down so often by this and that that we are making
no rash promises. All we know is that No. 14 will appear as soon as
possible. It will contain, in addition to the usual correspondence, the
true story of Mother Eve's corset, and also an eye witness' account of a
certain suburb since the impact of Bizarre No. 10.

BACK NUMBERS

All back issues are now available—except 1, 5, 7, and 11 of which
reprints are being made in the near future.

Steel Corset Cover

13 inch circumference: 4 inch diameter. (see tape measure in waist.)

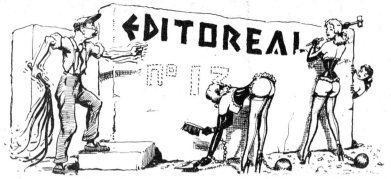

This is Bizarre number 13, and so many people are really most awfully superstitious. They say that this brings bad luck, and that brings bad luck—broken mirrors, black cats, and so on—but menacing over and above everything else is the number "13". This we think needs some explaining.

Now there are all sorts of legends which give their own versions for thirteen being considered so unlucky, but they are comparatively modern when looked upon from an archaeologist's point of view—and all incorrect.

We have the true story and it antedates them all. A story which incidently we discovered only at considerable expense and at no small risk to our necks.

Now if you are, as we assume, an avid reader of Bizarre you of course know that on page 5 of Number 10 we reproduced a sketch of an ancient hieroglyphic, which someone sent us, which conclusively proved that baseball was not first played on the Elysian Fields at Hoboken, New Jersey,

in 1846: But what you do not know is that ever since then we have all become rabid archaeologists! We leave no stone unturned. Every day you will find us, glued to knot holes watching with eagle eye as the steam shovels sink deeper in each new excavation project. Watching and waiting for each chawing grab to expose maybe an Etruscan vase, maybe a piece of Ming china, maybe a scarab, a mummy, or a merkin. Things which to the average curb-stone superintendent would be nothing but so much trash, but which, to the keen perception of true archaeologists like us, are relics of priceless value—each telling it's own fantastic story of ancient drama!—treachery! intrigue!

So engrossed have we become in this fascinating study that to be quite frank, the delay in producing this issue is not due to our printer agreeing to go ahead with the reprints of all back issues, getting cold feet in the middle of the stream so to speak, bailing up, and demanding some cash;

it is not that we have been hard pressed financially (such rumors have been about) ; but simply that after publishing number 12 we took an extended vacation with the sole purpose of discovering the origin of the corset, relying on our natural genius as archaeoligists to guide us to the likely spots on the earth's surface where a little steady digging might prove fruitful. (We archaeoligists are positive tigers when it comes to digging—we're as keen as ferrets, and as tenacious as a bulldog— we never let go.) Under the circumstances, success was of course a foregone conclusion, but it was success beyond our wildest dreams.

You can now take it as authentic that Eve wore a corset—a tricky snakeskin affair; she also wore six inch heeled snakeskin sandals—we saw them—but we'll tell you all about that in our next issue.. More important so far as this particular issue of Bizarre is concerned, is our discovery that not only was the corset worn as far back as 999999 BC—but in addition, that this is the date of the first belief that the Number "13" could be unlucky.

We found hieroglyphics to this effect carved on a massive stone slab, much too big for us to move, down at the bottom of the Grand Canyon of Colorado.

How this mighty chunk of rock came to be there is a bit of a mystery, for it is quite clearly dated 999999 BC and signed by the artist, "C.A.P." Whereas the Colorado River has ripped through only about 175,000 years of accumulated deposits on the earth's surface.

Probably, the stone was regarded as of such value that, for about 850,000 years, it was kept religeously on the surface.—Then, its glory faded, perhaps after some disasterous war or pestilence, it became lost in the sands of time, only to be unearthed once more by our expedition. Here we reproduce for your edification the translation of this priceless stone relic of bygone years.

"In the year 999,999 BC there weren't many people around—but what few there were, were ruled by a tribe of mighty giantesses. These women were all magnificent creatures, shapely and beautiful and oddly enough they all grew to exactly the same height which was eleven feet and eleven inches in their bare feet. However, they always wore boots with twelve inch heels which gave them a height of twelve feet and eleven inches.

Their bodies were protected by a sturdy leather corset whose waist measurement was a universal fourteen inches which, as they

portion of "Colorado" stone. J. Willie expedition, 1953 A.D.

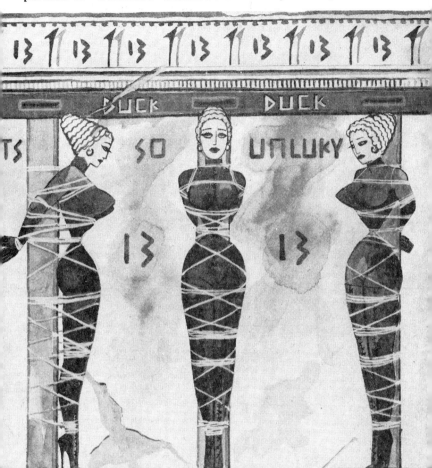

were otherwise perfectly proportioned, gave them a really fantastic figure.

They ruled the world because not only were they swift, agile and extremely strong but also because the thick pickled mastodon hide of their boots, gloves and corsets was supple but tougher than steel, and protected them from the blows of any club.

Their heads were bare, but not even a six foot man could reach high enough to crack their skulls even if he could get inside the reach of their powerful arms. They reigned supreme and all people were their slaves until one day they captured and took prisoner all the males of another tribe, who were noted for their skill at wood carving and also the art of leather work.

"Now you shall make all our footwear." these women said to their captives. "Make them well and make them truly for in a moon's moon is our race for the Queen, when the winner shall be queen for a year and a day. Carve the heels with your greatest skill and remember that all heels shall be the same—just twelve inches high from the needle point where they touch the ground. You shall also make beautifully embossed corsets with a waist of fourteen inches, no more, no less.

Make them strong, make them well!"

But the conquered craftsmen didn't take kindly to being the slaves of these enormous women. They were small men, as men went in those days and against these giants none stood a chance; no not even six or seven together could match one of these mighty maidens. But these men were not only skillful with their hands, they were also guileful and very cunning, and in secret they held meetings to devise a means of overcoming their captors and turning the tables on them.

Now it so happened that the race for the Queen started at the same point each year. This point was marked by a colonade, a row of slender columns thirteen feet and one inch high, across the top of which was a solid stone pelmet. The runners all stood on one side of this stone starting gate, in a row half a mile long, and on the word "go" they lunged through to start their two mile sprint, and it was considered lucky if, in this initial spring they rose just two inches so that their hair brushed the stone slab above their heads.

"We cannot bean them with a club," said one craftsman. "Because we cannot reach that high, but perhaps we can help them to bop themselves. We are making their boots—let us make the heels

fourteen inches high—all we need is two more inches and as they jump forward at the start they will crack their skulls mightily— then as they fall stunned, we can leap upon them and bind them."

"But no," said another wiser one, "if we put two inches more on their heels they will notice it. We could perhaps, put just one extra inch to make them thirteen inches high, and by flattery we can no doubt convince them that they're really still twelve inch heels; but alas, the stone overhead is still one inch higher."

"Then," said another, "let us scatter one inch of dirt on the ground. We can do it a little at a time as the moon wanes and rises, and beat it well down with our feet until it is tightly packed and the clearance is exactly thirteen feet. Since with their "special" heels they will also be exactly thirteen feet tall, when they leap two inches in the air towards the colonade—whoosh!"

"And hark ye" said one "lets make their corsets one inch smaller at the waist. Being only thirteen inches they will be more confining and will help make the women too short of breath to struggle too violently when we have them secured—lest they break their bonds."

That we'll take care that they do not do," said several. "We must not fail, for if we do we will suffer most terribly—they will show us no mercy."

"Then," said another, "let us use our secret preparation on the leather of the corsets, which when warmed by the body makes leather as rigid as stone—Let us use it on the gloves too, and the boots."

"No," said still another, "not the boots nor the gloves, they might notice the stiffness—just the corsets."

And so the craftsmen worked with a will at the plan they had devised, and on the day of the race, as the women were being dressed by their male slaves, the one would say, "Somehow my heels seem higher, but can it be for my feet are more comfortable?" And a slave would answer, "but yes, fair lady, we are skilled shoemakers."

And another would say, "Oh, dear, this corset does seem tight." Then the slave would reply, "perhaps my lady was over-eager with the haunch of dragon meat which her servant cooked." And the lady would answer.

"Guess you're right bub! lace it in—Ouch!"

At last everything was ready for the race . . . all the women were lined up at the barrier, and at the third blast of a trumpet blown by one of the slaves, they all sprang forward—and cracked their heads

such a mightly blow that it sounded like thunder and all fell stunned —to lie inert upon the ground. True, one or two seemed only half unconcious and struggled vainly to rise, but all the slaves immediately fell upon them and producing cords which they had concealed in their smocks, quickly bound them hand and foot. Some recovered before they were completely tied up and even pinioned as they were put up a violent fight before finally, like the others, they were trussed up so securely that they could not move.

Then the craftsmen really got busy. They cut hides and they stitched and they hammered through the livelong day, fashioning weird arrangements of leather, while the wrathful abuse of their captives slowly changed to groans and to pleadings for mercy as the terrible cramp of their position, and the tightening of their corsets became fiendish torture; but the craftsmen took no notice until they had finished their tasks, then each captives bonds were loosened just enough for her arms to be placed in the requisite position, but not enough to allow her to use her strength to get free; and once in place folded behind her, her arms were quickly enclosed in a leather tubelike bag which reached from one armpit to the other, to which shoulder straps

were added to prevent any possibility of its slipping. Her arms now useless, a bridle was fitted to her head to hold a detachable leather gag in place while stout leather hobbles, made of the toughest and heaviest leather were attached to her ankles.

As the captives regained the feeling in their limbs they began again to struggle violently and, had they been able to make a sound, to curse and to swear, but a plaited leather thong like a halter tethered them to the pillars of the starting gate and against this they thrashed in vain while their former slaves beat them unmercifully and humiliated them in every way.

However, in spite of this severe handling some of them continued to be rebellious for a week or more, but eventually all were completely subdued. The craftsmen however took no chances with their prisoners and the bonds were never removed till the day they died.

On the anniversary of the race each year, all the "slaves were tied immovably to the pillars of the starting gate while their captors indulged in feasting and revelry,—singing.

"Oh, what's so unlucky as number thirteen?

When a thirteen inch heel makes a thirteen foot Queen."

10

fashion features

NOSE-RINGS

for 'fifty four

Around about April 27th of last year Paulette Goddard is reported to have remarked that "The old line about women enjoying domination by the opposite sex is a lot of male propaganda."

To quote from the article by Clement D. Jones (U. P. Correspondent) in the New York Post of that date, Miss Goddard went on to say that any woman who lets herself believe that the male sex should dominate, and allows a man to put a ring in her nose, instead of on her finger, will live to regret it.

It's time girls stopped kidding themselves. That part of the Declaration of Independence that says "all men are created equal" refers to the fair sex as well as their brawny husbands, and it's up to the woman to see that that is understood."

Miss Goddard overlooks the fact that the wedding ring was originally a symbol of bondage—whereas the ring in the nose was not. Certainly a ring is put in the nose of a bull or a pig so that it can be lead around, but so far as human beings are concerned

the nose is just another place for an ornament.

Ever since the dawn of time women have been hanging decorative gizmos on any portion of their anatomy which would serve as a hook. They have worn necklaces, bangles on wrists, arms, and ankles, earrings and sometimes nose rings—but the latter, though common in the Orient are not so popular in Northern Europe and America. The reason for this could be simply that doctors so far have found no cure for the common cold. A runny nose is bad enough, but to have that organ further cluttered up by a ring would be nothing but an annoying nuisance.

However, a lot of women in Britain are apparently inclined to ignore this inconvenience and according to a London correspondent the nose ring is now very much in fashion—with a corresponding upsurge in the popularity of earrings.

The newspaper "People" September 13th, 1953 reports that "Mr. Cyril Wilkinson, Britain's prince of ear-piercers, reports

11

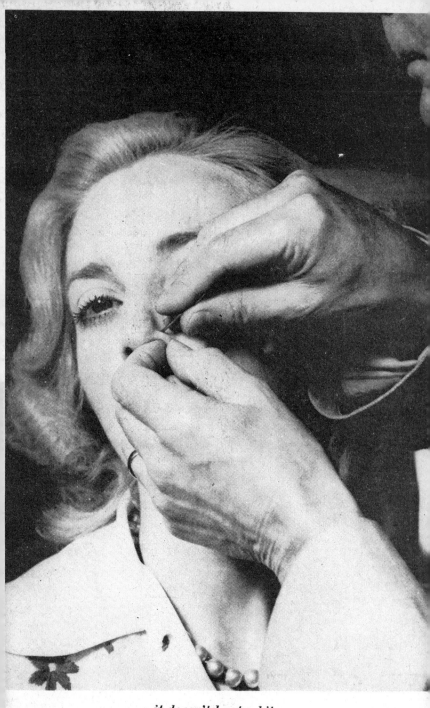

it doesn't hurt a bit—

more and more requests from women who want their noses drilled so that they can wear heavy jewelled rings in them."

To show women just what is involved, Mr. Wilkinson gave a demonstration on the finely chiselled nose of stage star Annette Gay.

But before you adopt it, read what a London psychiatrist said about the new fashion: "It is clearly a symptom of civilization rejection. These women are expressing a subconscious desire to return to the jungle."

(John Willie says that though he doubts that the learned doctor knows what he's talking about, he's all in favor of it and is practising up on his wolf call, while swinging on a trapeze which he has rigged up in the studio. Jemima the typiste isn't game to come into the joint and we have to dictate our letters through the keyhole.)

But to continue our quote, "Annette is not impressed. The idea of nose jewelry just appeals to me," she said. *(A remark which seems to us extremely sensible.)*

And now, so to speak, Oh ye fair maidens! Here's the pay-off! Again we quote—but this time from "Reveille" (Britain's all-family newspaper) of November 20th, 1953. On page 1 under the head-

ing, "She doesn't sneeze at Diamonds."

"I've never had so many boy friends in my life," said dazzling twenty-two-years-old blonde Annette Gay, turning her dazzling nose towards me so that the diamond just above her right nostril flashed luxuriantly in the sunlight.

"It's amazing what wearing a diamond in my nose has done for me. It seems to fascinate men. In the seven weeks since I first went for a diamond-in-the-nose fitting. I've had four proposals of marriage.

"Men follow me in the street, unable to tear their eyes away

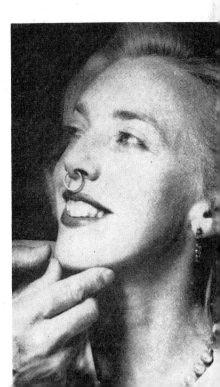

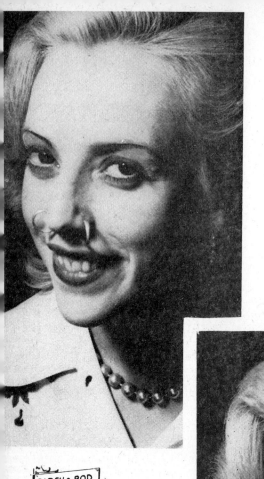

*it looks cute—but
it can give your
old man ideas*

BIRCH & ROD
SADDLERS
&
HARNESS MAKERS
BY APPOINTMENT

from the sight of my twinkling nose. In my local pub they salaam when I come in for a light ale.

Annette, with Noel Baron and Vera Blaine, is part of a stage act. At the moment the're doing a Malayan fantasy.

"That's why I had my nose pierced in the first place," Annette told me as we sat sipping tea at her country cottage in East Grinstead, Sussex.

"We thought I'd go down better as a Malayan glamour girl if I had a jewelled nose.

"So I had an old diamond ear-stud set on a flat base, and went along to Mr. Cyril Wilkinson, the famous ear-piercer who recently pierced the Queen's ears.

"My nose-diamond is attached to a small pin which extends half-way across the inside of my nose.

"It doesn't hurt at all. In fact I don't notice that it's there. I take it out every now and then to give it a rub and polish it up.

"The first time I sneezed while I was wearing it I was scared I might shake it out. But it stayed firm. And blowing my nose doesn't dislodge it either.

"We're thinking up another act now which we shall call 'Jungle Jitters.' I'm going to have a change from diamonds and will wear a huge nose ring instead. Hope it won't get in the way when I reach for a high note in my solo number!

"I'm not going to wear the big nose ring in my off-duty hours. That might frighten the natives of East Grinstead too much when I take the dogs out for a stroll in the evening.

"But from now on I'm a diamond-in-the-nose girl I recommend the idea to any girl who feels it's fun to collect admiring boy friends by the dozen!" *Unquote.*

Now what do our readers think about that?

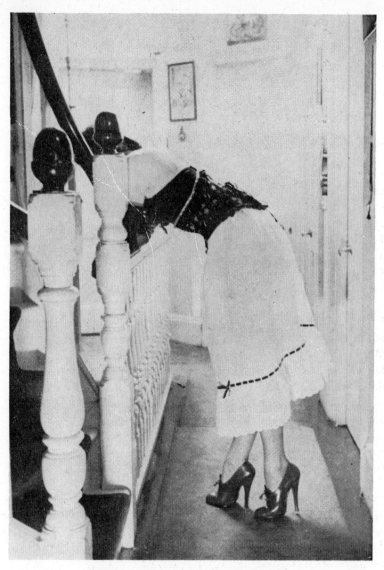

"Come right on up, cousin Pepita"

FOOTWEAR FANTASIA

"with Cousin Pepita"　　　by Sylvia Soulier

Dear Mr. Editor:

Yes! I have made a strange discovery recently, due to a chance meeting with a cousin of mine over here on a visit from France . . . She likes attractive boots! So! I got my little camera out and took a few odd shots in her flat which I have enclosed here for admiration! Unfortunately she is so very shy, and just blankly refused to let me make a real job of the photos, anyway I hope Mr. Editor that you will be able to make something of Pepita's little boots.

When I started to take quite a nice pose Pepita just made a dart for the heavy curtains and hid her head, so we shall have to be contented with a snappy look at those six inch heels gleaming beneath the high arched little boots, but after a little persuasion Pepita did at least make a little effort to 'show a leg', which I hope gives us all a slightly better idea of those tan soft kid boots.

After a little while I managed to persuade Pepita that a shot along the lines of one produced in Bizarre a long time ago, lying upside down in a chair, would be a splendid scheme, but of course the little devil defeated me in the end by snatching up a copy of a fashion paper and once again hiding her pretty little face. (*Yes! Pepita is so like her name might indicate, too terribly attractive really.*) Hush! And I shall tell you that she has an ACTUAL nineteen inch waist, and is still straining every silken corset lace to get down to even tinier dimensions still.

Shy as Pepita is, I believe that one fine day I shall manage to get some snaps of Pepita's little corsetted waist, she has some really marvellous little corsets in satin and kid and appears to revel in lacing them in and sweeping about her little flat. As a matter of fact I really do believe that Pepita's waist is certainly one of the smallest I have actually seen ever.

From the close up snaps of Pepita's little brown boots you can see that they have an unusual fastening, closing tightly to the knees with laces and little catches right the way up. As you know,

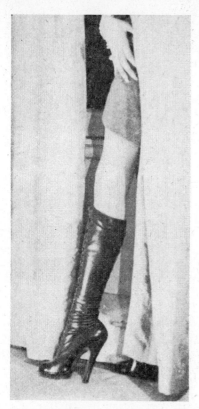

close-up photos make footwear look a little larger than in fact they are, Pepita's boots are a true size THREE with actual SIX inch high heels as you can believe from my snapshots, they are heavily perfumed always and have high soft kid tongues down the front.

Incidentally the one of the black kid very tight fitting knee boots is a friend of Pepitas, she wears a four and a half with five inch heels, I managed to get a snap of hers from Pepita as well to send, I should love to meet her

as she too is terribly keen on these sort of fancy dress things. Pepita told me that on a wet day her little friend always gets all 'dolled up' in a glorious pure white mackintosh coat with a wide patent belt round her small waist, and these boots in the snapshot, and goes out shopping in the West End.

From what Pepita tells me I have a sneaking idea that Pepita got a lot of her funny ideas from her girl friend of the shiny little boots, because none of us ever guessed that Pepita had the slightest interest in such bizarre attire. though Pepita's husband is far from being against girls looking their best always, poor Guy he has hurt his back lately, and got rather shaken, when his doctor told him he might have himself to wear corsets for awhile! Of course Pepita has been pulling his leg unmercifully about it and suggesting that he will have to get into some of her "old" ones.

Anyway one of these days I have challenged Pepita to come shopping. She in her little brown boots, and me wearing my Purple kid ones with the six inch heels, WOW! That will stop the traffic I guess, no need for the new Zebra crossings to stop the buses that day. But believe me we girls have made up our minds to do this soon, because we are just fed up

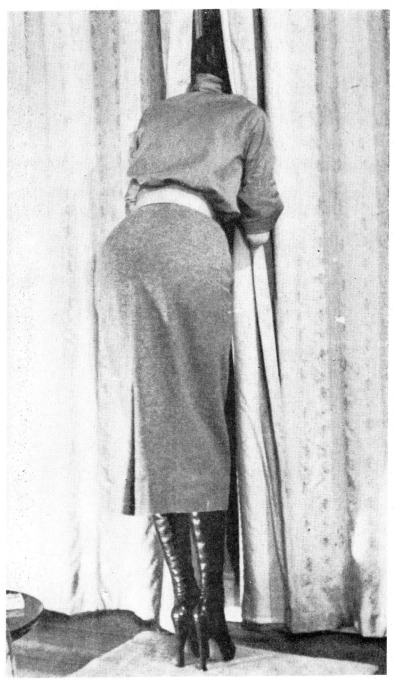

"Boo!"

with Pepita's husband saying that it is more than we dare.

Now Mr. Editor, as you probably know it is never too wise to DARE a girl to do anything is it? And believe me Pepita has just as much devilry as Sylvia has at times.

Incidentally we both loved the drawing of the Pony Girl in No. 12, what an idea, and why not, it looks quite practical to carry out anyway. As a matter of fact Pepita's girl friend did some years ago know a woman whose husband used to sort of "harness her up" like that for fun and drive her round thier small garden behind thier house, about the only difference was she says, that this girl used to wear a short little sort of black kid Ballet skirt, and and rather Cowboy style horsey kid boots with quite high Cuban heels, and little toy spurs.

I am surprised that more American women do not take to something like that for up country etc.. a smart Tan or yellow calf boot with high Cuban heel, and loose sided legs, ornamented with bizarre designs—they should come to half way up the calves to show a nice trim muscle encased in shimmering nylon hose. Such boots always give the arched insteps their most elegant appearance.

Whilst talking about Pepita's boots and her girl friend's I nearly forgot to mention that I called on a lady friend last week, who asked my advice about boots, and I really did envy her when she told me that she was having a pair of "thigh high" black kid boots made for her, she isn't having too high heels, somewhere around five inch to four and a half she says, as she fully intends wearing them for long periods at a time. It appears that she has always been keen on these very high boots since she was quite a girl on the stage, where she first got to like them in Pantomine shows.

When I asked her what she meant by wearing them for "long periods" she replied shortly, "Well! my dear Sylvia, if I am going to have the bother of buttoning up such high boots, believe me dear! I don't intend to keep taking them on and off. Bless You, Sylvia dear, I shall keep them on all day long"!

But I asked her, "what about going out shopping?" To which I got an equally short terse answer, as if I was talking stupidly. "Heavens child! Do you think anyone is going to know how high my boots reach under my skirt and coat outside?"

But! Said I . . . "But nothing Sylvia," she replied, "you talk as if everyone was walking about with thier eyes glued to the pave-

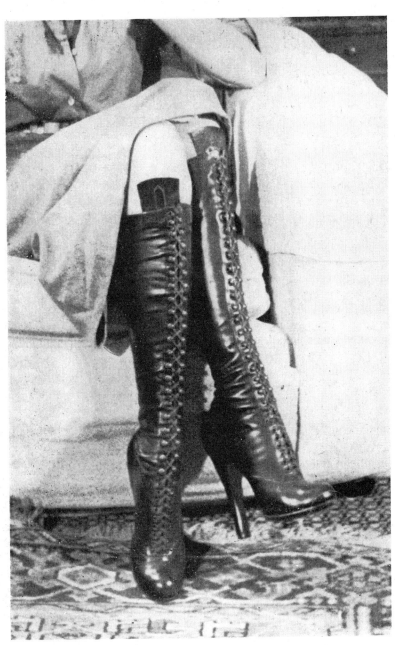

Pepita's tan kid boots

ment or something! Besides," she added grinning mischieviously, "Let them look," and she added naughtily, "maybe I shall be noticed for a change." I gave the conversation up.

Sometime this week I am going down to the shoemakers shop with her when she orders thĕm, so shall have more news of these delightful apparitions at a later date, she has agreed to let me take some photos of them, so we shall be allright we Bizarre readers I hope—Leave it to little Sylvia to do her stuff! Anyway she is going to have her initials worked on them in front at the tops in Gold kid or something like that, who on earth she thinks is going to be able to admire that hidden under her skirts, I haven't a clue.

Funny how light brown seems to have a vogue here for knee boots, for strangely enough this lady also has a pair of kid boots with three inch heels, and knee height, buttoning to fasten, and whether you care to believe it or not, no matter, but Sylvia can vouch for it, she *does* go shopping in her little boots quite often, and rather likes the fact that she gets a little admiration from passers.

What with small waists, higher and spindlier heels, fancy gloves, shorter skirts and wide belts dear old London town is looking up this year quite a lot, and whereas Sylvia might have considered it daring to go out in five inch heels

just after the war, believe me, six inchers wouldn't make people turn round now.

Oh! Yes! The Males are trying also to look a little brighter lately, one can see plenty of those old fashioned Brocaded silk waistcoats in the shops around Burlington Arcade. Ties follow very much the American Trend of dashing colours, and those handlebar moustaches abound in plenty. Yes! It only wants a good shoemaker to get cracking and we shall have these husbands crawling around tired after a days work, on thier four inch heeled shoes, yelling thier heads off for corsets to show thier little fancy waistcoats off etc.

Oh! You can laugh I saw a Johnny in Bond Street last week, might have stepped off a 'Hollywood set' . . . He had gone all "Edwardian." The "Lot"! Curly Bowler hat, three-quarter length jacket corset cut and pretty well corsetted into the bargain, fancy silk waistcoat, Walrus moustache, immaculate white kid gloves, with two darling little buttons, walking stick, and Oh! Boy! Oh! Boy! The nattiest pair of little narrow patent topped button boots with three inch Cuban heels.

Did Bond Street stop? . . . Bless your life no. One or two guys turned round and stared, a girl smiled openly at him as she passed by, but beyond that, the sensation was over, and "Johnny went marching on" gaily enough and completely unconcerned.

Well! All good things must come to an end as the sailor said (as he glanced at the girls six inch heels), so this is little Sylvia, signing off Mr. Editor. Incidental-

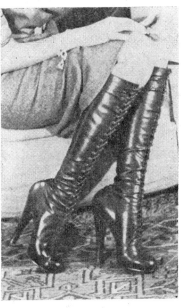

ly I do *not* thank th charmer who sent in that sketch illustrating the "Chinese Flute" story, I have had the "Old Man" getting ideas in his head about that one, never want to encourage my old man like that, besides we have enough litter around this place already, in the way of fancy footwear, corsets and what not else.

SYLVIA SOULIER

23

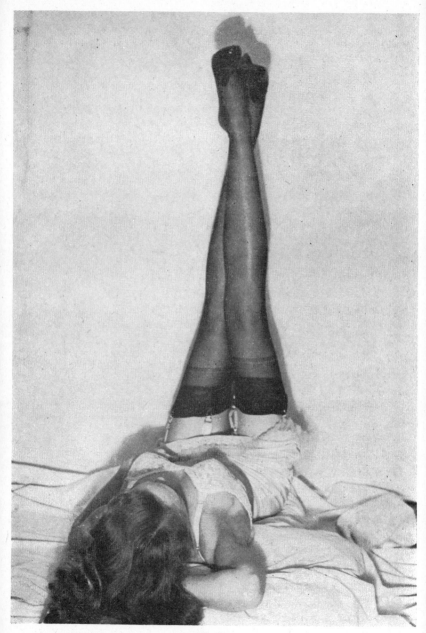

Well?

orrespondence

Under no circumstances do we publish names and addresses, nor do we put readers in touch with each other. If photos or sketches are sent in, please write a short commentary and please do NOT send in photos which you got from someone else.

ANSWERS PLEASE

Dear Editor:

Away back in No. 6 a young lady signing herself Caroline complained that *quote*, men seem intent on putting all girls into the highest heels, the tightest clothes and the most stringent discipline possible, *unquote*. Miss Caroline also mentioned that perhaps they would not be so eager for such practices if they had "a taste of their own medicine."

In issue No. 8 appeared my answer to this challenge an invitation to Miss C to back up her statements with a little shall we say, physical action. Now I don't mind losing an argument, or having to admit I was wrong and apologizing—but this—TO BE IGNORED ENTIRELY!—this I find a little annoying, to say the least.

However, undaunted by such cavalier treatment I am about to try again—this time regarding a most interesting item in No. 11 written by Miss Bettie C. Perhaps she will be a little more—how shall I say—understanding?—cooperative? simpatico?

This letter, on page 50, purports to be from two sisters in business for themselves running a dress shop. For some time now I have been considering the same idea myself, i.e., opening a little shop of my own, etc. I have been "in training" for about two years but have discovered that there are certain problems which I cannot solve alone. These, and other matters I would most earnestly like to discuss with her since I feel that her experiences would be of most invaluable help to me in attaining my goal.

Bettie, if you read this will you please lose no time in answering my plea. I assure you that anything constructive you can do will not go unrewarded.

Sincerely,

GAURON

THE WISHING WELL

Dear Sir:

Your magazine fascinates me as it contains all that I have longed for in my subconscious desires and dreams.

When your readers speak of subjugating and disciplining their husbands into becoming lovely and obedient maids, then I become positively jealous of the lucky males because that has been my dream for many a long year.

Another desire of mine is to be laced into lovely tiny waisted corsets and forced to wear extremely high heeled shoes.

I do have the corsets and two pairs of six-inch heeled pumps, but the real thrill of being forced to wear them is not there.

Oh, to have two lovely ladies like "The Lion Tamer" and the recumbent lady "for my leather moments" to train and tame me as their very obedient servant.

With regard to the ladies in bondage, I think that it is over done and crude to a certain extent and would much rather see them in bondage by corset, high heels, etc., and then bound by strong satin ribbons.

By the way, why don't you allow corsetiere's, dressmakers and shoemakers to advertise in *Bizarre* so that we corset, heel and feminine dress lovers can get things made for ourselves without the embarrassment of going into public stores for them.

MARLENE GREY

This letter gives us an idea. We'll start a "Wishing Well" section. Just send along your wish— anonymous — we'll print it and Titania can do the rest. Ed.

ARE WASP WAISTS ARISTOCRATIC?

Dear Sir:

As a corset lover I am delighted and thoroughly interested in Damon's fascinating account of how he and his sisters not only wear tight, wasp-waisted corsets, but actually have elegant hour-glass waists of eighteen and nineteen inches as well. This is most delightful and gratifying to every genuine corset devotee, and it constitutes an achievement of which all corset conscious people may well be proud.

Surely, nothing can be so esthetically pleasing or so graceful as a real wasp-waisted figure. The prominent bust, the tiny waist, and the full-hipped figure embodies a beauty, charm and elegance which is sadly lacking in our modern day society with its unesthetic and unhedonistic pleasures.

In a refined, cultured and aristocratic society elegance of dress, politeness of manner, and sensible decorum produce a feminine so-

ciety and age in which every woman strives to be a lady and every man a gentleman. Women and girls in such a society live restricted lives, and in conformity with the spirit of the age they dress as restrictively as custom and fashion dictate; hence we have tight-laced corsets, hobble skirts, petticoats, pantelets, bloomers, high-heeled knee and thigh-length boots and in short an amplitude of many, elegant and restrictive garments designed to emphasize, enhance and glorify the feminine figure in the eye of eligible males.

The rightful place for women in a society of this sort is the home, and not the world of commerce or industry. Marriage is her true career and the one for which she is trained from infancy. Needless to say a society which is of this nature is totally unlike our proletarian, mass-minded society of the year 1953 which is concerned with social security in the form of government handouts and has no conception of beauty or appreciation for anything worthwhile.

Men and women like Damon and his sisters, and countless others, including myself are not of the masses. We instinctively prefer a restrictive, aristocratic sort of life in which all the essentials of a true aristocratic society are present. We love privacy, and by nature are esthetes and hedonists

who seek beauty and pleasure from the restrictive environment in which we live.

Our pleasures are those of the refined, cultured, sensuous lady or gentleman. In our choice of bizarre costumes and unconventional, prohibited dress, we are not only unconsciously protesting against the proletarian manners and dress of contemporary society, but we are likewise exhibiting a preference for all that is unproletarian, hence at heart we thoroughly hate and abhor all that is contrary to our conception of an ideal society. The real truth of the matter is that we, the majority of readers of *"Bizarre,"* are patricians or aristocrats by nature who would be happier living in Victorian days than in the present atomic age.

As a student of sociology I can proudly and truthfully say that the proletarian society of 1953 has not supplanted the aristocratic genteel society of 1893. The best of Victorian days not only still lives but many of the customs, dress and mannerisms yet flourish among a selective few, who wisely refuse to yield to that proletarianization of society which people of the masses mistakenly refer to as progress.

So you readers of *"Bizarre"* who are constantly seeking new thrills from the unconventional

and bizarre experiences of other readers are to be complimented for your preference, and praised for your whole-hearted support and interest in all that's unconventional.

In conclusion I should like to express a hope that someone of our many readers may be able to furnish us with some more factual information on figure training as practiced during the ninety's or early nineteen hundreds.

FRED S. MAC

SHE IS ASKING FOR IT

Dear Mr. Editor:

Perhaps you will be interested in what happened to me as a result of my writing that letter to Bizarre which you titled "Corset Model and Cautious Husband."

As I mentioned, my husband has frequent business trips to New York. Before he left on a recent one I reminded him that No. 9 was about due and that he should try to get a copy for us as we both get so much enjoyment from *Bizarre*. Well to make a long story short, he came back from the city and was quite gay—a symbol of a successful business trip. He said it was a special occasion and asked if I would like to celebrate it. As any woman would, I was delighted and asked him if there was anything special that he desired me to wear.

He suggested that I wear my new Cincher Corset and Sheath Dress. The corset is one we designed and had made by a corsetierre. It is very severe as modern corsets go and even severe compared to those of the 90's. It is made of heavy black satin with many ribs of spiral steel wire and is rather long, fitting with half cups under the breasts and down well over the hips. It laces up the back and the waist closes at a small 17 inches, leaving me rather breathless. I am well rewarded for the feeling of tightness that it gives for in it I achieve a genuine hour glass figure with a wasp waist, breasts lifted up and out and a swelling ripeness at the hips.

My husband helped me don the corset, pulling and tugging the laces until the garment closed. I wore dark sheer nylons fastened to the corset with short garters and then put on a pair of black patent pumps with skyscraper heels. The only other garment I wore was the Sheath Dress. It is of heavy black crepe with a high neck and long sleeves, zips up the back and fits like paper on a wall.

The dress is a genuine sheath— in fact I almost feel immodest while wearing it as it outlines every curve I have and draws attention to my tightly corseted waist and outthrust bosom and rounded hips. A wide patent leath-

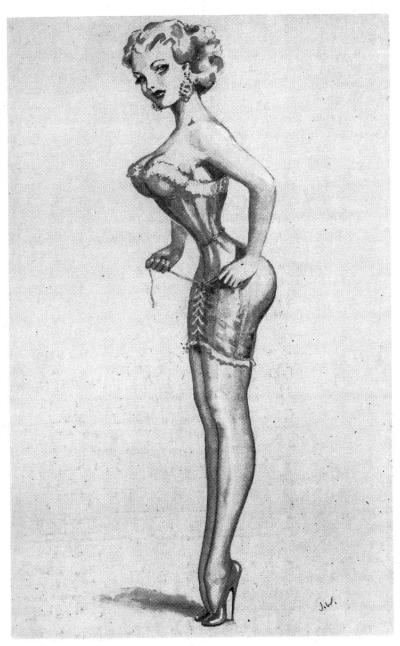

the Gibson Girl corset

er belt cinches the waist emphasizing its slenderness.

I asked my husband to help me with my coat and when he was behind me, instead of helping with the coat he reached around and quickly fastened a handcuff on my left wrist. It was connected to a length of light chain which he drew around my right side, about my waist and fastened it to my right wrist and I was caught. Then he took the hem of my dress, lifted it up over my chained arms and fastened it, by means of a wide leather collar about my neck!

Dear Editor—I was dressed in one of your UD skirts—and helpless! As I read *Bizarre*, as well as my husband I know where he got the idea. But as yet I had no idea why he put me in such an embarrassingly helpless condition. Next he led me to a straight chair and told me to sit down. I sat, and then he gagged me and strapped me to the chair with one of his belts.

There I was, helpless and not even in a position to protest, either verbally or physically. While I was wondering what was going to come next, he brought a comfortable chair over in front of me, opened an envelope and took out a copy of your number 9, flipped the pages and read me—my letter! When he finished he looked up at me and smiled saying, " So I am a 'Cautious Husband'!"

He was not really mean about it, for he ordered two excellent dinners sent over from a nearby restaurant and took off the gag and the belt and fed me, bite by bite—all the time chiding me for writing to you without his permission. He told me if I was quiet and didn't talk back he wouldn't gag me. I was discreet and said not a word.

After several hours punishment in my "straitjacket" he released me, but said for punishment I was not permitted to go with him to New York for at least six weeks. This is the first time I've been here since the UD skirt episode. To be sure my husband is living up to his "reputation" as he calls it of being a "Cautious Husband." Before he left he forced me to don my chastity belt and handcuffed me. Then he locked my clothes in the clothes cupboard.

Dear Editor—Here I am, alone in my hotel room, nude save for my handcuffs and chastity belt writing my experience to you. I sincerely hope that you are kind again and find space in *Bizarre* to print it as just between us I'm wondering in what way my "Cautious Husband" will punish me for writing. If he does—I'll tell you.

Sincerely

Mrs. R. W.

Rubber for Rainwear

Dear Sirs:

Your photo's showing rainwear are most interesting and unusual. I am enclosing a few photos just to show how interesting modern rainwear can be. The all rubber latex coat alas is dying out although the photos show models purchased last year in Florida.

One photo shows two of the coats worn thus ensuring complete protection from the heaviest deluge and at the same time looking most attractive. I have several photos available of recent shiny black mackintoshes which have been made to special order. A well known model is shown depicting one of the latest styles. If you would like more of this type of photo I'll gladly send some. (*Send them along by all means. Ed.*)

M. A.

The Rubber Romper

Dear Sir:

Over the years, many refinements in my home techniques of manufacturing rubber garments have been developed. However, it is still not possible to equal in detail and fineness, the manner in which rubber garments can be produced by commercial firms. They use vulcanization equipment that actually sets a seam permanently. It is quite satisfactory though, to allow any home-cemented seams to set for two days before attempting to wear the garment. This is quite a difficult period to resist, as I have found out. A real rubber devotee wants to immediately wear his or her creation and consequently only succeeds in destroying the handiwork as the seams will not hold

photo from M.A.

unless they are absolutely dry.
Several years ago I succeeded

in reaching a commercial firm
that manufactured several gar-

32

ments to my specifications. At present I have two pairs of hip length opera hose in pure gum-rubber and a complete suit, front laced, of pure gum-rubber. The stockings are worn often, and serve a double purpose. First of all they are thrilling to feel, and their soft even pressure adds a support and molding feature which allows long hours of tireless leg use in my daily occupation. They are worn in company with a standard, unlined rubber brief, that makes an ideal costume beneath every-day clothes. For real pleasure, however, the complete suit is worn over whatever other costume is worn. The finest feature of these commercially made garments is their durability and easy storage.

Being a "rubber romper," as I prefer to call myself, has naturally led me to figure training in various forms. There is always some rubber involved in my costumes though, just so I won't be drawn too far away from its spell.

Somewhere along the line I met several kindred souls who shared my thoughts on the subject of rubber and corsets. Needless to say we did as we pleased from then on in company.

One young lady, who I shall name Karen, used to taunt and tease us to clothe her in rubber garments over which we placed sheer opera-length nylons, a tight-ly laced, wasp-waisted corset, shoulder length black kid gloves and a silk leotard. On her feet we placed the highest heeled shoes we could find. Once thusly arranged we would force her to parade around for hours until she begged to be allowed to sit down to rest. At that moment it would constitute the signal for us to tightly bind her with leather straps at ankles, knees and thighs. Then her arms, still encased in their black kid gloves would be pinioned behind her, at wrists and elbows, so they met, and she would be made to simply stand in the center of the room. As her protestations would sometimes become quite voluable at this stage we would then resort to gagging and blindfolding her with three strips of rubber, about three-inches wide, cut from an automobile inner tube. These were applied across the mouth and eyes with the third strip encircling the head from top to beneath the chin and jaws. Being thus helplessly devoid of all sight and speech she could only hear and breathe. If she snorted too loudly we would then truss her completely to a chair, table or raise her pinioned arms by means of a long rope over the top of a door.

About an hour of this "bliss" we found was her maximum tolerance and we would then release

drifting an' dreaming—(*and a trifle damp.*)

her. Subsequently we all shared the same experiences to a greater or lesser degree but, we could never equal Karen's record of four and one-half hours in costume and pinions. This remarkable person has long since married and I presume does not indulge in her earlier hobbies today (*what makes you think that? Ed.*) She was responsible for the idea to create a custom-made rubber mask which though quite intricate to produce was well worth the trouble.

How to Make a Mask

This mask was actually made from a plaster cast of her face and head. To produce it, it was necessary to make a mold of her face using a semi-liquid preparation known as Negocoll. This material when warmed will reproduce every detail, even skin texture and can be placed on the face or body and does not adhere to the skin or hair.

We placed her on a table and made a template of stiff cardboard to fit the contours of her head and jaw line. This was accomplished by using lead wire or ribbon solder to get an accurate outline first. This outline was traced on the cardboard and the corresponding opening cut out.

This cardboard template was then slipped over the face and top of the head. It encircled the head just in front of the ears. Once in place she held her head absolutely still and we inserted two quarter inch glass tubes in the nostrils so she could breathe. Now the warm Negocoll mixture was carefully poured over her entire face, hair and neck until a layer about one-half inch thick was formed. This hardens to a rubber-like consistency in about 15 minutes but must be reinforced before removal of the mold. Over the outside of the Negocoll we poured a one-half inch layer of semi-liquid plaster of paris which hardened in about 15 minutes. Then the mold was removed carefully.

A perfect duplicate in negative was the result. We repeated the process for the back of the head and ears and when both halves were fitted together we had Karen's head mold.

The two halves were placed together and the sections wrapped with twine and tape. Into this "hollow head" was poured a very liquid mixture of plaster of paris. This we swished around to coat every part of the mold. When this layer hardened, we added more liquid plaster and swished it around to thicken the coating within the mold. When it was approximately one-half inch thick, it was allowed to set.

When separated we had a duplicate in every detail of the wondrous creature's face and head.

This positive casting was the basis for the rubber mask.

Without further preparation, other than to fill up some minor air holes, we then dipped this head into a mixture of self-vulcanizing latex and set it aside to dry overnight. The next morning the mask was dry so when the outside was thoroughly dusted with talcum it could be peeled off the plaster head like a bathing cap. When off the cast the inside required powdering as it would stick together unless powdered.

This mask needed only nostril openings cut into it to become the most-fitting prison for Karen's head. It served as gag, ear plugs, blindfold and hair net and was used in all subsequent meetings with our ever-willing subject.

All mask devotees can follow these simple directions (more explicit can be obtained on books on sculpture if desired) to produce the most perfectly fitting mask you have ever seen. Need I say that when Karen left us for marriage she kept the mask and plaster cast of her head. I often wonder how she explained their existence. (*We just don't get it. Ed.*)

Perhaps I have bored you till now but shall continue if you wish at another time with my experiences in figure training and leather.

Sincerely, T. R. S.

Miss Masked Marvelle

CORSETS FOR SEX APPEAL

Dear Sir:

Ran across this the other day in perusing the works of that grand old human being, Havelock Ellis.

"Not only does the corset render the breasts more prominent; it has the further effect of displacing the breathing activity of the lungs in an upward direction, the advantage from the point of view of sex-allurement thus gained being that additional attention is drawn to the bosom from the respiratory movement thus imparted to it . . .

37

The corset may thus be regarded as the chief instrument of sex-allurement which the armory of custome supplies to woman, for it furnishes her with a method of heightening at once her two chief secondary sex charactertistics, the bosom above and the hips or buttocks below."

Ellis was here talking about the hip free, waist-diminishing, bosom supporting corset of the 1890's— the "hour-glass" figure, and not the hip-suppressig girdle or the breast-confining brassiere. (*Did you say "confining"?—oh you falsie. Ed.*) Checking with the records of corset makers of that time, we find that in 1868 17 inches was considered the *average* waist size. In 1890, 19 was considered "large." So for about thirty years women held to the hour-glass ideal, which, in the words of a fashion writer of the 1870's demanded that: "A waist may vary from 17 to 23 inches, according to the general proportions of the figure and yet appear in all cases slender and elegant."

Yours, G. W.

Cure for Tired Businessmen

Dear Mr. Willie:

My wife is a bug on rubber also and I would like to hear from some of the gals on the subject. Below is a short description of how we enjoy our mutual love for rubber. If you like and it fits in with your scheme of things, I would like to publish it under the intials "T.C."

At least twice a week after a rather bad day at the office I can expect to be greeted at the door by a sight that certainly starts the blood flowing a little faster. As an outer garment my wife will be wearing a dress that was tailor made for her completely of rubber. The sleeves are three quarter length and it has a flared skirt which rustles as only rubber can when she walks across the floor. Her waist is confined by a five-inch three strap patent leather belt which sets her 36-inch bust off to glorious heights. The footwear consists of a pair of shiny zipper type black rubber platform boots which I managed to get last year and are now practically impossible to find. The gloves she wears are of pure latex. Underneath the dress she is clad in shiny black rubber girdle and latex bra both of which were made to order for her figure, to top it off she wears a shiny red bathing cap. As such she is completely clothed from head to foot in rubber. If anyone thinks that plastic or ordinary clothing can do the job that rubber does, egad, does he have a treat in store if he trys the above mode of dress for his lovely wife. On rainy days we go out for a drive and the above

ensemble is augmented by a brown shimmering latex raincoat. Of course, she doesn't wear the cap. Now if you don't think the above costume is a head-turner just try it some time. Many women and men on the street have stopped us and asked where the lovely rubber rainwear was purchased. Of course, they all receive the sad answer that it was all custom-made. I hope this will stimulate the rubber fans to a point where we can get a little action. What do you think editor?

Very truly yours,

T. C.

Caning Hurts—But

Dear Sir,

Mrs. Guthrie's letter was not so surprising. The birchrod stings the skin but the cane hurts more, for it bruises. There was the celebrated instance, at the end of last century, of the birching of a number of suffragettes in a London prison. Although not officially sanctioned, it came out that the authorities wished to make an example and it is said that each wrongdoer received in turn six dozen strokes of the birch, and from a male arm, too, since a deterrent effect on their political activities was desired. Of course, such a count with the cane would be out of the question. Victorian memoirs seldom quote more than twenty strokes

with the cane for the strongest of schoolboys.

In my youth both my sister and I were caned, though very seldom. I don't suppose I can remember being caned more than five or six times by mother, including the one day when I had two goes! We had to lean forward and got it about four inches above the back of the knees, hard. Usually we were given six or, for more serious offenses, ten. We never saw anything humiliating in it. When we were both due for a "dose" one of us would have to watch the other taking it first. That was always an anxious moment. I always recall being surprised by my sister's face when she stood up after it was all over, for she never made a sound during the operation. However at the end she was flushed and unsettled. I'm sure we American girls can "take" it as well as your French and your Scotch correspondents. The day I had a double-dose, both occasions were quite merited (the one a follow-up from the other) and I got ten and twelve. There had only been an interval of a few hours and the second caning was quite trying. But I think I can say I leant over nicely and kept my knees back and my skirt up throughout just as mother wanted. I never called out, though I thought it'd never be over! However, I did dance a bit when she'd

gone out of the room. I feel sure there is nothing wrong in c. p. properly used. A good caning without any fuss is an excellent correction.

Stella Sewell

HOPEFUL, HELPLESS HEROINE

Dear Sir:

Not that I want to start anything with Blind Girl Fluff or Shackled Susan, but I bet I have had more experiences over a longer number of years experimenting with masks and restraints than either of them. I remember when I was 15 or 16 in a game. We had a summer place on a lake in northern Wisconsin and ran like wild Indians all vacation. I was supposed to be a beautiful Indian Maiden and was captured by some boys on the opponents team. To keep me from warning anyone on my side, they bound me hand and foot, stuffed a red bandana in my mouth and secured it with another bandana. Oh, you can be sure I fought but while they were gentle, they were thoroughly efficient. They left me helplessly struggling on a soft cushion of pine needles while they went after the others on my side.

In the spirit of the game I wanted to be a heroine, get away, warn my team-mates and thus turn the tide of battle. But though I rolled and wiggled what seemed to me like hours, while the boys captured the others, I accomplished nothing except to become thoroughly exhausted. To make this episode complete, I must confess that I fell in love with the boy who released me.

After that I used to think up games and delightful situations where he would secure me in different ways, always leaving me for awhile helpless and effectively mute. I only saw him during summer as we lived in entirely different cities, but I would look forward all school year to seeing him during vacation.

Eventually, of course, he and his parents went somewhere else for the summer. I was broken hearted, but by then had become quite clever at arranging games, plays and situations which always involved someone being strapped to a chair or tied to a tree or secured to a fence post or bound with rope in jack-knife position, blindfolded, gagged, and completely helpless— and that someone was inevitably I. Occasionally, another of my sisters or girl friends would beg to be the captive, but I wouldn't let them get away with it often, you can be sure.

I could fill a book with these reminiscences, but I'm a housewife now and my time is limited and I'm sure yours is too.

"BILLIE"

(*We've got lots of time. Ed.*)

40

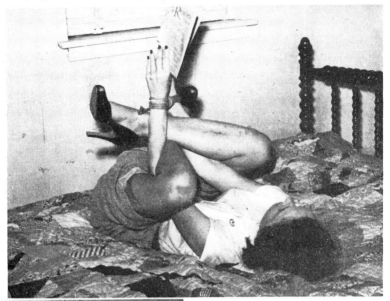

ON A QUIET AFTERNOON

you can relax like this, and read a good book—

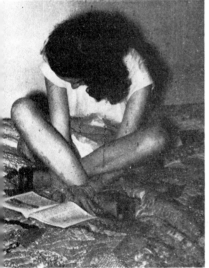

or just relax!

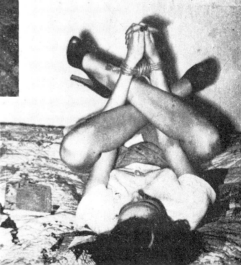

ays "Chained Letter Writer.")

Dear Sirs:

Jean R., of No. 10, has evidently seen a classmate punished for wearing clothing, namely a pair of bloomers, that did not belong to her; I had a similar experience, though this included correction for wearing too little! When I was fifteen I spent three years with an Aunt in the country. Mother had never whipped me, but Auntie, who was definitely "bizarre" in some ways, believed that such was the only way of instilling ready and unquestioning atonement for a fault. Although she was rather severe, I knew that no whipping would be more than I could truly bear. Yet I confess that the stripes never "thrilled" me as they seem to have Jean R.'s friend! For me it was always a painful lesson painfully learnt.

The incident in question took place in my last year with Aunt and resulted in the worst whipping I ever had. There was a very special dance on and I was being taken by a man (who is now my husband) on whom I particularly wanted to make an impression and one who I knew was very fond of jewelry. I went in my close-fitting cream satin evening dress with no underclothes on! What was more I "borrowed" from Aunt's jewel-case a pair of garters she had given her in Paris. These were of steel (or platinum?), magnificently encrusted with rubies and sapphires, and with them I held my dark mesh hose right up my thighs. When I let my dress down they stood out each time I moved. I soon found that although they bit into my flesh a little under the hips, they produced the most agreeable sensation imaginable, and the *frisson* of the soft, luxurious material over them was delightful. I certainly let Rob feel my new ornaments close to him as we danced and he kept me long past the time when I was allowed out.

I was over half-an-hour late back. Aunt called me in to her bedroom, lectured me, and told me to position myself for a "taste of the cane." I had to kneel on a low shiny table, I remember, upon my knees and elbows, my back quite arched in to give proper prominence to the part to be chastised. I was very frightened as I had meant to return the garters before Aunt went upstairs herself. I resolved to endure my count with all the fortitude I could muster. This time, however, when she had given me about seven cuts with the pencil-slim cane, gleaming with wax all its three feet of length, which she particularly favoured, she stopped and said, "Is it true, Dorothy, that you have nothing on beneath that thin satin

dress?" I confessed immediately, terrified she might make me take it up; after a brief talking to in my humiliating position, I was accorded double the dose for this extra error. Then that damnably pliable, yet tough stick Auntie used so expertly seemed to search out the tenderest parts of my anatomy, and try as I would to bear it well, I could not keep from wriggling furiously and making a positively shameful scene. Suddenly there came a sharp rapping sound—the tip of the rod had struck the garter on my right side! There was utter silence, except for my slight panting.

"Stand up, Dorothy," said Aunt in a tone I shall never forget, "and lift that dress up to your waist." I did as she bid, my back to her. "I see. Not content with going to a dance in an unbecoming fashion and staying out late, you are also a thief. You may have a few moments in the corner to compose yourself and then we shall proceed to a second installment of this salutory lesson. But first, give me back my garters, will you, please." Aunt took them from my trembling fingers and adjusted them slowly high up on her own legs, where they shone and scintillated as she raised her velvet skirt. Well, the second correction made the first seem like child's play and to endure it perfectly I had to

have my arms secured behind me at wrist and elbow with small straps and lean forward over the bed, my skirt around my armpits. When it was all over, I was naturally very contrite. Auntie studied me as I twisted about before her and said, "Now, Dorothy, you can put them back where you found them." As my arms were still bound tightly and since Aunt was standing with her legs apart, smiling, I knew what she intended. "And no ladders in my stockings, thank you." I took those garters off her silk-clad legs with my own teeth and dropped them back in her jewelry box. Yes, Aunt knew how to drive home a lesson. But after this scene, she allowed me to wear the beloved garters whenever I asked, even once, under my jodhpurs, when we went riding, which produced a fascinating sensation. I never bore Auntie any grudge. Though she knew how to make me squirm, there was a certain indefinable kindness about her and the strong influence she exerted over me then has lasted to this day.

Yours,

DOROTHY F.

CURE FOR MR. WONTWORK

Dear Sir:

I came across *"Bizarre"* quite by chance and was amazed at the number of cases of men in female

clothes mentioned therein, for I had quite thought that the transformation of my own husband, Phillip, into an attractive girl, Phyllis, was a solitary instance. Perhaps a few details about our life will interest your readers and may even lead to some others writing about theirs.

I had originally been attracted towards Phil because of his decidedly feminine characteristics, and I had often wondered what sort of girl he would make if dressed and made up. The first time I suggested he should let me dress him up he just laughed at me and refused.

My chance came, however, when he lost his job and, seeming quite satisfied to live on my earnings, he did nothing about finding another post. Instead, he spent most of his time drinking at his club. I soon got tired of this situation and told him I was going to change it. The following day, when he came home the worse for drink, I was ready for him. I quietly told him I wasn't going to put up with his wasting any more of his time and, as he hadn't taken any steps to get work, I was going to do so for him and get a post for him as—a waitress in the restaurant where I was head supervisor. He just laughed again, till I produced a cane and started to beat him unmercifully. With him crying and cowering before me, I said he could choose between getting out and staying out, or agreeing to my proposal to dress him as a girl and to train him at home, till he was ready to begin working at the restaurant. As an afterthought, I reminded him that he had always enjoyed lacing me in tightly and seeing me wearing high heels and my pretty things; now he would be able to appreciate these things from a different viewpoint—on himself. He began to make excuses of every sort—that he'd never look like a real girl, that his voice would give him away, that he'd never be able to go to his club again, etc., etc. I listened to him patiently and then replied quite firmly that missing his club would be a good thing and, as for the success or failure of his changeover, I should be the judge about that, after a period of trial at home. He became sullen again, and I had to give him another sound thrashing before he would submit.

I took him to the bathroom and made him take a hot, scented bath. I rubbed him down and powdered him all over, in readiness for the long, stiff corset I had procured in anticipation of success. This I clasped round his shapeless middle and then began to pull in the laces. In spite of his protests, I made good progress, reducing his

DON'T LET THIS HAPPEN TO YOU

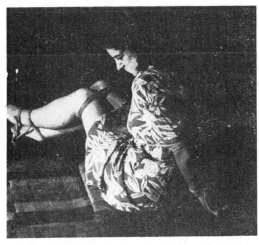

time to do something about it is before—

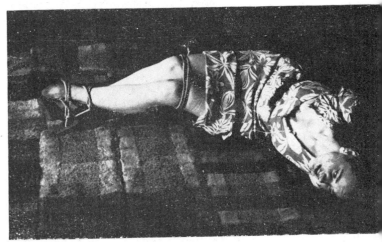

after Ivan decamps with the secret plan

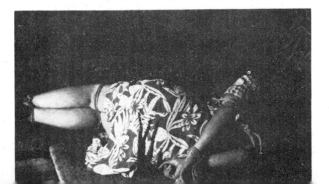

**learn
jiu-jitsu
the art
of self
defense**

waist-line by several inches. Then long silk stockings followed, to be attached to the corset by frilly little suspenders. A padded brassiere came next, before his undies, in the form of lace-trimmed satin cami-knickers, were put on. Then a pair of cross-strapped shoes with four-inch heels caused him to complain again, but all to no avail. A neat cotton printed frock came next, and then I put on his make-up. As I had no wig for him, I swathed his head in a scarf, to look like a turban, and clip-on earrings completed the picture.

I stood back and surveyed the result, a decidedly pretty girl, as I had anticipated, though a sullenly frowning one at the moment. I led him to the mirror and left him there, unable to hide his surprise at his very realistic transformation, while I went out of the room for a moment. I came back quietly to see what he would be doing, to find him preening himself before the glass and obviously admiring his girlish reflection, in spite of his former attitude to the whole affair. He had good reason for holding up his frock to admire his long, silk-stockinged legs, for they were most attractive, and would certainly have made several of my girl acquaintances envious. Catching sight of me, he dropped his skirts and stood there blushing deeply. I congratulated him on this

initial success, laughingly telling him he would always have a pretty pair of legs to look at whenever he wanted to.

He became quite accustomed to his unusual attire as the evening wore on, and, with this familiarity, he began to be far more cheerful and willing to listen to my ideas. At times he protested mildly, but without avail, for I was now determined to have my way in everything. I laid my plans before him —three months of progressive training at home, with some occasional sorties after dark, until he should be thoroughly accustomed to his feminine role and so be ready to become a "waitress."

And so it was. Phil's opposition gradually died away, and in the end was replaced by willing co-operation. I disposed of his male attire, having decided he should live entirely as a girl. Systemmatic tight-lacing produced a waistline of 19 inches over his clothes. This corsetting pushed his bosom up and, after a while, pads were not necessary to give him a figure. He became accustomed to six-inch heels, and the muscularity of his legs and arms gradually disappeared, as did also all sign of hair growth both there and on his face, following special treatment. The hair on his head, however, was encouraged to grow, and was treated and trained into a neat,

girlish style, so that at the end of three months, he could dispense with a wig, and so remove one more fear of discovery in public — by the wig coming off. I had his ears pierced—I had quite a struggle with him over this — and his eyebrows plucked, and I also had his hands attended to, till they became a pair of daintily manicured feminine hands. A course of vocal training ensured his being able to talk in a soft, husky way, which was almost alluring in its femininity.

Side by side wth all these physical changes came changes in his mental outlook, as, apart from our maintaining a happy married life at home, he came more and more to think and act as a woman would. Feminine mannerisms became quite natural to him, and he began to take a keen interest in his female things, even to the extent of learning to do minor darning and mending. We had long since moved to another district where we were not known, and where, from the first, we passed as two sisters. Apart from our more and more frequent sorties, including some in daylight, such as shopping expeditions, Phyllis (or Phyl, as I continued to call him) had to answer the door all the time to the tradesmen. Unbeknown to him I watched him once as he answered the door in a rather diaphanous

house gown over his pretty undies and long silk stockings, and I had to warn him of the danger of playing with men's affections and even passions, for I had seen him deliberately trying out his feminine attractiveness on the unknowing male. He made a hit all right, both then and on a number of occasions later. Indeed, he became a really pretty girl by the time I considered he was ready for work.

I had no qualms on that first day, even though he felt uncertain of himself at first. Long before the end of the day, he was happy in his new job, quickly becoming popular with customers and staff alike. The uniform of the waitress suited him, for the black satin fitted close to his girlish figure and hung in a short flared skirt from the hips, thus giving him ample opportunity to show off his best points, his shapely legs in fine black silk stockings, and his trim little feet in high-heeled shoes. At the end of the day, after he had changed out of his waitress uniform into a smartly tailored coat and skirt and he had put on his chic little hat and his kid gloves, we walked home together. I told him of the small faults I had noticed in his behaviour, he telling me of various things he had noticed. In mirrors he had more than once caught clients secretly admiring his silk-clad legs and

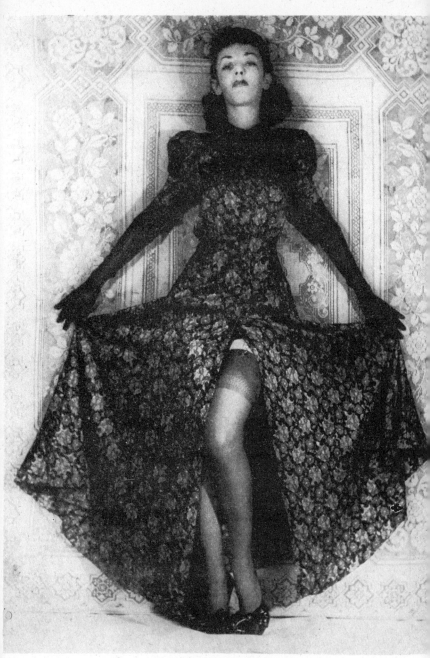

for special occasions it's nylons by "Poinsett

trim little feet, and he had got quite a kick out of it. I pulled his leg about his having to change his frock in the girls' retiring room, and he said that the girls had become quite friendly, saying how nice were his undies. He even told me without hesitation just what each of the girls was wearing, so openly in fact that I knew he was speaking as a girl.

And so began Phyl's life in public. He has had his share of would-be amours, and has, at my instigation, had more than one "affair," my intervention at the crucial moment preventing trouble. Maybe you'd like to hear further of Phil as Phyl. If so, you must say so, and I'll write again. In the meantime, take it from me that Phil is perfectly happy with his effeminised features and in his girlish things. I would mention that, almost since the beginning, in spite of our being much of a size, he has had a completely separate wardrobe, and one which would gladden the heart of any girl. He knows I'm writing this letter, for he's sitting opposite me in an armchair, reading a fashion magazine, and rather daringly dressed—or should I say "undressed"—in a filmy wrap over his chic crepe-de-chine camiknickers, opera-length sheer nylons gracing his shapely underpinnings and held taut by suspender clips just visible

through the lace edging of the brief legs of the camis, black court shoes with six-inch pencil heels and last, but not least, a pair of emerald-green satin ribbon garters right at the tops of the legs just below the suspender clips, a present of mine on Phyl's third birthday. Phil is half curled up in the armchair. What a picture of girlish "innocence"! ! !

With best wishes,

Yours sincerely,

PHIL-PHYL'S BETTER

TURNOUTABOUT

Dear Sirs:

It seems that a certain English gentleman had a wife who was fond of employing a restraining bit and extremely tight check rein on her horse, not entirely in sympathy with his taste. He is reported to have had a special set of harness made up with which one day he hitched his spouse to a small cart and drove her about the grounds of his estate as an object lesson.

Yours truly,

D. M.

FOOT COMFORT?

Dear Sir:

I am rather in favor now and again of seeing the older type bar button shoe, showing the bar cutting into the instep—*not with a buckle*. When in conjunction with a super heel the strap gives a firm support and moreover cannot be

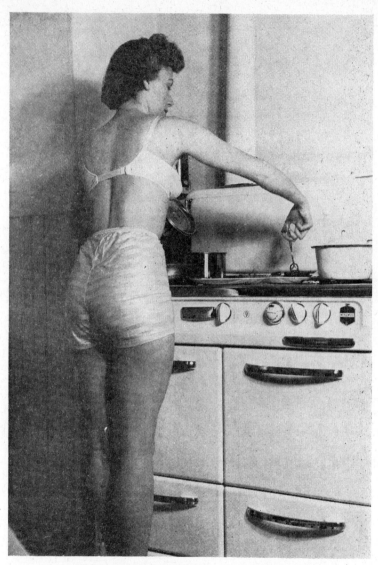

*you keep much cooler in a hot kitchen
if you wear lingerie—says "Dell"*

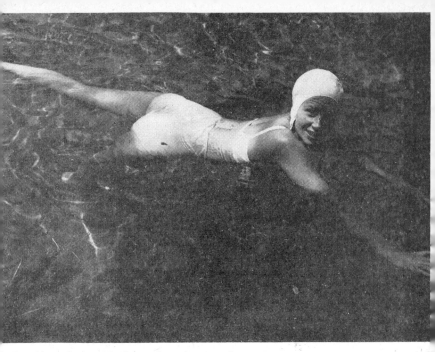

then just jump in the swimming pool

removed for relief like a court type. I once saw a pair of button boots, punishment type, with a row of buttons sewed inside the boots opposite those on the outside. These when fastened tightly, let the model know she was well and truly booted.

G. G.

SMARTER HORSEMANSHIP

Dear Editor:

In your No. 6 issue a letter signed "P.A." starts off with this paragraph.

"I think that 'Smart Severity' really has something. It is titillat-ing to think of a lovely lady mounted on a handsome horse whose fractiousness she controls with a severe curb bit, the while she uses her silver spurs and wicked little whip, to make him prance and cavort."

Now, this little paragraph, although only acting as a kind of heading to a letter on a different subject altogether, was extremely interesting to Me and many other readers here in England. It has always been a mystery to me that the lovely art of really *smart* riding and driving of horses has been allowed to die or nearly so at any

rate. The modern, careless, slap-happy style of riding may be all right as a healthy exercise and a bit of fun for the animal who always seems to be more in command of the situation than its owner or rider, but compared with the ultra smart style of, say the 1890 to 1910, it is drab and completely uninteresting. The sight of a smart lady or gentleman of today, riding or driving scarcely gets a second glance from an onlooker. The horse is either drooping its head and slouching along as it wishes or throwing its great head and enormously strong, neck muscles about just at will, jerking its rider's arms about and pulling her or he all over the place till the poor girl looks more like a limp rag doll than a thing of flesh and blood. What a contrast the ladies and gentlemen of 1900 (and some of today) were. Their horses, mounted or driven, were severely and sensibly controlled by bits and harness which were designed to keep the lazy beasts smartly erect, heads well back and up in the case of carriage horses, and nose pulled well in to the neck in a fine curve, in the case of mounted animals. There was none of this ridiculous throwing about of the head and neck, and riding and driving was sheer pleasure for the owners. And what a grand opportunity for ladies and gentlemen to indulge in smartly exaggerated dress fads. For riding the man could at last express his hidden longing for a firmly laced in waist, ultra-smart, skin-tight breeches and dainty boots with ultra high stilt heels, while for the ladies driving in elegant open carriages would give every opportunity for showing off the most startling and eye-catching fashions. I have always held the view that when riding, ladies should *never* ride astride with their dainty legs sprawled and stretched awkwardly round the great "middle" of a horse. The "old-fashioned" side-saddle method was infinitely more becoming, and the comfort of this type was something which the so-called modern astride miss could never believe till she tried it. I admit I often use a ladies' side-saddle and find it most fascinating, like sitting in a comfortable arm-chair. I have introduced the side-saddle to many ladies who, since children, have always ridden astride. They have never wanted to go back to the modern method, being amazed how utterly comfortable and elegant and dignified the side method is. And another thing —let us be frank and admit that there *is* a tremendous thrill in using one's spurs to get the best out of one's mount—how easy it is for the lady to use them under the delightful privacy of the correctly

fitted "apron skirt," and then to bring her smart little cutting whip into play to punish her mount for its "naughtiness" as it cavorts at the goad of her wickedly armed heels.

With carriage outfits the possibilities are even greater, for the lady or gentleman who places any value on appearance can go to terrific lengths to insure ultra smart style. Gag bits with long levers, will produce oceans of snowy white foam, tight bearing reins, martingales and various check reins will keep the animals' heads rigidly erect in fine style to suit their owner's whims and produce that lovely high stepping action which will make even the cheapest hacks look like thousand guinea thoroughbreds. You will perhaps gather that we of the "smart horseflesh" cult do not pander to our animal's feelings, some people may immediately scream the word "cruelty." We neither admit nor deny the latter, but do openly say that we ride and drive for our *own* pleasure and satifaction, not the horse's.

Finally whatever one's feelings on the question of "smartness at all costs" may be. I wonder if among your readers of either sex are others who are interested in riding and driving?

Your sincerely,

SMART HORSEMAN

ONE MAN'S IDEAL

Dear Sir:

I am making an effort to write a letter of compliment to ladies who are high heel enthusiasts. I am unaccustomed to writing this type of letter but this is written in utmost sincerity. I have only admiration for the adorable ladies who are devoted wearers of high and skyscraper heel shoes. They must surely love beautiful things. And what can surpass the splendor of dainty shapely feet in elegant little shoes poised gracefully on stilted heels?

They know how important it is to keep up a pleasing appearance at all times and they are always a lovely picture from their superb little feet to the crown of silky tresses atop their lovely little heads. They do everything to make themselves as fascinating as possible. Their waists are hugged in to a very small measure by brief but very efficient corsets. Their pretty little ears are pierced and adorned by the most fascinating earrings. Their form fitting dresses are made in the most fascinating designs. Their shapely feet and legs are clad in the sheerest gossamer nylon hosiery with lots of arch and ankle interest. One shapely ankle is adorned by a dainty anklet. The nails of their superbly kissable little toes peep

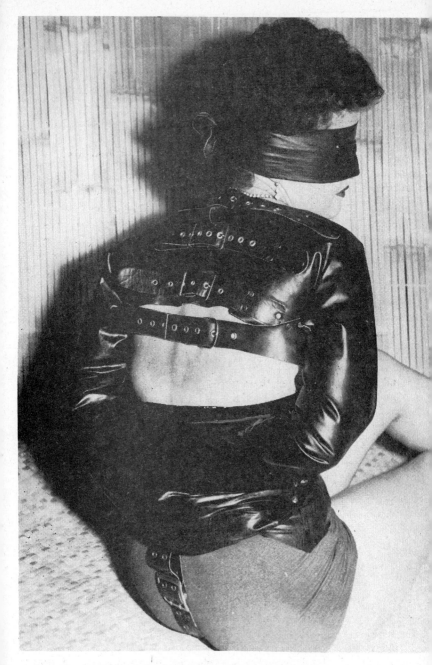

a leather straight jacket for peace in the home photo from a reader

prettily from each elegant little shoe.

Every eye is upon them as they trip daintily along with graceful rhythmical steps. Other women envy their ability to wear this elegant footwear. Men find themselves enslaved by the splendor of these adorable creatures who walk on their hearts with their tiny little feet. How they would love to kneel and cover their divine little arches with kisses and to kiss the beautiful little toe that peeps prettily from each little shoe. To do so would only be an attempt to show how much they admire them. Their fondest desire would be to be enslaved by the magnificent creatures.

I hope you will find this letter suitable for publication, that all your lady readers who are high heel enthusiasts will know what we feel.

E. S.

No Arms Please

Dear John Willie:

Your latest fancy dress, that *P.B.I.* and that *Nelson*, now you're really down my alley with my armless women, if you'll recall some of my previous letters. The P.B.I. girl is excellent—completely unhampered in any fashion, except that her arms have been so neatly eliminated. Just for my own personal pleasure, I'd like her as is, armless, but without the pack on her back.

Please continue the good work, for More Lovely and More Helpless Girls.

J. D. J.

Look — No Hands

Dear Ed:

Here's a very simple plan I've found to be most effective in keeping my woman under control and just helpless enough to be even more lovely than she is normally. I'm an advocate of useless hands for women, and the usual methods of tying or chaining the hands behind the back have their drawbacks . . . The hands and arms thus bound are usually in the way when she's sitting down or lying down— and are definitely a nuisance when you're undressing or dressing the gal.

So I've come up with this solution. Just bend the arm at the elbow with the hand flat on the shoulder—and fasten it there with ribbons or tape—strapping the wrist and upper arm tightly together and holding the hands and fingers in place with adhesive tape if desired. Naturally, this position of the arms could be quite harmful if done in a careless manner, but longer and longer periods of practice have made my gal quite used to it and now she can stay this way for several hours at a time.

When she has thus been transformed into a living Venus, I dress her in a tight-fitting crew-necked sweater with sleeves which end just short of the elbows so that about three inches of the rounded elbow is bare. The sweater is good with very brief black velvet practice shorts or panties—or perhaps with smooth-fitting slacks—but I prefer a very short tight skirt, with the highest heeled shoes possible. No matter what the outfit, or occasion, there is always a wide polo belt in black saddle leather—quite severely stiff—and fastened with four brass buckles, just about as tight as the lady can stand it. This not only draws in her waist to breath-taking smallness, but also prevents the sweater from working up and getting loose. Sometimes with the short, slinky skirt and the high heels, I add the most vivid make-up—dark suntan base—blue-violet eye-shadow — black-pencilled eyebrows— and over-full crimson lips. My gal then looks like a very provocative, very curvesome, very inviting, street-walking Venus. She doesn't like the way I make her look sometimes but there isn't much she can do about it.

After I've fixed her up all nice and pretty, she's strictly on her own. Of course, being short-armed, has its disadvantages, but she has learned to do a lot of things in her new role as Venus. She can carry my pipe and slippers and things—held between her elbows—and I see that she does; but I prefer her bare-footed, working at a jig-saw puzzle on the floor, with her toes. Naturally, there must be disciplinary measures taken at times, and I find a blindfold best—as that really leaves her helpless. I use one of black kid-skin, shaped like a domino mask, with cotton and gauze pads sewn inside so that her eyes are sealed completely. Another fascinating item we've devised is a hobble skirt with a vengeance. We started with a floor-length skirt of black satin and restyled it so that it binds her legs tightly together from the thighs to the knees—then it's cut almost straight to the ankles, so that she can't take more than a four or five-inch step. In this outfit especially, she is most helpless, and can't do very much at all except to sit or lie on the sofa—but she makes a most lovely and attractive siren in her own disarming way.

Sincerely,

FOR LOVELIER AND

MORE HELPLESS WOMEN

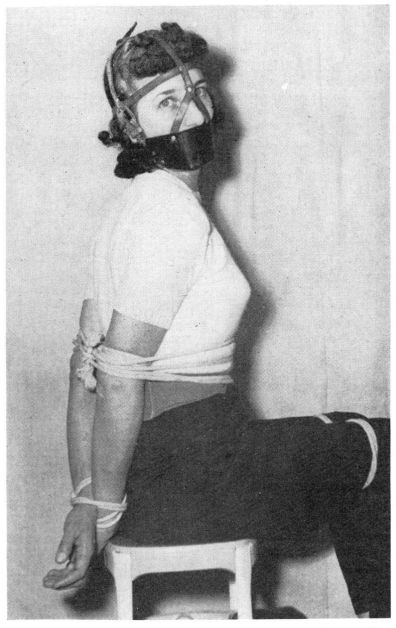

is your wife too talkative? *(for further details see next issue)*

Tight Lace for Beauty

Dear Sir:

For some years I was a motion picture extra whose specialty was appearing in those costume pictures which for authenticity demand small waists. My face has seldom appeared before the camera and I do not pretend to be an actress, but my tiny waist, large bosom and hips often have appeared. I was brought up by a grandmother who had been brought up in France and who did not believe in the current nonsense of women being as much like men as possible. When quite young I determined to enjoy a waist as small as hers and she laced me into my first "waist" when I was eleven. Until fifteen I was allowed to expand above and below the waist and at that time was laced into a wonderful, heavily boned hourglass corset of the 1899 vintage. Quite frankly, it hurt at first, but I was delighted to see a rather insignificant girlish bosom push out into lusher curves. The best and only real bust improver is the high front, tight waisted corset that raises the chest and supports the bosom. It must be tight enough at the waist to prevent breathing there and to cause the chest to expaid directly upward When such a corset is properly adjusted flat-chestedness is impossible.

Following my grandmother's in-structions I have encouraged a certain amount of plumpness, because to get the maximum effect of the hourglass corset the flesh must press out over the top and from under the bottom. Dieting is fool ish unless one wants a "boyish" figure, or unless one has an unusual predilection for getting fat.

As clothing is sold nowadays I would qualify as a medium size, but due to corsetting my proportions are far from average. Without corset I measure 35-18-38. The average 35 bust these days would have a waist only 8 or 10 inches less than the bust. The true hourglass figure requires a waist as much as 20 inches less than bust and hips. I often lace to 15 inches for special costumes and at such times my erected bust will press forward to 37 inches and my hips will spread a little.

It is very hard to convince people that snugly laced corsets are a positive source of pleasure, stimulation and satisfaction to the wearer. After one has trained one's figure, talk of discomfort is all bosh. Many primitive peoples have tightly strapped their middles because of the feeling of supported strength that it gives them and not at all on account of appearance. It is also true that tightly laced people are more ready for love. It produces a delightful sensation of fullness in just those special areas.

My grandmother tells me she always laced particularly tightly when she was lonely and that it brought her great satisfaction.

As for health I have never had a really sick day in my life. I find that if I try to lace under 14½ I get dizzy if I am active, but not if I am sitting still. This is not real discomfort, it is a little like the dizziness from a glass or two too many. I even enjoy it at times when I feel safe to do it, and at such times enjoy eating a very full meal.

I have persuaded a few friends who "wondered how I stood it" to break themselves into tight lacing and they are all surprised how good they feel once the training period is over. There has been so much nonsense abroad about tight lacing that most modern girls are scared to try it. You will do a real service if you popularize the well-laced waist which has been the standard for European women since Roman times.

It takes about five days, wearing a corset which is tight at the waist but loose enough at the bust and hips to allow full expansion there. In order to avoid shifting of the laces and thus bring pressure to bear above and below the corset should be laced completely closed. This is very important and means that the corset must fit.

Of course the training period

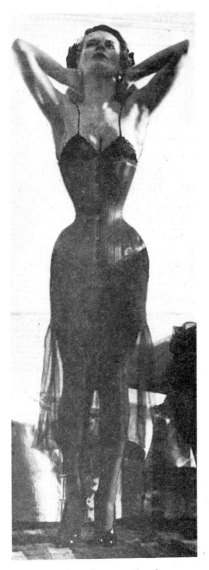

a reader demonstrates a firm leather corset

would not be necessary if corset wearing had begun gradually as with me. But if one wants a spindle waist right away one must take a little punishment which for most turns out to be quite enjoyable, strangely enough. Most women give in during the period of adjustment when actually the battle is more than half over.

To begin figure training measure the bust and hips at their largest dimensions and add about an inch then subtract twenty inches to get the waist size. Thus a corsetless 35-25-35 would become a corseted 36-16-36 or thereabouts. Get a corset from a costume company. Get also a very thin chemise of material that is elastic and will follow the lines of the figure as it changes. Now liberally powder the nude figure in the corset region, don the chemise and powder again over the chemise. This is to prevent sticking and binding as the laces are tightened. Loosen the corset laces until it can be loosely clasped around the figure. If one is doing this alone a "front-lacer" is easiest, but for best results a back lacer with help from a friend or two is desirable. *Many men love to do the job!*

This would-be wearer must pull in the waist muscles as much as possible raising the chest to the fullest by standing in an open door and taking hold as high up as one

can on the sides, standing on tip toes, but pulling down on the arms. The friend now pulls the laces in at the waist quickly as far as possible and snubs them around a pencil or some such thing lest they slip. Now the wearer may relax as the upper and lower part of the corset are brought gently into place. Three sets of laces, one for the waist region, one for the bosom region and one for the hip region allow independent control. Then the lacee must stretch as before. A great big breath should be taken, the laces tightened with a jerk and continue tightening as far as possible with the forced exhalation. Now the lacee should be encouraged to move around, bend, twist. The hands should be placed on the jutting hips akimbo and the shoulders pulled out of the corset as far as possible. The hand should be placed below the bosom and the flesh there massaged upwards. At any sign of dizziness the lacee should lie down with feet higher than head and then continue when feeling better. This process may take a full hour. At the very end the corsets may be brought together with the lacee lying face downward. They should be tied firmly and now the wainting period begins. If the wearer is subject to fainting the corset should not be laced fully closed the first day. During the waiting period the

wearer should sit around taking it easy but moving often. In my Hollywood days I often held little "corset parties" with girls getting ready for a costume picture. These would last as much as four days. There will be aching where bones and muscles are adjusting themselves to new positions, but chafing will be avoided by the proper preliminary powdering.

The corset should be worn all night and in the morning everything removed, a warm tub taken, then, *before breakfast and before the figure spreads* laced up again immediately. Perhaps this time the corset can be closed if it was not before.

By the third day at the latest the breast bone and ribs will have taken their desired positions and breathing upward in the corset will be easier and lacing it up less difficult.

Deep breathing, raising the chest to the fullest and continued upward massage of the parts below the bosom continue.

If the average woman sticks it out she can reduce her girth by eight to ten inches in a few days by this process. For the first few months it is best to wear the corset almost continually. After that it can be left off without losing ground ten or twelve hours at a time.

Soon you will get the rewarding sensations which will cause you to love to lace tightly. I do not know anyone who has started properly who has ever given it up.

With things as they are at present low cut dresses as often as not expose only an uninteresting bony expanse, but not if you have a plump, well-laced figure. Instead of the breast being tightly shaped and confined they should be left free to undulate with walking and breathing—to spread and press together to create that seductive dividing line known as "cleavage" which was a center of interest in all the bosomy, low-cut bodies of the 90's.

When high heels are worn with the hourglass corset that is properly laced walking produces an indescribably interesting movement of both breast and hips which cannot in any way be compared to the effects of the present bra and hip girdle. The slight jar produced by extra high heels results in an eye-catching quivering wave in the plump, protruding breasts, which alterna ely press out and fall back into the corset almost vertically. There is an alternate side to side movement of the hips, a sway in the direction of which ever foot happens to be carrying the weight. With a tightly constricted waist and very high heels this hula-like movement becomes automatic with every step and the

tighter the corset the more emphatic becomes this movement of the *derriere*. This feminine strut is most associated with Mae West and is the opposite of the masculine stride.

I apologise for the length of this letter, but if it pleases you I will write again, telling something of my grandmother's experiences as a "corset slave" in the estate of a gentleman of Paris, where the corset cult developed extreme forms hardly imaginable in these days. She went there as a maid, but discovered her duties consisted chiefly of getting as plump as possible and at the same time lacing cruelly. The master kept a group of young women, paid them well to appear as he wished. If I hear that you have used this letter another one on this other subject will be forthcoming.

Again, I hope to see more of your excellent magazine and to exchange ideas on corsetry, etc.

Sincerely,

Paula Sanchez

SOME THOUGHTS ON THE HIGH HEEL

By Jonathan Scrivener

We have to thank a reader for the following commentary.

What contradictions and controversies the artificial appendage to the feminine heel has provoked through the ages.

Women have patiently, sometimes painfully followed this fashion from time immemorial. How few have ever fully appreciated its subtle appeal, much less experienced its exotic possibilities.

Have you ever seen a pretty girl wearing really high heels, tripping along between you and the sun. Her slender heels look like pencils silhouetted against the light as she seems to literally float along on her pretty toes, bare and deliciously chiselled as they quiver in the shiny little patent tips of her sandals. Her shapely legs tensing and rippling divinely from the delicious strain of her arching heels. Such sights as this are sure to attract more devotees to higher and still higher heels.

One might not see these higher heels too often in the street, where extreme heels are rather conspicuous, but the pretty Miss who is smart and observant has her shoe closet well filled with an intriguing assortment of exotic high heeled footwear, for use indoors, with which she can delight and indulge herself, and her guests to any extent or extreme.

The fortunate and exceptional girl who discovers how startlingly exciting her dainty shoes can be, and discovers what a magical influence they can exert on the men she desires to interest, has a very unusual and subtle advantage over

her contemporaries. If you don't think so, try this on your boy friend the next time you have him alone. Wear your highest heels, even if they are only the ordinary three-inch kind, and when you are curled up on one end of the lounge, with him at the other end, put your foot out and press his leg with the sharp tip of your heel. Watch his reaction. Then suddenly put your other foot with its pretty shoe, right in his lap and ask him to examine it, and see how smooth and shiny it is, especially if it is patent leather or kid. He will probably look too surprised and intrigued to say much of anything. Then hold your foot up so he can see the pretty heel, and remark how nice it feels to wear high heels. Even a three-inch heel looks so very high and slender when seen this way, and he will be completely under your spell. This is only one of many ways you can use your tall heels to captivate the male. Who knows who first conceived the idea of heels for women, but what an inspiration it was. How graceless most girls are in flat heels, and how glorious is the feminine form, balanced on tip toe, the pretty foot arched on tall slender heel, with high set calf trembling and flexing volumptiously. Truly the graceful heel, so characteristic of the feminine shoe, has become the symbol of woman-

ly loveliness, yet how few of its privileged wearers ever know, or even suspect the fascination their high heels have for the male mind; what a mystical power their subtle curves can confer upon a lovely girl, who knows how to use them along with her other charms.

When one realizes that the great majority of women only put up with heels for fashions sake, or wear them merely to increase their height, one wonders that such general stupidity is possible. Truly the girl who understands the aesthetic possibilities inherent in her feet and their adornment is an exceptional person. How few women realize the strange fascination of lustrous patent leather, as is evidenced by the many fussy, and sickly colored shoes so generally worn today. How unimaginative are the great mass of women who slavishly accept the homely, awkward, platform shoes now in style, which so completely transform a pretty foot into a clumsy, deformed looking atrocity no matter what the height of the heel. The extra height of heel the platform affords doesn't fool anyone. If a two-inch heel is all a girl can wear gracefully, how much nicer it looks on a delicate thin soled shoe, than mounted on a thick, club footed block, and absurd extended heel. How refreshing, the knowing young lady, who understands the

beauty, the thrill, and the attraction of a fragile shoe with the thinnest possible sole, and the highest heel she can wear and walk on gracefully. The higher the heel she aspires to, the more of an artist she must be, and how tragic the girl, who could handle a three-inch heel gracefully, but insists on suffering along awkwardly on four-inch heels. So few girls understand the subtle tricks of fit, and technique which the higher heels involve. Most any young lady, with a little training can master and enjoy the thrills of a three-inch heel, but four-inch heels are more difficult, and very few can ever hope to master and enjoy the five- and six-inch heels, so rare and exquisite, when worn correctly. Such mastery calls for infinite patience, finesse, and great skill and most of cinderella's sisters who venture to try them only flounder about unhappily and hopelessly. The rare and fortunate Princesses who can on occasions properly adorn their pretty feet with these remarkable enchanted shoes, rise to glamorous, undreamed of heights of beauty.

"AN EXPERIMENT IN NO HEELS"

Dear Sir:

Your No. 8 was priceless — I think your magazine is wonderful but this last one is the best of those I saw. I loved the way the men got treated in many of the letters. It is about time they got laced up, tied up; bound and masked, for a change. They love to do it to us gals but all too seldom get a dose of their own medicine. Please have more like that, only treat 'em even worse.

About the shoes without the heels—I know of one place where the idea was used effectively—very. If you had ever been a girl and had a high heel break off on the street, or shopping, you'd know what it meant; with only one heel it's so hard to walk. You have to walk entirely on tiptoe. With both heels off—well, here's an experience a crowd of us girls had a few years ago before I left the small city where we lived and came to Chicago.

There were twelve other girls and I—making 13. We called ourselves the "lucky bunch." There was also a club of boys in town and while we didn't exactly pair off permanently, the two groups would get together to dance, etc.

The boys decided to throw a party at the lodge hall in town. They sent out fancy invitations

and their "entrance" fee was one pair of old shoes with high heels. We were instructed to either bring a pair of our own or get a pair that we could wear. They must be high heels. Prizes would be given to the gal or gals that brought the highest heel. It was of no matter how tight they were as long as the girl could wear them.

When the night of the party came, the girls were ushered into a small room off the hall. The boys collected the old shoes, and also the ones we were wearing, putting our names on them. When they finally had all the shoes in, they started bringing back the old ones minus the heels which they said they kept to measure to see which were the prize winners.

They instructed each girl to put on the heelless shoes and stand up. One at a time they led us through a door and as we went by they snapped handcuffs on us with our hands behind us. We found ourselves in the big dance hall of the lodge but it had been completely cleared of chairs. There we all stood teetering on our tiptoes. You can't stand on your heels in a pair of high heel shoes with the heels missing like that without falling over backwards. We had to keep shifting from foot to foot or walk around to keep from losing our balance, nor could we hold to the wall or anything with

hand-cuffed hands—so there we were and a sillier sight you never saw.

The boys came in laughing—so did the musicians and we began to dance. It was fine while the dancing was on though we felt a little helpless and the boys could kiss us and push us around and we couldn't fight back, but when the music stopped and the boys let go—there we were back teetering around. By the time refreshments were served we were all exhausted and some of the girls who had borrowed tight shoes were really in misery. They loosened our hands so we could eat, or try to, while we balanced the food in our hands and balanced ourselves on our toes. And the mean things never gave us our shoes back till they'd walked us all the way to our front doors. Oh what a night that was.

Regards,

"Susan"

Let's Live in Lingerie
To the Editor:

I find myself in complete sympathy with Miss Dell H. in her view (expressed in No. 12) that a young woman today is dressed with perfect decency if she is clad only in shoes, stockings, garter belt, panties, and brassiere. Only a few years ago, young women were arrested for appearing on

the street in shorts, while today, feminine "playclothes" consisting of shorts and a bra top are standard attire for informal wear. I think Miss Dell's picture on page 41 shows her very tastefully and attractively dressed for informal occasions in hot weather; and although doubtless inappropriate for the opera, I see no reason why women should not visit the neighborhood movie theatre in such costume. Nor do I see any reason why a woman should not drive downtown to do her shopping dressed as Miss Dell is on page 2. This admirable young lady's courageous efforts will doubtless speed the trend in the right direction. I may add that I consider the young ladies on the front and rear cover of No. 12 also quite decently, tastefully, and attractively dressed for informal occasions in warm weather.

Yours very truly,

Gerald Moulton

If your local newsstand has not got Bizarre, order from us direct at $1 per copy.
Bizarre P. O. Box 511, Montreal 3, Canada.

If you are disappointed with Bizarre why not write a letter for publication on the topic which interests you, and so encourage others to answer in a similar vein.

And whenever you want an answer please enclose a stamp, or a stamped addressed envelope.

And once more PLEASE — ALWAYS! — sign your name in full. Initials are no help.

The Sir d'Arcy Cartoons will be published separately, at a later date, in complete magazine form, as well as "The Diary of a French Maid." (Which used to appear in that high class publication "Flirt.")

As the price of these will depend solely on the cost and the demand you will help us considerably by letting us know if you are interested—as soon as possible.

Printed and published by the Bizarre Publishing Co.

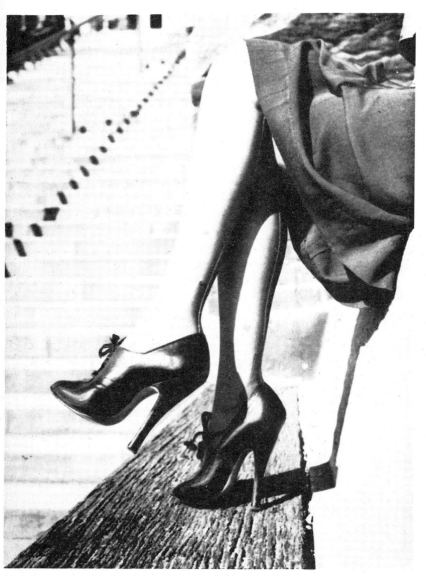

the pause that refreshes

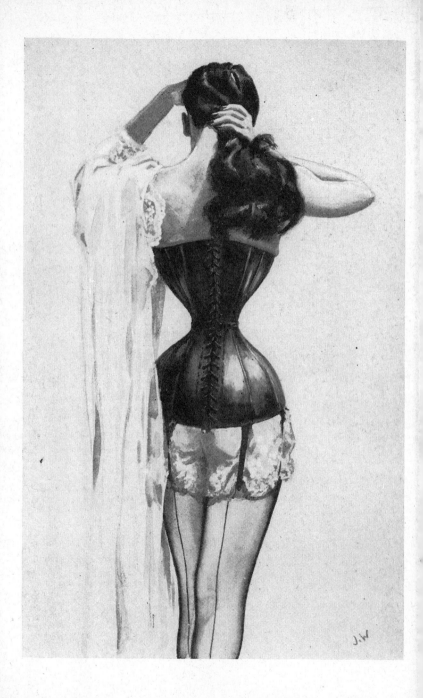

The Complete Reprint of John Willie's

Bizarre

II

Cover / Umschlag / Couverture:

Original cover image from *Bizarre* Vol. 11, 1952

Ill. p. 4 / Abb. S. 4:

John Willie, "Entre Act" from *Bizarre* Vol. 18, p. 13, 1956

© 1995 Benedikt Taschen Verlag GmbH,
Hohenzollernring 53, D–50672 Köln
© 1995 Text: Eric Kroll, San Francisco

Printed in the Czech Republic
ISBN 3–8228–9269–6

The Complete
Reprint of
John Willie's

BiZARRE

Edited by Eric Kroll

TASCHEN

KÖLN LISBOA LONDON NEW YORK OSAKA PARIS

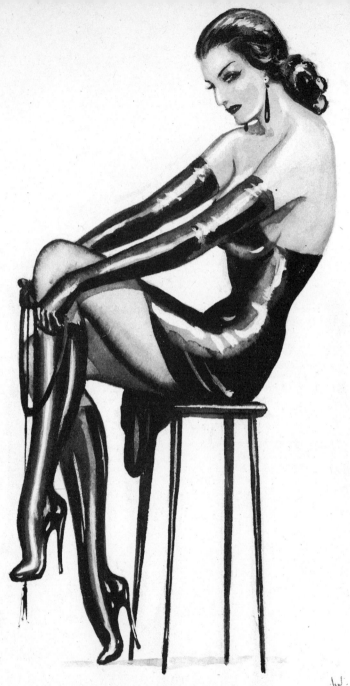

" ENTRE ACTE "

Contents
Inhalt
Sommaire

Bizarre Vols. 14–26

Bizarre

Nº 14

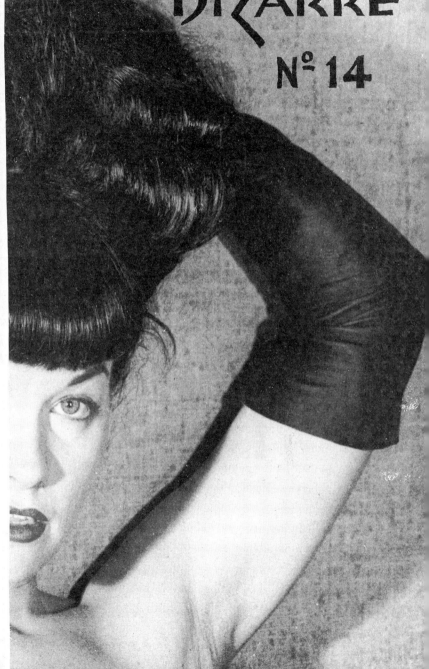

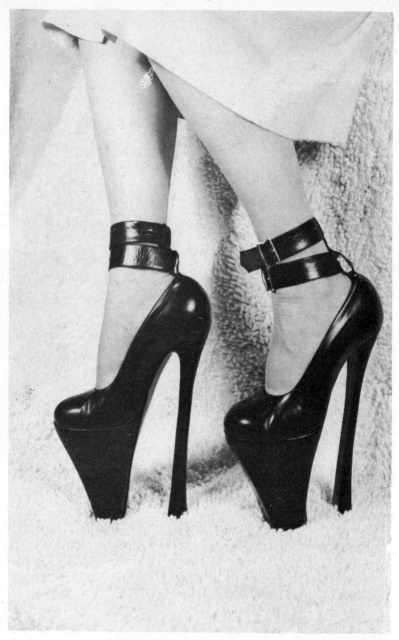

See Letter p. 55 *Photo from U.C.*

5″ platforms, 10″ heels

BIZARRE

Copyright 1954 by John Coutts

"a fashion fantasia"

No. 14

And strange to tell, among that Earthen Lot
Some could articulate, while others not:
And suddenly one more impatient cried —
"Who is the Potter, pray, and who the Pot?"
 OMAR KHAYYAM

PLEASE DO NOT ORDER

the next issue — No. 15

KEEP THE $1 IN YOUR POCKET

We will advise you when it's ready.
We appreciate advance subscriptions — but — they make
our bookkeeping more difficult.

 Thank you, Editor

BACK ISSUES

The following back issues are available.
No. 1, 2, 3, 4, 5, 6, 8, 9, 10, 12, 13.

AWKWARD! — AIN'T IT?

Our fame as archaeologists is spreading. Therefore we weren't surprised when a posse of venerable citizens came into our office last week, announced that they were from the British Museum and would we please translate a weird hieroglyphic which had been found on a wall in one of the tombs of ancient Babylon. (We reproduce it above for your edification.)

The thing depicts, on the left, what is obviously a Print-shop, while to the right are a lot of people reading slabs of rock. Our visitors said they got that part alright, but that they were rather confused by the damsel behind the ancient linotype operators who seems to be saying "no-can-do" — to the angry gent with the sword. There could of course be an old fashioned answer to that one — but — the thing that had them completely buffaloed was the picture of the citizen in the middle, hanging by his neck, — and in particular the letters on the chunk of rock tied to his feet. Therein lay the solution — or rather the interpretation — of the whole picture, they felt. Could we interpret?

. This was kid's stuff to us. Turning the thing on its side and reading from the bottom up it went "W A S A T D I P T I." The man whose neck was being wrung was obviously an editor (with a stylus behind his ear) and from the letters we have been receiving, threatening to do just that to us, we realized quickly that he hadn't delivered the goods (thank goodness we don't live in those times) — and that the letters were simply an abbreviation for 'We Are Sorry About The Delay In Publishing This Issue.'

We are having the "word" set up, and intend to keep the slug as the title to all future issues of Bizarre.

5

EXERCISE !
& KEEP FIT
by
Sylvia Soulier.

So! There are no such things as kid panties aren't there? Well! Get your monocle out and have a close look at this series of pictures of Sylvia at the Regal Gymnasium! Are they so Bizarre after all? Or are they just the thing? Well I leave it to the readers to decide.

This pair of mine actually lace down the sides half way, for slipping into, after which they can be tightly laced to a close fit. Anyway they are lovely for horseback riding, that I do know, or Bizarre's pages? You have them in glossy soft kid, eh? — and anyway one can sit down in them quite comfortably, contrary to what others say.

Sorry that, through me stupidly wearing my deep wide leather belt, the mauve waistband about three inches deep doesn't show this time, and the laces being Mauve to match possibly don't show too clearly.

Oh! — never again does Sylvia take a course at the local Gymnasium including what the dear instructor called "limbering up." He had me swinging from ring to ring down the Gym Hall. Stupidly I had rubbed my little kid gloved hands in the powdered resin, just as the other girls did, and did my gloved hands smart afterwards, completely ruined, but the silk elastic net stockings were all right as they gave a little to each movement. Alas! There was more to that evening than that, as you shall hear.

They told me that reasonable heels were not barred in these ballet limbering up classes, so little Sylvia with her usual daring and pride toddled along in her seven inch heeled black kid lace-ups. Oh boy! I am sure that instructor just sorted me out for a fool, which made me even more determined to stand up to it all. He got me on those parallel bars, swinging clear and over them. Believe me we stuck around that

6

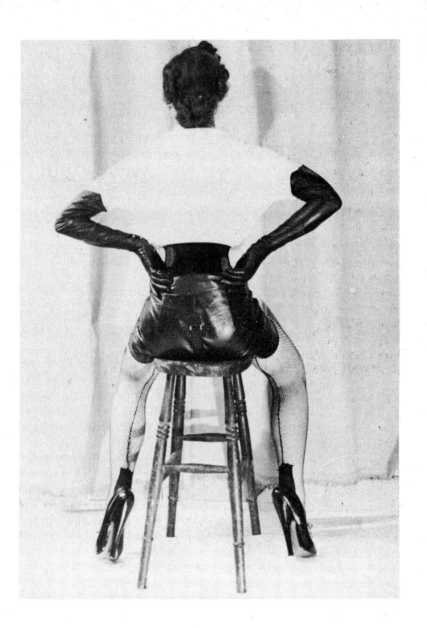

B-E-N-D!

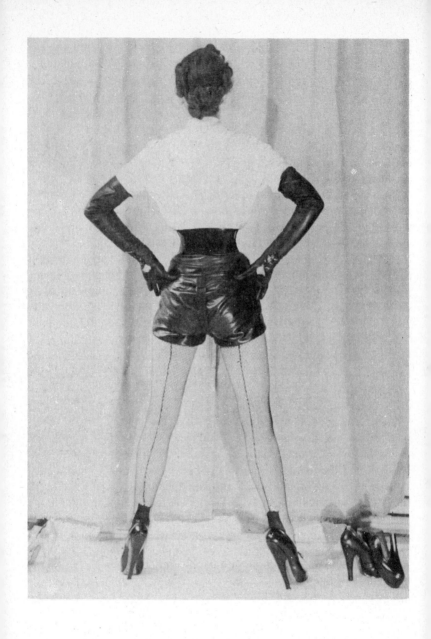

S-T-R-E-T-C-H!

darned appliance nearly a quarter of an hour before he managed to get me to make what he called simply enough, a neat "two point landing." Oh! I did it in the end after several what I should prefer to call "one point landings" — slap on the shiny part of the little kid panties!

Then we were made to climb to the top of the underside of the long ladders, rung by rung as it were. That was when I wished I hadn't tightened my wide belt quite so much. There I was hanging high up from the ladder when the instructor told me to keep my feet together or he would have to assist by tying my ankles, that threat was enough for little Sylvia.

Really I have never heard such a clattering of heels as we girls made at that class. Of course they all were highly amused at me turning up in such stilts, all very humiliating I can tell you.

After half time the instructor was decent enough to tell me to go and change into something more suitable for the work on hand, which I was ever so pleased to do I can tell you. Jolly good thing I had also brought with me my five inch black kid lace shoes — things went better after that.

The one where I was made to sit with my high heels also on the edge of the high stool took more

doing than may look likely, you try it lady readers! Again even in that position kid panties would have been quite practical, but later we all changed into just our slips for the dancing steps.

Well! Readers and Mr. Editor, there you are. I hope some of the little pictures can be reproduced, as they must surely be the first of their kind, but no more gymnasium for little Sylvia in seven inch heel. Yes! — it might have pleased some of your mean minded male readers, who are always out to see a little girl in distress or discomfort. Anyway Sylvia has done it and won her wager this time, I am afraid I am like that, anything I am dared to do, however daring, little silly Sylvia usually puts her best heels forward and makes the attempt at least.

I suppose I thought it was smart going along in those high heels, whereas the only thing that smarted was little Sylvia, but we won't go into that! If that's limbering up, little Sylvia prefers to forget ballet for the time being!

And people go and pay fees for it! Huh! Not little Sylvia again. No! Sylvia would rather die with her boots on, before she's caught again like that.

My mannequin days and classes believe me were child's play to that Gymnasium, and incidentally

from one of your early Bizarre sketches I should like to know who told J.W. we had to walk about with books upon our heads. Actually you were right, sometimes it was a glass of water, that took some doing.

I don't think I could do it with a few copies of Bizarre on my head though. No girl could keep calm and steady with Bizarre on her head could she Mr. Editor?

Oh! Heck, now I have gone and got some of the type ribbon ink on my white kid gloves. I shall charge that one up against Bizarre — maybe! Which reminds me of when we were girls at St. Leathers School, one spot of ink on a glove was asking for meals off the mantlepiece, and just a few "extra lines" more in our kid gloves as punishment. I am sure our Mistress used to love hearing us squeal.

These days things are different, but I think perhaps all the very strict training we underwent was worthwhile, at least compared with some of the present younger athletic ladies I think we looked more attractive, and we were pretty good at sports even then.

Anyway Sylvia has always held one theme, that a girl to be an efficient secretary in business, as I hope I am after many years, doesn't mean she has to wear double lenses and flat brogue

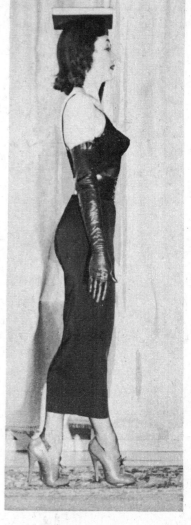

shoes. To the contrary any decent Boss surely prefers to have something a little brighter to look at around the place, — mine does I know! Bye-Bye.

Sylvia Soulier

10

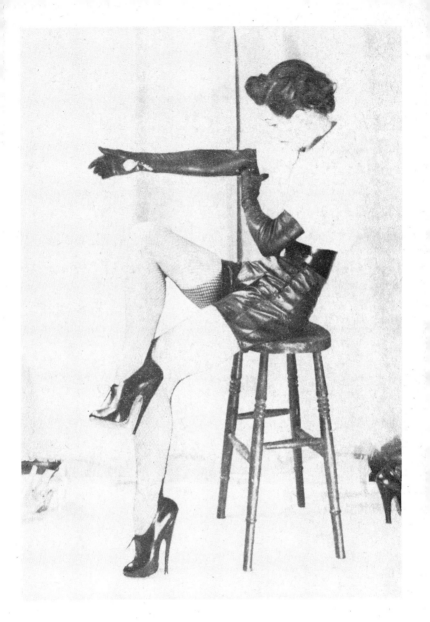

REST —

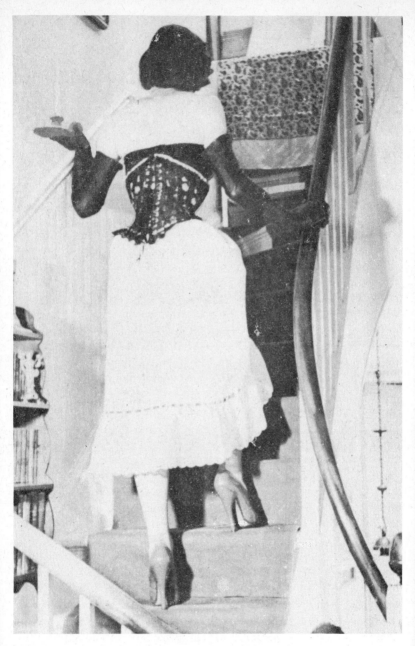

— and so to bed!

NOW IT CAN BE TOLD !

the true story of
ADAM & EVE.

Perhaps you, the reader, might not consider 100,000 years a short time, but us archaeologists think in terms of millions of years, millions! — and so a thing which happened 250,000 years ago is really quite a "recent event." As for viewing the bottom of the Grand Canyon of the Colorado — well, it's more like waking up and looking at last night's dirty dishes in the sink.

Once we had decided that we simply must find the origin of the corset the logical place to look for it was in the Grand Canyon — for there the noble River Colorado has dug through the centuries — doing as magnificent a job of excavating as you could want, thus saving every museum muscle-man a whole load of heavy digging. Laid bare before the seekers hawklike eye is the history of the world for about 175,000 years — all you have to do is clamber up and down the scenario to get whatever data you want, and as climbing is exhausting the logical thing to do is to start at the top and go down.

We made the most careful preparations.

As a result when we arrived at our destination on the rim of the great gash we wasted no time and, leaving Maggie our typiste at the top to attend to the stores, quickly lowered ourselves over the side in bosun's chairs, digging here and there in likely looking spots as we descended.

Now when we archaeologists dig we do it very gently. You just tap a little bit here and chip a little bit there and then contemplate the result. There's none of the good old gandy-dancer's slap bang pick and shovel business because if you give a mighty wallop you may bust a priceless relic of antiquity.

13

This is probably why archaeologists, like people who play bowls, are not noted for their zest for active exercise. Bowls really is a wonderful game when you come to think of it. You have a drink, pick sides, and then you go out onto a perfectly wonderful smooth green lawn and roll some balls away from the bar. Then you wander over to where the balls lie in the sunshine and roll them back toward the cool shade of the bar, and have another drink, and so it goes on all summer afternoon. Archaeology is like that — not too energetic — in fact hunting the hieroglyphic gives you just enough exercise to build up the thirst and at the same time break the monotony of too steady drinking.

But to continue — we dropped slowly down chipping away as we went but we found nothing until suddenly J.W. let out a yell and pointed — and there — believe it or not — there was a fig tree growing out of the rock face about four feet below us. True it was a bit stunted and haggard-looking but still quite definitely a fig tree.

Quickly we reached it, and did a rapid calculation. We had checked our dates from The Book of Genesis, (which as you know is indisputable) and it figured. We had still a long way to go to the bottom of the Canyon but right here would be about the Adam and Eve Period.

The Editor tapped with his hammer and the rock gave a hollow sound — he tapped again, and suddenly a whole chunk of cliff fell out revealing a large hole. J. W. peered in and promptly got hit in the face by a mass of apple cores. Almost immediately afterwards there was a swishy sweeping sound and a whole pile of faded fig leaves, dust and more apple cores flew out. Obviously we had stumbled onto the back gate to the Garden of Eden during sweep-up time and we figured it must be Eve who was wielding the broom, so we hung around.

Sure enough after a little while the dust and core storm died down and we heard a female voice call out "Hey! Adam you dope — lookit — sunlight! Now maybe we can quit this diet of apples." There was a resounding burp and a bleery voice bawled "What's wrong with apples? You can have your **## fig juice — gimme Cider!"

14

Quietly swinging nearer we peered into the hole again and there, resting on her broom was one of the cutest chicks you ever did see — and we both said "Oh!" very loudly, for her waist was nipped into vanishing point by a wasp waist of wasp-waisted corset which looked as if it were made of snakeskin — a snakeskin that glowed with an unearthly green light — as did her shoes; but apart from that she wasn't wearing a stitch — not even a fig leaf.

She appeared to be in a very bad temper for even as we looked she took a flying kick at an apple core and then seeing us, stooped down, took off a shoe, and with a yell of "Get the hell out of here" hurled it in our direction like a bullet.

Now John Willie used to be quite nimble as a fielder at Cricket so now, as that gleaming slipper zipped past, he shot out a hand and grabbed it.

For the briefest moment he held it while we examined it in wonder. It was snakeskin alright with a staggering six-inch heel as slender as a stiletto and it gave off the same weird green light as the corset — then "Whoof!" — There was a flash, a cloud of smoke, and the slipper had vanished.

When the fog cleared and we had recovered from the shock, lo and behold there was the damsel herself leaning out of the hole — still grasping her broom, and then over her shoulder appeared an amiable looking bewhiskered face, flanked by what, from the previous remarks, we rightly assumed was a demijohn of cider.

"And who might you be?" said the damsel. "Yes," said the face, "wha's your name. Have a drink."

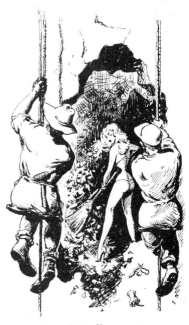

At this friendly gesture we swayed our lines across the hole again and hung on.

"This is the Editor of Bizarre" said J.W.

15

"And this is John Willie" said the Editor "and you, sir we assume are . . . "

"Adam," said the face, "and this is Eve — a simple soul who thinks apples were only meant to be eaten — foolish female — lets all have a drink — then you tell — where are we? — Ararat?"

J.W. took the extended crock gingerly — "Hope this doesn't go pouff too like that slipper" he whispered to the Editor. Fortunately it didn't and he drank deeply. "Heavens!" he said, coming up for air, "that's terrific stuff! Amazing! Adam, I congratulate you — but you were saying?"

"I said, is this Ararat? The old snake told us that if we kept digging we'd find Mount Ararat and Noah's Ark, and believe me we've been diggin' and diggin' ever since we got kicked out of Eden. Oh my achin' back."

"But why do you want to find Noah's Ark?" asked the Editor, wiping his lips and handing the crock back to Adam.

Adam took a healthy swig. "It's like this," he answered. "One day after we left the garden all the animals disappeared — just like that! Not a beast nor a bug within coo-ee — and according to the old snake they'd all gone into the Ark to shelter from the rain. Two by two they went in, he says! Yessir! Just a male and a female he says! But what with the long night and all — they've been streaming out of it in dozens ever since and so we figured if we could find it we might get a bit of meat for a change. A fruit diet palls."

"I've had apple dumpling, apple pie, apple stew, apple turnovers, apple jam, apple tart, nothing but apple, apple, apple until I'm sick of the sight of it — except in this form," and once more he took the demijohn from the Editor. "Of this I'll never sicken" — he burped again and then in a ruminative tone, "In fact I'm becoming a positive old soak, and that's what bothers me. Mustn't be a soak — No sir! Why — I dunno, but the little woman doesn't like it."

"You're damn tootin I don't," yelled Eve swinging again viciously with her broom, "and now thanks to the fright these two characters gave me I've got to go and find that old serpent again — I've only got one shoe."

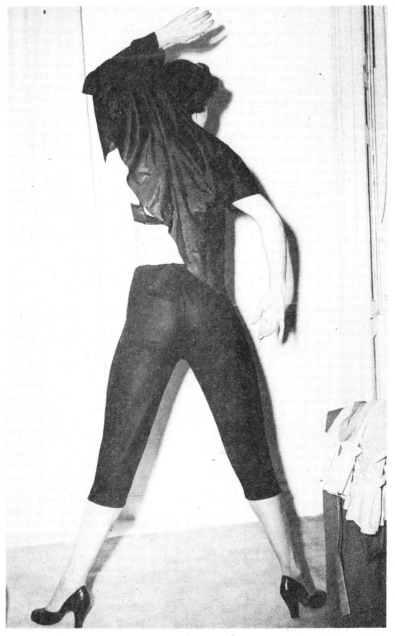

Keystone Photo

the new black frill-less "bloomers"

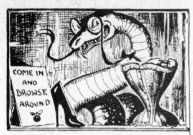

Ye Olde Snake Shoppe

"Does the serpent supply them?" asked John Willie.

"Does the serpent supply them?" said Eve, "Huh! I'll say he does — the old wolf! Come up and see my scales little girl!" "Everytime I need a new pair shoes or a new corset it's the same old story! — but what can a poor girl do? Darn it — I know every one of his damn scales by now, I've played them often enough! — every darn note — every chord on the whole flamin' key-board. I know their shape and I know their color and to make matters worse they scratch!" Him and his forked tongue! Oh brother!"

"Then tell me." said J.W. "did you, or did he think up the corset idea? I always thought you wore a fig leaf."

"A fig leaf?" gasped Eve in amazement. "Now who in their right mind would wear a fig leaf. A corset yes, but a fig leaf! Where on earth did you get that crazy idea?"

"Well it's sort of been noised abroad in certain circles — mooted so to speak" replied the Editor — "but skip it!" "You were saying you, or was it the serpent who invented the corset?"

"Neither of us," came the surprising answer, "that old snake told me it came from some people who lived aeons ago, and he coaxed me into it. I'd never have worn it if hadn't been for him and now, I must admit I'd hate to be without it — it does things with you," and she wriggled a bit in a very seductive manner.

The crock had been passing steadily around — Eve too taking her share — and under its mellowing influence the atmosphere seemed more relaxed and matey so to speak — but we were still mystified and very curious, so we asked for the full story.

"Well, it was like this," said Eve, sitting down and wriggling herself to the edge of the hole until she was dangling her pretty little feet in space — the one sandal which she still had on giving out the weirdest light.

"Old Adam and I were getting on alright — no worries — no troubles, no problems and the only difference we could see in each other was that he had one rib less than I had. Life was pretty smooth. And then one day along comes this old snake, and

18

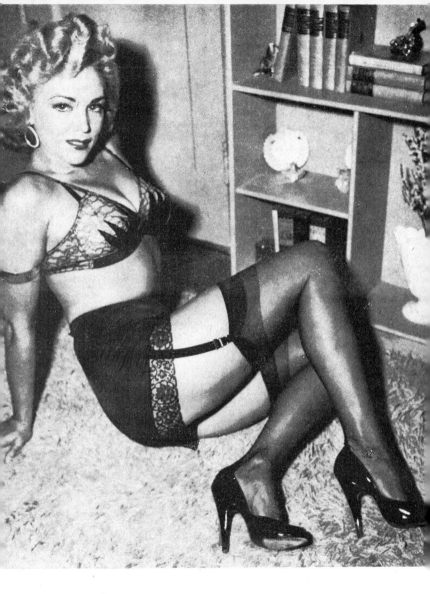

the modern trend in lingerie

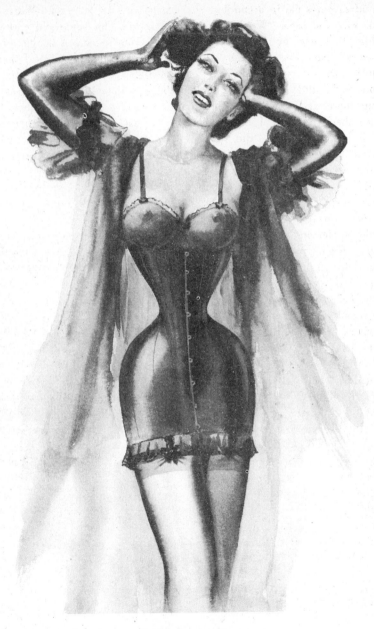

the black corset

he coils himself around my waist, and squeezes me in a cuddly sort of way and says, "Wouldn't you like to come up and see my scales? Now I'm *sure* you would little girl — so just take a bite out of that little old apple hanging up there and you'll be able to see them" — and I like a sap fell for it! Wow — did I fall! And then I saw his scales alright, and Adam's too — and the only difference between us wasn't one rib anymore. I'll say it wasn't! And then Adam took a bite of the apple and immediately his eyes began popping at me and he said "Woo Woo!" and let out a terrific whistle and I thought the old snake was still squeezing me and holding me up on tip-toes but he wasn't, he was away in the scrub laughing like crazy and I was squeezed by this corset made of his skin, and I was perched up on a pair of high-heeled snakeskin sandals. Then Adam — this cider-soaking jerk here, started to chase me and with these heels I couldn't run fast enough — darn it — Yeah! That blasted snake sure was able to raise cain." — and she kicked her remaining sandal off and we watched it sail away down into the depths below us.

"But that sounds as if the old serpent did invent the corset." said the Editor.

"Hell no!" said Eve, "as I started off to tell you. When I asked him, he said he'd picked it up from a race of people who lived aeons ago who based their downfall to the number 13. That's a mighty unlucky number he says — yessir! — mighty unlucky!"

At that J.W. solemnly handed the crock back to Adam, hiccupped, and bowing as low as is possible in a bosun's chair said "Ole' Adam and beauteous Eve we are pleased to have met you — very pleased — but we have a duty to perfom for mankind. We must find the origin of the corset — our readers expect it of us. You said it was started aeons ago — O.K. — that's further down this cliff — c'mon Ed' ole boy, on we go" and he began descending rapidly. The Editor followed after a polite interval while Adam and Eve disappeared into the hole again to continue their digging in search of Mt. Ararat and a change of diet.

Maybe it was the cider, which was potent, or maybe it was the odd nature of our meeting with Adam and Eve but whatever it was we just went on lowering ourselves down in a sort of trance until at last with a bump we were right down there at the bottom of the canyon with the Colorado River foaming past at our feet.

In a distracted sort of way we began chipping away at the face of the cliff — so distractedly in fact that J.W. had the stone — THE STONE (which we wrote about in No. 13) half uncovered before he realized what it was — in fact he didn't realize it at all until the Editor said gloomily "What's the idea of carving the rock? Carve your initial if you like — 'J.W. was here 1953' — but carving a pointing fingered hand — like a sign writer. Ugh.' Now all you've got to chip out is "Gentlemen" and it's pointing right for the river — which seems rather unnecessary doesn't it?"

"What hand? Pointing where? Oh my sainted aunt!" J.W. exclaimed, "I didn't carve that, someone else did though, and here we are at bottom of the Canyon! Someone 150 or 175 thousand years ago must have done it" — and with a yell he hoed into the cliff like a pneumatic drill. The Editor joined in and great chunks toppled out with a crash. Day turned to night but we scarcely noticed. The noise of our efforts thundered through the gorge — drowning even the mighty roar of the river.

Suddenly a cascade of apple cores hit us and a voice from above shrieked "For heaven's sake stop making such a godawful din and let people get some sleep!"

"Go back to Ararat" we yelled in reply for nothing could stop us now. Our hammers flew — so did the chips, in every direction, until at last that priceless stone was revealed in all its amazing beauty. The stone which told the full story of those magnificent prehistoric wasp-waisted women, giving the blow by blow ringside account of their downfall in that fateful year BC 999999. *(Which we reproduced for your benefit in our previous issue No. 13.)*

We fell back exhausted to realize that we had worked right through the night and that the sky was getting lighter above us — and as we looked up at it we saw two glowing objects descending rapidly. Nearer and nearer they came until bouncing off a couple of rocks they landed at our feet — a pair of snakeskin sandals. For a moment they lay there glowing with that weird light and then "poof" like the others they vanished in a cloud of smoke and voice came echoing down through the Canyon — "Get Lost!"

We looked at each other. "Here we go again" said J.W., and then the welkin rang as we sang in chorus — "DO - RA - MI - FA - SOL - LA - TI - DO!"

22

Early in the century people jokingly referred to a city as "The Big Smoke." Now there's no joke about it. Any town is a smokey mess, and in London, long famous for its "pea soup" fog, the atmosphere has been so thick that people in desperation have had to wear a form of respirator just to enable them to breathe.

The last time the necessity arose for the public wearing of respirators was during the Spanish Flu epidemic in 1918 — or was it '19? — anyway it was somewhere around that time but the exact date is unimportant. What is important is that Bizarre was not known then, but it is now, and the London lassies who work or play in The Great City have reason to be thankful for our fantastic flair for fashion, plus that wizard designing genius which resulted in the "Smog Mask" cover.

As soon as the public began to wear gauze bandages over mouth and nostrils, to protect themselves from suffocation, we were literally swamped with letters from the leading fashion houses. They wanted to know whether the ideas promoted in Bizarre #10 for ornamental gags for fashionable women could be developed along somewhat similar lines for a "smog mask." They felt that a simple gauze bandage was not very decorative. Could we help?

Could we? What a question! When the future of the Empire was at stake how could we refuse?

B.O.A.C. rallied round and placed a special plane at our disposal, and thus it was that one fine day John Willie was whisked across the Atlantic to Old England's shores.

His welcome at the airport was most impressive and the cheering was fantastic. It really was because the crowd only numbered about 200 — all very important people who as a rule are not given to wild ovations — while the cheers resembled the full throated roar of a football crowd at Wembly Stadium. This had J.W. puzzled until it was pointed

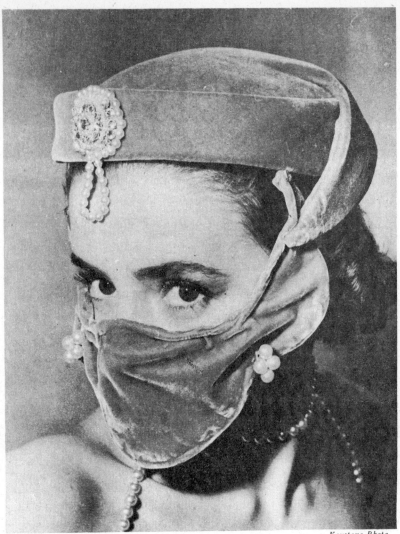

Keystone Photo

"Forty Thieves"

is the name of this ruby red velvet creation,

— with matching "smog veil"

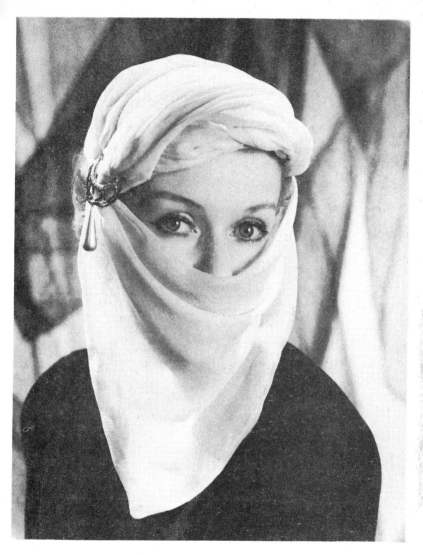

smog veil by "hugh beresford"

out to him that as it was impossible to open your mouth to cheer without swallowing smog — buckets of the stuff — the B.B.C. had made some special recordings. "Cheering" discs were now available for a small fee for all public occasions. Broadcast through loud speakers the result was really quite impressive. It was also very convenient, for when the Lord Mayor, who was there in person, held up his hand for silence, there was silence immediately because someone just shut the noise off.

Then our Willie spoke and it is needless to say that the first thing he did was to point out that so far as women are concerned the mouth, except when required for kissing, is rather unnecessary. Therefore if it is kept closed you miss nothing and can concentrate all your de-smogging attentions on the nostrils alone. As the nose itself is already equipped with a pretty good air conditioning system of its own your task will be much easier. Therefore the logical thing to do would be to seal the lips with adhesive tape.

At this profound remark someone switched the cheering record on again, and the Lord Mayor shook hands with the Chancellor of the Exchequer while the First Sea Lord slapped the C.I.G.S. on the back, and with everyone waving, and the loud speakers blaring the Wembley serenade, all hands began trouping off to the banquet which the city had prepared at the Guild Hall.

The "smog mask cover" fashion caught on like wild fire. Women could now breathe and still have "chic." The Silence was astonishing. Nothing but the deep rumble of voices from male throats broke the stillness of the City. Noon in Piccadilly and Bond Street was like a winter's midnight on Hampstead Heath.

Women learned the deaf and dumb language and did their shopping by pointing.

Honours were heaped upon us. J.W. was given the "freedom of the City" and there was some talk of removing Nelson from the top of his column in Trafalgar Square and putting a gold statue of John Willie up there instead, but nothing came of it. Probably this was because Scotland Yard did not approve when it was suggested that the lions should also be replaced by something more in keeping with the mood — such as damsels "couchant" in corsets, gloves and high heels, chained to their pedestals. For some quaint reasons best known to themselves they seem to take a dim view of these frivolities.

And now if you will just look at the delightful "smog mask"

creations "a'la Bizarre" pictured here you will perhaps agree that there was good reasons for all the whoop-de-doodle. The fair ones are attractive, and they can breathe. They don't suffocate, yet the gauze that filters the smoggy laden air is not seen. Neither is the adhesive tape which, as they are very definitely ladies of fashion, presumably covers their lips. That this gags them very thoroughly is incidental, and a condition much to be desired, as we and the B.B.C. pointed out one evening.

It was rather fun — that T.V. session. It was an informal setting and the models sort of sat or ambled around as women do at a hen party, but the cackle was conspicuously absent. And then the complaints started pouring into the studio — "What's wrong with your sound? We can't hear a thing."

"Why should you" J.W. answered "There ain't none."

He means "There is no sound" said our B.B.C. commentator "the ladies are quite silent — not dumb you know but quiet — very."

In conclusion we might add that if you don't like tape you can of course plug the mouth up with anything else that takes your fancy — the outward appearance will still be decorative.

dammit! read this . . .

The name "BIZARRE" and the photos and sketches appearing in this magazine have been reproduced by various people without our permission.

Our attorneys have the matter in hand.

Publication of our material by any other person is not authorized, and we strongly advise readers to write to us direct before answering any advertisement giving an address other than ours. Ours has NOT changed in the past six years.

Any other address is bogus.

nini
ninette
ninon

You know the more we think about it the more we like the idea of the Nini Ninette Ninon style of gowns featured in Bizarre No. 10.

Think ahead a few years. Picture a little love-nest — one where roses cling! Here, as the early morning sun reaches through the breakfast alcove, caressing the coffee pot and toaster with tentative, shimmering fingers, we see a scene of domestic bliss.

Well tubbed, looking cool in his palm beach suit, and reeking slightly of shaving lotion, my-lord-commuter has just finished his breakfast. There is no mad rush in this house. Leisurely he dawdles over that last cup of coffee, lights

his cigarette and then looking across the checkered table cloth at the light of his life, cook, bottle-washer, and general companion in fair weather and foul, remarks nonchalantly, "I'll probably be a bit late coming home this evening, honey. A guy in the office has some rose cuttings he doesn't want, so I've arranged to go over to his place and pick them up — probably won't be able to make it back much before 8:00 or half past."

There is a slight stirring on the part of the attractive little Ninon opposite him — you might almost call it a movement of indignation or rebellion, but that is all. The peaceful silence of the breakfast table remains undisturbed, in spite of the fact that she particularly wanted him to be home early so that she could wheedle him down to "Le Chapeau Chic" before it shut, and then wheedle him into buying that perfectly *divine* little hat before that *impossible* Rand woman could get her hands on it.

Ninon is furious — but what can she do — she can't eat her breakfast. The "Beanie" which she has worn all night prevents that.

Certainly she could reach the buckles on the thing but they fasten with a padlock, and the key of that padlock is on the top shelf in the kitchen which she cannot reach unless she stands on a chair, and she can't climb on a chair because the infernal powder blue satin dress is too impossibly tight

around her knees for her to raise her foot much above 3 inches off the floor.

She would like to say a lot but nevertheless she rises dutifully from the table and follows her lord and master to the door, where with hat in hand he turns and then, not for a particularly brief instant by any means, she feels his lips pressing against the soft leather which covers hers as tightly as a second skin.

She watches him as he goes down the garden path. Watches him as he walks with quickened pace down the road to the station. Watches the late comers hurrying after him, and then stands listening.

Presently there is the whistle of a train — loud, and long. Her attitude becomes more tense.

There is a long pause — then a short "toot!" — from the direction of the railroad station.

Like magic, all up and down the street from every house, Ninis, Ninnettes and other Ninons appear. Some hurrying as fast as five inch heels and a six inch step will allow — others kicking off their shoes and hopping — all moving frantically to this house or that house or to collect in twos or small groups so that helping fingers can unzip zippers and unbuckle straps.

Our little Ninon hobbles down the low step of the porch, and

looks expectantly to her left where an "Andromeda" is clanking along in her chains towards her.

"Yoo-hoo" Andromeda calls. "Has Bill locked you up in the Beanie again? My, My!"

Ninon bobs up and down in an infuriated sort of way and makes grunting noises.

Skirting an occasional shrub and a flower bed or two, Andromeda jingles across the lawn, her

pencil thin spike heels sinking into the turf and throwing her off balance if she forgets to keep walking on her toes. In fact, at one time so deeply does her right heel sink that she almost loses her shoe, and she would have done had it not been for its wide ankle strap which is fastened by a padlock and to which the short six inch ankle chain is attached.

As soon as they are together Ninon bends her knees and stoops forward so that Andromeda can reach the zipper at the top of the cape which joins her arms. Andromeda obligingly stretches her right hand up to it, until her left wrist, being drawn willy-nilly behind her back by the connecting chain, reaches the ring at the back of the waist belt thus preventing her from reaching any higher. However, it's high enough and she can undo Ninon's zipper. There is a long tug and her elbows and wrists are free from the gentle restraint.

Whirling her arms a couple of times in relief — and nearly hitting Andromeda in the process, Ninon hops with impatience while the zipper of the dress itself is pulled down.

"For heavens' sake, stand still" says Andromeda, tugging at the chain joining her wrists, "this thing will get stuck if you don't. Just remember, I'm somewhat han-

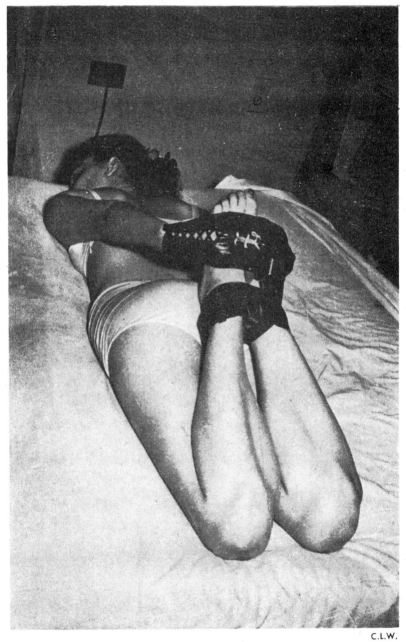

C.L.W.

rests — and, — well, rests.

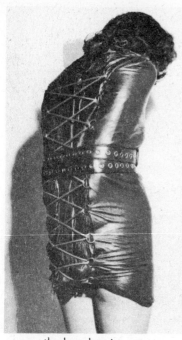

the laced waistcoat

dicapped too.' She tugs again and with a jerk gets the job done.

Ninon immediately begins to hobble as quickly as she can towards the door again — has trouble getting her feet up onto the porch and so without more ado pulls her arms out of the sleeves of her dress, peels it right down to her ankles, wriggles first one foot and then the other out of it and now clad in nothing but shoes, the briefest of briefs, and Beanie, she scapers inside. Getting a chair she reaches the key on the shelf and is busy fumbling with the lock fastening the buckles at the back of the Beanie when Andromeda hobbles in, ankle chains clinking.

"Do you know what that beast is doing?" Ninon says as soon as she can speak. "He's coming home late — and there is a hat I've simply *got* to have today. Darling, have you got *any* money you can lend me?" This is said over her shoulder for her hands are flying in all directions trying to fry eggs, make toast and pour herself her first cup of morning coffee all at one and the same time.

"I think I've got a couple of bucks I can spare until tomorrow —if you want something to pay down as a deposit — but anyway, why did Bill put the Beanie on you?"

"Oh, I got mad because I can't buy half the things I want and so I started to try and talk him into asking for another raise — and he wouldn't. I've been wearing this thing ever since 9:00 last night and this dress too for that mat-

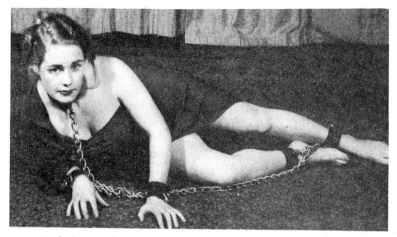

ter — isn't it a perfectly heavenly blue?"

"And it's a *marvelous* fit — Darling" A n d r o m e d a answers "where did you get it made — darling it's nearly like a second skin, and even more revealing — quite definitely" and she turns her head this way and that in appreciative inspection.

"Where are your keys" asks Ninon buttering a bit of toast and as she is answered only by a shrug and a wave of the hand — "don't tell me Herb has taken them to the office again."

" 'Fraid so" answers Andromeda. "I suggested going out for dinner and the measly skin-flint said we couldn't afford it — and then to make sure that I cooked a good meal instead of opening a can of spaghetti, he called over to the Andersons next door and asked them to dine with us. I haven't

seen Betty yet this morning so I suppose he's got her chained to the sink again. I think it's an awfully mean trick. She can just reach the front door to open it — the chain's long enough for that alright but if she wants to go out into the garden she has to go out the back door. Perhap she is out there now. Let's have a look through your window — yes, there she is — Yoo-hoo Betty!"

Mrs. Betty Anderson, dressed in nothing much but a gay frilly apron, high heeled sandals and a little waist cinching corset, waves a pair of manacled wrists, picks up the loose chain hanging from the shining metal collar round her neck and jangles it too as if to say, "well, here I am — see!" and then begins hanging freshly laundered whispy garments on the clothes line.

Ninon and Andromeda return

to their breakfast and when that is over and Ninon has bathed and changed into an ordinary print house frock she discards her six inch heeled operas for a pair of more conventional five inch sandals for she has the housework to do, and almost most of Andromeda's too, for that fair lady's left wrist is always kept tight against the ring in the small of her back for convenience, whenever she uses her right hand — even when smoking a cigarette.

So breakfast finished they wash

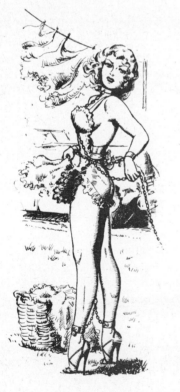

the dishes and put the place straight, Ninon free as the wind but Andromeda still hobbling around with tiny jingling steps, and then they go outside to talk to Betty Anderson, who, her washing all hung and fluttering in the breeze, has come to the full length of her chain.

"Oh, that aggravating brute of a husband of mine" she exclaims — "why can't they build cars with a corrugated finish like one of those copper-table-tops that come from India. It would be really smart and it wouldn't show the dents. Just because I put a little teeny-weeny dent in the car — look! — and she spreads out her wrists to the limit of the chain, twists them futilely, and then in despair drops them to her sides, with the result that the chain, which is quite heavy, gives her a solid smack on the knee — which makes her say "ouch" and jump a bit — which jerks the steel anklet as she rubs the sore spot — so she says "Ouch!" again, and a few more less polite words.

Ninon looks over at the cause of all this trouble — a new convertible, all shining and polished, whose beauty is unfortunately marred by one of the finest examples ever of a concertina'd fender.

"Did you do that?" she asks pointing. "Well — sort of" says

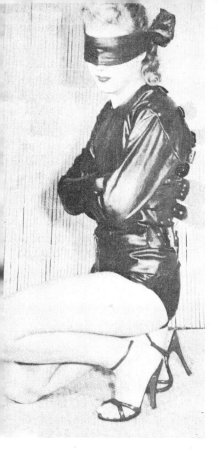
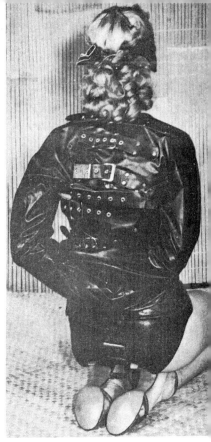

THE "STRAIGHT-JACKET" CAN BE WORN ANY OLD WAY

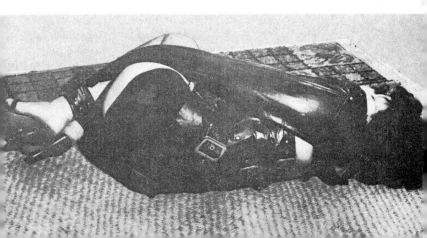

Mrs. Anderson. "Not actually though, it was all the other driver's fault — really. But that fool policeman said it wasn't and when I told Herb about it after dinner the beast didn't take my side at all."

Now he's deliberately left the car there, where it is, so that I can see it but can't reach it because of this damn chain. "Oh, to hell with it! Come on in and let's have a martini." — and she starts walking quickly to the house, for the chain shackling her ankles, unlike Andromeda's, is long enough to enable her to take almost a normal step and to prevent it dragging on the ground it is fastened at its center to another chain hanging from a metal wrist belt.

"Heavens, darling!" says Andromeda, tagging along behind, "what *have* you done to your figure? Every time I see you it seems to have gotten more like an hour glass than ever. It's *marvelous*, darling, quite marvelous — but how do you do it?"

"I don't", says Betty over her shoulder. "Herb does it with this wretched belt and corset. He laces me in to the limit and then with this metal belt squeezes my waist some more by a screw gadget at the back. He uses a common old screw driver to tighten it and there is a hole through the head of the screw for a padlock — and with the padlock on I can't un-

screw the darned thing — it covers the knots of the corset strings too."

"Then why don't you cut them?" asks Ninon.

"I did once — not that it made any difference," Betty answers, "I still couldn't get out of it — the belt stopped that — and did I have a time when the noble bread winner got home! Oh-me-oh-my!"

But by now they have entered the house and Betty Anderson is mixing the cocktails.

Andromeda, whose husband has graciously refrained from including the collar and back-stick sprawls in an arm chair, Ninon is curled up on a settee — and the chit-chat and cackle of the usual hen-party begins.

The same scene could be observed in any of these homes — Colonial Style, Split-level, Brick, California redwood or what have you — and "*all within easy commuting distance*" of that insatiable machine — the City. But unlike o t h e r suburban developments, where everyone is trying to outdo every one else and keep up with the Joneses, life here goes on in the relaxed and gracious manner of bygone years.

Even so, every now and again, something occurs which, like a breeze on a quiet backwater, stirs the peaceful surface, and there are subterranean female mumblings,

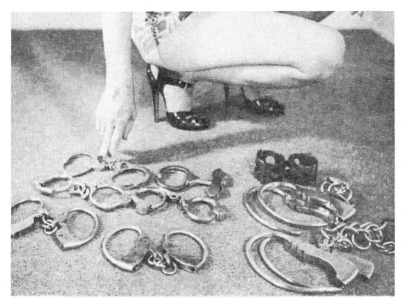

Photo from G.M.

take your pick lady!

futile we'll admit, but rumblings nevertheless.

Such is the case at the moment as in every house the conversation revolves around a new gadget which has made its appearance in this model suburb. It consists of a white four-sided pyramid some 4 inches high, on the sides of which are painted a spade, a heart, a diamond and a club. On the bottom there are just two letters "N.T." The simple invention of a simple peace loving husband with nothing about it, you might think, to draw even a second glance. But it has created a furor because its use ensures quiet Bridge, with the complete absence of those tedious "post mortems."

You can read about it in a later issue — and in the meantime just relax and wait patiently for our dream suburb to come true. Men cannot go on being trampled under foot forever — the wheel of fate rolls on, ever turning. Just remember that old proverb, "What Bizarre begets today — fashion features tomorrow," — and have confidence in the future.

☆ ☆ ☆

Correspondence

Under no circumstances do we publish names and addresses, nor do we put readers in touch with each other. If photos or sketches are sent in, please write a short commentary and please do NOT send in photos which you got from someone else.

COSTUMES AT A PARTY

Dear Editor:

I was interested to read of so many fancy-dress clubs in the country; well, we have one, too! As it was only a few nights ago we organized one of our more elaborate parties, I thought you might like a few notes on some of the participants. Here goes anyhow!

Ruth: Tall, slender, brunette, about thirty-five, I think. High heels, waist-length mesh hose, and the tiniest pair of pink satin shorts imaginable. Scanty little bolero to match and long amber cigarette-holder completed this ensemble.

Adelaide: Came as 18th century hussar. Huge shako, full dress tunic, which came to her lap, and only stockings and shoes below! I noticed that the tunic was fastened to prevent riding up by a strap going in between her legs.

Beth: Complete man's evening-dress tails costume, top hat, white tie, stick, only no trousers! Black mesh stockings.

Audrey: One of many in rubber outfit. Tight-fitting rubber mask over her head ending in a big, barbarically jewelled necklace. Ditto bracelets. Swishy hip-length cape which, when removed later in the evening, revealed simply a pair of very high-waisted, flesh-tight rubber shorts coming rather far down the thigh. Very odd effect as you could see every fold of Aud's flesh except her face!

Edythe: A well set-up colored girl, with a gorgeous coffee-cream skin. She had on a very simple outfit also. Immaculately pressed white flannel slacks, extremely tight-fitting over the hips, rubber-soled tennis shoes, and a jaunty white beret. That's all! Her breasts were made up to match her fingernails and she had thick silver make-up on her eyelids.

Alice: Came with her mother (v. Mary), and only about thirteen, I think. Very slim. Severe facial maquillage. French-fringe haircut. Long, willowy legs encased in waist-length black silk tights (not nylon) with, oddly

38

enough, no seams. High Eton collar, black tie, and "bumfreezer" jacket. An exquisite sight dancing, but so slender scarcely a fold of flesh visible at the back.

Mary: Mother of the above, a more elderly lady than most, but really beautiful. I never got to speak with her, unfortunately, though I considered her ravishing, despite a somewhat wiry figure. She came as a naughty schoolchild. Mocassins, bobby-sox, and a ridiculous little bibbed tartan tunic, the skirt of which was slit at the sides and pinned up at the back. Mary caused much amusement. It was distinctly comical when she made wry little "contrite" faces, contrasting with her sophisticated make-up.

Sally: Sort of pseudo-directoire, I guess. A red-head, who had put her hair into stiff plaits, she had a prominent bosom under which a brief pleated leather skirt showed off a pair of bloomers gathered at the knee. Buckled shoes.

Marianne: A charming French-woman of forty with a remarkable figure. She had on a floppy cartwheel hat, a backboard, and a wasp corset into which a chain bit at the waist, padlocked with a lovely old lock of chased gold. Glossy thigh-length boots very tightly laced. The corset was cut to cover her in front but became, behind, a single strap fastened to the back

on the loins, just under a small stiff plume resembling a horse's tail! Her beautiful exposed flesh was powdered dead-white. There was one further amusing detail to this fancy dress. A lean leather switch dangled from her waist and across the backboard was written *Whip Me Well!* As some of the men had actually fastened the woman's gloved wrists to the straps in the board before she'd entered the ballroom, more than one during the course of the evening laughingly took advantage of the invitation and several lively red weals sprang up. Before the evening was over, poor Marianne was begging in earnest to be let loose, but though we were all willing to ply her with champagne and cake, no one seemed to want to grant her request.

One of the late-comers, Bernice, a tall, pig-tailed blonde had on a tight schoolgirl's tunic finishing as shorts below the waist. These drew everyone's eyes when she turned for she was beautifully made and the material covered only the tops of her hips, leaving bare the graceful, opulent curves below. There was a Chinese girl in a Marie Antoinette bergère hat, starched ruffled shirtfront, long lacy cuffs, and below the waist the briefest of brief Bikinis, cut high on the thighs, and made, I think, of hospital sheeting. Many came

in this handy rubber material, in tight-fitting hobble skirts both short and long. I also saw several sateen breeches, velvet tights, and a pair of shorts of mink! Two wore skintight jodhpurs, armed with spurs and switches. One lady attracted much comment and praise for her well-cut skirt of black leather, polished till it shone like lacquer; it was just off the knee and her right leg had been amputated, after an accident in the

Photo from F.M.D.

British blitz, halfway up the thigh. The stump was visible when she moved. But she bore the handicap with courage and gaiety, and I can testify that she was never

without at least two male companions. Her left leg was slender and agile, and she had the tiniest of waists. Her name was Molly.

Towards the end, the party became hilarious, and we ended by playing a game of forfeits, drawing cards from a pack and the lowest cutting again till five of us were left. Actually the men, as you can imagine, so contrived it that most of us had, one way or another, to pay a forfeit!

Yours, Ricarda

TIGHT RUBBER

Gentlemen:

I want you to realize that your magazine cannot be any better than we, all of us, make it, and I am very glad to do all I can to help. So, I am enclosing some snaps which I hope will interest your rubber enthusiasts.

Note the cap with very tight throat piece, and the regular length gloves which easily stretch, a little at a time, to elbow length but must have a tight band round the elbows to prevent their slipping. Tying the fingers bent back gives a most unusual appearance to the hand. (*But for how long before it goes to sleep? Ed.*)

The boots of gleaming black rubber I think need no further description.

Yours sincerely,

F.M.D.

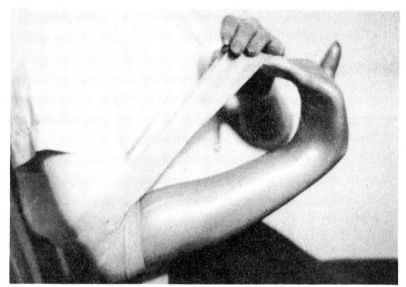

rubber gloves, with the hand held back —

Photo from F.M.D.

and rubber boots.

More About Rubber

Dear Sir:

My husband and I were so delighted with the picture of the white rubber mackintoch in your last number, as well as glad to learn there are others interested in rubber clothing. We love walking and sweethearting in the rain, for which we have a variety of costumes, capes, coats, hoods, boots and gaiters. Most of all, however, we like wearing bathing caps—thick strong black in the chin-strap style — and long ago we found we simply couldn't get along together unless we wore them around the house, under the shower, in bed etc.

As you can imagine we had a dreadful time during the war and though that period of rubber shortage is now mercifully over, we have both noted with dismay that bathing caps of rubber don't enjoy their popularity on the beaches. Plenty of those stupid white resin ones, — but who cares for them? Gone, it seems, are the good old days when a girl at a beach or pool had at least the chance of seeing some gorgeous man in a shiny black rubber cap, and perhaps of inveigling him into some innocent aquatic horseplay, ducking him or being ducked! Dear Editor, please ask Mr. Willey to give us some photographs or drawings of girls and men in bathing-caps, won't you? My Husband joins me in this plea.

——— "Madcap"

Jewelry for Decoration

Dear Sir:

Why don't more women realize the beauty of jewelry, and in particular earrings, and pierced ears, and bracelets worn on gloved arms. It is so seldom that we see a girl who knows what a difference they make in her appearance.

Before the chemists discovered how to make such perfect imitations in paste—to wear diamonds and pearls required a large bank balance. Today jewelry, good imitation I mean, is within reach of all, and yet is still conspicuous by its absence.

A long black velvet evening gown, and black shoulder length gloves form an ideal background for drooping sparkling earrings— and heavily jewelled arms.

It must have been wonderful to live in the courts of other years— what magnificent sights were there in every direction, what beautiful women, their dresses, their hair, their arms and even their ankles, and dainty slippers sparkling like the heavens on a starry night!

Perhaps women only like the genuine article and won't wear paste, I prefer it myself but I admit I am not such a connoiseur of jewelry that I can tell the difference between real and imitation,

and if there are girls who think as I do I will spend every penny I possess to see that she is gratified.

Yours—"Sparkle"

BLOOMERS

Dear Sir:

Like a previous writer, I also find bloomers a very appealing piece of feminine attire—especially if they are of sheer pink silk. The new style bloomerette panties are particularly attractive with their elastic waist and elastic high above the knees. I hope you can have more pictures of bloomer-cladgirls. Would appreciate a picture of a young lady dressed in a bra, bloomerette panties, and neatly rolled silk stockings. Another favorite of mine is the girl wearing tiny, very skin-tight satin or silk panties.

I agree with I. J. and Le K.'s letters, stating that many prefer a good spanking rather than a severe "talking to." I know several girls who definitely prefer a painful episode—to an upsetting "lecture." How do others feel about this?

Perhaps many think the ideas of the writer, who signed himself "Lingerie," sort of silly. But why so? Indeed, why should women have the monopoly on colors and beautifully made garments? — I think it about time for men to stop being so plain and conservative in their dress. And I don't think it silly or effeminate to prefer frilly, pretty undies. I have always felt that "every one to his own taste." Must we all be "standardized zombies," as a prominent scientist has said? What we need is more stressed individuality.

Yours, "Anon"

AN EVENING GOWN

Dear Sir:

This is my own design of an evening gown for summer time use, and it turned out to be beautifully cool and comfortable to wear, and I received many compliments on my turn out that evening.

The material of the dress is silver lamé, and the belt and shoes are of black patent, the latter with 6-inch spike heels. I had to have the belt especially made for me. It is a perfectly plain black patent belt, 9 inches in width, and fastening in front with lacing. It is reinforced and actually is used more as a corset than as a belt, and can be pulled in as tight as the wearer desires. I may say that it took my maid a good half hour to give me the 21-inch waist which I demanded of her.

Although it appears in the drawing that this is a three-piece dress, it actually is all one, the front edges of the gown being stitched in to the lining of the belt, the only way in or out of it being by undoing the front lacing.

43

The panties are very brief and are made of silver satin.

As I am not an admirer of the gap between stockings and panties, I managed to get a friend in Hollywood to get me ar pair of sheer black nylon tights ,horrible word) these were thrilling to wear and showed off to perfection my legs against the silver kid background of my skirt, and also drew attention to my glistening shoes with

A pair of sholder-length black kid gloves completed the outfit, which judging from the many compliments I received during the evening, was a great success.

Yours very truly,
"Daphne"

CORSET SUPPORT

Dear Sir:

I have alweys been interested in improving my figure and general deportment and, now that the war is over, my husband has promised to buy me any special appliances, accoutrements, etc., I may require to achieve my desires in this direction. Naturally I fully intend to make the most of the offer and I would appreciate advice from the readers experienced in figure training, etc.

I have always led an active life with plenty of golf, tennis, etc., but when not so occupied have preferred to be well corsetted and high heeled .My corsets are all well boned and when feeling tired

and droopy I find great comfort in lacing on a high well waisted pair fitted with shoulder braces. Now, however, I intend to intensify my training and soon hope to have several pairs of special corsets, including one pair in black patent leather. With these will be high boots both knee and thigh length, long kid gloves and perhaps a special collar to enforce an erect carriage of the head. Later I shall endeavour to forward some photographs of myself undergoing training, if readers would be interested.

Yours truly—E. F.

WHAT'S SWAT

Dear Sir:

I have just read in Vol. 2 of your Bizarre Magazine where I.J. mentions the fact that although she is 22 her parents (I presume I. J. is a girl) still threaten to whip her.

I don't think that is so unusual at 22. Although I can say that a whipping generally is given with a switch or cane or a slipper or hairbrush, I don't approve of using anything but the palm of the hand. It just doesn't seem right to strike a girl with anything but the palm of a hand.

My wife is 26 years of age but she still goes across my knee and gets a good spanking on her silk undies when she needs it which is fairly often. There is nothing

cruel or inhuman about the treatment. Our home is a very happy one and once the spanking is given no unpleasantness is involved. My wife, the one who should complain, sanctions this method of settling a dispute. We both think that other couples could derive a lot of benefits from this same method.

We would like to know thru your "Correspondence" Corner — how many other husbands spank their wives for punishment.

Sincerely,
"Hollywood"

LADY IN LEATHER

Dear Editor:

The letter and pictures about "Mrs. Satin" which appeared on pages 40-41 of your No. 4 issue were most interesting and have inspired me to write this letter.

My wife delights in teasing me in the same way and insists that all her skirts be very tight fitting and short; but she (and I) prefer that her garments be made from shiny black kid or capeskin leather.

As she is a blonde the contrast is very striking and she is usually the center of attention when we go out to the theatre, etc.

Apparently the stylists and the public are becoming increasingly aware of the attractiveness and serviceability of leather garments as they are very popular this year and are being offered in almost every conceivable color

Perhaps this letter will stimulate some more letters, or better yet, some photos on this subject from the "Modern Misses Club" of New York, and others, which I am sure many of your readers would enjoy.

As this letter is getting lengthy will sign off for now by enclosing some photos which you may use of my wife who I affectionately refer to as "Mrs. Leather" or my "Lady in Leather."

Let me know if you find these photos interesting (*We'll pass this on to the readers — you know our answer.* ED.) as I have others showing various costumes of "Mrs. Leather" which I think can be even more interesting.

Sincerely yours,
"Mr. Leather"

Hi! Anything up there?

Nope! — nut-in!

DOUBTING THOMAS

Dear Sir:

J.W. again has some very fine drawings. I like those for fancy dress. How about some costumes for the males? Or are they supposed to sit around in business suits, while the girls disport themselves in costumes as shown? How about a white silk or satin blouse

46

with very full sleeves, with deep cuff fastening at the wrist, with "V" or invented "V" closed at the throat, with or without standing collar at the sides and back, ruffled or plain, black satin knee britches, or shorts, with wide patent leather belt at the waist, black silk stockings, with buckled or plain pumps, with medium high heel? Take it from there J.W.

I am in a sceptical mood today; about those small waists and high heels. Those 13-inch waists would have a diameter of less than $4\frac{1}{2}$ inches, that I would have to see. And Anne's 7-inch heels, unless she takes about a size 12 shoe, I don't see how she could walk in them, or aren't you supposed to walk in heels of that height. Just for curiosity, I obtained a pair of women's shoes size 8 (which is a $10\frac{1}{2}$ foot size), I ripped off the original heels, and built a pair of 6-inch, adjusting the arch support to take care of the different angle of the foot. I found it was just possible to stagger around with bent knees and just the tips of my toes on the ground, and impossible to stand upright, without throwing the foot bones out of joint, or breaking them. Maybe the girls, who are used to wearing high heels, are conditioned to wearing those extreme heights. But 7 inch . . . I just can't believe it.

Yours,

"Sceptical"

Introduction to the Lacing Bar

Dear Sir,

I was very thrilled to see my letter published in Number 11. That letter won me a new pair of shoes, as I had bet with my husband, he saying that I could not possibly expect anyone to publish anything written by me. He was so sure that he accepted my challenge, and betted me a new pair of shoes against my current dressmakers bill. Was I relieved to see the letter in print, for the bill had become quite heavy. The shoes cost him quite a bit, but are what I have often covetted: black patent with 5" scarlet heels.

But I promised to continue with the story of my corset training in my letter, and as this has been printed I must keep my promise to readers if you consider this letter to be readable enough to print. I had only just started on my corsetting during that period about which I wrote. I was delighted with my first corset, and thrilled again each morning when I was laced in immediately after my bath. During the day while I was busy, I did not mind very much the discomfort that I suffered during the first two or three months. But directly I sat down to relax (as much as I could relax with a stiff corset on) the persistent aches about my body became irksome,

and after a time I had to get up and walk about, which gave a little relief.

At times I used to get infuriated with the "arrogance" of my corset. I couldn't escape it and it never let up its constriction and control. The inevitable happened one afternoon about four weeks after I had started wearing it. It had been tightened in a half inch that morning, and later, I became so angry that I suddenly dashed upstairs, tore off my frock and tried to take off my maddening harness. Of course it had to be unlaced first, and after struggling with the laces knotted at the back and being unsuccessful, I finally fetched a pair of scissors and cut the laces where they were knotted. The corset sagged apart at the waist and I was free.

Try as I could I was unable to conceal it from my husband when he came to tighten up any slackness in the laces that evening. My attempts at relacing with shorter laces were detected at once and he asked me straight away what I had been up to. I felt rather like a naughty schoolgirl. However this was nothing to what I felt like a little later that evening. Nothing more was said then, and I was allowed to have my evening meal and a rest afterwards before I was aware that I shouldn't get off scot free from my disobedience. Soon after the meal my husband went up to the spare room, and I could hear him moving about for about twenty minutes. When he came down he told me to go up to our bedroom and undress down to my corset. I started to ask why, but that was soon stopped. He watched me undress then led me by the hand to the spare bedroom. In the room I saw what looked like a trapeze hanging from a beam in the ceiling. On the bed lay two parcels, loosely done up. One, from its shape, was obviously a corset. I shivered and thrilled at the same time, wondering what was going to happen.

Within five minutes I had no doubts at all as to what was going to happen. I was, by then, strung up with my wrists strapped to the bar, almost hanging on the trapeze from the ceiling. I say "almost" for I could just touch the floor with the tips of toes. Even the 4" heels of my shoes were lifted off the floor. Clasped round me was a corset that seemed to me to be the grandmother of all corsets. I was encased in rigid black satin from armpits to thighs, and a high boned black satin collar was just being strapped round my neck. This came right up underneath my chin rising to a point behind my ears then lowering slightly to the back where three straps drew it together.

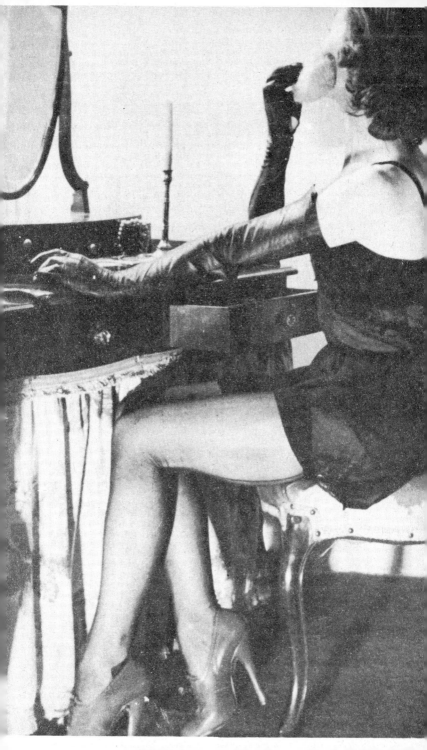

My husband spared nothing that evening in lacing me in. Strapped as I was to the lacing bar (its proper name) I could do nothing to stop him beyond begging him to stop. I must have been strung up like this for at least half an hour. although it seemed like hours before I finally felt the laces being tied at the back. A great deal of effort had gone into accomplishing that final act. The waist was not so extremely small, being 19″, only ½″ smaller than my smallest size up to that time. It was the length and rigidity of the corset that made the lacing-in such a long process and the laced-in feeling so much more crushing than in my every day corset.

At first it was just a matter of drawing in all the way up and down the line of lacing, taking in the slack and getting the corset to "sit" properly moulding my suffering torso. Then gradually more effort was needed from my husband as he slowly pulled the laces in. I could feel the increasing tightness making my body a hard solid shape instead of the soft flowing form when uncorsetted. First the thighs and hips. Then the small of my back, forcing it into a proud, Gibson Girl, arch, and then my chest and bosom, travelling down to the ribs, making me breathe short and fast. Finally a long, steady pull at the waist as I felt the band of pressure narrowing and hardening my waist until it became as solid as wood.

By the aid of two long mirrors I was able to see the lacing in progress. I could see that, finally, the corset was quite close, and not even the narrowest slit of white could be seen between the laces. My wrists were freed, but the final thing was the strapping of my arms behind my back to force my shoulders right back. While held there a shoulder brace was put round them, drawn backwards and downwards causing a deep arch to my back and making even more pronounced the outward curve and inward sweep of my derriere. My elbows were freed and then I was at my liberty. I have never felt so helpless as I did then. Walking became a tottering, with tiny, ladylike, steps on the tips of my toes. Bending was quite impossible, let alone any form of sitting. But as I tottered and teetered round the room I felt for the first time that odd, wobbling feeling in my tummy and back which I have found to be one of the more delightful sensations from being tight-laced. *(To be continued in our next issue.)*

Yours truly,
Wasp Waist.

☆ ☆ ☆

Rubber Club Support

Dear Editor:

I heartily agree that we should have a "Rubber Club" department in 'our' magazine for those of us who are so very much interested in rubber garments of all kinds.

Several years ago I became interested in wearing rubber garments and have worn them continually ever since. I have been fortunate in being able to find in past years a manufacturer who would make to my own measurements most any kind of garment I would want. Right now I have a two-piece gym suit style garment made from very thin but durable rubber, consisting of shirt with elbow length sleeves and knee length pants. I wear these quite a bit about the house during the daytime. Then I also have a complete one piece rubber suit with ankle length legs and wrist length sleeves which laces up the front. Both of these garments fit very tightly and thrill me beyond words when I am wearing them.

Of course at all times, other than when I am wearing these garments, I wear a regular rubber girdle and brassiere, unlined of course, as that would spoil the thrilling feel of the rubber next to my skin. It is so soft and caressing that I can't understand why more people do not wear them. They make me feel so well dressed with their tightness, and yet utterly complete flexibility.

So let's try to start a club for those who like to wear and discuss rubber garments. I will do anything and everything I can to help get it started. How about it, Ye Ed., and those of you who are interested?

Yours, Mrs. M.J.H.

Bondage Festival in Italy

Dear Editor,

As you probably know, in the town of Capio in Italy on St. Valentines day of every year they have a carnival of Capio, a kind of fancy dress ball on a city scale when the whole town seems to go mad for a day. The pageant is in the theme of the name of the town —Capio. Couples and even groups appear in the central square in costume depicting bondage. Lavish pries are awarded for the most imaginative groups, the best dressed, etc. I attended this festival with my wife in 1936. I of course bound her in a rather unimaginative way. As I recall, trunk straps around her wrists and elbows and a belt through her teeth and fastened behind her neck. I prodded her through the crowd with one of her hatpins. No one so much as noticed us. And, of course, we won no prizes. However there were some amazing tableaux.

Sincerely, J. Jordan

A Chastened Admirer
of "Lady-Masters"

Dear Sir:

It was with strangely mingled feelings that I read Ursula's answer to my letter entitled "Down with Slaverettes." Shock, wonderment, outraged pride, indignation all assailed me in turn, but finally finding myself fascinated by the truly amazing human document I read and re-read it — digesting it carefully, for to be perfectly truthful I simply couldn't credit the evidence of what it contained when I read it first.

Now, Mr. editor, feeling somewhat chastened, and my ego somewhat punctured after having assimilated a few bitter sweet but inevitable truths, I should like to learn more if the lady would be so kind as to enlighten me.

I can sincerely say that never — never have I known a lady to be so utterly candid; so amazingly truthful, or so ingeniously clever in defending her position and rights to be "Lady-Master," or to maintain as right, just and proper, that man should be the humble, submissive but adoring slave of his lady, and should yield to her authority and accept chastisement as part of her strict but necessary disciplinement.

Now, lady, I am sure many of the readers of both sexes would like further enlightenment on this fascinating subject of how to enforce discipline against a perverse but adoring husband, for we all know that even the best of mates can be obstinate at times, and since there are men who seem to be willing, even eager to be enslaved I don't think you need be afraid of frightening them regardless of what you say, and of course the ladies especially the younger ones would no doubt welcome any ideas or suggestions on this subject.

Please let us have the gist of your technique. For example: How far can the dominant female

My! what'y doing over there?

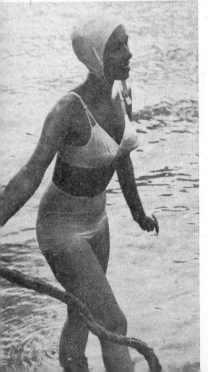

Oh! just splashin around —

— splashin around.

go in the matter of corporal punishment or chastisement without her mate becoming stubborn or sullen? Must a "lady-master" always rely on her beauty and feminine charm plus her will and intellect to maintain discipline, or must she make use of other means as well?

Do you not agree with those dominant males who advocate special restrictive devices — such as those pictured in vols. 2, 3, and 4 for erring wives, that the dominant female has the same right to apply them to her erring or mischievous husband for his own safety and well-being?

Being a person with a facile mind as your letter so plainly indicates doubtless you have acquired some truly intriguing ideas

in the matter of proper and effective chastisement, to be applied against an offending husband who still insists on clinging to foolish or harmful ideas, or who sometimes seems to be backsliding to his pre-marital status of indolence and irresponsibility.

I believe many gentlemen who apparently believe in love at any price regardless of loss of liberty or submergence of will, would be fascinated by your ideas of feminine dominance.

Yours,

Slightly Chastened

Dear Sir,

Especially interesting was "Esne's" letter, since I am a fellow-sufferer with him in being under the strict domination of "Madame, my wife." And how well she asserts and maintains over me the control which she loves — and how she delights in displaying that control to her various lady friends!

"Esne" relates how he was once made to appear before some of his wife's friends wearing one of her black lacy chemises visible under his open shirt. My own wife is less subtle and infinitely more cruel! For instance —

Bidden to Madame's room, I was compelled, under her cane's unmistakable threat, to let myself be arrayed in little white lace-frilled drawers, and frilled petticoats. Madame herself buttoned me up, and tied the drawtapes at neck and wrist of my petticoats, imprisoning me, then gloatingly watched me don a pretty child's frock — the high, smocked bodice hugging my chest, the skirt very free and absurdly short.

My arms were tied behind my back at wrist and elbows, and I was gagged and blindfolded. Then downstairs — to a drawing-room full of amused and excited ladies I could hear but not see! And the exquisite humiliation of being cuddled and caressed by my unseen tormentors.

To this day, I don't know who they were!

Yours truly,
John G.B.

PLEASE! PLEASE! PAULA.

Dear Editor:

I do hope you can either publish this letter or forward it to your correspondent Paula Sanchez whose letter appeared in No. 13. Oh Paula, *please*, PLEASE, PLEASE write more and more letters in every issue darling, and just to make things utterly perfect couldn't you or your friends illustrate your promised letter about the Paris Corset Slaves? Or perhaps you could persuade the Editor to get J.W. to illustrate it for you. I could read your letters for hours on end and everyone I've shown it to feels the same, we simply adore your idea of plump, tight laced beauties, we're fed up to the teeth with modern, half starved figures. We've often dreamed about our ideal lady. She'd be a real heavyweight, with tremendous contrast between ample swelling bust, tiny waist and prominent "rear curves," tiny little size two feet tottering on towering pencil heels, heavily made up face, bright yellow curls, loads of jewelry everywhere, long

red finger nails and a dress that threatens to burst assunder at the pressure any minute. She'd be a real artificial, helpless doll only just able to walk with tiny, tottering steps and if by any chance another correspondent signing himself 'Smart Horseman' could give her a lift in his lovely smart horse carriage — well that would make *all* his dreams come true. *More*, MORE, MORE, Paula, PLEASE.

<div style="text-align:center">
Yours,

Paula Sanchez Fan
</div>

Dear Editor:

I enclose some pictures. No. 1 —Black patent sandals with 6 inch heels. No. 2—Black patent pumps with very short round toes and 6½ inch heels. No. 3—Black kid boots with 6½ inch heels. No. 4— (*see front cover*) Black kid, 5 inch platforms, 10 inch heels.

This footwear is all size nine. I doubt that these pictures are good enough for publication, (*With all due respects to you, how much better photos can you hope*

1.

2.

Photo from U.C.

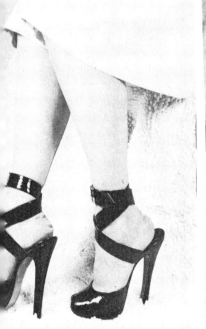

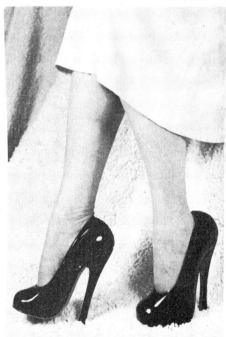

to get? ED.) but thought that they might interest you personally. Would be glad to receive any comments you might make.

I would like to see more space in Bizarre devoted to beautiful and unusual footwear.

<div align="right">
Yours sincerely,

U.C.
</div>

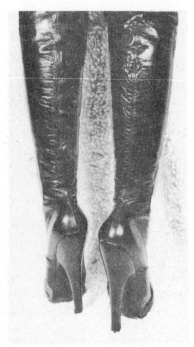

THE HOBBLE SKIRT'S RETURN?

Dear J.W.

Instead of a hobble skirt have a hobble slip. I couldn't expect my wife to go out in public out of fashion, but she could wear a hobble slip and get the same effect. We made one. It fitted tightly from hips to knees where it stopped. At the waist it was sewed to a wide leather belt and it laced from the widest part of hips up to the belt. Her appearance was normal but her walk was "different" and she couldn't sit down because she couldn't bend enough. If I locked it on in the morning she would have to stay fairly close to home as she couldn't sit in a car or bus. She could stand in a bus but she couldn't step high enough to get in.

There is another version. With a piece of flat chain about 6 ft. long and two padlocks a good hobble can be made. Several inches above the knees the chain is locked around both legs while close together passing the lock through a link in the chain in front after joining the chain behind. Then the chain is pulled up tightly at the back and locked around the waist. She cannot sit down or take long steps.

Frequently I would tie her hands behind her and then tightly pull them down toward the chain round her knees. She then can't bend over at all and is quite helpless. I start her off standing and when she is quite tired of standing she tries to lie down. This can't be done without a hard fall unless a sofa or bed is available. Sometimes I close the doors and keep her in the hall where there is no

furniture other than my desk which is not suitable. She cannot open doors because a heavy sock has been pulled over her hands and fastened with adhesive tape around wrists and knuckles making a single glove in effect. This is about as confining as the Chinese prison. (This was a very interesting article. Let's have more like it.) When a bed is available she simply falls onto it and is absolutely unable to get back on her feet again unaided. All the while she has no serious discomfort from the chain and tieing.

Yours, as ever,
"Doc."

BIZARRE EMANCIPATES A READER
Dear Sir:

My wife and I are anxious to know when issue #14 will appear, it has been a long time since #13 appeared and we are parched for the interesting contents of the next issue.

Since my wife has been reading Bizarre she has realized my interests are not so strange and that others do likewise. Thanks to you Mr. Editor I can now dress as I please on occasion. As a corset lover this means high heels and real original wasp waisted corsets laced to give a five or six inch reduction in waist measure. I have been collecting these for some time.

Issue #11 was very interesting especially the letters on pages 50 and 53 by Bette and Nicole. What kind of corset did Bette use and how about more from Nicole on how she first induced her husband to submit to feminine frills?

Yours truly,
R.W.

DECORATIVE ELDERLY TYRANT
Dear Mr. Editor:

I wonder if among your readers there are others, like me, who prefer older women? To me there is nothing more thrilling and fascinating than a middle-aged heavily built lady dressed up in every possible finery, heavily painted, powdered and mascaraed with long false eyelashes, long red nails, heavily bejewelled, her ample figure tightly corseted and shown off by a skin tight velvet or silk dress, her plump shapely legs forced into tight nylons with elaborate designs painted or embroidered on them, a golden anklet, and her little feet squeezed into the smallest possible lace-up shoes with towering pencil heels with the laces tied in large stiff bows which bob about as she minces along with tiny steps. I'd also like her to wear a diamond studded nose ring. I imagine her as a real tyrant, absolutely merciless in her treatment of her servants and her horseflesh (she would trav-

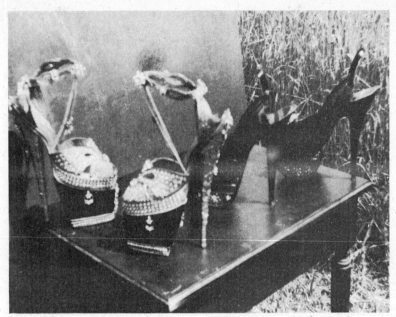

Photo from F.R.

el by horse-carriage of course). She would own vast acres of land and factories and houses, charging sky-high rents and forcing her employees to toil and slave for long hours to earn the lowest possible wages. At one time there *were* such women (and men) and perhaps there still are — people who dare to be different, wicked and cruel perhaps, but — oh how deliciously fascinating.

(*Obviously not a union man.* ED.)

Keep up the good work with Bizarre — it allows us freedom of opinion even if others don't agree with us.

Yours truly,
A.R.B.

JEWELLED SHOES

Gentlemen:

I am enclosing some pictures of shoes that carry heels varying in height from 5″ to 40″.

The heels 24 inches high and the 40 inch heels are called "lounging heels" which, of course, are too high to walk in.

Our basic NET height for walking is 6″. That is a heel that is 10″ high has a platform of 4″, or the 7½″ heel has a 1½″ platform.

Most of our shoes are covered with beautiful jewels and our heels which we call "Cigarette" are about the size of cigarettes in the smallest part of them. The

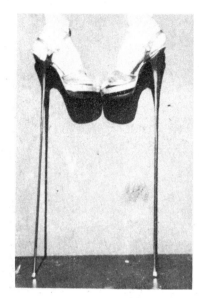

Photo from F.R.

shoes worn by the young lady in the colored pictures, 10″, are made of red velvet and gold kid.

Yours very truly,

F.R.

(*Owing to the very high cost of colour printing we cannot reproduce the colour photos sent in by F.R., which is a great pity because the shoes were the most beautiful we have ever seen.* ED.)

So Firm, So Fully Packed

Dear Editor Bizarre:

I am red headed and — let's face it — a fat girl, and for some years I didn't have much fun. That is, until I discovered the hour glass figure. About three years ago I took a look at myself in the mirror and said to myself: "What do you do when you don't like the shape of a sack of flour?" I'd tried every thing, but dieting makes me cross and haggard and made me lose the few friends I had! So I said: "No half measures. Let's get a real corset."

I started out with an ordinary modern corset and was surprised that the tighter it was the better I liked it. It bothered at first, of course, but I stuck it out till it felt like nothing at all. So I said: "If a little is good, more is better." I got the idea that I wanted an unusual figure. Whether they liked it or not people were going to notice this fat girl." So I laced in earnest.

They say: "Nobody loves a fat girl" but since I've poured myself into a wasp waist I can tell you it isn't true! I get all the dates I want now! Most men love that laced in, so firm, so fully packed figure the wasp-waist corset gives you. The extra size bouncy bosom and free-wheeling hips that go with this kind of corsetting fascinates 'em!

It's the first time in my life I'm glad I have a lot of extra soft flesh. I pull it up under the bosom in front and push it down to increase the hips. The full effects of tight lacings are impossible without a full figure to work on!

One of the first things I noticed

when I began to lace really tight was a very accented movement of my hips from side to side. When laced now my hips stand almost straight out to the sides, and sort of snap from right to left as I walk. I've discovered this sway or jerk or bounce of the derriere in the direction of whichever foot supports the weight is always part of the walk of a wide-hipped woman, but becomes quite emphatic if the waist is tightened and the hips left free. Mae West and all the strip teasers cultivate this feminine stunt, so why shouldn't I? I began dressing to show it.

The years I tried to conceal my big breasts! Now they stick out proudly over the high front of my corset. Even in daytimes I always wear a deep V neck. The breasts so supported press together in front and give me a cleavage of about six inches. You ought to see the eye popping *that* causes.

I work behind a bakery counter and I'll bet some wives are wondering why their husbands bring home so much bread! I used to wear flat heels, but I've discovered the higher the heels the better I look. The slight jar caused by walking in very high heels produces an eye-catching, quivering wave in the bosom which is not tied down in a brassiere, but is left free to rise and fall with the breathing in and out of an hour

glass corset. This rising, falling, gently vibrating bosom effect drew so much attention to my chest that I began to use make-up on my bosom as well as my face.

I have the creamy, pink and white complexion fat red heads often have, so don't use heavy makeup except around the eyes.

I have small hands and feet, wrists and ankles. I am convinced that I have kept my ankles slim by wearing tight laced boots part of the time for walking.

Being large lets me wear heavy jewelry which I use to accent the various points of interest on my new and different figure. I always wear a brooch where the cleavage disappears into the V. Evenings I wear a lavalliere that dangles just between the breasts. I like wide belts with big buckles. They make my waist look even smaller. I have many large earrings and bracelets.

I find men like clocked stockings which draw attetnion to a small ankle and spike heeled shoes. After getting used to them slowly I can now handle five inch heels. Balancing my weight on spikes took some self-discipline and practice, I can tell you!

Now I did all this because I was sick and tired of being just another fat girl but to my surprise it has turned out rewarding in other ways. I would never have

believed that very tight corsetting could *feel so good*. Even if men didn't like it I would now do it for my own feelings.

Anyone who has not gone in seriously and with determination to lace to the utmost and stay that way, as I did, could never understand this. At first you think you'll never be able to stand it, but the time comes when lacing extra tight is joyful and exciting. The massaging motion when I move in my corset causes indescribable pleasant feelings in the pit of my stomach and down my thighs. I often simply quiver with delicious excitement when lacing up. Also the movement when walking I have described before feels good in the stomach, hips and in the breasts. You sort of know they are there in quite a new way because of the involuntary artificial and unusual motions set up by breathing and moving in the hour glass corset. The slight unsteadiness added by high heels increases these feelings.

I have never fainted from lacing, but I think it might be pleasant to be laced till I fainted. I always lace until breathing is fast and I am slightly dizzy.

My corset problem is a tough one. Luckily I know how to remake ordinary corsets to fit me. I have one which laces both back and front and at the sides over the hip bone so it can be shaped in any way. This and others I have made by putting together parts of several corsets.

So I pooh pooh the fashion-starved slim-jjims. It may seem odd, but I love to lace tightly and then simply stuff in good food! I love that tight, full feeling and I know any extra weight can't add to my waist — it can't give. I always sleep in my corsets and wear a non-stretchable metal link belt around my waist.

The resulting figure thrills men I go out with and stimulates one to the utmost. I was just another fat girl till I discovered your magazine and the hourglass figure.

Yours,

Polly H.

A TRIFLE EMBARRASSING
Dear Sir:

How nice to read "Shackled Susan's" letter in Bizarre No. 8 and to know that other wives besides myself enjoy the pleasures of being tied up and fettered.

During one of the "punishment periods" to which I am frequently subjected, in addition to a gag, I am often blindfolded as well, and I love being so completely helpless. My husband loves showing off his powers to his special men friends, which I find embarrassing but secretly rather thrilling. My costume for these occasions is a short, tight-fitting black silk frock,

white bloomers, and black stockings. It makes me feel very self-conscious, as usually I am tied up in such a way that my bloomers are showing; also the dress is very low-cut, and I am not allowed to wear a brassiere. But his friends seem to enjoy these displays, and once I am tied up I can't do anything about it. And, in any case, as I say, it is quite a thrill to know that I am the centre of attraction in my pretty helplessness.

Several of his friends are allowed the "privilege" of actually tying me up, and during the process I have received many intimate little handclasps and squeezes, and stolen kisses that are very thrilling when you are helpless and can't do anything but surrender unresistingly.

Yours sincerely,
"Bond Wife."

BREECHES AND BOOTS
Dear Ed:

I agree with your reader, B.D.E., that the charming miss on page 46 of Vol. 7 is wearing an ideal outfit for a day in the country. Snug-fitting breeches and matching field boots enhance a woman or girl's natural feminine loveliness, and if worn over a short, tight-laced, form-moulding corset for mature women (i.e., mature of full figures), and a snug-fitting pantie girdle for young girls of slender figure, it would be the perfect costume for those of the opposite sex who are outdoor lovers, and who like to romp and play in the quiet, peaceful countryside far from the smoke, noise and uproar of a great city.

For ultra-fashionable wear I favor a riding costume of black glace kid boots (ultra-high heels); skintight blouse of silk or satin; shiny black riding breeches of soft leather and a bandeau for the hair. Such an equestrienne mounted on her prancing, spirited steed would be the envy of every woman and girl, and a source of boundless delight to every red-blooded man.

I regret that I am unable to furnish the readers with a photo of such a horsewoman but perhaps J.W. could manage to get his hands on one.

Yours sincerely,
Lover of Smart Riding Costumes.

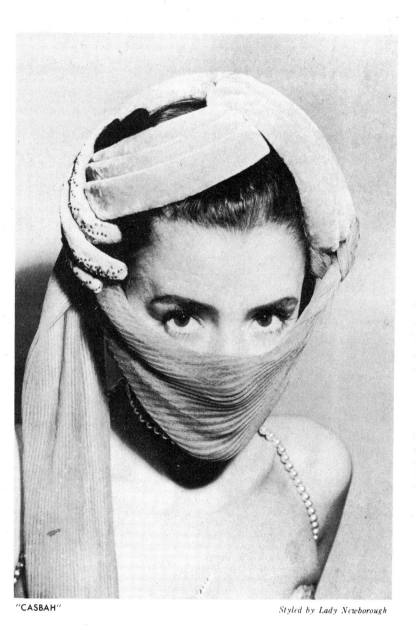

"CASBAH" *Styled by Lady Newborough*

a pale grey turban with emerald and diamante embroidery,
and, emerald scarf permanently pleated as a "smog veil."

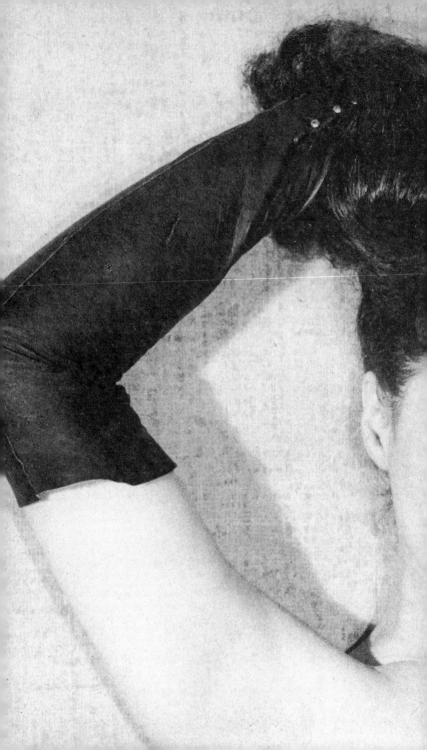

Bizarre

Nº 15/16

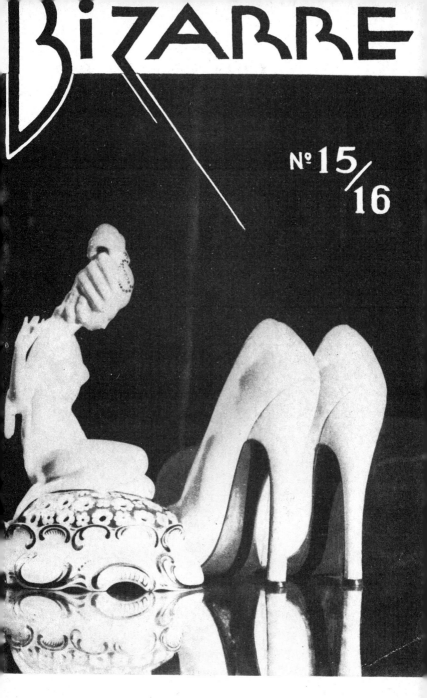

CORRESPONDENCE ISSUE

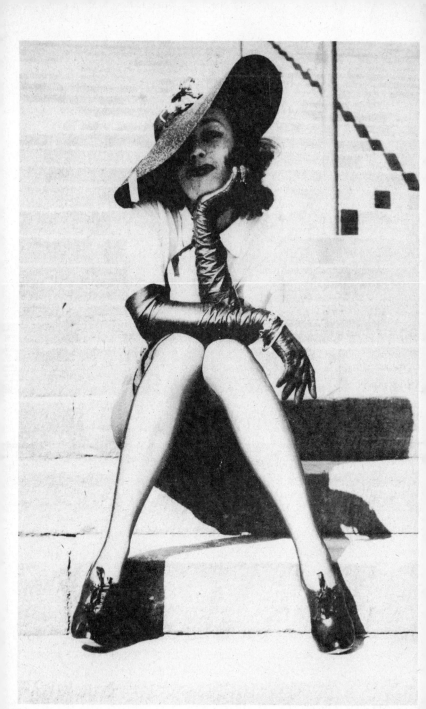

BIZARRE

Copyright 1955 by John Coutts

"a fashion fantasia"

No. 15/16

Dear Reader,

Please accept our apology for our carelessness in reprinting in No. 14 some letters which had appeared in earlier issues. This was a mistake on our part, caused, we can only assume, by the confusion of moving our offices.

That was bad enough but now you'll murder us, because Paula Sanchez wrote to us again in response to the many published requests for more — and though we've searched high and low we cannot find her letter. All we can do is ask, on bended knee, and on behalf of our readers — that she write again.

We hope you like this jumbo number — it's an effort on our part to cut down on the mountain of letters we have received.

(—and if you are a "New Reader" and cannot make out what it's all about we suggest you get the back issues and thus get your bearings.)

CONTENTS

Page

PLEASE DO NOT ORDER

the next issue — No. 17

We will advise you when it's ready.

We appreciate advance subscriptions — but — they make our bookkeeping more difficult.

Thank you, Editor

FOOTWEAR FANTASIA

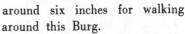

Hello Readers! and if it isn't too late, here's wishing you all the height of happiness for the coming New Year and Sylvia, being what Sylvia is, that height would be

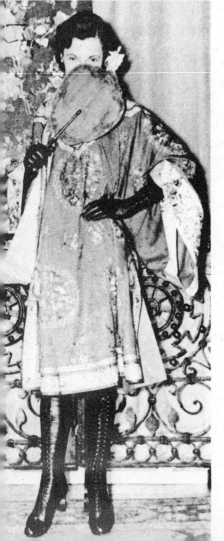

around six inches for walking around this Burg.

Got all mixed up in a Christmas party as a Geisha. It's merely that after all one cannot go to Christmas parties always in kid panties which tempted me to dig out my Chinese Bridal gown, a magnificent affair emblazoned with pink, green and yellow flower designs. There is a long skirt that goes with it, but Alas! it hides one's high heels far too much.

Someone at the party remarked "leave the skirt off Sylvia" and that set me thinking that after all, with such a three quarter length coat, what was wrong with showing everyone a little splash of delicately sculptured limb, so off came the skirt. My six inch heeled gold kid sandals were given due admiration.

Another girl I was intrigued to see, had arrived in a pair of very neat black knee-high boots, with a smart tailor made suit, and a slashed skirt that gave a pleasant glimpse of her scarlet silk garters worn just above her knees. At first I thought she was the rather severe type, but we soon got chatting and she told me that

whenever she and her husband went out to parties, she always found it best to keep the poor little man well to heel, especially after he had one or two more than was perhaps good for him. The furtive little glances that he kept giving her booted legs somehow told, all too clearly, that he knew his wife's strong points all right.

Believe me it was not long before she and I had found a good deal in common, and agreed to slip into one another's footwear, she seemingly was fascinated with my Gold spiky heeled sandals, while, believe me, I was as intrigued with her gleaming little boots. How they were going to look with my Chinese gown I wasn't really sure, though it wasn't long before I could sense pretty well that my rather mixed outfit was causing quite a little stir. Anyway I am sending these pictures specially to Bizarre's pages, so you, dear readers can judge for yourselves whether a little 'East and West' makes sometimes a pretty mixture.

Jennie, (that's the girl whose pretty little boots I am speaking about) was jolly decent about it

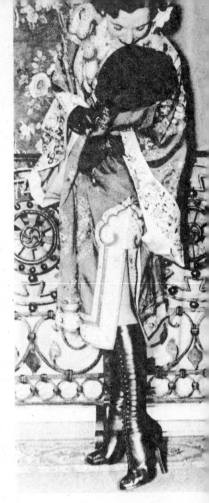

all, in fact she loaned the boots to me for the week-end so that I could have some really special Bizarre snaps made in them showing the little black kid skirt I made up myself recently just for party occasions.

When we've made them I'll send them along — 'Bye for now.

"Sylvia"

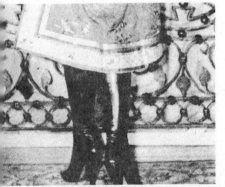

THE MAGIC ISLAND

tale from bottle No. 6

We collected our team from the parking lot and I noticed that the restraints, though attached, had not been tightened.

The little groom holding the ponies' head looked up expectantly as we climbed aboard. "Shall I buckle up?" she asked.

"No — that's alright" Malua answered taking the reins — and then to the team "But if there's any nonsense my beauties on they go again! — Hard!", and with a click of the tongue and a flick of the whip we were off, the team weaving their way through the congested, homeward bound, traffic with almost no assistance from the driver.

The run out to the home of the other "Radiance" was uneventful — so far as the ponies were concerned. They knew they had several miles of winding climbing track to cover, and once we had the road to ourselves they cruised along with that smooth, swinging, ground devouring stride.

Relieved of the task of curbing them Malua relaxed and seemed to recover some of her good spirits. Soon she began singing soft-ly in time to the rhythmic jingle, jingle of the elbow chains, and the soft pad-pad-pad of those little flying feet, now flashing in the sunlight, now whispering through the deep green shade of the trees.

The track wandered, as lazy as the day, winding along from one lovely spot to another as if in no particular hurry to get anywhere. But in front of me, always, were those graceful, rippling, golden brown bodies, the sun flickering on the polished leather, and buck-les, which held them so simply but so effectively controlled. It was pretty hypnotic.

Pad-pad-pad — we would flash past a gigantic Rhododendron towering above us in full bloom; jingle-jingle-jingle, and we'd be driving through the flaming centre of a great clump of canas from which dozens of huge butterflies would rise to flutter awkwardly around us.

One would settle, wings aqui-ver, on a golden brown shoulder, and a blonde head would shake and the harness would creak as brown arms and wrists tried to tear themselves free — until a

lazy flick of Maluas' whip dislodged the innocent tormentor.

Every now and then we would find ourselves in a clearing with fields on each side, or maybe an orange grove, or an orchard. Here and there we would catch a glimpse of a little thatched house tucked away in the trees — and then back again we would be in the thick woods.

I was jolted out of my reverie, and damn nearly out of the gig at the same time by the team wheeling sharply off the track and up a garden path with a screen of climbing roses on our right, and on our left a well-kept flower bordered lawn that sloped down to a pool. Ahead of us was the house — deck chairs beckoning in the shade of its wide verandah.

Malua reined in the team and gave a loud "Hoi" — which was answered by a "Hi", from somewhere around the back of the house. Then she got out of the gig, and as I followed suit, she reached under the seat. There was a jingling sound and she drew out a collection of chains and straps.

"Here — Jimmy — help me put their hobbles on" — she said handing me a short length of chain, at each end of which was a strap each decorated with four little bells. Fascinated I took the thing and examined it, then bent down to adjust it around the ankles of the near-side pony, who obligingly separated her feet slightly to make things easier. It was such an intriguing task that I only had one slender ankle buckled, and was fixing the other, by the time Malua had hobbled both the other two ponies. However, at last I had the job finished and straightened up to find that she had unhitched the team from the gig, letting the shafts drop to the ground. She then began unbuckling the bits, so now being quite an "all-around-willing-Willie" — I lent a hand. Unfortunately when I started to do so I wasn't quite sure where to begin. This bit was quite a complicated

6

arrangement of straps and so on.

"You only need to unbuckle the bit strap at the back of the neck," Malua said over her shoulder, "and then you can clear the whole thing over the top of the head — the bridle stays on."

I followed instructions and two straps then hung down from each side of the brow band, slipping through the rings as I eased the bit out of the pony's mouth. Incidently she had to open her jaws to the limit for me to do this, for this bit was quite a formidable affair with a great chunk of knobby wood inside the mouth. The knobs, though smooth could still be extremely unpleasant to tender skin. To give added force the ends of the bit bar were bent down at each end making a four inch lever, to the bottom of which the reins were attached. Any sudden tug and the pony knew all about it — it was no wonder that they had been so well behaved. However, I soon realised that they were as unsubdued, and as full of mischief, as ever.

Their chins were all wet — any bit makes them dribble like blazes all the time — so I wasn't surprised when the first one to become articulate said "Oh — get the tub please Malua — and I'd like a drink too if I may." — but her voice only followed her driver as she disappeared into the house, to reappear a few moments later with a shallow wooden tub full of water, which she placed on a shelf — all houses have one for this special purpose, — just outside the steps leading onto the verandah.

The ponies gathered round and with closed eyes began sloshing their faces about in it, one after the other, and then looked up expectantly, for Malua who had disappeared again.

This time she returned with three shallow bowls, filled to the brim, which she also placed on the verandah rail and each pony immediately moved towards them, hobble chains jingling.

I watched the girl nearest to me bend over and begin to take a few sips, and it seemed to me that though very pretty and attractive from the onlookers joint of view, it must be extremely awkward for the drinker. As she couldn't use her hands I thought I'd lend her mine, so, when she raised her head to take a breath, I took the bowl and held it up. She paused, looked at me for an instant and, as

I approached the bowl to her lips, began to drink looking up at me over the rim with twinkling eyes.

The other two stopped lapping and regarded me with a pleading look that would have melted an iceberg. I heard Malua say "Jimmy, you devil, you're spoiling them — you *never* help a pony to drink."

"But I do" I called back over my shoulder — "these ponies anyway" and the next thing I knew was that I was surrounded by those three lovely damsels, who, as they couldn't put their arms around my neck for greater encouragement, did the next best thing, and wriggled their soft little bodies against me, and wheedled for a sip with laughing eyes and pouted lips. What the hell chance had I got. I don't know if you've ever given a drink of wine to a girl with her hands tied behind her back but it's quite an experience. However, this delightful pastime was interrupted by Malua tapping me on the shoulder.

"Jimmy" she said "these little pigs will let you go on all day feeding them like that — stop it — we've a most important deal on hand, and darn you I have a sneaking suspicion that you are going to achieve the impossible."

"You never can tell" I replied — still engrossed in my task. But the bowl I had been passing around was now empty so I put

it down and avoiding those eyes — and the so softly whispered, "Just a little teeny bit more — please Jimmy darling," I followed her ladyship onto the verandah, and into the living room, just as our hostess came in through another door carrying a great beaker which obviously contained more wine.

"Good heavens" she exclaimed seeing our empty hands, "where are your bowls? Haven't you had a drink yet. Malua, what a way to welcome a guest to my house — but I can soon fix that." She quickly produced three pots, filled them from the beaker, and then turning to me said "—and my name is Rosalind, but most people just call me Roz, — and yours?" I told her. "Good" she said "I like it — and now let's find out what particular reason brings Malua and you out to this joint."

We sat down and Malua explained the situation, at which Roz threw her hands in the air. "Do you mean to tell me," and her glance went from one to the other of us, "that you want to use Judy — my quite utterly hopeless Judy as a pony?"

"That's the general idea," I grinned, "is she around?"

Roz opened her mouth wide in amazement "She's around" she said, "around near the back of the house finishing the washing — at least she's supposed to be — but

8

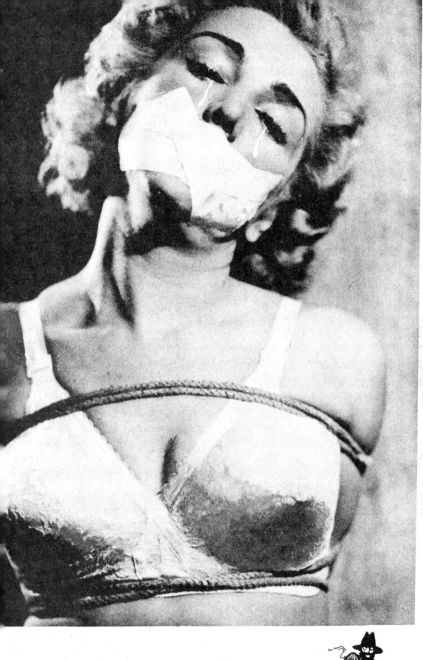

DON'T LET THIS HAPPEN TO YOU

learn jui jitsu and the art of self defense

a pony! Jimmy you're crazy — Malua shouldn't do this to you. Here let me fill your bowl again and we'll rassle this thing out. My daughter's hopeless — quite quite hopeless!

"Can she run at all?" Malua asked.

"Can she run!" Roz exclaimed leaning forward in her chair, "She can run like the wind, the little devil. I swear she can run faster than any girl on the Island — but she won't — at least not when you want her to."

"Then hold on a moment" said Malua, tapping the ash off her cigarette —

"This miserable man is a horse trader of the lowest type. He's just got one Radiance for himself at the sale today who is terrific — between the pair of them they fooled everyone including me — and now he's after another — I don't trust him a yard — in fact I'll take a bet with you right here and now that if he gets Judy too his team will beat mine, impossible though it may sound to you Roz!" and she took a long swig of her drink.

"No foolin'" said my hostess "Then take her Jimmy. You can

have her for nothing — but don't blame me if things become one heck of a problem.

"Fine" I said raising my beaker, "we'll drink to that — and my success, and now how can I view this problem child?"

My question was answered by some cheerful female voices outside, and a blaze of light on the verandah as the sun caught another of those fantastic heads of hair. Then gliding, with a motion that only Suhanee could have rivalled, into the room came one of the loveliest of all the lovely creatures on this island. Things were getting a trifle out of hand. It was one thing to see a lot of gorgeous damsels as a group, "the crowd effect" was so stunning that the impact of "one" was lost, but when you got down to individuals it was a different matter — and I was beginning to wonder where I was heading, and whether after all I was as fond of Malua as I had originally thought. Everyone I'd met so far was a born witch, each apparently determined to sink the unfortunate male, and it seemed to me that unless I played them at their own game — and a bit over — I'd be reduced to a pulp.

Suhanee was a menace and now this one, as she came toward us with the same lithe grace — was just as bad — if not worse. I was very glad when her mother said,

by way of introduction —

"Judy — this crazy young man wants you to be a pony — and I've told him he can try and make one of you."

Judy smiled, impishly — and wiggled a bit.

"You can stop with Aunt Cynthis down in the main village and if you're good come home for the weekend" — and then turning to me — "And Jimmy — if she doesn't come home for the weekend I'll know why — and good luck to you!"

"Now you two make yourselves comfortable while Judy and I get some things together, and she can go back with you right away — I suppose that's what you want, though I'd love you to stop for dinner and have some tennis."

"I'd love to stop too" Malua answered "and so would the others I'm sure, but I want to get Jimmy organized — though why I should try to organize such a disgusting old horse trader I don't know — just look at him! Roz! ! — did you ever see such a look of smug contentment on anyone's face?"

"Determination is the word" I answered sitting back, fingering my glass, and trying to look superior. "Determination and fortitude!"

"Determination my foot" Malua retorted getting up from her chair — "I'll save time by getting my

monkeys harnessed up — come on, Jimmy you can go on drinking and watch."

This seemed a good idea, so I gave Roz a wink, as she refilled my cup and followed Malua onto the verandah and sat on the top step.

Our ponies were grouped around a bed of magnificent roses—(Roz, I later discovered, was famous for them) — but when Malua called they came obediently — moving across the grass with little hobbled steps — ankle-bells jingling.

Without further order they placed themselves between the shafts — or at least the center one went between the shafts, which Malua raised and strapped to each side of her waist belt, the others stood on either side.

So quickly did Malua move that it seemed only seconds before the out-siders were buckled too and the braces adjusted. Then each pony opened her mouth and the bits were put in and strapped in place — followed a few minor adjustments and their mistress stood back to survey her handiwork. She seemed satisfied.

11

But for some reason, maybe a look in the ponies eyes, maybe some female quirk or something — I don't know — she suddenly moved round behind them and began pulling the first one's elbows back — exerting a certain amount of effort in the process. Then she moved on to the next and I saw that the first one now had her elbows linked till they almost touched. The same thing was done to the other two. The effect was striking. I thought they had stood erect before, now they were terrific!

My interest in this performance, and my drink which was excellent, was diverted by the return of Roz and Judy — the latter I noticed had changed from her sarong and now wore only the usual pony belt and tassel. In her hands she carried a medium sized basket which she at once put into the gig and then returned and stood in front of me, looking mischevious and expectant.

I'd forgotten all about Roz until I heard her say "Here you are Jimmy — and tie her up good and tight — she's a perfect little devil for getting out of things."

I turned and saw that my hostess was holding out some cords to me and that the end of one was spliced to a short strap.

"What do we do?" I asked, laughing, and a bit puzzled. "Hogtie her and throw her in with the luggage?"

"That would be a good idea," Roz replied "but actually all you have got to do is tie her hands, put a halter on her, and she'll run behind.

So I took the cords, and as I moved towards her, Judy obediently turned her back and crossed her wrists behind her.

It was an odd feeling tying those little hands — a new experience — but it seemed quite the natural thing to do and I tied them tightly.

Suddenly it occurred to me that the other ropes hadn't been given me just for fun and that I had to take rather elaborate precautions. The way I had tied her wrists she could perhaps get them free by spreading her elbows, and pulling her hands away from each other — it would be difficult but still, — so I passed the cord around her elbows and drew them back towards each other. This of course made the cords round her wrists tighter.

She could wriggle out of knots could she? then I had to prevent it so I draped a cord over her shoulders, under her arm pits and around her chest — tightened it — then laced the elbow lashing up to it — so that it couldn't slip down her arms.

I picked up the last cord — a long one, with the strap at the end — and looked at Roz. "This the halter?" Roz nodded — so I

12

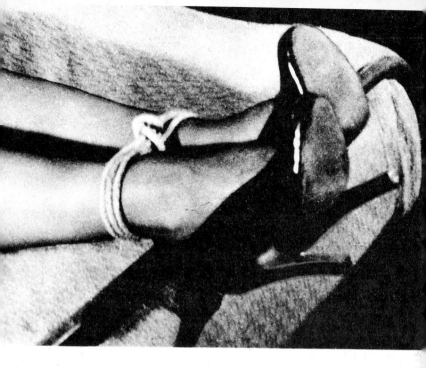

HAVING FOOT TROUBLE?

Then don't wear shoes too small, and too tight.

buckled it around my pony's neck and going over to the gig tied the end to a convenient ring at the back of the seat.

"A very nice job, Jimmy" Roz remarked, "very neat and I should think effective — treat her like that all the time, and don't let the little imp get you soft." I looked at Judy.

She stood there on tip-toe shoulders back, head held high — with an expression which seemed to say "well — now you've got me — and I don't mind it in the least — so what are you going to do about it."

I thought I'd adjust the halter strap a bit tighter, so I went over to her and as I bent forward and was working at the buckle I felt her parted lips brushing against my forehead — slowly — and deliberately. Without looking up, I leaned forward pressing slightly harder — the lips pressed back. This was indeed interesting.

TO BE CONTINUED

13

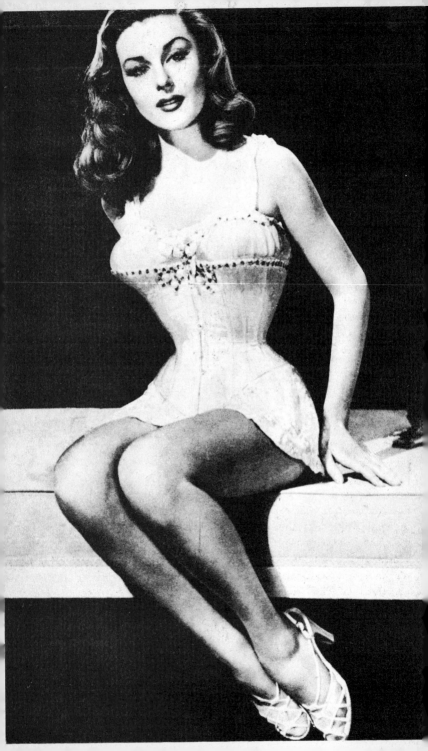

orrespondence

Under no circumstances do we publish names and addresses, nor do we put readers in touch with each other. If photos or sketches are sent in, please write a short commentary and please do NOT send in photos which you got from someone else.

FOR THE DOMINANT DAMSEL
Dear Editor:

The delightful and charming letter written by the lady who signs herself 'Babs' should be an inspiration to every lady who sincerely desires to be boss in her home. Truly, Babs is to be congratulated on having solved a domestic situation so cleverly and ingeniously, and it is to be hoped that she will not relent in her stern discipline of her erring hubby, but will continue to keep him firmly and securely under the feminine dominance she has imposed on him.

It is said that men do not wish to be enslaved by women. Well, the real truth of the matter is that the submissive, masculine type of man who is quite numerous to-day yearns for the delights of feminine servitude, and instinctively he turns to the dominant feminine type of woman for in her he realizes he will find the happiness he is so ardently seeking.

This type of man can be distinguished from the dominant masculine type by his extreme unselfishness toward women. A woman's health, happiness and pleasure always mean more to him than anything else in life. He has a natural desire to please which shows itself in his speech, manner and habits, but it is in his interest of feminine attire that he exhibits his natural submissive nature so clearly and distinctively.

To him feminine clothing possesses an irresistable allure which symbolizes everything that is beautiful; fascinating and captivating to his submissive nature.

He has highly refined, feminine tastes, and usually a knowledge of feminine clothing which many women might well envy. His instinctive preference is always for the colorful, the tasteful and the most feminine of attire, and if encouraged he will not only do everything to please his mate by selecting the attire most suitable for her, but he will also yield utterly to her will if she compels him to wear the clothing of her own sex.

15

Such a man really is unhappy and colorless when dressed as a man. He has a dislike for the mannish attire which social convention forces him to wear which amounts to a phobia because to him it connotes ugliness and unnaturalness, and the wife who parades around in such attire or who foolishly ridicules his preference for feminine attire will very soon regret her foolishness.

Ladies who have the same ideas as the charming Babs should compel their mates to wear the most restrictive of feminine attire. Heavy boned corsets; silk bloomers or knickers; fine nylon or silk stockings; frilly petticoats; high-heeled boots or shoes, and the most snug-fitting skirts and blouses imaginable.

The aim of these ladies should be to transform hubby into a charming French maid dutifully obedient and humbly submissive to the ladies' every desire, wish or whim. It can be done if the ladies have initiative and persistency and will apply themselves to the task of eliminating that ugly mannish waist by the judicious use of rubber reducing girdles and tight laced corsets.

Put your mates in corsets ladies and forbid them to remove them. Make corset slaves of them and you have them just where you want them — utterly in your power. Best of all a corseted man will

not make passes at any woman but you for fear of ridicule, and the garment by its resistlessness and rigidness will always serve to remind him that he is wholly in the yoke of his willing bondage.

Once you have forced him to be your maid do not relent no matter what he says. His protests if any, are to be ignored, because they are more designed to test your authority than they are expressive of any real desire for freedom. Actually, what he really yearns for is for you to impose a greater degree of authority and control over him.

Tell him that you intend to not only enslave him, but that you'll never permit him to regain a vestige of freedom again. Make him swear obedience and submission to you, and compel him to agree that you as his "slaverette' have the right to impose any punishment you may see fit.

The strictest of discipline should be imposed to mold him into the most ideal type of slave consistent with your tastes, pleasures, ideas and inclinations. Like Babs don't be afraid to use the strap, hairbrush or palm of your good right hand across his bare seat. If possible draw up a list of offences, and make him memorize them so that he'll see that you're not fooling; then when he disobeys or is slow to heed you chastise him according to the prescribed penalty.

Always administer a chastise-

ment in the most leisurely manner possible in order to increase its effect, and select for the occasion a costume which will impress him by symbolizing your authority over him as your slave.

Before administering a really good spanking you should have the culprit in such a position that either protests or resistance will be absolutely impossible. The use of restrictive binding cords or thongs for ankles, legs or wrists are to be recommended, as well as a suitable gag to impose the silence required in such proceedings.

Naturally, the clever 'slaverette' will adopt various forms of punishment besides corporal punishment or chastisement, not only for the sake of variety but also to increase the degree of slavery which she wishes to impose on her hubby.

The 'slaverette' should gradually increase the degree of slavery which she deems necessary, and she should exercise the utmost of sternness and determination while subjecting him to the various degrees of discipline which every male slave should be compelled to undergo.

Sincerely yours,
Admirer of Feminine Slavery

SLENDER HIGH HEELS
Dear Sir,

Next to a beautifully corseted figure with a slender ultra-feminine waist and exquisite earrings, the most appealing thing to my way of thinking is the high "spike" heel as depicted in your many delightful "high heel" studies.

Personally I think it most unfortunate that so many ladies seem to be unaware of the attractiveness of a slender feminine foot, and the sense of utter buoyancy that "high heels" alone can give, not to mention the delightful feeling of superiority that the added stature must impart to the wearer.

Please let us have many more high heel studies, especially thigh or even hip length boots in black or brown kid for riding, walking or promenading for discriminating ladies, which I am sure would meet with the hearty approval of many of your feminine fans. As well as that of Achilles.

Another thing of interest for the magazine would be a series of novel riding costumes for ladies or gentlemen introducing the use of black kid, plastic or rubber, both for ordinary and inclement weather, showing the application of high heels for riding, and the use of either sidesaddle or ordinary saddle for riding. With the various riding gears, etc.

Then of course there is the interesting subject of "high heel"

length to consider. What is considered the maximum length or height for high heels? And is it possible for a lady with a small foot to wear extremely high heels? Must the length or height correspond with the length or size of the foot?

I should be grateful if Achilles or someone else would write an article on this all-important subject, as I have met some ladies who claim that even 5½ inches is too high for many of their sex to wear, and that only ladies with very large feet can wear anything higher than 5½.

Sincerely yours,
Fred Mac

LOOKING FOR TROUBLE?

Dear Sir:

Since I do enjoy reading your curious little magazine, I feel it is high time I let you know about it. I am particularly interested in your articles and pictures about the wearing of rubber and the various methods of bodily restraint. For a long time I thought I was perhaps rather isolated in my interest in ropes and chains, etc., but your magazine has given me great encouragement. It is my hope someday to meet someone of the female sex who is as oddly inspired as I am. We could have such fun together, even as some of your contributors who seem to have found common ground in

their strange interests. I am indeed jealous of the fellows who have wives to truss them up and chain them and force them to undergo strict punishments and humiliating discipline.

Again may I say that it is a great relief to know that I am not alone in my bizarre interests. Please keep up the good work.

Sincerely,
Don

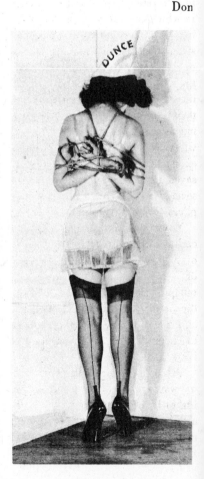

18

Dear J. W.

I enjoyed particularly in #7 the letter from Gertrude M. entitled "Discipline A La Francais" in which the whipping of a young french girl is entertainingly described. It is my belief that there should be much more correspondence and editorializing on this subject, and I am especially anxious to receive an issue (or issues) in which the entire field of spanking, whipping, etc. by hairbrush, strap, switch, and whip is thoroughly discussed. I myself could probably contribute some intriguing theories and suggestions on this neglected topic, prodded by memories of an angry step-mother who was perhaps not always angry enough, and could perhaps have saved me later unhappiness by a severe and prolonged series of applications of the whip.

Your readers' letters of the discipline of boys of difficult age; and of methods used by one member of a married couple to keep the other in line are fine. I have felt the need of the whip all my life, and have long been fascinated by the belief that a woman can dominate a man.

Of considerable interest also to me was your mention of the wearing of high-heeled shoes and other articles of "women's clothing" by men. Indulgence in this diversion from time to time can be a real help in escaping from the humdrum of daily routine.

I found pleasantly stimulating the description in issue #7 of the tantalizing outfit worn by Miss Daphne Atkinson to the New Year's Eve party of her Modern Misses Club. The full bust is a woman's loveliest charm, and the ways of attractively displaying it are almost endless. In cases where the partying folks are all of the same mind the display of swelling breasts carefully treated with matching cosmetics can add much to the enchantment of the evening. Incidentally, one way (perhaps not always to milady's liking) of displaying above-the-waist curves is at the old-fashioned whipping-post. I sometimes think that restoration of this much-maligned institution would be very much in order for some of our modern brats of "respectable" families. Perhaps one of your subscribers would enjoy discussing this matter with me through your correspondence column. For although conscious of my own need for correction from one qualified to give it, I can quite easily hand it out to any naughty female needing (or requesting) it.

Issue #7 devoted much space to high-heeled footwear. Now I'm all in favor of highheels, but when they're supporting some round-hipped, full-bosomed creature with a well-corseted waist and nylon

mesh stockings, not when they're simply on display in foot-racks "tout en ron." Of course, it takes all kinds to keep a magazine going, so I suppose I shouldn't expect it all my way. "Chacun A Son Gout," y'know, which, as everybody knows, is French for "chacun a son gout."

And if you don't think there's a circonflexe over that "u" in "Gout" get your nose out of that beer, Editor, and take another look at that lil' ol' French dictionary (Heath's of course).

<div align="right">Q.E.D.</div>

(*La plume de mon linotype-homme avait l'accent "acute," "grave" mais — PAS le circonflexe! Merde alors!* ED.)

CANE PLEASE

Dear Sir:

In regard to Corporal Punishment, there are a great many men and women to whom this activity holds a strange appeal as several of your readers' letters showed. Although there is no doubt that the use of the whip and rod was overdone during the last few centuries leading inevitably to a reaction against it in favor of psychology today, yet I know there are many that feel with me that the reintroduction of a light cane into schools would be of material benefit to the younger generation.

<div align="right">Yours faithfully,
R.E.H.</div>

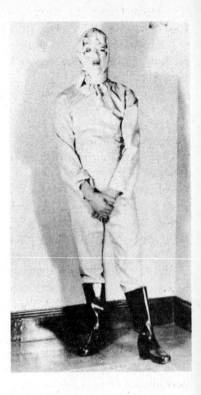

THANKS FOR RUBBER

Dear Sir:

I want to express my sincere gratitude for the thrilling type of magazine that you are publishing — it is indeed a wonderful service that you are performing for those of us who are unorthodox the country over and as you must know by now, mine is rubber goods, such as raincapes, aprons, gloves and especially intimate apparel such as all rubber panty-girdles and bathing suits.

<div align="right">Yours,
G.R.M.</div>

More Corset Support

Dear Sir:

I found the letter signed "corset lover" from N.Z. very charming. This young lady is certainly a practical-minded type who firmly believes in comfortable support combined by a proper sense of well-being. Her experience with old-fashioned corsets should be an inspiration to every intelligent, broad-minded girl or woman. Instead of the discomfort and torture of stays that women used to rave about this lady shows that such a complaint is utterly false. Evidently, the belief that stays are highly uncomfortable arose from the wearing of ill-fitting corsets, or the practice of excessive tight-lacing.

Her advice to young ladies is most timely and sensible. If it is possible for one to obtain a genuine old-fashioned pair of stays then let her at her leisure give it a fair trial. What one woman can do, another can do as well or even better. Of course, a trial of this nature is not for girls or women who either know it all, or who are afraid of corsets.

I wish to thank Mme. D.W. from Africa for the lovely photo of the beautiful lady with the well-laced figure. A woman of this sort is my ideal of feminine beauty. Just by comparing her with the uncorseted, mannish-waisted, hideous feminine figures one sees all too often today, one gets at least an idea of the importance of the corset and its vital role in correct posture and proper figure control

It's nice to know that even in this modern world there are still women sensible enough to know that a woman who forgoes wearing a corset does so to her sorrow as she reaches middle age. It's too late to expect as much for one's figure when one is really fat and forty, and has a waist like a cow.

Sincerely yours,

F.M.

Hurrah! for Sylvia!

Dear Ed.

I liked particularly the letters from Helen and Bettie C. in Bizarre No. 11. These have a ring of sincerity and realness to them, and make for interesting reading — much more so than any synthesized or imagined experiences. Also S.W.D.'s letter on page 65 — sounds real — and renews one's faith in the belief that there really are women who like to wear the ultra highs.

When are we going to have a letter from MMeD. of W. Africa. Her pictures in #7 — page 47 and 48 and No. 8 page 35 suggest a wonderful philosophy. It's not the young models, but the middle-aged and older women wearing their own ultra highs that really count.

21

(For some unaccountable reason Soulier's same shoes in #11 look better than in #10!!) To me, the greatest picture of all is on page 15 of #5. This one has everything — the optimum combination of the right size heel, the right pitch, the right everything! The wearer's instep is absolutely vertical without being distorted— a quarter inch one way or the other would have destroyed the perfect picture it makes.

Well, I've rambled on and on long enough.

Best of luck and wishes for your continued success.

Most sincerely,
R.S.

HOUSE WORK SOLVED

Dear Editor:

My husband and I were very interested in your article in #9 "The Great Revolt". Some weeks ago circumstances gave us an opportunity to see just what it would be like. My husband, Jimmy, was granted an extra week vacation and I was not able to obtain a leave from my position.

Jimmy agreed to be my slave for the week. I was to be absolute master and he was to do my every bidding.

Fortunately we are about the same size and as Jimmy is on the slender side some of my clothes fitted him. We did purchase two items — platform shoes with the highest heels obtainable (1 inch platform, $5\frac{1}{2}$ inch heels) and a heavily boned, back lacing corset. I remodeled the corset by taking in the waist about four inches to give it a more wasp-waist effect.

For the whole week he was dressed as a woman. He had to wear the corset both day and night, the high heeled shoes, make-up, and earrings from morning to night, and feminine clothes always. He did all the cooking, cleaned up the apartment, did the dishes, and waited on me hand and foot. Like Babs in #9 I ruled our home.

The only time Jimmie took off the corset was while bathing. I laced it each time and drew the cords as tightly as I possibly could and assure you that he could not take a deep breath without feeling its constricting pull. I supervised his wardrobe and made certain that the skirts were long and tight. I will say that Jimmy really made a most attractive woman with vivid make-up, curled hair, long earrings, tight blouses (over a padded bra), long narrow skirts, tightly gartered nylons and high heeled shoes.

Perhaps when I was at the office he took off the shoes, but I know he did not take off the corset as it laced at the back and I took the precaution of fastening his hands in front with hand-cuffs before I left home for work. He

22

behaved very well but once I did have to discipline him. He did not make the bed to my satisfaction and when I told him about it he talked back. For punishment he had to lean over a chair and I raised his skirt and applied ten strokes with a hair-brush.

After a week of being master and having my husband act as my slave I believe that I for one would like to have a civilization run by women. I am not so sure that Jimmy would like it as a permanent proposition, but Jimmie likes it so very much that on weekends he has agreed to be my slave — complete with tightly laced corset, high heels, make-up, and exotic feminine attire —!!

A willing master,
Mrs. Lois S.

PLANTATION PONIES
Dear Editor:

The following is a clipping from an old magazine (name and date unknown). I found it while cleaning out an old "family heirloom" trunk and thought it might interest your readers.

Anon.

My grandmother often used to tell me of her life as a "slave" in "The Old South".

"Once," she said, "when I was a young girl I was required to take the place of a pony girl who had fallen and cut her knee badly.

In the early hours of the next morning (before dawn) I was roused and taken to the stables where I was stripped, bathed and oiled. The harness was then fitted. This consisted of a 2" belt fastened tightly round the waist and a narrow strap between the legs to prevent it riding up. Two other straps went over the shoulders.

My arms were placed behind my back with the hands strapped up between the shoulder blades. Elbows were then strapped tightly together. A gagbit was produced and forced in my mouth. This consisted of a large pear shaped piece of metal which not only completely filled the mouth but forced it wide open at the same time.

Head gear was a strap round the forehead with 2 cross straps over the crown of the head. Two more straps came down the cheeks through the bit rings and fastened tightly under my chin. Two more straps went from the bit and were secured at the back of my head.

The strapping or harness was completed with a checkrein or head strap from the crown of the head down to the waist belt.

This to my distress, was pulled particularly tight so that my chin, neck and chest were all in a straight line. Running shoes completed my "wearing apparel".

I was led to a light gig and backed into the shafts which were attached to the waist belt. Reins

were fixed to the bit and I was taken to a hitching-post where I was left to wait the young master. By this time dawn was just breaking.

After what seemed like ages he came out, inspected the harness and found it too slack for his liking. He had the groom take all the straps up a hole more where possible. He checked the chin-neck line with a straight stick to see that chin, throat and chest were all in line. Apparently it was not good enough as the back strap was tightened.

Finally satisfied, he got in the gig, pulled hard on the reins and flicked me with the whip. Thinking he wanted me to back I went backwards. This produced a veritable round of lashes and I realized that he meant to keep a tight rein all the time. I accordingly went forward. I had to run as fast as I could and high-step as high as I could all the time.

We visited some of his friends, "to show off my points as he said", and meetings were arranged for the next day to compare ponys.

Eventually about midday we returned to the stalls where he told the groom that he thought he could make something of me as a pony girl but that I was a little slovenly in action and was a bad stander. He instructed the groom to release me from the gig but to keep me strapped up in harness for a couple more hours to teach me how to stand."

Such was the grandmother story but as a footnote it may be remembered that this was normal harness for plantation ponys and not a punishment harness. With this latter arrangement other refinements would be included such as a narrower waist belt, or the reins would go through the bit rings and be fastened to nipple rings. This would indeed be punishment.

(*Has anyone else ever heard of anything along these lines — Ed.*)

WORK BELT

Dear J. W.:

If you have trouble getting your wife to do the house work here is a practical solution. My husband solved this very nicely by building a "Work Belt" out of steel as shown in the picture. The pieces around the waist were padded with a garden hose split and fastened to the inside. The belt is a little heavy but perfectly comfortable, except when I try to sit or lie down. The belt edge is too uncomfortable to lie or sit on. The piece on the sides to which my hands are tied prevents lying on the side.

The belt was not completed at the time of this picture. Later a wing was welded to the nut that held it together so that a lock

see letter — "WORK BELT"

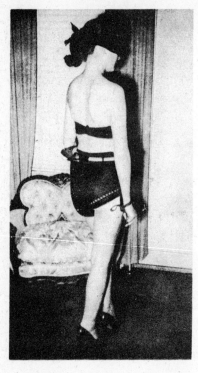

he just laughed at me for not having the work done, and informed me he was not going to remove it until I did it. I didn't believe it, but changed my mind when he immediately left for a movie. I decided then I had it to do and tired as I was I pitched in and did most of the ironing. When I heard him coming in several hours later I hid what I had left.

I haven't had it on since, I haven't given him an excuse to use it.

Sincerely, Diligent Worker

SOME WON'T READ
Dear Sir:

A girl I work with in Manhattan seems to get hold of your magazine quite often, but so far she has refused to tell me how she gets it. (*Probably because our address is imprinted clearly in each issue. Ed*) But I can tell you this, she's got some wonderful ideas in her head! (I know because she has tried out a couple of them on Yours Truly.)

Once when I spent the night with her at her place in town, she asked me to let her tie my hands behind me "just for fun". She would show me a "trick," she said — and boy, did she!

Next time I am going to try something on her. It will not be just her hands that get tied either.

"K. S."

prevented its removal. My hands were not tied after that so that I could catch up on my house work. The belt does not interfere with working. I can stoop, kneel, walk, scrub the floors and etc. in comfort, but sitting or lying down is not practical.

Before leaving for work one morning my husband put the "Work Belt" on me and suggested I get the washing and ironing up to date. I resented this and didn't touch the ironing all day, but I was just as tired as if I had, because nothing was comfortable but standing up. When he got home

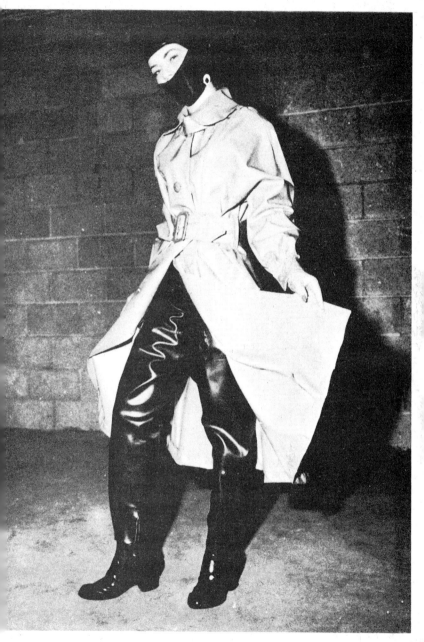

photo from "T.C."

Dear Editor:

I have enclosed two photos of my wife in complete rubber outfit consisting of rubber girdle, raincoat, cap and high heel thigh length rubber boots. If you think they are good enough you can publish them. Let me know if you are interested and I will send you more.

Very truly yours,
T.C.

(*Thanks a lot — please do. Ed.*)

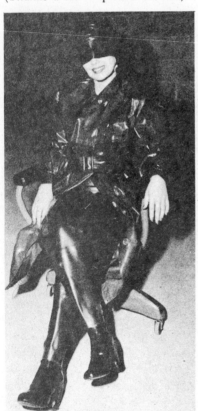

EARRINGS, BUT EARRINGS

Britain has gone in for earrings in no ordinary manner. Lamps that light up, flower baskets, and now a real live fish in a glass bowl.

28

Beautiful But Dumb
By Dolly

My husband is an artist, and you wouldn't know his name if I told you, but that dosen't matter.

He specializes in designing toys in general and "dolls" in particular. On the side he draws his own version of those very shapely girls with the well filled sweaters and the long, lavishly displayed legs, that grace so many calendars and make "pin-up" pictures for many of our less intellectual magazines. (Unfortunately no Art Director seems to appreciate his particular style of beauty.) Oh, I don't say that Peter couldn't draw anything else; he can, but he's been in the game long enough to know that it's his "dolls" that pay the rent — his "doll-girl pin-ups" are for his own amusement.

The particular type of girl he draws, she's sort of a trademark, really — has a waist that is a lot smaller than normal, and her bosom is a lot higher, and a lot fuller that the average. Her hips quite slim, by comparison, but not skinny either. Her legs, of which she is obviously proud, are always shown off by full length cobwebby stockings, and her feet are forced up on tip-toe by the extremely high, slim heels which grace her short-vamped shoes. Friends who visit the studio take one look and say, "Gosh, what an imagination these artists have. No girl really has a figure like that."

But that's where they're wrong. At least one girl does — me. I'm Peter's model.

When I started posing for him, before we were married, I had a thirty-six inch bust, a twenty three inch waist, thirty-four inch hips, and was only five feet two in my stocking feet. So you can see that I had a very well rounded figure to start with.

We were married a month, to a day, after I began modelling for him, and soon after that, Peter suggested that I should try some figure-training

To my surprise he turned out to be quite an authority on the subject, and under his guidance I ordered a couple of small waisted corsets. Now, a couple of years and several corsets later, I can boast a normal every-day waist measurement of eighteen inches, over my corsets. My bust line has also been raised about two inches, and as it was by no means low to begin with, the effect is really quite striking. However, since one dosen't want to be *too* striking in every day dress, I wear a special bra which minimizes my swelling bust and keeps it at thirty six. Even so, my progress down the street is usually marked by low whistles. This may be partly due to the fact that I'm proud of my legs, and wear my skirts about

an inch shorter than most people, and never wear less than a four and a half inch heel for walking.

But when I'm posed on the modelling throne — well, that's different. My waist is pulled in to sixteen inches, and my bust, raised yet another inch, is encouraged to attain its maximum of forty inches. Peter always finds an excuse to show the full length of my legs, which means either a "carelessly" displayed suspender, or opera length stockings. My "working" shoes never have less than five inch heels, and I often wear heels a full six inches high, which is about the limit that my rather small foot will take.

One part of me that doesn't suit Peter's style of art is my face. All his girls have very exaggerated, big eyes, with obviously false lashes and high arching, artificial looking eyebrows; their mouths too, are very generous, with extremely full lips. My features, unfortunately, are small. My eyes especially, are far from his ideal, and no amount of make-up will make them big enough. In fact, he has often complained, with good natured bitterness, that my face doesn't match my figure at all.

So, until recently, Peter has had to draw his girls' faces without using a model. Just how the change came about is really the subject of my story.

One day, two or three months ago, I happened to mention a child-hood dream to my husband. I explained that I used to have almost the same dream over and over. For a while I used to have it almost every night. I dreamed that I was a doll — at least I was myself and a doll at the same time. I can still remember the short, frilly costume I wore, and the bland unchanging expression of my china face. In my dream I was able to walk and run and play, and do everything that a little girl could, except that I couldn't talk, eat, or change expression. Having a china head and face made that seem natural enough. I used to love my dream, because in it, I had no worries; I suppose that even as a child, I had worked it out that having no brains to think with, a doll had nothing to worry with, and so I romped and enjoyed myself, without a care. I never missed my lack of speech; dolls didn't seem to need to talk.

Peter was considerably interested in my dream; and when I remarked that sometimes I still wished I could be a doll, and having nothing to worry about, he nodded, and answered, "Well, maybe it can be arranged."

He wouldn't enlarge on that statement, or say anything more, but he had me puzzled the following day by taking some very

careful measurements of my head and face. Then, for a couple of weeks, nothing happened.

One Friday afternoon, after being out most of the day he came home carrying some parcels. As he came in he said "Put on your working clothes, will you dear?" That meant, of course, my tightest corsets, my special bra., and my opera length hose. While I was putting these on, he asked me to complete the costume with a pair of very short tight white pants, which just came to my stocking-tops, a pair of six-inch heeled black patent pumps, a long-sleeved high-necked pink sweater, which I had knitted myself, so that it allowed room for my swelling bust, and still came in tight around my corsetted waist, and finally a skin-tight black velvet skirt that only just covered my very brief pants.

When I came mincing out into the studio, Peter nodded to a straight chair on the raised dais near the easel. As I sat down I asked idly, "What're we going to do, darling, some sort of a special rush job?" I asked because the light was beginning to fail, and I knew he didn't like to work by artificial light unless he had to. Peter answered, "Well, it's a special job all right, but I don't know about the 'rush' part of it."

He came toward me with several pieces of soft rope in his hand,

and so I wasn't too surprised when he began to bind me to the chair; he often painted me in "Damsel in Distress" poses, bound in one way or another.

I was surprised, though, at the thoroughness with which he bound me. Pulling my wrists together behind the chair, he tied them together; then he pulled my elbows together behind me and bound them so that they nearly touched. Of course, this dragged my shoulders back, and made my bosom swell out in the most arrogant manner. I wasn't used to being tied in such a severe manner, and began to wonder what he was up to. Next he made me sit all the way back, and bolt upright in the chair, and kept me in that position by tying my right ankle to the right rear leg of the chair, and my left ankle to the other back leg. Naturally, this made my legs spread wide apart, and caused my tight black skirt to ride up several inches. Finally, he ran a rope from one ankle, up through the cord around my wrists and down to the other ankle, pulling it up very tightly. As a result, I was completed rigid and quite unable to move. I was just saying, "This is a very uncomfortable pose, darling, I don't think I can hold it very long." When he told me to close my mouth, and before I knew what was happening, it was sealed shut

with a wide strip of adhesive tape.

There I was, bound, gagged and completely helpless.

For some reason, I found myself gripped by a wild panic, and tried to struggle. But the best I could do was a sort of writhing, which didn't accomplish anything except make my skirt ride higher. Suddenly I realized I was trying to scream, but not a sound emerged from my sealed lips.

In the midst of this, Peter came up behind me and slipped what I took to be a soft white leather bag over my head. That increased my fears and I fought harder than ever. All at once, I heard Peter's angry voice: "Calm down, confound it! How can I lace this thing if you bounce around that way? Calm down! Nobody's going to get hurt."

I got a grip on myself then. After all, reason told me that Peter would rather kill himself than hurt me. It was just the mystery of his actions that had upset me. Then I settled back, and let him go on.

I realised it was no bag that I had my head in. There were two little eye-holes to look through,

and the whole thing fitted my head and face almost like a skin. It seemed to be a leather helmet of some sort. My husband was busily lacing it close down the back of my head, smoothing and working it into place in the meanwhile.

At long last, I sensed that he had tied the lace in a knot, and cut off the ends. The helmet, which covered my whole head, extended down the neck too, and I felt him adjusting the collar of my sweater over it. It was adjusted terribly tightly. It managed to be very uncomfortable and terribly thrilling at the same time. The pressure was especially great over my mouth and around my jaw; even if my lips were not sealed with tape, I would still have been completely gagged.

At this point, my husband released my hands, though he left my legs bound to the chair. Corsetted as I was, I was quite unable to reach down to release myself; nor did I want to. Now that I was calm again, I was getting a terrific kick out of the whole thing. Reaching up, I felt the smooth covering of my head. As

I thought, the thin leather fitted without a wrinkle.

Peter, who had gone away for a moment, came back and began putting a pair of tight white kid gloves on my hands. These too, came up under the sweater, and I understood that I was completely covered, from head to foot. Not an inch of bare skin showed anywhere.

Finally, I felt him slip something on my leather-covered head; somethink that felt like a close fitting hat.

Then he untied my legs, and said, "Go and take a look in the mirror."

A thousand questions struggled for utterance, but I was as mute as a statue. So, in silence, save for the click of my six inch heels, I minced over to the mirror.

I looked, and could hardly believe what I saw.

Staring at me from the mirror, with an expression I can only describe as surprised amorousness, was one of my husband's own "doll" girls! The figure; tiny high arched feet propped up on ultra-high heels, the long silken legs, the slim yet rounded hips, the

wasp-waist, and the high voluptous bust, was mine. But the face!

Then I realized what it was. The leather helmet I wore was actually a mask. The full, faintly-smiling lips, the wide-open, staring violet eyes, shaded by impossibly long lashes, the high, thin arched eyebrows, were artificial features, applied to the face of my tight helmet. My attractive appearance was finished off by a beautiful coal-black wig, which rippled half way down my back.

My snow-white "skin" was actually white kid. Now I understand the reason for the white gloves — none of my own skin must appear to spoil the illusion. After I had been admiring myself excitedly for some moments, a quiet masculine voice spoke behind me: "Well, Dolly, how do you like it?"

I whirled around, to find Peter watching me eagerly. At first I tried to speak. But the pressure across my mouth reminded me that dolls cannot talk. That didn't matter though, there are other ways to express emotion.

Opening my arms, I started to hug him. But he stopped me, gently clasping my gloved hands

33

saying, "No dear, dolls don't offer affection — they ask for it."

Of course he was right, and even though I couldn't speak, or even change expression, I found ways to ask for it.

Later that evening, Dolly cooked her master's supper, and changing into a very brief French Maid's costume, Dolly served it.

As a matter of fact, I was not alowed to be human again until bed time, and I had to put on my doll-costume the first thing the following morning and keep it on all day, and all day Sunday too, except when we went out for a little while.

At present I'm "Dolly" more often than I'm not. Of course I wear the costume when I'm posing, but I wear it a great deal of the rest of the time too. Every time I put it on, the thrill gets greater, the thrill of being silent, expressionless, a human no longer, but something my husband has created.

Just the other day, as he sat down on the couch beside me, he ran an affectionate hand over my leather face and said, "Well, Dolly, you're one character who literally is Beautiful but Dumb."

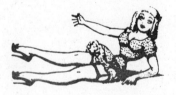

A COMMUNIQUE
FROM BUENOS AIRES
To "Blind Girl Fluff" & Co.

Perhaps you know already th your craving for being blin folded is due to the fact th you have a latent power of wh is called second sight or clairvc ance. It is really a kind of me umnic power, which enables tho who possess it to see into t past or into the future or into f away lands. This power has r been developed in you but m certainly could be.

Have you ever noticed that wh you are as you say "swathec sometimes you see, as in a viv dream, some scene or some even If this has not come yet, it is b cause you are allowed too much freedom of movement. The blind-folding arrangement you describe is perfect, but to this should be added some strict bondage. Your arms and legs should be tied to keep you perfectly immobile, absolutely unable to make the slightest movement.

Some years ago, I met a man whose power had been developed by a similar method. This man when blindfolded in a manner almost identical to the one you describe (except that he was not gagged) could read a letter, see dominoes put flat on the table without turning them over, or paint a picture, mixing his colours and painting with precision and

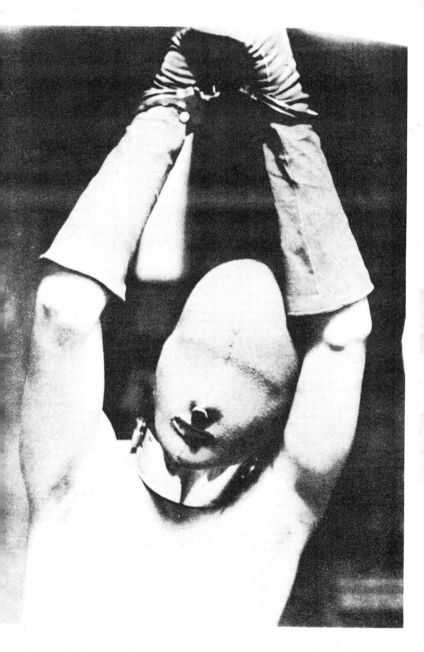

the Seabrook experiment.

ease. I was present at such an experiment and I am sure there was no trick about it. I read of a girl who after remaining 6 or 7 hours bound and blindfolded saw clearly something that was going to happen300 miles away, several months later.

Sincerely,
"Apprenti Sorcier"

INITIATIVE AND KNOW HOW
Dear Editor,

I must pass on to your readers a discovery I have made, for the benefit of those who, like myself, are privileged to administer spankings — something which is always a pleasure for me.

Living with me are my nieces, 19 and 16, and my nephew, 14. I, their aunt, discipline them in the good old fashioned way, even though I am almost as young as they are. My usual method is to have the naughty one bend over the foot of my bed so the spanking area projects well out. Then the other two are compelled to watch while I lay on with a supple flat yard stick.

The other day I discovered a very novel, effective spanking instrument to substitute for the yard stick occasionally! I bought a new rubber girdle and it came in a round tube of medium weight cardboard. A wonderful paddle! It is not so heavy as to bruise or do real damage but it really stings, and it swings so well. Similar tubes come as containers for large calendars, charts, etc. A new instrument to add to the hand, hairbrush, paddle, switch, quirt, and other traditional instruments of correction!

Very truly, Norma R.

PETTICOAT PUNISHMENT
Dear Sir,

In No. 12 you published a letter from "Modern Mother" telling how she dressed her son in little girls clothes to ensure his good behavior. I should like to bring to your notice the fact that in Britain this custom is very common, at least if letters published in Reveille are to be believed.

The series of letters started by a mother who had recently been widowed asking for help in controling an unruly son of 14 on whom corporal punishment had no effect.

The replies to her letter were nearly all in favour of dressing him as a girl and they gave examples of how their own sons had soon been mastered by this method.

I think the following method was the most interesting and should like your readers' comment on it.

The mother was dissatisfied with the conduct of her 14 year old son so for school wear she obtained a kilt and blouse outfit un-

der which the son had to wear a frilly girls vest and knickers and a small tight corset.

At home a schoolgirl's gym slip took the place of the kilt and on weekends he had to wear a frilly party dress. After a month of this the son was very obedient for reasons we all can appreciate.

In all the letters I've read on the subject of discipline for children of both sexes it has been agreed that humiliation for the boys and corporal punishment for the girls were the best methods.

Have any of your readers examples of a suitably humiliating costume for a girl.

Yours,
R. W. W.

IDEA FOR A COMPETITION
Dear Sir,

Through the good offices of a friend I have had the opportunity of seeing three or four copies of your unique publication "Bizaare". The correspondence and photographs dealing with bondage and figure training interest me enormously, but I have a suggestion to make which might increase the contributions from readers and thereby provide a constant flow of new ideas.

Why not run a competition with some such title as "Elegance in Bonds" or "How to 'secure' a neat Figure." The idea being that readers should submit photo-

graphs of their wives or girl friends bound or chained in various outfits of smart clothes with the form of bondage calculated to show off the girl's attractions to best possible advantage. It is important that the 'Victim' should be a willing co-operator and look thoroughly interested and pleased with the whole proceedings. She should look thrilled with her fashionable helplessness. A small prize could be offered for the best entry, although I feel sure that the publication of the photographs alone would be sufficient reward for all enthusiastic bondage fans.

Yours faithfully,
E. M.

WHAT A SWITCH

Like many other individualistic people who believe in "live and let live" in regard to personal interests, I very much enjoy reading your publication and wish it could be issued more regularly, monthly for instance.

I cannot get "with" the devotees of leather and rubber clothing or some of the other favorites including heavy corsets, but if others enjoy articles on these, I certainly do not begrudge them the space. Personally I believe that a girl is at her loveliest when she is moderately made up and dressed in sheer soft materials. In fact I think the sexiest and most interesting possible combination for a

girl is when she is wearing high heeled slippers and nylon hose, gartered with frilly black lace garter belt under sheer little panties with lace or net about the legs; and a sheer net or lace brassiere to match.

But most of all I like the articles and letters about woman's domination of men — I find the idea strangely appealing and while I have never been fortunate enough to find a domineering woman who could and would make me her "love slave" and perhaps even "make me over" into her maid or companion as a "girl", I have and wish I could meet someone like them. What exquisite thrills, what soul-stirring and cleansing experience to go thru the humiliation and discomfort of being dressed and placed in bondage under my mistress' every whim; to have to do her chores and kneel before her or suffer the consequences of her iron discipline to be kept helpless in ropes, chains or other discipline devices, perhaps blindfolded or gagged as she amuses herself or invites her girl friends to come enjoy the sight of her "slave" all dressed up in high heels, frilly dress and petticoats, lingerie and all the make-up and accessories.

Well, until I find such a woman, I will continue to dream about her as one of the many who write their experiences to "Bizarre'.

Ken B.

IT MAKES SENSE

Dear Editor:

Until I found three copies of Bizaare hidden in one of the drawers of my husband's dresser, I wondered where he had been getting all his fancy ideas. I mean about being "master" and treating me as his "slave". Now I know — although he had a lot of talent along these lines to start with.

In pouring over the three issues, and a couple I have found since then, one thing puzzled me. Why do most of the lovers of the kind of play that involves the willing or unwilling "bondage" of the man or the woman — depending on which likes to be boss and has what it takes to put it over — why do they dissemble so much in writing about their experience? They beat around the bush all the time, as though anyone with a brain cell working wouldn't know what the score is.

(*Must you put ALL your food on the same plate — Ed.*)

Believe me, there is no mystery about the treatment my lord and master dishes out — the treatment I would have to take whether I liked it or not. It is as simple as this: he likes it, and

38

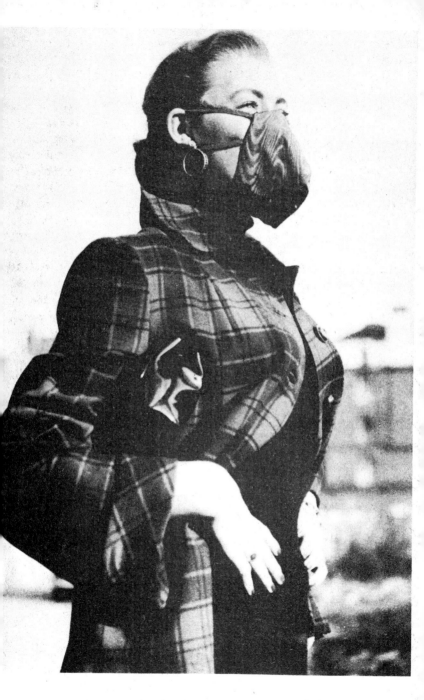

a London Smog mask.

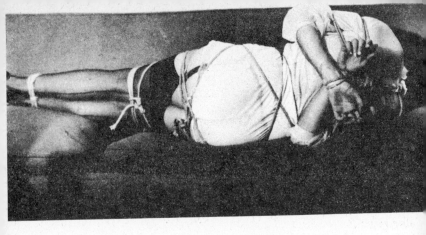

he likes me to like it, and I do!

In particular, I love to be physically helpless to prevent whatever he feels like doing to me — even if I am already committed to obey his commands, as I always am. It gives me a perverse, but exquisite kind of satisfaction to *have to* submit. And sometimes in the very act of submitting I imagine how I would feel if I did not want to do it. My man is a stern task-master, too!

I love to have my hands and arms tightly bound behind my back. I love to be blindfolded so I can't anticipate my master's next move when he begins to turn on the heat; and if it serves some purpose of his to silence me, I love the sensation that comes over me when he ties a gag in my mouth. I adore black undies — my standard costume as his slave-girl. I am thrilled by his subtle humiliations, also by the "punishments" he prescribes.

We like these things because we *like* them (period).

— Yes Girl

ANOTHER MALE CORSETTER

The Editor,

My friend Damon has shown me some copies of your magazine, which have been of great interest to me, and he and his sisters have asked me to send you some details of my own corset-wearing. Well, I am 33 years of age, have been in corsets since I was very small, probably since about ten years of age though I have no record of when I began to dress in that way. I had often helped my sisters to lace their corsets when only one of them was in, and I presently asked to be laced in one myself; I know that I was thrilled both at the idea, and afterwards at the experience, so, with the help of the two girls I was kept supplied with corsets until after my parents died when I was able

openly to become a tight-lacer. From 1935 we lived in Seville, not a good climate for extreme lacing-in, but all the same the girls and I kept our waists well confined, and we were in good company as small waists seemed to be the thing in Seville just then, and nothing was thought of it apparently, as shop windows displayed models boldly marked as made in all sizes from 36cm upwards, that is about 14½ inches. As I was in business I had to wear a straight sided corset over my smalls which were then 46cm (about 18 ins I think) and they were quite easy to lace closely; my hips were not tight, but I had to have high corsets to conceal my rather large bust line. During and after the war (we returned to Leeds in 1949) we had a good collection of different types of corset and I wore as my daily wear a circular waist type with shoulder straps I required no help in lacing it close. At night I wore a fairly thick rubber waist band, shaped, nine inches deep and laced, so that I had no trouble in the morning getting into my usual corset. We all had some very small-waisted corsets which we wore at home and at week-ends, or when we had some kindred spirits in for the evening, but I regret to say I never ventured out in them; I laced to 15½ with help, but did not feel comfortable when sitting even

with short hipped and low models, but the pleasure of so small a waist is always present. And we think onlookers have some satisfaction also in seeing one anothers efforts. My sisters and I know quite a lot of both girls and boys who tight-lace, and we notice the waists one sees when out on the streets are getting both well shaped and smaller by degrees, so another era of tiny waists may be with us soon.

Yours E. N.

OFFICE HIGH HEELS
Dear Sir,

Each issue is eagerly awaited in our house, as it must be to everyone who appreciates the glorification of the female figure with corset, belt, sheer stockings, and the stunning effect on deportment and carriage of the dainty stilt-heeled pumps and boots.

It is interesting to note that of late there are at least three large retail chain stores selling moderately priced women's shoes which sell open and closed toe pumps and sandals sporting 4½ inch heels, which in the small sizes are rather attractive on the wearer. They go under various titles as "skyscraper heels", "Tower heels" and "pinnacle heels".

I imagine the wives and girl friends of Bizarre readers must smile to themselves when they see these shoes listed as such, in-

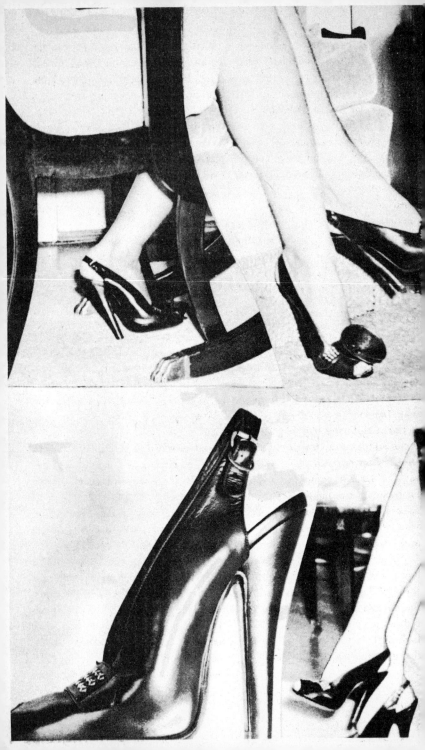

asmuch as they pale into significance beside what Bizarre readers have long known as the true pinnacle of the shoemaker's art, the 5½ and 6 inch pencil slim stilt.

I'll always remember the time when a friend of ours, who never wears anything else but a pair of these stock 4½ inch heeled shoes, used to make herself rather obnoxious at work by pointedly and with some sarcasm reminding the other girls in the office that a spike heel was the only true feminine shoe to wear, and inferred that she was the only one there who was woman enough to wear such a shoe. This went on for some time with our friend flaunting what she thought was her immeasureably greater allure and femininity in the faces of everyone, the men especially.

For a time she enjoyed the obvious admiring glances cast at her sleek nylon covered legs mounted in the highest commercial spike heel made. She made no effort to conceal her disdain of the others who she termed 'bobby soxers" and "flat-footed girls, not women".

Finally my wife decided to teach her a lesson she well deserved. So one day she wore to the office a beautiful pair of dark red sling pumps with a full 5 inch heel, in which she walks with the utmost ease and beauty.

It wasn't long before, as the saying goes, "the shoe was on the other foot", and our friend found herself completely ignored, which infuriated her and at the same time made her very curious. But my wife deliberately did not satisfy her curiosity by answering any questions, merely saying that occassionally when she dressed to go out she liked to wear a *real* pair of heels. The emphasis was subtle but not lost upon our friend, and the change in her condescending attitude became apparent at once, for she was no longer sure of her self-styled superiority.

To make a long story short, my wife kept her in suspense for a month or so, until our friend could bear it no longer. I found out later that one night while I was working, she came out to our apartment to attend one of my wife's "hen parties" and while there was allowed to "discover" my favorite pair of shoes, a custom made pair of highly polished gleaming black kid sling pumps with an open toe, a toe ornament, and pencil-thin 5½ inch stilt heels.

In front of all the girls whom she had chided as being unable to wear a real "woman's heel", she was made to wear the above pair of true stilts, and the effort was laughable. Her knees bent, her ankles wobbled, and in trying to walk she almost fell down. In

one instance, after sitting down, she couldn't get up from the chair and stand erect in these stilt heels without having someone hold her. My wife then took the shoes from her, donned them herself, and walked about with the utmost ease and grace serving refreshments etc. and then went to the closet and slipped into a pair of magnifiicient black patent leather pumps with an incredible heel of almost 6 inches. Mounted thus in such dainty pumps and elevated to new heights by the magnificence of her towering heels, she walked proudly to and fro before our friend, whose face was by now quite flushed and embarrassed. Not a word was said, however, and our friend soon left the party. The next day, she was very meek and docile at the office, and was especially defferent to my wife, which change has continued to this day. Let's have more from Melissa, Sylvia Soulier, and others.

Sincerely, L. J.

RUBBER COMING BACK
Dear J. W.

It is indeed very encouraging to see that the interest in rubber and mackintosh clothing is being kept up. I personally think that the trend is that rubber is being used more for various garments than ever before. The soft thin delightful fancy all-rubber apron is coming back and a large quantity have recently been exported from Germany. The rubber lined mackintosh has hit a new high in popularity in Britain and the garments are a sheer joy to see and wear. The materials used are exceptional and the rubber proofing well above pre-war standards. Silks, nylons, satins, and new shimmering materials are all being used. The rustle from these garments is sometimes greater than the best taffeta ball gown. The superb hang makes them look like a satin house gown, far too delightful to wear in the rain or outside at anytime. Rubber sheeting is available in very many delightful colours and is of the super light weight all rubber pre-war quality. This material can be made up into all kinds of garments and requires only a little care and trouble to handle. I therefore do not agree with some of your contributors that the rubber interest is dying. Surely it is up to all interested to boost the interest still further by asking for rubber materials and pre-war garments. I have recently heard that a manufacturer, due to many requests, is again to produce a small quantity of the really wonderful pre-war style of all-rubber swim suit. So then all you rubber fans, see to it that your photos are sent to the Editor and your letters and enquiries are kept up and we

shall all find an improvement in the supply and interest in all types of rubberwear.

Yours etc., Latex.

THE VANISHING MALE WAIST

Dear Editor:

My husband and I have just discovered your wonderful magazine and are completely thrilled with it. Since you seem to be interested in your readers experiences, I would like to tell you one of mine.

Some time ago, I had developed a problem with my husband. To an admirer of slim waisted men with good carriage, my husband's waistline and posture had deteriorated to an alarming extent. My suggestions that he try dieting and exercise went unheeded except that occasionally he would try dieting for short periods with no results. Despite his lack of interest in keeping up his own physique, he was always interested in seeing that I kept MY figure in line. This was very galling to me. Finally, when my patience came to an end, I decided to take drastic action.

One evening after supper I took the tape measure and carefully measured him without telling him why, except that it would be a surprise. Surprised he was when the next evening I brought out a high waisted, well boned, maximum control girdle which I pur-

chased that afternoon. I handed it to him and said, "This is for you dear, your little surprise." He was so stunned he did not know what to say and at first balked with embarrassment at trying it on. So I said, "I'm sick and tired of looking at your bay window. If you think a properly supported, shapely female figure is attractive to you, I feel the same way about yours. Now if you love me as much as you say you do, you'll give this a trial. That did it. And then I helped him into it.

After we got it hooked and zippered up, I led him to the mirrir to get a look at his new figure. The girdle was quite firm and fitted him well except the waist seemed a little too tight. But that was just what I wanted for him so I explained that he would soon become accustomed to it. The entire result was astounding. Gone completely was his former bulge and his posture was better because he had to straighten up to be relatively comfortable. One look in the mirror was all it took to convince him and he kept his girdle on the rest of the evening. Later he admitted that it wasn't as uncomfortable as he thought it would be and if a "mere" woman could stand a firm girdle, he certainly could too.

At first he would wear it only on occasion but now wears it constantly without my suggestion to

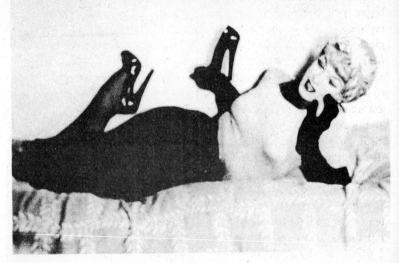

put it on. I have kept getting him smaller sizes as his waist decreased so that now his waist has gone from a horrible 40″ to a neat 30″. His body is now really attractive to me and we are both very pleased with it. He also discovered that wearing a tight girdle curbs the appetite accounting for his gradual loss of weight to normal without any starvation dieting.

We are now of the opinion that a well fitted firm girdle will improve the male figure as well as the female and there is no reason why men should look sloppy when the remedy is so simple. More women should encourage their husbands or boy friend to try a girdle. I'm sure there are none who would not benefit by looking and feeling much better.

After reading your magazine, my husband has become quite interested in wasp waists and figure training and wants me to have a real wasp waist. The idea is very intriguing and I have agreed, on condition that he does the same. We probably will not be able to nip his waist in as much as mine but to have him laced just as tightly will be thrill enough for me.

Yours, J. B.

RUBBER FOUNDATION

Dear Editor,

I have only recently become acquainted with Bizarre and both my husband and I have found it most interesting.

The correspondence on rubber clothing is really what got me started writing this letter!

My taste for rubber clothing began just before the war when my mother had me buy a Playtex girdle to wear with a formal dress for a high school dance. I took an almost immediate liking for its cool smooth sleekness and after I got home from the dance I bathed and washed out the latex panty-girdle and wore it to bed. From that time on, I have always worn a rubber girdle night and day!

It wasn't until after I was married that I ever thought of extending my liking to other clothes but this is a logical development, I guess. My husband liked me in the girdle too, so eventually we discussed its merits and so on and why I enjoyed wearing it. I told him that I would like to be dressed entirely in latex because I found it to be comfortable as well as pleasing to look at.

After our discussion, we set about to find ways of getting some all-latex ensembles for me. A short check revealed as other latex fans have also discovered that there are not very many variations to be had on the market! Soon we were involved in a study of the manufacturing processes and after considerable experimentation we were able to make anything we wanted. Anyway, to make a long story short, I believe I have as complete a rubber wardrobe as anyone you might name!

For underwear, I always wear a latex corset of my own design which encases me from neck to knees panty- style and having elbow-length sleeves. It is unique in several ways but perhaps the most outstanding innovation is the means by which it is laced up so that after it is pulled sufficiently tight and hooked up, the laces can be removed. This leaves me with

the Giantess.

47

a waist that is shy of 17 inches, a 36 inch bust and 36 inch hips. I am 5'-11" tall and very long waisted and long legged so the effect on my morale is just grand! That heavy boning is a "must" I discovered early in the game in a truly fine corset so my foundation garment has just about all the boning it can hold molded right into the latex. The rubber is so clinging that shoulder straps are unnecessary for a perfectly erect figure. The bust section is so made that my breasts are supported and elevated as high as possible with very wide separation and fullpointed-roundness of definition.

Over my corset I have several sleek rubber formal gowns to wear which detail my figure completely and also some beige latex stockings. Usually I wear figure clinging clothing of the more usual sort however but always with one of those lovely rubber corsets to begin with.

My letter is already so long I don't want to continue but I do have lots more to cover on the subject!

Sincerely,
Celeste O.

DUNKED

Dear Editor:

I have been very pleased to see that you have been publishing pictures of girls playing in the water with their clothes on. The picture in #13 of the young lady lying in the surf was tops, and the one of Dell swimming in her undies was most interesting. How much better this latter picture would have been if Dell had also been wearing nylons and high heel shoes.

While swimming or taking a bath fully clothed may not be particularly "bizarre", there is — to me at least — something very fascinating about an attractive girl in a dripping tightly clinging wet dress.

Some time ago, on a hot, summer afternoon I was driving about with a very attractive girl whom I shall call Nancy. We drove near a shallow, rocky stream, and Nancy asked that I stop near a secluded spot so we could walk along the bank of the stream. Accordingly, I stopped the car and we strolled down to the edge of the water. As we stood on the bank of the stream, Nancy tentatively dipped the toe of her shoe in the water. At that I dared her to wade into the stream with her shoes on. It took very little persuasion, and soon she was splashing about in the shallow water. I might say that she was wearing

an expensive dark-red crepe dress, black kid gloves, patent leather pumps and nylon hose. While she was wading about, her dress high above her knees, the combination of slick rocks and high heels brought about the inevitable: with a splash she fell backwards into the water.

Instead of the embarrassed tears that might have been expected she seemed to enjoy the dunking. I wish that I could describe the breath-taking vision she made as she arose from the water, sleek and gleaming with the drenched red dress molded about her body in liquid beauty, her nylon-clad legs shimmering, and the tiny soaked pumps glistening with water.

Though her dunking appeared accidental, I suspect that the fall into the water may have been intentional. At least she submitted to wettings on a number of subsequent occasions, and on one such occasion I was able to get photographs of her both in the water and as she emerged drenching and dripping from the water.

I enjoy your publication immensely, and I hope that in the future you will include — along with your excellent stories and letters on high heels and tight corsets — some stories and letters on wet clothing.

Yours very truly,
R. M. S.

COSMETICS AND CORSETS

Dear Editor:

The women of today have done wonders in artificially enhancing their beauty, and don't think we men don't appreciate it! After all, within the last two generations they have made the liberal and skillful use of cosmetics and the display of nylon-clad legs and wear, where 50 years ago these fascinating aids to beauty were anything but respectable. True, even now women tend to be a bit self-conscious about wearing heels over four inches high or employing the more unusual colours of lipstick, eye make-up, and nail polish. But more of them are doing it every day!

History shows that the various artifices of feminine allure tend to come and go, sometimes being neglected for generations only to be rediscovered in time. Consider for example the intriguing effects obtained by outlining and extending the line of the eyelids with black eyebrow pencil. This cosmetic practice, well known to the ancient Egyptians, has in recent times been largely confined to the stage. Yet within the last five years its use has become much more general for evening and even street wear. And it may be hoped that like lipstick it will soon come to be considered a necessity of good grooming. There are other practices, employed in almost every age and place, which our own generation has unaccountably neglected and is only now beginning to rediscover. Such is the charming custom of ear-piercing, almost universal in every culture from classical Greek, Roman, and Chinese to nineteenth century European and American.

But by far the most important artifice being passed up by the women of today is *tight-lacing*. Women of other periods of history well knew that a wasp waist is at once the most attractive and pleasurable asset a women can have. This aspect of the pleasurable sensation of being tight-laced needs to be emphasized. For, not having tried it, the emancipated women of today find it hard to associate corset-wearing with anything but discomfort. Most corset devotees grant that there is an initial period of irksomeness, usually not lasting longer than a month, before tight-lacing becomes a positive source of delight. But often the pleasurable stimulus is present from the outset, sometimes overwhelmingly so, as Havelock Ellis has pointed out. No doubt many women of today would find this true of themselves if they took the trouble to experiment. This very fact was brought out in the intriguing London experiments on tight-lacing reported in Bizarre No. 8. (By the way, Editor, what ever became of the promised follow-up article from this London group?) (*They never sent it in. Ed.*) Another fact noted by the London experimenters was this: the combination of a very tight corset and very high heels tended to intensify the charming sensations produced by the corset alone. And any woman who doubts the irresistable attraction of this combination for men need only try it!

Paula Sanchez, in a fascinating letter (which we hope is the prelude to many others!) in Bizarre No. 13, confirms these facts, observing that she has never known a woman who, once properly introduced to the pleasures of tight-lacing, would ever dream of giv-

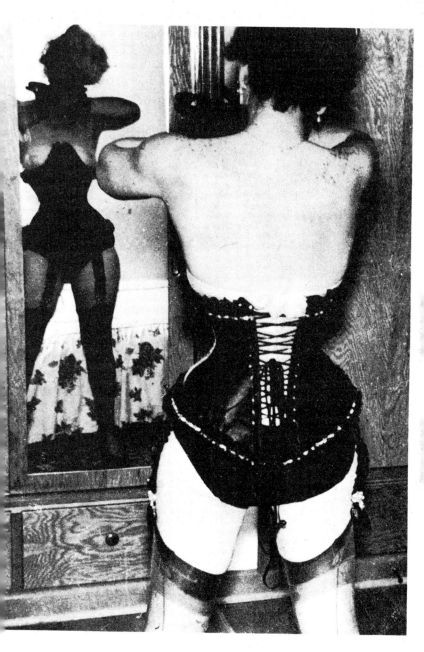

Lace 'em close for me — or BOOM!

ing them up. Paula also tells you, girls, just how to go about attaining a wasp-waist for yourself. How about it?

<div align="right">Sincerely
A Male</div>

IT PAYS TO OBSERVE

I don't know if this experience would be of interest to Bizarre or not, I will leave it up to John Willie.

A few evenings ago I was enjoying a little relaxation at a local night club, when a very interesting event took place.

My attention was first attracted by a very nice looking girl and her companion as they entered the club, and started walking towards me.

She was dressed in a tight skirt, dark sheer hose, and very high heeled shoes of red leather. Around her waist she wore a metal belt made of silver, that I would judge to have been about five inches wide, and at least a 1/4 inch thick. As she walked toward me I noticed the exceptional grace and poise with which she carried herself. Shoulders back, head up, and eyes straight ahead. She handled her high heeled pumps as though they were a part of her.

Over her shoulder loosely hung a short cape that came about to the bottom of the belt she was wearing. But her arms were not visible at her sides, nor were they folded in front of her.

As she passed me I noticed they were in back of her. Her fingers but not her wrists showed, fairly close together below the bottom of the cape.

Alhtough this seemed odd I really don't believe anyone else noticed her circumstances, for the light was quite dim, and the crowd quite lusty with interests of their own. In any event she seemed calm and unconcerned as she made her way to a booth in rather a secluded corner across the isle directly opposite from where I sat.

Her companion then removed her cape and handbag that was suspended from her right shoulder by means of a long strap, and put them on a coat rack beside their table.

As he stepped from behind her, (she was standing with her back to me) for a brief instant I could see a large lock that held her silver belt around her small waist, and that a chain from her wrists was fastened to a large ring directly in back of her belt. This left about a five inch movement with each arm. She then quickly slid in behind her table and sat down, so that she was facing me.

The waitress presented herself, the order was taken and their drink was served. While I was wondering what was going to happen next, my questions were

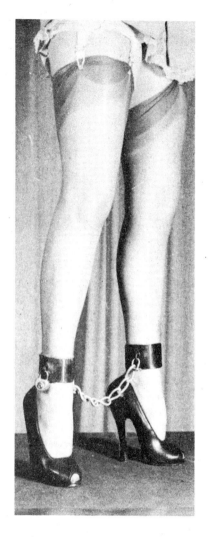

photo-from N.Z

she was still dependent on him for all her requirements.

Next he removed her red leather hand bag from the coat rack, and opening it produced another pair of large handcuffs connected by a long chain.

The girl then moved herself so the center leg of the table was between her own legs and then presented him with her right leg, by laying her small foot in his lap, and he promptly encircled her ankle with the steel ring of the handcuff and snapped it shut. She then raised her left leg and the process was repeated.

She then lowered both feet to the floor being very careful not to attract too much attention by the noise of the chain.

Her present position at this point of course, prevented her from leaving the table, for they are bolted to the floor. As the evening progressed he continued to be very attentive, and judging from her frequent outbursts of happy laughter she was thoroughly enjoying herself.

Never for once did she seem embarrassed or did she seem to resent her handicap. For at the time I had to depart, four hours later, they still seemed content.

To me they seemed to be enjoying a trend of thought they had in common, and even though it may seem a little foreign to anyone else what difference does it

soon answered.

He first held her drink to her lips and let her sip it, and then he lit a cigarette and let her inhale while holding it in his hand, for

53

make, as long as it brings contentment and satisfaction.

> Yours,
> "Merlin"

OH THAT WILD WEST

Dear Editor,

I thought perhaps your readers might be interested in some of my experiences. My husband and I are ardent bondage enthusiasts, with rarely an evening passing that doesn't find me tied in some fashion. My favorite days are spent during the summer in our small cottage in Colorado, however.

Since the cottage is rather remote, we hire some horses for the trip up from town. As soon as we are well clear of civilization, John ties my feet together beneath the horse, and ties my hands behind me, then leads me off at a brisk trot. After an hour or so, I find the saddle getting most uncomfortable, but since I am gagged, he rarely pays any attention to my mumbled protests.

Once at the cottage, far from civilization, I am kept virtually helpless, day and night, being released from the most stringent bondage only to do such menial tasks as washing the dishes or cooking, but even then I have to wear handcuffs and ankle chains. If dinner is late, or the eggs cooked too long, I am punished by having to eat my meal from a plate on the floor, with my arms tied tightly behind me, a very awkward and messy way to eat, believe me.

One morning I woke in a particularly grouchy mood, and made the mistake of refusing to cook breakfast. For this insubordination, John carried me out to the stable, and bound me, still in my nightgown, to a horse. By this time, I had changed my mind, and pleaded to be pardoned, but he tied my wrists and elbows tightly behind me, gagged me, and led the horse out to a small valley behind the lodge. There he blindfolded me, and with a slap, started the horse out into the valley.

For what seemed like hours the horse moved about, grazing. Since I had been tied on the horses bare back, I lacked the comfort and steadiness of a saddle. The heat and the flies were starting to bother me also. Not knowing where I was going, and being completely helpless, it was a relief to hear my husband come riding up, especially since I was getting pretty hungry and thirsty.

After removing my blindfold, he asked me if I was sorry, and I was foolish enough to shake my head 'no'. As a result, he released me from the horse, but tied me tightly to a tree, then he spread a cloth on the ground in front of me, on which he placed the

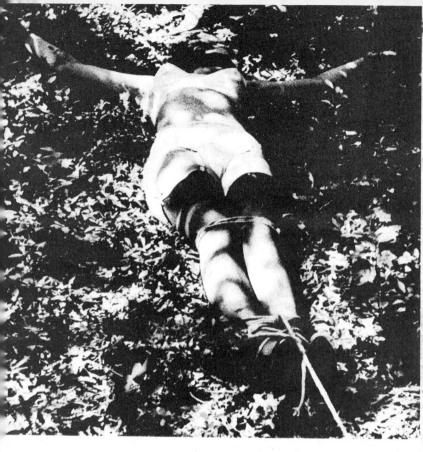

the country is so quiet and relaxing!

contents of a picnic basket. Helplessly and hungrily I watched him begin to eat the sandwiches, but when he opened a cold bottle of beer, my frantic struggles made him ask me again if I were sorry. This time I had learned my lesson. He removed my gag and I meekly told him that I was sorry. Even after releasing me, he refused to let me eat until I had washed myself in the creek and changed into a blouse and pair of shorts which he had brought along. By this time, my nightgown was in rather sorry condition.

One other experience worth mentioning was the time he decided that I didn't get enough sun. He built a large rectangular frame and tied me to it spread eagled. This he hung by a

single rope to the branch of a dead tree, raising me a foot or two off the ground. Next he cut off the shorts and halter top I was wearing 'just to let you get an even tan without strap marks'. As the breeze caused the frame, and me, to twist and turn slowly, I can assure you that I did get a good even tan in the two hours I was hanging there.

Does anyone wonder why I look forward to summer vacation?

Yours for pleasure,
P. H.

A New Idea For Rubbers
Dear Mr. Willy:

My husband is such an admirer of Sylvia Soulier that I, who cannot compete with her skyscraper heels, had to get his attention away from her swish, belted rubber mackintosh and back to reality with exclamatory stamps of my own spike-heeled shiny opera rubbers.

How nice to know "Crazy Over Rubber" will be reassured by the delicious letter from "Ruth In Rubbers" that the smooth, sensuous softness and bounce of rubber underfoot is pleasurable to just scads of women today despite the apparent increased use of plastics. Look about, dear "Crazy", and you'll see us, and we'll appreciate your admiration!

For instance, in my rubber footwear wardrobe is a pair of "ele-

vator boots" of glossy black rubber with the extra-high heels designed to be worn over platform shoes. I purchased them, fitted smaller, over slippers which were merely slim, high heels and thin soles with the sandal-lacing cords removed. At home, from a kneeling-pad were cut thick rubber innersoles and heel-plugs. These were fitted inside the sleek boots and the slippers then put in.

When I sank my stockinged feet into their soft rubber depths, zippered them smoothly high and tightly above my ankles and then

56

modeled them to and fro with dominating tread — yum yummy! — and my big brawny husband just "fairly drooled", to borrow a descriptive phrase from "Satisfied" in No. 9. Hers was a delightful letter — write more !

That evening I wore my new, jouncy boots of rubber to the movies although the sidewalks were clear of slush, but That Man fidgeted through the first pic and then insisted that we return home as he couldn't admire my rubbershod feet in the dark! To please him and, incidentally, to "keep him to heel" I complied with his wishes and we both enjoyed the results of missing the second film.

We have been shopping for unusual rubber-styles while here, with some luck and many thrills, but my letter is getting long enough for this time so with our best wishes to you, dear M. Willy, for your health and your good fortune in publishing "Bizarre" for the enjoyment of all your readers who have their pet fancies I am very truly yours, —

"Rubberette"

HENRI AND HENRIETTA

Dear Sir,

Your readers' letters dealing with cases of men wearing the silks and laces of women interest my husband, Henri, and myself very much. We do hope "Barbara" (No. 12) is lucky enough to find a wife who will let him dress as her twin—he'll enjoy life so much the more. Henri has his own complete feminine wardrobe, and I adore having "Henrietta" around.

Although we are both French, we met in Buenos Aires. An Argentine friend of mine took me along once to the rather exclusive "Mujerados" Club (founded originally for male and female impersonators, both professional and amateur, but later with broader membership. Recently I have heard that it has been closed under the Perón regime). The occasion was a sort of fiesta, and there were several excellent impersonators among the masqueraders. As one of these was French, I was introduced, and I was pleasantly surprised and secretly thrilled to find the pretty girl before me was in reality a Parisian youth, whose realistic transformation consisted of a lovely blonde wig, perfectly made-up face, ear-rings and necklace, figure-fitting blue silk frock over curvaceous contours, long white gloves, sheer nylons and high-heeled court shoes.

Perhaps it was our nationality, or maybe it was something deeper, but the fact remains that we were very much drawn to each other. I found he loved his feminine things and that he often dressed up for pleasure and to amuse his

friends. When he found that I, far from being shocked at his predilection for feminine attire, was deeply interested in all he said our conversation became almost girlishly intimate. The outcome you have of course already guessed — we fell deeply in love and were married. Henri and I are very much attached to each other, and there is no doubt that this is due almost exclusively to the fact that he loves dressing and making up as a girl, in which pursuit he has my complete acquiescence, for I love to have the charming "Henrietta" around. I can assure "Bar-

bara" that we are by no means unique, and he should be able to find an understanding partner, just as "Henrietta" found "her" Amalia (that's me). Many are the men to-day who secretly delight in dressing in the soft filmly silks, the figure-forming corsets, the highest of heels, the gloves, jewelry and cosmetics, of us fortunate women, but few are they who reveal their whim to their wives. It is a pity, for I feel sure there must be many women about, who would delight in having a husband capable of transforming himself at will into a pretty girl.

Yes, there is no doubt that Henri loves his pretty things, nor that I adore seeing him in them. I hope we'll read of lots more readers with similar inclinations. Good Luck, "Bizarre".

Yours sincerely,
"Henrietta's Amalia"

APPRECIATION OF AMPUTEES
Dear Editor:

I have read your magazine with great interest, particularly regarding high heels and pictures of such.

Also of great interest were the sketches of handicapped girls in ultra high heels in Vol. No. 1. Perhaps "Happy" in Vol. No. 2 would be kind enough to furnish a picture of herself standing while wearing one of her ultra high heels, either with or without crutches, possibly with her stump showing.

It would also be nice to see a picture of Molly wearing an ultra high heel and in the outfit described by Ricarda in Vol. No. 14. In fact, possibly you could develop a section in "Bizarre" for girl amputees in ultra high heels.

Several such prospects to start, in addition to the above, could be Louise Baker, the author of "Out on a Limb", Suzan Ball, the movie actress, and Bonnie Buehler, the airline stewardess who lost her left arm and leg in a boating accident in California.

Very truly yours, W. J.

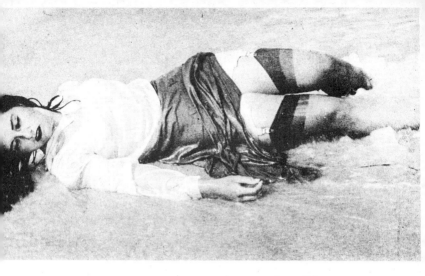

what are the wild waves saying?

DUCKING DOES IT

Dear Sir:

Have any of your readers ever indulged in the pleasant and exciting pastime of taking your shapely and beautiful girl friend for a swim, *while she is fully dressed?* I assure you it is a real thrill to see her in a modern, form-fitting gown, long silk hosiery and high-heeled shoes, long gloves and even a handbag, with water running off her hair, down her back, over the gown and shoes.

It took me quite a while to persuade my fair charmer to do it, for she was afraid of ruining her satin gown, and besides "what will people say?" But eventually she gave in and we drove to a quiet stream in the country, where the water was cold and deep. She stepped one dainty little high-heeled foot gingerly into the water

and squealed that it was too cold, but after I had teased her a bit, she stepped further in to where the water was up to her knees and the hem of her gown dragged in the water. After much coaxing, I got her into the deep water and when it reached her breasts, she screamed again that it was freezing, but she was game and kept on out with me until we were both in water to our shoulders. I held her gently and when she was off guard, I dunked her head under the water and her beautiful long hair was streaming down her back when she came sputtering up to the surface. After she got used to the cold water, she began to enjoy herself and offered no more objections. We waded out of the water, as little rivulets ran down her back and over her

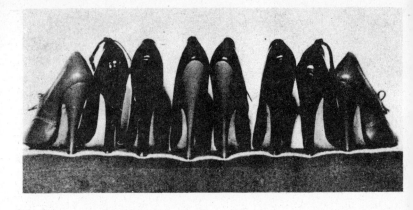

breasts, as the black satin clung to her like a second skin.

After that, I had no trouble getting her to go "ducking" whenever I wished, as she reported that she got a real thrill from the clinging sensation of wet clothing. Try it some time. Your sweetheart may rebel at first, but she will thank you after she has done it a few times.

Yours.
"Splash"

MORE ON PINAFORE PUNISHMENT
Dear Mr. Editor,

Since you were kind enough to publish, in No. 12, my previous letter about the "petticoat penitence" which my 18 year old son is made to endure in short frocks and very frilly petticoats and knickers — dressed, in fact, just like a pretty little baby girl — perhaps a few more details of his training would be of interest to readers.

It is one of my very strict rules that, when condemned to petticoats, he must remain in them until the end of the stipulated punishment period, no matter what happens. If, for instance, we have visitors, then he is compelled to appear in front of them dressed in his pretty baby clothes. If they tease him — as naturally they always do! — he must put up with it as best he can, and no amount of pleading will get me to spare him the shame and humiliation which he suffers as a result.

I mentioned in my last letter that the lady next door makes all his clothes for him, copying them exactly from the dainty little frocks and frilly undies that her own 4 year old daughter Nancy wears. And another of the indignities which the boy has to suffer is that of being taken in to this lady to be "tried on" and fitted for any new clothes. It is really very thrilling to watch him,

scarlet-faced with embarrassment, submissively allowing himself to be fastened by her nimble fingers into the humiliating bondage of his elaborately frilled and be-ribboned "petties" and knickers, and then the crowning misery of some very brief, very babyish, little silk or satin child's frock.

About a year ago, Nancy was promoted from a bib to pinafores for mealtimes, as her mother considered that she was now "growing up". But, to the boy's disgust, I have refused to allow him the same privilege and he is still compelled, before sitting down to a meal, to undergo the indignity of having a pretty little embroidered bib tied round his neck, so that he will not soil his lovely clothes! This rule again applies just the same when visitors are present, and it seems to afford them a good deal of amusement always to see a boy of his age treated in this humiliatingly babyish way.

Yours truly,
Modern Mother

H. H. Experience
Dear John Willie:

Perhaps some of your readers would be interested in my experience with high heels. When I returned to our apartment that awful evening almost four years ago to learn that my wife had left with the neighbor across the hall I thought my world was ending. Negga was a beautiful thing and I had cheerfully watched her spend just about all I could earn on the most exquisite lingerie, stockings and shoes. I enjoyed many wonderful evenings relaxing in my favorite chair watching her try first one combination, then another. I had never suspected that she was in the least dissatisfied, and her departure left me sickened, despondent, for months. Negga had been gone more than a year when I began packing these things, intending to dispose of them and move to a smaller apartment. It was a difficult task. I spent many hours clutching a dainty bit of wispy feminine adornment while, with eyes closed, I dreamed of pleasures now gone forever.

I had never given any thought to the size of Negga's feet, thinking only of their intriguing beauty. I'll never know what prompted me to slip my foot into one of her sandals with a very high heel one evening while doing this packing. I was nonplussed when it was a perfect fit, just teasingly snug. Possessed of the strangest feeling, I slipped on the other sandal and tried to walk, finding that highly impractical. I spent the rest of that evening trying on her shoes, of which she left about 30 pairs, a few with heels no higher than 1", but some ranging

up to 4½". Many subsequent evening I spent posing in front of her shoe mirror. I wanted desparately to walk on the high heels but I just couldn't do it and had to be content with standing or lounging before the mirror. I was wearing the low heel slippers about the apartment every evening now.

I had gone back to my wood block carving, which I had given up when we married. I usually worked at a low bench. Discovering that I could stand very well on even the highest heels, I extended the legs of the bench and would work as long as two hours on a block without attempting to move away from the bench. Quite by accident I found that after standing thusly for this length of time I could then get about safely wearing the 2½" or 2¾" heels. Gradually I was able to wear higher and higher heels and within nine months was walking gracefully on the highest. My experience may help another. I had noticed one of the fellows in the office wore "cowboy" shoes with high heels. Most of the fellows considered him a little "queer" and let him alone. Now I got friendly with him and he took me to his bootmaker. Now I never wear low heels.

At first I felt ashamed of the thrills I got from wearing these high heels, but I am over that

now, have in fact moved to another apartment where I have as neighbor's a lovely couple who share my feelings and who showed me Bizarre.

It had been my intention to dispose of Negga's lingerie, but after my thrilling discovery of high heels I just let it slide. When I moved here I was delighted to find that Paula could wear most of it. Now Joe and I spend many pleasant evenings watching Paula model these things and others of her own. Paula could not wear Negga's shoes, which did not displease me in the least. She requires a shoe just a trifle longer, but wears even higher heels. Like Negga, she likes very sheer stockings with colored heels and seams, as do both Joe and I. Paula is fond of fancy garter belts, but Joe and I much prefer neatly rolled stockings. Paula danced a nite club circuit for four years and she is a graceful and gifted model. She has some beautiful dance costumes, most of which are much more brief than ordinary lingerie, but Joe and I prefer the lingerie, as I believe Paula does also. By ordinary, I mean the kind you buy in a clothing store, though we all like intense colors, or white, rather than the insipid pastel pinks and blues.

I never enter their apartment except when Joe is there, always on his invitation, which I receive

several evenings each week. They have been very kind and simply lovely to me. Paula wants to introduce me to a friend of hers who lives out in the Heights, also a former dancer, now a widow. But I am not ready yet, though I almost never think of Negga now. Paula says Nickey would like to share our fun and maybe soon I'll agree.

Please give us more illustrations like that in the center of Page 12 in No. 7. I believe I like that best of all. The only way you could improve this is to turn the girl to face farther away, thus showing more clearly the dark heels and seams of her stockings. Why do your girls always wear *pointed* black heels? We like best the ordinary black heels. The kind now found in all the best stores, intensly black against very sheer nylon body, rather wide, usually an inch or slighty over at the top, and extending well above the ankle, but never ·pointed. On page 7 of No. 5 we found a reader we heartily agree with. LJC. I refer to his remarks in the first paragraph of his letter, tight panties and rolled stockings. "Roly" in his letter on page 30-31 of the same issue expresses our opinion clearly and concisely, and in much fewer words than we seem able to. Remember now, what we want is panties, *rolled* stockings, and high, high heels,

Frankly, while we do like the panties, bloomers, briefs and what have you, to please us you would begin with very high heeled sandals and go right on up from there with sheer stockings with very prominent, high black heels and black seams, rolled in a neatly tight roll just below the knee, below the hem of a skirt, slip or petticoat, or a lot of white thigh topped by tight brief panties or bloomers.

Sincerely
"Round Garters"

IT'S A SMALL WORLD

Dear Sir:

Some time ago I came across a copy of your magazine. I was pleased with the fashions you showed, and charmed with the idea of people wearing such things. But to be honest with you, it never really occurred to me that people actually did wear such clothes until my husband and I went on our annual shopping and theater trip to New York last September.

We had a late dinner with friends, and were strolling up Madison Avenue shortly before midnight. It was warm, though not unpleasantly so, and in the dim lights of the stores, people were strolling along and everything was relaxed and sort of pleasantly gay. We felt that we hadn't a care in the world and

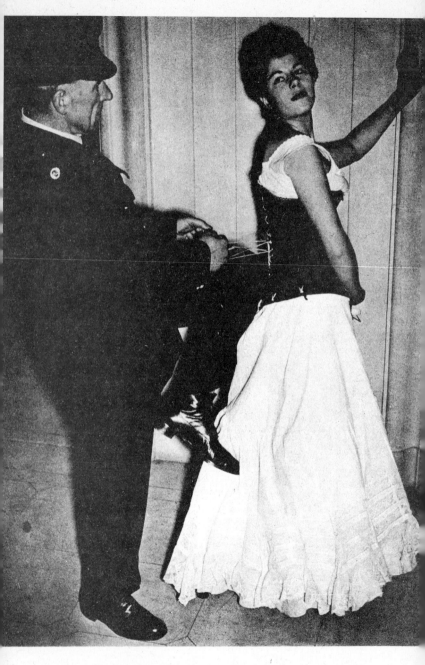

All applications for Commissionaires Jobs should
be mailed direct to the Editor.

that none of the people we saw did either. There was no crowd, no jostling, no hurrying. It was a perfect autumn evening in every respect.

We stopped at an intersection to wait for a change of traffic lights, when suddenly Harry tugged at my sleeve and nodded discretely in the direction from which we'd come.

Sauntering toward us at a slow, casual pace was the most striking couple I have ever seen in my life. The man was very tall, well over six feet, broad-shouldered, with the sort of face you might expect to see above white tie and tails at a royal reception. He was hatless and wearing simply gray flannel slacks and a brown sports coat. The woman with him was a knockout. I got just a glimpse of her face, as they paused beside us, and then the lights changed and they strolled across the street, Harry and me in their wake.

The one quick glimpse I got of her showed me a woman in her middle twenties, on the tall side, with a fine-cut face framed by an assymmetrical hairdo. On one side her hair came down in a sort of page-boy, like a dark, gleaming wave splashed on her shoulder, on the other side, it was swept up and away from her face, revealing one very long, ornate, heavy earring — just one! I saw a black

crepe dress, street length, sleeveless and close-fitting. It was a beautiful dress — everything had gone into the cut of it, that sort of a dress — with a wide, high-waisted band, in red and black, tight and absolutely form-fitting, edged all around the bottom with a red flounce like a peplum. She wore black kid gloves up to her shoulders and no jewelry except for that one long earring.

That was all I could see of her except that I noticed her shoes: delicate, rich-black suede pumps with incredibly high heels. So they really *are* worn then, I thought . . . and how lovely they do look!

As this couple strolled along, we followed as close as we could get without being unseemly about it. I did want to get a closer look at that dress she was wearing, especially the wide red and black band, which in the not-too-bright lights looked very much as though it were laced up the back like a corset.

She had a nice, easy, graceful walk — although how she could have been so comfortable on those stilt-like heels, I'll never know. I thought any any minute she might break in two, for she was so very small-waisted! I couldn't hazard a guess at the circumference of her waist, but I do know that I hadn't ever seen any so tiny.

To our great pleasure, the

couple turned into the hotel where we were staying, and strolled through the lobby and into the bar.

In that brief moment under the bright lights of the lobby, I got a good look at that dress. What she wore around her waist was a corset! I'm absolutely sure of it. A fabulous corset, of course, a wonderfully dainty thing of red satin with black lace applique and black lacing. The garters must have been tucked up and under somehow — it shouldn't be too difficult to do — and the silky red tulle of the flounce added a touch of extra glamour.

Harry and I went into the bar, too, for a nightcap, and sat at a table from which we could watch them without being too obvious about it. They were a most enjoyable couple to watch. They seemed so pleasant and debonnaire. For all the oddness of the girl's attire — and even you must admit that a corset (even as glamorous a garment as this was) constitutes oddness in any girl's attire when worn *over* a dress — these two people were at ease with each other, casually gay, and altogether happy about the whole thing.

Now there, Harry and I decided, was a young woman who had the right idea. Not only did she dress to please her audience, but obviously she dressed to please herself as well. Why, if a thing looks fine and you feel fine in it, not wear it to show — particularly if you thereby appear in a costume bound to be a feast for the eyes of all who see you.

I don't know if it took courage for her to dress as she did, whether it was a bet, or merely and supremely the expression of that young woman's impeccable taste and flair.

I'm still sorry that I didn't have the courage to interrupt her tete-a-tete long enough to tell her how much I admired her elegance, and how fortunate I thought she was to be living in care-free old New York.

Sincerely yours,
Mrs. H. G.

It's odd, but it must be. We knew Anne looked pretty terrific — but me-oh-my Buckingham Palace here we come — Ed.

Since our last letter in No. 10, we, brother and two sisters, have been making some notes of our recollections of the corsets we used to wear, so this letter although signed as before, is a joint product from the three of us.

About 1906 or 1907 Margaret had at least a dozen pairs of corsets, all cut to give her a perfectly circular 16 inch waist when worn; they were of different lengths, and two or three of them were little more than heavily steeled waist bands about seven inches deep, made of coutil covered with satin outside, with no front opening but a wide central steel from top to bottom. They were beautifully smoothly made inside and fastened behind with a thin rod pushed down through holes in the sides of a wide busk affair. We called these the "vice" as they were put on by means of a waist clamp, the back being drawn close so that when closed the back appeared to have a hinge without any holes or laces, the back in fact looked like a long door hinge.

Round the top of some of the other special corsets, the same waist size, were four flat but very strong hooks, each about two inches on each side of the center back and front. These corsets were always well chalk-powdered inside and put on next the skin, they too had no front opening. A pencil line was drawn on the skin at the bottom, when the back was closed, then we would be pulled up on the slings by the hooks on the corsets till our toes were only just touching the ground, and we were encouraged to wriggle about for several minutes till the corset worked up an inch or more as shown by the pencil line, this compressed the ribs to a tapering shape; then we were released and a similar corset half-an-inch or often a full inch smaller was quickly substituted and the pulling-up process repeated, until eventually the waist became extremely tapered and showed the "long-waisted" shape which was becoming so fashionable; this system of corsetting gave not only the very tiny waist, but avoided any sign of the hour-glass effect which was going out of fashion but remained for a long time for evening (especially for dinners) wear, when the smallest possible waist was "de rigeur", and that could only be obtained by the wasp-waist corset. Margaret was the one who could (besides Mother) stand the great compression caused by these long-waisted corsets plus the tiny waist, Ellen and Damon wore the ordinary wasp-waist type all the time, and we two had to submit, in Father's time, to really extreme lacing-in, Ellen had party dresses with 14 inch

waist bands and the corsets to wear with them were very little over 13 inches measured over them, and it often took a whole day to get the backs closed enough for the little rod to go into the "hinge". Damon was often laced into a pair of Ellen's fifteens, then dressed in her clothes, fitted with a boned and padded camisole and made to stay dressed as a girl for the rest of the day.

All three of us have had new corsets lately, the girls' are deep and well boned with waists of just 16 inches over them, and Damon's, alas, only 18 inches measured similarly; all these are laced in the normal way but have no front opening, just the usual flat wide steel placed centrally; Ellen and Margaret have flat wide steels covered with chamois leather which they use under the back lacing when they do not want to close their corsets at once, but we always lace closely by the afternoon and we then withdraw this back steel.

We are all very interested when we read about other male and female tight-lacers and hope many more letters and articles can be published, with illustrations if possible. We have a few friends who dress similarly, but only one is a "star turn", she is tall and slender and is always laced to a trifle under 15 inches measured, as we always do, over the corset

when worn. We do hope that this will interest others to write of their experiences and recollections.

Damon

It Takes 2 To Corset

Dear Editor Bizarre:

I wish to agree heartily with "Lucky Stiff", "4 H Club", Melissa, Damon, Wasp-waist, Fred Mac and the others who love the extremes of feminine apparel.

I went thru part of my life married to an otherwise fine girl, but one who refused to consider my tastes in her clothes in any way. Result: my feeling eventually strayed.

I am now happily married to a complete devotee of exotic costuming. She spares no pain and experiments constantly to discover and exploit my slightest preferences in such matters.

Yours,
"Sam Y"

Long Finger Nails

To the Editor:

I am glad to note, in your No. 14 issue, that one reader raves about the fascination of women with "long red nails," while another reader pictures the ideal woman as having "long red finger nails." Before the war, we were seeing more and more girls flaunting these thrilling painted nails of startling length. The

Chinese exotic dancer Noel Toy had long curved nails that were truly marvelous. One Hollywood beautician, as an example to other women, grew nails 3 inches long, which were photographed for newspaper and magazine publicity. Chen Yu was promoting blue, green, and black fingernail and toenail lacquer, and insisting that men were universally fascinated and thrilled by l-o-n-g feminine fingernails. Is it not time that such adornment, either natural or artificial, again became a feature of the fashion picture?

I am disappointed that your magazine has so far not shown any pictures of such female hands. Nothing is more beautiful than blood-red fingernails on the dainty hand of a woman, and when such nails are in inch or two inches long their exotic loveliness is breath-taking. Can we not expect some feminine readers of *Bizarre* to send in photos showing them in the act of smoking cigars held in hands adorned with extremely long painted nails? This would be a double thrill.

Yours truly, G. M.

CASUAL CORSET COMMENTS
Dear Editor Bizarre:

My husband and I are both interested in the effects of tight lacing and love to lace each other. It stimulates and uplifts us both.

When he comes home at night I meet him at the door in a Bizarre costume and as soon as possible

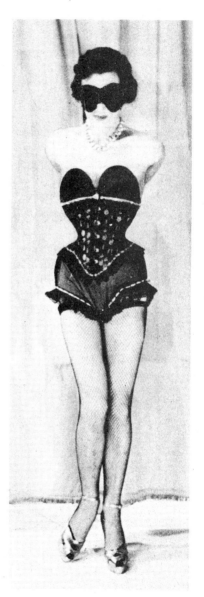

he gets into one, too. For this reason we find the many photographs and drawings in Bizarre very interesting. In No. 2 page 5 shows a mild lacing up picture which is good , but ours are much more strenuous than that! The falling picture on page 19 was fun, but have you ever tried to get up from that position in high heels *and* an hour-glass corset? It is a lot of fun, especially when your husband keeps pushing you down again. My husband likes to see me try to climb things, like step ladders and steep stairs in very high heels and laced just this side of the fainting point, so he enjoyed page 25 because it gave him the idea of adding a tight skirt.

We began to be interested in the correspondence in No. 5, and now find the letters from other tight-lacers one of our chief interests in the magazin.e We very much enjoy the quotations from old magazines on the same subject.

Issue 7 begins with a good photograph on page 4 and the drawings on page 38 and 39 caused us to try shoulder braces. Issue 8 began promisingly with that tight belt picture. Mrs. Billy T's letter was charming and our own experiences agree perfectly with those described in the "Nipped in Experiment". (We went thru the whole experiment ourselves!

But in the dancing part, when we danced together, *both* laced . . .)

Photos like those of Mme. D.W. from Africa showing the actual effects and improvements of figure training are grand (page 35). We did not think the corset on 46 was small enough in the waist to be very exciting. "Miss Satin Surveys the Scenery" on page 55 made us wish for more such photos of tight lacers out of doors. We don't know why, but this seems a thrilling idea and has caused us to wear our corsets while gardening in our closed patio. Page 63 is a drawing which should set the pace for more variations on the scene.

Issue 11 page 14 was much to our liking, and I tried out the shoulder brace on 15 (without the bridle) I think I have broadened my chest by much such figure training.

There is much of great interest in the Chinese Custom of Foot Binding. The same aesthetic reasons as given for foot binding apply to high heels and to corset wearing. Miss Bizarre on page 35 caused us to try out a whole series of assymetrical costumes and my husband likes the pose on page 41. We were both interested in "Sisters in Business" but neither of us has any desires to have my husband lose his masculine status.

He wears corsets around the house just as I wear trousers

when I ride or work in the garden. We don't change sexes by so doing.

Our taking up with tight-lacing came as a discovery that we both liked a snug feeling around the waist. My husband discovered a decided thrill when his hand touched my tightly belted waist, and he got a visual thrill out of my exaggerated body movements. When I began to use a corset I discovered the peculiar thrill only tight-lacers know and half in fun laced him into a corset one night to show him how it felt. I cannot describe the results here but they were amazing and after that he enjoyed evening lacing up as much as I. We do not lace tightly all the time, but always do when we are going to be alone at home of an evening. Our biggest thrill is dancing together with our hands clasping each other's tiny waists!

Yours,
Adele

In Brighton-On-Sea
My dear J. W.

Here is the long overdue letter. Life here is terribly dull and the only bright spark is represented by the only too rare arrival of "Bizarre", which is always worth waiting for.

We both have been intrigued at the recent wave of interest in "Blind Girl" techniques, and wonder if any readers have had experiences of being so "swathed" while corsetted and booted, which to the masculine mind must be the height of feminine helplessness? The idea of a tightly booted girl, perched on towering heels, that make her totter rather than walk, pulled in to the limit in restrictive and firmly boned corsets, gloved in the tightest of kid, shoulder-length gloves, with her head completely encased in clinging, shiny black kid, would make a picture worthy of your artistry.

The Festival Gardens here give a little interest to those of you readers who like uniforms, the Drum Majorette, is a dream in a really tight fitting scarlet tunic, based on a page boy style, with three rows of shining brass buttons, an extremely high and tight collar which obviously holds her neck and head quite rigid, and the shortest of pleated skirts, only about 12-15 inches in length, displaying generously the tight briefs worn beneath. This ensemble is completed by a towering and heavy helmet, with chin strap, (which is never removed even on the hottest days) plus gauntlet gloves, and snappy patent high heeled boots about calf length! The strutting that takes place, reminds me of the stories one hears about the deportment classes of old.

I am interested to see that you have reproduced in an issue a pho-

to of a pair of our corsets, these are displayed by our friend T. B. of Leicestershire, an exquisitely pretty corset lover, with a tiny waist.

Well, all the best in the world to you and Bizarre, the one bright light in the dull world.

Very sincerely yours, "B."

CORSET FOR A HAPPY MARRIAGE
Dear Editor Bizarre:

My husband certainly has taken a renewed interest in me since I've been reading your magazine! It had never occurred to me before that one could do anything about marital boredom. He had always admired my figure, but I found him paying particular attention to women who were very hour-glass. At the movie he sat up and took notice in the corset sequences. In fact, he went to see "Merry Widow" with Turner, twice. When I was buying shoes I found him looking somewhat longingly at the very high-heeled pumps that I had always thought of as impractical. I have always been a "practical" sort of person. Although quite buxom in a feminine way I have been mildly athletic. I have not realized till quite recently that this flat-heeled, tom-boy, women's gymnasium sort of approach to life is repellent to some men — if not to most.

A girl who had been a leader in women's affairs in our community came to our house for dinner one evening. After she left I asked my husband if he didn't think she was wonderful. His answer was rather funny: "Although she doesn't, it always seems to me that she smells of soap!"

I began to think and the result is that I am now enjoying our relations as never before. My experience was something like that of "Wasp Waist" who wrote such an intelligent letter in Bizarre No. 11.

My first experience in trying to get into a wasp waist corset was really comical. I got one, an 1899 model, from a costume house and after finishing up the breakfast dishes after my husband left one morning, decided to get into figure training. After considerable persperation and squirming I got into it, but here was a very wide gap at the back! That's where Bizarre came to my help. Hot and flustered and frustrated, with the little corset laced around me and gartered to my new clocked stockings I sat down with a glass of sherry to read what others had done in my predicament. I didn't want to ask my husband to lace me until I had tried the whole thing out and knew how to do it gracefully. Quite evidently there's a lot to know about getting into a wasp-waist corset! I found Sally Monson's letter about using a belt

as an aid, so I dug up my husbands money belt and used that. By alternately tugging on the belt and the strings I got my 27 inches down to 22 and decided I'd wear it till just before my husband came home.

The next day went a little easier. I discovered that liberal powdering caused the corset to slip easier as it tightened, and that a great deal of reaching upward seemed to help.

After a couple of weeks — to make a long story short, I was just able to make a 17 inch waist. I didn't dare wear the corsets while my husband was home because that would spoil the surprise I was going to give him. If he would put his arm around me and feel all those bones it would be a giveaway, but I found a very tight elastic girdle that kept my figure in without giving away the fact I was tightlacing. With this I wore loose clothes. I noticed glances of disapproval from him in the evenings when I would be wearing a loose sweater or a middie blouse type of thing! I purposely slopped around in flat heels. I wanted the contrast of the surprise to be so much the greater.

I knew he had to go on a business trip and planned to finish up my figure that week and surprise him when he came back.

I tried sleeping in corsets for the first time in my life. At first I could not stand them fully laced while doing house work and even then had frequent recourse to the sherry bottle to enable me to get thru the day, but I determined to settle it for once and for all during these ten days alone. I hung a strong hook in the wall next to my bed and the last thing at night leaned against the laces with my full weight till the corsets were quite closed. Strangely enough I began to look forward to the feeling of being so tightly laced I could hardly breathe after about four days of this. I began to experience the queer excited uplifted feelings that other tight-lacers have tried to describe. I began to look forward to being laced to the fainting point by my husband.

At a costume house I found a pair of green silk corsets with gold embroidery. These were very high in front and pushed my breasts way up and out. I added a ruffle of green tulle and gold garters and found a pair of stilt heeled sandals to match. I had a pair of opera length hose dyed to match. Every night I would posture before the mirror in this outfit, thinking of the effect on my husband. Finally I added a translucent green negligee to the outfit and worked gold ribbon into it.

I have not mentioned that I have normally a thirty eight bust,

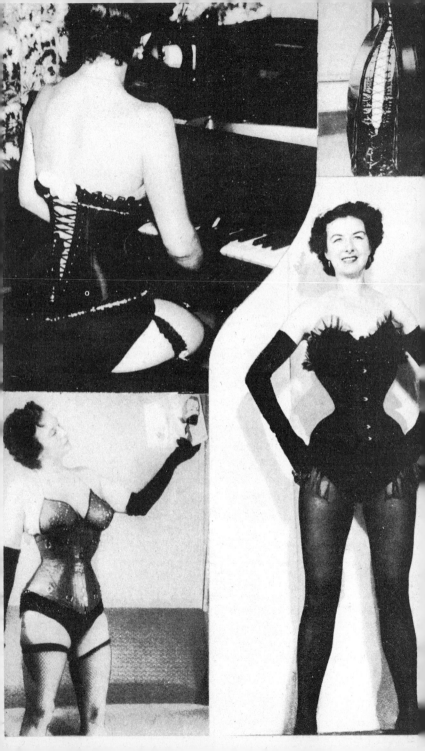

which I had always tried to more or less play down, but in this outfit I measured forty around the bust!

I practiced walking so my bust would jiggle, as I had seen Mae West do and found that when laced up my hips moved very satisfactorily.

Every morning I took off the corset and bathed and examined my skin very carefully for blemishes of any sort and then laced up for the day before breakfast as I found that was easier. Lacing up by degrees took as much as half an hour or more. But it went faster after my body was broken in to it. I broke a lot of laces at first, until I discovered the belt system. Sitting down and bending over were almost sure to break a lace during the first days and I would sometimes take a spill when this happened. So I started wearing a tight belt all day so the support would not suddenly give away.

As you can see it was quite a struggle during that week and I almost gave up several times. But I am very glad that I didn't for when I opened the door on my husband's return it was worth all the trouble! He stared and finally stammered, "What's happened to you!" I could have told him that I was trying to please him and all that, but I didn't. I just said: "I like myself better this way. Hope you don't object." He just gasped as I raised my arms and showed him the new shape. I had purposely left the corset a little open and made as to discover it with dismay. I said, " Oh, darling, my laces have slipped a little would you mind so very much tightening me up good and snug?" Without saying anything he started to tighten the laces as I took hold of both sides of the door . . . You can imagine the rest!

Yours very truly,
Madeleine S.
(for the pay-off see page 107)

U. D. PANTIES
Dear John Willie:

Recently a friend showed me several copies of Bizarre, the first time I had seen it. I was so impressed with the correspondence, and especially with your vivid description of the U. D. skirt in No. 7 that I feel moved to write you.

My husband and I have been very happily married for nearly six years. Georgie was very shy, and still is for that matter, and was very easily embarrassed before we were married. I chose my trousseau with extreme care, and wore not one stitch of anything but nylon. My panties were the sheerest of elastic leg briefs that I could find anywhere in New York.

I'm sure that Georgie had never

before seen a girl's underwear, and though fascinated, he was mortally embarrassed. I'm sure that he would have turned out the light, except that to admit his embarrassment would have embarrassed him further! As soon as we were settled in a nice motel room I hung up my dress, and after I put on a robe, I removed my bra and dropped my slip. I then peeled off my panties and tossed them on a chair near the bed, where Georgie was sitting frozen with embarrassment, and I sat down before the dressing table to comb my hair.

My panties stood in a crumpled little heap, as they will you know. When Georgie thought I wasn't looking he gingerly reached out and touched them wonderingly with the tips of his fingers. These things I have told you only to show that Georgie was fascinated by sheer panties right from the very first pair he saw.

As soon as we were settled in our apartment Georgie took charge of my panties and always carefully, almost reverently placed them on the chest of drawers at night. He insisted on making a little show of presenting them to me each morning.

Georgie rapidly changed from a shy lover to a bold and firm husband. Or at least he thought he was firm and I enjoyed letting him think so. When we had been

married about four months I made a sassy remark to Georgie one evening and he said "Watch your tongue girl, or I'll spank you!" "Why Georgie!" I said, "I know you wouldn't do that, I know YOU would never raise your hand to my panties!" "That would be after I had removed your panties," Georgie said. "Oh yeah!" I replied, uttering the most fateful words ever uttered in our household.

After the ensuing struggle, which both of us enjoyed very much, I found myself with my wrists bound with adhesive tape and my dress jerked over my head. I was standing in front of Georgie, who was sitting on the divan, and very carefully rolling my panties down over my hips with the palms of his hands, just as he had seen me do so many times when hurriedly peeling them off. When he could roll them no farther he quickly turned me across his lap and spanked me smartly, just where nature intended for it to take place. I was more thrilled than I had previously thought it possible to be.

For more than a year, all I had to do to liven things up was to sass Georgie and the fun was on! But one evening when we had been married about a year and a half, for some reason long since forgot, I did not want to play. Georgie teased me and I

TIGHT SKIRTS
THIS YEAR
says fashion :~

knew what he wanted but I asked him to let me alone. Finally he decided to spank me anyway and I resisted with genuine spirit. For sometime we had been using a ribbon on my wrists, since of course I never really resisted, and Georgie as usual removed my panties. About the time Georgie succeeded in getting my panties off I broke the ribbon around my wrists. In genuine fury I grabbed the panties and jerked them down over Georgie's head.

Instantly the most astounding transformation took place in Georgie. From a genuinely aroused and fighting male he became a totally subdued and abject person. "Sit down" I snapped. Instantly Georgie sat down, lowering his gaze as he did so. I stared spellbound at him for several minutes, during which time I lost all anger. He looked so pathetic! "Georgie, get me a glass of water" I said, and instantly he was up and off for the water, but when he returned with it he stood meekly and would not look directly at me. Though I didn't realize it at the time, here I had a man who would obey my slightest command far more promptly and efficiently than any robot science will ever devise.

Neither of us mentioned this for several weeks till one night Georgie timidly asked me to put him in my panties again. I laughed and it was a minute or so before I realized that he was deeply hurt by my laughter. I went to the bedroom and returned with a new pair of especially filmy panties I had purchased that day, but Georgie would have none of that. He insisted on removing mine in the usual manner and very formally presented them to me. I slipped them over his head and we then spent a most enjoyable two hours during which he obeyed my slightest command.

During the next few years our U. D. Panties Dates, as we have come to call them since reading Bizarre, have become quite ritualistic. Several times a week Georgie will return from the office to find me wearing a couple of plastic curlers in my hair. Always just two. This informs Georgie that tonight he is to be "Prisoner of my Panties". Rarely do we speak about it. If I put the curlers in my hair, Georgie knows what to do, and words are unnecessary.

Dinner over, Georgie settles down in his favorite chair, reading the paper. When I'm ready, I enter and step up on the footstool. Georgie lays down the paper and very deliberately raises my skirt, which I grasp and hold aloft while Georgie neatly rolls down my panties and removes them. I step down and Georgie formally and reverently presents me with the panties, which I roll

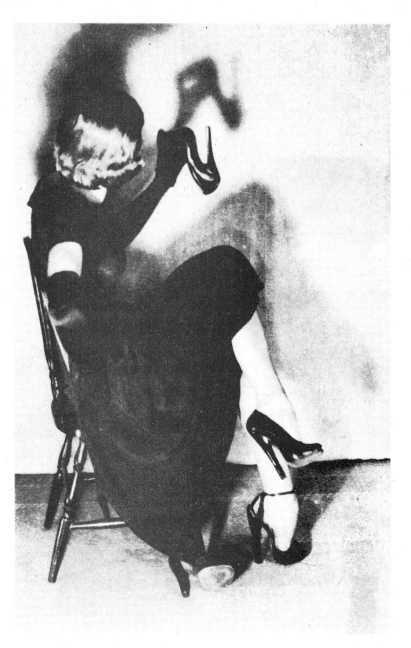

"наボта" photo

the Hi! Hi! Heel returns

"naboma" photo

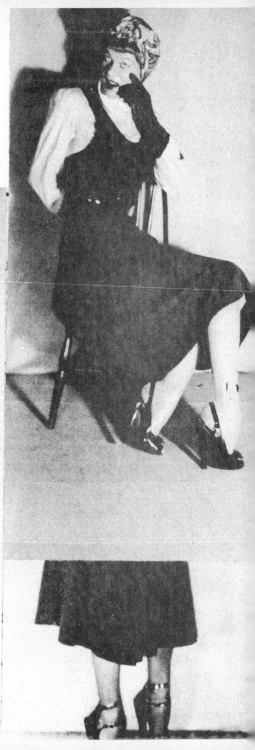

down over his head. I then kneel on the footstool and Georgie removes the curlers from my hair and hands them to me as I arise. Now I gather the leg openings of the panty and close each with a curler, after which I raise my skirt and place my right foot on the footstool and Georgie removes the fancy garter which I have placed on my right leg only. Georgie presents the garter to me and stretching it wide, I drop it over his head and around his neck, pulling the fullness of the panty from under it. Georgie then rises and I sit down as he steps backward and bows his head, awaiting my commands.

Georgie performs all commands without uttering a sound or showing the slightest hesitation. He moves not a muscle till the last word has been spoken, then bowing low, he kisses my hand or foot, or maybe sometimes my knee, whichever I raise and is off to perform the task. He particularly likes to kiss my knee when my stocking is rolled in a neat tight roll just above the knee. This last I usually reserve for those occassions when I have commanded him to perform some menial household task, such as scrubbing the bath, a task which I should have done before Georgie returned from the office. At these times I always manage to raise my knee in such a manner as to reveal to him a generous amount of thigh, which I know pleases him, though he does absolutely nothing to indicate it.

Now Georgie is away attending a home office conference of accountants and I am very lonesome for my love games and U. D. Pantie Dates. So far here they're our exclusive secret. I would never have had the incentive, or the time, to write this if Georgie were not gone.

Yours,
C. D.

"GO HIGHER ON PLATFORMS"
Dear Editor:

Enclosed find a few snapshots of my better half's new shoes. She had them made in Philadelphia, Pa. They are all black patent leather with full 10 inch pencil thin heels and 4 inch cork platform soles. Actually with the top innersole above the heel and with a ¼ inch lift the heel height measures 10¾ inches at the back of the heels. She is now getting a pair of shoes the same style, with 12½ inch heels and a 6½ cork platform sole, also in black patent. I have taken her out for walks in these shoes after dark but she tells me one of these days she is going to wear them in town

during the day. (*for heaven's sake why not? - Ed.*) The next pair I want her to get will be ballet slippers with 10 inch heels and padded toes of 3½ inches.

Hope you print a picture of these shoes in Bizarre. I will send you more of the other ones as soon as she gets them.

I remain sincerely yours,
E. W.

SPANKING PARTNER
Dear Sir:

Your readers may be interested in my experiences in physical punishment. I was spanked frequently by my mother until I came here to the big city to work when I was twenty. Mother believes that a girl is never too old to be spanked.

When I came here I struck up an acquaintance with Jane and we now have been room mates for two years. First we just had a room and bath, but now a very fine apartment. I was immediately attracted to her by her good looks and strong domineering personality. We had only been friends a couple of hours when we started talking about spanking. I told her about mother using the hair brush on me and she told how she had spanked girls in her capacity as president of her sorority at college. Soon we were room mates. She called me "naughty" and threatened to "turn me over her knee", but it was actually two weeks before she gave me the first spanking. I shall never forget it.

I had promised to meet her one evening at a certain restaurant. I forgot all about it til three hours later. Then I rushed there, but she was gone. I returned to our room and she was waiting. She was standing with feet wide apart, fist on hips, hair brush in hand, and clad only in high heels, pan-

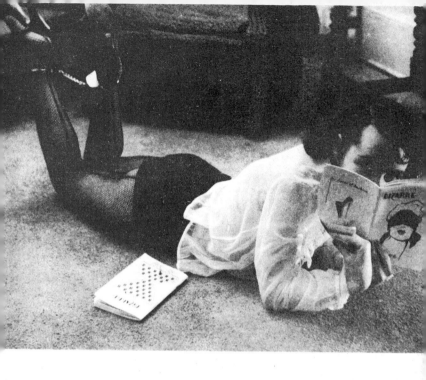

softly softly catchee monkey.

ties, and bra. She looked every inch the domineering, vengeful female as she delivered a brief lecture on how she didn't like to be kept waiting, the virtue of promptness, etc., and she told me that I was going to get the spanking of my life, so I wouldn't sit comfortably for a week. Then with quick strong hands she flipped up my skirt and bared my spank spot. Across her lap I went and she really used that hair brush.

Since then she has spanked me regularly (whenever, in her opinion, I deserve it). Her hair brush is busy quite often. Usually, when I do something during the day, she tells me that I am going to be paddled but waits till just before bed time to do it. But once in a while if she is really provoked she spanks me right then and there (but always in private of course).

I do not resent this, but like and admire my dominating mistress.

Naughty Mary

83

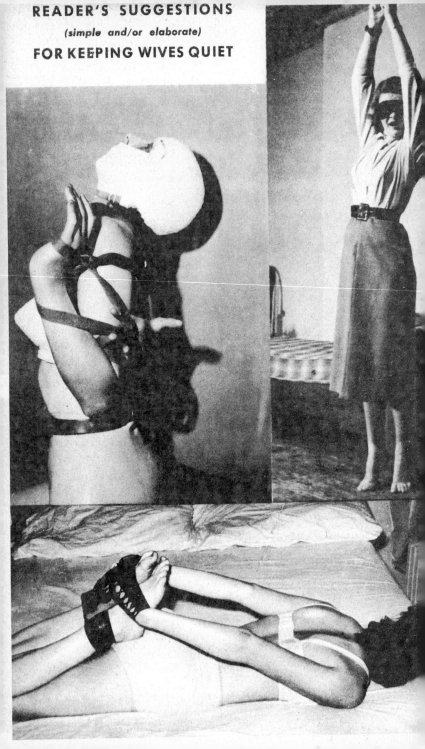

READER'S SUGGESTIONS

(simple and/or elaborate)

FOR KEEPING WIVES QUIET

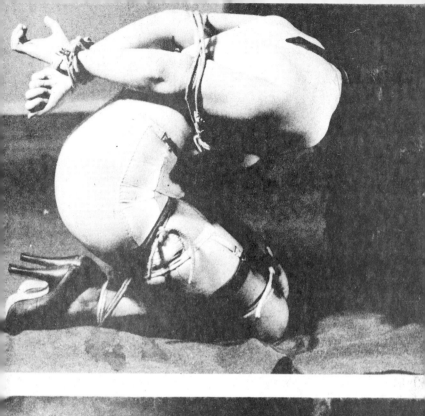
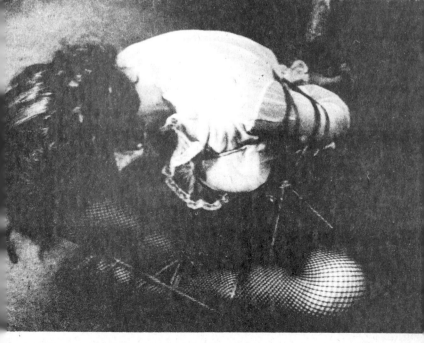

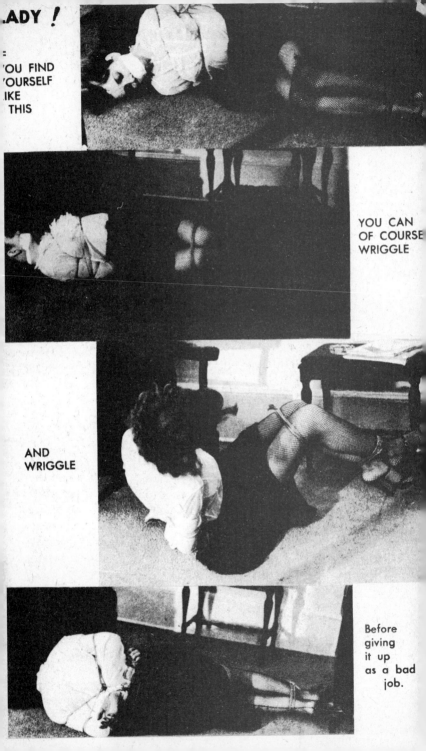

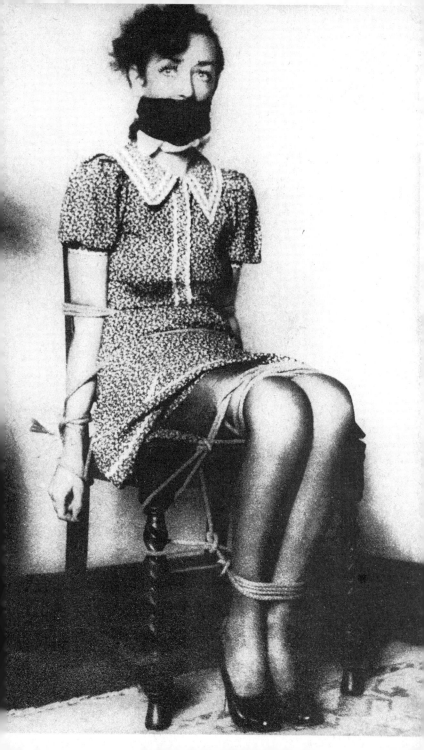

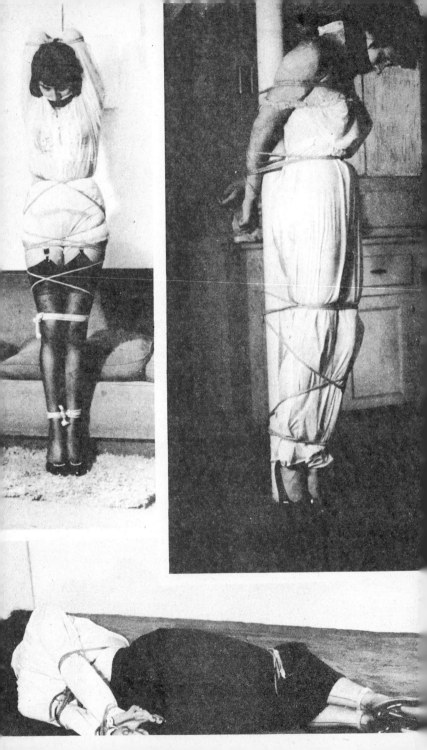

Dear Editor:

Thank you for the copy of the very interesting and amusing magazine Bizarre. We humans who abhor the conventional have had a need for a periodical of this type. So, keep up the good work and consider me a loyal reader.

I showed my copy to a friend of mine and he would like to offer a constructive critiscm. Referring to your serial "Magic Island" he suggests, in addition to serializing a story you should also present stories of this type in their entirety.

Now, if you don't mind, I would like to suggest, that you devote a page on book titles or reviews for your readers who appreciate the bizarre and the fantastic.

Here are the titles of some books that I know your readers will enjoy immensely:

Europa by Robert Briffault
Flood Tide by Frank Yerby
Swamp Girl by Evans Wall
Handsome by Theodore Pratt
Unholy Flame by Olga Rosmanith
The Great Beast by John Symonds

"The Great Beast" is a Biography of Aleister Crowley, a noted English poet who was a devotee of the unconventional and the fantastic.

I wish you continued success and tremendous growth with this magazine.

Yours,
J. M. P.

STOCK-HEELS GETTING HIGHER

Dear Editor:

It seems to me that the trend toward higher heels for general wear is definite and not merely wishful thinking on the part of a few of us males. In New York alone, shoe advertisements are making increased use of such terms as "towering", "soaring", "sky-high", "skyscrapers" in promoting the new ultra-high heel. This increased height is often combined, in the "stiletto" or "pencil-thin" heel with an attractive and femininely fragile slimness. These new heels turn out to be from 4 to 4¼ inches high (at the back) as compared with about 3¾ inches for ordinary high heels. When contrasted with the custom-made 6 or 7 inch heel this may seem unimpressive but all fashion trends must after all be gradual to be generally accepted. And the effect of a 4¼ inch heel on a size 4 or 5 shoe for street wear is really quite a satisfying extreme. Which brings up another point: it would be much more reasonable — though perhaps a little more expensive — if shoe manufacturers could be persuaded to increase heel height in proportion with the size of the shoe.

Thus a size 7 or 8 shoe would have, say, a 4¾ inch heel, giving the foot, leg, and walk the same graceful and fascinatingly precarious appearance that a 4¼ inch heel does for a size 4. At any rate, let us support the trend by urging our wives and/or girl friends to buy the new extra-high heels.

Yours,
High Heel Admirer

SOULIER ADMIRER
Dear Sir:

The beautifully written and exquisitely photographed article by Sylvia Soulier is sheer delight to every lover of high-heeled boots and shoes. This lady most cer-

tainly has an admirable collection of lovely and exquisite shoes and boots which I'm sure every admirer and devotee of high heels will not soon forget.

Although, unfortunately, I'm a man and hence lack the genuine, esthetic appreciation of discriminating ladies for exquisite feminine attire, I for once regret that this is so, and I can't help but think how really nice it must be to be a lady like Sylvia Soulier and have some of the delightful experiences which she must have had.

I am fascinated by the utter beauty of the gleaming black patent leather corset worn by Sylvia Soulier. In this corset she is so

boots for a day in the country.

irresistible lovely, and has such sheer captivating charm that no man could possibly resist her exquisite allure.

It is truly tragic that so many modern girls and women are so blissfully ignorant of the magical allure contained in a really good pair of stays, and equally so that they are likewise ignorant of the strange and pleasurable sensations of being firmly and rigidly corseted. Most assuredly all corset lovers, both male and female, should do everything in their power to combat the corset prejudices; the fallacious notions; the silly unfounded fears, and the false ideas which arose during the 'Mad Twenties' due to the overwhelming impact of masculine materialism on the femininity of the post World War I era.

I do not believe that any girl or woman can be either feminine or lovely unless she has a feminine figure, and most certainly no girl or woman has a feminine figure if she has a large mannish waist and a clumsy gait.. Were I a woman I would wear the most rigid of stays, and I'd keep lacing myself in until I had a waist which even Victorian and Edwardian women might well envy.

Personally, I sometimes think that the only reason why girls and women in general do not wear corsets is simply because they are too lazy and complacent to even go to the bother of giving them a decent trial, or perhaps they are

really fearful of the consequences entailed in the transformation of themselves into glamorous, feminine figures.

"Mac"

PANTY-WAIST PUNISHMENT

Dear Editor:

I read with much interest the letter from "John G. B." from England in Bizarre No. 14. I also read the letter from "Esne" as well as all the letters from all those under the domination of "Slaverette" wives. Heck some of these fellows have it easy compared to yours truly: "Nancy!" Let me tell you about my fate under the firm guidance of "Her Ladyship my wife."

My wife and four of her lady friends have a riding club. My wife is wealthy and holds the "purse-strings." Well I am afraid of horses and the "Country Club Riding Matrons" know it. When they return to the drawing room after their ride I never miss the chance to make cutting remarks about their boots and breeches. (I should say I *used* to never miss a chance, — things are a bit changed as you will see!)

One Saturday two months ago things reached a climax. I made my usual personal remarks. This had evidently been building up as "Her Ladyship" was prepared. I was at once taken to our bedroom and with the threat of her riding

whip I was arrayed in lace frilled bloomerettes, a petticoat, bra with "falsies", long black opera length hose and worst of all my bloomerettes buttoned to a real honest Bizarre panty-waist ! — This was and is a regular old fashioned little girl's panty-waist. (Of course all things are my size made à la the little girl style.) A little short ruffled dress was put on me and my hair was combed for a ribbon. Lipstick and rouge was applied by an artist! (Her Ladyship) I was cut about the legs as I was slow in getting my high heeled shoes on. Well my fellow sufferers, my face was not covered. I was marched down into the drawing room and appeared before Her Ladyship's four friends as well as our Irish maid who is a girl of 19.

I was made to kneel before each lady and humbly apologize. Following this my wife (whom I must address as "your ladyship") brought me a boot shining box and on my knees I had to polish my wife's and her four friends riding boots. When I slowed down her riding whip helped me along! There were many and varied remarks as I worked on my knees; "Nancy makes a perfect maid." etc., and I heard the humiliating words "panty-waist" several times. When this ordeal was over my wife showed them my "underpinnings" the shameful

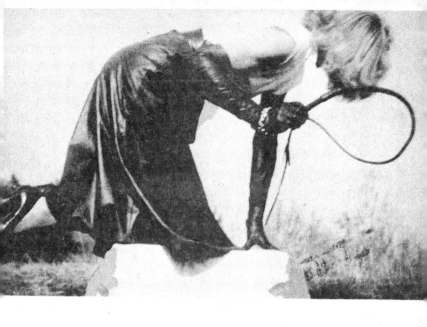

Oo-er! It's a BOOJUM!

panty-waist, my dainty supporters and frilled bloomerettes.

While they visited and had cocktails I helped the maid serve and how I minced in my high heels! This over I was sent to stand with my blushing face in the corner. When they went to the guest room to dress for dinner I was taken to my wife's room adjoining, here I received a severe and stinging spanking with a sole leather paddle. My shame was only exceeded by my pain, here over my big strong wife's lap being punished like a schoolgirl for all in the next room to hear.

I was marched down to dinner a well chastised "Nancy". And ready for me at the table was a child's high chair my wife had had made. I was seated in it in my short dress and long legs and my hands were tied behind my back. The maid spoon-fed me mush! Oh how those ladies laughed and enjoyed it and as if this were not enough; following the mush each lady took her turn at "bottle-feeding" me, yes a regular baby bottle with nipple was put into my mouth and each lady had her turn at it! I had to drink every drop too as her ladyship was liberal with her riding whip. This over I was taken to the bedroom where I received a sound whipping with the riding whip, my little "shortie" gown was put

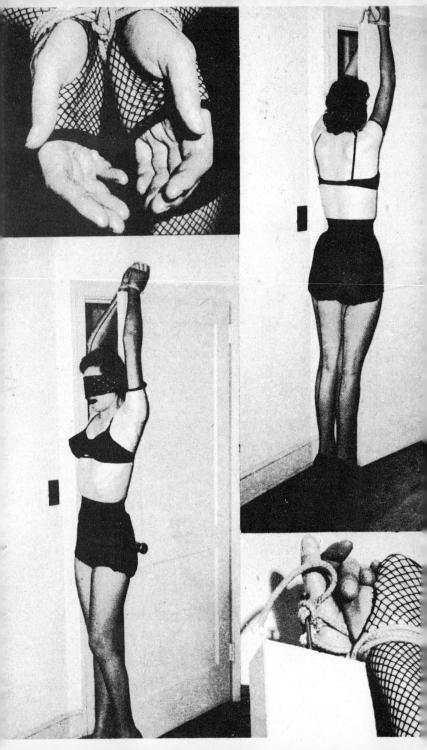

on me and I had to return to the drawing room and say "good night" to each lady. I was taken and put to bed. This my dear friends takes place each and every Saturday and according to her ladyship, will continue.

I wish to add that her ladyship always has her riding whip on the bed stand and never retires unless her black leather strap is under her pillow!

Does anyone else have it as tough as me?? I ask you,

Yours truly,
"Nancy"

D. H. Supporter

Dear Sir:

I think D. H. has a wonderful idea. Panties and brassiere are just as decent as a swim suit, and surely nicer than shorts or a cumbersome bathing suit. This outfit would be comfortable and alluring on any girl or woman regardless of whether she was slim or plump of figure. In secluded outdoor areas free of such pests as biting flies or stinging mosquitoes a girl or woman would be ideally dressed for warm weather in panties and brassiere. Needless to say this scanty costume is also perfect for a very warm house.

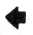 a bizarre, and moveable door stop suggested by "D.A." (patent pending)

My only objection to this delightful costume is the unsightly garter belt which believe it or not, lady, detracts from the charm of your unique outfit. In your lovely photo on page 41 you would have been twice as alluring if you had opera hose on instead of ordinary nylons. A fine silken clad leg is infinitely more alluring than a partly clad one, and a pair of decorative garters worn with the opera hose on the upper thigh would still augment your seductive charm.

It is my opinion that the best swim suits were those made of rubber in the early thirties. There were three reasons for this: First, rubber clings to the figure. Second, it is cool in the water. Third, a rubber swim suit fits like a pair of tights thus showing every alluring curve of one's figure.

Naturally, rubber swim suits are only a memory to-day, but a pair of rubber panties, or better still — rubber hospital bloomers wouldn't be a bad idea provided they fitted snugly or tightly whichever the wearer desired. Worn with quick drying nylon stockings and rubber bathing shoes plus brassiere and one would have a swim suit far superior to the most expensive suit sold to-day. Besides, this outfit would be very attractive and it would fit properly. Why shouldn't it when you, dear lady, would be the designer?

I for one would enjoy hearing from D. H. again. A lady with novel ideas certainly deserves all the encouragement liberal-minded people can give her, and when she is as shapely and lovely as D. H. it is a man's bounden duty to render her all possible assistance with what ideas he may have on the subject of undies for either outdoor wear or indoor use. Incidentally, if any of my ideas have been helpful I'm real glad.

"Mill"

FOOT SLAVE

Dear Sir:

My husband and I are enthusiastic fans of your excellent publication. I particularly enjoy the letters, articles and pictures about women who are made helpless by

their dominant husbands. Perhaps it is the inherent desire of women to be submissive to the male, I for one enjoy wholeheartedly such treatment.

My husband is ideal in this respect as far as catering to my desire to be dominated. While still engaged to my hubby, I often wondered why he wished to marry me; I am not at all good looking, but I'm fairly well proportioned. I found out after we were married that my husband was fascinated with my tiny feet. While still dating before marriage, I often wondered why he got a big kick out of removing my shoes and massaging my feet, now I know and enjoy his every attention involving my shoes, slippers and feet.

After we clear away the dinner dishes, I go to the bedroom and change to black nylons, panties and bras. I put on a very high heeled pair of mule type boudoir slippers and then await hubby's call.

At his command I sit in a chair let him bind me tightly, blind fold and gag me. This feeling of utter helplessness is ecstasy. My feet are then placed on a foot stool in preparation for their massage. My husband then kisses my nylon clad feet and toes for a good 10 minutes while I sit shivering in the pleasures of helplessness. Next he removes my nylon and begins

to tickle the soles and toes of my bare feet. This I admit is sheer torture as I'm very ticklish on the soles of the feet. After 10 minutes of this I'm given what I consider a reward for letting him enjoy my feet. It's a wonderful happy marriage for me and hubby.

<div align="right">Yours truly,
"Well Dominated"</div>

MASTERFUL

Editor of "Bizarre":

Ooooooh, that man! He is my boy friend. And is he the masterful type! Always thinking of different ways to keep me reminded that I am "only a slave," as he says. (Not that I need reminding; I feel I am his, body and soul, anyway most of the time at least.) This has been going on for a year now. I wonder which of us is the craziest.

Once when we were at the beach he produced a dressmaker's tape and carefully measured my waist and thighs. Result: a pair of black satin panties with lengths of chromium chain such as dog leashes are made of, threaded through the waistband and cuffs, with a tiny padlock to secure each chain once I had the garment on. He made me promise to wear the panties whenever I was out with anyone else. (He is cute. Once, on the pretext of showing me a "trick," he tied my hands behind my back, then forced me to pose in front of his flashlight camera in such a way that my beautiful padlocked panties were fully revealed!)

As to that sort of thing, one of his favorite pastimes when we are alone together at home is to handcuff my wrists behind me — he has all sorts of special apparatus — and bandage my eyes tightly so I can't anticipate any of

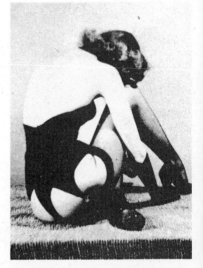

his moves while he is amusing himself (and me) by deliberately tormenting me. Boy, does he know how to do that!

Not long ago he presented me with sets of ankle and wrist chains, each with a little padlock and a single key — made with about eight inches of chain between wrists and ankles when they were secured in place. Sometimes, on telephone orders from him, I

have to go directly home from work on Friday, take a bath, and put on my manacles, snapping the padlock shut — after leaving the keys in a sealed envelope at a Western Union office to be delivered to him at dinner time Saturday! (I said he is cute, didn't I?)

Several times I have been severely punished for disobedience. Deliberate? Deponent saith not .. But I like to be spanked, by the right guy.

— Imp.

THE HAIRBRUSH

Dear Sir:

Don't you think that the hairbrush is the special prop of the dominant feminine role in a domestic scene? One could write quite a treatise on the psychology of this symbol of maternal authority. If women fully understood its implications to the men who have come under its influence during their formative years, there would surely be a demand for the return of the old-fashioned hardwood backed article to their dressing tables. It was a source of tremendous prestige, as few well spanked boys ever lost their respect for the woman who held one! This homely instrument was simply packed with the most potent psychology imaginable! It was a highly personal article, which not only shared the inti-

macy of her boudoir — but also held a prominent place among those articles which she used to care for her own person. It played the principle role in the grooming of her *hair*, always a very potent fetish and the proud banner of her womanhood! Thus it became an actual extension of the lady's personality, a symbol of her feminity and—when used for correction — a baton of maternal authority. In this last role it becomes associated with chastisement and the buttocks, both of which are strong erogenic influences. Believe me, no queen ever held a sceptre more commanding!

Hairbrush chastisement is really a punitive caress; possibly, we could trace similar undertones in the masculine use of the razor strop for correction. In any case, the use of such personalized implements implies a personal concern and an intimate relationship. A sort of a stinging compliment!!

Oddly enough, there is also subtle flattery of the "You great big hunk of he-man" variety when milady uses rather wicked horse whips, quirts etc. to bring the wayward swain to heel. Not only

does she pay tribute to his manly strength and endurance, but she also emphasizes her concern over his misdeeds — and hence over him! This is what we might call being flattered till it hurts! In any case, I think that any male who bows to the feminine rod will forgive an excess of severity before he will condone perfunctory treatment at the hands of his mistress.

Yours, "Anon"

JEOPARDY

Dear Editor:

My husband and I have been interested in many of the subjects discussed in your delightful magazine for a good many years. High heels, corsets, outer lingerie, stocks and bonds and domestic discipline have all played their part in adding spice and piquancy to our existence in a world inclined to be dull and stuffy. We were very favorably impressed by the letter signed "Sandra" in No. 12 as it came rather close to one of our own diversions. We call it "JEOPARDY" and it works this way. On one evening every week my husband must submit to placing himself in jeopardy by appearing before me in a costume reminiscent of that worn by the Burgesses of Calais immortalised by Rodin (en chemise et la corde au cou) and request me to strap his wrists firmly together behind his back, once this has been done I am completely mistress of the situation and I get a big thrill out of having this big athletic man of mine so completely at my mercy. This thrill has never been dulled by repetition and he feels just as thrilled by his helplessness and by the uncertainty of his future. Sometimes I will let him off with just some slight act of submission, such as kneeling down and kissing my feet; or I may first make him do penance by standing or kneeling in a corner for a specified length of time. However if some black marks have piled up against him during the past week he will not get off so easily but will be made to feel weight of my displeasure and submit to my most striking arguments. By the time my discipline is terminated he will find it more pleasant to stand than to sit for some time and I will have a very docile husband, very anxious to please me in every way, at least for as long as he prefers not to eat his meals off the mantelpiece!

Mrs. F. L.

DYE DOES IT

Dear Sir:

It wasn't until we read your magazine that I ever dreamed there were any other folks in the world that had the same ideas and enjoyed the same, what we thought, unusual pleasures that we

indulge in. However now I am encouraged to write you of our experiences, particularly for the benefit of the wives and girlfriends who have had a little difficulty perhaps in subduing their males and bringing them to time.

My system came to me by accident and on washday. My husband had always been pretty dominating about keeping me well laced in tight corsets, extra tight pinching shoes with the highest possible heels, and all variety of blindfolds, masks and shackles he could devise. I was washing clothes and dyeing some curtains a beautiful dark red when I got some on my hands. It took many washings before the stain had faded away. Why not use it on my lips, I thought, and save applying lipstick all the time? I made a small cupfull of the dye, real strong and concentrated and quite thick. I painted my lips on big and full and let the mixture dry. Then I applied a second coat, then a third. The result was a beautiful shade of real dark red. The lips were perfectly outlined, which took a long time, but were really on for good. My husband was very pleased with them too and something he said about them gave me my big idea. The next time he let me tie him up which happened now and then but which he really didn't like any too well, I concocted some more of the

ORDER OF THE GARTER

This "hobble garter" was invented in 1911 to check the stride, and thus prevent "baggy knees" in the hobble skirt.

102

dye and when I had him secure I proceeded to paint big lips on him like a chorus girl's most extreme make-up. He was frantic but when he wiggled the slightest bit I stuck him hard with a pin and he soon stopped that. While putting the last coat of the dye on the lips, I had another good idea. I had a laundry marking ball point pen to mark sheets and things before sending them to the laundry. Like a regular pen, you could make light or heavy marks only the ink was fast and washproof. With this I made heavy lines along the edge of his eyelids at the base of the eyelashes on the upper lid and a slightly lighter one, but still plain to see on the lower lid joining them into one black triangle at the outer corners of the eyes like you see the advertising models wear in pictures. After I'd finished with him, he really looked silly with his whiskers showing, his hair all roughed up, trussed up on the bed with the wildly painted eyes and lips. I had to laugh at him, *that* his masculine ego couldn't stand. He started to cry.

With that I loosened his bonds. He was in a towering rage and said he was going to kill me. But he looked so funny carrying on that way with his painted face, I broke into another fit of laughter and as he started for me with his fists clenched I simply reminded

photo from "Mrs. Satin"

him that if he so much as touched me I'd scream and the neighbors upstairs would come in and see him looking so silly he'd never be able to live it down. With that he just collapsed and I knew from then on that I was boss and he'd give me no trouble. I sent him to the bathroom and told him to shave carefully and put on the rest of his make-up and his feminine clothes and wig and settle down to his new role of being my

103

secretary - maid - companion and that the Manuel we knew of old was now away on a very long trip. I stored away all his male belongings against some future day when Manuel might return which I doubt.

Secretly he scrubbed at his eyes and lips each time he shaved and made up but for many weeks there was the outline of the dyed lips and the black around the eyes remained clear and sharp much longer thus prohibiting him at any time appearing in anything but full feminine guise. Twice I have renewed the lips but the last time was with no resistance on his part. He has become obedient and docile. The old Manuel is gone and Marie has taken his place. And a beautiful loving companion she is.

> Very sincerely yours,
> Luchetia

SUFFERING SINBAD THE SAILOR
Dear Sir:

Ever since I left home to go to sea, I have been under the thumb of a domineering woman, and I have learned not to regret it.

My ex-wife, a European girl, quickly broke me in to regard her as my superior. On our honeymoon, before I knew it almost, I was painting her finger and toe nails. If I did not do a perfect job how she would criticize me! She made me feel like a worm!

She made me get up at six o'clock in the morning to get her breakfast, and lay out her clothes. All day long she would make me work hard so that I was very tired, and I would get a little sleep in the early evening, I was permitted to sleep on the floor beside her bed, and we had such a wonderful night together the first night of our honeymoon!

I would be aroused by a trim, high heel shod foot prodding me awake. I would hear the curt command to get up and prepare her bed. I was lucky to get five hours sleep a night.

Once, when I had displeased her, she tricked me into a clothes closet. I did not get out until I crawled out on my knees, with the most abject apologies. I dare not fight with her as she has a good knowledge of Judo. I found that out the hard way. It was terribly humiliating, especially when she laughed at me as I lay between her beautiful legs.

When she tired of me, she got a divorce, and has since remarried. I have met her husband, and she is driving him crazy.

After that, I met a beautiful young lady in Manchester. She completed my education as to the superiority of the fair sex.

My hands pinned to the floor by her dainty high heels, she would whip me while I sobbed and cried for mercy. I had cigarette

There's a problem here it seems.

burn scars in the shape of her initials for a long time. She tired of me after she had broken my spirit.

My next defeat was at the hands of a girl in London. She would make me kneel before her and kiss her feet and legs. She would brandish a wicked looking pair of shears, nearly frightening me to death as she threatened dismemberment. Once, she made me lick the entire floor of her apartment with my tongue. I was released from her bondage when she had the opportunity to marry an elderly wealthy man.

I am now engaged to a beautiful Swedish girl. There was no mention of her dominating me until the time she asked me how I would like it if she beats me with a stick. I said that she would have to catch me first, and nothing more has been said on the subject.

I'll let you know how it turns out.

Sincerely yours,
W. W. E.

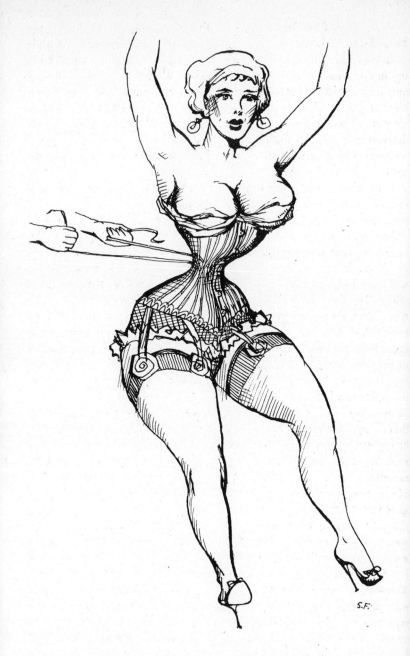

This is a reader's idea of Paula Sanchez.

THE PAY OFF

Dear Editor Bizarre,

At one time I was able to give up figure training as impractical and uncomfortable but something happened just when my husband went away to reinforce me in my determination to be more wasp-waisted. than ayone he had ever seen.

I went with him to his office to help him get some things to pack before he left.

Just at this time I discovered something that gave me something of a shock. A certain Miss X who worked in my husband's office was assigned to go along too. I had always known my husband liked her, but it never occurred to me until now that it might have something to do with her figure! Because Miss X, though somewhat severe and plain in the face, and somewhat older than my husband, had been brought up in corsets and had such a small waist that it was something of a joke around the office. She was always impeccably groomed and wore suits which showed off high, full breasts, tiny waist and wide hips. She also wore pumps with heels so high I wondered that she could walk. You could never have said she was dressing suggestively, but I was beginning to understand the appeal of the hourglass shape, so I determined to outdo Miss X

in every respect. I knew her roommate and decided to confide in her just enough to know more about Miss X. When I phoned her she told me that Miss X collected period corsets as a hobby and enjoyed wearing them and often had to be helped into them. It could be said to be her one dissipation!

And my husband and she were going on a trip!

Well, let them have their fun, I'd be ready when they got back!

By now I was able to wear 17 inchers, but I determined to get down to fifteen and had to have a costume corset altered for the purpose. I have red hair and decided to go in for gold and green as a color scheme. I went to a skin specialist and had every blemish, tiny as they were, corrected on my back, neck and shoulders and thighs. I got a new formula for make-up from a beautician. I had my hair waved and tinted so it shone a little gold. I got an eye-lash curler.

I hardly knew myself when I looked in the mirror and this gave me another idea. I'd have to have new clothes anyway, so I bought and altered a green silk dress, a more brilliant green than my husband had ever seen me wear, but which went very well with the new make-up. By wiring ahead I was able to reserve a room next to the one my husband always

asked for. This, of course was pure last minute luck.

I hate to admit it, but I peeked thru the keyhole long enough to know that my husband was an expert at lacing and unlacing corsets! My guess was right. He and Miss X were high on champagne and playing games!

I went home and stocked up the liquor cupboard, though I had never cared much for drinking and when my husband returned he found me quite jolly and dressed in my new regalia.

I never said anything about Miss X, but I notice he doesn't either any more. He goes on fewer trips and comes home earlier, and for some reason there are more evenings when he has time to be with me.

So I'm grateful to Bizarre.

Yours very truly,
Madeline C.

REPLY TO SMART HORSEMAN

Dear Ed.,

I was interested in the letter signed by "Smart Horseman" and I would like to say that I can agree with him that in the beginning of the century horses were treated much more severely than the present day. I am not prepared to argue the rights and wrongs of the matter with him however as I merely mention this from a professional point of view as I was an apprentice spurrier in my grandfather's shop just off Piccadilly in London. My grandfather was a member of the Spurriers Guild and was under contract to many leading saddlers in London. I was at this trade for over two years before going to sea.

"Smart Horseman" is right about the sharp spurs fancied by the ladies of the period and the way they rode their mounts was really cruel. They used to order spurs with very sharp rowels and their excuse was that the rowel had to be long enough to goad the horse through their thick habit skirt. It was pitiful to think what happened when the skirt was not in the way. This was before the modern apron skirt mentioned in the letter came into being. It was quite a common sight in those days to see a lady dismount from her foaming horse and to see the deep red spur-marks along its ribs

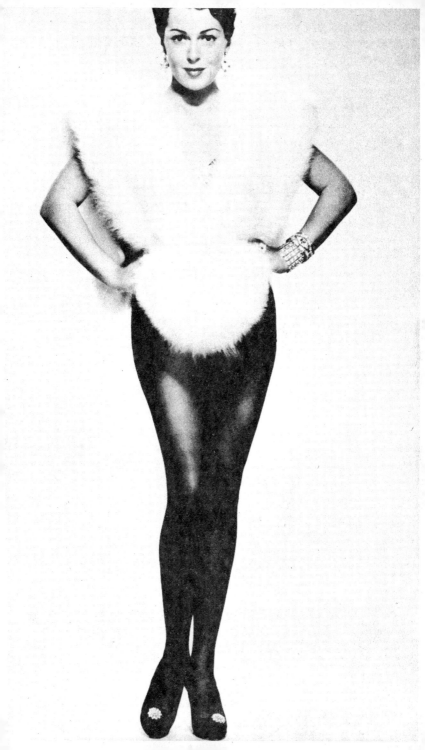

that her skirt had hidden when actually riding and many a servant has cursed her Mistress for her thoughtlessness when trying to clean the bloodstains on her habit before the next days riding. Even young girls in their early teens used to come to the shop to have their spurs properly fitted. Really smart ladies used to have a sharp spur fitted to the left heel and a dummy to her right heel to look well when walking as when riding she could only apply the left one to the horse. Some of the ladies who were not really good riders used to get the spur jammed well home and then use it to hang on by.

Perhaps the cruellest spurs that ever were invented was the Ladies Spike Spur and the Ladies Spring Rowel Spur (patents of which can be seen in the London Patent Office to this day) The first mentioned was simply a long spike fitted with a spring which when not in use was covered by the shank so that when the lady was not actually using her spur it did not catch on her habit and tear it as the shank end was nicely rounded. When the lady desired to spur her horse she had to jab the shank back against the poor dumb animal's flank with a sharp kicking motion thus depressing the shank end and exposing the spike which buried itself in the flank. She could then grind the point in until she was satisfied with the result. This was an extremely cruel weapon and it tore the hide instead of ripping it like the rowelled spur, it was however a very popular line in spurs and I have heard it described by ladys who have used them as being a perfect "Darling of a Spur". The other spur mentioned was on similar lines but instead of a spike it had a sharp rowel fitted with a depressable guard on a spring to expose the points of the rowel. The great trouble with them was that the springs used to get out of order and then the horse suffered greatly with a long exposed spike being dug into his ribs with no spring to act as a buffer. I also remember one of the Belles of the Smart Set in London who used to insist on having barbs or "teethas" she called them set along the edge of her rather long rowels.

There were also the whip spurs. These instruments were fitted on the shank of the whip by a screw and never gained much popularity at all for ordinary riding, but they were used almost continually in High School and the Menage. The rowel on these were filed sharp as the lady could not deliver a thrust with the same force as with her heel. The Menage Horses were not asked to do any strenuous galloping, but were expected to do fancy and intricate

movements in the ring. To get them up to the proper state of excitement before entering the ring the lady used to mount up

about fifteen minutes before and while two stout grooms held her mounts head she would sit and jab her spur into it's flank and apply her whip spur until she received her cue to enter. During this time her dresser would be in attendance to hold back her skirt and to wipe the blood off the animals flanks with a cloth dipped in some mixture which stung as well as dried. This was supposed to bring the animal up on it's toes as it were. These ladies were the toast of the town.

If "Smart Horseman" wants to see this period come back he is welcome to it but I think that it is gone and I don't think that there are many exponents of the Smart Severity left. The present apron skirt mentioned by your writer only comes halfway down the present side saddle rider's boot and both her spur would be seen and the gashes it left. No, nowadays most riders do not bother even to wear a spur except a dummy for show and perhaps it is best that way. I would however like to hear from "Smart Horseman" perhaps he can tell us about the ladies he has introduced to the side-saddle and how they like their horses and do they like spurring them for the love of doing it.

Yours sincerely,
China Hand

GAITERS

Dear Editor,

There is one article of feminine attire which has been absent from your magazine to date and I'd like to see some discussion on it. I refer to the old fashioned gaiter. Altho some attempt has been made by fashion experts to bring them back into vogue on at least two occasions since the war, both these were rather dismal failures.

It is my recollection that gaiters came into popularity as a measure of protection for the ankle and

lower calf during the winter season when low shoes first came into general use. The thought of exposing the ankle unprotected to the elements save by stockings was unthinkable to the good ladies of that day. Until after World War I, most women wore high shoes either laced or buttoned except for dress. It was natural therefore to feel the need of protecting when they got dressed up in pumps such as women today wear all the time. Gaiters were the obvious answer. They had style and attracted favorable attention outdoors, indoors they could be removed or worn as the wearer chose. Then too in that day there were no smart galoshes or zipper boots. The only choice was the heavy shapeless black buckled "arctic." Small wonder that the stylish females of that day gladly donned dressy gaiters over the plain rubber when she went forth on a winter's night.

Like the bloomer fans, then, I'd like to see them come back into common usage. That which is concealed has more allure. But I have little hope. Most women today go barelegged and wonder why men no longer stare.

Perhaps some of your older readers have pictures of themselves thus clothed which they would submit. I'd love to see such or hear any comment.

nostalgically, "Red Flapper"

CHAINS AND BELLS

Dear Editor:

Your magazine is amazing. My wife when she saw some of the illustrations (page 33 of No. 14) told me that she had always been fascinated by the thought of being in chains, and urged me to enslave her too. Now each evening when I return home she greets me at the door wearing nothing but a filmy brassiere, collar, wrist chains and ankle chains held off the floor by a chain belt. To add effect I have added tiny bells so they tinkle merrily as she walks.

Thank you for adding to our enjoyment.

Sincerely,
B. H.

AN APPEAL TO THE READERS OF "BIZARRE"

In the old days, I was almost happy in my role of slave. My mistress was very beautiful and I did not mind being compelled to wear feminine attire because it pleased her to see me thus. During these happy years the harshest punishment I could expect was a brisk spanking from milady's hair brush.

But now my Mistress has become a veritable Fury, and I, poor creature, become the piteous victim of her cruel experiments. Now, instead of a pretty housedress or apron, and a comfortable pair of sandals, I am laced into abomina-

bly tight corsets and my poor feet are forced into ridiculous shoes with 4 inch spike heels. I was once proud of my 32 inch waist and all that was needed to control it was a comfortable, rubber panty girdle. Now, laced so tightly I can hardly breathe, my waist is compressed to a meager 27 inches.

There was that fateful day when my mistress laid aside her hairbrush and bought a whip. In a short time she had accumulated quite a collection, some of which she made herself. Never a day goes by that my poor body does not quiver from the sting of her cruel lashings.

In the old days, I was free to roam the house and tend my duties freely. Now I am hampered with shackles and chains, and the threat of a whipping is ever present should I make some trivial error. Only last week she decided that I should be made to suffer the shame of a gag. I am still wearing it now padlocked so I cannot remove it. She only unlocks it for 20 minutes my three meals a day.

All about the house and ever threatening, are various evilly ingenious contrivances for restraining me during my daily beatings. "Discipline" she calls it. What irony!

While she is out shopping today, I dared enter her room, and on her dressing table found several lengths of stainless steel chain and padlocks of hardened steel.

I shudder to think what wicked thoughts are tumbling around in her lovely head. Only last night she was in a violent temper, and threatened to put me in a "mackintosh," whatever that is. Knowing my Mistress, I feel that it will be some awful device to make my life more miserable.

And so you see, kind people, the plight I am in and if things continue as they are, I fear I shall be forced into rebellion. The punishment I shall receive if my rebellion fails will indeed be formidable, but as I am in such a wretched state now, I shall be willing to gamble. And if I win — the tables will be turned; and then we'll see how the lovely lady enjoys the whips and shackles and humilities she has brought upon me lo, these many years.

And now I must go, for She is due back soon and if she ever discovers I have written this letter she will be furious and only I shall suffer.

Respectfully yours,
Carlos the Slave

IN VERY SOOTH!!
Dear Mr. Willie:

Hurrah for Bizarre! For those who may have been amused by some of your early predictions of high heels, wasp waists, leather

a Rubber ensemble

outfits, transparent blouses, opera length hose, nose rings, shiny boots, huge earrings, exotic make-up and dominant women I take pleasure in telling them to look at the magazines and newspapers. Recently the great Dietrich was photographed wearing a black leather coverall that encased her from neck to ankle. Although concealed in that outfit, she revealed in a transparent topped dress at a night club in Nevada.

Hi heels? — On 42nd Street in New York there are four stores in one block which feature shoes with heels over 4 inches and one high fashion one of 5th Avenue that has them with 5½ inch heels (*But with platforms—Ed.*) and almost some with a disappearing heel (like your "no heel" suggestion). Long length hose are everywhere, so are heavy earrings. On stormy days shiny boots can be seen on about every other woman. Exotic makeup! Well! It is on about every young thing. Dominant women? What about all the black velvet red satin or black satin bull fighter pants the girls are all wearing! And wasp waists? How about all the cinch belts, the waist nippers and even brassieres with wide elastic bands at the bottom to whittle milady's middle.

I hope that I live a while longer until some of your Miss Tomorrow ideas get adopted — and I know they will. Oh, I forgot the

nose rings? Well, there was a photo of an English girl in a recent issue of a pocket magazine and she wore a nose ring.

I am from Boston and my travels take me to New York a dozen times a year. It is through these trips that I got introduced to your fine magazine. Our collection is almost complete and my beloved wife and I are patiently waiting for future copies to become available through the dealer who supplies us with the publications.

Perhaps your readers will be interested in the exchange of Christmas presents at our house. I gave my wife a red satin back lacing corset (custom made by a corsetiere located on upper Lexington Avenue). A pair of imported pumps with the before mentioned 5½ inch heels, long hose, a pair of red trimmed black velvet bull fighter pants that fit like a second skin, and a sheer black nylon blouse and a wide, contour leather belt. With her naturally small waist laced to a tiny 18 inches and her 36 hips and 37 bust she was a sight to behold.

Her gift to me was equally exotic — a pantie girdle of sleek nylon that reached from mid-thigh to several inches over the waist. It is further reinforced over the waist by a wide, boned front fastening elastic band, a long sleeved heavy white satin

blouse and black velvet lounging slacks and high heeled black patent leather pumps completed the outfit. It was patterned after "Informal Evening" on page 37 of your No. 6 issue.

I will say that when both of us don our outfits we will qualify as Mr. and Mrs. Bizarre. Speaking of Mr. and Mrs. Bizarre why not sponsor a contest and choose a Miss Bizarre, a Mr. Bizarre and a Mr. and Mrs. Bizarre. Perhaps that will entice the photographs and even improve the already great interest in the magazine.

Yours very truly,

L. H.

Smart Shoes

Dear Sir:

Thought you'd be interested in some pictures I took of a few pairs of my wife's high-heeled shoes. The notes on the back of each shot are self-explanatory but some of the photos do not do justice to the fine workmanship and polish on these shoes.

My favorite pair are the black kid sling pumps with the toe ornament as shown. As my wife has small feet, the slender polished 5½" heels of these shoes are truly incredible, and force her to walk with exaggerated gracefullness and care, being almost on tiptoe with her instep arched beautifully forward.

All her shoes for daily use at the office have spike heels, usually not less than 4 inches and often she wears the red sling pumps shown (with 5 inch heel) to the office, attracting much envy and attention. She knows the power she holds over me with her fascinating stilts, and delights in bringing me to my knees when she desires, to worship at her magnificently shod feet.

If other readers would be interested, I'll send along other shots of her wearing some of these shoes. Keep on with the good work, Bizarre is a delightful magazine.

Sincerely,

L. H. J.

Figure 8 Club

Dear Mr. Willie:

Before going to our regular meeting of the Figure 8 Club I feel that I should write to Bizarre. In my last letter I gave you the figure dimensions of the members of our club and demonstrated, beyond any shadow of doubt, the added advantages a tautly laced wasp waist corset gives to a woman's figure. I also mentioned that I was on my way to visit San Francisco.

The trip was quite eventful and although the sway and vibration of the train and my relatively small roomette prevented me from lacing myself as tightly as I had desired I did the best I could.

116

From the glances of my fellow passengers it could easily be seen that the men admired, and the women envied, my extremely slim waist and my dexterity with high heeled pumps.

As it was a bit chilly when we arrived in San Francisco I wore a knitted wool two-piece dress of light tan. A wide pre-shaped natural leather belt set off my wasp waist. Taking a cab to my friend's home she greeted me with open arms. As I removed my coat her eyes went immediately to my waist — she was amazed at my small waistline and asked me how I did it.

I had brought an extra pair of stays with me thinking perhaps I could make a convert out of her. After I had unpacked and showed her the corset nothing would do but that she try it on. Stripping to bare essentials, we slipped it over her body and I laced her into it and did a thorough job. She complained of the tightness and the difficulty of breathing but when she surveyed the results in a mirror she soon stopped complaining and was pleased with the results and her new figure. She donned a half slip, tight sweater and skirt and a wide elastic belt and had difficulty keeping from admiring herself in the mirror.

When her husband arrived from work he noticed the change im-mediately. When told that she was wearing a tight lacing corset he confessed that, of all the attributes of a woman, he most ardently admired an extremely thin stem-like waist.

The next day we went shopping and purchased a long heavily ribbed corset. My friend was a high heel faddist so we didn't have to shop for shoes although I told her where to order some special occasion pumps with thin 6 inch heels. When we returned to the house we rebuilt the corset along hour glass lines. She was quite adept as a seamstress so it was not long before the remodeling job was completed. It was great fun lacing her into it and the garment did a wonderful job of reshaping her figure.

It is time now that I get ready for our meeting so will have to say goodby now until next month when we will report on more activities of our Figure 8 Club and present additional facts about corsets and the wasp waist figure.

Yours very truly,
J. M., Sec.
Figure 8 Club

More Jewelry Wanted
Dear Editor:

During the last few evenings I've been re-reading some of my back numbers and coming to No. 5, I find some letters to which I simply must reply. First there

is the letter from "sparkle" to which I fully agree. More jewelry which has gone out of fashion somewhat is the ordinary finger ring. I love to see plump white fingers ending in really long pointed nails, coloured of course, and with the lower finger-joints simply buried beneath a flashing, glittering load of diamonds. And what of another fascinating jewel — the anklet. I love to walk the streets just to try and spot the ladies who sport this thrilling style. A golden chain with perhaps a diamond clasp gleaming beneath a sheer silk or nylon stocking can make even the most ordinary turnout look extra smart. Reluctantly I must go on to other letters which also appeared in No. 5. C. McC and Hank B in particular, both write on a subject which I find most exciting — different and revolutionary clothes for men. I could write on this subject alone for hours but I'll try to be as brief as possible. Why oh why must we men cling to our hideous trousers, conventional suits, drab underwear and thick socks and flat-bargelike shoes. How can we expect our ladies to dress to please us when we wear such uninteresting masses of wool and serge and tweed.

Yours sincerely,

S.A.A.C.

(Smartness at all costs)

BRIGHT BEAU — BUT BRIGHT!
Dear Ed.

What a thrill it is to get Bizarre again. Its the only mag us girls can see which shows men glamorously dressed. I have a thrilly pash for men wearing breeches instead of ugly, drab trousers. Couldn't that darling John Willie give us some of his lovely drawings but with men in thrilling skin tight breeches? My prince charming would not be a boy, he'd be a real man dressed in a white silk shirt with extremely high, tight, stiff collar, green velvet jacket pulled in to fit his hourglass figure, the jacket cut very short and skin tight to show off his wasp waist, proud, full chest and hips and thighs, in turn fully outlined by a skin tight pair of green velvet corduroy breeches, laced high up the sides with bright yellow silk laces laced upwards so that they tie in smart tasseled bows on the thigh. His boots would be fairly short, about mid-calf length, laced with yellow laces (boots would be brown lace kid) The heels would be real stilts to lift him right up on tiptoe and that means at least seven inches. Golden spurs would be fitted neatly in the heels, the spurs tipped with long steel points wickedly sharp. He would always carry a riding whip. His fingers would blaze with gold and diamond rings and his long pointed nails would

be tipped with gold and the rest painted bright green. His hair would be long down to the waist, brilliant yellow in heavy masses of curls and drawn in at the neck with a huge green and gold silk bow. His ears would be pierced and carry long, massive gold pendants, and there would be gold and diamond bracelets at his wrists and a gold and diamond bracelet around one ankle. He would never ride in a motor car, all his transport would be either riding or driving horses, the animals looking as smart and reined up as possible.

Now there's one girl's idea of her dream man, after all we *do* dream just as you men do.

Best wishes to Bizarre and all its readers, especially to my prince charming if he exists.

Yours lovingly,
Matilda

MASKS IN N. Z.

Dear Sir,

First of all I must compliment "Blind Girl Fluff" on her novel ideas, it is certainly "the goods." I have the ideal piece of leather for our helmet but so far have got no farther. We are limited so far to showercaps and bathing helmets here I am getting around to "Mac Fan's" ways of rubber clothing which really appeals to me. It is quite a good thought to strap my wife to a chair and fit on a shower cap, and over that her helmet, rubber brassieres (no panties yet unfortunately, and high-heeled shoes, only 3½ inches, but we are on the track of some 6″ ones — I hope.) And then to go over all a plastic coat and hood, some people don't like the plastic but I think it is good in some places.

I think it was "R.D.F." or some similar initials, who wrote about girls and make-up and smoking, again ideas we fully share. Also "Slave Girl Una" has given my wife ideas about getting an outfit for me. What delight!

Yours in helmets,
and high heels
Mr. & Mrs. J. A.

COLD WATER CURE

Editor:

Your magazine is a fascinating one. My husband travels and he brings home copies which I manage to "find" no matter how carefully he hides them. He has certainly got some ideas out of your magazine, but believe me he has some ideas all his own.

Some time ago I found some odd pieces of rope in his bedroom drawer. I had an idea what they were for, so I waited to find out. I found out, all right. One afternoon after I had nagged him a little too much, he came out of the bedroom carrying the ropes. Before I could open my mouth he

had forced my hands together and tied them securely. Next I found myself tightly blindfolded and finally in spite of all the kicking I could do, he also bound my ankles together then he lifted me and carried me to the basement of our little house. There he raised my hands above my head and tied them to a rafter at a height that I could just touch the floor by standing on my tip-toes. Then I could hear him moving about and I waited to feel his belt applied. But imagine my surprise when instead of feeling the belt, I heard a swish and felt a hard stream of icy water from a hose directed at my feet and legs, drenching my suede shoes and nylons. I could only gasp as he next played the cold water over my entire body, soaking me to the skin through my thin dress. When I was completely wet from head to toe, he raised the skirt of my dress and tied it above my head, then he played the water all over me again.

I have no idea how long the water treatment lasted. It seemed like hours before he finally turned it off and let me down. Needless to say, I was quite contrite after the treatment and after he loosed my hands and feet, he made me walk back upstairs with the water dripping from the hem of my dress and water squishing in my shoes at every step. He then removed my drenched clothing down to the bare skin and rubbed me hard all over with a towel until I felt my body fairly glowed.

I had thought this treatment was the ultimate in punishment, but I found out soon enough that he had other tricks in his bag. If you're interested I'll tell you about them.

Please publish my letter, but just sign it "Betty." My husband knows I am writing this letter and he said he was going to dunk me in the bathtub if I mailed it, so I guess I am going to get dunked because I am going to mail it.

Yours very truly,
Betty

P.S. I would like to hear from other of your correspondents who also get the water treatment.

P.P.S. The brute didn't even wait for me to mail it. He read it, laid it down, picked me up and the next thing I knew I was in the bath tub again.

SUPPORT FOR PANTIES

Dear Editor:

Having worn a girl's girdle, panties, bra and dress several times as a masquerade costume, I certainly must agree with you "Skirts for Males" enthusiasts that the skirts and panties of the modern miss are very delightful and pleasant to wear.

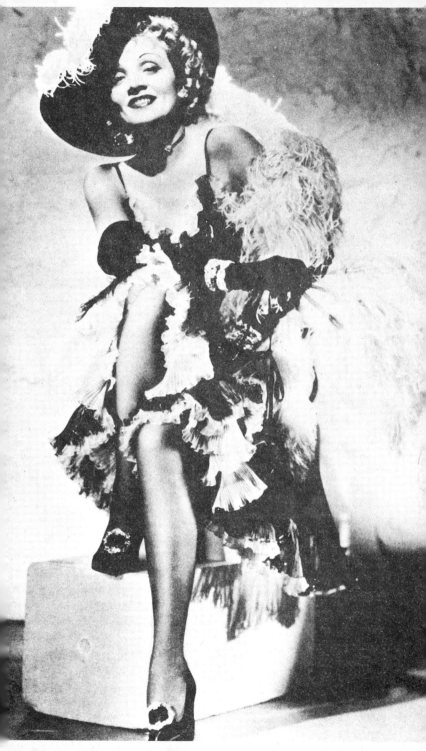

I think silk, nylon or other styles of girls panties are far cooler and more comfortable than mens' briefs or shorts. I have several pairs and often wear them under my regular clothing as I prefer the feel of them.

Yours,
Glamour Louis

WHY SYLVIA! NO RUBBERS?
Dear Editor,

When No. 12 was announced I feverently hoped there would be much in it for the Rubber Fans. So when I opened to see Sylvia Souliers' Footwear Fantasia and saw her in that splendid black rubber coat, I was indeed thrilled. But as I looked closer I was disappointed. In none of these pictures is she wearing rubbers. She even goes on to say that the high kid shoes are ideal for wet weather. For shame, Sylvia! With that beautiful outfit the one thing you should be wearing is a pair of shiny black storm rubbers over those kid boots.

Then the letter from R.U.B. saying she had formed a Rubber Club and telling a little about it. It was fine but not half enough. We'd like nothing better than to see pictures of the members wearing their rubber outfits with the caps.

But the prize is reserved for Ruth in Rubbers. Here is a girl after my own heart. I only wish her account of her job experi-

ences were longer. How late in the season does she continue to wear her rubbers. Certainly not through the summer. I wish she would write more but in any event I want to second her plea to John Willie. Please encase the lovely feet of some of your beautiful high heeled misses in shiny black rubbers — not boots. That would be perfect.

Crazy over Rubber

MORE SATIN PLEASE
Wear J. W.—

The rubber fans or shall we call them "rubber bands" (yuk yuk!) seem to be gaining ground. While nobody likes rubber more than I do, I prefer the silky smooth, clinging texture of good satin. I am enclosing three pictures — one of Miss Satina — 1954, my wife, of whom you will see much more before many more issues — providing you desire to. *The photos you sent weren't properly washed — or sum'p'n. They are now too faded and stained to reproduce. You aren't at your old address — we're stymied. — Ed.*

She has a wardrobe of satin from shoes to hats and then some. Nothing delights us more than for the both of us to don black satin custom made bloomers and high heeled pumps and play "tag" around the house. This is made doubly more interesting since we do the "tagging" with heavy leath-

er straps with handles and the "seat of the Government" is the only place eligible for "tags." A most delightful game. Further, if any of your readers care to, they should write to "Scintilla" in Chicago for quotations on the most delectable satin sheets and pillowcases.

<div align="right">
Sincerely

Tom G.
</div>

TIGHT WAIST

Dear Bizarre:

Ever since I was a little child I have enjoyed a feeling of tightness around my waist. As soon as I was allowed a belted costume I pulled the belt as tight as possible. After our family broke up I lived with an aunt who believed in figure training and I was allowed to lace somewhat from the age of twelve on. My aunt wouldn't let me lace very tightly at first so I used to surreptitiously lace till I gasped and then pad out my dress so it wouldn't be noticed. I do not know why but I am never happier than when laced to the fainting limit.

I have a very sweet tooth and there has always been a competition between my waistline and my appetite. I like to eat a lot, at the same time being very tightly laced. I like the wonderful feeling of my bosom rising over and out of the corset and the exquisite pressure around the ribs. I have always been a bit reticent about it because many girls and men do not seem to feel as I do, but finally I met a fellow who betrayed enthusiasm for the gay nineties hourglass figure. We were married and he was amazed and delighted that I wanted him to lace me as tightly as possible. We both enjoyed it so much that finally he got a corset for himself and we enjoyed lacing each other. He is a very masculine man, with a broad chest and narrow hips, but he looked so cute in a corset I wanted to dress him up in bra and panties, so I got some for him and we had regular dress up parties after that in which each would wear what the other wanted. He liked the highest heels, opera length hose with clocks, sometimes even long gloves and a big hat. Sometimes I would wear only one stocking. We used every ingenuity to find all possible variations on the costumes we liked.

In No. 12, the issue I read, I was interested in Mrs. LH's letter because I find that the truly tight lacers will agree with her. The back can arch only so much. I believe I have cultivated about as much of a back arch as is anatomically possible, for this raises the bosom. But let us face it, there is a spine in the way. The corset must push in at the sides first and after that in the front and since the flesh must go somewhere

it goes up and down, to support the bosom above and to round the abdomen in front. Having tried it I do not believe it is possible to achieve as small a waist with a straight front corset as with the 1895-1899 models. I do not believe Mrs. LH means that there would be no *derriere*. It is only that after a certain point in lacing the indentation must come from the front inwards. My husband definitely liked my rounded tummy under the corset as much as he liked the rounded bosom above and used to tease me to eat more because he liked plumpness "in the right places." The "right places seemed to be the thigh, the upper arm, the breast, the *derriere and the lower abdomen*. He hated the effect of corsets which constricted the hip region. He wanted these plump regions free to quiver a little when I walked in my stilt heels. He thought the effect on walking of the combination of very tight corset and stilt heels was exquisite. The slight jar of walking in very high heels produces an undulation in the bosom and an alternate movement from side to side in the hips in the direction of whichever foot supports the weight. A hula-like movement becomes quite automatic with every step. This walk is instinctively adopted by women when they want to be seductive.

He enjoyed to the fullest any little awkwardness or helplessness which occurred because of the tight corset and the five inch heels insisting that they were feminine graces.

The change in breathing Mrs. LH mentions he also liked, and liked the exaggerated cleavage effect. I massaged the plumpness under my breasts upward with my hands as he laced the corset, so as to support them to the fullest. I was, luckily "well-endowed." In fact I used to suppress the fullness of my bosom a little because I thought they were too large and prominent until I learned that he could never have enough of them! After that they became like a shelf protruding directly out in front of me! I sport 39½—15—36 and am 5 feet 7 inches without heels. My husband has recently passed away but I still enjoy dressing as he liked me.

Like Mrs. LH I understand such predilections as birching, blindfolding etc., but corsets, costumes and heels are the parts of your magazine I love. I also like lace and peek-a-boo effects and heavy jewelry and have even considered wearing a jewel in my nose in the East Indian fashion.

I also enjoyed the letter of Bernadette Brown. I too have my share of whistles. Her description of dressing for her husband is very like my own experiences,

but I would add that now that my husband is not here I get a deep satisfaction and thrill out of lacing very tightly every day.

Sincerely
"Margaret"

THE FASCINATION OF FOOTWEAR
Gentlemen:

I have read your excellent magazine for many months and agree with most of your readers that the appeal of improved feminine wearing apparel is fascinating to men. As is the case with most men, those daring tall heels on girls are my particular weakness. I don't know just how it got started, but from about 15 years I delighted in observing ladies wear smart footwear with high heels which were I suppose only about 3 to 4 inches high. After doing this for a number of years I decided to buy a pair of blue kid sling pumps which, due to the war years, had heels of only about 3¾ inches. To my great surprise, the wearing of the shoes pleased me so much that I even wore them all night so I would have the enjoyable experiences of seeing them first thing in the morning.

From this time on I was converted. It was necessary for me to try on new styles of shoes of every type. I kept searching for higher and higher heels with little success except for some platform styles with 5 inch heels which

were most exciting. Imagine how pleased I was to find a pair with 6 inch pencil spikes. They were all of perfection. The soles were thin and the heels so expertly made that the taper and shape were ideal. The fact that I could not walk in them didn't matter; just so they would fit and I could see their graceful loveliness.

Since that time I am a confirmed lover of shiny smooth patent shoes with the graceful long shafts. But although I like to wear the shoes, I still cannot resist a girl who has beautiful legs and wears expensive shoes with tall heels, no matter what she looks like. When I marry it is essential that my wife love stylish footwear. In return she can expect plenty of attention from me.

Sincerely,
"High Heel Artiste"

SIR WALTER RALEIGH 1955
Dear Editor:

We were happy to read the recent letters from Fred Mac and McLover and were thrilled with the delightful letter in Issue 9 from "Satisfied", relating the delicious experiences she shares with her husband Jim in their mutual enjoyment of her high-heeled rubbers and sleek rubber boots, and to know that we have company in our devotion to the fascinating feminine rubber-shod foot.

From the time we met, some

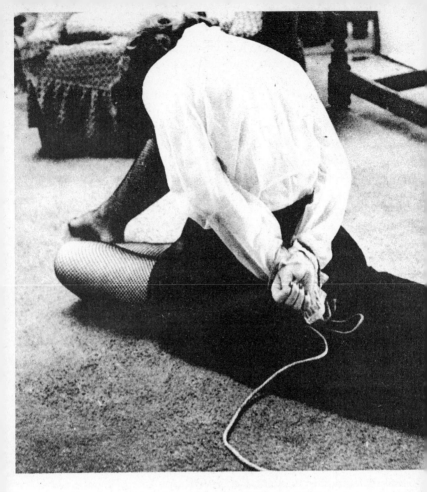

" 'aint misbehavin' "

years ago, my wife Elinor has revelled in captivating me with the sensuous allure of her dainty shoes sheered in spike-heeled rubbers, galoshes and boots. Whenever a new style in ladies' rubberwear is offered in the shops she promptly purchases a pair and models them at home for my enthusiastic approval, and I have often surprised her with a new style or color in sleek rubbers before she window-shopped them.

To start with, on our first date I stopped at her apartment with plans to dine out and then see a movie. Seated in her livingroom while she completed her makeup I thrilled to see a shapely pair of shiny black storm rubbers with slender heels nestling in the tissue of their cardboard box. Picking them up, I was examining their glossy fascinating curves and ridged, rolled-edge soles and heels when Elinor swished into the room.

She smiled and said, "My new rubbers — aren't they just too good-looking? Do you think I should wear them this evening?" and she seated herself with an expectant air while giving me a look of what I fondly hoped was an invitation.

"It was just starting to rain when I arrived," I lied happily, hastening to kneel before her, "Let me help you put them on." I slowly fitted the high-arching

dainty rubbers on over her slim black-patent opera pumps, prolonging the delicious task as she crossed and uncrossed her silken legs (nylon was then but a gleam in the chemists' eye) under my directions. Elinor's tight skirt slipped above her knees as she leaned forward and intently watched mv ecstatic fumbling efforts until her feet gleamed in smooth rubbered softness.

Still seated, she stamped down on her spiky rubber heels with more than emphasis to ensure their snugness. I said something about Sir Walter Raleigh's cloak

127

being outmoded by a girl's rubbers; her teeth flashed a mischievous smile and she replied, "No, no! gallantry should be practiced as well as be remembered. For instance —" and with that she planted a rubbered foot on my chest as I still knelt before her and toppled me over on my back

Before I could recover from my surprise of the sudden attack she had jumped to her feet and then bounced tip-toed upon my chest. "For instance," she continued, jouncing down on me with her resilient heels while she raised her skirt and bent forward to gloat on my helplessness, "I am walking on your coat only, unlike Sir Walter, you are IN IT! And how do you like modern practice of gallantry?"

Staring up at Elinor in an ecstacy of pleasurable pain, my only answer was a whistling groan as the breath was forced out of me under her jiggling weight. But she took mercy on my discomfiture before my face turned blue, stepping down off me with a merry laugh to parade around the room with soft-trampling tread while I began to breathe again and stare avidly at the luscious silk-and-rubber display so generously offered for my delectation.

Well, our plans for the evening seemed to have changed! We never did see the movie and our dinner was a late sandwich at a counter-lunch where other patrons' eyes ogled Elinor's shiny black storm rubbers which she still wore altho the Autumn skies were clear.

Since that first exciting date and our subsequent marriage Elinor and I have investigated many fascinating facets of our rubber-enjoyment. We will gladly tell of them if other aficionados wish (and if the Ed. has space to spare) but meanwhile we're hoping to read letters from you devotees of feminine rubber footwear!

Rubber-Stamped

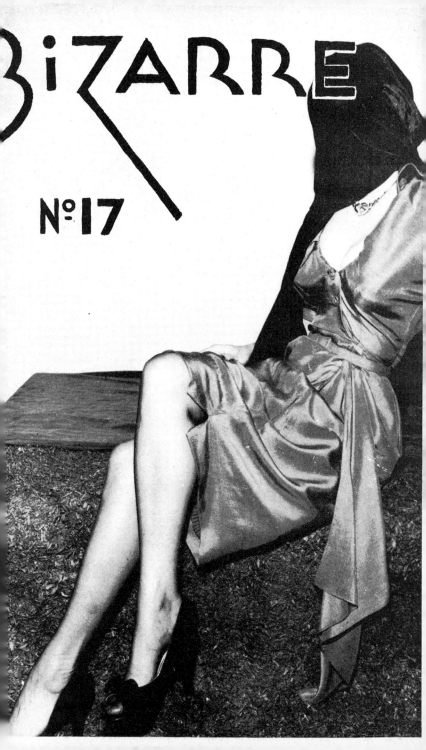

BiZARRE

Nº17

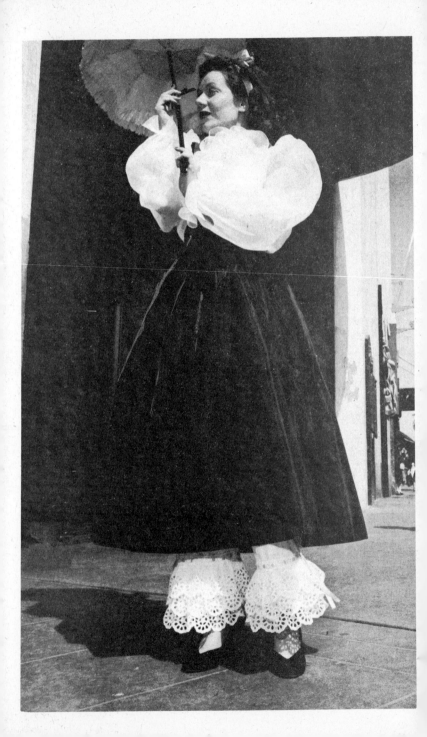

BIZARRE

Copyright 1956 U.S.A. by John Coutts

"a fashion fantasia"

No. 17

Here with a Loaf of Bread beneath the Bough,
A Flask of Wine, a Book of Verse — and Thou
* Beside me singing in the Wilderness —*
And Wilderness is Paradise enow.

OMAR KHAYYAM

CONTENTS

NEXT ISSUE No. 18
(BRACE YOURSELF FOR THIS—)
WILL BE PUBLISHED IN ONE MONTH'S TIME

BACK ISSUES

All back issues are available — except 12 — of which reprints are now being made.

If your dealer cannot supply you write directly to:-
P.O. Box 511, Montreal 3, Canada.

3

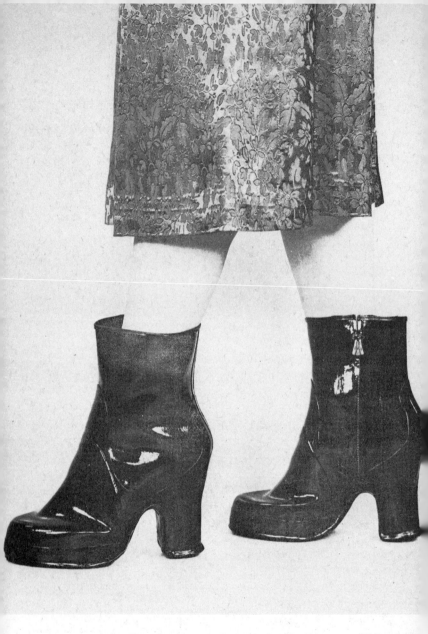

SHINY BLACK RUBBER BOOTS *from G.J.Z.*

WE SPEAK

The moment you get the happy idea that everyone should be entitled to his own opinions, you come up against someone who says: "You're wrong! Freedom is not license!" It seems useless to point out to these people that freedom means "Freedom", with no qualifications (or use some other word), but that for the sake of a decent society you also must have good manners — which means that you must consider the feelings of other people.

There is an ever-mounting yell against the Soviet because it appears to be a Police State beside which the Nazis were sweet children. Unfortunately, the thundrous blast against "communism" serves to conceal the true intention of the blasters, which is to apply a censorship stranglehold on all forms of expression. With their battle cry of "Freedom!!" all they wish to do is to institute their own particular brand of Police State here and now. To them you can only be right if you "do as I do, wear what I wear, read what I read, and think as I think" (in other words, don't think at all — be guided by me.)

The modern age stresses that an education which does not pay off in money is a waste of time; and so our schools produce nothing but a bunch of witless wonders filled only with the superstitious fears of the savage, and all behaving in the same animal manner. Fearing the witch doctors, (who alone know the Great Unknown) and afraid to think for themselves they blindly join in condemnation of anyone who does not conform.

As for sex, ignorance is abysmal, because for centuries those who could not satisfy themselves, except by denying pleasure to others, have taught generation after generation that "sex is taboo." Thou shalt not think about it or discuss it. In fact it's a dreadful thing, but it's all right so long as you don't enjoy it. If you have any other ideas on the subject, you are a pervert.

The basis of a decent society is a happy home. Marriages break up almost invariably because of sex. What you do, or do not do, is your own business, all that matters is that the enjoyment be mutual, — and the time to discuss these things is before you get hitched up. There is a partner to suit everyone somewhere, but the search will be difficult until we can discuss our likes and dislikes, openly, in good taste, without threat from our own brand of standardized Police State.

THESE
ARE CLIPPINGS FROM LETTERS
FROM READERS, FOR PUBLICATION

YOU PROBABLY CONSIDER THESE TWO PAGES A WASTE OF SPACE. PLEASE FORGIVE US, FOR BY THEM WE HOPE TO CONFOUND, ONCE AND FOR ALL, THOSE PEOPLE WHO REFUSE TO BELIEVE THAT OUR "LETTERS FROM READERS" ARE GENUINE.

ONLY A SUPER-MAN WRITER COULD PRODUCE SUCH A VARIETY OF STYLES AND BE SO WELL INFORMED ON SO MANY DIFFERENT TOPICS — YET WE HAVE BEEN CREDITED WITH THIS SKILL — BUT AFTER SEEING THESE PAGES WE'RE DAMN SURE NO ONE WILL BE DUMB ENOUGH TO CLAIM THAT WE OWN SEVERAL HUNDRED TYPEWRITERS AND CAN CHANGE OUR HANDWRITING IN SO MANY DIFFERENT WAYS.

restricted in enjoyment

... use to include a fe...
...mateur poses of my rubber...
so adorably adorned in vari...
latex garments, such as r...
swim suit, etc of purest l...
I was really quite flatte...

high heeled shoes in furs and/or boud...
...ous will cover the cost. ...

to someone I am ...
in B...

As I am interested in very high heeled
boots, corsetry, gloves, etc., I would like to
... & feel sure ... hitting ... high heeled
soon. I have been ... that the ... lovely ...
"things" every so often ...

first issue
in New York. I
is so very good
captured all of
wear that down
h is woman to ...
think of a fou...

...je suis très content de recevoir de ...
expédité ... de savoir ...
raging in your correspondence ...
issue which might contain quite ...
previous letter that I would like the "private Tutor, The Girl's...
girls in home or school, such as I often do...
similar, and ... able to
... it took over the ...
...aughter even advocated girls told on their
...iscussed because the neighbor was fall...
...from the various ... fall...

heels, tight
interested ...
nbelievable
I an experience
nowsabout and that

FOOTWEAR FANTASIA

by Sylvia Soulier

Since I wrote to you about going to that Christmas Party where I met my old friend and schoolgirl chum Jennie, the girl with the attractive knee boots, I have with a little persuasion managed to get her to pose for a snapshot or two for Bizarre, though all she would do was deck herself up a little so that we might have a glimpse of her shapely limbs. Better that than nothing at all thought I, so I got her all frilled up for the occasion with a pair of thigh-high net tights and a little leather Ballet skirt and off we went. Here they are, as neat a pair of five inch

heels as you could want to see, and one shows her six inch patent courts quite well, backview.

The one I rather liked was where Jeannie got all domineering and I caught her pointing a gloved finger of sheer scorn at the floor, exclaiming "Listen Sylvia darling, I'm telling you, IF you DARE get more than my legs in, woe betide you girl"!

Her boots were specially made for her and are a perfect skin-tight, fitting everywhere, with catches to lace up quickly. In one where she is sitting unlacing her boots after the fray, do you notice the odd way in which Jennie always slips the pair of laces round her fingers somehow and manages, believe me, to unlace a pair of knee boots in a third of the time I have ever seen anyone else manage that tiresome task. She slips them from side to side at lightening speed and does them up the same way, pulling them tighter every three catches or so, as she goes up.

Her leather skirt is not exactly the same as the one I used in some of my snaps. Hers is slightly heavier kid and stands out all

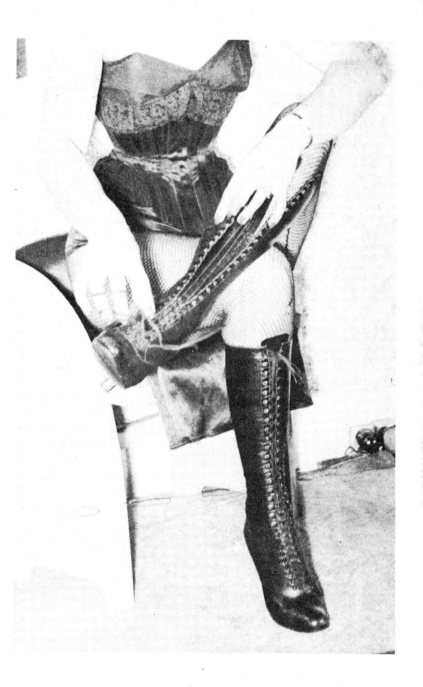

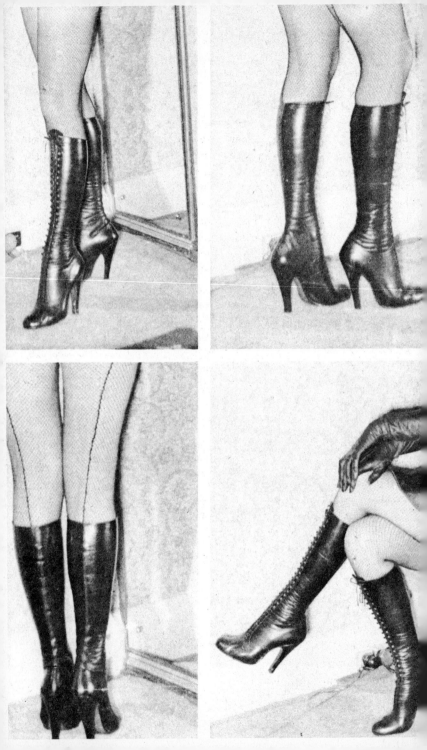

round in a revealing sort of way. She has a corsetted waist-fitting leather jacket as well, which goes with it, zipping all down the front, Alas! Jennie can only get into the dashed thing when she is very tightly laced in, she has a marvelous figure, models always have, to my chagrin, and believe me when Jennie is really pulled into her 21 inch waisted corset, she looks pretty terrific I can tell you, for she is a tall girl of some five feet and ten inches, with a mass of electric black hair.

Of course women being women, little Sylvia just had to include a close up of her own actual seven inch heeled black kid lace shoes, you know what I mean, just to show that seven inch heels have no fears for Sylvia, even if they have for her male chaperones. And if you readers don't quite believe in such heights being useable, get your optics on that pair under the cocktail stool there!

And now comes the 'piece de resistance' of this subject of footwear, a boy friend of mine asserts that for indoor wear, he just cannot see why males shouldn't wear reasonably high heeled footwear, that is if you like that sort of thing. As he is an inveterate wearer I am trying to sneak up on him and get some snaps of HIS knee boots in use around his home surroundings, so that readers can see and judge for themselves whether the fashion IS after all, as silly and grotesque as it might sound in this modern age.

He assures me that he never wears a heel higher than allows him normal movement, though he thinks that it should be a heel high enough to restrict steps during more leisurely moments. He favours boots, I rather gathered, on account of the extra support that a tightly laced ankle gives him, and agreed nothing looks worse than a wearer whose slender heels go over.

He seemed rather scared that I was going to send his elegant limbs to Bizarre, but there you are, when a girl is a wearer of really high heels, I think she can usually manage to be pretty persuasive, Eh?

Cheers readers, see you again soon!

SYLVIA SOULIER

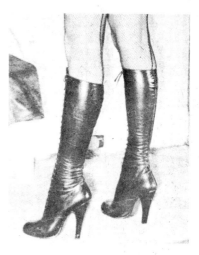

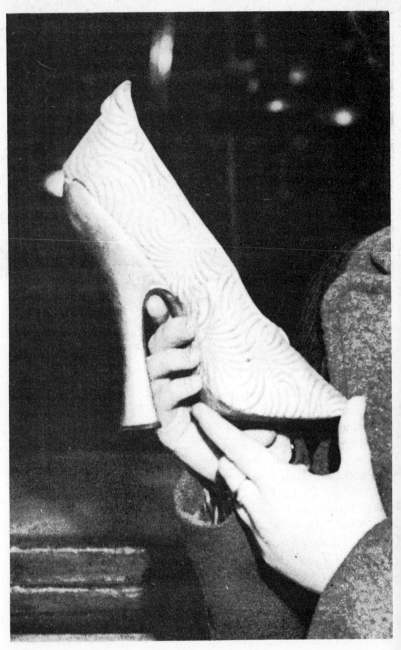

MILADY'S SLIPPER *circa* 1890 *I.N.P.*

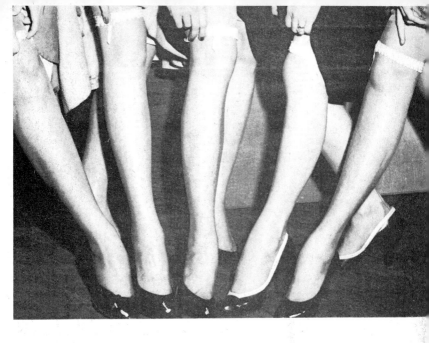

LEGS! WE LOVE 'EM

Being greatly interested in female legs — especially when covered in sheer nylon — we got to wondering who invented stockings — and this is what we dug up.

We are told that Henry II of France was the first who wore silk stockings, at his sister's wedding to the Duke of Savoy, in 1509. Howell, in his "History of the World," says that, in 1550, Queen Elizabeth was presented a pair of black silk knit stockings by her silkwoman, Mrs. Montague, and she never wore cloth ones any more. He also adds that Henry VIII wore ordinary cloth hose, except there came from Spain, by

great chance, a pair of silk stockings. His son, King Edward VI, was presented with a pair of long Spanish silk stockings by Sir Thomas Gresham. Hence it would seem that the invention of knit stockings originally came from Spain.

Anderson tells us — others relate — that one William Rider, an apprentice on London Bridge, seeing at the house of an Italian merchant a pair of knit stockings, from Mantua, took the hint, and made a pair exactly like them, which he presented to the Earl of Pembroke, and that they were the

Continued on Page 16

13

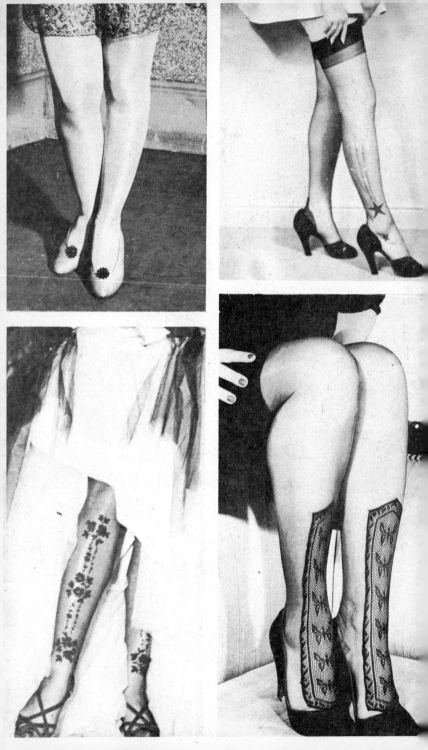

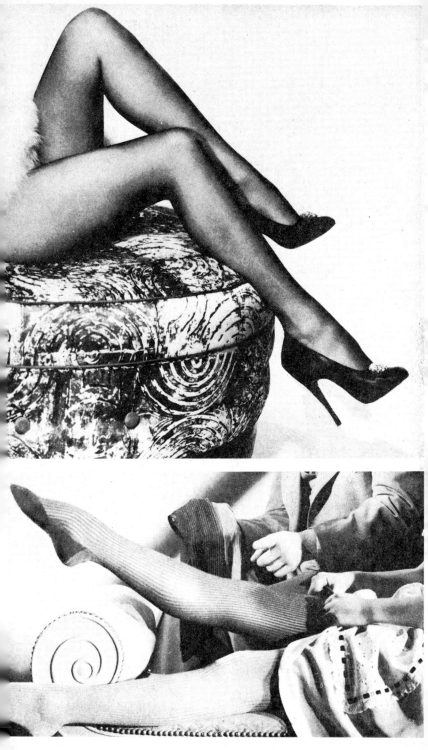

first of that kind worn in England.

There have been various opinions with respect to the original invention of the stocking-frame; but it is now generally acknowledged that it was invented in the reign of Queen Elizabeth, in the year 1589, by William Lee, M. A., of St. John's College in Cambridge, a native of Woodborough, near Nottingham.

In the "London Magazine," vol. iv p. 337, we are told that this gentleman was expelled from the University for marrying contrary to the statutes of the College. Being thus rejected, and ignorant of any other means of subsistence, he was reduced to the necessity of living upon what his wife could earn by the knitting of stockings, which gave a spur to his invention; and by curiously observing the working of the needles in knitting, he formed in his mind the model of the frame, which proved of such advantage to that branch of our manufactures. Mr. Lee went to France, and for want of patronage there and in England, died of a broken heart, at Paris.

The Framework Knitters' Company was incorporated by Charles II, in 1663. In their hall is the portrait of Lee, pointing to one of the iron frames, and discoursing with a woman, who is knitting with needles and her fingers.

June Haver pulls on the really fabulous stockings once worn by Miss Marilyn Miller (Broadway star of yesteryear). The stockings are bejeweled, and were made in 1925, at a cost of $2500.

16

The Bridge of Sighs

by Clint-Jefferson.

In the last issue we promised to tell you more about the new gadget which has our "Ideal Suburb" by its ears.

It happened this way.

Angus Clonlocherty, an upstanding member of the community, owns a junk yard, and Jean, his wife is a most delightful creature with curves where they should be, and a pair of legs that brings much distant business to the junkyard on Saturday mornings — that being the one day in the week when she visits the "office" to help Angus with his books — wearing what she calls her "junk outfit".

Maybe business would still be brisk if this "junk outfit" did not consist of an extremely tight, cleverly cut, and well filled black kid jacket, and a pair of very tight and very brief kid shorts — held up by a wide, double-buckled belt. And maybe the customers would still come if her delightful and well exposed stems were not covered in the sheerest of opera length black nylons that give a subtle dark shade to every inviting curve and dimple — and maybe the buyers woud still hang around buying all sorts of trash which they don't need if the laces of her little black kid oxfords were not always coming undone (which of course means having to rest a slender 5 inch spike of heel on someone's bended knee while the matter is attended to) and maybe — oh well what's it matter, the customers come and business is brisk — which has absolutely nothing whatever to do with the particular incident about which I'm writing, so let's go back a bit.

Reasonably enough Jean is the apple of The Angus eye — except when she plays bridge, or to be more exact "played", for all that trouble is past and gone.

It used to be — "Why didn't you call this?" "Why didn't you play that?" "Now if you had lead a spade!" Post mortem's ad infinitum.

Be it said that the other wives, most of them anyway, were just as chatty, and the menfolk, who liked the sociable get-togethers at home, were seriously considering making gin rummy and scrabble mandatory and confining their Bridge to "men only" — at the Golf Club. The dark clouds of

rift and dissension were gathering. But then came the great change — just through one of those fortunate accidents.

One Saturday Angus was sitting in front of the shed, which serves as his office at the junk yard, moodily puffing at his pipe. Though the sun was shining the

sky looked grey to him, for Jean had been worse than usual the night before and as a result he'd played atrociously, and had lost $4.59. With dull glance his eyes wandered over the assorted scold's bridles, chastity girdles and fetters which with old bath tubs, back axles, wrecked autos, trucks, and prams formed his horizon. He was thinking that everything including his life was "junk", when his gloomy thoughts were diverted by the arrival of a large panel van bearing the imposing title of "The Shore Line Iron Works'.

This looked like a sale, but to his annoyance the driver got out and came towards him carrying a small 4 sided metal pyramid, and after remarking on the beauty of the weather announced that he had a thousand of these little pyramids and was Angus interested in buying them.

"What the hell are they?" said Angus.

"Post Caps", answered the driver "got the wrong dimensions. Scrapping the lot. Interested?"

Everything was grist to the mill so far as Angus was concerned and so after a certain amount of haggling the deal was completed and the load dumped off.

"What the heck's that" the driver asked, as pocketing the cash with one hand, he pointed with the other to a somewhat rusted object hanging from a nail outside the shed.

"That" said Angus "is a scold's bridle, an old fashioned but excellent device for keeping women quiet. Stops 'em talking. Unfortunately you can't put it on them when they're playing bridge because they wouldn't be able to call. It's a bit tarnished so I'll let you have it cheap. If you have a chatty wife you can't beat it."

"Keeps 'em quiet eh?" said the driver examining the thing closely. "Handy little gadget — yeah — very handy. OK, Buster, you've got yourself a sale. You don't

throw in a book on sign language too do you- No? — Too bad — but I guess I'll be able to make up one of my own." And whistling merrily he wandered off to his van, swinging the contraption by its short chain as he went.

Angus returned to the contemplation of his junk — now augmented by this pile of tin pyramids. He picked one up and turned it over and over in his hand.

Somehow the words of his visitor, about "A sign language", kept ringing in his head while in the background was Jean's voice — echoing from the night before — 'spades, hearts, diamonds, clubs, no trumps — yatter ta yatta.

"Spades", thought Angus looking at one side of the pyramid, "Hearts" he mumbled to himself as he turned it over — "Diamonds", he said aloud — turned it again — "Clubs! and no trumps!" he shouted tossing the thing into the air and slapping his knee with the other hand.

"I've got it" — he yelled. "Now for peaceful Bridge!"

For an hour or so he was busy with brushes and paint. Then satisfied with his work he made a telephone call or two.

That evening, after dinner, Jean, wearing a sheath of black satin which did nothing to detract from the very agreeable lines of her figure, produced at her lord and master's bidding, some lengths of rope, strong but soft and well worn from constant use, and then seated herself in a high backed chair. In spite of her habit of discussing and arguing about, each hand at bridge she was an obedient and otherwise dutiful wife. Not that she had always been that way — but time, and a sufficient amount of what is necessary where it will do most good — had worked wonders.

"This" she thought to herself as the cords were passed around her body, tying her rigidly to the back of the chair from shoulders to thighs, "Will be only a temporary arangement. The Littletons are coming over to play bridge in a few minutes."

She placed her slender feet together, obediently extended them in front of her, and watched the cords being neatly but tightly tied around her slender ankles, and felt the bite as they were drawn back and tied tightly to a rung of the chair.

Her arms were free and so she cooperatively smoothed down her skirt so that her legs could be tied just above the knee, noticing with quiet appreciation the symmetry with which Angus completed the task by fastening the cords to each side of the chair — knotting them tightly and then leading the ends down to be tied finally to her ankles, thus ensuring that her legs were as immovable and rigid as her body. Suddenly it occurred to her that her arms being free was rather odd.

Puzzled she sat in silence, her head cocked slightly to one side — as Angus went to a cupboard and returned with steel wristlets, each of which, when they had been snapped on, he attached, by a short length of chain, to a ring on each front leg of the chair.

"There you are my dear" said Angus, 'now let us see if you can clasp your hands. Jean obligingly did so. "There's a spot on your chin, wipe it off" said Angus. Jean attempted to do so — but the chains prevented her from reaching high enough, and neither could she bend her head forward far enough to overcome this problem.

"Excellent" said Angus, "There was no spot there anyway — I just wanted to be sure". And at that moment the front door bell rang.

Although the evening was fine the Littletons entered wearing rubber capes. Mr. James Littleton gave a cheerful hello, Mrs. Hazel Littleton gave a gay shake of her head in welcome but did not speak. Neither did she make any attempt to take off her cape, or her hat and veil.

When Mr. Littleton obligingly removed them for her, the reason for her passive behaviour became apparent, for her arms were secured behind her back in a single glove and her mouth was sealed with flesh colored adhesive tape, smoothly applied without a wrinkle. Over it, make up, complete with rouged lips had been applied so that even in the soft but clear light of the room it was impossible at first glance to detect anything unusual in her appearance.

"Good evening, Jimmy" said Jean — "Angus told me we were going to play bridge but it looks as if it was a trick and the pair of you have got some low scheme in mind.

"But we are going to play bridge, heart's delight" said Angus, sliding another high backed chair for Mrs. Littleton. "Quiet Bridge" he said as he gave James some suitable cords — "Silent Bridge" — he almost whispered — as he opened up the card table and drew it up to his wife's chair.

And while James secured his charming Hazel in a similar man-

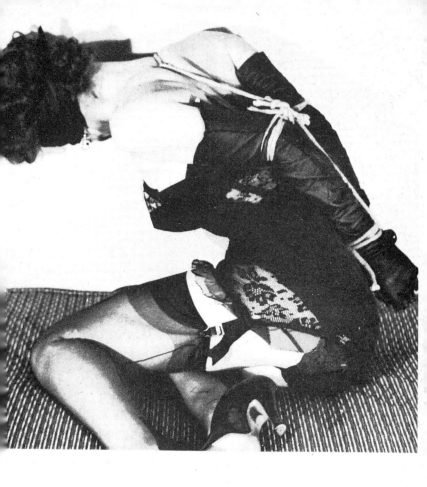

DON'T LET THIS HAPPEN TO YOU

Learn jiu jitsu, the art of self-defense

21

ner to Jean, Angus proceeded to strap a "beanie" tightly on his still very puzzled little wife thus silencing her too, very affectively.

As both ladies sat facing each other across the table making puzzled conversation by a shrug with their hands, and a questioning shake of the head, Angus slapped James on the back and poured him a stiff drink. Then with much ceremony and magic passes, like a conjuror, he unlocked a cupboard and produced a cardboard box.

James, drink in hand, looked on in gleeful anticipation, and both fair ladies stared with eyebrows about climbing into their hair as Angus opened the box and tipped onto the table two of his tin pyramids — but not the junk he had bought earlier in the day. Now they shone with spotless white enamel, and on each side was painted one of the suits in a deck of cards. Turning the pyramid on its side he exposed the 5th, or bottom, on which was "NT", in bold capitals.

"My Scottish ancestors" said Angus puffing out his chest and raising his glass "are proud of me this day!"

"Observe the simplicity of the device! Without saying a word my bonny Jean can call "Clubs" — simply by placing yonder pyramid with its "Clubs" side toward the centre of the table. If

she wants to increase the bid to two she holds up two fingers and so on!"

James swayed back on his heels positively beaming with delight, glass raised to his nose, index finger extended, while the ladies' expression changed to annoyance.

"You will also observe" said Angus now addressing the ladies, "that you can quite easily deal, hold a hand, and play — but you can do nothing to disturb the peace and quiet of this magic and epoch making evening. Oh — incidentally you use this rubber knobbed little stick thing to play from dummy — just rest it on the card and draw it toward you — see?" — And he gave a simple demonstration.

"Angus" said James "You're a wizard. Put the bottle close to my hand and let's start".

The first hand went quietly enough, with the ladies playing somewhat awkwardly but managing nevertheless to overcome their handicap.

The play continued — the two men calling in the usual way. The women turning their pyramids, but just after the start of the second hand the excellence of Angus' invention became evident.

Hazel had the contract at 3 No Trumps and Jean having Q.J.10.-9.5.2. of Diamonds opened with the Queen. James had put down his dummy to show K.4. So Hazel

covered with the King. **Angus** won with the Ace and returned a spade. Jean's chains began to rattle.

Angus looked up at his wife — then across at James, winked and both raised their glasses in silent toast.

Meanwhile, Jean, to whom it never occurred that Angus had the Ace bare, was going through an astonishing performance trying to reach the leather sealing her lips, now picking futilely at the locked steel around her wrists, now playing a card, and now trying to tear the ropes off — knees quiverering, bosom heaving and all the time getting purple in the face at her inability to express herself in any way except by grunts. To make matters worse her husband had a look on his face which resembled nothing so much as a contented, cud-chewing cow. He sipped his drink — he blew smoke down his nose, while she sat rigid — tied to her chair, stiff and mute as a mummy

As it turned out the spade return was a very shrewd move and the Littletons went down, but this only added fuel to the fire so far as Jean was concerned. She had one hell of a lot to say and she couldn't make a sound.

When the new hand had been dealt her, she refused to pick it up — but just sat there, eyes flashing fire. James and Angus refilled

their glasses, sat back contentedly, and blew smoke rings.

This delay didn't suit Hazel at all and she tapped the table with her fingers, wriggled her hand and made a noise which sounded like — "Umum-um-umm!"

"That" said James, "means 'for heavens sake call' — I know her mumbles" — then grinning — "but we're in no hurry — are we Angus?"

Jean just glared at him—glared into space for a few seconds, gave one last frantic tug at her wrists, picked up her hand, and from then on offered no further resistance. True, she, and Hazel too, went through a grunting and chain rattling performance now and then but it was a very muted grunting and a very frustrated rattling — in no way disturbing to male ears.

So the first quiet bridge evening was held in the Clonlocherty home, one of many to follow, and one which brought peace to this entire suburb where the roses bloom and the birds sing at reasonable hours.

Incidentally the local carpenter has been kept extremely busy ever since turning out custom-made high-backed "Bridge chairs" — complete with straps and chained wristlets — all made to measure, and guaranteed to fit. (*For the "do it yourself" brigade — full working drawings are available — just write c/o The Editor*)

orrespondence

Under no circumstances do we publish names or addresses. If photos or sketches are sent in, please write a short commentary and please do NOT send in photos which you got from someone else.

LEGLESS WITH LEGS

Dear Sirs:

I have just finished reading your large No. 15/16 issue which incidently is the first time I have ever read your magazine. I assure you it will not be my last.

For the benefit of your amputee readers and amputee fanciers, I would like to relate my experiences dealing with this fascinating subject.

Several years ago a young woman in our vicinity had her right leg taken off above the knee as a result of an automobile accident. I noticed my husband showing an unusual amount of interest in the case and when she recovered, he would go out of his way to pass by her home where she was frequently seen sitting on the porch or working in the garden. She always wore crutches which she would leave on the porch while she hopped unaided the short distance to her garden where she would balance herself on her one leg, using a rake or a hoe to work the ground.

Some months later we were in town and when we got out of the car, who was in front of us but this same one-legged girl gracefuly walking, using crutches. She was tastefully dressed in a knit sweater, flared skirt and her single, well shaped leg was clad in a nylon with a solid black heel. On her foot was what I judged to be a patent leather sandal with a heel of about four inches. My husband raved about how nice she looked and how well she took her misfortune. I agreed with him because at that moment there were many other girls on the street who had both their legs and were much less attractive.

On later occasions he frequently brought her into our conversations and it was then that I realized that his interest was much more than casual. One day while we were discussing her, I asked

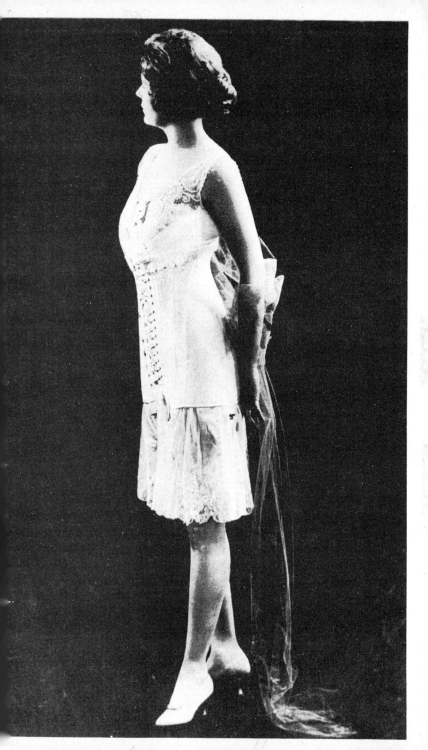

him what he would think of me if I should ever lose one of my legs. His answer was almost what I expected as he told me that as long as I wore the right kind of clothes I would always be attractive to him.

Then several weeks later while I was cleaning a closet, I found a pair of crutches I had worn when I had sprained an ankle, before we were married. I put them under my arms and discovered that they were a perfect fit. I walked up and down the bedroom holding one foot in the air. A strange feeling came over me and I imagined myself as the young girl in whom my husband took such great interest. I took off my left shoe and with one of my belts, fastened my ankle tightly against my thigh. I then stood up, took the crutches under my arms and walked over to the full length mirror on the door. The full skirt I was wearing completely hid the bulge of my doubled-up foot and for all practical purposes, I had only one leg. No one would ever guess that my left leg was not really amputated above the knee. And the funny thing about it all was that I had a feeling of great satisfaction, probably because in this condition I was almost completely helpless without my crutches. The feeling of being helpless has always made me feel good and I have often

had the desire to be bound or tied so that I had to depend on my husband or someone else for my every want.

I didn't say anything to my husband right away, but every day after he left for work I would strap up the leg and use the crutches. Each day I could stand it in that position longer without suffering the cramp I got after that first day. I substituted several long pieces of elastic bandage for the leather strap and found that with them I could keep up the leg almost indefinitely.

The other problem I had to lick was that of the tendency of my doubled-up leg to push slightly forward due to the weight of my useless foot and leg. This I took care of by taking the one supporter which I did not need and sewing it into a new position where I could unite it with the other, forming a small loop through which the instep of my doubled up foot was passed. The elasticity was just enough to counteract the weight of my foot and made the doubled-up leg hang straight down.

I decided then to let my husband discover me as an amputee by accident, to test his reaction.

(To Be Continued)

26

Dear Sir:

I would like to suggest that you give some space in your next number to games. In issue number 11 on page 21 you described a party game where the hunters (preferably the girls) have their hands tied behind their backs and are blindfolded to hunt for quarters on the floor. Beyond this you have little to say on other games.

Your game might be improved if instead of quarters, a single piece of cheese had been set down, (introducing the added skill of the element of smell) and a prize given to the winner or a punishment given to each loser.

I should like to see a whole treatise on games. Games for two can start with a simple throw of a dice or some other means to decide who shall be "master" and "slave" for the evening. Better still you can start with a form of strip poker, which, when either party has lost all his or her garments, starts a step by step "tying up". First a strong leather waist belt, then an ankle chain, then a neck collar, then a saddle strap, then a gag. The next and last point is crucial — namely the hands tied behind the back. The first to reach this position is helpless and must expect to provide the rest of the evening's entertainment; the other player can disentangle him or herself and be "in the drivers seat".

Another game for two is "copy cat". Each player takes a turn at doing something the other must copy. The male player may start by stripping to the waist, the girl copies him and may respond by painting her nails. Subject to few rules, the game can provide an exciting and interesting evening.

For four or more players of mixed sex there are inumerable games, which I hope the editor will develop through the correspondence columns. Any game can impose on the loser a Bizarre forfeit either chosen by the rest of the party or by the loser of the previous forfeit. If the party is only four it is fun to play "obedience". Two players, preferably the two girls, agree to compete to decide who can remain perfectly obedient the longest. A dress or other attractive prize is offered for the winner, and, if the players are game, a punishment for the loser. It is as well to start with simple commands for the contestants. Later the orders should become more demanding.

Dressing in bizarre costume comes at this stage. Before setting tasks at which one of the contestants is likely to jib, it is best to make the contestants first gag, then blind-fold, themselves. Then increasingly exasperating tasks should be set. When one contes-

tant gives up, the other will be unaware she has won and can be set more and more "unusual" tasks until she too gives up, thinking she has lost.

I hope you, Mr. Editor, and your readers will develop these ideas further.

<div align="right">Yours sincerely,
"Playboy"</div>

Tattooing

Dear J. W.

I am somewhat disappointedly surprised how few show any interest in Tattooing. If there is one field in which one can show his or her own individuality it is in the attitude to and application of the art of Tattooing.

Only in two very early issues were a few brief, partly half-hearted communications. Since then "silence has covered the earth." To live up to one's belief in the right to be bizarre, nothing finer, more personal and expressive could be found than a systematic covering of one's body with designs that create beauty. If readers are interested I shall be happy to oblige with some articles on the art, character, benefits and satisfaction to be gained by being tattooed. One of the benefits of Tattoo is that it is not a passing hour of pleasure, as for instance some of the other bizarre actions. The flowers and butterflies, scrolls and symbols and an imitation bra

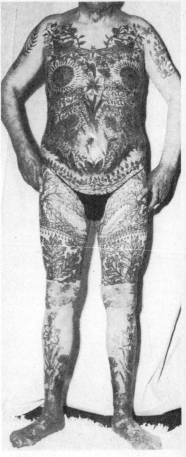

(which gave me lots of satisfaction) stay with me, and are a never ending joy and satisfaction. It is a lot of fun to work out a program and plan of getting tattooed with an ever growing number of designs and ornaments, especially if you design the ornaments yourself.

There is one thrill that always remains alive with one who thus has surrendered himself to the

"lure of the needle". This thrill is your first tattoo being put on.

My own experience, I am sure is more or less the same as that of others who like myself have gone in for large measure of tattoo work on their bodies. My interest in tattoo was aroused in my mind as a little boy when I beheld the large piece on my father's left arm. He had acquired it while serving in the army and it represented a document of military character. Two infantry rifles crossed with a helmet crowning it, his own name, that of his regiment, battalion, company and date of service. It had been done in the old days before the electric tattoo machine was invented. Instead of modern pigments, gun powder had been used to imbed the designs into the skin. It always fascinated me and fired my imagination. It took many years until my early manhood before my longing for a tattoo was satisfied. For many years the thought and desire was with me, but where I lived there was no chance to acquire any tattoo decoration. One day, in the neighborhood of Chicago, was the sign of a tattoo operator and my plans became more realistic. But then thousands of questions rose in my mind, what to put on, will it hurt much, will it take a long time to heal, will it be very expensive, will I like or regret it afterwards and so on — many questions! Finally one day I simply decided it had to be done. I designed a large seven inch leaf, working into it my own name, in bold lettering. With this I went to Chicago and walking up and down State Street had a hard time deciding which studio should make my first tattoo. I decided on one located in a basement. Fortunately I had come to a friendly younger man whose manners at once put me at ease. Then came some minutes of curiosity when I watched the man preparing the stencil, getting his machine ready, and putting on the powdered stencil design I had made. Then came the most momentous minute in my eventually long career as a tattoo subject. I was all aquiver with excitement when the man turned the switch, dipped his needles in the black ink and stuck it into the skin on my upper right thigh. Before I knew fully what happened I saw the needle moving up and down cutting in the oak leaf outlines. There was a bit of a slightly burning sensation, but nothing as painful as I had feared. Then came the engraving of the name. The man worked very swiftly, but he certainly took pains that this first piece of my tattoo would never come off. What I beheld was real, and the fulfilment of a desire of almost twenty years. It seemed like magic to me.

In less than a quarter of an hour all was over. He cleansed the engraved design, which looked like a gift from heaven, so beautiful in lines and color and distinctness on the white skin. A bit of vaseline to cover the fresh lines, a piece of clean white tissue paper and a strip of tape over the covering and I was ready to walk up the steps. All at once my hundred questions had been answered, all my problems solved, and the feeling was as if I had gone through a transformation of myself. When I stepped on the street I thought the whole population of Chicago would rejoice with me, I felt like a "marked man" in the most desirable manner. In fact I felt as if I was walking on clouds.

But there is a different kind of magic in the tattoo needles: They always ask for, and lure you to more. I had not arrived home on that eventful day before I was determined to add a counterpart

on the left thigh, which after a few weeks was done. And then more, and more. Not always wisely, not always beautifully because I at times fell into the hands of operators who possessed nothing of the artistic sense to create beauty in a technically beautiful way. Finally I had the good fortune to become acquainted with an operator who is a real master of his craft. He made me over during a whole summer and fall. He made a new man out of me, tattooingly speaking, and then he and I formed a team. I worked out a program to cover my still unmarked back and made the designs which I desired. He did the engraving in his masterly way. Now while I write this I am so to speak down to my last leg. We have missed no part, even my seat has been transformed into a beautifully embroidered cushion with my initials large and surrounded by a frame of garlands of leaves and berries etc.

It is a most fascinating hobby, and it is a pity that in our country the general public has not as yet learned to appreciate the beauty that can be created in one's body. Sailors and roustabouts still have the monopoly on the output as well as on the character or lack of it. So different from Europe, where ladies of high society, in Germany for instance, have themselves beautified, literally so, with tattoo designs of first class art. I have photos before me that are a delight to look at and no doubt are a delight and a source of pride to the owners. Here is one cause that ought to be cultivated by us bizarreists.

Yours, "One Covered All Over"

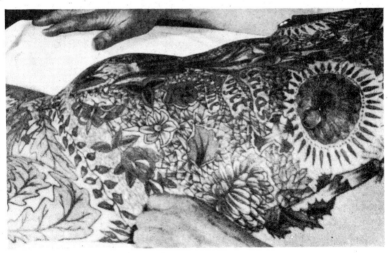

31

Ropes Please

Aesthetic Sir:

After all the space you have committed to clumping stilt-heels and to metal-banded corsets, to clinking chains and snapping padlocks, I hope you will allow some room for this letter in order to present an alternative viewpoint, which is in choosing ways to bring the feminine form to favorable view in many aspects and situations. We should work with and not against the natural beauty of the symmetrical human figure.

I think the suggestion offered by E. M. on page 37, for a bondage photo contest is a stimulating one. I would suggest extending the idea to embrace a contest for some of the best bondage experience stories. Your readers have shown that they can offer some fine-spirited ones. It would, for example, be inspiringly delightful to read some accounts from ladies who find pleasure in wrestling each other to see who can overpower and then tightly enrope the other. Photos showing gallant girls sinuously wrestling each other would add tingling luster to the pages of "Bizarre".

Incidently, it would help some of us if you did not print photographs on both sides of a sheet. Sometimes we like to cut out a good illustration and paste it in our book of choice scenes. If there is a good photo on both sides of the sheet, we are in difficulties. (*No you're not — buy two copies and increase our circulation. Ed*)

There was one part of E. M.'s suggestion which was not appealing. This was a mention of photos of chained ladies. Soft ropes and pliable straps, used in the right spirit on willing subject, can be sensitive and alluring captors of the feminine form. Chains and locks are cold and hostile, clumsy and discordant of appearance. They are essentially unfriendly pieces of unfeeling metal, and they show the feminine form to unattractive disadvantage.

The cuban heel should be more than high enough for the lady of discernment. Any heel which is higher or narrower cannot give the lady proper support, with the result that the feet tend to become distorted, and the spine, with its major nerve-connecting system, is forced out of balance. Many feminine ailments are produced because of the harmful consequences of these anti-natural, spike heels. What is beautiful or graceful in such results?

So please do not spike the health and well-being of the ladies by inducing them to wear spike-heels. The truly graceful maiden can walk attractively in stocking feet. or in low heels, or in cuban heels.

So here's to seeing photos of

34

and reading about naturally shapely ladies, uncorsetted and unstilted, unchained and unpadlocked, but roundly roped or strapped.

Gallant ladies of flexible, beauteous bondage, I salute you and wish you well.

K. G.

P.S. In case you have not surmised why I addressed you as 'Aesthetic Sir' instead of the convential 'Dear Sir', it is because I think we need not be restricted to this almost undeviating form in all our correspondence. I trust you will consider the salutatory phrase I chose for you, harmonious and welcome.

WOOD-CRAFT

Dear Editor:

Last summer, while on vacation in Maine, my wife and I took a camping trip far into the wilds. Of course I took my camera along. Enclosed you will find a sequence of pictures that we took on our three day trip. We are both ardent "Sweet Gwendoline" enthusiasts and in these pictures you'll notice a familar pattern.

If any of your readers have never experienced a camping trip like ours just remember to take your bondage equipment along the next time.

I am particularly fond of silky smooth clothes and black stockings. Also high heels. You will

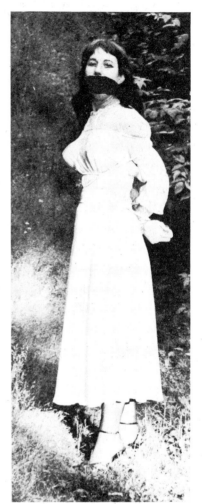

Photo from "D.E."

notice this from our pictures. I am also a firm believer in a real gag. That is, a gag is not a real gag unless something is actually stuffed into the mouth filling it completely. We usually use a large silk kerchief. If the victim is unusually hard to keep quiet then

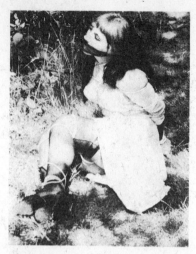

of prompt physical chastisement for wrongdoing has returned to favor. Based upon discussions on the pros and cons of corporal punishment, I find that seldom, at least in this area, is an instrument other than the maternal hand, hairbrush or slipper employed. It is also evident that in at least half the cases, spankings are applied on the bare skin where the effects can be readily observed and the degree of severity accurately judged and there appears to be no age bracket where it begins or ceases.

we have a special gag made of a rubber glove with sponges inside it which does a wonderful job, believe me.

Here's hoping you like the pictures. You may publish them if you wish.

Yours truly,
Mr. & Mrs. D. E.

SPANK DON'T SPOIL
To the Editor

I find the letters from your readers on the subject of corporal punishment most interesting. However, the element of brutality in the use of birch rod, whip or cane is such as sometimes leads one to question the authenticity of the incidents depicted. Having been brought up in an age of progressive education wherein "spanking" was a naughty word, I now find that, perhaps due to the rise in juvenile delinquency, the theory

I believe you would find considerable reader interest in an article on current usage of corporal punishment as employed in the home, not only as a disciplinary measure for children but as component of domestic relations, as well. I know of one young couple who settle their differences by application of the hair brush to each other. They claim this ends nagging, sulking and lasting recriminations. I know that I have often been tempted to still the nagging of my own sweet little helpmate by taking her across my knee and warming her plump fanny, but to date I haven't mustered the courage. I'd like to hear the opinion of some of your readers on the subject.

Yours truly,
GEORGE D.

Dear Editor:

Just thought I would drop you a line and tell you how I first came in contact with BIZARRE.

It happened about 4 years ago. I met a friend of mine, a fellow I hadn't seen since we graduated from school 3 years before. We were all set to hold a reunion right on the sidewalk, but it seemed Jack had some business to take care of so he invited me to a party which was being held that night. I, of course, was game for any party so I accepted.

When I arrived at the hotel that evening I discovered an entire floor had engaged for the goings on, and it looked as if it might be a terrific party. I went up in the elevator and when I started down the corridor on this floor looking for Jack's room I got a shock. I had noticed that most of the voices doing the talking sounded masculine and upon entering Jack's room I found out why and got my shock at the same time. Of all the women in sight there was only one who did not have a gag in her mouth or a gag helmet on her head, and that one had a bit in her mouth and the reins from the bit were tied to a man's wrist.

The rest of the women were wearing costumes which were not only beautiful but showed off all

their charms to best advantage.

These costumes were very strange to my eyes at first, but at no time disagreeable.

It was then that I met a very beautiful girl who is now my wife. She was dressed in a very sheer white nylon blouse, off the shoulder, which was very tight over the bust and had wrist length flowing sleeves, a red satin cummerbund below which was a pair of black satin shorts cut very high on the thighs, a pair of very sheer black nylon opera hose and a pair of black patent baby doll pumps with 5 inch heels.

She had on a black velvet gag which covered her face from just below the nose down to her chin, under which was concealed several strips of 4 inch wide adhesive tape which covered her mouth and gagged her very effectively. The velvet went all the way around the head and the knot was concealed under her very long, flowing, ebony-black hair.

Her wrists were fettered together behind her by a pair of black, velvet covered gold bracelets with small padlocks on them, and interconnected with about 4 inches of gold chain.

Her ankles were fettered together with the same type of anklet interconnected with about 10 inches of chain which allowed her only a very small mincing step on her high heels. These also were

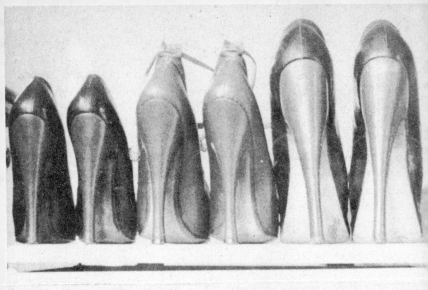

locked on her ankles with small padlocks which were nevertheless strong enough to hold any strain put on them by anything except a very heavy prying tool.

I don't think I need to tell you what a pretty picture she made standing there at her full height of 5' 2" and heels.

About this time I started wondering how she ever got dressed in this costume all by herself and who, if anybody, had the keys to the padlocks?

At this time Jack had introduced her to me as Miss Joyce Merrick. I asked him a couple of questions and it came out that he had been the one who had gagged and chained her. As she had no escort Jack asked me to do the honors, handed me a key which

he said fitted all the padlocks and walked off.

At this point I was really surprised. I asked Joyce if she wanted to be released and she shook her head very vigourously and gave me a look of definite disapproval. I didn't know what to do or say and the only thing that came to my mind was to ask her if she wanted to dance. She accepted and, with misgivings, I escorted her to the floor. The evening was full of nothing but surprises for me because she danced like a dream, high heels, fetters and all. I enjoyed it as much, if not more, than she did.

The evening passed all too quickly and about 4 in the morning I asked her if I could escort her to her room. Jack overheard

me and told me she had her own apartment uptown and he also told me that at these parties unescorted young ladies were told, not asked, by the fellow that took them home. It was part of the deal and they offered no resistance.

He then gave me her address and cape. I went back to Joyce, put the cape over her, and told her I was taking her home.

When I acted masterful she got a twinkle in her eyes but offered no resistance.

When we got to the apartment I wondered how we were going to get the door open as I could see no place where a key would be hidden and Joyce had no handbag and no pockets in the cape.

Joyce had a twinkle in her eyes again and with the heel of her shoe she stepped on a small metal stud in the floor and a slot in the heel dropped out and there was her key. I made her put the other heel on the stud but that didn't work, and as there was only enough room in the slot for one key I could not find the extra key to the padlocks, if there was one.

I opened the door with her key and replaced it in her heel.

When she took her weight off the heel it closed automatically, and there was no sign of it. Ingenious little device.

She went on in and I gathered she wanted me to follow. If I didn't she would remain chained and gagged until somebody else came along and released her.

(To Be Continued)

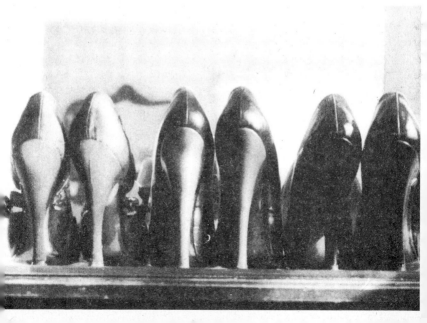

More Rubber

Gentlemen:

The letters from your readers that appreciate the sight of a beautiful woman wearing feminine rubber and latex clothing have a very special fascination for me. I prefer white latex and would like to see more photographs of that nature if possible.

For example the photograph on page 46 of Vol. 3 from "Mac Fan" was excellent and I envy him for having the garment in his possession. But how much more interesting would the picture have been had the model (or wife) been posed against a darker background and wearing a pair of shiny black or white, high heel, rubber boots. He has a priceless piece of clothing in his possession and I hope he will give us more photos of it on the same model.

I would like to make a suggestion that may enable you to kill two birds with one stone. Very often in your bondage photos, and I have in mind Vol. 9 page 55, the emphasis appears mostly to be on a pretty girl tied to a stake — she could very easily have been wearing a white latex or rubber girdle instead of a conventional pair of black panties. Very often you do, combine in one photograph a situation that appeals to the request of several types. I merely wanted to suggest that you try it more often.

It would be nice too if you could ressurect some unretouched photographs of the smooth rubber swim suits the ladies used to wear. They were eye openers.

I do dislike seeing a woman over-dressed. In volume 12 page 55, the model is so loaded down as to look utterly ridiculous. Her face is attractive enough, but there is isn't even a suggestion as to what fine curves may be concealed beneath. And by having her spread her arms we have been denied a closer view because of the law of proportion.

The inside cover of volume 8 was one of the best photographs you have published. The model is probably wearing a leather skirt or perhaps rubber (but I doubt it) but no matter — the pose, the model, the photograph show excellent taste. I feel sure that I am not alone in my desire to see this young lady wearing the same clothing but posed so we can see the delicate highlights reflected by the creases her exciting figure gives so generously to the skirt.

"Slick"

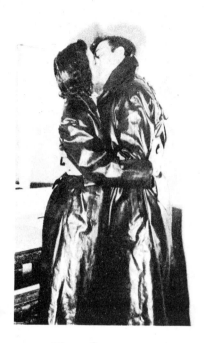

MACK COLLECTION

Dear Sir:

I think perhaps some of your readers would be interested in hearing details of the rubber, plastic and oilskin mackintosh outfits which my wife and I collected in the past few years.

One of our earliest acquisitions and one of my favorites, was a long shiny black rubber, hooded and belted mackintosh, which on special occasions my wife wears with black rubber gloves and rubber boots. We also have a very heavy, shiny plastic raincoat in black which has a long zip fastener up the front. This is also worn with the black rubber gloves and boots.

About a year ago, in an old-fashioned store in New England we were lucky enough to find three all-rubber capes of the kind you cannot get nowadays. These were red, blue and white and we have obtained rubber gloves and rubber boots to match.

We have a larger number of plastic raincoats and capes including a particularly heavy gauge transparent raincoat, which is worn with plastic rainboots and gloves. Among our items are an all rubber gas-protection suit and a plastic suit for slimming. We have two oilskin slickers and sou'-westers, black and red.

On special nights we play an interesting game. Each outfit has

41

a number. We write all the numbers on scraps of paper, fold them up and I pick one. My wife then goes to the room we keep these in and puts on the number I have drawn. I am not allowed to see this number and so I do not know what to expect until she walks into the living room. Since it sometimes takes five minutes or so for her to put on the outfit, you can imagine the suspense I feel is terrific.

I hope soon to be able to send you photos of some of our outfits. Unfortunately I am not a very good photographer and my efforts so far have not been very successful.

Please continue to publish letters and pictures of interest to those of us who are devotees to that most wonderful of all garments — the rubber mackintosh.

Sincerely yours,
RUBBER WORSHIPPER

I SPANK MY WIFE

To the Editor:

I am a man, and look at Bizarre from a man's point of view, and I find the illustrations superb for I can never resist taking a second look at a girl wearing shoes with the highest of heels.

However, to discuss high heels further, I am fortunate to have a wife who knows I like high heels, and she always wears as high a heel as is comfortable to walk in. She has a beautiful foot and a lovely leg too, and to see her legs in smart nylons and a pair of high-heeled patent leather shoes is really something. She even goes farther than this, she is a wife in a thousand, she knows my failings and will wear the prettiest and daintiest of lingerie to please me because she knows I like it. Some of your photos in Bizarre actually remind me of her because she is pretty and smart. She knows well that she has only to mention the fact that she has seen some high-heeled shoes, or some new styles in lingerie, panties or slips. I am always more than eager to take her to buy them and on arriving home, she will dress up in her new purchases like a child. I love to see her like this.

Another subject I am interested in, and in Bizarre there is never enough of it, and that is spanking punishment.

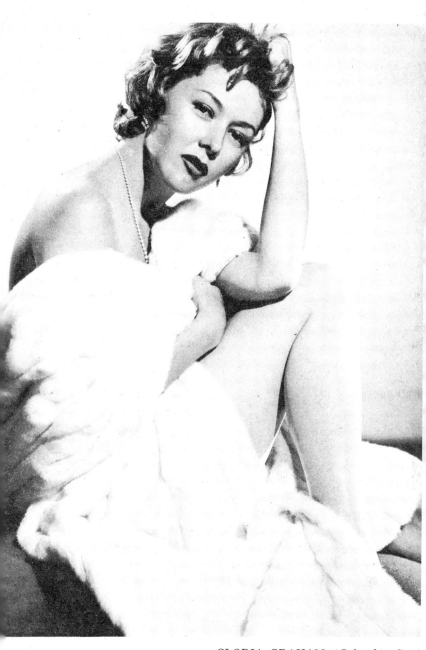

GLORIA GRAHAM *(Columbia Star)*

Whenever there is a letter or an article in your Bizarre that describes some spanking espisode, I always show it to my wife and very soon this written episode is re-enacted in reality because — yes, you are right — my wife is subjected to being spanked at my hands. This is reminiscient of our early days before we were married, when I found that my wife's mother used to punish her daughter in this manner. I suspect that the mother had a fascination too, because she used the flimsiest of excuses to give Yvette a spanking, using various methods, spanking her with bare hand, and sometimes making Yvette bend over a couch-head, and with her dress and petticoat raised above her waist, she would be thoroughly caned. She has even had Yvette laid full across a bed. In fact, one of her favorites was to have a bunch of pillows in the center of the bed, and make Yvette lie down, face downwards, with her clothes lifted, the pillows throwing into prominence the part that was going to be spanked. One thing that was very noticeable and this was the fact that made me think it was fascination, (rather than the wish to correct Yvette) was that she always made Yvette keep her shoes and stockings on when she was to be punished. This I learned from my wife after we were married.

Apropos of this, I once had the memorable experience of actually seeing Yvette being punished, but out of respect for Yvette and the fact that I was there, (it was while Yvette and I were engaged) she was not bared. Her mother had found some such fault with Yvette and she went through the whole ceremony of making Yvette go to bring the strap. Then, bend over the settee and lift up her dress, then her petticoat and then draw her knickers up tight. Yvette received about a dozen strokes of the strap. The sight of Yvette being spanked like that remained in my memory always. I could never forget a beautiful sight like that and it was after this that Yvette always told me when she was punished.

However, after we were married I made my mind up that I would spank my wife and very luckily for me, she allowed me to do this. So now I am able to indulge in this fascination.

(I use the term "spanked", but really the actual meaning of the word covers the whole of the punishment, spanking means to smack with the bare hand but sometimes she is strapped, again she is caned but seldom I use a cane on my wife, because this instrument does inflict genuine pain.) When I am going to spank Yvette it is a sort of ritual. She always dresses

44

in the smartest of her clothes her highest heels, her prettiest undies and a nice dress. I too order her to go and bring a strap.

I hope you can find space to print this in Bizarre and if any other readers have any experience in this fascination of spanking their wives or financee why not send it along.

<div align="right">AN ARDENT SPANKER</div>

A GOOD IDEA BY J.D.J.

Dear Ed,

First and foremost, whatever happened to the rest of the story "Tale From A Bottle". I've been dying to hear more about "Jimmie" and his progress in securing a matched pair of 'Radiants', and training the stubborn 'ponies'. Also, I'd like to know more about that courtship of his — with the fascinating island customs.

Secondly, I realize that you probably have a lot of readers who are interested in female dress for men, but as far as I am concerned I can take that stuff or leave it, and I usually leave it. I want my woman to know that I wear the pants in our family, and believe me, she usually knows it. But every one to his or her own taste.

Third, and most important, the John Willie drawings. I was somewhat disappointed in the lack of drawings in this last issue — My God, not even one "Fancy Dress" costume—well, I was disappointed

Now perhaps I can express myself on another subject — the photos this last time from

A REALLY PLEASING SIGHT — THE FULL-CURVED ARCH, AND THE MEANS TO KEEP THEM IN SHAPE

'Chained Letter Writer". I cannot recall any photos which impressed me as these last three did. The bondage was the ultimate in simplicity — perfect — merely a rope or cord to tie the wrists — And yet I think that this girl is just about as helpless as anyone could be, without actually being bound to some outside object. I feel sure that the little woman couldn't possibly even get off that bed without breaking an arm or something — and even

then — I'm sure that she would remain just as helpless as before she fell off the bed. Also, I admire the idea of the dress. Almost all pictures of girls in bondage show the victim in 'bra and panties' and somehow to me give the impression that the bondage is in private, or in secret. That's why these pictures from "Chained Letter Writer" appealed to me so much. It is the most natural thing to look at these pictures and imagine one's self caling on this couple and finding the little woman "Relaxed" on an easy chair, just as pictured. I'm wondering if her husband has any more cute little ideas like that which he and she might be willing to let us look at. A great big "Thanks" to the both of them.

Now I'm coming to the gist of the matter. You published several of my letters about armless beauties and their fascination to me — perhaps my views on footwear might be of interest to your readers.

To me the female foot is most beautiful when the arch is bent to the maximum. The extreme five or six inch high heel brings the foot into this position — almost — but in all my life, I have never known, nor have ever seen in person, any girl who really wore or even owned such shoes. I have found one place in New York where these shoes can be

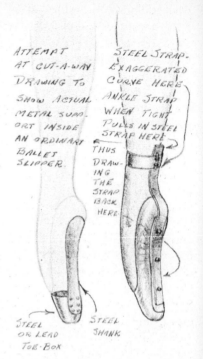

ATTEMPT AT CUT-A-WAY DRAWING TO SHOW ACTUAL METAL SUM-PORT INSIDE AN ORDINARY BALLET SLIPPER.

STEEL STRAP-EXAGGERATED CURVE HERE ANKLE STRAP WHEN TIGHT PULLS IN STEEL STRAP HERE THUS DRAWING THE STRAP BACK HERE

STEEL OR LEAD TOE-BOX

STEEL SHANK

custom-made, but as far as I am concerned, the price is too prohibitive for the average person. So — I buy my gal shoes which serve the purpose admirably, even better than the high heel variety, and they can be bought from a hundred and one manufacturers, for a very reasonable amount. I refer to the regular, hard-toe, ballet slipper. This particular type of footwear is excellent for bringing out the finest curve in any little arch you can find. And believe it or not, there is honestly no pain or great trouble involved in wearing this type of shoe. I can vouch for this statement un-

equivocably, for my gal had never worn a pair of these slippers in her life until the night I tried a pair on her little feet, — and without any practice at all, she promptly stood on her toes, and before the evening was over, she was walking about the room, perhaps a bit unsteadily, but nevertheless on her toes. And, as far as I am personally concerned, there is no nicer sight to see, nor any more exciting thing to feel or caress or even to kiss, than two small, neat, taughtly-straining arches ending in a definite bulge where the arch ends, and the smooth, rigid, box-like tip of the shoes, squeezes the little toes in their tight, satin-covered confinement.

Now all this is very fine — seeing the little woman prancing about on the tips of her toes — but there is a definite let-down when she gets tired and relaxes and drops to her heels, so that she flops around flat-footed like one of these modern 'bobby-soxers'. Obviously, some means must be devised to prevent this, so we do a little research. In a close study of the ballet slipper, we find that there is a rigid arch, usually of steel, fitting along the base of the foot from the toes to the heel and serving as a support when the foot is poised on the toes. And then we discover that the toe of the slipper is really a metal, cup-shaped, cone-like tip, attached to

the metal arch. Of course, the rest of the shoe, fabric and satin, hides these parts in the finished shoe, but they remain the hard 'core of the matter'. So it is with this basic core that we start to work. First we take an iron or steel strap about a foot long. This we bend and shape into a curve to fit from the toes up the base of the foot, on up around the heel, then a reverse curve to follow the ankle and on up the leg for sever-

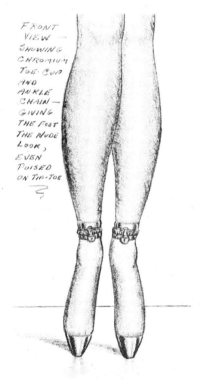

FRONT
VIEW —
SHOWING
CHROMIUM
TOE CUP
AND
ANKLE
CHAIN —
GIVING
THE FOOT
THE NUDE
LOOK,
EVEN
POISED
ON TIP-TOE

These sketches were sent into us by reader "J.D.J."

al inches. Now we drill several holes along the steel arch of the shoe, then matching holes in the inch-wide steel strap, and rivet the two together. Now the shoe, when placed flat on the floor, has an extension about six inches long, sticking out from the heel something like the handle of a soup ladle. (I believe some sketches would give a better idea of what I mean.) At any rate, the slipper is now ready to be worn. It is put on exactly like any other toe-shoe and may even be secured with the customary satin ribbons, but now my little invention is brought into use. When the foot is arched so that the toe points straight down, the metal strap rises to approach the back of the ankle. This is where a good design of the strap counts for when the foot is balanced naturally on the toes, the top of the metal strap should still be about half an inch or so from the back of the leg. — And now for the final touch. At the top of the metal strap we have rivetted a leather strap about an inch and a half wide, to go around the ankle. This wide leather strap covers the neatly-knotted satin ribbon of the shoe and is wide enough to pull the springy steel strap up against the back of the ankle. Now you should be getting the idea of the whole thing.

The secret of the metal strap is in its slightly exaggerated curve — so that when it is drawn up against the back of the ankle, there is always a tension carried down to the sole and toes of the foot, always tending to draw them further and further back — and thus compelling the foot to be held with the most tightly strained arch possible.

Naturally, when these specially-made toe shoes are put on the girl, she is actually 'On Her Toes' with a vengeance, as long as the straps remain secure about the ankles. And also naturally, the little gal may object to all this and unfasten the straps the minute our back is turned — so we eliminate this possibility by using a buckle on the ankle strap which has a fitting for a small padlock, (like those used on dog collars), (which incidentally, is where I got mine.) Now when we feel dull or listless or in need of a little pepping-up, we just put the shoes on the little gal, and then find a dozen or more errands for her to do about the place. I can think up more reasons for her to go upstairs, for it is a charming sight indeed to see her going up and down the steps, balanced precariously on her toes.

(To Be Continued)

Photo sent by "G.J.Z."

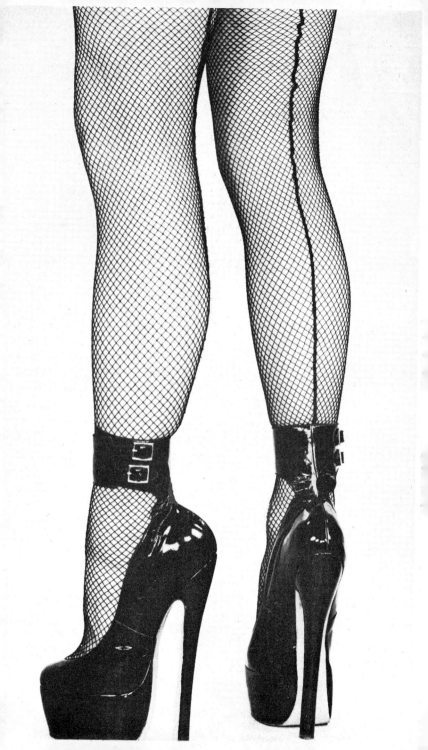

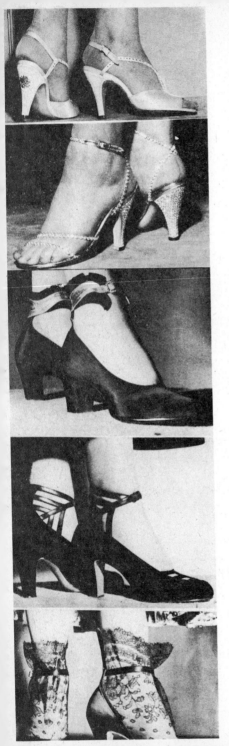

London

A glance at these photos shows — so far as the Paris models are concerned — that even the latest flights of fancy have a distinct similarity to what was worn many years ago.

In fact it would seem that the latest designs of the leading "high fashion" shoemakers have ben inspired by the creations of old Venice, Zanzibar, China, Turkey and Persia.

We could sum it up by quoting the person who said "there is nothing new under the foot" — everything has been tried before.

Be that as it may, it is quite clear that French and American women, particularly the latter, are the most foot conscious in the world. The Austrians and Czechs used to be, but since the advent of Ivan, things have changed. sadly.

British women are hopeless — charming — Yes — but quite dreadfully dull about the feet (which are enormous anyway) Even in the West End of London smart shoes are conspicious by their absence, and the few that are seen usually belong to someone who has been lucky enough to get an imported pair.

Of course we may be condemning the women of Britain unjustly.

50

\mathcal{P}aris

It may be that the shoemakers of that muddy rainy island have an outlook as grey as the weather.

To them a heel is just a hunk of something to raise the foot slightly. We show these samples of their latest creations, not because we think they are beautiful — we think they are dreadful — but they make a good comparison with the others.

American women, like their Continental cousins really pay attention to their feet, and in the U. S. A. they have the great advantage of being able to buy smart shoes cheaply.

The American typiste can buy the smart, top quality foot wear of Ansonia or I. Miller for 1/6 of her weekly salary. For the cheaper but still stylish lines at Beck or Simco, she only has to pay 1/12. On the other hand the typiste in Europe or Britain has to fork out from 1/2 to her full week's wage, for anything at all presentable. Under the circumstances it is obvious that she has to consider the wearing qualities of a shoe, first.

And how can a shoemaker turn out the little strips of nothingness on stilt heels, which these days pass for shoes, if he has to study "wear and tear"?

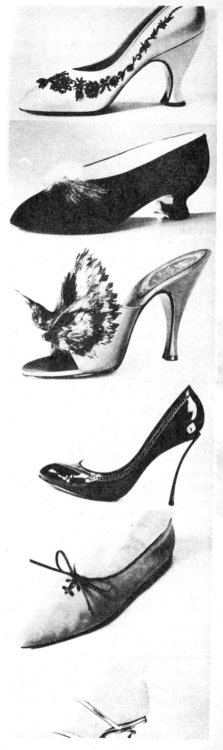

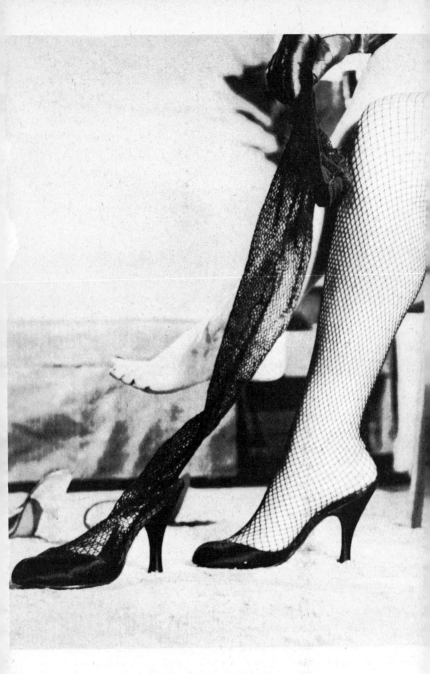

A RECENT STYLE FROM NEW YORK
stocking and shoe combined

Editor Bizarre:

A friend called my attention to your 15/16 issue. I was very amused by the imaginary sketch on page 106. Strange thing is — although exaggerated — its not too far off!

Do you really want my grandmother's story? My last began the long tale of her strange experience in the household of an *afficionado* of hour-glass figures in Paris. Although not literally a slave, she there became a "slave" to tight-lacing to a degree now unknown, and imbibed a liking for the practice which she passed on to my mother and to me. It will take me some time to write it up again. Right now it seems best to describe her as I knew her. My mother and father travelled a lot and I was left much in her care. It was due to this that from the youngest days of childhood I associated tight corsetting with femininity, for while in her home I never saw a woman who was not tightly laced. It is no wonder that I looked forward to my own first real corsets much the way boys do to their first long pants.

Our household consisted of grandmother, two colored maids, a coachman and me. There was an uncle who appeared at occasional rather formal dinners, vaguely known as something of a rake, who brought magnificent ladies with him sometimes. I was permitted to view only the earlier stages of these affairs, but I revelled in the general glitter of napery and jewelry, silks and satins. And how handsome I thought grandmother when dressed for these occasions!

Grandmother ruled her household with an iron hand. Although really quite able and healthy she delighted in acting almost helpless physically. Mornings she spent in her bedroom, where I was seldom allowed. About one o'clock she would appear at the head of the grand stairway, assisted by a maid and a cane. After a dignified descent she made immediately for her armchair by the window of the parlor, tottering on very high spool-heeled shoes and sat down slowly with a great creaking of corsets. She leaned back, panting from the slight exertion, her huge bosom swelling and falling, pressing the black shiny, jet-studded silk of her dress outward till it looked about to burst, her knees rather apart to allow for a plump rounded stomach and immense thighs which contrasted amazingly with the completely round, constricted waist above. I was immediately invited to climb upon this large, inviting lap, where I could bounce upon the stomach and thighs, pummel the breasts and at times clasp her tiny, hard, immovable

waist in my baby arms, enjoying the feel of the rigid bone under the black silk. I can remember grasping the curved shape of the newel post at the base of the big stairway and thinking that the only difference in feel was that Grandma's waist was warm.

Grandmother would now call for coffee, sherry and sweets for which she seemed to have an insatiable appetite and she would sit knitting or embroidering all afternoon, calling out commands to servants and observing passers by. Sometimes business men would call, whom she invariably bullied and terrified.

We rarely went out, but sometimes exchanged visits, by way of the landau and the coachman, with certain other grand ladies. Two or three of them might arrive in the afternoon in carriages, dismount, plump and puffing at our *porte-cochere* and enter grandly in ostrich plumed hats and full regalia to take coffee, cake and sherry with grandmother.

These ladies were also corsetted to such an extent that their balloon-like hips swivelled and twirled with each step as they walked. I used to be immensely diverted and absorbed in the combinations of breast-heaving, quivering and violent jerking of torso and hips as these ladies teetered towards their chairs, aided by tightly rolled parasols or canes, eased them-

selves downward gingerly, faces purpling as their corsets tightened at the waist with the extra pressure of the sitting position. They would lean back with explosive sighs and fan themselves with handkerchiefs and pant, arms well back and pressed outwards by the plumpness which overflowed the tops of their corsets. They would then proceed to consume quantities of sherry, cake and coffee, and converse, largely gossip about other women and the doings of their children. After an hour or so of this the ladies would make their adieu, departing much as they had come. After they left grandmother would call the maid to help her upstairs to dress for dinner.

On rare occasions I saw my mother; she had a fifteen inch waist. I have seen my father exerting his full strength in getting her corsets closed, when it measured about five inches across the front and was perfectly round and tube-like. Mother was exceptional for the length of her narrow waist, but she was the rangy type, slender and tall, more like the modern girl, to whom small waists come rather easily. Grandmother was quite a different type of woman, one — I think, — perhaps no longer extant, who glorified in every thing which made her different from men. She believed implicitly that it was wo-

SEE WHAT WE MEAN ?
JIU JITSU — GET IT ?

man's part to suffer, to be helpless, and to dress the part. She condemned any athleticism for women as tending to masculinity. She was undoubtedly proud of her figure. I have never known her exact dimensions, but from other women whose dimensions I have known I think she must have been about five feet six, weighing around 175. But her waist measure was well below the clasp of a three-year old's arms.

My curiosity led me to secrete myself in her bedroom on one evening when she was to prepare for one of my uncle's rather special dinners. I was able to view the proceedings with awe from behind an open work chair in a shadowy corner.

Grandmother was in a thin chemise and one of the colored maids was engaged in powdering her torso liberally, the other in laying out a new black satin corset so rigidly boned it stood alone on the bed. The two maids hooked the corset around her. It went only a little way over the hip, was high in front and back and had laces up the back and also at each side. Grandmother lifted her breasts with her hands until the maids tightened the laces enough to support them by the corset. They worked at the side laces first till all was very snug, then tightened the upper lace at the back and then the lower lace. From that time onward most lacing was done by tightening the double laces of the mid-section.

Grandmother prepared herself for this by resting in a chair, taking a liberal gulp of sherry. Then she rose and proceeded to a doorway into the next room and took hold of two handles set in

THE SINGLE "GLOVE"

the door jamb just above her head and braced her feet apart. Each maid took one lace. She breathed in deeply and at this signal each maid leaned back and grandmother's breath came out with a "Huh!" The laces were quickly snubbed around her waist and tied temporarily. She then began stretching and wriggling, so as to move the upper part of her torso up and out of the corset as much as possible, lengthening her figure. She put her hands inside the corset from the top and massaged the flesh upward. She put her hands on her jutting hips and pressed downward with all her strength, thrusting her chest upward and outward. At this moment Lizzie and Dinah tightened the side laces again. Then she took hold of the handles and hung from them.

Then came a rest and more sherry, she grasped the handles again and as the weight of her body swung against the laces the corset came closed in a series of small jerks.

Quite red in the face from her exertions grandmother now moved to the full-length mirror and seated herself before it, her breasts thrusting proudly upward and outward, straining grandly at the thin fabric of the chemise, her hips rotating and jerking from side to side, so her whole body was an interesting study in coun-

ter movement as she walked. Her firm rotundity was increased everywhere by the pressure of the corset, so that when she had donned her highlaced boots and staggered a little in rising, without the aid of the cane, the fleshy parts of her body quivered tautly.

Now she donned a charming pair of lace bloomers. Heavy black silk stockings were drawn tight with suspenders from the corset. On this occasion all her lingerie was black. Grandmother had, I knew, many matching sets of underclothes of various colors which went with gorgeous corsets made to her measure.

One could not envy the life of grandmother's two maids, who were at her constant beck and call. She demanded of them, not only implicit obedience but concerned herself with every detail of their costuming. On this occasion stout Lizzie came under her baleful eye as she sat cooling off before donning her evening gown. She ordered Dinah to bring the tape measure and she measured Lizzie's waist. It appeared that Lizzie had loosened her corsets a bit and grandmother said: "I can't abide maids with sloppy figures." As punishment she was laced three inches tighter by the cowering Dinah. To finish the job they laid Lizzie down on her face on the floor and grandmother assisted Dinah at the laces. When it was

57

done Lizzie was ordered to get up, which she did only with the greatest difficulty. So as punishment she was made to practice getting up from this position several times and then to do standing and squatting exercises, with grandmother standing by to throw her off balance occasionally. Lizzie's waistline and appetite were in constant conflict.

When grandmother couldn't think of anything else to do she was always requiring Lizzie to practice figure training exercises. Since grandmother's discarded corsets could be worn by Lizzie, grandmother took a personal concern in how they fitted her. She required quick and deft service and woe betide either of the girls if they exhibited any awkwardness. The penalty was to lace them extra tight and put them through exercises such as walking in high heels with a book balanced on the head, brisk squatting and standing exercises and balancing exercises of various kinds, which grandmother made more difficult by unexpected shoves. The punishment for failure at any of these was to lace the offender to the fainting point and send her to her bedroom.

But to return to grandmother's preparations: After a rest from the lacing process she would be walking around the room with her cane, occasionally viewing her charmingly remade self in the mirror, sometimes running her hands, as though it were for reassurance, over her amazing contours. After this she would call the maids again and don her chosen evening dress. It was on one of these strolls that she discovered me behind the chair. I expected to be punished, but I will never forget the graciousness with which she leaned toward me, her kimono-like dressing gown of thin silk falling open, and took my hand. It was then that she began the story which I attempted to tell you in the earlier letter which you say you lost, as to how and why she developed an especial love for corsetting. When I have time I shall write you again since there seems to be interest.

Yours,
PAULA SANCHEZ

PIERCED EARS

Dear Sir,

I want it made clear at the start that I am not an M.D., I am one of a vanishing line of Jewelers, taught in the old school, and one of the first things I can remember the Old man teaching me was how to pierce an ear. Many of your older readers may remember that the jewelers used to pierce all the ears. We have a very quick painless method of doing the job.

As you have stated in Bizarre

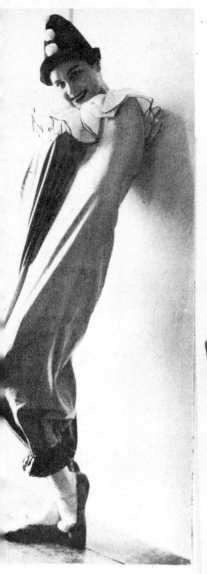

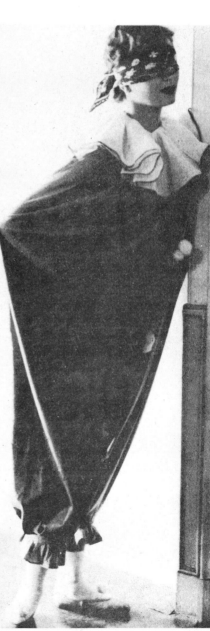

HIDE
AND
SEEK

*Helpless Clown
costume-half
pink-half blue
with white pom-
poms, black hat.*

the fad of pierced ears is back. In the past three years I have processed approximately 300 pairs of ears, they come in groups of twos and threes, mothers and daughters, even men have come to me to pierce their ears. If anyone is thinking of having pierced ears, I will tell you the Method.

FIRST: It does not hurt, as the tissue of the ear contains no nerve centers. Of course you may feel the prick of the needle, but through experience I can pierce the ear without you even feeling the prick of the needle.

SECOND: When properly done there is never a drop of blood during the process or after.

THIRD: It is most essential that the ears be pierced properly, centered and balanced so that the finished job will enhance the face and shape of the head. It is unsightly to see one ear ring lower than the other.

FOURTH: Do not use anything but solid gold or sterling silver ear rings in your ears. In spite of what the salesman may tell you, it is dangerous.

Now for the proper way to pierce the ear. Be sure that you as a layman follow my advice to the letter, as any deviation may cause infection. I have been piercing ears for over 24 years and so far as I know, have only had eight cases of infection and that was because the customers did not follow my instructions.

It is necessary you have the proper things ready. Alcohol, cotton, darning needle, heavy cotton thread, small medicine bottle cork, iodine, small cup.

Now that you have everything we will proceed. FIRST thread the needle, use the thread folded four times to give thickness greater than the needle, drop the needle and thread into the cup of alcohol, also drop in cork. Next wash hands and dip them in Alcohol. You can't be too clean.

Place the lady in a chair and wash both her ears with alcohol and cotton, then take the iodine and make a small spot on the lobe of each ear, right where you want the holes. In case you make a mistake the iodine may be removed by alcohol and you may start over. Next take the thumb and finger and pinch the lobe of the ear to numb it a little, be sure not to press too hard as you may bruise the flesh. Just press firmly.

Next place the cork in back of the lobe and pick up the needle and thread out of the cup and again place the tip of the finger over the lobe and press, then quickly place the point of the needle on the spot and press through as quickly as possible, The faster the move the less pain. Hold the lobe of the ear with the left hand and take the point of

the needle in a firm grip (I use a small pair of pliers so they won't slip) and with a strong motion pull the needle and thread quickly through the lobe of the ear, leaving about two inches of thread at the end which you can tie into a small ring with your finger and then cut excess thread leaving a small ring of thread in the ear. Proceed as before with the other ear and wash both ears with alcohol and leave alone.

CAUTION: Never touch the thread in the ear. If you wish to wash the ear, use alcohol for the first three days. Do not try to move the thread in the ear as any moving of the thread would only draw a dirty thread into the open sore of the ear and cause infection. Some people think the thread will stick to the sore, this is not so, IT NEVER STICKS.

On the third day get yourself a pair of LIGHT WEIGHT solid gold ear rings, place them in a cup of alcohol and then cut the thread in one ear and you will be surprised at how easily it slips out. Insert the ear ring into place and lock, then do the other ear the same way. After about the first hour you will have forgotten that you have pierced ears. The first or second night you might be bothered a little as the new rings will be felt between the pillow and the head but by the third night you will not notice them at all.

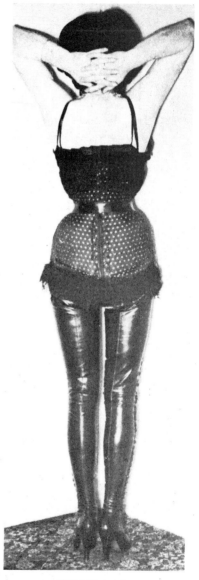

Photo from a reader

An excellent example of well fitting thigh boots sent in by a London reader.

61

THE CAN-CAN — IT NEVER GROWS OLD

By the third day again you will have so far forgotten them that you will have to be careful not to catch your comb in them as you comb your hair. Don't be surprised if this happens to you as it always does, at least once.

In one of your back issues a writer said that he liked to see the slit in the ear instead of the hole. He may like this but I assure you it is not good as the slit is caused by wearing too heavy an ear ring before the ear is healed. I prefer the small hole as there is nothing as dainty as a small jeweled stud surrounded by the lobe of the ear, that way everyone will know that the ear is pierced.

If you like this information and would like more, I have had some additional experience in placing jewels on other parts of the body. I don't advise the ring in the nose as it is very painful. But surprisingly enough, a jeweled stud of 18K gold placed in the cheek is not at all painful as you might suppose and may be very cleverly worn to hide scars on the face. I know of one case where it actually built a new life for a lovely lady who had a badly scarred face on one side.

If you like I will write more of this later.

Thank you for your time,

BROWNIE

MISS ISABEL GEORGE WEARING A
"YASHMAK" SMOG-MASK IN RED
WITH BLACK BRAID EDGING.

BiZARRE

Nº 18

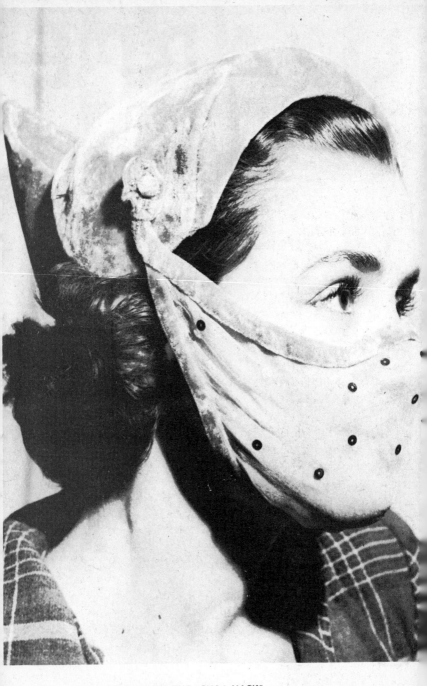

WE DO LIKE THE "SMOG MASK" —

IT HAS SUCH POSSIBILITIES

BIZARRE

Copyright 1956 U.S.A. by John Coutts

"a fashion fantasia"

No. 18

And as the Cock crew, those who stood before
The Tavern shouted — "Open then the Door!
* You know how little while we have to stay,*
And, once departed, may return no more."
 OMAR KHAYYAM

CONTENTS

NEXT ISSUE No. 19

RUNNING ON TIME — DUE NEXT MONTH

— so don't stand there and let other readers do all the work —
send your photos and letters along for publication.

BACK ISSUES

All back issues are available — except 12 — of which reprints are now being made.

If your dealer cannot supply you write directly to:-
P.O. Box 511, Montreal 3, Canada.

3

the Spirit of '56

*F*ashion leaves us with our Editorial head in a spin.

Glancing over our well ordered files on the subject we find such consistent inconsistency over the years that, as we have already said, one can only regard the average woman as a completely malleable bit of putty.

To prove our point — we felt we could not do better than present here some direct quotes from newspapers and periodicals.

Oddly enough, in the general melee, only with the corset is there any steadiness. That, like old faithful, just keeps pounding along — probably because though many robust males like their women plump — this plumpness never includes the waistline. So, since time began woman has always pulled herself in at the middle by some device — often to the great consternation of the "bluenosed," — *(Hail ! to thee, ye Corset Prodders of Pennsylvania)* —who regard all such feminine wiles as the work of the Devil in person. To which

stayedness, with a toss of her head and a flip of her rump, each sauncy wench pays no heed whatever, but carries on in her delightful way, making life pleasanter for all the rest of us.

As shown by the little sketches on these pages reproduced from the "special corset number" of "C'EST PARIS."

4

But to return to chaos; and let us start by storming the breast-works with a quote from the Washington Daily News, *some while back, when the fabulous Marlene Dietrich,* :— ". . . in a "bosomless dress" — transparent from the waist up — became the country's highest paid nightclub entertainer when she stood in a spotlight and sang "men cluster to me like moths around a flame . . ."

"It *(the dress)* was black net and skin-tight. The skirt lined with flesh-colored chiffon and sprinkled with sequins and rhinestones.

"The high-necked top was transparent and disguised by a few rhinestones that didn't get in the way. She said she wore "nothing" underneath . . .

"Miss Dietrich also showed her famous legs in a lion tamer's costume with long black stockings."

Now there are two styles which we think are well worth keeping in fashion — but just as we settle back with a contented sigh, to enjoy the scenery, along comes the following U.P. dispatch *from over in London:*—

"A famed fashion authority said today the emphasis in women's clothing was shifting from the bosom "back to the bottom."

"It's the inevitable cycle," *explained James Laver, curator of design for the Victoria and Albert Museum and author of many standard works on fashions.*

"In 1910 it was the bust, and cleavage went down to the limit," he said. "In the 1920s the sex emphasis was on the legs. In the 1930s it veered to the back and posteriors. In the 40s it concentrated on the bust again . . . And now we are back to the bottom."

"Woman is such a collection of

loveliness that mere man cannot embrace all her charms at one time," he said. "It is the duty of fashion designers to direct his attention to specific zones — speaking in a fashion sense; of course. Now look at Joy Ricardo's models, they are seductive head on but what catches your eyes as the models recede? They look as good going as they do coming." . . . *(This supports the contention of*

the reader who signs himself "Bot-
toms, NYC," whose letter appears
in this issue on page 40.)

Comes now another London
fashion expert to confuse us still
further. Anne Scott-James, *com-*
menting on the work of the late
Jacques Fath:—

"I have just been watching some
of the tightest-fitting clothes I have
ever seen on the female form.

"Jacques Fath has gone for suits
and dresses clinging like corsets
with many even constructed and
boned as though they *were* corsets.

"Are they difficult to wear? Im-
possible — unless you have a su-
perb figure, for I don't see how
you can wear a corset underneath
a dress which is pretty well a
corset itself.

"Are they attractive? Yes —
really beautiful on a woman with

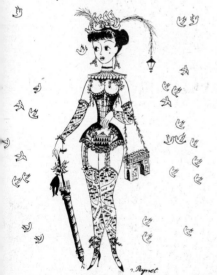

all the right curves and none of
the wrong ones.

"However, this skin-tight, mould-
ed , corseted look stops at the bust-
line . . ."

Getting Dizzy?

Then how'd you like this little
bit from the N.Y. World Telegram
and Sun:—" . . . a few years
ago, a local idea man got the no-
tion for what he called '*knee*
advertising.' He figured no male
subway rider could miss a message
flashed on a band worn just below
the knee of a lady fare across the
aisle. His plan was to hire a flock
of ladies with what used to be
called 'well-turned ankles' and
have them display knee-advertising
in the underground.

"Somehow, the plan fizzled, pos-
sibly because to show off the ads
effectively, the ladies would have
to be seated with knees crossed
demurely, and no dame has been
able to get a seat in the subway
since 1907, the year of the panic."

Hold on, there's worse to come.
Today Paris *contents itself with*
half-starved mannequins and Mink
Bow-Ties *for Milady, but it seems*
the British have the mink field
by the throat:—

"Mink-lined raincoats emerged
Sunday as the latest British fash-
ion," *says the New York Daily*
Mirror.

"Mrs. John Ward, whose hus-
band commands the Household
Cavalry, is wearing the first model.

I.N.P. photo

"OH WHERE ARE THE BOSOMS OF YESTER-YEAR?"

" 'It's not wasted,' Mrs. Ward said of the mink. 'I think it is much more chic to wear it where it can't be seen.' "

Quite ! and the next thing we'll know is we're back to the Merkin.

To sum up all this confusion we feel that we cannot do better than quote from the London Charivari — *"PUNCH"* — *which says*: —

"Fashion has developed a complicated sophistication since it originated, in relative simplicity, with Eve. It was easier for Eve, of course. She had no competition. Nowadays we must not only please and impress but we must do it better than the-girl-next-door.

She wears the new tight waist, so ours must be tighter; she lowers it to her hips, ours shall drop to our knees. The fact that the-girl-next-door has a waist measurement of thirty while ours is thirty-two has nothing to do with it — fashionable we want to be, and fashionable we shall be. No matter if we are compressed until we cannot breathe, padded until we cannot get through the door, hobbled until we can't get on the bus — we are *fashionable*.

"The depressing truth is, of course, that to all of this the-girl-next-door is quite possibly oblivious. She'll gossip cheerfully in the

8

shops serenely unaware that we are observing with gnashing teeth that she wears the new (but *new*) neckline. She has, in all probability, been wearing it unnoticed for five years. Hers is a happy, placid life, fashionable in cycles with the same well-loved garment . . .

"To be fashionable this season Navy-and-white displaces black-and-white, says one designer; black-and-white is in, says another. Or you can wear grey, red, yellow, green, creamy beige, cinnamon toast, blue grass, ash-blue, smoke-blue, smoke-beige, strawberry pink, new geranium, Devonshire cream, deep mole. And you'll be all right in anthracite, porridge, or chewed string. On hemlines, only the very irresponsible will ignore Mr. Digby Morton, who tells us that clothes will be longer for a well-bred look . . . Evening dresses were magnificent, with wide, fabulous skirts; the kind, says Mr. Mattli, that go *swishshshshshshsh* down the stairs, and possibly, I fear, *rrrrrrrip* on the way up. Others, quite obviously, were too tight to leave the ground floor at all.

"So there it is. Fashion straight from the top designers, provided you have the bank roll. The only trouble is, of course, that even bank rolls have a depressing habit of saying they much prefer the blue thing we wore on Monday when we bathed the dog."

As for the poor male, here's the only real news along that line. The World Telegram and Sun again, commenting on the sleeping attire of the Frenchman:—

"The question of sleeping garments — or lack of them — has not been prominently in the news here since a certain actress let it be known that she wore only Chanel No. 5 to bed.

But the French National Institute of Statistics has announced the fascinating results of a study of French clothing habits, in and out of bed.

Not many Frenchmen sleep in their underclothing, partly because 21 percent of them don't even wear underclothes in the daytime.

However, one-fourth of the males surveyed do sleep in the same shirt they wore during the day, as against 15 percent who wear a different shirt to bed and 12 percent who wear the old-fashioned nightshirt.

The fact that 39 percent wear pajamas is not surprising, as the French are conservative in personal matters, and the small number of nude sleepers (4 percent) is understandable to anyone who has visited France in the winter.

But what is most intriguing is the other 5 percent who, according to the Institute, sleep in "divers accoutrements."

Shoes, maybe?" — *unquote!*

THE LAST STRONGHOLD (translated from the French)

A learned sage, the worthy Doctor Marechal, has just gone to war against that foe of the human race which is ca
the "corset", and which remains in our modern society indifferent to comfortable well being, as a last bastion of st
which neither time nor the efforts of man have been able to throw down. We salute as a hero the learned physician v
would engage in hopeless battle with an adversary.

Which has resisted the victorious commands of kings

Which has mocked the decrees of emperors

Which has laughed at the excommunications of popes
and the curses of bishops

Which has shrugged its shoulders at the exhortatio
sacred orators

Which has ignored the advice of doctors

and the enlightened counsel of savants and philosophers

hich hasn't even wished to hear the voice of painters
and poets

And, has announced the new crusade, the garrison swo
to die, rather than be free.

TRANSPORT SECTION

The greatest invention in history — or should it be "discovery?" — is the wheel, and ever since mankind found that by using a wheel he could cart enormous loads around he has always been in search of some means of propulsion other than his own muscles.

The first and obvious idea was to get another human being to do the donkey work. Primitive man being a simple, solid citizen who kept peace in the home by use of a club naturally relegated the chore of cart-upllink to his wife and family.

The practice of using human beings to pull carts and things about has never completely disappeared. Instances of its use today are continually cropping up. In the primitive areas which still exist in this world men and women toil in the yoke dragging the homemade plough or cart — while in others, where the old pomp and circumstance is still to be found, slaves are used to draw rickshaws and light carriages.

The Rickshaw boys of Durban and the coolie in the East are "volunteers" when all is said and done, and so for that matter are the peasants still ploughing their land in the yoke, but the slaves in the early days of settlement in the U.S.A. were not volunteers, and neither are those in modern India, China, and Malaya who are in private "employ".

To a whole lot of people the idea of driving a team of shapely human beings around the place has quite an appeal — Look how the famous Pony dance of the Dolly sisters used to pack them in — and all they did was to prance around the stage in a pretty elaborate costume.

Under the circumstances it does not seem extraordinary at all that Planters in "the South" in the old days should have had the same idea — the only difference being that whereas the Dolly sisters were volunteers pulling down large quantities of cash, the slave in the South would not only be no volunteer but well and truly se-

11

cured by harness so that she could not escape — or resist — and wouldn't get a cent for this discomfort.

From old letters and manuscripts of the period the practice was not by any means unusual, but those who were pony slaves in the South had a pretty sad time.

As soon as a girl or a man — the preference seemed to be for octaroons — was chosen as a pony her hands were tied behind her back and from then on all through the period of her "use" she could not use them again. They remained tied or strapped up in some manner — even when eating. She ate and drank from a bowl like any animal.

She lived in a special "hut" or "stall" — the floor covered thickly with straw for a bed. A steel collar and chain attached to a ring in the wall ensured that she would not escape if the door was left open. Sometimes the collar was spiked as a punishment and the chain might be shortened to keep her standing on tiptoe all night — the spikes digging into her neck and chin the moment she tried to lower her heels.

Ordinarily the harness used when between the shafts was a simple arrangement of straps, keeping the pony's hands securely fastened and at the same time ensuring the most convenient means of exerting his or her strength. A strap over each shoulder, joining and then passing between the legs — together with a waist belt — was universal — and somewhere to these foundation straps were others to secure wrists or elbows. For the pulling itself trace chains were sometimes used — these being either attached to a shoulder harness or from the waist. The shoulder harness was not used on recalcitrant ponies because as one writer of the period pointed out, "It interfered with the full use of the whip."

The shafts as a rule were naturally attached by straps or chains to the waist belt — and on several designs of harness the weight of the shafts would be taken on each side by a strap passing directly over the shoulders.

To control the "pony" a variety of methods were used. If the slave wore a nose ring or earrings the reins might be attached to these direct, but otherwise a regular steel bit, held in the mouth by a bridle was customary.

It may seem strange but no one seemed to think it cruel to remove the pony's back teeth on upper and lower jaw so that a studded bit rested on the tender gums where its fullest effect could be felt. If she gave too much trouble there was always the jagged metal ball, or the "scold's bridle" or the "expanding pear" — both in general use at that

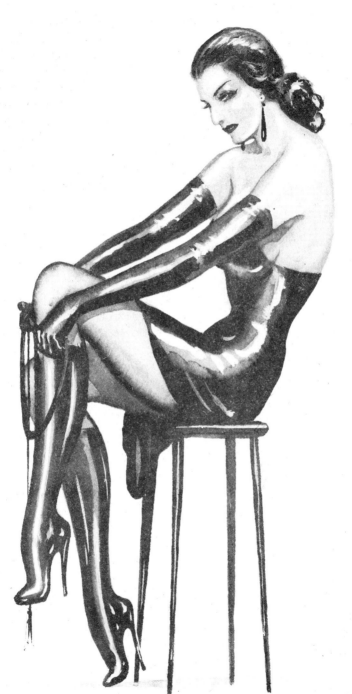

time — the former to control scolding wives and the latter in France to prevent prisoners from talking to each other in gaol — or from appealing to the crowd for help while being led through the streets.

In addition to these severe bits the "training harness" itself was designed to create as much discomfort and pain as possible. One

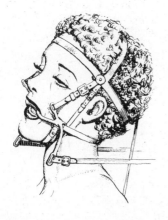

session of training would be sufficient in most cases to curb a rebellious slave but a few owners, and children in particular, seemed to delight in torturing their pony almost all the time. Never sufficient to maim her but just to make her life one of continuous misery.

The carriages were light for they were only used to transport owners around the plantation or the young masters and mistresses on their "dates". They were built to carry one or two people but no

more — and some were four-wheeled, others two, and some three — the third wheel being small and light and to take the weight off the shafts (the "balance" being slightly back of the axle).

It must have been an amazing sight to see a lovely girl of eighteen or nineteen, or an autocratic lady dressed in the magnificent costume of the period, coming up the drive of an old mansion, her carriage drawn by three tall and beautiful male or female octaroons, plumes waving from their headgear, harness jingling, the runners moving in perfect step with a high-action spring, slowing down to a halt, and then standing there on tiptoe, motionless — except for the heaving of their panting breasts.

A liveried groom would come forward and take their heads while another helped Milady to dismount — then the team would be taken off to the stables until the afternoon of music and nonsensical chitchat over, Milady's team would be brought round and she would drive home in the cool of the lengthening shadows.

The young bloods and their companions would vie with each other for the most startling team — and would proudly display them in harness so rigidly fastened that the head would be drawn "proudly" and immoveable back

and the arms so tightly strapped that not even a shudder was possible, but no one seems to have gone to the extreme of some eastern potentates in our modern times.

How long since the custom died out in America it is hard to say but from various reliable sources it was still going on just before the end of the British Sovereignty in India, and not in just one or two isolated instances, either.

The general idea seems to have been that human ponies were there for the convenience and entertainment of the Nabob and his guests.

There is a story of one Rajah, or Maharajah or whatever they call themselves solving the problem very simply — horses don't have arms anyway, so why waste time tying a girl's hands to prevent her untying harness straps — just cut her arms off. That is exactly what he did — this writer has not seen it but he will bank on the reliability of the informant. This great Panjandrum had his

Ponies — quite a few of them — all beautiful young girls and all of them with their arms amputated at the shoulders. Everything went fine until the British Raj caught up with him.

There are also reports of similar ponies in Siam and parts of Malaya being used on large estates for the convenience and entertainment of guests — but there it would seem that a harness is used to fasten the arms — they are not cut off.

Perhaps other readers have come across instances of "human ponies"—if they have they should write about it — I'm sure it would be of universal interest.

Yours

"Antiquarian"

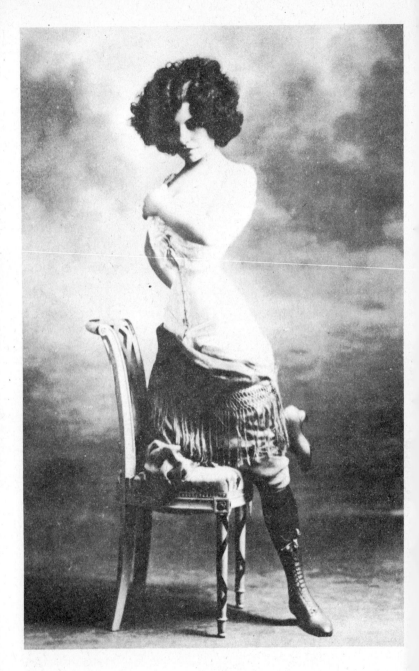

LA POLAIRE

"Polaire"

by A.P.W.

I used to be a dresser for the French actress Polaire who was over here in 1905 and advertised the smallest waist in the world — 13 inches — so I've been interested in your corset pictures. You can see pictures of her in Harper's Weekly of that year and also in the old Green Book. I also have dressed many other artists of those days who wore very tight corsets, so I know something about the art of tight lacing.

I do not think there are very many women left who are used to real tight lacing though the styles have run that way again. Most men nowadays have never experienced the peculiar thrill of lacing a well rounded woman into an "hour-glass corset" — but in those days it nearly always took a man's strength though sometimes two women could do it.

Mme. Polaire was superb and had a special corset for her stage appearance. Ordinarily she wore her waist at 15 inches. She was laced just before appearing and unlaced again afterwards, and put on a 17" corset. Strangely enough she always ate heartily before enduring this lacing because she believed that plenty of nourishing food caused a better readjustment of the internal organs than lacing on an empty stomach.

Getting the corset laced closed without pinching the flesh of her back was accomplished by having laces at the sides as well as the back. The waist part had its own laces and they were double. This was tightened first to force the flesh upwards and downwards and as we tightened we massaged it that way. Mme. Polaire would stretch and wriggle so her figure would lengthen in the corset. After the waist was fairly tight we would lace downwards and upwards, then tighten the waist again, etc.

Mme. Polaire was not thin and when finally laced, her big bosoms jutted out above the corset like a shelf. Quite a big stomach pushed out beneath the short corset. She had large hips too. Her figure thus laced was considered magnificent by the great crowds of her men admirers. She never fainted from tight lacing like some others. She believed it was because of the food and deep breathing while being laced and moving around a lot so the body adjusted itself.

She would even do bending exercises after lacing to insure circulation, etc.

As she found a sitting position brought more pressure to bear on the corset she would squat and stand several times. It was amazing. She looked as though she would break in two.

Seen from the front HER WAIST WAS EXACTLY 4 INCHES ACROSS FROM SIDE TO SIDE AND PERFECTLY ROUND. She was truly an hourglass since her bust was 35 and hips 37.

Most of the stage beauties of that day were quite fat by present standards and from tight lacing had big protruding stomachs with rolls of fat just below and above the corset line, though the rib section would be skinny from constant corseting. It wasn't till later when the straight front corsets came in that anyone worried about a protruding stomach. It was considered part of a proper feminine figure. Most had to lean back in

their chairs when they sat down to make room for this pushed-down stomach between the corset and the thighs. Most of them could not sit or stand for any time at all without a tight corset to hold them up, and couldn't have quit tight lacing if they wanted to. That is why some of those still alive still wear tight corsets. In some cases they wore a corset protector, which was a belt made of metal links which was put on over the corset to insure holding the waist in case a lace would slip or break, and would help keep the steels from breaking. A doctor of that day told me most women exerted an outward pressure of about eight pounds to the square inch against their corsets, so you can see they had to be strong and full of steels.

There is much that is interesting and unknown about corsets and I hope your magazine will continue telling about them.

Most men were eager for their wives to lace as small as possible without fainting and though they made jokes about it actually they enjoyed the process of squeezing their wives and daughters waists to a mere nothing. Some said it gave them a peculiar and delightful sense of mastery.

The men liked tight lacing in their women and that's the true reason it was so prevalent for such a long time, and the women liked it because the men liked it. Many

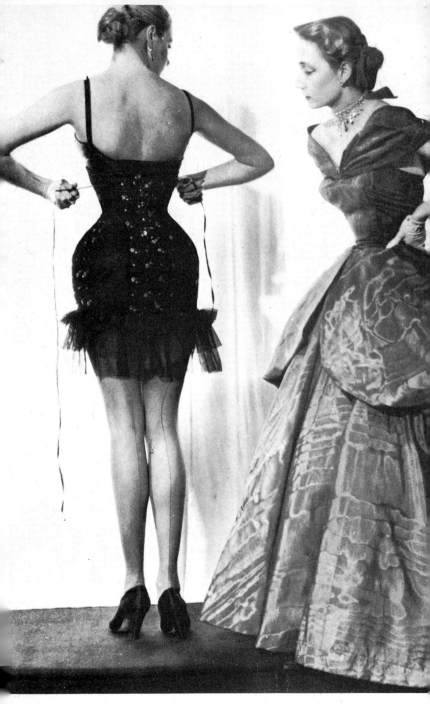

UNDER THE NEW GOWNS — THE CORSET

times I have heard a wife, squirming and panting a little in her tight corset say in explanation: "Well, John laced me this evening and you know how men are — I can hardly breathe but he loves it dearly!"

Most women boasted a little of their husbands severe lacing and most husbands boasted of their wives small waists. Girls who were proud of their developing figures re-laced each other's corsets three or four times a day and wore bust and hip pads and stuffed with food to get properly plump above and below the corset.

Huge dinners were the order of the day and most women became plump, but fought continually to retain their small waist measure. I have seen a woman who was going out to dinner at night begin lacing at five in the afternoon, tightening every fifteen minutes and usually munching chocolates between times. Then she would eat an eight course dinner. There was no place for the excess flesh to go but to hips, shoulders and arms. Many more mature women measured bigger around the upper arm than around the waist!

Often women would retire to a bedroom on arrival at a party to have a final corset tightening. There were usually two strong maids in attendance for such purposes and extra corset laces, smelling salts, etc., were on hand. Fainting was not considered serious and usually the fainting lady, after leaving her corsets loosened a little took some smelling salts and had herself laced right up again, but more slowly. If the ladies at a party discovered that some new lady was there with an extra small waist they would often retreat to the dressing room and have themselves pulled in further. This was possible because most corsets were left three inches apart at the back.

When Mme. Polaire would appear at a party most of the women would be purple and gasping and hardly able to move because they knew they would look large compared to her and had laced their tightest. Other actresses often refused to appear with her because she made them look so large.

The rage of men for small waists was so great that in Paris bordellos there were rooms where patrons could indulge their passion for lacing corsets on girls. Since men enjoyed having the girls lace them into a corset, too, it was a recognized way of gratification. I heard of one house where all the servants were forced to keep their waists below sixteen inches and were discharged if they exceeded that and they were fed rich food to make them very plump.

The tightness of corsets caused some funny accidents. The rage in evening clothes was for very

low cut decolletage. Ladies arranged their bosoms over padding on top of the corset so as to get the maximum spread and uncovered them to just above the nipple. On one occasion I saw a big bosomed woman who also had a real fat stomach below her corset sit down rather suddenly. Evidently her garters broke and the corset released from below rode up, pushing her breasts and they popped right out of her dress! I have seen a woman eating dinner and her strings broke and she split her dress up the back with a sound of rending silk!

You will notice, if you look, in photos of the time that most women leaned back when sitting or spread their knees. This was to accommodate the big round stomach below the short corset that almost all had. I also saw a dress split in front because of a sudden push of her stomach when the lady sat down quickly. Strangest of all was a young lady who had been laced tightly since the age of seven and whose waist had never grown since that time. The mother had done this because the family ran to flesh and she was very ambitious for her daughter's stage career. The result was the girl was very soft and plump and large but had grown into the corset like a cucumber in a bottle, and absolutely depended upon a strong, tight corset to stand up

right. When it was taken off to bathe she had to lie down until she was laced up again. Her breasts and upper body were so heavy she couldn't sit up without the corset! Yet she was quite healthy and made many stage appearances.

It is said Anna Held had a rib removed so she could lace smaller. I don't know if that was true, but she did lace very small and offered her corsetiere $100.00 for every inch less in her waist measure. It is said the corsetiere refused to take her money for fear of lacing Anna to death!

Such was the interesting cult of the corset!

Correspondence

Under no circumstances do we publish names or addresses. If photos or sketches are sent in, please write a short commentary and please do NOT send in photos which you got from someone else.

HAPPILY HANDICAPPED

Dear Editor:

Being a devoted admirer of your fine magazine and having read the "Chained Letter Writer's" article in Number 9, I thought you might be interested in publishing my experience in one of your future issues.

My husband is a surgeon and likes to see me in laced, boned corsets and very high heel footwear. Also, he likes to see me wear heavy makeup, and above all else, skintight clothes. Since I love him dearly I consented to wear the shoe he chose for me and started corset training right after we were married.

The severe training he chose for me was so painful that, to endure it, I accepted his suggestion to keep my arms immobilized almost continuously, to keep from trying to loosen the lacing and taking my high heels off.

After a few weeks of this, my arms often became numb and quite painful and I wondered how long I would be able to stand it. Then one day I was in a terrible car smash.

I woke up in the hospital, after being unconscious for days, aching in every bone, and unable to use my arms. My husband was constantly with me and as the days passed by my aches and pains disappeared, but I still couldn't move my arms, which swathed in bandages lay limply beside me. It was odd but whenever the dressings on my arms were changed I always was blindfolded.

Later when I was allowed to get up and take exercise my bandaged arms were tied to my body at the waist with another bandage to keep them from swinging about, so I was told.

Everything seemed to be mending grandly except for those arms of mine and I went home. I was so happy about it. To celebrate my recovery, my husband, who was

22

with me of course, had bought me a new dress as a present which I immediately wanted to put on. Then I remembered my arms and asked him if it was sleeveless and he answered that it was, but that he had another surprise for me, he was now going to take the bandages off my arms and so for the last time I was to be blindfolded.

In darkness I stood there feeling the bandages being taken off my shoulders. My dress followed. Then I was told to lift my feet to step into my new dress. As it was pulled up I could feel by the way it clung to my legs and thighs that it was extremely tight, and when the zipper was pulled up at the back I knew that the upper part fitted like a second skin — but my arms were still completely numb and I could feel nothing at all with them.

Able only to take the tiniest steps I was led over to one wall of the living room which is mirrored. Then the bandage was removed — and what a shock I got. *I had no arms.*

A modern version of the Venus de Milo sheathed in clinging black satin stared back at me from the mirror. I had no answer for a moment, I was too amazed to think. Surely I must have arms somewhere — but the solid black of the satin covering the shoulder joint — from which my arms should have come gave it the lie

direct. It may sound strange but suddenly I felt supremely happy.

I will admit that later I did have periods of depression and felt utterly helpless when I found that I could not feed myself, or dress, or do a thousand other things we all take for granted every day, but since I had had little use of my arms for several weeks before the accident, I soon got over it. I resumed the corset training, with his help, and once again returned to tight, high heeled shoes. He was, and is now, always very helpful in taking care of me, feeding me at meals and helping me with my hair and makeup.

On Sundays, if we don't go out, he allows me to go barefooted and during that time, I have learned how to use a typewriter with my toes and sometimes I paint a little.

I am proud to say that I now like corsets and the highest heels I can wear. My measurements, after nine years of training are 39" bust, 16" waist and 34" hips. Are yours as good? Since I have a very small foot (3AAA), I love to wear extra high heels and high platform shoes. I am only 5 ft. 5 in 3" heels, so my extra high 7 and 8" heels with platforms make me just the right height for my husband. Even without arms, I have learned to dance quite well in my excessive heels. Although people star at my specially designed dresses without sleeves, I

do not feel embarassed. I have grown used to it and depend on them.

If any of you girls have experiences similar to mine or like "the Chained Letter Writer" I would like to read about them in some future issues. Will write more later about my exciting life if you should desire to hear about other things.

Your devoted reader,
THE ARMLESS WIFE

HIGH HEELS A MUST

Gentlemen:

I have missed the regular issues of Bizarre with all the latest fads and fancies in dress. Lately have met a young lady who likes these things as much as I do — corsets, rubber and my definite love, those breathtaking high spike heels. I can hardly wait until she fits her lovely legs snugly into some custom made operas, and parades in front of me. For some reason heels of 3″ or 4″ do not seem to impress me a great deal — but the minute they rise above 4½″ I can't feast my eyes on them enough. We intend to experiment with all sorts of dress and situations. If we think up anything new we'll send it on. Perhaps some new picture angles might be in order. Know that many of your readers are going to envy me. Among things I would like to try are 6″ heeled slippers (black pa-

tent with bright red heels adorned with large bows) and a corset which is long and restrictive. Some say these are delightful to wear and I'm thrilled to see how they feel.

HIGH HEEL ADMIRER

ENCOURAGEMENT
FOR CONTRIBUTORS

Dear Sir:

Have just been glancing through No. 13 again (one of the best issues ever) and must tell you that the whole paper is wonderful. The special highlights for me are "with Cousin Pepita" by Sylvia Soulier including splendid pictures, the photos of rubber by M.A. (no need to limit this to rainwear!), the tantalising letter by T.C. (and where are these things made?), the delightful letter by Phil-Phyl's Better, which is captioned "Cure for Mr. Wontwork." Then there is a masterpiece on p.54 (again where can I buy peace in the home???? . . . why keep it a dark secret?).The letter by Paula Sanchez is excellent, and so is the picture on p.59 . . . all part of "tight lace for beauty" (quite true!).

You can imagine that I can't wait to see the latest issues, so please hurry the mag along soon! Thanks.

Sincerely, V.P.

* * * * *

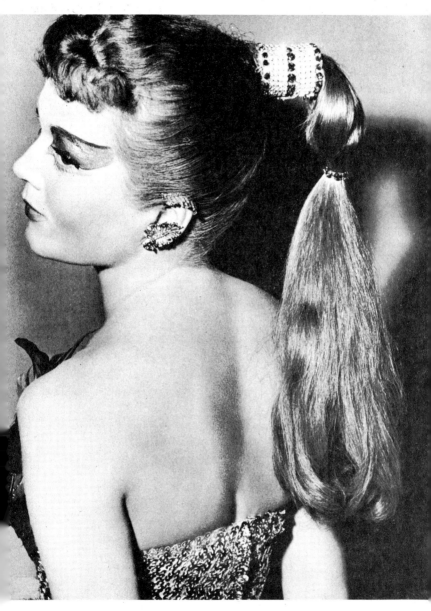

HAIR STYLE BY MYRTLE STULTZ

WHO'D BE AN EDITOR *!*

One fine sunny morning the Mailman brought us this letter.

Dear Sir:

Why don't you learn something about boots before you start showing pictures of them, and the things your artist draws are dreadful, so he can learn too.

On the perfect boot the gap between the lace holes should not be closed. When laced to the limit it should be at least 1½ inches open — 2 inches is ideal. If the lace holes meet the boot cannot be drawn tighter, but if there is a gap not only can the laces be tightened but they look tight.

Only by extreme tightness will the flesh bulge out at the top of the boot and between the laces — which is the most desirable and attractive feature.

Anyone who knows anything about the appeal of the knee-length boot knows that nothing is more beautiful than a heavily built foot and leg bulging, and obviously squeezed into the boot, and laced with difficulty. By this means and no other is it possible to get the absolutely smooth tight fit without wrinkles which is so desirable.

Yours,
N.C,

Personally we always thought that a boot or a shoe should fit like a second skin, but we do our best to oblige the readers so when another reader sent us the photos you saw on Page 32 (No. 7) we thought everyone would be happy. Then we got the following letter.

Dear Editor:

I have enjoyed your magazine immensely, ever since I first saw it, and now for the first time I am disgusted with a picture in Bizarre. I never thought this would happen. Needless to say that I am a high heel fan, an admirer of beauty of every kind, leaning to the bizarre. High heels are an accessory of the natural beauty of feminine legs and feet,

keeping the muscles under tension.

You published a number of exquisite photographs of models with high boots and high heels, three of them in volume 3 (pages 1, 25/26, 27), one on page 21 in volume 6 and one of special beauty and decency on pages 34/35 in volume 7. In all these the boots, obviously made by a true craftsman, fitted perfectly, the laces meeting and the top of the boot merging in to the leg smoothly as a boot should.

But, dear editor, how badly could you slip in your otherwise excellent good taste, just two pages away from the beautiful center spread picture in volume 7, is the dreadful picture collection on page 32. In my opinion this is the most vulgar and disgusting display of boots with high heels I have seen. It certainly has no place in a high class publication like Bizarre. In these pictures there is no beauty, nothing bizarre, it is just a display of the bulging legs and fat feet of a 400-pound lady in shoes that belong to a gracious woman.

I know well, that the tastes are different, that the orientals, (in no way all of them), like their women fat, in Farouk proportions, if possible. But in the Western world, for more than 2000 years, since the classic art flourished in old Greece, and in the Americas, such overweight and such ill fitting boots as your model displays, are considered ugly.

If you borrow a female hippopotamus from the zoo and put her four feet in high heeled boots, you would have a nicer picture, more decent and more bizarre than the one you printed.

Yours truly,

G.K.

— *and then almost by the same mail this*:

Dear Sir:

I'm glad to see that you pay some attention to what your readers tell you. The boots shown on page 32 of your excellent issue No. 7 are perfection.

Yours,

N.C.

By this time we were only swaying gently and gasping for air — until we got the following letter — from someone with a simple fixation of purpose.

Dear Sir;

Why do you not print more pictures of Girls in Boots and High Heel Boots as I love Boot pictures.

Cousin Betty says, She likes Boots too but she and I agree that girls tied up in issue after issue is very silly.

You could get more readers If you cut out the tyed up's of girls and printed more Boot Pictures and then some more Boot pictures.

Why cant we Have more photos of the girl in boots and black rid-

ing brechees from No. 2. These were High Heel Riding Boots and are the most beautiful Boots better looking than the Laced or Button ones.

Betty wants to know where she can write to Achchelles the Boot-Maker and If he has a catalog etc Prices of Boots like these.

Why Do you not Publish Bizarre more often. Did you ever hear of London Life they Published Boot Photos too and stories.

Would J.W. be interested In my C story about a Princess and Prince (its a Womens World) who like to wear Boots I will sell it to him for 5c a word and include the rights to republish etc But Not rights to Make into a Movie or Stage Play this would cost 10c a word additional.

The reason we buy your Magazine is because of the Girls in boots why not a Girl in boots on the next cover.

Very truly yours,
R.E.H.

(to which we can only answer — "Well why not send in the b . . . story !" . . . Ed)

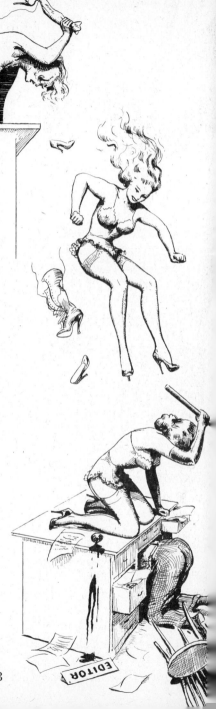

NOW WHAT WOULD SOLOMON DO?

Hints on Rubber Care

Dear Sir:

It is indeed with great pleasure to see our "Rubber Club" flourish. Everybody who is a rubber enthusiast should contribute pictures and a few ideas on the subject.

Our Rubber Club is what we make it. Ever since I can remember the sight, feel, and smell, of rubber excited me beyond the imagination of the average person.

As a child, I spent many hours wearing a rubber raincoat which my parents purchased for me.

I knew one thing and that was, while in my rubber coat and boots I felt as if in a trance. Like a hypnotized person I'd live in a fantasy world of my own, where all the women were dressed in Rubber. Everything was made of rubber. Nothing like the world we live in, but a real paradise of rubber.

Today, as a full grown person, I have met a good number of men who enjoy rubber. Some are successfully married.

I know of a Rubber Club in active session in London. It seems to me that in England, rubber enthusiasts are fare more active than in the U.S.A.

We have a "Rubber Club" here in New York City with about 30 members. The meetings are very interesting — and I would like to tell you that there are many married couples, who have a private "Rubber Room" of their own. One room in which every thing is made of rubber from ceiling to floor.

My own collection of Rubber is quite large. I have over 18 raincoats — several pairs of boots, ladies and mens, rubber gloves, bathing caps — all gum-rubber suits, used by frogmen. Over 50 yards of rubber coated cloth (for Rubber Raincoat construction) and 20 yards of gum-rubber latex sheeting, and many other rubber goods too numerous to mention.

In my spare time I'm continuously looking for odd rubber rainwear and I hope some of the readers will send in more rubber photos.

I think that all gum-rubber latex raincoat photo of M.A. page 31 of No. 13 is wonderful, I hope he or she sends more. Perhaps M.A. can tell us where such a rubber latex coat can be purchased. All of us should contribute something on the subject.

I also enjoyed "How to make a mask".

Rubber Fans should remember to keep their rubber goods away from sunlight and heat, also free from grease and oils. If a lubricate is desired use cold cream which has no harmful effect on Rubber.

Gum rubber goods should be dusted with talcum powder, before putting away or storing. I found

that drug stores sell plain talcum powder, with no odor at all. You may have to order it but its the best, especially when a rubber fan doesn't want to perfume the rubber with common talcs that are scented. Ask your druggist for "plain U.S.P. Talcum". Last but not least never store or wrap up a wet rubber item. Always permit it to dry thoroughly. Since rubber is a vegetable matter it deteriorates rapidly, so one should exercise some care.

Yours truly,

S.P.

BACK TO BALI, COYLY

Dear John:

"The Frisky Five," — that's what we call ourselves. We are five business girls, all employed in the main office of a large oil company. We like your unusual mag a lot and thought perhaps your readers would enjoy hearing of our activities, especially our party costumes, which we, not to mention our enthusiastic boy friends, like so well.

We just drifted together over a period of about two years, during which time we gradually learned that each of us had similar tastes in dress and pleasure. Almost three years ago we conceived the idea of leasing a large enough apartment for all five of us and having it done over just as dreamy as possible.

We selected a large three bedroom apartment with kitchen, dining room, a large living room and two baths. After most of the partitions were removed and the apartment completely done over we had one large bedroom, kitchen, two baths, and the rest is one huge "romp" room. Of course, it costs us plenty, but the fact that Madge's boy friend is the grandson of the building owner helped a lot. Each of us sleeps in her own three-quarter hollywood bed which has shelves and cabinets built into the headboard that makes each almost an efficiency apartment in itself.

Now here is comes — I always have a choked up feeling when fully dressed and can hardly wait to get home to free my upper torso.

I had roomed with Madge only a few months when she surprised me one evening when I thought she would work late, and I had dozed wearing only a pair of shorts. Madge was a little embarrassed, but the ice was broken and she soon admitted to a secret desire to dress similarily. Before long we were wearing only make-up and jewelry above the waist when alone in our room.

Madge had a good friend, Alice, who lived with two other girls from the office in a small apartment. Madge confided to Alice that she had become a bare bosom fan, and though intrigued, Alice

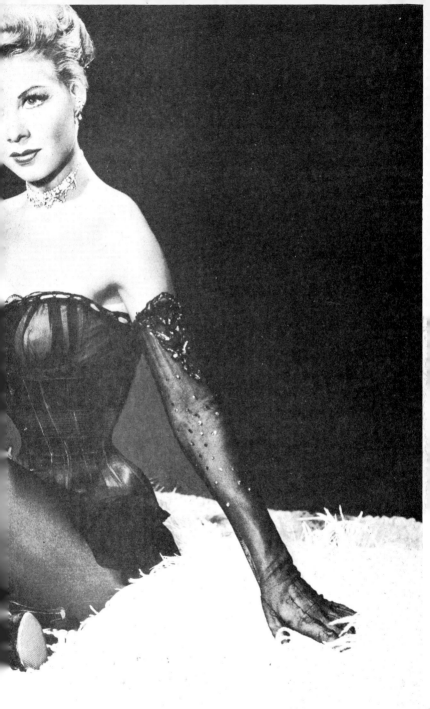

visited us many time before she began to peel off her confining upper garments.

Alice initiated her two friends and we all visited back and forth. We were soon experimenting with all sorts of bizarre costumes, all featuring one or both breasts entirely bare, or decorated attractively. Pat, who is quite small, had a pair of gym pants that we all thought set her figure off attractively, and she became a bloomer fan. But don't get the idea there is anything old fashioned about Pat's bloomers! Beth had done some ballet work and she always featured long stockings and tight pants, or a leotard with openings worked in for the release of her breasts. Alice stuck with her skating skirts, which seemed to get shorter and shorter, usually wearing opera hose, often the lastex mesh type in a very bold pattern. Always, for all, the highest heels we could find.

By this time we were all career girls, with no thoughts of marriage. And all of us had settled down to more or less steady boy friends who also were not ready to marry. Madge's boy friend's family has a lovely, very secluded, beach cottage, and we had many wonderful times there. I never knew just how it began, but of course it was inevitable that sooner or later we would begin bathing in the moonlight with bosoms bare. The fellows were delighted, enthralled. Hints of our delightful hen parties had been leaking out, and now the facts came out. The boys were intrigued and demanding a share in the fun. However, we had to be very circumspect. It was finally agreed that one by one we would model our costumes for them. But only one girl at a time, only one per evening, and strictly on a "mustn't touch" basis. Just modeling, nothing more. This took many, many evenings to model all our costumes for the fellows. They were delighted, of course, but all of us felt a little cramped. So a safe and adequate place to enjoy our fun and freedom became a must. That's why we took the apartment.

We stage a very informal private party every Saturday. There is no set time to begin, the only thing ever planned being the dinner. Two of the girls are secretaries now, and are often required to do extra work. We always have a conference Friday evening or Saturday morning and try to arrange for at least two of us to be on hand by midafternoon. The fellows begin drifting in from five on.

I catch up on my shopping, laundry, and such on Saturday mornings, help plan and prepare dinner, and soon after lunch I am dressing. I enjoy this immensley.

At times it takes as long as three hours.

In another letter I'll describe my favorite costume.

Yours, "One of Five"

QUIET PLEASE

Dear J. W.

All of us interested in the art and science of keeping a nagging wife quiet are familiar with the difficulty of keeping a gag from slipping down over the chin. You can overcome this problem by a simple device consisting of three handkerchiefs.

The girls' hands are tied behind her back, of course; her feet too if she's not in the mood to play. Then two opposite ends of the first handkerchief are knotted together. The loop thus formed is placed on the girl's head with the wide part on top with the knot in back. A second handkerchief is folded to about a three inch width, and the third is rolled into a ball and stuffed into her mouth. The ends of the second, previously folded, handkerchief are passed under the loop on her head at the level of the ears. The free ends are then pulled downward tightening the loop and pressing the folded part firmly across her mouth. The free ends are drawn forward and tied tightly at the neck.

The resulting gag is quite effective, especially when large hand-kerchiefs are used. The piece over the mouth cannot be wriggled down and any attempt to open the mouth produces a choking effect. To try it out I have been wearing a gag like this for over an hour now with comfort except when I try to get free of it without using my hands.

I suggest you try one on your typist and let your readers know how she liked it.

Yours, R.G.S.

If you cannot understand this just take a regular course in "first aid" and learn how to bandage a broken jaw — it's identical. Without any discomfort the jaws are held closed tight. — Ed.

BEAR WITH IT

Dear Editor:

I have seen several copies of your magazine and I was pleased to see the several letters from girls about being spanked. However, as a male I must report that spanking is also very effective on the boys as well as the girls.

I was raised by an aunt who said she had the right to give me a spanking when I needed it until I was 21 years of age. People often think of boys being marched to the woodshed for a tanning, but I always got mine in the privacy of my aunt's bedroom!

My aunt was a firm believer in the use of the hairbrush and how well she laid it on! Whenever I

got a bad grade from school, stayed out too late or disobeyed her, I knew I was in for it. She would take me to her room. She sat on the bed and made me go across her lap, the bed supporting my head and legs. So I really felt the hard wooden back, of a heavy black hairbrush, I had to lower my trouser or jeans and take down my shorts. She would soundly paddle me, then reprimand me, then give me another good tanning with the brush.

How well I remember the night I came home smelling of beer. She waited till I was in my pajamas, before she called me to her room. I was 20 then and well grown but I still went across the lap with my pajamas down! With loud resounding whacks she "warmed up" one side and then the other. She used the brush hard all over and down the backs of my legs which left me red and burning for hours.

I must admit to the girls who read it and think that the brush is reserved only for them, that I was no hero on those occasions. I guess I kicked and squirmed and yelped as much as any gal and often gave way to tears. But auntie always thought that by kicking my legs it was an indication that I desired more of the brush, so I tried to be still if I could as the brush was being put on me.

Spanking is a childish, humiliating and painful kind of punishment but the only thing that commands the respect of the teen age boy or girl. It may be even more effective on teen agers than younger kids because of the awful embarrassment of going faced down across the knee! I know how I felt when I was destined for my aunt's knee.

Yours, H.H.

Gloves Please

Dear John Willie:

I am very pleased with Bizarre and like all the pictures especially those displaying long kid gloves and high heels. But I think it is a pity that more correspondents do not write in favour of long kid gloves. They seem to me to be so delightfully feminine and add the final and essential touch to a Lady's appearance. They should be worn on all smart occassions, afternoon tea, dinner, theatre, suppers, garden parties, Sunday promenade etc. They should also be featured in your delightful sketches of more colourful attire for men. It we are to wear silk stockings, high heels and corsets why deny us the exquisite feel of luscious long kid gloves clinging to our arms. They smell nice too!

In the days before the war they could be obtained in various lengths, described as so many

buttons, and varying from 8 to 30. An 8 button glove reached half way up the forearm, 12 buttons to just below the elbow, 16 buttons just turn the elbow, 20 buttons to about the middle of the upper arm, the length most shown in your illustrations, 24 button reached right to the arm pit and were delightfully thrilling both to see and wear. 30 button gloves were even longer and could be pulled onto the top of the shoulder but their big attraction to me lay in the fact that whilst they could and did fit skin tight from finger tip to elbow yet above the kid displaying a mass of interesting creases and wrinkles thereby displaying on each arm the perfection of fit and the lovely sight of a glove not pulled up to the limit.

So, please, let us have more letters on long kid gloves and also some fancy dresses which include this delightful article of attire.

Yours sincerely,
"G"

IN FAVOUR OF FRILLS
Dear Editor,

My fad is white frilly lace drawers, knee-length nice width, 3 inch frills, ribbon-run and lace insertions. Not the too old fashioned ones of the Victorian era shown on very attractive actresses in your articles on lingerie in No. 6, with frills below knees, but the dainty ones worn every day by young women and girls "bien soignees et bien lingees" around 1900 to 1910. Chemises and petticoats of same richness. The new nylon materials, easy to care for, are bringing this frilly lingerie back as to slips and petticoats, but drawers are still too short and skimpy. I wish, for Pete's sake, people would not call them panties, scanties and bloomers. Horrible words and horrible garments.

Even though Bizarre appears to appeal chiefly to lovers of corsets and high heels, I notice my fad is shared by some of your correspondents.

Yours, F.B.

BATTLE OF THE SEXES
Dear Sir,

True to the promise made in my first letter, here is a short account of a wrestling bout between me and my girl friend Terry. Both of us like wrestling and do so quite often. Sometimes Terry's sister joins us too and if your readers are really interested I could write and tell you about the time they both put me through it.

To cut a long story short, we cleared a space in the middle of the living-room, locked hands and circled warily. Suddenly, Terry seized me around the waist and lifting me off my feet threw me. Landing flat upon my back I

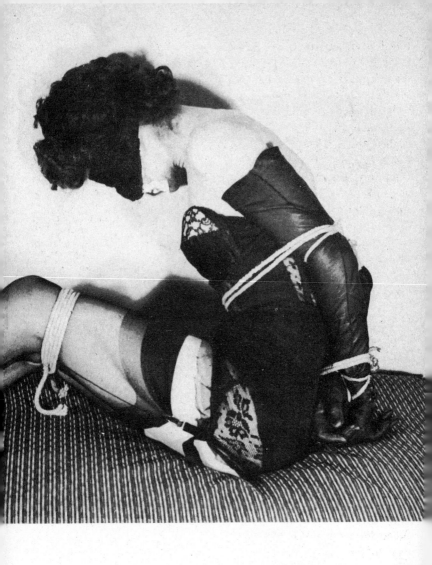

DON'T LET THIS HAPPEN TO YOU

Learn jiu jitsu, the art of self-defense

rolled over quickly in an effort to get to my feet again, but Terry, following up her advantage, descended squarely on top of me while I was still on all fours knocking me flat upon my stomach again. Seating herself upon my head she proceeded to twist my right arm behind my back. Needless to say that a few minutes of such gentle treatment were sufficient to make me give in. Round two found me giving her a taste of her own medicine. Tilting her hand in a vicious armlock I kept her down until she begged for mercy. This now made us even but not for long. There was a sudden rush and somehow Terry's head was in my stomach. I hit the floor with a thud that knocked all the breath out of me and before I could recover Terry was upon me. Sitting astride my chest she pinned me down and kept me there until I declared myself beaten. After that we stopped for the day.

Now here is a question I would like to ask some of your readers: What do you consider as the best way to pin an opponent down? There is quite an argument about it here and it is apt to get quite heated at times.

We would like to hear readers suggestions about it which we can try out.

Yours very truly
I.I.

ANSWERS PLEASE

Dear Ed:

A question I meant to ask the other day. Have you ever heard of a "Berkeley" chair?

I've found it mentioned several times in literature. Always with a sort of stand-off-ish awe.

This much I've learned from the journals — Mrs. Berkeley ran a house of ill repute in London, brothel is hardly the word for it for her clientele was strictly top flight. One Monarch, this would be around 1890, when a Prince — was among her clients.

He had difficulty with normal procedures because of his portliness — so the story goes. Mrs. Berkeley, always willing to satisfy a client, including a Monarch, rigged up a device — a chair — to help him beyond his fat belly.

Another story is that the "chair" was a device to hold the occupant absolutely helpless in a constrained position.

Always — in the available literature — one finds the "let's not talk about it too much" attitude.

Yours — E.J.

WATERY WISHING

Dear Editor:

You seem to have something for most of the admirers of the unusual but have overlooked my favorite. I know there are many others who have the same feelings that I do and hope that you can

39

find space in your future issues for something to amuse and entertain us.

I refer to girls who get into the water fully dressed, or who are in wet clothing. I like pictures of girls in dainty lingerie, high heels, long hair, etc., but the thing that looks most fascinating to me is to see a beautiful girl in a complete outfit of typically feminine attire, disporting in the water, standing in a downpour of rain, or playing in the shower bath.

Fortunately, my girl friend enjoys getting herself wet and we have a lot of fun. While other young couples go off on picnics or hikes or find other types of recreation, we go off to a secluded stream or pond and go swimming, she in her nicest dresses, hosiery, shoes and lingerie. She doesn't spoil many things because she chooses most of her clothes for "washability" so she can humor me without ruining her wardrobe. Only her shoes seem to suffer from the frequent dunkings and so she has reserved a few old pairs of high-heeled shoes to use when we go "ducking."

In the winter, we spend as much time in her bathtub as we do on her davenport. The sight of the water running down over her hair, down her dress and onto her shoes, is a thrill. You fellows who have never tried it, should not miss.

Best wishes for a good magazine.

".JM.W."

VIVE LA DERRIERE

Dear Sirs:

Whilst not against the corset and high heels lovers I think that a little more space might be given to those of us who are more interested in tight skirts. I find that this is a subject which appears to be sadly neglected, and somehow I fail to see why. For a couple years or so now Marilyn Monroe has gained a tremendous amount of popularity and I venture to think that it is not on the size of her bust or waist but the beautiful view she exhibits when her back is turned.

According to a noted costume historian the fashion cycle has moved once again from the bust, and has shifted to the derriere. On the streets of New York one can see the evidence of this in the many slim skirts, however I would like the feminine readers of Bizarre to come up with some pictures of ultra tight skirts, both in evening dress and street dress, skirts that will emphasize every

40

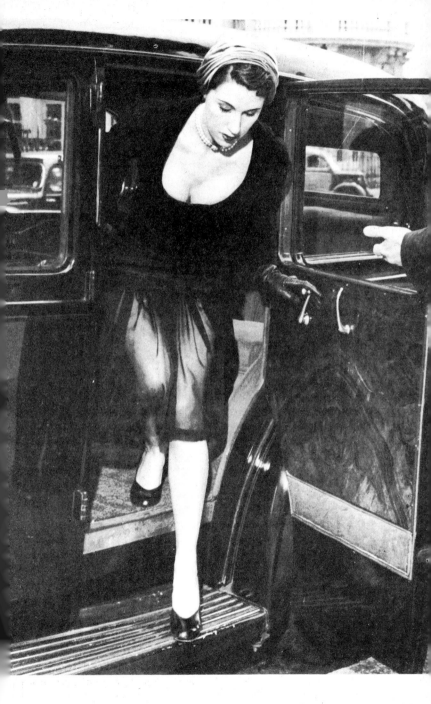

THE TRANSPARENT SKIRT (London)

curve of the female derriere, unhampered by girdles or corsets and I am hoping that some of your readers will send in pictures proving that not every girl conforms to what has been so aptly called in this age of girdles — "the one buttock era."

I would also like to hear from any of your female readers who do wear tight skirts with the definite intention and knowledge that they are doing for the derriere the same as was done, with so much success, by the sweater for the bust.

Hoping that you will find sufficient space for this in one of your issues in the very near future.

Yours truly,
"Bottoms" NYC

COMES THE REVOLUTION

Men have made a mess of the world. Their time has come. Women must unite, subjugate men and rule supreme. They must enchain men and control them completely, through the use of force. Men must be rounded up and placed in camps, similar to Nazi concentration camps, where they can be broken through slow torture. Obedient ones can be used as slave labor to build schools, churches, highways. Their brains, brawn can be harnassed for the good of the world through the skilled, imaginative control of woman. Peace will be ensured. The world will be saved through woman alone.

"Cesar"

FUR AND MORE FUR

Dear Sir:

Only yesterday I became acquainted with your magazine, and it occurred to me immediately that it would be in "Bizarre" if anywhere that I might expect to find girls clad as I have always wanted to see them . . . in furs!!

Of course I have a tremendous collection of "pin-ups" from ladies' fashion magazines, fan magazines, and even news magazines of pulchritudinous models wearing fur coats, fur-lined coats, etc. But pictures are few and far between in which the lucky girl in furs wears more than one item of fur at once, and then it usually matches. I'd like to see some pictures of a young thing in a fur coat or a fur-lined coat, carrying a big muff of a contrasting fur, a hat of still another, and perhaps carrying a spare coat or jacket of a fourth fur. The coat she wears doesn't have to be closed, and this could hold a whip (with a sheepskin-covered handle), wear high boots (fur-lined), and be depicted against a background containing a fur-blanketed bed and a closett filled with more furs. Her figure would be little concealed by a tight sweater (which can be almost as luxuriously soft as fur itself) or a

fur bikini such as we see occasionally in girlie magazines.

But if you're not averse to concealing the figure for a few pictures, show a girl or two in a sleigh against a bleak, snowy background. The sleigh would have fur coverings over the seats as well as fur laprobes. The girl or girls would be bundled up so cozily that you could only see part of the face(s). Either a parka or some thick, light-colored fur, or a coat with a tremendous collar turned up supplemented by a fur hat; and of course, fur mittens.

The latter idea could greatly enhance a bondage picture. The victim would not only be bound helplessly, but outdoors in wintry weather in minimum attire. The "feminas dominatus" would be wrapped up in heavy furs, envy of which would be one more torture for the victim.

Let's get something along the line of a "heroine" who changed from ordinarily desirable to 100% irresistable when she dressed in furs!

But just a little fur is better than none at all. Why not embellish your regular pictures with fur rugs, fur blankets, or a fur wrap in the background hanging on the wall or draped over a chair? For that matter, what could make the whip-wielding woman more regal-looking than having a large fur-lined cape casually draped over her bare shoulders?

Sincerely,
"FOXY"

(*Well, let's see it.—Editor*)

H. H. ABROAD

Dear Editor,

After being a Bizarre HH fan for about two years I had the interesting experience of going to Europe, and thus had the opportunity to check up on some of these tales I've heard about in your magazine. From the statements in some of the published letters, I expected to see lovely ladies occasionally tripping along in sleek towering stilts rarely seen in the U.S.. These letters exaggerated, but I did see some pleasant sights.

The first pair of smart looking shoes that I saw were worn by a tall, severly dressed Parisian girl. She was clad in a close fitting dark green gabardine suit and wearing a matching pair of luxurious, snug, green calf pumps. They were tiny shoes with a magnificent $4\frac{1}{2}$ inch thin heel, which poised her in a tantalizing pose. Unfortunately, she soon departed on a bus, but she could handle her heels without difficulty or hesitation.

Later in the evening I was walking along Place Pigalle and saw a sight I know I'll never forget. Standing in one of the many clubs there, with long black hair cas-

cading smoothly over a stylish cocktail dress, was a handsome girl leaning casually against a bar. As I glanced she inhaled deeply and exultantly on a long cigarette and carelessly forgot to exhale. With each later breath long plumes of smoke trailed from her dark red lips and finely chiseled nose. (Frankly I don't see how she could smoke this way as her cigarettes were strong and harsh). One foot was placed with the heel hooked over the bar rail, the other on the floor. She wore custom made sling pumps of rich, black suede with a classic 5 or 5½ inch perfectly pitched heel. The total effect when she looked at me was numbness. One hardly expects such sights in the movies. Gazing at those pale wisps of smoke curling enticingly about her face, I was hardly articulate. She was indeed pleased when I praised the graceful curves and aristocratic slenderness of her dark heels. The beauty of them seemed to come from the base being a bit wider than those made here; they were not so thin and delicate. They gave her an appearance of superiority and authority. Otherwise, she would have been teetering insecurely on high wire spikes, rather than on lofty domineering heels. The workmanship on these shoes was superb and they were beautifully brushed and cared for.

The next night in a nightclub I happened to see another thrilling sight. This was a girl pulling up a sheer rolled stocking in an ante-room with the door left open. As one might guess, at the end of that slender leg was a skin tight black opera. The lights shimmering on the smartly polished intoxicatingly dainty slippers. The heels were certainly close to 6 inches, or a Continental 15 cm. heel. These then were the famous haute talons Francais' (high French heels). It was delightful to speculate that the French were the first Westerners to appreciate the lure and enticement of thread-like heels with their pin point tips. She didn't seem to hurry when she saw me staring nor mind my evident embarrassment. Suddenly, with a flounce of her thickly ruffled skirt she stood up and walked quickly away without a tremor or quiver. The sad ending came when she went to an occupied table, and I could hardly see the shiny spires projecting proudly in the dim light. What belle talons!

I haven't much to say for Scandanavia, Germany, or Italy as the girls didn't seem to like to wear tall heels. Possibilities exist for the Italian stiletto heel if Achilles would be kind enough to have one modeled. The metal strip or needle heel might be enchanting too.

In England conditions im-

proved. Although high style was not as evident as some contributors to Bizarre allege, I found the trim metal heel plate the girls wear worth speculating about. I'm afraid the story you printed about a young girl impressing her smart heels on the fingers of her admirers wouldn't be realistic in London. Leather heels some might stand, but those unyielding and cruel dancing, metal tipped sandals would be impossible.

Thanks to a Bizarre contributor I decided to look for one of the custom shops specializing in custom footwear which were around Picadilly. At Regent Shoe Stores, 31 Wardour St., W.1., London was a sight that left me breathless. In the window were about 50 pairs of shoes with heels ranging from flats to cob heels to the glamorous 6 inch. Also in one corner was one of their special "Everest" styles with an incredible 20 centimeter heel (8 inch). It was so high, it was of necessity ballet style to accommodate the long heel. Although I wanted to do more than ask for a folder and view a few samples. The heels seemed somewhat different than here, which made them unique and charming. Considering duty charges, I think the prices

were about the same as here. The folder indicated a novelty of heel styles to interest all heel enthusiasts. Here, one could order anything from jeweled French wisps to the gay cocktail Italian court. My first order will be an exquisite, brilliant red, patent Grecian court made on Spanish lasts with a 5½ inch tapering Italian stiletto heel. This shoe is unsurpassed in classic lines and graceful beauty.

I hope that some readers abroad will correct my modest impression of Europe. Incidently, the young lady I saw waiting for a bus was very similar to the left hand picture on page 77 of No. 15/16 minus gloves and veil, and every bit as attractive. Perhaps Bizarre could pose the other one I saw in the club. If more readers would send in letters and pictures perhaps Bizarre could publish the correspondence issues more often. Also one could see such interesting styles as on pages 58, 59, and 55 of No. 14. I would never have believed such beautiful shoes were possible. In my opinion this was one of your best issues. Let's have them more often!

Yours "The Traveller"

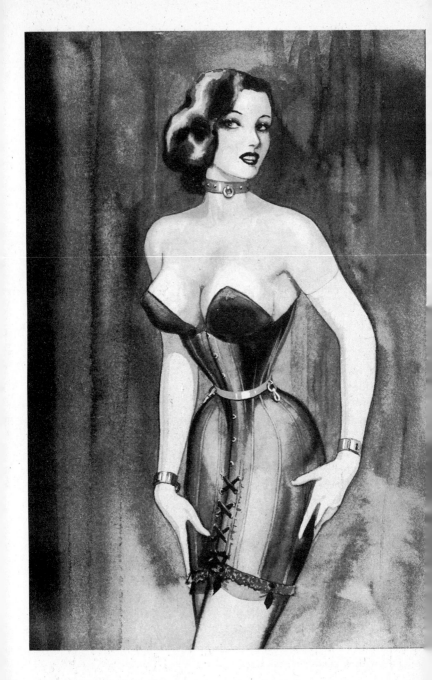

TRAINING CORSET WITH SAFETY BELT

Toe Tantalizers

Dear Mr. Editor,

It is a pity that only in your first issues did you depict or mention what E. W. in issue No. 3 calls 'that most provocative of feminine ornaments', which is also mentioned by J. S. and appears in the 'Peasant' costume, all in the same issue. The anklet! I have worn anklets since I was 13 though then I had to wear it concealed under my socks or under my shoe's ankle strap, when I wanted to avoid the hungry looks and the comments of the boys and the angry looks and comments of the girls. I just love that strange feeling the anklet brings when it is wound up round my ankle, either tightly fitting, hurtingly delicious or loose, caressing the instep and heel! I remember strolling around with my schoolmate Pat when each of us sported one, and the boys couldn't decide at which they should stare. I have all sorts of anklets, from the tiniest and almost imperceptible chain to a 4 in. broad silver plate worn on 'special occasions'. Since I was a kid I've also enjoyed wearing the rings though it is only now I dare wear them in public. When a kid I just used common elastic bands, just to have the feeling, until I had the idea of having a sort of 'toe bracelet' made with a tiny chain and a plaque, with a clasp. I now wear

with my playsuits and bathing suits, one ankle loaded with bracelets and the opposite foot bedecked with real rings, one on the big, one on the middle and one on the little toe.

Another item of feminine fascination which is never mentioned in Bizarre is the barefoot thong sandal, be it flat- or high-heeled. Its being flat does not mean a thing because the seductive look of the high heeled feet and legs can be easily achieved if I raise myself on my toes. This is no problem for me as I am a ballerina. The thong sandal displays the foot so wonderfully, at the same time taking away its complete nakedness and implying so seductively the idea of bondage that I think it is one of the most alluring pieces of female apparel. Besides, there is such a morbid intention in the thong between the toes that it is almost equal to the saddle strap. Do your readers agree?

I have a pair of black chamois mules with 5¾ inch heels made up with this wicked thong and I assure you that it is terrific both in feeling as well as in sight. I can send you photos of my feet in it, if you or your readers care for it. (*Please do — Ed.*)

I am lucky enough to have a husband who loves ropes, chains, gags, bits, straps, corsets, high heels, thong sandals, anklets, heavy

make-up and beautiful and adorned feet as much as I do. I could tell you many ingenious pastimes we have invented if you want. The only thing he does not like is my frequent wishing him to sport *his* anklet or his pretty feet to other girls. He becomes terribly embarrassed but I also love that embarrassment. On our honeymoon I made him wear red thong sandals (fortunately his size is almost mine), the most feminine one though flat heeled, and a thin gold anklet, around the hotel, making sure that only the girls would see him. (We had a spare pair of shoes for him to enter the building, but I made him change them in the park and roll up his pants). I should not like men to see him, I do not know why, though, of course, many of the girls who saw him and stared, went right ahead to tell their boyfriends about it; and perhaps some adopted the idea in private.

Hubby now has to wear his anklet all the time, the same as I do, except when barelegged. In this case, when there are nothing but girls around I force him to

wear it and I simply love to feel his shame and ignore his pleading. Many times I make him wear it over his socks or without socks at all. I am thrilled and amused to see his efforts to prevent the anklet from showing, though sometimes he is unsuccessful. As an example, once when a former schoolmate of mine was paying us a visit, I intently pulled up his pants — while he was holding a tray with glasses — bringing the anklet in sight and watching it for some seconds. Though my friend didn't make any comments I could see that she was startled. She pretended not to have seen it, so I candidly asked her which would be the most appropriate anklet for a man, a silver or a gold one. She laughed and said that the silver one would be more discreet, so out I went and bought a silver one and fastened it around hubby's other ankle. Then I raised both legs of his pants to compare the two. Out of sheer charity for Hubby, I told my friend that he didn't like wearing it but I forced him to, as a token of bondage. I wonder how many of your lady readers enjoy anklets and make their lords and masters wear them too?

If you want to hear further, I could give you some hints on foot-bedecking, fancy dresses and exotic bondage. How about it?

"DIANA"

SOMEONE'S BEEN DRINKIN'

THE OBSERVANT ONE

Dear Sir:—

Am glad to hear that you have finally come through with a couple of numbers of your publication. After a lot of effort I finally have accumulated all of your former numbers and would hate to miss any of your subsequent editions.

Personally I would like to see some more of your stuff relative to transvestisism. It has finally broken out into the open, shall we say, and even some of the more conservative sheets have mentioned this peculiarity of certain of our brothers. The interest that it has evidently kicked up speaks for itself.

That it is relatively widespread is evident if you want to look for it. Any lodgeroom where robes are customary gives a fairly good insight into the hidden desires of a lot of our friends and the staging of a "womanless wedding" or some such production is very illuminating. A lot of the boys envy their more fortunate sisters their comfortable garments but fear the consequences if they should happen to copy them. The finger of scorn pointed their way by someone who even might want to "go and do likewise" or the suspicion of being a "homo" in the eyes of the less well informed is a deterrant that a lot of them do not want to risk.

Yours truly, L.M.

SAILOR BEWARE ! —

UHUH! — NOW WHAT A MESH YOU'RE IN!

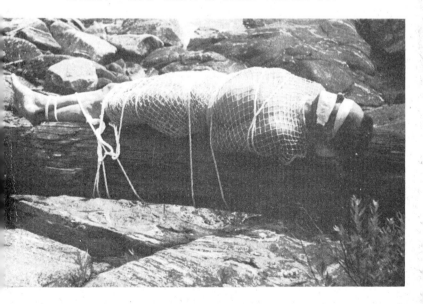

FINALE — J.D.J.
(*Continued from No.* 17)

There is of course a sort of anti-climax to this whole business, but for me personally, it's the *whole* climax. When we realized the possibilities of this thing, I really went to work. Starting with an old pair of these slippers, with razor blade and knife and scissors, I removed all the fabric and satin down to the steel shank and metal 'toe box'. On this base I fastened my metal straps, and then in place of the wide leather ankle strap, I used a flat link chain and padlock. Since the chain and lock were silver-finished, I sent away the other part of the contraption and had the whole thing chromium-plated. Then, to protect her ankles from the bite of the locked chain, I made ankle bands of black satin, heavily padded.

Now, for special occasions, we go through a sort of ritual, for strange as it seems, the gal doesn't seem too happy about wearing these things.

First, she dons long, shoulder-length, black kid gloves, (made in Italy, and just about as tight-fitting as she can get on), then she folds her arms behind her back, with the right hand grasping the left elbow and vice-versa, then I fasten her arms in that position with one-inch, grosgrain ribbon. (I have found that this type ribbon is excellent for it does not

slide or slip over leather.) Securing the arms is quite necessary, for there would be no sense in me putting on her 'footwear' if sh could do it herself. Next, she si on a high stool and I remove her shoes and stockings, then I fasten the padded ankle bands in place, and finally, squeeze her toes in' the 'boxes', carefully draw up t chain over the ankle bands, an snap the little padlocks shut. Then I release her arms, still seated on the stool, and from then on, she's strictly on her own. Her feet ar most fascinating to see when sl is facing you, for apparently, she is standing barefoot, with her toes in a shiny pair of chromuim cups, and wearing ornate black and silver anklets. But when she turns around, the effect is even more startling, for then the shining band seems to accentuate the bare footed toe stance.

I've turned this letter into a regular book and I can't stretc it out any more, much as I'd lik to. Me and the gal have used same idea with other footwear, but that will have to wait for another time.

yours, JDJ

P.S. I must add this before I stor My dream footwear for the ga friend is something I've never been quite able to realize. I refer to my own little invention used with full-length boots. I wrote to the only qualified shoe-maker

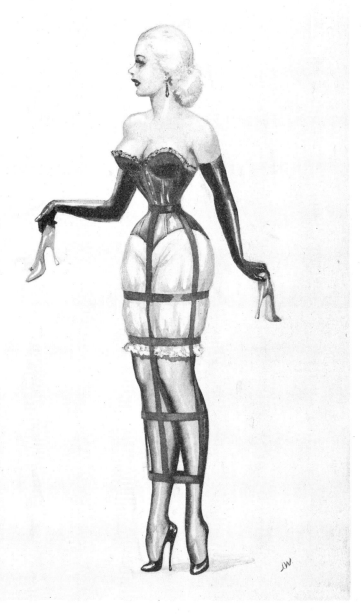

AN OLD INVENTION FOR THE HOBBLE SKIRT —

TO TAKE THE STRAIN OFF THE SKIRT ITSELF

I ever heard of in New York, and he told me that he could make the boots to my specifications, with regulation ballet slipper box-ties, and with my own steel strap built into the boots — but that knee-high boots of black kid would run around ninety five dollars and thigh-length boots would be at least one hundred and fifty dollars or more. Needless to say, that sort of money is out of the question, but the idea of the thigh-length boots intrigues me. — Imagine a pretty pair of legs, poised on tip-toe, encased in gleaming, tight-laced black, kidskin, and best of all, knowing that those lovely legs would remain in their severe, strained position, for as long as I chose to keep them that way. Makes a pleasing thought.

Sincerely, JDJ

SILENT PARTNER
(*Continued from No.* 17)

A gallant gentleman cannot leave a helpless beauty on the doormat, so I followed Joyce into her apartment.

She made sounds at me and when I asked her if she wanted me to remove the gag she nodded. After I had it off she asked me to remove her cape and refetter her hands in front of her so she could get us something to eat. I was willing, as by this time it was 5:30 in the morning.

After we had finished eating

she asked me to put her hands back behind her and produced a couple of leather straps to pull her elbows together behind her. I did this and then we sat down and had our coffee, which I fed to her, and did quite a bit of talking.

It was quite a talk and it was during this talk that I first found out about Bizarre, and about the Modern Slaves, her club, which had sponsored the party that night.

She showed me several copies of Bizarre she had, and I really became interested. It seems that somebody had introduced her to Bizarre simply by tying her up and showing it to her. As she had always loved being tied up she was then delighted to find there were so many others beside herself who enjoyed it too. So was I.

As time went along we saw more and more of each other and I attended several meetings of the "Modern Slaves" and all the time Joyce was trying to talk me into wearing some of your Men's fashions. It seems that quite a few of the husbands and boyfriends had been persuaded to do so and had really enjoyed themselves and now Joyce wanted me to wear them. She was gradually wearing me down but I still wouldn't give her a definite answer.

One night when I got to her apartment she said she didn't feel like going out, she just wanted to spend a comfortable, slave evening

at home. After I had helped her to get dressed she got really cuddly and started trying again and I finally relented. I told her that when she got me a costume I would try it around the apartment. With that she jumped up, asked me to remove her chains and follow her into the bedroom. I should have smelled a rat but I didn't. I went into the bedroom and there, on the bed, she had laid out a perfect copy of the "Hnnter" from Bizarre No. 10. Not only that but she had all the fixings that went with it. When I saw that, I was ready to back out but she said I had promised so I got dressed.

I started right from scratch with the underclothes. Where she got them I will never know, but I was surprised when I discovered how different nylon and silk and lace feel against the skin.

She had gotten me a pair of filmly black nylon panties, a pair of very sheer black nylon opera hose, and a black kid corset to wear and I really rebelled when I saw the corset but she talked me into putting it on and laced me in. I thought she was going to cut me in half but after wearing it for a while it was comfortable.

She had made the costume of Black Slipper Satin, with the underside of the skirt and the panties made of red slipper satin.

(*It isn't a skirt. The whole costume is a mediaeval "Jerkin" and should be made of suede; and the page-boy bob was the style worn in those days. — Ed.*)

I put it on and it felt wonderful although I still had my misgivings. I was right. She came back into the bedroom and in her hand she had a pair of black, slipper satin babydoll pumps with 4 inch spike heels and in the other hand she had a blond wig in the same style hairdo you had drawn. I put them on and when I stood up I thought I was going to do a header but she steadied me and walked me around 'til I got the feel. After that it wasn't too bad.

I thought that I had it made then but she towed me into the bedroom and started to do a make-up job on me.

She took me to the next meeting of the "Modern Slaves" to show me off and when I saw how much attention I was getting I felt a little better. After we were married we used to spend our evenings at home this way and also at our friends home.

I received orders from the Navy to report for active duty during the Korean situation and while I was away my wife opened a hosiery shop catering to just such people as the "Modern Slaves" and she made quite a success of it.

Since I have returned from the Navy I have gotten all dressed up and helped Joyce in the shop and

nobody except our immediate circle of friends has suspected that I was not a girl. With 4 inch heels I only stand 5'9" and I am very small bodied and with padding in the right places and laced into the right corset I have no trouble at all posing.

I only go out in public this way once in a great while although Joyce is very unhappy if I don't dress up for her at night when I get home from work. I enjoy it, there is no doubt of that, because the nylon, silk, and lace feel so much softer against my skin than the normal men's clothing.

During our evenings at home Joyce always wears chains and sometimes more stringent devices.

Since I have been released from the Navy she has talked me into wearing ankle fetters around the house in the evening and I can understand why she likes it so much. I also have a pair of her "key" shoes and at night we trade keys and keep them in our heels.

Lately we have added a chain from our ankle fetters which interconnects us and we are chained together during our evenings at home. Last week we wore it to the meeting of the "Slaves" and excited much comment. Seems that the men think it is a fine idea to keep their wives under control, in addition to whatever bondage they already use.

Well it looks like this letter has gotten out of hand so I shall end it right here.

If you or your readers care to hear anymore I shall be glad to add to this epistle.

Yours for more recognition of Bizarre.

Keep up the good work!
"Bob"

JUI JITSU

Dear Sir:

The thrilling photo on page 32 (No. 12) of a man wearing a gleaming patent leather mask and jacket being bound by a woman who had subdued him by jiu jitsu is of most vital significance to every slaverette.

Ladies who acquire a good knowledge of Jiu Jitsu have men absolutely at their mercy, and as in the photo so graphically depicted utterly under their wicked spike heels. No man could ever hope to cope with a woman who knew jiu jitsu, unless he also had a knowledge of this great science, and since it would be to her interest to keep him untrained he would never be permitted to learn it.

Men, like myself, who are devoted to the cause of feminine dominance, and who believe most ardently in the ideas and perogatives of the slaverettes, could not oppose ladies of this type if they considered it either necessary or desirable to learn jiu jitsu. How-

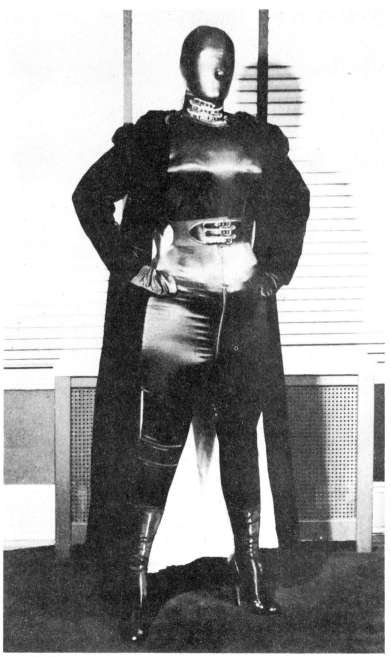

photo by H.V.

THE BAT WOMAN

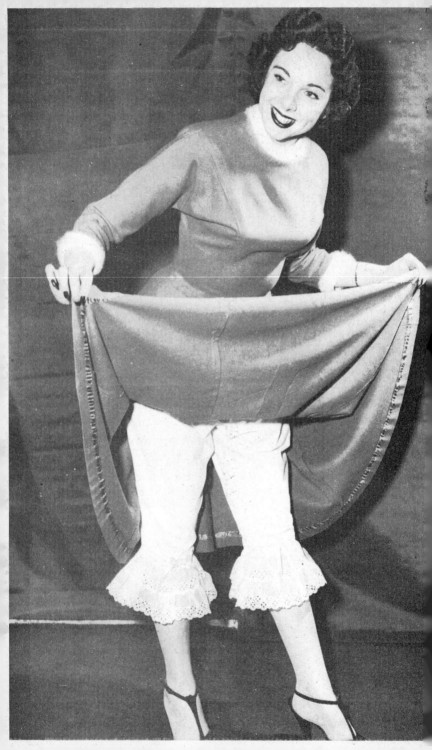

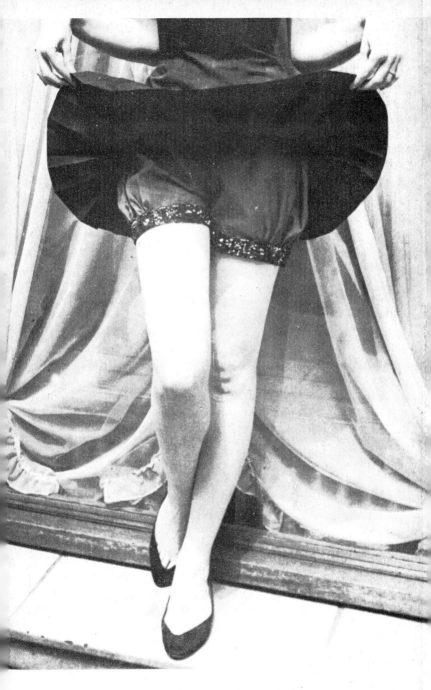

PANTALOONS ARE BACK IN NEW YORK — BUT NOT IN LONDON

ever, due to a perverse masculine quirk in our nature we would naturally resent the efforts of the ladies to use jiu jitsu on us, just as we sometimes rebel against the wearing of such restrictive feminine apparel as tight laced corsets; hampering petticoats; enslaving bloomers; punishment rompers, and skirts that remind us of our lowly position every time we move.

Will our charming slaverettes really learn jiu jitsu? Well, if they do, they can thank the efforts of the Editor of "Bizarre" who has repeatedly urged all lady readers of Bizarre to learn this most useful of arts.

I hope to read many interesting letters in "Bizarre" dealing with the experience of slaverettes. The various methods they use to keep their hubbies in a state of silken bondage make very delightful reading, and are of great encouragement to many other ladies who, while not yet slaverettes, nevertheless do believe that it would be nice to have a well-trained and obedient husband.

I believe that in the not too far distant future the world will be a woman's world in every sense of the word. The domineering, brutish type of man is becoming scarcer every year — soon he'll be a passing memory: then around about A.D. 3000 he'll finally emerge as a myth of the Pre-Emancipation Age, unless of course the world is atomized before this.

All kidding aside the day of world control by men is drawing to a close.

V.S.M.

PARTY GAMES

Dear John,

We thought your readers may be interested and entertained, by a game that we invented. We feel it will really liven up an evening or a rainy Sunday Afternoon for any couple who would care to try it.

The game is simply this: On the surface it appears to be a game of chance, but by stacking the odds it is impossible to come out with more credits than debits.

(Now that's the sort of game we like.—Ed)

The game is called "Ouch", there are sixty squares on the board; each square indicates so many debits and/or so many credits with a few marked, "go back to start" or "double your debits", and four squares marked in red "ouch". All that is needed to play the game is a dice, a couple of buttons, and a ladies hair brush, or a riding switch.

The following rules must apply: The husband must assume the liability of paying off all of the wife's debits by receiving a spank for each of her debits. He must also assume the penalty for all of his debits at the same ratio. (This will

usually result in hubby being on the receiving end of from 60 to 400 spanks at the end of the game)! Each time hubby lights on a square marked "Ouch", he must immediately, turn himself over for ten spanks. Whereas, whenever the wife lands on a square marked "ouch" she gets 10 kisses, and he *must* deliver them in any manner she may direct.

It is indeed a very interesting and entertaining game because; (1) you never know where you will light next when you throw the dice. (2) It goes without saying, of course, that hubby is in for a tanning whenever the wife wants to play (3) Hubby is usually amazed at the various ways the wife might direct the kisses to be delivered. (4) Hubby might not be looking for a stray bewitching witch for some time if he can't sit down.

Yours for better times at home, we remain,

Mr. & Mrs. "Ouch"
(that's o.k. but why not stack the deck the other way — we would. Ed.)

WELL *!* BOTTOMS UP *!*
Dear Editor:

I love your magazine very much and can hardly wait until the next issue. I enjoyed the letter from 'Naughty Mary' in your last issue and I hope to read other letters on the subject of spanking soon. I have (I hope) some interesting experiences to relate on spankings and whippings.

My mother was a firm believer in corporal punishment, and even when I was as old as seventeen I got spanked. When ever I had done something during the day that deserved one, I was told to come to Mother's room when I was ready for bed, in my nightie. My mother would be there with a thick leather strap. I would have to take off my nightie and stand there in the nude while she gave me a lecture on right and wrong. After the lecture I would have to bend over the foot of her bed and receive a whipping — bare. My mother always thought it was more effective if I was naked. Sometimes my cousin would be visiting us and my mother would let her watch me being spanked in the nude to humiliate me. While these spankings were painful, I sort of enjoyed them and even looked forward to them.

When I went away to college in Boston, I found myself having a desire to be spanked every now and then. My cousin lived close to Boston and I would spend weekends and vacations at her house. I told her of my desire and she told me that if I wanted, she would give me a good spanking any time. After that every now and then we would have a spanking session. I

would have to undress and I would then bend over a low table and she would use a belt or hairbrush on me. This seemed to give me a rather thrilling feeling. My cousin said that she got a great delight in spanking me. It was her by the way that showed me your magazine.

Last Spring after graduation six of us girls spent a day at my uncle's private camp in the woods. It was a very warm day and we were running around in our bras and panties, playing tag. One of the girls suggested that we use switches and tag only on our fannies. We found that this was ruining our panties though, so we took them off and our bras and played in the nude. It was really a sight, six pretty girls romping about naked. We all found the sting of a switch a rather pleasant and exciting feeling. We decided to stay naked for the rest of the day and later we played a game with forfeits. There was only one forfeit though, to bend over a bench and let one of the other girls give you ten strokes of a switch. I had to pay five forfeits and it was a very exquisife feeling. After that day I hoped to someday find a man who would satisfy my bizarre desires.

I did, on a picnic with one of my boyfriends last summer. I was doing something that he didn't like and he told me if I didn't stop he would give me a spanking. I kept on bothering him and before I knew it I was across his lap, my shorts and panties were pulled down and I received a sound spanking, to my great delight. Since then we have become engaged and will be married soon. I have told him all about my desire to be spanked and our dates now usually end with me getting one.

Yours sincerely

"Well Spanked Julie"

TIT FOR TAT

Dear Sir:

Recently I read in a Paris newspaper of a court case, in which a youth was being tried for working as a waitress. He had been doing this for some months, and he might never have been discovered if it hadn't been for the fact that his allure caused male clients to press their attentions on him. In the same article reporting the case, mention was made of several similar cases during the last year or two.

All of which adds up to this —

"Girls! you are gradually usurping men's jobs and taking to masculine-looking attire. You have no right to expect the male of the species to do other than to retaliate to effeminise his appearance and attire and to oust you from your posts.

Yours sincerely,

WMG

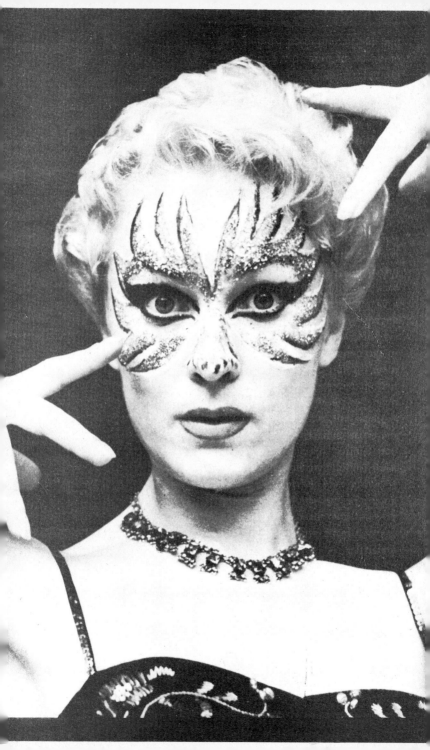

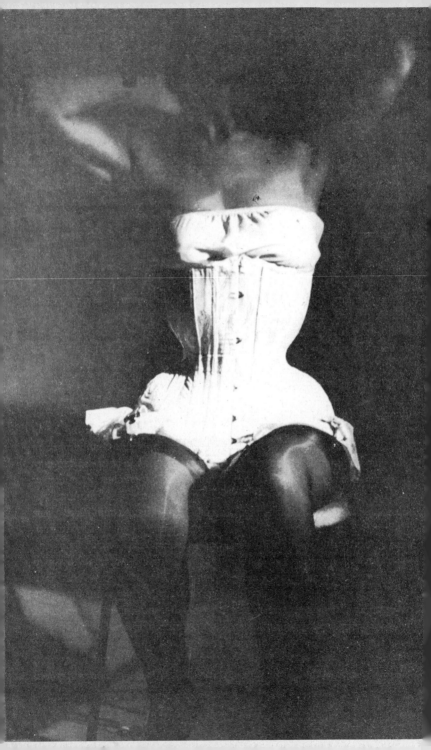

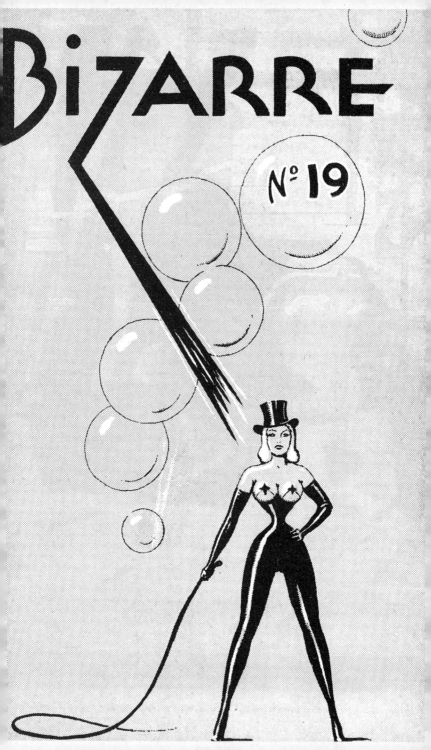

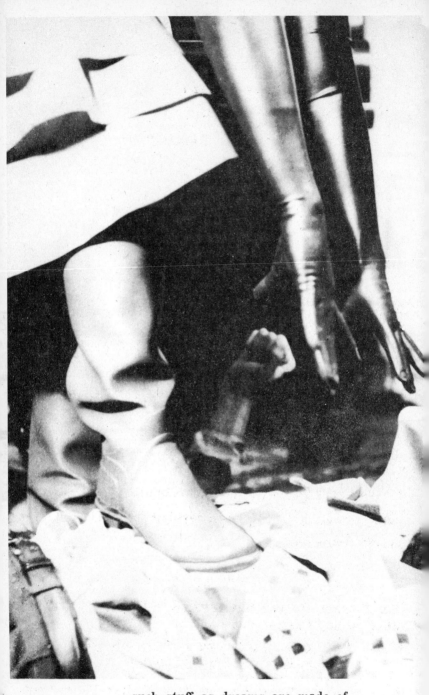

such stuff as dreams are made of

BIZARRE

Copyright 1956 U.S.A. by John Coutts

"a fashion fantasia"

No. 19

For "IS *and* IS-NOT" *though with Rule and Line*
And "UP-AND-DOWN" WITHOUT, *I could define,*
I yet in all I only cared to know,
Was never deep in anything but — Wine.

OMAR KHAYYAM

CONTENTS

NEXT MONTH'S ISSUE No. 20

RUNNING ON TIME — with another "tale from a bottle" and maybe — we said maybe — the next installment of Sir d'Arcy and the Wasp Women.

BACK ISSUES

No. 12 reprints are now available together with all other back issues—

If your dealer cannot supply you write directly to:—
P.O. Box 511, Montreal 3, Canada.

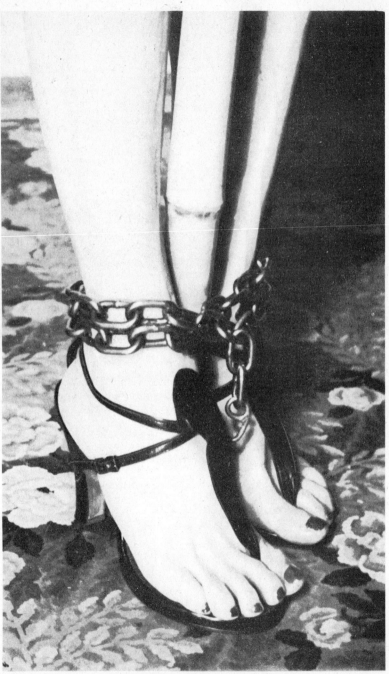

the slave of the bamboo *photo from A.T.D.*

SAUDI ARABIAN NIGHTS

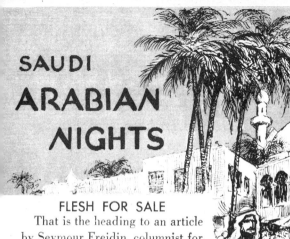

FLESH FOR SALE

That is the heading to an article by Seymour Freidin, columnist for the N. Y. Post (March 27th, 1956)

Writing from Geneva, Seymour Freidin states that the slave traffic, with captives being sold on the auction block to the highest bidder, is apparently flourishing in oil rich Saudi Arabia. As he dryly puts it "—the biggest, wide open traffic in slave girls leads to Saudi Arabia. Relaxing from a hard day's work counting oil royalties, Saudi Arabian families furnish the cash and competition for slavers.

The whole matter will be open for hearing in the U.N. in a few weeks, but obviously there is little chance of the U.N. being able to do much about it.

Apparently the whole slave business is quite legal, and open air markets flourish in the same manner as "market day" in our own country towns.

According to the Post article the slaves are fettered together in chains and the broker has his victims paraded around in teams of four or six so that a client has plenty of time to make up his mind.

This is rather different to the report of a British agent who was through the area in the early 30's. According to him the slaves were certainly shown in a group, but when it came to the actual auction the women were specially spruced up for the occasion and were presented one at a time.

Their skin oiled, the nipples of their breasts dyed, and their hair brushed, shining, and hanging behind them in a long plait.

The slave appeared, head erect, hands clasped behind her neck, her waist nipped in by a wide

leather belt — shaped to the figure — like a waist-cinching corset.

On tiptoe she moved, taking little steps, because her ankles were fettered by ornamental but none the less strong brass or bronze shackles joined by a short chain. A wide metal collar engraved with the name of the broker was round her neck, and there she stood while the bidding went on.

To the casual observer she would seem to be just a girl displaying herself, in the same manner as a contestant in a beauty parade, and apparently quite enjoying the attention she was getting, which would be a false assumption. For though she might have felt like lowering her head she could not do so. It was held erect by a leather thong plaited in with her hair which was then tied

at her waist dragging her head back. Her belt was laced in to squeeze her waist to the limit. She kept her hands behind her neck, thus showing every line of her figure to the best advantage, because her thumbs were tied together with a thong, which again was tied to the plait behind her neck, and she stood on tip toe because though her sandals were heeless a large spike (blunted so as not to break the skin) stuck up and encouraged her to forget about lowering her heels.

The sale completed all this "show only" paraphenalia of the broker (the belt, the sandals, the ankle chains and the collar) were removed, and with her hands tied behind her back and a rope halter round her neck she was handed over to her buyer.

In those days all sorts were coming up for auction including Russian refugees escaping from one form of slavery only to find themselves landed in another. Rumor had it that many titled ladies of the old Russian aristocracy, believed to have been killed by the Bolsheviks, were to be found in the harems of Arabia.

Times change and nowadays to protect their investments Mr. Freidin says:— the brokers in-

6

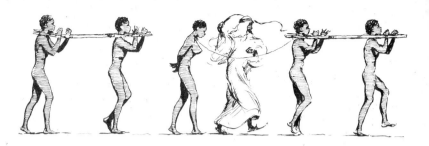

stall the slaves up for the highest bids on the open market in barred rooms in their own homes. That's considered the safest way of keeping your property undamaged. A little water, a little rice or bread are provided twice daily. The turnover is quick and brokers don't spend much on food — it cuts down on profits.

Kidnaping raids flourish mainly in the Qata and Buraimi desert areas these days, where Nomadic tribes provide many of the victims for the trade, and according to the Post:—" it appears that before a profitable raid can be pulled off a few technical arrangements must be made. Slavers get in touch with itinerant entertainers who are preparing to give a show in a particular district. The entertainers after getting their palms crossed also arrange for a big dancing party."

"Once this is settled a slaver talks to the leaders of the tribe hovering around the point destined to be raided."

More haggling takes place in which custom and tradition are obligatory, and once a price is agreed on the raid takes place. The slaver gets his captives who are then sent over well known slave routes to Riyadh "Nesting point of Saudi Arabian royalty."

But sometimes a client wants something special in a slave girl. The whole procedure then becomes more personal and of course more expensive, and once a suitable victim has been spotted the individual abduction technique is put into motion. When the chosen "suitable" moment arrives the victim is seized, gagged and bound before she can make any outcry, and spirited away across the desert to a regular slave caravan.

On the spot business is often done through brokers, who, anxious for a quick turnover, sell to

other brokers so of course the price rises considerably — but in that land of oil-money, who cares.

Mr. Seymour Freidin points out that if the U.N. steps in they would like to be able to keep vigil by air over the slave lanes and any slave found would of course be freed on the spot. Then he adds:—

"Realistically, no hope exists that Saudi Arabia will accept any such international agreement. The rulers there brook no law but their own. When they call for slaves, or tanks, they get them.

In the Post article no mention is made of the possible influx of slaves from South Africa. Arab "slave-raiding" in Africa was still big business before the last war. The raiders, with information from native spies, would descend on a village when all and sundry were drunk after a huge feast. Those sober enough to offer any resistance were quickly clubbed into submission, and then the whole tribe, even women and children, were bound hand and foot. This done, the slavers then picked out at their leisure those who would fetch a good price. These were then fastened in pairs by a yoke, made from a stout sapling some ten feet long and split at each end to take the neck and wrists of each captive — wooden pegs driven across the opening held neck and wrists, and made all escape impossible. The captives were then driven down to the coast where they were put aboard a dhow while those left behind at the village could do the best they could do to untie each other.

This makes rather astonishing reading, and we think we could do with a little more information on the subject — so will any of those readers of ours who write to us from Saudi Arabia, and who can find the time to scout around, please find out all they can about it — and let us know further details.

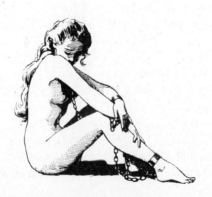

BOOTS n' SHOES
by "Torrina"

I have just come across a copy of your delightful little Magazine Bizarre, which seems to me to give vent to all the little secret fancies of readers, male and female not to mention fashions dictates generally.

Now in my humble opinion this is a very good thing, this letting off of steam as you might call it, after all between Bootmaker, Corsetiere and Glover, surely we all have pretty firm points of view, and these should be aired somewhere and not be hidden under some sort of secret cloak.

In Italy we have some superb footwear, like Paris and London. Though one may not be aware of extremes in any fashions being worn generally, I can assure you there are some fantastic fashions in attire amongst the followers of extremes.

For myself I aspire to nothing higher than a six inch heel for indoor wear, and a five inch out of doors, but must admit that I have greater adoration for my rather fetching six inch heeled footwear indoors, not to mention that my men admirers certainly show a marked preference for me tottering around on six inch stilts, as the English call them sometimes.

Surely we as a country were almost the first to show the world these sheerest of thin spiked heels, some sharp enough to dig uncomfortably into the floor, if one was not a pretty well trained walker in such slender heels. I have both high boots and shoes, and one pair of thigh high boots of beautiful soft clinging grey kid.

I favour for boots the lace up style, with catches for quickness, but find that a well tautened lacing exerts a far more rigid lacing in, and in consequence a more creaseless fitting all the way up the legs.

My highest heeled shoes are a pair of superb red kid lace fronts, with actually six and a half inch heels. The tips I have to maintain a balance upon are almost as sharp as a pencil, with silver tipped ends to them. I wear these for special admirers with the finest of grey silk stockings to the thighs, they are laced with gold silk laces which stand out smartly

9

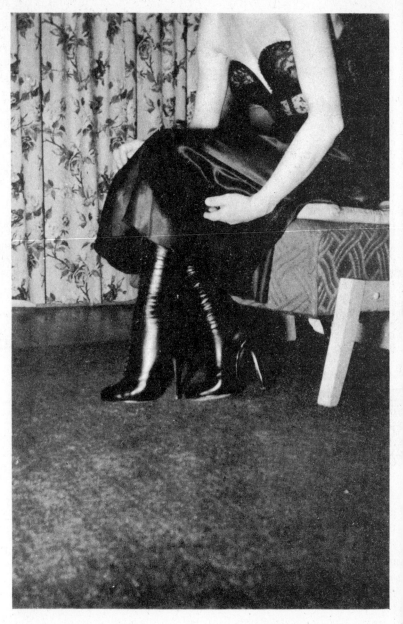

perfection in black kid

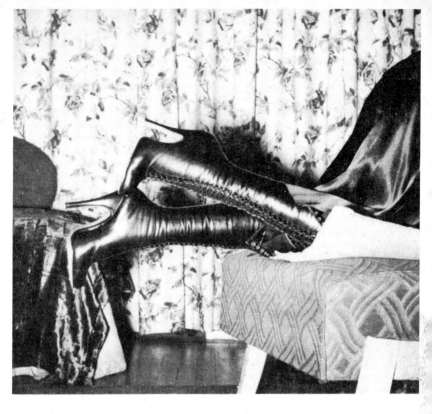

as they criss-cross, embedding themselves deeply into my insteps which are only protected by their very high fancily worked kid tongues.

I suppose you would like me to speak of my thigh boots. Alas! my only pair was made some time before the last war, when the Bootmakers Craft was at its zenith, and as I have said they are made of the softest thinnest beautiful kid, highly perfumed and kept in a special box when not in use. These have only six inch heels like thin pencils, the tips a quarter of a centimetre in diameter, and are very troublesome to stand and walk in.

I used to have to walk around my lounge like the girl pictured in your recent number of your Bizarre, with a heavy thick book balancing on my head and my gloved arms straight to my sides like she had. My *fiancee* insisted in this, and in fact it was he who trained me in the perfection to be attained by the patient wearers.

Firstly I was made to lie on a couch whilst he fitted the terribly high boots upon my delicate legs, and a tight strap was buckled round the upper part of my thighs

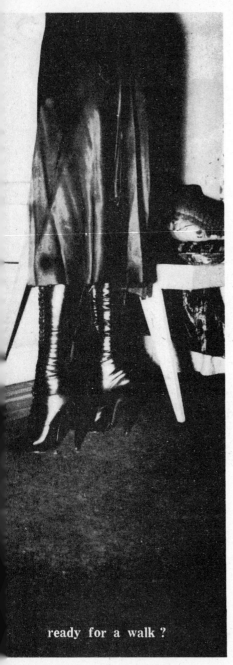

ready for a walk ?

to keep the loose boot in position whilst he laced the boots in place. Then the long solf leather tongues were pulled up the full length of my legs and affixed under the supporting straps.

The lacing up of such high boots is a fascinating feeling. One first feels the high arched insteps being squeezed into the tiny foot part of the boots, and gradually the slender ankles are similarly encased tightly into the lower boot, bit by bit the lacing creeps slowly up one's legs, mercilessly confining the softest parts of the calf and leg, forcing the flesh slightly upwards all the time towards the calf. One has the idea that the laces will never be long enough to complete the work in hand, and though the lacings of mine meet almost over the knees, above that point one is aware that closing is not so complete, and the slightly increasing gaps towards the tops, make one aware that in anyone's hands, not entirely merciful, their tightness can be very cruel indeed for the wearer to endure, and that last final tug together of the last lace catch and the knot "jerked" into a finished tie is quite painful.

Unless this is done with expert hands one is quite unable to endure the awful constriction of such a boot as soon as one places ones entire weight upon the floor, especially with such delicate high-

est of heels, in fact one's legs simuly ache madly and have to be eased off a little, but my *fiancee* is quite an expert at lacing mine now, and after a fairly tight lacing and a short waiting period, I am able to walk comfortably in them for some hours around the house. These boots I wear all through dinner with him, and I shall have to admit, sometimes afterwards at a cabaret too.

As all my shoes are specially made of very very thinnest kid, I never have them lined at all. They are made slightly smaller than my normal size, so that when tightly laced they don't hurt me anywhere, but fit my tiniest of feet, almost as smoothly as a soft kid glove does.

What with all these latest talks about fashions "A" or "H" line I should best describe my own footwear as far as the foot it-self is concerned, as the "S" line, starting at the heel my "S" sweeps vertically down to my toes and then with equal suddenness sweeps out again forming the tiny soles I have left to stand upon. My insteps have acquired a completely vertical aspect since wearing very high heels, and to me that is an admirable line.

To make me sensible to how I trod the floor in high heeled shoes, my *fiancee* used, in the beginning, to place a few tiny hard pepper corns in the soles of my shoes and boots, causing me to think each step out with unusual care and caution and also making me very conscious that the highest of heels were nevertheless meant to be walked firmly upon.

But perhaps I'm boring you with so much talk of my boots.

Au'vo ¨

"Torrina"

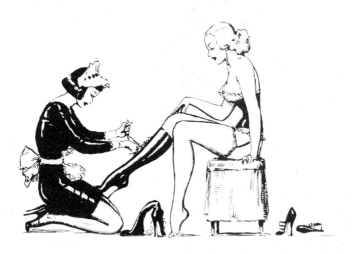

More Memoirs

of Paula Sanchez

Apparently you are interested in my grandmother's attitudes towards tight-lacing, so, as I have time, I'm continuing.

As I described previously our household included the two maids, Lizzie and Dinah, on whom G-mother practiced what she had learned of figure training in her Paris experiences in the house of the gentleman who was a connoisseur of hour-glass figures.

I always thought G-mother a little jealous of the ladies Uncle brought home. She had a theory that women were "getting lazy" in attracting men. Her efforts with the maids were, in part, a way of shaming the visitors into more rigorous figure-discipline. "I'm no longer as attractive as I once was, but is that any reason young blood should not have its stirrings?"

So some years before she had picked out Lizzie and Dinah, both very handsome colored girls, and trained them to be as alluring, by her standards, as possible. So successful was she that Uncle's visiting ladies, coming to dinner, when they got one look at G'mother and

the maids, would retire to the dressing room, where not the least of their activities would be to lace their corsets tighter and to arrange their clothes to display more bosom!

As a small child I wandered pretty much as I willed and have a vivid recollection of standing by, open-eyed, while each lady in turn would command the services of Lizzie and Dinah, who gave their full weight to pulling in their corset strings with a will, but knowing that the visitor's temporary methods could never outdo or surpass the results of G'mother's figure training!

Some of the ladies would faint, others burst into tears of vexation when it became apparent, that though trussed to their limit, they could not compete with G'mother or the servants.

This, of course, had the effect of making Lizzie and Dinah very proud and conscious of their figures, in spite of the difficulties which G'mother put them thru to attain and maintain them in their extreme attenuation.

At odd moments they were al-

ways placing their hands around their waists, as if to demonstrate that they could be easily spanned; and fingering, or complacently stroking their constricted ribs, and and the immense, jutting line of their hips; or tying and retying their apron strings so as to show off their proportions to the best advantage.

A result of their training was also that they never displayed any awkwardness, nor did their corsets seem to bother them in the performance of their usual duties. In spite of their small middles their corsets seemed rather loose. They could breathe, turn and bend in them, which was more than the red-faced ladies, who only laced up for the special occasion of the dinners, could do.

Although stem-waisted corsets didn't come in until later I am certain that these girls had stem-waists due to the twisting and other exercises prescribed by G'-mother, which forced movement of the body within the corset.

In spite of being tightly garter-ed and laced their corsets would ride up an inch or so with squat-ting or bending, for I have seen them surreptitiously pulling them down after such an effort. If they had not developed a rather long, stem waist this would not have been possible with this degree of lacing.

I have seen Lizzie's bountiful bosom pushed up nearly to her chin when she leaned over, and it would stay more or less this way when she straightened up until she took a full breath and pressed downward upon her hips

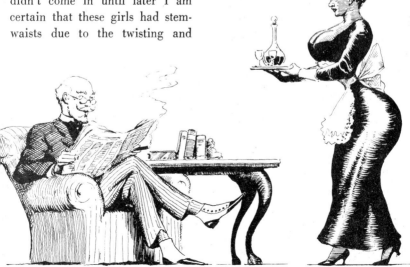

15

with both hands, to slide the corset into its position again. Inside the small waist of the corset was a *longer* small waist, perfectly round and tube-like, brought to these proportions by the following means:

(Let me say in beginning that both girls never showed the least signs of sickness. The only thing which has deterred me from seeking the same degree of constriction is that it is not practical when one is much alone. For neither Lizzie nor Dinah could so much as sit up unless she had her corset on, let alone stand, and neither could G'mother. So they never removed them except for bathing, when the bather would always be assisted by one of the others. This would not be practical under the more active existence imposed on women by contemporary standards.)

Three times a week the girls were called before G'mother for figure discipline. In turn each was stripped, while supporting herself by holding on to handles set at arms length in the door frame between G'mother's bedroom and dressing room. She was powdered and another, smaller, corset placed about her and laced not quite close. Then both were given a big helping of soft, filling food.

Since they were mortally afraid of G'mother a stern glance was enough to cause them to stuff mashed potatoes, hash, beans or other such bulky food until they could hardly swallow.

I later discovered that this stuffing routine was quite common practice used by ladies before going out during those periods when tight lacing was most fashionable in the past.

You will find Scarlet O'Hara, in "Gone with the Wind" made to undergo it, though the reason given there was that it was unfashionable for young ladies to have big appetites at a party.

G'mother had a more practical reason! It was to "keep the passages open" during figure training. The necessary "passages" must be kept open during tight-lacing and the way to do this was to fill them so they resisted closing and forced less essential parts to change position. So to cause the food to move downward into "the passages" the next step was to lie on the floor, a few minutes on the back and a few minutes on the front, rolling, stretching, drawing up the knees and moving the body in every way possible.

After a few minutes of this they were given a large glass of sherry to stimulate their appetites further and more food. Then more floor exercise and so on until they had consumed so much food that it distended them to the proportions of the loosely laced corset. Their

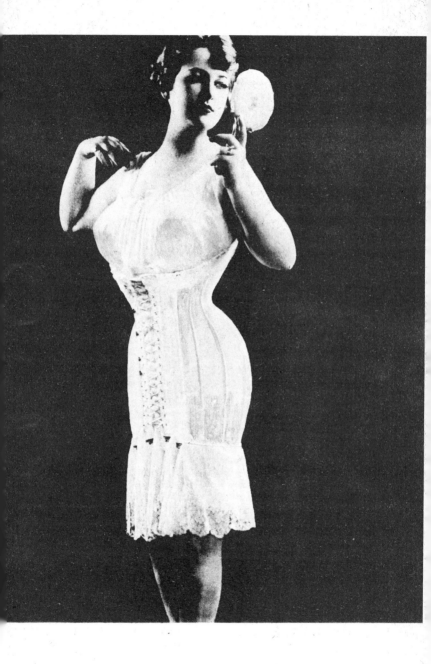

the glass of fashion
— and the mold of form

breathing would now be rapid, interspersed with inadvertent grunts and sighs and they leaned back in their chairs.

Now came the part that nobody but G'mother seemed to enjoy, though they knew it was necessary.

Since Lizzie was always the more difficult to reduce to G'mother's dictated proportions she was first made to stand at the doorway and grasp the handles. It would usually take G'mother and Dinah, working together, about three efforts to close the extra-small training corset. Lizzie still sometimes fainted and slumped to the floor before this was finished, but the corset would not be loosened. She would simply have her feet propped higher than her head and given smelling salts till she "came to herself," then rolled over and the job completed with her lying prone.

She could then arise only with help and her heavy upper torso would seem almost to be too much for the tiny waist to support. At first she would rock from side to side dizzily and could walk only with the most exaggerated balancing efforts, which required the most exaggerated waving and jerking of hips from side to side in countermovement to the torso above. But with continued walking around she would become more sure of herself as her figure adjusted itself to the smaller contours.

Now Dinah, who was tall and supple, would be subjected to the same treatment, but will tell you about that another time.

Paula Sanchez

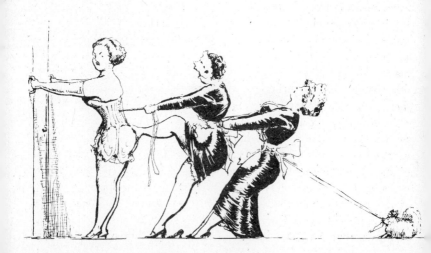

orrespondence

Now Fight It Out

Dear Editor:

I have just finished reading No. 17 and am angry and appalled at finding so much of the issue devoted to tattooing, so much precious space devoted to the pictures of a person who has made of himself a drawing-pad for an incompetent "artist."

Your editorial was timely, and I find myself in complete agreement with it; censorship has always been the forte of those lacking in appreciation or understanding of the ideas of their fellows, of those who fill themselves with malice toward the pleasure of others, and seek to bring all to their own dull level.

I do not want to put myself into the same catagory with these narrow, self-appointed guardians of the "free" press, but I find it necessary to express my concern about the lack of taste evidenced by inclusion of an article on tattooing in your magazine. Tattoo-

ing is not "bizarre"; it is only visually, esthetically grotesque.

Bizarre is dedicated to the advancement of the beautiful, to the cultivation of those delicately unique attitudes which enable man to make of his life a constant cup of appreciation of beauty in its myriad forms. Tattooing does no such thing; in fact, it is a desecration of the esthetic quality of the human body, a form of camouflage which distorts the naturally graceful curves of man's limbs.

How does J. Willie attain such beauty in his people? As any artist, he does so by reproducing the imperceptably fine gradations of shadow that shape for the human eye the full curve of thigh or turn of full-fleshed bosom.

Look at the attempted camouflage of warships and planes; contours are broken by slashing across the true shape of the object with grotesque dark lines and patches of color, by destroying the actual definition of shape. And

19

the tatoo accomplished the same objective, hiding the naturally beautiful contours of the human form, blending beauty into the gray haze that surrounds it, making of the art of nature a slate for dirty words. Why has the modern artist turned his back on reproduction of nature in favor of the symbolic? He has done so because he recognizes both the futility of trying to improve on the beauties of nature and the need for enhancing man's appreciation of this beauty by symbolic means.

Is the tattoo "artist" so advanced of Picasso or Klee that he can afford to "dash in where angels fear to tread?" I think not. He is more than likely as the adage describes him — a fool!

Tattooing is the art of savages, people who lack appreciation of beauty, worshiping only power, crude might, and the physical strength. The savage, like the animal, knows nothing of symbol; the limit of his intelligence is the sign, the lowest form of communication.

What place has this in a publication devoted to beauty and the symbol of beauty? If the attitudes that produce *Bizarre* were as base as that which injects ink into humanity, the magazine would be just one more devoted to worship of man's physical might, to glorification of men who strangle lions, men who strangle women, strangle life and beauty. Sex can be just that, a forceful taking, an animal satisfaction periodically attained and then forgotten; sex can be purely animal, and its literature can be pornographic. But I seriously doubt that this is the intention of your editors.

Man symbolizes in his sexual thinking as he does in every phase of his life; what man who has kissed the glittering heel of his lady's shoe can doubt it? Man appreciates the tantalizing promise of satisfaction as much as he does the attainment of it; the scooping, revealing neckline bespeaks the truth of this. And these are the nuances that you must promote to the absolute exclusion of crude, unbeautiful practices like tattooing.

Yours, L.E.S.

ONE SIDED BEAUTY

Dear Sir:

In view of recent correspondence articles about amputees wearing ultra highheels, perhaps my experiences may be of interest to some of your readers. Like Molly I had been in the Blitz and as a result my left leg and left arm had both been amputated, in each case leaving a very short stump, so that I was unable to wear artificial limbs. In addition my right hand has been amputated just above the wrist. Prior to the ac-

cident I had been a devoted servant of the high heeled boot and the corset and it now seemed as though the pleasures of donning those articles and lacing them tightly had gone forever.

However, during my convalesence I had become very friendly with one of the nurses, who seemed particularly touched by my disability, so much so that after some time she decided to leave the hospital and devote herself to looking after me.

Some months later when going through my belongings she found a trunk containing my high heeled boots and corsets and one evening she suggested I try them on again. I had the boots especially made in Italy, and your readers might be interested in the details. They were of black patent leather with a thin tapering stiletto heel of eight inches in height, (I take a size nine), and had a small platform built inside the foot part, thus avoiding the rather clumsy appearance of the usual platform sole. The boots laced to the thigh and had a special steel stiffener let into the tongue, so that as the boot was laced up, the foot was forced and held rigidly in the vertical position dictated by the heel height.

I could of course no longer put the one boot on my leg and lace it up, but my nurse who was a strongly built woman did this for me, pulling the laces until I could feel the blood throbbing against the tight pressure of the leather. This done, she put on the corset, a black kid affair and gradually laced in the waist until my body also became rigidly imprisoned and bound. As time went by it became more and more difficult to persuade her to release me when I became exhausted with the increased pressure, and finally she would leave me completely helpless, my remaining arm bound tightly behind my back.

After much pleading she eventually agreed to release me if I would "walk" from one side of the room to the other, using one crutch and without any other support. (I was of course unable to use two crutches because of my left arm being off at the shoulder). You can imagine the difficulty of balancing on an eight inch heel with two legs, let alone one, but after many days of practice I managed to develop a kind of mincing hop with which I could progress very slowly across the room, watched with satisfaction by my task mistress.

As the months went by I became more and more accomplished and began to enjoy the sense of restriction and helplessness. I can now stand for quite long periods without a crutch and am hoping eventually to move about with only slight support from the odd

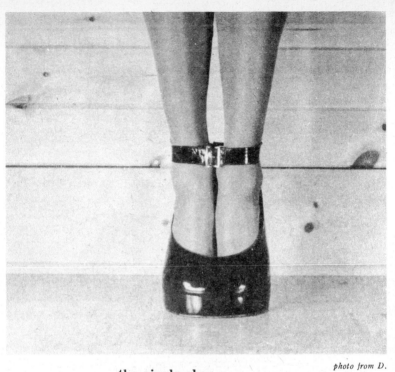

the single shoe —

photo from D.

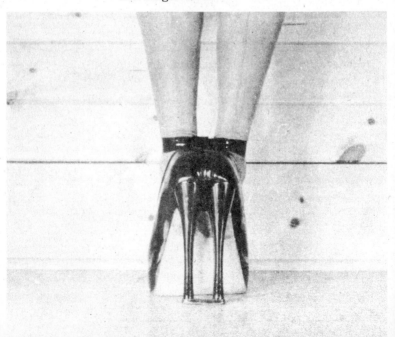

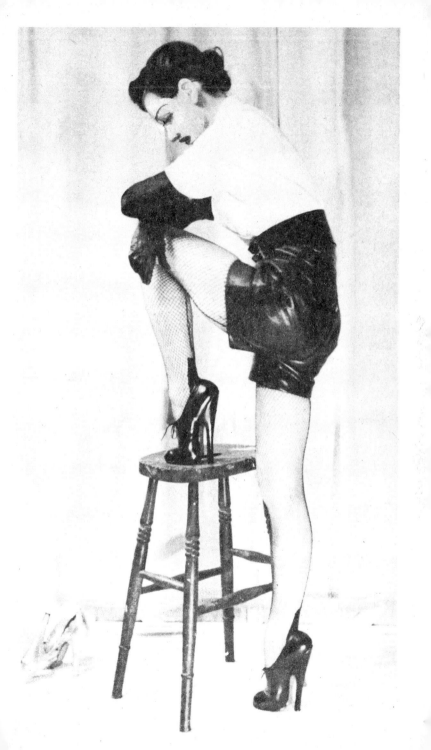

chair or sofa. Nowadays I very rarely have the boot taken off, but when I do I find that my foot has become almost permanently set in the position corresponding to the high heel, and that to put it into what was originally the normal position is quite painful and difficult.

I find the combined support of the high heel, the tightly laced leather of the boot and corset has rather an exhilarating effect and can thoroughly recommend it to any of your disabled readers.

Yours,

P.C.

FOUNDATION CONTROL

Dear Editor:

The enclosed sketch shows a contrivance which has been found useful around our household. The thing started out as a means of combatting the little woman's tendency to get to bed after midnight, with a resulting lack of sleep which wasn't doing her looks any good. Arguing about it didn't help, although she admitted the error of her ways.

As a result I fabricated (with her help) what we called "super garter belt". The original version was as illustrated except for the wrist and elbow straps and the three bits of satin. She agreed every time she got to bed later than ten thirty without a first-class excuse, she would wear the "super belt" under her clothes one whole day, cinched up tight enough to be fairly uncomfortable. The thing had some effect, except that when she did slip beyond ten thirty, she figured she might as well make it one o'clock. So we amended the agreement. We added the wrist and elbow straps, (which are detachable) and agreed that when she stayed up beyond eleven thirty, she would not only wear the "super" all day, but after dinner she was required to spend the rest of the evening with her arms strapped to her sides. That has almost cured the habit.

It was of course impossible to remain clothed while the arm straps were in effect. So the three brief satin items were arranged so they could be snapped into place when needed. She wears them sometimes in lieu of panties and brassiere under her dress on "retribution days".

The contrivance could probably be adapted to other uses. It has served our purpose admirably.

A. B.

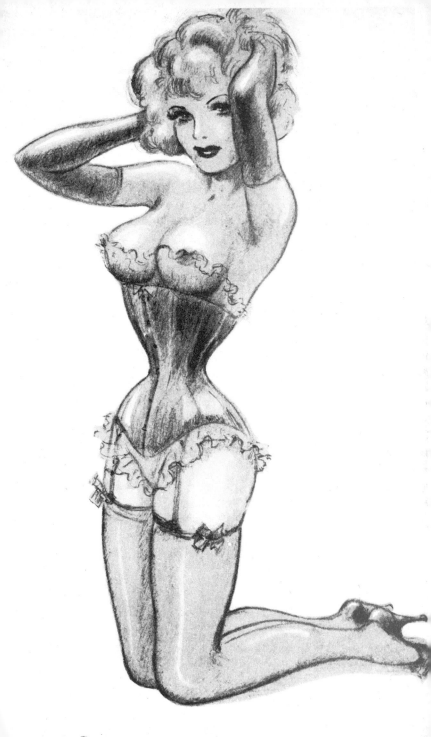

Well ?

PLAINTIVE MONOPEDE
Dear Mr. Editor:

In your vol. 2 Bizarre an. 1946 Issue. You had an article entitled, "A Happy Monopede" and signed "Hoppy". It told of a young girl who lost a leg, and with crutches as a help wore an extremely high heeled shoe similar to a ballet shoe which puts her one foot on the tips of her toes. I too lost my right leg five inches above the knee. As I had always been used to wearing my heels very high before my amputation, I still wear an extremely high 5½ inch heel on my remaining leg. But at home and in the garden plus going hiking, and fishing with my boy friend I wear a peg leg with a patent knee lock and adjustable for length, in wearing up to a six inch heel on my remaining leg. My latest shoe is size 6 in black patent, lace style Oxford with a 5½ inch heel. I am 26 years of age, blond and am 5 feet 1½ inches tall and considered fairly good looking. With my peg type leg I can get around without crutches or cane as an aid. The remaining leg with a sheer nylon and my high heeled shoe does wonders for my figure, I still get whistles. At first people stared at me wearing a peg and the high heel but that soon passed. I myself get a great thrill out of wearing a peg leg and walking on it fascinates me greatly, especially the tap of its rubber tip as I walk. My boyfriend is greatly attracted to my wearing a peg leg and insists that I wear it all the time along with my high heeled shoe, which I do. I must say for comfort, agility and convenience you can't beat a peg leg. My peg leg laces on my stump in a sort of a leather boot stump and I wear a shoulder strap. I have been wearing a peg leg now for over two years. Mr. Editor, can't we get more mail from others who have lost a leg, perhaps we could get some snap shots. If you print this letter in your next issue of Bizarre I will send some photos of myself. You know, us monopedes get twice as much wear out of our nylons. And when we get a cold foot we get only half as cold. My boy friend and I are both lovers of high heels, he is having a shoe made for me in a brown suede, ankle strap with a 2½ inch platform sole and which will have a full 8 inch heel. Please print my letter and you will hear from me again and next time with pictures.

Very truly yours
"FIVE TOES"

INEPT STUDENT

Dear Mr. Editor:

I think you are the nastiest person. You have completely ruined my life, my home, and everything. Up till that dreadful day when I bought Bizarre I had been able to manage my husband — now I can't any more. I have been forced by brute strength and Sir d'Arcys cunning to swear to obey "implicitly"!! and as part of my pennance I have to write this letter. I can do so only with difficulty because I can only use one hand and with that I cannot reach any of the knots which tie the rest of me to this chair and the typewriter. You see how it is.

Your "Learn Jiu-Jitsu" suggestion is just applesauce. What you need is some instructions for unwilling Houdinis, that is what tricked me into allowing myself to be tied up for this experiment. I think you are both horrible, and I think I'd like to know where the brute learnt how to tie ropes. I can assure you that I cannot get loose.

Like a fool I boasted I could get out of any knots and when the mean thing said "OK but let me know when you want to be untied" I was even more stupid (he's reading this over my shoulder and likes that bit about my saying I'm stupid — well I was) I said he could be sure of one thing and that was that I'd never ask him

to untie me even if I had to stay like I was on the floor for the rest of my life so he stuck my mouth closed with adhesive tape and just left me.

I struggled all I could but I couldn't get my fingers near the knots and the ropes wouldn't slip and if you've never had your mouth taped up let me tell you that tape sticks and you can't open it. Furthermore I'll now get no fun out of detective stories because the heroine always manages to wriggle around the room, and cut herself loose. Maybe her elbows aren't tied in the middle of her back some place and maybe she's an acrobat. All I could do was roll over this way and that way only with a terrific effort and I could hardly sit up — let alone stand up.

In spite of this you can believe it or not I found I thoroughly enjoyed wriggling and straining even though I knew it was quite useless. I suppose if it wasn't someone you were especially fond of who had tied you up it would be different. Try it sometime Ed and if you're a woman — which I doubt — you'll find out what I'm talking about.

Finally I quit and to my surprise found that I could be quite comfortable if I curled up a bit and because it was quite obvious to me that I couldn't do anything much about anything I went to

sleep. After I don't know how long I woke up. Then I was picked up like a sack, dumped in this chair against the table and my arm untied so I can reach the typewriter — ordered and commanded to write to you. This next sentence is for the benefit of him who reads over my shoulder — "Now I've said all I can. Please will that do?"

O.K.

Yours,
Slave (temporary)

More Rubber Please

Dear Editor:

As of now I would like to say lets have more rubber corsets, girdles, bathing caps, boots and if any pics of rubber brassieres are handy, that too.

Send lotsa corsets, high heels and long black mesh stockings. Very tightly gartered of course.

To get back to my favorite rubber attire. Frequently I wear a rubber girdle, at home, at work and play too but so far my wife isn't yet a convert. Maybe some day. I have gotten her a girdle which she wears when I'm not home.

I also enjoy wearing mesh stockings and garter belt along with my rubber girdle, and bathing caps too! So far I have not been able to secure a rubber corset, perhaps a reader could help there. Can't find that I care much for

pictures of rubber "Macs" — they look like any other coat — sorry.

Oh! Almost forgot, Hows for some art work consisting of thighboots, mesh long stockings, rubber girdle and bathing cap.

Yours, R.A.W.

Man Maid

Dear Sir:

Like Babs in Bizarre Nine, I too enjoy the delights of having a well-trained husband-maid, or "Milly", to dance attendance on my friends and myself.

His costume on these occasions —worn blushingly and very much under protest!! — consists of a tight-fitting black silk dress, white frilly maid's cap and apron, black silk stockings and dainty high-heeled shoes. For underwear, two white linen petticoats, well starched and elaborately belaced, and a pair of white lace-frilled drawers buttoning tightly at the waist!!

The petticoats and knickers, or drawers, are actually some which my own mother wore as a young lady, over 40 years ago. Properly and firmly corsetted, they fit him nicely, and look really lovely with dainty lace frills and embroidery-work showing coyly under his short, full skirt.

Very self-conscious and ashamed but adorably helpless in his petticoat imprisonment. "Milly" humbly waits upon us, and we beride him if he is not quick enough in

28

now where IS that corkscrew ?

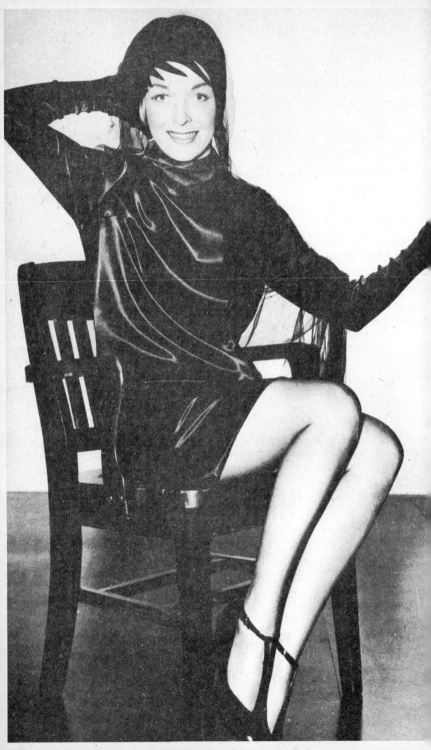

carrying out any orders he may be given!! I have adopted Babs own system of "punishment rompers", and when he has misbehaved or been slack, he is made to stand in the corner, like a naughty child, hands tied behind his back and humiliatingly attired in a pair of fleecy-lined white woolen schoolgirl bloomers "loaned" to him by the young daughter of one of my friends!! I may say that he does not often risk the ordeal of this intensely, humiliating punishment!!

Yours truly,
"Gwendy K—"

LEGLESS WITH LEGS
(Continued from No. 17)

One pay day — I knew he always quit a little early on pay day — I put on my nylon and best heeled patent leather sandal and waited. I was in the bedroom looking into the mirror, with my back turned to the door, when I heard that he was standing in the doorway. He stood silently for a full two minutes then I turned and pretended to look surprised as he quickly rushed over took me in his arms and kissed me. My crutches were still under my arms as he put his hands on my waist and held me at arm's length surveying me with a look in his eyes I had never seen before.

I quickly explained that I found the crutches in a closet and was curious to know what I would look like with only one leg. I said I would unfasten the leg and finish making the supper but he insisted that I keep it that way and try to make supper using the crutches. Little did he realize that this was exactly the way I had it planned and had practiced for months to do. I finished the supper and even ate the meal as an "amputee" while he watched every move I made. I could see the satisfied look in his eyes, but it was no more than the wonderful feeling I was experiencing. The fact that we both were enjoying it has made the last year or so of our lives almost a paradise.

When we go away on trips, I always travel that way and to this day no one has ever suspected. When I walk down the street in strange cities in my nylon and four-inch heeled patent sandal I get as many stares of admiration as I do of pity.

My husband has since made me a neat peg-leg on which my knee rests and he always insists that he be allowed to double up my leg and fasten the leather straps which hold it to my thigh. He also chooses a nylon stocking and a spike-heeled shoe which he puts on my one shapely leg. I always wear the highest heels we can buy even when I am wearing the peg-leg. I have become quite adept at wearing it and have worn it

Presenting!

A NIGHTMARE DRAMA (in 3 spasms)

ENTER BATWOMAN (looking fierce)

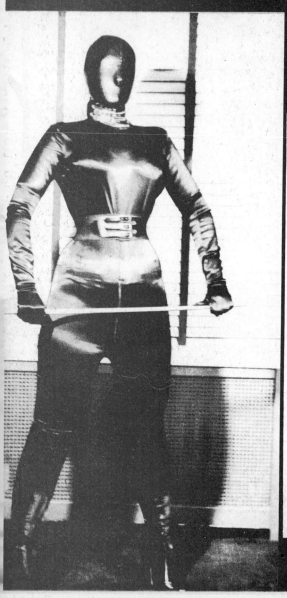

followed closely
by a BATMAN

There is a wild battl

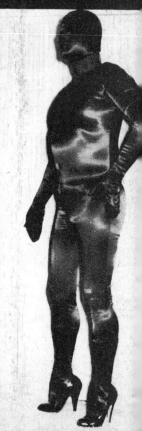

photos from a reader

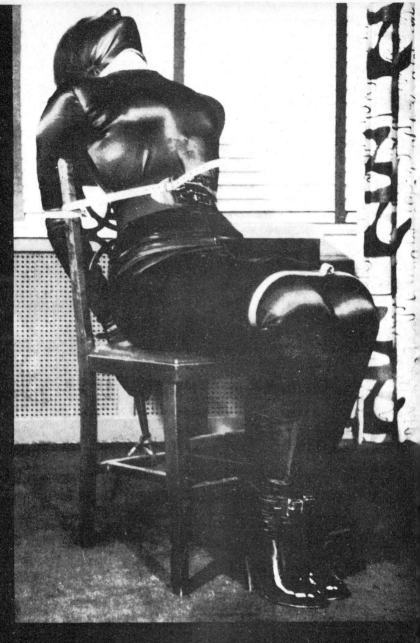

—BATWOMAN IS OVERPOWERED
 —and that 's that.

so put away the bottle — go back to sleep — and remember
— broiled lobster is lousy for a goodnight snack.

while we go hunting in the fall. I have bagged numerous amounts of small game on the peg. While I wear a hunting shoe with a fairly high heel I must wear a skirt because if I wear hunting breeches it destroys the illusion of being one legged.

The only way my life could be more complete is if I could have my left leg taken off so that my "bondage" would be real instead of artificial. I have no desire to walk on both my legs as I have learned that one can bring me *more* than my share of happiness. My husband has urged me to try to have it amputated but as yet I haven't found a way to have it done without having a fake accident. I would like to be able to go to a hospital and request that it be taken off but I fear that that sort of action might have unfavorable reactions.

For any of your bondage fanciers who would like to try something a little different I heartily recommend that you girls do as I have done and discover real satisfaction. Or for you fellows whose wives submit to bondage, dig up a pair of crutches and strap up one of her legs. You will thrill at her helplessness as she tries to walk for the first time, stumbling and falling like I did. We have been doing this for over a year now and our enthusiasm has not dampened one bit.

Yours truly,
"Peggy"

SOLILOQUY

One might say, "You decry naked force, but isn't bondage force?" Alas, they have missed the point. Bondage is not the end; it is but the symbol, the signification of surrender to beauty that is the ultimate phase of appreciation of beauty. This is women's most useful tool in her ascent to glory. In savage races man is the ruler, because he possesses the brute strength and speed that his environment necessitates, but as civilization progresses and man's appreciation of beauty is born and nurtured, women find at their disposal a means to assume the upper hand. They merely weaken man with their half-hidden beauty and veiled promises until he is *willing* to sacrifice everything to them, until he is kneeling, pleading, and enslaved.

There are few women who are capable of overpowering a man by use of strength alone, which makes it all the more bizarre that she should be able to command him. You may say, "This is foolishness. Men still rule the world after centuries of civilization; wo-

men have not attained any great prominence in all these generations of civilized living." Remember, I predicted this situation on man's appreciation of beauty.

Are our art museums mobbed, turning away overflow crowds? Does the classically beautiful music of the world outsell popular "junk?" It has taken man these many centuries to completely conquer his environment, to bring to him the means to live healthfully and comfortably without necessitating his spending all his time laboring to attain these ends. And with each stroke that increases man's leisure time, his appreciation of the beautiful is deepened.

Woman is the natural ruler, because nature has given her all of the means to rule. She has all of the softness and desireable beauty that are the levers to control; man's body is the hard and muscular "useful thing" while woman's body is the soft, pleasing "esthetic thing."

Few women are empassioned by man's strong, muscled frame, and no matter what one does to drape it, hide it, or change it, no male leg will ever assume the majestic beauty that a woman attains with smooth silk and high-heeled polished leather. Nor can this delicate power that they have ever be taken from them.

Enslave a woman and you will experience the utmost in futility and frustration. The more you try to degrade her, the more her beauty seduces you. Force her to wear restraining corsets, and her beauty is merely emphasized; press her feet into the highest of heels and make her walk before you, and what should be an awkward, stumbling gait becomes an enrapturing symphony of movement.

No matter how you bind her, her tugging and wriggling to freedom simply bewitches and overcomes you.

Two more traits that enable woman to enslave man are her knowledge that "to reign, one must rule constantly," and her boundless imagination which supplies unending means to chastise and humiliate her "slave." Give a man a whip and he will put it where he can always find it; give it to a woman and she will carry it forever! And in these two facets of woman's dominance lies the beauty, even for the dominated male.

The man who says that he will never serve a woman is a man that has never been made to do so; once he feels the excitement of having his life turned upon the capricious whim of a demanding, imperious queen, of having the tender invitation of her beauty suddenly replaced by her regal command to kneel before her and adore her, then he will realize why

man is ever "slave" and woman ever "master."

Yours ever,
"Her Slave"

SPANKING

Dear Editor.

In issue No. 17 George D. says he has often "been tempted to still the nagging of my own sweet helpmate by taking her across my knee and warming her plump fanny, but to date I haven't mustered the courage." I say to him; Don't be so bashful, George. Warm her plump fanny well; she will be thrilled and love you for it. There is nothing a woman loves more than to be soundly paddled when she has been "naughty."

She will also love it if you play "naughty boy" or "slave" to her now and then.

Sincerely,
Betty R.

BUST PROBLEM

Dear Editor:

It would be very much appreciated if some of the readers of Bizarre of either (preferably both!) sex would write in and discuss this problem through correspondence in future issues. I feel it is not mine alone, by far.

Being a pretty robust man in late thirties, I am, luckily, still blessed with a good figure, to wit: 42" chest, 31" waist, and 38"

hips. Since I would fit, I think, a "straight hip" type in the girdle or foundation garment line, there still is the problem of what to do with the creation of an artificial bust.

I know there are available many bust forms, pads, etc., but none of a size that I would like to sport in my dressing as a female, monumentally-proportioned bustwise. I should imagine the size breasts I'd like to wear would approximate a D-cup. Now, could someone among our readers help me? It might not be a bad idea to have some of the women who have initially whipped and browbeat men into the idea of dressing as females give their views.

There is nothing smoother or nicer to the touch than the feel of satin-like panties, brassiere, petticoat, slip, etc., etc., as well as a nice long housecoat or perhaps a duster. Nylons along the thighs and calves of the legs give me a thrill as they slide on. And once donned, so comfortable! Wonder how many of our male readers are of the same opinions as to the foregoing?

I have a job, unfortunately, that keeps my nose closer to the grindstone than I like; so have no chance to get away among those who like to dress differently. It is a pleasure, naturally, to read via Bizarre's page of those who depart from the ordinary in the

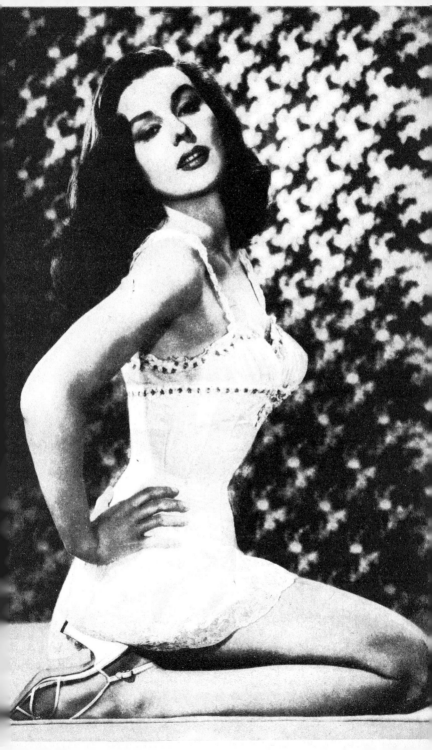

way of dress and deportment and enjoy themsevles with the method or methods of their individual choices.

I have tried to keep this letter well along the lines of dressing as a woman, the problem of getting clothing made, etc., rather than dwell on the pleasures attendant upon whipping the body with all manner of instrument. Best to save another letter of this nature for the future.

In closing, I'd like to say that there is, in California, a place where anything can be made, espacically of leather. Would some reader mention as nearly as they can, other places catering to female impersonators' clothing?

Ever truly yours,
Tessie, the Whipped One

NIPPLE RINGS
Are Nipple Rings Bizarre?

I am inclined to answer the question with an unreserved "Yes". And yet, up to now among all the "bizarre" subjects and actions reported or commented upon in all the issues of the magazine this point has never been mentioned. Perhaps some of the readers will thank me that I will call it to their attention.

Nipple rings are exactly what the word signifies, rings in the nipples of the breasts, both women and men. The subject of earrings in pierced ears has been treated quite frequently, and rightly so. There is a special charm about earrings dangling from the pierced ears. There is no smaller charm caused by rings dangling from the nipples. We have been treated in several pieces of correspondence with the manner by which breasts are made prominent either by certain forms of corsetting or on occasions of special costume parties by the freedom and liberties that have been accorded them, while being brought out of hidden places. There were two distinct mentions in connection with reports on costume parties in which the freedom of the breasts were put to good use. The one readers will recall was delicately but very frankly described by a member of the Modern Club and an other one in which a description was given of the variety of costumes shown by a similar club. In both cases it was stated that at least one member made sure that the other members had no doubt about the fact that she had a bosom worthwhile looking at. In both cases the owners took the trouble to color the nipples.

When I read this I could not help thinking how much more they could have been attractive and distinct if the owners had taken the trouble to wear rings in their nipples. A golden hoop earring will do very well. A num-

Cinderella's slippers were no daintier

London features the heel peeper

ber of years ago I read a chapter in a book dealing with a fashion in England to wear nipple rings. There it was stated that one jeweler had pierced in one year 40 pairs of nipples and fitted in golden rings. And other jewelers could report similar sales of nipple rings. There were some very enthusiastic comments made by ladies who had adopted the new fashion. I was so attracted by the article as an answer to a desire which I had for quite a while that I wrote asking a doctor what I could do to satisfy my longing for such a ring. He told me to pierce each nipple close to the base by using a heavy needle which I had sterilized in a flame. I followed his advice, and the result is that I am still wearing two rings in my nipples, now more than 20 years. I have received quite a few compliments on my decoration.

I ask myself now, why is it that seemingly nobody thinks of this opportunity to appear in such a specially attractive manner? I must say that it takes a bit of will power to pierce the nipples, because they are somewhat tougher than earlobes. But if one does not want to do it herself — or himself for this matter — a doctor will have no difficulty. It may take a few more days to heal than it does on ear lobes, but the effect is worth the price. Per-haps our friend Brownie in No. 17 will give expert advice how to proceed in the best manner. I have seen photos lately of ladies in Germany wearing them. Why should we be backward in this country? With the wearing of these rings goes a bit of tickling which is very pleasant, since it is a reminder to the wearer that she or he has something which is out of the ordinary.

Perhaps this contribution will bring to light some who already are wearing them, and they can give us supplimentary information.

More as a curiosity I may mention that I knew of an actress who was the subject of much attention by her men friends who had a diamond in each of her nipples. A doctor friend of her's had inserted in each nipple one of the diamond studs that used to be fashionable in the past with men in their white shirt. The stud had a bent wire which held it in the shirt. As far as I know the doctor had to slit the nipple open, inserted the wire into the opening, tied it together again and after it was healed there were two sparklers on the lady's bosom, and she never hesitated to let her friends admire it.

M. F.

EAR - NOSE - RINGS & CORSETS
Dear Sir

I recently came across a copy of your very interesting magazine — and immediately bought up all the back copies I could find.

I thought that Volume 13 was particularly interesting. The article on "Nose-Rings" was excellent. I pierced the septum of my nose for a ring quite a few years ago — my ears are also pierced for earrings. Reading how Annette Gay had her nostril pierced for a diamond was thrilling and I immediately pierced my right nostril for the same purpose. If other readers of Bizarre would like to do the same thing without it being obvious while the hole is healing they may be interested in my method — particularly the men like myself.

The instrument I used is a crochet needle with the hook point broken off and the shaft filed down to a needle point. This instrument is ideal for piercing as it is the right diameter and long enough to hold firmly. I found the nostril, unlike ear lobes, require quite a bit of pressure to force the piercer through. However, just as with the ear lobes, there is no pain or bleeding — nor is there any amount of soreness while the hole is permanently formed. A way that the hole can be kept open during the forming period is to insert a white nylon bristle from a hairbrush in it . . . the bristle should be pushed well through the hole into the inside of the nostril and then be cut off flush with the outside of the nostril. It is almost invisible and entirely unnoticeable. In about four days it can be removed, and nose stud inserted at one's pleasure.

As I mentioned my ears are also pierced and since my nose is, too, I am able to give myself unique decoration when it pleases me. One way is to run a very thin gold chain through my nose-ring hole and fasten the ends of the chain to my earrings. It is quite an effect with the chain dangling on my cheeks.

Mr. Pierced-Nose

RUBBER ENCOURAGEMENT
Dear Sir:

I just read of the rubber club. I think the idea is fascinating and I was delighted to know that people now have discussions on this delightful subject. I noted the use of rubber girdles; soft elbow length rubber gloves; and the ingenuous use of rubber skirts. Excellent ideas! Let's hope the members report the most unusual ideas concerning rubber and the various uses to which it can be put.

The novel idea of rubber hospital bloomers mentioned by the "Bloomer Fan" on page 63 should be investigated by the Rubber Club. I only hope that they are

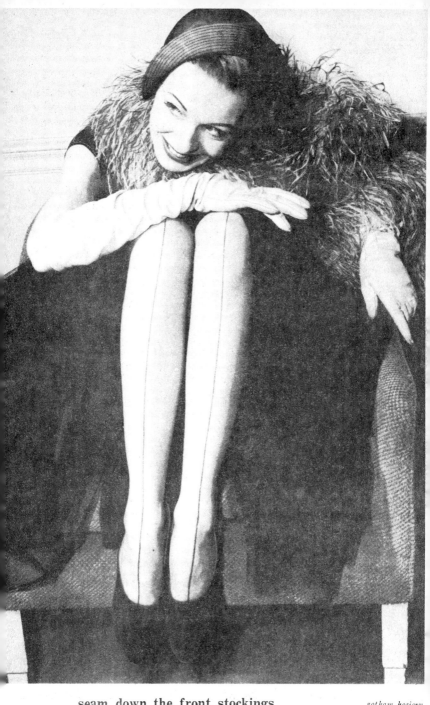

seam down the front stockings

gotham hosiery

obtainable. Such an accessory should prove most delightful to the members of the club.

I trust that we'll hear more about this original club soon. Send in some photos of yourselves in your favorite costumes, and if possible photos of your lady friend wearing the hospital bloomers plus other interesting accessories. The use of domino masks will preserve your identity and lend an aura of mystery and glamor to your appearance so it would be wise to wear them while posing in your exotic costumes.

I present two ideas to the Rubber Club which I believe the members would find interesting. A lounging costume could be designed by means of the following accessories: (a) Rubber Hospital Bloomers or Skirt (b) Black Silk or Nylon Stockings (c) Calf Length Ladies' Winter Rubber Boots (d) Elbow Length Rubber Gloves (e) Bathing Caps (f) Light Weight Rubber Fishing Shirt or Ladies' Rubber Coat. The following could be used: (a) Rubber Waders (b) Short Rubber Jacket with straps at wrist (c) Rubber Gloves (d) Rubber Bathing Cap.

Yours, "Mac"

MORE PLEASE DOREEN
Dear Editor:

I found Doreen M's letter on page 56 concerning the discipline of teen-agers to be greatly interesting. The novel bloomer costumes plus the wide leather belts with loops in back could easily be used as disciplinary or figure training costumes for modern girls.

Yes, Doreen M., I for one should like to have you recount some of your experiences during your stay in London, and probably other readers would be as interested.

"Fred"

SUSPENDED SENTENCE
Dear Editors,

Your correspondent in No. 9 wondered if any other wives have ever hung on a chain. I never have but I have hung on a rope for punishment and so has my husband. We have a special harness which consists of a low cut canvas vest which laces up the front, is slightly padded at the armpits and has a metal ring fastened in the back.

When I am to hang I first put on this vest and it is tightly laced up — loose lacing is no good. Then my arms are securely bound behind me, the rope is fastened to the back ring and then through another ring in the cellar beam. Then I walk up a short stepladder.

When my head is nearly the height of the beam, my husband tightens the rope and secures it to a hook on the wall. Then I step off into space and the ladder is taken away. I hang suspended in midair. At first it is a thrilling experience but after a few minutes it becomes painful and I begin to suffer. My usual sentence is fifteen minutes and the last five are really tough. Once or twice I have had to do twenty minutes which was very severe. If my husband is to be punished we reverse the roles but he has a slightly longer sentence. We feel that we have an ideal method of expiating our offences — thrilling yet severe.

Yours in hanging,
Lou

PORTABLE PRISONS
John Willie; Sir:

The following is taken from a book Edited by an Arnold E. Hirsch, M.D., Ph.D. I believe that you might find it of interest in your illustrations, or for use in Bizarre.

"The portable prison, was sometimes used with metal masks," (Punishment Masks) "but more often it was used alone. Its object was the same, to publish the prisoner's shame to his fellow-citizens, and bring down upon him as much disgrace as possible. The main part of the contrivance was a broad band of iron, fitting round the chest; to this was attached an upright rod, at the top of which was a crossbar, above which again was a semi-circcular sharply-toothed chin-rest. To the crossbars, hanging by chains, were handcuffs, while below the belt leg-irons were fastened."

"When used, the chin-piece forced the head back as far as it would go, the spikes piercing the flesh and inflicting wounds that would not heel for many a day; the arms were brought over the cross-bar and shackled, while the remaining menacles were snapped round the victim's legs. A man wearing the unique machine suffered very great pain. The portable prison was exceedingly heavy and permitted of only the slowest and most laboured movements, while the wearer was never able to rest himself, either sleeping or waking."

I would be interested in seeing your impression of a young woman restrained in such a manner. And I believe that this unusual device would make a good article for collectors of such data.

Yours, "Anon"

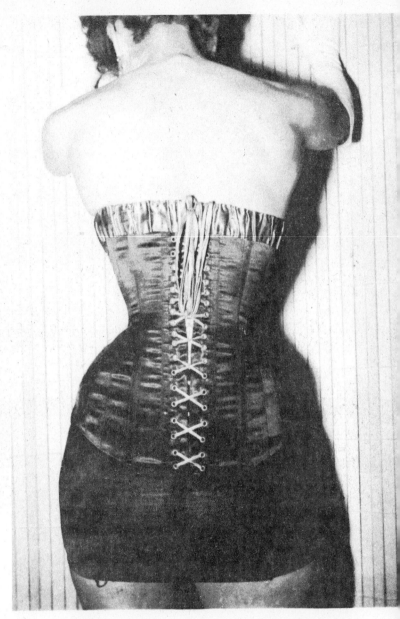

the black satin corset

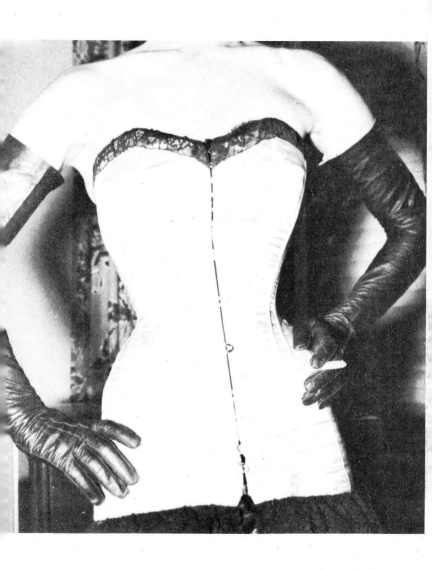

Oh corset me my love, and lace me in
That I may feel its tight clasp round my waist,
Then when thou'rt gone —
* I still may feel thy touch.*

ANON 1765

TIGHT LACING AND TIGHT REINING

Dear Sir,

As "Smart Horseman" suggested recently in Bizarre, I believe many readers are fascinated by the sight of a beauteous woman making "a nice piece of horseflesh" do her bidding — and the harder she is to please, the better! It is really intriguing how some winsome little ladies remain so poised while their strapping horses get frantically excited "over nothing". Some years ago I came across a collection of articles describing ultra-stylish show horses of 1890-1900, and was surprised at the severe restrictions imposed upon both ladies and their horseflesh for the sake of "correct" bearing; it is easy to see why those laced into constricting corsets were more inclined to keep their curb-reins taut!; and they soon found that persistent urging up to a "good " curb with whip and spurs not only enhanced their horses' bearing but did things for their "high spirits" as well!

The following is typical of severe dealing with the "elegant art" of high stepping a pair of superfine, if highly resentful, Park Phaeton Hackneys:

"This is addressed mainly to the style-conscious "Blonde Widow" who is so impatiently awaiting her carriage and pair, or as she so disdainfully calls them, her "smart horseflesh"; just now they are in the all-too-capable hands of a New York dealer who specializes in "high-reining" hot-blooded horses that do not seem to appreciate the finer points of the special gag-bits needed to induce the much-coveted Haughty Pose; if it will make her any happier, I can assure her that his customers are rarely disappointed — but these luckless horses will not share her enthusiasm when they find their new driver intends using the very same harness and bitting — they were trained in!; and later, he will send her even stricter curbs and considerably shorter gag-reins; if she is brazen enough to take advantage of these sinfully strict Reins of Fashion their cocky-looking heads will delight the most fastidious Smart Severity admirers while the casual onlooker will be impressed by their "proud" bearing; since these trim little leather cords are non-adjustable, it would be futile for anyone to try persuading her to slacken them off; and so they will simply have to carry themselves "stylishly" to the very end of the longest drive!

I happen to know quite a lot about Smart Severity Show Harness because a wealthy friend of mine has just such a pair which this trainer "improved" to such an extent that they seem entirely different now. Since their "haute ecole" disciplining they behave

autifully, even when gagged and urbed so strictly that they hardly know what they are doing. She just never seems to tire of high stepping these perfectly lovely olden chestnut mares, and takes chievous delight in keeping m "on pins and needles" and snowing how quickly they obey her every whim. Whenever I attempt to reprove her for such unreasonable strictness the impetuous Miss Marie pouts disarmingly claims she is merely following latest craze, and that if she turned them out the way I suggested no one would ever notice besides, were they not a lady's sure horses?; well, she was ving a great deal of pleasure out of them, and that was all that really mattered to her! Yes, she alized those horrid bits might e a "trifle" too severe, but they kept them panting and snorting ffily, and she could tell I too ved riding behind such lively horseflesh — I had to admit it was true!

"Admirer of Smart Horseflesh"

EARRINGS FOR CONTROL
Dear Sir:

I have a suggestion for husbands whose wife's ears are pierced. If you want to train her to obedience and subjection try his. Run small wires through her arring holes and then fasten her thumbs to the wires. She will be obliged to hold her arms motionless without support for fear that movement will tear her ear lobes. This calls for intense concentration aggravated by muscle strain. To make her really toe the line, when you have her in this predicament, pierce her nose, insert a ring in it and suspend her from the ceiling by a chain or rope to her nose-ring — if she is obliged to stand on tip-toes she will soon become completely docile. I know because I have experienced it myself.

Another article in Volume 13 that I thought was most interesting was the one by Paula Sanchez entitled "Tight Lace For Beauty." I have always worn a girdle when I wear my feminine finery, but this article made a corset convert of me. I am now in training. I went to a corsetiere with my problem — I intend to train down to an hour-glass wasp waist — and she decided that I had better start my training with a conventional corset specially taken in at the waist. As soon as this fits comfortable which she thinks will take about two weeks, she is going to make me a custom-built wasp waist corset which will train me down to 22 inches. I have now worn my first training corset for three days, and Paula is right. It is a most enjoyable feeling once the first discomfort wears off. I heartily recommend it to other

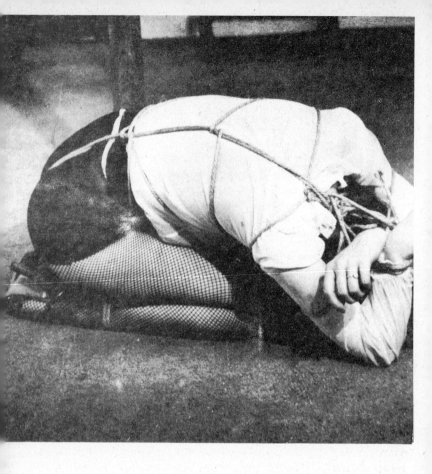

DON'T LET THIS HAPPEN TO YOU

Learn jiu jitsu, the art of self-defense

men who like myself delight in wearing women's clothes — men we can have better figures than the girls.

yours, P.N.

On Saddle Straps

Dear Sir,

The beauty of the "Roehampton" and other horsey gags is not so much their value with reins (rather impractical in a small apartment) as with a saddle-strap — by which I refer to that most effective article of harness connecting front and back or corset or belt through the legs.

The "Roehampton" can be martingaled to a ring between the shoulder-blades from which a single strap can be run through another ring in back of the belt, led between the legs, and buckled tight in front. The result is very smart. For the bit being thus drawn rigorously back, any inclination to stoop or get the head down exerts pressure on sensitive areas. If a good glace kid is used for the "saddle", rambunctiousness will be further discouraged. If exceptional seeverity is warranted, a slender chain "saddle" can be used and I think "C.L.W." would have been brought to her senses more quickly, and with far less waste of time for herself, if her husband had fastened the chain from which she is shown hanging on p. 49 of No. 9 in

this way. I have heard of "saddles" made of flexible steel about half-an-inch wide, and a friend of ours called Irene ,whose husband Ralph is a regular martinet in these matters, confided to me when I asked her why she was fidgeting at the theater one night that she had been put into one made of horsehair for twenty-four hours. There is also, of course, the "double-saddle", with two straps buckling fore and aft, connected by something like a piece of bone or hardened leather, whose presence is especially difficult for the wearer to forget and grow slack.

The chain "saddle" is no invention of mine, incidentally. I only learnt about it a year ago after Irene and Ralph had visited with us once. Irene, wearing a tight black velvet skirt and her flaxen plaits starched absolutely rigid, had looked rather absent-minded all evening and once I caught her making a distinctly wry face when Ralph asked her to pick something up for him. She had, for part of the time, vanished into the bedroom with Pat, my wife, excuse being that she wanted to show Pat her new bloomers. After they'd gone I asked Pat about them and she described them to me as a gorgeous pair, plum-colored, soft, thin, and clinging. Then she told me that under them Irene had had on a cruel chain "saddle" padlocked

to a chain belt (this chain as thick as that shown on p. 66 of No. 9). She added, "That beastly thing was cutting poor Irene in half." I thought I detected a note of insubordination in that and was confirmed a moment later when Pat said, "She's got to keep it on till noon tomorrow and she had an appointment with her dentist at ten. If she makes the slightest fuss, Ralph has promised to gag her with her brand new bloomers, I do think it's unfair." I decided that Pat would have to have three hours in rather a severe bit.

Pat is a biggish girl, facially rather like the girl J. W. drew wearing the "Roehampton" in No. 10, only dark. She has the same wide-apart eyes, though. Being strongly made she can stand a good go of the ordinary snaffle without too much bother and I find she just has to have something a little heavier to remind her not to be uppish. This time she made a great fuss about being "saddled" and bitted. As I was greasing the corners of her mouth, for instance, she actually said, "Not that *horrid* bit, I won't wear it." Now this one I had chosen consists of two bars, forcing the jaws wide open, and operating on a sort of scissor-like pivot at the side of the cheeks, in such a way that any closing of the mouth, let alone dropping of the head, autimatically tightens the straps leading to the ring in back of the shoulders and, consequently, the "saddle". It's a curb, really. As she continued to make a ridiculous fuss, when I attended to adjustments of the "saddle", I had to caution her quite strongly. She still seemed heated, however, so I took in the "saddle" a couple of extra notches, and affixed a small, studded ball to the bit, which has a special fixture for this, allowing the ball — about the size of a golfball — to dangle in the mouth. This appeared to calm her somewhat.

I put a pair of steel wrist-cuffs on her and ran the short chain joining them through a regulation "Andromeda" in front. The effect was excellent and as the "saddle" was fastened really tight, Pat's head was thrown back even further, I'd say, than that of the girl on p. 47 of No. 8 and a very attractive camber imparted to her hips. I made her do the washing-up with only stockings on, high-heeled shoes, and a pair of dark blue serge shorts. A riding switch was clipped to the back ring, so that she could feel it dangling down her back each time she moved — a stern reminder. However, afterwards, she looked at me so pleadingly, I slipped an open rubber cloak round her neck, rather like that on p. 58 of No. 9, except that it only reached to her knees. This is a heavy cape and

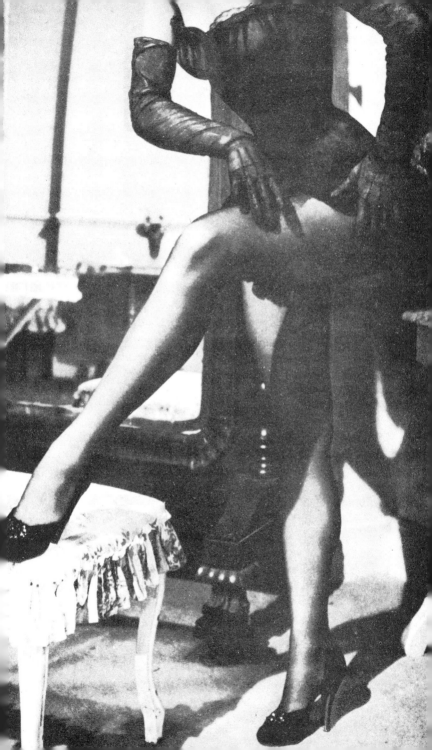

made a lot of noise when she moved.

At bedtime, alas, when I let her out of harness, there were further signs of rebelliousness. As she rubbed herself ruefully, she so far forgot herself as to say, "That bit's an absolute brute, I think you're a mean bully, so as you can understand further discipline was required.

The best to *Biz* from us both,
Sam

ATTENTIVE ATTENTION
Dear Editor,

Usually, Georgie is commanded to perform for me some purely personal service, such as brushing my hair 300 strokes, giving me a dry shampoo, plucking my brows, making up my face or breasts, or giving me a manicure or pedicure. In 1950, instead of a vacation, Georgie attended a school of cosmetology, and he has become very efficient.

The pedicure is Georgie's favorite task. I usually make this in several commands, prolonging the project as long as possible and tantalizing Georgie to an extreme. First he is commanded to remove my shoes and then my stocking. Though sometimes, if I remembered to put on a discarded pair of stockings, I will command him to massage my feet and then my calves before removing my stockings. Then to prepare for a pedi-

cure. This means first to spread a rubber sheet, then to bring a basin of warm water, towels, soap, bath salts and polish remover and other cosmetics.

Many times at this point I apparently change my mind and ask Georgie to bring my stocking case, and maybe my shoe rack. I wear only stockings with novelty heels and seams, or occasionally seamless with custom clocks, and shoes with the highest heels I can find. Then I try on at least six pairs of stockings probably several pairs of shoes, rolling and re-rolling the stockings, parading back and forth with skirt lifted, commanding Georgie to inspect and straighten seams, tighten rolls, etc. Since, next to sheer panties, Georgie is most attracted by neatly rolled stockings and a display of thigh above, and much more strongly by those, shall I say with "bizarre" heels and seams.

If Georgie does a real good job on the pedicure I permit him, as soon as the polish is dry, to kiss each toe. Occasionally I then command Georgie to slip my garters and stockings over my feet, leaving them bunched about my ankles and to put my shoes on. Then I command him to stoop slightly in front of me and placing my heels in his arm pits, pushing as hard as I can, I command him to finish putting on my stockings. This elevates my feet considerably

and since I always choose unusually long hose for this and Georgie has to start rolling way up there, and since I squirm about a lot to be sure he is doing a good job, well naturally my skirt works higher and higher.

When I think Georgie has performed sufficient tasks I command him to be seated. I then ungarter my prisoner, remove the plastic curlers and then the panties, handing each in turn to Georgie who reverently places them on the side table. Instantly my abject slave explodes into a man, all man, and what a man!

Bizarre? or just plain queer? Anyway, it's good clean fun and no couple ever had any more.

Sincerely,
"Clara"

LITTLE LORD FONTLEROY
To the Editor

Although I am slightly past the legal voting age I am the Ward of my maiden aunt who has governed most of my life. She is the social butterfly type who trys to remain pereptually young. To help effect this illusion she treats me like her little boy and always has. She supports me and will not let me work or become independent. If I do not go along with her ideas she will cut off my allowance and since I have never been allowed to become skilled in anything I could not support myself.

She makes me call her "Auntie", and she has all my clothes special made. Most of my suits are made with short pants with which I must wear knee socks. The suit I am now wearing has extremely short pants which button onto a blouse. She buys me little boy toys and makes me drink milk and go to bed at 8 o'clock.

When I am disobedient, which she calls "naughty" she punishes me "little boy" fashion by turning me over her knee and spanking me with a hairbrush .

She has several friends who, like her, are young at heart, and when she invites them to the house I must wear a black velvet suit with short pants, a white lace collar and a flowing red bow tie. She lets her friends hold me on their laps and cuddle me. One lady likes to tickle my bare knees, and another lady likes to spank me. I have to submit to all their whims and fancies. Sometimes after I am spanked I am made to stand in a corner for an hour.

I must admit that I am now and always have been a sissy and I can't do any of the things that a real boy can do. Being rather short my little boy clothes make me look like a twelve year old.

I have been living this way for so long I guess I'm getting to like it: I wonder if any other Bizarre readers have had similar experiences. Do any other boys my age

get spanked and dressed in short pants.

I must close now as it is time for my afternoon nap.

Cordially yours,
"Sissy"

HAPPINESS SECURED

Dear J. W.

I have read in Bizarre several letters from women who wished they could find a man who would be their lord and master and place them in bondage. This is the reason I am writing this letter. I am happily married to a man of this type, but it was not easy finding him.

I am now twenty-nine years old, and I have always loved being tightly bound and gagged.

For several years, while I was dating, I discussed my feelings on bondage and my desire to be rendered helpless with the men I dated. I always carried lengths of cord in my purse and when a date parked in a lonely spot, I would always insist upon my hands and arms being tightly tied behind my back, before courting. Most men thought I was kidding and after deciding that I was serious would tie me half heartedly, trying not to hurt me. I kept marking these men off my list until I met my husband. His name is Dan.

On our first date we were returning home from a movie, when Dan turned off on a side road and parked. We sat there and talked for awhile and then I brought up the subject of bondage and right away learned we shared the same feelings on the subject. We then drove to my apartment and I don't need to tell you we had fun that night. Before too long we were married and now spend all our spare time in bondage sessions, in which I am subjected to various ordeals and sometimes even mild torture. I love it. Most of my punishments I would not dare write about but my husband consented to let me write the following for your readers.

One afternoon, Dan came home enraged because he though I had failed to forward to him an important business message that was phoned to the house. Actually I received no message, but thought it might be interesting to pretend I was just not going to tell. When this happened he was furious, grabbed me by my wrist, and dragged me upstairs and into our bedroom. He then threw me across the bed and roughly stripped off my clothes, then went over and took out some sheer black panties, a bra and a pair of my sheerest black hose and threw them on the bed, telling me to get them on. When I refused he said that if they weren't on in three minutes I would get the water treatment. This is when he ties my hands to

56

the shower faucet and turns the cold water on. I am tied directly below the spray of water and can do nothing but just stand and shake. This is one treatment I cannot stand and Dan can force me to submit to anything by threatening me with it. After I had put on the undies and hose plus a pair of five inch black patent leather pumps I was led down into the basement, where I spend many hours in various types of bondage. On the way down I was told that I had better tell or be sorry. I just acted stubborn.

I was just wondering what was in store for me when Dan grabbed both my wrists together and twisted them up between my shoulder blades. He then fastened them together with a solf leather strap that was connected by a rope, to a pulley in the ceiling, so that it could be raised or lowered. The strap is soft so that is does not cut into my flesh. This is one thing Dan is very careful of. He never cuts or injures me although he can make every bone in my body ache. After my wrists were secure Dan pulled the ropes up until my toes could barely touch the ground. He hurt me but I said nothing. He then taped my eyes shut, I usually am gagged, but I guess he wanted me to be able to tell him what he wanted to know. He asked if I had anything to say and when I remained silent he told

me to holler when I changed my mind and then went upstairs.

The first few minutes in this position were the worst because after a while the ache seemed to leave my shoulders and if I hung very still nothing else hurt much. It seemed like hours, but actually it was only fifteen minutes when Dan returned, removed his leather belt and gave me another chance to talk before giving me about a dozen good lashes where it does the most good. My seat was on fire and I would have given anything to be able to rub it, but I was determined to outlast anything Dan would do to me. Anyway I enjoyed it more when he was angry. After tormenting and giving me a few more lashes this time on the upper part of my legs, around the thighs so the marks would not show beneath my dress, Dan finally let me down. It was some time before I could lower my arms from the position they were in. Moving them was almost as painful as having them twisted behind my back.

Then I confessed that I had just pretended to receive his business message. So Dan decided I needed more punishment for that.

I was taken back up to the bedroom, with my wrists, tied behind me, and given a very strong lecture on telling the truth. I was then laid face down on the bed and my ankles were spread apart

and tied to the bedposts. At this time I was given one of the soundest spankings ever imagined possible. When Dan finished he untied me and made me take a hot bath and put on a sheer red shortie night gown. I was then bound hand and foot and put to bed without supper — still glowing from the spanking.

My husband is not cruel. He is stern with me because he knows I like it and I love him very much.

I hope your readers enjoy this account of an evening at our home.

Sincerely
"Just a wife in Bondage"

PARLOR GAMES
Dear Editors:—

What a bright little magazine you have and what interesting and "bizarre" subjects. But I do believe I enjoy your correspondance section the best. Your subscribers seem to write in just anything they want to and you go right ahead and publish it without a word pro or con. How amusing and broadminded.

It has given me an idea that maybe I can suggest a new subject for discussion which I feel sure many of your sophisticated readers can contribute to — and that is new and amusing parlor games that mixed groups enjoy. The group of Eds and co-eds that I run around with are always look-ing for something new and would appreciate it if some of your other readers would write in and tell us of new games, dances and devices for enlivening an evening of fun and frolic.

An example would be the game that Life magazine wrote up some time ago called "Fumbling" in which the lights were turned out, everybody exchanged clothes and then got in a pile in the center of the room. The boy or girl who was "it" then had to come in and fumble around in the heap until he or she could identify one of the group . . . then that person was "it". We tried it and it really is a kick. For a girl, though, it is more fun to be in the pile than to be "it" as when you are fumblin around you never know what you are going to find in the dark but if you are in the pile if you keep quiet it is hard for the fumbler to tell who you are. Usually it is the girl or boy who is playing "it" for the first time and lets out a squeal or exclamation that gets identified. In Life even judges and Congressman's daughters were playing it.

A friend of my boy-friend who was back on a vacation from the Univ. of California told us of a game they played down there that sounded like it might have come right out of Bizarre. He said he was on a square dance party and after they had gotten tired one of

the fellows hit on an idea. The girls were all wearing these long, ankle-length, very full skirts fastened at the waist with a belt. So the boys secretely agreed among themselves to lure the girls into a room one at a time where three of the boys were waiting.

When the girl came in they grabbed her before she could squeal, pulled her full, ankle-length skirt up over her head and tied it at the top which left her arms, head and all her familiar clothing tied up "in a sack" from the waist up. He said by the time they had all the girls in the room and all tied in a sack they had milled around together so much the boys couldn't tell which was which . . . in fact he said the rest of the evening was spent in each boy trying to identify his own girl by trying to get her to identify herself, dancing with her etc. but to no avail. The poor girls, unable to use their arms or hands, unable to see, their voices and ears muffled were equally in the dark as to which boy was pestering them but once they realized that, while they were trapped, they were unidentified, they naturally refused to give themselves away. In the end they again herded all the girls into one room, loosened the ties enough so they could wiggle out and left them to straighten themselves out and join the boys. He said some of the girls were

mad but that most of them were good sports about the whole thing.

Well, this might give you some idea of what I meant by a "Party" Suggestion Department". I am sure some of your readers must have invented a few party games themselves they might like to exchange with other readers . . . even if it is only some new version of the old high school game of "Post Office" which, I understand has been modernized somewhat with "jet propulsion letters".

If you think I have a good idea here and if you care to publish this letter and your readers show an interest, there are a few more parlor games ours and other groups have invented that I might write in and tell you about. In fact since we have become acquainted with Bizarre we are thinking of having a "Sweet Gwendolyn Dance" in which all the girls bring "Sweet Gwendolyn costumes" with them and the boys all dress up as villains. I wonder if any of your readers have tried that idea?

Yours sincerely
Gloria Jean

TWO TO SERVE
Dear Sir:

Reading your wonderful little magazine is always an anxiously awaited moment with my wife, my Aunt, (who lives with us) and my-

self. In regards to figure training for boys using corsets and girls clothes, I'm well qualified to give your readers some experiences. I am a healthy young man of 25 years of age, but to look at me now you would never know it, as I am writing this letter (under orders from my wife) dressed in a lovely blouse and wide skirt with a flouncey petticoat underneath. And all feminine lingeries too including nylon hose, corset, bra and very high heels.

It all started when I was 15 years of age and I was forced to live with my Aunt who is a very strict and beautiful woman. She used to spank me very often and one day she told me that I was much too pretty to be a boy, so from that time on, until I was 20 I was dressed as any young teen age girl might be. I had my own room all prettied up with ruffles and frou frou. My Aunt laced me in very tightly too until my corsetted waist was reduced to a neat 17 inches, what it is today.

Then I met my wife who also liked to see me in feminine clothes dresses, lingeries and above all high heels. We were married and I had to swear to her that I would obey all her wishes and serve her always in all things. My Aunt then moved in with us and now I have to serve both of them and they have little fashion shows with me as the model every weekend.

My wife says that I'm to tell you that I make a wonderful maid and that I'm her cute lil' "sister" to all her friends. I am also to tell you that very soon I will write again and relate what happened at a party she gave for her girl friends one night with me as the French maid.

I will close for now hoping you will publish this letter for the benefit of other readers.

Sincerely
Billy R

RUBBER MUDLARKS
Dear Editors:

An ardent reader of your magazine, Bizarre, I would like to make a plea for more photos and articles on rubber rainwear and for the publication of more letters by rubber enthusiasts. How about a feature story in some future issue on the history and development of ladies' rubber rainwear . . . rubber footwear in particular? I think all we rubber fans would enjoy such an article. I've been a devotee to rubber clothing for quite some time. Love to see it worn by the female sex and also enjoy wearing it myself. Fortunately, I have a girl friend who has the same intense intesest (due to my influence, no doubt) and we both enjoy romping in the rain and in rubber gloves. One of our favorite pastimes is sloshing through deep, thick mud while wearing

BIZARRE'S
$50
LEG COMPETITION

To prove our point that from the waist down what suits women also suits men — we are having a competition.

HERE'S WHAT YOU DO:-
Send in a photo. (and the negative) of your legs — wearing nylons and high heels (no platforms allowed) together with the information (*which will not be disclosed until the end of the contest*) as to whether the legs are male or female.

The photos will be published in issue No. 21 — when readers will be asked to pick which are male and which female legs. The winner of this contest will receive
A CASH PRIZE OF $20.

The owner of the most shapely legs in J. W.'s judgment will receive
A CASH PRIZE OF $20.

There will also be a prize of $10 for the best legs of the opposite sex to the winner.

No one connected with our studio is eligible.

ALL ENTRIES MUST BE IN BY JUNE 15th 1956.

Note:— Hairy legs are a dead give away — shave them.

rubber boots. Are there any readers who enjoy this activity? The girl friend and I know just the spot a short distance from the city for "mudlarking" and we spend all of our free time there in the Spring of the year.

My collection of rubber gear is rather modest, limited to a couple of pairs of knee-high rubber Wellington boots and hip-length fishing oots, a rubber mackintosh and about a dozen pairs of rubber gloves. However, my young lady friend has a complete closet full of rubber clothing (most of which I bought for her). At last count she had 19 pairs of rubber rainboots . . . of the type to be worn over the shoes, both flat heels and high heels. All colors are represented . . . black, white, red and brown. There are 8 pairs of knee-high Wellingtons (in the same color assortment) to be worn over stocking feet and 5 pairs of fishing boots (both hip-length and thigh-length). She has 2 rubber mackintoshes (of pure rubber, not rubberized material) . . . one is black, and the other white. Both are hooded. There is also a white rubber raincape. Our latest craze is for the currently popular oilskin (or plastic imitation) slicker with matching sou'wester rain hat. Both of us despise plastic (es-

pecially in footwear), but these rain slickers and hats seem to appeal to us strongly for some reason.

Our favorite is the yellow style, and besides this she also has a set in black, red and white. We don't care for the transparent gloves, ranging from wrist length household gloves in red rubber to shoulder length surgical gloves of an amber hue. I might also mention several rubber bathing caps and about half-dozen rubber girdles and panties. For her birthday I intend to buy her a frogman suit to make her rubber wardrobe complete. I think I am most fortunate to have found a girl to share my hobby. As a matter of fact, there are very few women who are interested in rubber. Wearing rubber boots on a rainy day seems to be quite an ordeal to the average woman. Please, J.W., let's see more space in Bizarre devoted to rubber, and how about some photos showing a pretty young miss attired in a yellow rain slicker and matching hat. Soon as I get myself a good camera I promise to send you some excellent shots of a very charming miss attired from head to toe in rubber rainwear.

Most sincerely,
"Wet Weather Fan"

still another smog mask style —
LONDON

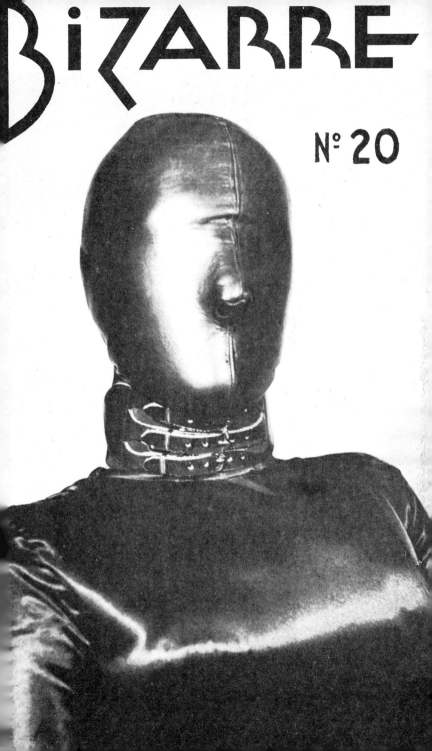

BiZARRE

N° 20

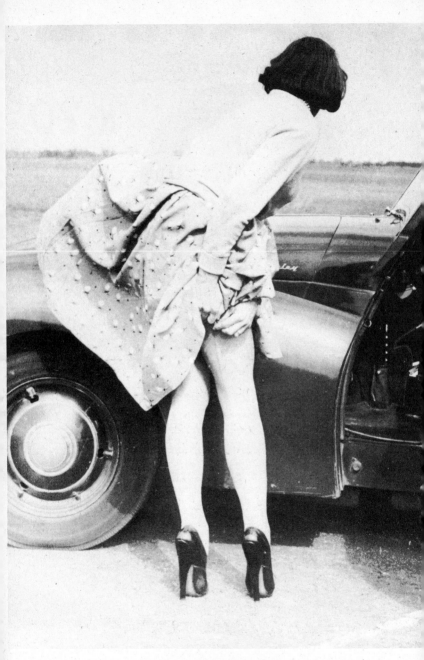

the car is a Riley

BIZARRE

Copyright 1956 U.S.A. by John Coutts

"a fashion fantasia"

No. 20

Ah, with the Grape my fading Life provide,
And wash my Body whence the Life has died,
* And in a Windingsheet of Vine-leaf wrapt,*
So bury me by some sweet Garden-side.

OMAR KHAYYAM

CONTENTS

ENTIRELY CORRESPONDENCE FROM READERS

THE COVER:— BATWOMAN

illustrating the old saying "blind as a bat"

BACK ISSUES

All back issues are available from No. 1 inclusive at $1.50 each post free.

If your dealer cannot supply you write directly to:—

P.O. Box 511, Montreal 3, Canada.

Editorial

Please do not send any subscription for No. 21 etc. we will let you know when it is ready. At the moment we can give you no definite date — all we do know is that it will not be in one month's time.

The reason for this is that on top of the effort required for a monthly we have had so many problems that we're absolutely worn out — and we're afraid the magazine shows it.

We have always tried to turn out nothing but the best, even if many readers are satisfied with any old thing, and so rather than be mediocre we think a rest is called for to revive our shattered tissues. Summer is here, and vacation time, so we are all taking off in our several directions, for the month of July.

For those of you who are disappointed at the omission of the next tale from a bottle about "The Magic Island" we apologise — but we got so many letters since the publication of No. 19, saying that the serial "stunk" — that we decided not to put it in. Oh well we can't please everybody.

As you know this is election year in the U.S.A. — and the do-gooders are really whooping it up trying to blame everyone (and publishers in particular) instead of themselves for all the juvenile delinquency that's around. You can believe it or not but there really are people who are firmly convinced that every reader of Bizarre is a potential homicidal maniac — if therefore you find your local bookstore or newstand suddenly has no more Bizarres, don't despair, just write to us direct at P.O. Box 511, Montreal 3, Canada.

And while we're at it will all readers please note that we publish no other magazine but Bizarre. We publish nothing else — period! and we always sign every sketch and every copy of Bizarre.

All sorts of strange wild fowl are using the name Bizarre in various ways. They have absolutely no connection with us whatever — so if you do business with them and get clipped — don't blame us.

4

DOWN ON THE FARM

with "Sylvia Soulier"

there's the farm ! — over there — see ?

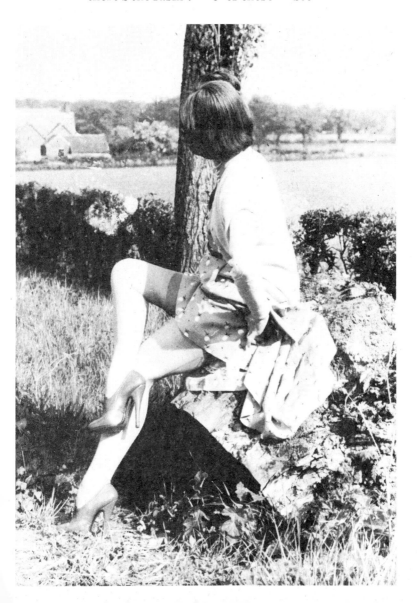

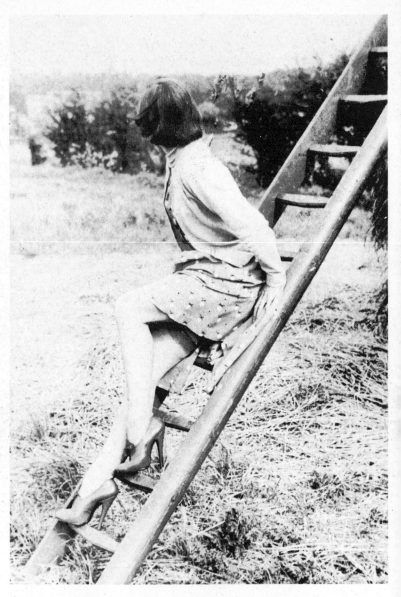

you get a better view from up on a hay stack

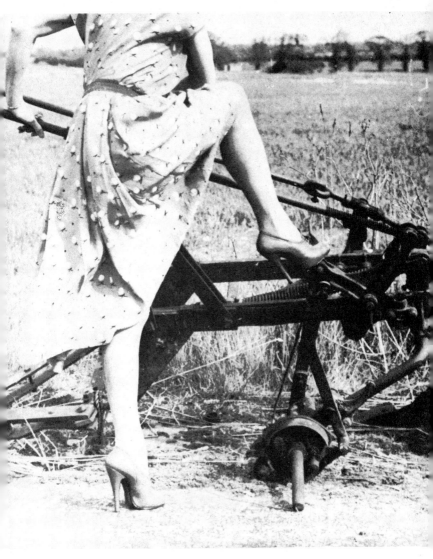

of course there's lots of ploughing—

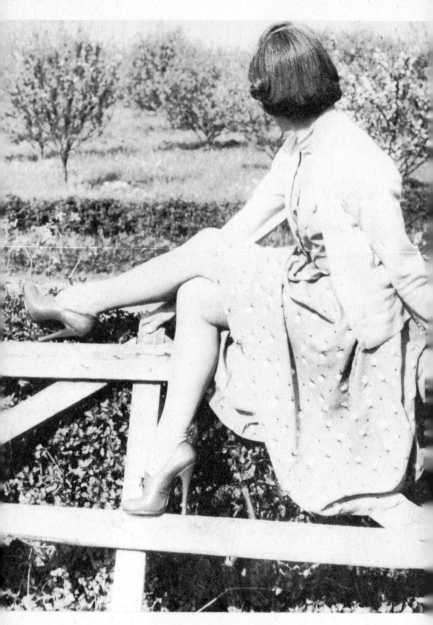

and there's the orchard—

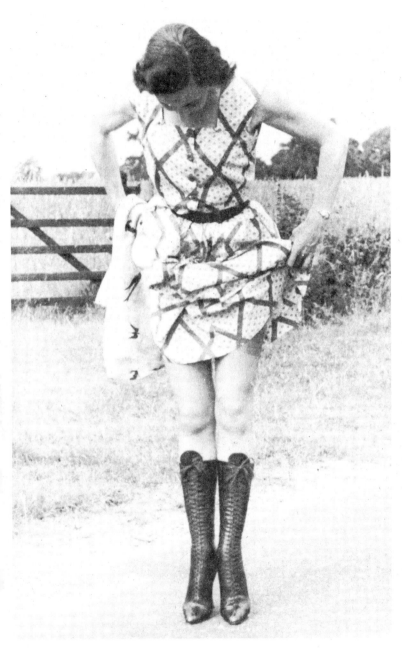

now isn't life on the land grand !

orrespondence

Under no circumstances do we publish names and addresses, nor do we put readers in touch with each other. If photos or sketches are sent in, please write a short commentary and please do NOT send in photos which you got from someone else.

Quite Embarrasing

Editor,

A cartoon in the Sunday comics shows "Mrs. Schmaltz", who has just spanked her husband, saying, about children and husbands generally, "I think they ALL need a good spanking now and then, whether they've done anything or not!" What brought up the subject is that Myrtle is about to be spanked by her mother with a ping-pong paddle.

Well, Mrs. Schmaltz, expresses my wife's philosophy exactly, although my wife is a lot younger and prettier than Mrs. Schmaltz; and it is this philosophy which has given me many uncomfortable moments. By a coincidence the ping-pong paddle is one of my wife's favorite spanking instruments too.

This cartoon, like your magazine, shows that our household is not so unusual.

My wife is a great big beautiful gal. She is 16 years my junior. I thought my money would be enough to get her to marry an "old man" like me, but in addition to my "wordly goods" she made me promise to submit to her discipline. This means humiliating myself by kissing her feet in their glistening high heels, acting as her personal servant, etc.; but worst of all, submitting to whatever corporal punishment or restraint she may devise. Most often this means a good sound spanking.

Believe me, I endure a lot to gain her small favors. But they are worth it!

She has also made me hire a pert young maid at a salary so high that Madam can spank the maid whenever she wishes without danger of the maid quitting her job.

Now I don't mind her spanking the maid. In fact I get a kick out of it, seeing that pretty young thing over my gorgeous wife's ample lap like a naughty child,

10

her skirts up, legs flailing, while the hair brush, or paddle, or my wife's good right hand smacks those tightly drawn lace panties. And if the mistress is especially angry, the spanking is administered on the bare derriere, but I don't like being spanked myself in the maid's presence. I enjoy my "slave life", being servant to my beautiful wife; but to have that pert young maid know that I am spanked just as she is — that is humiliating! It happens often. The first time was when Annette, the maid, had only been in our employ two days and had received only one spanking herself. I was slow in coming to Madam's bedroom after she had sent Annette to summon me. Madam lectured me and then told me to arrange myself over her lap for a spanking. She told Annette to bring her the hairbrush from the dresser, and then proceeded to use it with her usual vigor in the place nature intended. How embarrassing! — but I was to know that embarrassment often.

It is thrilling to live under the dominance of Madame, my wife.

Sincerely yours, J.M.

A CURE FOR "JEANERS"

Dear Editor:

I note that one of your readers was wondering if girls were ever punished by being made to wear certain types of clothing, the reader mentioned the fact that many boys were "put in dresses" as a punishment but that girl's were never mentioned as regards this type of "beneficial humiliation."

Well here is the answer. In 1919 I was 16 and not so sweet as aunty would have liked. In those days you never saw a girl in 'jeans' and boyish garments as we do today, girls were strictly feminine. But to the point; I had a temper and if it be ladylike or not I was a bit of a 'scrapper', it all started at Sunday School. Another girl made a remark I didn't like and I slapped her face. This brought things to a head as there had been many previous such actions on my part.

My Sunday School teacher took me to her study and I received a sound spanking, my modesty was not spared! (We wore many frills, ribbons and ruffles in that era.) I was taken by my teacher to my aunty (we lived nearby), aunty and teacher discussed my present and past in private. I assure you that it was not angelic! When my Sunday School teacher had left aunty took me out and made me cut a switch, into the family woodshed I was marched and over

11

aunty's lap I received a switching that I shall never forget, also again my feminine modesty was 'bared!'

The next morning when I got up I was held by aunty and our hired girl and my hair was shorn like a boy's, how I cried and sobbed! You may recall that boys at that time wore stockings and knickerbockers, well I was put into coarse boy's porous underwear, coarse ribbed cotton black stockings held up by the regulation supporter harness. I begged on my knees when I saw a pair of boy's knickerbockers in the hired girl's hands, my screams to be let off did no good, the boys knickerbockers were pulled on me, a boys coarse shirt was tucked into my pants, my fly was buttoned up and my belt pulled thru, clubby boys shoes were put on me, my face was scrubbed of all make-up, I was marched to a full length mirror and here I sobbed as I saw myself, a 'me' that I did not know! My boy's knickerbockers were very tight, my hips wide, I protruded in a most shameful way! The knickerbockers came to just above the knees and my very shapely legs were indeed a sight! Oh how to describe it, I felt just like a girl minus petticoat and dress being exposed in her skin-tight bloomers. My shirt was also tight and that made my shame all the more deep. A boy's neck-tie was put on me and a boy's cap placed on my head and I was dragged to school. What a sight I made and how the girls giggled and how the boy's feasted their horrid eyes! Aunty told my teacher not to spare the strap when I needed it and believe me teacher did not spare it! I was made to play boy's games and was treated just like a boy. My punishment lasted 3 months and during the whole time I could scarcely ever sit down! As I would pass by a group of my fellow students I would hear remarks, they all called me 'Don' and in my humiliating knickerbockers and long black stockings with my very girlish legs and wide hips, with myself protruding, there I was with a boy's hair-cut, all the time in all my blushing shame trying to pull myself 'in' and feeling like a girl caught out in her tight black bloomers!

To this day I will not wear slacks or 'pushers', all my masterful husband has to do to make me obey is to wave a pair of slacks or men's pants at me. Several times he had found it necessary to administer a sound spanking to me and put me into men's clothing — and at my buxom age!

I wonder if some other women have had like punishments?

Shamefully yours, Dora

* * * *

12

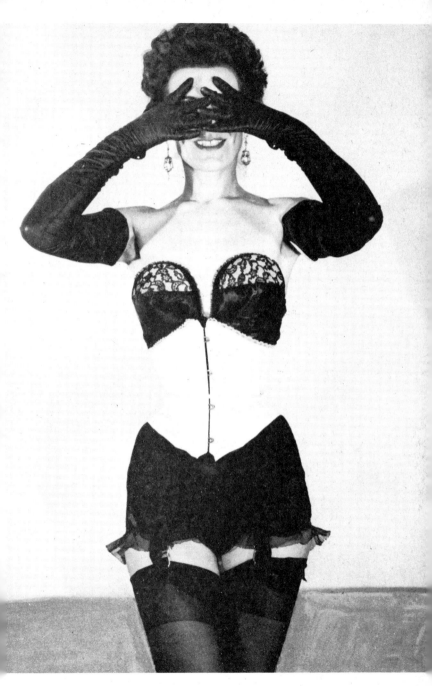

peek-a-boo !

2 Months Hard

Dear Editor;

I have read many of your 'Slaverette' letters from readers and a dear friend has begged me to tell you my unique story.

My husband loves the races, he has helped for years to keep the bookmakers in Cadillacs. Well the grand climax was reached two months ago when he took the church money that I had charge of to bet on a race. The church ladies paroled him to me. (The Ladies' Aid are not without imagination I can tell you!)

My husband Jack is 27 and I am 32, Jack works as mate on a fishing boat, he works three months and is off two. Well to get at it; we of the Aid Society had a tread-mill made at a foundry here in town and set up in an old barn that we have out back (we have five acres of land here on the edge of town.) Until we decide that Jack has paid his debt he must spend his two months off his regular work at hard labor. And I mean hard labor, I am going to cure him or else!

For his time on the tread-mill he is dressed in "reformatory" garments, what we girls call our own special idea of "reformatory clothing!" He wears women's square heeled shoes, long brown cotton hose held up by supporters that are attached to his tightly laced old fashioned corset, he wears white flannel bloomers that fit him like skin and a dress that just reaches the knees, the dress is of cheap cotton and white. The tread-mill does not tread easy, he must really work to make it revolve. I keep a rawhide whip hanging handy at the scene of his labors and I use it when he needs speeding up at his task of paying for his crime. When not at the tread-mill he must pull a wagon loaded with rocks around the five acres. for this I hitch him and I ride while he pulls, I use a regular buggy whip when he needs tickling up. I tell him that he likes horses so well that he should like this. I have the barn heated by an oil furnace and so he sleeps there and eats there, *in a horse stall.* At night he is fed in the regular feed box and when he retires I lock a special bridle on him, and the chain is long enough to permit him to lie down and sleep — *in the straw!*

The members of the Ladies' Aid love to call and watch him sweating at his tread-mill in his shameful 'reformatory uniform' and they love to watch him pull the rock wagon around the field (The field is closed in by a thick hedge and private). Most of all they like to see him jump when I use the raw-hide whip.

Once a week, on Saturday night before 'Jackie' retires I

14

fasten him in his stall and after preparations that expose him properly I whip him soundly, I alternate each Saturday from rawhide whip to leather strap. We do not know how long this will go on but I am sure it will be quite some time, he will report for his two month off period to us until we feel he has paid well and that he is cured, he had to take this or prison. Begging does no good, I love him and he loves me and I feel that this will bring us closer together, indeed I can tell that it has changed him, he seems to have become more like a loving slave than I ever dreamed or hoped he would. I am very pleased as I look into the future!

Well I must get back out to the barn, the ladies are coming and we wish to check up on a 'horse-lover' and of course do some 'horsing around!'

Respectfully, Juanita

THIS INTERESTS US

We are publishing this letter— *with our Editorial comments in italics* because it expresses the views of a multitude of readers, and our own feelings on the matter—

Dear Sir:

There is just one thing that troubles us.

At the head of the correspondence section in each number you place great stress on the fact that you do not print names and addresses of correspondents, and do not put readers in touch with one another, etc. The tone of these proclamations seems to us — if you will forgive the expression — as pious and puritanical as that of any censorious old bluenose. (*our nose is bucolic and rubicund, not blue.*) What on earth can you be afraid of? (*nasty people*) If you really believed there was anything wrong with the subjects discussed in Bizarre's articles and letters, you wouldn't print them, would you? (*no — so?*) And as for respecting the confidence of your correspondents, how can you be so sure that there are not many of us who would actually welcome the opportunity of hearing from other readers having similar interests? (*The number is not "many" — it's enormous.*)

Of course, all correspondents who prefer to remain anonymous

deserve to have their privacy respected, and you are surely to be commended for showing them this consideration. (*Thank you*) But there must be others like ourselves, who, feeling somewhat alone in this world of rigid and asinine conventions, would be delighted to make the acquaintance of fellow enthusiasts. (*again quite correct.*) Where the different parties specifically request it, what possible objection can there be to putting them in touch with each other. (*In this world there are all sorts of strange people who in various and devious ways make life unpleasant for others. We are not going to be responsible for introducing a "Sinbad" to the Old Man of the Sea — so — we flatly refuse to introduce someone of whom we know nothing to someone else of whom we know still less — no matter how agreeable they may sound in their letters.*) The Saturday Review, through its "Personals" columns, offers this very type of service every week. Their system is simple but effective, and, incidentally, it is responsible for a good part of their circulation. If the Saturday Review can do it, why not Bizarre? (*the answer to that should be obvious — just think it over*)

Sincerely yours,
J.D.R.

TORRINA ON CORSETS

Dear Mr. Editor,

In corsets I favour the short but very tightly laced-in short style, enough to cover and hold in my hips and support my bust well above the corset, for I am not of the school that believes a woman's glorious bust should be squeezed into nasty un-natural shaped brassieres which are part of the corset itself, I favour my soft kid brassieres above the corset. But more of the corset itself, all mine are of the sofest kid like my footwear, rather stiffly boned to a shape and cut that I must force my body to accept and follow when completely laced together. I said together because I do not admire the easily laced corset which does not allow its fullest shape and beauty to be kept.

Opposite to lacing the long style corset, a slow long gradual lacing in is not called for, the short lacing corset can be very quickly drawn in and closed, though I must admit I do at first have to hold my breath from the extreme suddenness of the tightening in. Again I lie upon a perfectly flat soft couch whilst either my maid or *fiance* pulls me together. To the couch are attached two wide leather straps which are buckled across my thighs and upper waistline and pulled tightly firm. In this position my relaxed body has

16

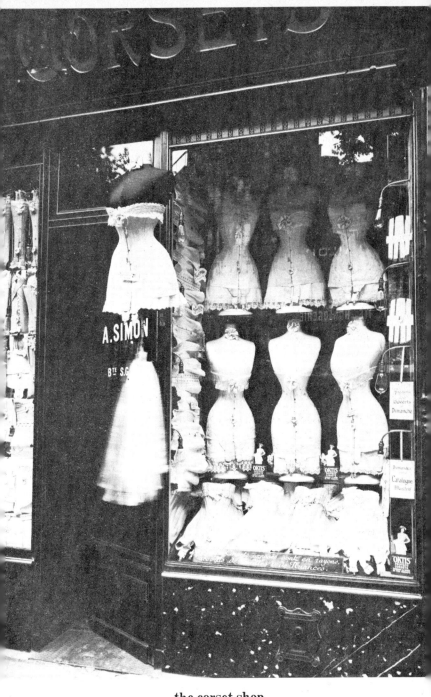

the corset shop
(*Paris*)

no tendency to lift with the firm pulling which I must Alas! undergo during the lacing. The feeling is odd at first, quickly my waist is squeezed in feeling as though I should be cut in two halves, then after a few moments I feel my thighs get a little numb at first, and these two sensations in some way that is always odd to me, completely take away the sensation I have at the small nipped in waist. But oh, horrors, when those lacing in hands return to that already small waist I lose all sensations around my waist, as the laces now the more easily drag my waist into its stupidly tiny dimensions. This process I describe happens in three separate ordeals, before finally and almost unable to breathe, I am just aware of that final waist fastening and the knots being secured and knotted.

Before I was properly trained for such tight lacing my *fiance* used a contrivance made of two inch deep brass strip which having been placed round the corset before it was finally laced up, could be screwed tighter and tighter round the actual loose corsetted waist, thus pulling it in sufficiently for the corsets to be more easily laced to that dimension, after which sometimes the brass belt for lacing was finally removed, allowing me a queer sensation of my body being sud-

denly left to itself to expand into the tightly laced in corset. Though drawn into 22 or 21 inches believe me dears I hadn't much expanding left to do.

All my short severe corsets are back lacing with steel busks down their fronts about two and a half inches wide. Fastened together, at the front bottom end of the corset to take the strain, was a small leather strap and buckle to finally close the lower ends of the corset.

At first when I was being made accustomed to such severe corsets I fainted off once or twice during lacing, but was quickly revived with smelling salts and made to face up to my discomfort. Since those awful days of my training I have of course become quite an inveterate tight lacer and would feel simply awful in anything slacker, in fact I do often sleep reasonable tightly laced in special satin sleeping corsets of black satin with nice frilly laced tops and bottoms.

Over all my outward dresses and attire I like to have the full effects of a corsetted figure shown off to advantage, and for that favour the well tightened leather belt with one or more strong little buckles that can be easily diminished hole by hole.

My gloves hardly seem worthy of mention, being so comfortable in comparison with my other fa-
(Continued on page 22)

The Judgement of Paris

(corset division)

No. 1 VERA ELLEN

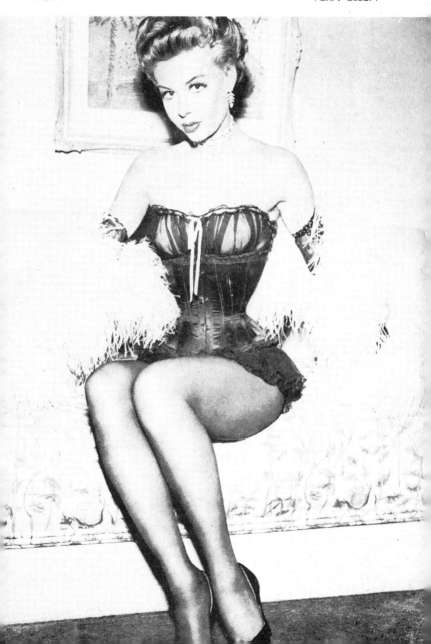

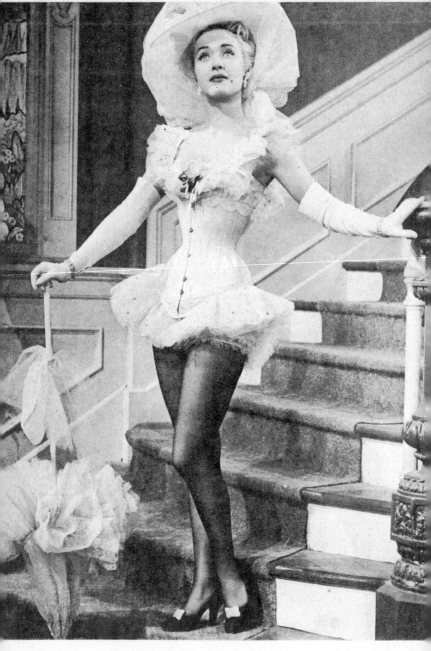

No. 2 JANE POWELL

No. 3 LANA TURNER →

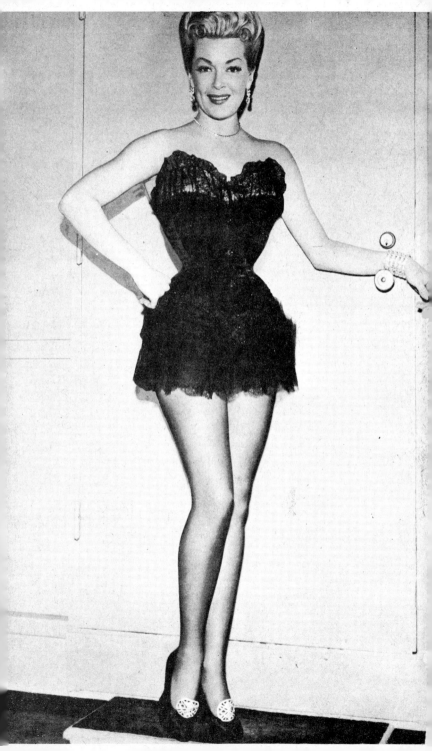

vorite fashions that please my *fiance*. All gloves that I wear must be full length, or what is known as thirty button, sometimes twenty four button, never lower, this doesn't mean actually buttoning, but that they reach the round of the shoulders as you probably know already. My arms have of course to be heavily powdered before easing these softest kid skins along the entire length of the arms. Gradually from finger tips to wrists they are eased up and buttoned, then slowly I have to ease up the rest of the long glove, inch at a time, tightly over the shaped elbows and so on to the shoulders. I have gotten over the usual complaint of shoulder high gloves being too ample. The last six inches of my gloves are fashioned smaller and opened, with eight tiny neat lacing eyelets, and are laced with the arms fully stretched out with fine silk laces. These tighten the forearm of the glove, and have the advantage of biting into the soft fleshy part of the upperarm, thus preventing any vestige of slipping afterwards. I loathe to see a woman's kid gloves slipping baggily around her forearm.

All my rings and bracelets I wear over and outside the glove itself, a somewhat unusual Barbaric idea of my own.

In one of your recent Magazines I saw a photo of many steel shackles or handcuffs, which makes me relate to you that I have a pair of solid silver handcuffs with detachable chains, and wear each handcuff separately locked to my small gloved wrists, when I dine out at a fashionable restaurant. Wearing them, at a fancy dress party some time ago in Milan my *fiance* made me wear them with the little connecting chains in place, making me feel terribly self conscious and slavelike with him as an escort.

Well, Mr. Editor I hope this account of real life facts will not bore your readers who like myself like wearing the bizarre fashions, for they have their proper place, and that to my mind is in the company of the man who admires you the most and of your choice, I married my *fiance* some years ago now, and have never regretted the rather severe training he enforced upon my rather unsophisticated girlhood at that time, for we have of course now in marriage no quarrels and a complete understanding together, and what is more I am sure he wouldn't look at another woman, and if he did, well! I should think I was slipping badly, and the modern Miss who is prepared to undergo the training I underwent to attain what my husband calls "Perfection" . . . Well! I'll have to start all over again, I suppose.

But believe me I have no worry, and my husband is well contented

with his wife who can wear these days up to a seven inch heeled boot or shoe, and lace down to eighteen inches over the rigid laced corset, and if he did, believe me his shaven face will meet the softest of kid gloves smartly cracking across it.

<div style="text-align:center">Yours very sincerely,
Torrina</div>

FROM THE CLASSICS
Dear Mr. Editor:

I thought this translation from the Diary of a Chambermaid by Octave Mirabeau might interest your readers.

—"Thus it would not displease you if I were to call you Marie?"

—"Not at all, Monsieur . . ."

—"Ah, such a good girl . . . So pretty and with such character . . . very nice . . . very nice indeed!"

He said this to me with a preoccupied air, very respectfully and without staring at me, without any of those looks that undress the person beheld, seeking to discover the secrets of the blouse and skirts, without any of the lewd directness so typical of most men. In fact he had hardly looked at me at all. From the moment he had entered the downstairs parlor, he had kept his eyes obstinately focussed on my high laced boots.

—"Do you have any others?" he asked me after he had been thus absorbed, and it seemed to me that his eyes had suddenly taken on a gleam of strange intensity.

—"Other names, Monsieur? I asked.

—"No, my child, other high laced boots?"

And saying this, he darted his tongue quickly over his moist thin lips, as if he were a cat about to savor a dish of cream.

I did not answer him at once. The tone in which he had pronounced the word "high laced boots" had in it a saucy, if not impudent quality that made me think of an insolent coachman. Disturbed by I knew not what, I could tell that his interest had *meaning.* As he began to question me strongly on the subject I finally answered him but with a hoarse and troubled voice, as if I had been forced to confess to an amatory indiscretion.

—"Yes, Monsieur I have other pairs . . ."

—"Are they . . . well . . . well polished?"

—"Yes Monsieur."

—"Very, *very* highly polished?"

—"But of course, Monsieur."

—"Good . . . *good* . . . and are they yellow leather boots?"

—"Not in that color Monsieur . . .

—"You simply have to have such a pair . . . I'll see you get 'em!"

—"Thank you, Monsieur."

—"Good! good . . . but . . . quiet about this!"

I was afraid for I noticed that the expression of his eyes was troubled . . . he seemed to be on the verge of a nervous disturbance . . . drops of sweat appeared on his forehead. Thinking that he was about to collapse I was about to call for help but he suddenly took hold of himself and began to calm down, and after a short moment he began to speak again in a slightly agitated voice and I could see that a touch of saliva foamed at the corner of his mouth.

—"It's nothing, really . . . all over now . . . Believe me, child! I'm a bit of a . . . maniac you know about this . . . Heavens, at my age a chap can be allowed his little . . . shall we say eccentricities? Forinstance . . . I simply cannot abide that a woman debase herself to the point of polishing boots . . . even mine . . .

Marie, I have the greatest respect for womankind and I simply cannot allow it . . . *I* shall polish your boots, your little boots, dear girl, your *dear* little boots! I . . . I shall take them to my arms . . . Listen to me! Every night, just before you go to bed, bring your little boots to my room . . . put them right by the bed and every morning, as you come in to open the windows to air out the room, you'll take 'em back, your little boots!

Seeing my look of astonishment he added.

—"See here! I'm not asking you to do anything dreadful . . . it is the most natural thing in the world . . . and you're so nice!"

Quickly he took out two five franc gold pieces and thrust them into my hands.

—"If you're very sweet and do just as you're told, I'll see that you get many little presents. The governess will pay you your wages as usual but Marie . . . just between us, I'll have little gifts for you . . . often, Marie . . . and what do I ask of you? Is it so dreadful? Good God, is it?

Monsieur became more and and more agitated. His eyelids were fluttering, in his excitement, like leaves in a windstorm.

—"Why don't you answer me, Marie? Say something . . . why won't you walk for me . . . *do* walk for me so I can see them

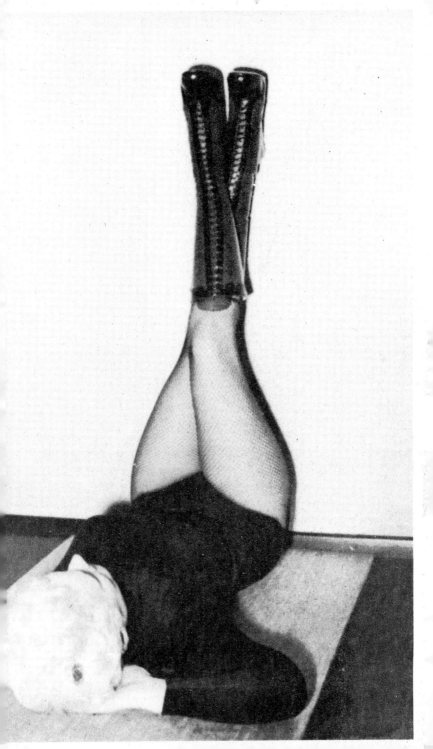

move, so I can see them alive, those lovely little boots of yours!"

Suddenly he threw himself on his knees, and kissed my laced boots, grasped the fine textured leather in his feverish hands, and began to unlace them. As he thus worshipped my boots caressing them, kissing them he kept murmuring over and over again with the voice of a whimpering child: —"Oh Marie . . . Marie . . . your little boots . . . let me have them now! right away! right away . . . I must have them right away . . . give them to me!"

I was paralyzed . . . I wasn't sure if I were dreaming or awake. I could see the fine red veins that made a network at the base of his bulging white eyes and his mouth began to dribble.

Suddenly he ran off with my unlaced boots and remained locked in his room with them for over two hours.

Four days later I entered his room at the usual hour to open the large windows that gave out onto the garden. I nearly fainted . . . Monsieur was . . . dead! Almost completely undressed, his rigid form was sprawled on the bed. He did not appear to have struggled at all. The bedclothes were undisturbed, and he was smiling like a contented child, in fact I would have thought him asleep if it had not been for the terrible purple flush of his face, a dread purple, with the implications of doom. Then I saw on coming closer that he held one of my boots clutched in his hands — tightly — held in the vice-like grip of death.

SMARTER MEN?

Dear Editor;

Your article entitled "The Great Revolt" in a past issue was very interesting from a feminine point of view and since you asked for comments, let me give you mine.

I think a situation as described in the GR would be delightful for a change. Perhaps after the reluctant males had been subjected to various beauty and grooming treatments they would have a better appreciation of what a woman goes through to look exceptionally attractive. Men in general would be more attractive even in this day and age if they would utilize available grooming aids to help them present a more refined appearance. Little things like well manicured nails, better skin and hair care, are quite important. But most of all, there is a crying need for male figure control. The fat slobs who think their corpulence is a sign of prosperity would be surprised to know how revolting they really look. Wearing a good girdle would be the least they could do.

Believe me, I would delight in figure training my slaves down to

size. Wasp waisted males would surely make a better appearance than the pig waists do now. I'd begin their figure training with corsets that started at their armpits and came down low enough to insure a firm hip line. Any slave with a double chin or weak chin line would have to wear a corrective collar and a tight leather mask-helmet that would act like a firm chin strap. The mask-helmet would have nose and eye holes and be laced on skin tight. Naturally while in the mask, speaking would be impossible so there would be no need to bother with a gag. As a matter of fact, I think I would mask all my slaves at least two days a week just for discipline with bad cases getting more time.

Type of slave dress would vary at my discretion but short, snug skirts and opera length hose with high heels would be worn as street dress. No slave could appear in public unmasked. One last important item to guarantee fidelity would be male chastity belts. I'm sure many wives even in the 20th century would feel more secure if such an item were in general use. Yes, it would be a delight to have the men restrained.

Such a revolt would result in a better world. How could any wasp waisted male be anything but docile when taking a deep breath would be exertion enough.

Who knows, after the men got used to their new figures and restraints, they might even like it that way.

Sincerely, B.L.

INFORMATION PLEASE—
Dear Mr. Editor:

Having seen your unique magazine at a friend's house, I was very much interested in a letter from "Pierced Ears" in which he refers to his daughter as just turned 13 years of age and just commencing cigarettes and high heels. It seems to me he might have some valuable pointers to give your readers on the bringing-up of a modern daughter and the habits of teen-age girls today, and we would welcome more information.

For example, considering the time elapsed since the magazine appeared, his daughter must be at least 14 years old now, and in high school. How many cigarettes a day does she smoke now? (My niece, who is 15 boasts proudly that she is a chain-smoker and smokes "all the time.") Does she smoke on the street? Has she tried cigars or a pipe yet, and if so, did she enjoy them and continue them or give them up and decide to stick to cigarettes? Does her high school allow the boys and girls to smoke on the campus or not? Does it have a smoking room for the students or not? Do most of her girl-friends

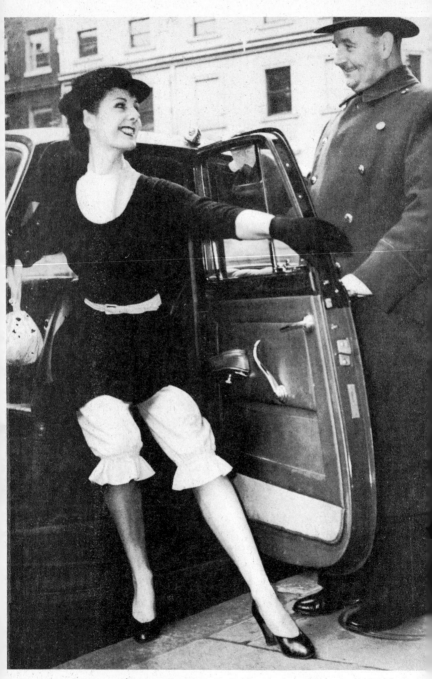

is London going back to bloomers ?

smoke, and do they have their parents' approval? Do they smoke as much as she does? Do they ever smoke cigars, or a pipe?

This is just a sample of the interesting and valuable information on one aspect of modern teen-age girlhood which a parent like "Pierced ears" might furnish your readers. There are many other things we would like to know. At what age did she first use lipstick? Does her high school allow the girls to come to school with bare feet (without either shoes or socks)? Have the girls of the city adopted this delightful fad? What do the boys think of it? Does she wear three-inch heels at parties? Has she tried four-inch heels yet? And so on.

And I would suggest that "Pierced Ears" should adopt a name, or initials, so that readers can refer to him conviently and sensibly. It seems pretty silly to have to call a man "Pierced Ears."

Yours truly,
R.G.B.

CORRECTION PLEASE

Dear Friends:—

I seek help. I address this esspcially to those women that have boys in their care, step-mothers, mothers, aunts, etc., etc.

I have a 16 year old step-son. He is mean and a bully, he abuses his step-sister, that is he hits her and teases her, makes fun of her

clothing and calls attention to her things when they are on the clothes line, he is just getting impossible with his mean sissy ways.

Can any of you please offer a solution, maybe you have had a like problem, please help me if you can.

Thank you, thank you very much.

"Worried"

RECOLLECTIONS OF A BOOTMAKER

Looking through perchance recently a copy of your Magazine Bizarre I noticed that many of your lady readers still cling happily to some of the good old fashions in Footwear and the delightful High Heel and all that goes with it. As an old time Master Bootmaker I thought that possibly you might have a little space for a few words from an admirer and craftsman in that line.

To my mind the modern Miss can still hold her own when it comes to elegant footwear, and no doubt being more athletic than her Victorian Sisters, her supple limbs and muscles lend more easily to these higher heels of today, that have everywhere and in every country found favour again with the ladies and men. In my days a lady would endure torture from shoeware with super high heels, so long as she became the talk of the town. She would endure several sizes smaller than she actually

29

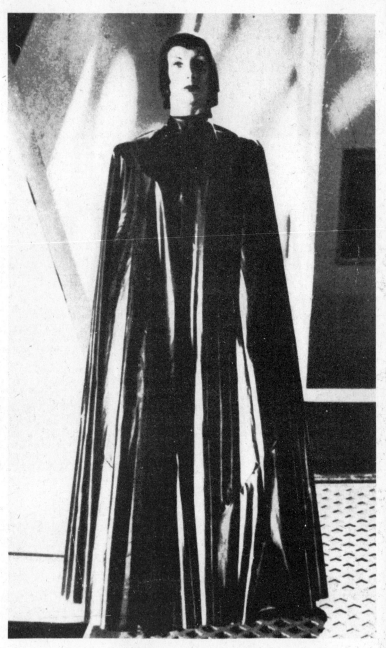

the black rubber cloak

took to achieve this end, and as a Maker I well recall many little interesting incidents relating to their achievements in these directions.

In those days High Boots were quite as much the Vogue as shoes were, and most shops showed fine examples of these delectable fashions openly and for sale to all who would be in Fashion's Gay Parade.

We Master Makers thought nothing of being asked to make a pair of shoes or boots for m'lady fair with five and six inch heels. In those days it was the Semi-Louis and Full Louis styles as they were known, well curved under in a deceiving manner, but nevertheless just as difficult to manage, unless you were a lady of Society well and truly trained from girlhood and at school, in the Art of proper Deportment and walking.

Favourite amongst the styles in shoes were perhaps the ever elegant, and glistening Patent Court shoes with their massive diamante encrusted and bejeweled buckles vertically poised in front. Lace up shoes for more ordinary wear were tightly laced, long and very narrow, many with elegant sharp pointed toes. How women ever managed to squeeze their little toes into some of those cruel shoes I have often marvelled. Some of those pointed sharp toes were a few inches longer than the

actual foot itself, and many raised along the top edges which we called 'Knife Edged' style.

In those chivalrous days a gentleman would think nothing of carrying a lady to her carriage over a wet street or puddle, for the little soles were as thin as paper, delicately shaped and softly made, all of which was a little deceiving because a shoe in those days was very capable of giving a good deal of severe punishment to a wearer who thought she knew better than the shoe-maker. Ladies then always wished to have their menfolk believe that they took a size smaller than actually they did, and I always thought that their menfolk got rather a pleasure in encouraging this weakness.

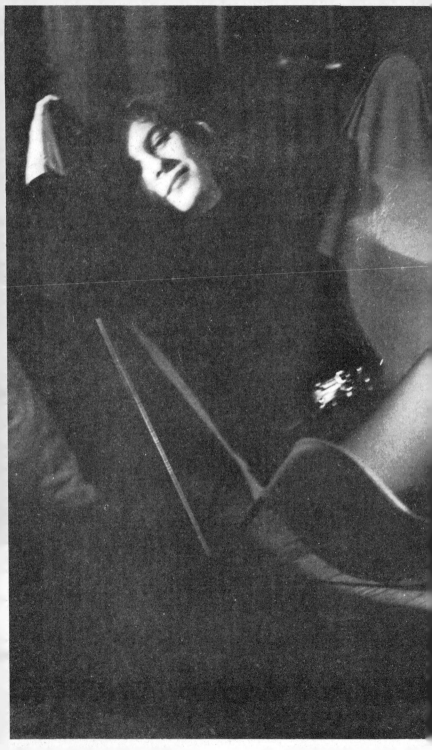

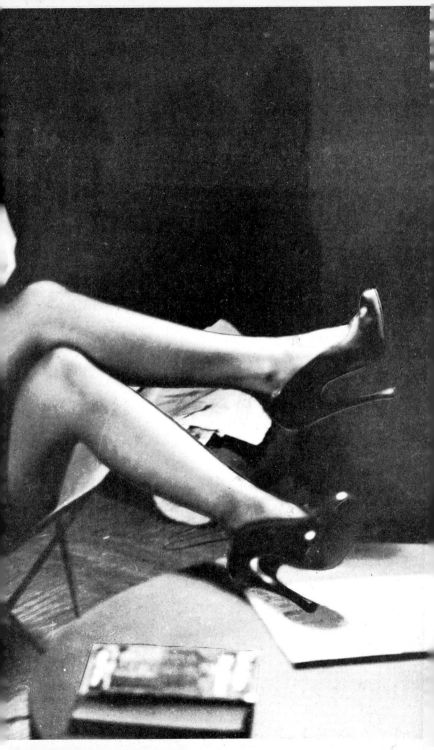

Many a time have I witnessed the struggles in my Shoe Salon with those long handled shoe horns with which we 'persuaded' an over tight little boot or shoe into place, and not infrequently did the lady resort to her smelling salts which she carried 'just in case she felt a little faint,' a little affectation which after all they could always blame on to the Corsetiere and say that their stays were a little too tightly laced that morning.

Many so called Viennese models were superbly made emblazoned with fantastic designs in hand sewn bead work. Heels had brass tips at their ends, and the actual kid used for them was indeed, kissed with all reverence and admiration, as worthy in craftsmanship and wearer.

Boots were normally about to the calf, in the softest of kids, in many lovely colours as well, either laced up or more often tightly buttoned the entire way up the legs. The more fastidious ladies preferred the knee high boots, with fancy curved tops adorned with some pretty designs on the sides of the calves, and certainly nothing less than a six inch heel for them, and a seven inch heel was far from unusual and could be seen in the streets anywhere.

Yours,

R. Chinstep

PADDLING IN SCHOOLS

Dear Editor,

I am enclosing an article from "The New York Post" entitled "Teacher Paddles Girls for Laughs." In it you will see that the York (Ohio) Township Board of Education fired Jack Eberle, a 25 year old schoolmaster, and that he now also faces possible grand jury action for the allegedly "pleasurable" way in which he paddled teen-age girl students.

According to the Board's attorney (Mr. Mercer) the worst thing about it all was that he lined up a bunch of girls in front of a mixed class and with a running commentary proceeded to give them all a sound spanking with a heavy wooden paddle. The paddle had been made specially to Mr. Eberle's design by a local carpenter.

Mr. Mercer went on to say that the girls probably needed paddling but the customary procedure was to administer the punishment privately in the superintendant's office. Mr. Eberle not only did it openly but obviously thoroughly enjoyed himself in the process.

Apparently the girls at this school seldom got paddled. It was a punishment reserved mainly for the boys, and I am pleased to note that there is no suggestion that, as a result of Mr. Eberle's conduct, paddling was to be denounced. The Post article gives the impression that paddling at this

school is a well established prac-
tice in which both parents and
teachers are in full agreement.

On the next page of this
same issue of "The Post" you can
find the story of a teenage youth
electrocuted for the slaying of a
17-year-old Toledo girl.

Although I quite agree that the
teacher cited may have been at
fault in administering seat-of-gov-
ernment correction in front of a
class, I firmly believe c.p. does no
harm and probably does a lot of
good in preventing youth crimes.

For the interest of your readers
I was also educated in Ohio where
such punishment was definitely
permitted. The reason I have not
sent in my opinion on the sub-
ject before is simply because I
was afraid it might look like a
"tall" story. Now with this news-
paper clipping I feel more con-
fident that my experiences would
be believed! Anyway I hope so.

We girls were frequently caned,
not paddled, at our school, and I
don't believe the majority of us at
the time bore any illwill about it
at all. Most of us were between
13 and 18 and looked on a licking
by the principal as a necessary
evil for naughtiness and it was a
point of pride to swallow our med-
icine courageously. Of course, the
first cuts with a cane always make
you jump, but after that it's a
matter of gritting your teeth and
bearing it. The first moments af-

ter the last one are perhaps the
worst of all, but all things come
to an end and even "six of the
best" can't dampen the spirits of
a well-fed teeanager. In fact, the
few canings I received always
sent up my appetite that night
considerably!

Actually the boys were dealt
with by the principal, the girls
were sent for, lectured, then pun-
ished by a member of the Hygiene
staff, a lady of about thirty who
came from Wisconsin and taught
swimming and dance. The story
was that she laid on far harder
than the male principal. Perhaps
she was frightened of being over-
lenient or something, but she cer-
tainly never gave less than four
and usually six, eight, and nine.
She gave her strokes at good in-
tervals and prided herself on the
accuracy of the infliction. How-
ever, we bore her no grudge. It
was all part of an adolescent
game, I suppose, and I well recall
the ribbings we used to trade
with ourselves ,and even with her
afterwards.

I remember the last one she gave
me was just after I'd had a shower
and I had to put on a pair of
cotton shorts, Bermuda style, for
the whipping, since no one was
ever beaten on the "bare." I had
no time to dry myself and the
shorts clung very snug and she
gave me eight absolute whistlers
that fairly took the starch out of

me. "Wow, Miss T-," I said to her when I met her later that evening, "Gee, those last two were beaut's." She smiled and pinched my cheek as she went by. "Nonsense, Bina, you scarcely felt a thing. I was way out with the tip." I protested that she wasn't and she went off, murmuring, "Well, don't be a silly girl again."

There was, in short, a distinct espirit de corps over c.p. at the school and it actually had compensations for the prestige of those who weren't good at sports. For instance, a charming but rather delicate girl with spectacles called Carole won our universal admiration for her stoicism under the cane. She would emerge with an impassive face from what we called the "tightest" Miss T- could give. The custom was that if you were wearing a skirt you fixed a clothespeg in between your legs, bringing the material taut before you bent down. Carole once got a prolonged nine, over the marks of which you could have put a ruler they were so accurate, and she didn't even flinch, so Miss T- told a friend of mine. In fact, Carole blushingly congratulated the teacher on being such a good shot! No compliment was greater than to be told "You took it like a trooper" by Miss T-!

In conclusion, I am convinced that quite a few of our current "dungaree dolls" would profit from an occasional brief but brisk study of the pattern of the toes of their saddle-shoes, while the contact of good old American hickory with well-stretched cloth promotes the circulation of healthy ideas from behind! That some do receive c.p. is shown by the clipping. However, a paddle is senselessly brutal and bruises deeply. A cane is more elegant, scientific and in every way more suitable for the delinquent derriere!

Yours,

Bina L.

CORRECT RITUAL?

Dear Mr. Bizarre:

"An Ardent Spanker", writing in No. 17, mentions a couple of times making a ritual or ceremony out of the spanking. I would like to comment further on that, for I think that it is something which many spankers neglect and hence miss a lot of fun. Generally in spanking I'd say, "Haste makes waste". Not always of course; there are times when a paddling should be administered on the spur of the moment and with quick and great gusto. In fact not knowing when the next spanking may suddenly happen out of a clear blue sky may keep the spankee in a state of pleasant suspense. However, generally the matter of applying "education" to the "seat of learning" should be a leisurely thing.

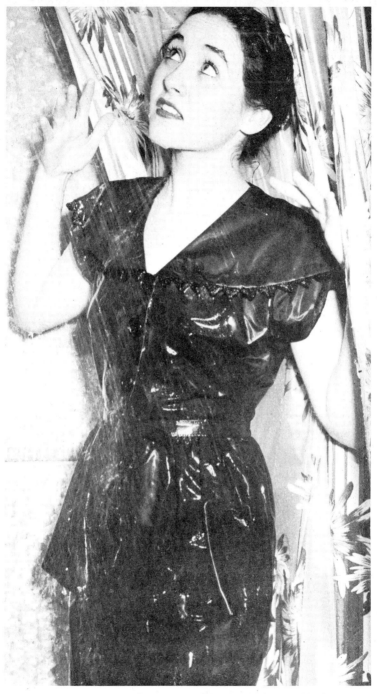

the shower-bath

Let the spankee be made to go to spanking room fifteen minutes before the punishment, to contemplate what is coming. Or make the culprit fetch the hairbrush, paddle or strap. The preliminaries should be prolonged to increase the anticipation. Such things as assuming the position, baring the spanking area (if such is to be done), or binding the culprit can all be part of the ceremony or ritual.

If the naughty one is a man and he has a "French Maid's" costume, let him be made to don that. Other things can be done to put him in humiliation.

If the naughty one is a woman, she should wear her highest heels and frilliest, filmiest garments. A beautiful ceremony can be made of preparing for the spanking . . . dressing, fetching the spanking instrument, etc. I know one lady who insists that the female spankee is bound so tight she cannot budge (generally tipped far over the back of an upholstered chair). But I consider the young lady should be more free — at least as to her legs, so the legs can kick, and she can squirm a little as the spanking makes her tingle.

This is a good way to make a naughty little boy squirm in anticipation of a spanking (and I know). Let the lady who is going to spank him pick up the hair brush in her boudoir; but instead of going right to the task, seat herself at her vanity and proceed to use the brush to brush her hair. The brush is so much a part of her femininity as well as authority. But best of all the naughty one can see the plump smooth muscles of her upper arm and beautiful shoulders work as she brushes; and he knows that soon those same beautiful feminine muscles will make his bare butt burn.

One more thing. I enjoy the writings of Sylvia Soulier and Paula Sanchez. However, I am sure from their writings (for example: "Listen Sylvia darling, I'm telling you, IF you DARE get more than my legs in, woe betide you girl!") that they have had many many experiences along the line of spanking also. Perhaps both as spanker and spankee. And I would like to have them write about those.

Yours,
"A Faithful Reader"

BUSINESS OFFICE
Dear Sir,

I was drinking in a bar with a friend of mine, and at one point she came out with the most beautiful *non sequitor* I have ever heard.

It was so brief that I could remember it word for word, and immediately interrupted our conversation to write it down. I

thought you might find it as entertaining as I did — so here it is *quote*:—

"I knew a man once — I worked for him actually — He was a shoe fettishist — loved high-heeled black satin shoes. He used to lie on the floor and I dug my heels into him while we discussed the day's business.

He said to me once, "you know you can't wear high heels really" — and I can't, I just don't like them — However he proposed to me all right, but that had nothing to do with the shoes — it was because I could add better than he could.

Yours,
"Mary"

No Corsets — No H.H.
Dear Sir:

I am certain the excessive emphasis placed by some on grotesquely high heels and voraciously constrictive corsets is something which can be harmful, and which is not a sound way of seeking grace and beauty of appearance. The way for a woman to develop a fine walk is not to be found by posting herself on top of high heels and letting them throw her spine harmfully out of line.

Yours, "Natural"

Nip—Don't Corset
Dear Sir,

I am in favor of naturally bountiful bosoms and full-formed hips flowingly connected by softly tapering waists. Tight-corset wearers have claimed in your pages that a snugly fitted corset will emphasize these qualities in hips and bosom and will also pleasingly shape forth the abdomen into a tenderly rolling outline. Because I like the sight of the nicely rounded feminine abdomen, is one of the reasons I regret the use of the flattening girdles that some of the girls wear to make their stomachs look as bleak as ironing boards. The feminine stomach must certainly be gently rounded.

It is possible, as some of your readers have described, that corsetting done in private may to some extent induce the bust to protrude, the hips to roll roundly out, and the waist to stay within bounds. But such results would be more firmly achieved by suitable exercise or appropriate physical activity, by sensible eating habits, by intelligent direction of one's physical development and posture through natural facilities of the body and the self-suggestive influences of the mind — a choice of effective, natural means to use singly or in combination.

However, if any corsetting happens to be used, it should be used with moderation and only at

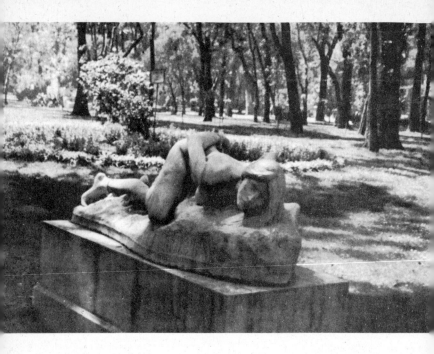

this statue in Mexico depicts "Love," quite simply by a young girl in chains — so ?

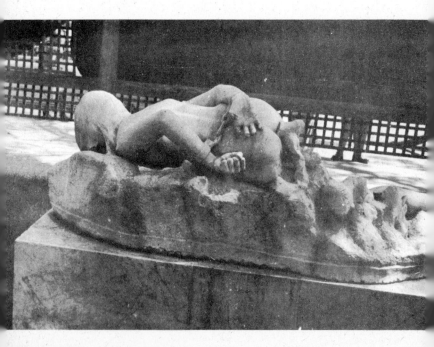

home. Corsets worn under the clothes when appearing before others, become instruments of unwelcome deception. The wearer is saying that she has a shape not really hers. It belongs to the concealed corset and is a falsehood.

If corsets are worn too long or too regularly, the abdomen muscles may turn prematurely flabby, causing the hastened loss of the natural firmness of the youthful figure and taking resiliency away from the mature figure. So again the ladies are made to work against the happiness of those who genuinely wish them well.

I am in sympathy with the desire, expressed by some of the ladies who have given us their inclinations in "Bizarre", for having their waists firmly strapped around. I warmly understand the enjoyable feeling which may be so obtained. Those who like to move through their day with a snugly strapped waist, should not deceptively wear a corset under their garments, but can very attractively wear a wide snug belt, firmly fitted over the waistband of their skirt, pants or dress.

Excessive corsetting, to try to manufacture a noodle-thin waist, is an unsound and misguided distortion of the feminine figure. A moderately tapered waist has charm and grace. One of the allures of modern, smooth-tailored, body-conforming attire, is to see a taut belt sinking its circle into a lady's clothing to press itself around her gently tapered waist. But there is no point and no beauty in seeing a belt drawn around a waistline that has already been chiselled down or poked down to look like a noodle.

The excessive constriction of the the proportions of the feminine wasp-waist is out of harmony with figure. It is opposed to all the basic symmetry of design of the human body. Even its name, wasp-waist, suggests its anti-human qualities. Wasp-waists may be fine for wasps or ants; they are not designed or meant to serve the purposes of fair ladies who wish to see wholesome beauty in themselves, and in the human race we desire to see grow more generally beautiful.

Yours,
"Anti-Corset"

PEEPING TOM
Dear Sir:

It was with interest that I noted that most usually corporal punishment is applied by women. Once while I was staying in Montgomery, Alabama, I observed a mature sixteen year old spanked like a small child. The house I occupied was one of the few two story homes on the street and from my bedroom I could look into the bedroom of the single story adjacent house. One even-

ing, hearing voices raised in anger, I looked from my window, into the bedroom of the house next door. The curtains on the lower half of my neighbor's window were drawn, but from my vantage point I could witness everything that took place in the brightly lighted bedroom via the upper half of the window.

Mrs. Johnson, my neighbor, was berating her daughter and, as I watched, she pulled the girl over her lap, raised her skirt and applied a smart spanking with her hand. I was later told that this was no isolated instance, that Mrs. Johnson raised all three of her children in this manner and that they were all considered exceptionally well-behaved. The incident made a deep impression upon me at the time and led to rather detailed study of the subject of corporal punishment, both past and present.

<div align="center">Yours, "T.H."</div>

High — but no heels

one version of a single-boot

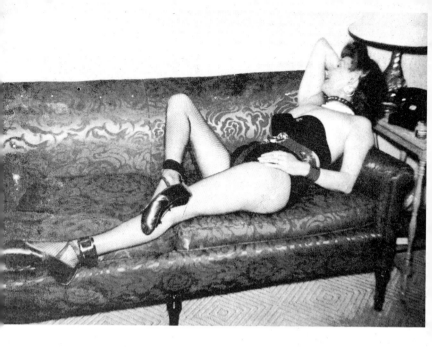

Dear Editor,

I enjoy your magazine very much and can hardly wait until the next issue. Especially interesting to us are letters on subjects of tight lacing, chains and high heels.

I am pleased to know that other wives beside myself enjoy the pleasure of being tied up. Perhaps it might be of interest to you and your readers that all my leather belts from 1" to 8" are custom made and the wrist and neck straps are of red leather. I always enjoy the peculiar thrill only tight lacers know.

My favorite belt as you can see in the enclosed photograph has a front piece of 8" and a back piece of 4" which are laced together and can be locked with a padlock. Also the strap which runs from the front down and then up the back is so delightfully tight and locked with two padlocks, it cannot be removed without a key. I personally enjoy the feeling of such tightness especially when I am forced to lie down and cannot get up myself due to additional chained hands and feet.

Recently I had the toe shoes made with steel support and straps as described in issue No. 17 on page 45 (as you can see in the photograph). First it was some what inconvenient, but I like being forced to wear them.

Sincerely yours,
Mrs. Louise T.

SKIRTINGS

Dear Sir,

As a fairly well-fed housewife, who is proud of her back view, may I say how delighted I was to see your letter "Vive la Derriere" which a friend of my husband showed me.

Egged on by the letter, I have been long experimenting with the tight-fitting skirt in an effort to do justice to that part of the body the Greeks thought most desirable in a woman, and I feel that some of your other lady readers would find these experiments to have considerable return in masculine attention, apart from the satisfaction obtained from the feel of really tautly drawn cloth about the hips.

Long before I married even, I used to insert coin-like lead weights into the hems of my skirts. It's quite surprising what a difference the pull of such weights will make to the set of a well-belted thin gabardine. (*Even 30 years ago this was standard practice for well-tailored coats and skirts. Ed.*) Needless to say, rigid tailoring, an erect posture, and little or no underclothing enormously enhance the bi-buttock effect your reader so understandably wants to see come in again.

A more elaborate method of obtaining a snug fit of the skirt under the seat is to sew the whole on to an ordinary elastic girdle, taking care to join the stuff of the skirt right up to the marks made by drawing a chalk along the cleft of the seat of the fitted girdle. In this way the skirt will tailor right to the back of the legs when standing, in an even tighter effect that that achieved by your charming model who appears constricted by her skirt in No. 1 (p.16) and subsequently — yes, we have now checked through back copies of Bizarre!

A less spectacular type I have tried successfully I call the D-D skirt. It is made simply by sewing a piece of matching material between the legs, in the fashion of a trouser only starting below the crotch and ending above the hemline. The effect is excellent, the hips and thighs are outlined at each movement made, however small, and a slightly narrower joint at the top ensures a delightful drawing of the skirt under the fatty overhang of the sit-upon. Jersey- cotton, flannel, worsted, poplin, even wide-wale corduroy and leatherette, can be treated in this manner and converted into comfortable D-D skirts.

Another arrangement we tried was to suspender my stockings to the skirt itself. This was found to be successful in keeping a thin stuff absolutely taut over the upper bottoms (and abdomen), but unless the stockings are very strong it results in numerous ladders. I might add that, as my husband pays for my clothes, he makes me

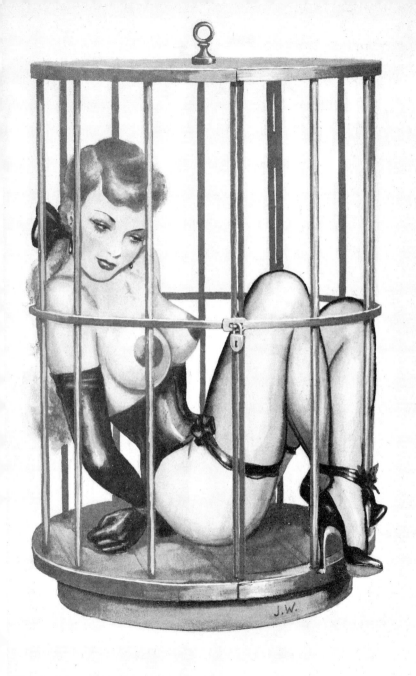

" PRETTY POLLY "

"pay" in the old-fashioned way, for more than two ladders a day! As I ran up as many as eighteen in a week with this type skirt, the resultant sessions were found to be unrealistic and the skirt was discarded as impractical. It has its value, however, as a party garment. The D-D is standard with us, though.

There are all sorts of means of tightening a skirt, but I can hardly go into them here. (*Why not? Please do. Ed.*) Two final pointers: a small strap, sewn just above the hem below the knee and adjusted tighter than the hem, will prevent the wearer stretching the material there. It is awkward to wear, but makes a good training device for "striders" — such as I was until I wore this in company a few times. The first time I really thought I couldn't move an inch but I had to fetch the drinks and things and I should also mention that I am penalized for careless spilling or tripping. The second tip is a good cure for those who insist on pulling up their skirts when bending or sitting in order to prevent a "sat-out" look. Of course, skirts do get "sat-out" but constant tailoring will correct this and is far preferable to sitting with folds slopping over the curve of the hips. So, simply insert a fairly heavy grade of emery paper into the back of the skirt beneath the seat and, if the underclothing

is confiscated, it is most unlikely that the habit will last long.

Finally, I cannot over-emphasize the pleasure and uplift to be had from constanly wearing a really binding skirt. On one occasion my husband dunked one of my navy blue serge skirts in a heavily shrinking chemical and made me put it on still wet and then dry off in the sun of our terrace. It was the most extraordinary sensation as the material dried on me, growing tighter and tighter until I thought the slightest movement on my part would split it. In fact, I sometimes do split skirts bending down, I'm afraid to say, and here again, even though it's hardly my fault, a good juicy taste of hickory is the medicine used to make me more careful in future.

Indeed, while the D-D skirt has many advantages (it certainly can't be converted into that nasty U-D skirt you've featured!), I certainly don't recommend it for protective purposes to teenagers or others who, from time to time, may have to touch their toes at short notice. Unlike your reader, Mr. Hickory is no respecter of the derriere!

Yours,

Barbara

PS. Having read this through, my husband bids me tell you there is a variation of the hem strap that consists of stitching two thin straps high up either side of the skirt to

encircle each thigh, rather similar to a man's riding mackintosh in style. For aesthetic purposes the buckles should fasten between the legs. To which I personally add that for purposes of crossing the legs they shouldn't! But it is more agreeable to wear than another device he has, and of which I could tell you another time, for arching out the whole pelvis so that the "camber" of the rump is most pronounced. I call this belt, which is worn under the skirt, my "black devil" and while it is revealing and stylish it takes all the fun out of life for the wearer.

B

A BIT MORE FROM J.D.J.
Dear Ed:

First of all, I was pleased to see that you thought my ideas and sketches were good enough for publication, just as I sent them to you. (The "Toe-shoes-with-a-vengeance" my Gal calls them.) I'm glad you liked the idea too. It not only makes the foot extremely attractive, it also makes the gal poised and always aware of her posture, for I know from experience that she cannot slump or slouch while standing on tip-toe. Some people may think that a girl could not stay on her toes for long periods of time, and that is perfectly true. It is not necessary, and I don't require her to do so. The foot keeps its lovely shape, whether she is standing or sitting or even stretched out on the davenport.. But it is fun to see her doing little things about the house, and I've often seen her lean on the sink and lift first one foot and then the other, to rest her feet a bit when there is a big stack of dirty dishes and she's been at it for about half an hour. But enough of this. Back to my comments on the new issue.

Your first letter, "Legless With Legs," to be continued, I hope, sounds delightful and I for one am most anxious to learn the ending of the story. Why it particularly appealed to me is that it is quite similar to a lengthy letter I wrote to you quite some time ago about another girl who enjoyed the same feeling as your letter writer. Perhaps you do not remember that old letter of mine, but I did tell you about this friend, whose delight was in having both her legs bound, ankle to thigh, and the outfits we devised for her to wear so that eventually she was able to "walk about," as it were, on her knees, with her feet and lower legs entirely abolished to all outward appearances.

And finally, for my money, the Photo Sent by "G.J.Z." on page 49, portrays just about the most perfectly designed and built pair of shoes I have ever seen pictured anywhere. If I knew where they could be ordered, I'd have a duplicate pair made for my gal at the

first opportunity. They are to my way of thinking, the ultimate in high-heeled footwear. Please ask "G.J.Z." if he has any more photos of those delightful shoes.

Yours,
J.D.J.

PARTY GAMES

Dear Ed:

Speaking of games to play, the victims ankles and knees are bound tightly, she is blindfolded, and her wrists are handcuffed behind her back. The key to the handcuffs is placed on a table as far away as the size of your apartment or house will allow. The victim then wriggles and rolls beautifully toward her goal with skirt slipping high now and then showing off her legs to all the delighted onlookers who cheer her on. As each girl reaches the key and opens her handcuffs the time is stopped. Each girl must try it with the one taking the longest time paying a forfeit.

As ever,
Linda

DIPPING (*photo on opposite page*)
Dear Sir,

Enclosed find a photo of a Gal friend. As you can see, she couldn't wait to get in the water — so didn't even bother to undress all the way. I caught her "in the act" with my Rollei. If you think your readers would like it — you are welcome to publish it.

Sincerely yours, Robert

TICK-TACK-TOE

Dear Ed:

Enough putting it off, it's time to write you a letter. When is Doreen M. — Well Trained Children #11, going to write again? My husband and I enjoyed her letter very much. I have not worn a bra since being married, and I wear only the tightest sweaters and blouses, many low cut and very revealing. I have always had nice full, firm, upturned breasts; and since I have a 35 inch bust, I have a nice jounce to them. Men are always giving me the most fascinated stares which I must confess that I enjoy. My husband likes my clothes to fit quite snug, especially thru the bust, hips and buttocks. He agrees with 'Bottoms' NYC-#18. I have found that since then, my skirts are getting tighter and my derriere is being emphasibed, not that I mind. The picture on page 7 of that number was very good. We also liked the letter on love games by C.D. #15/16 and all the other letters on party games. We hope to find more of the same in your coming numbers. We have a game we play that we call strip-dice. You roll the dice and the high man wins, with the loser having to take off an article of clothing. This continues until we are both unclothed, and then we let our imagination take its sway. Sometimes the loser has to do anything that the winner desires. This

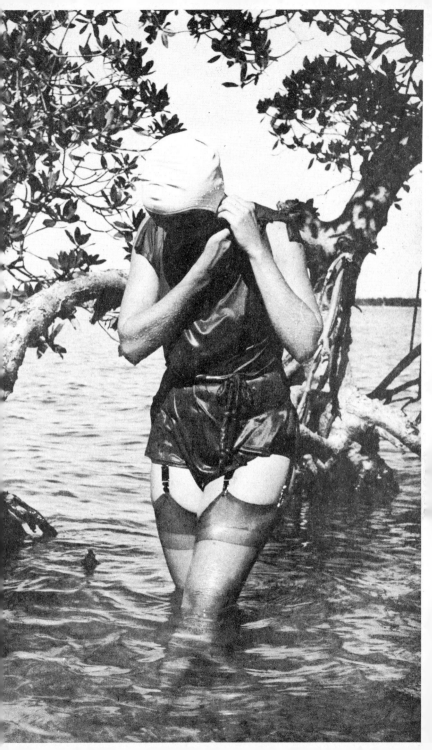

could either be something that the loser would have to *do to* the winner or something the loser would have to *let* the winner *do to* him/her. Mmm, this has proven very interesting and lots of fun!

We have another little love game too. I have quite small feet and my husband likes to caress and kiss them. When I am at my dressing table he'll kneel on the floor kissing and caressing my dainty feet. One night I pushed him onto his back and began to dance upon his bare chest and face, I put my toes into his mouth and had him lick my entire foot. He seemed to enjoy this very much and gets quite a thrill from it, so this love game is repeated two or three times a week.

We hope you will have more letters from Diana on exotic bondage and fancy dress, #18. The pictures on page 34-#9, page 41-#11 and the back cover of #12 are among my husbands favorites by the way.

While we don't go in for it, we both enjoy the letters on spanking and find them very interesting. I guess I have rambled on enough for now.

<div style="text-align:right">

Sincerely yours.

Mrs. T.A.T.

</div>

GIRDLED AND STRAPPED

Dear J.W.

Every issue of your magazine is wonderful. I have found nothing like it to open mental blocks to the ways of the unusual.

My discovery of you led to one of the most enjoyable chapters of my life. It all happened as I opened a stack of morning mail. Without looking at the addresses, I tore the wrapping off your no. 14 and as it came to light there was a gasp from my secretary's desk. It was supposed to go to her but got mixed in my mail. As I leafed through it I knew immediately that it was something that I had been looking for for a long time. I dropped it into my desk and locked it. Turning toward Nancy, I smiled and her frozen face broke immediately into an embarassed grin.

When she had readied for home that evening she came over to my desk and held out her hand. It could only mean "give." I opened the desk and handed it to her along with the suggestion that we have dinner. I got a wink and met her downstairs, and that was the start of a wonderful life.

Talking it over the other evening we agree that our favorite is vol. 8 and your little portable prison. Of course we have coupled it up with many inovations of attire from your other issues.

We both love restricting but

pliable garments so my "dress" consists of the following in order. Everything has been purchased here in local stores. My size is male 32 but I like 28 Female. While they are a struggle to get into they are tighter and most constricting. We each have a black and white set of apparel.

First is a satin lastex panty brief followed by danskin waist length tights, silf-skin brief (which we find ties everything together best underneath), a turtle neck, long sleeve zippered leotard of fine cotton lastex; and, outside, a dancer's silk woven panty called a "panteze" with a zipper at the rear. We have several other very comfortable outer panties such as nylon or rubber.

With this as a basis we add patent pumps, elbow gloves and lastly one of the most enjoyable of all, a head wrapping of double faced satin strapped around the neck and tucked down inside the leotard.

When the winner of the coin flip (or should I say loser) wants complete silence, we gag the "victim" before putting on the hood. We have found that a folded piece of chamoise the best silencer. Tucked in to fill the mouth and cheeks, it does not slip into the throat and gag. Teeth can clamp down on it softly and it really drowns efforts to make noises. Several long strips of two inch satin ribbon hold it firmly in the mouth. Assorted straps, chains and locks are available.

We have altered your "prison" a bit. Instead of the metal loops we have found leather straps more suitable by preventing the "prisoner" from withdrawing his or her arms should the mood desire.

It can confine the arms to the rear, in front or over the head. The most constricting of all is to have your ankles encased and then drawn up so that the neck can be placed in the top loop of leather. Nancy won't permit it since the night I left her on a bed and went off to a show for three hours. She couldn't stand when I came home and released her.

I am making a longer bar now so that we can strap the ankles, pull them backward and fasten the neck loop at the rear. I'll have to figure out a way to get Nancy in without her knowing what I am going to do.

We hope you have spreading success with your magazine as it will open new fields to many people.

We have an X frame with wrist and ankle fetters attached to coil springs at each point of the X. It keeps the body in a taught and extended position of wonderful delight. An hour and all resistance has gone from the body.

Yours, S.F.

* * * *

51

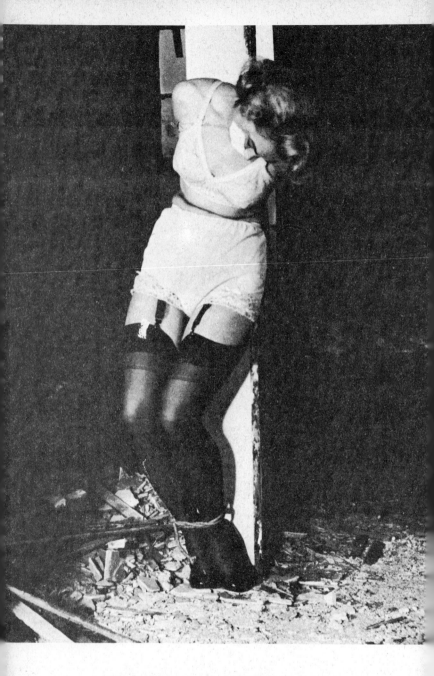

DON'T LET THIS HAPPEN TO YOU
learn Jiu Jitsu, the art of self defense

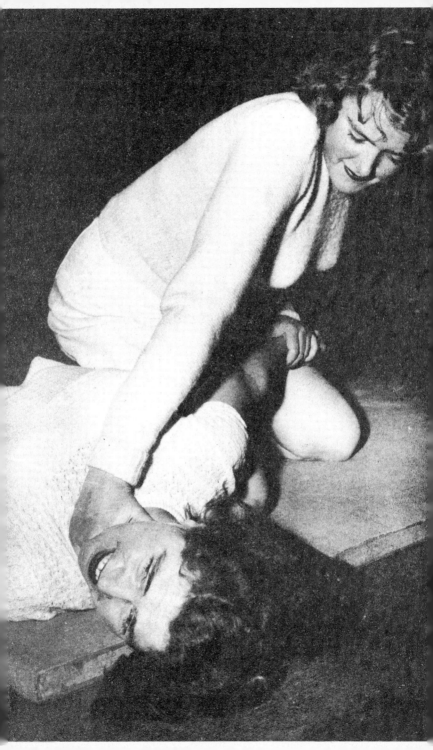

And Relaxing

Gentlemen:—

The correspondence section in a magazine, such as you have started, gives a lot of us a chance to express ourselves in language that can be understood by the rest of us. Most of us go through life wondering what makes us have the fantasies that bother us, and when expressed, make our associates wonder.

If they are lucky a group of like minded people may get together but the vast majority must wait until something like your publication comes along to show them that they are not alone in the world.

It probably helps to be able to tell your story even though fact and fiction may sometimes get a little mixed up in the telling.

Evidently some of your correspondents have one or several hobbies that intrigue them and having a place where they can discuss it makes it interesting for all concerned.

If you can get onto a monthly schedule of publication your circulation should increase. The oftener you are in print the more you are remembered, the more you are talked about and the more potential subscribers are curious to find out just what is going on.

Yours truly,

L.M.

FURRED HEELS

Dear Editor:

I felt rather inspired tonight (even at the late hour of midnite) regarding an article signed by "Helen" in #11. Just imagine a girl who is interested in "delicate heels" and who "are utter slaves to ultra-high heels." These words seem like sweet music to my ears. How I would delight in meeting a girl who is as fond of sweet, perfumed, tender footwear as I am. Speaking of being a slave, I think any girl who had well formed ankles and contrived to wear beautiful expensive shoes, would have me dwelling on her slightest wish. Oh Helen, if you only knew how such words as your "dainty spike-heeled feet" and "tripping along in heels" inspires me. I feel almost like writing a poem about my favorite weakness. What an inspiration are these mirror-black patents rising on a delicately shaped heel.

I hope one day to meet a girl who loves heels like Helen. For her I will do my utmost to afford the most expensive and extensive wardrobe. I will buy her the most beautiful silks, furs, and leather goods. Her shoes will always be of the most exquisite custom made types—of all the fanciful fashions. I love variety in heels. Can you imagine spikes made in the most bizarre styles? Fur heels for the warm and vibrant: stainless steel heels for the cold and aloof. Thus girls could express their personality in high spikes and all the proper men of the world could gather around to adore and pay the most abject homage to them. It may be a fault to adore those lovely tendrils which cause one to gasp in astonishment when a lovely girl's ankles are poised at undreamed of heights. So threadlike, so wirelike, so needlelike. These firm, strong heels make beautiful and esthetic heels. One could forever adore the perfectly executed silhouetted heels raised in the most slender splendor.

As always,
High Heel Artiste

UNDIES FOREVER

Dear Editor:

It was a pleasure to read D.H.'s letter about undies for "outies." And the photos of her in sheer stockings and in bra and panties were interesting and enjoyable. D. H. is a very attractive lady in addition. Let us have further views and experiences from you and more pictures attired in lovely lingerie. I believe a young lady is definitely more beautiful and alluring when wearing bra and panties, especially if they are very frilly and feminine. They are not only attractive, but as D.H. says, they are also economical. Personally I find that the panties that have an elastic waist and elastic at the legs even more appealing. I wonder if D.H. would express her opinion on the topic of

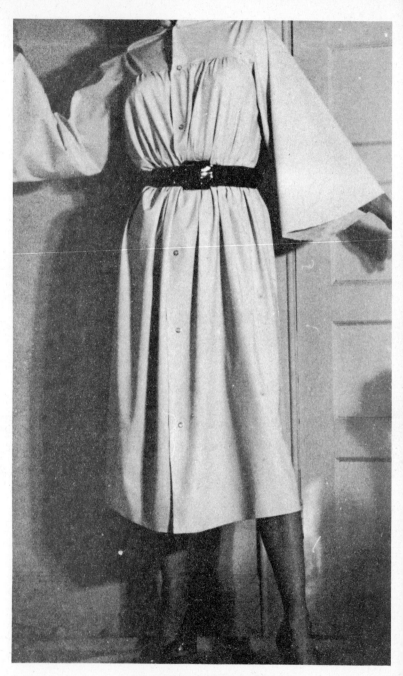

the white rubber dress

bloomers or bloomerette panties. Bloomers seem to be returning to some extent in bathing suits and sleepwear. Let's hope that they return as a lingerie trend, soft, silken, and beribboned, dainty and beautiful as they once were. And let us have more photos and drawings of bloomer girls, and more detailed accounts of ladies who have worn bloomers and would wear them occasionally today to enhance their glamour and femininity.

Also let's have more articles about lingerie, about nylon and silk panties, brief or band-legged, lacey or otherwise. What are the choices of some of your lady fans? Can anyone inform this fan where bloomers may be obtained, or some one who can make them?

Very truly yours,
LJC

NEW TYPE STRIP POKER
Dear Sir:

The success of your publication depends so much on the correspondence column that I feel I must myself contribute a letter.

My wife, Joan, and I do not engage in the bizarre as frequently or as strenuously as some of your correspondents but we do have lots of fun, both on our own and with close friends, Jack and his wife Bee. Joan is not so experimentally minded as Jack and I but when Bee is in the mood and has you in her power she can be a real devil.

Alone, Joan and I enjoy as much as any game our version of strip poker. We play any suitable game for two which does not take too long, or we may just draw cards, the loser forfeits a garment each turn. To avoid all disagreement, shoes, stockings, and garters, (if worn) count as one garment and using a similar procedure for jewelry, ties, belts, etc. the total number of garments is kept at 5. The game does not end when one of us has lost all her (or his) clothes because we then start to don restrictive attire. First fancy shoes or boots, then a broad leather belt, a neck collar, ankle chain, gag, wrists tied to the back of the belt. The first person to reach this last stage is definitely the loser and may be made to provide varied entertainment for the evening. The winner can of course return to more normal attire. Joan is kind in usually allowing me a handicap of two garments as she knows how I like to win.

When we are together with Jack and Bee we usually play cards for forfeits. Recently we had an unusual evening which may interest other readers. We were having dinner at their house and Bee asked Jack to give her a mouthful of cocktail through a kiss. This suggested we should tie the girls hands behind their backs for the cocktail period. When it came to the din-

ner which was all prepared and had been laid formally, I suggested we should keep the girls' hands tied. Bee objected strenuously because only the previous week Jack had fed her that way and had been particularly messy about it on purpose to annoy Bee. In the end we compromised, the girls would be released if we could enjoy an uninterrupted view of their beautiful fronts throughout the meal.

After dinner we played "obedience." Each man put $10 in the kitty and each girl $5. Then Jack and I took it in turns to issue orders which both girls had to perform exactly. The first girl to refuse lost the game and the winner took the substantial kitty. It was amazing what really peculiar things we managed to get those girls to do by working up slowly. Towards the end of the game we had to avoid the girls agreeing to both refuse an order they did not like. This we did by placing them in adjoining rooms so that they could not see each other and ordering them to gag themselves with adhesive tape.

The girls had played so well

that Jack and I agreed to draw lots as to which of us should provide amusement for the girls for the remainder of the evening. I lost and did those girls work me over, particularly Bee who despite winning the kitty was sore about some of my orders earlier in the evening.

This letter is already too long but I hope other readers will tell us of their games and forfeits.

Yours,
A.B.

Dear Sir:

ANOTHER RUBBER FAN

I heartily agree with Mrs. M.J.H. in her recommendation for starting a Rubber Club department in your magazine. Your stories in Issue 15/16 inspired me to write to you about a most memorable experience of mine last July.

Approximately a year ago my husband gave me a rubber panty girdle for Christmas. I took a liking to it, wore it rather frequently, but other than that never thought much about the significance of my girdle. Several months later I happened to notice on occasion my husband watching me very closely as I slipped into my rubber girdle, and twice saw him gloating upon ads in Life magazine of a woman modeling a rubber girdle.

I then decided that maybe he too would find pleasure in wearing a rubber girdle. At that time I

started my plans. Since the ratio of his waist and hip measurements were slightly on the feminine side, I had always wanted to see, for the fun of it, what he would look like dressed as a woman. Although my husband is slightly shorter and lighter than me, I was afraid that I couldn't completely control him should he resist my plan. Since my unmarried Sister lived on the third floor of our home, I let her in on my ideas which she thought would be a lot of fun to try out. My plan was not only to put a rubber girdle on him, but to don him completely in rubber from head to foot with the exception of his shoes.

Within a week we located a supplier of very thin amber colored rubber, and bought five or six yards of the material. My Sister fashioned, with the rubber, a gorgeous peasant type of blouse which had large billowy seleves and was tight fitting around the waist. I made up a long tight fitting rubber sheath skirt, that measured only ten inches across the bottom which almost was ankle length. I made this skirt a little small so that it would fit with extreme tightness throughout its entire length. I then purchased from a local department

store a small size rubber panty girdle, a pair of shiny black patent leather shoes with 4 inch heels and a patent leather belt for my husband, and a shiny black rubber bathing cap.

The following Saturday morning while my husband was sleeping late, my sister and I sneaked into his room with the rubber girdle, cap, and a length of rope. Simultaneously we both grabbed him then tied his hands behind him and put the bathing cap on backwards so as to cover up his eyes, in fact most of his head. To say the least, he hardly knew what had happened. Practically before he realized it, we had pulled off his pajama pants and slipped on to him the rubber panty girdle. Then we tied his feet and hands to the corners of our four-poster bed.

I then asked him how he enjoyed the feeling of a rubber girdle next to his skin. At first he made no comment, but after lying there for half an hour or so finally confessed. He admitted that he enjoyed the coolness of the girdle as we put it on him, and now was enjoying the thrilling tightness of the rubber girdle next to his skin.

Before we released him he had to promise to do what we said, and not to touch the bathing cap which was still secured over his head. We then untied his hands and pulled the rubber blouse over his head, and then tied his hands

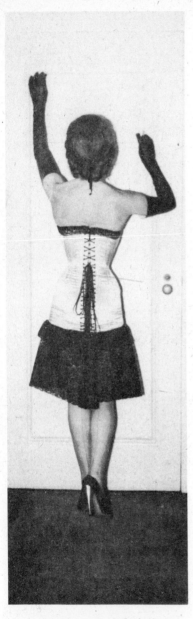

the newest style is to wear the corset — outside the dress

again. The next garment to go on was the sleek, tight fitting rubber sheath skirt which fit amazingly well. The high heel shoes came next and to complete the outfit the 4 inch wide black patent leather belt which I tightened as much as possible.

With his hands still tied, we helped him stand up and then had him tip-toe around the bedroom so we could admire his outfit. I must say, he looked simply adorable in his rubber outfit. Due to the thinness and tightness of the skirt, it was possible to see through to his rubber panty girdle which made the get up quite exciting. I called him my "Prince in Rubber."

Shortly afterwards my sister left since my husband was now fully under control. Finally, I had to untie his hands. To my surprise as soon as I did this, he reached out and literally threw his arms around me. He said that he was practically speechless because of the thrilling experience we had just put him through. He said that he thoroughly enjoyed the cool smooth feeling of the rubber girdle and the overall feeling of sleekness and tightness that the entire outfit gave to him. He then told me how happy he was that I had discovered and appreciated his fondness for rubber garments.

It's now getting late so must close.

Sincerely, M.C.

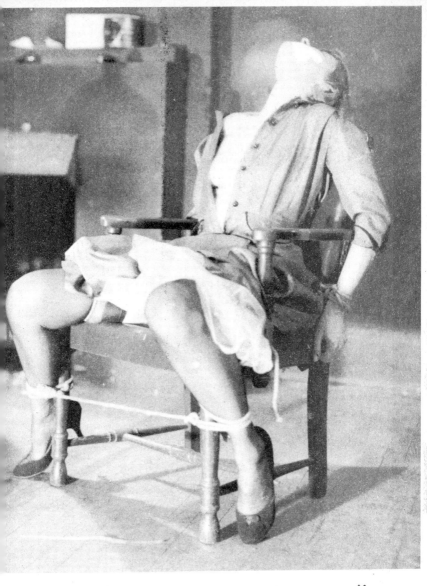

WE REPEAT — "LEARN JIU-JITSU"
and don't let Ivan steal the secret plans

Dear Editor:

How To Buy

As a corset and Hi Heel advocate, I have had to rely on an understanding mother for these items, never having any of my own, as a result, I often doubted the statements by other devotees that they have purchased these items themselves.

However, recently I took phone-book, and phone to task and contacted 23 of 35 listed corsetieres and corset shops in the directory. I requested price of a clincher type, full corset, not the short girdle as is so popular here in the States. And when asked for whom I requested this information, since it was unusual for a man to call, I simply stated that I enjoyed wearing this item and wanted it for myself, further requesting possible appointment for a fitting.

To my surprise I find that 10 will be happy to properly fit any stock garment I may desire. That 4 will make or have made any type of garment I wish, regardless of material and measurements. That 5 will be happy to sell any stock garment, but will not assist in fitting. While only 4 were not interested in any way.

One national manufacturer of custom fitted garments told me that they have quite a demand for ladies garments fitted to men and make a special men's full corset.

I might add that the most expensive was a black satin and lace affair, with full removable bust forms, made to measure for $35.00

Any Orders, anyone??

D.S.K.

Rubber Girdled

Gentlemen:

I am not as fortunate as most of your correspondents seem to be. I have always been much interested in corsets and girdles; but my wife will only wear one on special dress-up occasions and then complains long and loud when getting in and out of them. Several years ago I persuaded her to buy a Playtex Girdle, but she would not even wear that. I had noted that it was advertised as being invisible under the most revealing clothes so I decided to find out if girdle-wearing was as bad as she claimed it was.

I bought one in my size and decided I would wear it for at least a week. Rather than finding it so terrible, after the first few days I actually began to like the feeling of sleek firmness it gave me. Now I wear a latex panty girdle nearly all the time; sometimes even sleeping in one.

Sincerely yours,
R.E.B.

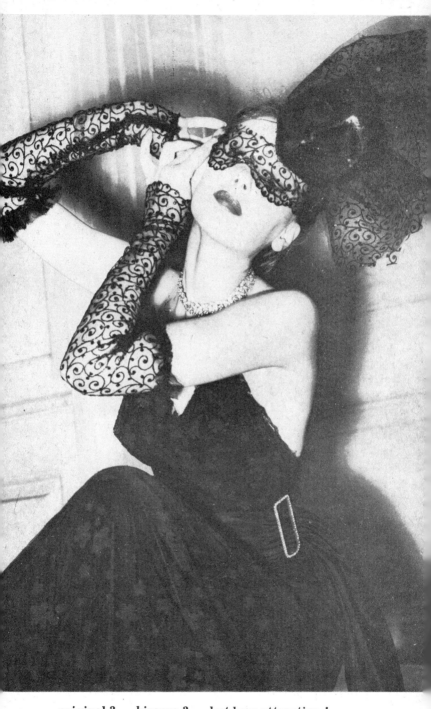

original ? — bizarre ? — but how attractive !

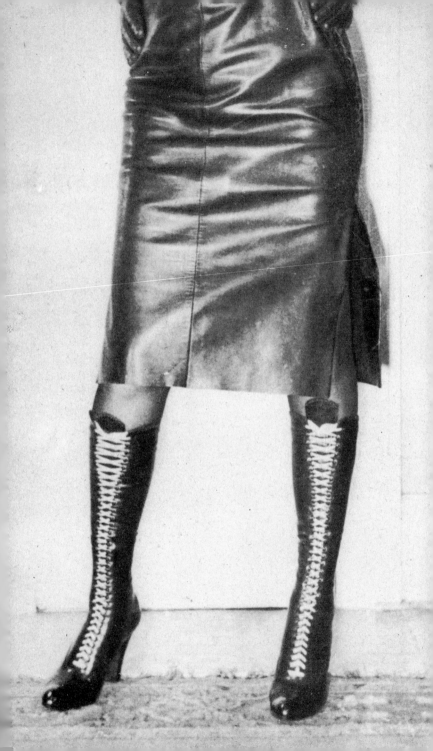

BIZARRE

21

CONTENTS

CORRESPONDENCE

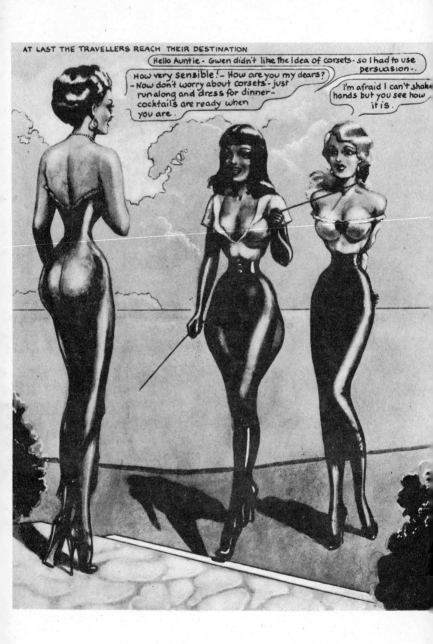

BIZARRE

"a fashion fantasia"

No. 21

And we, that now make merry in the Room
They left, and Summer dresses in new Bloom,
Ourselves must be beneath the Couch of Earth
Descend, ourselves to make a Couch — for whom?
OMAR KHAYYAM

Contents

PHOTOGRAPHS

8 x 10 photographs of those on page 28, 29, 44, 49, and 60 are available at $1.25 each. ($1 for the photo. 25c for shipping charges) Write to the Editor, P.O. Box 511, Montreal 3, Canada.

Printed and Published by Bizarre Publishing Co. P.O. Box 511, Montreal 3, Canada.
Copyright 1957. All rights reserved.

BOREDOM IS . . . TO BE ALONE . . .

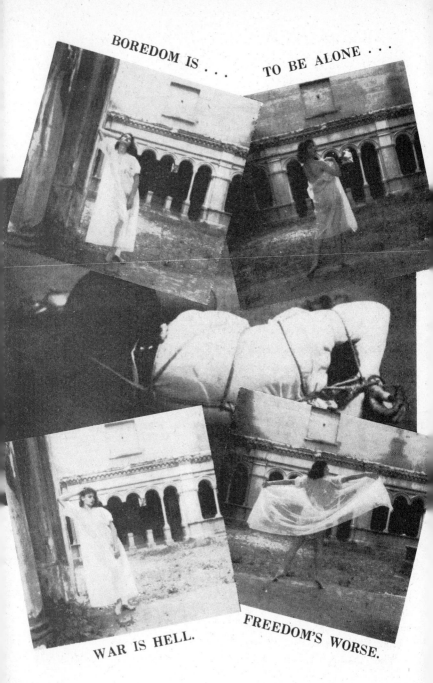

WAR IS HELL. FREEDOM'S WORSE.

Nudity Is The Veil Of God. —Michelangelo

The Englishman Thinks He's Moral If He Feels Uncomfortable.
—G. B. Shaw

ON SOCIAL MASOCHISM

Like many words whose meanings are culturally implied, rather than defined, "masochism" has connotations but not denotation for the educated, and for them, belongs in the category of "mystic", "insanity", "barbarian", and the like. "Masochism" in the legal sense applies to criminal masochism; in psychoanalysis, it applies to pathological perversion.

While the word itself comes from the nineteenth century Austrian novelist Von Sacher-Masoch, "masochism" names a pattern of human behavior that was being woven when the Greeks were little boys.

To Freud, we are indebted for the modern garb of the three masochistic forms; moral, feminine, and erotogenic, and most of the organized material that we have concerning the subject is derived from his original investigation and classification. It was unfortunate that because he found masochistic tendencies in neurotic and asocial personalities, the phenomena was defined as sub-class of those personalities and attained a stigma which has survived until today.

When the flash and the thunder of his sex theories had lost their original impact, psychoanalysis, in a more quiet atmosphere, revealed the role of moral masochism in normalcy, and in contrast, to that in neurosis.

(Of the authors of the subject, Stekel, Krafft-Ebing, Horney, Fromm, Menninger, and Reik, I find that Reik (Masochism in Modern Man) has the nicest balance of theory, case history and integration-with-personality.)

Reik gives the main characteristics of masochism as: phantasy, suspense (the prescribed course), and the demonstrative factor.

In chapter III of Masochism in Modern Man, he says "Phantasy is the source, and at the beginning there is nothing but masochistic phantasy." The importance of this factor cannot be over-emphasized. It is the guiding drama of the individual's life, the mold into which he casts all raw material.

Throughout Reik's case histories this is the pattern which becomes the basis of masochism: 1) There is a submissive, pleasure-toned traumatic experience, usually at a tender age. 2) The experience is remembered unconsciously and is usually symbolized in day-

5

dreams. 3) A ritual for its expression is developed.

This is the phantasy that indelibly stays with the individuals. The ritual is the performance of the phantasy; the individual being the leading player and stage manager of the drama, and the pleasure derived is that of his early trauma.

The second characteristic, the suspense factor, has a divided nature: the tension of anxiety (the ecstacy of oppression) and the tension of pleasure. It seems as if the mounting tension of anxiety is transferred to the tension of pleasure. Reik points out that the suspense factor is not restricted to the field of masochism but is a nuance of feeling tone which encompasses a wide range of psychic phenomena.

K. Horney mentions the universal nature of this dionysian ecstacy and its evocation by music, uniform rhythm of flutes, raving dances, intoxication, sexual abandon, fasting, and bondage in a painful position.[1]

She further states, "and there are few persons who do not know the satisfaction of losing themselves in some great feeling, whether it be love, nature, music, enthusiasm for a cause, or sexual abandon. How can we account for the apparent universality of these strivings? ...

"The most poignant and beautiful expression of this striving is found in the Upanishad . . . 'by vanishing to nothing, we become part of the creative principle of the universe' ".

It is not too curious that she finds this association, for the Upanishads embody elements similar to the masochistic phantasy: a transmigration of soul and a feeling that the true character of a man is determined by a former existence.

The tools of the masochistic suspense factor are submission, humiliation and physical suffering, but as Hirschfeld points out, "the expression 'pain' becomes devoid of meaning." The tools are means to pleasure: a necessary part of the play.

The third characteristic of the masochist is the demonstration of his condition of humility, etc. but according to Reik, it is not narcissistic or exhibitionistic as supposed by K. Horney and K. Menninger. Rather it is a concealment for the pride in one's victory, the joy of conquest, or the power of suffering.

Suppose we scramble Reik's analysis and exemplify in a logical form, easily digested —

In the following, a common form, our hero has found that the purest pleasure lies in invoking sympathy and attention, achieved by being oppressed and unjustly

[1] The neurotic personality of our time.

6

treated. For this drama an audience is usually necessary.

This person casts his life-situations into the drama wherein he is the victim of oppression. By every creative means at his disposal he shapes events so that he is the wronged party (a trite example: as a passive bystander he puts himself in the way of a rushing pedestrian for the purpose of being rudely jostled). The drama is played before an audience who pays with sympathetic attention, and the villain is a member of the family, his employer, the church or minister, or any person of personal importance.

In addition to the pleasurable sympathy derived there is the pleasure of the power of stage-managing people's emotions (a major propaganda effort —). If used correctly, "the meek shall inherit the earth."

This is the main theme, and the immoral aspect of it is the unwanted suffering he causes in others.

How innocuous by comparison is the sexual masochist who by sacrificing his cultural dignity achieves satisfaction through willful self-abasement.

The sexual parallels the social but the sexual masochist doesn't destroy the lives of others. His method is a personal answer to a challenging society. It is a triumph of personally unbearable, ambivalent cultural impositions.

Reik continues, "The wrongs, offenses, and self-injuries of social masochism thus reveal their nature as unconsciously self-inflicted sacrifices, or atonements for the subsequent realization of otherwise forbidden wishes. They are attempts to bribe the higher moral courts, to which a tribute is paid by these privations and self-punishments.

Where else in psychic life do we find similar phenomena? We meet them on a small scale in those unconscious symptomatic actions of atonement and sacrifice. What is expressed there in unobtrusive and harmless mishaps and self-injuries, here rules the life of the masochist and determines the course of his existence. Psychopathology does not intrude into his everyday life just occasionally; it dominates all his days. We know a sphere that is ruled by a similar conception: the religious sphere. That is where the voluntary submission to sacrifice and privation, the renunciation of instinctual gratification and frequent self-injuries, become preconditions for attainment of the prospective goal."

But here I would depart from Reik. Religion may appear to be masochistic in format. Certainly the early Christian martyrdom seems to have all the elements, but it does not. Both religion and masochism contain a drama of salvation, satisfaction through sacrifice and gratification through goal attainment but they differ in the construct of the all-important phantasy. For the masochist the phantasy is experienced; in religion it is god-given or "revealed". From there, human nature takes over.

For an excellent treatment of mystical religion the reader is referred to Carlo Levis', "Of Fear & Freedom."

TO THE PURE
ALL THINGS ARE PURE
ARAB PROVERB

AND

TO

THE

EMPIRICAL

?

FIGURE TRAINING AND DEPORTMENT 1840

The following is from a distinguished reader who knows the WHYS and the WHEREFORES whereof. It is interesting that, in even so short an account, there is ample evidence of the English marriage of anglo optimism and saxon justice.

DIARY OF A LADY OF

FASHION (circa 1840)

September 17th. Meggs, my groom, to fetch the new French governess today from the London post halt. I must say I was curious, having made the arrangement through a friend in Paris. Dorothy and Joan, my two young ones, having become totally unmanageable, there was no other course than to take milady T.'s advice and send for someone recommended for severity. Well, Mlle. Jousse is all elegance BUT she has only one leg!!!! She stepped down from the phaeton on her crutch with considerable agility, however, and I must say gets about with great grace. She is about thirty

perhaps and has a severe manner. I had no idea of her sad handicap but she at once assured me that it would not detract from her expected duties, the which had been made plain to her in a letter. She evidently prefers to leave her crutch at the foot of the stairs and hop up. She had on a leather skirt, fairly tight, and she was strictly corsetted. A strange impression to see her poor leg moving under the stuff. Dorothy, quite a big girl now, her golden plaits swinging, greeted her rather curiously. Joan, slight, dark, was more polite, I thought.

October 9th. My dear daughters have improved beyond all measure. This day I discovered them being given a correctional exer-

size in the ballroom by their governess, which cannot help but improve their posture. A long shiny table was set down the room and they must walk up and down this without "broncher", or tripping. Their heels were six-inch. Dotty, who has a big body for her willowy, flamingo-like legs, was in difficulty. Later, I attended a class in the schoolroom at the top of the house. Both my young sons at their desks, feet in the stocks and backboard at their backs, looking very submissive. What is this wonderful change?

October 11th. Alas, I must reprove one of my most faithful of the staff, a young maid called Mary. A fault lengthily indulged in, I fear. She came in to me in her Holland apron and dimity, quite unrepentant. There was a distinctly rebellious little "poke" to her neck as she awaited execution of the sentence. I resolved to induce proper contrition. Before it was over, the punishment indeed was not unattended by a few tears, but she is as accustomed to the rod as my own maid, Alice, and I warrant the affair did not cost her more than temporary inconvenience.

October 13th. A fine canter on my grey this noon. He is hot and I must use my spurs a deal or he will buck. (Too many oats, I must see Meggs about this.) Once

I had to rein him in and drive my spurs in sharp, three or four times, putting my weight behind them. I used a short needle spur, an inch or so long, it is as good as any rowel, I declare, though I had to drive it in to the hilt several times before he came to his senses.

Milord Molian to dinner; he seemed very taken by my Mlle. Jousse, who appeared in a daring gown with ear-rings all over her shoulders.

October 18th. To London to see Tom and execute a commission for Mlle. J. It seems she advises my two be really taken in hand for a brief, salutory period to cure them of their previous slackness. My corsetiere advised me where I might procure the kind of rod required for everyday use. The place turned out to be an elegant establishment in Oxford Street (how this street does grow). A delightful young lady escorted me in to an inner room and showed me a selection. I must say I considered these canes costly. "But their effects are worth every penny, Ma'am," she gently counselled me. "You consider them more efficacious than the birch?" I enquired, and related what my new governess advised.

"The birch has more charm and the martinet more distinction," she conceded with a becoming little

10

blush. "I myself was brought up on the strap and I think it cured me of my worst faults. However, we consider the willow will to do the same work more quickly, less elaborately, and of course it is a more durable instrument."

"Yes, that is my opinion," I said.

"I do believe young ladies like it less," my pleasant assistant responded. "This model in particular, Ma'am," and she bent in two a thin, yellow stick about three feet in length, "this may be relied upon to produce immediate sensations of a salutory nature. This one here, with the thickened tip, would be yet more vexing. I trust you realize, Ma'am," and here she modestly lowered her eyes, "that we sales ladies are entirely at your disposal here. If Madam wishes to test a willow like this, to try the pliability of this ash, say, I have only to prepare myself instantly."

She made a motion but I restrained her. "I do not think it necessary, thank you."

"We have other models, Ma'am," she went on with what I thought was some relief. "We have a whalebone stick that is both tough yet supple. Its effects are, however, rather exquisite and may be more than Madam requires. We find our customers generally re-serve it for cases needing a stringent deterrent."

I thanked her and having tested one or two through the air selected a dozen for my dear ones. They were of the thickness of a pencil, smooth and shiny in all their $3\frac{1}{2}$ feet of length, altogether graceful. When I later gave them to Mlle. J. she expressed herself satisfied with my choice.

November 14th. A fine fancy ball at milord M.'s. I went as a cuirassier, in tight-fitting trousers that extracted many a glance. On returning, found my governess awaiting me. My two were supposed to have been "pert" and, in the case of D., to have pushed Mlle. J. as well as having "cheeked" her. This at bedtime, and they had been made to wait in silence in the schoolroom. I went up. Thought the correction severe but no more than merited by the gravity of the offence. They must stand with their ankles in the desk-stocks and lean over. Mlle J. drew up their skirts and administered the stripes slowly over the poor dears' silken bloomers. I thought my chicks bore it all splendidly. Joan swallowed fifteen with a wry face and then Dorothy must stand as many more again, for her extra fault. Poor D. did her best to be brave, but must cry out once or twice before the end. I warrant their thin bloomers gave little protection.

The governess pulled Dotty's plum colored pair perfectly tight and did all she could to break down my dear's resistance. Which she did, Dotty writhing under the last three that seemed to lap her from side to side. The two made to kiss the rod, the which my elder did not like at all, I believe. Oh la, what it is to be a mother in these hard times.

December 20th. The corsetting proceeds apace. Both my girls in the stiffest of busked whalebone corsets and a wide belt over their tunics, in which is placed in the morning classes a long needle to lift up their chins. Woe to the one who has a scratch there later! Joan gave me a quick answer at luncheon and was sent upstairs. Later she came to apologize to me and I kissed her little tears away.

January 11th. To the charity school to see a passel of ill-disciplined young misses, some of whom will soon be put out, too, firmly dealt with. Mlle. J. came with. To wound the self-willed girl's sense of propriety, my new governess considers the indelicacy of any operation of correction a benefit. Corporal correction, which we all detest inflicting so much, should never be unbearable, she asserts, but unless attended with due ceremonial, it is no whipping at all. I revised the rules at the schools.

January 29th. My daughters have improved out of all proportion under my gem of a governess. This day I discovered them undergoing a severe correctional exercize in the ballroom. Standing in the center of the room Mlle. J. held a driving rein attached to a bit in each girl's mouth. Their wrists secured behind them, they must pace the room round, lifting their feet high as they step. I noted Mlle. J. carried a switch but only for show, I am sure. A week ago, however, I may examine one of these bits closer to. They are specially made and brought over from la belle France. Mlle. J. informed me that Joan was spending the day in her room for excitedly fidgeting during her morning's corsetting. I went up to her with some small delicacies during dinner (she having been starved all day, poor dear). Joan was at the corset bar in a severe corset. There was a belt that must have been simply horrid under her body and a padlocked chain drove into her waist. Her little head was drawn cruelly back by a formidable bit, the rings of which were attached to the chain at the back of her waist. Being taller than she I might see into her mouth. The bit went in deep with a floating stud compressing the tongue. A spiked ball prevented further rambunctiousness. Joan gargled slightly

and stamped the floor. I refrained from feeding her at these signs and ate the delicacies in front of her. Poor Joanie has still a little way to go yet.

February 13th. Deportment drill under my new jewel continues to be excellent. To the ballroom this morning. Both girls on seven-inch heels, their arms drawn behind them in the punishment glove, heavy posture collars on. They must walk to the end of the room and back blindfold. Then Mlle. Jousse has another practice. She will make them wear an anklet chain, not more than ten inches in length, and walk with this on to the speed of a metronome, set quite fast. Again, she will chalk their heels, cause them to walk the length of the ballroom down a dark felt carpet, though retaining the collars fixing their eyes so attractively on the ceiling. Mlle J. teaches them to walk with the thighs brushing, the toes turned slightly out, so that the heelmarks should be in a straight line. I was happy to say I could execute all these practices with ease. Mlle. K. complimented me and we left the room arm in arm. My young ones are far more submissive each day and am full of admiration for the influence this foreign lady exerts over the pair. This evening, find Joan writing out one hundred times, "I must not turn over on my heels." The governess takes her duties seriously, I see.

February 24th. A very severe lesson meted out to my two dears after class this noon. Mlle. J. decided that the punishment should be on the bare skin. She made the pair pick their twigs from the garden and tie each rod with a pale blue satin ribbon. They steeped in pickle in sight of their eyes all morning. Joan suffered first in the customary position over the desk, her wrists secured in stocks in front. She was accorded about a dozen and a half, I believe, let up and bidden kiss the rod lovingly, for, Mlle. Jousse declares, submission must invariably accompany any correction worthy of the name. This was hard for my Joan to do, but she managed it after a moment or so to compose herself. She was then — Lordy! — made to undergo the same count again. Mlle. Jousse stands perfectly balanced, holding only on to a walking stick and gives sharp strokes, pausing between each for a little wholesome effect to sink in, the which was soon visible in the appearance of my daughter's person. Dotty, who had been watching with a bright eye, followed. She seemed to feel the ignominy of her state acutely and flushed up as her bloomers were drawn off her hips. She suffered her two salty installments and then heard, "Now then, Dorothy, since you

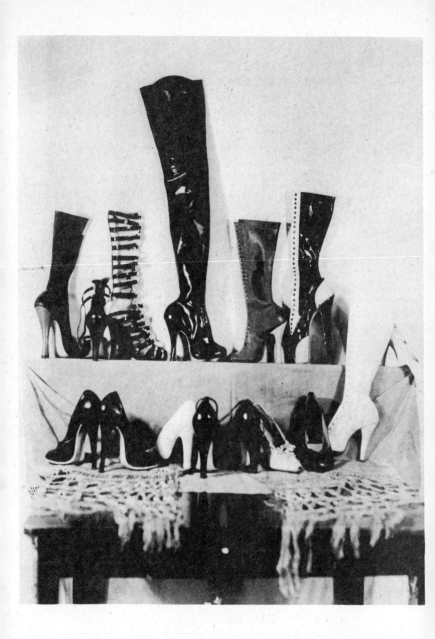

AT LAST! A CUSTOM SHOE AT A FAIR PRICE

5", 6", and 7" heel

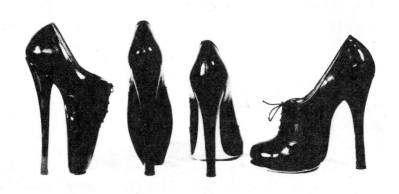

**WRITE TO THE EDITOR, P.O. BOX 511,
MONTREAL 3, CANADA
AND ASK FOR THE SHOE BROCHURE.**

are a big girl and I do not want any more trouble in this direction, I must ask you to put yourself in position again." And she must listen to the acid whistle of the whippy twigs all over again. My poor one bore all well and when released, but for an unusually red face and a few tears, seemed little the worse for her punishment, adjusted her underthings and quietly left the room, after her ankles had been released from the stocks. Mlle. J. later told me that to wound the sense of propriety is all, that a state must be attained when the offender is more anxious to atone than the one inflicting the correction is to punish. "Lean always to the side of mercy," was her motto, she said.

March 2nd. Milord Molian rode over at luncheon and proved himself most affable to my Mlle. J. I dare say he is smitten with her. At any rate he accepted my invitation to stay on till dinner. My Joan looking troubled. Asking her what it was, she confided "a dose to be taken at bedtime, Mama!" Poor little thing, she is so slender and my governess does not spare them. Mlle. Jousse down to dine in a beautiful gown of ivory satin (HOW these French know how to dress!). Molian rushed at her to assist, but she declined his offer, moving slowly and yet graciously on her crutch. The effect of her disability is indeed, strange. And

rather moving, too. Learnt that the poor culprit had swallowed her medicine bravely. But three dozen in a "robe de nuit" and that turned back! I considered this excessive for having dirty fingernails at lunch. Molian disagreed and had a spirited defense of my elegant governess. The gist of this being that by bringing pain to a more logical area, many minor complaints in young ladies, such as pimples, colds, and even sluggish bowels, are eradicated. Mlle. J. all agreement (is this a romance?")

March 20th. Withal I do confess that Mlle. Jousse mixes her severity with a certain indefinable kindness of manner. Nearly always she makes Dotty and Joan kiss her after some little punishment has been successfully completed. I have often known her give her delicious soft French chocolates to an offender after some breathtaking little session over an ottoman. And the little one must take her fill of the melting things with a good grace, even though the tears do stream down her face.

Only the other day I burst into her bedroom to borrow something for my gown to find her in deshabille instructing my two on the use of make-up (thoroughly approve). Her own face was as if waxed, so thick the maquillage. Dorothy before the mirror, bare to the waist, her shoulders and

back powdered until it were whiter than white. Dotty is quite grown-up now. Her face a white mask, crayonned with oppoponax, her eyelids mauve. She was obviously enjoying herself, though I noted "le stick" lying over a schoolroom stool a few feet away and wondered whether her lower back were as peerlessly pallid as her upper!

March 27th. Shame, says Mlle. Jousse, my infinite jewel, (soon to be reft away by milord M.??), is a sensation only grown ladies experience. Accordingly she takes pains to eradicate this sense in my girls. If they betray the slightest feeling over a comment or remark, or over the adjustment of their dress, however small, they are sorry for it. They are different lasses, I am amazed at the change wrought in them. And they seem infinitely happier than in the bad old days. Dotty, however, still clearly feels it hard to soften the deep feeling of humiliation Mlle. J. designs for her — such as exposure before strangers, being punished before one of the staff. At a recent tea-party she was made to atone in the presence of four of my lady friends for a trifling misdemeanor on a low deal table upon her knees and elbows, her skirt thrown over her head, her bloomers drawn perfectly tight, and her back quite arched in to give proper prominence to the part to be chastised. Nor did any

of Dot's dancing partners at my ball a month since know the well-built miss they held in their arms had an hour previous been made to squeal as the rod stung up her skin, I wager!

April 9th. Today to the races, a blowy afternoon. Milady Dawson did look smart, in laced bonnet and prettily gusseted boots. Could not take my D. on the governess's advice. It was a rank fit of rebellion, evidently. The impeccable Frenchie showed me the severed laces herself. Dorothy had been "cutting"! When charged with the fault later in the day (no food to reduce her resistance) she said the corset was so tight she could not breathe. Mlle. J. counselled a strict "punition" at which I should attend. I agreed, though with heavy heart. It seems quite once a week my D. goes under the rod now, and no fuss nor struggling neither.

It was decided that Miss must endure "Madame la Verge" in the withdrawing-room, and in order to induce a lasting sensation of regret have her plaits shorn off. This I protested but was persuaded. A haughty D. came in, wearing a kind of REFORMKLEIDE Mlle. J. is making her wear for a month, a short, skimpy, tight-fitting sort of thing of serge. D. was well lectured, arranged her dress and inclined her body forward, her dear hands in mine, with a

17

supercilious mien. To instil a proper sense of gratitude for her correction she was told she must say "Thank you" after each stripe. At the news she threw a thoroughly disdainful look about her, but it was quick forgotten in the more serious task of enduring physical pain. Soon the twigs flew about over the floor and that feeling for implicit obedience so necessary in a girl was being inculcated in my beloved child. I have seldom seen my governess fulfill her unhappy role with such liveliness and, at the same time, finesse. She applied the unfeeling instrument about my daughter's upper legs in a manner that made me want to cry to look at it. Yes, she cut about the poor child's thighs until a maddening severity was reached and she could no more utter her "Thank you" in tranquil tone. Thrice she was made to take the stripe over for this negligence. Once she flinched and tugged at my restraining wrists. "Since you move," said the governess, "you must take six further." And she must endure the six extra after the thirty originally allotted. Yet Dorothy bore them bravely as ever and I felt proud of her fortitude that did such credit to the family and, before this French lady, to the nation. Beyond a gasp, a movement of her upper body, she suffered stoically the painful lesson so painfully instructed.

Having adjusted her dress she must now lose her lovely hair. She stood trembling all over before me as I sadly approached with the huge garden shears Mlle. J. had given me for the occasion — for it was I who must perform the duty. I took the stiff, starched golden pigtail in one hand and arranged the scissors in the other. Mlle. Jousse placed them closer to the girl's head. Using both hands I snipped them to. With a brief, chopping sound the heavy plait fell to the floor and Dotty burst into tears. "You see, Madame," said my governess, "she is a hardened thing and is only now ready to repent fully." I snipped off the other and a flood of tears followed.

"Well, Dorothy," I said, "you have been a silly girl and there are your plaits. You may hang them over your bed. Your hair will take some time to grow again and during that time I want you to reflect on your fault. You will go upstairs and be laced into the tightest corset you have. Perhaps Mlle. Jousse will consent . . ."

"As you wish, Madame," said the French jewel, curtseying and leading the sobbing girl out. (*From this point on the references to the French governess become more and more fragmentary; it seems likely however that she married the English lord.*)

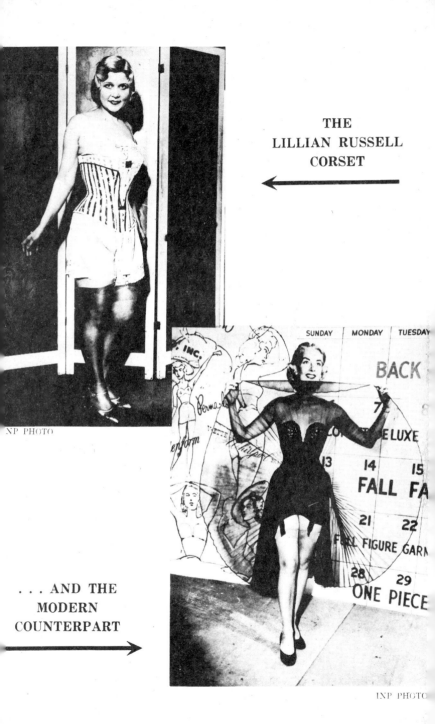

THE
LILLIAN RUSSELL
CORSET

←

NP PHOTO

SUNDAY MONDAY TUESDAY

BACK

... AND THE
MODERN
COUNTERPART

→

INP PHOTO

PATTERN FOR MODERN WASP CORSET.

Half corset shown. Repeat when cutting.

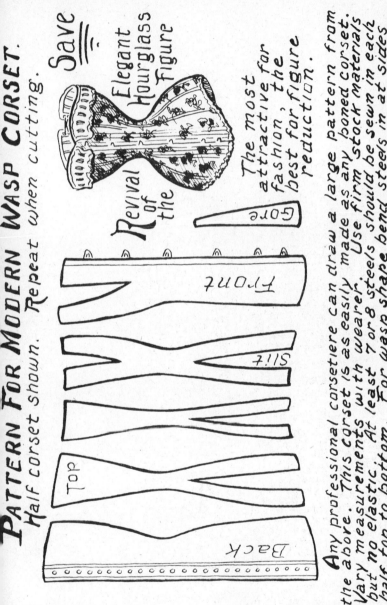

Save

Revival of the

Elegant Hourglass Figure

The most attractive for fashion, the best for figure reduction.

Gore

Front

Slit

Top

Back

Any professional corsetiere can draw a large pattern from the above. This corset is as easily made as any boned corset. Vary measurements with wearer. Use firm stock materials but no elastic. At least 7 or 8 steels should be sewn in each half, top to bottom. For wasp shape bend steels in at sides of waist and round them out over hips. Use long lacers. Slits are for gores, important for stylish curves. A simple short clasp can be made with a 12 inch front clasp.

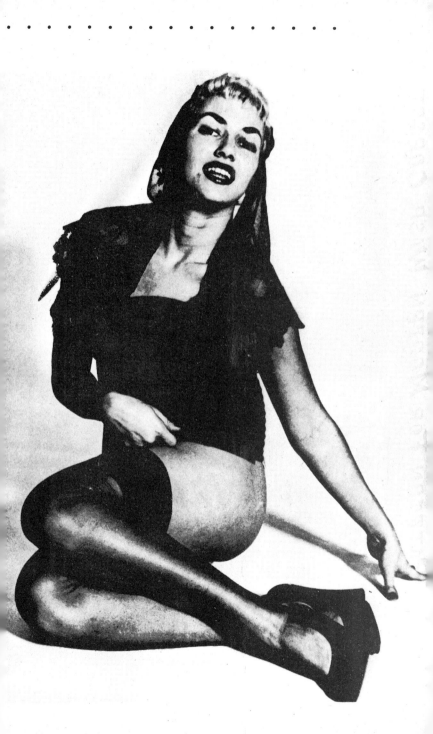

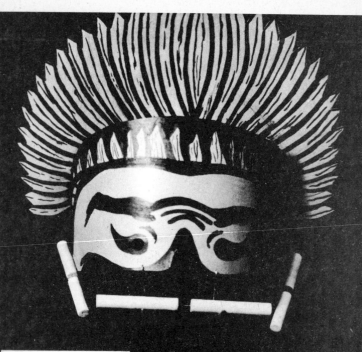

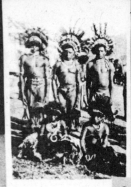

"Ibitoe"

IS THERE AN IBITOE IN THE CROWD?

IBITOE IS THE NAME GIVEN A NEW GUINEA BOY OF THE RORO, WAIMA, OR ELEMA TRIBE WHEN HE HAS BEEN INITIATED AND HE HAS ASSUMED WEARING THE *ITABURI*, OR TIGHT WAISTBAND.

At the time when the women of the tribe begin their life of druggery and submittance, the *ibitoe* is a dandy, a slave of fashion, whose crowning achievement is to obtain as small a wasp-waist as possible. When a Roro boy enters manhood, his ears and nose are pierced and his father asks his maternal uncle, "suffer now that my son assume the *itaburi*"; the uncle places the *itaburi* on the boy and he is then subjected to further "restrictions and disabilities." (C. G. Seligmann, *The Melanesians of British New Guinea*)

John Foster Fraser in *Quaint Subjects of the King* writes, "when a Papuan boy gets to the age at which an English boy begins thinking about taking to stand-up collars, instead of encasing his neck in a rampart of stiff linen, he crushes his waist into a wooden belt so tight that his ribs protrude over it like the chest of a pouter pigeon. The belt terminates at the back in a kind of tail which trails upon the ground, and the more wasp-like his waist, the more airs the boy gives himself. When he has assumed this wooden belt he is called *ibitoe*, and becomes entitled to all privileges of a full-grown man (including the choice and domination of a woman.)"

The material of the *itaburi* varies from tribe to tribe and is usually beaten bark (wood), hide, or boned snake skin. Tight arm and leg bands, a high shell collar, pierced ears and a pierced and enlarged septum, or slits in the nostrils, complete the beauty of the *ibitoe*. It is difficult to find any accurate information on the size of an *ibitoe's* waist, but one French naturalist, who claims to have cut by force an *itaburi* from a full-grown *ibitoe*, gives the measurement of 20 inches on the inside of the belt. In recent times the assumption of the *itaburi* has practically ceased. Civilization has enlightened the savage! In the times prior to World War II, the

(2) First Itaburi

(1) Embossing: First Itaburi

itaburi was assumed at about the age of 15 and was worn for life; the only occasion for removing the *itaburi* was to replace it with a tighter one. As the young *ibitoe* became adjusted to the *itaburi,* he could walk, run, hunt, and do all other strenuous physical activity without removing it. Those youth of New Guinea who still wear the *itaburi,* wear it only for about a week during the initiation and on special occasions.

I first saw a picture of an *ibitoe* when I was 15; the sight of the boy-about-to-fall-in-two made my pulse jump. He was practically cut in half by a solid black belt 4 inches wide. The caption read: This Melanesian youth from one of the islands near New Guinea must be the talk of his village. For above all things, his people admire small waists and well-spiked noses.

(Note to Editor: This picture appeared in Volume "P", under "Pacific Islands", Compton's Pictured Encyclopedia, first post-W. W. II edition. Another good picture of five *ibitoe* on initiation day is to be found in Loomis Havemeyer's *Ethnography;* this photo is courtesy of Dr. A. C. Haddon.) Immediately after seeing this picture, I had the strong desire to emulate the boy with the wasp-waist. I began my career as an *ibitoe* several weeks later when I found an old-fashioned, heavy leather, ladies' belt in a box of old cloths. This belt was 2 inches wide with a double-pronged buckle. It had slit-like notches on both sides for the entire length and could be decreased to zero circumference if desired. I sucked in my stomach, stretched, and pulled the belt in as tight as possible over my bare

24

skin. I felt bisected and especially strange when I moved or walked. After several hours, I felt a pleasant lightness, though I still had difficulty moving about and doing simple tasks. I wore this belt as tight as I could pull it for a while each day from that day on.

After several months, I became adjusted to wearing the *itaburi* and I could do all sorts of bends, squats, and the like without losing my balance. At first I could only wear the *itaburi* for several hours, or even less if I moved around a great deal. Wearing the *itaburi* is unlike wearing a tight corset; the edges are not padded or conical and ones full weight rests or presses on them. Even when well powdered or greased, these edges soon feel like two hot wires, one around your pouting chest, the other around your hips. I tried wearing the *itaburi* over various items of clothing, but this never gave the same effect as on the bare skin; over clothing, the *itaburi* would suddenly move to a slightly different position and my whole body would have to adjust to the change.

With my first several *itaburi*, I used to pull my waist in to 16 inches. Sometimes I would wear them for two days without touching them; sometimes I would pad the indentation and take a long

walk in them. I gradually developed tough, calloused skin about my waist and the edges of the *itaburi* did not cut or burn any longer. An interesting side effect of my first *itaburi* can be noticed in photograph one; because this belt was full of notches and slits, it left a long-lasting embossed pattern around my waist after it was removed. In photograph two, a very old picture, I am wearing this first *itaburi*.

When I was inducted into the Army in 1952, my 5′ 9″ had a normal waist measurement of 22½ inches, to the amazement of the medical officers and the confusion of the quartermaster's people. During this two years service, a horrible thing happened; the *ibitoe* had to resign temporarily. I could not belt properly and on my release my waist had expanded to a miserable 32 inches! Since my release, I have become the *ibitoe* again and have managed to reduce this to a more comfortable 24 inches. I am also wearing a number of new *itaburi*; I have specially designed these and made them of heavy leather. They vary in width from 2 to 7 inches and in minimum circumference from 21 to 17 inches; some of these *itaburi* wrap around, some fasten with straps, and some are like vises with built-in screws. In photographs 3 and 4, I am wearing my

current favorite. It is 3½ inches wide and is adjusted to its minimum 19 inches. Incidently, "One Covered All Over" of Number 17 should appreciate the tattooing; this kind of design goes well on the *ibitoe*. Photograph 5 is a recent side view of *Ibitoe* minus *itaburi*; notice the structure of the ribs as seen in the shadow in this picture.

I have a stuffed album of such pictures and it has been very hard for me to decide which few to enclose with this letter. If your readers take kindly to the idea of the *ibitoe*, I'll send more for following issues. I have many pictures of Ibitoe exercising as well as photos of Ibitoe's favorite accessories and party costumes; Ibitoe thinks they are all very bizarre and interesting and would appreciate comments.

Yours for smaller waists,
IBITOE

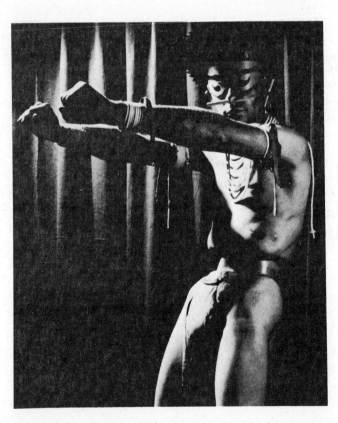

(3) IBI'S DANCE

THE INCOMPARABLE MISS HOUDINI

ATTEMPTS AN ESCAPE FROM THE RED-KID SACK

NOPE: NOTHING YET

←

1 HOUR LATER

WORSE

→

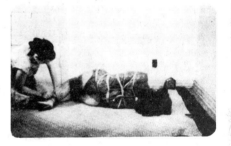

2 HOURS LATER

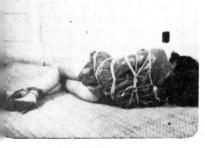

MIDNIGHT

WHAT THE HELL!
I'LL TRY TOMORROW

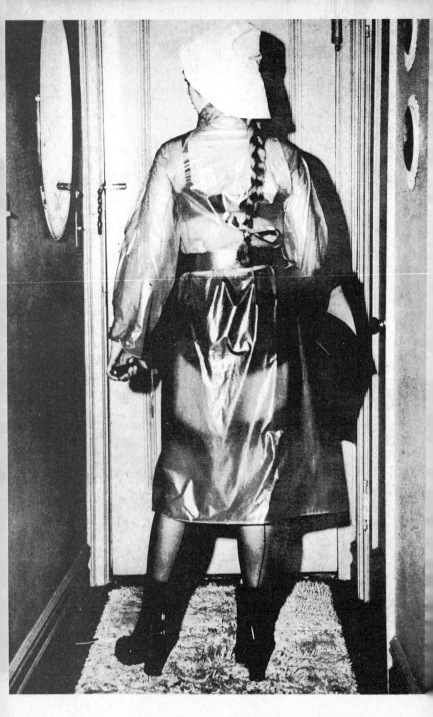

ALL SET FOR A RAINY AFTERNOON . . .

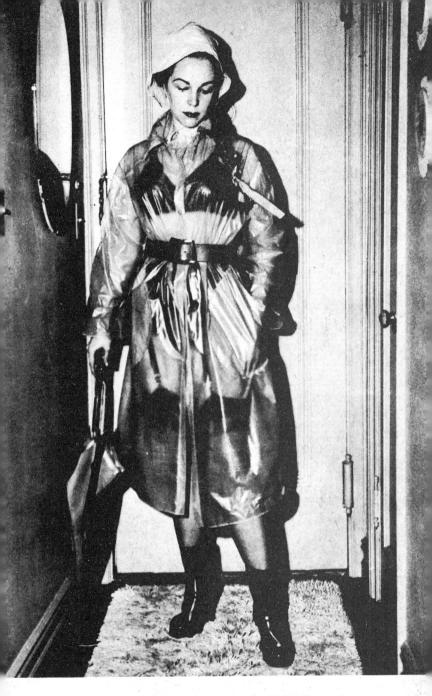

GOSH! I DIDN'T EVEN GET WET.

orrespondence

MOMISM VS. SELF ASSERTION

Dear Mr. Willie:

Subjugation of women shows up even in ancient art, as in the beautiful reprint of Correggio's "The Punishment of Juno," enclosed.

One of my patients has shown me some copies of your interesting publication, BIZARRE. This patient questions his sexual potency and, though he goes on dates, he stands in awe of women and often makes up slim excuses to get rid of them. Why are so many men timid these days? I don't know about Canadian men but, since the War, there has been a greater awareness in the U.S. of the problem of "Momism:" the timidity of young men and women that results from fearful and domineering mothers who keep their sons and daughters overly dependent and "protected" from the real world outside. (The patient I mentioned above has a younger brother who, at the age of twelve, is still not allowed to go on dates or to play outside with other kids. He is kept a prisoner in his own home, a criminal way of delaying his maturity and socialization.)

Men brought up like this often fear and distrust women, and therefore marry late, if at all, unless some woman takes the initiative in the relationship. For the over-mothered male, a tied-up woman seems more like a woman than the masculine person she may try to be. When a husband takes the masculine role in his home as well as business, this may not only help his ability to assume his proper life role, but also may

30

prove therapeutic to his wife who now has an opportunity to discover her own *essential feminine nature* that God has given her. (Pictures such as that on page 55 in BIZARRE No. 15-16, or on page 42 of No. 11 obviously place woman in a most feminine sexual position that even the most timid and inexperienced male could not resist. Thus BIZARRE may give hope and courage to the faint of heart and lead them to self-assertion, self-esteem, and a more abundant, instinctual sexual life, which civilization tries so hard to crush.)

The strange aspect of all this is that there are so many men who would never admit to such timidity as described above except on an analyst's couch. They may think they are fooling their girlfriends or wives, but whom are they kidding? However, it is time for men to stop this nonsense and become again the real males that women secretly and openly *want* them to be! (And my shotgun is ready for the next male patient who asks me such a question as whether he should *ask* his girl for a kiss instead of just doing what comes naturally!)

Sincerely yours,
H.K.F.
Psychoanalyst

A PHOTO IDEA

Gentlemen:

I've been a long time in getting around to writing to you, simply because I don't like to write letters. But, I feel that it's about time that I express my appreciation of your magazine, and besides, I have compiled some information which may be of interest to some of your readers.

First, however, just to prove that no-one ever agrees completely with anyone else, let me state a few opinions. As far as I'm concerned, rubber is strictly for tires, boots are strictly for cowboys, and corsets, ultra-high heels, and leather hoods are a complete waste of time. But I realize that someone else may enjoy seeing a pretty girl clad in a raincoat and rubber boots as much as I would enjoy seeing the same girl wearing an ordinary dress but tied firmly to a chair. So I have no complaints; just keep on publishing a little of everything and I'm sure everyone will be fairly happy.

There is one suggestion, made by "Slick" in No. 17, that I cannot go along with. Namely that you publish more combination photos, such as maybe a girl wearing a raincoat and boots while tied to a chair. I assure you, for those of us who enjoy seeing a shapely pair of nylon-clad legs

with a few twists of rope around the ankles, the effect is ruined by a pair of rubber boots or shoes with heels so high that the foot is twisted into an awkward and unbecoming angle. I think that the shoes worn by "Chained Letter Writer" on Page 41 of No. 13 have about as high a heel as I ever want to see. But, again, to each his own!

I wonder how many times my fellow readers have seen a scene in a popular movie, be it a girl in corsets, boots, or bound and gagged, that they would like to have a still picture of for their collection. Well, anyone who can handle a camera can do just this. Using any camera with an f/3.5 lens and Tri-X film, go to your local theater and get a seat just far enough back so that your pictures will include the entire screen. Set the lens at f/3.5, the shutter at 1/25 second, slump down in your seat, brace your elbows against the arm rests and snap away at any scene that appeals to you. If you have, or can afford, a camera with an f/2 lens, an exposure of 1/50 at f/2 is better because helps eliminate blur due to camera motion. A handy accessory is a rapid-winding lever (for a 35mm camera,) which will enable you to make several exposures of short scenes. (I have found that most bondage scenes are annoyingly brief.) I am enclosing several pictures in support of my statements. I will let you worry about whether copyright restrictions will permit you to publish them.

The following is a list of movies in which bondage scenes appear. Those under "Good" contain good scenes of reasonable length. "Fair" are good scenes of rather short duration, while "Poor" are so rated because of extremely short duration or poor camera angle or both. These ratings are my own, from my own experience, and do not reflect my opinion of the pictures as a whole. The name of the star involved is included wherever I remember it. (*) indicates bondage scene on poster art.

GOOD:

Thief of Venice — Maria Montez*

Pony Soldier — Penny Duncan

Prince of Pirates — Barbara Rush

Return to Treasure Island — Dawn Addams

Adventures of Hajii Baba — Elaine Stewart

African Manhunt — Karin Booth

The Long Wait — Peggie Castle*

Apache — Jean Peters

Port Sinister*

Gunfighters of the Northwest, Serial, Chap. 15 — Phyllis Coates

Tarzan's Hidden Jungle — Vera Miles

PRINCE OF PIRATES — A WARNER PICTURE

KARIN BOOTH IN "AFRICAN MANHUNT"

Son of Sinbad — Sally Forrest
Thief of Damascus
Unconquered — Paulette Goddard
Quo Vadis — Deborah Kerr*

FAIR:

Hunchback of Notre Dame — Maureen O'Hara
The Black Knight — Patricia Medina
The Golden Idol
Tarzan & She Devil
Tarzan Triumphs
Problem Girls** (Good Poster)
Desert Sands — Marla English

POOR:

Battle at Rogue River — Martha Hyer
Fair Wind to Java — Vera Ralston
Woman they almost Hanged — Joan Leslie
Blackbeard the Pirate — Linda Darnell*
Khyber Patrol — Dawn Addams
Bengal Patrol — Arlene Dahl
Overexposed — Cleo Moore
Killers Kiss
Mobs, Inc.
Land of the Pharoahs — Joan Collins

That about finishes me for now; maybe I'll get ambitious again sometime and write you another letter.

HDM

* * * * *

THE FRENCH TOUCH

Dear Sir,

I receive your lovely magazine regularly from friends in my old home in England, and I must say that my hubby, Maurice, whom I met while serving in France in the W.R.A.F., and I both get a real kick out of it. We are members of a small, rather select, club, and, in view of the interest shown by your readers in dressing-up parties, etc., I felt that the following account might interest them and stimulate them to try something of the sort themselves, particularly if they are able to get together into groups.

An argument sprang up at the club as to who could achieve the best change-over impersonation, men or women, and, as a result, there was a general challenge thrown out to the members to prove their word. It was agreed that we should hold two special sessions, in one of which all the girls should come dressed as fellows and all the men should be in the guise of girls, while in the other session a change-over love scene should be enacted by the best "girl" and the best "boy."

Maurice, who makes quite a pretty girl, and I often have fun changing over at home. Indeed, it was at a fancy-dress dance, where we were both masquerading as members of the opposite sex,

34

A reader photo

voice and even looked at home with a pipe! But you should have seen the "girls"! Bewigged, made-up, tightly-laced, clad in dainty frocks, shoes and gloves, they tripped lightly about on their high heels, sipping small drinks instead of their usual pints and affecting girlish gestures. As the evening wore on, we were amused to see the "girls" groping for non-existent pockets, trying to ease their by then tortured waists, sitting most immodestly with nylon-clad limbs fully revealed or patting their "bosoms" back into place, where too-ardent "male" attention in a darkened alcove had caused things to go awry! More than one "girl" was called upon to demonstrate the extent of the girlish underneaths being worn, much to the amusement and sometimes admiration of the others present, while the very dominating half of one couple insisted on frequently pulling up "his" partner's frock to test that the suspenders were not too tight. A highlight of the evening was the leg competition. In this, all the "girls" were lined up behind a sheet hanging down from the ceiling to about the level of the waist. In order not to reveal too quickly their identity, they had to pull up their frocks out of sight behind the sheet, and then stand close to the sheet, while the "boys" on the other side judg-

that we first got to know each other.

The "change-over" evening was a huge piece of fun, and, in view of the competitive nature of the party, in which everyone seemed to be trying to outdo everyone else, there were many good impersonations on both sides. The girls made handsome boys, though there was no doubt from the start about who would be the girls' representative in the love scene, for Adele looked so boyish, with her short hair brushed back and her borrowed suit fitting her so well. She walked with an unexaggerated manly stride, talked in a deep

35

ed which pair of legs was the prettiest. Naturally, their legs were completely visible and also their undies. Actually their appearance undoubtedly represented their preference, and the results were interesting. Only one had his nylons rolled above the knee, while three showed a liking for opera-lengths; two used chic garters, while the others wore beribboned suspenders and one had both saucy rosetted garters and half-a-dozen short suspenders for his full-length sheer nylons; two wore close-fitting panties, two filmy nylon and lacy camiknickers over brief, skin-tight slips, while the undies of the others were typical, wide-legged, French knickers. What fun we had judging their legs, affecting to measure them, but in reality naughtily caressing them to make the owners tremble. Maurice, who was able to wear a higher heel than most, was the winner, and, to our amusement, someone cut the supporting string and brought down the sheet before the competitors could drop their frocks into a more decorous position. The prize was a chic pair of diamante garters, and needless to say everyone clamoured for them to be put on then and there by Adele. With a show of gallantry, she handed Maurice up on to a table, where he stood smiling down at the others, as he slowly pulled up his frock to his hips, revealing once again his shapely legs sheathed in opera-length nylons, topped by the lacy legs of the georgette camiknickers he prefers. Then amid applause he held each leg forward in turn, amusing us all by his pretended (or was it?) trembling as Adele caressingly slipped the garter right up to the top of his leg. After a brief pose with the garters in place, Maurice dropped his skirts and prepared to step down; but now came a surprise for him, for Adele reached up, took him by his slender waist and lightly swung him to the ground, planting a kiss on his painted lips as she did so. We all knew Adele was strong, but we didn't know she was that strong! It augured well for the girls' representative in the scene to be enacted on another evening. Maurice was chosen as the "girl" of the evening, and in my next letter I'll have to tell you how he got on with Adele.

Suffice it to say for now that he took the whole affair very seriously and went into strict training, with my help. The intervening fortnight was spent in extra tight-lacing every evening, while he wore a light corset to work under his male clothes. Also at home he got used to shoes with even higher heels. Fortunately Maurice and I are much of a size, and he ran

through my wardrobe, trying on everything in the evenings, always making up, using his wig and jewelry. Had any stranger visited me then, he could not have thought other than that my chic companion was a pretty girl. Indeed, at times he would have found Maurice alluringly fetching, for he would sit about in a loose wrap over his figure-fitting cami-knickers and sheer nylons.

This letter is already long, so I'll call it a day for now. Hoping to read more from your "dressing-up" readers, and promising to write again later.

With best wishes,

Yours sincerely,

Maurice's "Hubby"

Lille, France

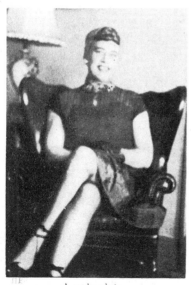

A reader photo

WATCH THOSE DRAFTS

Dear Sir:

I enjoy reading your magazine from time to time, especially the stories submitted by your male readers who like to dress in female attire.

I do this quite often and have a wardrobe that would satisfy a lot of women. When I first indulged in this pleasureable practice, I did so only in the privacy of my apartment, dressing completely as a woman and doing all of the chores the lady of the house would normally do. (Making beds, dusting, cleaning, cooking etc.) I derive an indescribable feeling of exhileration and pleasure when I'm working or lounging around in high heels, long nylon stockings, girdle, bra (padded of course) wig, make-up and all of the other feminine finery to complete the illusion.

Recently, however, I have the irresistible urge to venture out in public wearing my feminine attire. I usually go out in the evenings for a long stroll, or a ride in my convertible. I feel an extra thrill when my 3 inch heels click on the hard sidewalk, and an occasional wolf whistle is directed towards me from one of the male gentry, who apparently mistake me for what I appear to be — a

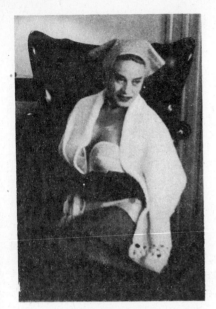

A reader photo

OFFICE ROUTINE

(JUST AS I SUSPECTED)

Dear Editor of Bizarre,

I have always loved your magazine and it has brought me new friends and interesting experiences. I am a girl, 26, and have worked in a certain large office for almost two years. I have read and reread your magazines many times and I always try to dress as close to your style ideas as I can. I love nipped-in waists and high heels. A certain Mrs. R. is the office manager where I work and I noticed that she always dressed in clinging soft fabrics and high heels. Even when she wears suits they are usually "hour glass" style. She is a tall glamorous brunette and I always admired her; and I was especially proud that her taste in clothes was so similar to mine.

I always keep my copies of Bizarre in the back of my desk drawer at the office. About 6 months ago I began to suspect someone was reading them when I was not there. Then, early this summer I discovered who. One day, when I had made two inexcusable mistakes in my work, Mrs. R. asked me to stay after the rest of the girls left. She told me to come into her office. She discuss-

gal out for a little fresh air.

None of my friends suspect that I indulge in this bizarre practice, and living in a large apartment building with front and back entrances has its advantages.

Two girls who share an apartment across the hall from me, have seen me on several occasions coming in late from one of my sorties, and usually kid me about my good looking late visitor that they have seen. I don't think they suspect and that's the way I want it.

Yours truly,
L.S.T.

(Continued on page 43)

LEG COMPETITION

— HERE IS THE FIRST CROP —

SOME PHOTOS HAD TO BE RESHOT, BUT WE COULDN'T
HOLD THE ISSUE FOR THEM — SO THE BALANCE WILL
BE IN #22.

NOTE TO THE LATE ENTRIES:—MACHT SCHNELL!!
CONTEST RULES IN ISSUE #19, P. 61.

READERS WANT OTHER CONTESTS. YOU NAME THEM:
WE'LL ORGANIZE'M.

1 2

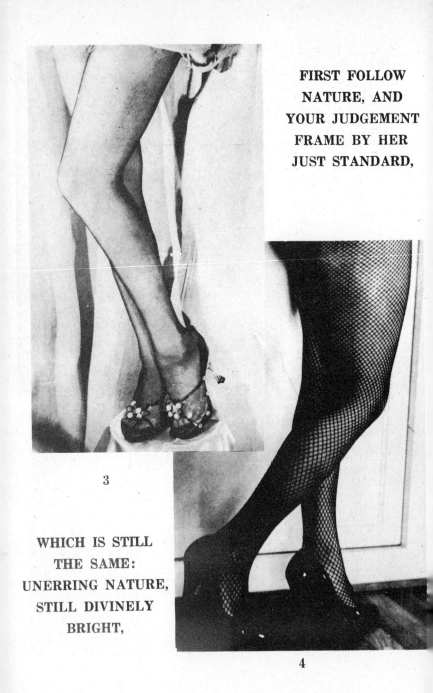

FIRST FOLLOW
NATURE, AND
YOUR JUDGEMENT
FRAME BY HER
JUST STANDARD,

3

WHICH IS STILL
THE SAME:
UNERRING NATURE,
STILL DIVINELY
BRIGHT,

4

5

6

ONE CLEAR,
UNCHANG'D, AND
UNIVERSAL LIGHT.

7

LIFE, FORCE, AND
BEAUTY, MUST TO ALL
IMPART,

8

AT ONCE THE
SOURCE, AND END,
AND TEST OF ART.

ALEXANDER POPE

9

Continued from page 38
ed my mistakes with me. "Now, Ruth", she said, "We cannot have that sort of sloppy work. I have decided to punish you. I am going to spank you." I could hardly believe my ears. I was a grown-up adult, 26 years old, not a child; and here this chic brunette, hardly more than 10 years my senior, was going to spank me just like a child. My heart fluttered and my mouth became dry. But I didn't have much time to think, for Mrs. R. took me over her lap in the time-honored manner and after lifting my velvet skirt spanked me slowly and soundly.

I kicked and wiggled a little bit at first until my bottom really started to get warm; then I decided I might as well take it. It was the most unusual feeling. I felt just like a naughty little girl over this dominant woman's lap. I had not been spanked since my step-mother did it when I was 16; and I realized I was actually enjoying being upside down over Mrs. R's lap while her strong right hand made my tender bottom tingle and smart.

When Mrs. R let me up she smiled a sly smile and said, "Just as they tell about in Bizarre, huh?" Then I suddenly saw it all! Mrs. R was the one who had been reading my copies of your magazine. She then told me how one day she had seen me thrust a copy of Bizarre into the back of my desk drawer just at quitting time and had stayed to see what it was. She had read them all many times after that and was very pleased that one of "her girls" in the office had tastes like her own. We discussed bizarre ideas over dinner that night, though I must say I sat a bit uncomfortably in the restaurant booth.

Of course I had been a faithful reader of your darling book for a long time, but I was mainly interested in the fashions. I read the letters on spanking with amusement, but not real interest. After that first session over Mrs. R's lap I realized what I had been missing. Being spanked by her made me feel so strange and unusual. I was thrilled; and I was pleased even though the spanking hurt. It made me think of the last time my step-mother spanked me. I had come in very late one night and she marched me right up to her room, bared me completely and turned me over her lap. I got the longest and hardest spanking she ever gave me. She really blistered my fanny with that hairbrush! But I recall the next morning as I studied that still-red area in my long mirror I had a certain sense of satisfaction and pleasure.

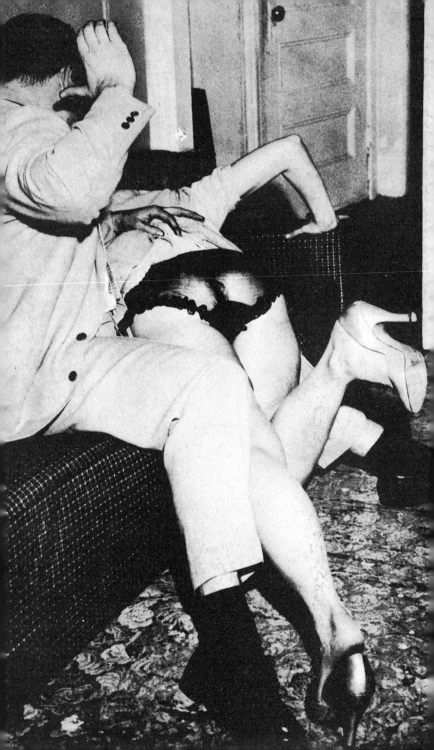

Well, Mrs. R and I have become great friends. I have been "kept after school" several times since that first episode and each time have received a nice sound spanking. She has bought a wooden clothes brush, very like a hairbrush in shape, and made of hard smooth wood. This she hangs in her office closet supposedly to brush lint from her clothes. That is what she spanks me with now. I must get it from its hook in her closet and present it to her. I must tell of my wrongdoing and ask her politely for proper correction. Then I place myself across her lap for the spanking; which is now applied to the bare derriere I might add.

I told my girl friend, Lisa, about Mrs. R. Lisa likes your magazine and I knew she would be thrilled to hear about Mrs. R. She insisted she must meet Mrs. R, so I arranged it. I also arranged with Mrs. R something Lisa did not expect. Lisa came to my apartment one evening to meet Mrs. R. When the lady arrived, Lisa caught her breath. Mrs. R. is quite tall and she had on the highest heels and a clinging black dress with an unbelieveably small waist. After a while I got around to the surprise I had connived with Mrs. R. I got the conversation around to a trick Lisa had played on me and Mrs. R said, "That girl ought to be spanked!"

"I agree", I said, and jumped for the brush which I had taken home from the office and was handy on the table.

Before Lisa knew what happened she was over Mrs. R's lap being thoroughly spanked. What a thrilling sight that was! I enjoyed it so. Later Lisa admitted to me that she was thrilled by it also; though she looked mighty distressed as that brush was smacking her, and yelled loud enough to disturb the neighbors.

So we became a bizarre trio and have enjoyed each others company. Recently Mrs. R told us that she enjoyed the letters in Bizarre which tell how wives dominate their husbands and make them humble and obedient servants with the aid of a strong arm and a hairbrush or strap. She said she thought she could easily make a nice little servant out of her husband and invited us to join in the experiment. I was astonished when I met Mr. R, to find he was only about 22 years old! A meek and mild little blond about a half-foot shorter than Mrs. R. He was quiet and bashful and completely dominated by his wife.

Well, we started right out by tieing his hands together in front of him and tieing his ankles so he could take only 8-inch steps;

then we made him hobble around the room. We laughed at his clumsiness and added a blindfold. Then we took turns pecking him on the cheek and told him to guess which of us had kissed him. Mrs. R pretended to be angry when he couldn't identify his own wife's kisses, said he was a naughty boy and declared he should have a spanking. She dragged him over her lap on the davenport, bound and blindfolded as he was, and sent me to the bedroom for the hairbrush. After she spanked him, we all took turns and made him try to guess who of the three was spanking him.

After only brief training he is now Mrs. R's humble and obedient house servant and we all have fun teasing and humiliating him. Mrs. R keeps him strictly in line by spanking him with the hairbrush, and we all have a go at it whenever we wish. Sometimes to humiliate him we make him dress like a little girl and wear a wig of long blonde curls. Then if the little girl is naughty any one of the three of us may turn "her" over our lap and spank "her". We use other various means of entertaining ourselves with him; and Mrs. R's house is immaculate since she has this "servant". Mrs. R still spanks Lisa and myself regularly too, and this "servant" always enjoys watching that.

Once Mr. R did start to show signs of rebellion. Mrs. R told me how she handled it. "I noticed he was rebelling against this servant business a little more every day," she said, "So one day I bought a heavy black strap and put it in the basement. Then the next time he showed temper I took him down stairs and tied him over the work bench. I took down his trousers and I really laid on with that strap, and I mean laid it on. Since then he has been a mighty good boy. The strap still hangs in the basement, but I have had to use it only a few times. All I have to do is say, 'How would you like to take a trip to the basement?', and that cures him generally. About the only discipline he needs is a taste of the hairbrush in the parlor or boudoir regularly. And he remembers I am his mistress and he is my slave: every morning and night I make him bow down and kiss my feet as I stand in my glistening high heels."

I wish others would write of their bizarre experiences and acquaintances.

Yours, Ruth C.

Dear Bizarre:

'Faithful Reader' in #20 is quite correct. The ritual is a most important part of any spanking and the writer agrees that it should be a liesurely thing.

In our family, order was kept by adherence to the advice of Solomon, "spare the rod-etc." and age or sex made no difference. So long as we lived at home any of the six of us was apt to hear either mother or father say — "We'll want to see you tomorrow evening." That meant that the following evening no matter what, you were in for it.

There was, of course much teasing by brothers and sisters during this entire period of waiting. As part of the evening prayer, father would always ask for forgiveness for the child who had erred.

It was after dinner that the spanking took place and this too was a formalized routine. Immediately after dinner the culprit in order to make other preparations was excused from kitchen chores. First, to the living room where the ottoman was moved to the end of the room and two of the sofa pillows placed upon it. Then upstairs to get into costume for what was to come. We girls removed all under garments from the waist down and replaced them with a garment not unlike a "G string". The boys had a similar garment but had to remove their trousers and reported with their night robes on.

One waited upstairs until one was called. This was the most delicious wait of all. Finally, when the word was forthcoming you picked a short leather strap that was always on each of our bureaus and went downstairs into the living room.

The switches and the strap were handed to the spanker of the evening who immediately bound your wrists together with the strap. This done you draped yourself across the pillow covered ottoman. The spanker then raised your outer garments pinning the hem of your skirts to your shoulders.

The other members of the family who were seated about and you, of course, then received a long lecture on the actions that had brought you to this estate.

Then and only then were the switches brought down on your turned-up bottom. Slowly and in measured strokes that left us with brightened bottoms and upper thighs, that brought tears and sobbed promises that there would be no repititions.

I married when I was 25 and received my last parental spanking but a few months before leaving home. My husbands good right hand displaces the covering and

reddens my fanny to this day but I much prefer what my parents did to any other treatment they might have given.

Perhaps if more young ladies had their bottoms turned up for a good spanking our daily newspaper reading would be much pleasanter.

Spanked Sylvia

CELESTE GOES MODERNE

Dear Editor-

It was a surprise and quite delightful to find my last letter published in the #15-16 issue when I wrote about my latex corsetry. Since then I had made a good many more accessories to my rubber wardrobe and finally ended up by beginning on some leather attire.

It wasn't easy to turn out a neat leather corset, I discovered, but I was able to turn out lovely results by covering a cloth corset with a leather facing. My first finished attempt has been very nice, indeed, and it is most extreme in its figure controlling features. The night I finished it my husband and I had planned a "fitting party" to go with it. He had been planning a few things for me to do to add to the fun and I was in for a real surprise.

After giving him full instructions on how to lace me into it,

I was blindfolded and I heard him unlock the door to one of our unused rooms into which he led me. In a few moments he had me all trussed up on an overhead "lacing bar" which I've read so much about in your little magazine. To my surprise he strapped my feet to the floor and put tension on my arms which spread me awfully tightly as well. I found it quite exciting to wait like this while he readied my corset and soon it was draped about me. After the front clasp was closed he took the slack out of the laces and began to pull them snug all the way up the back whereupon he massaged my flesh through the leather to make the corset settle about me well. I asked him how I looked but he told me to wait until he was done in a curt reply! Now he began to pull in the laces in real earnest and as he pulled I could feel my torso stretch out of the top and bottom of the corset thus aiding in slimming my waist considerably as it caused my arms and legs to be pulled quite hard up and down. After what seemed an interminable time he stopped and rested some and said he had to pull it down another inch to close me up! I had made the diaphragm and chest quite tight to be sure I had a smooth tapered, long-waisted figure and the pressure simply was

48

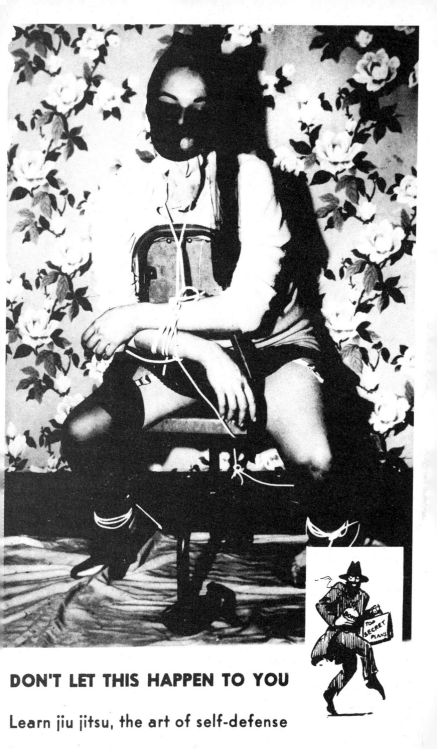

DON'T LET THIS HAPPEN TO YOU

Learn jiu jitsu, the art of self-defense

appalling and I was already so tight my breath came in very tiny puffs with such rapidity I thought I would faint with further lacing. I whispered a plea for quits but he didn't hear me or just pretended and worked on the last inch before my closure with lots of muscle. I felt utterly ready to faint and I was so breathless I couldn't utter a sound when he announced the awaited closure and my ears were ringing a little too. But I wasn't done he told me, and commenced to lace up each thigh panty to a very tight fit. I thought that with the cinching of my shoulder straps he would take me down from the lacing bar and let me lie down awhile but no! He made me stay there as-is for a few minutes and I heard him tearing paper.

My corset was so excruciatingly snug I hardly felt like asking what he had in mind but even if I tried to talk my breath seemed exhausted on half a word! The blindfold came off quickly and I looked around but he was already behind me so I waited silently for his next move. Shortly I got a glimpse of a leather mask he pulled over my face and head and I realized I was about to be done up a'la bizarre from head to toe. He worked the mask over my face and it felt like it fitted every undulation of my face and head as

he drew it tight. I could see nothing of course and neither could I open my mouth as it was very snug under my jaw and across my mouth. I sensed its presence about my neck as well as he finished drawing up the laces.

Presently he loosed the lacing bar and my ankles and my arms dropped numbly to my sides and my hands found my leather hips and I rested breathlessly. I felt like a wet noodle inside of a rigid pipe! I wanted to "sag" into a bed and rest for hours but I could not twitch a muscle inside the corset's confines as I minced across the room on my five inch heels to find a wall to lean on. I found a wall but was almost "winded" by the exertion.

My mask was most exasperating in my breathless state as I felt it was suffocating me and I reached to undo its laces only to find them secured under a zippered flap! My feelings were certainly all to myself now without any means of expressing myself — a shockingly intense blow to me who so likes to talk with people. I wanted to plead for some respite but how could I? After about ten minutes my hubby did me a little good and he unsnapped the eye covers.

My surroundings were revealed to me through tiny peepholes in the mask but the covers folded to the side which allowed

me only vision straight ahead! I started for the mirror but he pulled me back and told me to stand still and at this point he gathered my elbows together in back with a strap, then did likewise with my wrists! I couldn't argue with him and I couldn't move very well because still on the verge of fainting with any exertion but then he told me to go look in the mirror.

(Cont. in No. 22 — time out for a beer)

Dear Editor:

In your publication I find a few people who seem to enjoy being spanked; "Naughty Mary" in #15/16 and "Well Spanked Julie" in #18 as a couple. Well, my wife enjoys being spanked and I enjoy spanking her. We also agree with the person in #20, that a spanking would not be a quick thing but should be sort of a ritual.

When I feel that she deserves a spanking she has to put on her spanking undies. They are a set of black lace bra and panties, a fancy garter belt, black net stockings and a pair of her highest heels. I use a short leather strap which she must get and present me, and ask me, to please spank her as she has been naughty. First she has to walk about in her undies so I can admire them on her. Then over my lap she goes and I give her pantie clad bottom a brisk strapping.

Sometimes for the second part of her spankings I have her kneel on a hassock and bend over with her hands on the floor.

We would like to read more of people who enjoy spankings, especially more from "Well Spanked Julie" as we enjoyed her letter.

Mr. & Mrs. Spanking

* * * * *

BEHIND CLOSED DIOR

Dear Mr. Willie:

I was delighted to read your advertisement in one of the magazines and to hear that it was available again.

I have never seen a magazine done with as much charm and savoir faire and edited as well as your "Bizarre."

I am a corset enthusiast and have done my utmost to try to bring back the fashion of the "Gay 90's", by telling all the women I knew, that narrow waist is a universal Sex appeal to man; also by writing to Dior and all the interested fashion designers many letters about the type of dress and fashion that I think would sell. I think at times, there must have been many others who wrote, because since the era of "New look" the wasp waist fashion has been fairly well holding out. I feel, however that with correlated efforts perhaps through your maga-

zine we could come a lot closer to what we want.

I thought perhaps you might be interested to hear that on my trip to Cuba and Mexico 6 months ago I noticed that women are aware of the charm of a narrow waist and tighten their cinch belts extremely; (at times obviously over a corseted waist.)

There is another thing that I find interesting. That although I am 39 years old and have never been (unfortunately!) in my life time exposed to the beauties of tight lacing, I am an ardent enthusiast of this practice. I have only met two other men of my age who feel the same way. I always felt that probably most of us who feel the same way would be older (because of the question of childhood experience) and "our group" much to my sorrow would die out. That is why I am so enthusiastic about your Magazine, hoping it would keep the trend up. I would be very much interested in your expert opinion as to age groups of corset enthusiasts.

C.D. of Seattle

C.D.

The wheel will turn: your spoke will support the wagon. — Ed.

THEY LOVED US IN LONDON

Dear Sir:

A friend just gave me Bizarre Nos. 12 and 15. Was ever so surprised to find that I'm not alone in my love of corsets, tight-lacing and all that goes with them. I'm enthusiastic about pictures in 15-16 and framing up 14, 51, (wow!) 64, 69, 74, 90-1, 106 (shouldn't that artist be encouraged?) Also letters from Madeline Adele, E.N., "Margaret" and "A Male."

Being male too, rather definitely, I have wondered where I got these interests and feel happy to find such people as Adele's husband, Damon, Bernadette Brown's etc.

Wish to register my agreement with Margaret's husband re-emphasis on both feminine breasts and stomach. Their free movement above and below corsets is much to my taste. Disagree with editors comment: "Small Waist—but Odd Shape." Mrs. L. H. and husband are right. Perhaps it is because of the Lost Lap of the '90's. Modern girls haven't any because of starved thighs and abdomens! With the short, handspan corset waist and plump tummy, legs are forced apart in sitting, thighs pressing against the skirt tightly. These three delectable cushions which were our refuge in childhood no longer exist! (The modern style

52

does what it can to emphasise bosoms on relatively emaciated figures!)

A new book "Corsets and Crinoline" by Norah Waugh (Batsford, London) should interest corset fans. Here's a verse from among many delightful quotations from early publications. This one from Englishwoman's Domestic Magazine, 1869.

"Don't lace me tighter, sister dear
I never had supposed
That it would give me so much pain."
"My dear, they're not near closed!"
"Then I must get a larger pair
To clasp my clumsy waist
Of this I'm sure, I cannot bear
To feel myself tight-laced!"
"Oh the misery of tight lacing
None but have tried can tell
I'm sure that as to figure
I'll never be a belle.
The pain, you say, it will not last?
Well, I will try again;
Lace me up tighter, sister dear,
I'll try and bear the pain."
"Lace me *yet* tighter, sister dear
I never had supposed
It would give me so much pleasure!"

"My dear, the corset's closed!"
"Then I must get a smaller pair
To clasp my slender waist;
For now, you know, I cannot bear
To feel I'm not tightlaced!"

Of the pleasure of tight lacing
I that have tried can tell.
Besides that as to figure
I feel I'm quite a belle
This is the burden of my lay
Lace tightly while you can
Because you'll soon forget the pain
You felt when you began."
 Yours, ED. C.

MORE HARMONY

Dear Editor:

Like many of your readers, my wife and I are both interested in the fad of figure training and tight lacing. Shortly after we were married last year, we "discovered" our first copy of Bizarre and read of several "corset enthusiasts."

We made an agreement that when my wife wore a girdle, I would do the same. She promised that there would be no embarrassment connected with it. One Saturday evening, we planned to go out for dinner and a show. My wife wore a girdle . . and I spent the evening getting used to wearing my new one, which she had fitted on me when I got dressed. It took a little while to get used to the tightness of the garment.

Each time we went out or when my wife wore her girdle, I did the same and each time it seemed a bit easier to do. I found myself happy to be the recipient of a

girdle for my birthday. As I found that it would not be discovered under my clothing, I started wearing it during my working day. I find I like the comfort and support it gives.

One evening when I returned from work this spring, my wife showed me a large package that had arrived from New York. I opened it and found myself gazing at two rather feminine looking corsets.

That evening, in the privacy of our bedroom, I was introduced to the pleasure of corseting. We had a little "lacing party." My wife talcum powdered my back, clasped the corset about my middle and laced it up. Then I had the thrill of doing the same for her. We wore our corsets all that evening.

Since then, every weekend we wear corsets. I don mine when I come home from work on Friday evening and wear it till Sunday night. I am 23 and my wife 21, so we may be the youngest of your corset enthusiasts. Gradually we have learned to lace tighter and tighter and my wife can now take several inches off my middle when she laces. I wear a good girdle to keep me in shape for the weekend corset sprees. This Saturday afternoon as I sit writing this letter, I am in my corset and my wife is in the kitchen cooking, similarly attired.

Even on warm summer weekends we did not give up our corsets!

By now I am quite prepared to agree that the girdle and corset is a quite fascinating and appealing garment and as I have learned — a really comfortable one. Let's hear from other young married couples who like to lace!

Sincerely, G. R.

THE RACIAL THEORY

Dear Bizarre:

I sometimes believe that what today is called "bizarre" is actually normal; it may be that our social codes are actually bizarre, if we compare them to the history of past ages.

There has been talk now and then, in the pages of BIZARRE, of men who have dressed in feminine clothing; of some wives who have so dressed their husbands. There is an urge in some of us to change our "character" now and then. Some who have done so have been wrongly critized as "bisexual." But do you realize — historical records prove this, — that the early Aryans (our own ancestors), publicly boasted of their bisexuality!

Ancient literature, and records, prove that man, eons ago, was hermaphroditic. This meant that mankind was also androgynic; an Reeminate man and a mascu-

54

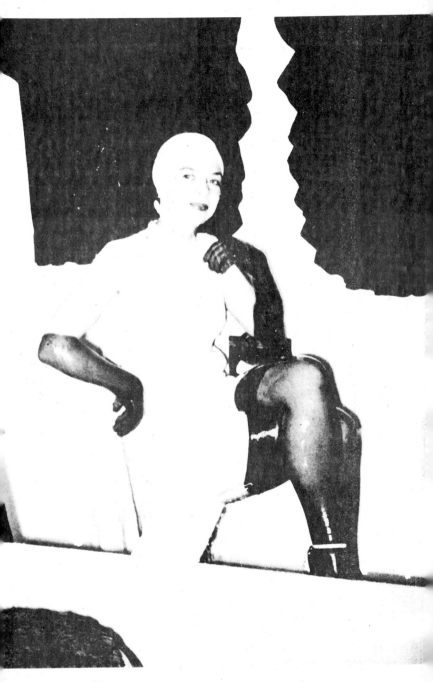

Letter on page 57

line woman. We find these types today, and they may be an atavistic throwback. By records of the past, they are not "bizarre creatures," but natural products.

One can think of some of the great female impersonators of the past, and wonder about them. But don't wonder! Some males, for example, have soft, feminine, white skin.

The writer of this letter has always had white, soft, smooth skin. His chest is (with the exception of about three hairs), devoid of hair. His legs are almost clear of hair; what there is of hair, is lightish brown. On his job he walks a lot so he has developed muscular legs; otherwise, clothed in women's stockings, his legs are "pretty" though (because of the muscularity), a little bit too big for a female.

The writer has been married 26 years. He has two stalwart boys, both an inch or two more than six feet tall. For 30-odd years he has been a writer and newspaperman. He likes the girls. And yet, every little while, he will seclude himself, and tell himself that he'd like to be a female impersonator. Is this bizarre? I don't believe so. It is inborn in men and women, many of them, to imitate. In an ancient apocryphal book, "The Dzyan," it is told that the original human being was double-sexed. It is truly possible that today, a man or a woman, may feel such a force. I am masculine, and yet I have liked the feel of feminine clothing around me. This does not make me, nor many others, homo-sexual; for I am not, and many are not. It seems just to be a throwback to eons ago.

Such urges in men, and in women, today are called "bizarre"; and yet this "bizarre" is realistic, and comes out of the past.

The writer, who has been a police reporter, and has done some masculine things in his career, still "blushes like a woman." It has been commented upon. It seems bizarre. But maybe, it's natural. Someone of these days he will take things in his hand and submit to BIZARRE, photos of himself in female garb. One has only to read Eugen Georg's book, The Adventure of Mankind, (translated from German in 1931 by Robert Bek-Gran and published by E. P. Dutton,) to find out this relationship between man and woman. It is one of my most thumbed-through books.

So let me dress as a girl! I've known some mannish girls who, if they dressed as men, would be quite presentable. In fact, lately, I've made a study of women wearing slacks and trousers. You'd be surprised how mannish and unfeminine they appear! Yet the

majority of them are still women. It seems bizarre — but it isn't. It's only in the prudish "Anglosaxon mind that we misinterpret.

And one of these days that "Anglosaxon" mind is going to be outmoded and cast aside. I hope the day will dawn, soon, because it is too one-sided. The Great Jehovah help the so-called Normal Mind. It is stunted.

Maybe we are, as that German book suggests, descended from one strain of half-men. It is in the blood. Of Herodotus, he quotes that "The 'Black Doves' of Nubia were beast-women . . ." and he writes that "for those Assyrian half-men are real, they actually lived." And, "There is no lack of literary proof for this series of half-men."

Further, to quote: "The initiation rites of some ancient mysteries required men to dress as women and women as men." And so you see, men and women are "bizarre" beings . . . and what they do often is done because, in the past, that was done! Thus a man, or a woman, should never really be ashamed of what they do! What today is bizarre tomorrow may not be, because we will understand the history of the past eons!

DOUBLE-M

D.M.
Esoteria is welcome, but unnecessary here. The following is an example of secondary school reading: charming, if only by inference:

"Primitive morals are especially shocking to those accustomed to tyrannical, male-made, bisexual codes founded on neither rhyme nor reason and biologically silly, psychologically crazy, and socially worse than Masai morals."
George Amos Dorsey
Man's Own Show: Civilization

DOUGH NUTS — SOFT AND SWEET

Dear Ed:
I have been an avid reader of Bizarre ever since I saw my first copy about a year ago. I like to read about all the different tastes and experiences of readers, but my own special hobby is what we call "dunking." Several of us, with wives, sweethearts or paid models, as the case may be, like to go wading, swimming or just playing in a stream, pool or the ocean, or simply take a shower. But we do this while fully dressed. We like to see the girls getting their high-heeled shoes, nylon hose and dresses (and sometimes gloves, hats and jewelry) soaking wet. It fascinates us to see the curves of a nylon-clad calf and thigh, a patent leather shod foot,

or a taffeta or satin-sheathed figure glistening with wet highlights. If the girls will get their hair wet, so much the better. Then they can just let themselves go, be completely natural, have fun splashing and get completely soaked.

I am more fortunate than some of the others in our circle in that my wife (and best model) likes to dunk and often dresses prettily, then suggests we take a shower or wash the car.

Recently, we took some photos of her. She was wearing a white satin and lace evening gown, a white rubber Playtex, black nylon hose, white strap sandals, and long

black nylon jersey gloves. After soaking under the shower, she changed the gloves for red rubber ones, added a white rubber shower cap, and we made a U-D skirt.

I see in a current magazine that rubber bathing shoes are back in style. Let's hope the rubber swim suit will follow again.

My immediate aspiration is to buy a make-it-yourself frogman's suit, and tailor it to fit my wife. They are available in black as well as in colors, complete with hood and feet attached.

S.C.L.

UNTAUGHT BY BIRDS

Dear Sir:

Some of the letters in your magazine confuse me, particularly so, those in which a woman dominates her husband. They seem to have taken over the job of the male. It is not so in my family.

Like my father before me, I am boss — the only boss — and my wife obeys my every whim — and loves it.

When I come home from work, supper is on the table and it is a supper she has spent hours in preparing. Woe to her if it doesn't please my palate. After supper her evening is spent in catering to my enjoyment and I don't need a whip nor handcuffs to enforce it.

About two years ago when she was ill, I relaxed my dominating demands out of consideration for her condition. Never have I seen such contempt on a face of a woman. It was my first and last show of weakness, and now in retrospect, I see that I was completely wrong. Since that time her life has become one of complete subjugation and she loves it.

A note to these dominant women, Mr. Editor: if they had married yours truly, they would know the sweetness of being a true woman.

Dan

NOT YET UNTAUGHT

Dear Editor:

As I sit here I am under the constant surveillance of my "boss" for the night. She has released me only for this purpose: to encourage others to give vent to their desires for pleasures that are not generally accepted as proper by the repressed and stilted people who are so often considered "pillars" in the community.

My hands had been secured behind me in real hand-cuffs, my ankles are "ironed" and held by a bar about twelve inches long. You see, I lost the throw of the dice and became a slave to a new mistress.

In our Club one signs up as a "boss" or a "slave", and I wanting to learn more about it signed as a slave. I still am, and I can't say that it is without emotional compensation. I was married twice before I was twenty-five, which I now am, and this is it!

We have only four male members, and at initiation I ended up the "slave" of one for the evening — but we did have a job to put on the show for the entire crowd. He was swell inasmuch as the worst I had to do was extract stuffed-olives from between his toes with my hands tied behind me.

I have read several copies of Bizarre since I joined (three

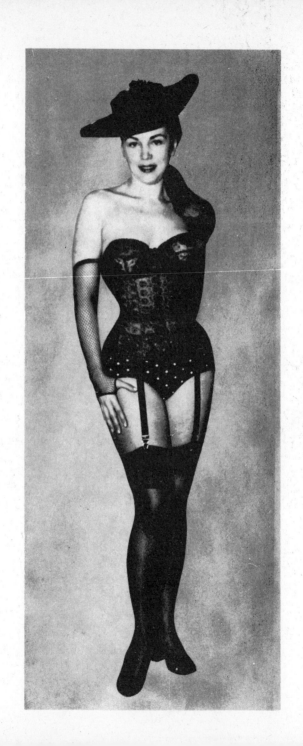

weeks ago) and I have enjoyed them very much. There was one about the preparation for spanking; about the smooth muscles showing in madame's arm as she brushed her hair. This little demon who is my boss tonight is flexing her muscles constantly — and she has them (she nods approval over my shoulder).

She promises to make me do more than I have done before — as a slave . . . I just was forced to kiss her foot, and she laughs while I write this — she should be proud of those pretty little size fours. I wear a seven and am proud of my own high arches. She can point even more than Belita. You remember her?

Barefoot slaves here — the bosses wear the high heels and make the slaves shine them with hair or whatever. The boss-lady wears the tight leather belt with the keys to our restraints.

One lovely little blonde was held here at the Club for eight days until she willfully kneeled before the Madame, kissed her feet and promises to never reveal anything that has transpired.

I should give up my membership??? I love it —

Wanda

BOSSY BETTY

Dear Editor:

I read the letter of Elsa in No. 10 with interest because I have also trained my husband to really fear, love and obey me; thru my training he has become a perfect maid (although unlike Elsa I do not make him dress in feminine attire). He is a masculine servant doing ALL the household chores and attending me personally. I am very strict with him and make him obey me completely. He is not allowed to sit on a chair while in the same room as I am but must stand at attention or lay on the floor at my feet. He is not allowed in bed with me but must lay on the floor next to my bed. He gets up early in the morning and prepares my breakfast which he serves me in bed. When he returns from work at 4:30 he prepares dinner which he serves to me — but does not partake. When I have finished dinner I allow him a few left overs — if I happen to leave any. After I am comfortably seated in my easy chair reading or watching TV he does the dishes and then proceeds to clean up the house, also doing the washing and ironing as needed. The rest of the evening he spends doing my bidding for my entertainment, sometimes just lying under my hi-heeled patent leather shoes.

On evenings when I go out I allow him to bathe and dress me — and then give him some task to do and finish before I return — with threat of punishment if he doesn't complete my orders. Sometimes I give him impossible tasks to accomplish in the time I expect to return so that I may punish him. That is the way I keep him in line. Sometimes when I go out I bind him and lock him in a closet. (On one ocassion I unexpectedly went to the shore and stayed for two days — with him in the closet. He seemed none the worse for it however and when I finally released him it seemed to make his love for me greater. He kept kissing my shoes until I finally kicked him away).

Oh yes, the punishment. I have all kinds of punishments but the one that really brought him to my feet and kept him there is the whip. I have all kinds of whips which I apply to his manly back for the slightest thing. It gives me a wonderful feeling to have this 6' 3" · 225 lb. man so completely in my power — and so madly in love with me. The more I whip him the more he loves me and the more I *want* and enjoy applying the whip. I reward him for something extremely well done by allowing him to kiss me or by parading around in opera hose and my 6" heels. We both anxiously await the week ends when we can be near each other uninterrupted for almost three days. In the summer we spend my husband's three weeks vacation in our small cottage in the mountains. There he can really serve and slave for me in doors and out. Sometimes we take long hikes only he does all the walking. I ride comfortably on his back in a contraption I rigged up.

Any beautiful woman can get her husband to be her slave by using her feminine allures. Always dress glamorous and a little on the bizarre side. Go easy at first and then increase your demands and bizarre attire gradually until you have him worshiping at your lovely feet. You will love it and so will he. I know we do, he loves me more than anything and I love him. It is wonderful to have an obedient husband who adores you. Try it girls. You can do it and you will both love it.

BETTY

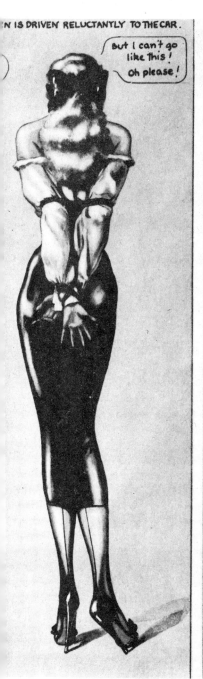

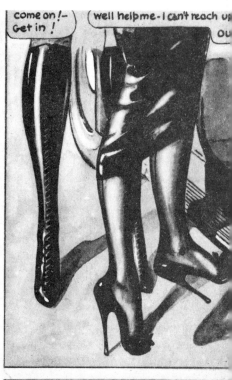

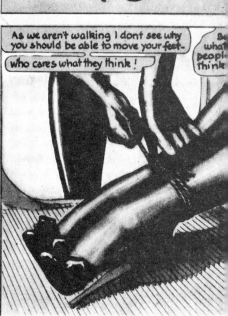

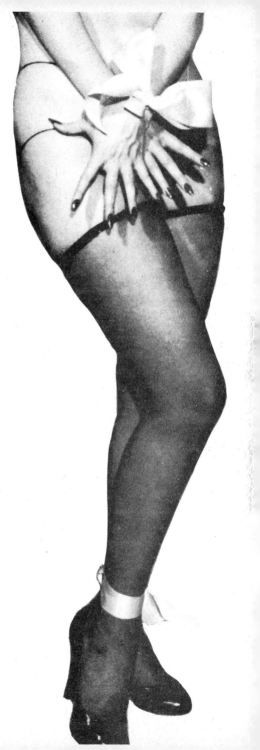

Bizarre

TWENTY
TWO

BIZARRE

"a fashion fantasia"

No. 22

*Ah, Love! could you and I with Fate
 conspire
To grasp this sorry Scheme of Things
 entire,
Would not we shatter it to bits— and
 then
Re-mould it nearer to the Heart's Desire!*
 OMAR KHAYYAM

Contents

*Printed and Published by Bizarre Publishing Co., P.O. Box 511, Montreal 3, Canada.
Copyright 1957. All rights reserved.*

DON'T LET THIS HAPPEN TO YOU

Our Dublin Correspondent has come up with an interesting photo-article that we thought we might pass along.

The problem of securing a person in ropes is an age old one, and has been solved by various peoples in various ways. Today, other than sailors and boyscouts, few know what a knotty problem it is.

It is our contention that if you do not know what to avoid, sooner or later it will happen to you. Of course, if you know Jiu Jitsu, you'll never be in this predicament and therefore, kindly skip the article. If not, study it carefully and you'll be bound to learn.

It is not easy to secure a human being in such a way that escape is impossible. In the following pages we illustrate and describe one method which, though taking time to apply, is at least reasonably efficient. The captive pictured we will call Rita, and the assumption is that she is a criminal who has been caught while in the act of burgling a house.

Rita has put up a fierce struggle to get away, and honors are about even, though in the fight she has had the misfortune to lose her sweater and skirt. She has real-

ized, however, that masculine strength is bound to prevail in the end, and at the point where our picture story starts, she is submitting to being bound. (She's something of an escapologist, by the way, and is secretly pretty sure that she'll be able to get away. We shall see.)

Here she is, looking very confident. Her wrists have been crossed behind her, and tied together with five feet of thin cotton line. Not too thin, or it cuts into the skin, and not too thick, or it cannot be efficiently knotted. Thick

rope must be reserved for body, arms and legs, and then only if it is a question of tying to a chair or post.

It is *most* important that the rope is crossed between her wrists as well as passing round them. And on no account must the 'hitching tie' be forgotten. This is applied by using the last two feet of the rope between her wrists, So:

The end can then be neatly tucked under one of the coils, pulled tight, and knotted well away from groping fingers.

The hitching tie has the effect of tightening every individual loop, making in effect a pair of closely fitting rope handcuffs.

So far her wrists only have been immobilised. But there is a great deal more to be done before we can sit back, quietly confident that our pretty little captive is firmly held.

The next stage is to take fifteen feet of the same rope that we used for her wrists, and tie her ankles together the same way. Use the hitching tie, and leave some eight feet over.

For her elbows we shall want

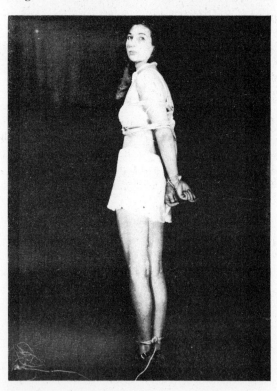

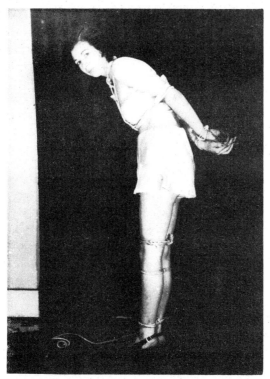

the same amount of rope. Draw them together so that her shoulders are thrust back, and pass the rope round her arms and body as well. This will have the effect of locking her upper arms.

Rita obviously thinks that so far it's a piece of cake — she'll get away all right!

Now that her wrists and ankles, the two main avenues of escape, are taken care of, attention can be paid to real security.

Two long lengths of rope are used now, round her arms and body, above her elbows. Her arms have already been trussed, so it's not necessary to pass the cords round her upper arms, because circulation may be stopped. Which Rita would find most uncomfortable.

Pull the ropes tightly round her body. The horizontal loops are held in place by a harness passing over her shoulders, behind her neck, and crossing over her chest. Take care to cinch these crossing loops where they pass the horizontal cords, or there will be a danger that a determined captive could wriggle her arms sufficiently — a

fraction of an inch at a time — to slip them down over her elbows.

Rita, who is thinking "Well, I can still move about by jumping on my toes if I'm left alone", must be further immobilised by the securing of her legs.

It is most important that these should be lashed above and below her knees as well as at her ankles. But, when knotting the cords below her knees, make sure that at least a quarter-of-an-inch of slack is left. This sounds a lot, but when her legs are bent, as they will be shortly, her calf and thigh muscles relax, and her legs swell, thus taking up the slack.

If her leg ropes are drawn too tightly to begin with, it is impossible to make the captive double her legs up under her, and this is necessary.

And now, even if Rita is a female edition of the great Houdini, it is beginning to look as if her chances are very, very slight.

She is sitting on her heels, and the rope left over from her ankles is now passed over her wrist ties, and back to her ankles. There is enough for it to pass through four

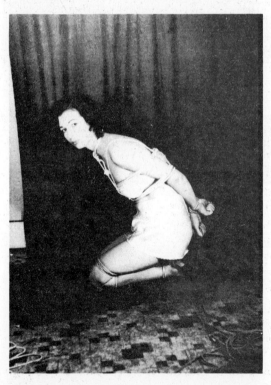

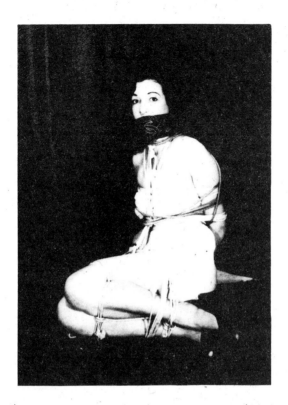

or five times, and it must be made absolutely certain that no knots are tied anywhere within reach of her fingers. This is done by fastening the end of the rope to the cords joining her legs above and below her knees, passing in a series of half-hitches en route.

Rita has only one chance left, now. She *might*, if she's left alone, wriggle over to the window, and call out for someone to come and release her.

But the last stage will take care of that.

For now all the ropes left over can — and should — be used.

Before going on to this, though, Rita must be gagged. A small handkerchief and a scarf are the requisites for this. The former is folded and inserted in her mouth, and the latter is used to keep it in place. The scarf must pass under her back hair, and be tightly knotted at the nape of her neck. A muffled mumble will come through, no more.

If Rita was to be a captive for only a short period, then she would find that her shoulders would be fastened to her knees.

9

But this becomes painful after a while, so she is allowed an upright position. She must be put on her side while the leg ropes are wrapped round her thighs and calves, and the further arm ropes are tied round her body.

Her neck must be linked to the ropes round her knees and thighs, and the last arm ropes will altogether tighten this link so that Rita, held before and behind, will be completely static.

Before you leave to 'phone for the police to come and collect your girl burglar, prop her up so that she is leaning against the wall. Then she'll know that if she does struggle at all she'll fall on her side or her front, which she would not find very pleasant.

We can guarantee this rope tie as being efficient. It will hold anybody, providing that the instructions are followed closely. But remember that short, individual lengths only must be used for wrists, ankles and elbows.

Anything over twenty feet must be reserved for legs and arms.

As regards escape, Rita has had it.

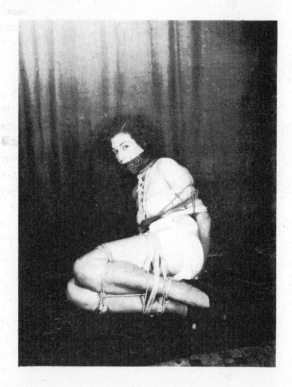

10

orrespondence

Under no circumstances do we publish names or addresses. If photos or sketches are sent in, please write a short commentary and please do NOT send in photos which you got from someone else.

SCRATCHING THE SURFACE

Dear Ed.:

Most contributors dealing with spanking do so by describing the usual methods. Some of these methods "scratch only the surface" so to say and the effect is rather superficial. There is no doubt, that when spanking is applied it is done so to either punish or prevent for the future evil doing. The more thoroughly the spanking is applied the better the desired effect. My young wife and myself have discussed this subject and have agreed, that both of us should be subjected to this form of penalty when either of us has acted in such a way that either punishment is called for or a preventive for future. The two of us also agreed, that it should be very thorough, and that it hurts plenty.

We have further agreed on the "tools" to be used. No paddling with hairbrush or the hand will do. Thus speaking with experience we have agreed on a cane and a long leather whip. The subject to be spanked has the choice. As mentioned before we are in agreement that the spanking is to really hurt in order to be effective.

If the cane is to be used it is to be used in such a way that each stroke is to hit the same line, and always on the bare bottom, and there should be no less than 12 strikes and not more than 15. In order to be able to hit the same line all the time a piece of adhesive tape is run across the buttocks and a second one parallel with a one inch space between, which is to be the space that is to receive all the strokes. This concentration on this one line makes

11

for severity and causes a welt of the skin, thus prolonging the desired effect. Before starting the procedure each wrist is chained to the corresponding ankle, thus causing a complete bending which allows complete access to the chosen area. The strikes are to be given in a measured tempo. A kiss preceeds the action and one closes it.

If the whip is chosen no fixed line is marked and the strikes may hit the buttocks as well as the upper thighs. The reason for choosing the whip is that one will not forsee where the next strike is to hit, and the whip will wind itself around the whole body and the hips and abdomen share in the blow. In this case the one who is receiving the lashes has to stand, with ankles chained together and the arms bound together and held on the neck.

As you can see the two of us mean business when we think that the punishment is due. At first I was afraid that the gal would hesitate and would let her heart run away with the head. However it did not take long and she handled the tools most expertly.

By the time I had my 12 I knew that there was a specialist doing the job. What she enjoyed most is to see how the whip does wind itself around the whole body and leaves the mark. While the application proceeds she seems to be inspired to a crescendo and the last few are unforgetable.

When the time and occasion came that she was on the receiving end I nearly became a softy and pitied her. When I initiated her with a fairly good touch she jumped and ouched. But right there and then I learned of what material she is made. When she noticed that I hesitated she encouraged me and said, "Do not let up, but lay it on good and hard." I saw how she shivered and twisted her body under each stroke, but she urged me not to cheat her of her fair share. Since then, we had several occasions to give and take penance of this kind. Now we are at a state that "no quarter" is given and it has brought us closer together just because we conduct ourselves with greater confidence. SEVERUS

COMPOSITE CRITIQUE
Dear Sirs;

It seems that some of your correspondents promise to write further on their experiences and never do. Maybe they want to be coaxed. So I will endeavor to coax them a bit.

To Doreen M. #12; I agree with Fred in #19, you really should write and tell us more (much more) about your visit to London and discipline of children.

I am sure that Fred and I aren't the only ones who enjoyed your letter.

To Billie #13; Lets have more about the games you played as a girl where you were tied up and blindfolded.

To Rubber Stamped #14/15; You and your wife should tell more about feminine rubber footwear. I enjoyed reading about your Sir Walter Raleigh act.

To Paula Sanchez; When are you going to tell us about your grandmother as a corset slave in Paris? Let's get on the ball! I have enjoyed your letters very much.

Now for some words of encouragement to some of the later writers.

To One of Five, of The Frisky Five #18; I do hope you write more about bare bosoms, and soon. I for one really enjoyed your letter very much.

To Diana #18; I am sure that quite a few of us are waiting for more on fancy dress and bondage. Don't let us down.

To Tessie the Whipped One #19; I don't think that I am the only one who would like to read about your experiences concerning, as you put it, "the pleasures attendant upon whipping the body with all manner of instrument."

To Billy R. #19; Don't forget to write more about being a maid to your wife and aunt, and about the time you had to act as a French maid at your wife's party.

To Just a Wife in Bondage #19; You should get your husband to consent to you writing more about your ordeals in bondage and mild torture. I found your letter very fascinating.

I would also like to hear more from Naughty Mary, #15/16, on her room mate and spankings.

Also to H. C. #12, on his answer to Ed Livingston, #7; I would like to hear more about these places you mentioned. These dances with whip snapping girls, finger grinding and races with the girls astride the men sounds fascinating. In which state is this? I'd enjoy reading more about this.

Yours truly, C.G.T.

AESTHETIC MAGNITUDE
Dear Editor:—

It is all very well to see this parade of beauties, lashed, tied, girdled, locked and what-not, but once in a while couldn't you grant us a plump girl really bulging in the proper places. She too could be lashed, tied, etc.

One gets tired of a weary procession of underweight females with angles instead of curves. Yours aren't underweight but they aren't a bit overweight either. A photo of a full grown gal in your

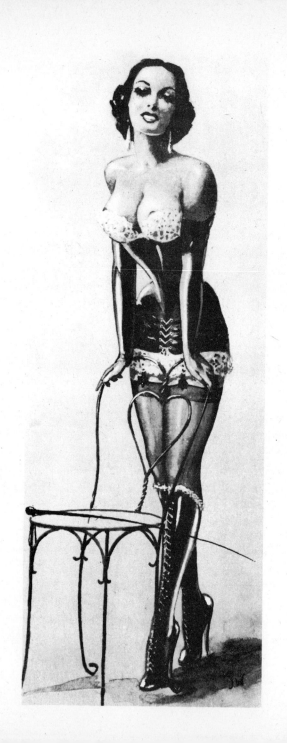

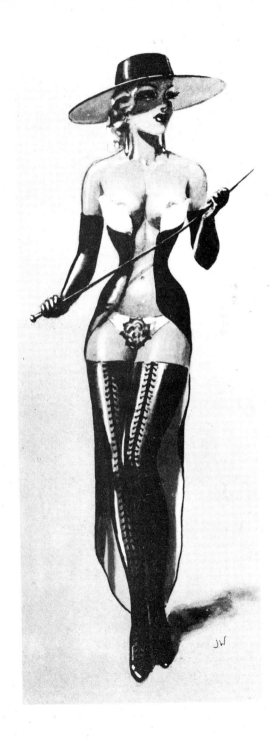

excellent mag would make life worth living. What do your readers think?

E.S.

AGAINST BOSOMS

Dear Bizarre:

The American male is being bombarded with bosomy pictures of females — buxom. broad, billoy and even, sometimes bare — until he comes to believe that this is all that girls are made of.

Among the stronger members of the male sex there are some rumblings of discontent. A bosom revolt is brewing down upon our glamor photographers and artists. On some fronts the male is protesting; this male ululation is becoming louder. The pendulum (tho' you may not yet notice it) *is* swinging away from the Jane Russels, the Jane Mansfields and the Marilyn Monroes, their ilk and their imitators.

The buxom and billowy pinup gals are becoming too, too plentiful, pointing to us from walls of washrooms, clubs, the pool room, taverns, et al, ad nauseum!

Besides their faces and ther bosoms girls really do have legs. Legs are pretty to look at. I'm a leg-man, personally. In many cities, — and I've visited many, — I've found some startlingly pretty women without those fiontal ornamentations around which a

sweater may be plastered. They are the women who, to date, have often been ignored. Mere man has too long been hypnotised by bosoms that he has overlooked lovely legs, glamorous gams, the luscious limbs of women who even may have flat chests!

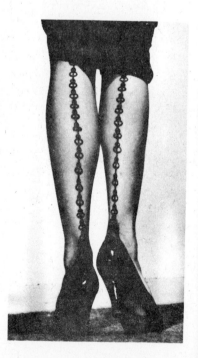

16

A lot of males have lost sight of the fact that a fascinating face, a woman with fabulous facial features, who may have no chest measurements, may possess delightful legs.

The main thing to note in doting upon these bosom-developed women, is that almost all of them are similar; similar in bigness, shape, and with little variation. But the legs of a gal! Here is room for difference! One may enjoy the elongated stems or the shorter peddle pushers; but so long as there is shape and form to them, there will be an increasing following. In legs the enthusiast has many choices.

Mere man, if he stops to cogitate about it, will discover that there are a great many more possible poses of a woman's legs than there are of her bosom — with and without stockings, garters; G-strings and panties, legs up and legs down, stretched out, sidewise, upside down — the variety is varying. But the bosomy woman. How can she pose other than on one position, or possible three?

The time is coming when there will be no bounty on bosoms, — but there will be a legacy in legs!

— "Double M."

CELESTE GOES MODERNE
(Cont. from issue No. 21)

It was indeed startling to behold myself in my bizarre attire! In the mirror I saw a faceless feminine form, snow-white from head to toe, without arms and with extremely curvy outlines. My hands and my eyes were frustrated from going over the whole effect in much detail which irked me immeasurably! The arm straps I wore forced me to lean back enough so that I possessed an unnaturally high, prominent bust line, but this with the wide breast-cup separation and the hip curves emphasized by the tight fifteen-inch waistline gave an effect that looked superbly neat and lovely. It was then that I sensed the glamor of sternly effective figure training. I was very pleased and excited about the results even in this uncomfortable posture and I found the feeling of helplessness to be keenly thrilling to me even when mixed with the little corset pains and aches . . . After awhile I lay down on the day bed to rest and get used to this unusual containment and let the corset do its settling on my figure. Eventually I regained my breathe but it still came in only the tiniest of puffs over the tight diaphragm control. I certainly didn't rest as well as I might have had my arms been unbound but after some time

I felt my hubby undo the flap on my mask that enclosed my mouth clenched teeth that I wanted out for awhile! He kissed me firmly twice and closed the mask up again and announced that I could be fed some bouillon for supper and then remain well-laced and strapped until ten the next morning when I could have some coffee and a raw egg! After that announcement I felt simply gruesome! . . . Such mortification. Such arrogance on his part! Perhaps I had relied on being able to remove my confining garments too soon to please his fancy but I was absolutely furious with him and all the more so because I couldn't tell him so. He came near me and I gave him a kick in the shins which wasn't politic in my condition! I had misjudged his mood and the instant I had done it I knew it. Anyway he picked me up and dumped me on the day bed again and in a twinkling I realized that he had strapped my knees and ankles together to complete my helplessness. The worst was yet to come. He knew I was hungry and thirsty so he brought in tasty foods and things and let me smell them, each and all, but nary a taste did I get! I wiggled and threshed about trying to express my feelings but he was unrelenting so there I lay to be pestered and teased at his fancy

in breathless anger. I was so miserable after he had eaten and I became frightened for the first time and had wild ideas about being forced to stay this way until I fainted from hunger. I foolishly fought my bonds again and exhausted myself wiggling until I nearly passed out. I was so frightened and worked up I cried for a long time inside the mask and at last fell into a fitful sleep . . .

I guess I had been awake for some time when I finally realized my legs were free. I struggled into a standing position and realized my arms were terribly stiff from the cramped position I had them in all night. I stepped a short distance to find something I recognized but before I could my hubby came to me and unstrapped my mouth shield and told me he wanted me to promise him that if he set me free I would not retaliate! If so, I could take off as much of the outfit as I cared and have breakfast with him. I told him I really wasn't mad at him and that I would never do anything like kicking again. I explained that I was scared as much as anything and really I had asked for the whole affair, after all! Well, he said he hoped I'd learned my lesson and he'd take my word and promise. Soon he had unmasked my perspiring face and unbound my arms for breakfast. With arms

18

ing, and what a surprise it was for me to discover that he was around every day to keep me just so! During this time he waited on me for everything, and every morning I was put up on the lacing bar and retightened from top to toe after which he took me down for breakfast as soon as he had it ready. Usually he made me wait on the lacing bar for an hour before eating. In the morning I had to do housework and get everything done by touch and feel by noon or he would secure my elbows behind my back with straps and the same with my legs and subsequently spend the afternoon lying on and head free I began to feel like normal again for a change. I experienced a frightfully hard time eating with my waist laced so small. I have been used to seventeen inches but I think the difficulty was with the tightness about my diaphragm which almost made swallowing impossible.

After my snack I was told by my ever-lovin' that I had to go back in the mask, without delay. He said he was going to keep me in it until I learned to like it and that from here on I'd better not count on having it off for eating or sleeping, anytime that I was around the house! What I didn't realize at the time was that he had taken a six weeks leave from his work to be sure I stayed in train-

the daybed silently. This I had to do eight times in the first two weeks of training. After the first few days of this I was able to eat without difficulty while fully laced in and I had less and less trouble doing my housework in darkness, although I couldn't eat much at a time.

At the end of a month of this routine, I had become remarkably accustomed to it and even more so than I had thought possible. At first I felt I'd never get used to the mask encasing my head but it became less and less bothersome every day and I ended up liking it immensely. All this was nearly six months ago and since then I've seldom spent more than an hour at home unmasked. It was several months ago that I decided to shave my head so that the mask would fit better and tighter. Now when I appear in public I wear a full wig which is easier to keep nice than my own hair! All this time my figure hasn't changed an iota and I possess a neat 36-14½-36 shape, thanks to the exceptional control of my leather corset. Now, one of the pleasantest things I do every day is to get bathed, powdered, perfumed and then corseted and masked for dinner, after having worn it all for the previous 24 hours!

Now you know how "Rubber Foundation" tried something new and liked it. My husband is certainly in love with his leather-dressed spouse and calls me "Leatherhead" (a' la Bizarre).

Very sincerely yours,
CELESTE

HOW I READ BIZARRE

First of all not out of mere curiosity, but out of the urge to inform myself of both, about the number of fellow Bizarrists at least in a general way and the manner in which they express their bizarre mentality and carry into practice their particular kind of ideas, and inclinations and cravings. This intention guides me in my careful study of Bizarre in all its contents. I say "study" because it is just this. I thus read carefully every article, every bit of correspondence in the magazine, even those that are either of no special interest to me or have been treated so many times from every angle possible that they do not have to offer any longer anything new. My desire is while reading BIZARRE to simply live bizarre mentality and atmosphere. This gives me the opportunity to gain in knowledge of bizarre psychology and of the practical performance, with the added benefit that I can compare my brand of Bizarrism, that I can find considerable satisfaction in seeing others do or think things the way I have been doing for years. At the same time I learn of any number of new and different and more or less original ways and manners to make Bizarrism an almost inexhaustible source of enjoyment and personal satisfaction.

One, to indicate an example, is the frequency with which binding and chaining are employed and treated as a matter of course in the relation of husband and wife. Likewise the method of making the partner helpless by hanging her or him up for some time in such a way that they either can support in a slight way themselves with their toes touching the floor or even being raised that she or he swing completely in the air. Or take the piercing of ear lobes, septum of the nose, or the nipples and carry rings in them, or wear girdles etc. are all "old stuff" to me, because I have experimented or practiced all of them, partly, even in my youth, 30 and 40 years ago. I thought these things were bizarres entirely my own. The articles in BIZARRE are proving to me that we Bizarrists are after all not as singular as we thought before we learned that there are fellow Bizarrists, male and female all over the country. The articles and correspondences in our magazine are of special interest to me and

are the reason why I study them, because they make me see how others do them, and I am learning a lot of new and interesting angles and methods and "tricks of trade."

I am a bachelor and in my supposed isolation had no idea how numerous the lady-Bizarrists really are, how they are just as inventive in the field of the Bizarre as are the men, in some cases even more so with finer points and original practices, At any rate to my joyful surprise I find them just as courageous and willing to undergo the hardships that are unseperable from a great number of practices as we men are. Take for instance the "Lady in chains" or Lou in No. 19. These and others of their kind certainly are brave. Though they have gone through the ordeal and felt how it can hurt when hanging on a chain or rope, it seems to be a matter of course for them to let themselves be strung up again, evidently without resistance, whenever friend husband thinks that he should repeat the treatment of his willing slave. My heart goes out to those good wives that submit to be shackled and made helpless, or are treated to the torturous saddle straps or the chastity belt with a day's discomfort. Then again I notice and admire those that are unafraid to be very frank in showing themselves in daring costumes or dress

and undress as we have read a number of times the detailed correspondence of the members of such clubs as the Modern Club. Likewise one cannot help but being impressed by the evident willingness of so many women to be the subjects of bizarre ideas executed in practice. Knowing from my own experience can be very painful and these ladies too know it, and yet they are game enough to let themselves be chained and strung up or lashed time and again. Not to forget those heroines who go in for corset training for weeks and months, even years, to re-form their bodies to please their husbands or friends by being laced and made very uncomfortable, or even if they do it for the sake of beauty that is evidenced by a well curved woman's body. Thus I let my reading BIZARRE convince me more and more that at least as far as these female Bizarrists are concerned one should not think or speak of them as the "weaker sex."

I am further looking in the contributions in the Correspondence section for expression of satisfaction or a feeling of triumph and victory after a bizarre idea has been carried out successfully, either on oneself or on others. For instance I myself have felt this kind of satisfaction with a feeling of triumph or victory whenever I put an idea of this kind into real-

ity. To mention just one or the other occasion: The idea of piercing my nose has been alive in me since my early boyhood. I had a paper route that brought me to a neighboring town two miles distance. It was a lonely way, and I hardly met anybody. This was just to my liking. While walking I took out one of the pins I carried with me and tried to push it through the septum. Once in a while I succeeded, but had no way and means to make it a lasting opening. But many years afterwards I returned to this same idea in order to carry in my septum a ring which I formed out of a thin golden chain as a memory of a very dear girl friend who was moving to the West. By that time I had the proper tools and the proper plan. All I needed was sufficient courage to execute it. I went to work on it and found that it was taking considerable effort to get the rather heavy needle through. But eventually I succeeded, and when I realized it I felt so elated and victorious that immediately I went to work to make a second hole, this one on top of the septum while the first one was placed on its base. This way I could insert the piece of the chain and lock it with a very small ring link. I could hardly believe that I had succeeded in something that at first seemed to be so difficult. I still wear this flexible ring, and people, when they notice it, compliment me on the courage and skill. A similar experience came to me when after a few futile trials I succeeded in piercing my nipples and started carrying some hoop rings. The feeling of success in these and similar undertakings not only brought special satisfaction to me but made me anxious to share my ideas and practical knowledge with some dear friends. Thus time and again I talked ear piercing and wearing hoop earrings to the grown up daughters of a family, until one day the oldest surrendered and let me do the piercing and inserting of the nice golden rings which I had procured. I was especially proud of my success. Then later on the other girl, after a long delay, surrendered, and a few years after that I succeeded in her little daughter of three years having her ears pierced. None of them would want to be without their dangling earrings.

It is with such experiences in mind that I look for similar elation and satisfaction in the bizarre undertakings of fellow Bizarrists. But where could I learn of such if it were not for having BIZARRE magazine making it possible. I know I am not the only reader of it who likes to add such knowledge to his mind.

M.F.

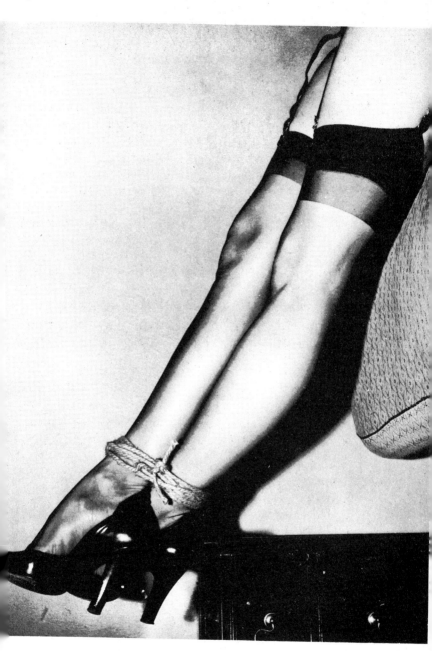

PYRRHIC VICTORY

23

FACT AND FICTION

Dear Editor,

Along with many others heres hoping you will publish this letter to help you establish a few more ground rules for your unusual and most entertaining publication. For the benefit of readers it seems that BIZARRE should keep an open mind to all new ideas. For example in a recent issue there was a diatribe against tattooing, which, personally I agree with. But, after all, the article was very interesting and took up only several pages. What is wrong with that? Everyone should be given opportunities for all ideas relating to the purpose of the magazine. I have felt that recent issues have not stressed beautiful high heeled shoes enough; yet it seems I'm getting more interested in corsets and party costumes now. So the more detailed and personal the articles are the more they are enjoyed by the readers. I recall reading in one issue just how one should be measured for corsets — this is exciting information.

Also readers will be much more helpful if they would stop saying, "I have some photos which I will send in if you like" or "will send in more details if you think it permissible." As the editor has often said; send in all details and photos possible, then let him decide what to print. He will probably put it all in eventually.

(*Oh how right you are! — thanks and thanks again. — Ed.*)

Another point is that I'm sure the editor would welcome short fiction tales related to BIZARRE subjects since that makes his job easier — provided, of course, they read well. I further believe that the vigor and permanent qualities of BIZARRE depend on the interests of the reader. Besides that the magazine is definitely for those who prefer certain esthetic qualities which are both stimulating and a source of continuing enjoyment. A recent reader has pointed out that articles of clothing and certain activities have accentuated the world of symbols which is most important to the enjoyment of living. Some articles by those who are well informed in this area would possibly be welcome. In short, many opportunities are available for those with imagination and a yen for frolic!

And one final bit of information. I chafe at those readers who mention some handsome article of attire and do not state just where they purchased it. Or those who state articles or references and do not identify them. Lets have all parties who write in supply complete information. Readers could also cite articles in magazines or books of interest which a few have had the care to include. I have

tracked a few of them down and found them most entertaining.

Oh, and a personal item is just that readers who send in photos make sure that if hi-heels are involved they show the heel and shoe as clearly and prominently as possible provided it does not interfere with other interests.

Very truly yours,
High heel artiste

We can dream up fiction ourselves: we rely on the readers for facts. — Ed.

ANSWER FOR THE FRISKY FIVE

Sir:

The Frisky Five might well be reminded that, during the Directory period in French history, women wore dresses cut so low that the slightest movement revealed the tips of the breasts, and some of the more daring ladies left them constantly exposed. (An excellent drawing of this latter style is that by John Maxwell on the title-page of the 1931 Bibliophilist Society edition of Defoe's *Roxana*, and I suggest you make a similar picture for your magazine. An interesting example of the peek-a-boo style is the enclosed picture from the same volume, which I suggest you also copy for the magazine. The Frisky Five will be doing a public service if they help to reintroduce such styles into ordinary social life.)

SPY'S FATE

Dear Sir;

Several months ago my wife and I were visiting some friends when I noticed a little magazine called "Bizarre" lying on a table next to me. I began to read it and was fascinated at what I read and saw. I suddenly realized that I have always received a pleasant sensation at seeing women tied up in movies or magazines but had never thought much about it. I didn't realize that there were so many people that actually got so much pleasure from rendering females helpless. After buying several copies of your publication I decided, with the approval of my wife, to send you this harrowing experience that happened to us while hunting deer in a mountain region in New Mexico two years ago.

About dark one afternoon my wife and I were returning to camp when we came across a cabin in the wilderness. We would not have noticed it if we had not seen the lights. As we approached we heard noises that sounded like a party in progress. We reached the cabin and had started around to the front door when we stopped in our tracks after glancing in a side window. We were so shocked at what we saw we just stood there and watched.

(Continued on page 29)

DO IT YOURSELF DEPT.

Dear Sirs:

Enclosed you will find the outline, and a few diagrams, describing how I have successfully converted standard high heels into six inch spikes.

At first I thought that I would have a great deal of trouble but, as it turned out, it was simple. It gave me something to do while waiting for No. 21. The whole job was done within two weeks during the evenings, and when my wife first tried them on she was a bit taken back by their height but, she kept walking in them until now she moves with graceful and dainty steps. I was delighted with her willingness and perserverance.

HOW TO CONVERT STANDARD HEELS TO GRACEFUL 6 INCH SPIKES

First, select a shoe that is a half size larger than what is normally worn. The toe should be more or less plain, while the heel should be as high as can be obtained at a regular shoe store, the design is of no consequence.

Second, decide what type of heel that is eventually desired, and if there is enough material in the original to accomplish this. The toe will stay the same as the original except for about a half inch at the instep. For the sake of explanation I shall describe how to make the casual shoe into the spiked heel shown in fig. 1.

DIRECTIONS

Lift the insole with your fingernail, and carefully peel it from the backbone until it is loosened well into the toe. When this is done, the screw and/or nails that hold the heel to the backbone will be exposed. Remove the fasteners and discard the old heel. Next, remove the sole from the backbone. This will have to be done with care, and a sharp razor blade, as the sole is cemented solidly to the backbone and body of the shoe. Loosen the sole to point A (see Fig. 2). Then open seams B and C and cut the inside lining away from the leather body of the heel and peel the leather down away from the formed heel stiffener. Cut away the inner lining and discard it, and cut away the heel

Fig. 1

Before After

Fig. 2

stiffener to a point level with the backbone. Bring up the leather body and fold it over the backbone, and using a razor, trim away all but a half inch of the overlap all around the heel. After sufficient darts have been cut into the remaining body, so that it will lay flat on the backbone, cement it down with "Weldwood Contact Cement" or a comparable brand. During this step you will notice that the backbone has become very loose, and flops about. This is to be expected. Now, in order to raise the heel the leather body of the toe must be very carefully loosened from the backbone down to point A. Once this is done almost any height may be given to the heel. Hold the sole of the shoe flat on a small board with a C-clamp, raise the backbone to the desired height of the heel, and hold it there with a block and rubber bands. Now, carefully move the body of the toe, at point A, inwards until a graceful curve is formed in the leather, and the excess now overlaps the backbone. A dart may have to be taken in at this point if the heel is to be extreme. Cement the body to the backbone and let it dry thoroughly. Now the heel height is set. Remove the shoe from the jig, and fashion a heel strap from the ex-

cess leather of the old heel body, or any other soft kid that might be handy. Stiffen this strap with a piece of material such as sail cloth by cementing it to the inside surface. Now, locate the strap under the backbone just forward of the heel, and cement it in place. At this point it would be a good idea to drill several small (1/32") holes through the backbone and the leather body of the heel strap and toe cup. Lace the strap and the altered toe cup section firmly to the backbone for additional strength. All that is left to do now is to cement the sole back into place along with the insole, and the carving of a new high pencil thin heel. This can be done quite easily with a sharp knife and a block of soft pine. Once the heel is formed it is a good idea to wrap it with silk or nylon for additional strength. Cement the nylon smoothly to the heel with "Duco", and sand lightly. Remount the new heel to the shoe with the same type fasteners that were removed. Now, dye any discolored or exposed raw leather, paint or cover the heel with leather, and there you are. You now have a fine present for your wife or sweetheart, and at quite a saving.

MICK

28

(Continued from page 25)

Inside were four women and three men that seemed to be in their late twenties. One of the women and one of the men were on a large mat on the floor, bound in the most cruel manner possible. Thery were struggling, in vain, to free themselves as the others just walked around and shouted words of encouragement to them. We finally decided that they were having a bondage and escape contest. We had watched about twenty minutes and were so fascinated that we failed to notice a fourth man enter the room and leave again with the two men that were standing around. Suddenly I heard a gasp from my wife and felt my arms being pinned behind me. The fourth male member of the party had seen us as he returned to the cabin. My wrists were quickly tied behind me before I was allowed to see that the two men who had been inside were now holding me as a third was tying up my wife. As we were led inside I noticed, for the first time, that the people inside had been hitting the bottle pretty hard. We were given a push and several sarcastic remarks followed. I heard one of the men say that if we were so interested in their party we would just join it, then every one laughed. One of the men that was pretty tight, but not quite so much

as the others, told us not to worry, that they would not harm us, they were just going to have a little fun. Some of the others were not so friendly, however, and just as I was asking for our release they stuffed a rag in my mouth, sealed it in with several strips of wide tape and told us if we did not do exactly as they said our clothes would be removed and we would be left in the nearest town with our hands bound behind us. After the lecture my wife, Jean, asked me to do as they said and I shook my head to agree.

At this point one of the women said that Jean would be no fun dressed in hunting clothes and took her into another room as the other women followed. While they were gone I was bound again in a spreadeagle manner with my back to the wall. Large nails were used to secure the ropes from my wrists and ankles. I could not move. I was just wondering what was happening to Jean when the door opened and she was pushed into the room. Her hair was combed and she was wearing a pair of skin tight black panties, a bra, black opera length hose and a pair of extra high heeled shoes that were about two sizes too small. When I saw the cruel gag I strained at my bonds and wanted to kill the whole bunch of them.

29

My wife is twenty-six and very lovely with blond hair and curves just where they should be. She did not resist as they tied her hands in front of her and looped the rope over a rafter above her head pulling her hands up until she could just reach the floor with her tiptoes. Next they bound her lovely legs in such a manner that I could see the twitches in the skin around the ropes.

Someone suggested a toast and everyone started drinking again and telling dirty jokes. They would look at us and make some kind of remark then laugh and drink some more. I was just thinking that Jean would faint before long when they untied her and told her to lie on the floor. At this point they untied me also and tied us both again on the floor. Our wrists and elbows were tied together and then our knees were tied and our ankles brought back and tied to our wrists. This is the way we spent the night, since every one passed out in the next hour or two.

The next day, when the party sobered up and realized what they had done, they were truly sorry and offered us anything to make up, (and to persuade us not to press charges) but seeing that they were really nice people, and had not really harmed us, and just had too much to drink, Jean and I decided to forget the whole thing.

Later we decided that we would have enjoyed the experience if we had not been so scared. Also, Jean has agreed, on several occasions since then to dress for me like those people dressed her, and let me tie her in various ways. She won't admit it but I think that she enjoys it nearly as much as I do.

Very truly,
Mr. and Mrs. V.M.

PARTY FAN

Dear Sir;

I have enjoyed your magazine for about 6 months now and find some of your articles to my liking and some that have no interest at all, but you can't satisfy everyones taste. The articles that I enjoy most are from men and women who have been able to meet and participate in bizarre party's and dress. Also the articles from men and women who are dominated and subjected to their mate's whims and enjoy doing so.

My case is one of enjoying being dominated by a woman and subjected to bizarre apparel and also I like to subject her to the same treatment that she inflicts on me. Unfortunately I have not succeeded in making such an acquaintance but have hopes of doing so someday soon.

I am single and have met men who are willing to subject me to their forms of pleasure but some-

how I never succeed in inflicting my whims on them. They are willing to become my master and punish my misdeeds by binding me in bizarre fashion and using a whip or switch to make me their slave for the night, but I would much rather have a roomate who also enjoys your magazine and we can enjoy acting out many of your articles.

I am a firm believer in tight skirts, or dresses with sweaters and blouses also high heels, sheer stockings gartered by a belt under skin-tight panties and no corset; corsets are O.K. only on those bizarre parties not for everyday wear.

When alone with my mate I would willingly wear a small waist corset and rubber or leather costume and submit to any form of bondage or any form of punishment she may wish to inflict upon me. She would also be attired in bizarre dress and make-up of her own liking or copied from one of your many descriptions or photos from former issues.

If I get more time or make an acquaintance of my liking I shall write and let you know how our sessions come out. Until then I remain an ardent subscribed and anticipate your next issue with great delight.

Carle B.

THE GOOD OLD FASHIONED
Dear Sir:

Was sorry to see that No. 18 had only two items on spanking (both of those were letters). I am sure your readers' interest in the subject warrants more than that.

My interest in the subject goes way back to my childhood. Children of today miss something, for the day of numerous family servants is gone. Back in my time, at least in my neighborhood, it was possible for a child to be spanked by a buxom cook, a pretty parlor maid, or even his mother's personal maid, all in one day (in addition to any female relatives who might decide discipline was necessary). A naughty boy, such as I apparently was, never knew what female lap he was going to be turned over next.

We had a pretty blonde German girl working in our household. She was big and strong and believed in spanking. My sister and I were turned over her knees frequently, and how it stung! Both my mother and her maid also knew what the backside of a hairbrush was for, and I had many a merry session in the boudoir. In addition my sister and I had an older step-sister, fifteen years my senior, and she thought she had the right to spank us also.

One of the biggest thrills I would get was at a neighboring house-

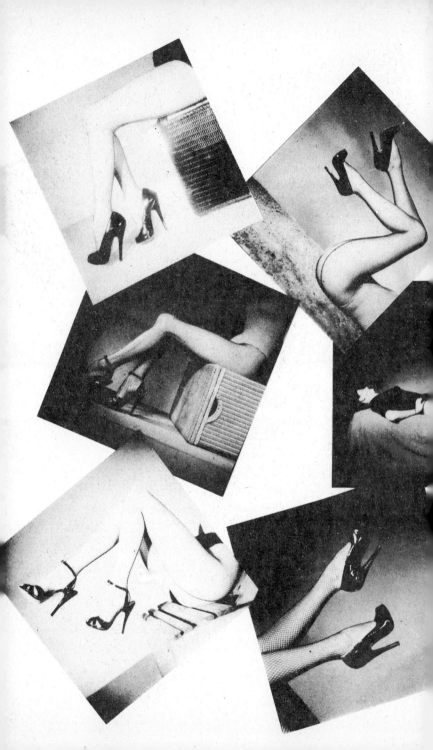

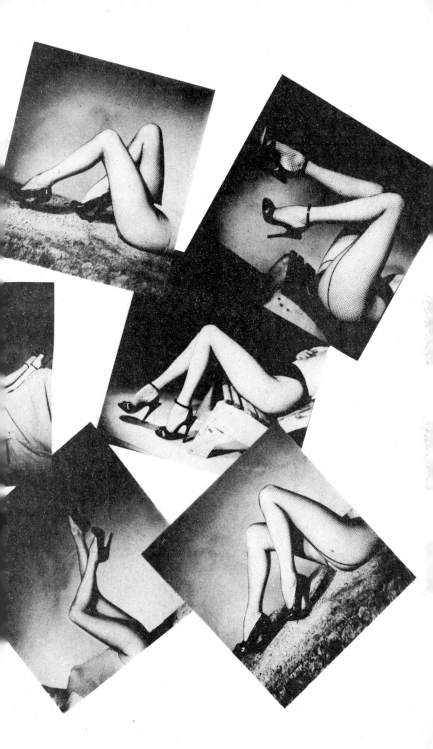

hold. The little boy was younger than I, but I played with him often. There was a pretty brunette girl employed in that home and she had charge of the boy most of the time. She was so pretty that it gave me a great thrill to see her spank her little charge; and she never minded if I was present to watch. Sometime, if he had been very bad, she would bare his little fanny before she spanked him. I became very clever at contriving misdeeds for which he would be blamed and spanked.

The lady in our household whose spankings thrilled me most was Aunt Flora, who visited us often. She was a real beauty, and though unmarried had many admirers. Her threat of punishment to us children was always, "I'll upend you over my knee and paddle your bottom till you can't sit." She often made good her threat too. Though I was scared to death, I was always thrilled when she took me to her room for a spanking.

F.D.R.

SYNCOPATED HIT PARADE
Dear J. W.:

The many letters in your magazine about corporal punishment prompt me to write to you about the old time discipline to which I am subjected. I am a young lady of 32; my blonde room mate is 4 years older. If you saw the French movie "Diabolique", you saw a perfect representation of us in those two ladies. My room mate, Helen, is like Simone Signoret was in that movie, tall, blonde, handsome, a dominating person, dressed in well tailored clothes. I am more like Vera Clouzot; smaller, a more timid brunette. As in that movie, the big blonde is the boss.

Helen knew my step-mother, who brought me up. My step-mother was a close friend of Helen's mother. That is how I came to share this apartment with Helen in the first place. We hadn't been together very long when Helen told me that she knew my step-mother used to spank me (as a matter of fact she used to watch sometimes) and that she intended to do so also. She said she figured I needed a continuation of that discipline. So I have had to go to work quite often with a tender, well-spanked bottom. Fortunately, I have a job (department store clerk) where I stand most of the time. I am glad I am not a secretary like Helen; I am sure there would be many days when I could not sit comfortably at work. Usually Helen just spanks me with her hand; but that is enough when it is applied to one's bare bottom! However, if she is really provoked, she uses the old hairbrush she got from my step-mother.

Then a few weeks ago (May 26, to be exact) a new *musical* aspect was added to our spanking. We were watching "Your Hit Parade" on TV and saw slim-waisted Giselle MacKensie turn a plump little girl over her lap and spank her taut panties to the rythm of "Picnic." Helen was delighted! She thought the idea of spanking to the rythm of music a terrific one! She insisted immediately that I arrange myself over her lap there on the couch in the usual position. And you should have seen (I *felt*) the *syncopated* spanking she gave me to the music of "Heartbreak Hotel," which was first on the Hit Parade that night! *Hit* Parade in more ways than one. — Or should I say *Hip* Parade?

Helen and I both agree that any program that would show more spanking sequences like that one with Giselle Mac Kenzie would soon be the most popular program on TV. (Sponsors take note!)

Since that fateful Saturday night Helen usually administers my spankings to the rythm of music. If I have been naughty, she either turns on the radio or puts a record on the turn-table. Then my bare bot suffers a "rythym serenade." I will say this — She does not spank as hard when she spanks to music; but it usually lasts longer than an ordinary spanking, so it's just as bad. Mostly for the musical spankings she just uses her hand, but sometimes the hair brush.

Of course if she is really mad at me for something, she doesn't waste time to turn on the radio or phonograph. She just grabs that awful old hairbrush, bares my spank spot, drags me over her lap, and blisters me. She has no thought for music then; except the music I make! It is those spankings which leave me sitting uncomfortably for 2 or 3 days.

Why is it that some girls like to administer spankings? Why is it that some girls like to be spanked? I would like to hear a discussion of that via your pages.

Yours,
Dorothy F.

PAGE FROM
PATRICIA'S DIARY
Dear Editor:

The mistress of the house here where I'm boarded is quite old and stiffish — early thirties, I'd say; while I'm just this morning turned eighteen, blonde, a senior at school. Another school girl boards here — Jacqueline. Pretty and chestnut-haired, she's a perpetual problem, because of her willfulness and good looks. It's true that sometimes I've had to be given a lecture by the mistress or her youngish husband (whom, I confess, I secretly love) but it's Jac-

queline that's the headache — I've seen her, at the age of 18, sent to bed without supper, deprived of good times, forbidden desserts, to teach her "obedience". Much to my amusement, the mistress lately has adopted an intriguingly different method. She actually took away Jackie's regular clothes, and the surprised girl found herself attired in a made-over, short-kilted, child's white dress. You'd laugh to see her wandering penitently around in this pathetic round-collared little frock which, to her embarrassment, does not reach nearly to her pink knees or conceal from view entirely two frilled legs of white, bothersome drawers. When the mistress feels ready, over her lap she quickly turns Jacqueline in her little white pleated skirts, the naughty young lady's knickers come down, and as if she were a 10 year old Jacqueline is given a spanking with a mahogany hairbrush.

It is afternoon. I'm all a-flutter, I'm biting my lips in vexation. It isn't that I'm tired because I got in too late last night, against orders; or that the mistress saw me making eyes at her husband. No, I just caught another look at myself in the long, door-mirror which reflected, of all things, a rumpled hoyden in a little purple dress. Imagine such foolishness as wearing a pastel-hued Princess frock with

From Reader J.R.B.

puffed brief sleeves and flaring starchy little skirts that end a shocking five inches above my bare knees, almost at mid-thigh; silly white ankle sox telescoped down at my shiny black pumps, blue eyes in the mirror darting a hurt, wild look under a tousled page-boy bob in utter disarray like a blonde mop. I turn away, pulling down on my provokingly short outfit. I have nothing on under it. I blush when I look across the room, in spite of myself, at my mistress's now — vacant armless chair seeing beside it on the floor where she left them her red mahogany hairbrush and my childish white bloomers —

(Her husband just came in, he

kissed me! — what rapture! — and told me to be a good girl.)

My dear diary, I feel like hugging you! Love triumphs over pain at last, doesn't it always? Like the setting sun gilding the close of a dark and stormy day.

Blue-Eyed Patricia

WHO ENVIES WHO

I have always liked the feeling of nylon or silk next to my skin. However, the unfortunate thing is that I am a male of 21 years of age and unable to wear the clothes that I wish on the street. Therefore, I am only able to wear them in my room or under my regular dress suits.

I love the feeling of slipping my foot into a pair of black nylon hose and then fastening them tightly with eight garters that bite into my legs as I walk. Being unable to shave my legs, I wear three or four pairs of hose and the effect and shine are beautiful. I particularly enjoy rubbing my hand over the smoothness of them and feeling the seam . . . my, how lucky you girls are!!!

Under a tight sweater I wear a bra with falsies. Naturally, I wear very thin and fancy panties over my garter belt with the eight garters, which I made myself by adding the extra garters to the belt.

Being unable to obtain a corset, I must use the next best thing and that is wrapping myself around the waist with cloth as tight as possible which helps greatly to hold the padded bra up high, and makes my hips look larger. My only wish is that I could have someone to lace me into a corset . . . the feeling must be wonderful.

On my feet the 3 inch-heeled shoes fit very tight, adding to the beauty of the black hose. I love to walk in my room as often as possible with them on, and even many evenings I'll slip them on and walk outside. I own two pairs of shoes each with 3 inch heels.

I own about 15 pairs of black nylons. However, I am not completely dressed unless I've pulled at least 4 pairs of them over my head. I can hardly see, and it is hard also for me to hear since I put wax in my ears.

Many evenings after I get dressed as above, I lie on my bed with my ankles tied tightly together and with a gag made of nylon hose in my mouth and of course the black hose pulled down over my head.

Gee, I could go on and on but I'm getting a little long. I have such wonderful tales to relate, but I'll stop for now. If you would like to see some pictures which I have of myself just let me know and I'll send them.

Yours truly,
Black hose fan

MASQUERADER

The letter from E.N. in your Correspondence issue has made me pluck up courage to write about myself as I am a real tight-lacer and a permanent masquerader, and to save detection I am sending this note to be posted in London from my address on the Continent. I am in my middle twenties and from about age ten lived here with my sister in whose clothes I often dressed up with her aid. When she was killed in a car crash I kept all her clothes and began to wear her corsets every day and her complete outfit in the evenings, going out dressed as a girl very soon after. I think I must have a good bit of the female in my make up as I have an almost hairless face and my bust filled out nicely without more than massage with olive oil. helped naturally by the tighter lacing I indulged in; when I was eighteen years old I had assimilated most if not all the attitudes of a girl and a change of residence made it possible for me to take a girl's post and to carry it off successfully as I am still in it. My work lies with girls principally and all are chosen for good figures and smallish waists so there is no comment on me so far as I know; my corsets are 95cm bust; 42cm waist; and 85cm hips (37½-16½-33½ inches) and I wear 10.5cm heels (a trifle over 5½ inches) Louis type. I am 5 ft. 9 ins. tall.

From the letters I have read in your magazine I think that it is not generally realized that waists of 35 to 45cm are not at all uncommon now, that is 13½ to, say, 18 inches, at least here in France, I am working with girls with much smaller waists than mine and whose tight-lacing is much more severe, one, a six-foot girl, looks just marvellous with a 33cm waist, and her lacing is not a long process nor very difficult, as I can testify having assisted many a time, she wears 10cm heels but not thin, and none of us have platform shoes.

May I suggest to you that back view illustrations, or even front views without any visible heads are not of much interest? May we have some pictures of corset wearers full length or at least to knees, they would be very welcome; for instance page 51 of the double number shows the corsets not nearly closed — why? Similarly the lady at the piano on page 74. The girl on page 14 is very good, that is the type of illustration which we here would like to see more of.

With much apreciation,

Truly,
M.L.

Dear Sir:

Coming across a copy of Bizarre in the wilds of New Hampshire recently I wondered if any of your readers could clear up an odd point I have often pondered since my sojourn in a British boarding school some years ago. That is: why is it the *birch* that is universally favored for application to the seats of refractory maidens?! Are the twigs of this tree especially painful? What is it that gives the wood its traditional status in correction? (*Birch is plentiful, pliable and moisture retentive—Ed.*)

I am not one to deny its efficacity. In my own "happiest days" at Heathley (as I shall call it) we were birched infrequently, but with astonishing severity. Two whippings a year were perhaps the average but each would be agony, and I have since often wondered about the advisability of giving some four dozen lashes with a long, tough, but supple selection of twigs to a sensitive thirteen-year-old, secured in wrist and ankle-stocks, and crying her heart out the while. Fortunately such barbaric practises have died out, if ever they existed, in America, but a birching at Heathley was meant to be, and was, torture!

A sturdy male performed the offices in the presence of the "Head," a gorgon-like lady close on sixty, and the stripes were ad-ministered so slowly that an application of fifty, which was not unusual, took quite a time! During this period of reform you writhed like a worm, yelped like a puppy, and in general wished you had never been born with a sit-upon! The instrument itself made a perfectly horrible swishing sound and each stroke, which appeared to be given as hard as possible, seemed to catch one at the peak of the previous one's pain, until you literally felt able to scream aloud. Such, however, was considered highly "bad form" and there was nothing for it but to go through with the wretched business. The ends of the branches, meanwhile, flew out all over the floor, and when one rod was used up, the maid picked another from a bucket where it was set to steep in hot salted water, to give it fiber and elasticity.

I remember that some of us used to soap our posteriors beforehand, in the vain hope of mitigating the smart, but I never found out whether this actually worked or not. The only time I dared try it the Head directed her henchman to "whip down well on the thighs" for special severity and I received my count on the backs of my legs! My dire offense on that occasion was posting a letter outside the school grounds and for this I received sixty anguishing slashes.

And with its all-obliterat-
ed Tongue
It murmur'd—"Gently,
Brother, gently, pray!"

For I remember stopping
by the way
To watch a Potter
thumping his wet clay

Ah, lean upon it lightly! who knows
From what once lovely
Lip it springs unseen!

And this reviving Herb
whose tender Green
Fledges the River-Lip on
which we lean—

41

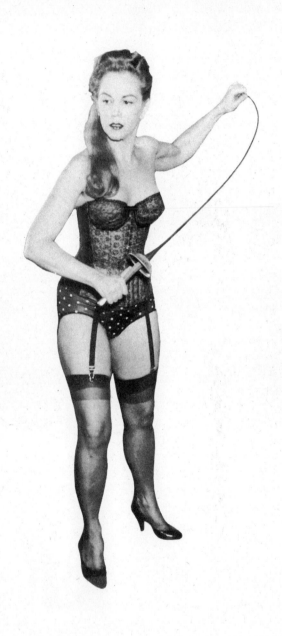

each single one of which took my breath away. I wept my eyes out for two hours afterwards, I recall, and while this sort of severity seems to me virtually feudal, I must admit I never posted a letter outside the school again!

In short, I am not doubting that the birch stings frightfully. At the same time I wonder as its reputation. I have a son in an English school who gets six with a bendy willow, which appears highly uncongenial to him, I gather. The other day I found it necessary to correct my youngest daughter in this manner. She got ten touching her toes from an ash-plant I picked in the garden and she didn't seem to like it a bit! She took it over tightly stretched gabardine (slacks) and the ash did not break off like birch. In fact, it seemed to have a lively whip which made things so hot on the right side the girl flinched badly twice. I was worried later lest I should have given her extra for this. What do you think? Or is it simply that young girls are growing up softer these days? Could one of your readers enlighten me?

Sheila

SUSPENDED PUNISHMENT

In the #20 issue of Bizarre. "Worried" inquires of readers what to do with a rebellious 16 year old step son. As I was raised by a maiden aunt, perhaps I can be of some help.

At the age of 15 I was sent to live with my aunt who was 32 and lived alone. I had been living with her about a month. One day it was necessary that I stay after school to finish some homework. I returned home late to find my aunt waiting at the door. She was very angry and demanded to know why I was late. Since my explanation was not good enough she said I was to be punished. She took me to the basement of the house thru a locked door where I had never been before. Here to my astonishment was a collection of devices which my aunt has collected to inflict various degrees of punishment. I was ordered to remove all my clothes and put on a pair of sheer tight fitting womens panties. My wrists were then bound tightly together over my head, and fastened to a rope and pulley from the ceiling. The rope was then pulled tight, so that my toes just touched the floor. I was then left in this position and my aunt left the room.

Since this was my first experiment with my aunt's punishment. I did not know what to expect. My arms and shoulders began to ache with pain from the weight of my body. In about 10 minutes my aunt returned. She was dressed in a tight panty girdle, bra, sheer

stockings, and 6 inch heels. This was the first time I had seen her so attired. The bra she wore emphasized her well developed breasts, her waist was pulled in tightly by her girdle, she was exquisite perched on her 6 inch heels. She lectured me for about 5 minutes on the importance of getting home early. She then said it was time for my punishment.

She went to a rack on the wall which held several whips. Selecting one, she put it in a bucket of water to soak for a minute. This I soon found made it pliable so as to lay on the body better. She took the whip in her right hand and with great skill began applying it to my bare body. She was very adept at making the whip do what she wanted. She carefully applied it to the most tender parts of my body. Soon the panties I was wearing were in shreds. My first whipping lasted 15 minutes. After it was over, my aunt cut the rope which held me, and I fell. I lay on the floor for about 3 hours, unable to move. Finaly I was able to crawl upstairs and in to bed. I fully recovered in a few days however. As I learned later, my aunt is very careful not to do re .nanent damage to my body.

Many other punishments have followed this first one, and I have grown to look forward to our sessions in the basement. Some-

times my aunt allows me to punish her when she has been bad. If your readers would like to hear of more of my aunts devices for rebellious boys, I would be glad to write of them. R.L.

ALWAYS ROOM

Hello:

Is there room for a new correspondent? Some of the letters in your unusual magazine (it reminds me of the old "London Life" that passed out with the Blitz, and was revived in a different form) have the ring of truth to them, others are a little hard to believe. Of course they are exciting and that is what is wanted, is it not? Men have sucessfully masqueraded as women for years, and women have exercised domination over their men for a whole lifetime, but it has usually been with the full consent of the man involved in each case. Frequently he has invited the fate that has overtaken him and while objecting to some phases of it, he would not have the picture changed, even if he could. Many a man has openly asked the woman in his life to take full control of his life after indicating what he would like to have happen to him. The man who finds that he cannot tolerate it always finds a way out and reasserts his manhood.

 L.F.

Dear Editor:

Male transvestism is both a delight and a drudgery . . . if the transvestite is as completely enraptured with transvestism as I am. The *details* of feminity hold great attraction for me — and it is here that the drudgery enters the picture in the constant feminizing of myself.

First the matter of body hair. Unfortunately we men are afflicted with unsightly hair on our legs, arms, chest and stomach which must be removed for feminine appearance. I spend on the average of two hours a week on this chore, and since I remove the superfulous hair by the wax method it is slightly painful, but well worth the time and effort.

Next detail — pierced ears. No male transvestite can achieve the true feeling of being feminine without having pierced ears. The sensation of wearing earrings which pierce the ears is thrilling beyond description — and there is the added thrill of being "marked for life". Once the ears are pierced it is for all time. At this point I want to remark how unobservant people are — my ears have been pierced for over ten years and only in half a dozen instances has it been noticed including the scrutiny they must get in barbershops.

Another detail of feminity — on the oriental side, is the pierced nose. As I am writing this letter I am wearing a nose-ring which is so large that it hangs down to lip level. In order to smoke my cigarette, I have to lift my nosering out of the way. The sensation of wearing a nose-ring is most pleasing, and I was happy to see the article on this type of adornment in a recent issue of Bizarre. For those faint hearts who would like to have this decoration let me say that it is not painful to pierce the septum of the nose, and there need be no fear of discovery that the nose is pierced.

Next in order, I think, is the matter of manicures and pedicures. I have my finger nails manicured and my manicurist never fails to remark about their beautiful length and compliment me on their feminine appearance. I do my own pedicure, and if I do say so myself, have very pretty toe nails.

Then there is the matter of eyebrows. They require constant attention to keep them neat, and I must be careful not to pluck them to too feminine a contour.

Then there is every-day wear of jewelry. I would like to run rampant on this but must confine it to the wearing of a beautiful solid gold bracelet which I had the jeweler fasten to my wrist in such a way that I can not remove it. It

has somewhat the feeling of being "chained" since it is a chain bracelet. My only other item of jewelry that I wear constantly is an anklet which looks very pretty when I wear my high heels.

Then there is the detail of figure. This is real drudgery for we males since we tend to thick waists and small hips. I have solved my figure problem by wearing a "waist slimmer" at all times — so successfully that my dressmaker has complimented me on my feminine figure and said that she wished her women customers had as nice figures.

I can not help but compare the problems of the male transvestite with those of the female transvestite. As usual, women have all the best of it. (But why a woman would want to be a man is beyond my comprehension) Here is a brief outline of the advantages of the female transvestite as I see them.

Let's start with "hair-do." The female transvestite can have her hair cut man style and cause no comment. We males don't dare let our hair grow too long without being accused of being queer.

Clothing — women can wear men's shirts, pants etc. and it is accepted as a fad. A man who appears in public in a skirt would wind up in jail.

Shoes — women can wear any style of shoes and get away with it. Men can't. And this is a terrible handicap for men that will be quickly recognized by any male who has ever worn the wonderfully light, comfortable and pretty high heels that are the height of feminine fashion.

Why oh why would a woman with all the wonderful advantages of being female want to be a man? There is no limit to the adornment of a woman — she can pierce her ears, her nose, be tattooed, wear exotic bracelets, necklaces, anklets . . . tint her hair . . . wear any type or style of clothing . . . and importantly recognize that she has a master who can punish her at his whim. Her clothing is more comfortable and far more attractive than the males. (If you have never worn women's clothing with its "sleek" feel and comfort you have passed up one of the most thrilling experiences in life.)

Speaking of being punished — I have never been whipped, but think I would enjoy it at the hands of a "slaverette." While I like to be feminine I would get an added thrill out of being forced to be so. I would love to be a subordinant woman at the complete mercy of a domineering, tyranical woman who would chain me to household tasks by my nose-ring . . . and keep me on a nose-ring leash at all times.

I would like to see a rebuttal to my arguments by female transvestites. I doubt if there is a female transvestite who is as completely "male" as I am "female." If there is, I challenge her to relate her experiences.

Pierced-Nose

ABJECT FOOLERY

Dear Sir,

I must thank you for printing my letter on "Skirtings," in No. 20, as you put it. I certainly hope it amused your readers and as for my husband, he's hardly let me out of a D-D since!

Seriously, however, I have been interested in some of your readers' comments on correction, although I feel that Bina L. scarcely knows what it is. It is one thing for a child, quite another for a grown woman; believe me, it hurts like anything, much more than you expect, and I personally dread the rip of another split "skirting"!

For the interest of "Ardent Spanker" (17) or "Faithful Reader" (20), I must add, however, that the most disagreeable part of the "Ritual" of these little affairs is undoubtedly the humiliation involved. The objective of correction is cure, and if the offender is female, you will have gone a long way to achieving your goal if you make her feel thoroughly ashamed and absurd. This might well apply to our young "Dungaree Dolls" mentioned by Bina, too, and I for one have learned that "prelimins" can be deeply humiliating and aggravating. My husband usually makes me feel a complete fool before punishing me and I find this intensifies the whole thing greatly.

For example, he will talk about a forthcoming dose over drinks before dinner with friends; it is discussed just how much and where it is going to hurt me, I am kiddingly asked my reactions, but it is no joke for me I assure you. I may have to leave the room and bring back my underclothes in a neat pile to be set before the guests. Then, I will find the ration extra low (and highly painful therefore), and the next day be compelled to acompany him swimming in some public pool. I go absolutely beet red when I walk past people with those marks on my thighs, frequently going a nice green and yellow already. One thing (touch wood!), I have never had to take it in public before our friends, though I know several of his personal chums have asked him this. Perhaps that good fortune awaits me.

Naturally "preliminaries" can be made inconceivably varied — from remaining bent over with the cane in one's mouth for half an

hour or so beforehand to having to cut a switch, vinegar it daily, and finally describe aloud, clad in only a floppy hat and long gloves, just how it ought to be applied, and where, to the good old gluteus maximus to cause most damage. Yes, I've had to do that! I also find the effusion of water, via a sponge or otherwise, over the parts to be treated an inexplicably galling procedure. Modern furniture, by the way, seems admirably designed to adapting for the most humiliating and degrading positions. In short, my flesh is never struck a blow until my pride has received several, and I feel thoroughly silly all over.

Yes, discipline during application can be made to humble the most stout-hearted, too. I have had to lean forward, hands over head, with a ripe peach in my mouth — if I bite through and it drops before the count is over, I start once more. Another peach, another count. The same thing holding out two full glasses of water. One drop on the rug during . . . and . . .!

In conclusion, I trust I have not made my husband sound a monster; it is simply that being made to feel completely absurd and ignominious is highly unpleasant for a grown woman, and for that reason all the more corrective. Although I am a wel-built woman

in the prime of health, I can be made to feel a child by my husband. By "prelims" he can make me feel so worthless and weak that as few as four strokes will undo all my courage and cause me to dissolve in tears. Which, of course, makes me all the more miserable for my lack of strength.

Yours,
Barbara

WHITE CIRCLE CLUB

I am fascinated by your magazine because, even though I am in my thirties, this is the first time I have been able to avail myself of the sincere, uninhibited thoughts of others regarding leather and bondage. So, due to Bizarre, I know my hidden desires are not quite as isolated as I had feared.

An attractive girl, clad in snug, well-tailored jodhpurs or breeches which are well reinforced with suede or some other soft, resilient leather at the seat and the inner sides of the legs is certainly a lovely sight. And the thought that such a girl might entertain the desire to put me in bondage, or that she might even enjoy giving me some discipline, is encouraging to say, the least.

But it is indeed frustrating, here in staid old New England, to find the company of such a person. To be sure, I attend horse shows and ride often at nearby stables, but with no success, despite many conversations with attractive girls.

So why not suggest that those whose thoughts are similar to mine put a little circle of white paint on each of their riding boots, and at the rear, just where the heel is stitched to the softer leather? By so doing we could identify others with whom we have ideas in common.

But, at any rate, I enjoy using your magazine as a "clearing house" for thoughts from other readers, one of whom might be intrigued in having a six-foot, 170-pound bachelor for her prisoner. J. FOSTER

UNMILITARY DISCIPLINE
Dear Editor:

I was a WAC major during the war and a good, respected officer. I have always been just a bit on the masculine side, that is in my clothing and actions. I have a name that is also given boys. I guess that helped me in my war work. I am strictly feminine in all other ways. I just like to be obeyed. When I came out of the service I married a fellow 7 years younger than myself. His mother told me when I married him: "he is a spoiled brat." He was, but I soon changed that. Via certain legal actions that I haven't room for here, I let him know that he is completely in my charge. From Friday after work until Monday morning he is my "House Girl" and I mean he gets K.P. and all. I call this week-end training: "Operation Discipline." He must address me at all time on these week-ends as "Sir" and "Major." He must follow strict military rules at all times and must learn them all. He got out of the war by getting strings pulled etc., and he is going to get some now. (some

51

good old strict WAC training). Only his "uniforms" are much more feminine than the WAC uniform. He wears the long net opera length hose held up by the garter belt, a large hair ribbon in his hair, and is made up "fit to kill" (as a WAC sargeant said!) He wears large "falsies" under his bra, and no slip. The panties are the short skin-tight dainty lace trimmed bloomers that one sees on a "Cigarette-Girl", and his little short dress is of white silk just like the bloomers. The dress is ruffled, of course. Oh, I have "changes" and I have my ideas as to "punishment clothing" just like "Babs" and the others. He wears high heeled slippers, and I keep handy at all times a short leather riding whip. Today I had several of my sister officers in for a few cocktails and a general visit. As soon as we girls were seated as per his training my "Gertie" entered the room, he came over to my chair and made a deep curtsy (I am surprised that more "Slaverettes", or that none have mentioned this — my advice to ALL "Slaverettes" is: — train your "Maid" "House Girl" or what have you to CURTSY, this helps keep him in his place and aids the "Beneficial Humiliation" as Elas calls it') Well, he made his curtsy and was ordered to turn around and let the girls see him, (he has those long pretty legs). I had to sting him with my whip several times about the thighs. Of course very much activity and the little bloomers show. I ordered him to tell the girls what was going to happen in the afternoon after they left. He hesitated but one look from me changed his mind. With blushes he said: "This afternoon I will stand in the 'punishment corner' for an hour and think about the plate that I broke this morning, then my 'superior officer' wil take me by the arm into the bedroom where I will receive an old fashioned spanking, next I will be undressed and my "shortie gown" will be put on me. I will be put to bed like a naughty house girl, and later on in the evening I will be sent to cut a switch out in the back yard. My major will switch me soundly with gown lifted and I will again be put to bed." I asked him; "do you deserve to be punished 'Gertie'? (With deep blushes) "Yes Sir, my dear major, I do deserve to be soundly punished." He waits on us during the party and blushes all the time, my fellow officers are all going to be "Slaverettes" when they marry. Well my "Operation Discipline" is a success, my "Gertie" obeys well and is a regular slave — his training is doing him good.

Like others that have sent letters I use different methods of

punishment. I use the switch, riding whip, hair brush, razor strap and my palm. Let me insert a little psychological advice. Many times, especially when women friends are about and your "maid" etc. displeases you and you wish to cause deep humiliation, take him to the bedroom and with windows left up and the door ajar so that nothing hinders the sound; give the naughty darling a good old fashioned smacking on his bare backsides, make it long and make it loud. After this stinging "prolonged spanking" make him go out and face the guests. When I was a girl I remember how effective this method was as far as I was concerned! I just pass all this advice on to other "Slaverettes", you see I hope that all "psychological warfare" of this sort gets around so that maybe someday we can have — "The Great Revolt" — FOR REAL!

Later on I will tell you about some of my methods of punishment as regards types of clothing I put him into and several of my friends wish to send in articles and letters also. One friend of mine will later tell you how she cleared up a lot of trouble by keeping a strap under her pillow, she now has a "GOOD" husband!

There is so much but let's wait until another time as I have written so much already this bright Sunday. MY 'Gertie' is now waiting for me. I will say "as you were" and go to the bedroom and soon a certain "House Girl" by the name of "Gertie" — (Private ZERO class) will really "Sound Off" — and HOW!

At ease, MAJOR

IMPULSE SWIM

Dear Editor:

A picture in No. 14 prompts me to write you this letter. It shows a Girl leaving the water clad in her underwear, bra and pants. This would doubtless be classified as "unconventional" bathing attire by most people. This picture suggests that she might have been wearing more clothes when she first entered the water, and after a short swim, stripped down to her underwear.

The urge to enter the water clothed is stronger in many individuals than the desire to bathe nude — (This, despite the fact that it is seldom that one sees anyone taking the plunge in street clothes). This is, I suppose, because most people would, because of "convention", consider it improper, — even indecent, to bathe or swim in other than garments labeled for that purpose. Such is the narrow thinking of the masses. Actually, the proper garb to wear is the one that will provide the most satisfaction and self-ex-

pression at the moment. Many persons (more than is suspected) avail themselves of this privilege when they feel quite sure they will not be observed by others. Some disport themselves thus on lonely stretches of ocean, beach or lakeshore. Others, under cover of the Summer evening darkness, defy convention in more public places. It is quite common at evening poolside parties at private estates, to have one or more guests liven up the affair by ending up in the water dressed in the evening formals, be it gown or "Tux." Almost invariably, it produces a chain reaction, and before long, others have joined the "pioneer" and the fun is on!

Some like to enter the water completely dressed — shoes and all. If it is a male, and he happens to be driving in the country and spots a lake, he is liable to park his car and head for the water without removing a thing—thereby satisfying the urge to transfer himself from one element to another without a change of apparel. Once in the water he will enjoy the sensation for awhile, then doubtless remove his shoes, as they become filled with sand quite readily. He might next remove his coat and tie for more freedom, and then spend as much as an hour in the water, wearing trousers, shirt, underwear and hose. If the water is cold, he will find that his clothes will tend to keep him warmer than if he were wearing bathing trunks. From time to time he may run from the water, and fling himself on the warm sand, and even roll over — allowing his clothes to become covered with sand. Then he will return to the water and after a quick dive, the garments are as clean as before. This is done frequently by bathers in conventional swimming attire, but the wearer seems to extract more satisfaction from this effect if he is in street wear. He may or may not remove all his clothes before leaving the water for the last time. Once ashore he will either change to dry garments, or wait for the sun to dry his "swim clothes."

In the case of a female, she is even more prone to satisfy this desire to swim fully clothed. If she is an office girl, and it is the Spring season, she is liable to take the afternoon off, and head for that remote lake; taking along two or three girls who never swam clothed before, but think it might be fun. Arriving at the lake, they will all pile out of the car, and prepare for the Plunge. If our Girl is wearing a business suit, she will doubtless remove the jacket; leaving on her blouse and sheath skirt, along with whatever she is wearing underneath. Dressed thus, she may announce she is ready, and, while

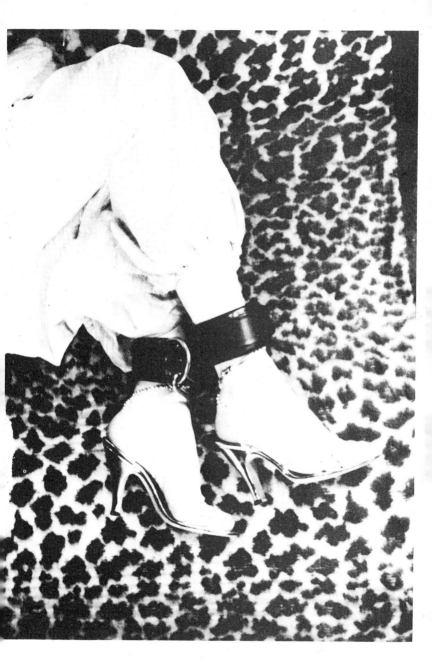

EASTERN HUMILITY

55

the others wait for the first "lesson", mince her way to the waters edge. As she feels the water closing over her high-heeled pumps she braces herself as best she can in her tight skirt, as she knows from past experience that the spike heels will at once sink into the sandy bottom, and since she is on "parade" this particular time she does not want to fall in the shallow water. If she has good balance, she can tiptoe her way to deeper water, and from then on she is no longer afraid to fall, as the water lends support. The girls will gather at the edge and watch, perhaps even cheer, as the water closes over her narrow skirt hem, then rises to her waist — playfully caresses her satin blouse, and finally reaches her armpits. From then on, her progress will depend upon several things. If she is wearing a Bathing Cap, she will doubtless dive under, and come up completely wet. If she does not have a cap on, she will perhaps swim around awhile with her head held high to keep her hair dry, and the water out of her eyes, as she watches her "students" follow her in.

This description is but one of many variations of the "impulse swim." Persons have been known to even wear topcoats into the water, over a complete street wardrobe. It is not uncommon for a female to leave her lakeside cottage in the cool of the evening and plunge in clad in her nightgown. This impulse also prompts others to bathe, smiliarly clad in their private pool, both at night and in the day.

One could go on and on, enumerating the many variations of the clothed swim, and the circumstances under which it is indulged in, but the fact remains, that few people, even among those who practice this mode of "getting wet", begin to suspect just how widespread are the followers of this means of expression. Perhaps this letter will serve to stimulate others to write in on this interesting subject.

"ROBERT"

ANYONE FOR POKER

Editor of Bizarre:

My husband said I was getting "too bossy." Maybe he was right. Lots of women try to take advantage of a man's good nature; but my boy — whe-e-e-eu, he had a cure for it!

One evening he wanted to have some of his friends in for a poker game. I wanted him to take me to a show. A knock-down, drag-out argument ensued and in no time I found myself on the losing end of it. A fellow can be "pushed just so far," he said. I know that now.

He pretended to give in and told me to go and get dressed to

go out. When I was next to naked — I had on only my corselette and stockings, in fact — he came into the bedroom and started to make love to me playfully. Before I realized what he was up to, he had me face downward on the bed, my wrists crossed behind my back. Using a silk scarf, he bound them — oh, so tightly; then my arms above the elbows, and my ankles and legs above the knees. This left me helpless, but not helpless enough to suit him. I could have murdered him!

After he had sealed my mouth with adhesive tape, my husband carried me to a clothes closet and deposited me face downward again on the bare floor. He passed a strap through the bonds on my wrists and ankles, pulled them as closely together as possible, buckled the strap, and threw a heavy wool blanket over me. Still without uttering a word, he closed and locked the closet door . . .

And that's where I was, and that's the condition I was in, while a liesurely poker game was in progress in our apartment.

Was I helpless? Was I hot and otherwise uncomfortable? Was I chagrined? Did I feel, was I, completely subdued during that long period of solitary confinement and afterwards? Yes, believe me! It must have been two and a half or three hours until my husband came

and released me — and added a vigorous hairbrush spanking to the lesson that I will never, never forget.

When he wants to have some of the men in for poker now he hears no objection from me. As for me, I wait patiently to be invited to take in a movie. I haven't demanded anything since this incident occured; but do you know something — I may sometime soon just to see what will happen?

M. O'B(edient)

CUPID'S DARLINGS

Dear Editor:

I was a spoiled brat who enjoyed it and had the looks to become a "spoiled-woman." I inherited a small fortune, married a much older man when I was twenty, and he conveniently left me a large fortune before I was twenty-seven. So, having always enjoyed "bizarre" things, I fell into a way of life that coincided with many of your slaverettes long before I heard of your magazine. I don't have to bow to anyone, and I have them not only bow, but kneel to me.

I am twenty-nine, a dashing (they tell me) brunette with blue eyes, five-four in my size five ballerinas, and one-hundred-twelve, with the curves all smooth and proper. I know I have sex-appeal because I get a fine response from both sexes when travelling with no visible luxuries other than my

God-given, beauty-parlor enhanced ones.

I spank my present twenty-two year old husband whenever I choose, and I make him wait on me hand-and-foot at home or in private. He dresses as I tell him, and he looks fine in ballet slippers, pink leotards, with ear-rings and lipstick and eye-shadow. He was a chorus boy before I met him at a party — and now he is my private "chorus-boy." I like to tie his hands behind his back, blindfold him and make him dance to the tune of my riding crop. When he objects at all to any of my orders I often make him lie down and kiss the soles of my feet while I really whip him but good. Once I made him dress me completely to go out and then tied him securely to the toilet where I left him over-night. On my return he was indignant and demanded to know where I had been. I slapped him viciously until he begged me to stop, after which I let him kiss my feet and both hands and then stuffed his mouth with cotton, taped it in, and there he sat all day.

When I released him that evening, I kissed his face (which was slightly bruised) and had him join me in the oversized shower where I let him bathe me completely. He has never crossed me since, nor have I ever left him so long, at least not without staying near.

His step-sister from New York came to visit us last Spring, and she turned out to be a big, gorgeous blonde, with creamy complexion and a lot of spirit. I learned that she got a kick out of the unusual and that she had always felt that her brother had received all the favors at home. She enjoyed herself thoroughly when I made "Jackie" wait on her too — and when I asked her to come in and whip him in my place after a complaint from him — did she love it. She got in the spirit of the thing at my suggestion and he was made to crawl to her, beg her forgiveness for ever having been the favored child — well, she got a pedicure out of it and his hind end got another touch of my riding crop in very spirited hands. After that, to prove I was boss I had him licking my feet until she went to her own room. Jackie was burned — so what? — I love him, he worships me . . . Nothing wrong with that.

I hope Juanita (of the "horse-player") reads this. It can be fun, honey, and that's a lot of life. He loves it too. It isn't my money because I never let him have more than enough to cover the evening (if I go out with him).

Viola

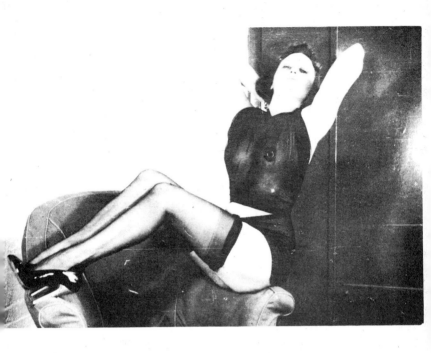

FIVE INCH STANDARD

Dear Sir:

About a week ago I mentioned in a letter that some time in the future I would write again and give you some of my experiences with (and on) high heeled shoes. Perhaps you may think of me as being too forward, by writing without first getting the "go ahead" sign from you. But I do hope you will not think of it in that way — because it is indeed a pleasure to at long last, be able to share my experiences with someone else. Hence — I could wait no longer to put it on paper! I assure you that every word of it is true, including the statement of my ability to walk on 5½ inch super spikes for hours at a time, with no ill effects! But how I will make out on a pair of 7 inch heels is a matter that only patience and plenty of experience will solve. Sometimes I wonder if some of the readers of "Bizarre" are fully aware of the correct method to determine exactly how high a heel actually is. For instance, one feminine reader stated in Issue #7, that she had a pair of boots made which carried a 6½ inch spike heel. While I have no reason to doubt her letter, nevertheless I would say that her foot really must require an extraordinary large size shoe (for a woman) — inasmuch

as it does not seem hardly possible to carry such a towering heel on a shoe much smaller than a size 9, at the least. Perhaps this reader (and possibly others) do not understand about heel height. To determine how high a spike heel really is, it must be measured at its *inside* height - or at the part nearest to the front of the shoe. For instance — my custom made pumps have heels which are 6¼ inchs at the *back* of the heel. I do not claim however to be wearing 6¼ inch heels - as my lovely spikes are only 5½ inchs tall at their *inside* extremity. Citing another instance — this time of a woman friend. She has a very small foot which a size 4B shoe fits to perfection (size 3½ if open toed or sling back styles). Recently I ordered her a pair of red leather closed toe mule pumps in size 4 and specified the highest, slimmest spikes which were possible to be carried on a shoe of that size. As soon as they came and I had duly presented them to her, she grabs a ruler to measure the heels and gleefully announced that hence forth she would gayly trip along side me on 5¼ inch spikes; and best of all, that her lovely heels were a full inch higher than those of any other woman in town! No amount of persuasion on my part could even begin to shake her faith in the fact that from now on,

she would be perched on 5¼ inch stilt heels, while in reality, her lovely spikes are 4½ inches high and no higher. But after all — a 4½ inch high heel attached to a tiny size 4B mule pump is something not seen every day! Which all goes to make me wonder how many other high heel devotees are fooling themselves when it comes to actual heel height? It would be interesting to know how many women there are who believe they have accomplished the next to impossible feat of walking gracefully on 6 inch heels, but are actually on heels from ¾ inch to a full inch lower! Wish someone would enlighten them. Mainly because of the fact that if a woman is determined to wear 6 inch spikes, she will — come what may. So it probably wouldn't be too long until we would be feasting our eyes on countless brand new pairs of high heeled shoes, each and every pair towering on a set of lovely pencil thin stilt heels which were at last, an undeniable 6 inches in height! Wish you would mention this heel measurement problem sometime in your editorial page or elsewhere, and see what sort of comments it would provoke. While I fully realize that my letter or story(whichever is proper) is probably much too long to ever appear on the pages of your grand magazine, nevertheless I do

RUBBER DANCER

Dear Mr. Willie:

It was simply tutti-fruitti to see my letter Printed in your #12 issue — thanks, dear Editor! May I also thank Crazy Over Rubber for his prize award to me in that lush #15/16 Bizarre, while whispering to him my secret for enjoying rubbers in the office at all seasons of the year? (Whissssper: Air-conditioning!)

Of course the weather dictates my indulgence in wearing rubbers between home and office, but at the least threat of a shower my jaunty rubber footwear is sure to bright-

hope that at some future date you will find it possible to at least publish certain parts of it which you may be inclined to believe would be interesting to your readers, and which might induce them to write in and also tell of their experiences. Thanks again for giving us such a wonderful magazine as only "Bizarre" is — and keep up the good work. Let's hope some day soon, that not a single solitary pair of feminine footwear of size 5 or larger will leave the factories with heels of less than 5 inches in height!

Yours for lovelier, thinner, and still higher spikes!

C.H

en the sidewalks and subway, to the apparent delight of many who openly stare at them.

After being employed by my wonderful Boss with the provision that I wear my rubbers during office hours whenever he asked, I was so thrilled that I didn't always await his request, but pranced about in my high-heeled rubbers or zippered gaiters whenever I fancied, which was often.

Eventually this distracted us from our work-efficiency and led us to agree on a plan which would allow of our mutual enjoyment of the bizarre, while keeping abreast of business in the smallish branch office where I was the only secretary.

So, with letters dictated, typed and mailed and with no out-of-office visits calendared for ensuing time, my dear Boss might say, with a suggestive leer at my trim pumps, "Ruth, your high heels make such a clickety-clack they'll give me a headache — couldn't you try wearing rubber heels on them?"

"To please you I'll try wearing them right now," I'd respond with tingling thrills of anticipation, clicketing to the main office door with the Out Until — O'clock sign, and hastening back to the Inner Sanctum where the venetian blinds were being adjusted for privacy.

There, one file drawer was filled with a seductive selection of rubbers, gaiters and boots, tissue-wrapped to keep them supple and gleaming. I teased my intently watching Boss for a delicious interval while I made my choice of a pair from our exciting collection. Perhaps I chose the ankle-height Oxford cuts, the appeal of their sweeping high fronts and curving spike heels heightened by the smoothness of their glistening black rubber surfaces.

I became the Dominant Damsel at this juncture, seating myself atop his desk with my shoes in his lap, or on the office sofa where he knelt before me in humble admiration while I brusquely commanded him, "Now put my rubbers on!"

The snappy rustles and squeaks of those alluring rubbers being stretched over my dainty slippers thrilled us with their soft hushing. If he dallied over his fascinating fitting I warned him that he'd feel the weight of my displeasure and my rubbers together. Sweet dalliance being his choice in daring defiance of my orders, I waited grimly until my feet were rubber-shod to my satisfaction and, sternly exulting, meted out the punishment that he had been promised.

(To Be Continued)

for *slaves* of fashion

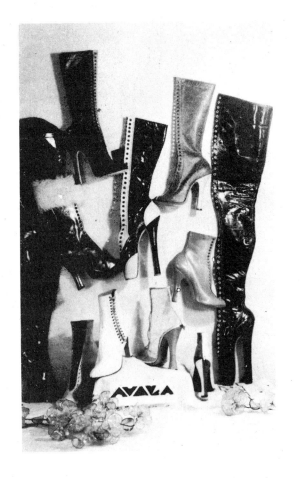

theatrical footwear

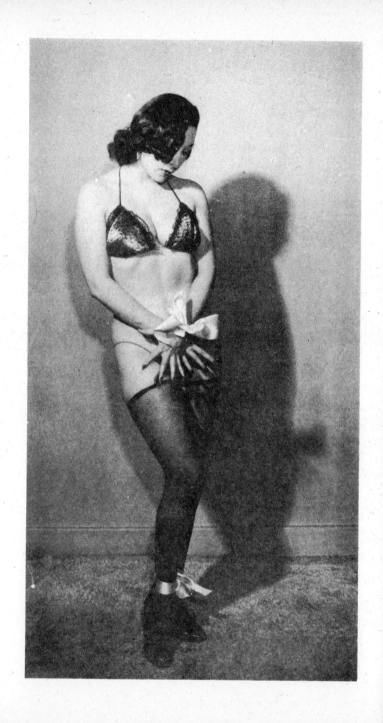

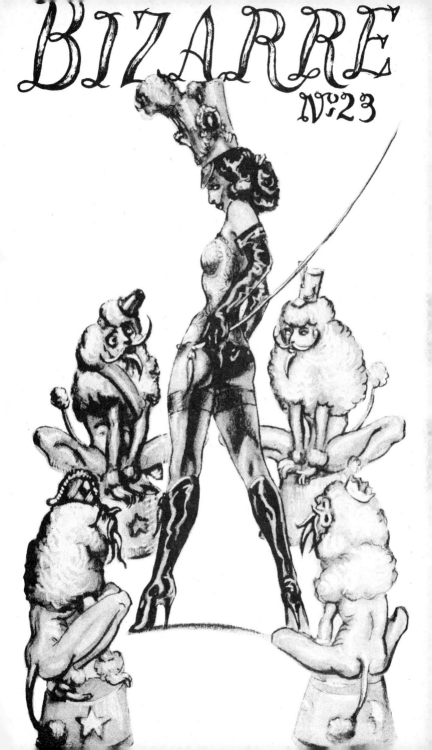

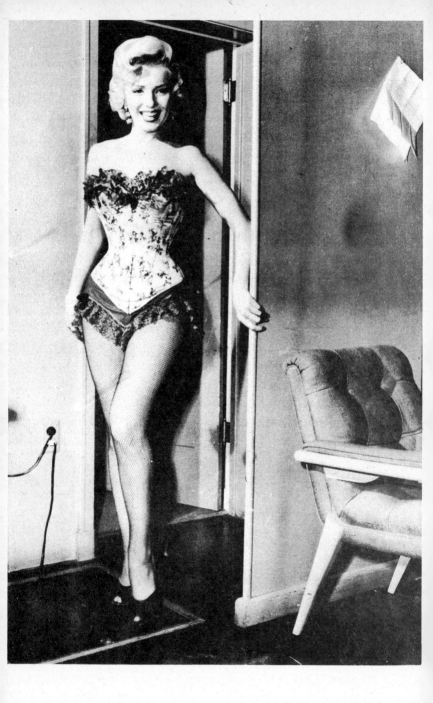

WELCOME HOME

BIZARRE

"a fashion fantasia"

No. 23

"How sweet is mortal Sovranty!" — think some
Other — "How blest the Paradise to come!"
Ah, take the Cash in hand and waive the Rest;
Oh, the brave Music of a DISTANT *Drum!*

OMAR KHAYYAM

Contents

NEXT ISSUES No. 24, 25

Our readers have been let down so often by this and that, that we can state only that No. 24 will appear as soon as possible. When No. 25 is "on hand" we will sound the trumpets.

In No. 24 will be a diary recollection by Paula Sanchez (we are awaiting its sequel, Paula), a short on wife silencers, some movie scenes, and whatever we can allow to burst forth.

BACK NUMBERS

By all means, patronize your local dealer. If he can't supply you write directly to:— P.O. Box 511, Montreal 3, Canada.

Printed and Published by Bizarre Publishing Co., P.O. Box 511, Montreal 3, Canada.
Copyright 1958. All rights reserved.

FROM A GERMAN READER

WHO'D BE AN EDITOR !

SLINGS AND ARROWS

This is a "Reader's Issue"—

Even the editorial was written by proxy — and it mirrors our reflections of this season.

In the composition, we aimed to fill direct requests and still be representative of all. 'Twasn't easy, but we think we've hit a fair target.

With this bow, we don't expect applause, but only the over-ripe apple of screaming Charlie letters, "What happened to OUR group? You COMPLETELY forgot OUR group."

Alright, Charlie — we'll get your group next time, honest canuck injun. In the meantime, we appreciate the grouching reminder; it keeps us tempered and honed.

One other thing, Charlie — *our mailbag is never ignored* — The letters are interesting and we read them all with more than a bleary editorial eye, but we can answer only a small fraction of them. If we don't use that new idea of yours, kiddo, it's either a duplication, dubious, or it's TOO good. You know what we mean, Charlie . . . You know . . . Where did you dig up that stuff anyway? You haven't led that many lives. And those people you know!! Wow-Whee!!

Keep'm coming down the middle, Charlie, — Yours is a good group.

Sincerely,

ED — Montreal

5

PROXY EDITOR!

TO YE EDITOR,

Bizarre is, and has been, a great little magazine for those of us who appreciate the unusual. It should be kept that way. The ordinary run of the mill "girlie" shots, in Bikini, show costume, or other "exotic" attire are a dime a dozen in any of the dozens of girlie mags on any newsstand. The shots with no attire at all are easy to come by in the various "art" studies obtainable from several sources.

Bizarre should be, as its name implies, bizarre — unusual — different. In it, the discipline fan should be able to find intelligent discussion on his favorite topic, usually supplied by other readers of the same ilk. Tasteful photographs or drawings should be supplied by the magazine and readers. The bondage addict should be entitled to read of, and see, *his* favorite pastime, and those who prefer certain modes of fashion, whether it be hi-heels, corsets, rubber, leather, boots, satin, burlap or horse blankets should be able to find it in Bizarre.

This means that the magazine is non-existant without the aid of the readers, for without material to publish, it is folly to expect the editor to be favorable to *all* the various desires, fantasies and practices. The readers therefore have a duty to perform by writing of their favorite items, intelligently and interestingly, enclosing photos and sketches if possible. The editor has a terrific load to carry, *(Terrific - ED)* as he must act as judge and jury to make each issue interesting enough to *all* fancies, and to supply illustrations for stories that seem to warrant them. If the editor pleases the majority, then the magazine will survive. He

6

cannot possibly please all in any one issue. No doubt there are many more hi-heel and corset fans than there are rubber and bondage fans and the majority should rule. Nevertheless, if the mag is always full of hi-heels and corsets, the burlap fan will quit buying it, and unless the horse-blanket fan sees something on his subject once in a while, then he too is gone. People who have some unusual (by modern society's standards) quirk in their make-up which impels them to do certain things or wear certain clothing, feel alone and frustrated until they know that they are not the only ones with that "unusual" compunction. Thus Bizarre renders a great service to people like this.

For good reasons, known to intelligent people, the editor cannot put readers in contact with each other. What he can do, is to label each picture accordingly, instead of just letting the reader guess. Instead of a full page shot of a girl with blue hair brandishing a snow shovel (assuming here that there are snow-shovel fans in the crowd) and not a word of explanation anywhere, he might add a caption stating. "photo from B. Z., Chicago." By putting a geographical tag on the thing, he does two things. He lets the reader know that the shot is genuine and not some phony thing dreamed up in the editorial office, and he lets John Smith, who also lives in Chicago, know that he is not the *only* snow-shovel addict in town. Naturally, many readers will send in shots with the request that their anonymity be respected. In this case, a simple caption of "green horse-hair girdle— photo by a reader" will suffice. In short, unless proper captions go with the pictures, many readers naturally assume that the shot was professionally posed. When the illustration has a caption that it came from a reader, other readers will know that they are *not* alone or that the only reason their particular "hobby" is given any space at all is for some magazine to make a quick buck on. Bizarre is the magazine *by* and *for* the readers. They make it what it is and it becomes enjoyable to most of us after the editor intelligently puts it together to satisfy *all* tastes. Nuff said?

Sincerely,
D. B.
Stamford, Conn.

7

OUR GUEST ARTIST: MAHLON BLAINE

Born in the jump-off point of Albany, Oregon at the turn of the century, Mahlon Blaine has been a perpetual travelling man, a painting Baedeker.

By the time he was ten, he had lived in most of the west coast states and provinces. By his fortieth birthday, he had had passports to sixty-eight countries, ranging from Australia east to India.

In general, the mode of his existence has been to zealously visit each far away place, frantically sketching landscapes, street-scenes and the life-style of the country. Having captured it on canvas he was ever determined to return and settle there, but the pull of the exotic was too strong and too constant.

Artistically, Blaine teethed on Manet and developed on the Bronzino originals in Florence at the age of fourteen. He later found his style in a combination of Hokusai and the classical greek ballet. He has illustrated over eighty major books, winning the Grolier award for his artwork in Beckford's VATHEK.

His commissions have been as varied as his travels, among them being: — camouflage consultant in the Canadian Army, set-designer in Hollywood and muralist in New York and Paris.

At present he is doing free-lance artwork and restoration of Chinese silk painting in New York City.

And Mahlon's still searching for that one place to settle and take root.

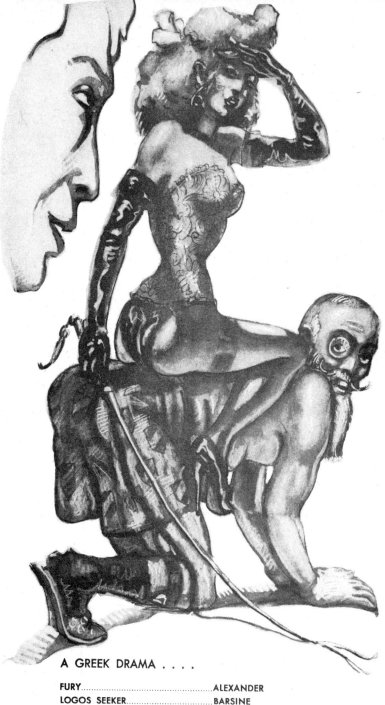

A GREEK DRAMA

FURY...ALEXANDER
LOGOS SEEKER....................................BARSINE
BUCEPHALUS......................................ARISTOTLE

POET'S

CORNER

(The many bards amongst us haven't been given enough expresssion through these pages . . . Poetry plays the music of feeling while prose dances to its melody.)

THOUGHTS AFTER SEEING BIZARRE'S CATALOGUE

Goody! A goodie for us who like kicks

. . . offbeat amusement . . . odd little tricks

that break the monotony, add fresh new fun

to human relations . . . *cute* things to be done!

To each her own taste . . . to heck with your chains,

your rubber, your whips, your leather, your pains!

I love the sweetness, gentleness, grace,

the self-proving beauty of nylon and lace

. . . definition of form, the shape of romance

which girl or man feels at a touch, or a glance.

Man looks at woman and thrills at her waist,

legs, hips and breasts . . . well, *I've* the same taste!

I love beauty, too, and thrill to my heels

at another cute trick . . . I know how she feels

. . . and wonder if *my* form . . . hair, smile and grooming

sends her pulses pounding, skip-beating and zooming?

If she's not too square we both can just tell
By our smiles.
 Then we meet.
 Then we .. well, we just .. well ..
Men I *adore!* They're *so* good at looking
and showing they know just what dish I'm cooking
... what I mean by the show of a knee or a slip
... a half-buttoned blouse ... a tongue-moistened lip.
When a guy looks you over, and likes you, you *know* it!
Because, the dear darling, he can't help but show it.
Each to her taste ... those girls *you* show fighting
I do not find very thrilling, exciting
(unless I imagine they're good friends and getting
over-ambitious in necking and petting.)
I love the thought ... and what is the harm ...
of nymphes each in love with the other one's charm.
Men I take straight (*hate* masculine *she's!*)
Still, a man's more fun when he likes me, and frees
his dull inhibitions, and flatters me ... ooooooo!
Says, "Were I a girl, *I'd* look like *you!*"
(which, of course, is my cue. I smile and say, "I
would adore you as me. C'mon baby, try!)
Then in minutes I've got him in skirt and sheer hose,
his petticoats blooming like some precious rose,
hair falling to shoulders, breasts jutting like mine,
lips red-appetizing, bracelets, earrings ... divine!
And oh when he slips into high graceful heels
His walk! ... I can see! ... I feel as *he* feels!
What do we do? Just ... girlfriends at home!
as though he'd been born a girl from the womb ...
YOU know ... trying on all sorts of cute clothes ...
how *I* look in these ... how *he* looks in those.
Nothing naughty, or sexy ... (unless just a dance
or a kiss with each other is "harmless" romance!)
MY tastes! ... and it seems that I'm not the only
girl in the world who sometimes feels lonely
because some cute trick whom I love *so* much
does not return her touch for my touch

(*Continued on page* 14)

11

TOO MUCH

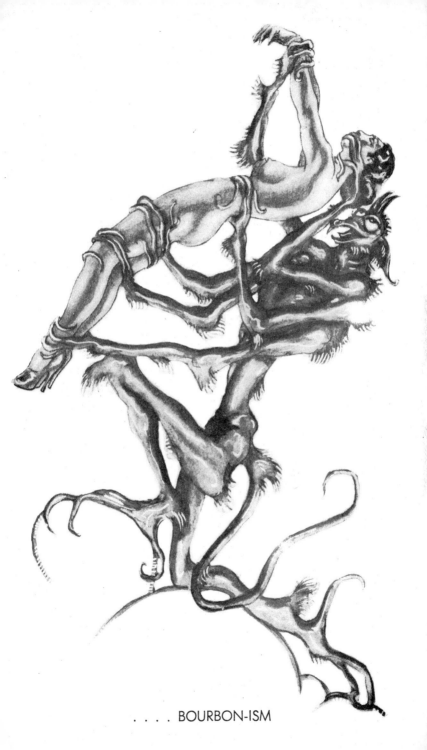

. . . . BOURBON-ISM

... who feels lost and hurt, too terribly shy
with some friendly fellow, some really gone guy
whom I'd *love* to be friends with ... if only he guessed
how easy I'd feel if he only dressed
in a way to relax me, make me feel at ease ...
cozy! ... seductively gowned just to please.
So here is my kick, the thing *I* adore
the thing I want more of and more of and more
... *feminine* gals who *like* feminine gals
and guys who adore being feminine pals.

MISS N. Y.

A Bouquet For A Secretary

Here's gifts and greetings for a helper fair!
Two strips of satin (starched) for plaiting in her hair
And a delicate bow to tie on the top.
Then, something for when she's caught listening to bop —
A single glove, glacé kid, to lace tightly behind,
Will do wonders to brace back her shoulders, you'll find,
And chuck out that chest (oh the best!) soft-sweatered and young:
A good-looking steno can type with her tongue.
Opera-hose — a ring for her nose — an ankle-cuff
Or two (with chain) for restive feet. A bit is enough
For sulking at work: martingaled to her waist
With a nice deep notched bar going back for taste.
Yes, a bit for her lips, pulled so hard back and down
M'lady will scarcely be able to frown!
Mascara galore, a rubber cape, and — thee!
Six-inch heels (12-inch weals?) and a corset you'll agree,
Not of kid but of leather boned, rigid as steel,
The sort that a latecomer to office can be made to feel,
Laced till Miss Lazy has not a breath left,
Then take in the laces still tighter, be deft,
Stretch her high to a corset-bar, pull hard, and hope!
(A dig in the midriff beforehand will help;

with this bit on her tongue she'll dribble, not yelp!)
Then invite her to sit down and type up a letter;
The front of the thing cuts her thighs and she'd better.
(Does she lollop her legs later and feign to be cool?
Remind her of a "seat" over the window-stool
Where once before she "warmed" deuced quick
E'en tho' the process meant swallowing a lick
Or so — the stick was hickory and, I guess,
Occasioned our taut-trousered heroine no small distress!)
A backboard? Boots? The "pear of agony"? No, wait.
Here's a gift to make even *her* sit up straight.
A saddle-strap, studded (inside, may I add),
Will soon deter your Miss Mischievous from being bad.
Another mistake? What, more dictation wrong?
Come here and I'll tighten by one notch that thong!
One hour for coffee break? Two holes are enough,
I'm sure you'll see, to make her puff!
Yet, still she reads the movie magazines in stacks?
Right. At her heels, set rowel spurs ,filed sharp as tacks,
And if she's still rambunctious, full of guile,
Let her kneel back on these rowels for a little while
(A lead from waist to ankle-chain's all that required
To make miss of her rambunctiousness quite tired!)
Finally — smoking you find her and IN YOUR CHAIR!
Thus, for her "lower back" of You-know-where
A switch of cutting whalebone, eel-smooth, needle-thin,
Toe-touching's an exercize so beneficial to begin
A stenographer's day with, even in a tight skirt:
Just quick black whalebone, Fffst!, and "Ouch, that hurt!"
Phhisp! Phhisp! Phhisp)! "For Pete's sake Uncle JW, Waow!
My b.t.m. is going to look like Todd-AO!"
(P.S. No hard feelings, Maggi — *straighten your knees!*
Except where it hurts most — *right over, please!*)
 WM. T.

Fugue for a Quiet Afternoon

Reader N. B. sends these photos of his mate in their domicile. He suggests, "A bondage contest where readers could take pictures of tie-ups and send them to BIZARRE. Sounds like fun, and I'll bet you would get a lot of good photos."

Takers welcome — ED.

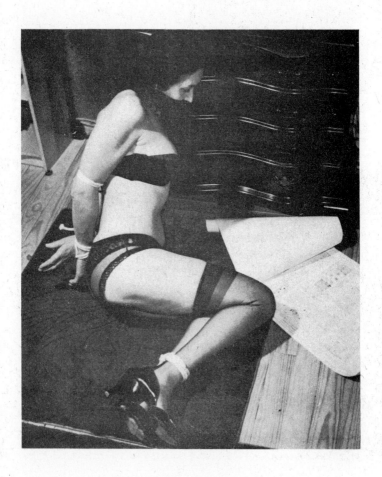

EXPOSITION

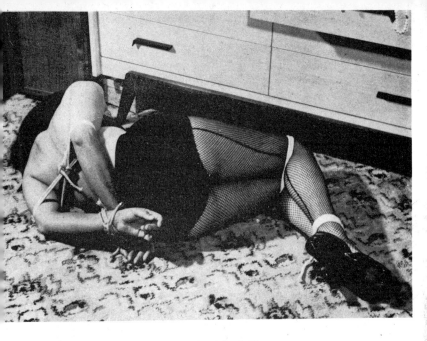

DEVELOPMENT

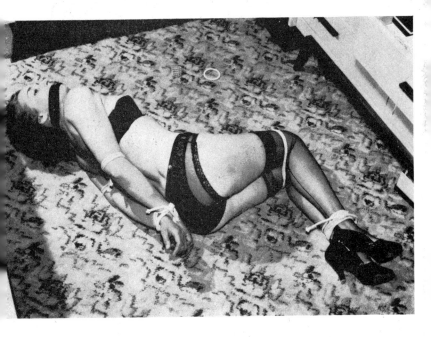

CONCLUSION

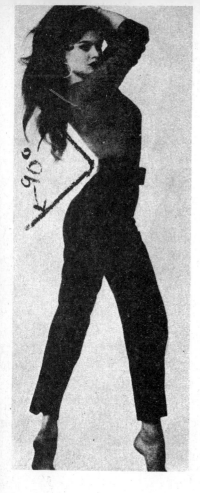

90°

Look carefully at this picture . . . She is bizarre from head to toe! Long, long tumbling hair; large earring; cool, detached face; small, waspish waist (probably due to some kind of figure training); a beautiful connection between legs and hips; long straight legs ending in beautifully high-arched feet. AND most unusual of all . . . the extreme, rakish angle of her arched back. As sharp and severe as the J.W. drawing in No. 5, page 30. In fact, the resemblence between Miss Bardot and the girl of the drawing is to me astonishing!!

R.L.

This is not a reproduction of an old instrument of torture from the Inquisition—it is merely what a "Modern Miss" will look like if she takes up figure training "a la 1880", according to the old steel engraving picture sent to us

(From No. 5)

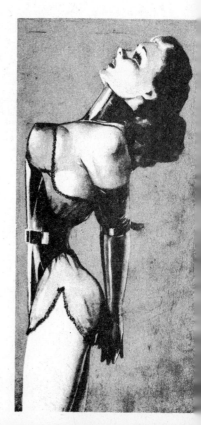

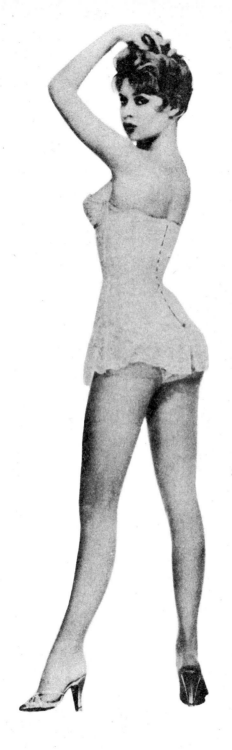

BÉ BÉ

THE
FAMILY DOCTOR
AND PEOPLE'S MEDICAL ADVISER.

No. 154. SATURDAY, FEBRUARY 11, 1888. PRICE ONE PENNY

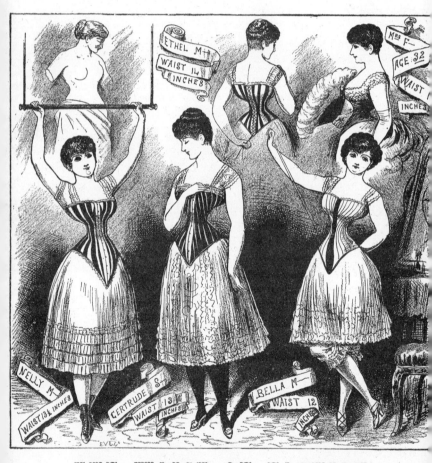

THE WAIST OF FASHION.

(For Description see next page.)

(*From "The Family Doctor"*)

THE WAIST OF FASHION

Our readers will find on our front page illustrations reproduced from photos taken by a lady amateur of her sisters, and a young lady friend, who follow the pernicious practice to tight-lacing to an almost incredible extent.

It is by the kindness of our contributor, "Hygiea," that we are enabled to reproduce these photos for the benefit of the fair sex among our numerous readers. The following letter accompanied the photos, which were sent to our contributor, and which we have permission to publish:—

Dear Maggie,—I have actually succeeded in getting what you wanted. I send you photos of Nell, Bella, Gerty S—, and myself. Mabel is getting on with her photography, but, of course, they are not so good as they might be. We could none of us take her, for which I am sorry, as her waist is quite as small as Bella's.

It is all nonsense about there being no 12-inch waists, I know several girls who are quite as small as that. But I don't think many of them would like to venture far with a waist of that size, as there is always a risk of a faint. I think I can hear you utter a word of triumph at this confession, but you will never convert me to your way of thinking. I think your trouser dress is just horrid. And I wouldn't give up tight-lacing for all you alarmists say for the world.

When a girl has laced from thirteen you "Dress Reformers" have little enough chance of conversions.

Nelly has had a wooden bar made. I suppose it is somthing like the one Oscar Wilde describes in "The Woman's World." By holding this above our heads we find we can be drawn in more easily.

If you send the photos to the paper cut off the heads except mine, which, being a back view, I don't mind being seen. Of course we would rather you did not send the photos themselves, as Nell says she would, if she had known it, put at least a petticoat on, like the rest.

You asked me for some particulars as to size of our busts, etc. I give them you when laced up:—

Nelly	waist 13½,	bust 37
Bella	waist 12,	bust 38
Myself, Ethel	waist 14,	bust 36
Gerty S—	waist 13,	bust 38

You know we have been tight-laced from girlhood. Gerty wishes me to ask you not to send the photo unless you alter or smudge over her face.

Yours faithfully,

ETHEL M.

January 16, 1888.

SKIRTS ARE GETTING SHORTER

(And for good reason ... See page 47)

Correspondence

Under no circumstances do we publish names and addresses, nor do we put readers in touch with each other. If photos or sketches are sent in, please write a short commentary and please do NOT send in photos which you got from someone else.

LET'S HEAR FROM

READER	ISSUE #	PAGE
Figure 8 Club	15/16	116
Five Toes	19	26
Betty	21	61

(*See Steady Reader Letter, page 46*)

CHINESE DEFEAT

Thank you Bizarre—

I am personally pleased with your confidential handling of your reader's letters. If Bizarre's contributors constitute a select set, we are honored to indulge ourselves in cooperative discussions of ways and means in zestful living. We refer of course to our intense enthusiasm for the trussed body, both viewed and endured, and the inner fires that feed and grow on endless varieties of restraint techniques. As a bachelor girl rooming in the home of a married couple. I can testify to the overpowering thrills resulting from the immobilized female body, from the viewpoint of both "victor and vanquished."

The total turnabout of Jerri's personality after her marriage was so incredible to me that I wondered whether she had become a psycho. When we roomed together at college, I was the plunging neckline type, and Jerri was so modest she kept her delicious little figure completely wrapped, even in the privacy of our own rooms. I thought I was dreaming when she first told me with fiery eyes of how her husband tied and teased her, and how she grew to *want* to be bound, because it boosted Lew's

24

ego and made her feel enslaved to his demand. Some months later, after I moved in with them, I discovered what she meant when she said, "You can give so much more, and you can *be* so much more, when you are utterly helpless in the presence of the person who applied the bonds." I accepted their invitation to try tight lacing as a starter, but got a much bigger starter than I had expected. After the first few minutes of constriction about my waist, I found I could breathe with extra chest expansion and actually felt exhilarated. I was pleased too with the extra roundness of my hips and the new fullness of my bosom.

Next thing I knew Jerri had tied my wrists behind me with a length of rawhide, and they asked me if I felt any different. When I said I couldn't tell, they decided to go all the way. Both Lew and Jerri worked fast, escorting me to the bed, doubling my legs under me and strapping each ankle securely to the thigh. Now I began to feel cramped and helpless, and tears oozed from my eyes. "She'll come out of it," Lew said and hitched a belt to a loop on front of my corset, passed it under me and drew it up tight thru a loop at the back. "Your security" stated Jerri with a deadpan. I felt exactly what she meant.

My first moment of stimulation in bondage came when Lew said "Strap her thighs." Two harness belts were drawn around my bound legs and my thighs were buckled securely together. There was something very special about hearing that order given, and then having it executed.

Lew looked exceptionally manly. Jerri asked me how it felt to stir up a storm in which I couldn't possibly participate. I confess an intense sensation of both victory and defeat, knowing that I was the motivation for the rising tide in my friends, and ecstatically defeated by thighs crushed in unrelenting straps and hands rawhided behind me. Only Lew and Jerri could tell you of the ensuing half hour (I was tied up!), but Lew had Jerri's permission to return alone and unstrap my imprisoned body. It took some time for my legs to regain their circulation, but it was scarcely an inconvenience. Lew was real happy when I told him he could strap me again.

I realize that my situation maybe rather unique, but we would like to read the adventures of other couples who concentrate on severe bondage as a trigger of the blue flame.

Strap-lovin' C.L.M.

25

STILL HUNTING

Being twenty nine years of age and single I have wondered how wonderful it might be to have one's wife or girl friend dress one up delightful brasierres and panties, gorgeous lace edged slips, a panty girdle and nylons with pretty garters also high heels with a party frock.

I have hunted and hunted for the girl of my dreams who would do such as that but lo and behold my dreams have never been answered.

I wonder how many men are in the same situation as I and I wonder how many femmes desire to have their fellow dress such as they do.

Understand the very very unlikelihood of ever being able to communicate with such of the opposite sex I wonder if you would be able to print this in a coming issue. Perhaps there are women who would like to express their feelings more certainly than have been published before.

DREAMY

Dreamy,
Show "Poets Corner" (p. 10) to the g. f.
The lass who composed this is keen but not unique.

ED.

ORIENTAL SLAVERETTE

Gentlemen:

While in the Armed Forces in Japan, I visited a night club on the Ginza in Tokyo one evening. As all Japanese night clubs are full of attractive hostesses who are most eager to please, I was surrounded by a bevy of beauties the moment I entered. However, I noticed a particularly beautiful girl sitting aloofly in a corner, paying no attention to those around her. My curiosity was aroused and I approached her for a closer look.

She was even more beautiful at close range and her attire was extraordinarily beautiful and simple; she wore a form-caressing black satin gown, black silk hose, and 5 inch heels.

I sat down and offered to buy her a drink to which she agreed in a condescending manner. After a while, I suggested that I would like to see her outside of the club. She consented but only on condition that I promise to obey her implicitly. I immediately accepted and we started for her home.

When we arrived, she made hot saki and proposed that I drink it while relaxed on the futon — a quilted mattress on the floor. She sat above me on a chair and exposed the full sheer beauty of her long legs to my gaze. I could not

keep my eyes off of her glistening heels. Noticing this, she placed one heel on my hand — which was on the floor — and pivoted her foot this way and that. She then asked me how I would like to feel her heels all over me; before I could answer, she jumped on my chest and began performing a sensuous dance while simultaneously grinding her heels into my chest and even my face. I need not express the emotions which were overwhelming me at that moment although I later found out that she enjoyed this experience even more than I did.

This, however, was only the beginning of many interesting experiences with this beautiful Oriental Slaverette. If you feel that these will be of interest, I shall write again.

AJA

* * *

HYDROPHILOSOPHER

Dear Editor,

To me, as to many other persons, there is nothing more exciting than to see a beautiful girl plunge fully dressed into water and to emerge dripping wet with her clothing moulded in liquid beauty to her body and her hose and shoes gleaming with water.

From long study of the subject of dunking, I would like to make some comments for other people who are interested in "hydrophilia." The term "hydrophilia" (Gr. Hydros - water, Philos - love of) has been coined to describe the art of getting wet while fully clothed (as contrasted to getting wet in a bathing suit or in the nude), and the person who is interested in hydrophilia may be termed a hydrophile.

What man does not enjoy the sight of a pretty girl getting drenched? There are many men today who are making a hobby of hydrophilia. The object of the hobby is to get as many girls as possible wet with their clothes on, and in as many different ways as possible, and in as many different costumes as possible. All that is needed is a willing girl and some water. The person who has never dunked a girl has missed a thrilling experience, and it is strongly urged that he give it a trial. Most girls if properly approached will not object to a dunking, and many will enjoy it greatly.

The ultimate in hydrophilia is to photograph the girl during her wetting. Photo-hydrophiles frequently exchange photographs with each other, and in this manner, the writer — a hydrophile from away back yonder — has built up a magnificent collection of photographs of over fifty differ-

ent girls getting wet under almost every conceivable circumstance.

It is of great importance to the hydrophile that the lady be fully and completely dressed in feminine attire for her wetting—dress, hose, shoes and, if possible, hat and gloves. Slacks, dungarees, saddle oxfords and bobby sox are not considered proper attire by most hydrophiles.

The dress (or blouse and skirt) should be of a material that will cling when wet and will hold water sufficiently to appear wet. Wool is very bad in both respects. Most rayons wet very nicely but get rather stiff when wet. The exception is *rayon jersey* which is very soft and clinging when wet. Cotton is an excellent material for dunking purposes and it has the advantage of not being ruined by water. Thin cottons — sheers, bembergs, tissue ginghams—make excellent materials for wetting. They remain wet, appear wet, cling enticingly and some are quite transparent when wet. Nylon is particularly good from the standpoint of transparency and it dries rapidly in case the young lady has neglected to bring a change of clothing. Generally, darker colors like black, navy, dark green or brown retain the shiny appearance of wetness better than do the whites or yellows.

The true hydrophile insists that

the girl be wearing shoes when she gets wet. In fact, some (myself included) consider the shoes to be the most important thing, and a thrill can be had from an attractive girl wading in shallow water getting nothing wet but her shoes and hose. Preference is almost invariably for dainty, high-heel shoes of patent leather, calfskin or suede. Many hydrophiles prefer suede because it appears "wetter" and is softer to the touch when wet than are other leathers. Extremes in shoes — wedgies, platforms and extremely high heels — are generally less appealing than is a simple pump, well soaked and soft with moisture.

My personal preference is for an opera pump with closed toes and heels for the reason that they hold water and make a fascinating squishing sound as the lady walks about.

There are few sights more satisfying to the hydrophile than that of a shapely leg in a gleaming wet, sheer stocking. Full fashioned hose are much to be preferred over the seamless variety which are made to appear as if the wearer is entirely bare-legged. Darker colors of hose usually seem wetter and make a better appearance when wet than do the lighter shades. Hose should be full length and held up by a supporter belt, *never* a girdle. The ideal situation is a

thigh length stocking that shows just a peek of skin between the top of the hose and the wet panties. As for ankle sox, the purists feel that they are only slightly better than no hose at all.

As to undies, the girl may wear panties or panties and bra although the bra will of course hide the nipples that might otherwise appear through the wet dress or blouse. A slip is to be avoided, and a girdle or bathing suit under the dress are strictly out! These items interfere seriously with the clinging of the wet clothing. At one time in my career, I was enjoying a frolic in a rocky stream with a well dressed girl when a playful current of water lifted her dress and revealed a bathing suit underneath. The thrill was instantly gone.

The most common (and least satisfactory) way to get a girl wet is to walk with her in a rainstorm. It is much more desirable to put her under a shower or into a filled bath-tub, but it cannot be too strongly emphasized that ducking should never be used as a punishment for a girl unless she desires it. Otherwise she is likely to resent the wetting and will refuse to indulge in future dunkings. (If she is naughty, turn her over your knee and apply the palm of the hand where it will do the most good.) The tub and the shower

represent the ultimate in intimacy and are often most used by husbands and wives for wet parties. During cold weather there is no other alternative than the tub or shower.

Less intimate but equally enjoyable is to wet down the lady by turning the hose on her. This method has several advantages: first, the water may be directed to the spots where it is most desired; second, the girl's clothes can be kept thoroughly soaked and remain entirely visible and not be concealed by being underwater; and finally, the force of the water may be used to enhance the clinging of the wet dress.

Another method often used is that of wading or swimming with the clothes on. To me, this is the most enjoyable form of hydrophilia and is probably the form that the girl will enjoy most and will most readily agree to.

Advanced hydrophiles have developed refinements in the art. One hydrophile of my knowledge has taken some striking photographs of an attractively dressed girl in a bubble bath. Others get the girl not only wet, but also like to see her covered with thin, wet mud.

But regardless of which type of hydrophilia interests you most, don't delay — get that girl wet! You haven't had the tops in thrills until you have seen your girl

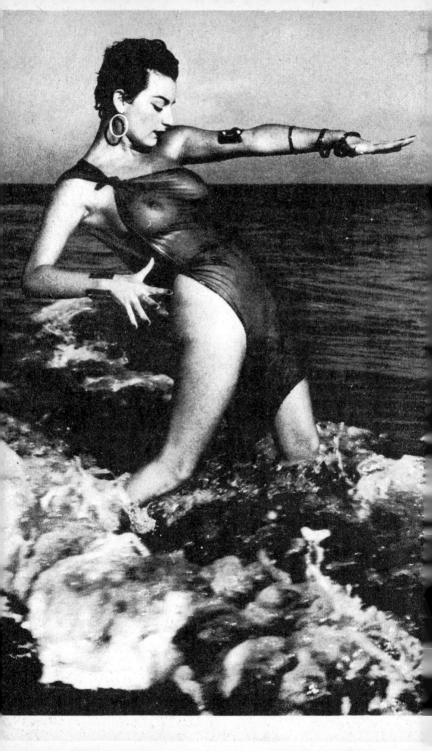

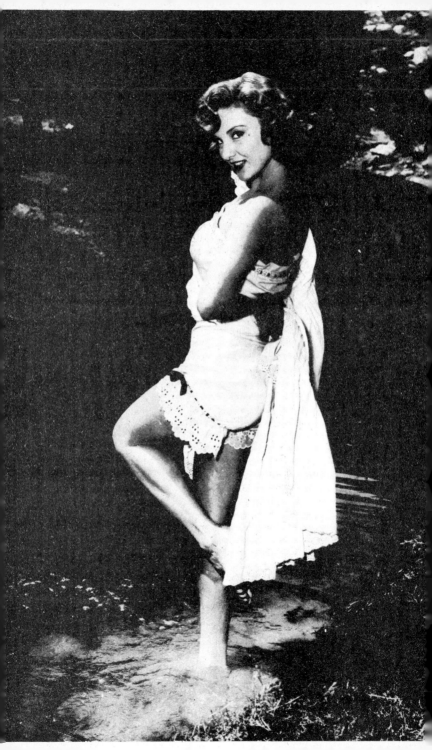

friend at close range in a sopping wet dress, or swimming about with her skirt floating up gently to reveal the breath-taking beauty of her soaked silken legs and the appealing wet softness of her delicate little high-heel shoes, and maybe a peek of a pair of glistening wet panties clinging softly to a firmly rounded pair of buttocks.

And especially, hydrophiles are urged to write up their experiences and get photographs to share the thrill with others who like to dunk a beautiful girl. Make known your interest in your hobby so that other hydrophiles will not feel that they alone have the desire to see a girl get wet.

R. M. S.

* * *

IDEAS FOR RUBBER CLOTHING

My first interest in rubber clothing occurred when I was eight years old. For some reason, I began wetting my bed again at this age. After several threats and many other methods used by my mother to get me to stop this habit, she finally thought to shame me out of the nightly occurrance. She went to a department store and bought some of the largest baby's rubber panties she could get. To this day I remember that they were white, pink, and blue

ones, and she bought several pairs so I would have a fresh pair every night. Just before I got into bed mother would force a pair of these soft rubber pants up over my hips to save her sheets. They naturally fitted very tightly since they were made for much smaller bodies. I began to like the smooth, cool feeling of the rubber stretched so tightly about my body as I lay in bed, but, of course, the habit went on. Later she also placed a large white rubber sheet over the whole bed on top of the regular sheet. Unfortunately for her this only increased my enjoyment as I lay on the smooth cool material.

Without her knowledge I began to wear a pair of these rubber panties under my clothes during the day, and I remember vividly the pleasure I got. I seemed to be in a world of my own when I had these panties on. Later other articles of rubber clothing began to interest me. On several occasions I put a soft red rubber apron she had in the kitchen on under my clothes. It was one of the frilly all-rubber ones which are so hard to find nowadays. I hid this rubber apron under the rug in my room, and would secretly put it on at night. Mother replaced this with a new blue and white checked one which she always left hanging in the kitchen. She almost caught me one day as I was feeling and

smelling it, tempted to steal this one also.

Next came the soft all-rubber raincapes which were so prevalent in the 1930's. At college I had at least twenty of these capes in all the different colors I could find. I was always searching for new raincapes of different colors. These served the same purpose as the original white rubber sheet mother had first placed under me as a child — only by now it was voluntary.

I began to collect soft rubber bathing caps, which I would carry in my pockets, rubber girdles, sanitary panties with a rubber piece between the legs, rubber gloves, ladies' rubber boots — mainly the high heeled kind — especially if they were shiny. Black appealed to me the most. And every rainy day when I was free, I would stand at 42nd Street and 6th Ave. watching the ladies in their soft colorful rubber capes, coats, and shiny boots. This has given me feelings I have never been able to duplicate any other way.

Naturally, having such a love for rubber in these forms, I have devised ways of making rubber wearing apparel for my own personal use at home, and to wear under my clothes during the day. One of the easiest to make is a full circle rubber skirt which swishes and hangs about the hips very ex-

citingly. This is done by buying four yards of a very thin soft rubber material called Dental Dam. There are several thicknesses of this, but I personally prefer the thinnest. Any surgical house carries it at about a dollar seventy-five cents a yard. The four yards are folded and cut so that you have two two yard strips. These are then glued to each other along their long edge so that you have a two yard square rubber sheet. This is good for covering a bed or anything else, but I like to make it into a skirt. To do this the sheet is folded four times so that the whole thing makes one square yard. Then the corner which is closed completely is held and cut about three inches down from the pointed angle, making a symmetrical hole in the very center of the sheet. (This may be varied according to waist size). Then the opposite two edges are cut in a smooth semi-circle to get rid of the square edges, leaving a complete circle of thin rubber with a small hole in the middle through which the skirt is entered. It makes a full, swishy cocktail-length skirt which may be worn under clothes, or at home without anything else.

It is especially fun if you can find a girl who will wear this rubber skirt, which is partially transparent, over a red or black taffeta

petticoat. The effect is marvelous. Also it can be worn as a rainskirt, at football games, or just as an unusual outfit for evening. When this skirt is combined with a rubber girdle, long silk stockings, high heeled shoes (covered by shiny boots if the weather is bad), a silk or satin blouse (or rubber), and topped by a tightly belted rubber coat of some color to match the skirt or contrast with it, any devotee of rubber will do handsprings. You will find many people staring at your girl — both women and men, some with much more interest than others.

The making of a raincape of this same material is a little more difficult, but very possible. For this you need five yards of Dental Dam and a pattern for a full cape (bought at any department store). Mine was obtained from a Halloween costume of a devil, and I discarded everything but the cape. This also can be worn in the rain or at home with much or nothing underneath. A matching silk umbrella is very effective here. Also thigh length high heeled rubber boots. Your girl, or you, will be a hit anywhere in this outfit.

I shall send more details and pictures if anyone is interested.

Sincerely,

R.U.B.

Send 'em — Ed.

RUBBER CHALLENGE

Dear Editor:

From the point of view of the rubber enthusiasts No. 19 was a real good issue. There were three good letters and the final by Mudlark was fine. They all bring up the same request which was originally made by Ruth in Rubber way back in No. 12. Why don't you show the models in some of your photographs and drawings as wearing shiny rubber boots in their tied up poses. As was recently suggested this would really kill two birds with one stone and I'm sure we'd all love it. That lucky guy T.C. sent in two delightful pictures of his charming wife attired in rubber costumes but that's about all we have had. Pictures of just a pair of boots with legs as on pages 56 and 127 in No. 15-16 are unsatisfactory. We'd like to see the damsel so shod. I have one request above all others and if you show it I'll buy a lifetime subscription to Bizarre. That is a picture of some attractive girl wearing shiny black high heeled rubbers — not boots — over a pair of truly high heeled shoes. This is a challenge.

Crazy over Rubber

34

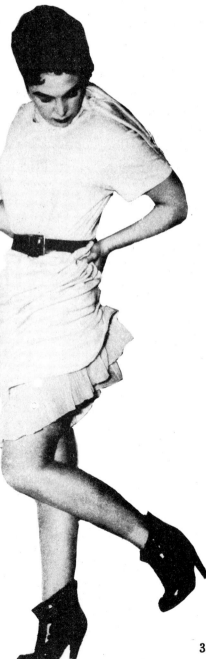

AN IBITOE ADVENTURE

Dear Editor,

How much TURNABOUT is fair play?

It all began about five months ago when Ibitoe made a compact with the Little Lass. I allowed her two full weeks of freedom. Since she is seldom without muzzle, she took full advantage of the situation and plagued Ibitoe incessantly with tauntings she must have cooked up for weeks in her silent head.

"Ibitoe, you're a complete savage! Look at you, sulking around like a wild, unbridled panther. I'll bet if you had to wear things like I wear, things that slow you down, you'd go mad in an hour! Furthermore, I'll bet that if you ever put on anything civilized and refined, you'd look like so many lumps of coal in a sack!"

I silently nodded agreement to all of her statements except the last. Perhaps it is Ibitoe's vanity, but he WOULD NOT LOOK LIKE SO MANY LUMPS OF COAL IN A SACK! At this point, the duel was on, a duel that finally was settled in a wager. At a photographic sitting, I would allow the Little Lass to dress me in what she considered "refined and civilized" clothing (she was given two days to assemble these items) and the photos she took would be used as

a basis of deciding the issue. If I was not a sack of coal, the Lass agreed to submit to two weeks of rigid restrictions. If I did look like a sack, I decided in my mind to give her the punishment anyway, for her insolence.

The Little Lass was very busy for the two days before the sitting. She made many phone calls and I heard her sewing machine busy in the distance. At last her day arrived and as I set up the photographic gear, she assembled her little treasures. Then my body was hers to decorate. First came a bath in perfumed water. After she had rubbed me dry, came a pair of very small rubber panty briefs. Next she laced me into one of her lightly boned, front-lacing waist nippers. She had decided her corsets were too small, and besides, she thought if she used anything longer she might pop one of Ibitoe's pouting ribs! Next came some wide strips of adhesive tape and a padded bra. The next garment the Little Lass produced really amazed me. If was a grey wool skirt, or maybe it was a variety of trousers, that the Lass had concocted all by herself. It has a panel sewn down its inside center, "so as to be more like what you are used to wearing," she said. What she didn't say was that this also emphasized the skin tight fit she had made it, and all without a *single fitting!* The next items she had me don were my own, one of my old shirts that was decidedly small, and a black belt used for extreme constriction. Now the Lass produced her make-up kit and daubed away giving me what she called, "a moderate make-up." She finished this process with a flowered kerchief on my head and a single, heavy, solid silver earring in my left ear.

As I thought the Little Lass was finally finished, I stood stationary before the camera obliging with a variety of poses. The Lass clicked away and finally, with a faint smile, from an unnoticed box, produced her last item of revenge: a pair of high heeled shoes. She said she had trouble finding a pair that she thought would fit me. It seems that she finally found a pair of white calfskin pumps with five inch heels at one of her large-footed friends. Since I was quite unable to reach my feet, she had to force them on for me. Either her friend's feet were not large enough, or my feet were shaped all wrong because at first it did not seem like the shoes would go on at all! Finally the Lass helped me to stand on my throbbing feet and suggested that I walk around a bit. With much waving of arms for balance, I did manage to wobble and stagger a few feet, about six inches at a time. All this must

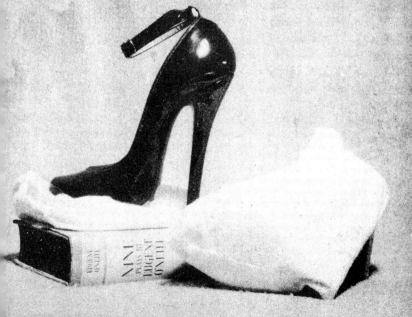

have been terribly amusing to the Little Lass for after I developed her pictures, I discovered that she only managed to take one picture of this! After a few minor costume changes, I thought we had finished the photo session. I sat down to rest under the hot lights, loosened the belt, and clawed my way out of the shoes. About two seconds later I heard a zippp; the Lass had taken her final picture!

That's about all there is to this story, except that both the Lass and I were quite pleased with the finished pictures. After she saw the prints, she just smiled and walked to the closet. I might add that for two months after this episode the Little Lass, every time she got a chance of course, apologized for having me wear such poorly fitting shoes. She insisted that ultra high heels could be comfortable if they fit right and one's feet were trained for them. I took this all silently until one day when I drove her down-town for one of her *rare* shopping trips. She asked me to park by a shoe store and there she pleaded with me to come in with her and have my feet measured . . . for specially made high heels! She had everything arranged. We would enter the rear of the store where her friend, an expert in foot measurements, would make sketches and take the measurements. The shoes would

be made in another place by the craftsman and delivered by mail. Since she insisted that these shoes would be comfortable, I bared my feet.

The shoes were delivered about a month later. From the first moment I saw the package, I thought something must be wrong. It was TOO SMALL! I thought a mistake must certainly have been made. All that would fit in that box would be one shoe, or a pair of *baby shoes!* I brought the Little Lass out to open the package as any mistake would mean her neck. In the box were two elongated flannel bags. I slipped the contents out of one of the bags; it was a shoe, a beautiful shiny-black patent pump with a full six inch heel; but it was too small. I held the shoe by my foot and must have shook my head; it could never fit. In an instant, the Lass was at my feet with powder and shoehorn. I hesitated to unshackle her, but finally gave in because of my curiosity about this puzzle. She did get the shoes on but they were far from being comfortable and loose-fitting. I tried to stand but this was sheer torture. I examined my feet in the shoes and discovered that my arches didn't follow the soles of the shoes and that the balls of my feet were far from where they obviously were meant to be. I growled at the Lass

and she quietly reminded me that she mentioned a little matter of "training", "just like the itaburi," she said.

At first Ibitoe was happy with just looking at the non-fitting shoes. It was strange how all of my feet would even go inside the shiney black leather. Soon the challenge became too great and Ibitoe decided to train his feet to the shape of the shoe. But before the training began, I felt I had to photograph the shoes before they became nicked and scuffed by the abuse they were likly to see. I realize many people think it is ridiculous to photograph shoes without feet in them, but I think that photos of empty shoes can be exciting if one stops and contemplates the appearance and shape of the foot that MUST FIT THE SHOE. I know I didn't appreciate the shape of one of these gracefully curved creations until I held it beside my foot, the foot it was made to fit. At this photo session, I even went so far as to squeeze one of my feet into a shoe again and try and force it into the position that standing would cause. The idea of this was the old "before" and "after" pose. Needless to say, the training has now brought about changes. After all, the instructress has been through all this before! At the time of this letter, three months of train-ing has been completed and Ibitoe can nearly walk gracefully and certainly with ease and comfort in these shoes. If your readers are interested, we will soon have some photos of a super tall Ibitoe with well rounded metatarsals walking about and lolling in them while dressed in some real "fine feather" clothing.

Yours for smaller waists and elevated heels,

IBITOE

P.S. The Little Lass is now suggesting a pair of calf boots to match hers. Wouldn't the two of us make a picture!

NEAT FEET

Dear Editor,

Having run across your publication in a book store, here in Cleveland, I was more than pleased to see such a book on the market. After reading several of the issues I note you like suggestions on the type of pictures your readers would like to see. I noticed you give preference to high boot type shoes and corsets; this no doubt sells numerous copies. My preference though, is the dainty and fetching stockinged foot and leg of a lovely lady. I know from considerable study on this subject there are numerous other people interested in the same thing. To me and many others the delicate lines of the leg, ankle and foot, the sweep of the arch and dainty toes incased in a sheer stocking is a thing of real beauty. I am sure you would receive many letters from enthusiasts of this type if you would print more pictures of this kind. I will be looking forward to seeing them.

J. C. S.

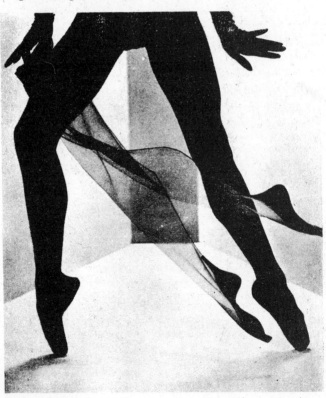

GENTLEMEN!

MUJERADOS DE S.A.

Dear Sir,

Your wonderful double number 15-16 to hand, for which many congrats and thanks. May it be the first of a series of such numbers!

One letter in particular interested me, that by "Henrietta's Amalia", for in it she mentions the "Mujerados" Club in Buenos Aires. I used to live in Argentina, and I knew the club very well. I am sorry to hear of its having been closed, — the same fate as that received by the "El Dorado" in Berlin when Hitler came into power. Both clubs were of the same type, being places where the man or woman who liked dressing and making up as a member of the opposite sex could move about in complete freedom. Why, I wonder, do some authorities consider such action taboo and close such establishments? For, as your writer rightly says, there are many men about who delight in wearing the silks, satins, corsets and high heels for so long considered the prerogative of the fair sex.

In Buenos Aires I had a friend who was never happier than when dressed and made up as a woman, and as a pretty one, too, all with the complete cooperation of his wife. These were not French, so

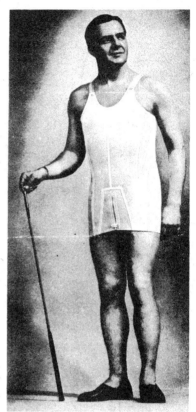

Hold
That
Line!

WITH
Stayformen

41

THE UBIQUITOUS PERENNIAL MARLENE

they could not have been your writer and her husband. He believed in tight-lacing and had a remarkably trim figure, which was always emphasized by the chic things his wife got him to wear. His slim shapely legs were his forte, as he well knew, for his skirt length was always such as to allow of a generous view of long nylon-clad limbs as he sat with crossed legs and a dainty high-heeled shoe balancing up and down in front.

It was my friends, indeed, who took me along for the first time to the "Mujerados." This word, by the way for your feminist-minded readers, means, "effeminished males," and indication of the origin of the club, though, as your contributor mentioned, it later became the rendezvous for both male and female impersonators, amateur and professional. I saw many men there in dainty feminine guise, all thoroughly happy to be able to appear in public in their transformation. As your writer said, the club was exclusive, and I know it was very expensive, — a guarantee in itself that those members appearing "changed-over" would only do so complete to the last detail, regardless of expense.

The floor show always had a strong element of impersonation in it, and many have been the un-knowing visitors who have been completely taken in by the daring, ogling dancing or singing "girls" appearing there before them. Even the two cigarette and hat check girls, in their close-fitting satin frocks with diminutive skirt, revealing the full length of shapely legs in prettily gartered nylon mesh stockings, and swaying on their pencil heels, turned out to be two youths who had learned to make up and act perfectly as girls, and who obviously loved doing so. They had learned all the tricks of luring the male, — ogling, tucking a note away in the vee of a realistic bosom or in the top of a hip-length stocking — and the measure of the success of their transformation was reflected in the attention they received. One of them I saw at the close of the evening leave the premises arm-in-arm with a young lady — probably of the masterful type — but they would apparently be two girls together, for the youth looked chic in a little hat, gloves, fitted costume and high heels. Such was the erstwhile life at the "Mujerados," and I for one am sorry to hear it has been curtailed, — or has it, I wonder, gone underground? Such habits are not easily shaken off.

Yours sincerely,

"ELVIRA"

LIFETIME RECORD

Dear Editor:

Three cheers! that after long last we have our BIZARRE friend with us again. Gee, how we missed it all these many months, but now we feel compensated seeing that it strives to be its good old self again. I say strives, because naturally enough after the long interruption some of the familiar features and contributors are still missing, but there is hope, that with the resurrected friend, inspiration for interesting contributions will come alive too. We can stand a few experiences and practices as reported in former issues of good wifes being suspended on chain or rope, with a bit of whipping or water treatment in the bargain. What about ear and nipple piercing for hoop rings to wear, and septum and nostril rings like the Highcast India Ladies. Original costume parties a la Club Modern etc. are always interesting and inspiring for imitation or new ideas, "Bizarre" ideas are not always too bizarre when they serve to strengthen the bond between husband and wife. I know of at least half a dozen of my friends, married. couples, some with several children, who make it a special festivity to figure out some nice design and put it on each others body in tattoo work. One couple is especially original in having it made a regular feature in their life, whenever there has been a day or event, that has been caused by one or the other or together and has given them special joy it is recorded by tattoo on their front, having started slightly above their breasts, the date and a word or two of the special joy engraved within an oval frame. It is unique, but it is surprising what a record of mutual love and joy is growing up in the course of the years. It is not much work, can easily be done by handwork, both man and woman can without difficulty learn to do it.

It is remarkable how many men and women have ideas of their own, very individualistic, 'bizarre' if you like, but very interesting, many put them into practice, but being unaware of the surprising fact that there are hundreds or

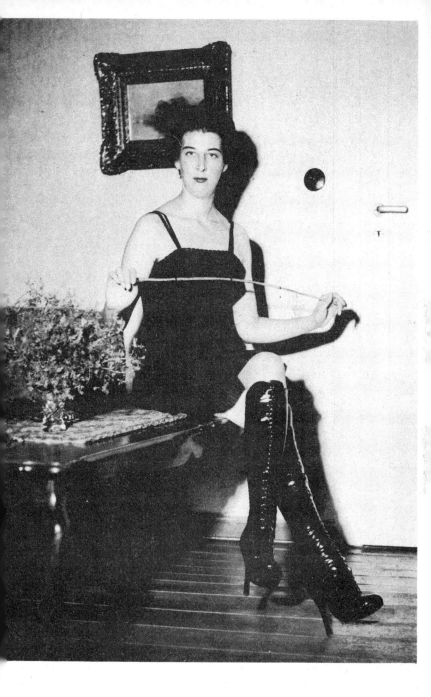

ANOTHER MODERN FRAULEIN

thousands of a similar mentality. And what a satisfaction it gives, when we learn of the others who think and feel and practice how and what we do, and thus that we are after all not such isolationists as we, in a spirit of inferiority complex believed we were. Therefore, please, friends and fellow Bizarrists, take out a little time and write out that contribution to be published under *Correspon-*

Semi-abstraction of human forms characterized Gastom Lachaise's final style, as TORSO, 1930.

dence for the benefit, enlightenment, inspiration, encouragement and enjoyment of the readers of this magazine.

And one more point: There have been and will be contributors whose articles and what they had to say were of very particular charm or interest and value. They should be encouraged at least to contribute one or the other article from time to time, which can be done by mentioning their name or initial and title of former contributors and asking for repeat performance. In fact I suggest, that the editor arranges to have on the first page of the Correspondence section regularly if possible a small box with: We want to hear again from So and So. Or what has become of so and so? Why so silent?

I have been an interested reader and follower of BIZARRE from its first issue until this one. Using my experience I am convinced that this magazine has its greatest source of attraction and hold on the readers and chance for widening its subscribers lists is the individual Correspondence contributions of the readers. Thus let us all be correspondence minded — and willing to. If we do, there will be none other like this magazine.

Steady Reader

Bully! Let's all get behind the editors. — Ed.

DON'T

LET

THIS

HAPPEN

TO

YOU

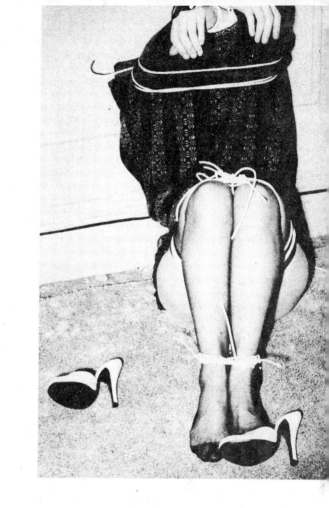

learn jiu jitsu
and the art of
self defense

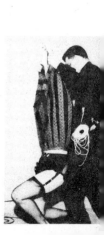

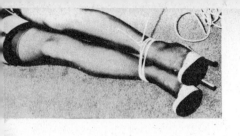

THE ICEMAN COMETH

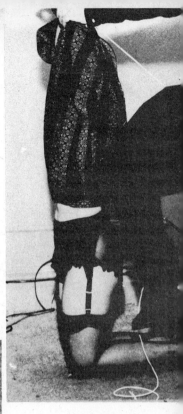

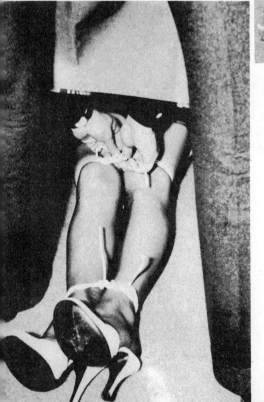

HE MOCKETH FRE-ON

COMPRESSES

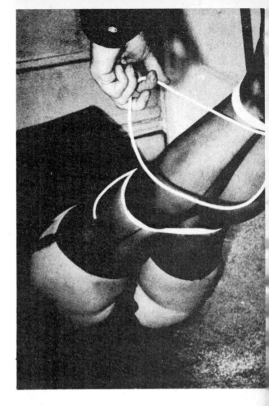

Now
to
get
rid
of
that
refrigerator

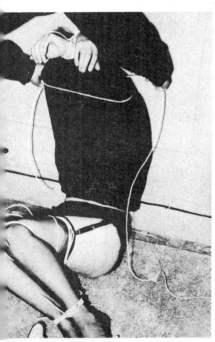

EVAPORATES

Bon Voyeur

I realize many of your readers are devotees of the unusual and want the high leather boots, corsets, etc. which are seldom worn publicly now-a-days. I am not insensible to the attractions of such garments but I want to register one vote that you also continue giving us more views of the glamorous garments modern girls wear when they adorn themselves to please and attract their male admirers. Give us the unusual, but also give us the especially attractive examples of the usual garments modern girls wear. To show you what I mean I will mention especially attractive examples from the few issues I have. In No. 9 page 4, showing a lovely slim pair of legs, in sheer hose and shiny pumps, with a trim little skirt slipping up over one knee as she climbs in the car, the caption is wonderful. How I'd love to have you give us as close and detailed a view of her lingerie as you have of her hose and legs. To me such a picture has even greater impact because it is so very true to life. In No. 10, inside of back cover, another pair of lovely legs marches up the steps ahead of us, just as we often see them in real life. It's a very fine photo as it is, but could you follow it with one where we can see at least some of the

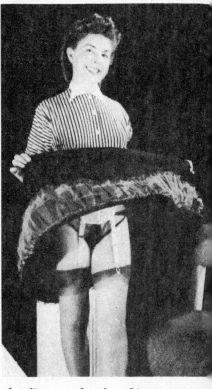

loveliness under that skirt — perhaps her slip, or her garters, or best of all her silk and lace step-ins? In No. 9, page 15 you do give us one lovely example of a lady in modern lingerie. I hope you will give us more, showing the many different types of brassieres, garter belts, and panties. Also I imagine many of your readers are devotees of the old game of playing garter inspector or lingerie inspector. There is an especial thrill in inspecting a love-

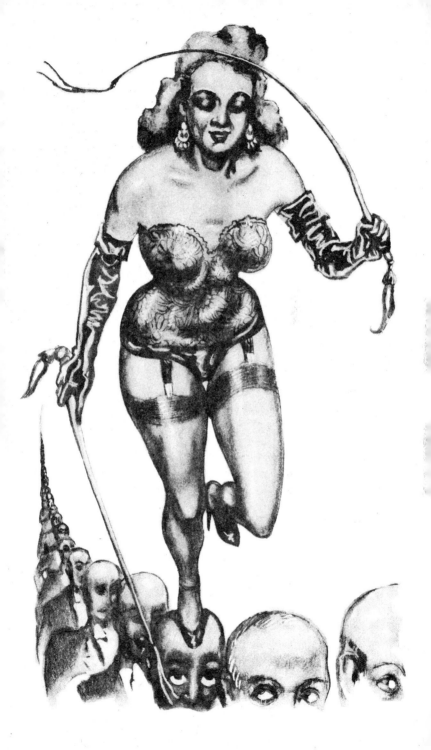

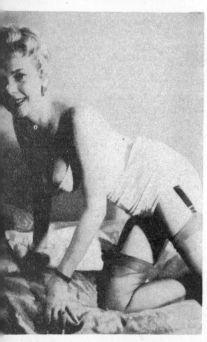

ly lady's lingerie while she is completely dressed and I hope you can give us more photos like that in No. 10, pages 30, 31 where the model's skirts are lifted to allow her hose and lingerie to be viewed. The unusual in position or angle of view is as attractive to me as the unusual in clothing. Many of your readers who have watched a lovely pair of nylon clad legs going up the steps ahead of them must have wondered what the view would be like if he could be directly under that skirt and see, with good lighting, the play of the lady's silk and lace underthings about her legs as she mounted.

I'm sure I'll like a lot of the articles and photos in your magazine and I hope you can continue to give us the unusual — the unusually beautiful examples of modern feminine finery as well as the unusual designs.

Sincerely yours,
W. S. S.

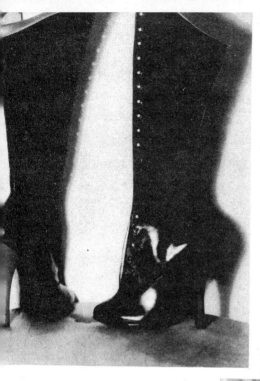

BOOTS

AND SATIN

Ou Peut-Etre Un Chat

Dear Editor,

Last autumn, strolling through the "Printemps", one of the famous Department Store Houses of Paris, I witnessed an exciting episode I will not forget in many years.

Standing at the pet counter, a slender man and his elegant although somewhat plumper spouse, perched on very high heels and with a heavy veil over her face, were apparently interested in buying a dog collar. Or rather, she was selecting and rejecting one collar after another, until she decided to take a wide red-leathered collar, heavily studded with small bells, while he was standing beside her, his hands and arms motionless behind his back.

Suddenly she spoke to him. He bowed low — and the fair lady, calmly and without the slightest hesitation, put the dog collar around his neck, adjusting and buckling it firmly, attending to details, and even jingling the bells with her hand touching them.

The man's face reddened, but he said nothing, neither did he resist — and his arms remained just as motionless on his back as before.

She had him turn around, apparently to have a closer look at the unfortunate neck and its sur-

prising ornament, while the clerk and I stood rather speechless nearby, watching this extraordinary spectacle.

Finally satisfied, she then unbuckled the collar and remarked aloud, certainly in view to humiliate him: "I think I will take this one; it fits him."

She took the collar and departed, followed by her husband. Trailing the pair, I saw them departing in a taxicab. She opened the door of the cab, motioning him to enter, which he did, — still with his hands and arms on his back. The hands were covered by black gloves so that no chain would be visible. But hands and wrists were so close together that I have no doubts as to the cause for the strange acceptance of such a humiliation in front of strangers and in the middle of Paris.

LIGOTE
Bonn, Germany

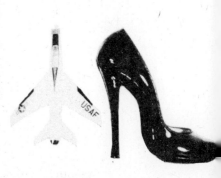

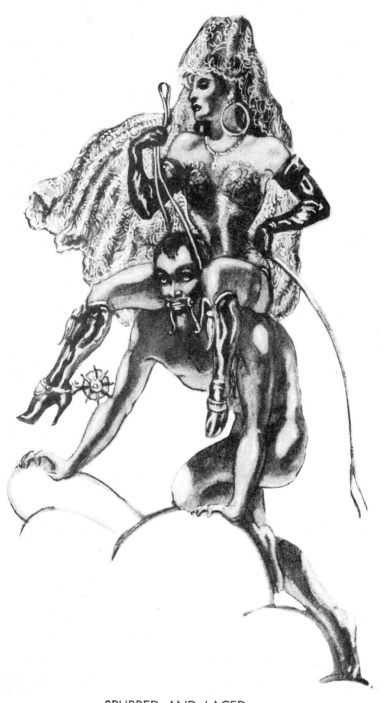

SPURRED AND LACED

WE'RE A HELP

Dear Editor,

"Boy-oh-Boy" what a help you have been to me. Now I've got some ideas of how to handle females. They had me going for a while but now, thanks to you it's different. The characters I'm involved with are practically the same as those of C. L. in your No. 12 issue. One is a redhead named Margie and the brunette is Madelein. Every once in a while now they have to be held or tied down. Margie is the worse of the two. One day I tied her hands behind her back but that didn't slow her down. So next I

tied her elbows and her arms against her body but she only caused more trouble by standing before the television set and making a general nuisance of herself. So next I put her on the cot and tied her legs at the ankles and again at the knees. She only rolled off and started yelling and making more disturbance. So this time I tied her securely to the cot and then I gagged her and left her there for about an hour and a half. She has been pretty good since but with her you never know, her being a redhead. Having a flash camera, I took pictures of her predicament.

Madelein is about the same case but with her it happened a day or

two later and I used a different tying technique. In case they both go on a rampage together I think I have the solution to that too. Margie has a sassy sister who has not been "subdued" yet. There will be more on this issue too. I can feel it in my bones.

Signed

Double Trouble Shooter

56

"STRAIGHT FROM THE HORSE'S MOUTH"

Dear Sir,

My Mistress a member of the Smart Severity Cult has allowed me to write this my story. I am 14.2 hands chestnut mare called Eureka and I am owned by a young lady employed as a mannequin in a big city. She keeps me in a stable in the care of an old retired groom near to the Downlands of South England. Owing to my Mistress's employment she can only ride me about three to four times a week and on these days she usually rides me all day.

I can always tell when my Mistress is coming as I get an early feed and a special grooming and than I am saddled and bridled. This bridle is fitted with a double bit with long cheeks and a high sharp port which causes me great pain. I am also fitted with a martingale that runs from my bit to the girth very tightly causing me to arch my neck and pull in my chin. As I hear my Mistress arriving in her car I am led out of the stable to allow her to mount.

By the time I reach the yard my Mistress is already standing on the mounting block awaiting me. She is a nice looking young lady dressed in velvet cap, polo sweater, black jacket, cream breeches and highly polished knee boots. She weighs about 10 stone and is quite strongly made as she rides a lot. As I feel my Mistress toeing the stirrup I turn my head and I get an excellent view of the long shiny sharp spurs on the heels of her boots and I shudder as she swings astride to bring them close to my flanks and I also see the thin cutting whip in her hand. I am given no time for reflection however as my Mistress as she gathers up the reins gives me a smart jab with both heels and reining me around hard drives me out of the yard with a series of cruel digs. From then on she drives me over the Downs usually at a breakneck gallop spurring and whipping as often as she pleases. When she stops for a smoke she keeps niggling with her spurs at my sides which are by this time cut and sore. On our return to the stable she takes me into a nearby field which has some jumps erected therein and rides me over these jumps for an hour or so. This is the part I hate worst of all because my Mistress digs her spurs in deep at the take-off and if I should slip or have to stop, owing to a bad approach my Mistress takes this as a deliberate refusal and she wrenches my mouth and grinds in the biting points of her spurs while her thin cutting whip lashes down seeking the tender spots of

FROM
THE DAILY SKETCH

FLAT OUT!

So keen to smooth her curves she fainted 10 sec after this picture

ROCHELLE LOFTING has a 42-20-36 figure that most girls in show business would envy.

But she thinks her curves get in the way of her ambition. She wants to be a straight actress.

Now 21-year-old Rochelle—"I can't help my figure "—is trying to flatten things out with a steel belt.

She bought it at a Manchester chain store. It measured 22 inches, so her husband—manager Gerald—cut a couple of inches off it.

Rochelle—born in France of English parents—has her first big role in the play "Glamour Girl" at Aston Hippodrome, Birmingham.

When she walks on there's a buzz in the audience that upsets the cast.

Says Rochelle: "The belt makes me feel so ill."

And ten seconds after Sketch cameraman David Adams took this picture, she fainted—flat out!

my anatomy. I am glad when she takes me back to the stable, but I get no sugar or parting pat. Instead I invariably get double spurs driven cruelly home as a parting gift.

Recently I have been doing a lot of jumping as my Mistress lately has been accompanied by another young lady whom she addresses as Angela. She has not ridden me as she is a side-saddle rider and my Mistress won't let her ride me. This does not mean I have an easy time as my Mistress demonstrates the use of a spur on each heel while her friend believes in the one single spur. Now I hear that Miss Angela is buying another horse and that it will share my stable so that the two friends can ride together. Perhaps my Mistress will not let me tell you about the other pony if this letter is published as of interest.

"EUREKA."

Dear Editor,

Of My Horse's Story, excuse her phrasing. I hope that you find it interesting. Perhaps I will allow her to write again if it is any good.

Yours sincerely,

"MOUNTED MANNEQUIN"
London

CORSETS AND FRILLS

I am so pleased to know that so many men enjoy wearing their stays and keeping-in-form so to speak. I was interested in the account in a recent issue telling about his experiences in getting fitted for a corset. Perhaps my own corset experiences might interest some of your readers.

As I had a couple of older sisters, I frequently saw their beautiful corsets, bust pads and bustles lying around in their bedroom, etc. When I was about ten years of age, I found I was alone upstairs one Sunday afternoon and in passing by my sister's room, saw a pile of undergarments etc. on a chair with a corset on top of the pile. Out of curiosity I tried it on. It fit very well. Then the idea came, to see how tight I could lace it, and naturally hoped I could lace it together. Sure enough after quite a struggle, I did get the very wasp waisted corset laced tightly together at the back, and much to my delight I enjoyed the sensation immensely. And as there was a full length mirror handy, I rather admired the figure it gave me. From that moment on, I was addicted to tight lacing. At every opportunity I donned one of my sister's corsets. How to get one of my very own became the next problem. Soon afterward the whole family

moved to another house. In the attic in an old trunk I found many articles of feminine apparel of that day and among them two very fine corsets in excellent condition. Of course they became mine alone, and from time to time I took them from a secret hiding place and wore them.

Not long afterward I was called into the army, having enlisted while in school. For several years my chances of indulging in my love for corsets and my ever growing desire to wear fine silken lingerie and hose which was the natural outgrowth of my continued corset wearing, was practically nil. I was in Paris and saw the wonderful shops there with the beautiful window displays and although desirous of obtaining some of these beautiful garments I could not carry them along and keep them hidden. So further indulgence had to wait my return to the homeland.

As quickly as possible I acquired several corsets and several teddies, the then popular type of lingerie and at every opportunity wore these things. The styles had changed from the hourglass figure to a straighter line, and the front lace became very popular. Many times I wore my corsets outside in the evenings, when I went to the show etc. It reached the point where I did not feel comfortable

without my supporting cast, you might say. It was no problem at all to lace down to the very low twenties in inches.

I believe this early figure training has helped me to keep a very trim figure. Even today when the average man of my age has a big bay window, my waist is still a very satisfactory thirty inches without laces and easily goes to twenty six inches. I find this very comfortable for me, and can go for hours laced down to 26 inches. Also I find that because bust and hips are about 40 inches, a smaller waist does not look in proportion with todays standards. If I laced in too tightly my gowns would not fit properly and therefore I make no effort to lace down to a smaller dimention. The measurements and ratios I notice in magazines and newspaper articles regarding fashions, all seem to decree a waist line ten inches smaller than bust and hips.

The corsets I wear today are custom made of course. No stock garments are high enough or long enough in the skirts to satisfy me so I must have them made to order. Heavy satin or nylon I find to be the most satisfactory and enjoyable. I prefer the front lace style also, finding them much easier to adjust. I find that the higher cut helps to accent my bust line, and if I were able to wear

LINGERIE FOR THE WARM DAZE

my corsets constantly I am sure I would eventually develop a beautiful natural bust contour. I always insist upon eight garters equally distributed around the bottom. I also like to have the bottom edged with lace about 10 inches deep with plenty of fullness. I may send in a picture later if you would like to have it for publication.

As to personal fittings, I have never asked for one, being sure of my own measurements and laying them out carefully on paper so there can be no mistake. I am sure the saleslady always knows that the garment is for me, and I get a laugh out of it when they always say . . . "I am sure the lady will enjoy wearing this beautiful garment." Of course I always nod assent and assure them that this is certain to happen.

I must admit that to make my bust line really attractive I find it necessary to resort to some falsification. One of your readers had requested suggestions as to best methods found by others to achieve a nice bust line. I have found that the plastic forms made for inflating by means of a tube are the very best. However instead of filling them with air completely, I use them partly filled with water. I defy anyone to tell by touch that they are a substitute for the real thing, and they have weight which makes them behave as realistically as the real thing when walking. They give under pressure instead of appearing as a lump which is the objectionable characteristic of the sponge rubber article.

As you may have guessed, I not only wear my corsets and underthings but I have a very extensive wardrobe of dresses for all occasions and of course shoes to match, with purses, gloves etc. for each outfit. Several fur stoles and hats for every occasion also. If you find the above interesting enough to print I would be encouraged to try my hand again and describe some of my experiences while dressed in my beloved finery. Incidentally, my ears have been pierced for many years, and after the story of the nose rings in England, both of my nostrils now accommodate a jewel and the septum carries a lovely gold hoop when I am in the mood. Quite attractive too. As previous issue have described the methods of ear piercing and fixing the nostrils to receive jewels, any one can enjoy these novelties without danger. Simple precautions against infection are all that is necessary.

And please do not get any erroneous ideas from all of the above. I can ride, shoot, hunt, fish or box or roughhouse it with the average guy. It just happens that I also like nices things.

Perfect Twenty Six

BYE

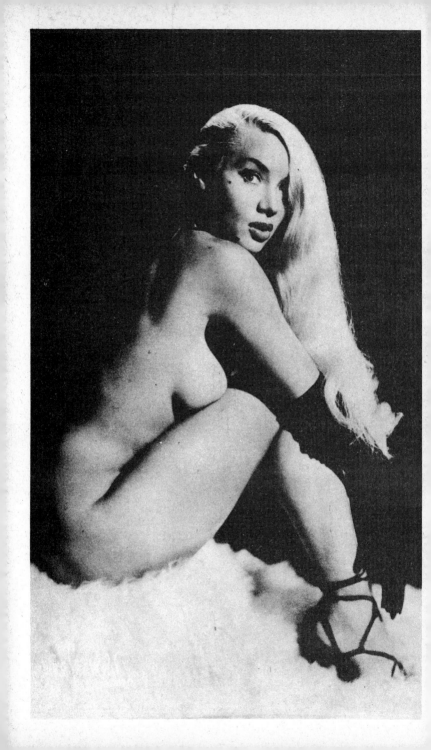

BIZARRE

Nᵒ 24

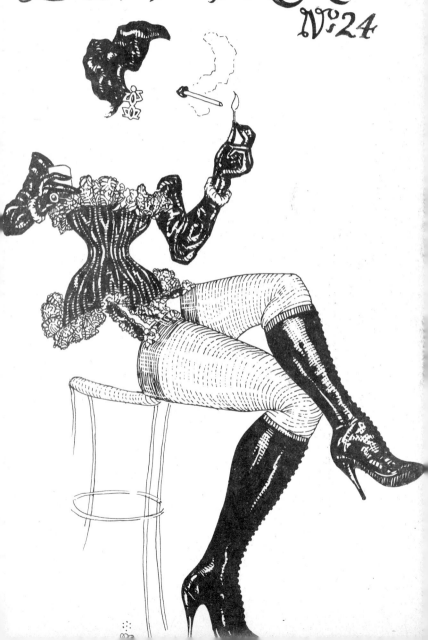

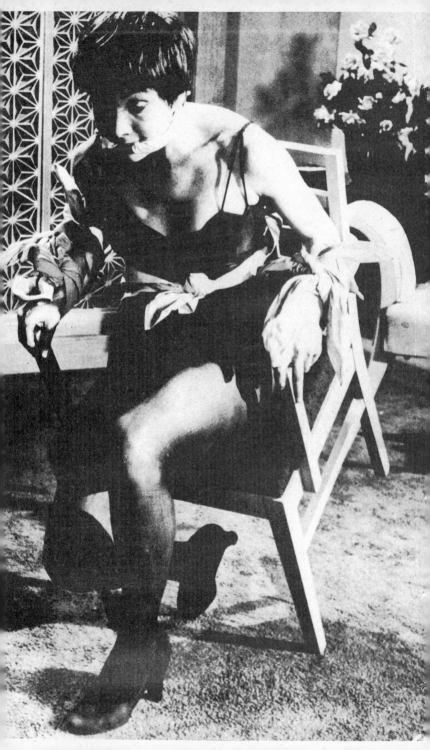

BIZARRE

"a fashion fantasia"

No. 24

I sometimes think that never blows so red

The Rose, as where some buried Caesar bled;

That every Hyacinth the Garden wears

Dropped in its Lap from some once lovely Head.

OMAR KHAYYAM

Contents

NEXT ISSUE No. 25

We're not talkin' — but we're workin'.
Good luck to us.

BACK NUMBERS

By all means, patronize your local dealer. If he can't supply you write directly to:— P.O. Box 511, Montreal 3, Canada.

Printed and Published by Bizarre Publishing Co., P.O. Box 511, Montreal 3, Canada.
Copyright 1958. All rights reserved.

3

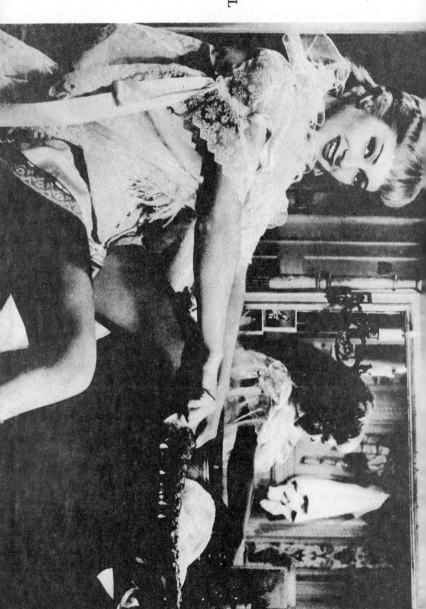

MARTENE CAROL

"NANA"

WHO D BE AN EDITOR !

"A chicken is an egg's way of making another egg."
Samuel Butler

We had our share of complaints on the last issue, ". . . far, far too many pictures, not enough correspondence."

We agree. There isn't enough tub-room for all faucets, and that lazy no-good red-nosed editor sleeps on the job. In the olde days when paper stock was thick and the letters short, the mag had heft and meat. Now the lengthy correspondence has taken over (who can write a descriptive precis?) and the slick paper gives the illusion of thinness. "Who'd be an editor" when, after a careful layout, the whole issue goes on the chopping block because of the lack of "space"?

It's about here we lose control — too bleary-eyed and too close to the pieces to focus on the whole picture. But that's life, buddy! When's the last time you were *really* in focus? We all could use bifocals.

We were thinking about the "whole picture" the other day, contemplating the role of the poets in the Poet's Corner. (Swinburne & Samain are products of the staid and highly influencial Victorian Period.)

As Victoria grew old, the approved customs aged with her and solidified into a formalism of dress, behavior and thought that labelled artificiality, "reality", and banished emotional-thinking to the tabooland of perpetual twilight. While this was the antithesis of Paine's "Commonsense" and Locke's "On Civil Government", the twilight was not darkness and the poets had a discerning following, large enough to grant them classical status.

Today, these same men, like many other original thinkers, would be frowned upon for being "different". It is a disquieting thought that we who pride ourselves on the courage and self-reliance of the individual should be enslaved by naive ignorant intolerance. Only history can give the objective evaluation, but I fear that the Victorian Period was more liberal than our own.

Imitation & Flattery*

Goody!! A goody for us who like kicks
. . . offbeat amusement — odd little tricks.
My dear, I don't mean to plagiarize
just to agree and to sympathize
Born a man . . . I have no regret
if only society would forgive and forget
Let every man be free to pick his place
and . . . if he chooses, silks, satins, and lace
I long for a woman, one who thrills
. . . the scent of a rare perfume, feminine frills
A gentile smile . . . long flowing hair
well-rounded breasts, I can't help but stare
I love her tiny waist — her curvaceous hip
in a merry widow's mould, sheathed in a lacy slip
Shapely thighs, legs, ankles — on heels pencil thin
a luscious pair of nylone — sends a quiver to my chin
Only another gal . . . when passing by
will get the message — the flash of an eye
The magic power of the feminine mind
in my soul I am searching that I too may find
The deep feeling one girl has for another
the closeness, nearness, a daughter to her mother
All of this beauty — is missed I regret
by ordinary man, fulfilling society's debt
My mind is different — trials and tribulations
tenderness, happiness, and a bit of humiliation.

6

Were we to pass up on some great city's street
I am an ordinary looking guy, lest our eyes should meet
And if you got their message, we both could tell
here's a feminine friendship . . . a wishing well.
You would know at once my desire
to be like you . . . my heart's on fire.
To spend happy hours in some sweet repose
engulfed in your affections and your feminine clothes
Pink silk panties, billowing petticoat, and brassiere,
high-heeled shoes, nylon hose — I love them, my dear
A lovely frock with make-up divine
I am yours . . . Will you be mine?
Our chances of meeting, they're one in a million
they could be worse, one in a billion
It makes me happy to know you are real
my heart is with you, I know how you feel.
You have dissolved my inhibitions — dressed me as a gal
I adore you for doing it . . .

<div align="center">Your feminine pal!
KIM</div>

*See p. 10 No. 23

CLEOPATRA
by Albert Samain (1858-1900)

Silently gazing from the tower, apart,
The Queen, whose night-black hair is bound with braid,
Feels, in a trance of censors slowly, swayed,
Your sea O immense love, mount in her heart.
Her eyelids close on dreams, and she is laid
Among her cushions, swooning as she rests;
The heavy gold chain lifted by her breasts
Tell the mute, fevered longing of the maid.
Over the monuments float strange farewells;
The evening, soft with shade, is full of spells;
And, while the crocodiles far distant weep,
The Queen, hands clenched and sobbing to have sinned
Shudders to feel lascivious fingers creep
Among her hair and spread it to the wind.

CHARLES BAUDELAIRE

Strays far from the perfume and flowers type of poetry . . .

THE LOVE OF DECEIT
(L'Amour du Mensonge)

I

Whenever I see you pass, dear indolent one,
Amidst the surge of music in breaking waves,
Dangling your somnolent and slow allure,
Flaunting the ennui of your moody gaze,

III

I muse: How lovely she is, how fresh, bizarre!
The massive tower of memory looms above
And regally crowns her. Bruised as a fallen peach,
Her heart is ripe as her body for subtlest love.

VI

Shall not the semblance alone suffice for me,
To rejoice my heart, since Verity I forswore?
What matter stupidity or indifference?
Hail, mask, dear counterfeit! I bow, adore!

* * *

(. . . and his English follower, Swinburne, measures his tracks)

DOLORES
by A. C. Swinburne

Cold eyelids that hide like a jewel
 Hard eyes that grow soft for an hour;
The heavy white limbs and the cruel
 Red mouth like a venomous flower:
When these are gone by with their glories,
 What shall rest of thee then, what remain,
O mystic and sombre Dolores,
 Our Lady of Pain?
O lips full of lust and of laughter,
 Curled snakes that are fed from my breast,
Bite hard, lest remembrance come after
 And press with new lips where you pressed,
For my heart too springs up at the pressure,
 Mine eyelids too moisten and burn;
Ah, feed me and fill me with pleasure
 Ere pain come in turn.

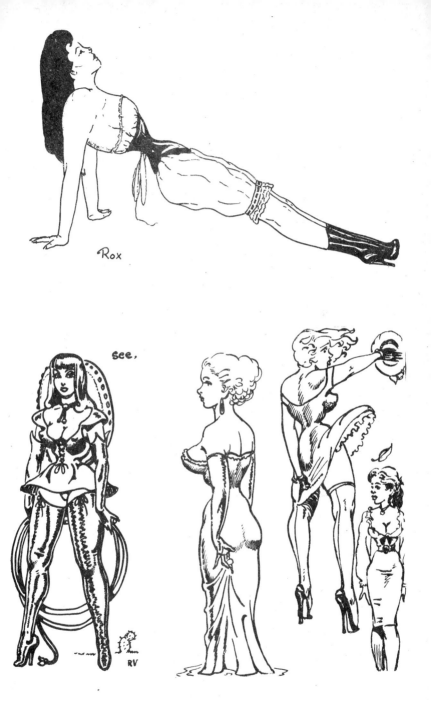

Rox

see.

RV

READER DRAWINGS

There are sins it may be to discover,
 There are deeds it may be to delight.
What new work wilt thou find for thy lover,
 What new passions for daytime or night?
What spells that they know not a word of
 Whose lives are as leaves overblown?
What tortures undreamt or, unheard of,
 Unwritten, unknown?
By the ravenous teeth that have smitten
 Through the kisses that blossom and bud,
By the lips intertwisted and bitten
 Till the foam has a savour of blood,
By the pulse as it rises and falters,
 By the hands as they slacken and strain,
I adjure thee, respond from thine altars,
 Our Lady of Pain.
Love listens, and paler than ashes,
 Through his curls as the crown on them slips,
Lifts lanquid wet eyelids and lashes,
 And laughs with insatiable lips.
Thou shalt hush him with heavy caresses,
 With music that scares the profane;
Thou shalt darken his eyes with thy tresses,
 Our Lady of Pain.
Thou shalt blind his bright eyes though he wrestle,
Thou shalt chain his light limbs though he strive;
In his lips all thy serpents shall nestle,
 In his hands all thy cruelties thrive.
In the daytime thy voice shall go through him,
 In his dreams he shall feel thee and ache;
Thou shalt kindle by night and subdue him
 Asleep and awake.
Thou wert fair in the fearless old fashion,
 And thy limbs are as melodies yet,
And move to the music of passion
 With lithe and lascivious regret.
What ailed us, O gods, to desert you
 For creeds that refuse and restrain?
Come down and redeem us from virtue.
 Our Lady of Pain.

A MODEL'S DAY AT HOME

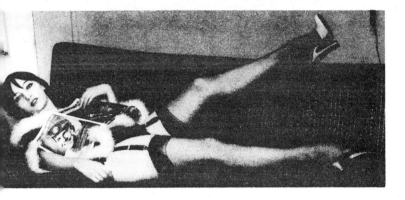

READING

RECESS

RESTING

REFLECTION

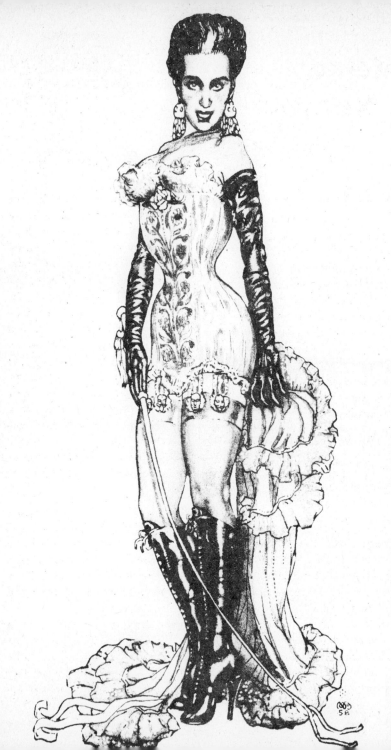

More Memoirs

of Paula Sanchez

Editor Bizarre:

According to all that I have read about wide, tight belts worn by men, they impart a feeling of virility and strength to a man. This has been discovered in many parts of the world. A friend read to me an interesting article: *Corsets and Corpulence* which was on page 312 volume XIV of the *London Society Magazine* of 1869 in which a middle aged Englishman describes the pleasure he had from tight belt wearing.

My friend, bringing me back issues of Bizarre called my attention — among other things — to several requests for more about Grandmother.

It is a lazy spring day, rather warm, and I'm sitting by the window looking out over the San Francisco Bay with the typewriter before me. It may intrigue some of your readers to know I am laced to 17 inches. I like the support of a corset when I sit typing. Beside me is Grandmother's diary from which I shall try to reconstruct what she told me about the

household in Paris in which she stayed for some years as a quasi-servant, where the master was an *afficionade* of hour-glass figures.

Gmother came from the country in France to Paris to escape the drudgery of the farm. She had no prospects, but anything was better than what she had had on the small place run by her ill-tempered distant relatives, her closest of kin. She was a buxom, strong, country lass of full figure and pink-and-blonde complexion. Like any girl of those days who hoped to get ahead she had inured herself to tight lacing. It was as normal a wearing high heels is today.

She had failed in finding a place as a maid and was despairing of being able to stay and subsist in Paris when she heard of a lady who was interviewing girls for a country estate near Paris and went to see her.

The lady turned out to be a middle-aged woman, past her first good-looks perhaps, but quite beautiful in a large, maternal way and although dressed in the ap-

proved quiet housekeeper's garb, looked more like an actress playing the part of a housekeeper than a real housekeeper. For one thing she was skillfully but heavily made up. For another, she was laced to such an extreme that it seemed as if she must break in two as she lowered herself carefully but gracefully into the chair. Even in those days of hour-glass figures Gmother had never seen such a large woman with such a small waist.

Gmother began to be a little curious and uncertain, but being in no position to be too particular, decided to see the thing thru. Routine preliminaries ascertained that the pay was good and the duties surprisingly light. The lady seemed to hesitate about going further so Gmother prompted her by saying: "There must be some other special conditions attaching to this place of which I have not yet heard." The housekeeper replied: "Yes, but I am not yet sure how to put them to you." "Perhaps if you gave me a general idea of what kind of conditions there may be I could tell whether I might be able to accept them," said Grandmother.

"The one chief condition, upon which others depend, is that my master stipulates that you shall dress exactly as you are told at all times and that you never leave the premises unaccompanied during your term of service. If you can assent to these, then we can discuss further, otherwise let us give up now," replied the housekeeper. Gmother inquired as to whether some sort of uniform was not think of any reason why she should not dress as the master pleased. Also, since she had no friends or relatives she wanted to visit she would not find the second condition too much of a hardship.

"I notice that you have a good figure" said the lady, "your master will be interested in seeing that you have a much better one while in his service. Are you willing to submit to whatever training is necessary?" Gmother could see nothing wrong with that either, so proceeded to reach for the contract which the lady had prepared.

"Now that you have agreed to these conditions I think I should give you one more opportunity to decline the position. You will be treated very generously if you will accept it, but it means giving up certain liberties and submitting to a rather unusual routine of training. My master is a very rich and powerful man whose whim it is to surround himself with women hose figures represent his sophisticated taste. In short he can endure only very tightly corsetted women in his establishment.

14

Are you willing to be very tightly laced?"

Gmother had already felt a strange excitement about the housekeeper's tiny waist and now, to her own surprise, the words fairly tumbled out: "I should ever so much love to be laced as tightly as you are!"

The housekeeper smiled and put her hands to her waist. She could completely encompass it with her two hands. Then she said: "You will get along very well, I am sure, but let us waste no time, even before we drive to the villa your training should begin. The master neer permits any woman past the gates who does not bow to his dictates about corseting. So we must lace you up in a preliminary way now."

Gmother's diary notes that they went into a bedroom where a maid was in attendance. She was asked to disrobe completely after measurements had been made over the corset she was wearing. While she was doing this a number of corsets of beautiful design and finish were laid out on the bed. She had never had a chance to wear such finery and by now was quite excited by the whole prospect. She was further titillated when several pairs of high-heeled slippers were brought out. She made every effort to walk without turning the heels of those which were chosen for her, but it was with difficulty because she had never worn such high ones. Mrs. Boule, the housekeeper, told her not to worry about that yet, for learning to walk in heels was simple compared to the business of reducing the waist.

Gmother was told to take hold of the tops of two posts which arose from the foot of the single bed. She was powdered liberally over the middle torso and a rather short corset placed around her. Mme. Boule said it was a training corset and would later be replaced by others. The corset was laced to conform to Gmother's hips below and to her chest above, the middle section remaining loose at first. Then the top laces were tied off as were the bottom. She was asked to take a full breath and just as her breast heaved upward with the inhalation the strings of the middle section were quickly tightened while she held her breath. With both the maid and Mme. Boule pulling on the laces she felt her abdomen being pushed downward and her chest upward. She grimly held the air in her lungs tho she felt as if she would burst with the sudden pressure. Her midsection became quite numb and she felt somewhat dizzy. The laces were tied off and Mme. Boule said: "Rest, take a little sherry.

You are doing very well. Do you feel faint?" Gmother had never fainted, and said so. With the lacing halted she felt strangely cut in two, but not bad, tho when she essayed walking in the heels that a minute before had been only a small problem she found her hips swung so violently from side to side that she staggered. And when she essayed sitting down the pressure was so great that she had to lean backward and spread her legs. She caught sight of herself in the mirror and was astounded at her changed figure.

"What are my measurements now?" she panted, between sips of sherry.

"My child, you are only beginning, don't worry about that yet. I should say you were around eighteen inches. That is not at all unusual. We have much further to go before I dare show you to the master. But be patient."

After a rest Gmother stood at the foot of the bed again. Now a leather belt was placed around her and tightened over the corset until the waist laces loosened a bit as it came together. Then they were tightened and the belt tightened again. By now Gmother felt as if she had completely lost track of the lower part of her body. She felt delightfully taller and she could see that her bosom had become a much more important fea-

ture of her anatomy than it had been previously. "Like a pouter-pigeon." she announced, rather giddily, between gasps.

"I have been waiting for you to show signs of fainting, but you are remarkable, you do not. Even though you could probably stand more I think this is enough for now" Mmme. Boule announced. "Now you must eat and drink as much as you can. This it to help your body to adjust. Also, you must exercise."

Gmother felt she could not walk, let alone exercise, but first she was given deep breathing, which raised he chest quite out of the corset and she felt that it did not settle into the corset again. Then she was told to place her hands on her hips and press down as hard as she could, raising her chest still more. At first she tried walking in her new shoes, but could not keep her balance, and they were taken off. Mmme. Boule told her to stand with legs braced apart and arms outstretched to each side and then to swing to the left and to the right as far as she could. This twisting motion was followed by bends to the right, left, forward and back, which she performed with considerable difficulty. Then the shoes were donned again and this time she was able to carry out the same twists and bends and to walk with-

16

out losing her balance completely, though her hips jerked wildly from side to side as the weight went from one foot to the other. Mme. Boule told her to keep her heels on a straight line and turn toes out and she found this a better way to walk in the corset. Between bouts of exercising she was offered various kinds of bulky, filling food, such as potatoes and other vegetables. In order to increase her appetite she was given glasses of vermouth during this period. Mme. Boule told her there was a limit to what lacing could do. To achieve the desired figure she should also have to gain weight, but above and below the corset. Finally, quite purple from stuffing and tired from exercising she was allowed to lie down. The corset suddenly seemed looser and she felt quite comfortable and sleepy. The maid and Mme. Boule now dressed her and she was helped to the carriage in the rear of the house. As she sat in the carriage drowsily watching the houses pass by as they jogged along she felt as though the morning had marked a transition into another life. It all seemed like an unlikely dream and she surreptitiously put her hands to her waist to see if it had really all happened. She put her hands in the position where she usually clasped her waist and

there was nothing there! For a wild moment she felt as tho she had completely lost her lower body! But the numbness was now receding and faint aches were appearing here and there. On bringing her hands together she finally found her new, tiny, stem-like waist, completely round and as hard as if it had been turned out of wood. She felt the thick steels of the corset under her light gown and looked down at her feet, which loked very small in the stilt heeled shoes. Mme. Boule, beside her, asked if she felt any discomfort. Gmother said there were a few faint throbbings and aches here and there.

"That you must bear, my dear, until your figure has adjusted. Many parts of the body must take new and unaccustomed positions. For instance, do you feel a small tendernes just below the pit of your neck? That will be due to the upward and outward movement of the breast bone accommodating itself to the pressure from beneath. You may have a sedative if you wish and sleep the rest of the way, for the jouncing of the carriage may cause some discomfort altho the movement is good for you. Rest now, for when we get to your new home there will be much strenuous work to do."

17

Mme. Boule placed a large cushion behind Gmother's back. She was encouraged to lie in a spread eagle fashion, legs apart and arms apart in the roomy carriage. So she dozen off to sleep as the carriage carried her towards her new adventure.

Gmother awoke with a start. She was in a large comfortable bed with a softer mattress than ever she had slept upon and bolstered comfortably by many feather-soft pillows. She was conscious first of sunlight streaming from a large window thru which she could see trees and blue sky and then, as her eyes strayed to the appointments of the exquisitely furnished Victorian bedroom she became conscious of various dull aches and pains in her torso. The ever-so-tight corset was still gripping her in a vise of steel and for the first time she felt irritated and angry at it. Its edges seemed to be chafing her skin and she wriggled, trying to change her position a little within its unyielding pressure. Then she tried to sit up, but found she could not. Finally the determination to loosen the laces even a little caused her to make further efforts. She rolled over on her stomach and succeeded in pushing herself erect with her arms and then felt for the laces in the rear. She discovered the knot of the middle section was

covered by a wide leather belt that had been strapped tightly around her and that this belt was secured with a small padlock! There was no way out without cutting the laces and even then the belt would retain the small waist. The sitting position made the pressure of the corset greater. The bosom was thrust up almost level with her chin and her abdomen thrust out like a small shelf below the short front of the corset. She essayed getting out of bed and stood up bracing her feet wide apart to avoid falling. When she took a step she was almost thrown by a violent jerk of her hips to that side. She took the next step and her hips, seemingly propelled by some force outside herself sprung far out on the other side. She could only keep her balance by adjusting the upper part of her body to these movements. By dint of a carefully calculated series of movements she was able to make her way to the lace curtained window and for the moment forgot her immediate troubles at the sight of the sunny garden below her.

It looked almost as if a garden party were in progress, for a bevy of beautiful girls in pastel-colored, summer-light gowns were moving around garden walks. Wide summer hats and gay parasols were much in evidence. Never had she seen such an array of

frills, furbelows and summery elegance. The pleasant confusion of feminine chatter reached her third story window like a murmur. It was not until one of the girls dropped her parasol that she noticed anything unusual but the elegant appearance of the gathering. There was a noticeable slackening of the chatter. Gmother wondered why the girl did not just lean over and pick it up. This indeed she essayed to do . . but stopped half-bent and straightened up again. Gmother suddenly realized that the girl was so tightly laced that she could not lean over. Then, carefully and with considerable grace, the girl bent her knees slowly, sank to the grass with wide skirts billowing around her and retrieved the parasol. She arose swaying a bit perilously, and after a bit of breast-heaving and deep breathing returned to her decorous walk. The others, who had watched this performance as though it were a matter of some moment again relapsed into conversational chatter.

There was a high wall between the garden and a deserted lane. But most of the place was surrounded with shrubs and trees with pleasant open lawns and some areas of formal gardening which displayed the curious form of tree-training known as topiary work, in which trees are trained in the forms of animals. She noted a swan, a peacock and even a deer recognizable in the shapes of these trimmed trees.

She was interrupted in these observations by a knock on her door. Mme. Boule greeted her briskly: "I trust you slept fairly well because we must be on with your training. I see that you have been watching the girls at their morning walk. You will be allowed to join them as soon as you have learned the rules of the establishment and the deportment required of you."

Gmother said, somewhat querilously: "I do not wish to complain, but this corset is giving me a good deal of trouble. May I remove it for even a little while?"

"That is just what we are about to do," said Mme. Boule. She went to the door and called to someone outside and two smiling girls entered the room. "This is Celeste," said Mme. Boule, gesturing toward a peaches and cream blonde, "and this is Marta." Marta was as brunette as Celeste was blonde. Both were dressed in white smocks which covered them down to their ankles. "These girls will help you get started. Leave everything to them and do exactly as they say." Mme. Boule left.

"While we are preparing you should have your coffee." said Celeste, bring a tray in from outside.

Gmother sat down gingerly and accepted it eagerly. She was surprised to find it liberally laced with a liqueur with a pleasant orange blossom aroma. She felt better immediately after the first cup. Meanwhile the two girls were busying themselves, one in an adjacent bathroom, the other laying out various articles on the dresser. When she had finished her coffee Gmother essayed to rise, but Celeste said: "One of the rules of the establishment in figure training is never to hurry about anything. You must cultivate the habit of complete relaxation. Consciously slow up every movement and execute it correctly and with grace and rhythm until you can do the same thing faster with no uncertainty. Now you must eat this." She placed a huge bowl of oatmeal cereal before Gmother, liberally drowned in cream.

"I am so surprised at many things that I am full of questions," said Gmother, "I hardly know what to ask first! May I ask why you give me this bulky food, which will surely make me fat, now?"

"Your questions will all be answered in due time, so don't ask too many at first, but I can tell you that since you are about to undergo rigorous figure training you must eat for two reasons: first, to keep your passages open and functioning during the period of adjustment to your corsets and second, to gain enough weight so there will be flesh to readjust into your new shape. By our standards you are too thin for your bony structure. So eat your oatmeal."

So Gmother ate more breakfast than she had ever done before, marvelling at her own appetite and afterward felt as tight as a drum head inside the corset. But this situation was immediately relieved. She was helped to a reclining position on the bed, the lock was undone and the laces untied. The released corset split open and collapsed on both sides of her as she took what seemed to have been her first deep breath for hours. She was helped up, for she felt strangely unsupported without the corset, and to the bathtub, where she was allowed to soak deliciously for several minutes. Then she was again helped to the bed where she was annointed with cream and massaged, with particular attention to the tender spots. Several red chafe marks had appeared where the edge of the corset had rubbed her skin.

"We shall attend to that with a better fitting one, which will have a soft material which cannot chafe at its edges," said Celeste. So still reclining in a prone position, a somewhat longer corset was placed around her and laced up

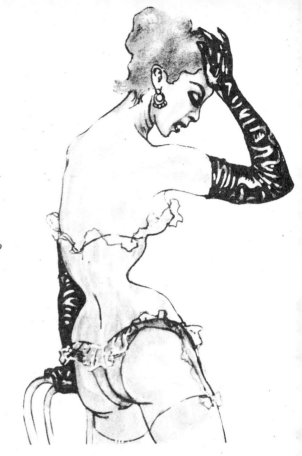

*Her midsection
became quite numb
and she felt
quite dizzy.*

the back and sides until it con-
formed loosely to her figure. "Now
the fullest breath you can take,"
said Celeste, and Gmother filled
her lungs. A sudden, vise-like grip
caught her waistline. "Hold the
breath," commanded Celeste.
Gmother held her breath grimly
but turned her head to see, if she
could, how this relentless contin-
uing pressure was being applied.
She was amazed to see Marta pull-
ing downward on a cord from the
ceiling. The double laces of the

mid-riff section of the corset had
been looped over a hook which in
turn was fastened to a cord run-
ning thru a pulley in the ceiling.
Celeste was manipulating the laces
deftly so they slid easily while the
cord took up any slack thus pro-
duced. Gmother felt her body
being slightly raised from the bed.
Celeste now climbed on the bed
and put a dainty, high-heeled foot
on the small of Gmother's back
and pushed down. The corset
tightened to the point where again

21

Gmother could feel nothing at all at her waist.

A tape measure was brought, Celeste pronounced the constriction "enough for now" and the wide leather belt with the lock was again installed.

Gmother was instructed to pull her knees up under her slowly. She felt as if her lower body had nothing to do with her and wondered that she had any control of it. Then she was helped to a standing position. A kind of harness was put under her arm pits and hooked to the same cord over the pulley and her ankles were strapped to a hook in the floor.

"Now we are going to stretch you. While we are doing this you must breathe deep and wrigggle as far out of the corset as you can. Push down on your hips with your hands and breathe until you feel your chest pushing up out of the corset." The girls threw their weight on the cord and Gmother pushed on her hips with might and main. She could feel her body lengthening and as it did so the pressure was somewhat relieved. While Marta held the rope Celeste put her hands inside the front of Gmother's corset and massaged the flesh there upward. At her command Gmother leaned as far back as she could. The cord was tied, holding her in stretched position and a new device was placed around her shoulders.

"This is a chest improver," said Celeste. "We will tighten it at the back and it will cause your shoulders to come back and your chest to widen."

There was a pause, when Gmother was given more of the coffee.

"Now let us release the cord and see if you settle too much into your corset," said Celeste. Gmother felt the floor once more pushing against her feet and a very little shifting downward of her torso in the upper part of the corset. Celeste immediately called for stretching again and the corset laces at the side were tightened. Now the lifting cord was released and this time her body settled not at all.

"Well," said Celeste, "Marta, we shall have to look to our honors around here. This one doesn't seem to faint easily!"

Gmother thought now she might be allowed to rest, but was soon disabused of that idea. "The more you move the sooner you will adjust. The more bulky food you can get down the sooner your interior will properly adjust. It's walk, wiggle and stuff my dear, for these first few days! Well, after that I think we can relax a bit and have some wine."

Gmother, now free of the cords

22

and straps, but still wearing the "chest improver" tried sitting down, but found the increased pressure of the corset intolerable. Marta, who had not said a word, so far, suddenly spoke in a deep voice: "Sit on pillows at first and then take them out one by one as your body adjusts." So Gmother sat on two pillows on the chair, legs spread wide apart. She looked down and was surprised to see how her abdomen protruded below the corset. She *had* to spread her legs to accommodate it!

The two girls were drinking the wine thirstily. Gmother said: "It is early in the morning. I am rather surprised that we are allowed to drink while in service—especially so early in the morning."

"You are allowed all you want and encouraged to take it, but woe betide the girl that gets really drunk. When you begin to stagger and giggle a little mark my word — that is enough! The punishments for exceeding are severe. Let us not even consider them!"

"I feel as if I were being prepared for taking a prize at a fair," said Gmother," can you tell me more about what I shall be expected to do? So far, I have only been pampered. What work is there to do? I thought I was to be a maid waiting on a table and here I find myself treated like the mistress, instead."

Celeste fixed her with a knowing eye. "We are slaves of our master's whim, my dear. You would not have been brought here if you had not indicated that you were willing to submit to his harmless little notions. Your duties here will be very light. Your chief duty will be to *look as he would have you look.* By following this rule you will become a success in this strange establishment. If you excel you will be able to retire from it with a very pleasant amount of money. If you cause trouble you will find yourself suddenly transported back to the place you came from. If then you think you can make a scandal you will be surprised how soon you will be called mad and hysterical. Our master is a very important man who happens to enjoy feasting his eyes upon plump, corsetted women. He pays well to satisfy this whim and, so far as I know has never made any other demands. In this rough world one must always choose certain compromises. We have chosen this one and find it an odd, but very completely satisfying way of living. You would do well to join us whole-heartedly. Really, our only duties, aside from negligible household tasks, are concerned with pleasing the master. You may as well know now that we are all in competition, to a certain ex-

tent. There are prizes and bonuses of various sorts for achieving the proper corset deportment. To begin with, to give you some idea, there is a prize for the girl with the most weight and the smallest waist! This is given once a year. But there are also many others. You will have to decide in what category your natural abilities will allow you to compete successfully. But for the present, learn to move gracefully in high heels and a tight corset and gain some weight. After that we shall see."

After this little speech Celeste applied herself to the wine. Gmother felt pleasantly giddy, whether from the wine or from the constriction, she could not tell and decided it would be pleasant to try to walk in her new high slippers. So her stockings were brought and gartered up and the little slippers put on. When she stood up she was amused. It seemed funny that she did not quite know what her legs were going to do. Her feeling of constriction was now definitely mixed with strangely pleasurable sensations. She took a step but the sway of her hips and the involuntary movements of her upper body were so exaggerated that she would have fallen if Celeste and Marta had not helped her. They steadied her on her first trip across the room and on the return and indeed until she was able to balance herself. She finally was able, by moving very deliberately, to walk without being jerked off balance.

"Now pick a straight line in the floor," said Celeste, "and place your heels on it every step, keeping the feet turned out. Take very short steps and shift your weight very slowly."

Gmother practiced that until she felt she had considerable control. But Celeste added another difficulty: "Now balance this book on your head and do it looking straight ahead instead of down at the line."

They kept at her in this way, stopping now and then for sips of wine, for an hour or more.

One of the difficulties in walking had to do with the fact that Gmother could scarcely stand in the high-heeled shoes without bending her knees. Quite aside from the adjustment to the corset she began feeling stretched muscles in her legs. The girls told her that the leg muscles must also adjust to the new vertical position of the foot, and that this too would take much time and practice.

"I found foot-corsets of great use in my first days here," Marta said. "The difficulty about heels

24

is that the minute you sit down the muscles spring back to their old position. You can cause them to adjust sooner if you keep them in the high-heel position even in bed. It is a little like Chinese foot-binding. Slowly you get used to walking on your toes."

A pair of curious little boots with no heels, but with stiffening along the sole and up the ankle, with straps across the lower leg and across the foot, to hold it in position against the shaped metal were brought. These were not for walking but for foot training while resting. They held the foot in the position of a ballet dancer on her toes.

Celeste and Marta had all this time retained the voluminous smocks which covered them almost from head to toe. Their only indication of glamour were the beautifully shod feet which peeped out from under the gowns and a certain care and elaboration of *coiffure* and *maquillage*. It occurred to Gmother that when they were resting the rather stiff smocks fell into folds which betrayed rather unusual figures underneath.

"Must you always wear these smocks when you work around the house?" asked Gmother.

The girls exchanged glances and Celeste said: "Well, you seem to be one of us now, so there is no longer any reason for concealment.

we wear these only when we have a new candidate to break in, for sometimes it comes as something of a shock to them at first to see us as we really are." With this she stood up, unbottoned the garment and let it fall to the floor.

Gmother gasped. Celeste was a vision in pink and black satin and of a figure that could hardly be imagined. A swan-like neck surmounted dimpled shoulders. Great expanses of bosom were revealed above a kind of frothy black ruffle which sprang like the corolla of a flower from the top of her corset. As she breathed the nipples peeped above this ruffle. On each was a pink jewel which gleamed in the changing light. The soft, billowing flesh burst above a pink-satin corset which enclosed her to the line of the hip bones. Here another black ruffle, like a short tu-tu. The garters were again pink and jewelled and the stocking long, sheer and black. Pink satin pumps finished the ensemble.

Celeste had small hands, small feet. Her ankles and wrists were delicate. Attention was focused upon the smallness of these parts by delicate bracelets and enclosing them. In contrast her hips and bosom were truly vast and quiveringly plump. There were dimples in the peaches-and-cream elbows just as there were in her cheeks.

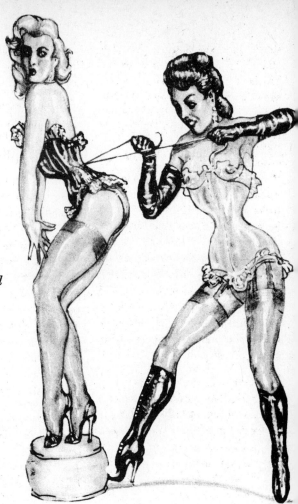

*The strings
of the middle section
were quickly tightened
while she
held her breath.*

Her knees showed dimples thru the silk of her stockings. Plumpness pouted over the tops of her pumps and around the delicate constriction of the bracelets. But the point of greatest diminution was the waist, which appeared to be smaller than her neck.

The corset itself was the most elaborate garment of its kind

Gmother had ever seen. The graceful lines of the steels, wide apart at the top and bottom came together, so there was very little space between them at the long narrow waist. Their lines increased the effect of diminishing to nothing. Whereas at first glance the corset had appeared to be black satin, on closer examination the

steels showed outlined in grey stitching. The satin was richly brocaded in a design which showed up now dull, now shining. Celeste's wide hips distended the garment at the bottom. Indeed it was cut out over the hips, but came down severely in front, with many steels to force the abdomen inward. In contrast the hips and buttocks were quite free and moved in an exaggerated way with her slightest step. When she walked down the room and turned Gmother saw how the jerking from side to side which she had experienced could be turned into a graceful swivelling motion which made the hips and buttocks an exciting center of attention.

Celeste's breathing caused another kind of movement, for her chest rose up and down directly upward out of the corset causing her breasts to appear to spill out over its edge and then to sink back in. A deep breath caused the nipples to be fully exposed and the breasts to spread outward as well as upward. To accommodate this swelling Celeste stood with her arms well back and a little out to the sides, for the plumpness pushed up by the corset under her arms made it difficult to hold them close to her body.

But the tiny waist, which cut almost horizontally inward above the jutting hips held chief attention.

Gmother was staring unbelievingly at Celeste's waistline when Marta, who had been a little slower about doffing her smock, stood up and threw it to one side.

Instead of black and pink her color scheme was chartreuse and emerald. And instead of her corset covering the abdomen as did Celeste's it was cut out in front, though gartered firmly down the sides, to display a beautiful, jutting abdomen. The navel, visible a few inches below the corset line, faced upward and was marked by a large, green jewel. Whereas Celeste jutted out behind and was strictly corsetted in the front, Marta's free abdomen was a feature of her costuming.

Her skin was creamy brown, but very pale, so as to seem almost translucent. As she turned she displayed chartreuse laces in an emerald corset which was richly brocaded in two tones. Where Celeste's buttocks were free, pinkly powdered and made up, Marta's were tightly confined by the back length of her corset, which was held in position by straps around her thighs. Although also large breasted and plump by ordinary standards Marta's costume obviously featured the abdomen. She was larger in build than Celeste

and bigger boned. Very long legs supported very wide hips and whereas Celeste stood with her breast protruding Marta's abdomen led the way.

Gmother was so surprised as to be speechless at first. Finally she gasped: "Here I am thinking I'm laced tight! How do you stand it?"

Smiling, Celeste put her hands on her hips and bowed forward smartly almost from the hips, because of the inflexibility of her waist. Then she showed that she could lean to the side. And lifting her arms rotated the upper part of her body, to show that she was quite free in the corset. Then, balancing herself with her arms outstretched to the side, she placed her tiny stilt heels together, turned her toes outwards and executed a squat, with knees bending outward at right angles to each other.

"The exercises you have seen me do are the secret. You must practice them until you have perfect control. Of course I've been at it a long time."

"Celeste won first place in the body control competition last week," said Marta.

"If I can only gain a little more weight I'll take that weight against waistmeasure prize too," said Celeste. "I'm able to hold thirteen all the time, but so far I get faint after more than a half hour of twelve, so I'll probably have to put on some pounds instead of lacing tighter. But each of us has some specialty that we cultivate, depending on the kind of figure we choose. You should see Marta make that navel of hers do tricks! And how she can bend forward! She can pick up a coin on the ground without bending her knees!" Marta obliged by causing her stomach region to gyrate thru muscular control. The emerald-like stone flashed in the light.

"I don't think I could ever compete with you," said Gmother.

"Oh yes, you will," Celeste laughed "You're taking the preliminaries faster than anyone I ever saw."

"But I've only been in this corset about two hours and it hurts terribly!"

"Then it's time to massage your skin and change corsets. You'd be surprised how just a little difference makes you more comfortable."

This time, when the corset was taken off Gmother's waist felt so numb she couldn't sit up and the girls rubbed the skin where it exhibited signs of pressure with cold cream. This time her body was quite liberally greased with cold cream and as the new corset tightened she felt her ribs slipping

upward as the pressure increased. Just when the pressure seemed intolerable the laces were eased off again and the belt replaced. After this exertion everyone was panting and had recourse to the wine decanter again. Gmother was helped to her feet, and rather to her own surprise was able to walk slowly across the room to the chair where she had sat before. Her chafing was entirely relieved.

She drank liberally of the wine and soon felt quite happy and adventurous. Having seen Celeste do twisting and squatting exercises she felt moved to try them for herself. There was much merriment as she tried suddenly twisting and succeeded only in throwing herself off her feet and she fell rather heavily on one side. As she essayed to rise she was surprised to find Celeste and Marta gleefully pushing her downwards instead of helping her to rise. When she would almost make it to her feet she found herself pushed off the precarious balance on the high heels so that she was forced to go through the business of drawing up her legs under her and pushing herself off the floor with her arms several times. The girls just laughed when she protested. She grew stubborn and angry, determined to get up without asking for help. Finally they sat back and let her get up, puzzled and angry

at their unfriendly treatment.

"You probably think we are mean, but that is the best corset training you can practice. The more you tumble around and have to adjust yourself to being so tightly bound the sooner you will be graceful," said Marta. "In fact," Celeste added, "the very fact that you can get up shows you could be laced tighter right now. The sooner we get you down to your limit the better, because after that it is only a matter of holding the line, instead of spending days getting there."

So Gmother lay on her back and 'the new corset, which had seemed easy on her since she had been cold creamed, was again tightened until she felt a dizziness overtaking her. When she complained about that they eased off the strings and gave her more wine. She felt tired and drowsy now and she was quite willing to lie down for a nap. In doing so she became again aware of the changed contours of her figure, for her back had to be supported by a specially shaped pillow, such was the indentation. The corset was so stiff with steel that her body could not bend to accommodate itself to the bed. So she now lay in a special U shaped cushion which held her waistline, letting her hips and bust touch the sheet, but supporting her

Gmother fell asleep on a very full stomach, so very full that she put her hands down to the place where it bulged below the corset front. She soon fell asleep.

In looking over the succeeding pages of Gmother's diary it appears that the next few days were pretty much alike. Gmother was laced and unlaced several times a day and her body continually massaged. She was given all the rich food she could eat and much vermouth and wine to give her an appetite. Contributing to the appetite were the continual exercises. It seemed that every few hours she would be groaning thru some impossible feat. She learned to keep her balance on one leg with a book on her head. She bent, twisted, squatted and rolled on the floor. Marta and she engaged in wrestling matches, to see who could put the other flat on her back and hold her there. Soreness of bones and muscles readjusting to the unaccustomed activity and the tight corset and high heels was ameliorated by frequent hot baths and massage. The corset was laced no tighter, but higher heels were brought.

hour-glass middle. As she dozed off she could feel her breast-bone giving a little as she took a deep breath, for her breathing now was entirely upward.

Celeste came to her once more before letting her go to sleep. "You must drink this cream three times a day until you gain weight," she said. "We cannot lace you any tighter, so you must fill out in bosom and hips to set off your waist. Here, drink it like a good girl."

During this time Celeste and Marta introduced other girls, each of whom seemed to have some special interest in beautifying. The story of the various *coiffures* which were tried fills several pages,

for two of the girls were skilled hairdressers. It was considered for a time that Gmother should be made into a red head, but that idea was given up because of the quality of her skin coloring. -Another whole set of experiences had to do with settling on cosmetics. The story of choosing shoes and types of shoes is a long one. It was decided that Gmother was more suitably shod in the delicate, fragile type of shoe than in boots. Accordingly she had to learn to walk in shoes which offered very little support except at the tip toe and the heel: she had to train herself to stand on her toes like a ballet dancer. All this time Mme. Boule was observing and counselling with Celeste and Marta. The big question now was: to what *type* of figure should Gmother be trained? There were girls with great bosoms and narrow hips, with wide hips and small pointed bosoms, girls in which emphasis was upon the legs, or upon the arms, or upon the hair, or some other part of the body. There were girls trained to acrobatic feats: one little Spanish lady, thirteen inch waist and all could do handsprings and walk the tight-vated plumpness to the point of rope. There were girls who culti-immobility. Every type of hour-glass figure was to be seen amongst the group. Gmother was finally advised that her hips and breasts together should be her chief points of attraction, with small hands and feet secondary. Instead of doing up her hair it was to be worn down the back and long. Gmother's hair had always been assiduously brushed and cared for and it fell behind to her knees, having never been trimmed. This was unusual for even those days. As to occupation, it was decided that Gmother should perform the services of a dining-room maid and that her secondary occupation was to be fine stitchery, at which she already had considerable skill.

Since these pages are already becoming so many it seems best to continue the story "in our next" —if the good editor indicates that he wants more of it! Next in the diary comes the description of the formal dinner, on which occasion Gmother first met "the Master," and of an amusing competition in which she surprised herself by winning a high place.

Until then . . .

Paula Sanchez

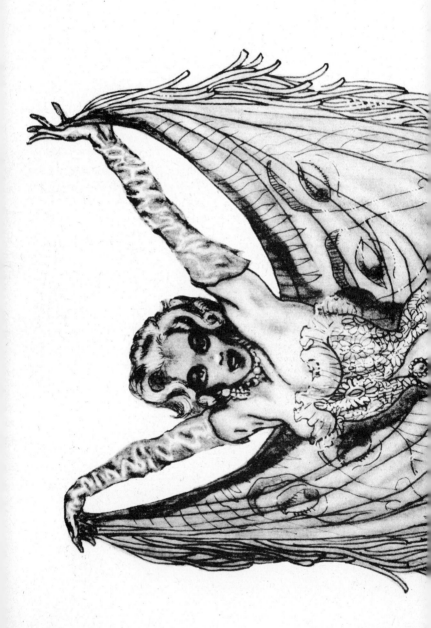

The navel, visible a few inches below the corset line, faced upward and was marked by a large green jewel.

Correspondence

Under no circumstances do we publish names and addresses, nor do we put readers in touch with each other. If photos or sketches are sent in, please write a short commentary and please do NOT send in photos which you got from someone else.

APOLOGIES TO "CHARLIE"

Dear Editor of Bizarre:

"Slings and Arrows"? — Yep, here comes a "Screaming Charlie" letter. Issue No. 23 was most disappointing. The reason? — Because there were no items or pics on the subject of spanking, though I will admit the picture in the upper right of page 49 and the one in the upper left on page 52 show feminine bottoms admirably well positioned and displayed for spanking. Why no letters, etc. on the fine art of corporal punishment in this issue for which we have waited so long?

An unusual experience in my youth has caused me to have a special interest in the subject of spanking. When I was about 12 years of age I played often with another little boy who was quite a bit younger, being about 6. He had a very attractive mother, and I was at the age when I was just beginning to become aware of feminine beauty. One day this boy invited me into his house and we began playing hide and seek.

I thought his family was not at home, so imagine my surprise when I burst into his mother's upstairs bedroom and found her seated at her vanity brushing her hair and *completely nude.* I shall never forget that beautiful sight — nor what happened next. Quite angry, she did not bother to cover herself, but seized me and took down my trousers and underpants. She then took me across her bare lap and spanked my nude bottom very long and very soundly. I can recall as if it were yesterday that thrilling but painful sensation as I was across her beautiful nude thighs, being punished in that manner. It left a lasting impression, and I still cannot see a photo or painting of a nude woman (especially if she is seated) without recalling that childhood experience.

Thus do the adventures and misadventures of youth shape our tastes and thoughts for life.

Yours for more on upturned derrieres.

"CHARLIE"

FIELD WORKER

My interest in "Slaverette Psychology" became active after I visited a girl-friend in the South.

Ruth owns a few acres of cotton. She has a husband who is the 'play-boy' type. Well things reached a climax and Ruth had the goods on Jack. She wrote me and invited me down to visit her and in the letter told me that she had solved her problem. I had an instructive visit and a most enjoyable one.

I arrived in the middle of the afternoon and Ruth took me out to the cotton field and introduced me to her older sister who lived with her and was in charge of the cotton operation. Ruth's older sister is a typical Amazon, but to get to the facts. In the hot sun with a large sack on his back was Jack picking cotton, and to top it all he was dressed in clubby work shoes (women's), black cotton stockings and a short cheap cotton dress. When he leaned over in his work I noted that he had on cheap frilled cotton bloomers and I noted also his hose were held up by plain white elastic garters. His bra contained 'deceivers' and his hair had grown into a short bob. I noted that despite the hot, hard work he was made-up with rouge and lipstick.

When he paused in his work of picking cotton Ruth' sister, this up" as she called it with her riding crop and believe me she made him move fast. He must work during the cotton picking season from sun-up to sun-down. The rest of the year he slaves at all sorts of tasks and I mean he slaves. As Ruth told me: "Jackie has lost all desire to run around at night; when bedtime arrives he is quite ready to put on his coarse flannel gown and drop to his cot in the little room next to mine. Why he is too tired to even remove his stockings and bra!"

If each day he does not pick his quota of cotton or perform his assigned tasks completely and satisfactory he receives the riding crop before he puts on his night gown. Ruth has many and varied punishments. I saw several administered, one gave me much amusement. He talked back one morning upon arising and as a punishment he was made to work all day in a pair of old fashioned women's drawers! No dress, just the shoes, stockings, bra and very frilly old fashioned drawers. To make him feel his punishment more Ruth invited her girl's "Chit-Chat Club" over and they witnessed 'Jackie' at his cotton picking. They got a kick out of it, especially when big sister tickled him with her riding crop as she did several times. How he danced in his frilled drawers to fine Amazon woman "perked him

35

the tune of that vicious little whip!

Sunday is 'Meditation Day'. On this day he is dressed in Sunday clothing, lace and frills, and on Sunday afternoon the "Deportment Book" is checked and read to him, all faults and misbehavior noted and if the week's report is not up to par he receives the leather strap. For this he is placed over a barrel in the barn out back and well fastened: he is prepared a ndwell strapped. I saw him get the strap and really, I assure you, it was complete and severe punishment! His modesty was not spared and I heard a 'lordly male' beg, and yes, scream and cry for mercy with promises to do better and be a better Jackie.

I intend to visit Ruth and her sister again and she is coming to visit me: you see I too had a problem and I, like Ruth, have solved mine, but that is another true story.

We would like to hear how other women have handled such situations and I assure you we get much help from your fine publication.

Yours for a better cotton crop!
DARLENE

RUBBER CLAD

Dear J. W.

I was interested to see your photograph "The Black Rubber Cape" in Issue 20. It is a still from a British film called "Devil Girl from Mars", which was made at the same studios where I was working in 1954. Needless to say, I took every opportunity to visit the set while they were shooting this film, as the "devil girl" was a dream! Once she had been fitted into the costume (which was a specially woven 'metallic' rubber) she had to keep it on all day, and her appearance in the restaurant at lunch time always created a sensation!

Having been a fan of yours for some years, I am slightly disappointed in the recent issues, as we rubber fans have been practically ignored. I have never written to a magazine before, but I felt it was time somebody struck a blow for our side!

We have recently formed a Rubber Club here, which I may describe some other time. At this point I would like to tell you how it was formed.

Last year I got very interested in a girl who passed the building where I work, as she constantly wore *different* raincoats on wet days — always a promising sign! — and eventually I got to know her. We had dinner several times, and I soon realized she was one of the Fans. After several weeks, she eventually asked me up to her apartment. Having had a few "noggins" together, she then ask-

36

ed me if she could change into her "comfortable' clothes. I did not tell her I had been waiting three hours for this, and off she went into the bedroom.

I speculated whether she would be dull and come back in a negligee — or whether she might come back in a raincoat of rubber — I had another drink, turned round—and zowie! Audrey (not her real name) was standing in the doorway to her bedroom. She was dressed in a smooth black rubber "siren' suit, which fitted her like a glove. The tight legs disappeared into curious thigh length rubber waders, but which had 5 inch heels, and which were zipped up the back. Her tightly rubbered arms ended in black rubber gloves. On her chest hung a large mask-like affair.

She asked me if I would zip up her back. After some difficulty, as the suit was so close-fitting, I did so. Loosely round her neck was a two-inch collar of metal. She lifted the mask on the front, and on inspection I saw it was a complete hood. She asked me if I would please fix the hood into position, and "follow on." I was a bit vague about this, but drew the attached hood over her head, and tried to zip it down the back. She sputtered a bit and I took it off her head. "Dear boy" she murmured "Unless you get it fitted correctly, breathing is difficult." I realized then that the only breathing space were two tiny holes at the nose. I pulled back the hood smoothly over her face, and finally zipped it down the back. I now found that the zip on her suit and the zip from her hood met at the clasp of the metal band round her neck, on which there was a small gold padlock, and I locked them all together. Attached to the front of the hood was a wide rubber strap, which I tightly secured at the back.

Well, there she was, a vision in black rubber, helpless, lovely — and loving it. Attached to the suit were various straps which could make her even more helpless, and which I had great fun experimenting with.

We eventually found other friends who had similar tastes, and now have a regular once-a-month meeting, which lasts from after lunch till midnight. Being blessed with a good salary myself, (And Audrey already had a fabulous rubber wardrobe), we have devised some of the strangest costumes ever!

Yours, etc.
Blackmaster
Roma Italiana

WIGS AND FANCIES

Recently I sent you an article which was mostly about pierced ears, corsets, etc. Tonight I have been looking over some back issues of Bizarre and thought perhaps some data on my experiences in wigs and accessories would be of interest.

At the moment I am dressed in four inch heeled blue kid pumps, nylons of course, long black satin corset, black satin bra, blue crepe slip, light blue cashmere short sleeve sweater and blue gabardine skirt, wide blue calfskin belt, and a dark blue long sleeved cardigan cashmere sweater. Perky blue tam and my purse is blue kid also. Blue kid gloves are lying on my table and as soon as I finish this I will go get in the car and drive to the post office and mail it.

The wig I am wearing tonight is dark brown with grey touches, just the perfect style and color for my age. Short curly hair do with sort of bangs arrangement in front. I find that a roll or bang curls soften the lines of my face and I am able to comb them about so that I get the most nearly perfect balance of hair and features.

I have four beautiful wigs all custom made of course. Three brown ones, one of which is rather long page boy style very full and this style makes a lovely frame for the face, so easy to work with and make attractive. The other two brown ones are short bobs. I have them cleaned frequently but make them up myself from, time to time. I do it just like a woman would do her own hair, and find it much easier to do it while wearing it than on a block. Wet the strands and wind into a curler and let them dry and it's ready to comb and fluff out for wearing. Of course for street wear wigs must have the French lace edges. If the hair is to be combed up in back this lace should be made into the wig all the way around front and back. Applying the adhesive or spirit gum is a tricky job and takes some practice to make perfect so that the junction line is not too apparent. But I find that fitting my wigs before putting on any makeup at all is the ideal way and permits the blending of the foundation makeup into the lace so that only minute close inspection will show the lace line.

Then I have a beautiful blonde wig which does not require the French lace at all because it is constructed in such a way that it fits like a glove and the hair is trimmed at the first try on in the wig shop and then the waves are

set and trimmed just like a real head of hair. This one is really a beautiful transformation and is so easy to slip on at a moment's notice. It really is the most convenient of all but of course the most expensive also.

Then I have another one I almost forgot. This one is a beautiful shade of red, a most appealing shade and just the right shade so that it is not too conspicuous. This one is quite long although when making it up I curl up the ends to shoulder length and when it is combed out it is very fluffy and abundant. For a man who is going to go on the street or in public, no wig should be so unusual as to attract undue attention. The laws being what they are one cannot be too careful.

If wearing a wig in public, also be sure that every hair is in place. I notice that almost every woman nowadays has her hair in excellent shape even while shopping unles it's just a quick trip to the market in the neighborhood, so an unkempt hair do would attract undue attention also. Spraying a little brilliantine on and brushing it in carefully gives a wig the sheen and gloss of a well kept head of hair also so this is a must if going on the street.

In packing them away be careful to see that the wigs are handled with care. If each wig can have its own block that is fine. In my case this is not possible so they must be carefully packed in boxes and stored. Place tissue paper inside them to hold the shape as nearly as possible. So much for the wigs.

As to accessories I find that it is absolutely essential to acquire the basic colors, black, navy, blue, dark red, grey. These are interchangeable in many cases so they are a worthwhile investment. And again if wishing to escape detection on the streets you must have a well co-ordinated costume that looks well and with all the elements of the costume made for each other so to speak.

Gloves, handbags, kerchiefs and neckwear and hats, must all be co-ordinated as any thoughtful well dressed woman would do, or the illustion is completely lost. Leathers or fabrics in the handbags and purses must match the shoes worn, and I never wear smooth leather shoes with a rough textured handbag or vice versa. The same goes for gloves with me. Kid shoes . . . kid gloves and smooth leather handbag is my rule. With belts I follow the same pattern. I make many of my own belts and dye them to match where necessary.

In jewelry, I find it easy to over dress, and therefore pass a word of caution on to others. Do not over do it with jewelry. It attracts attention and many unfavorable looks I have found out by experience. The simple way is always the best. A simple necklace is far more effective as a rule than a large ornate flashy piece. I find the biggest problem is to under dress rather than overdress. In selecting gowns or shirts and skirts any man who wishes to be effective in my opinion should stick to the classic lines and the simple lines in every way. I am speaking from the point of view that many men desire to appear in public and be accepted as a real woman, going about her business in a normal way. In a private home or for example in a night club as an entertainer, yes then all stops may be let out and the sky is the limit. A couple of years ago I spent an entire evening on the streets of New York City, dressed in a very high style black satin dress, large black hat, large pearl ball earrings, and a pearl neckband, with a massive black satin purse, and black satin slippers embroidered on the toes with black beads. A beautiful pair of black satin gloves I purchased on 57th street that very day, and to top it all a mink stole. The only difficulties I experienced was the

problem of my voice with the cab drivers. I took a cab several times and two of the drivers were somewhat puzzled by such a husky voice. They sort of shrugged their shoulder though in the final analysis and figured perhaps the lady had laryngitis. Only one couple stared. In this case I was interested to watch their reaction. The lady, a young woman about thirty was either suspicious or admiring the ensemble I couldn't actually determine. The point is that what does not attract any particular attention in New York City would not necessarily be acceptable in a smaller town or a midwestern city. I have found that each city has sort of a character of its own, and therefore on the streets a tranvestite would have to be extremely careful to dress in keeping with the rest of the women on the street.

As to purchasing garments etc. I have never had the courage to try dresses on in the shop. I know my size so well I have no difficulty in selecting dresses and slips etc. that fit properly. I slim down all of my skirts myself, and in the case of some dresses I slim the skirt section down. The first few attempts were laborious indeed, with tailors chalk and it's a matbut I have my chart of dimensions all made up now and I lay it out ter of a few minutes to put it on

40

the machine and do it and then tack the hem again. My slender skirts fit like gloves and are just wide enough to permit walking, without again attracting undue attention.

In my wardrobe I have about fifty pairs of shoes all four inch heels, and about twenty five hats and also twenty five pairs of gloves in various lengths and fabrics. My earring collection is superb. Many antiques of course, and in some cases bracelets to match, and now and then a necklace to match also. However my real joy is my collection of earrings, all for pierced ears of course. I cannot abide the screw on types for a moment, and when I do see a pair of that type that fits into my plans I buy them and have them fixed so I can insert them in my ears. Incidentally some may wonder how I cover up the holes in my ears. It is very simple. I find that a chap stick in the pink color is the perfect material to use. Take a bit of the material on the end of a knife blade or a cuticle cutter or nail file end, and simply push it into the hole and smooth it all round. If I don't wear my earrings for a few days this is not even necessary as the material fills and sort of hardens so it fills the hole, yet it remains soft enough to insert earrings at any time.

This has almost gotten into book lenth I see, so will close for this time. Hope the above has been of enough interest that you may print it for some of the men who are interested in these matters.

A FAN

Calif., U.S.A.

THERE'S ALWAYS HOPE

Dear Editor,

I wonder if your readers would like to hear about my experience? While reading a No. 14 copy of your unique publication, which my husband brought to me, I came across an article asking about amputees and decided to write.

I was the victim of an auto accident and fire several years ago and survived it, but lost both arms and a leg an dreceied a very severely scarred face. I thought at the time I was destined to be a lonely charity case for life, but two years ago, I met a man who soon became my husband for the very reason that I had thought would be my downfall as a potential bride — my lack of limbs.

He admired my armless shoulders and the fact that my right leg was off at the hip! He offered to marry me if I would let him try to beautify me and needless to say, we were married soon after. I couldn't imagine, at the time, how I could ever be beautiful without

41

arms and only one leg and an almost hidious face. My face was almost ugly before the accident and now was permanently twisted and very badly scarred for life. I had only one eye and could barely talk thru my mouth.

Since I could neither walk nor stand with only one leg and no practical artificial limb could be fitted, I was doomed to a wheelchair for life, in which, I was almost entirely helpless, since I have no arms. After the first shock of being helpless wore off, I began to feel differently about it. As a youngster, I used to like the feeling of being tied up while playing cowboys and indians and I often thought of it and wondered why I should feel so different now. I surmised that it was the fact that I was forced by others to be helpless and not lack of limbs that made the difference, so I was more elated than ever when my new husband said that he wanted me helpless. It was a clue to his feelings.

I gave him a free hand to do as he pleased about my looks, not that I could have done anything about it if I had felt differently, and he set to work with glee. From parts of several corsets, he constructed a garment which extended from my shoulders to my one thigh and its numerous lacings and enormous quantities of extra heavy boning made it a marvel of restraint and compression. In fact, I could hardly breathe in it and was just about as rigid as a board from my shoulders to my one leg. In a months time, I got used to it as well as I ever could and my measurements revealed that I had a 36-16-34 figure which didn't satisfy my husband, so he built up my bust measure to 42 inches with falsies!

After taking a mould of my deformed face, he set to work and made a full face mask for me. Made of ceramic over heavy steel mesh and lined of live rubber, it fits and fills every contour of my face and is held immovably in place with a rear laced, leather helmet, over which, I wear a full wig of long hair. To make it fit better, he keeps my head shaved and the lashes of my one eye plucked out. I am able to see fairly well while wearing the mask, but cannot utter a sound nor eat or drink because I am totally gagged extremely tight. I am completely incapable of any facial expression while masked except for the built in expression of the mask which appears like a cross between inferiority and snobery. It appears obviously artificial, being quite glossy and very highly colored, very like a maniquin. Even tho it is quite heavy and cumbersome as well as

extremely confining, I insist on wearing it in public rather than have them see my face!

About 4 months ago, he brought me a single shoe with a very high heel, higher than I had ever seen. He told me that it was a custom made 6 inch heel and my enthusiasm over it has brought me others with heels as high as 10 inches with a 4 inch platform. Since I don't wear them to walk in, I am able to tolerate the painfully tight fit and enjoy the curious looks which people have on their faces.

I now have quite a large wardrobe of beautiful velvet and satin dresses and skirts and blouses and with my new artificial face, my new artificial face, my volumptuous figure and my one very high heel. I can well be called: GLAMOUR IN A WHEEL-CHAIR!!!

TIGHT LACER

Dear Mr. Editor:

My own introduction to corsets and tight-lacing came as the result of an auto accident in which my back was badly injured — beyond the hope of ever a complete recovery. Due to my injury I was forced to wear a heavily boned brace which fastened with straps in the front and was equipped with leg straps to hold it in place. As I traveled at the time these straps at times would become unbearable from the brace riding up while in a car and I would be forceed to leave it off with oftentimes a lot of pain and eventually disastrous results with two slipped dicsc. My orthopedic doctor, after a study of my problem, had me fitted to a high, heavily-boned front-lace corset equipped with 4 pairs of heavy garters with which I was forced to wear heavy black silk stockings. Of course I objected strenously but he informed me that if I did not follow his advice I would eventually become badly crippled or partially parayzed and that I must accept the fact that I would have to be heavily and tightly corsetted the rest of my life from rising in the morning until I retired for the night. I realized that this was a "must" and decided to co-operate. My corset was custom-made by one of the large custom corset companies. The garters were placed strategically to hold the corset firmly in place — two on the front of the skirt — one on the side and the fourth on the back for each stocking. These were anchored tightly to the garter welt of my stockings. Naturally they pulled and hauled as I walked or bent over — as much as I could bend in my stiff corset. My corsetiere was very co-operative and eliminated my embarrassment to a great extent

when I went for my first fitting. She told me she had a number of male customers.

My first corset laced me from 34" to about 30" over my corset. Of course I was very uncomfortable in the rigidity and tightness of my harness and was considerably embarrassed at my situation altho the corset was not noticeable under my clothes except when I bent over in the back and when I went without a coat in the summer and my rather small waistline was apparent. However I knew I had to make the best of it and had made up my mind to go thru with my doctor's orders. I must admit I did cheat occasionally and would go without or remove my corset in the evening, with the result I suffered pain and discomfort from my back. Finally he caught me and really laid down the law and from that day which was about four years ago I have never been uncorsetted except when I retire as he did not feel it necessary that I remain laced-up during the night.

Gradually I became used to my waspish waist and when the time came for me to re-order a new corset I decided to lace even tighter as by then I had come to like the sensation as all tight-lacers do eventually, and I also felt so much better physically. After a discussion with my corsetiere and with the approval of my doctor I de-cided to order a back-lacer. It was the corsetiere's thought that a back-lacing corset would be better for very tight-lacing which I had decided to follow. This corset was much higher and longer coming well down over the hips and we fitted it with five heavy garters for each stocking. These of course were fastened to the skirt of the corset which came somewhat over the thighs. I had the waist made an inch smaller giving me a 29" waist. It was boned very heavily with double boning all around the front, every inch back and even the sides as the doctor insisted on very stiff corsetting. My corsetiere laced me into it to check the fit and she did an excellent job. I almost weakened before the day was over but stuck it out until bed-time. The next day went a bit easier for a few hours tho' I had knack of handling a back-lacer to have my wife lace me up in the morning as I hadn't gotten the alone. She did a fine job too and even knotted the laces so I could not until them if I had wanted and the corset was so stiff and I was to tightly laced that I could not unhook the front clasp.

As time went on I learned to lace myself up in the morning tho' when time was essential I had her lace me. I really acquired the habit and desire for very tight-lacing from this second corset, I believe. I had the sensation of

pleasureable pain and discomfort which all tight-lacers enjoy. It is hard to describe for actually there is no pain unless a section of the corset chafes or digs. A heavy meal may cause a bit of discomfort for a short period of time but walking or moving around will eliminate that soon.

It wasn't too long before I had to order a new corset as I became more used to tighter lacing and I discovered that due to the laces being pulled so tight my single corset did not wear for too long a stretch. I decided to order two corsets of the same size and alternate them. These I had made with a 28" waist and found that with my wife's help I could be laced until they closed. At the end of about a year I re-ordered again and had them made with a 27" waist. These are the corsets I now wear but from their appearance I know I must re-order in the fall and intend to order a 26" waist. My corsetiere is very anxious to have me achieve eventually a 24" waist. She herself is a tight-lacer and understands the problems involved in extreme lacing in detail. I imagine I will probably make 24" in a year or two. Incidentally all measurements which I have mentioned are taken *over* the corset and when it is laced to close completely. My uncorsetted waist has not changed in size from 34" in spite of my being so tightly laced. My figure in my corset is extremely wasp-waisted as the reader can imagine for I have wide shoulders and naturally my hips expand slightly when I am laced-up. I might add that my tight-lacing has done wonders for me and my back. I am entirely free from pain but the doctor still tells me that I must be resigned to being tightly-laced and very stiffly corsetted and firmly gartered the rest of my life in spite of freedom from distress. People may think this isn't much to look forward to but I can assure them that once you have become an addict to tight-lacing and cultivate a wasp-waist the knowledge is rather pleasing. Four years ago, if any one had told me that I would enjoy being laced into a seven inch waist reduction, and I hope more, I would have laughed them off with scorn.

In closing, if this letter isn't now too long, I am going to give those who, by desire or by necessity, must and desire to become tight-lacers, some, what I hope, is good advice.

First of all get a specially made back-lace corset and get it very heavily boned. The Spencer is probably the best and biggest corset firm custom made, in the country. I found that it is best to wear a corset next to my skin tho' some prefer ever a light shirt or chemise of light but tight material.

Have the corset equipped with at least four pairs of heavy garters located so they will hold the corset firmly in place. Incidentally I recommend garters and women's stockings for men as well as women. They are much more effective than leg straps. Order a corset very high in front, back and sides, reaching from almost the arm-pits to well down ovevr the hips and fitted with a skirt from which the heavy garters may be fastened. Be sure and get a "straight-front" corset which will push the abdomen in and raise the chest. Get the top of the corset large enough so you can breathe, tho' you will find that you will have to and will soon learn to breathe, as all tight-lacers do, with the upper chest and not the abdomen. Be sure and have your corsetiere order your corset so that the boning in front is not long at the bottom to dig you when you sit. The bottom of the corset around the hips should not be too snug as your hips will expand slightly as you are laced up.

The amount of lacing and waist reduction is up to you. I would recommend a lacing in of four inches for your first corset and then you can reduce as you desire when you re-order. My corsetiere tells me that a girl and I are her most tightly-laced customers. The girl achieves a 15" waist from an uncorsetted waist of 24".

Mine is a reduction of about 7½" but I hope to hit around 10" with perseverance. I recommend long nylon lacest with two loops, one for the hips, the other for the waist and top of the corset. Some like three loops but I manage quite well and usually lace myself up to start the day. Here's luck to you beginners and don't get discouraged.

An Ardent Tight-lacer

NO PENANCE IN PIE
Dear J. W.,

Both my wife and I have always been interested in bondage and moderate restraints. I say "moderate" for you and your readers know that no restraint is moderate if endured sufficiently long. Take a tight shoe lace or corset, for example. Over the years wc have acquired a pretty fair collection of equipment and devices to suit any occassion. More important we have arrived at a mutual understanding that goes with it.

We play games when both of us are on good behavior, but we also use the stuff for punishment or discipline in case of all altercations or household spats between us. We never go to bed mad at each other. When a fault is noted the sentence is pronounced on the spot, and the punishment is effected before we go to bed that night. We have penalties ranging from

DON'T LET THIS HAPPEN TO YOU

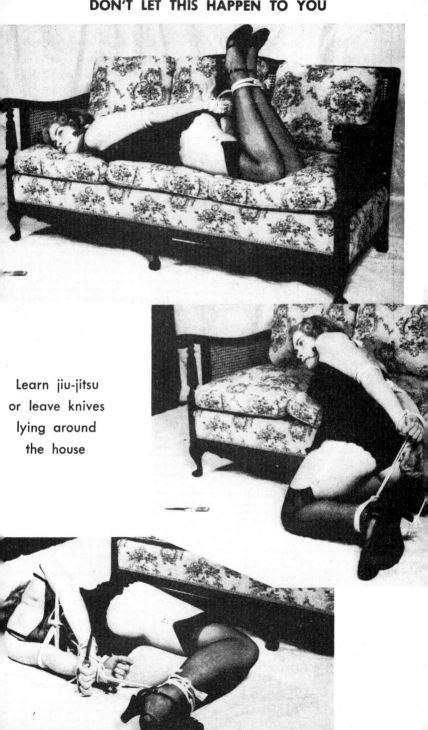

Learn jiu-jitsu
or leave knives
lying around
the house

No. 1 to No. 10 in severity of tie-up and duration of bondage. Whatever the other has done, or however mad one of us may be, the aggrieved party sets the penalty and the other has learned to accept it. Most of the time it is fair — and if it isn't, your chance will come soon — so we have learned to be moderate.

For game we frequently play one of the usual two handed games, cards, dice, or whatnot. The looser pays by being "IT" for the evening. The size of the score determines the severity of treatment. At a bridge party we have our own little side bet, for instance, but I don't like that because Bess plays better bridge than I do. Like as not she will win the prize for the ladies, and I will be low man among the men. When she has won several high-scoring rubbers in the course of the evening, it's tough on me when we get home. If I go out to play poker with the boys I am always playing against Bess too. If I win, she pays. If the boys take my money, she all but takes my hide when I get home. But if I get home later than I promised, all bets are off and I pay anyway. Like the time I was winning big and the boys wouldn't let me quit while I was ahead. She didn't meet me at the door with the conventional rolling pin, but she had all the stuff out of the closet and started clapping me in irons before I could hang up my hat.

And that brings us to penalties. If I make a slighting remark about her in public Bess will give me a sweet smile and say, "That will be No. 3". If I forget an errand it may be No. 5. On the other hand if she keeps me waiting on an appointment it is No. 1 for five minutes or No. 6 if she is half an hour late. She never could be prompt. And we have our own little scale for carelessness or lapses around the house. Whatever it is the penalty is exacted at the first possible moment. We try to go to bed with a clean slate.

I remember one time when Bess pulled a real dirty trick on me. I don't remember what it was, but it was mean and unworthy of her. I was furious and gave her No. 10. I tied her hands behind her as tightly as I could. Her elbows were almost meeting. I tied her ankles and knees, then rolled her over on the floor and hog-tied her by drawing her feet up tightly to meet her hands. I was too mad to have any thought for her comfort. Then I jammed a rough gag in her mouth and rolled her over on her side while I inspected my handiwork. I didn't care how long she stayed that way. But when I saw her sweet blue eyes a trifle teary over the gag that forced her delectable lips apart so harshly —

I couldn't stay mad. I didn't feel sorry for her either, — not right away. But when I let her up and kissed away the hurt, she said she was sorry for what she had done, and everything was swell. See how it works? Some men would have gone to bed mad, and you don't know when they would have got over it.

But there was one time that I will never forget. It was the only time I ever really got my money's worth. Beth had made her first lemon pie. It was yellow and juicy and all fluffed up with that white stuff on top. She was terribly proud of it. I picked it up to better inspect it and the devil got in me. I said, "I think we will play low comedy and I'll sqush this in your face". She said, "If you do, Jack, I'll think up a new one, No. 77, and you will wish you never were born before I let you free". Well, I let her have it, Socko, right in the kisser. You never saw a madder white woman in your life. And I laughed and laughed — near died laughing! She hardly waited to wipe the stuff off her face, but just marched me down to the cellar. I submitted, for that was the deal. I guess what she did to me that night was pretty near No. 77 on our scale of No. 1 to No. 10 at that. Did you ever try to laugh thru a gag? Even after she had me so I couldn't move a finger and all tied in knots, and with a gag AND a punishment helmet in place I could still see in my minds eye — that's all I could see with — her cute little face all gooked up with lemon pie. That's when I almost choked. I guess you would call it Laughing-Fit-to be-Tied.

JACK

Odds-on favourite

BRIGHT-EYED Cherie Denton, who is the daughter of a bookie, has one big ambition—to make her name in show business.

Cherie, of Wanstead, Essex, is studying acting and has already appeared on TV. Judging by her form, we would say she is an odds-on favourite!

49

"DO IT YOURSELF" DEPARTMENT

Dear Sir;

One way I can show my appreciation to your magazine is to contribute to it. I have often wondered where a person could find some genuine shackles or fetters, but such things seem to be museum pieces now, so I got to thinking.

Metal is difficult to work with unless a lot of special tools are available, but leather is easy to work as well as comfortable when fitted snugly around a wrist. Going on that basis, I designed and made a pair of leather and chain handcuffs which are versatile, comfortable, secure, and easy to make. I think the accompanying photographs and description will fit nicely into your "Do-it-yourself" department. I'm sure many of your readers will readily see many uses for these inexpensive (about $2.50) cuffs.

In this case, the leather was secured from a worn out pair of boots. The brass pieces at each end of the leather straps are made from ornamental hasps. (Choose the size according to the desired width of the straps.) The hinged part of the hasp is cut off, leaving only the slot and room for three holes. The other part of the hasp is used as is.

The hasps, padlocks, chain, and copper rivits are available at most hardware stores. The padlocks used here are "Master" locks. This

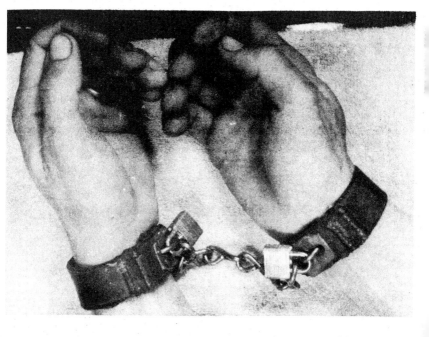

is their smallest size, yet they are strong enough to support over 150 pounds, should a person somehow be left hanging by the wrists.

The photographs should pretty well explain construction details. The length of the straps should be determined by fitting the intended subject. They should be quite snug when made in order that any future stretching of the leather will not render the user any possible chance of escape.

First, put the part of the hasp which the lock hooks into on one end of the strap; rivit it with four rivits. Then fit around the wrist and determine the location for the slot in the leather and the slotted part of the hasp. Then simply rivet the slotted half of the hasp in place.

It will be noted that the leather straps are curved. This is a feature, not a mistake! The curve allows the straps to work up the wrist and firmly against back extremities of the hand without cutting or discomfort. This feature allows for a lot of pull to be exerted without discomfort to the subject.

The chain and leather handcuff may be used in a variety of ways. Separate chains for each wrist would allow "spread-eagle" techniques, or even better, the fabrication of a "lacing bar."

A variety of applications will undoubtedly be realized by future users. I will look to future issues for accounts of the use of these chain and leather handcuffs.

Sincerely,

J. R.

The Queen Knight's Square

52

EN AMI

Dear Ed:

In the new issue, my attention was immediately attracted to the interesting article entitled "Is There An Ibitoe In The Crowd." There is indeed. I find in self-analysis that I am one of the crowd. I am a slave of fashion—with great appreciation of a small waist. I wear a corset continually (have many in my collection) and occasionally a belt. By continuously I mean that at night I wear a corset, lacey nightgown, and toe-tethers (chain and rings linking my toes together restricting leg movement to inches) . . . During the day, under my male outer garments, I wear a corset with garters, full length nylon hose, lacey panties — and of course, my pad-locked-on anklet and gold bracelet. My ears are pierced for earrings; and I have made a practice of wearing extremely heavy earrings so that the holes in my ear lobes are now slits (I wear the earrings, of course only in private—making a nightly practice of wearing them while sleeping). My nose septum is pierced for a ring, and my favorite nose-ring is an inch and a half in diameter and has four tinkling bells which ring with every movement of my head. My right nostril is also pierced for a nose stud. Rings are a fetish with me and my breast nipples are also pierced for rings which I think are most bizarre and attractive.

My during-the-day jewelry consists of my nipple rings, a solid gold bracelet which can not be removed from my wrist, and my padlocked-on gold anklet on my left ankle.

My deviation from being a true Ibitoe who dominates women is that I (with all the other characteristics of an Ibitoe) wish to be dominated by women. I have never . enjoyed the experience of being soundly whipped and subjected by a female — of being made her abject slave — but believe that I would like it. I have pictured myself in such a circumstance: my thumbs securely wired to my ear lobes with wires running through my earring holes — and being restricted in movement by a chain from my nose-ring to a staple in the floor.

It is perhaps needless to add that I am a devotee of all feminine wearing apparel — and wear it on every possible occassion. High heels are of great interest to me, and surprisingly, I have found that after wearing heels of 4 and a half inch height that lower heels are most uncomfortable to wear. Again let me say how wonderful it is to see Bizarre in publication — it is like meeting an old friend after a long separation.

Yours,
Pierced-Nose

NAGGING WOMEN WERE TONGUE-TIED

Any husband caught creeping up the stairs in the small hours after a heavy night out can expect an equally heavy ticking-off from his suspicious spouse.

But until a century ago angry wives had to curb their tongues for fear they would be forcibly silenced by the scold's bridle.

Records suggest it is just 100 years since this cruel and humiliating punishment was last used publicly on too-talkative women. In 1856, a Lancashire woman whose tongue had been working overtime was led round the streets of Bolton in a scold's bridle to suffer the jeers of the townsfolk.

Scolds' bridles — also known as gossips' bridles, nags' harnesses and branks — were iron cages hinged to enclose the heads of busy-tongued females. Some resembled iron masks, with holes for mouth, nose and eyes.

The victim's mouth was clamped shut by an iron band passing under the chin, and a flat piece of iron projected inside her mouth.

This was the cure for a talkative woman. The scold's bridle (above) fitted over her head. Into the opening at the front went the mouthpiece, three types of which are shown on the left.

This mouthpiece which was sometimes armed with a short spike, cruelly rasped her tongue if the woman tried to speak. The whole contraption was fastened round her neck with a heavy padlock. She was then dragged round the town on a chain to endure the sneers and jests of her neighbours.

The bridle was not taken off until the woman began to show "all external signs imaginable of humiliation and amendment."

Branks were not only used to punish nagging wives. Any women found guilty of malicious

gossip and slander, abusive language or breaches of the peace were silenced in this way.

In 1824, Ann Runcorn wore the branks for abusing and slandering the churchwardens of Congleton, Cheshire, when they carried out a Sunday-morning inspection of alehouses.

In April, 1574, two Glasgow women, Marione Smyt and Margaret Huntare underwent the punishment of the branks for public brawling. In 1600 Kirk constables used the branks on a shrew.

The branks were also padlocked on women convicted of witchcraft and condemned to die at the stake — but for a different reason. They prevented the unfortunate creatures from screaming horrible curses on their tormentors.

Branks were used in Scotland for more than 100 years before they reached England in the 17th century. They were considered less dangerous to the health of the victim than the traditional ducking-stool.

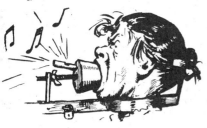

*(See "The Chinese Flute"
Page 22 #12)*

First used by the Spanish Inquisitors on slaves in the West Indies, branks were originally adapted from a military mask used to silence mutinous soldiers.

This was constructed so that when the wearer tried to speak, he merely succeeded in blowing a loud whistle attached to the mouth piece.

Asses' ears and a huge pair of spectables were also fixed to the mask to make him look even more ridiculous.

Although the branks were widely used until Victoria's reign, little mention is found of their function in official town records.

The probable reason for this is that city fathers could not deny the fact that use of the branks was not sanctioned by law. It was altogether illegal!

A few remote villages still retain their branks but the menfolk would soon be in trouble with the police if they tried to bridle their scolding wives to-day.

TIGHT SQUEEZE

Dear Mr. Editor,

I am only 23 years old, but have loved tight lacing and extreme high heels as far back as I can remember. It was only after I left home at the age of seventeen, that I felt I could be free to indulge in my fancy's, which I promptly did. I went to beauty school and now run my own shop, giving me an opportunity to indulge in tight lacing and high heels as well as heavy makeup, all the time. Also, I can wear long tight gloves all the time, which I dearly love. After a lot of research, I was able to have several pairs made of a fairly heavy grade of white rubber which extend the full length of the arm to my armpits, very tightly encasing the entire arm and hand in a compressing sheathe of pure white. These gloves greatly restrict the movements of the fingers, wrists and elbows and also impede the circulation enough to make my fingers numb after a few hours and produce a wonderful sensation. Usually at the end of the day, I have no feeling in my hands at all which is the ultimate to me.

Tho my regular shoe size is size 5B, I manage to wear size 4B by forcing and squeezing my feet into an extremely tight and unnatural position and get a thrilling feeling of satisfaction from the extreme tightness and high heels. The shoes that I wear every day at the salon, have a full 5 inch heel which keeps me practically on tiptoe all day. They are ankle strap pumps, made of white buck and I have to have them made to order. While in the privacy of my apartment, I usually wear training shoes which have a full 6 inch heel and poise me on the ends of my toes like a ballerina. These are made of black patent and are quite hard to walk in, but I love the helpless feeling they create. I cannot see why every woman who wants to be a WOMAN, does not treat their feet to the highest heel that they can wear. I will admit that there is a certain amount of pain and discomfort to highest heels and tight fitting, but for me this is sheer extocity.

Tight lacing in rigid corseting has become a permanent practise with me and I wear them constantly night and day, only removing them for short periods to bathe. I cater to those with extra long skirts and combined with rigid shoulder bracing. The pair that I wear daily at work, extend from the base of my neck almost to my knees and when the lacing meets, I am tightly compressed and constricted to a hard rigid figure and absolutely rigid from neck to my knees. I am unable to sit down and cannot move my thighs while

walking, thus forcing me to walk from the knees down. This keeps me on my feet all the time thus making full use of my heels constantly. Also, it keeps me from removing my shoes when they hurt. Since my gait is quite severely restricted, I have trouble getting up or down stairs or over high curbs, but the wonderful sensation of being partially helpless, plus the paralyzing effect of the tight lacing in restricting the circulation and causing numbness is worth the effort. My figure, laced in this corset measures, 36 bust, 14 waist and 35 hips. On weekends, I have a special corset which I wear, that gives me a 12 inch waist, but so tightly laced, I go completely numb from the bust down and getting little or no cooperation from my legs and feet. I have to depend on help from my roommate to move. Usually, while wearing this corset, I have my arms and hands tightly encased in a special pair of shoulder length leather mits which lace the full length of my arms, are heavily boned and hold the fingers and thumbs compressed into a tight fist and completely immobilized, thus making the arms and hands useless. Someitmes, if I get too restless, my roommate helps me endure this rigorous training by shutting off my hearing and sight and sometimes my speech. When confined, absolutely helpless this way, unable to see, hear nor speak and unable to move, I find myself in the ultimate way of life as I see it. The feeling of compression and absolute dependence on others is an experience that I dearly love. I shall insist that my husband, if I ever marry, will consent to my way.

To give you a word picture of what I look like, while at the salon working: in addition to wearing the above described corset and shoes, I wear a fitted white nylon uniform with long sleeves and high cossac style collar buttoned tightly around the neck. The skirts hug the waist, hips and laced of these uniforms are made to thighs like a 2nd skin and flare slightly from the knees down, ending about three inches below the knees. Since I cannot sit down, the entire uniform is fitted extra tight, and nothing has to be allowed for movements. I use unusually heavy makeup in extreme shades, daily, also artificial eyelashes and heavy jewelry. I have my ears pierced in three places and wear large studs in the two top holes and extremely long, heavy pendulents in the bottom holes. These pendulents brush my shoulders and show up quite obvious because I wear my hair in a tightly upswept coiffure.

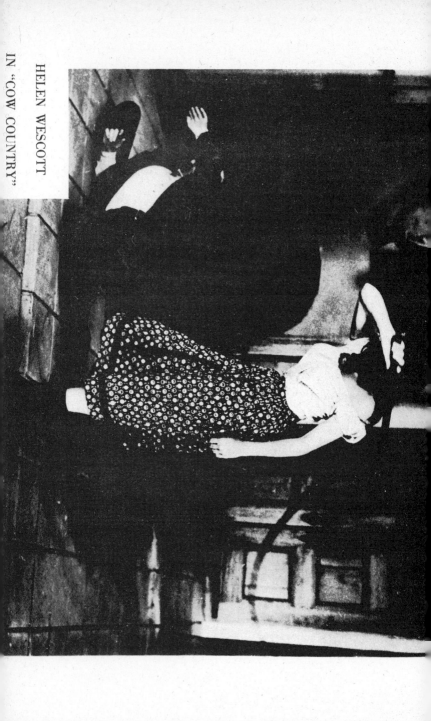

Many of my customers have noted my extremes in figure and makeup as well as my clothes and shoes, and have, as a result, taken u ptight lacing, high heels and extreme makeups. One such customer, a daughter of a wealthy widow, is so completely addicted, that she comes in every day to have her hair fixed and makeup applied, often appearing in such constricting attire that she cannot walk nor stand without the help of her maids. She has prefered the "Venus Style" of corset training and insists on going about, night and day, without the use of her arms. She wears expensive, custom made clothes, designed without sleeves an of the many other customers that have seen her here, not one would suspect that she has arms tightly pinned to her body beneath those clothes. She has often stated that she gets the utmost thrill out of not being able to use her arms and the reaction of those about her.

I could tell you readers about about many other customers who are equally as attractive as the above mentioned case, but I think my letter is already long enough and will wait until a later date.

Yours for higher heels,

MISS EILENE

PAUCIS VERBIS

Dear Editor of Bizarre:

I have meant to write to you long ago and tell you that I enjoy your publication and that I wish you published more frequently. I am a career woman, single, age 33, the beauty and fashion editor of a city newspaper. I enjoy the discussions of discipline which appear in your magazine. I recall from my sorority days in college how effective it was to control the underclass girls by taking them across the knee and applying a sorority paddle. So when I took myself a room mate a few years ago I used the same method to discipline her. Because of this, we have a very well regulated and enjoyable life together. Actually my room mate is only 3 years my junior, but I use the discipline of childhood on her.

When my room mate misbehaves or disobeys I take her to our bedroom. There I bare her spanking area, take her across my knee, and apply my hairbrush just as if I were her mother. This makes for a very harmonious relationship between us, and l am all in favor of spanking.

I must admit that I get enjoyment out of administering a good sound spanking, so naturally I looked around for other areas in my life where I might use it. It

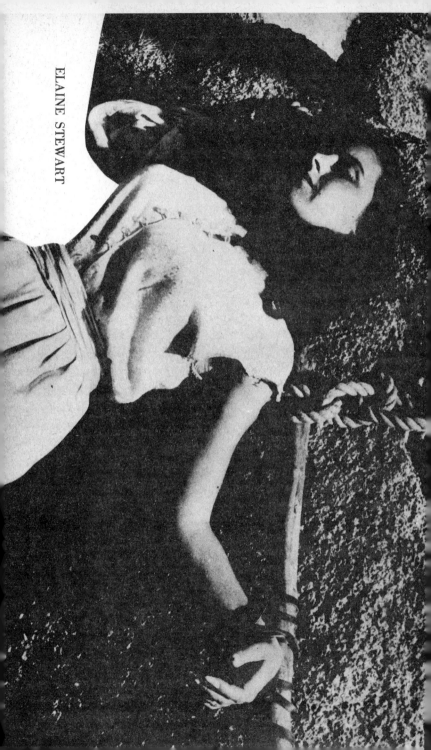

ELAINE STEWART

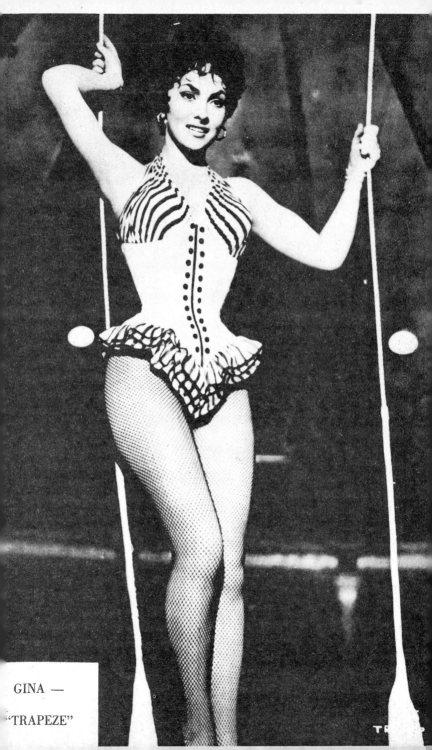

GINA —

'TRAPEZE''

occurred to me that our copy boy here at the paper had a tendency to be inefficient and that a good old fashioned paddling might do him some good. So I brought my sorority paddle down here to the office and placed it in my desk drawer. The next time this 14-year-old boy was sloppy in his work, I invited him into my office and locked the door. You should have seen the look on his face when he realized I was going to take him across my knee and spank him with that paddle. It was a look of half fright and half admiration. Then he had a slightly different expression when I told him to take his trousers down. I let him have his underwear remaining to cover the spank spot, but the way I applied that paddle I'm sure it made little difference. I really spanked him good. In spite of his tears I think he got an unusual thrill out of being spanked by his lady boss. I have spanked him several times since, and although he is reluctant about being spanked, he seems to anticipate his punishments with a certain pleasure. He has never really resisted going to my office with me when he knows a spanking is forthcoming.

We have a grocery boy who delivers at our apartment and he is about the same age as the copy boy. One day he was late with our groceries and I decided to use the same punishment on him. He didn't know quite what to make of it when I ordered him to my bedroom after scolding him for being late. When I picked up my hairbrush, I believe he knew what he was in for but I was very dominant, giving him the impression he had no choice but to submit, and when I told him to lower his trousers and get across my knee he did so with only a moment's hesitation. I gave him a thorough aplication of the hairbrush — as good as I have ever given my room mate; but he took it well. Believe it or not, the next time he delivered groceries he was late again and called my attention to his tardiness by apologizing for it. I believe he really wanted another session with my hairbrush in the bedroom. After that spanking he tried to get fresh with me, so I tipped him across my knee again and gave him a little more.

So you see we can all find opportunities to spank or be spanked if we look about us and use a little ingenuity.

Let's hear from others about similar experiences.

Sincerely,

GLORIA M.

"WOMEN'S PRISON"

BIZARRE

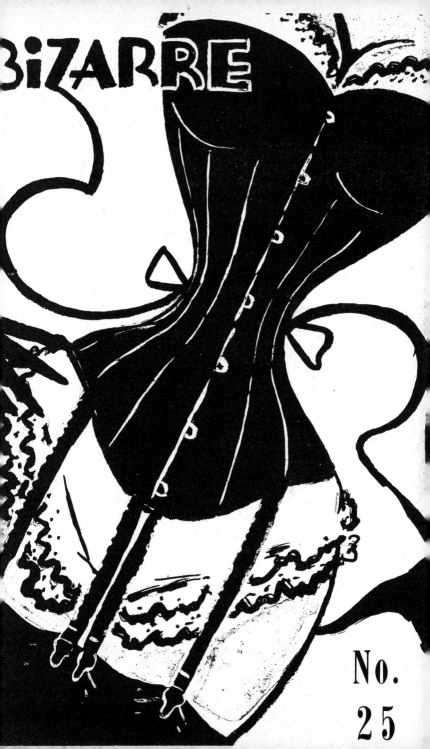

No.
25

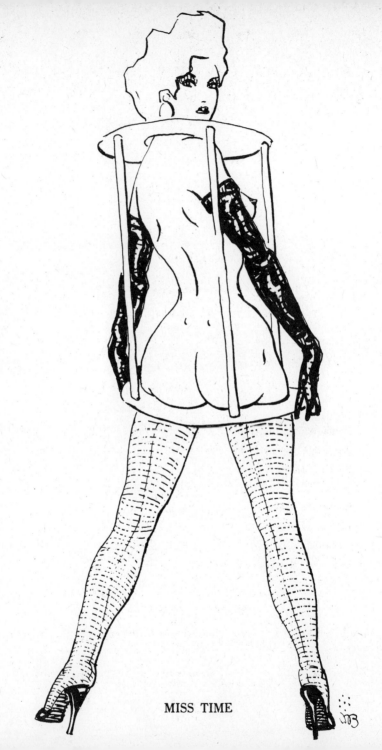

MISS TIME

BIZARRE

"a fashion fantasia"

No. 25

Then said another with a long-drawn Sigh,

"My Clay with long oblivion is gone dry:

But, fill me with the old familiar Juice,

Methinks I might recover by-and-by!"

OMAR KHAYYAM

BACK NUMBERS

By all means, patronize your local dealer. If he can't supply you write directly to:— P.O. Box 511, Montreal 3, Canada.

Printed and Published by Bizarre Publishing Co., P.O. Box 511, Montreal 3, Canada.
Copyright 1958. All rights reserved.

3

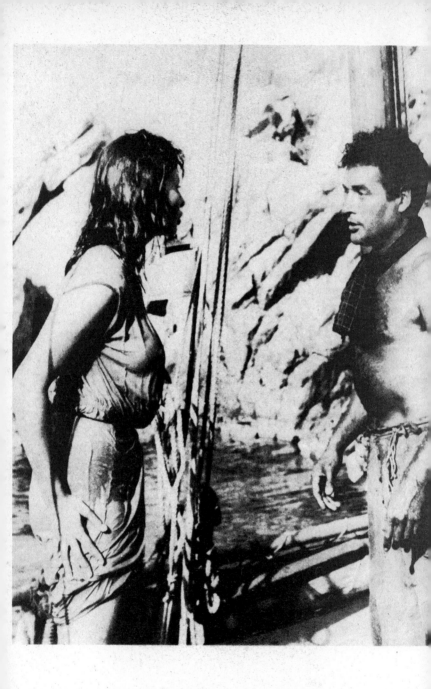

THE CEASELESS WONDERS OF THIS OCEAN BED — KEATS

Editorial

"TO MISS THE QUESTION IS TO HEAR AN ANSWER"
J. Reinhardt

A group of readers (and we too) have been wondering why we have been concentrating of late on the history, philosophy and psychology of Bizarre ideas.

We agree with those dissenters who feel it is better to cook the bird than the cook book, but we are also inclined towards Omar, "Oh! The Brave Music of a Distant Drum!": it is that same bird's drum-sticks that beat the rhythm. G.A. Dorsey picked up the beat of Omar's toe-tapping, "Civilization's main street is not the whole town." So, and so, we feel that if we hear enough answers we won't miss the whole question. The process is not as much the "what" as the "how" and "why": who today can simply say, "Nevertheless, it does move."

Number two on the editorial agenda is prompted by letters of complaint that they've been took. We want to repeat what we've said in #20. All readers please note — we publish no other magazine but BIZARRE — period!

All sorts of strange wild fowl are using the name "Bizarre" in various "come-on" deals; caveat emptor — let the buyer beware.

Our policy has been to try to turn out nothing but the meaningful in the various fields. We're not infallible, but we try. We can't do it without your help, and responsibly, we present an honest and accurate record, discriminating between reality and fantasy, with no snow-job.

This is a specialty magazine, not for the casual reader and not for the infant. The bandwagon jumpers completely miss the point. We don't seek wide distribution: ours is not the profit motive. And we object to many current practices, including that of dealers putting magazines in transparent sealed wrappers. You don't examine your morning paper before purchase, but you buy neither a muzzled horse nor an uncertified original painting. Literature is somewhere between the two: you have the right of familiarization prior to trust.

BIZARRE is a specialty magazine, yet we feel we have the finest context contributors of any magazine we've ever seen. How can you do better than Paula Sanchez, M. F. the Spartan (this issue), or Ibitoe? — to mention three. Civilization's Mainstreet is not the whole Town: we're grateful for the map-makers.

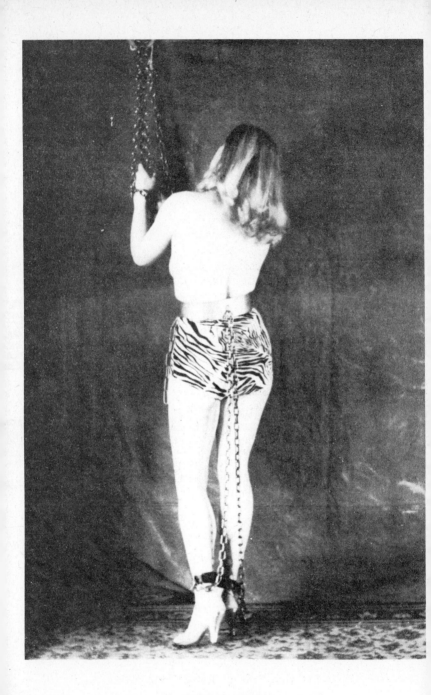

BRAVE MUSIC

WASP-WAISTS IN ANCIENT GREECE

We generally think that the wasp-waist was only the beauty-ideal of the civilized world in the centuries immediately preceding ours, but as far back as 2000 B.C. the wasp-waist was kept in high esteem by the Minoans who lived on the island of Crete in the Mediterranean.

In a recent article the weekly "Life" has given an interesting description of the life and culture of this people, bearers of the first civilization in Europe.

From the testimony of statuettes and wall paintings discovered in Crete the costume worn by this people was most attractive and seemed designed to emphasize both the slenderness and curvaceousness of their figures.

The main feature of the Minoan fashions was a large but very tight belt, which was worn both by men and women and which seemed to pinch-in their waists so much that they looked almost ready to break in two. This belt was made of metal, of bevelled from and about six inches wide. Apart from the belt the men wore only a short trunk or tight loincloth and high laced boots. The dress of the women consisted of the same metal belt from which

below sprang a very modern looking flounced and flared skirt and above rose a tight-fitting bodice which was cut so low that it left the breasts totally exposed.

As we will see later this belt played an important part in the life of the Minoans and in order to achieve the smallest possible waist when grown up, figure-training was commenced in early youth.

At a certain age the boy was allowed to have this tight metal belt riveted round his waist. This belt could not be removed and without relaxation, so that when grown-up the young man had his waist artifically constricted to the size of a small boy. The cincture of the boy by the metal belt was a kind of initiation ceremony and was a great event in a boy's life for which he looked out longingly months in advance.

The size of the metal belt when riveted on was deciding for the smallness of his waist in later years and in connection herewith the waist of the young boy was already gradually tightened-in during the period preceding the fitting of the metal belt by means of leather belts or corsets.

To obtain the smallest waist was a subject of continuous rivalry and the size of the belt which was eventually riveted on showed in how far they had been successful. The belt was probably padded inside to prevent bruises of the skin caused by the metal.

The wasp-waist obtained in this way seemed not to hamper the men in their movements, as they are very good athletes. As a nice by-product of their tight-belting they acquired very well-developed chests, which they carried well-backward, giving them an ant-like figure tapering down from wide shoulders in an amazing manner to a waist of no more than a neck's circumference.

The young women wore the same constricting belt, but their chests were not allowed to expand so freely: immediately above the waist, the chest of the Minoan girl was clasped in a corset or bodice which was laced so tightly that as a result the chest rose almost as a cylinder from the metal belt. This attenuation was continued upwards till the breasts which in contrast were left quite free and uncovered and which were pushed upward and outward by the tight-ly laced bodice in a most alluring way.

It will be evident that Minoan girls were quite unable to hide defects of their figures by wearing falsies and brassieres. They were however very proud of their nice and firm breasts and took special care to draw attention to their charms by painting the nipples in striking colours.

Here again tight-lacing was started at an early age, but contrary to the metal belt, the bodice was not worn permanently. When performing games, such as the religious sport of bull-leaping, which had to be fit exactly into the belt, was quite a popular pastime in Crete, the girls removed their bodices and skirts and wore only the belt and trunk like the men. As the metal belt could not be removed and the skirt and bodice the upper and lower edge of the belt were fitted by a metal ring, which could be removed and replaced after donning the bodice and skirt. These rings were often of a contrasting colour and beautifully chiseled.

For the Minoan the wasp-waist was not only a feature of attraction for both sexes, but the mere fact that one had succeeded in achieving such a narrow compass

was considered a sign of good health and perseverance of the wearer. A young man who had remove his belt and had lost his wasp-waist was earmarked in the community and his chances of marriage were greatly reduced. There was, however, yet another consideration:

As we already know from more modern times the tight compression of the waist provokes in many people pleasurable feeling of an erotic nature. This may be one of the reasons that the practice of tight-lacing was so persistent throughout the history of Western civilization, notwithstanding the obvious discomfort of the practice to the wearer.

In Crete, where the Matriarchy reigned, the smallness of her lover's waist was a guarantee to the girl that he was in good health and would give her sexual gratification. Here again the fashion was very revealing, because sometimes the men wore attached to the belt a metal sheath for the penis. This sheath was beautifully decorated and served not only as protection, but also as an eye-catcher.

Later in life when they became more settled and obesed the belt was removed and the body of the man assumed its natural form.

The belt of the woman had to be opened when she became pregnant. Here too the belt performed an important social function and would guarantee the young man that his bride-to-be had nothing to hide. After pregnancy women kept their waist laced tightly by leather belts, but a metal belt of such small circumference was not worn anymore. It may quite well be that because of their craze for waspwaist the women were not very foud of bearing children and they had generally few children and often none at all.

It is a pity that we do not know more about this people and its very outspoken and charming fashions, but as long as their language has not been diciphered there is not much chance of learning more about these virtuoso's of the wasp-waist.

"HISTORICUS"

of the Netherlands

9

The following article by A. P. Major aroused two ideas in us. The first was that this article is typical of history: accurate in what it says but not in what it omits. Take early 20th century earring history for example; it will go into the books as a "precious gem" era, brilliant and step-cut diamonds, pearl pendants etc., but it will omit what is most prominent (costume jewelry) and what is secondary (expressionism or wierdy jewelry. Modern expressionistic jewelry is made out of old metal buttons, medals, keys, statuettes, horns, petrified eggs, bells, etc. The rule is, 'If you can drill it or cage it, it's an earring'.) We strongly suspect that any chosen era would be the same; history chooses purity, not mass. Poor History; it's an artistic lament.

The second idea was that somewhere in our *archives* we had a picture of the girl with the fish-in-bowl earring: she was a toothy English blond who probably didn't know which end of the fish was 'up'. *This* was about the same year that dentists were drilling holes in perfectly good eyeteeth and inserting diamonds . . . So we opened our secret door and descended four stories below to our private files. Looking under 'H' we found 'earrings' but no fish-picture. We found substitutes however, "Earrings; pencil, clock, bottle, chandelier, pipe, lantern, and a few we shouldn't mention". Also we caught the sniffles down there, so we have retired to our robes and nip, and are now typing this up. Ah deman.

BEAUTIFULLY BOTTLED

Bring your o bottle," but the who wears these e rings can bring t And that's not when she opens bottles she finds a p of dice. So she's alw ready for a game

OTEWORTHY

s pendant earring
tains a minute
cil which can be
ped out in a jiffy. If
are a girl with a
memory, make a
note of it.

ME TO MEET

n your earrings çan
you to keep time.
hands of the
ks can be moved to
time of your date.
excuse for your

10

BY CANDLELIG

In gleaming gilt y
crystal drops, t
earrings look like n
ature chandeli

EAR-RINGS THROUGH THE AGES

By Alan P. Major

Recently an Australian archaeologist was shown a pair of gold ear-rings by a British emigrant. The archaeologist immediately recognised them as being of immense value and at least 2,000 years old. Eventually the ear-rings were bought by the University of Sydney's Nicholson Museum.

The emigrant had bought them on the Mediterranean island of Rhodes at the end of the War, in 1946. They came originally from treasure found at Patmos. Made of pure gold, the ear-rings comprised finely-worked gold discs, each set with a garnet, from which hung figures representing the Winged Victory of Samothrace. It is highly probable that eventually women will be wearing a modern version of this design.

Present-day designs may be either the simple and practical clip-on type for everyday use, the more complicated and expensive pendant screw-type for formal occasions, or those for pierced ears. Incorporating a wide range of styles, shapes and subjects, modern ear-rings are made in an almost endless variety of metals and minerals, including diamonds, sapphires, pearls, acquamarine, platinum, gold, silver, bronze, to mention only a few. Plastic button ear-rings have proved popular.

A celebrated event in the news often gives birth to a new design. The success of the *Mayflower* in crossing the Atlantic has inspired Mayflower ear-rings, a topical replica in miniature of this famous ship.

The earliest method of facial adornment began in the Stone Age. During that period our ancestors gruesomely pierced their ears and nostrils and plugged them with pieces of bone, as do some primitive tribes even to-day. This use of bone was supposed to ward off evil spirits from entering the body of the adorned person.

Bronze Age people were amongst the first to pierce their ear-lobes so as to hang basket-shaped metal objects from their ears. At the Babylonian Court, noblemen wore heavy gold ear-rings in the shape of fruit and acorns.

In the Oriental countries, where the most beautiful designs of fine workmanship originated, both men and women wore ear-rings, but the Ancient Greeks and the Romans considered their use effeminate, and only women wore them. Gold ear-rings are mentioned in the Bible, by Aaron to the Children of Israel.

In Britain the Roman-Britons and Anglo-Saxons are reputed to have worn ear-rings, but in the tenth century the fashion declined in popularity.

For five hundred years they were out of fashion, until the Renaissance brought a renewed interest in clothes and jewelery. Pearl ear-rings became the rage. Both Queen Elizabeth I and Sir Walter Raleigh wore double pear-shaped pearls. Shakespeare also wore ear-rings, as did almost all the men of fashion, courtiers, writers, composers of that time.

The South American Incas wore cartwheel-shaped ear-rings with a long hook, that hung *over* the ear, eliminating the then-painful process of piercing the ear-lobe.

One of the most spectacular pairs of ear-rings in existence are those found several years ago while excavations were taking place on the site of the Ur of the Chaldees in Persia. Originally worn by Queen Shubad, the heavy gold pendant ear-rings, combined with her fabulously intricate head-dress of flowers and leaves made from beaten gold leaf, have become world famous.

A " snowflake " design which was shown at last year's watch and jewellery trade fair. Cost? £60 the pair

Up to the reign of Charles I, pearls retained their popularity, and men continued to wear ear-rings, too.

With a change in hair-style, in Charles II's reign, a demand was created for a different shape in ear-rings and a triangular design, known as the girandole, came into being, comprising both diamonds and pearls. At the French Court of Louis XIV diamonds lost their popularity and marcasites were worn by the royal ladies instead.

In the eighteenth century fashion changed again and diamond ear-rings resembling miniature chandeliers, were back in favour. But men no longer took any interest in ear-rings to wear themselves. Now, 200 years later, simple, gold ear-rings are gradually being worn more often by the more daring intellectual-type of twentieth-century man.

In the 1790s' styles went back in time to the Ancient Greeks, for the cameo ear-ring became highly popular. When Queen Victoria came to the throne she popularised plain, simple designs. But with the advent of the Victorian mania for gaudy overdressing, everything suffered and ear-ring designs became fantastic and even ridiculous.

With the turn of the century, small, plain ear-rings came back into favour.

Between the two World Wars, in the 'twenties, there was a slight return to the Victorian period for styles. Tiny, live fish were worn in miniature bowls hung on gold chain. But this was a brief phase. At the end of World War II, hoop ear-rings became all the rage, hanging like over-large curtain-rings, but this design appears to be almost out of fashion, too.

Yet anything can happen and a new design may rapidly become fashionable. Who knows? Now it's the Mayflower. What next?

This is the effect of the illuminated earrings. A little eary—sorry, eerie! —on a dark night, perhaps, but as good a way of attracting male moths as any other.

POET'S CORNER

Dear Sirs:

I came across a poem I wrote to a girl friend several years ago—

J. M.

ODE TO A VERY ATTRACTIVE PRUDE

Isabella, funny face,
Do you *like* your bits of lace?
Do you want to swing your hips
When they're clad in cotton slips?
How much nicer, to be dressed
In a way that when caressed
You feel the power to drive me mad—
And yet that feeling isn't bad
For deep down in your heart, you dope,
There is a bit of tart (I hope!)
Don't you sometimes yearn to be
Just a little bit more free?
And go to town instead, with me?
To throw aside your Ph.D.
So dress thyself in slinky black
Wear a soft and shiny mac
Let its rustling folds encase you
Let its coolness thrill and brace you
Masked and hooded, gently chained
Gloved in rubber ('case it rained!)
Stately in your six inch heels
Darling, could there be such bliss
Revel in the way it feels
To know you really *wanted* this?
For I must love you in my fashion
Before there is a rise of passion
Imagine how much more elastic
This would be with you in plastic!

P.S. The girl took my advice!

14

Dear Sirs:

I thought that you might like a poem I ran across the other day. It is found in a book called *Types of Poetry*.

"My Mistress's Boots" by Frederic Locker-Lampson (1821-1895).

She has dancing eyes and ruby lips,
delightful boots — and away she skips.
They nearly strike me dumb,—
I tremble when they come
 Pit-a-pat:
This palpitation means
These boots are Geraldine's—
 Think of that!
O, where did hunter win
So delicate a skin
 For her feet?
You lucky little kid,
You perished, so you did,
 For my sweet.
The faery stitching gleams
On the sides and in the seams,
 And reveals
That the pixies were the wags
Who tipt these funny tags,
 And these heels.
What soles to charm an elf!—
Had Crusoe, sick of self,
 Chanced to view
One printed near the tide
O, how hard he would have tried
 For the two!

For Gerry's debonaire,
And innocent and fair
 As a rose;
She's an angel in a frock,—
She's an angel with a clock
 To her hose!
The Simpletons who squeeze
their pretty toes to please
 Mandarins,
Would positively flinch
From venturing to pinch
 Geraldine's!
Cinderella's lefts and rights
To Geraldine's were frights:
 And I trow
The damsel deftly shod
Has dutifully trod
 Until now.
Come Gerry, since it suits
Such a pretty puss (in boots)
 These to don,
Set your dainty hand a while
On my shoulder dear, and I'll
 Put them on.

15

Fifteenth Century Woodcuts

Sirs:

I am giving myself the pleasure to submit (under other cover) to the Editor of "Bizarre" four (4) photostatic copies of late 15th century (c 1470) French wood-engravings recently acquired by myself from an antiquarian book-seller's stall over the Seine from Notre-Dame.

I have found your charming magazine "Bizarre" interesting, diverting and (shall I say enlightening—for although I am a resident of Paris, where it is said, the life is very bizarre, I conduct a real-estate enterprise and have only enjoyed bizarrity vicariously.

It is the apparent parallel existing between the ideas expressed in your valued magazine and the motives expressed in the wood-cuts—together with (to me) a most interesting continuum of identical subject matter from the 15th century at least to the present that has impelled me to send the copies to the editor with the hope that he will find them of interest. Should it occur to the editor that his readers would be interested in seeing these prints your correspondent would be pleased to have the editor print same. The editor and his readers will be more than welcome.

The "High-Heel" motive seems to be absent from the 15th century subject matter. It is, perhaps, a "Johnnie-Come-Lately" inspiration.

With every good wish for continued success with "Bizarre" and bizarrity, I remain,

Yours,

Rive Droit

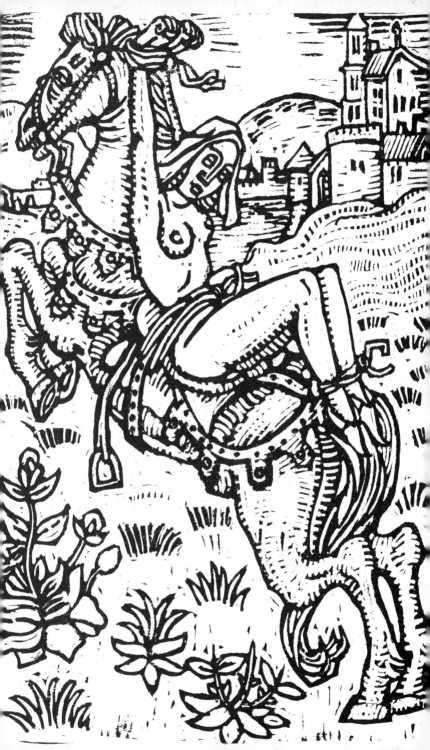

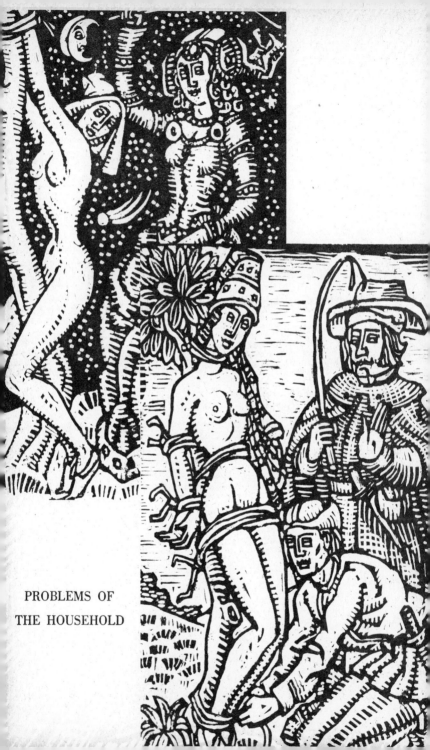

PROBLEMS OF
THE HOUSEHOLD

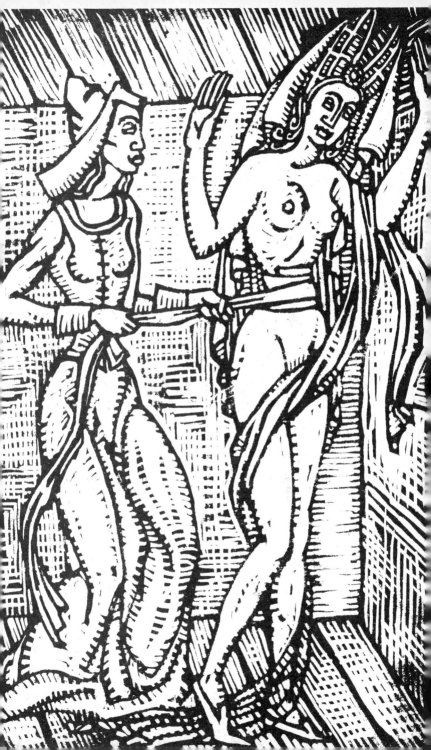

orrespondence

Under no circumstances do we publish names or addresses. If photos or sketches are sent in, please write a short commentary and please do NOT send in photos which you got from someone else.

ONE FOR THE THEORIST

Editor, Bizarre Magazine:

Among your readers you seem to have many philosophers, theorists, psychoanalysts, psychologists, essayists, etc., etc., such as Double-M and HKF who write in #21. Now I much prefer the letters from people who describe action, but maybe these deep-thinkers can answer a question for me. At least I would like to hear their theories via your publication. This is the question—: Why would a strong vigorous man (in this case me) submit to a sound, painful spanking or strapping from a woman, when it is obvious he could successfully resist and escape such corporal punishment since he is *physically* stronger than his spanker?

Let me start my story from the beginning. I lost my own mother when I was quite young, and when I was 12 my father married a very pretty young lady who was much younger than he. I believe she was only 25 at the time. I was very pleased and impressed with my new mother. I loved her charm and the femininity which our house had lacked for some time. She was a pretty brunette, not especially tall but with a nice figure; and she always wore high heels which showed her trim ankles to great advantage. My father was gone a great deal and she was a fine companion for me. She also ran the house efficiently and firmly.

A few weeks after she became my mother I got my first spanking

20

from her. When she sent me to her bedroom to fetch the hairbrush, there was no doubt in my mind as to what she intended to use it for, nevertheless I obeyed quickly and without hesitation. I did not try to run away. When she bared my backside and got me over her lap I did not kick or try to get away, yet at 12 I was already quite a strong boy and might have tried to resist—though I am not sure I would have succeeded then, as she was a strong woman herself. After that she warmed my bare bot quite often with that hard-backed hairbrush, yet I always lay docilely across her knees and accepted my punishment, painful though it was. She had one funny little habit—: after spanking for a while she would place her left palm first on one cheek of my buttocks and then on the other and would say, "There, I guess that's warm enough", or, "I guess that's enough for this time" or more frequently, "Not enough heat there yet", or, "We must generate still a little more warmth here, young man."

Now by the time I was 15 I must have weighed at least 145 pounds and was a pretty fair athlete. My pretty stepmother weighed only about 120 I would guess. Yet I still did not try to resist or escape her discipline, and she still warmed me with her hairbrush with great regularity. It seemed that at those times when I was to be spanked my knees became very watery and I would turn all hollow and weak inside. I could not resist; in fact it seemed I almost desired to be spanked by her.

As I grew older my spankings by her continued. The only change was that she took me over her lap less frequently and instead would have me bend over the bed or a chair for my punishment. Also when I was about 18 she acquired a strap which began to replace the hairbrush as her instrument of chastisement.

Even when I was in college and would come home on vacations she would strap me soundly—for grades that were not quite high enough, for spending too much money, for not writing home often enough, and for many other reasons.

Now I am a strong grown-up man, yet I still have that same weakness. If a beautiful woman wishes to spank me, I cannot resist. Any attractive female could turn me over her knees for a sound whipping and I would not try to prevent it—I would experience that same weak-kneed, hollow and helpless feeling. Why? I am a strong man, and all male.

21

As a matter of fact, I seem to have a strong desire to be spanked on the bare by strong attractive women and to be otherwise humiliated by them; and I have arranged such many, many times. I would like to hear your readers theorize on this—or better yet, to tell of similar feelings or experiences.

By the by, that picture on page 44 of #21 is one of the most beautiful I have ever seen. What attractive legs she has! And what an attractive position she is in! Please print more pictures like that.

Very truly yours,

AL McM.

MY RUBBER LIFE

I am a man, 160 lbs. built to scale, having had a full youth, rugby, hockey, parachuting, and war. I am still young (under 35). How is it therefore that I must be considered abnormal, were people to know of my loves and desires. I love the feel of rubber clothes. The silky smoothness of my thin rubber skirt, and blouse. I adore the hampering restrictions of rubber bloomers, making me part girl, part slave. I found once a lady who discovered this, and did not object, though unfortunately she was married to a friend of mine. She did however on one of two occasions make me dress in a tight waisted corset, (one made for me in London), rubber bloomers, satin slip, long evening frock of satin (belonging to her then, and now mine). I also wore nylons and some very high heeled shoes which again I had found in London. Over the frock I wore a red rubber apron, and a rubber bath cap was put over my head. She tied my wrists, and made me parade in front of her. After I had done some chores for her, she ordered me to change into a complete rubber outfit. This was bloomers again, and a type of rubber home made shirt, below which was a home made skirt of thin rubber sheeting. She again tied my wrists, then my arms, before leading me out onto a balcony. There I was pushed over onto my tummy, and my legs and ankles were then quickly and efficiently secured. I could now only wriggle, however as I did not then know what was to come, I lay still. She lectured me about humility, and the domination of the male by the female, she teased me, and whacked me with a belt, I can assure you it was well applied. It was then that she stood with her legs astride my helpless rubber clad body, and looking down at me with a great air of superiority, poured out her final scorn and derision upon me. I

22

was crushed, and humiliated. There was then nothing that I would not have done for her, at her slightest bidding, indeed if ever I am lucky enough to endure such gorgeous humiliation again, I will be delighted.

Oh to meet a similar lady again, surely London has one somewhere.

Yours

PEPITA

SLUGGER

Dear Sir:

I think that it might be interesting, since Bizarre is a means of exchanging ideas, to run a "box score"... and see how many readers have adopted which Bizarre ideas that have been put forth.

We "Bizarrites" like to know that we are not alone in our idiosyncracies and I am sure would not hesitate to report the bizarrisms which they have adopted after reading about them in this wonderful magazine.

I'm ready to start the score. Thanks to "paula" I am a corset fan ... wear one during the day and sleep in it at night. I am now trying to set an endurance record for myself by going a full week without taking it off. I've had it on for over 72 hours now, and it's laced tight. Then thanks to "pierc-

ed ears", I punched my ears for earrings and found that it is a lot of fun wearing earrings. I read about how he pierced his wife's and daughters ears, but he never said if he had his own ears pierced. I'll bet he did. If so I sure would like to read about it. Maybe we could compare notes. Then thanks to "F. N." I took his idea and began to wear nipple rings. I don't know where he got the idea that they tickle. Mine don't. But they sure are thrilling to wear. Then I read about Annete Gay wearing nose jewelry—and I tried that. I like my nose ring even more than my nipple rings and that's saying a lot. I don't have anybody to tie me up, but I've tried bondage by myself. It's a lot of fun and I wish that I could be really tied up—and then be whipped. I've thought about it a lot and wondered what I'd do if someone gave me a real good whipping. I'd sure like to see how it feels. I started buying high heels after reading about how nice they are in Bizarre. And you know those stories were right. You feel different when you're on five inch heels. They hurt your feet in a nice way. I sure get a lot of fun going bizarre all the way. The only thing that spoils it is there's no one else to share the fun with. I'd like to get tattooed in a real bizarre way but I haven't gotten up enough nerve yet. I bet I do

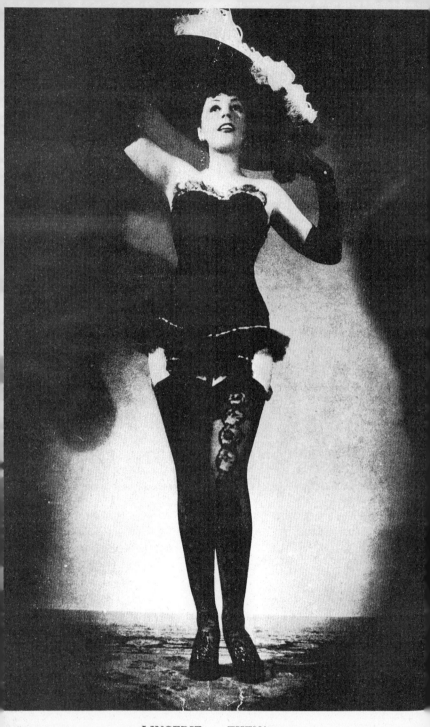

LINGERIE — THEN!

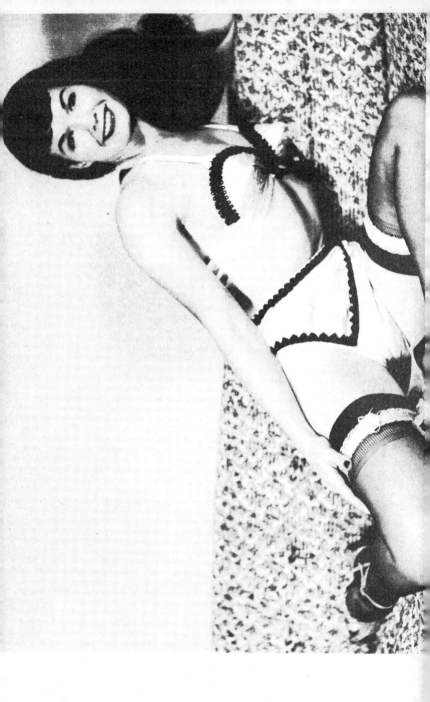

and NOW!

though. I wonder what design I ought to have and where I ought to have it put. Maybe some of the tattoo enthusiasts have some ideas I could use. I don't want it to be where it can be seen all the time and I want it to be really bizarre. If I could find a slaverette I'd get tattooed saying I belonged to her and hands off but I don't have anyone to make me toe the line. Sure wish I did. F. N. said how he put a chain nose ring in his nose. I couldn't figure how he did it ... piercing his septum low down and high up and then running a chain thru the holes. I had trouble just punching my nose low down and I can't figure how he did it on top. I wish he'd explain it as I'd like to try it too.

FRANK

TATTOO SPONSOR

Dear Sir,

Being a devoted reader of your exquisite magazine "Bizarre" for a long time, I feel obliged to contribute to the understanding of my favoring subject "Tattooing". Judging our readers would rather look into today's situation than into the history I enclose one of my snaps and tell you the story about it.

Last year I got acquainted with a charming young divorcee named Jane. Although only 4' 11" tall she was okay in every respect. At our second meeting I carried with me a huge scrapbook which I had received from one of my friends in Upper New York State, with quite a lot of selected articles and pictures concerning our hobby. I noticed with pleasure the interest Jane developed reading in the scrapbook and after awhile she told me one of her former co-workers which has been married for ten years sported a nicely tattooed snake encircling her left wrist. Janes second try to contact her by telephone was successful and the following day I met Helen and her husband Bob.

Bob himself was elaborately tattooed on both his arms but Helens wrist tattoo was really an outstanding product of a skilled tattooist. The body of the snake, tattooed in blue, green and brown, encircled her left wrist one half inch above the root of her hand and on the outer side of her forearm, head and tail of the snake crossed in direction of the elbow. Helen got it as she visited a carnival in Eastern Pennsylvania. She was so fascinated by the tattooists work—a dragon on the forearm of a young fellow—she could not resist the desire to bear a tattoo herself and selected the

26

snake, which is commonly known as a symbol of health and fertility. She said the engraving was not at all painful but thrilling and since then she never made an attempt to hide it. She was 21 at this time and now after 10 years of happy marriage she seriously intended to continue with the decoration of her skin, encouraged by her husband.

Jane surprised me with her decision to have a large design tattooed on her thigh as soon as I would take her to a tattooist and I should have her name tattooed on the back of my left hand. I was convinced Jane was just kidding but on our way to Philadelphia the following Saturday I found out she had made up her mind. After extensively studying the designs on the walls of the tattooists studio, Jane asked me to select a design for her thigh and agreed with a heart-dagger and snake motif about 5 by 7 inches in size.

Jane displayed her shapely thigh with a skin as clear and creamy as a baby. I hurried to make the first snap with my camera and a second one after the stencil was put on and then six more during the procedure. Jane cried a little as the needles started pricking the black ink into her tender skin but with respect it was her first acquaintance with the tattoo needles she took it very courageous. It was a work of 75 minutes and as our readers will recognize the tattooist did his best. We treated our tattoos properly with Listerine during the first hours, later on with Ungentine to keep the skin smooth and after about three weeks Jane collected the first compliments whilst mowing her lawn wearing the briefest pair of her shorts. Now we are looking for a pendant for her right thigh in matching size and shape to obtain a balanced impression.

And herewith I am following Jane's repeatedly expressed desire to ask whether some of our female readers have similar experience with the thrill getting tattooed. We found it is great fun, harmless and not expensive.

Very truly yours,

CHARLIE.

RUBBER DIRECTED

Dear Ed.

What ever happened to those all-rubber bathing suits women used to wear?

I am 30 years of age, about 6 foot, 205# am a struggling artist, but during the last war I traveled all over the world and because of foreign contacts, I became attracted by rubber goods. I quite naturally had many exciting affairs for and with properly dressed persons—and because I am an introvert there has never been anything that I wouldn't do for such an excitingly rubberized body!

I would be more than happy to write out in detail many of my experiences to and for any interested party or persons, so far, unknown.

My ideal would be a lovely young lady who would actually enjoy being adored while being adorned and encased in all-rubber garments.

I've purchased quite an assortment of real-rubber garments from my many travels and my favorite past-time is dressing myself for the lack of a similarly-inclined individual and I sleep between extra-smooth full-length rubber sheets!

A RUBBER CUSTOMER!

℞ FOR MANHOOD

To the Editor:

I have been glad to see in recent issues of "Bizarre" letters dealing with the discipline of boys because with all the talk that went before about girls getting spanked I was beginning to wonder if perhaps my own experiences in that direction had been unusual.

When I was ten years old, due to family circumstances, I was given a home by a widowed aunt, a practical nurse who had raised a family of four boys, then all married, and who in her nursing career had had full charge of a number of "difficult" children. The management of another small boy presented no problem to her because her ideas on this subject were pretty well fixed.

It would be conceeded, I think, that my aunt was an unusually well dressed woman, in the style of an earlier period. She was then in her fifties, retired as a nurse, but still in robust health, a buxom

figure that would attract attention in any crowd. Usually her dresses were of silk, closely fitted, and I think she could not have been unaware of the admiring glances she received when out doing her shopping.

Living alone with her in the house it was not strange that I had more than one opportunity to see her put on the heavily boned corset that so firmly controlled her generous curves, to see the six broad garters fastened and the careful adjustment of the laces before a full length mirror as they shaped the full roundness of hips and bust.

I was small and sometimes I used to wonder, idly, how it must feel to be so large and to be so firmly laced up and to creak so audibly when you sat down. Having witnessed the lacing process I could not fail to notice the faint raised pattern the crossed laces made under the tight silk of the dress when viewed in a suitably oblique light.

But what I started out to tell about was her firmly fixed ideas of discipline for children of all ages, even fairly well grown ones, as I turned out to be a few years later. I don't believe she ever knew there was such a thing as child-psychology or maybe psychology of any sort. When anyone under her control needed "straightening out" (her expression), that per-

son, ten or twenty years old, was immediately attended to in a thoroughly professional nursely manner by being placed across what can be described without exaggeration as her very ample lap, face down. Firmly held there with one hand, the other hand was free to undo buttons, slip down interfering clothing and generally clear the decks for action.

I can still remember the feeling of utter helplessness as I lay pinioned across those broad thighs, plainly feeling the corset stays beneath the silky dress and the hard lumps of the garter buttons. It was futile to struggle or cry, although I did both without any need for thinking about the why or wherefore. The steady cadence of the spanks, first on one buttock and then on the other was not affected in any way. It was all done so impersonally, just as if my aunt were carrying out a doc-tor's prescription. In fact, in my later years she told me that a doctor had actually prescribed a spanking for a youngster in her charge if the child threw another temper tantrum and refused to take a vital medicine. This was a woman doctor who had success-fully tried out the treatment on her own child, in that case a girl of not too tender years.

Perhaps I shouldn't admit it but my aunt continued to "straighten

me out" when she thought it necessary till I left to go to college at eighteen. Of course by that time I might have resisted the 'treatments' but I really greatly admired my aunt and would not have thought of questioning her authority in view of the long care and affection she had given me. I suppose from her viewpoint, being thoroughly accustomed to dealing with the human body, she saw no reason even then for abandoning a tested method of raising boys to be right thinking and right acting men. When a boy needed it, he had to be spanked, and even in her sixties she knew she was quite capable of doing a creditable job of it. Well, that's how it was. And from your letters I judge now that it wasn't a unique experience.

"RONALD"

A SCENARIO NO FILM

Dear Editor,

I was extremely delighted when I heard that Bizarre was going to resume publication. It has been my favorite magazine for years and has no connection or association with other similar types now in the field. In an esthetic way it caters to my favorite fashion, the lovely, lengthy rapier heel.

I just returned from a trip to Europe and maybe some of your readers would like a little factual information rather than some of these exaggerations and generalities. For a long time now I have urged more details and explanations in this magazine. Why not be more interesting and informative?

In Europe, from Athens to Copenhagen, there is one item that girls seem to wear consistently. This is a high heel pump of plain black leather and is most captivating, since all of them are above 3" in height and look snug and sleek on these slender European legs. The shoe shops, too, feature this type of shoe more than all the others—they don't seem to gravitate to colors or other styles. I still say that for a person interested in heels, dresses and style, either Paris or London is the place.

In Paris I have seen more girls wearing five and maybe six inch heels more than anywhere else. In Place Pigalle the girls walk about on the most lovely heels. They are so entrancingly thin and curved. Together with their good looks and accommodating manners — this is difficult to beat! Although I can't give any information on shoe shops, I'm certain a visitor can easily find out where these custom-made lovelies are sold.

London to me was much more productive. First of all there was no language problem. Secondly,

30

London seems to cater more to the Bizarre than other places. If I am disbelieved the visitor should go to the Soho area around Dean and Compton Streets. Starting from there as a center, radiate outward and look at the ads in the newspaper stalls. These cover every interest from costuming to birching. If a reader of Bizarre cannot be satisfied I will not only be surprised, but amazed. In the bookstores around one can read (and rent) copies of the old London Life which is the predecessor to Bizarre. Very entertaining. Further, on Wardous Street in London (in Picadilly) there is a shop of Regent Shoe Stores which have a lovely collection of fantastic shoes. (There is another store which has a few theatrical shoes around the corner on Compton in the windows) They have every convenience including a private fitting room. Right down the street there is a costume shop which, of all things, not only buys high heels but rents their shoes. I saw a pair of thigh length boots which I liked but couldn't get around to making the move. Right now I'd like to be back there and feel the tight embrace of those long kid beauties.

Not only this, but the girls there seem to understand and appreciate the male interest in smart footwear. I met a girl there who had the most beautiful legs of any girl I've seen. To add to the attraction, she modeled for me a gorgeous pair of 6 inch shiny slippers that made me forget that I was living. Cut off from the pleasant affairs of life as many Americans are, I will never forget this episode.

So, readers of Bizarre, write in like I have with information and places.

High Heel Artiste
And Photos!! — Ed.

WE'RE ANTIQUATED

Dear Editor

Bizarre has in the past been much too partial to only one phase of corsetry — that of 30 to 50 years ago. Many more pictures and much more information is available on corsetry in the last 20 years or so. You can't please everyone, but please don't be too one sided. I am certain that material and photos on modern corsetry would please your satin (of which I am one) rubber etc. fans. Since you encourage mainly ancient corsetry to such a great degree, I'm sure you discourage many readers from writing you about their everyday modern cor-

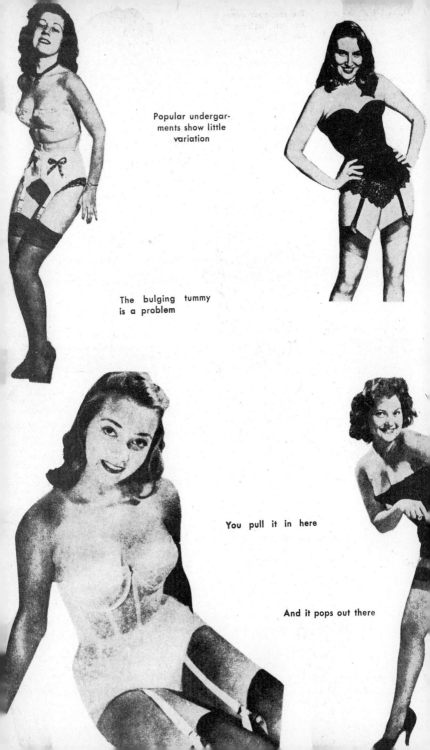

Popular undergarments show little variation

The bulging tummy is a problem

You pull it in here

And it pops out there

The teenager wears a bit of nothing to break her in

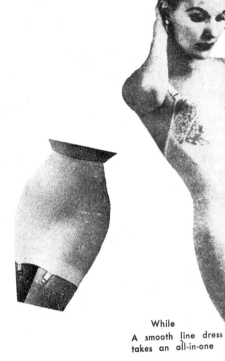

The two-way stretch holds its own

While
A smooth line dress takes an all-in-one

A rounded figure likes a bone here and there

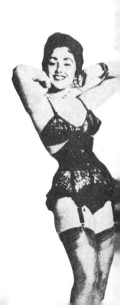

And the saucy miss sports the minimum, p'haps a bra & garter combo.

setry experiences. Oh well, this is just my opinion and it probably won't change things, but I thought I'd try. Here's hoping.

<div align="right">SAM</div>

Damn it reader, let's all get behind Sam. Let's push the modern corset and see what gives. Surely there's a tale or two not yet unfolded. I can't write the experiences; I only edit what comes in, but I'll plug it, Sam.

<div align="right">—Ed.</div>

SAM, MEET SUE
Dear J.W.

While reading through a copy of #6 I was inspired, truly inspired. I thought I wanted 'the' one corset, but after reading the corset section, I realized I wanted all of them. I got a mail order catalogue and ordered one of each. Now I have one for every day of the week and five for Sunday!

<div align="right">SUE</div>

ABOUT RUBBER
Editor, Bizarre

My own forte is rubber, and the letter from R. U. B. was quite interesting. However, I have a few missiles of my own to launch, and think that something should be said of the niceties of a readily available rubber product. Dental dam, as mentioned by R. U. B. is very nice, provided everyone likes yellow. Crib sheeting, which is available in department stores in the form of yard goods or packaged sheets up to size 36" x 54", comes in white, maroon, blue and pink, and also with one side white —one side colored. This material is just as easy to work with as dental dam. The enclosed photo shows a Mother Hubbard type gown in reversible blue and white rubber. The outer surface is pale blue and the trim is white. Naturally, it takes quite a bit of time to put together a home-made item like this, but the final results are most satisfying to the true rubber enthusiast. All that is necessary

to produce items like this is a can of rubber cement, a pair of sharp scissors, a proper paper pattern, a seam roller and lots of time and patience. Even buttons can be sewn on rubber garments if a reinforcing strip of rubberized cloth is first cemented along the button area, but its easier to put in snap-fasteners.

Speaking of rubberized cloth brings us to the next item. R. U. B. mentions the dental dam as being useful for bed coverings. I find that the regulation hospital sheeting, available in 36 and 54 inch widths, in either white or maroon, is just as smooth, and much longer wearing. It is suitable for clothing also, but seams have to be both cemented and sewn to hold well and the stiffness of the cloth does not allow it to drape in exactly the same way as the thin, all rubber sheeting. One thing it does have, which nothing else seems to match, is a rustle all its own. To those who feel that acoustical effects are important, this is it!

All rubber swim trunks for men are now on the market and I know of at least 2 outlets so far. (You won't find them in Macy's or Gimbels, but check some of the ads in the muscle-building and health magazines.) Swim suits for the ladies are in an experimental phase right now, and we hope it won't be too long before these are also on the market.

For those people who feel like they would like to lose a few pounds while wearing a rubber sweat-suit—again— check the ads in the muscle mags. These suits are 2 piece shirt and pants outfits, and can be had in dental dam yellow, or plain white. Sleeves and pants are long, with snug fitting cuffs. What more could a rubber fan desire?

Sincerely yours,

"STRETCH"

(Don't miss the Skin-Diving and Scuba Magazines. They advertise suits, kits, cements and ideas!!— Ed.)

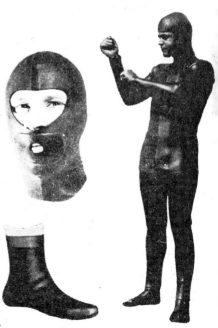

PREFERRED PAYMENT

Dear Sir,

I once worked for a large city Credit Agency, and my job was to collect small sums of money from creditors who had borrowed from my firm. I had many unusual and peculiar people on my books. There was the man who shouted before opening his door and then unlocked it holding a loaded shot gun. There were the two old dears who kept fifteen cats, and a bachelor who always appeared with only a towel around his mid-rift. In my regular visits from door to door, I became used to many eccentricities, but I think the strangest of all was a newcomer to my books in the form of a tall young married woman whom I thought to be rather naive, and rather frightened.

She often called into the office to make her payments and I began to look forward to seeing this blonde beauty with her long hair piled up on top in a plaited bun. She wore tight short black skirts and had very long slender legs.

After many weeks without seeing her, the boss instructed me to give her a call, and so I found myself in due course ringing her door bell. I rang about three times without an answer and was about to turn away, when the door opened and an astonishing sight met my gaze. It was my customer in

all her beauty, but her hair was in two pigtails tied with bows of ribbon. She wore a tight blouse, and a skirt so short that I beheld her stocking tops with the two suspender straps at the front. She wore high patent leather heels and a thick cord was fastened to her ankle, the knot being sealed with sealing wax. She beckoned me in anxious that no one passing should see her. I saw the cord stretched along the passage to the post at the foot of the staircase where more knots and sealing wax held it in place. She walked stiffly and very erect, as she said to bend at all would display, what lay beneath her very short skirt, and that I gathered was precisely nothing. She paid the money due hiding the lower part of her anatomy behind the settee in the lounge, and seeing from my astonishment and partial embarrassment that some sort of explanation was necessary, she told me that she had been a naughty girl at the weekend, and that her husband was punishing her in this fashion, but that she would be out of 'bondage' when he returned that evening, after being kept like that for three days. She also said that he had brought some friends home the previous evening and that she had waited on them in that costume. She also told me that she would be soundly whipped when he returned, and the

36

punishment would be over. I proposed going to the police, but immediately realised I had said the wrong thing, as she explained that the whole charade was as much her own idea as her husbands.

Holding her skirt well down with both hands she ushered me quickly out. I do hope she's late with her next payment.

Yours etc.,
J. R. G.
Manchester, England

STILL AT SEA

Dear Ed.

I'm in the same "Boat" as quite a number of your other Male Readers that is, I enjoy dressing up in "Feminine Clothing" whenever I get a chance. They say everyone should have a "Hobbie" so mine is Female Impersonation and I love it.

Of course I enjoy most, the stories sent in by other Male readers who like to wear Skirts but I also find that stories sent in by other readers are very interesting to me, no matter what their "Hobbies" may be. The type story that always gets the best of me, are the ones about Men who are lucky enough to have "Wives or Girlfriends" who help them to dress and enjoy seeing them in Skirts. I've never been fortunate enough to find a Girl who would enjoy this "Hobbie" with me. I can imagine that a lot of Women would be very unhappy to hear that their "Husbands or Boyfriends" want to dress up in "Female Clothing", but they react this way not knowing that it could lead to many happy moments. To cite a couple, if the Lady of the house was going out to shop, instead of the Man refusing to go, he would gladly go along and maybe see a Dress he liked in one of the stores. Then at night, instead of the Wife worrying where her Husband was going she could look across the room and see him, in Blouse and Skirt, reading a book or helping her with the sewing. Of course there are many more to add to the above.

One little Gripe I have with some of your readers is, they ask you if you would like them to send "Photos" in. Why don't they just enclose them and see? I'm sure if they are Printable, they will be in future issues.

JAN

37

"DO IT YOURSELF" DEPARTMENT

Dear John Willie,

In your Bizarre #12, I came across your drawings of how the 6" heel is made possible, and after reading "From Girl to Pony", in issues #11 & #12 the idea in my nasty little brain began to form. I had a very weird idea and retired to my work room to ponder and experiment.

The drawings that I enclose (I'm not much of an artist), are the best that I can do but maybe you can improve upon them and submit them to the other readers in a future issue of Bizarre. (It was easier to make these HOOFS than to draw them!)

In drawing #1, I used hard wood (that I had saved from an old overstuffed chair) and fashioned the main part of the "hoof". I made it in two pieces and using metal dowels and a good iron and wood glue I fastened them tightly together, using clamps to exert pressure.

Drawing #2 shows the position of the foot on the wooden form. I used my own foot as a pattern. Incidently, I'm a male and wear size 9 shoe!

Drawing #3 shows the completed "Hoof"! I had a worn out pair of highcut leather boots that came in very handy in the final finished product. I carefully cut the soles and removed the heels from the uppers, leaving all the original leather possible. I then sewed and tacked the leather, from the boots, around the wooden forms that I had constructed. When I had finished, the wood and leather were as one. I cut the top of the boots off about two inches above the ankle and riveted a strap on the top that would buckle in front. The lacing eyes were already in place so all I had to do was to buy new rawhide laces for strength, which I promptly did!

I showed my wife the pair of "Hoofs" that I had made and she was intrigued, to say the least. The first thing she said was, "How can anyone possibly balance themselves in them, there are no heels for support?" I laughed and said, "That's the idea, honey. I'll bet it's almost impossible to stand up straight in these things, let alone "trot" or "highstep" in them!"

I hadn't realized it but I had built my own trap, for as they were made for my size foot, I would have to try them out! I was as excited with the experiment as my wife was and when she suggested that I should have my arms bound behind me I

agreed. After she bound my arms, she tightly laced my feet in the "Hoofs". I never wear pajama tops and as soon as the "Hoofs" were laced, she removed my pajama bottoms leaving me in just a pair of briefs. The little shedevil then gave me a good pinch and when I yelled "ouch!" she forced a bit between my teeth and adjusted a headharness on my head. She then pulled my bound arms up to my head with a strap from the top of the headharness making my face point toward the ceiling. Snapping reins on to the bit rings she stood back and surveyed her male pony. She evidently liked

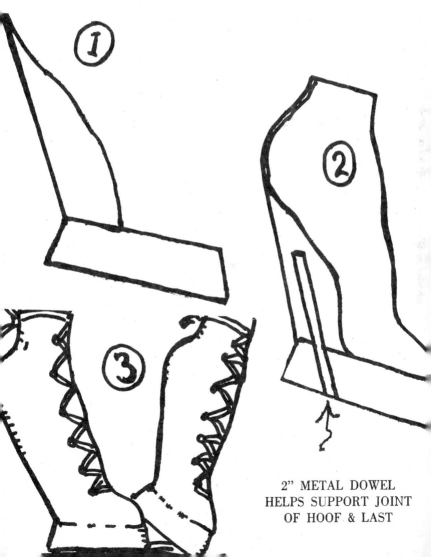

2" METAL DOWEL
HELPS SUPPORT JOINT
OF HOOF & LAST

what she saw for she suddenly produced a two and a half foot whip and taking the reins in her left hand, she commanded me to get up. I was sitting on the edge of the bed and as she pulled the reins, I began to rise. I never quite straightened my body before I landed on my knees on the floor. The whip began to sing and I was forced to try again and again. I protested wildly through bitted teeth that I couldn't stand but she only laughed and said she couldn't understand what I was saying.

Finally she put me to bed just as I was and woke me up in the morning to begin all over again.

Well, anyhow, it took most of the next day before I was able to balance my bound body on those damn "Hoofs" and I was well whipped in the process, too!

This story is as complete as I can possibly make it, for there are a lot of things that went on in this trying period that I cannot describe on this paper due to their personal nature.

I would like to know what you think of my idea. If I measured correctly, these "Hoofs" elevate the heel about 6 or 6½ inches without benefit of heel. Rugged, huh?

Thank You,

R.G.

SPARKLING LEGS ◄

G OLDEN girls also have golden legs, for the back seams of their sheer nylons sparkle with gold or silver thread. If they want only one leg to g l i t t e r, they wear a gold bead anklet under their stockings.

Dance shoes in gold or silver kid glitter like chandeliers. The newest ones have dangling rhinestone drops hanging from the tops of the heels—a good way to use up a broken necklet!

Others have coiled metal heels with rhinestones swinging from them.

"But if you p r e f e r, you can trim your heels with gold coins instead of rhinestones," they say.

American g i r l s are giving their bathrooms a golden touch by insisting

on gold-coloured towels and bathrobes. And in bed t h e y sleep on golden sheets —w e a r i n g gold-coloured nylon nighties.

Guess what m a n y American girls gave their boy friends for Christmas this year? A tie woven from gold thread, to remind him, when he goes shopping for her, that she *IS* a golden girl. If that isn't a hint, what is?

NICE TEARS

Dear Editor,

I recently received #23 and believe it's one of your best. The photo story on pages 47-49 was very good. It had some wonderful pictures in it. The picture on page 50 of the young lady lifting her skirt, so you had a good view of her stockings and undies was excellent. I'd like to see a full page picture like that. The two pictures on pages 52 were also of the much needed variety. I especially liked the top one. After seeing it, I had my wife dress accordingly and pose like it and variations of it, for me to admire. The sight of a woman's buttocks so exposed, is a delightful sight.

I hope we will hear more from A. J. A. and his Oriental Slaverette. I am quite interested. I would also enjoy hearing from R. L. #22 and the punishments given him by his aunt. Another fine letter was from Ruth C. on her office routine. I'd also like to see more pictures like page 44 #21, of a young lady being spanked.

My wife is a very well built and attractive young lady, and I get a great joy out of buying her all sorts of nice lingerie. When I bring her home some new panties and stockings, she puts them on and gets on top of the table. There in her high heels, she'll parade about swinging her skirt high. The picture on page 50 #23 is a fine example of this.

One fact I particularly enjoy, is that she doesn't wear a bra. She has nice firm breasts and I love the sight of them jouncing beneath her clothing. Many of her clothes are so they will show off this fact. At home she often goes about bare breasted. We both wonder if there are many other women with this habit?

My wife likes to dress up and model things for me. One of the ones I like the best is when she wears sheer panties, a fancy garter belt and stockings, high heels, with just a sheer lacey half slip over them. Her breasts are bare and maybe a strand of pearls about her neck. To me this is a thrilling sight. Some times she doesn't wear a garter belt but hold her stockings up with garters on her thighs like the top picture on page 52 #23.

Another exciting costume, is a short skirt with just a garter belt and stockings underneath, high heels and a tight jersey. Moving about, clad like this gives a viewer a lovely sight of her bottom under the short skirt and of her bra-less breasts under the tight jersey.

Another one of our enjoyments is what R.M.S. calls hydrophilia or what we call dunking. My wife loves to put on a thin dress, undies, stockings and heels, and get completely soaked. It is a lovely sight, seeing her with the dress

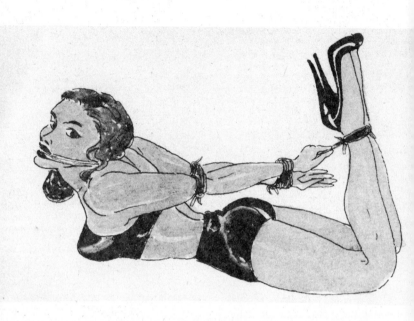

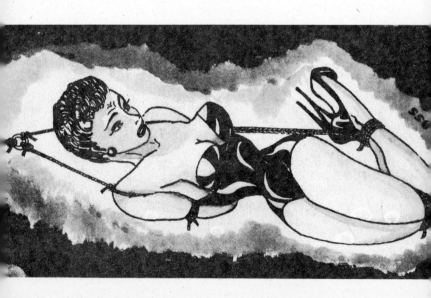

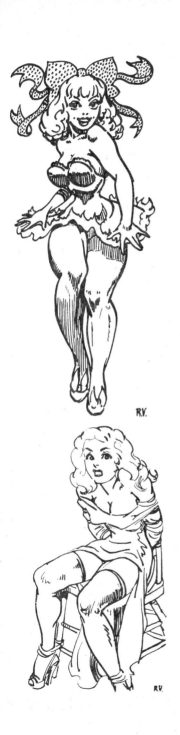

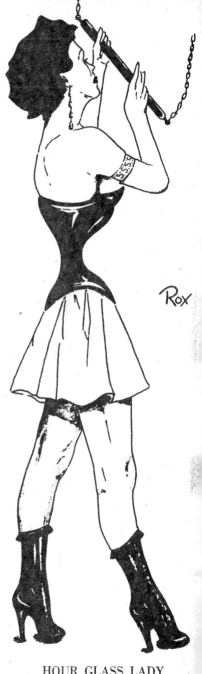

Rox

HOUR GLASS LADY
INSPECTS HER
LACING-BAR

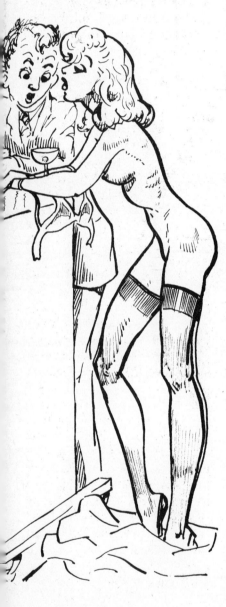

dripping and clinging to every curve. I can see why R.M.S. thinks a bra shouldn't be worn, as the breast is vividly outlined by the clinging material. The way it clings to a nice rounded fanny is another nice sight.

One of my favorites is when she wears just a sheer nightie. When wet it clings like a second skin and is very transparent.

When I got married my mother-in-law told me that my wife was spoiled and would need to be spanked now and then. This I did and my wife never objected, in fact sort of liked it. I would put her over my lap, bare her lovely bottom and spank it well with a paddle. After a while she thought that if I could spank her when she was naughty, she should be able to spank me when I was naughty. Now when I misbehave, I have to undress and bend over the foot of the bed. Then my wife usually clad in just her panties and stockings and high heels, spanks my bottom with a short leather strap. She can really make me squirm.

When she is spanked, she has to strip to just her stockings and heels, and go over my lap. I then give her a good paddilng with a wide paddle. I don't stop until her fanny is good and red and she is really squirming about. If she has been heal naughty, she has to

bend over the bed and receive a light touch of the switch on her now reddish bottom and thighs. We both enjoy giving and receiving these spankings and find the feel of a strap or paddle on our bare bottoms is a thrilling and exquisite feeling. None of our spankings are severe and we never leave any marks on each other.

My mother-in-law visits us occasionally. While visiting, she is allowed to witness our spankings and has even administered them to both of us. She is only in her very early forties and is an extremely attractive woman. She also likes to join us in our dunking parties. As she has a very good figure, I find this quite exciting.

She gave us the idea, that if a severe spanking is in order, for the one who is being spanked to put on a tight pantie girdle. In this way the spanker can really lay it on and not worry about leaving any marks. We have both tried this, and to insure that the spankee can't resist he or she is tied down. This has left us both in tears, but find it quite nice.

ALAN C.

PACE SETTER

Dear J. W.

What ever happened to our masked friends? Are they on the wane? Or busily silent? (turn the I think that batman article in issue 19 ended all reasonable contributions since it presented us in a bad light. We are a quiet bunch who love peace and tranquility.

Nothing annoys me more than the sounds of the day, unless it is the sounds of the night. I abhor radio and television. I could scream when I hear, "How should I clean my dentures, doctor? With toothpaste?" or "What cigarette should I smoke, doctor?" To escape this idiot world, I wear a mask of soft rubber which covers my eyes and ears (I wear soft earplugs to eliminate the pressure on the inner ear that makes you hear the sound of your own breathing — this can be as disturbing as a ticking clock) When masked, I am alone with my thoughts, at peace and far from the artificialities of the mania Ubania.

My husband used to think I was "tetched", trying to do my housework in my "fashion fantasia". Now he tolerates it as husbands are prone to do. Once he asked me if I didn't miss my "hearing". I do. I envy those people who listen to the stars and those who hear the snow fall. But I have a motto, "He does not run who cannot set his own pace."

MARTHA

45

ROXANNE

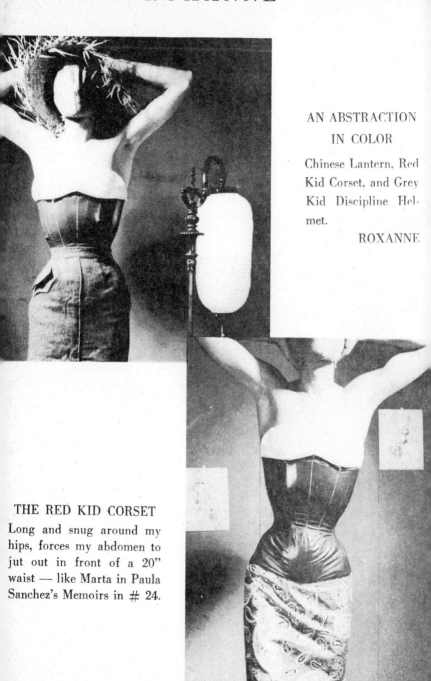

AN ABSTRACTION
IN COLOR

Chinese Lantern, Red
Kid Corset, and Grey
Kid Discipline Hel-
met.

ROXANNE

THE RED KID CORSET
Long and snug around my
hips, forces my abdomen to
jut out in front of a 20"
waist — like Marta in Paula
Sanchez's Memoirs in # 24.

I dreamed a dream one day,
That my waist was laced this
 way

And now I tug and fight,
And feel the laces bite . . .

My dream is coming true, I
 pray;
Strange, how wonderful I
 feel today!

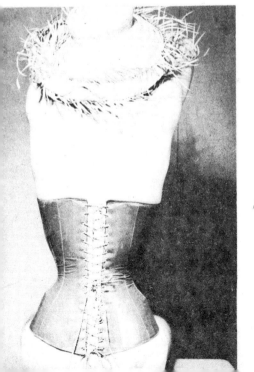

THE RED KID CORSET
An inch and one-half to go . . .
 ROXANNE

ANY QUESTS?

Dear Sir,

These wives who run off to a lawyer to charge their husbands with cruelty, just makes me sick! Do they not realize that a husband by law has a right to chastise his wife, providing it is within reason and in private.

When I was a young bride of twenty, I knew that I was going to be a difficult subject, and I knew that pure love and patience from my husband was not always going to make me into a model wife, and I was fully prepared to shed a tear or two in my early training.

The first time I did wrong my husband slapped me across the cheek. I was intelligent enough then to realize that such blows would lead to even more ungainly and perhaps dangerous blows, and I immediately remonstrated with him, and told him that if I was to be slapped, then it should be on the proper place, and since then I have lain across his lap or bent over the arm of the settee and received it like a spartan.

Why not? It saves smacks and blows that can do damage or even cause discoloration, in places where it shows. Beatings can be immoral and cruel and show the outside world the secrets of one's married life and I know from regular experience that a vigorously applied leather, across one's elevated skirt, is the safest the best and the most effective.

My husband and I are gloriously happy and have been for many years. I have nothing but admiration for a man who can take his wife to the bedroom when she has upset him, and soundly spank her. After such a session all is forgotten and there is no sulking or resentment.

Yours truly,
D. M. (Mrs.)
Harrogate, England

PANTIES FOR PLAY

Dear Editor:

Issue 23 of Bizarre was quite enjoyable. Your poems were very good and "Fugue for a Quiet Afternoon" was very fine. Hydrophilosopher gave the clearest description and explanation of this interest I have ever read. I hope he will write again.

I have been trying to interest the three ladies in our group, consisting of three young married, childless, couples in "dunking," perhaps this article will help.

Our main "Bizarre" interest in group practice is one hinted at by hydrophilosopher when he advised "If she is naughty, turn her over your knee and apply the plam of the hand where it will do the most good."

All three ladies were quite frequently punished as children, us-

ually by their fathers, who used wooden paddles or razor straps on their upended, bare buttocks. Although they all agreed this was painful they unanimously preferred a quick spanking to bickering or denial of allowance or dates. They all vow that if they have any children the rod will not be spared.

There have been discussions by and about teen-agers and working girl spanking and many seem to feel this a splendid disciplinary method, even though they are on the receiving end.

If my wife is particularly slow in her housework, nags, too far exceeds the budget or something of the sort she knows she can expect a stinging paddle applied to her lovely 37" buttocks. For her punishment she wears quite long hose attached to a suspender belt,

"BOOTS AND SHACKLES"

Contrary to the opinion of "J. R." in No. 24, metal shackles are very easy to make with simple hand tools. This pair of "stride regulators" were made of brass stock 3/4" wide; The only tools used were a hack saw, file, pliers, hammer, and hand drill. The shackles are 8 3/8" around and fit snugly around the boots for which they were made. The chain is nickel plated and limits the stride to 12". The boots themselves are size 8 with a full 5" heel.

R. L.

DON'T LET THIS HAPPEN TO YOU

Learn jiu jitsu, the art of self-defense

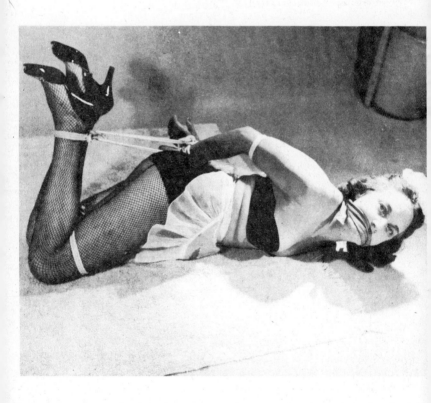

DOMESTIC RELATIONS

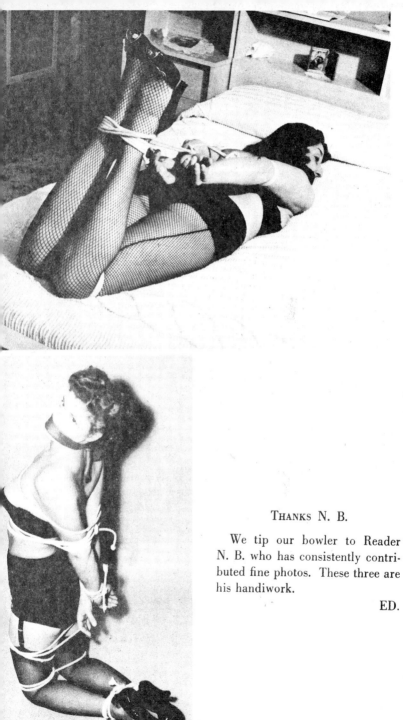

THANKS N. B.

We tip our bowler to Reader N. B. who has consistently contributed fine photos. These three are his handiwork.

ED.

high heels and a sheer panty and bra set. I usually bend her over my knees, and pull the panties down to her knees and give her 30 to 50 solid whacks with bare palm or paddle depending upon the severity of the offense. For very serious offenses, I bend her over the back of a high arm chair, so that her legs are off the floor and use a razor strap or belt, but sparingly as this is very painful.

My wife dislikes this position, not entirely because of the extra pain but the exposure and resultant helpless feeling.

Our group discussed the spanking as punishment theory and began kidding about it, and soon we were practicing it. Often we play a friendly card game, betting a small fixed amount. The girls seldom really concentrate on their playing so we men usually win. We have "gallantly" given the ladies the option of taking a reasonable number of spanks and forgiving their monetary losses.

The ladies have come to rather enjoy the spanking ritual. As a by product they have become more interested in the quality and appeal of their lingerie, so that each tries to outdo the other in originality and beauty as they are exposed for the spanks.

The girls all favor sheer silk or nylon in pastel colors and usually the tight brief type. Often they add some lace or ribbon or embroider their hubby's name or some saucy motto. At one particular party all three girls, (by mere coincidence?) exhibited tightly pantied buttocks upon which they had embroidered "Don't spank, please." We enjoyed the view, but naturally, disregarded the admonition. Others such as "Fragile," "Handle with Care," "This End Up" etc. appear quite frequently.

The ladies, bless their hearts, have learned that all they need do is mention they have seen some lingerie that will outdo the others, and they are provided with the wherewithal to purchase same, and all concerned consider it a good investment.

Occasionally we use a question and answer game with spanks as penalties for incorrect answers. Sometimes we put on a record and spank the ladies pantied on bared buttocks in rhythm. They groan in unison if they hear the opening strains of a lively tune as they know their "sit-upons" will tingle harder and longer than if a slower piece is played.

We would like to see more spanking photos and stories, and as you may have guessed, we also support "Bon Voyeur" in his bid for some revealing photos of everyday undies stretched to be spanked or otherwise.

"Panty Warmers"
Nebraska

52

BIZARRE TRAINING TO DEVELOP
A STRONG WILL

The contents of *Bizarre* make very interesting reading. The first thought might be that it satisfies the average reader's curiosity, or it gives him the satisfaction when he realizes that he in his own personal bizarre ideas and practices is not alone. But besides these and similar impressions there is quite a bit of interest to be found "between the lines." I have been an interested reader of all the volumes from 1 to 24. What perhaps most impressed me in so many of the contributions of fellow bizarre friends is the amount of *willpower* applied. If I think, what it takes for the lovers and victims of tight lacing with all the discomfort and pain, resulting from it or for the victims of chaining, and especially stringing up for some time, not to forget of those that submit voluntarily to whipping, or caning or strapping, and not only once but habitually, or the piercing of septums nostrils and nipples I cannot but recognize and admire the amount of extraordinary *willpower* in all these performances. Though not everybody may be fully conscious of this element, I am sure that it explains the deep personal interest or the attraction caused by these reports This application or demonstration of extraordinary willpower

is especially valuable, and in some way is one more justification to think and act "bizarre."

I know of myself that in a number of traits I have acted and still do act as an inveterate "bizarre." I have no apologies to make for them. When analysing my ideas and actions of this kind I have to recognize the fact that it takes a lot of more than usual willpower in the practical performances, and that I can say, that I furnish it. At the same time I know that this possessing and using this more than average willpower is not confined to these "peculiarities" if you will call them thus, but that the rest of my actions in every day's life benefit from it. I think I am more of a successful individual just because of it.

A truly honest self-examination brings me to the question: Was this willpower born into me, or did I acquire it? If the latter, can others likewise acquire it, and how? May be the acquisition of it leads through a chain of practices which in themselves may appear to be "bizarre" to some extent certainly provide at least the pleasure and satisfaction as such, while at the same time equipping me with some more for other, perhaps more difficult performances.

My self-examination leads me back to my very earliest youth of about six years or even earlier.

My parents were a hardworking selfdenying team. They had to, with 9 children, a small cash income the father being a laborer on the railroad, the mother besides doing all the housework, cultivating a tiny bit of farmland, far from the home. Only extraordinary willpower kept them going. We children became early aware of this fact and it was hammered into us to make as useful helpers as possible at our very earliest age. We were lovingly but constantly encouraged to develop and use our willpower. Eventually it became an addiction with me to seek and use every opportunity to increase my willpower. Father had dug a well in our garden 20 feet deep, six feet wide. It contained 15 feet water. For a while it was uncovered until a pump could be installed. Looking over the open well with 15 feet water I became frightened to think that I could fall in and drown. It was fear. I must overcome fear, must use my willpower. Thus I went back a little distance to get a start, run and jump over it and landed on the other side. It was most foolish as I saw afterwards. because if I had failed I would have been drowned unfailingly. I was nine years old.

In those days people at home did their thrashing by hand flail. A strong man's job. with muscles and sound lungs and with good breath. I insisted to join in swinging the flails in rhythm with the grown ups, for hours. It was very hard work, but I gained willpower. I was about ten or eleven years old. When fourteen I sought new fields to increase my willpower. I figured out that it would not be easy to hang unsupported in a belt around the chest swinging free from a rafter on top of our barn. Time and again I climbed up to the floor right under the roof, stood on a bale of straw, hooked myself on a hook fastened on a rafter, stepped from the bale and swang free in midair. A wonderful thrill, but soon it became painful, but I held out, always adding a few more minutes. I kept up practicing over many months. Result: more willpower, less fear. Then I tried with both wrists in leather bands to hang on the hands. Difficult, I should say, because of the stop of blood circulation. But I learned to stand it for quite some time. Then one more difficult: To hang on both feet downward. It was a bit complicated to manage safely. especially to be able to get back to the support and lower the feet to free myself from the hook. With the aid of an extra pulley it worked. Quite a sensation and thrill. Then to make it a bit more difficult: To hang on one foot. Swinging completely free without

touching anything. I felt rather proud to have that much will-power to do it.

Getting towards the twentieth and older I tackled *mastering pain*. I began with sticking a pin into my skin. It hurt. I put two in, it hurt a bit more, then eventually several; I simply decided to do it, pain or no pain, and I got through with it. I increased the number of pins until one day while riding over an hour on a streetcar I pushed one pin after the other into my left breast. When I arrived at my destination I had 75 sticking in my breast, each one and a half inch in the flesh a veritable pin cushion. For several years I continued experimenting with actions that made me disregard pain by sheer will-power. I cut an armful of Canadian thistles brought them to my room and spread them over my bed and laid upon them naked. For the first moment one shrinks from the sticking thistles. Just disregard it, and it is wonderful, how pain disappears. I repeated it frequentlry until it had no effect on me anymore.

A step further: Lay down on an ant hill with hundreds of excited ants crawling all over your nude body. I know when I stood before such a hill to try it, I hesitated for a minute. But I had to get the experience and overcome my fear. I undressed and laid on top of the hill, just protecting my eyes and ears, nothing else. It was some experiment and experience. The crawling of myriads of ants on one's skin, their biting or spraying their acid which causes a bit of a burning sensation. Since I simply was determined to stick it out, the sensation soon wore off. I repeated the experiment many times on hikes in the woods etc. Though I did not lose my sensitivity however it did not deter me at all. But in each case I emerged with increased will-power. There are a hundred if not more different kinds of such experiments, especially trying to overcome any fear of pain which I carried out. Later on when I went in for very extensive tattooing I often had the tattoo operator work on me for two hours without interruption, making millions of punctures and cutting up the skin surface to about a square foot at the time, without troubling me, that the tattooer remarked, she (who had been a nurse) had never seen a man who could stand pain as I did. Willpower explains it.

I am determined to keep it up. Fortunately I have found a partner in my wife who has come around to share my ideas and assists me in my willpower efforts. In fact she is a living proof what systematic and continued training in this manner can accomplish.

She was just as timid a gal as any average female. But she loved me enough and had confidence in my theories that she went in for my training method, and she is today my equal when it comes to willpower and fearless spirit.

We have worked out a plan, by which we both keep ourselves fit to have and use the greatest possible amount of willpower by a simple practice. Once or twice a month on a Saturday or Sunday we take an hour off and devote it to willpower practice. We have acquired a long leather whip which we use on each other. It is rather serious business when we do so. We have a nice basement, where we can execute our plan without any hindrance or disturbance of others. When we are ready we undress completely. No protective underwear to lessen the effect. We have the arrangement that the one time wifie has the start, the next time it is my turn. The "victim" has his or her hands tied and bent upwards on the back, to get them out of the way of the whip. A padded leather belt is slung around the chest, with a piece of rope running over the back unto a pulley fastened on a rafter in the ceiling of the basement. If we want to make it "easy" the "victim" is kept standing on the floor free all around. Then the whip is brought into play. No less than ten strokes and not more than fifteen, except if the "victim" asks for additional punishment. There is no denying, that the whip properly handled burns like fire on the skin. When I layed it on the first time on my gal she just jumped and whimpered. I lost courage, and stopped. But she scolded me for trying to deprive her of her part of our agreement and insisted that I continue. I did and it was remarkable how she gained in fortitude with each new stroke. Territory extends from hips to knees. Honestly when I beheld her chastised body that looked like an automobile map with all the red welts showing my heart went out to her and I expressed my sympathy. But good sport as she is, she did not want any sympathy. In fact when it was my turn to be the "victim" and she the whipper, I could see and feel that she was given bach to me what I had given her, with interest. After our hour we both take a little rest. But we are keeping up our exercise. We even found that we need to give it a bit more vigour, because we get kinda used to it. Thus we pull the rope a bit more over the pulley until the body hangs free without any support for the feet. At the same time the "victim" is blindfolded, which adds to the suspense not knowing when and where the next blow will hit. We

56

both prefer the whip because it hits "all around." I concede, and so does my brave wife, that it is a hard school to acquire more willpower, but we think it is worthwhile.

It is not so much that we find special pleasure in the pain as such but rather find special satisfaction in the fact that after each "lesson" we have once more become victors over our human weakness of fearing things that are hard and painful.

Yours for more willpower

M. F.

FEMALE BONDAGE

Dear Editor:

Please excuse the poor handwriting. As I write this letter I am heavily manacled, my wrists being encased in tight handcuffs which are locked to the end of a short iron bar, the other end of which is bolted to a heavy iron collar locked around my neck. My ankles are also shackled and connected by heavy chains to a steel band locked around my waist. This is my usual costume when my husband and I spend an evening at home by ourselves. When I finish this letter, however, my handcuffs will be unlocked, the collar turned around on my neck so the iron bar with the cuffs, hangs down in back, and my wrists re-fettered behind, the short bar holding them drawn up high behind my shoulder-blades in a double hammer-lock position!

I am only 19 years old but already a confirmed bondage enthusiast! I was married last January.

My husband is a Toledo manufacturer whose name I do not wish to be known. Besides he is looking over my shoulder as I write!

Having ample means, my husband has generously provided special bondage equipment in our home, which include a sweat-box built into the basement wall; an oubliette under the cellar floor; several sets of chains with manacles custom-made to fit snug on my wrists, neck and ankles; several leather straitjackets which

are custom-tailored, one lined with fur, an assortment of branks, gags and masks, etc.; plus a large stock of bondage "staples": these include such items as rope of many sizes, leather straps, rolls of wide tape, chains, padlocks, handcuffs, dog-leashes, in addition to a rack full of whips which get occasional use.

Thanks for the new gagging idea on page 35 of issue No. 18, I will be wearing one when I am roped up in bed for tonight!

Sincerely,
"Bondage Betty"

WHO'S THE BOSS?

Dear Mr. Editor,

I am probably the best disciplined wife you have ever heard from and my Lord and Master has some very ingenious ways of enforcing his will. Some of his methods are highly uncomfortable to say the least; but I do get a thrill from being made helpless and to have to depend on him for release.

Perhaps we are unusual people; but I note from some of the letters from your readers that many wives, and husbands too, for that matter, have to endure bondage and punishment. I am glad I'm not the only wife who has to obey her husband or suffer punishment. I love him and want it that way; but I do think some of my punishments are unusual so will

pass just a few of them on to your readers if you care to print my letter.

About a year ago my husband had our family doctor pierce my nipples and insert small nipple rings as well as piercing my ears and nose. All these rings are small and my husband brazed them so they cannot be removed without cutting the metal. I am not even self-conscious of my nose ring as it being small does not attract too much attention and I have had some nice compliments regarding it.

When my husband wants me to stand in one place he merely has to fasten me with a small padlock and light chain through either my nose ring, nipple rings, or ear rings and I can assure you I stay there until he releases me.

If he wants me to stand in the corner he secures me by my nipple rings at any height he desires. If he wants me on my toes he has two rings inserted in the wall at just the right height and simply snaps two small padlocks through my nipple rings and also through the rings in the wall. I stand there until he lets me go no matter how tired my toes and legs get.

He has a ring in the ceiling and by attaching this to my nose ring with a small chain and padlocks he can force me to stand on my toes in the center of the room un-

til I'm completely docile. He never ties my hands as it isn't necessary because escape is impossible.

If he wants me to stay flat on my back he runs a chain from each nipple ring and locks it together under the bed and there is no turning over until the chain is released. He has similar control over me by using the ear rings as he can stand me in the corner facing the room and fasten each ear to the rings in the wall. I cannot turn my head nor can I do anything but stand there until he decides to release me. I think being fastened by the nipple rings makes me feel more helpless, although he uses many other restraining devices on me.

Most of the time I have to do my house work under some handicap and very seldom am I entirely free because if I am not wearing some device or other I am chained by my nose ring or by my nipple rings with enough chain to reach the parts of the house where I'm working.

Almost all the clothing he puts me into is locked on in some clever manner. Among these articles are one pair of so-called shoes that while leaving my feet almost bare, keeps me on the very tips of my toes. The device consists of a wide anklet which locks on with a curved piece of metal similar to a shoe horn extending down my instep almost to the toes. This is curved to fit the top of my foot, and is bent down so that my foot is almost in a straight line with my leg. From the rear it looks as if I'm bare footed and am merely standing on my toes! but my foot is held rigidly in this position and I cannot do otherwise but stand and walk on my toes.

My husband has various ways of saddle strapping me too. These are fastened to a wide locked belt around my waist which he really pulls tight. Some of the saddle straps are single straps fastened to the belt in front and passing under the body are pulled extremely tight and locked at the rear of the waist belt. They are of various materials from small chain, ordinary hemp rope, horse hair kid (I shudder when I think of the horse hair strap), to just a plain strap.

He also has a couple of other straps that have a larger saddle and has two straps running to the front of the belt and connected to a single strap behind.

One of the saddles is of leather and he has pads of horse hair which he can insert if he wants the punishment to be greater. The other saddle is made of carved wood. The wide saddles make one much more aware of her punishment as they are decidedly un-

comfortable and take all the joy out of life for the wearer especially if the knees are hobbled too.

I think the saddle strap to end all saddle straps though is the one he calls his "electric saddle." It is also a wide saddle and has small electric wires running down the outside of front strap and passing through the saddle itself to connect with a small metal piece about the size of a pencil which is fastened on the inner side of the saddle. He has batteries and a coil and simply has to press a button from his chair to make me jump out of my skin.

Whatever he tells me to do while I'm wearing the electric saddle I do no matter how silly or humiliating it might be. I have been made to dance sing, recite poetry and many other embarrassing things to keep his finger off the controlling button. When ever he does give me a shock I jump straight in the air and fall on my knees to beg him to stop. I am afraid of electric shocks anyway, and this is one shock I'll do anything to avoid. I'm thankful that he doesn't use it often.

He has one other punishment similar to the saddle strap which consists of an ordinary one half inch rope stretched tight across the walls of the basement about four feet from the floor. When I'm to be punished in this man-ner, he sits me astride the rope and ties my wrists to a rope from the ceiling. My arms are not pulled up high; but I am able to balance myself while my entire weight is resting on the rope. He then ties various weights on each of my ankles to increase the pressure. It doesn't take much of this to bring me to tears and make me beg for release.

I am also spanked often and even in the spanking he has a very painful method he uses occasionally. He puts a pair of panties on me that are lined with emery paper with the rough side next to the skin. He then bends me over a low table and ties my arms and legs and proceeds to spank me with a paddle. The spanking itself is very painful and I usually have to cry with only a few strokes; but the real sting and burn comes awhile afterward when the emery paper begins to get in its work. I am left tied in position after the spanking and believe me, fire couldn't burn more. Sometimes I'm released but my arms are tied and I have to wear the emery panties all evening. Once after an emery spanking we had to go out with friends and he made me wear the horse-hair saddle strap plus a pair of panties lined with coarse horse hair. You can imagine how comfortable I was sitting.

He has many other restraining

devices, unusual clothes etc. which I am forced to wear but I will tell you of those at another time if you are interested.

Among them is a clever device to keep me standing all day even though he might be gone and yet it still allows me to do my work.

Do you think we are unusual people, and do you think I should rebel? Well, I can't rebel even though I really wanted to. The punishment and restraints are tough; but I wouldn't have my life changed. I love my husband and master, and he loves me. If this is how he wants it I am content.

My girl friend now has her nipples pierced and wears nipple rings. Sometimes when the men go out and leave us they sit us in chairs facing each other with a small upright pipe between us. They fasten our nipple rings together with short pieces of chain and padlocks or sometimes simply snap the padlocks through both our nipple rings and there we sit until they return. It isn't really too unpleasent as we can visit and get caught up on the gossip; but can we move? No! we have to sit face to face untill they return with the keys. Once they took us hunting and wanted us to stop talking so we wouldn't scare the game so they locked our nipple rings together with a small tree between us and when they had finished hunting they released us.

Betty, my friend, says her husband bends her over a bar when spanking her and fastens her nipple rings to rings in the floor. She says she can't even squirm with this arrangement.

Please don't think from what I've written that my husband is a beast. He isn't! He's a nice guy and I love him.

Yours truly,
Laurie, M.

TEX'S TRICK

Dear Editor:

I know from reading your correspondence section that I am not the only one among men, who are intrigued by extremely high heels, and like to wear them. Naturally, their wear has been, prior to last month, been confined to the privacy of my home, simply because wearing them in public would result in scorn and disgrace.

Some time ago, I conceived the idea of designing a means of wearing them in public without anyone knowing. Naturally, the problem seemed impossible until I noticed a picture in the paper of a man in cowboy boots. I have worn them frequently, myself, over a period of sixteen years, and enjoy them. But, naturally you wonder: "How can they have anything to do with extremely high heels?" Upon examining the

61

"Tex"

immediately tried them on, and found them to fit perfectly, and they felt wonderful. Naturally, it took a bit of practice to learn to walk normally in them; but after a week, I could go out in public with no fear of anyone even suspecting. Now I wear them almost all the time, and get great pleasure out of them. One would think that the somewhat extended toe would seem clumsy, but after a little while, it isn't even noticeable.

The shaded parts of the sketch are filled in, to allow just the space required by the foot. The hard solid filling; but the parts space under the raised heel is around the toes, and above the heel are foam rubber, to hold snugly in position, and prevent the foot from slipping or shifting. The soft bulge above the heel prevents the heel sliding up and down, as it would in pumps that are either a trifle too large, or are stretched out of shape by long wear.

enclosed sketch, you will see that it is quite simple. I drew the pair of feet in the position required by stilt heels, and then sketched, around them, quite an ordinary looking pair of western boots. Upon close scrutiny, it can be noticed that they are just a trifle wider, from front to back, than boots ordinarily are. That was necessary to enclose the feet as drawn; but in reality, is not even noticeable.

I sent the sketch to one of the fine custom shoemakers outside of the U.S., and requested a price on such a pair of boots. The price was high, but not exorbitant, so I sent complete measurements of both feet, and ordered a pair made up. Then came the hard part — waiting! After about three weeks they arrived, and I

Since I have been wearing them regularly, I have been kiddingly called "Tex", but no one even dreams what I am really wearing. Now I am quite at home in them, and wouldn't give them up for anything. Try a pair, fellows, and experience the pleasure they can afford for you. Even your closest friends won't suspect anything.

The enclosed sketch should be all that is required to enable any skilled shoemaker to fit you out with a pair that will fit perfectly. The sketch is a duplicate of the one from which mine were made, so if your custom shoemaker is worthy of his name he'll need no further information, except your complete foot measurements.

Now, at last, your desires can be satisfied, without your pride or social reputation suffering.

Sincerely,
"Tex"

Beats Eggrolling

The women of Czechoslovakia will face an "ordeal" by whipping and water Eastertime.

According to ancient custom the men have the right to whip every woman they meet before midday on Easter Monday.

In the Eastern parts of Slovakia they throw buckets of water over the women instead.

But these days the traditions have become less harsh. The "whips" on sale in shops all over Prague are no longer made of 12 willow twigs, but of paper thongs.

The men usually conceal them the previous night, and the women try to hide themselves in the morning.

When a woman is caught the man keeps up the beating until she "buys him off" with either a kiss or an Easter egg.

The girls in some country districts hide in their gardens while boys search for them.

When caught, two boys hold the girl's arms while a third one "whips" her until she names her sweetheart.

R. F.

‚‚‚‚‚‚‚‚‚‚‚‚‚‚‚‚‚‚‚‚‚‚‚‚‚‚‚‚‚‚‚‚‚‚

A woman attracts a civilized man in proportion to the angle her feet make with the ground. If this angle is as much as 35 degrees, the attraction becomes acute. For the position of the feet on the ground determines the whole carriage of the body, and women who wear low heels are not very attractive and preserve their virtue with ease.

BIZARRE

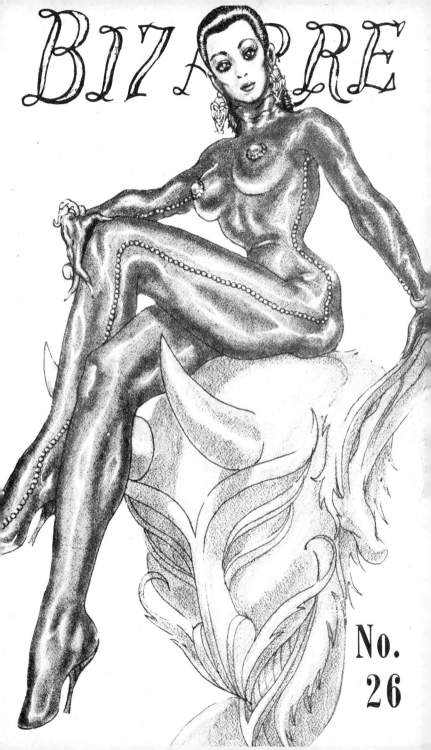

No.
26

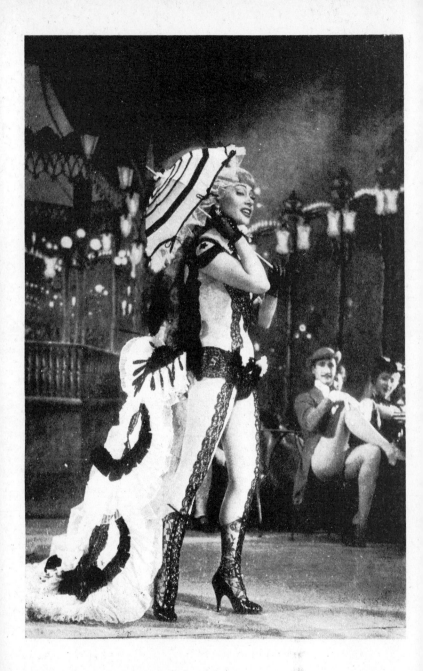

BIZARRE

"a fashion fantasia"

No. 26

*Oh, come with old Khayyam, and leave
the Wise*

*To talk; one thing is certain, that life
flies;*

*One thing is certain, and the Rest is
Lies;*

*The Flower that once has blown for ever
dies.*

OMAR KHAYYAM

CONTENTS

BACK NUMBERS

By all means, patronize your local dealer. If he can't supply you write
directly to:— P.O. Box 511, Montreal 3, Canada.

*Printed and Published by Bizarre Publishing Co., P.O. Box 511, Montreal 3, Canada.
Copyright 1959. All rights reserved.*

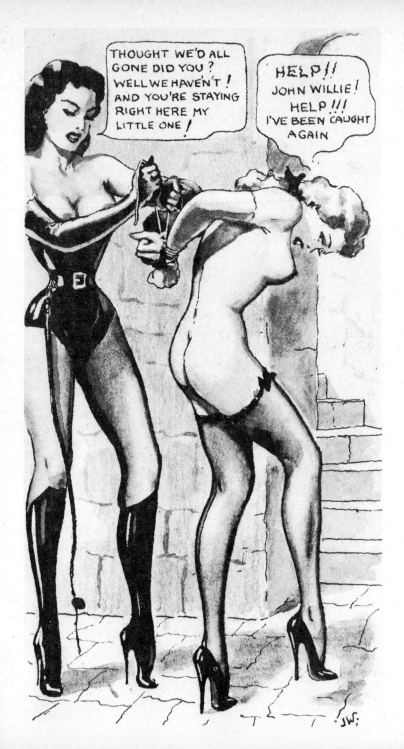

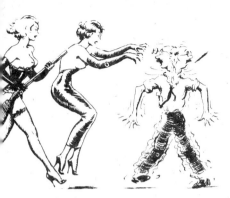
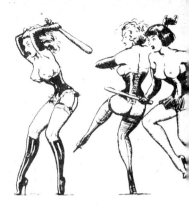

WHO'D BE AN EDITOR !

Yesterday, with the dummy copy of this issue by our side, we were staring at the empty editorial page. Somehow, like the preface to a book, the editorial is the last to be written. There are no rules on the contents of either but by some innate inference, authority should indicate that he pre-comprehends the scope, and theme and matter of what follows. He doesn't. Not until it is put together, disassembled and reassembled is there a distinct characteristic apparent. He is more of a critic, claiming foresight; an apologist beating his peers to the punch.

We had two ideas buzzing in our head. One was the problem of presentation; the other, the contents of this issue.

Sometime ago, Fantasia did a nice editorial on the former topic. And lately the problem has been aired publicly. We decided to let it go by with only the above mention.

Secondly, we found the temper of the following articles to have lasting qualities. This conclusion hit us yesterday when we were doing some rereading. Usually when the issue goes to press we've had it up-to-here and it affects us like the sight of a martini glass on the following morning.

Additionally, the galleys have been with us so long that they seem to belong to some ancient issue, long forgotten, so we were somewhat surprised to find the dummy held our interest.

One other word — Thanks for sending in your letters and pictures for publication. Keep'm comin'!

Fashion Expert Cites History

Men were First To Wear High Heels, Silk Stockings And 'Foundations'!

Why do women like to wear men's clothes? And why are feminine fashions styled in the male tradition?

Fashion expert Miss Agnes Borgia, acting head of the department of art and instructor in costume design at the University of Florida, says this is a natural trend.

She parries critical thrusts from the male sex on today's trend by pointing to Beau Brummels of the past who also originated other feminine mainstays, including high heels, silk stockings and even foundation garments!

MAN - TAILORING has become so popular that some men's clothing manufacturers have begun making their products in women's sizes, the former assistant editor of McCall's Magazine pointed out. Men, meanwhile, have done little to change their own styles.

"Men have always been complaining about their clothes, but they've never done anything about it," she said. "The most radical move they've made has been the Bermuda shorts."

Items considered exclusively in the realm of women's dress more than likely were inspired by men years ago. The "feminine" styles to which men would like their women to return, were once masculine styles, she revealed. The first knitted silk stocking, the first high heels, the first laces and frills were worn — by men.

SHE TURNS to the history pages for proof.

—In 1558, Henri 11 wore silk stockings to his sister's wedding in England, starting the curious new fad in that country. They were knee length, joining long breeches.

— High heels were inspired by Louis XIII of France. The first ones were red and elevated him by the "uncomfortable height of three inches."

—Louis XVI put jewels into his high heels, an idea which is only now becoming popular among women, she said.

Even foundation garments were men's! Corsets with curved steel rods pinched first men, then women, in at the waist about the 16th century. The stiffened bodice came into fashion during the Elizabethan period. Stuffed hips, achieved by padding the colorful doublets worn by men, came into vogue after the age of chivalry and Sir Walter Raleigh began.

MEN WERE the leaders during the lace and ruffles period. They wore shirts with ruffles, sleeves with lace cuffs and carried perfumed handkerchiefs.

But it was during the French Revolution that simpleness in clothes replaced the elaborate designs, she continued.

During this period the men returned to wearing their breeches skin tight, in imitation of the Greek and Roman athletes, she continued, adding, "and then they criticize women today for wearing skin tight clothes."

The greatest impetus to the modern trend in simplicity was the introduction of golfing and bicycling to the American scene, she thinks. Women looked to men's clothes again, and adopted sports wear, which in turn gradually shifted to the home.

Does she think men's fashions ever will return to the frilly styles, luring women's fashions with them?

"I don't think so," she said. "Not after having tasted the comfort of simplicity. It would cereainly be a step backward if they did," she said.

LES THROUGH THE AGES—The first elevator shoe (1) stood a foot off ground; 2 & 3 reflect ormed feet of Chinese and Turkish ladies; 4 & 5 were concessions to aching toes; 6 & 7 go back t are toe; 8, 9, and 10 are the richly embroidered boots of the 12th century; 11 represented the ult gh shoe fashion for the gaily plumed court dandy, hardly suitable for battle but grand for the ball

Punishment: The Old Chestnut's Still Hot

That old parental theme song, "Whatever you do you're wrong," is never truer than when heard as insistent background music to the handling of a disciplinary episode. What to do with the 5-year-old who has just kicked his father soundly in the shins or the irate 10-year-old who has thrown a glass of milk at his brother? How to handle the 14-year-old who, after consistent reminders, continues to come home late from evening activities at the community center?

The beginning of an answer to any of these questions is, of course, "It all depends." It all depends on what the child is like, what the parents are like, what went before the episode, what efforts have already been made to ease the basic situation causing the difficulty, what other means have already been tried to control such behavior.

Just where punishment fits into the picture is, as we've mentioned a highly controversial point again

attracting attention among the specialists.

Some, although stressing that good discipline is a matter of what parents do "for and with a child —not to him," have suggested that reasonable punishment, judiciously applied, may occasionally seem called for. The very use of the word "punishment," others appear to feel, will open the way to excesses and abuse. One reader wrote:

"Many years of volunteer welfare efforts have taught us that the very term 'punishment' and all that it implies should be exorcised from our lexicons * * *. We do not by any means say there should be no penalties for wrong-doing; especially for deliberate wrongdoing, when the perpetrator knows he is doing wrong — with malice afore-thought, as the legal phrase has it.

"But correction should be correction and NOT vengeful employment of authority. There are two parties to punishment—the punisher and the punishee. In the case of children, the first party is also the complainant, prosecutor, jury, judge and hangman — executor of the penalty he has himself decreed. Could anything be more barbarous?"

This point of view has strong support from a whole school of specialists. It includes those who oppose the idea of punishment primarily on moral and ethical grounds and still others who hold that it is not only dangerous but also it is useless as a long-term method for controlling general aspects of behavior.

For pre-school children particularly this would appear to be so, a newly published research study indicates. ("Patterns of Child Rearing," by Robert E. Sears, Eleanor E. Maccoby and Harry Levin, Row, Peterson & Co., $5.25). In this study of methods used by 379 suburban mothers, techniques of training—including punishment—came in for detailed study. Although this is only one element in a far larger investigation, it sheds light on the question we are examining.

Of the mothers questioned only 1 per cent reported that they never used physical punishment. Twelve per cent said they occasionally slapped the children's hands, but had administered only one or two real spankings in the youngster's lifetime; 35 per cent reported occasional slaps and rare spankings, two or three times a year perhaps; 29 per cent slapped fairly often, gave occasional spankings; the rest admitted to fairly severe spankings, ranging from "fairly often" to "frequent."

Forty-seven per cent said they felt the spankings did at least

some "good", 40 percent, that spanking did practically none. Eight per cent felt that spanking was good in some ways, bad in others. The remaining 5 per cent included those who never spanked or did not express an opinion. Those who followed spanking with reasoning, an explanation of what the child had done wrong and a word on what he should or could have done that would have been "right," seemed—in their own opinion at least — to achieve more effective results.

Deprivation — of television, of ice cream, of outdoor play or a special trip—was used from "sometimes" to "very frequently" by 60 per cent; "withdrawal of love," a method most mothers were extremely reluctant to admit to, was used from "moderate" to "much" by 24 per cent, and another 23 per cent said that they used it on rare occasions. Closely related to this approach was isolation, used slighty by 20 per cent, moderately by 29; to a considerable extent by 24 per cent and "much" by 12.

On punishment of pre-school children, the researchers had this to say:

"The unhappy effects * * * have run like a dismal thread through our findings. Mothers who punished toilet accidents severely ended up with bed-wetting children. Mothers who punished dependency to get rid of it had more dependent children than mothers who did not punish. Mothers who punished aggressive behavior severely had more aggressive children than mothers who punished lightly. They also had more dependent children. Harsh physical punishment was associated with high childhood aggressiveness and with the development of feeding problems."

We were interested to compare this study of mothers' reports on how they punish their pre-schoolers with adolescents' reports of how they are punished if they "do something wrong." A nationwide study of girls, 11 to 18 years old, conducted for the Girl Scouts, and a similar one of boys 14 to 16, conducted for the Boy Scouts of America, indicated that types of punishment used were very much the same as those meted out to pre-schoolers.

Thirteen per cent of the girls and 20 per cent of the boys reported some form of physical punishment was used by their parents. Ninety per cent of the girls and 83 per cent of the boys reported deprivations or restrictions — being "forced to stay home" was the most general for both girls

and boys. Others were sent to their rooms or sent to bed early, had their allowances cut, their television restricted, were kept from dating or using the family car; had disagreeable jobs assigned to them. Thirty-two per cent of girls and 31 per cent of boys reported "psychological punishment" — scoldings, lectures, being made to feel sorry or guilty. Only 3 per cent of both boys and girls claimed they had never been punished.

Neither boys nor girls, however, seemed to resent parental restrictions or authority. Both studies indicated that the young people felt rules were made "for the children's own good," "to keep kids out of trouble," "to help children mature," "to give them standards." If parents did not exercise their authority, the young people believed — or so they reported—that "children would lose sleep," "do badly in school," "run wild or get in trouble." Only 1 per cent of boys and 5 per cent of girls indicated that they thought young people could manage their lives without the aid of adult authority.

Clearly the situation of pre-school child and teen-ager differ greatly. No question of punishment can be considered without asking, "Who is punishing whom —how and for what?"

Paddle Tennis, Anyone?

Each list of pleasures should include
The fun I have in being rude
From well-placed kick to cruel remark
Being mean can be lark
Though virtue is its own reward
An insult relieves me when I'm bored.

Chatsworth Chatter

PROPER CORSETING IN LONDON

By B. Hilliard

The Fashion Center for Proper Corseting to-day is London. Paris is still suffering too much from the war to support the corsetiers who made their shops famous for the waspwaist. Recently I spent ten months in London where I had the pleasure of becoming well acquainted with perfectionists whose ideal is the elegantly laced figure.

I found in London two corset makers who were doing a splendid business in the waspwaist. One of them advertized every week in the best newspapers, "modern and Victorian corset for both sexes." The other had so much trade you had to wait until your order receive attention. Two other corsetieres did some work in hourglass stays. Recently, friends write to me, two more have appeared on the scene.

Their customers include some of the celebrities of the glamorous 1940's when my novel "The Triumph of Elaine" was printed in a London magazine. As I am a painter as well as a writer I was able to paint the portraits of four of these tightly laced paragons of fashion. All were devoted wives to worshipping husbands. Their unity with their husbands in the ideal of the Corset provided the world with high example of marrage at its best. Some day, if space permits, I wish to tell you how their husbands described the idealistic determination of their wives to acheive and enjoy the divine Corseted Look.

One word they were fond of was "encased." This word is old in the vocabulary of corsets but is as revered as the corseted look itself. It expresses to the corset wearer the supreme feeling of being completely strapped in majestic corsets, elevated to heaven.

I painted the portrait of Marianne, whose corseted beauty brought many letters to London Life in the 1940's. Her continental loveliness looked appropriate in a style suggesting the Renaissance, an attempt to paint something rose. Then I painted the wife of a man who used to contribute to magazines under the name of corsetphile and sautien— gorge. His flair for the artistic is so ardent that he stood behind me as I painted directing me what to do. The result, his wife in an Edwardian frock of yellow silk, waspwaisted, regal of bosom and hips, talking with another tightly laced lady, in turquoise silk, framed in a window through which broad lawns and stately trees pictured the era of elegance.

GRANGER
LOOK

One of my daintiest subjects was Mrs. A. in red silk fitted like a glove, a slim young figure, sixteen inches of waist, a delight to see and hear. Listening to the polite English voice is a joy. With the soft tones and delightful inflections go manners correctly courteous to other people. Civilized voices.

Most of these friends do not wish to be embarrassed by publicity concerning their corseting. If this year were 1890 society could approve. Perhaps in 1970 society will esteem corset lacing again. However Mr. and Mrs. William A. Granger of Peterborough, Horthants, believe the ideal figure should be shown to the world. I painted Mrs. Granger laced to fourteen inches and immediately her husband had the news in the papers. Possibly her waist is the smallest in the world. For persistent determination to attain the ideal the Grangers exceed everybody else. Their devotion to the ideal is spiritual. They aim at thirteen inches!

To the minds of many people the loveliest woman in England is Lady B. Her tapering waist is one of the tiniest yet it avoids the large—ribbed appearance that causes some figure to look like sacks pulled tight in the middle. Dressed in exquisitely fitted Victorian and Edwardian clothes all the time her straight backed dignity is charming. She and Lord B. have been annoyed so much by unkind reporters that they ask friends to let them live in privacy. However they love dancing so much they dance twice a week at the Savoy or Dorchester. Lady B. is a corsetiere, with excellent taste. I had the pleasure of meeting Lady B and Lord B twice and can praise them sincerely.

The acquaintances I have mentioned, and several others, I found urbane. They were cultivated people, established in business and in society, schooled in good manners. Meeting them was a pleasure. Possibly I could have found less polite users of the corset in England, but I am sure not many. Artists' models who posed for my costume drawings knew good manners. Two or three who applied on the telephone did argue in a voice that lost them work.

How far real corsets are being worn in the general population of England I can not say because many women would avoid looking conspicuous on the street. The brisk trade of corsetieres indicates many customers who cultivate waspwaists at home. One day I saw two young girls in Berkeley Square who were well laced. Very pretty figures! Another day, in the same place, not far from corsetiere's, I saw an exceedingly beautiful lady so tightly laced she wobbled a bit and looked

blushingly confused. In Whitehall one night I saw a young man and young woman going to the theater, the lady with a miraculous little waist, leaning affectionately on her escort, laughing in tightly laced delight.

Among actresses I saw Sabrina on TV and Roberta Lofting at a Hammersmith theater. Both consider a tight little waist a profitable allurement. Miss Lofting, seen in person, has an artificial waist that holds everybody's eye like an irresistible magnet. Sabrina's name in on everyone's tongue.

I spent a pleasant hour or two "B" at his club. His tastes in little waists and high heels are exquisite. I hope he will send you more material.

On Picadilly I saw so many lovely girls, with that pale English complexion that comes from the moist sunless weather, that I congratulated my British friends on having the prettiest women in the world. In an exchange of such courtesies with Lord B he said the loveliest were seen in New York at the hour when office workers left for home. After that I can only believe the ladies of Bizarre's office must elevate the heart at exit hour! In any event my friends in England were always asking to see Bizarre.

London Life begins to print again items on the corset, small items. I tried to find Mr. Millmore, the owner and editor these many years, but was told he was retired and not well, living somewhere near Arpington, Kent. Caven Street office, near Charing Cross Station, is attended by a part time editor. The British popular press comes out frequently with news of women who are properly corseted.

Simon Ward reported in the Daily Sketch that 79 year old Frederick Roberts was marrying Velia Dawes, 39—17—38. Mr. Roberts, interviewed at his Park Lane home, is reported to have said he was marrying her because he wished to have somebody to leave his money to. Proper corseting predicates love and wisdom.

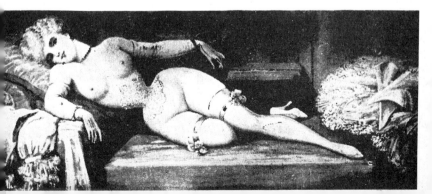

SABRINA went to Ascot yesterday—apparently determined to be a winner if only by a neck. A few women in the paddock hissed. Sabrina didn't seem to notice.

TO PIERCE OR NOT TO PIERCE?

(From London Life)

One of the fiercest controversies ever to range in print is that of pierced *versus* unpierced ears now that earrings are again in fashion. The old fashioned method of needle-piercing and the consequent wearing of sleeper earrings for months is gradually yielding place to the newest method favoured by society women.

The lobe of the ear is first cleaned with surgical spirit, and the ear pierced by a needle slightly larger than usual threaded with a length of sterilised thick silk thread. As the needle goes through the lobe, the thread is carried through off before and behind.

Thus the "patient" has an invisible, new piercing kept open by the threaded silk, which is invisible while being worn, and this thread is worn for three or four days. There is no need to "draw it through" to keep the piercing open. It remains put, while the flesh heals round it.

When the slight soreness (and in most cases there is none at all) has worn off, back goes the "patient" for the next stage. The thread is drawn out from the pierced lobes by a pair of tweezers, and into the newly-made hole is inserted a tiny silver rod that fastens behind the ear by means of a push-on stud (not unlike an ordinary press-stud). This holds the rod in place while complete healing takes place, but as soon as the rod is fitted, earrings can also be worn, and here's how.

The rod is fitted with a round "head" which cuddles the outer lobe of the ear (often made of pearl or diamanté). This "head" is big enough to hold securely any earring fitted with a tiny ring, which is threaded on to the rod.

Look at the picture of Anita Ekberg, wearing long pearl drops. Those drops were slid on to the rod, then the rod inserted into the lobe piercing, and the "fastening stud" slipped on to the rod at the back of the lobe. It's an incredibly easy operation, and within three days of piercing the heaviest earrings can be worn by the rod method.

So much for the modern method. Now let's look at another way, as described by reader Mrs. M. Granger, who decribes in detail her method.

"Strictly speaking, it is what is worn after the piercing, while the permanent tunnels are being formed through the flesh that is most important," she says. "This may take *from a week to two or three months*, depending on the individual and how the piercing is done. Until the skin has 'grown through' from front to back any unsterilised object will cause trouble."

This of course, is perfectly true, and the modern silk-and-rod method demands sterilisation of everything also, but Mrs. Granger continues: "Therefore it is *wrong* to 'turn' *sleepers* unless they are bathed with a sterilised liquids first, and the same procedure should be adopted if the earrings are to be changed while healing in is progress. For this reason small studs with a butterfly fitting are better than sleepers."

(Mrs. Granger did not describe this butterfly fitting for us, but no doubt we shall be hearing more about this from her in due course.) She then goes on to described her own adaptation of the traditional needle and sleeper style by saying: "However, the piercing can be made permanent by nothing more than a length of silk thread drawn through by a sterilised needle. This can be dipped in a solution of alum which which will cauterize the holes. A knot at the back of the ear, then another tied on and worked down the ear to the front; clipped off close, and the piercing can be forgotten for *a month or so*. When the knot is clipped off the thred comes out, leaving a nice, clean hole."

17

" Pierced ears are necessary when wearing heavy, dangling earrings," vows Yvonne de Carlo (*left*), Republic Pictures). " Mine were done when I was a child, and I wore sleepers for years."

" My ears were pierced by the modern method favoured by most actresses who can't wear sleepers for months," says Anita Ekberg of Paramount (*right*).

" I keep my ears unpierced and wear the clip-on style " Yvonne

orrespondence

Under no circumstances do we publish names or addresses. If photos or sketches are sent in, please write a short commentary and please do NOT send in photos which you got from someone else.

THE BERKLEY HORSE

Dear editor:

I have here some data relevant to E.J.'s query (No 18, p.39). An elderly gentleman once told me some of his experiences with low life in London in the '90s, and mentioned a device known as the Berkeley Horse, in use in a pleasure-house of that neighborhood. (E.J.. attributes the name to Mrs. Berkeley, but I got the impression, from my informant, that the house stood on or near Berkeley Square, so I don't know.) The contraption resembled a kind of rack. It was an openwork frame: the victim would be strapped on it in a prone position, with legs and arms extended, and then half of it would be lowered on hinges, bending him at the waist and stretching him tightly. (The tension was adjustable, of course, to the taste.)

The whole thing sounds very complicated. I suppose that such an ingenious machine could be hinged around in several different ways to suit different people, and may have afforded some relief to the unwiedly Prince of E.J.'s query; or perhaps Mrs. B. of B. had all sorts of machinery in her place. I hope you turn up more detailed information than this.

Yours,—H.B.

PIVOTAL PRIDE

Little has been heard from the devotees of the panty girdle. And I feel impelled to speak up for this wonderful garment—even at the risk of incurring the scorn of the corset cult.

The panty girdle, when worn by the male of the species, effects an almost magical change. The arro-

gant male stance is forced into the spraddle-leg posture of a wide-leg posture of a wide-hipped female . . . the swaggering male walk becomes a feminine hip-swivel despite any effort to maintain a male stride . . . and the proud, erect male is forced to assume the female position.

In effect, the panty girdle, is a male chastity girdle. Its wearing subordinates maleness and constantly reminds its wearer that he has elected or has been forced to bow to female domination.

Surprising to men who have not worn it, it gives support and shapeliness to the male figure as well as to the female. More men should discover the value and pleasure that comes from wearing panty girdles. Many of us wear them now and would not be without them.

Girdle Bertie

VARIATIONS

Messres. Bizzare:

Not since the "Twenties", have those "slaves of fashion", our women folk, shown their adherence to the edicts of the leading couturiers, to such an extent than they have this year. At least that is the case as I see it in London, England.

For ordinary street wear, I have seen everything from boat-neck so low cut that a modesty veil is an essential, to skirts slit so high in the thigh as to show the top of the stocking.

Footwear is as varied as our weather (which incidentally, I believe made our grandfathers the colonisers that they were).

The most common seem to be, either those topless creations, or equipped with super pencil heels of at the very least $4\frac{1}{2}$ inches height.

Harem or balloon skirts with their built in hobbles, short, superslim skirts, so tight that I don't see how the wearers can sit down, so tight that they are their own hobbles, causing those short mincing steps. One shapely pair of legs I saw, in a restaurant, were crossed and adorned, for they certainly weren't covered, by a short slim skirt, black of course, and we all know what happens to such a skirt in those circumstances. Again in restaurants I have seen several slit skirts.

Off the shoulder dresses, not off the collar bones but coming down some three or four inches along the arms, again this one was black, others just, but definitely, came off the shoulder.

Miniature bustles, "look what I've got, and proud of it bosoms", one pair was perfectly pointed, due, my wife tells me, to the design of the brassiere.

Skirts are of three lengths, just below, level with, and just above the knee. All of which makes a walk in London just now very pleasant.

M. F.

HARMONY

To the Editor of "Bizarre",

At my husband's suggestion, I take up my pen and scribe this tale of how we maintain marital harmony in the home. We have been "Bizarre" fans for some time, and enjoy reading of the various pleasures people describe in the "letters" department. Bizarre is a wonderful little magazine and I hope you will continue to publish this one, so that we may later read of the pros and cons of others.

As for keeping peace in the home, we do it this way, and find that it avoids all arguments:— Shortly after we were married, we set up a rule book. listing all the short comings of both. The idea was that when one of us broke a rule, we were to allow the other to administer a spanking. I must admit that this was my idea, but my husband immediately saw the merits in such an arrangement, and took to it like a duck to water. He has added a few twists of his own, to add excitement to the game. Let us take a hypothetical case. Suppose that John came

home after a tough day on the job and found a note like this—"Dear John, am over at Mrs. So and So's playing bridge—help yourself to can of beans in icebox." Such a situation would give him every right in the world to be angry, and according to our signed agreement, would also give him the right to apply a lesson to my "seat of government."

Now because of the new twists that John has introduced, this no longer involves a mere spanking. We have made a ritual of the thing that we both find immensely exciting. And so when I finally returned from Mrs. So and So's he might say, "my dear, that little faux pas is going to cost you 30 lashes! Go get ready!" And so, to be properly chastened, I must climb the stairs to our bedroom and strip off my everyday clothes and put on my special costume. This consists of a long satin skirt under which is worn, (of all things!) a *rubber* diaper. (John just loves the feeling of rubber, and sometimes wears nothing but a rubber raincoat around the house.).

Once in my special costume, I must lie flat on the bed on my face, with the two pillows tucked under my tummy. This causes my rather prominent rear end to become even more so. My wrists and ankles are then strapped firm-

21

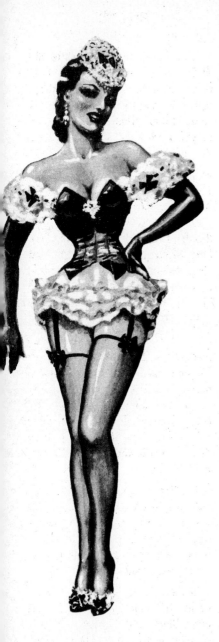

ly to the bedposts and just before he places the gag in my mouth, John tells me to pick a number. This means I must pick a number from 1 to 6 because on the back of the closet door the instruments of punishment hang from numbered hooks. John has arranged these at random so I don't know what instrument I have chosen.

Here is the real exciting part. All I know is that I'm going to get 30 lashes, but whether it will be with a hair brush, strap, switch, cat o' nine tails, riding whip, or rawhide quirt I don't know.

Having picked my fateful number, John applies the gag and I am powerless to move or cry out. He then checks my bindings to make sure all is secure, throws up my skirt and unfastens the rubber diaper. I can tell by the cool currents of air on my skin that I am as ready as I'll ever be for the whip. Then he goes to the closet and takes down the instrument I have blindly chosen. My full punishment is delivered regardless of whether it's the cat o' nine tails or the hair brush.

Once I have been "corrected," he releases me and the incident is forgotten. No arguments, no resentment, no running home to mother. Perfect marital harmony.

And he gets the same treatment from me, when he errs. Because

I am of the so called "gentle sex," I am allowed to administer twice as many lashes as he. On many occasions I have given him more than he cared for! As "slaves" to each other we are happy so what more could anyone ask? I could go on and on with this subject but by now your readers should be getting bored, so I will sign off.

Regards—Helene

Amazon Beefeater

Dear J. W.

My favorite is where one girl completely over powers the other girl and ties her hands and feet tightly together and gagging her victim. I prefer that, at least one of them be dressed in English style riding boots and breeches, both dressed thusly if possible.

I have always admired the strong Amazon type woman and there is nothing I would rather see than the amazon tie and gag her victim and pick her up in her arms and carry her around bound hand and foot.

I enjoyed very much in particular the article and pictures from Dorothy Lamat in your No. 11 issue on pages 42 thru 44, lets have lots more of this kind of article and pictures in all of future issues of Bizarre.

R. & B.

Showgirl

Mr. Editor:

A couple of years ago while still in my teens, I won a beauty contest in Florida. I could never figure if it was my long hair or my short bikini that won for me, maybe it was a little of both.

After the contest I accepted a contract for nightclub work where I had to fix my hair in a bun. The bikini stayed (in briefer form with spangles), but the life was a ball. I love Show Biz, the glamour, excitement (and work) but what I loved most of all was; to be costumed, to walk around and be admired.

Now I'm married and away from all that. I wouldn't change places, but I sure miss it. Now I'm coming to the part that makes me write. Bizarre is the only magazine that expresses my mood, and when I'm home alone in the daytime I play my little game dedicated to Bizarre readers.

I dress in the costumes I know they would like to see me in, and I practice my walking or dance steps (if the costume permits), pretending that I have an appreciative audience..

Today, it is the French-Maid outfit. It's chic but not glamourous; black kid shoes with sky-scraper heels, long black taffeta

shirt that just reaches the stocking top, a white dicky-type french lace apron and a cap to match. When I finish this letter I will dust the room and tidy-up, making certain to keep my knees straight when I bend over. It's very good exercise.

Recently I've had the yen to have a small tattoo (under my bikini where it wouldn't show) of the letter 'B'. My husband's name is Bernard, smartey. I guess the next step is to find a female tatoo artist. I will let you know how I make out. In the meanwhile, regards to my unseen audience.

Margie

MORE ABOUT THE RUBBER CLUB

I was glad to see my letter published in the issue #24. It was read with much hilarity by the Club members, who decided that Audrey should be suitably punished for being involved (Luckily, being president of the Club, I am absolved from all punishments— a rule I myself made). It was voted therefore that Audrey should be given the Heat treatment. Much to my surprise, she agreed (I found out later she had been putting on weight, and this is a very good, if rather drastic, way of reducing!) Sometime I may describe this quite fascinating treatment.

In answer to readers' queries about the Club itself, it's really very simple and lots of fun. Every fourth Sunday we meet for lunch. There are fourteen members, all personally known to me, but not to one another. Each member arrives at the house between one and two o'clock. She or he is let in by Maria, a very attractive showgirl whom I have known for several years, and who is genuinely crazy about rubber. She is dressed as a maid, in a tight black plastic dress which ends well above her knees, black silk stockings and five inch heels. She conducts each members to a "dressingroom", where there is (now) a large selection of rubber costumes. Many of the members bring their own, but others either cannot afford them, or prefer to wear the somewhat bizaare house costumes.

On a rack on the wall are fourteen black rubber hoods, each with their own number stitched in white, and corresponding to the member's club number. After having dressed, the member slips on the hood, which is then zipped down the back by Maria and padlocked to the reinforced neckband. Maria keeps the key, which makes sure that no one can remove the hood and identify himself. The hoods fit tightly and snugly over the head (They are individually made by our 'tame' dressmaker), leaving only the mouth and small eyeholes (There are interesting variations of this, of which more anon.) The member then dons long rubber gloves, white for girls and black for men, and it is a strict house rule that these are never removed while the meeting is in session. The girl member then puts on shoes of no less than $4\frac{1}{2}$ inches, and these are made more restrictive by a light gold chain fixed round the ankles, allowing only a twelve-inch step.

From then on the members can do as they wish. They can go anywhere in the house except the outer hall and dressingroom (To prevent members meeting when entering and before being hooded -up). A cold buffet is available, with plenty of drinks always handy. The Meeting itself does not start until 4 p. m., and can go

on until the small hours, certainly until midnight. If a member cannot stand being rubbered and locked into a mask for ten hours, then obviously they should not be members!

We pride ourselves that the Club is a social one, and to start off the Meeting each time one member gives a talk for half an hour on some topical subject. (Last time it was a somewhat technical lecture on the advantages of jet engines over piston engines). No doubt to a fly-on-the-wall it must be very amusing to see fourteen people sitting around a large room discussing world events, every one of them clad from head to foot in strange rubber suits! But we have no complaints.

Next, as president, I usually take the stage (It literally is a raised part of the room on which usually stands a grand piano). Usually I wear the Presidential outfit, which the members had made for me last Christmas as a present. Actually, I suspect it was a double-edged present, because it is so heavy that after a few hours in it I am exhausted! It consists of a one-piece bright red rubber 'siren' suit (as the English call it) with hood and gloves attached. It zips from the small of the back to the top of the head, so arms, legs and face must all go

in at the same time. When it is zipped into position by Maria it closes around one like a strait-jacket. It has a wide red leather belt at the waist, and one at the neck. A heavy rubber cloak, ankle-length, clips round the neck, and the outfit is completed with a pair of brightly polished thigh length rubber boots. It is an intriguing outfit, because although one can move freely, eat and drink (with difficulty because of the thick moulded rubber gloves), one is absolutely helpless and imprisoned in it.

After greeting the members, and giving out any bits of news, I then outline the various plans of the evening, which includes various initiations and tests, competitions (which are very popular, because we always have some good prizes), and any special punishments which a member may have incurred. Then the secretary takes over and announces the intended programme for the next meeting, such as deciding that it is Miss X's turn to give the opening lecture; it has been noticed that Mr. Y is too lightly clad and therefore will arrange to wear not less than 25 lbs. of rubber at the next meeting, and so on.

Well, dear J. W., this letter is already much too long, but if readers are interested then I can give you a further report on the activities of the Club. There is one point, however, which non-supporters should note: all fourteen members are highly educated, well respected people; more than one of them have told me privately that our club forms a much needed "safety-valve" in this hectic life we lead, either from a business or matrimonial point of view. We have no fixed rules as to members, except that each one is personally screened for many weeks before being even allowed to attend a meeting, and any new member must be thoroughly vouched for by an existing member. We do not want people interested in cheap thrills. They must contribute a sense of value, and a sense of humour, and, of course, a true love of the beauty of rubber!

Yours, etc.
Blackmaster

VAN ZYL

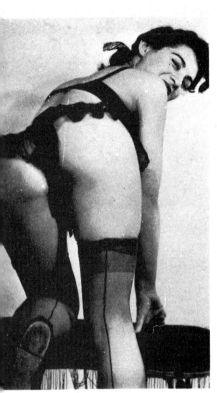

BRIEF ENCOUNTER

Dear Ed

I am also sure that your readers will enjoy this anecdote from my life. I met this girl at a cocktail party at the country home of some business friends of mine in the lovely state of Connecticut. She was in her middle twenties and her name was Rhonda. Most of the people were older than this girl and myself, but what really drew me to her was her fabulous beauty. We chatted briefly with various small groups of people. She spoke in the plain, unembellished manner of American midwesterners, which to my way of thinking is the most beautiful way of speaking the English language. I gathered from some of her remarks that she may have come from around Detroit.

I lost her for some time in the crowd of mingling guests. Later after we had both had a few drinks I suddenly came upon her alone in a littered drawing room on the second floor. She was leaning with her hands on the back of a settee with her right knee on the seat of the settee and her left leg stretched straight back, left foot on the floor. This exposed a bit more of her legs, which were very long and straight, and I realized that they were the most beautiful legs I had ever seen. I drank in this nylon clad display for a

Hey there Willie,

Who's in charge there. He's the guy I want to speak to. This is the third snapshot I sent you. The first was high heels and white undies. The second was no shoes and a negligee. Now I'm wearing flat and black undies. What do you want Willie. You name it. My rival was in No. 22 so I just gotta make a showing. What do you say Willie old pal.

Helene

This is the first pic that is reproducable. I enjoyed the other two, Helene, Thanks—Ed

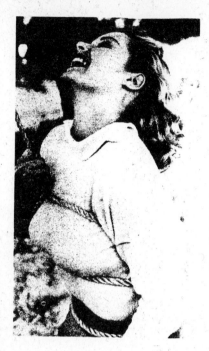

moment, also enjoying the high-heel pumps which glistened on her feet. Her position threw her buttocks into prominence and the shapeliness of that portion of her anatomy brought a lump to my throat. I walked up to her side and put my arm around her waist; she gave me only a brief side glance and continued to look out over the vast expanse of lawn. Two boxer dogs were romping on the lawn, but she did not really seem to be watching them.

We both seemed to be a bit bolder than one would expect of two strangers, and I found myself saying to her, "You were in such a delightful position as I came into this room that I found myself tempted to give you a little spank on the bottom."

To my surprise she responded, "I really have felt rather naughty all day. But why a little pat? Why don't we go where you can give me a really proper spanking."

I was even more taken aback as she led me to an adjoining bedroom and clicked the lock behind us. Then she suggested I sit on the bed. I was no sooner seated than she placed herself bottom-up across my lap like a naughty little girl for a spanking.

"Go ahead," she said, "I really deserve a paddling; and I want you to do it."

I drew up her skirt and beheld the most beautifully filled black lace panties that I have ever seen. Her buttocks were not fat but very shapely; and as I later ascertained as I spanked, her bottom was quite firm. I gave her a right good spanking with my good right hand, taking my time about it and enjoying the task immensely—as she also appeared to be enjoying it, though I really warmed her well.

When I let her up she said "Thank you", gave me a quick kiss on the lips and darted from the room; and I have never seen her since. If she reads your pub-

lication I want her to know that I would like to see her again and she can contact me through the same friends with whom she was visiting at that time in Connecticut.

<div style="text-align: right">M.A.L.</div>

Secured Bliss

Dear Editor:

Just a note to let you know how much my wife and I enjoy your magazine and how much we look forward to each new edition.

Joanne could probably do a much better job of typing this letter but inasmuch as her wrists are handcuffed behind her right now, she is unable to type.

We met just about 2 years ago. It was a nice summer evening and I had just gotten through work. I was a police officer at that time, and on my way home I noticed a car parked alongside the road. I probably would not have paid much attention if it hadn't been for the good looking girl seated on her rear bumper looking very disgusted.

I pulled over to see if I could be of service and sure enough she had a flat tire. We got the jack and tools out of her trunk and I was just getting set to jack up the car when she asked me what was in the two black cases on the back of my belt. I told her they were handcuffs and started to jack the car up.

She was a very pretty little lady, about 5′2″ tall with long black hair, and very simple makeup. She was wearing a black turtleneck sweater, with long sleeves, and a kelly green satin skirt, very full. On her legs she had sheer black nylons and her shoes were black patent pumps, springolater type. No back to them just a sole with a tall heel and a wide band across the instep. She looked very pretty.

She surprised me very much when she said "Now you can help me satisfy one of my suppressed desires."

"What are you talking about?" I asked her.

"Being handcuffed" she replied. "Handcuff my hands behind me, so I can see how it feels."

When I started to laugh, thinking she was joking, she got very mad and demanded I handcuff her. I started to protest and she just looked at me and said "If you don't do it immediately I shall report you to the station as molesting me."

I began to think that she was a little nuts and that I would actually be better off with her in the handcuffs so I got out one pair, put her hands behind her, and fastened them there. I asked her if that made her happy, and she replied: "Not completely but I shall be in a minute." She then

sat on the edge of the front seat on the right side of the car and said: Now the other pair of cuffs, please."

"One pair is enough for your wrists" I told her.

"I wasn't referring to my wrists." was her reply. "I want them on my ankles."

I told her that the cuffs would not fit her ankles and she insisted that I at least try them. I did so and they just did fit, although a trifle tight.

When she was all set and quiet I finished putting the spare tire on the car and put the jack and tools away.

I pulled out my keys to unlock her ankles and she would have none of it.

"I want to stay this way for a while." she said. "Lets go for a ride."

By this time, as you can imagine, my curiosity was fully aroused so I carried her over to my car, put her on the front seat and off we went.

After about 2 hours I took her back to her car, but before I released her I asked her for a date the following evening. She replied in the affirmative but with the condition that I bring both pairs of cuffs along with me. I agreed.

When I rang her doorbell the following evening about 7:45

Joanne came to the door herself, and was I surprised when I saw how she was dressed.

Her long black hair was pulled back into a pony-tail, her face was made up very exotic. She was wearing a black turtleneck leotard with long sleeves and cut very high on the thighs, and a wide black belt about her waist which made it appear that it could be spanned with a man's hands. I found out later it could almost be spanned.

On her legs she again had very sheer black nylons, which I discovered later were dancer' stretch tights so they would cling tightly and not wrinkle.

On her feet were the same type of shoes she had worn the previous night, but with much higher heels. She told me later they were 4 inch heels, which she loved.

She is never without her extreme corsets, almost never without high heels, and in the house is never free to move her arms or legs except to do the house work and the cooking.

Chuck & Joanne

DUNKING

Dear Ed:

I have been an avid reader of Bizarre ever since I saw my first copy about a year ago. I like to read about all the different tastes

and experiences of readers, but my own special hobby is what we call "dunking". Several of us, with wives, sweethearts or paid models, as the case may be, like to go wading, swimming or just playing in a stream, pool or the

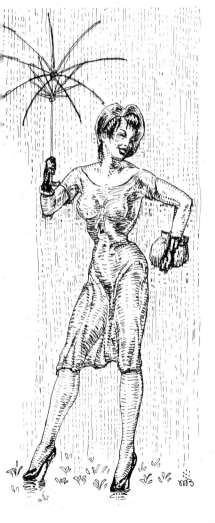

ocean, or simply take a shower. But we do this while fully dressed. We like to see the girls getting their high-heeled shoes, nylon hose and dresses (and sometimes gloves, hats and jewelry) soaking wet. It fascinates us to see the curves of a nylonclad calf and thigh, a patent leather shod foot, or a taffeta or satin-sheathed figure glistening with wet highlights. If the girls will get their hair wet, so much the better. Then they can just let themselves go, be completely natural, have fun splashing and get completely soaked.

I am more fortunate than some of the others in our circle in that my wife (and best model) likes to dunk and often dresses prettily, then suggests we take a shower or wash the car.

Recently, we took some photos of her. She was wearing a white satin and lace evening gown, a white rubber playtex, black nylon hose, white strap sandals, and long black nylon jersey gloves. After soaking under the shower, she changed the gloves for red rubber ones, added a white rubber shower cap, and we made a U-D skirt.

I see in a current magazine that rubber bathing shoes are back in style. Let's hope the rubber swim suit will follow again.

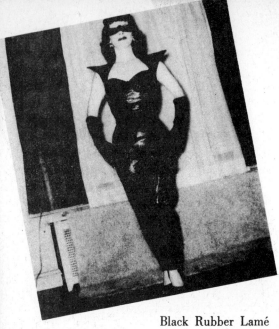

Black Rubber Lamé
Leather Gloves
Gold Metal Mask

Leat
Elasti
Elasti
Leather

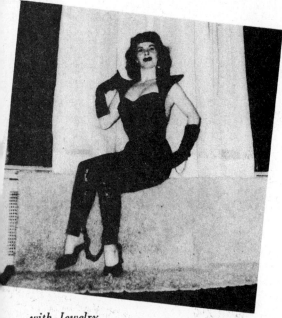

with Jewelry

6"

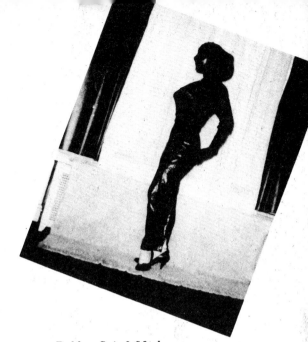

Rubber Suit & Mask
Elastic Sweater

rt
ngs
er
& Belt
G.

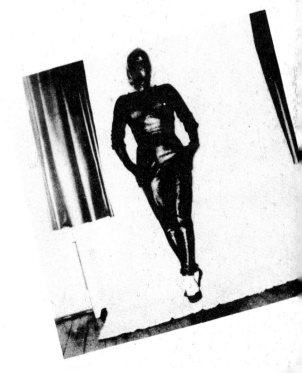

My immediate aspiration is to buy a make-it-yourself frogman's suit, and tailor it to fit my wife. They are available in black as well as in colors, complete with hood and feet attached.

<div align="right">S. C. L.</div>

'CORSET FANTASIA'

CORSETS! Shh! that unmentionable feminine garment that in a more Victorian time would never have been mentioned before the gentlemen, that sheath of mystery within whose rigid bones many a sad tale could be told in a bygone age.

Crinolines and Bustles have come and gone, high waists, low waists, small waists & perilous waists, each has its day in turn, and all in good turn fashion brings forth from the fashion bag, revived again, and again, in this or that form, and woman, poor benighted suffering woman, she has to go through fashions Hoop every time, uncomplaining, but as ever—utterly unable to resist the corsets little pressure here and there.

They called them "STAYS" at one time, gridles, Cuirass (in France,) but it was all the same, they came to enforce their steel or whalebone rule upon suffering womanhood, and she it always seems, is ever ready to hold out her little hands ready to grasp their silken but unresisting long laces, whose gradual manipulation could enforce whatever shape or contour the fashion Dictator of the day called for.

"Seems" like, women really *do* like being squeezed into things. They will wear a shoe half a size too small if they believe it makes a fellow believe they take smaller. In actual fact, they do the same with their gloves, but when it comes to getting that "middle spread" down a little, they are gluttons for punishment without a doubt.

But let us here stick to the almost cruel means which they will go to to achieve this end, that petite little tiny waist, that hard little circumference into which everything "just has to go." as a German would say, "DAS KORSETT".

One time they had them made hinged in two pieces of hammered out light steel plate, talk about being 'nipped in the bud', it was a case of "once you're in Lady, there you stay," for those sorts had not any delightfully slack-lacing for easing after the party, or to eat that extra sticky Bun. Oh! Yes! that's no kidding, you can look them up if you're that way, in the Cluny Musem or the British Musem should you so desire.

They became a little more light hearted in that matter at a later date, and made them thoughtfully in a sort of lattice work of light steel strips. Still you had to stay. If you didn't get into them, Well! for, and you can imagine it was which she was paid her wages your little French Maid did that as well to be nice with her, for she had the means to be a little Vixen if she owed you a grudge.

Who was the wit who called them 'Foundation Garment,' and that at an Era when the steel boned affairs came into being, Bust high affairs, with long laces right down the entire back lacing sometimes to the knees, where a thoughtful little bit of gussetting allowed a few modest steps to be taken for walking. That was at the time of the long slinky figures, until some bright Guy went one better, and shortening the corset, decided that what he had lost in length for Madame, he would now get back in some other way. So in went those waists, suddenly and cuttingly, sixteen inches, fifteen, fourteen, twelve, it didn't seem to matter so long as it couldn't be pulled in any tighter by hand power.

Poor dears! Now they couldn't stand up to be laced, so an additional little fixture came into the Boudoir, the 'Lacing Bar'.

The lacing bar to which the all willing victims hands or wrists were strapped whilst Madames maid did her best or worst with the tugging in of yards of laces, slipping to her bended little silken hosed knee, to steady her Mistress as she pulled those laces in.

But, all in what was apparently considered a good enough feminine cause, so long as Madame could vie with her fashionable competitors in smallness of waist.

Oh! women were not alone the victims of fashion at one time, for the Elegant Brummel of his day also endured a good deal of tight lacing also, a sort of idea "WHAT

YOU CAN DO, I CAN DO BETTER," and a twenty inch waist was not uncommon for those gallants.

The leather corsets did not seem to find much vogue in general use, but examples were certainly quite freely found in the latter Eighties and even to this present day they are made, though usually of a light kid style, glossy in finish and well stiffened through out, there seems also to be no little evidence that Patent leather also was, and is, used in some cases, though the Patent leather corset is a stiff and very unyielding affair.

Training corsets" as they were called seemed to have had some vogue in certain Cities in France and Germany, usually a softly boned affair which was sometimes used as a sleeping corset, but capable of extreme lacing and thus capable of holding the figure closely in shape, when a corset proper was not in use. There is some considerable evidence from all accounts, that the ardent tight lacer usually had a figure that uncorsetted, still held its shaped waist without further aid, when a corset was not in actual use.

Opinions differ about the alleged bad effects of tight lacing, but all that can be said upon that point is to note the large families that were the rule of the Victorian day and earlier and the extremely tightly laced figures of the ladies of that time. Our Grandmothers considered a twelve or thirteen inch waist quite the fashionable measurement of that time.

A good deal has been written about the uses of the corset in young Girls Schools for proper training of young pupils, though much of this seems to be rather romantic wishful thinking. Nevertheless there is ample evidence of a pretty severe routine in corsetting being the fashion amongst young ladies schools. We see no reason to differ on accounts where the tightly laced and stiffly boned corset as a mode of young girls dress was no doubt also used as a severe method of enforcing a ruling upon the wretched victim.

The only conclusion that we can come to upon that delicate point is merely that upon leaving School in those days, young girls were certainly very obedient and polite to their forbearers, (and doubtless all school Mistresses were not paragon angels themselves if they wanted complete obedience from their unruly pupils.)

Strangely enough turning from the possibly ridiculous to the sublime it is a known fact that during the last war pilots to avoid black

outs did use a form of tight belt or short corset, which was found to have decidedly beneficial results, but whether these wearers eventually developed a taste for this form of support is hard to say, certainly some male wearers did adhere to the corset in after-life.

Modern fashions and times do not lend themselves easily to male wearers of the corset, though from statistics we find that there are many more male wearers in this modern age, than possibly Madame might guess, and some quite severe tight lacers. So it would appear that the ladies have not entirely the monopoly in the corset world as yet.

Here in this matter fashion designers have to make their changes gradually, for the modern female form cannot be suddenly slipped out of an accustomed Roll On of elastic, into a multi boned affair capable of great restriction, she has a short but painful period of getting down to "hard facts" about corsetting, to the gradual ever increasing tighter lacing each week or month. Once the figure has undergone the "breaking in process," she may reduce gradually to what seem almost unbelievable waist measurements without any ill effects, other than that stoic endurance which every real corset enthusiast enjoys accepting.

Of course there are, and always have been special corsets with a distinct purpose; with shoulder bracing straps, and other restrictive arrangements to gradually overcome some defect such as round shoulders or stooping, or special deportment needs as for instance for fashion modelling in the big commercial dress houses.

Artists impressions of these special corsetting affairs may at times seem a little of the Artists license, but in fact many of their ideas are sometimes used in special cases. "Backboards" and "elbow boards" are not entirely the artists dreams of imagination, and the ultra high heel wearer of these modern times know all too well, that a certain amount of tight lacing and corsetting has a distinct steadying effect in deportment, whilst holding the figure properly in place in complete comfort.

Once a wearer has got used to using the corset that suits them best or gives them the best support for their sort of daily routine, there is little chance that they will return to the tiring feeling of being without the benefit of those stiff body supports, and elegant carriage, which the well turned out corset offers, as for leisure moments where fashion makes its demands for smartness.

That corsets have in some ages past even been designed purely

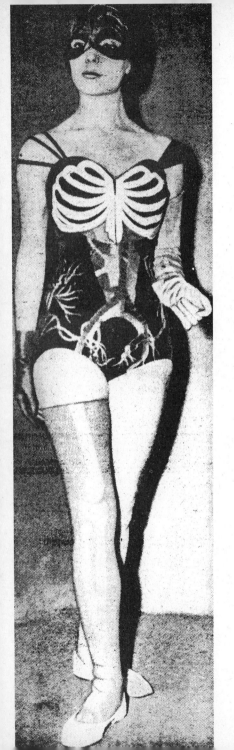

REVEALING?
SHE'S BARING
HER 'HEART'

WHEN it comes to revealing swimsuits, this girl's design has bikinis beaten . . .

Why, you can see her bone-structure, left. And when the top's unzipped, she bares her heart, below.

It's all a pattern in paint, of course. The idea comes from Paris.

with an idea of being some sort of punishment garment is without doubt fact, for examples are to be found here and there, just as the Iron Boot in Londons Tower is still there revealing a past savagery of squeezing from a victim some confession under the increasing pressure of the Boot as its sides were mercilessly tightened until the wretched victim either had some bones broken or submitted, fairly or otherwise.

So also the steel or heavy leather corset has found its way amongst instruments of torture in the past, and a heavily boned heavy leather corset can be a decided means of making the wearer consider a change of mind under tight lacing in the extreme. The evil screw steel belt of a bygone age was an evil probably kept well hidden in the Castle precincts for much the same purpose, with its nasty internally placed little spikes and turn screw fastening.

Artists impressions here and there of ladies with elbow straps and side straps to corsets are not really as fictitious as might seem. For without adding greatly to a wearers discomfort, such strappings can be, and are, used in certain cases of deportment, and when removed usually leave the desired effect of teaching the pupil an elegant manner of walking or stepping in fashionable attire.

But as a general rule the real Old Time Corset makers are a fast dying craft in a commercial world where speed of changing, sport and locomotion are rule of the days. Nevertheless many makers of the old order of styles still carry on their trade in England, America, and on the Continent. Paris is not the least in coming forward when its designers call for a 'New Shape,' and so Madame must rush off to her pet Corsetiere for all the false rigorous demands for fashions aids called for and endure their dictates.

There is still another form of Corsetting, if one can call it that, a method commonly in use today. The figure is encased in a satin and boned sheath, sometimes arms and all, and then gradually laced into the shape the garment is fitted for when completely closed. Women are known to undergo this softening up process in their privacy, prior to taking to the corset in its more arduous forms. A recent example of this in London, totally enclosing the form was exhibited recently. From the high laced neck to the knees almost, (the garment allowed for the arms not being enclosed, if worn outside anywhere,) the lower extremities were deeply lace skirted, making almost a complete evening garment, of indeed quite attractive

lines. The neck part was also dispensed with of course, leaving simply a complete high bust bodice and evening dress in one piece, not very different from a low cut evening dress one might see at any dance, but the great difference being in the under boning, which though not obvious to the eye, was there, capable of some severe lacing of the figure.

And so Madame, if you would be fashionable with the lines of one of those exotic looking ladies one sees in Bizarres pages, such delicate lines, are not Madame! attained in one evening, but rather they are the perrogative of the smart women who are prepared to pay the price of corsetting de luxe, and whose benighted Husbands are also prepared to pay the Corsetieres fashionably shaped accounts.

There is a strange simile about Corsets and footwear, the four inch heel wearer usually has a twenty four inch waist, a five inch heel wearer a twenty waist, and Madame believe me when they wear six and seven inch heels, they are pretty adept at an eighteen inch waist as well into the bargain. That sort of fashion seems to run concurrently, small waist, small feet are the rule of fashion, Hour Glass Waists mean usually Hour Glass spindly heels too.

And lastly dear readers, do you have any idea how much lacing is wanted for the average full length corset, believe it or not! some six or seven yards to go on with, and six or seven yards of lacing can pull a lot of things a long way, believe me!

Iver Pare

Amen Ed.

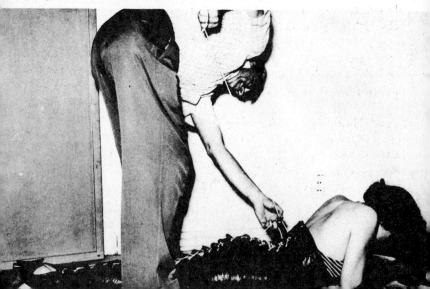

Back around 1917, one Mustafa held sway in the mysterious land of Turkey. Mustafa has since been called "The Father of Modern Turkey." He had decided, long ago, that it was essential for Turkey to hold her position in the world, but to do so, she must modernize. He therefore decreed that the English alphabet be adopted in place of the weird squigglings that the Turks had used for centuries. The people must not only learn the new alphabet, but must also adopt the Western mode of dress instead of appearing in public looking like something out of "The Arabian Nights." As was to be expected, there were dissenters. There were also penalties for those dissenters, and little by little Turkey went modern. To hasten the process, Mustafa threw a number of fancy balls. His Turkish Delights were ordered to tog themselves out in formal gowns, high heels, etc. and show the western dignitaries how modern they could be.

But Mustafa's jaundiced eye soon spotted an anomaly. Whereas the western ladies, for the most part, appeared chic and slender in their evening gowns, the Turkish dolls appeared fat to the point of overflowing their duds in several places.

Mustafa thereby decreed, that the Turkish dolls get their figures down to western standards by diet and exercise, and since dancing was exercise, and conducive to dissolving the accumulated lard, he insisted that his ladies dance instead of sitting and spreading, and sipping high caloried cocktails.

Naturally, the dolls didn't take him seriously and he became slightly enraged as they grew rounder instead of slenderer. So at the next fancy fling, he ordered an anteroom reserved, and called upon one of his palace guards to assist. This fellow was a big bruiser, one of the biggest and ugliest in the guard. Mustafa told him to stay in the room and await further instructions. We'll call this character Abdullah—that sounds Turkish enough. (It's practically certain that *one* of his names must have been Abdullah anyway.)

So Mustafa roamed the ballroom, and when he spotted a Turkish lass sitting, he offered profuse apologies to her escort (sorry old chap—state business y' know—we'll toddle back shortly) and took her to his anteroom.

The doll was in for a surprise, for no sooner had the door closed when Mustafa grabbed her and held her across a convenient chair. He then instructed Abdul-

lah to lay on with the bastinado across milady's plump rear, which that worthy did with gusto. The bastinado was a nasty little implement of bamboo, heavy, springy, and flexible, and was usually applied to the soles of the victim's feet.

But Abdullah applied it where it would do the most good and didn't stop until his master signified that the lady's sitz-platz had been well tenderized and she couldn't now sit if she wanted to. And so she was returned to the ballroom with instructions to dance, dance, dance, and never mind her aching feet unless she wanted another go round from Abdullah.

Mustafa gave a few more sitting pretties the same treatment before word got around that he wasn't kidding. So it wasn't long before the Turkish dolls were dancing their feet off, and their escorts' too, and gained a reputation of being the most tireless ballroom dancers in the world.

So all hail Mustafa! He had a problem and he solved it in his own inscrutable Near Eastern way. Clever people, the Turks.

A. Y.

Passed Opportunity

Dear Sir,

I am a twenty two year old lad, and recently became infatuated with a young married woman who lives a few blocks down the street. She must be about ten years older than I, but is tall, slim and blonde with a wasp waist and the highest heels I have ever seen. When I saw her out shopping, I would follow her for the sake of watching her shoes, and she soon became very annoyed and would glare at me in anger.

One day I did a crazy thing, I wrote her a passionate love letter and dropped it through her letter-box. The next morning I was terrified at what I had done in the 'heat of the moment', and as I was in the house alone, kept a watch on the window in case her husband should come and seek me out.

I didn't have to wait long, for she came hurrying up the path with her shopping basket, dressed in a green velvet coat and trim little hat to match. She looked angry, rang the bell loudly and as I opened the door she brushed past me and stood clutching my letter, at the foot of the staircase. "Is anyone else in?" she asked. "No," I replied. A small girl of about ten sidled in through the door, the woman's daughter, and eyed me with interest. I closed the door, trembling. She looked at me and pushed the crumpled letter at me and said, "I'm going

42

to give you a good whipping for this and she pulled a black leather tawse from her wide pocket. I said, "Come in please," and waved her into the lounge. "Get your trousers down and get over the arm of the settee," she hissed, "If I tell my husband it will be worse for you." The girl whispered, "Is he going to get spanked, Mummy?" The woman deposited her shopping bag on the floor as my trousers came down and I stood in my shirt. "Yes," darling," said the woman. "He's been a naughty boy—a very naughty boy." Dry in the mouth and trembling with eager anticipation I pulled my shirt up and bent over watching her shoes dance on the carpet and the hem of her coat flap as her arm 'rose and fell with the tawse, and the gasps of her exertion together with the loud raucous cracks of the leather, were the only sounds other than my gasps and grunts. The little girl said, "How red his bottom is mummy!" and she said, "Yes . . . darling! . . . he needs a few more yet."

Finally I was choking for breath when she laid off, and the child was quite close fascinated with my whipped posterior.

"I hope that will be the last of this nonsense," she rapped. "Next time you won't get off so easily." She picked up her shopping bag and dragged her reluctant daughter towards the door, as I fumbled my way back into my trousers and saw them both out.

Naturally, I was more madly in love with her than ever after that, but did well to hide my feelings, although I have often wondered what would have happened if I hadn't.

Yours truly,
T. R S.
Exeter, England

THE UNWEARER BEWARE

Dear Editor:

Madam, my corsetiere, has related to me many interesting incidents in her long career of corsetry. Some of these incidents, I feel sure, will be of interest to male devotees of corsetry as they have to do with her men customers who delight in wearing corsets, bras and girdles. About one percent of her clientele is male. She does not seek this business, but being warm hearted and understanding she will accept it from well behaved persons.

She has a word of warning to men who are considering going into corset training. Wearing a corset can become a compulsion. This is illustrated by one incident she told me about. In this case it is a male customer who came to her several years ago. He told her

frankly that he wanted to wear a corset and she made one for him which was very feminine with ribbons, lace and garters. Since then she has made several garments for him as he began to wear a corset under his male clothing at work. He recently decided that daily wearing of his corset was a risk. He might get into a situation where it would be exposed. So he decided to "break the habit". Shortly thereafter his back and legs began to pain him severely. He went to the doctor and had a complete examination thinking that he might have sprained his back. He was in perfect physical condition. The pains were psychosomatic . . . traceable to his love of corset wearing. Now he is forced to wear his corset at all times, and probably will be for the rest of his life. He has tried to minimize embarrassment if his corset wearing should be disclosed by having Madam remove the lace, frills and garters.

Male corset fitting, as conducted by Madam, is done in this way. When the customer comes into the shop, Madam tries the garments over his clothing, then discusses fabrics, boning, garters, lace and the other requirements. He is then told when to return for a fitting, which is always after regular shop hours. He is shown to a curtained fitting booth where he is told to remove his clothing with the exception of panties, bra if he wears one, and shoes and sox. In her experience most male corset wearers also wear women's panties, and quite a few wear bras. Madam then hands him the corset through the curtain and tells him to put it on over his panties. Over the panties as she must be taken in or let out for a perfect fit and remove it from the wearer. She then goes to her sewing machine and makes the alterations meantime conversing with the customer to put him at ease. When the alterations are completed, she shows the customer the proper positioning of the garment, instructs him on garment care, and tells him some of the little tricks of corsetry — when laced tightly it is easier to sit down if the feet are crossed at the ankles before sitting. This also makes it easier to stand up. Another bit of information she passes along is how to properly knot corset laces. This is done by passing one loop of the lace through the other and then tying an ordinary knot. The knot can then be released by pulling on a ace running from the corset eyelet to the knot. Exactly which lace depends on whether the knot was tied left handed or right handed. The now beautifully corseted customer is told to return for refitting after two weeks of wearing the garment. The garment

won't stretch as most people think, but the body changes shape.

An expert in corsetry with years of experience (Madam is in her early sixties) she is continually amazed at the ignorance of women in how to properly wear foundation garments. Accordingly she goes to great lengths to tell her male customers how to wear their garments. In starting corset training, her advice is not to start out with continued tight lacing. The exquisite thrill of tight lacing is something that must be earned by arduous training. Lacing too tight at the start can displace vital organs in the human body. These must be repositioned gradually. So her advice is to start with snug lacing, and wear the corset continually night and day for weeks.

Quite a few of Madam's men customers visit her shop at their wives insistence . . . sometimes alone and sometimes with their wives. She can always tell when one of these customers is due for a fitting or a new garment. She receives a small gold key in the mail from his wife. When the husband presents himself, Madam uses the key to unlock a small but strong chain that secures the garment to him. One end of the chain is soldered to a hook-eyelet at mid-waist, and the chain then passes across his midriff and through a lace-eyelet. This end of

the chain is secured with a small gold padock. It is effective. The poor man can unhook his corset if he dares, but he can't get it off his body. Madam follows instructions and after locking him back in his corset, mails the key to his wife. Recently a woman ordered a corset for her husband which was evidently a punishment corset as she insisted that it be lined with scratchy wool. She told Madam that her husband suffered from a cold stomach.

Madam of course is in position to have seen some unusual examples of tatooing — on men and women. The most outstanding to her was a tatooed "corset" which was done in beautiful detail. The 'fabric" was pink and the decorative stitching and fabric design had been left in white or natural skin color. White lace outlined in pink surrounded the top of the "corset" and a pretty blue ribbon with flowing knot was worked into the lace. No detail had been left off. There were dangling corset strings complete with knot, hooks and eyelets, and even garters which had been tatooed on the legs. Madam said that from even a short distance away the illusion was perfect.

Madam sells bras and custom makes them to order. If her male customers wear bras, she tailor fits their bras in the same way she fits

their corsets. Some she has made are to be inconspicuous as to size when worn under male clothing and still have the pleasant bra "feel". For bras to be worn under dresses ,she usually recommends the air-inflated type. "Perfect Twenty-Six's" suggestion of partially filling this type with water for solid weight is an excellent one.

L. M. M.

SPANKING TOMS

Dear Sir,

I have been reading an interesting report, on an epidemic of "Spanking Toms," which existed in mid-Victorian England. It appears that these 'gentlemen' lurked in the dreary gas lit streets of London, waiting for any lonely hurrying servant girl, on her mistress' errand. The unsuspecting girl was pounced upon, carried into a doorway or dark alley. Her skirts and numerous petticoats were pulled up and her drawers pulled down and belt, cane, or manly palm was delivered on to her protesting bottom, until her screams brought help, when the unknown gent would disappear.

One such maid returning with her master's medicine, was seized five times in succession and was found in a hysterical condition, and evidence from those who had been attacked, indicated that the culprits were the gay young bloods, and not the criminals of the town.

No one took these attacks very seriously, and the Victorian ladies spoke of it in excited whispers, until it became something to brag about, if one had been "smacked on the bustle."

In contrast to the terrified servant girls, many women began to go out and look for it. Such a case was Mrs. M. the wife of a London Magistrate, who after roaming the streets in anticipation was seized by the arm in a side street near Hyde Park. She was pulled into a doorway by a dark cloaked stranger, and apparently raised no objection or struggles as the man wrenched up her petticoats. Seeing this, she said in her own words, "He halted, looked at me sharply then taking me by the arm, lifted me over the railings of the park and deposited me on a quiet patch of grass. He swung a great heavy leather belt and made me undress down to my corset and stockings, which I had to roll down to my ankles.

In this condition I was made to lie on my face with my knees bent under me, he stood astride of me and gave me a glorious thrashing until I was 'blue', my nails filled with soil as I clawed the grass beneath me."

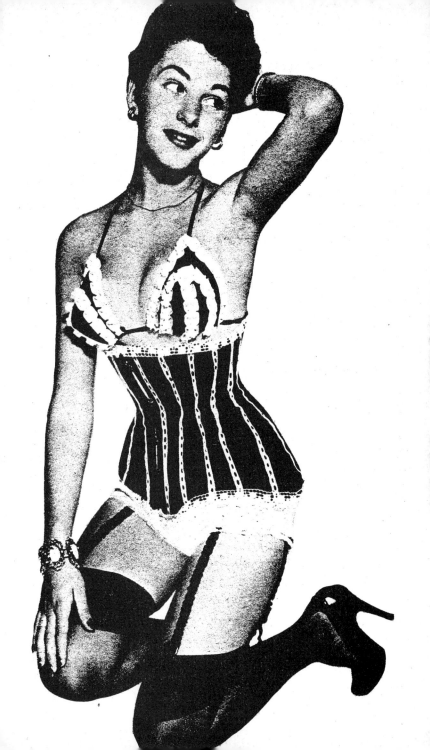

Then he cut off my suspender straps as souvenirs, watched me painfully dress, and escorted me gaily to a hansom cab, paying the driver and instructing him to take me safely home."

None of the "Spanking Toms" were ever caught, as insufficient evidence was received. The victims apparently being too reluctant to make spectacles of themselves in a courtroom . . . or perhaps because they enjoyed it?

Yours, truly,

G. W. M.

Newcastle on Tyne.

REAL GONE ORBIT

Dear Sir,

Since this is my first letter to you I'll just sort of stumble along.

When I first got your magazine I was pleasantly suprised. I didn't believe your advertising, but I took a chance. I was glad I did. I can find but one fault, there's not enough of it. In the idom of Rock "N" Roll-"I dig you the most", or something like that.

Many facets of your mag. attract me. About all I don't like is tattooing & Jewelry (Earrings, Nipplering, etc).

There is one difficulty concerning your publication. My wife does not see eye to eye with me. When I first acquired Bizarre I asked her to try the ideas on me.

She did, but soon tired of my eccentricity. Now she dislikes it. Ah, well.

I have a few adventures tho. When I first broached the subject she reluctantly agreed. We bought 2 Corsets, Ropes, Chains, and a pair of Boots. The boots were made in about 1900. They had very pointed toes and were very narrow. But they had flat heels. I took 4 inch heels off a pair of my wife's old shoes and mounted them on the boots. It was a lousy job. But worked. Since the boots were so narrow and were made for low heels, walking in them was extremely difficult. The corsets were remodeled, making them wasp waisted.

For the benefit of those interested I'll tell of one incident.

It all began with my wife getting the idea that she could possibly break me of my "habit" by giving me an overdose. She set about it with a vengeance. It was made simpler for her because I had just been laid off work due to poor business.

One morning I was happily surprised when Jane suggested I dress up. For once she gladly helped me. First, panties and bra were put on and padded appropriately, giving me proper breast and hips. Then she helped me into a body length corset.

Since this wasn't tight enough around the waist she made me put on her waist cincher. She wanted me to suffer good. With it on, my waist was laced from 29 inches to 22 inches. I thought I was going to die. Then she made me put on an old dress of hers. She tied this between my legs and had me put on her bright red jeans. She then ran a length of chain (an old dog leash) thru the loops around my waist. Using a small podlock she secured the chain to the puller on the zipper of the jeans. Dressed this way I couldn't undress even with my hands free. Since I couldn't bend over, Jane put the boots on me, she laced them up tight too. My hands were chained behind me and I was marched into the clothes closet where I was tied to the clothes bar. She tied my feet and knees together and gagged me. Using, I might add, J. W.'s. Nautilys from No. 10. Then she told me she was going out and would be gone most of the day. But so that I wouldn't know when she had left and returned I was to be blind folded and made deaf. She stuffed my ears with cotton (that she dipped in some kind of goo), padded my eyes with more cotton, wrapped a scaff over my eyes and ears, and over that she put on her bathing cap backwards.

Then to top it all off she wrapped a 3 inch wide role of bandage around my head, leaving only my nostrils exposed, and secured it with a liberal supply of tape.

By the time she had finished my feet were on fire and my waist was aching terribly.

Then I began to get worried. I doubted if I could last very long the way things were going. I tried to tell Jane. If she was still there the sounds I made must have sounded pretty silly to her. But they didn't have any effects. She left.

She later told me I was in there only an hour. It was hard to believe.

Finally I felt her untie me from the bar. She then untied my feet and knees. I had to be helped to the bed where I sat down.

Out of kindness she loosened the cincher. But I stayed dressed. And my hands stayed chained behind me, and head stayed bandaged. My feet were chained with enough slack for half a step and I had the run of the house.

I stayed imprisoned for the rest of the day. You can imagine the shape I was in when I was finally released. Nature called with great insistence, my mouth burned, and ached because of the

nattilus, my stomach muscles wouldn't work, my back hurt, and my feet were numb. Wow! boy did I have troubles. I didn't dress up for two months.

Luck to your magazine.
Sincerely,
L.J.W.

FLUFF SEEKER

Dear Editor,

Where are all the "Blind Girl Fluff's" and their fans? For awhile those of us with a penchant for "girls in darkness" were fairly well represented but lately . . . no letters, no picture, no stories. Since Bizarre is the ONLY place we can seek common ground I think we might be shown more favor.

I'm certain many of the bondage fanciers include blindfolding in their rituals and for many of us it is the favorite restraint.

I've known several girls who have accepted the idea of being blindfolded and come who became quite fond of being "blind". But when I met the lovely, slender Toni, who is now my bride, I found the perfect companion. Toni had long nursed a yen to be rendered helpless . . . and kept that way. On all of our dates she spent part or all the time "in the dark" and often restrained some other way. She has great imagination at devising new restraints and delightful costumes.

Now she spends more time "blind" than sighted. After tightly bandaging her eyes I put on a special half-helmet that locks with a small padlock so there is no possibiity of her seeing even a glimmer of light when I am away. (Of course scissors would cut the leather in an emergency where she would have to go out, such as a fire)

I also have such a helmet and she keeps the key to it. Often we are both "blind" . . . unable to see each other or anything else. Toni is very skilled at doing housework while in the dark. Sometimes she is incredibly appealing groping about the house in her bare feet. She has lovely, small feet and is always barefoot at home. All her shoes and stockings are kept locked up and doled out by me only when she must go out.

We made a sort of leotard out of heavy Jersey which hugs her figure from neck to ankles. This is not only an exciting outfit but keeps her warm without hiding anything. It is made with no openings for her arms so she always wears the single glove with it. She is here beside me as I write garbed this way. I have put a cigarette between her toes and she is smoking contentedly . . . a blind and armless Venus on which I feast my eyes while

she is in absolute darkness. On occasion I strap one leg behind her and she spends the day one-legged as well as blind, feeling her way around on crutches. Occasionally I strap her left wrist to her right ankle and she has to hop around on one bare foot and do everything one-handedly in her darkness. However, she is quite helpless when like that and gets uncomfortable after a short while.

Toni's enthusiam is as great as my own for our games and our greatest desire is to find a way in which she can go out in public while "blind". Perhaps some of your readers will have suggestions. We are eager for any.

Toni has just told me that as soon as I mail this I am to lock on my bandages and helmet. . . then she will take the key with her toes and pad off to hide it. We're off on a "dark weekend" but my groping hands will "show" me that lovely armless figure in her very special special costume.

Sincerely,
H.R. and "Blind & Barefoot"

CELESTE RETURNS
Dear Editor:

Since I wrote to you last, I've been very careful about continuing a formidable figure training regimen to keep well-disciplined curves. I have made a new leather coverall corset which is fitted to encase me from head to ankles so that I am stoutly corseted and laced-up tightly all over. This new one is lined with rubberized, coutil for strength and easy cleaning and of course requires lots of powder to make it lace tightly without pinching my skin anywhere.

It has surprised me no end, how I've come to love this most extreme corseting of my whole body! It is extremely thrilling to me to get all laced and strapped up for a training period, at my husband's insistence. He is now adding a new routine to my training which has me very uncomfortabe.

Up until recenty, my training has been mainly to get me thoroughly accustomed to my heavy corset and its unusual details. During this time I've spent much time just living in it, getting used to my full head and face mask so I don't need to see and hear or speak to do things around the house! At the same time, of course, I've been letting the torso part hold my wasp-waist in its minimum size of 14 ½ inches as it also slims my thighs, rounds my hips and keeps my breast molded as I desire. It has really done as I'd hoped,

too, but as I began to say, I've now added a training routine which I think is very unusual.

My husband told me he likes girls with rather long, slim neck lines so I've enlisted his help in making a neck trainer for me. I'm obliging his fancy by doing three things which are faster than the African girls way of wearing neck rings. First, I am in my training corset and helmet with my feet strapped to the floor and a head harness on, which permits a rope and pulley affair to stretch my neck by a weight on the end of the rope. I can, of course, stoop down some, but the tension is always on during this time. When I sleep or nap, I must have tension on my head too but less of it.

When it's time for me to get out of this fixed harness every day, I wear a sort of "shoulder saddle" which connects each shoulder pad by a bar of steel arching over my head. With this in place, I have my helmet harnessed by straps to the arch for traction on my head so that my husband is insistent that I wear this or remain in the fixed traction harnesses which make me stand in one place and motionless for long periods. Anyway, in either case I have to wear a tightly laced boned leather collar to help slim my neck too. Luckily,

there's a limit to "neck corseting" beyond which a girl must choke. He uses this to train me too, however. What happens is this: first I'm laced in my coverall corset just as tight as it will go where I can only breathe in faint puffs and cannot exert myself. When, this is done I must then be put in neck traction and have the collar on. Then he watches my breathing after ten minutes when I've been still and quiet and he commences lacing my collar until he sees my breathing slow down because of the constriction of my neck. This means any movement on my part exhausts my available breath and I then have to remain utterly still for several minutes to regain my "air". If I forget, I must endure much pain as I gasp for air: it is then like a hot wire running down my neck. It does sound like rather cruel torture when I write about it, but really, I don't mind it too much. I must admit, I wasn't used to "training" before I married and I didn't have all the attributes of what my husband likes in female beauty but he should have me as he dreams of me I think! Anyway, "il faut souffrir pour etre belle!" (I wonder how I would have appreciated my beauty if I had been born with all he wants in a female figure! I fancy I would have married some gentler man sooner, and missed out on

my real husband's fabulous repertoire!)

My neck training for five months has given me an additional 2 inches of length to my neck from shoulder level to chin level and reduced my neck 1 inch in circumference. Not only this but, it has also made my skin very taut and blemish-free and white around my neck in the same way my coverall corset has done all over me otherwise. It is amazing my husband wants my neck to be lengthened by another inch and then I quit (unless it begins to shorten again!).

I don't want a ten inch long neck like some of those African girls but it will be 6½ inches or so when I'm done! I presume I'll have to wear a collar in private to protect this length even when I'm done.

(If you put the first Drum Majorette of #9 page 22 into an "Ultra Mask", shoulder brace, and laced her arms like her legs, then collared her like "Bat Woman" you'd have a sketch of my training costume pretty well done, except for the neck traction harness.)

My husband is now fitting me with some ballet "slippers" like those shown in #7 page 45 and of course fitted with the ankle bands to mold and train my feet too. Actually, I have to **wear,** but they are so painful to **wear** due to the extreme arching imposed by them that I can only train for about an hour and a half so for each day. He makes me endure them for an additional five minutes each day while I'm strapped up for neck training so I can't take them off. They seem to be good foot training for extreme high heels though. High heels feel good after wearing these stiff "slippers". I'm sure my life sounds like one of constant discomfiture and agonies of self-imposed duress but I'd not deny it's not all pure pleasure. However since I've been training I've been able to obtain a number of well-paid modeling jobs (without my Bizarre costumes of course!). Before I went into training many attempts on my part to model clothes failed because of figure faults.

Celeste O.

POET'S CORNER

"THE GOOD OLD DAYS"

When I was a lad, and the weather was bad,
 No matter what time of the year,
I always was faced with being encased
 In shiny-black rubberized gear.

My boots went on first, and they were the worst
 Of this stormy weather disguise.
To keep my feet dry, they were pulled way up high
 And fastened with straps at my thighs.

My black rubber slicker brought many a snicker,
 For it was so big on me too.
When buckled within, from ankles to chin,
 I nearly was hidden from view.

And topping all that was my helmet-type hat—
 -A shoulder length black rubber hood.
When pulled down in place it enveloped my face,
 And I was "protected", but good.

Oh my, how I pained, whenever it rained;
 I felt almost helplessly trapped.
So great was the shame that unfailingly came
 With being all booted and wrapped.

I felt so disgraced by the teasing I faced
 When clocked in my black rubber shroud,
When ordered outside I wanted to hide,
 Away from the jeers of the crowd.

What made me hurt more as I'd clump to the door
 Were these final words in my ear:
"It's still raining yet, so don't you get wet.
 "And watch out for puddles, you hear?!"

But now that I'm older, I somehow feel bolder;
 I've lost all the old childish dread.
I no longer fear to wear rubber gear—
 It seems to delight me instead.
The sight and the feel of rubber that's real
 Now make me so strangely elated,
I just have a yen to put on again
 The same rubber things I once hated.
My big rubber boots were really black beauts,
 So shiny and sleek in the rain.
I'd love it, and how!, to pull them on now
 And clump about in them again.
My slicker would be just perfect for me,
 All buckled up snug and secure.
When wraped up inside of that black rubber hide
 I'd really be happy for sure.
And naturally, I, to keep my head dry,
 Would put on my black rubber hood.
Pulled snugly in place, encircling my face,
 That helmet would really feel good.
I know I'd enjoy being clad like a boy,
 In little-boys' water-tight clothes.
So don't be surprised should you see me disguised
 In rubber right down to my toes.

Don S.

A MATCH

If you were queen of pleasure,
 And I were king of pain,
We'd hunt down love together,
Pluck out his flying-feather,
And teach his feet a measure,
 And find his mouth a rein;
If you were queen of pleasure,
 And I were king of pain.

—Algernon Charles Swinburne

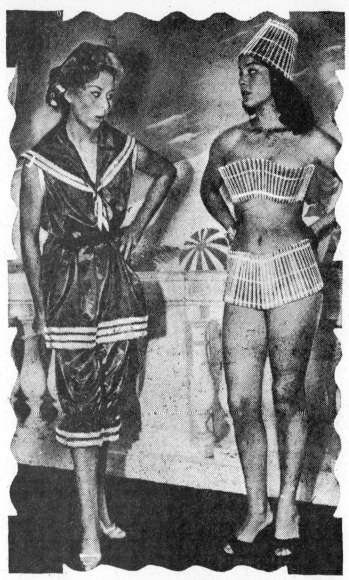

THE new bathing costumes are bound to stick. Here's one, shown in Paris last week, made of nylon and **THIN CANES.** Compare this with the 1900 bathing vogue. No wonder the modern miss takes some beating!

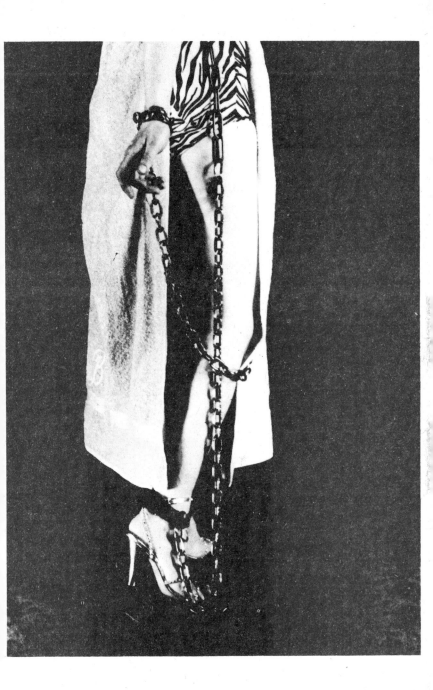

GO EAST, YOUNG MAN!

MARIO and JOHANNA

Dear Sir,

We (my husband and I) have just seen a copy of your lovely magazine, No 11, and we enjoyed it so much that we are writting to friends of ours in the States to obtain other issues.

In particular we liked the letters from Nicole about solving the maid problem by converting her husband into a pretty maid, "Gisele", and from Bettie C. about transforming her hubby, Robert, into her "sister" in business, Roberta. Both letters make reference to other correspondence dealing with dressing boys and men as girls and women, so that, as this seems to be a popular subject with your readers, we thought you would like to hear how Johannes (my hubby) became my sister, Johanna, although I still call him by the name I knew him by, when I first met him four years ago in New York, - Johnny, as this is accepted here as the shortened form for either name. By the way, Johnny is Danish, while I was born in Bristol, England. I was a school-teacher in the States on an exchange basis, when I met Johnny at a lively fancy-dress party.

I have always been something of a feminist, and I always got a kick out of seeing a female imper-

sonator, wheather professional or amateur, and I confess to having secretly taking a great delight in transforming boys into pretty girls in school theatricals (I was teaching in an all-boys school), so that when, dressed at the party as a man, I was introduced to an attractive girl, whom I was told was a man, I was thrilled to bits. It was, of course, Johnny, and we hit it off well together from the first. He made a really pretty girl, and when he found that I openly admired him in skirts, he told me all about himself.

He had been sent to America by his father to study and he was shortly returning home to Denmark. His friends had talked him into masquerading as a girl once or twice, and a sister of one of the friends had helped him achieve this end. He said he got quite a kick out of it, and finding me sympathetic, he blushingly said he quite liked the feel of being laced in and wearing soft silks and laces. This excited me no end, and I determined then and there that Johnny and I were going to get married. Naturally I said nothing, but the fact remains he is now my hubby.

Long before he left for Europe, we had become the closest of friends, though, if he sensed my interest, he never showed it. We corresponded regularly, and, on

my return to England, it was not long before Johnny felt affiinity towards me, and we were soon deeply in love. Shortly after we were married, but not before I had told him, when he proposed to me, that I would only accept if he were prepared to become "Johanna" whenever I wanted him to. He laughed at this, but agreed - that was almost three years ago now, and, in our flat and frequently outside it, Johnny has become my "sister" nearly every evening, at week-ends and even for prolonged spells during holidays.

Although Johnny is just my size and has very small hands and feet, he has a feminine wardrobe all of his own, though in many respects identical with my own. But I must say that, on our honeymoon, there was more than one occasion when Johannes became Johanna and Maria (that's me) became Mario, - and what fun we got out of it.

Good as Johnny's transformation was, when he saw how keen I was to make it perfect, he agreed to every suggestion I made. First I gave him a course of progressive tight-lacing and of vacuum cups, so that he now has a figure many a girl would love to have. His ears have been pierced and unwanted hair removed by electrolysis, while

THE COLD & THE HOT

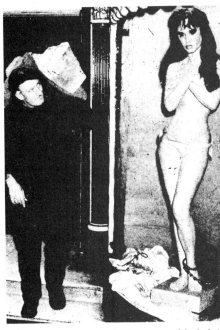

Iceman gets an eyeful of chain Bardot statue in London thea

Item: *A life-like semi-nude plastic statue of Brigitte on display in a British movies house has attracted tremendous crowds, and has to be watched carefully lest someone get too friendly with it and try to take home.*

creams, etc., have worked wonders with his skin. Massaging removed any muscularity in his arms or legs, while walking with a short step and feminine swinging of the hips was induced by the use of higher and higher heels. I obtained two very expensive real-hair wigs for him, and these so suited him that he gained in confidence when he had one on.

Side by side with all this protracted treatment, he became thoroughly accustomed to his feminine attire. Each evening his routine on arriving home was a hot, scented bath, corseting, bosom treatment, etc., and then dressing in whatever I had laid out for him. Finally the making-up of his face and hands, the fixing on of the wig, the putting on of jewellery - and there was my sister for the evening. Johnny has said from the first how much he likes it, but I have to laugh sometimes when I catch him unawares, like a modern Narcissus, admiring in a mirror, reflecting a pretty girl in figure-fitting filmy undies, tautly-suspendered and gartered sheer nylons and pencil-heeled shoes. His wardrobe is extensive, and his taste in clothes is costly, but fortunately we are fairly well off and can afford to satisfy our whims.

He has often been out with me to a restaurant or theatre, but his most daring escapade was when he went, as a girl, to a stylish shop to buy a frock for himself, and tried it on there. I thrilled as I sat and watched the assistant helping him. She obviously admired this smart client, but I wonder what her reaction would have been, had she known that she was dressing a man and not a lady, as seemed obvious from the smiling face, lovely hair, dainty camiknickers over prominent girlish curves, shapely legs in sheerest of nylons and tiny feet in chic high-heeled shoes. There's no doubt about it that Johnny was enjoying being so daring, and, in the end, the girl, too, was quite content, when she received a handsome tip from her charming, husky-voiced customer.

I do hope my account proves of interest to you and that we will read of other boys who enjoy becoming girls.

Yours sincerely,
"Johanna's Sister

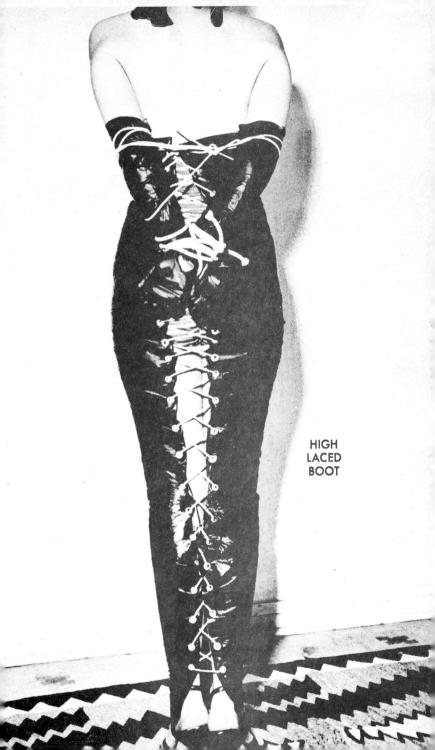

HIGH
LACED
BOOT

TWO PIECES

Dear Mr. Willie:

Being rather enthusiastic about your magazine and its particular brand of idealism I read rather er interestedly all communications particular brand I read rather interestedly, all communications and articles. Not only is there a certain flavor exuding from these magazine numbers but no less a very interesting contribution to the chapter: Human Psychology, or Kinsey might call it Human Behavior. However there is a certain amount of danger, that certain topics are monopolizing the space and interest. I think this would not favor the spread of the magazine and slows down the growth of your subscription or gives your readers a disagreeable repetition of the same ideas, the same experience and reactions. I am not trying to tell you what to do in a criticising manner, but I think it would help your own cause, the ideal one as well as the material one, if you see to it that there is a greater variety of subjects treated than the few almost exclusively, heels, corsets, etc. I could have written considerable about my experience and reaction to and love for things feminine but I felt that the piercing subject should have the priority just for the sake of variety in the diet. I may later on if agreeable write about the other subjects that have my interest which I would like to share with my fellow "bizarristies." O. K. Boss? If so print my letter in one piece or two as you see fit.

Very sincerely yours

M.F.

INITIATION

Sirs,

I thought you might be interested in reading about my experience when a boy of eleven.

My sister, who is five years older than I, belonged to a club at that time which was made up of girls her own age. They met at different members' houses periodically and, of course, I was excluded from the proceedings. At the age of eleven I was quite a "brat" and got to see many of their meetings.

One evening when my sister was taking care of me while our parents were out, I pleaded with her to let me in on one of the meetings sometime and she said that only official members could be allowed into the meeting and that I wasn't a member. When I asked how I could become one she said I had to be initiated first. I told her I was willing to be initiated (although I hadn't the slightest idea of what the word

meant). After a little persuasion she agreed to give me the initiation but said I would have to dress in the official uniform of the club first or I couldn't be initiated. I was told that the uniform was a white blouse and navy blue jumper of the kind that was popular then. I eagerly agreed to put on the uniform if she gave me one, and sure enough she got the outfit out of her closet. Along with the blouse and jumper she brought a pair of powder-blue panties and pair of knee length stockings. When she told me I had to wear those too, I balked, but then I soon agreed to it when she wanted to call the whole thing off.

I took the garments to my room where I put them on. When I came out and confronted her, we laughed at the way I looked. Then I was "initiated". This was simply a good old fashioned spanking lying over her lap with the skirt of the jumper lifted and the seat of my pants being warmed with a ping-pong paddle. It didn't hurt much and I got a great kick out of it. I guess I associated that paddling with the clothes I was wearing, for whenever I saw my sister in them or any other girl in similar attire, my bottom tingled with remembrance.

Gerry

Positional Tactic

Dear Sirs:

I think taboos on discussion of discipline seem to be lifting. My wife and I are very interested in the subject and are corresponding with, and know of, a number of other couples equally interested.

In our cases, the man dominates—spankings are given for punishment—but other spankings are given in fun for pleasure. It can be effective for punishment —it is, otherwise, even more effective. I believe that part of it is responsible for misunderstanding. When the sex stimulation enters prudish people consider it dirty or immoral as they are ashamed to admit their physical reactions etc. We, and our friends, think that for couples who understand it, has a place in marital, parental and sexual life.

Most of our punishments involve the use of a paddle, bare palm or occassionally a belt or strap applied to the bare posterior while bent over knee, desk or chair. We do not approve of riding crops, Canes, towse etc. although we know some people who do use them. Occassionally the woman lies on her back and draws her knees under her chin to be spanked but in most cases the simpler positions are most frequently used. MDP